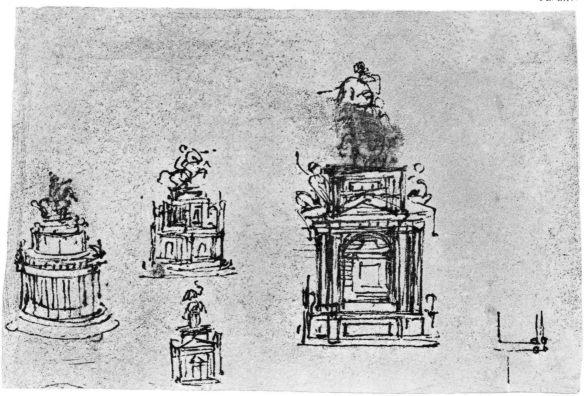

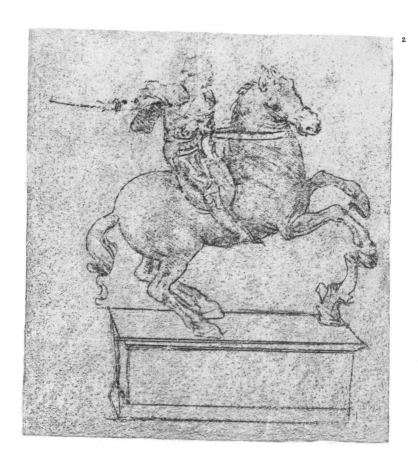

THE NOTEBOOKS OF LEONARDO DA VINCI

Compiled and edited

from the original manuscripts

by Jean Paul Richter

In two Volumes

VOLUME II

Dover Publications, Inc., New York

This Dover edition, first published in 1970, is an unabridged
edition of the work first published in London in 1883 by Sampson
Low, Marston, Searle & Rivington, with the title *The Literary
Works of Leonardo da Vinci*. In the present edition the typo-
graphical errors which have come to our attention, including all
those noted on the Errata pages of the first edition, have been
corrected in the text. The illustrations printed in color in the
original edition are reproduced here in black and white.

Standard Book Number: 486-22573-9
Library of Congress Catalog Card Number: 72-104981

Manufactured in the United States of America
Dover Publications, Inc.
180 Varick Street
New York, N.Y. 10014

CONTENTS OF VOLUME II.

All drawings here reproduced are in pen and ink, unless otherwise stated. The reproductions are of the exact size of the originals, except that Plates LXVI, XCVIII, CVII, CIX, CXI No. 1, CXII, CXIII, CXIV, CXVI, CXVII, CXVIII and CXXII are reduced, and Plate CXIX enlarged. Plate LXV is the frontispiece; Plate LXVI is on p. 134; Plates LXVII–XCVI follow p. 134; Plate XCVII is on p. 312; Plates XCVIII—CXXII follow p. 312.

LIST OF ILLUSTRATIONS IN VOLUME II.

XI.

The notes on Sculpture.

Compared with the mass of manuscript treating of Painting, a very small number of passages bearing on the practice and methods of Sculpture are to be found scattered through the note books; these are here given at the beginning of this section (Nos. 706—709). There is less cause for surprise at finding that the equestrian statue of Francesco Sforza is only incidentally spoken of; for, although Leonardo must have worked at it for a long succession of years, it is not in the nature of the case that it could have given rise to much writing. We may therefore regard it as particularly fortunate that no fewer than thirteen notes in the master's handwriting can be brought together, which seem to throw light on the mysterious history of this famous work. Until now writers on Leonardo were acquainted only with the passages numbered 712, 719, 720, 722 and 723.

In arranging these notes on sculpture I have given the precedence to those which treat of the casting of the monument, not merely because they are the fullest, but more especially with a view to reconstructing the monument, an achievement which really almost lies within our reach by combining and comparing the whole of the materials now brought to light, alike in notes and in sketches.

A good deal of the first two passages, Nos. 710 and 711, which refer to this subject seems obscure and incomprehensible; still, they supplement each other and one contributes in no small degree to the comprehension of the other. A very interesting and instructive commentary on these passages may be found in the fourth chapter of Vasari's

Introduzione della Scultura under the title „Come si fanno i modelli per fare di bronzo
le figure grandi e picciole, e come le forme per buttarle; come si armino di ferri, e come
si gettino di metallo," &c. *Among the drawings of models of the moulds for casting
we find only one which seems to represent the horse in the act of galloping—No. 713.
All the other designs show the horse as pacing quietly; and as these studies of the horse
are accompanied by copious notes as to the method of casting, the question as to the
position of the horse in the model finally selected, seems to be decided by preponderating
evidence.* "Il cavallo dello Sforza"—*C. Boito remarks very appositely in the Saggio on
page 26,* "doveva sembrare fratello al cavallo del Colleoni. E si direbbe che questo fosse
figlio del cavallo del Gattamelata, il quale pare figlio di uno dei quattro cavalli che sta-
vano forse sull'Arco di Nerone in Roma" *(now at Venice).* *The publication of the
Saggio also contains the reproduction of a drawing in red chalk, representing a horse
walking to the left and supported by a scaffolding, given here on Pl. LXXVI, No. 1.
It must remain uncertain whether this represents the model as it stood during the pre-
parations for casting it, or whether—as seems to me highly improbable—this sketch shows
the model as it was exhibited in 1493 on the Piazza del Castello in Milan under a
triumphal arch, on the occasion of the marriage of the Emperor Maximilian to Bianca
Maria Sforza.* *The only important point here is to prove that strong evidence seems to
show that, of the numerous studies for the equestrian statue, only those which represent
the horse pacing agree with the schemes of the final plans.*

*The second group of preparatory sketches, representing the horse as galloping,
must therefore be considered separately, a distinction which, in recapitulating the history
of the origin of the monument seems justified by the note given under No. 720.*

*Galeazzo Maria Sforza was assassinated in 1476 before his scheme for erecting a
monument to his father Francesco Sforza could be carried into effect. In the following
year Lodovico il Moro the young aspirant to the throne was exiled to Pisa, and only
returned to Milan in 1479 when he was Lord (Governatore) of the State of Milan, in 1480
after the minister Cecco Simonetta had been murdered. It may have been soon after
this that Lodovico il Moro announced a competition for an equestrian statue, and it is
tolerably certain that Antonio del Pollajuolo took part in it, from this passage in Vasari's
Life of this artist:* "E si trovò, dopo la morte sua, il disegno e modello che a Lodo-
vico Sforza egli aveva fatto per la statua a cavallo di Francesco Sforza, duca di Milano;
il quale disegno è nel nostro Libro, in due modi: in uno egli ha sotto Verona; nell'altro,
egli tutto armato, e sopra un basamento pieno di battaglie, fa saltare il cavallo addosso
a un armato; ma la cagione perchè non mettesse questi disegni in opera, non ho già
potuto sapere." *One of Pollajuolo's drawings, as here described, has lately been discovered
by Senatore Giovanni Morelli in the Munich Pinacothek. Here the profile of the horseman
is a portrait of Francesco Duke of Milan, and under the horse, who is galloping to the
left, we see a warrior thrown and lying on the ground; precisely the same idea as we find*

in some of Leonardo's designs for the monument, as on Pl. LXVI, LXVII, LXVIII, LXIX and LXXII No. 1; and, as it is impossible to explain this remarkable coincidence by supposing that either artist borrowed it from the other, we can only conclude that in the terms of the competition the subject proposed was the Duke on a horse in full gallop, with a fallen foe under its hoofs.

Leonardo may have been in the competition there and then, but the means for executing the monument do not seem to have been at once forthcoming. It was not perhaps until some years later that Leonardo in a letter to the Duke (No. 719) reminded him of the project for the monument. Then, after he had obeyed a summons to Milan, the plan seems to have been so far modified, perhaps in consequence of a remonstrance on the part of the artist, that a pacing horse was substituted for one galloping, and it may have been at the same time that the colossal dimensions of the statue were first decided on. The designs given on Pl. LXX, LXXI, LXXII, 2 and 3, LXXIII and LXXIV and on pp. 4 and 24, as well as three sketches on Pl. LXIX may be studied with reference to the project in its new form, though it is hardly possible to believe that in either of these we see the design as it was actually carried out. It is probable that in Milan Leonardo worked less on drawings, than in making small models of wax and clay as preparatory to his larger model. Among the drawings enumerated above, one in black chalk, Pl. LXXIII—the upper sketch on the right hand side, reminds us strongly of the antique statue of Marcus Aurelius. If, as it would seem, Leonardo had not until then visited Rome, he might easily have known this statue from drawings by his former master and friend Verrocchio, for Verrocchio had been in Rome for a long time between 1470 and 1480. In 1473 Pope Sixtus IV had this antique equestrian statue restored and placed on a new pedestal in front of the church of San Giovanni in Laterano. Leonardo, although he was painting independently as early as in 1472 is still spoken of as working in Verrocchio's studio in 1477. Two years later the Venetian senate decided on erecting an equestrian statue to Colleoni; and as Verrocchio, to whom the work was entrusted, did not at once move from Florence to Venice—where he died in 1488 before the casting was completed—but on the contrary remained in Florence for some years, perhaps even till 1485, Leonardo probably had the opportunity of seeing all his designs for the equestrian statue at Venice and the red chalk drawing on Pl. LXXIV may be a reminiscence of it.

The pen and ink drawing on Pl. LXXII, No. 3, reminds us of Donatello's statue of Gattamelata at Padua. However it does not appear that Leonardo was ever at Padua before 1499, but we may conclude that he took a special interest in this early bronze statue and the reports he could procure of it, form an incidental remark which is to be found in C. A. 145ᵃ; 432ᵃ, and which will be given in Vol. II under Ricordi or Memoranda.

Among the studies—in the widest sense of the word—made in preparation for this statue we may include the Anatomy of the Horse which Lomazzo and Vasari both mention; the most important parts of this work still exist in the Queen's Library at

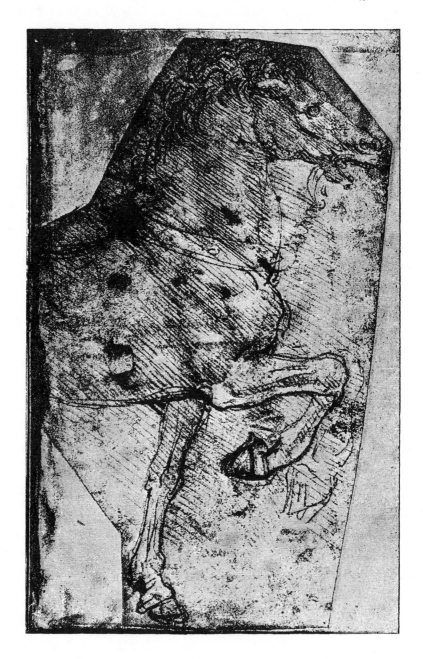

Windsor. It was beyond a doubt compiled by Leonardo when at Milan; only a few interesting records to be found among these designs are reproduced in Nos. 716 and 717; but it must be pointed out that out of 40 sheets of studies of the movements of the horse belonging to that treatise, a horse in full gallop occurs but once.

If we may trust the account given by Paulus Jovius—about 1527—*Leonardo's horse was represented as* "vehementer incitatus et anhelatus". *Jovius had probably seen the model exhibited at Milan; but, need we, in fact, infer from this description that the horse was galloping? Compare Vasari's description of the Gattamelata monument at Padua:* "Egli [Donatello] vi andò ben volentieri, e fece il cavallo di bronzo, che è in sulla piazza di Sant Antonio, nel quale si dimostra lo sbuffamento ed il fremito del cavallo, ed il grande animo e la fierezza vivacissimamente espressa dall'arte nella figura che lo cavalca".

These descriptions, it seems to me, would only serve to mark the difference between the work of the middle-ages and that of the renaissance.

We learn from a statement of Sabbà da Castiglione that, when Milan was taken by the French in 1499, *the model sustained some injury; and this informant, who, however is not invariably trustworthy, adds that Leonardo had devoted fully sixteen years to this work* (la forma del cavallo, intorno a cui Leonardo avea sedici anni continui consumati). *This often-quoted passage has given ground for an assumption, which has no other evidence to support it, that Leonardo had lived in Milan ever since* 1483. *But I believe it is nearer the truth to suppose that this author's statement alludes to the fact that about sixteen years must have past since the competition in which Leonardo had taken part.*

I must in these remarks confine myself strictly to the task in hand and give no more of the history of the Sforza monument than is needed to explain the texts and drawings I have been able to reproduce. In the first place, with regard to the drawings, I may observe that they are all, with the following two exceptions, in the Queen's Library at Windsor Castle; the red chalk drawing on Pl. LXXVI No. 1 *is in the MS. C. A. (see No.* 712) *and the fragmentary pen and ink drawing on page* 4 *is in the Ambrosian Library. The drawings from Windsor on Pl. LXVI have undergone a trifling reduction from the size of the originals.*

There can no longer be the slightest doubt that the well-known engraving of several horsemen (Passavant, Le Peintre-Graveur, Vol. V, p. 181, *No.* 3) *is only a copy after original drawings by Leonardo, executed by some unknown engraver; we have only to compare the engraving with the facsimiles of drawings on Pl. LXV, No.* 2, *Pl. LXVII, LXVIII and LXIX which, it is quite evident, have served as models for the engraver.*

On Pl. LXV No. 1, *in the larger sketch to the right hand, only the base is distinctly visible, the figure of the horseman is effaced. Leonardo evidently found it unsatisfactory and therefore rubbed it out.*

The base of the monument—the pedestal for the equestrian statue—is repeatedly sketched on a magnificent plan. In the sketch just mentioned it has the character of a shrine or aedicula to contain a sarcophagus. Captives in chains are here represented on the entablature with their backs turned to that portion of the monument which more

strictly constitutes the pedestal of the horse. The lower portion of the aedicula is surrounded by columns. In the pen and ink drawing Pl. LXVI—the lower drawing on the right hand side—the sarcophagus is shown between the columns, and above the entablature is a plinth on which the horse stands. But this arrangement perhaps seemed to Leonardo to lack solidity, and in the little sketch on the left hand, below, the sarcophagus is shown as lying under an arched canopy. In this the trophies and the captive warriors are detached from the angles. In the first of these two sketches the place for the trophies is merely indicated by a few strokes; in the third sketch on the left the base is altogether broader, buttresses and pinnacles having been added so as to form three niches. The black chalk drawing on Pl. LXVIII shows a base in which the angles are formed by niches with pilasters. In the little sketch to the extreme left on Pl. LXV, No. 1, the equestrian statue serves to crown a circular temple somewhat resembling Bramante's tempietto of San Pietro in Montorio at Rome, while the sketch above to the right displays an arrangement faintly reminding us of the tomb of the Scaligers in Verona. The base is thus constructed of two platforms or slabs, the upper one considerably smaller than the lower one which is supported on flying buttresses with pinnacles.

On looking over the numerous studies in which the horse is not galloping but merely walking forward, we find only one drawing for the pedestal, and this, to accord with the altered character of the statue, is quieter and simpler in style (Pl. LXXIV). It rises almost vertically from the ground and is exactly as long as the pacing horse. The whole base is here arranged either as an independent baldaquin or else as a projecting canopy over a recess in which the figure of the deceased Duke is seen lying on his sarcophagus; in the latter case it was probably intended as a tomb inside a church. Here, too, it was intended to fill the angles with trophies or captive warriors. Probably only No. 724 in the text refers to the work for the base of the monument.

If we compare the last mentioned sketch with the description of a plan for an equestrian monument to Gian Giacomo Trivulzio (No. 725) it seems by no means impossible that this drawing is a preparatory study for the very monument concerning which the manuscript gives us detailed information. We have no historical record regarding this sketch nor do the archives in the Trivulzio Palace give us any information. The simple monument to the great general in San Nazaro Maggiore in Milan consists merely of a sarcophagus placed in recess high on the wall of an octagonal chapel. The figure of the warrior is lying on the sarcophagus, on which his name is inscribed; a piece of sculpture which is certainly not Leonardo's work. Gian Giacomo Trivulzio died at Chartres in 1518, only five months before Leonardo, and it seems to me highly improbable that this should have been the date of this sketch; under these circumstances it would have been done under the auspices of Francis I, but the Italian general was certainly not in favour with the French monarch at the time. Gian Giacomo Trivulzio was a sworn foe to Ludovico il Moro, whom he strove for years to overthrow. On the 6th September 1499 he marched victorious into Milan at the head

of a French army. In a short time, however, he was forced to quit Milan again when Ludovico il Moro bore down upon the city with a force of Swiss troops. On the 15th of April following, after defeating Lodovico at Novara, Trivulzio once more entered Milan as a Conqueror, *but his hopes of becoming* Governatore *of the place were soon wrecked by intrigue. This victory and triumph, historians tell us, were signalised by acts of vengeance against the dethroned Sforza, and it might have been particularly flattering to him that the casting and construction of the Sforza monument were suspended for the time.*

It must have been at this moment—as it seems to me—that he commissioned the artist to prepare designs for his own monument, which he probably intended should find a place in the Cathedral or in some other church. He, the husband of Marghe- rita di Nicolino Colleoni, would have thought that he had a claim to the same distinc- tion and public homage as his less illustrious connection had received at the hands of the Venetian republic. It was at this very time that Trivulzio had a medal struck with a bust portrait of himself and the following remarkable inscription on the reverse: **DEO FAVENTE · 1499 · DICTVS · IO · IA · EXPVLIT · LVDOVICṼ · SF ·** (Sfortiam) **DVC ·** (ducem) **ML1** (Mediolani) **· NOĪE** (nomine) **· REGIS · FRANCORVM · EODEM · ANN ·** (anno) **RED'T** (redit) **· LVS** (Ludovicus) **· SVPERATVS ET CAPTVS · EST · AB · EO.** *In the Library of the Palazzo Trivulzio there is a MS. of Callimachus Siculus written at the end of the XVth or beginning of the XVIth century. At the beginning of this MS. there is an exquisite illuminated miniature of an equestrian statue with the name of the general on the base; it is however very doubtful whether this has any connection with Leonardo's design.*

Nos. 731—740, which treat of casting bronze, have probably a very indirect bearing on the arrangements made for casting the equestrian statue of Francesco Sforza. Some portions evidently relate to the casting of cannon. Still, in our researches about Leonardo's work on the monument, we may refer to them as giving us some clue to the process of bronze casting at that period.

De statua.

²Se vuoi · fare · vna · figura · di marmo · fa ne · prima vna ³di terra ·, la quale, finita che l' ài, secca e mettila in vna ⁴cassa · che sia · ancora capace ·, dopo la figura tratta ⁵d'esso · loco ·, a ricieuere il marmo · che vuoi scoprir⁶vi dentro la figura · alla · similitudine · di quella · di terra ·; di poi ⁷messa la figura di terra in detta cassa · abbi bacchette ch'ētrino ⁸apūto · per i sua · busi ·, e spingile · dentro · tāto · per ciascuno ⁹buso · che ciascuna bacchetta biāca · tocca · la figura · in ¹⁰diuersi lochi, e la parte d'esse bacchette, che resta · fori della ¹¹cassa, tigni di nero, e fa il cōtrassegno · alla · bacchetta e al ¹²suo · buso · in modo · che a tua · posta · si scōtrī; ¹³e trai d'essa · cassa · la figura · di terra · e mettivi il tuo¹⁴pezzo · di marmo, e tāto leua del marmo ·, che tutte le ¹⁵tue · bacchette · si nascondino · sino al loro segnio in detti busi, ¹⁶e per potere questo · meglio fare · fa che tutta · la cassa si po¹⁷ssa · leuare in alto, e'l fondo · d'essa cassa resti sēpre · sotto ¹⁸il marmo ed a questo modo ne potrai · leuare coi ferri ¹⁹con grā facilità.

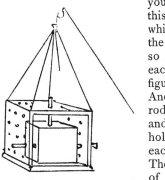

Of a statue.

If you wish to make a figure in marble, Some practical hints (706—709). first make one of clay, and when you have finished it, let it dry and place it in a case which should be large enough, after the figure is taken out of it, to receive also the marble, from which you intend to reveal the figure in imitation of the one in clay. After you have put the clay figure into this said case, have little rods which will exactly slip in to the holes in it, and thrust them so far in at each hole that each white rod may touch the figure in different parts of it. And colour the portion of the rod that remains outside black, and mark each rod and each hole with a countersign so that each may fit into its place. Then take the clay figure out of this case and put in your piece of marble, taking off so much of the marble that all your rods may be hidden in the holes as far as their marks; and to be the better able to do this, make the case so that it can be lifted up; but the bottom of it will always remain under the marble and in this way it can be lifted with tools with great ease.

1. desstatua. 2. sevolli. 3. tera . . chellai essecha mettila nvna. 4. chassa chessia anchorá [dop atta] "capace". 5. loco . . [chē] schoprir. 7. tera . . chassa . abi bachette. 8. apūto . . esspignile . . tāto [che] per ciasschuno. 9. ciassuna bachetta biācha tocha. 10. bachette . . ressta. 11. chassa . . effa . . chōtrassegnio . . bachetta. 12. sio buso imodo . . atta . . sisschōtri [ettare lasi]. 13. ettrai . . chassa . . tera. 14. pezo . . ettāto . . chettutte. 15. bachette . . naschōdino . . aloro. 16. chettutta . . chassa. 17. chasa ressti. 18. acquesto . . cho. 19. chon.

W. P. 5a]

707.

Alcvni àño errato a insegniare alli scultori ²circundare con fili i mēbri · delle loro figure, ³quasi credendo che essi menbri sieno d'equale ⁴rotondità, in qualunque parte da essi fili ⁵circundati sieno.

Some have erred in teaching sculptors to measure the limbs of their figures with threads as if they thought that these limbs were equally round in every part where these threads were wound about them.

A. I a]

708.

MISURE E CŌPARTITIONE DELLA STATUA.

²Diuidi la testa in 12 gradi, e ciascuno grado · diuidi in 12 pūti, e ciascuno ³pūto · in 12 minvti ·, e i minvti in minimi, e i minimi ī semiminimi.

⁴Grado — punto — minvto — minimo.

MEASUREMENT AND DIVISION OF A STATUE.

Divide the head into 12 degrees, and each degree divide into 12 points, and each point into 12 minutes, and the minutes into minims and the minims into semi minims.

Degree—point—minute—minim.

Ash. I. 19b]

709.

¶ Le figure di rilievo che pajono · ī moto ·, posandole in piè, per ragione deō cadere jnāzi.

Sculptured figures which appear in motion, will, in their standing position, actually look as if they were falling forward.

W. X.]

710.

Notes on the casting of the Sforza monument (710—715).

3 Ferri che cingā la forma. ²[Se uolli fare presti gietti e ³senplici, fagli con vna cassa ⁴di sabbione di fiume invmidito con ⁵acieto.]

Three braces which bind the mould. [If you want to make simple casts quickly, make them in a box of river sand wetted with vinegar.]

 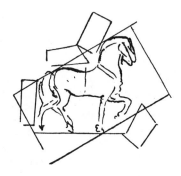 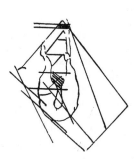

707. 1. alchuni . . erato ansegniare. 2. chirchundare. 3. menbr. 4. retondita. 5. circhundati.
708. 1. chōpartitione. 2. 12 [parti e] gradi. 3. minvti iminimi e e. 4. grado [minvto] punto.
709. 1. pajano . . chadere.
710. *These passages are written in ink and subsequently crossed through with red chalk.* 3. chon. 4. sabiō . . cho. 6. arai .

709. *figure di rilievo.* Leonardo applies this term exclusively to wholly detached figures, especially to those standing free. This note apparently refers to some particular case, though we have no knowledge of what that may have been. If we suppose it to refer to the first model of the equestrian statue of Francesco Sforza (see the introduction to the notes on Sculpture) this observation may be regarded as one of his arguments for abandoning the first scheme of the Sforza Monument, in which the horse was to be galloping (see page 2). It is also in favour of this theory that the note is written in a manuscript volume already completed in 1492. Leonardo's opinions as to the shortcomings of plastic works when compared with paintings are given under No. 655 and 656.

⁶[Quando · tu . avrai · fatto · la ⁷forma · sopra · il cauallo e tu ⁸farai la grossezza del metallo ⁹di terra.]

¹⁰Nota · nello allegare · quante · ore · vā · per cētinajo ¹¹[nel gittare ognuno tenga stoppato · il fornello col ¹²suo · infocato]; ¹³[nel dentro di tutta la forma · sia inbeuerato olio ¹⁴di lin seme o di tremētina; e poi sia dato vna mano ¹⁵di poluere di borace e di pece greca con acqua vite, ¹⁶e la forma di fori inpeciata, acciochè stādo sotto ¹⁷terra l'umido non la . . .

²⁴[Per maneggiare la forma grāde, fa ne modello della pi²⁵ccola forma; fa una piccola stātia a proportione;]
²⁶[fa le bocche alla forma, mētre ch'è in sul cavallo;]
²⁷¶Tieni le corna · in molle ·, e fondile con cōlla di pesce¶ ²⁸pesa le parti ²⁹della forma, da che quātità ³⁰di metallo ella à a essere occupata, ³¹e tāto ne da al fornello, che ³²a quella parte à a porgere il ³³suo metallo, e questo cognio³⁴scerai a pesare la terra di quella ³⁵parte della forma, dove il fornel³⁶lo colla sua quātità à a rispōde-³⁷re, e questo si fa aciochè 'l ³⁸fornello delle gābe le ēpia, e che ³⁹dalle gābe non abbia a socorrere ⁴⁰alla testa che sarebbe inpossibile] ⁴¹[gitta nel medesimo ⁴²gietto del cavallo ⁴³lo sportello della]

[When you shall have made the mould upon the horse you must make the thickness of the metal in clay.]

Observe in alloying how many hours are wanted for each hundredweight. [In casting each one keep the furnace and its fire well stopped up.] [Let the inside of all the moulds be wetted with linseed oil or oil of turpentine, and then take a handful of powdered borax and Greek pitch with aqua vitae, and · pitch the mould over outside so that being under ground the damp may not [damage it?]

[To manage the large mould make a model of the small mould, make a small room in proportion.]
[Make the vents in the mould while it is on the horse.]
Hold the hoofs in the tongs, and cast them with fish glue. Weigh the parts of the mould and the quantity of metal it will take to fill them, and give so much to the furnace that it may afford to each part its amount of metal; and this you may know by weighing the clay of each part of the mould to which the quantᶦtᵥ in the furnace must correspond. And this is done in order that the furnace for the legs when filled may not have to furnish metal from the legs to help out the head, which would be impossible. [Cast at the same casting as the horse the little door]

FORMA DEL CAVALLO. THE MOULD FOR THE HORSE.

²Fa il cavallo sopra gambe di ferro ferme e stabili in bo³no fondamēto, poi lo inseva e fa gli la cappa di sopra, ⁴lasciādo ben seccare a suolo a suolo, e questa ingras⁵serai tre dita ·, di poi arma e ferra secondo il biso⁶gno; oltre a di questo cava

Make the horse on legs of iron, strong and well set on a good foundation; then grease it and cover it with a coating, leaving each coat to dry thoroughly layer by layer; and this will thicken it by the breadth of three fingers. Now fix and bind it with

facto. 7. chauallo ettu. 8. grosseza. 10. hore va . . ciētinaro. 11· hognivno . . stopato . . chol. 12. infochato mādiriano ea ū tenpo di stoppi. 13. holio. 14. poi dato. 15. grecha chon acq"a". 16. ella . . chesstādo. 17. lomido nolla \\\\\\\\\\\\\\\\\\ chose. 18. fatte subito chella \\\\\\\\\\\\\\\\\\\. 19. il sabione di for \\\\\\\\\\\\\\\\\ azzo cioe di. 20. quello da fforme\\\\\\\\\\\\\\ chon acieto. 21. e ben \\\\\\\\\\\\\\. 22. miscia nella forma \\\\\\\\\ uno quadrello. 23. pesto . e cienere cō ciara douo e a ceto. 24. manegiare. 25. cholla . . falle una pichola. 26. falle boche. 27. chorna imole effondile chōlla di pesscie. 28. pensa [la forma] le. 30. ella essere ochupata. 31. ettāto. 32. acquella parte a porgiere. 33. ecquesto chogɴio. 34. sscierai . . tera. 35. forne. 36. cholla . . risspōde. 37, ecquesto. 38. ecquesto. 38. gābe ēpinteche *doubtful*. 39. ale . . abiasschorrer. 40. chessa rebe inpossib. 42. chavallo. 43. sportello della. *Here the text breaks off.*
711. 2. ghanbe . . esstabile. 3. sondomēto . . effagli la chappa. 4. scechare assuolo assuclo . . ecquesta. 5. efferra sechondo. 6. chava

710. The importance of the notes included under this number is not diminished by the fact that they have been lightly crossed out with red chalk. Possibly they were the first scheme for some fuller observations which no longer exist; or perhaps they were crossed out when Leonardo found himself obliged to give up the idea of casting the equestrian statue. In the original the first two sketches are above l. 1, and the third below l. 9.

la forma, e poi fa la ⁷grossezza, e poi riēpi la forma a mezza a mezza, ⁸e quella integra, poi con sua ferri cierchiala e ⁹cigni e la ricuoci di dētro dove à a toccare il brō¹⁰zo.

iron as may be necessary. Moreover take off the mould and then make the thickness. Then fill the mould by degrees and make it good throughout; encircle and bind it with its irons and bake it inside where it has to touch the bronze.

DEL FAR LA FORMA DI PEZZI.

¹²Segnia sopra il cavallo finito tutti li pezzi della for¹³ma, di che tu voi vestire tal cavallo, e nello interrare ¹⁴li taglia in ogni interratura, acciochè quādo si è fini¹⁵ta la forma che tu la possi cavare e poi ricōmettere ¹⁶al primo loco colli sua scōtri delli cōtrasegni.

¹⁷a b quadretto · starà infra la cappa e'l maschio, cioè ¹⁸nel uacuo dove à a stare il brōzo liquefatto e questi ¹⁹tali quadretti di brōzo manterrāno li spati della for²⁰ma alla cappa con equal distātia, e per questo tali ²¹quadretti sō di grāde inportantia.

²²¶La terra sia mista ²³cō rena;

²⁴tollicera, a rēde²⁵re, e pagare la cō²⁶sumata.¶

²⁷Secca la ²⁸a suoli. ²⁹Fa la forma di fori ³⁰di giesso per fugire ³¹il tēpo del seccare, ³²e la spesa di legnie, e cō ³³tal giesso ferma ³⁴li ferri di fori e di ³⁵dentro cō due dita di ³⁶grossezza, fa terra ³⁷cotta.

³⁸E questa tal forma ³⁹farai in un dì; vna mez⁴⁰za navata di giesso ⁴¹ti serue.

⁴²Bono.

⁴³Rītasa cō ⁴⁴colla e terra ⁴⁵over · chiara d'ovo ⁴⁶e mattone e ro⁴⁷sume.

OF MAKING THE MOULD IN PIECES.

Draw upon the horse, when finished, all the pieces of the mould with which you wish to cover the horse, and in laying on the clay cut it in every piece, so that when the mould is finished you can take it off, and then recompose it in its former position with its joins, by the countersigns.

The square blocks a b will be between the cover and the core, that is in the hollow where the melted bronze is to be; and these square blocks of bronze will support the intervals between the mould and the cover at an equal distance, and for this reason these squares are of great importance.

The clay should be mixed with sand.

Take wax, to return [what is not used] and to pay for what is used.

[27]Dry it in layers [28].

Make the outside mould of plaster, to save time in drying and the expense in wood; and with this plaster enclose the irons [props] both outside and inside to a thickness of two fingers; make terra cotta.

And this mould can be made in one day; half a boat load of plaster will serve you.

[42]Good.

Dam it up again with glue and clay, or white of egg, and bricks and rubbish.

C. A. 213b; 628b] **712.**

Tutti · i capi de²lle chiavarde. All the heads of the large nails.

. . falla. 7. grosseza. 8. ecquella . cosua . . ec. 9. ella richuoci . . dove attochare. 11. pezi. 12. pezi. 13. chettu . . vesstire . . chavallo. 14. quādo se fini. 15. chettu . . chavare ricomettere. 16. al p"o" locho cholli . . cōtrassegni. 17. infralla chappa elmasscio cioe [di]. 18. uachuo dove asstare . . liquefacto ecquesti. 19. lisspati. 20. dallalla chappa chon . . disstātia . . quessto. 22. tera sie. 27. sechalla soli. 28. assu oli. 31. sechare. 32 espesa. 36. rosseza fatterra. 38. ecquesta. 39. farai nūdi vna me. 43. ritasa. 44. etterra 47. ssume.

712. 1—2 R. 1. tucti i chapi.

711. See Pl. LXXV. The figure "40," close to the sketch in the middle of the page between lines 16 and 17 has been added by a collector's hand.

In the original, below line 21, a square piece of the page has been cut out about 9 centimètres by 7 and a blank piece has been gummed into the place.

Lines 22—24 are written on the margin. l. 27 and 28 are close to the second marginal sketch. l. 42 is a note written above the third marginal sketch and on

the back of this sheet is the text given as No. 642. Compare also No. 802.

712. See Pl. LXXVI, No. 1. This drawing has already been published in the "*Saggio delle Opere di L. da Vinci.*" Milano 1872, Pl. XXIV, No. 1. But, for various reasons I cannot regard the editor's suggestions as satisfactory. He says: "*Veggonsi le armature di legname colle quali forse venne sostenuto il modello, quando per le nozze di Bianca Maria Sforza con Massimiliano imperatore, esso fu collocato sotto un arco trionfale davanti al Castello.*"

W. XII.] 713.

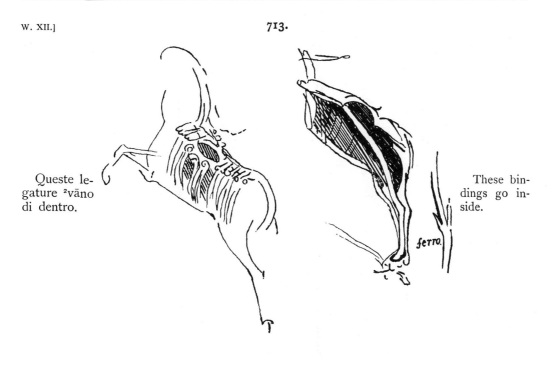

Queste le-
gature ²vāno
di dentro.

These bin-
dings go in-
side.

ferro.

W. XIII 714.

Sale fatto di sterco vmano
bruciato ²e calcinato e fatto-
ne liscia e que³lla distesa
al lēto foco, e tutti li ster⁴chi
in simile modo fanno sale, e
quelli ⁵sali destillati· sono molto
penetrāti.

Salt may be made from human
excrements, burnt and calcined,
made into lees and dried slowly
at a fire, and all the excrements
produce salt in a similar way
and these salts when distilled, are
very strong.

714. 1. stercho. 2. chalcinato effatto neliscia ecque. 3. disecha allēto focho ettutti lisster. 4. quali. 5. desstilati.

714. VASARI repeatedly states, in the fourth
chapter of his *Introduzione della Scultura*, that in
preparing to cast bronze statues horse‑dung was
frequently used by sculptors. If, notwithstanding
this, it remains doubtful whether I am justified in
having introduced here this text of but little interest,
no such doubt can be attached to the sketch which
accompanies it.

W. XII.] 715.

MODO DI RICUOCERE. METHOD OF FOUNDING AGAIN.

[2]Questo si potrebbe fare fatto [3]il for- This may be done when the furnace is

nello [4]ferma e pillata. made [4] strong and bruised.

W. H. 64.] 716.

Models for the horse of the Sforza monument (716—718).

Ginnetto · grosso · di messer Galeazzo. Messer Galeazzo's big genet.

W. H. IV.] 717.

Siciliano di messer Galeazzo. Messer Galeazzo's Sicilian horse.

C. A. 286 b; 870 a] 718.

Misura del siciliano, la ganba dirieto, Measurement of the Sicilian horse the leg
[2]in faccia, alzata e distesa. from behind, seen in front, lifted and extended.

C. A. 382 a; 1182 a] 719.

Occasional references to the Sforza monument (719—724).

Ancora si potrà dare opera al cauallo di Again, the bronze horse may be taken in
bronzo che sarà gloria īmortale e eterno hand, which is to be to the immortal glory and
onore della [2]felice memoria del signore eternal honour of the happy memory of the
vostro padre e della īclyta casa Sfor- prince your father, and of the illustrious
zesca. house of Sforza.

C. 15 b (1)] 720.

A di 23 d'aprile 1·4·90 comīciai On the 23rd of April 1490 I began this
questo libro e ricomīciai · il cavallo. book, and recommenced the horse.

715. 1. richuocere. 2. potre. 4. pilata. 716. 1. gianecto . . galeaz.
717. 1. ciciliano . . meser galeazo. 718. 1. ciciliano. 2. alza.
719. 1—2 *written from left to right.* 1. Anchora si potera . . honore dela. 2. S"gre" vost . . dela.
720. chomīciai . . richomīciai.

715. This note in l. 4 is written below the sketches. San Severino, the famous captain who married Bianca
716. 717. These notes are by the side of a the daughter of Ludovico il Moro.
drawing of a horse with figured measurements. 719. The letter from which this passage is here
718. There is no sketch belonging to this pas- extracted will be found complete in section XXI.
sage. Galeazzo here probably means Galeazzo di (see the explanation of it, on page 2).

Leic. 9 _b_] **721.**

Vedesi in nelle montagnie di Parma e Piacētia la moltitudine di nichi e coralli ²intarlati ancora appiccati alli'sassi, de' quali, quand'io facevo il grā ³cavallo di Milano, me ne fu portato vn grā sacco ne⁴lla mia fabrica da cierti villani che in tal loco trovati.

There is to be seen, in the mountains of Parma and Piacenza, a multitude of shells and corals full of holes, still sticking to the rocks, and when I was at work on the great horse for Milan, a large sackful of them, which were found thereabout, was brought to me into my workshop, by certain peasants.

C. A. 316 _a_; 958 _a_] **722.**

Credetelo a me, Leonardo fiorētino che fa il cauallo del duca Francesco di brōzo che non ne bisognia fare stima, ²perchè à che fare il tenpo di sua vita ·, e dubito che per l'essere si grāde opera, che non la finirà mai.

Believe me, Leonardo the Florentine, who has to do the equestrian bronze statue of the Duke Francesco that he does not need to care about it, because he has work for all his life time, and, being so great a work, I doubt whether he can ever finish it.

C. A. 328 _b_; 983 _a_] **723.**

Del cauallo nō dirò niēte perchè cogniosco · i tēpi.

Of the horse I will say nothing because I know the times.

C. A. 272 _b_; 833 _a_] **724.**

Del marmo operasi dieci añi; ²io nō vo' aspettare che 'l mio pa³gamēto passi il termine del ⁴fine della opera mia.

During ten years the works on the marbles have been going on I will not wait for my payment beyond the time, when my works are finished.

C. A. 176 _b_; 533 _a_] **725.**

SEPULCRO DI MESSER GIOVĀNI JACOMO DA TREVULZO.

THE MONUMENT TO MESSER GIOVANNI JACOMO DA TREVULZO.

²Spesa della ³manifattu⁴ra e materi⁵a del cauallo.

[2]Cost of the making and materials for the horse[5].

The project of the Trivulzio monument.

721. 1. in nelle . . mvltitudine. 2. apichati . . sacho. 3. fabricha.
722. 1. me saluo [quel] | "lonar fiorētino" cheffa il chauallo . . franc"o" "di brōzo" chēnone. 2. lesere . . nella.
724. 1. marmoperassi. 2. inōvo. 3. ghamēto. 4. dela.
725. 1. giovāni iacomo da trevlsa. 3. manifatu. 7. inel . . ellegrame ella. 11. soma. 15. pezo. 16. lungha br 4 ellargho br.

722. This passage is quoted from a letter to a committee at Piacenza for whom Leonardo seems to have undertaken to execute some work. The letter is given entire in section XXI.; in it Leonardo remonstrates as to some unreasonable demands.

723. This passage occurs in a rough copy of a letter to Ludovico il Moro, without date (see below among the letters).

724. This possibly refers to the works for the pedestal of the equestrian statue concerning which we have no farther information in the MSS. See p. 6.

725. In the original, lines 2—5, 12—14, 33—35, are written on the margin. This passage has been

recently published by G. GOVI in Vol. V, Ser. 3ª, of _Transunti_, _Reale Accademia dei Lincei, sed. del 5 Giugno_, 1881, with the following introductory note: "_Desidero intanto che siano stampati questi pochi frammenti perchè so che sono stati trascritti ultimamente, e verranno messi in luce tra poco fuori d'Italia. Li ripubblichi pure chi vuole, ma si sappia almeno che anche tra noi si conoscevano, e s'eran raccolti da anni per comporne, quando che fosse, una edizione ordinata degli scritti di Leonardo._"

The learned editor has left out line 22 and has written 3 _piè_ for 8 _piedi_ in line 25. There are other deviations of less importance from the original.

[6]Vno corsiero grāde al naturale coll'omo sopra vuole per la spesa del metallo duc. 500.

[7]E per la spesa del ferramēto che ua in nel modello e carboni e legname e la fossa per gittarlo [8]e per serrare la forma, e col fornello doue si de' gittare duc. 200.

[9]Per fare il modello di terra e poi di cera duc. 432.

[10]E per li lauorāti che lo netterāno quādo fia gittato duc. 450.

[11]In somma sono duc. 1582.

[12]Spesa de' m[13]armi della [14]sepul·tura.

[15]Spesa del marmo secōdo il disegnio; jl pezzo del marmo che ua sotto il cauallo [16]ch'è lungo braccia 4 e largo braccia 2 e oncie 2 e grosso oncie 9, cētinara 58, a L. 4 e S. 10 per cētinaro duc. 58.

[17]E per 13 braccia di cornice e ō 6, larga ō 7, e grossa ō 4, cēt. 24, duc. 24.

[18]E per lo fregio e architrave ch'è lungo br. 4 e ō 6 ·, largo br. 2 e grosso ō 6, cēt 20 duc. 20.

[19]E per li capitelli fatti di metallo, che sono 8, vaño ī tavola ō 5, e grossi ō 2, a prezzo di [20]ducati 15 per ciascuno montano . . . duc. 120.

[21]E per 8 colonne di br. 2 e ō 7, grosse ō 4 e ¹/₂ · cētinara 20 . . duc. 20.

[22]E per 8 base che sono in tauola ō 5 e ¹/₂ e alte ō 2 cent. 5 . . duc. 5.

[23]E per la pietra dou' è su la sepultura, lūga br. 4 e ō 10, larga br. 2 e ō 4 e ¹/₂ [24]centinara 36 . . . duc. 36.

[25]E per 8 piedi di piedistalli che uā lunghi br. 8 e larghi ō 6 e ¹/₂ grossi ō 6¹/₂ [26]centinara 20, mōtano . . duc. 20.

[27]E per la cornice ch'è di sotto, ch'è lūga br. 4 e ō 10, larga br. 2 e ō 5, e grossa ō 4, cēt. 32 . . . duc. 32.

[28]E per la pietra di che si fa il morto ch'è lunga br. 3 e ō 8, larga br. uno e ō 6, grossa ō 9, cent 30, duc. 30.

[29]E per la pietra che ua sotto il morto · ch'è lūga br. 3 e ō 4, larga br. uno e ō 2, grossa ō 4¹/₂ . . duc. 16.

[30]E per le tauole del marmo īterposte infra li piedistalli, che sono 8 e son lūghe br. 9, [31]larghe ō 9, grosse ō 3 cent 8 duc. 8.

[32]In somma sono duc. 389.

A courser, as large as life, with the rider requires for the cost of the metal, duc. 500.

And for cost of the iron work which is inside the model, and charcoal, and wood, and the pit to cast it in, and for binding the mould, and including the furnace where it is to be cast . . duc. 200.

To make the model in clay and then in wax duc. 432.

To the labourers for polishing it when it is cast . · duc. 450.

in all . . duc. 1582.

[12]Cost of the marble of the monument[14].

Cost of the marble according to the drawing. The piece of marble under the horse which is 4 braccia long, 2 braccia and 2 inches wide and 9 inches thick 58 hundredweight, at 4 Lire and 10 Soldi per hundredweight . . duc. 58.

And for 13 braccia and 6 inches of cornice, 7 in. wide and 4 in. thick, 24 hundredweight duc. 24.

And for the frieze and architrave, which is 4 br. and 6 in. long, 2 br. wide and 6 in. thick, 29 hundredweight.. duc. 20.

And for the capitals made of metal, which are 8, 5 inches in. square and 2 in. thick, at the price of 15 ducats each, will come to duc. 122.

And for 8 columns of 2 br. 7 in., 4 ¹/₂ in. thick, 20 hundredweight duc. 20.

And for 8 bases which are 5 ¹/₂ in. square and 2 in. high 5 hundᵗ. . duc. 5.

And for the slab of the tombstone 4 br. 10 in. long, 2 br. 4¹/₂ in. wide 36 hundredweight duc. 36.

And for 8 pedestal feet each 8 br. long and 6 ¹/₂ in. wide and 6 ¹/₂ in. thick, 20 hundredweight come to . . . duc. 20.

And for the cornice below which is 4 br. and 10 in. long, and 2 br. and 5 in. wide, and 4 in. thick, 32 hundᵗ. . duc. 32.

And for the stone of which the figure of the deceased is to be made which is 3 br. and 8 in. long, and 1 br. and 6 in. wide, and 9 in. thick, 30 hundᵗ. . duc. 30.

And for the stone on which the figure lies which is 3 br. and 4 in. long and 1 br. and 2 in., wide and 4¹/₂ in. thick duc. 16.

And for the squares of marble placed between the pedestals which are 8 and are 9 br. long and 9 in. wide, and 3 in. thick, 8 hundredweight . . . duc. 8.

in all . . duc. 389.

[33] Spesa della [34] manifattu[35]ra ne' marmi.
[36] Attorno allo inbasamēto del ca-
uallo vā figure 8 di 25 ducati l' una,
duc. 200.
[37] E nel medesimo inbasamēto ci
vā festoni 8 cō certi altri ornamēti e
di questi [38] ve n' è 4 a prezzo di du-
cati 15 per ciascuno, e 4 a prezzo
di 8 ducati l' uno duc. 92.
[39] E per isquadrare dette pietre,
duc. 6.
[40] Ancora pel cornicione che ua
sotto lo inbasamēto del cauallo, ch' è
br. 13 e ō 6 a duc. 2 per br. duc. 27.
[41] E per 12 br. di fregio, a ducati
5 per br. duc. 60.
[42] E per 12 br. d' architrave, a du-
cati 1 e ¹/₂ per br. duc. 18.
[43] E per 3 fioroni che fā soffitta
alla sepultura, a 20 ducati per fiorone,
duc. 60.
[44] E per 8 colonne accanalate, a
8 ducati l' una duc. 64.
[45] E per 8 base, a un ducato l' una,
duc. 8.
[46] E per 8 piedistalli, dè' quali n' è
4 a 10 duc. l' uno, che uā sopra li
cātoni, e 4 a 6 duc. l' uno . . duc. 64.
[47] E per isquadrare e incorniciare li
piedistalli, a due duc. l' uno, che sono 8,
duc. 16.
[48] E per 6 tavole con figure e trofei,
a 25 ducati l' uno duc. 150.
[49] E per la scorniciatura della
pietra che ua sotto il morto . . .
duc. 40.
[50] Per la figura del morto a farla
bene duc. 100.
[51] Per 6 arpie colli candelieri, a 25
ducati l' una duc. 150.
[52] Per isquadrare la pietra dove si
posa il morto e sua incorniciatura
duc. 20.
[53] In somma duc. 1075.
[54] In somma ogni cosa insieme
giūta sō duc. 3046.

[33] Cost of the work in marble [35].
Round the base on which the horse
stands there are 8 figures at 25 ducats
each duc. 200.
And on the same base there are 8
festoons with some other ornaments,
and of these there are 4 at the price
of 15 ducats each, and 4 at the price
of 8 ducats each duc. 92.
And for squaring the stones duc. 6.
Again, for the large cornice which
goes below the base on which the
horse stands, which is 13 br. and 6 in.,
at 2 duc. per br. duc. 27.
And for 12 br. of frieze at 5 duc.
per br. duc. 60.
And for 12 br. of architrave at
1¹/₂ duc. per br. duc. 18.
And for 3 rosettes which will be
the soffit of the monument, at 20 du-
cats each duc. 60.
And for 8 fluted columns at 8
ducats each duc. 64.
And for 8 bases at 1 ducat each,
duc. 8.
And for 8 pedestals, of which 4 are
at 10 duc. each, which go above the
angles; and 4 at 6 duc. each . . duc. 64.
And for squaring and carving the
moulding of the pedestals at 2 duc.
each, and there are 8 duc. 16.
And for 6 square blocks with figures
and trophies, at 25 duc. each . . duc. 150.
And for carving the moulding of
the stone under the figure of the
deceased duc. 40.
For the statue of the deceased, to
do it well duc. 100.
For 6 harpies with candelabra, at 25
ducats each duc. 150.
For squaring the stone on which
the statue lies, and carving the moul-
ding duc. 20.
in all . . duc. 1075.
The sum total of every thing added
together amount to duc. 3046.

G. 43 a] 726.

ZECCA DI ROMA.

[2] Puosi ancora fare sanza molla; [3] Ma
sempre il maschio di sopra debbe [4] stare
congiunto alla parte della gu[5]aina mobile;

MINT AT ROME.

It can also be made without a spring. The mint of Rome.
But the screw above must always be joined
to the part of the movable sheath:

31. larghi. 36. va. 37. li va fessto 8 cō . . queste. 38. ciasscuna . . luna. 39. issguadare. 40. cornicone. 41. frego.
46. piedistalle. 47. issguadrare esscorniciare lipiedisstallo . . chessono . . luma. 48. trufei. 50. affarla. 52. essa scornica-
tura. 54. soma ōnicossa . . gūta so duc.

726. See Pl. LXXVI. This passage is taken from a note book which can be proved to have been
used in Rome.

⁶Tutte le monete che ⁷non àño jl cierchio ⁸intero, non sieno acci⁹ettate per buone, e a ¹⁰fare la perfectione del lor ¹¹cierchio è neciessario ¹²che in prima le mone¹³te siē tutte di perfetto cir¹⁴colo, e a fare questo ¹⁵e' si debbe in prima fare vna ¹⁶moneta perfetta in peso ¹⁷e in larghezza e grossez¹⁸za, e di questa tal lar¹⁹ghezza e grossezza siē fat²⁰te molte lamine, tira²¹te per una medesima tra²²fila, le quali resterā²³no a modo di righe, e · ²⁴di queste tali righe si ²⁵stanpī fuori le monete ²⁶tōde, a modo che si fā²⁷no i criuelli da casta²⁸gnie, e queste mone²⁹te poi si stanpino nel ³⁰modo sopra detto ecc.

³¹Il vacuo della stanpa ³²sia più largo da alto ³³che da basso vni³⁴formemente, ³⁵e insēsibile.

³⁶Questo taglia le monete di perfetta ro³⁷tondità e grossezza e peso e ris³⁸parmia l'omo che taglia e pesa, e ³⁹rispiarmia l'omo che fa le monete ⁴⁰tonde; adūque sol passa per li mani ⁴¹del trafilatore e dello stanpato⁴²re e fa monete bellissime.

All coins which do not have the rim complete, are not to be accepted as good; and to secure the perfection of their rim it is requisite that, in the first place, all the coins should be a perfect circle; and to do this a coin must before all be made perfect in weight, and size, and thickness. Therefore have several plates of metal made of the same size and thickness, all drawn through the same gauge so as to come out in strips. And out of [24]these strips you will stamp the coins, quite round, as sieves are made for sorting chestnuts[27]; and these coins can then be stamped in the way indicated above; &c.

[31]The hollow of the die must be uniformly wider than the lower, but imperceptibly[35].

This cuts the coins perfectly round and of the exact thickness, and weight; and saves the man who cuts and weighs, and the man who makes the coins round. Hence it passes only through the hands of the gauger and of the stamper, and the coins are very superior.

C. 15ᵟ (1)] 727.

POLUERE DA MEDAGLIE.

²Stoppini · incombustibili · di fungo ridotto in poluere, ³stagnio bruciato e tutti i metalli, ⁴allume scagliuolo, ⁵fumo di fucina da ottone, ⁶e ciascuna cosa inumidisci con acquauite o maluagìa ⁷o acieto · forte di grā, uino bianco ·, o di quella prima acqua ⁸di trementina destillata, o olio, pure che poco sia ⁹invmidità ·, e gitta in telaroli.

POWDER FOR MEDALS.

The incombustible growth of soot on wicks reduced to powder, burnt tin and all the metals, alum, isinglass, smoke from a brass forge, each ingredient to be moistened, with aqua vitae or malmsey or strong malt vinegar, white wine or distilled extract of turpentine, or oil; but there should be little moisture, and cast in moulds.

On the coining of medals (727. 728).

Mz. o'] 728.

DELLO INPRŌTARE MEDAGLIE.

Polta di smeriglio mista con acquavite ²o scaglia di ferro con aceto ·, o cenere di foglie di noce ·, o cenere ³di paglia sottilmēte trita.

OF TAKING CASTS OF MEDALS.

A paste of emery mixed with aqua vitae, or iron filings with vinegar, or ashes of walnut leaves, or ashes of straw very finely powdered.

726. 1. zecca di roma. 2. Puossi anchora. 3. masscio. 4. chom giunto . . ghu. 9. ectate . . eaf. 10. perfectione. 12. prima ne mone. 13. perfecto. 14. cholo e affare. 15. e si . . in pᵘ"a". 16. perfecta. 18. quessta. 19. sie fac. 24. queste . . sis. 26. chessi. 28. ecqueste. 29. sisstan pino. 30. decto ele. 31. vachuo. 32. larcho. 33. chedda. 36. Quessto. 37. grosseza eppeso eriss. 38. spiarma . . chettaglia eppesa. 39. rispiarma . . falle. 40. istanpito. 42 effa.

727. 1. stopini inchonbusstibili. 3. brusato ettutti. 4. alume schāgliolo. 6. essciasschuna . . inūmidissci con acqᵘ"a". 7. biancho o di ella prima acqᵘ"a". 8. desstillata o holio.

728. 1. polta di smeriglo . . acqᵘ"a". 2. ho cenere. 4. inolto [inp] in . . battutto. 5. radopiato [cre] essitiene. 6. accochettal

726. See Pl. LXXVI No. 2. The text of lines 31—35 stands parallel l. 24—27.

Farther evidence of Leonardo's occupations and engagements at Rome under Pope Leo X. may be gathered from some rough copies of letters which

will be found in this volume. Hitherto nothing has been known of his work in Rome beyond some doubtful, and perhaps mythical, statements in Vasari.

727. The meaning of *scagliuolo* in this passage is doubtful.

⁴Il diametro si presta inuolto in nel piōbo ·, è battuto con martello ⁵e disteso piv volte; tal piōbo è raddoppiato e si tiene involto nel⁶la carta, acciochè tal poluere nō si versi, e poi fondi il piōbo e la pol⁷vere vi è di sopra al pionbo fonduto, la qual poi sia fregata infra due ⁸piastre d' acciaio tanto si poluerizi bene, di poi lauala coll' acqua da partire ⁹e risoluerassi la negrezza del ferro, e lascierà la poluere netta;

¹⁰Lo smeriglo in pezzi grossi si rompe col metterlo sopra vn panno in mol¹¹ti doppi, e si percuote per fianco col martello, e così se ne va; poi mischia lì ¹²a poco a poco, e poi si pesta cō facilità, e se tu lo tenessi sopra l' ancu¹³dine, mai lo rōperesti, essendo così grosso.

¹⁴Chi macina li smalti debbe fare tale esercitio sopra le pias¹⁵tre d' acciaio, tenperato col macinatojo da conio, e poi met¹⁶ter lo nell' acqva forte, la qual risolue tutto esso acciaio che si è ¹⁷cōsumato e misto con esso smalto e lo fece nero, onde poi ¹⁸rimā purificato e netto, e se tu lo macini sul porfido, esso ¹⁹porfido si consuma e si mischia collo smalto e lo guasta, ²⁰e l' acqua da partire mai lo lieva da dosso, perchè nō può ²¹risoluere tale porfido.

²²Se volli fare colore bello azzurro risolui lo smalto, fatto ²³col tartaro, e po' li leva il sal da dosso.

²⁴L' ottone vetrificato fa bello rosso.

The diameter is given in the lead enclosed; it is beaten with a hammer and several times extended; the lead is folded and kept wrapped up in parchment so that the powder may not be spilt; then melt the lead, and the powder will be on the top of the melted lead, which must then be rubbed between two plates of steel till it is thoroughly pulverised; then wash it with aqua fortis, and the blackness of the iron will be dissolved leaving the powder clean.

Emery in large grains may be broken by putting it on a cloth many times doubled, and hit it sideways with the hammer, when it will break up; then mix it little by little and it can be founded with ease; but if you hold it on the anvil you will never break it, when it is large.

Any one who grinds smalt should do it on plates of tempered steel with a cone shaped grinder; then put it in aqua fortis, which melts away the steel that may have been worked up and mixed with the smalt, and which makes it black; it then remains purified and clean; and if you grind it on porphyry the porphyry will work up and mix with the smalt and spoil it, and aqua fortis will never remove it because it cannot dissolve the porphyry.

If you want a fine blue colour dissolve the smalt made with tartar, and then remove the salt.

Vitrified brass makes a fine red.

G. 75 b]

729.

STUCCO.

²Fa stucco sopra il gobbo del di giesso, ³il quale sia cōposto di venere e ⁴mercurio, e impasta bene sopra esso gobbo ⁵con equal grossezza di costa di coltello fatta colla ⁶sagoma, e questa copri cō coperchio di canpa⁷na da stillare, e riavrai il tuo vmido cō ⁸che inpastasti, el rimanēte ·asciugga bene e poi ī⁹foca e batti over

STUCCO.

Place stucco over the prominence of the which may be composed of Venus and Mercury, and lay it well over that prominence of the thickness of the side of a knife, made with the ruler and cover this with the bell of a still, and you will have again the moisture with which you applied the paste. The rest you may dry

On stucco (729. 730).

.. ella pol. 7. bere vi e. 8. piastre dacaio .. lauolo chollacq"a". 9. la negredine del ferro ellascieara. 10. lossmeriglo .. chol .. imol. 11. essi perchote per fianco .. misscagle. 12. a pocho appocho .. essettu. 13. rōperessti .. chosi. 14. lissmalti. 15. chol macintatoio. 16. accaio chesse. 17. missto .. ello. 18. purifichato ennetto essettullo. 19. essimissca collossmalto ello. 20. ellae qua dosso [s] perche nō po. 22. azurro .. lossmalto. 24. vetrifichato.

729. 1. stuccho. 2. fasstucho .. ghobb del . a engui di giesso. 3. cōposso di erenev e. 4. oirucrem e inpassta . ghobbo. 5. grosseza .. cholla. 6. saghoma ecquessta .. choperchio. 7. dasstillare erriarai. 8. inpasstassti .. assciugha. 9. focha

729. In this passage a few words have been written in a sort of cipher—that is to say backwards; as in l. 3 *erenev* for *Venere*, l. 4 *oirucrem* for *Mercurio*, l. 12 *il orreve cō ecarob* for *il everro* (?) *cō borace.* The meaning of the word before "*di giesso*"

in l. 1 is unknown; and the sense, in which *sagoma* is used here and in other passages is obscure.— *Venere* and *Mercurio* may mean 'marble' and 'lime', of which stucco is composed.

12. The meaning of *orreve* is unknown.

brunisci cō buon brunitoio e fa [10]grosso inverso la costa.

well; afterwards fire it, and beat it or burnish it with a good burnisher, and make it thick towards the side.

STUCCO.

[12]Poluerizza il cō borace e acqua, in[13]pasta e fa stucco, e poi scalda in modo si sec[14]chi, e poi vernica con foco in modo che lustri.

STUCCO.

Powder . . . with borax and water to a paste, and make stucco of it, and then heat it so that it may dry, and then varnish it, with fire, so that it shines well.

C. A. 313 *a*; 951 *a*]　　　　　　　　**730.**

STUCCO DA FORMARE.

[2]Togli · butiro parti 6 ·, ciera parti · 2 ·, [3]e tāta farina volatile · che, messa sopra [4]le cose strutte ·, le facci · sode a modo [5]di cera · o di terra · da formare.

STUCCO FOR MOULDING.

Take of butter 6 parts, of wax 2 parts, and as much fine flour as when put with these 2 things melted, will make them as firm as wax or modelling clay.

COLLA.

[7]Togli mastice tremētina stillata [8]e biacca.

GLUE.

Take mastic, distilled turpentine and white lead.

S. K. M. III 50 *a*]　　　　　　　　**731.**

DA GITTARE.

On bronze casting generally (731—740).

[2]Il tartaro bruciato e pol[3]verizzato col giesso e gitta[4]to fā che esso · giesso si [5]tiene insieme · poi, ch'è ricot[6]to, e poi · nell' acqua si disfa.

TO CAST.

Tartar burnt and powdered with plaster and cast cause the plaster to hold together when it is mixed up again; and then it will dissolve in water.

S. K. M. III. 53 *a*]　　　　　　　　**732.**

PER GITTARE BRŌZO · IN GIESSO.

[2]Togli per ogni 2 scodelle · di giesso una di [3]corno di bo bruciato e mischia īsieme [4]e gitta.

TO CAST BRONZE IN PLASTER.

Take to every 2 cups of plaster 1 of ox-horns burnt, mix them together and make your cast with it.

S. K. M. II.1 95 *a*]　　　　　　　　**733.**

Quādo voi gittare di ciera, abbrucia la schiuma [2]con una candela, e'l gietto verrà sanza busi.

When you want to take a cast in wax, burn the scum with a candle, and the cast will come out without bubbles.

S. K. M. III. 55 *b*]　　　　　　　　**734.**

2 ōcie di giesso da libbra [2]di metallo; [3]noce che fa simile alla [4]curva.

2 ounces of plaster to a pound of metal;— walnut, which makes it like the curve.

. . brunissci cō biō brunitoio effa. 10. chossta. 11. stucco. 12. il orreve cō ecarob e acq"a" in. 13. passta effa stucho eppoi scal"d"a. 14. eppoi vernicha con vocho . . lusstri.

730. 1. stucho. 2. toli bituro parte . . parte. 4. chose. 5. tera. 7. tomastice temetina. 8. biaccha.

731. 2. tartero. 3. verizato chol. 4. hesso.. 5. tiene sieme . . rico. 6. acq"a".

732. 1. giesso ĩ di. 3. bruciata e misscia.

733. 1. abrucia. 2. chandela. 　　**734.** 1. libra.

734. The second part of this is quite obscure.

S. K. M. III. 56*a*] **735.**

[Terra asciuta 16 ²libbre, 100 libbre di metallo ³la bagniata terra 20, ⁴di bagniato 100, di metà, ⁵che cresce 4 libbre d'acqua, ⁶una di cera, una libbra di me⁷tallo, alquāto māco, ⁸cimatura cō terra, ⁹misura per misura.]

[Dried earth 16 pounds, 100 pounds of metal wet clay 20,—of wet 100,—half,—which increases 4 lbs. of water,—1 of wax, 1 lb. of metal, a little less,—the scrapings of linen with earth, measure for measure.]

H.² 52*b*] **736.**

Tal fia il gietto ²qual fia la stāpa.

Such as the mould is, so will the cast be.

Tr. 52] **737.**

COME SI DEBBONO PULIRE I GIETTI.

²Farai uno mazzo · di fila · di ferro, grosso · come spaghetto, ³e coll' acqua fregherai, tenēdo sotto uno tinello, acciò nō facci ⁴fāgo sotto.

HOW CASTS OUGHT TO BE POLISHED.

Make a bunch of iron wire as thick as thread, and scrub them with [this and] water; hold a bowl underneath that it may not make a mud below.

COME SI DE' LEUARE I RICCI DEL BRŌZO.

⁶Farai uno · palo di ferro che sia a uso d'uno largo · scarpello, ⁷e cō quello fregherai · su per quelle · creste · del brōzo, che rimarrāno ⁸sopra · i gietti delle bōbarde, che diriuano dalle schiappature della ⁹forma, · ma fa che 'l palo · pesi · bene ·, e' colpi sieno lūghi e grādi.

HOW TO REMOVE THE ROUGH EDGES FROM BRONZE.

Make an iron rod, after the manner of a large chisel, and with this rub over those seams on the bronze which remain on the casts of the guns, and which are caused by the joins in the mould; but make the tool heavy enough, and let the strokes be long and broad.

FACILITÀ DI FONDERE.

¹¹Allega · prima · una parte del metallo alla · manica, di poi lo metti ī fornace, ¹²e questo farà prīcipio · col suo bagnio al fondere del rame.

TO FACILITATE MELTING.

First alloy part of the metal in the crucible, then put it in the furnace, and this being in a molten state will assist in beginning to melt the copper.

PER PROVEDERE AL RAME CHE SI FREDDASSE NELLA FORNACE.

¹⁴Quando · il rame · si fredasse nella fornace fa · che subito ·, quādo tu te n'avedi, ¹⁵di tagliarlo cō frugatojo · mētre ch' eli è · ī paniccia ·, overo se fusse ¹⁶īteramēte · raffreddato, taglialo, come si fa il piōbo, cō larghi e grossi scar¹⁷pelli.

TO PREVENT THE COPPER COOLING IN THE FURNACE.

When the copper cools in the furnace, be ready, as soon as you perceive it, to cut it with a long stick while it is still in a paste; or if it is quite cold cut it as lead is cut with broad and large chisels.

735. 1. assciutta. 2. libre 100 lbbre. 5. cressie. 4. librdacq"a". 6. ī di . . ī libra.
737. 1. debe. 2. fara ī mazo . . spagetto. 3. echollacq"a" frecherai . . ī tinello. 6. ī palo . . chessia . . largho. 7. chō . . rimā.
 8. isciappature. 9. maffa . . chalpi. 11. ī parte . . manicha. 12. ecquesto . . chol . . derame. 13. chessi fredassi.
 14. chessubito. 15. chō . . imētre . . overo [mēte] seffussi. 16. raffredo taglalo chome . . chō chargi . . schar. 18. affare
 ī. 19. affare ī . libre fallo . . cho 2006 libr. 20. ciasschuno . . libr.

735. The translation is given literally, but the meaning is quite obscure.

Se avessi a fare vno grā gietto.

[19]Se avessi a fare uno gietto di cento mila · libbre, falo cō · 2 · fornelli con 2000 libbre [20]per ciascuno · o īsino . in 3000 libbre il piv.

If you have to make a large cast.

If you have to make a cast of a hundred thousand pounds do it with two furnaces and with 2000 pounds in each, or as much as 3000 pounds at most.

Tr. 53] **738.**

¶ Come fare bene a rōpere vna grā massa di brōzo. ¶

[2]Se volli rōpere · una · grā · massa · di brōzo · sospēdilo · prima, [3]poi · lì fa da 4 · lati · uno muro · a vso di truogo · di mattoni, e fa lì grā foco ·, [4]e quādo è bē rosso, dali · uno colpo con vno [5]grā peso levato · in alto cō grā forza.

How to proceed to break a large mass of bronze.

If you want to break up a large mass of bronze, first suspend it, and then make round it a wall on the four sides, like a trough of bricks, and make a great fire therein. When it is quite red hot give it a blow with a heavy weight raised above it, and with great force.

Tr. 54] **739.**

¶ Del fare vnire il piōbo con altro · metallo. ¶

[2]Se volessi per masseritia · mettere · il piōbo · nel metallo · e per sopire . alla soma [3]dello stagnio · che si · richiede · nel metallo ·, allega · prima · il piōbo · collo [4]stagnio · e poi metti sopra · il rame fōduto.

To combine lead with other metal.

If you wish for economy in combining lead with the metal in order to lessen the amount of tin which is necessary in the metal, first alloy the lead with the tin and then add the molten copper.

¶ Come si debe · fondere in uno fornello. ¶

[6]Il fornello · de' essere · īfra 4. pilastri bē fōdati.

How to melt [metal] in a furnace.

The furnace should be between four well founded pillars.

¶ Della grossezza della cappa. ¶

[8]La cappa nō debe · prevalicare · la grossezza · di 2 · dita ·, e debesi interrare · [9]in quattro volte . sopra · la terra · sottile · e poi bene armare, [10]e sia · sola · mēte · ricotta · di dētro · e dato · poi · sottilmēte · di cenere · e bouina.

Of the thickness of the coating.

The coating should not be more than two fingers thick, it should be laid on in four thicknesses over fine clay and then well fixed, and it should be fired only on the inside and then carefully covered with ashes and cow's dung.

Della grossezza della bōbarda.

[12]La bōbarda · de' essere da 600 libbre di ballotta · ī su, cō questa regola; [13]farai la misura del diametro della · ballotta · e quel-

Of the thickness of the gun.

The gun being made to carry 600 lbs. of ball and more, by this rule you will take the measure of the diameter of the ball and

738. 1. be a . . ī grā. 2. ī grā. 3. ī muro . . effa . . focho. 4. ecquādo . . dalli ī colpi chon.
739. 1. chol. 2. e per soperire. 3. chessi . . cholo. 4. eppoi . . arame. 5. fondere ī fornello. 7. grosseza . . chappa. 8. chappa . . prevalichare la grosseza debessi. 9. gutro . . soctile. 10. essia . . richotta. 11. grosseza. 12. libr. 13. ba"lo"ta . . dia-

la · diuidi · ī 6 · parti, [14]e una d'esse parti· fia la grossezza · dināzi e la metà sēpre · piv rieto, [15]e se la ballotta fia di libbre 700, $^1/_7$ del · diametro della ballotta fia la sua [16]grossezza · dināzi ·, e se la ballotta · fia 800 ·, l'ottavo del suo diametro [17]dināzi, e se 900 · ⅛ e ½ | e se 1000 ⅑.

DELLA LŪGHEZZA DELLA TRŌBA DELLA BŌBARDA.

[19]Se voi · ch'ella · gitti · una ballotta · di pietra · fa la lūghezza della trōba [20]in 6 o insino ī 7 ballotte ·, e se la · ballotta · fusse di ferro ·, fa [21]detta trōba · īsino in · 12 ballotte ·, e se la ballotta · fusse di [22]piōbo · farai la insino · in diciotto · ballotte, dico quādo la bōbarda [23]avesse · la bocca · atta · a ricieuere · in se da 600 libr · di ballotta di pietra ī su.

DELLA GROSSEZZA DE' PASSA·VOLANTI.

[25]La grossezza dināzi de' passavolanti· nō deve passare dalla · metà [26]īsino · al terzo del diametro della ballotta, E la lūghezza da 30 īsino ī 36 [27]ballotte.

divide it into 6 parts and one of these parts will be its thickness at the muzzle; but at the breech it must always be half. And if the ball is to be 700 lbs., $^1/_7$th of the diameter of the ball must be its thickness in front; and if the ball is to be 800, the eighth of its diameter in front; and if 900, ⅛th and ½ [³/₁₆], and if 1000, ⅑th.

OF THE LENGTH OF THE BODY OF THE GUN.

If you want it to throw a ball of stone, make the length of the gun to be 6, or as much as 7 diameters of the ball; and if the ball is to be of iron make it as much as 12 balls, and if the ball is to be of lead, make it as much as 18 balls. ·I mean when the gun is to have the mouth fitted to receive 600 lbs. of stone ball, and more.

OF THE THICKNESS OF SMALL GUNS.

The thickness at the muzzle of small guns should be from a half to one third of the diameter of the ball, and the length from 30 to 36 balls.

¶DELLO · ILLOTARE · IL FORNELLO DI DĒTRO.¶

[2]Il fornello · debbe ināzi · che tu · īforni il metallo · essere · illotato di terra di Valenza, [3]e sopra quella · cienere.

¶DEL RISTORARE · IL METALLO, QUĀDO · RIVOLESSE FREDDARE.¶

[5]Quādo · tu · vedi il brōzo volersi cō-gielare · tolli legnie di salice, schiappate [6]sottilmēte, e cō quelle · fa · foco.

¶LA CAGIONE DEL CŌGIELARSI.¶

[8]Dico · la cagione · d'essa cōgielatione derivar · spesse volte · da troppo foco [9]e ancora da legnie · mal secche.

¶A CONOSCIERE LA DISPOSITIONE DEL FOCO.¶

[11]Il foco · conosscierai, quādo fia bono e vtile ·, alle fiame · chiare, e se uedrai [12]le

OF LUTING THE FURNACE WITHIN.

The furnace must be luted before you put the metal in it, with earth from Valenza, and over that with ashes.

OF RESTORING THE METAL WHEN IT IS BECOMING COOL.

When you see that the bronze is congealing take some willow-wood cut in small chips and make up the fire with it.

THE CAUSE OF ITS CURDLING.

I say that the cause of this congealing often proceeds from too much fire, or from ill-dried wood.

TO KNOW THE CONDITION OF THE FIRE.

You may know when the fire is good and fit for your purpose by a clear flame,

mitro. 14. e ī . . grosseza . . ella. 15. esse . . di br 700 . . balotta . . diamitro. 16. grosseza . . sella . . diamitro. 17. esse . . | e ese. 18. lūgeza. 19. ī ballotta . . lügeza. 20. essella . . fussi. 21. essela . . fussi. 23. avesse . la bocha. 24. grosseza. 25. grosseza . . debono. 26. diamitro . . lūgeza.

740. 1. ilotare. 2. chetti . . tera di ualēza. 4. uolessi fredare. 5. chōgielare . . sciapate. 6. chō. 8. dicho la chagione . . dirivar. 9. anchora . . seche. 10. focho. 11. conosscierai . . ale . . esse uederai. 12. effinire co. 13. arai . . acq"a". 14. alegare.

740. l. 2. *Terra di Valenza.*—Valenza is north of Alessandria on the Po.

pūte · d'esse · fiāme turbe e finire cō molto · fumo ·, nō te ne fidare, e massime ¹³quā-do · avrai il bagnio · quasi · in acqua.

¶ DELLO ALLEGARE IL METALLO. ¶

¹⁵Il metallo · si uole fare vniversalmēte nelle bōbarde cō · 6 · o uisino 8 ¹⁶per ciēto ·, cioè 6 di stagnio · sopra · ciēto · di rame, e quāto meno ve ne metti, ¹⁷piv sicura fia · la bōbarda.

¶ QUĀDO SI DEBE ACCŌPAGNIARE · LO STAGNIO COL RAME. ¶

¹⁹Lo stagnio · col rame si debbe · met-tere · quādo · ài il rame cōdotto in acqua.

¶ COME SI DEBE AVMĒTARE IL FONDERE. ¶

²¹Il fondere fia da te avmētato · quādo sarà cōdotto il rame in ²/₃ ²²in acqua ·, al-lora · con v̄ legnio di castagnio ispesso rimaneggerai il rima²³nēte del rame an-cora ītero · īfra la · parte · fonduta.

and if you see the tips of the flames dull and ending in much smoke do not trust it, and particularly when the flux metal is almost fluid.

OF ALLOYING THE METAL.

Metal for guns must invariably be made with 6 or even 8 per cent, that is 6 of tin to one hundred of copper, for the less you put in, the stronger will the gun be.

WHEN THE TIN SHOULD BE ADDED TO THE COPPER.

The tin should be put in with the copper when the copper is reduced to a fluid.

HOW TO HASTEN THE MELTING.

You can hasten the melting when ²/₃ds of the copper is fluid; you can then, with a stick of chestnut-wood, repeatedly stir what of copper remains entire amidst what is melted.

15. metalo. 17. sichura. 18. acōpagniare . . chol. 19. acq"a". 21. datte. 22. chastagnio . . rimanerai.

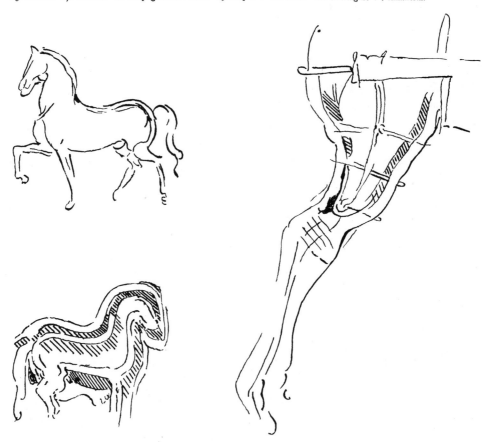

Introductory Observations on the Architectural Designs (XII), and Writings on Architecture (XIII).

Until now very little has been known regarding Leonardo's labours in the domain of Architecture. No building is known to have been planned and executed by him, though by some contemporary writers incidental allusion is made to his occupying himself with architecture, and his famous letter to Lodovico il Moro,—which has long been a well-known document,—in which he offers his service as an architect to that prince, tends to confirm the belief that he was something more than an amateur of the art. This hypothesis has lately been confirmed by the publication of certain documents, preserved at Milan, showing that Leonardo was not only employed in preparing plans but that he took an active part, with much credit, as member of a commission on public buildings; his name remains linked with the history of the building of the Cathedral at Pavia and that of the Cathedral at Milan.

Leonardo's writings on Architecture are dispersed among a large number of MSS., and it would be scarcely possible to master their contents without the opportunity of arranging, sorting and comparing the whole mass of materials, so as to have some comprehensive idea of the whole. The sketches, when isolated and considered by themselves, might appear to be of but little value; it is not till we understand their general purport, from comparing them with each other, that we can form any just estimate of their true worth.

Leonardo seems to have had a project for writing a complete and separate treatise on Architecture, such as his predecessors and contemporaries had composed—Leon Battista Alberti, Filarete, Francesco di Giorgio and perhaps also Bramante. But, on the other hand, it cannot be denied that possibly no such scheme was connected with the isolated notes and researches, treating on special questions, which are given in this work; that he was merely working at problems in which, for some reason or other he took a special interest.

A great number of important buildings were constructed in Lombardy during the period between 1472 and 1499, and among them there are several by unknown architects,

of so high an artistic merit, that it is certainly not improbable that either Bramante or Leonardo da Vinci may have been, directly or indirectly, concerned in their erection.

Having been engaged, for now nearly twenty years, in a thorough study of Bramante's life and labours, I have taken a particular interest in detecting the distinguishing marks of his style as compared with Leonardo's. In 1869 I made researches about the architectural drawings of the latter in the Codex Atlanticus at Milan, for the purpose of finding out, if possible the original plans and sketches of the churches of Santa Maria delle Grazie at Milan, and of the Cathedral at Pavia, which buildings have been supposed to be the work both of Bramante and of Leonardo. Since 1876 I have repeatedly examined Leonardo's architectural studies in the collection of his manuscripts in the Institut de France, and some of these I have already given to the public in my work on "Les Projets Primitifs pour la Basilique de St. Pierre de Rome", Pl. 43. In 1879 I had the opportunity of examining the manuscript in the Palazzo Trivulzio at Milan, and in 1880 Dr Richter showed me in London the manuscripts in the possession of Lord Ashburnham, and those in the British Museum. I have thus had opportunities of seeing most of Leonardo's architectural drawings in the original, but of the manuscripts themselves I have deciphered only the notes which accompany the sketches. It is to Dr Richter's exertions that we owe the collected texts on Architecture which are now published, and while he has undertaken to be responsible for the correct reading of the original texts, he has also made it his task to extract the whole of the materials from the various MSS. It has been my task to arrange and elucidate the texts under the heads which have been adopted in this work. MS. B. at Paris and the Codex Atlanticus at Milan are the chief sources of our knowledge of Leonardo as an architect, and I have recently subjected these to a thorough re-investigation expressly with a view to this work.

A complete reproduction of all Leonardo's architectural sketches has not, indeed, been possible, but as far as the necessarily restricted limits of the work have allowed, the utmost completeness has been aimed at, and no efforts have been spared to include every thing that can contribute to a knowledge of Leonardo's style. It would have been very interesting, if it had been possible, to give some general account at least of Leonardo's work and studies in engineering, fortification, canal-making and the like, and it is only on mature reflection that we have reluctantly abandoned this idea. Leonardo's occupations in these departments have by no means so close a relation to literary work, in the strict sense of the word as we are fairly justified in attributing to his numerous notes on Architecture.

Leonardo's architectural studies fall naturally under two heads:

I. Those drawings and sketches, often accompanied by short remarks and explanations, which may be regarded as designs for buildings or monuments intended to be built. With these there are occasionally explanatory texts.

II. Theoretical investigations and treatises. A special interest attaches to these because they discuss a variety of questions which are of practical importance to this day. Leonardo's theory as to the origin and progress of cracks in buildings is perhaps to be considered as unique in its way in the literature of Architecture.

HENRY DE GEYMÜLLER.

XII.

Architectural Designs.

I. Plans for towns.

A. Sketches for laying out a new town with a double system of high-level and low-level road-ways.

Pl. LXXVII, No. 1 (MS. B, 15 b). A general view of a town, with the roads outside it sloping up to the high-level ways within.

Pl. LXXVII, No. 3 (MS. B, 16 b, see No. 741; and MS. B, 15 b, see No. 742) gives a partial view of the town, with its streets and houses, with explanatory references.

Pl. LXXVII, No. 2 (MS. B, 15 b; see No. 743). View of a double staircase with two opposite flights of steps.

Pl. LXXVIII, Nos. 2 and 3 (MS. B, 37 a). Sketches illustrating the connection of the two levels of roads by means of steps. The lower galleries are lighted by openings in the upper road way.

B. Notes on removing houses (MS. Br. M., 270 b, see No. 744).

B. 16 a]

741.

Le strade · *m* · sono · piv · alte · che le strade · *p* · *s* · braccia 6., e ciascuna ²strada · de' essere larga braccia 20, e avere ¹/₂ braccio di calo dalle stremità ³al mezzo, e in esso mezzo sia a ogni braccio uno braccio di ⁴fessura, largo uno dito, dove l'acqua che

The roads *m* are 6 braccia higher than the roads *p s*, and each road must be 20 braccia wide and have ¹/₂ braccio slope from the sides towards the middle; and in the middle let there be at every braccio an opening, one braccio long and one finger wide, where the rain water may run off into

741. 1. strade . [m] M . . chelle. 2. largbr . . chalo. 3. mezo [eda esse stremita einesso mezo . . br unobr. 4. deba. 6. largeza

pioue debba scolare nelle ca⁵ve fatte al medesimo piano di *p · s ·*, e da ogni stremità della ⁶larghezza di detta strada · sia · uno · portico di larghezza di braccia 6 ī sul ⁷le colonne, e sappi che, chi volesse andare per tutta la terra per le ⁸strade alte, potrà a suo acconcio usarle, e chi volesse andare ⁹per le basse, ancora il simile; per le strade alte non devono andare ¹⁰carri, nè altre simili cose, anzi siano solamēte per li giēteli o¹¹mini; per le basse deono andare i carri e altre some al uso ¹²e commodità del popolo ·; l'una casa de' volgiere le schiene ¹³all'altra ·, lasciādo la strada bassa in mezzo, ed agli usci · *n* ¹⁴si mettano le vettovaglie, come legnie, vino e simili cose; per le ¹⁵vie sotterrane si de' votare destri, stalle e simili cose fetide ¹⁶dall'uno arco all'altro

hollows made on the same level as *p s*. And on each side at the extremity of the width of the said road let there be an arcade, 6 braccia broad, on columns; and understand that he who would go through the whole place by the high level streets can use them for this purpose, and he who would go by the low level can do the same. By the high streets no vehicles and similar objects should circulate, but they are exclusively for the use of gentlemen. The carts and burdens for the use and convenience of the inhabitants have to go by the low ones. One house must turn its back to the other, leaving the lower streets between them. Provisions, such as wood, wine and such things are carried in by the doors *n*, and privies, stables and other fetid matter must be emptied away underground. From one arch to the next

B. 5*b*] **742.**

de' essere braccia 300, cioè ciascuna via che riicieve il lume dalle fessu²re delle strade di sopra, e a ogni arco de' essere una scala a luma³ca tōda, perchè ne' cātoni delle quadre si piscia, e larga, e nella ⁴prima uolta sia vn uscio ch'entri ī destri e pisciatoi comuni, e per ⁵scala si disciēda dalla · strada alta · alla bassa,· e le strade ⁶alte si comīcino fori delle porte, e givnte a esse porte abbia⁷no conposto l'altezza di braccia 6; Fia fatta detta terra o presso ⁸a mare o altro fiume grosso, acciocchè le brutture della ⁹città, menate dall'acqua sieno portate · via.

must be 300 braccia, each street receiving its light through the openings of the upper streets, and at each arch must be a winding stair on a circular plan because the corners of square ones are always fouled; they must be wide, and at the first vault there must be a door entering into public privies and the said stairs lead from the upper to the lower streets and the high level streets begin outside the city gates and slope up till at these gates they have attained the height of 6 braccia. Let such a city be built near the sea or a large river in order that the dirt of the city may be carried off by the water.

B. 15*b*] **743.**

Modo di scale | le scale · *c · d ·* discendono ȷ̄ *f · g ·*, e ²similmēte *f · g* ² disciēde ȷ̄ · *h · k*.

The construction of the stairs: The stairs *c d* go down to *f g*, and in the same way *f g* goes down to *h k*.

Br. M. 270*b*] . **744.**

MUTATIONE DI CASE. ON MOVING HOUSES.

²Le case sieno trasmutate e messe per ordine, ³e questo cō facilità si farà, ⁴per-

Let the houses be moved and arranged in order; and this will be done with facility

. . ī portico di largeza di br . . īsu. 7. le colone essapiche . . volessi . . tera. 8. assuo anchoncio . . volessi. 9. no de antare. 10. cari . . simile . . sia. 11. cari. 12. chomodita . . chasa . . lesciene. 13. lassciādo . . imezo edal ussi. 14. mettino le vetto vaglio . . essimili. 15. socterane . . essimile. 16. archo allaltro *5*.

742. 1. br . 300 . . ciaschuna . . ilume. 2. ī schala. 3. cātō dele . . pisia e a e. 4. piscatoi. 5. schala . . | elle |. 6. abbi. 7. chonposte lalteza . . facta decta tera. 8. mere . . acioche le bructure. 9. cicta.

743. 1. disciēdano . . essimilemēte.

744. 1. chase. 2. chase. 3. ecquesto cō facilita (?). 5. eppoi. 6. cōmettano. 11. chase . . novela.

chè tali case son prima fatte ⁵di pezzi so-
pra le piazze, e poi ⁶si cōmettono insieme
colli lor ⁷legniami nel sito dove si debbono
⁸stabilire.

because such houses are at first made in
pieces on the open places, and can then be
fitted together with their timbers in the site
where they are to be permanent.

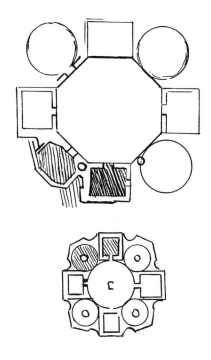

⁹Li omini del pae¹⁰se abitino le nuo-
¹¹ve case in parte, ¹²quando nō v'è la
cor¹³te.

[9] Let the men of the country [or the
village] partly inhabit the new houses when
the court is absent[12].

744. On the same page we find notes referring
to Romolontino and Villafranca with a sketch-map
of the course of the "Sodro" and the "(Lo)era" (both
are given in the text farther on). There can hardly
be a doubt that the last sentence of the passage
given above, refers to the court of Francis I. King of
France.—L.9—13 are written inside the larger sketch,
which, in the original, is on the right hand side of
the page by the side of lines 1—8. The three
smaller sketches are below. J. P. R.

II. Plans for canals and streets in a town.

Pl. LXXIX, 1. and 2, (MS. B, 37ᵇ, see No. 745, and MS. B. 36ᵃ, see No. 746). A Plan for streets and canals inside a town, by which the cellars of the houses are made accessible in boats.

The third text given under No. 747 refers to works executed by Leonardo in France.

B. 37ᵇ] **745.**

La fàccia *a* ²*m* darà il lume ³alle stā-⁴ze; ⁵*a · e ·* sarà · braccia 6·, *a · b* fia braccia · 8·, *b · e* fia braccia 30; acciochè le stanze sotto i portici siano ⁶luminose ·, *c · d · f ·* fia il loco donde se vadi a scaricare le navi in nel⁷le case; A volere che questa cosa · abbia effetto bisogna che la inondatione ⁸de' fiumi non mādasse l' acqua alle ca-nove; è neciessario elegiere sito accomo-dato, ⁹come porsi uicino a vno fiume, il quale ti dia i canali, che nō si possino nè per ¹⁰inōdatione o secchezza delle acque dare mutatione alle altezze d'esse acque, ¹¹e il modo è qui di sotto figurato, e fac-ciasi eletione di bel fiume che nō intorbidi, nè ¹²per pioggia, come Tesino Adda e molti altri; il modo che l'acque senpre

The front *a m* will give light to the rooms; *a e* will be 6 braccia—*a b* 8 braccia —*b e* 30 braccia, in order that the rooms under the porticoes may be lighted; *c d f* is the place where the boats come to the houses to be unloaded. In order to render this arrangement practicable, and in order that the inundation of the rivers may not penetrate into the cellars, it is necessary to chose an appropriate situation, such as a spot near a river which can be diverted into canals in which the level of the water will not vary either by inundations or drought. The construction is shown below; and make choice of a fine river, which the rains do not render muddy, such as the Ticino, the Adda and many others. [12] The construction

745. 2. ilume. 5. br . 6 . . br . 8 . . chelle . . socto. 6. donde [si dia lum] se . . asscharicare . . ine. 7. chuesta . . abbi effecto bisognia accio chella nōdatione. 8. mādassi . . achomodato. 9. vissino. 10. rinōdatione ossecheza . . alteze. 11. el modo . . soto . . effaci . . nōnintorbidine. 12. per piogie chome tesino adda . . chellacque. 13. alteza . . disocto. 14. tera . . sare . . disfaciesino.

745. L. 1—4 are on the left hand side and within the sketch given on Pl. LXXIX, No. 1. Then follows after line 14, the drawing of a sluicegate—*conca*—of which the use is explained in the text below it.

12 *Tesino, Adda e molti altri, i.e.* rivers coming from the mountains and flowing through lakes.

On the page 38ᵃ, which comes next in the original MS. is the sketch of an oval plan of a town over which is written "*modo di canali per la città*" and through the longer axis of it "*canale magior*" is written with "*Tesino*" on the prolongation of the canal.

J. P. R.

stieno [13]a un altezza sarà una cōca, come qui disotto, la quale fia all' entrare della [14]terra, e meglio alquāto dētro aciochè nimici nō la disfacciessino.

to oblige the waters to keep constantly at the same level will be a sort of dock, as shown below, situated at the entrance of the town; or better still, some way within, in order that the enemy may not destroy it[14].

B. 36 a]

746.

Tanto sia larga la stra[2]da ·, quanto è la universale [3]altezza delle case.

Let the width of the streets be equal to the average height of the houses.

Br. M. 270 b]

747.

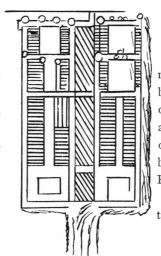

Il fiume di ' mezzo [2]nō ricieva acqua [3]torbida, ma tale ac[4]qua vada per li fossi [5]di fori della terra [6]con 4 molina nell' ē[7]trata e 4 nella u[8]scita, e questo si fa[9]rà col ringorgare l'acqua [10]di sopra a Romolontino;

[11]Facciāsi fonti [12]in cia-[13]scuna piazza.

The main underground channel does not receive turbid water, but that water runs in the ditches outside the town with four mills at the entrance and four at the outlet; and this may be done by damming the water above Romorantin.

[11]There should be fountains made in each piazza[13].

746. 3. alteza . . chase.
747. 1. el . . mezo. 3. mattale. 7. nella vs. 8. ecquesto. 9. ringhorghare. 12. [chome] in cias. 13. piaza.

747. In the original this text comes immediately after the passage given as No. 744. The remainder of the writing on the same page refers to the construction of canals and is given later, in the "Topographical Notes".

10. *Romolontino* is Romorantin, South of Orleans in France.

Lines 1—11 are written to the right of the plan lines 11—13 underneath it. J. P. R.

III. Castles and Villas.

A. Castles.

Pl. LXXX, No. 1 (P. V. fol. 39ᵇ; No. d'ordre 2282). The fortified place here represented is said by Vallardi to be the "castello" at Milan, but without any satisfactory reason. The high tower behind the "rivellino" ravelin—seems to be intended as a watch-tower.

Pl. LXXX, No. 2 (MS. B, 23ᵇ). A similarly constructed tower probably intended for the same use.

Pl. LXXX, No. 3 (MS. B). Sketches for corner towers with steps for a citadel.

Pl. LXXX, No. 4 (W. XVI). A cupola crowning a corner tower; an interesting example of decorative fortification. In this reproduction of the original pen and ink drawing it appears reversed.

B. Projects for Palaces.

Pl. LXXXI, No. 2 (MS. C. A, 75ᵇ; 221ᵃ, see No. 748). Project for a royal residence at Amboise in France.

Pl. LXXXII, No. 1 (C. A 308ᵃ; 939ᵃ). A plan for a somewhat extensive residence, and various details; but there is no text to elucidate it; in courts are written the three names:

Sām
arch *(St. Mark)* cosi
mo *(Cosmo)* giovā
nino *(John),*

o

C. Plans for small castles or Villas.

The three following sketches greatly resemble each other.
Pl. LXXXII, No. 2 (MS. K³ 36ᵇ; see No. 749).

Pl. LXXXII, No. 3 (MS. B 60ᵃ; see No. 750).

Pl. LXXXIII (W. XVII). The text on this sheet refers to Cyprus (see Topographical Notes No. 1103), but seems to have no direct connection with the sketches inserted between.

Pl. LXXXVIII, Nos. 6 and 7 (MS. B, 12ᵃ; see No. 751). A section of a circular pavilion with the plan of a similar building by the side of it. These two drawings have a special historical interest because the text written below mentions the Duke and Duchess of Milan.

The sketch of a villa on a terrace at the end of a garden occurs in C. A. 150; and in C. A. 77ᵇ; 225ᵇ is another sketch of a villa somewhat resembling the Belvedere *of Pope Innocent VIII, at Rome. In C. A. 62ᵇ; 193ᵇ there is a* Loggia.

Pl. LXXXII, No. 4 (C. A. 387ᵃ; 1198ᵃ) is a tower-shaped Loggia *above a fountain. The machinery is very ingeniously screened from view.*

C. A. 75ᵇ; 221ᵃ] 748.

[Il palazzo del principe de' auere dināti vna piazza.]

²Le abitationi doue s'abbia a ballare o fare diuersi ³salti o uari movimēti con moltitudine di gente sieno ter⁴rene, perchè già n'ò veduto ruinare colla morte di ⁵molti; E sopra tutto fa che ogni muro, per sottile che ⁶sia, abbia fondamēto in terra o sopra archi bene ⁷fondati.

⁸Sieno li mezzanelli delli abitacoli ⁹diuisi da muri fatti di stretti mat¹⁰toni e sanza legniami per ri¹¹spetto del fuoco.

¹²Tutti li neciessari abbino esalatio¹³ne per le grossezze de' muri, e in ¹⁴modo che spirino per li tetti.

¹⁵Li mezzanelli sieno in volta, le quali ¹⁶sarā tanto più forti quāto e' sarā mi-¹⁷nori.

¹⁸Le catene di quercia siē rinchi¹⁹use per li muri acciò nō siē offese ²⁰da foco.

The Palace of the prince must have a piazza in front of it.

Houses intended for dancing or any kind of jumping or any other movements with a multitude of people, must be on the ground-floor; for I have already witnessed the destruction of some, causing death to many persons, and above all let every wall, be it ever so thin, rest on the ground or on arches with a good foundation.

Let the mezzanines of the dwellings be divided by walls made of very thin bricks, and without wood on account of fire.

Let all the privies have ventilation [by shafts] in the thickness of the walls, so as to exhale by the roofs.

The mezzanines should be vaulted, and the vaults will be stronger in proportion as they are of small size.

The ties of oak must be enclosed in the walls in order to be protected from fire.

748. 1. palazo. 2. abitationini . . abballare offare. 3. chomoltitudine. 4. rrene . . cholla. 5. Essopra tucto . . persottile. 6. ossópra arachi. 8. mezanelli . . abitacholi. 9. mac. 10. tono essanza . . ris. 11. fuocho. 12. Tucti. 13. grosseze. 14. chesspirino . . tecti. 15. mezanelli. 18. chatene diquercie. 20. focho. 21. Lesstāze . . adesstri. 23. il ferore non isspiri.

748. The remarks accompanying the plan reproduced on Pl. LXXXI, No. 2 are as follows: Above, to the left: *"in a angholo stia la guardia de la sstalla"* (in the angle *a* may be the keeper of the stable). Below are the words *"strada dābosa"* (road to Ámboise), parallel with this *"fossa br 40"* (the moat 40 braccia) fixing the width of the moat. In the large court surrounded by a portico *"in terre No. — Largha br. 80 e lūgha br 120."* To the right of the castle is a large basin for aquatic sports with the words *"Giostre colle nave cioè li giostrā li stieno sopra le na"* (Jousting in boats that is the men are to be in boats). J. P. R.

²¹Le stãze d'andare a' destri sieno ²²molte che entrino l'una nell' al²³tra, acciochè il fiero odore non spiri per ²⁴le abitationi, e tutti li loro usci ²⁵si serrino colli cõtrapesi.

²⁶La massima diuisione della frõte di que²⁷sto palazzo è in due parti, cioè che la larghez²⁸za della corte sia la metà di tutta la predetta ²⁹fronte; La 2ª ...

The privies must be numerous and going one into the other in order that the stench may not penetrate into the dwellings, and all their doors must shut off themselves with counterpoises.

The main division of the façade of this palace is into two portions; that is to say the width of the court-yard must be half the whole façade; the 2nd ...

K.3 36b] **749.**

Largo per ogni lato br. 30; l'entrata da ²basso è in una sala larga braccia 10 e ³lunga braccia 30 e a 4 camere cõ sua cami⁴ni.

30 braccia wide on each side; the lower entrance leads into a hall 10 braccia wide and 30 braccia long with 4 recesses each with a chimney.

B. 60a] **750.**

Il primo grado sia · tutto ²ripieno.

The first storey [or terrace] must be entirely solid.

B. 12a] **751.**

Padiglione del giardino della duchessa ²di Milano.

Fondamẽto del padiglione ch'è nel ⁴mezzo del laberinto del duca di Milano.

The pavilion in the garden of the Duchess of Milan.

The plan of the pavilion which is in the middle of the labyrinth of the Duke of Milan.

24. li . . ettutti . . vssci. 25. cholli chõtrappesi. 26. ques. 26. chella larghe.
749. 1. Largho . . dab. 2. basso [e ino] e in . . la"r"gha br . 10 el. 3. lungha br 30.
751. 1. zardino. 3. del [z]. 4. mezo.

749. On each side of the castle, Pl. LXXXII. No. 2 there are drawings of details, to the left *"Camino"* a chimney, to the right the central lantern, sketched in red *"8 lati"* i. e. an octagon.

751. This passage was first published by AMO-RETTI in *Memorie Storiche* Cap. X: *Una sua opera da riportarsi a quest' anno fu il bagno fatto per la duchessa Beatrice nel parco o giardino del Castello. Lionardo non solo ne disegnò il piccolo edifizio a foggia di padiglione, nel cod. segnato Q. 3, dandone anche separatamente la pianta; ma sotto vi scrisse: Padiglione del giardino della duchessa; e sotto la pianta: Fondamento del padiglione ch'è nel mezzo del labirinto del duca di Milano; nessuna data è presso il padiglione, disegnato nella pagina 12, ma poco sopra fra molti circoli intrecciati vedesi =* 10 *Luglio* 1492 *= e nella pagina 2 presso ad alcuni disegni di legumi qualcheduno ha letto Settembre* 1482 *in vece di* 1492, *come dovea scriverevi, e probabilmente scrisse Lionardo.*

The original text however hardly bears the interpretation put upon it by AMORETTI. He is mis-

taken as to the mark on the MS. as well as in his statements as to the date, for the MS. in question has no date; the date he gives occurs, on the contrary, in another note-book. Finally, it appears to me quite an open question whether Leonardo was the architect who carried out the construction of the dome-like Pavilion here shown in section, or of the ground plan of the Pavilion drawn by the side of it. Must we, in fact, suppose that *"il duca di Milano"* here mentioned was, as has been generally assumed, Ludovico il Moro? He did not hold this title from the Emperor before 1494; till that date he was only called *Governatore* and Leonardo in speaking of him, mentions him generally as *"il Moro"* even after 1494. On January 18, 1491, he married Beatrice d'Este the daughter of Ercole I, Duke of Ferrara. She died on the 2nd January 1497, and for the reasons I have given it seems improbable that it should be this princess who is here spoken of as the *"Duchessa di Milano"*. From the style of the handwriting it appears to me to be beyond

B. 19*b*] **752.**

Il terreno · che si cava · dalle · canove ²si
debe elevare da cāto tāto · in alto che ³fac-
cia un orto ·, che sia alto quāto la sala, ⁴ma
fa che tra'l terreno dell' orto e'l muro
⁵della casa sia uno · intervallo, acciò che
⁶l'umido nō guasti i muri maestri.

The earth that is dug out from the cellars
must be raised on one side so high as to
make a terrace garden as high as the level
of the hall; but between the earth of the
terrace and the wall of the house, leave an
interval in order that the damp may not spoil
the principal walls.

752. 1. tereno chessi chava delle chanove. 2. ellevare da chāto. 3. chessia. 4. chettral tereno. 5. chasa. 6. maesstri.

all doubt that the MS. B, from which this passage
is taken, is older than the dated MSS. of 1492 and
1493. In that case the Duke of Milan here men-
tioned would be Gian Galeazzo (1469—1494) and

the Duchess would be his wife Isabella of Aragon,
to whom he was married on the second February
1489. J. P. R.

IV. *Ecclesiastical Architecture.*

A. *General Observations.*

B. 39*b*]

753.

Senpre vno edifitio vole · essere ²spic-
cato dintorno a volere dimostra³re la sua
vera forma.

A building should always be detached
on all sides so that its form may be seen.

Ash. II. 8*b*]

754.

Qui nō si può nè si debe fare ²cāpa-
nile, anzi debe ³stare separato come à il
do⁴mo e Sā Giovanni di Firēze·, ⁵e così il
domo di Pisa · che mo⁶stra il cāpanile per se
dispicca⁷to ī circa e così il domo, e o⁸gni
vno per se può mostrare la sua ⁹perfet-
tione, e chi lo uolesse pure ¹⁰fare colla
chiesa, faccia la lā¹¹terna scusare cāpanile
¹²come è la chiesa di Chiaravalle.

Here there cannot and ought not to be
any *campanile*; on the contrary it must stand
apart like that of the Cathedral and of San
Giovanni at Florence, and of the Cathedral
at Pisa, where the campanile is quite detached
as well as the dome. Thus each can display
its own perfection. If however you wish to join
it to the church, make the lantern serve for
the campanile as in the church at Chiaravalle.

753. 2. ispichato.
754. 1. po nessi. 2. chāpanile. 3. chome. 4. essāgiovani. 6. chāpanile . . displicha. 7. circho e chosi. 8. po. 9. perfectione.
10. colla. 11. schusare chāpanile.

753. The original text is reproduced on Pl. XCII,
No. 1 to the left hand at the bottom.

754. This text is written by the side of the plan
given on Pl. XCI. No. 2.

12. The Abbey of Chiaravalle, a few miles from
Milan, has a central tower on the intersection of the
cross in the style of that of the Certosa of Pavia, but
the style is mediaeval (A. D. 1330). Leonardo seems
here to mean, that in a building, in which the cir-
cular form is strongly conspicuous, the campanile
must either be separated, or rise from the centre of
the building and therefore take the form of a lantern.

B. 18*b*] **755.**

A nessuna chiesa sta [2]bene vedere tetti,
āzi [3]sia rappianato e per ca[4]nali l'acqua
discē[5]da ai condotti fatti nel [6]fregiō.

It never looks well to see the roofs of
a church; they should rather be flat and the
water should run off by gutters made in the
frieze.

755. 3. rapianato . . cha. 4. la ch . gua dissie. 5. chondotti.

755. This text is to the left of the domed church reproduced on Pl. LXXXVII, No. 2.

B. The theory of Dome Architecture.

This subject has been more extensively treated by Leonardo in drawings than in writing. Still we may fairly assume that it was his purpose, ultimately to embody the results of his investigation in a "Trattato delle Cupole." The amount of materials is remarkably extensive. MS. B is particularly rich in plans and elevations of churches with one or more domes—from the simplest form to the most complicated that can be imagined. Considering the evident connexion between a great number of these sketches, as well as the impossibility of seeing in them designs or preparatory sketches for any building intended to be erected, the conclusion is obvious that they were not designed for any particular monument, but were theoretical and ideal researches, made in order to obtain a clear understanding of the laws which must govern the construction of a great central dome, with smaller ones grouped round it; and with or without the addition of spires, so that each of these parts by itself and in its juxtaposition to the other parts should produce the grandest possible effect.

In these sketches Leonardo seems to have exhausted every imaginable combination.[1] The results of some of these problems are perhaps not quite satisfactory; still they cannot be considered to give evidence of a want of taste or of any other defect in Leonardo's architectural capacity. They were no doubt intended exclusively for his own instruction, and, before all, as it seems, to illustrate the features or consequences resulting from a given principle.

[1] In MS. B, 32b (see Pl. C III, No. 2) we find eight geometrical patterns, each drawn in a square; and in MS. C.A., fol. 87 to 98 form a whole series of patterns done with the same intention.

I have already, in another place,[1] pointed out the law of construction for buildings crowned by a large dome: namely, that such a dome, to produce the greatest effect possible, should rise either from the centre of a Greek cross, or from the centre of a structure of which the plan has some symmetrical affinity to a circle, this circle being at the same time the centre of the whole plan of the building.

Leonardo's sketches show that he was fully aware, as was to be expected, of this truth. Few of them exhibit the form of a Latin cross, and when this is met with, it generally gives evidence of the determination to assign as prominent a part as possible to the dome in the general effect of the building.

While it is evident, on the one hand, that the greater number of these domes had no particular purpose, not being designed for execution, on the other hand several reasons may be found for Leonardo's perseverance in his studies of the subject.

Besides the theoretical interest of the question for Leonardo and his Trattato *and besides the taste for domes prevailing at that time, it seems likely that the intended erection of some building of the first importance like the Duomos of Pavia and Como, the church of Sta. Maria delle Grazie at Milan, and the construction of a Dome or central Tower* (Tiburio) *on the cathedral of Milan, may have stimulated Leonardo to undertake a general and thorough investigation of the subject; whilst Leonardo's intercourse with Bramante for ten years or more, can hardly have remained without influence in this matter. In fact now that some of this great Architect's studies for S. Peter's at Rome have at last become known, he must be considered henceforth as the greatest master of Dome-Architecture that ever existed. His influence, direct or indirect even on a genius like Leonardo seems the more likely, since Leonardo's sketches reveal a style most similar to that of Bramante, whose name indeed, occurs twice in Leonardo's manuscript notes. It must not be forgotten that Leonardo was a Florentine; the characteristic form of the two principal domes of Florence, Sta. Maria del Fiore and the Battisterio, constantly appear as leading features in his sketches.*

The church of San Lorenzo at Milan, was at that time still intact. The dome is to this day one of the most wonderful cupolas ever constructed, and with its two smaller domes might well attract the attention and study

[1] Les Projets Primitifs pour la Basilique de St. Pierre de Rome, par Bramante, Raphael etc., Vol. I, p. 2.

of a never resting genius such as Leonardo. A whole class of these sketches betray in fact the direct influence of the church of S. Lorenzo, and this also seems to have suggested the plan of Bramante's dome of St. Peter's at Rome.

In the following pages the various sketches for the construction of domes have been classified and discussed from a general point of view. On two sheets: Pl. LXXXIV (C. A. 354b; 118a) and Pl. LXXXV, Nos. 1—11 (Ash. II, 6b) we see various dissimilar types, grouped together; thus these two sheets may be regarded as a sort of nomenclature of the different types, on which we shall now have to treat.

1. Churches formed on the plan of a Greek cross.

Group I.

Domes rising from a circular base.

The simplest type of central building is a circular edifice.

Pl. LXXXIV, No. 9. Plan of a circular building surrounded by a colonnade.

Pl. LXXXIV, No. 8. Elevation of the former, with a conical roof.

Pl. XC. No. 5. A dodecagon, as most nearly approaching the circle.

Pl. LXXXVI, No. 1, 2, 3. Four round chapels are added at the extremities of the two principal axes;—compare this plan with fig. 1 on p. 44 and fig. 3 on p. 47 (W. P. 5·ᵇ) where the outer wall is octagonal.

Group II.

Domes rising from a square base.

The plan is a square surrounded by a colonnade, and the dome seems to be octagonal.

Pl. LXXXIV. The square plan below the circular building No. 8, and its elevation to the left, above the plan: here the ground-plan is square, the upper storey octagonal. A further development of this type is shown in two sketches C. A. 3ᵃ (not reproduced here), and in

Pl. LXXXVI, No. 5 (which possibly belongs to No. 7 on Pl. LXXXIV.

Pl. LXXXV, No. 4, and p. 45, Fig. 3, a Greek cross, repeated p. 45, Fig. 3, is another development of the square central plan.

The remainder of these studies show two different systems; in the first the dome rises from a square plan,—in the second from an octagonal base.

Group III.

Domes rising from a square base and four pillars.[1]

a) First type. *A Dome resting on four pillars in the centre of a square edifice, with an apse in the middle, of each of the four sides. We have eleven variations of this type.*

aa) Pl. LXXXVIII, No. 3.

bb) Pl. LXXX, No. 5.

cc) Pl. LXXXV, Nos. 2, 3, 5.

dd) Pl. LXXXIV, No. 1 and 4 beneath.

ee) Pl. LXXXV, Nos. 1, 7, 10, 11.

b) Second type. *This consists in adding aisles to the whole plan of the first type; columns are placed between the apses and the aisles; the plan thus obtained is very nearly identical with that of S. Lorenzo at Milan.*

Fig. 1 on p. 56. (MS. B, 75ᵃ) shows the result of this treatment adapted to a peculiar purpose about which we shall have to say a few words later on.

Pl. XCV, No. 1, shows the same plan but with the addition of a short nave. This plan seems to have been suggested by the general arrangement of S. Sepolcro at Milan.

MS. B. 57ᵇ (see the sketch reproduced on p. 51). By adding towers in the four outer angles to the last named plan, we obtain a plan which bears the general features of Bramante's plans for S. Peter's at Rome.[2] *(See p. 51 Fig. 1.)*

Group IV.

Domes rising from an octagonal base.

This system, developed according to two different schemes, has given rise to two classes with many varieties.

In a) On each side of the octagon chapels of equal form are added.

In b) The chapels are dissimilar; those which terminate the principal axes being different in form from those which are added on the diagonal sides of the octagon.

a. First Class.

The Chapel "degli Angeli," at Florence, built only to a height of about 20 feet by Brunellesco, may be considered as the prototype of this group; and, indeed it probably suggested it. The fact that we see in MS. B. 11ᵇ

[1] *The ancient chapel San Satiro, via del Falcone, Milan, is a specimen of this type.*

[2] *See* Les projets primitifs *etc., Pl. 9—12.*

(Pl. XCIV, No. 3) by the side of Brunellesco's plan for the Basilica of Sto. Spirito at Florence, a plan almost identical with that of the Capella degli Angeli, *confirms this supposition. Only two small differences, or we may say improvements, have been introduced by Leonardo. Firstly the back of the chapels contains a third niche, and each angle of the Octagon a folded pilaster like those in Bramante's* Sagrestia di S. M. presso San Satiro *at Milan, instead of an interval between the two pilasters as seen in the Battistero at Florence and in the Sacristy of Sto. Spirito in the same town and also in the above named chapel by Brunellesco.*

The first set of sketches which come under consideration have at first sight the appearance of mere geometrical studies. They seem to have been suggested by the plan given on page 44 Fig. 2 (MS. B, 55ª) in the centre of which is written "Santa Maria in perticha da Pavia", *at the place marked A on the reproduction.*

a) (MS. B, 34ᵇ, page 44 Fig. 3). In the middle of each side a column is added, and in the axes of the intercolumnar spaces a second row of columns forms an aisle round the octagon. These are placed at the intersection of a system of semicircles, of which the sixteen columns on the sides of the octagon are the centres.

b) The preceding diagram is completed and becomes more monumental in style in the sketch next to it (MS. B, 35ª, see p. 45 Fig. 1). An outer aisle is added by circles, having for radius the distance between the columns in the middle sides of the octagon.

c) (MS. B, 96ᵇ, see p. 45 Fig. 2). Octagon with an aisle round it; the angles of both are formed by columns. The outer sides are formed by 8 niches forming chapels. The exterior is likewise octagonal, with the angles corresponding to the centre of each of the interior chapels.

Pl. XCII, No. 2 (MS. B. 96ᵇ). Detail and modification of the preceding plan — half columns against piers — an arrangement by which the chapels of the aisle have the same width of opening as the inner arches between the half columns. Underneath this sketch the following note occurs: questo vole · avere 12 facce · cō 12 tabernaculi · come · a · b. *(This will have twelve sides with twelve tabernacles as* a b.*) In the remaining sketches of this class the octagon is not formed by columns at the angles.*

The simplest type shows a niche in the middle of each side and is repeated on several sheets, viz: MS. B 3; MS. C. A. 354ᵇ (see Pl. LXXXIV, No. 11), and MS. Ash II 6ᵇ; (see Pl. LXXXV, No. 9 and the elevations No. 8; Pl. XCII, No. 3; MS. B. 4ᵇ [not reproduced here] and Pl. LXXXIV, No. 2).

Fig. 1.

Fig. 2. Fig. 3.

Fig. 1.

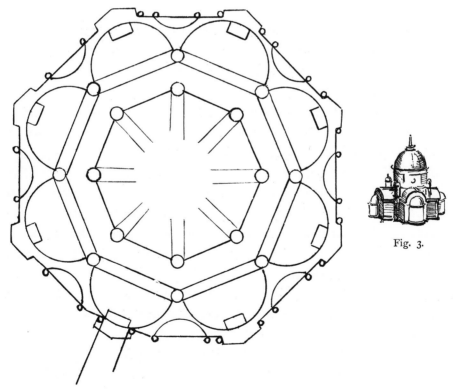

Fig. 3.

Fig. 2.

Pl. XCII, 3 *(MS. B,* 56*ᵇ) corresponds to a plan like the one in MS. B* 35*ᵃ, in which the niches would be visible outside or, as in the following sketch, with the addition of a niche in the middle of each chapel.*

Pl. XC, No. 6. *The niches themselves are surrounded by smaller niches (see also No.* 1 *on the same plate).*

Octagon expanded on each side.

A. *by a square chapel:*

 MS. B. 34*ᵇ (not reproduced here).*

B. *by a square with* 3 *niches:*

 MS. B. 11*ᵇ (see Pl. XCIV, No.* 3).

C. *by octagonal chapels:*

 a) MS. B, 21*ᵃ; Pl. LXXXVIII, No.* 4.

 b) No. 2 *on the same plate. Underneath there is the remark:* "quest'è come le 8 cappele àno a essere facte" *(this is how the eight chapels are to be executed).*

 c) Pl. LXXXVIII, No. 5. *Elevation to the plans on the same sheet, it is accompanied by the note:* "ciasscuno de' 9 tiburi no'uole · passare l'alteza · di · 2 · quadri" *(neither of the* 9 *domes must exceed the height of two squares).*

 d) Pl. LXXXVIII, No, 1, *Inside of the same octagon.*

 MS. B, 30*ᵃ, and* 34*ᵇ; these are three repetitions of parts of the same plan with very slight variations.*

D. *by a circular chapel:*

 MS. B, 18*ᵃ (see Fig.* 1 *on page* 47) *gives the plan of this arrangement in which the exterior is square on the ground floor with only four of the chapels projecting, as is explained in the next sketch.*

 Pl. LXXXIX, MS. B, 17*ᵇ. Elevation to the preceding plan sketched on the opposite side of the sheet, and also marked A. It is accompanied by the following remark, indicating the theoretical character of these studies:* questo · edifitio · anchora · starebbe · bene affarlo dalla linja · a. · b · c · d · insù. *("This edifice would also produce a good effect if only the part above the lines* a b, c d, *were executed").*

 Pl. LXXXIV, No. 11. *The exterior has the form of an octagon, but the chapels project partly beyond it. On the left side of the sketch they appear larger than on the right side.*

 Pl. XC, No. 1, *(MS. B,* 25*ᵇ); Repetition of Pl. LXXXIV, No.* 11.

 Pl. XC, No. 2. *Elevation to the plan No.* 1, *and also to No.* 6 *of the same sheet.*

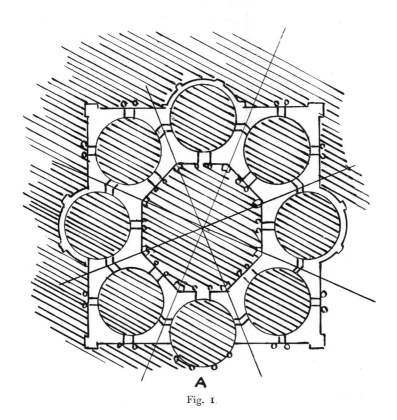

Fig. 1.

Fig. 2.

Fig. 3.

E. By chapels formed by four niches:

Pl. LXXXIV, No. 7 (the circular plan on the left below) shows this arrangement in which the central dome has become circular inside and might therefore be classed after this group.[1]

The sketch on the right hand side gives most likely the elevation for the last named plan.

F. By chapels of still richer combinations, which necessitate an octagon of larger dimensions:

Pl. XCI, No. 2 (MS. Ash. II. 8ᵇ)[2]; on this plan the chapels themselves appear to be central buildings formed like the first type of the third group. Pl. LXXXVIII, No. 3.

Pl. XCI, No. 2 above; the exterior of the preceding figure, particularly interesting on account of the alternation of apses and niches, the latter cantaining statues of a gigantic size, in proportion to the dimension of the niches.

b. Second Class.

Composite plans of this class are generally obtained by combining two types of the first class—the one worked out on the principal axes, the other on the diagonal ones.

MS. B. 22 shows an elementary combination, without any additions on the diagonal axes, but with the dimensions of the squares on the two principal axes exceeding those of the sides of the octagon.

In the drawing W. P. 5ᵇ (see page 44 Fig. 1) the exterior only of the edifice is octagonal, the interior being formed by a circular colonnade; round chapels are placed against the four sides of the principal axes.

The elevation, drawn on the same sheet (see page 47 Fig. 3), shows the whole arrangement which is closely related with the one on Pl. LXXXVI No. 1, 2.

MS. B. 21ᵃ shows:

a) four sides with rectangular chapels crowned by pediments Pl. LXXXVII No. 3 (plan and elevation);

b) four sides with square chapels crowned by octagonal domes. Pl. LXXXVII No. 4; the plan underneath.

MS. B. 18ᵃ shows a variation obtained by replacing the round chapels in the principal axes of the sketch MS. B. 18ᵃ by square ones, with an

[1] *This plan and some others of this class remind us of the plan of the Mausoleum of Augustus as it is represented for instance by Durand. See* Cab. des Estampes, Bibliothèque Nationale, Paris, Topographie de Rome, V, 6, 82.

[2] *The note accampanying this plan is given under No.* 754.

apse. Leonardo repeated both ideas for better comparison side by side, see page 47. Fig. 2.

Pl. LXXXIX (MS. B. 17ᵇ). Elevation for the preceding figure. The comparison of the drawing marked M with the plan on page 47 Fig. 2, bearing the same mark, and of the elevation on Pl. LXXXIX below (marked A) with the corresponding plan on page 47 is highly instructive, as illustrating the spirit in which Leonardo pursued these studies.

Pl. LXXXIV No. 12 shows the design Pl. LXXXVII No. 3 combined with apses, with the addition of round chapels on the diagonal sides.

Pl. LXXXIV No. 13 is a variation of the preceding sketch.

Pl. XC No. 3. MS. B. 25ᵇ. The round chapels of the preceding sketch are replaced by octagonal chapels, above which rise campaniles.

Pl. XC No. 4 is the elevation for the preceding plan.

Pl. XCII No. 1. (MS. B. 39ᵇ.); the plan below. On the principal as well as on the diagonal axes are diagonal chapels, but the latter are separated from the dome by semicircular recesses. The communication between these eight chapels forms a square aisle round the central dome.

Above this figure is the elevation, showing four campaniles on the angles.[1]

Pl. LXXXIV No. 3. On the principal axes are square chapels with three niches; on the diagonals octagonal chapels with niches. Cod. Atl. 340ᵇ gives a somewhat similar arrangement.

MS. B. 30. The principal development is thrown on the diagonal axes by square chapels with three niches; on the principal axes are inner recesses communicating with outer ones.

The plan Pl. XCIII No. 2 (MS. B. 22) differs from this only in so far as the outer semicircles have become circular chapels, projecting from the external square as apses; one of them serves as the entrance by a semicircular portico.

The elevation is drawn on the left side of the plan.

MS. B. 19. A further development of MS. B. 18, by employing for the four principal chapels the type Pl. LXXXVIII No. 3, as we have already seen in Pl. XCI No. 2; the exterior presents two varieties.

a) The outer contour follows the inner.[2]

b) It is semicircular.

Pl. LXXXVII No. 2 (MS. B. 18ᵇ) Elevation to the first variation MS. B. 19. If we were not certain that this sketch was by Leonardo, we might feel tempted to take it as a study by Bramante for St. Peter's at Rome.[3]

[1] *The note accompanying this drawing is reproduced under No. 753.*

[2] *These chapels are here sketched in two different sizes; it is the smaller type which is thus formed.*

[3] *See* Les projets primitifs Pl. 43.

MS. P. V. 39ᵇ. In the principal axes the chapels of MS. B. 19, and semicircular niches on the diagonals. The exterior of the whole edifice is also an octagon, concealing the form of the interior chapels, but with its angles on their axes.

Group V.

Suggested by San Lorenzo at Milan.

In MS. C. A. 266 IIᵇ, 812ᵇ there is a plan almost identical with that of San Lorenzo.—The diagonal sides of the irregular octagon are not indicated. If it could be proved that the arches which, in the actual church, exist on these sides in the first story, were added in 1574 by Martimo Bassi, then this plan and the following section would be still nearer the original state of San Lorenzo than at present. A reproduction of this slightly sketched plan has not been possible. It may however be understood from Pl. LXXXVIII No. 3, by suppressing the four pillars corresponding to the apses.

Pl. LXXXVII No. 1 shows the section in elevation corresponding with the above-named plan. The recessed chapels are decorated with large shells in the halfdomes like the arrangement in San Lorenzo, but with proportions like those of Bramante's Sacristy of Santa Maria presso S. Satiro.

MS. C. A. 266; a sheet containing three views of exteriors of Domes. On the same sheet there is a plan similar to the one above-named but with uninterrupted aisles and with the addition of round chapels in the axes (compare Pl. XCVII No. 3 and page 44 Fig. 1), perhaps a reminiscence of the two chapels annexed to San Lorenzo.—Leonardo has here sketched the way of transforming this plan into a Latin cross by means of a nave with side aisles.

Pl. XCI No. 1. Plan showing a type deprived of aisles and comprised in a square building which is surrounded by a portico. It is accompanied by the following text:

Ash. II. 7 a] **756.**

Questo edifitio è abitato di sotto · e di sopra come · è san Sepulcro, ²ed è sopra come sotto, saluo che 'l di sopra · al tiburio · c · d · e'l di sotto ³al tiburio a · b · e quãdo

This edifice is inhabited [accessible] below and above, like San Sepolcro, and it is the same above as below, except that the upper story has the dome c d; and the

756. 1. socto . . chome . . sansepulchro. 2. chome. 3. a . b . e ecquãdo. 4. nela . . socto. 4. chali 10 schalini. 5. schalini . .

756. The church of San Sepolcro at Milan, founded in 1030 and repeatedly rebuilt after the middle

of the XVIᵗʰ century, still stands over the crypt of the original structure.

entri nella chiesa di sotto, ⁴tu cali 10 sca-
lini, e quãdo mõti in quello di sopra tu sali
20 ⁵scalini, che a ¹/₃ l'uno fãno 10 braccia,
e questo è lo spatio ch'è ⁶iñfra i piani
dell' una e l'altra chiesa.

lower has the dome *a b*, and when you
enter into the crypt, you descend 10 steps,
and when you mount into the upper you
ascend 20 steps, which, with ¹/₃ braccio for
each, make 10 braccia, and this is the height
between one floor of the church and the other.

10. br . e. 11. ellaltra.

*Above the plan on the same sheet is a view of the exterior. By the aid
of these two figures and the description, sections of the edifice may easily
be reconstructed. But the section drawn on the left side of the building
seems not to be in keeping with the same plan, notwithstanding the expla-
natory note written underneath it: "dentro il difitio di sopra" (interior of
the edifice above)[1].*

*Before leaving this group, it is well to remark that the germ of it
seems already indicated by the diagonal lines in the plans Pl. LXXXV
No. 11 and No. 7. We shall find another application of the same type to
the Latin cross in Pl. XCVII No. 3.*

[1] *The small inner dome corresponds to* a b *on the plan —it rises from the lower church into the upper—,
above, and larger, rises the dome* c d. *The aisles above and below thus correspond* (è di sopra come di sotto,
salvoche etc.). *The only difference is, that in the section Leonardo has not taken the trouble to make the form
octagonal, but has merely sketched circular lines in perspective.* J. P. R.

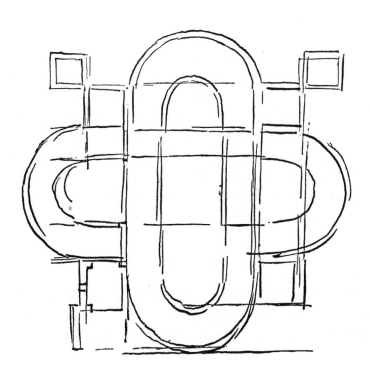

2. Churches formed on the plan of a Latin cross.

We find among Leonardo's studies several sketches for churches on the plan of the Latin cross; we shall begin by describing them, and shall add a few observations.

A. Studies after existing Monuments.

Pl. XCIV No. 2. (MS. B. 11ᵇ.) Plan of Santo Spirito at Florence, a basilica built after the designs of Brunellesco.—Leonardo has added the indication of a portico in front, either his own invention or the reproduction of a now lost design.

Pl. XCV No. 2. Plan accompanied by the words: "*A* è santo sepolcro di milano di sopra" (A *is the upper church of S. Sepolcro at Milan); although since Leonardo's time considerably spoilt, it is still the same in plan.*

The second plan with its note: "*B* è la sua parte socto tera" (B *is its sub-terranean part* [*the crypt*]) *still corresponds with the present state of this part of the church as I have ascertained by visiting the crypt with this plan. Excepting the addition of a few insignificant walls, the state of this interesting part of the church still conforms to Leonardo's sketch; but in the Vestibolo the two columns near the entrance of the winding stairs are absent.*

B. Designs or Studies.

Pl. XCV No. 1. Plan of a church evidently suggested by that of San Sepolcro at Milan. The central part has been added to on the principle of the second type of Group III. Leonardo has placed the "coro" (choir) in the centre.

Pl. XCVI No. 2. In the plan the dome, as regards its interior, belongs to the First Class of Group IV, and may be grouped with the one in MS. B. 35ª. The nave seems to be a development of the type represented in Pl. XCV No. 2, B. by adding towers and two lateral porticos[1].

On the left is a view of the exterior of the preceding plan. It is accompanied by the following note:

B. 24 a] 757.

Questo · edifitio è abitato di sopra e di sotto; ²di sopra · si va · per li campanili · e uassi sù per lo piano ³dove sono fondati · i · 4 · tiburi, e detto piano ⁴à uno parapetto dināzi, e di detti tiburi nessuno ⁵ne riesce in chiesa, anzi sono separati ī tutto.

This building is inhabited below and above; the way up is by the campaniles, and in going up one has to use the platform, where the drums of the four domes are, and this platform has a parapet in front, and none of these domes communicate with the church, but they are quite separate.

757. 4. a ī parapecto. 5. neriessie . . tucto.

Pl. XCVI No. 1 (MS. C. A. 16ᵇ; 65ª). Perspective view of a church seen from behind; this recalls the Duomo at Florence, but with two campaniles[2].

Pl. XCVII No. 3 (MS. B. 52ª). The central part is a development of S. Lorenzo at Milan, such as was executed at the Duomo of Pavia. There is sufficient analogy between the building actually executed and this sketch to suggest a direct connection between them. Leonardo accompanied Francesco di Giorgio[3] when the latter was consulted on June 21ˢᵗ, 1490 as to this church; the fact that the only word accompanying the plan is: "sagrestia", seems to confirm our supposition, for the sacristies were added only in 1492, i. e. four years after the beginning of the Cathedral, which at that time was most likely still sufficiently unfinished to be capable of receiving the form of the present sketch.

Pl. XCVII No. 2 shows the exterior of this design. Below is the note: edifitio al proposito del fōdameto figurato di socto (*edifice proper for the ground plan figured below*).

Here we may also mention the plan of a Latin cross drawn in MS. C. A. fol. 266 (see p. 50).

Pl. XCIV No. 1 (MS. L. 15ᵇ). External side view of Brunellesco's Florentine basilica San Lorenzo, seen from the North.

Pl. XCIV No. 4 (V. A. V, 1). Principal front of a nave, most likely of a church on the plan of a Latin cross. We notice here not only the

[1] *Already published in* Les projets primitifs *Pl. XLIII.*

[2] *Already published in the* Saggio *Pl. IX.*

[3] *See* MALASPINA, il Duomo di Pavia. *Documents.*

*principal features which were employed afterwards in Alberti's front of
S. Maria Novella, but even details of a more advanced style, such as
we are accustomed to meet with only after the year* 1520.

*In the background of Leonardo's unfinished picture of St. Jerome
(Vatican Gallery) a somewhat similar church front is indicated (see the
accompanying sketch).*

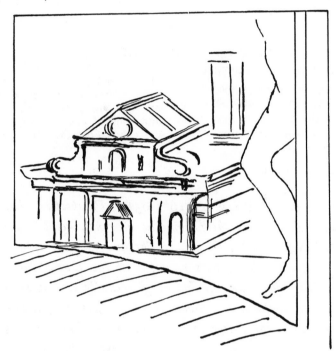

*The view of the front of a temple, apparently a dome in the centre of
four corinthian porticos bearing pediments (published by Amoretti Tav. II. B
as being by Leonardo), is taken from a drawing, now at the Ambrosian
Gallery. We cannot consider this to be by the hand of the master.*

C. Studies for a form of a Church most proper for preaching.

The problem as to what form of church might answer the require-ments of acoustics seems to have engaged Leonardo's very particular attention. The designation of "teatro" given to some of these sketches, clearly shows which plan seemed to him most favourable for hearing the preacher's voice.

Pl. XCVII, No. 1 (MS. B, 52). Rectangular edifice divided into three naves with an apse on either side, terminated by a semicircular theatre with rising seats, as in antique buildings. The pulpit is in the centre. Leonardo has written on the left side of the sketch: "teatro da predicare" *(Theatre for preaching).*

MS. B, 55ᵃ (see page 56, Fig. 1). A domed church after the type of Pl. XCV, No. 1, shows four theatres occupying the apses and facing the square "coro" (choir), which is in the centre between the four pillars of the dome.[1] The rising arrangement of the seats is shown in the sketch above. At the place marked B *Leonardo wrote* teatri per uldire messa *(rows of seats to hear mass), at* T teatri, *and at* C coro *(choir).*

In MS. C.A. 260, are slight sketches of two plans for rectangular choirs and two elevations of the altar and pulpit which seem to be in con-nection with these plans.

In MS. Ash II, 8ᵃ (see p. 56 and 57. Fig. 2 and 3). "Locho dove si pre-dica" (Place for preaching). A most singular plan for a building. The interior is a portion of a sphere, the centre of which is the summit of a column destined to serve as the preacher's pulpit. The inside is somewhat

[1] *The note* teatro de predicar, *on the right side is, I believe, in the handwriting of Pompeo Leoni.* J. P. R.

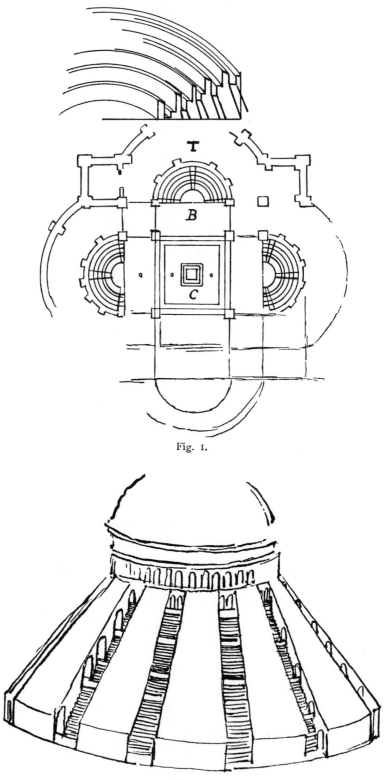

Fig. 1.

Fig. 2.

like a modern theatre, whilst the exterior and the galleries and stairs recall the ancient amphitheatres.

Page 57, Fig. 4. A plan accompanying the two preceding drawings. If this gives the complete form Leonardo intended for the edifice, it would

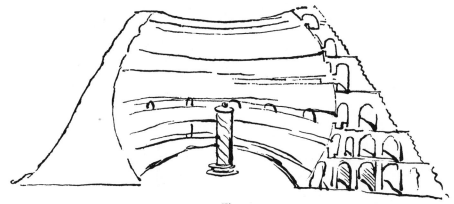

Fig. 3.

Fig. 4.

have comprised only about two thirds of the circle. Leonardo wrote in the centre "fondamento", *a word he often employed for plans, and on the left side of the view of the exterior:* locho dove si predicha *(a place for preaching in).*

D. Design for a Mausoleum.

Pl. XCVIII (P. V., 182. No. d'ordre 2386). In the midst of a hilly landscape rises an artificial mountain in the form of a gigantic cone, crowned by an imposing temple. At two thirds of the height a terrace is cut out with six doorways forming entrances to galleries, each leading to three sepulchral halls, so constructed as to contain about five hundred funeral urns, disposed in the customary antique style. From two opposite sides steps ascend to the terrace in a single flight and beyond it to the temple above. A large circular opening, like that in the Pantheon, is in the dome above what may be the altar, or perhaps the central monument on the level of the terrace below.

The section of a gallery given in the sketch to the right below shows the roof to be constructed on the principle of superimposed horizontal layers, projecting one beyond the other, and each furnished with a sort of heel, which appears to be undercut, so as to give the appearance of a beam from within. Granite alone would be adequate to the dimensions here given to the key stone, as the thickness of the layers can hardly be considered to be less than a foot. In taking this as the basis of our calculation for the dimensions of the whole construction, the width of the chamber would be about 25 feet but, judging from the number of urns it contains—and there is no reason to suppose that these urns were larger than usual—it would seem to be no more than about 8 or 10 feet.

The construction of the vaults resembles those in the galleries of some etruscan tumuli, for instance the Regulini Galeassi tomb at Cervetri (lately discovered) and also that of the chamber and passages of the pyramid of Cheops and of the treasury of Atreus at Mycenae.

The upper cone displays not only analogies with the monuments mentioned in the note, but also with Etruscan tumuli, such as the Cocumella

tomb at Vulci, and the Regulini Galeassi tomb[1]. *The whole scheme is one of the most magnificent in the history of Architecture.*

It would be difficult to decide as to whether any monument he had seen suggested this idea to Leonardo, but it is worth while to enquire, if any monument, or group of monuments of an earlier date may be supposed to have done so.[2]

[1] *See* FERSGUSON, *Handbook of Architecture*, I, 291.

[2] *There are, in Algiers, two Monuments, commonly called* "Le Madracen" *and* "Le tombeau de la Chrétienne," *which somewhat resemble Leonardo's design. They are known to have served as the Mausolea of the Kings of Mauritania. Pomponius Mela, the geographer of the time of the Emperor Claudius, describes them as having been* "Monumentum commune regiae gentis." *See* Le Madracen, Rapport fait par M. le Grand Rabbin AB. CAHEN, Constantine 1873—Mémoire sur les fouilles executées au Madras'en . . par le Colonel BRUNON, Constantine 1873.—Deux Mausolées Africains, le Madracen et le tombeau de la Chrétienne par M. J. DE LAURIÈRE, Tours 1874.—Le tombeau de la Chrétienne, Mausolée des rois Mauritaniens par M. BERBRUGGER, Alger 1867.—*I am indebted to M. LE BLANC, of the Institut, and M. LUD. LALANNE, Bibliothécaire of the Institut for having first pointed out to me the resemblance between these monuments; while M. ANT. HÉRON DE VILLEFOSSE of the Louvre was kind enough to place the abovementioned rare works at my disposal. Leonardo's observations on the coast of Africa are given later in this work. The Herodium near Bethlehem in Palestine* (Jebel el Fureidîs, *the Frank Mountain) was, according to the latest researches, constructed on a very similar plan. See* Der Frankenberg, von Baurath C. SCHICK in Jerusalem, Zeitschrift des Deutschen Palästina-Vereins, *Leipzig* 1880, *Vol. III, pages* 88—99 *and Plates IV and V.* J. P. R.

E. Studies for the Central Tower, or Tiburio of Milan Cathedral.

Towards the end of the fifteenth century the Fabbricceria del Duomo *had to settle on the choice of a model for the crowning and central part of this vast building. We learn from a notice published by G. L. Calvi[1] that among the artists who presented models in the year 1488 were: Bramante, Pietro da Gorgonzola, Luca Paperio (Fancelli), and Leonardo da Vinci.—*

Several sketches by Leonardo refer to this important project:

Pl. XCIX, No. 2 (MS. S. K. III, No. 36ª) a small plan of the whole edifice.—The projecting chapels in the middle of the transept are wanting here. The nave appears to be shortened and seems to be approached by an inner "vestibolo".—

Pl. C, No. 2 (Tr. 21). Plan of the octagon tower, giving the disposition of the buttresses; starting from the eight pillars adjoining the four principal piers and intended to support the eight angles of the Tiburio. These buttresses correspond exactly with those described by Bramante as existing in the model presented by Omodeo.[2]

Pl. C, 3 (MS. Tr. 16). Two plans showing different arrangements of the buttresses, which seem to be formed partly by the intersection of a system of pointed arches such as that seen in

Pl. C, No. 5 (MS. B, 27ª) destined to give a broader base to the drum. The text underneath is given under No. 788.

MS. B, 3—three slight sketches of plans in connexion with the preceding ones.

[1] G. L. CALVI, Notizie sulla vita e sulle opere dei principali architetti scultori e pittori che fiorirono in Milano, *Part III*, 20. *See also:* H. DE GEYMÜLLER, Les projets primitifs *etc. I*, 37 *and* 116—119.— *The Fabbricceria of the Duomo has lately begun the publication of the archives, which may possibly tell us more about the part taken by Leonardo, than has hitherto been known.*

[2] *Bramante's opinion was first published by* G. MONGERI, Arch. stor. Lomb. *V, fasc.* 3 *and afterwards by me in the publication mentioned in the preceding note.*

Pl. XCIX, No. 1 (MS. Tr. 15) contains several small sketches of sections and exterior views of the Dome; some of them show buttress-walls shaped as inverted arches. Respecting these Leonardo notes:

L'arco rivescio è migliore per fare
²spalla che l'ordinario, perchè il rovescio
³trova · sotto · se · muro resistēte alla sua
⁴debolezza, e l'ordinario nō trova nel suo
⁵debole se non aria.

The inverted arch is better for giving a shoulder than the ordinary one, because the former finds below it a wall resisting its weakness, whilst the latter finds in its weak part nothing .but air.

758. 1. larcho. 2. isspalla . . riverscio. 4. deboleza ellordinario.

Three slight sketches of sections on the same leaf—above those reproduced here—are more closely connected with the large drawing in the centre of
Pl. C, No. 4 (MS, Tr. 41) which shows a section of a very elevated dome, with double vaults, connected by ribs and buttresses ingeniously disposed, so as to bring the weight of the lantern to bear on the base of the dome.

A sketch underneath it shows a round pillar on which is indicated which part of its summit is to bear the weight: "il pilastro sarà charicho in · a · b." *(The column will bear the weight at a b.) Another note is above on the right side:* Larcho regierà tanto sotto asse chome di sopra ᵉe *(The arch supports as much below it [i. e. a hanging weight] as above it).*

Pl. C, No. 1 (C. A. 303ᵃ). Larger sketch of half section of the Dome, with a very complicated system of arches, and a double vault. Each stone ⁱs shaped so as to be knit or dovetailed to its neighbours. Thus the inside of the Dome cannot be seen from below.

MS. C. A. 303ᵇ. A repetition of the preceding sketch with very slight modifications.

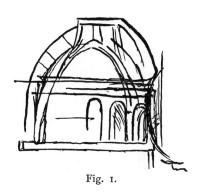

Fig. 1.

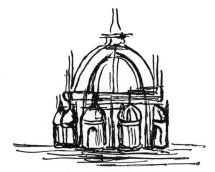

Fig. 2.

MS. Tr. 9 (see Fig. 1 and 2). Section of the Dome with reverted buttresses between the windows, above which iron anchors or chains seem to be intended. Below is the sketch of the outside.

Pl. XCIX, No. 3 *(C. A.,* 262ª*) four sketches of the exterior of the Dome.*

C. A. 12. *Section, showing the points of rupture of a gothic vault, in evident connection with the sketches described above.*

It deserves to be noticed how easily and apparently without effort, Leonardo manages to combine gothic details and structure with the more modern shape of the Dome.

The following notes are on the same leaf, oni cosa pōderosa, *and* oni cosa pōderosa desidera de(scendere); *farther below, several multiplications most likely intended to calculate the weight of some parts of the Dome, thus* 16 × 47 = 720; 720 × 800 = 176000, *next to which is written:* peso del pilastro di 9 teste *(weight of the pillar 9 diameters high).*

Below: 176000 × 8 = 1408000; *and below:*

Semjliō e se cē 80 (?) il peso del tiburio

(six millions six hundred (?) 80 the weight of the Dome),

Bossi hazarded the theory that Leonardo might have been the architect who built the church of Sta. Maria delle Grazie, but there is no evidence to support this, either in documents or in the materials supplied by Leonardo's manuscripts and drawings. The sketch given at the side shows the arrangement of the second and third socle on the apses of the choir of that church; and it is remarkable that those sketches, in MS. S. K. M. II², 2ª and 1ᵇ, occur with the passage given in Volume I as No. 665 *and* 666 *referring to the composition of the Last Supper in the Refectory of that church.*

F. *The Project for lifting up the Battistero of Florence and setting it on a basement.*

Among the very few details Vasari gives as to the architectural studies of Leonardo, we read: "*And among these models and designs there was one by way of which he showed several times to many ingenious citizens who then governed Florence, his readiness to lift up without ruining it, the church of San Giovanni in Florence (the Battistero, opposite the Duomo) in order to place under it the missing basement with steps; he supported his assertions with reasons so persuasive, that while he spoke the undertaking seemed feasable, although every one of his hearers, when he had departed, could see by himself the impossibility of so vast an undertaking.*"[1]

In the MS. C. A. fol. 293, there are two sketches which possibly might have a bearing on this bold enterprise. We find there a plan of a circular or polygonal edifice surrounded by semicircular arches in an oblique position. These may be taken for the foundation of the steps and of the new platform. In the perspective elevation the same edifice, forming a polygon, is shown as lifted up and resting on a circle of inverted arches which rest on an other circle of arches in the ordinary position, but so placed that the inverted arches above rest on the spandrels of the lower range.

What seems to confirm the supposition that the lifting up of a building is here in question, is the indication of engines for winding up, such as jacks, and a rack and wheel. As the lifting apparatus represented on this sheet does not seem particularly applicable to an undertaking of such magnitude, we may consider it to be a first sketch or scheme for the engines to be used.

[1] *This latter statement of Vasari's must be considered to be exaggerated. I may refer here to some data given by* LIBRI, Histoire des sciences mathématiques en Italie (II, 216, 217): "On a cru dans ces derniers temps faire un miracle en mécanique en effectuant ce transport, et cependant dès l'année 1455, Gaspard Nadi et Aristote de Fioravantio avaient transporté, à une distance considérable, la tour de la Magione de Bologne, avec ses fondements, qui avait presque quatre-vingts pieds de haut. Le continuateur de la chronique de Pugliola dit que le trajet fut de 35 pieds et que durant le transport auquel le chroniqueur affirme avoir assisté, il arriva un accident grave qui fit pencher de trois pieds la tour pendant qu'elle était suspendue, mais que cet accident fut promptement reparé (Muratori, Scriptores rer. ital. Tom. XVIII, col. 717, 718). Alidosi a rapporté une note où Nadi rend compte de ce transport avec une rare simplicité. D'après cette note, on voit que les opérations de ce genre n'étaient pas nouvelles. Celle-ci ne coûta que 150 livres (monnaie d'alors) y compris le cadeau que le Légat fit aux deux mécaniciens. Dans la même année, Aristote redressa le clocher de Cento, qui penchait de plus de cinq pieds (Alidosi, instruttione p. 188 — Muratori, Scriptores rer. ital., tom. XXIII, col. 888. — Bossii, chronica Mediol., 1492, in-fol. ad ann. 1455). On ne conçoit pas comment les historiens des beaux-arts ont pu négliger de tels hommes." J. P. R.

G. Description of an unknown Temple.

C. A. 280 a; 852 a] 759.

Per dodici gradi di scale al magno tempio si saliva, il quale otto cento braccia circundaua, e con ottāgulare [2] figura era fabricato, e sopra li otto anguli otto gran base si posauano a un braccio e mezzo, e grosse 3, [3] e lunghe 6 nel suo sodo, coll' angolo in mezzo, sopra delle quali si fondauano 8 grā pilastri: sopra del sodo della basa si le[4]vava per ispatio di 24 braccia, e nel suo termine erano stabiliti 8 capitelli di 3 braccia l'uno, e largo 6, sopra di questi se[5]guiva architraue fregio e cornice con altezza di 4 braccia e ¹/₂, il quale per retta linea [6] dall' un pilastro all' altro s'astendea, e così con circuito d'otto cento braccia il tempio circundava infra l' ū [7] pilastro e l'altro; per sostentacolo di tal mēbro erano stabiliti dieci gran coloñe dell' altezza de' pilastri e cō [8] grossezza di 3 braccia sopra le base, le quali erā alte vn braccio e ¹/₂.

[9] Salivasi a questo tenpio per 12 gradi di scale, il quale tempio era sopra il dodecimo grado fondato in figura ottan[10]gulare, e sopra ciascuno angulo nasceva vn gran pilastro; e infra li pilastri erano inframessi [11] dieci

Twelve flights of steps led up to the great temple, which was eight hundred braccia in circumference and built on an octagonal plan. At the eight corners were eight large plinths, one braccia and a half high, and three wide, and six long at the bottom, with an angle in the middle; on these were eight great pillars, standing on the plinths as a foundation, and twenty four braccia high. And on the top of these were eight capitals three braccia long and six wide, above which were the architrave frieze and cornice, four braccia and a half high, and this was carried on in a straight line from one pillar to the next and so, continuing for eight hundred braccia, surrounded the whole temple, from pillar to pillar. To support this entablature there were ten large columns of the same height as the pillars, three braccia thick above their bases which were one braccia and a half high.

The ascent to this temple was by twelve flights of steps, and the temple was on the twelfth, of an octagonal form, and at each angle rose a large pillar; and between the pillars were placed ten columns of the

759. 1. di sala al . . otāgulare. 2. posaua alte v br e mezo. 3. ellungha . . collangholo imezo . . fondaua. 4. ne di 24 br e . . era stabilito . . di 3 br . luno . . "elargo 6". 5. alteza di 4 br e 1/2 [el simile] il quale. 6. pilastra . . circhuito dotto cento br . . infrallū. 7. ellaltro per sostentachulo . . era stabilito . . colone dellalteza. 8. grosseza di 3 br . . vnbr. 9. acquesto . . disscale . . dode | "cimo" . . otta. 10: tangulare [e inf] e sopra . . infralli . . era inframeso. 11. cola . . alteza . . 28

759. Either this description is incomplete, or, as seems to me highly probable, it refers to some ruin. The enormous dimensions forbid our supposing this to be any temple in Italy or Greece. Syria was the native land of colossal octagonal buildings, in the early centuries A. D. The Temple of Baalbek, and others are even larger than that here described.

J. P. R.

colonne colla medesima altezza de' pilastri, i quali si levauā sopra del pauimēto · 28 braccia e ¹/₂; sopra [12] di questa medesima altezza si posaua architraue fregio e cornice con lunghezza d'otto cēto braccia, e cignea [13] il tenpio a vna medesima altezza circuiua dentro a tal circuito sopra il medesimo piano; in giro in centro del tempio per spatio di 24 braccia nascono [14] le conrispondentie delli 8 pilastri delli angoli, e delle colonne poste a esse prime faccie, e si [15] leuauano alla medesima altezza sopra detta, e sopra tal pilastri li architraui perpetui [16] ritornavano sopra li primi detti pilastri e colonne.

same height as the pillars, rising at once from the pavement to a height of twenty eight braccia and a half; and at this height the architrave, frieze and cornice were placed which surrounded the temple having a length of eight hundred braccia. At the same height, and within the temple at the same level, and all round the centre of the temple at a distance of 24 braccia farther in, are pillars corresponding to the eight pillars in the angles, and columns corresponding to those placed in the outer spaces. These rise to the same height as the former ones, and over these the continuous architrave returns towards the outer row of pillars and columns.

br e ¹ 2. 12. .di queste sta . . alteza . . frego e corice cho collungeza dotto cēto br cigea. 13. alteza . . attal . . piano | ''iciero il centro del tenpio per ispatio di 24 br . nasscie. 14. e delle [ottamta] colone . . facce essi. 15. alteza sopra [di que] detta.

V. Palace architecture.

But a small number of Leonardo's drawings refer to the architecture of palaces, and our knowledge is small as to what style Leonardo might have adopted for such buildings.

Pl. CII No. 1 (W. XVIII). A small portion of a façade of a palace in two stories, somewhat resembling Alberti's Palazzo Rucellai.—Compare with this Bramante's painted front of the Casa Silvestri, and a painting by Montorfano in San Pietro in Gessate at Milan, third chapel on the left hand side and also with Bramante's palaces at Rome. The pilasters with arabesques, the rustica between them, and the figures over the window may be painted or in sgraffito. The original is drawn in red chalk.

Pl. LXXXI No. 1 (MS. Tr. 42). Sketch of a palace with battlements and decorations, most likely graffiti; the details remind us of those in the Castello at Vigevano.[1]

MS. Mz. o", contains a design for a palace or house with a loggia in the middle of the first story, over which rises an attic with a Pediment reproduced on page 67. The details drawn close by on the left seem to indicate an arrangement of coupled columns against the wall of a first story.

Pl. LXXXV No. 14 (MS. S. K. M. III 79ᵃ) contains a very slight

[1] *Count GIULIO PORRO, in his valuable contribution to the* Archivio Storico Lombardo, Anno VIII, Fasc. IV (31 Dec. 1881): Leonardo da Vinci, Libro di Annotazioni e Memorie, *refers to this in the following note:* "Alla pag. 41 vi è uno schizzo di volta ed accanto scrisse: 'il pilastro sarà charicho in su 6' e potrebbe darsi che si riferisse alla cupola della chiesa delle Grazie tanto più che a pag. 42 vi è un disegno che rassomiglia assai al basamento che oggi si vede nella parte esterna del coro di quella chiesa." *This may however be doubted. The drawing, here referred to, on page 41 of the same manuscript, is reproduced on Pl. C No. 4 and described on page 61 as being a study for the cupola of the Duomo of Milan.* J. P. R.

sketch in red chalk, which most probably is intended to represent the façade of a palace. Inside is the short note 7 he 7 (7 and 7).

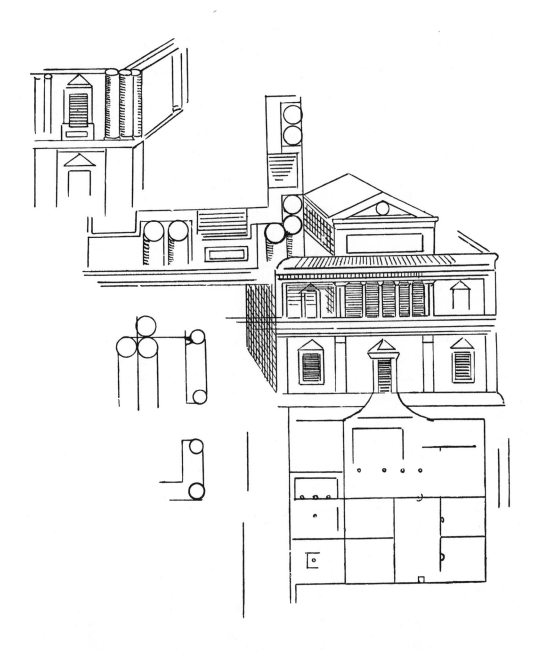

MS. J² 8ᵃ (see pages 68 Fig. 1 and 2) contains a view of an unknown palace. Its plan is indicated at the side.

In MS. Br. M. 126ᵃ (see Fig. 3 on page 68) there is a sketch of a house, on which Leonardo notes: casa con tre terrazi *(house with three terraces).*

Pl. CX, No. 4 (MS. L. 36ᵇ) represents the front of a fortified building drawn at Cesena in 1502 (see No. 1040).

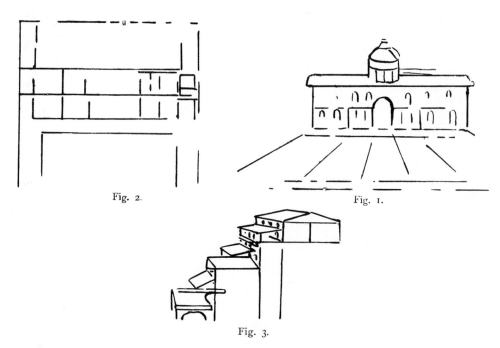

Fig. 2. Fig. 1.

Fig. 3.

Here we may also mention the singular building in the allegorical composition represented on Pl. LVIII in Vol. I. In front of it appears the head of a sphinx or of a dragon which seems to be carrying the palace away.

The following texts refer to the construction of palaces and other buildings destined for private use:

On the pro-portions of a court yard.

La corte de' auere le parieti ²per l'al-tezza la metà della sua ³larghezza, cioè se la corte ⁴sarà braccia 40, la casa deve essere ⁵alta 20 nelle parieti di tal ⁶corte, e tal corte vol essere ⁷larga per la metà di tutta la ⁸facciata.

In the courtyard the walls must be half the height of its width, that is if the court be 40 braccia, the house must be 20 high as regards the walls of the said courtyard; and this courtyard must be half as wide as the whole front.

760. 1. pariete. 2. lalteza. 3. largezza coe sella. 4. br 40 . la casa e essere. 5. alte . . pariete. 6. volerssere. 7. faccata.

760. See Pl. CI, no. 1, and compare the dimensions here given, with No. 748 lines 26—29; and the drawing belonging to it Pl. LXXXI, no. 2.

B. 39 a]　　　　　　　　**761.**

PER FARE VNA POLITA STALLA.

[2]Modo · come · si de' · componere · vna · stalla: Dividerai in prima la sua lar[3]ghezza · in parti · 3 · e la sua lunghezza è libera ·, e le · 3 · dette divisioni [4]sieno equali e di larghezza di braccia 6 per ciascuna, e alte 10, e la parte di mezzo [5]sia in uso · de' maestri di stalla ·, le 2 da cāto per i cavagli, de' quali ciascuno ne de' [6]pigliare per larghezza braccia 6 ·, lūghezza braccia 6, e alte piv dinanti · che dirieto · ¹/₂ · braccio; [7]la mangiatoia sia alta da terra braccia 2, il principio della rastrelliera [8]braccia · 3 · e l'ultimo · braccia 4 ·; Ora · a volere atenere · quello ch'io prometto, cioè di [9]fare detto sito cōtro allo universale vso · pulito e netto · inquāto al · di sopra [10]della stalla ·, cioè dove sta il fieno ·, debe detto loco avere nella sua testa di fori vna [11]finestra alta 6 · e larga 6, donde con vn facil modo si cōduca il fieno su detto [12]solaro, come appare nello strumēto *E* ·, e sia collocata ī un sito di larghez[13]za di braccia 6, e lungo quāto la stalla, come appare in · *k · p* · e l'altre 2 parti [14]che mettano in mezzo · questa, ciascuna sia diuisa in 2 parti, le dua diverso il fieno sia[15]no braccia 4 ·, *p · s* ·, solo allo ofitio e andamento de' ministri d'essa stalla, l'altre [16]2 che confinano colle parieti murali · sieno di braccia 2, come appare in *s · k* ·, [17]e queste sieno allo ofitio di dare · il feno alle māgiatoie · per condotti stretti nel [18]principio e larghi sulle māgiatoie, acciò che'l feno nō si fermi infra via, sieno [19]bene ītonicati e politi, figurati dov'è segnato *4* . *f · s* ·; in quanto al dare [20]bere siano le māgiatoie di pietra, sopra le quali sia l'acqua, si chè si possino [21]scoprire le māgiatoie come si scoprono le casse, alzādo i coperchi loro.

FOR MAKING A CLEAN STABLE.

The manner in which one must arrange a stable. You must first divide its width in 3 parts, its depth matters not; and let these 3 divisions be equal and 6 braccia broad for each part and 10 high, and the middle part shall be for the use of the stablemasters; the 2 side ones for the horses, each of which must be 6 braccia in width and 6 in length, and be half a braccio higher at the head than behind. Let the manger be at 2 braccia from the ground, to the bottom of the rack, 3 braccia, and the top of it 4 braccia. Now, in order to attain to what I promise, that is to make this place, contrary to the general custom, clean and neat: as to the upper part of the stable, i. e. where the hay is, that part must have at its outer end a window 6 braccia high and 6 broad, through which by simple means the hay is brought up to the loft, as is shown by the machine *E*; and let this be erected in a place 6 braccia wide, and as long as the stable, as seen at *k p*. The other two parts, which are on either side of this, are again divided; those nearest to the hay-loft are 4 braccia, *p s*, and only for the use and circulation of the servants belonging to the stable; the other two which reach to the outer walls are 2 braccia, as seen at *s k*, and these are made for the purpose of giving hay to the mangers, by means of funnels, narrow at the top and wide over the manger, in order that the hay should not choke them. They must be well plastered and clean and are represented at *4 f s*. As to the giving the horses water, the troughs must be of stone and above them [cisterns of] water. The mangers may be opened as boxes are uncovered by raising the lids.

On the dispositions of a stable.

761. 2. chome . . chomponere . . isstalla. 3. geza in parte. 3. ella . . lungeza . . decte. 4. largeza di br 6 . . mezo. 6. largeza br . 3 ellūgeza br 6 . . ¹/₂ br. 7. la mangiatoria sialta dacterra br . 2 . [larastella era] il . . dela rastelliera. 8. br . 3 . ellultimo br 4 . . attenere . . promecto. 9. decto . . necto. 10. feno . . decto . . nela. 11. feno. 12. apare . . essia colocata . . large. 13. br 6 . . apare in K. p. laltre e laltre. 14. metano imezo . . si diuisa . . feno. 15. no br 4 "p . s" . . ofitio [de mini si ribe] e andamento. 16. 2 che che chonfinano chole pariete . . br 2 . . apare. 17. ecqueste . . māgiatore . per condocti strecti. 18. sule māgiatore acio. 20. le māgiatore . . sia la sichessi. 21. māgiatore chome si schoprano.

761. See Pl. LXXVIII, No. 1.

B. 28 b] 762.

MODO COME SI FANNO ²L'ARMATURE PER FARE THE WAY TO CONSTRUCT A FRAME-WORK FOR
 ³ORNAMĒTO ⁴DI EDIFITI. DECORATING BUILDINGS.

⁵Modo come si debbono ⁶mettere le per- The way in which the poles ought to be

Decorations tiche ⁷per legare i mazzuoli ⁸de' ginepri placed for tying bunches of juniper on to
for feasts.
sopra esse ⁹pertiche, le quali sono ¹⁰confitte them. These poles must lie close to the frame-
sopra l'ar¹¹matura della vol¹²ta e lega essi work of the vaulting and tie the bunches on
ma¹³zzuoli con salci e ¹⁴sù per fare cimerosa with osier withes, so as to clip them even
¹⁵colle forbici e la¹⁶vora le cō salci; afterwards with shears.
 ¹⁷Sia da l'u¹⁸no all' altro ¹⁹cerchio uno Let the distance from one circle to another
²⁰ ¹/₂ braccio e 'l gi²¹nepro si de' ²²regiere be half a braccia; and the juniper [sprigs]
col²³le cime in giv ²⁴cōmīciādo ²⁵di sotto; must lie top downwards, beginning from below.
 ²⁶A questa colonna si lega ²⁷d'intorno Round this column tie four poles to
4 pertiche, dintor²⁸no alle quali s'inchioda which willows about as thick as a finger must
²⁹vinchi grossi uno dito · e poi ³⁰si fa da be nailed and then begin from the bottom
piè e vassi in alto legā³¹do mazzuoli di and work upwards with bunches of juniper
cime di ³²ginepro colle cime j̄ ba³³ssò cioè sprigs, the tops downwards, that is upside
sotto sopra. down.

Br. M. 192 a] 763.

Sia lasciata cadere l'acqua ²in The water should be allowed to

tutto il cerchio di *a · b*. fall from the whole circle *a b*.

762. 1. fa. 2. larmadure. 5. debe. 7. mazoli. 10. chōfitte. 11. madura. 13. coli chon salcie[l]e. 16. cosalci. 19. cierchio î.
 20. ¹/₂ br. 22. cho. 26. acquesta. 28. ale. 29. î dito. 31. mazoli di [gin] cime. 32. cholle.
763. 1. lacq"a". 2. totto il cierchio.

762. See Pl. CII, No. 3. The words here given 763. Other drawings of fountains are given on
as the title line, lines 1—4, are the last in the ori- Pl. CI (W. XX); the original is a pen and ink drawing
ginal MS.—Lines 5—16 are written under fig. 4. on blue paper; on Pl. CIII (MS. B.) and Pl. LXXXII.

VI. Studies of architectural details.

Several of Leonardo's drawings of architectural details prove that, like other great masters of that period, he had devoted his attention to the study of the proportion of such details. As every organic being in nature has its law of construction and growth, these masters endeavoured, each in his way, to discover and prove a law of proportion in architecture. The following notes in Leonardo's manuscripts refer to this subject.

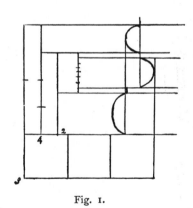

Fig. 1.

Fig. 2.

MS. S. K. M. III, 47ᵇ (see Fig. 1). A diagram, indicating the rules as given by Vitruvius and by Leon Battista Alberti for the proportions of the Attic base of a column.

MS. S. K. M. III 55ᵃ (see Fig. 2). Diagram showing the same rules.

S. K. M. III. 48 a] **764.**

B toro superiore	toro superiore
[2]B nestroli	astragali quadre
[3]B orbiculo	troclea
[4]B nestroli	astragali quadre
[5]B toro īferiore	toro īferiore
[6]B latastro	plintho

L. 19 b; 20 a] **765.**

<table>
<tr><td>

SCALE D' URBINO.

[3]Il latastro deve [4]essere largo quā[5]to la grossezza di qua[6]lūque muro dove [7]tale latastro s'ap[8]poggia.

</td><td>

STEPS OF URBINO.

The plinth must be as broad as the thickness of the wall against which the plinth is built.

</td></tr>
</table>

C. A. 318 a; 961 a] **766.**

<table>
<tr><td>

I nostri antichi architettori comīciando in prima dagli Egitti, i quali secōdo che descrive Diodoro Sicolo [2]furō i primi edificatori e componitori di città grandissime e di castelli ed edifizi publici e privati di forma, grandezza [3]e qualità · per le quali i loro antecedēti riguardevoli con stupefazione e maraviglia [4]le eleuate e grandissime macchine parēdo loro

[5]La colonna ch'à la sua grossezza nel terzo [6]quella che fusse sottile nel mezzo ronperassi nelle..; [7]quella ch'è di pari grossezza e di pari fortezza è migliore per l'edifizio, [8]seconda di bontà sarà quella ch'à la maggior grossezza dov' ella si cōgivgnie colla [9]basa.

</td><td>

The ancient architects beginning with the Egyptians (?) who, as Diodorus Siculus writes, were the first to build and construct large cities and castles, public and private buildings of fine form, large and well proportioned

The column, which has its thickness at the third part The one which would be thinnest in the middle, would break...; the one which is of equal thickness and of equal strength, is better for the edifice. The second best as to usefulness will be the one whose greatest thickness is where it joins with the base.

</td></tr>
</table>

764. 1. toro superio . . super. 2. nexstroli. 3. torclea. 5. inferior . . īferi. 6. [plato] plinto.

765. 2. [il muro]. 3. illatasstro debbe. 4. [g] largo. 5. grosseza di qu"a". 7. latastro. 8. pogga.

766. 1—. . *written from left to right.* 1. nosstri . . otalecine chomīciando . . daglitii'. . sechōdo . . desscriue . . sicholo. 2. edi‎ fichatori e chomponitori di cita . . chasstella. 4. grandeza . . anticiedēti [gestupessani che] righuardevoli chonnistupefazione . . loro; *here the text breaks off.* 5. cholonna . . groseza terzo qui . ve ana aroper se (?) 6. . . mezo . . nelle 2 ispasia.

<table>
<tr><td>

764. No explanation can be offered of the meaning of the letter B, which precedes each name. It may be meant for *basa* (base). Perhaps it refers to some author on architecture or an architect (Bramante?) who employed the designations, thus marked for the mouldings.

3. *troclea.* Philander: *Trochlea sive trochalia aut rechanum.*

6. *Laterculus* or *latastrum* is the Latin name for *Plinthus* (πλίνθος), but Vitruvius adopted this Greek name and "latastro" seems to have been little

</td><td>

in use. It is to be found besides the text given above, as far as I am aware, only on two drawings of the Uffizi Collection, where, in one instance, it indicates the *abacus* of a Doric capital.

765. See Pl. CX No. 3. The hasty sketch on the right hand side illustrates the unsatisfactory effect produced when the plinth is narrower than the wall.

766. See Pl. CIII, No. 3, where the sketches belonging to lines 10—16 are reproduced, but reversed. The sketch of columns, here reproduced by a wood cut, stands in the original close to lines 5—8.

</td></tr>
</table>

[10] Il capitello à a essere ɉ questo formato, dividi la sua grossezza da capo ɉ 8 d' ū piè · · · · · [11] e fa che sia alto $5/_7$ e verrà a essere quadro, dipoi dividi l'altezza ɉ 8, come facesti la colonna, di poi poni $1/_8$ l'uovolo [12] e un altro ottavo la grossezza della tavola che sta di sopra al capitello; [13] i corni della tavola del capitello àno a sportare fuori dalla maggior larghezza della cāpana $2/_7$ [14] cioè settimi del di sopra della cāpana che tocca a ciascū corno di sporto $1/_7$ · [15] e la mozzatura de' corni vuole essere largha quāt' è alta, cioè $1/_8$; ɉl resto degli ornamēti lascio [16] ɉn libertà degli scultori; [17] ma per tornare alle colonne, e provare la ragione secondo la forma di lor fortezza [18] o debolezza, dico così, che quādo le linie si partiranno dalla sommità della [19] colonna e termineranno nel suo nascimēto e la lor uia e lūghezza sia di pari [20] distanzia o latitudine, dico che questa colonna

The capital must be formed in this way. Divide its thickness at the top into 8; at the foot make it $5/_7$, and let it be $5/_7$ high and you will have a square; afterwards divide the height into 8 parts as you did for the column, and then take $1/_8$ for the echinus and another eighth for the thickness of the abacus on the top of the capital. The horns of the abacus of the capital have to project beyond the greatest width of the bell $2/_7$, i.e. sevenths of the top of the bell, so $1/_7$ falls to the projection of each horn. The truncated part of the horns must be as broad as it is high. I leave the rest, that is the ornaments, to the taste of the sculptors. But to return to the columns and in order to prove the reason of their strength or weakness according to their shape, I say that when the lines starting from the summit of the column and ending at its base and their direction and length . . ., their distance apart or width may be equal; I say that this column

Ash. III. 13*b*]

767.

Il cilindro d'vn corpo di figura colō²nale, e le sua opposité fronti sō due cierchi [3] d'interpositione paralella [4] e infra li lor ciētri s'estēde una linia [5] retta, che passa per il mezzo della grossezza [6] del cilindro e termina nelli ciētri [7] d'essi cierchi, la quale linia dalli antichi è detta axis.

The cylinder of a body columnar in shape and its two opposite ends are two circles enclosed between parallel lines, and through the centre of the cylinder is a straight line, ending at the centre of these circles, and called by the ancients the axis.

H.3 73*b*]

768.

[1] $a \cdot b \cdot 1/_3$ di $\cdot n \cdot m \cdot$; [2] $m \cdot o$ $1/_6$ di $r\,o$; [3] l'ovo sporta $1/_6$ di $r \cdot o$; [4] $s \cdot 7$ $1/_5$ di $r \cdot o$ [5] $a \cdot b$ si diuida in 9 e $1/_2$ [6] l'abaco è $3/_9$; [7] ovo $4/_9$; [8] fusaiolo e listello $2/_9$ e $1/_2$.

$a\,b$ is $1/_3$ of $n\,m$; $m\,o$ is $1/_6$ of $r\,o$. The ovolo projects $1/_6$ of $r\,o$; s $7^{1}/_5$ of $r\,o$, $a\,b$ is divided into $9^{1}/_2$; the abacus is $3/_9$ the ovolo $4/_9$, the bead-moulding and the fillet $2/_9$ and $1/_2$.

7. grosseza . . forteza.　8. sechonda . . magior grosseza dovela . . chōgivgnie cholla.　10. chapitello . . grosseza da chapo ɉ | 7 | 8 dupie ne me 5/7.　11. evera . . laltezza . . chome . . cholona . . poni 1/8 luovolo.　12. grosseza dalla . . chessta . . chapitello.　13. i chorni . . chapitello . . assorportera . . della magior largheza . . chāpana.　14. cio settimi . . chāpana che tocha aciasschū chorno dissporto 1/7.　15. mozatura de de chorni . . essre largha . . ɉ resto.　16. ischultori . . 17. cholonne . . sechondo . . forteza.　18. deboleza dicho chosi che quādo [che qua] le.　19. cholonna ettermineranno . . nasscimēto ella . . ellūgheza.　20. l disstanzia . . dicho . . cholonna. *Here the text breaks off.*

767. 1. El chilindro . . chorpo . . cholō.　2. elle . . fronte.　3. dinterpositio paraɉella . e infra li lor ciētri.　4. sastēde . . linia pa.　5. mezo . . grossetta.　6. chilindro ottermina.　7. linia e di detta.　8. linia cietrale e dalli . . assis.

768. 1—8 R.　6. labaco he.　7. hovo.　8. fesaiolo.

767. Leonardo wrote these lines on the margin of a page of the Trattato di Francesco di Giorgio, where there are several drawings of columns, as well as a head drawn in profile inside an outline sketch of a capital.

768. See Pl. LXXXV, No. 16. In the original the drawing and writing are both in red chalk.

Pl. LXXXV No. 6 (MS. Ash. II 6ᵇ) contains a small sketch of a capital with the following note, written in three lines: I chorni del capitelo deono essere la quarta parte d'uno quadro *(The horns of a capital must measure the fourth part of a square).*

MS. S. K. M. III 72ᵇ contains two sketches of ornamentations of windows.

In MS. C. A. 308ᵃ; 938ᵃ (see Pl. LXXXII No. 1) there are several sketches of columns. One of the two columns on the right is similar to those employed by Bramante at the Canonica di S. Ambrogio. The same columns appear in the sketch underneath the plan of a castle. There they appear coupled, and in two stories one above the other. The archivolts which seem to spring out of the columns, are shaped like twisted cords, meant perhaps to be twisted branches. The walls between the columns seem to be formed out of blocks of wood, the pedestals are ornamented with a reticulated pattern. From all this we may suppose that Leonardo here had in mind either some festive decoration, or perhaps a pavilion for some hunting place or park. The sketch of columns marked "35" gives an example of columns shaped like candelabra, a form often employed at that time, particularly in Milan, and the surrounding districts for instance in the Cortile di Casa Castiglione now Silvestre, in the cathedral of Como, at Porta della Rana &c.

G. 52a] **769.**

DELLI ARCHITRAVI DI UNO ²E DI PIÙ PEZZI.

³L'architrave di più pezzi è più potēte che quel d'ū ⁴sol pezzo, essendo essi pezzi colle lor lunghezze situati ⁵per inverso il cētro del mōdo; pruovasi perchè ⁶le pietre ànno il neruo overo tiglio gienerato per il tra⁷verso, cioè per il uerso delli orizonti opposti d'un mede⁸simo emisperio, e questo è contrario al tiglio delle ⁹piāte le quali ànno ...

CONCERNING ARCHITRAVES OF ONE OR SEVERAL PIECES.

An architrave of several pieces is stronger than that of one single piece, if those pieces are placed with their length in the direction of the centre of the world. This is proved because stones have their grain or fibre generated in the contrary direction *i. e.* in the direction of the opposite horizons of the hemisphere, and this is contrary to fibres of the plants which have ...

769. 1. di î. 2. eddi 4. 3. eppiu . . che cquel. 4. pezo . . cholle . . lungheza. 7. orizonti opopositi. 8. ecquesto e chontrario.

769. The text is incomplete in the original.

The Proportions of the stories of a building are indicated by a sketch in MS. S. K. M. II² 11ᵇ (see Pl. LXXXV No. 15). The measures are written on the left side, as follows: br 1ᴵ|₂—6³|₄—br ᴵ|₁₂—2 br—9 e ᴵ|₂—1ᴵ|₂—br 5—ō 9—ō 3 *[br = braccia; ō = oncie].*

Pl. LXXXV No. 13 (MS. B. 62ᵃ) and Pl. XCIII No. 1. (MS. B. 15ᵃ) give a few examples of arches supported on piers.

───────────

XIII.

Theoretical writings on Architecture.

Leonardo's original writings on the theory of Architecture have come down to us only in a fragmentary state; still, there seems to be no doubt that he himself did not complete them. It would seem that Leonardo entertained the idea of writing a large and connected book on Architecture; and it is quite evident that the materials we possess, which can be proved to have been written at different periods, were noted down with a more or less definite aim and purpose. They might all be collected under the one title: "Studies on the Strength of Materials". Among them the investigations on the subject of fissures in walls are particularly thorough, and very fully reported; these passages are also especially interesting, because Leonardo was certainly the first writer on architecture who ever treated the subject at all. Here, as in all other cases Leonardo carefully avoids all abstract argument. His data are not derived from the principles of algebra, but from the laws of mechanics, and his method throughout is strictly experimental.

Though the conclusions drawn from his investigations may not have that precision which we are accustomed to find in Leonardo's scientific labours, their interest is not lessened. They prove at any rate his deep sagacity and wonderfully clear mind. No one perhaps, who has studied these questions since Leonardo, has combined with a scientific mind anything like the artistic delicacy of perception which gives interest and lucidity to his observations.

I do not assert that the arrangement here adopted for the passages in question is that originally intended by Leonardo; but their distribution into five groups was suggested by the titles, or headings, which Leonardo himself prefixed to most of these notes. Some of the longer sections perhaps should not, to be in strict agreement with this divi-

sion, have been reproduced in their entirety in the place where they occur. But the comparatively small amount of the materials we possess will render them, even so, sufficiently intelligible to the reader; it did not therefore seem necessary or desirable to subdivide the passages merely for the sake of strict classification.

The small number of chapters given under the fifth class, treating on the centre of gravity in roof-beams, bears no proportion to the number of drawings and studies which refer to the same subject. Only a small selection of these are reproduced in this work since the majority have no explanatory text.

I.

ON FISSURES IN WALLS.

Br. M. 157 a]

770.

Fa prima il trattato delle cause giene-ratrici del²le rotture de' muri, e poi il trattato de'rimedi separato.

³Li fessi paralelli sono vniversalmēte gienerati ⁴in quelli edifiti che si edificano in lochi montuosi, li ⁵quali sien cōposti di pietre faldate con obbliquo ⁶faldamēto, e perchè in tale obbliquità spesso penetra ⁷acqua e altra vmidità portatricie di cierta terra ⁸vntuosa e sdrucciolante ·, e perchè tali falde nō sono ⁹continuate insino al fondo delle valli, ¹⁰tali pietre si muovono per la loro obli¹¹quità e mai terminão il moto insin ¹²che discendono al fondo della valle, ¹³portando con seco a vso di barca ¹⁴quella parte dello edifitio che per lo¹⁵ro si separa dal suddetto rimanēte;

¹⁶Il rimedio di questo è il fondare spes-¹⁷si pilastri sotto il muro che si move, ¹⁸e con archi dall' uno all' altro e be¹⁹ne ab-barbicati, e questi tali ²⁰pilastri sieno funda²¹ti e fermi ²²nelle falde le quali non sieno rotte;

²³Per trovare la parte stabile delle sopra dette falde è neciessario fare vn ²⁴pozzo sotto il piè del muro cō grā profondità infra esse falde ²⁵e di tal pozzo pulirne cō piana superfitie la larghezza d'un palmo

First write the treatise on the causes of the giving way of walls and then, separately, treat of the remedies.

Parallel fissures constantly occur in buildings which are erected on a hill side, when the hill is composed of stratified rocks with an oblique stratification, because water and other moisture often penetrates these oblique seams carrying in greasy and slippery soil; and as the strata are not continuous down to the bottom of the valley, the rocks slide in the direction of the slope, and the motion does not cease till they have reached the bottom of the valley, carrying with them, as though in a boat, that portion of the building which is separated by them from the rest. The remedy for this is always to build thick piers under the wall which is slipping, with arches from one to another, and with a good scarp and let the piers have a firm foundation in the strata so that they may not break away from them.

In order to find the solid part of these strata, it is necessary to make a shaft at the foot of the wall of great depth through the strata; and in this shaft, on the side from which the hill slopes, smooth and flatten a

770. 1. chause. 3. [di] sono. 4. chessi edifichano illochi. 5. chōposti . . chon obbriquo. 8. essdrucciolente. 9. chontinovate. 10. tale . . simovan. 12. cheddisciendano. 13. chonsecho . . barcha. 16. Irimedio . . spe. 17. pilasstri . . chessi. 18. chon. 19. abarbatiati esti. 20. pilasstri. 21. effermi. 22. rutte. 23. per [del]. 24. pozzo [no] sotto . . chō. 25. pozo . . chō . .

770. See Pl. CIV.

²⁶ dalla sōmità insino al fondo da quel lato, donde il mōte discēde, ²⁷ e in capo d' alquāto tempo questa parte pulita, che si fecie nella pa²⁸riete del pozzo, mostrerà manifesto segnio qual parte del mōte si move.

space one palm wide from the top to the bottom; and after some time this smooth portion made on the side of the shaft, will show plainly which part of the hill is moving.

Br. M. 157 *b*] 771.

Mai le fessure de' muri ²sarā paralelle, fuor che se la ³parte del muro, la quàl ⁴ si separa dal suo rimanēte, ⁵ non discēda.

QUALE REGOLA È QUELLA CHE FA ⁷LI EDIFITI PERMANĒTI.

⁸ La permanētia delli edifiti è la regola contra⁹ria alle 2 anteciedēti, cioè che le muraglie ¹⁰ sieno eleuate in alto tutte equalmēte con e quali ¹¹ gradi, che abbraccino l' intera circuitione dello ¹² edifitio colle intere grossezze di qualunque sorte di ¹³ muri, e ancora che il muro sottile secchi più pre-¹⁴sto che il grosso, e' nō si avrà a rōpere per il peso che lui ¹⁵ possa acquistare dall' una all' altra giornata, perchè, ¹⁶ se il suo duplo seccassi in una giornata il dop¹⁷pio seccherà in due o circa, si uerrà ragguagli-ādo ¹⁸ cō piccola differētia di peso in piccola differētia di tēpo.

¹⁹ Dicie l' aversario ²⁰ che *a* becca²¹tello disciēde.

²² E qui dicie l' auersario ²³ che *r* disciēde e non *e*.

PRONOSTICI DELLE CAVSE ²⁵ DELLE FESSURE DI QUALŪCHE ²⁶ MURO.

²⁷ Quella parte del muro che nō disciēde riserua ²⁸ in se l' obbiquità del beccatello, copritore dell' o²⁹bliquità del muro da lui discesa.

DE' SITI DE' FONDAMĒTI E IN QUAL ³¹ LOCO SŌ CAVSA DELLE RUINE.

³² Quando la fessura del muro è più larga di sopra ³³ che di sotto elli è manifesto segnio che la mu³⁴raglia à la causa della ruina remota dal perpē³⁵diculare d'essa fessura.

The cracks in walls will never be parallel unless the part of the wall that separates from the remainder does not slip down.

WHAT IS THE LAW BY WHICH BUILDINGS HAVE STABILITY.

The stability of buildings is the result of the contrary law to the two former cases. That is to say that the walls must be all built up equally, and by degrees, to equal heights all round the building, and the whole thickness at once, whatever kind of walls they may be. And although a thin wall dries more quickly than a thick one it will not necessarily give way under the added weight day by day and thus, [16] although a thin wall dries more quickly than a thick one, it will not give way under the weight which the latter may acquire from day to day. Because if double the amount of it dries in one day, one of double the thickness will dry in two days or thereabouts; thus the small addition of weight will be balanced by the smaller difference of time [18].

The adversary says that *a* which projects, slips down.

And here the adversary says that *r* slips and not *c*.

HOW TO PROGNOSTICATE THE CAUSES OF CRACKS IN ANY SORT OF WALL.

The part of the wall which does not slip is that in which the obliquity projects and overhangs the portion which has parted from it and slipped down.

ON THE SITUATION OF FOUNDATIONS AND IN WHAT PLACES THEY ARE A CAUSE OF RUIN.

When the crevice in the wall is wider at the top than at the bottom, it is a manifest sign, that the cause of the fissure in the wall is remote from the perpendicular line through the crevice.

larcheza. 26. dacquel . . disscіēde. 27. chapo dalquāto lento questa . . chessi. 28. mossterra . . mōte si m\|\|\|\|. 771. 2. paralelle . . chella. 3. par del. 5. disscіēda. 6. reghola ecquella cheffa. 8. edifiti[e] . . ella reghola. 9. chelle. 10. che qual . . cho quali. 11. abraccino . . circhuitione. 12. cholle . . q aluche sorte. 13. anchora . . sechi. 14. ara . . chellui. 15. acquisstare. 16. il sudduplo sechassi innuna. 17. sechera . . circha . . ragualgliādo. 18. cho pichola diferētia . . pichola diferētia. 20. becha. 22. ecqui. 24. chause. 25. delle [mu]. 27. [I] Quella . . nō [si move] "disciēde". 28. bechatello copritricio dello. 29. delei disciesa. 31. locho sō chavsa. 32. largha. 33. chella. 34. alla chausa. 35. dichulare.

771. Lines 1—5 refer to Pl. CV, No. 2. Line 9 *alle due anteciedēte*, see on the same page. Lines 16—18. The translation of this is doubtful, and the meaning in any case very obscure. Lines 19—23 are on the right hand margin close to the two sketches on Pl. CII, No. 3.

Br. M. 138 a] **772.**

Delle fessure de' muri, le quali sō ²larghe da piè e strette da ca³po e lor causa.

⁴Quel muro senpre si fende che ⁵non si secca vniformemēte ⁶con equal tēpo;

⁷E quel muro d' uniforme gros⁸sezza nō si secca con equal ⁹tēpo, il quale non è in cō-tat¹⁰to d' equal mezzo; come se ¹¹vna parte d' un muro fusse edi¹²ficata in cōtatto d' ū monte ¹³vmido e 'l rimanente restasse ¹⁴in contatto dell' aria, che allo¹⁵ra il rimanēte si ristrigne per ¹⁶ciascun verso e l' umido si man¹⁷tiene nella sua prima grādezza, ¹⁸e allora · quel che s' asciuga ¹⁹nell' aria, restri-gnie e diminui²⁰scesi, e quel che è inu-midito nō ²¹si asciuga e volentieri si rō²²pe al secco dall' umido perchè es²³so vmido non à tenacità da ²⁴seguitare il moto di quel che al cō²⁵tinuo si secca.

Delli fessi arcati larghi di sopra ²⁷e stretti di sotto.

²⁸Quelli fessi arcati larghi di sopra ²⁹e stretti di sotto nascono nelle ³⁰porte rimurate che calā più ne³¹l' altezza che nella larghezza loro ³²per tanto quāto l' altezza è maggiore ³³che nella larghezza e per quāto le com³⁴messure della calcina son piv numerosi ³⁵in nell' altezza che nella larghezza.

³⁶Il fesso diminuisce ³⁷tanto meno in *r o* ³⁸che in *m n*, quāto ³⁹infra *r o* è mē ma⁴⁰teria che in *n m*.

⁴¹Ogni fessura fatta ⁴²ī loco cōcavo è larga ⁴³di sotto, e stretta di sopra, ⁴⁴e questo nascie, come ⁴⁵mostra *b c d* da lato figu⁴⁶rato.

⁴⁷pᵃ ¶Ciò che si inumidi⁴⁸sce cresce per tāto ⁴⁹quāto è l' umido ac⁵⁰quistato.¶

⁵¹2ᵃ ¶E ogni cosa umi⁵²da si restrigne nel⁵³lo asciugare per tā⁵⁴to quanto è l' umido ⁵⁵che da lei si diuide.¶

Of cracks in walls, which are wide at the bottom and narrow at the top and of their causes.

That wall which does not dry uniformly in an equal time, always cracks.

A wall though of equal thickness will not dry with equal quickness if it is not everywhere in contact with the same medium. Thus, if one side of a wall were in contact with a damp slope and the other were in contact with the air, then this latter side would remain of the same size as before; that side which dries in the air will shrink or diminish and the side which is kept damp will not dry. And the dry portion will break away readily from the damp portion because the damp part not shrinking in the same pro-portion does not cohere and follow the move-ment of the part which dries continuously.

Of arched cracks, wide at the top, and narrow below.

Arched cracks, wide at the top and narrow below are found in walled-up doors, which shrink more in their height than in their breadth, and in proportion as their height is greater than their width, and as the joints of the mortar are more numerous in the height than in the width.

The crack diminishes less in *r o* than in *m n*, in proportion as there is less material between *r* and *o* than between *n* and *m*.

Any crack made in a concave wall is wide below and narrow at the top; and this originates, as is here shown at *b c d*, in the side figure.

1. That which gets wet increases in proportion to the moisture it imbibes.

2. And a wet object shrinks, while drying, in proportion to the amount of moisture which evaporates from it.

772. 2. dappiedi esstrtte da cha. 3. ellor chausa. 5. secha. 6. chon. 7. Ecquel . . gro. 8. secha chon. 9. chōta. 10. del qual mezo comesse. 11. fussi. 12. fichato. 13. resstassi. 14. chontatto. 15. sirisstrignie. 16. cias chun . . ellumido 17. grādeza. 18. [il] quel chesassciugha. 19. restringnie 20. ecquel . . īnumidito. 21. assciugha. 22. secho. 23. nona[re. tenacita. 24. chō. 25. secha. 26. delli . . archati. 27. esstretti. 28. archati. 29. esstretti . . nasschano. 30. chalā. 31. lalteza . . larghezza. 32. magiore. 33. larghezza . . lecho. 34. mesurie. 35. larghezza. 36. diminuissce. 38. quādo. 41. Ōni . . tātta. 42. locho chōchavo ellargha. 43. esstretta. 44. ecquesto nasscie. 45. dallato fighu. 47. chessi inumidis. 48. scie cresscie. 49. ellumido. 51. chosa. 53. llo assciugrare. 54. ellumido. 55. dallei.

772. The text of this passage is reproduced in facsimile on Pl. CVI to the left. L. 36—40 are written inside the sketch No. 2. L. 41—46 are partly written over the sketch No. 3 to which they refer.

Br. M. 158 a] 773.

DELLA CAVSA DEL RONPERE DELLI EDIFITI PUBLICI E PRIVATI.

² Romponsi li muri per fessure, che ànno del diretto e alcune che ³ ànno dello obbliquo; le rotture che ànno del diretto ⁴ son gienerate dalli muri novi ⁵ in cōgiūtiō de' muri vecchi diiitti o cō morse giūte alli ⁶ muri vecchi, perchè tali morse, nō potendo resistere allo ⁷ insopportabile peso del muro a lor' cōgiūto, è necies ⁸ sario a quelle ronpersi e dar loco al discièso del predet⁹ to muro novo, il quale cala vn braccio per ogni 10 braccia, o più ¹⁰ o meno, secondo la maggiore o minore soma di calcina ¹¹ interposta infra le pietre murate e cō calcina più ¹² o mē liquida; E nota che senpre si debbe īprima fare ¹³ li muri e poi vestirli delle pietre che li àno a vestire, ¹⁴ perchè se così nō si faciesse, il muro facciēdo maggiore calo che ¹⁵ la crosta di fori, e' sarebbe neciessario che le morse fatte ¹⁶ nelli lati de' muri si rōpessino; perchè le pietre che vestono li mu¹⁷ ri, essendo di maggiore grandezza che le pietre da quel¹⁸ le vestite, è neciessario che ricievino minor quātità di calcina ¹⁹ nelle loro comessure e per cōseguēza faccino minore calo, ²⁰ il che accadere nō può, essendo murate tali croste poi ch'el mu²¹ ro è secco.

²² *a b* muro nuo²³ vo, · *c* · è muro vechio ²⁴ che già à fatto il calo, ²⁵ e lo *a · b* fa il calo poi, ²⁶ bēchè *a*, essēdo fonda²⁷ to sopra il *c* muro ²⁸ vechio, nō si può in nes²⁹ sū modo rōpere per ave³⁰ re stabile fondamēto ³¹ sopra del muro ve³² chio, ma sol si ronpe³³ rà il rimanēte del mu³⁴ ro nvovo *b* cō³⁵ ciosia ch'elli è murato di ³⁶ sopra dalla sommità del edifitio insino al fondo, ³⁷ faciēdo il rimanēte del muro nuovo beccatello ³⁸ sopra il muro che disciède.

OF THE CAUSES OF FISSURES IN [THE WALLS OF] PUBLIC AND PRIVATE BUILDINGS.

The walls give way in cracks, some of which are more or less vertical and others are oblique. The cracks which are in a vertical direction are caused by the joining of new walls, with old walls, whether straight or with indentations fitting on to those of the old wall; for, as these indentations cannot bear the too great weight of the wall added on to them, it is inevitable that they should break, and give way to the settling of the new wall, which will shrink one braccia in every ten, more or less, according to the greater or smaller quantity of mortar used between the stones of the masonry, and whether this mortar is more or less liquid. And observe, that the walls should always be built first and then faced with the stones intended to face them. For, if you do not proceed thus, since the wall settles more than the stone facing, the projections left on the sides of the wall must inevitably give way; because the stones used for facing the wall being larger than those over which they are laid, they will necessarily have less mortar laid between the joints, and consequently they settle less; and this cannot happen if the facing is added after the wall is dry.

a b the new wall, *c* the old wall, which has already settled; and the part *a b* settles afterwards, although *a*, being founded on *c*, the old wall, cannot possibly break, having a stable foundation on the old wall. But only the remainder *b* of the new wall will break away, because it is built from top to bottom of the building; and the remainder of the new wall will overhang the gap above the wall that has sunk.

773. 1. chausa . . pubbici. 2. ronpasi . . alchune. 3. rocture. 4. novi [murati in tēpo brevissimo]. 5. in chōgiūtiō de muri [no] ve "echi" . . chō. 7. allor chōgiūto. 8. acquelle . . locho al discièso. 9. chala vn br per ogni 10 br . . oppiu 10. sechondo . . ōminore . . chalcina. 11. interpossta infralle . . chō chalcina. 12. ōmē . . chessenpre. 13. eppoi vesstirl. chelli . avesstire. 14. chosi . . faciessi . . magiore chalo chel. 15. lacrossta . . farebe . . chelle. 16. vesstano . . 17. esendo . . chelle . . dacque. 18. vesstite . . chalcina. 19. chomessure e per chōseghuēza . . chalo. 20. achadere . . murato tale crosste. 21. essecho. 22. muro [vechio] nuo. 24. affatto il chalo. 25. ello . . chalo. 30. fondamē. 34. chō. 30. cio chelli. 37. bechatello. 38. \\\\\\il muro cheddisciède.

Br. M. 159 *b*] **774.**

Torre nova fundata ²sopra la A new tower founded partly on old
vecchia in parte. masonry.

Br. M. 157 *b*] **775.**

DELLE PIETRE CHE SI DIS²GIŪGONO DALLA LOR OF STONES WHICH DISJOIN THEMSELVES FROM
CALCINA. THEIR MORTAR.

³Le pietre d'equal numero nella loro Stones laid in regular courses from bottom
altezza, mu⁴rate con equal quātità di calcina, to top and built up with an equal quantity of
fāno equal ⁵calo nella partita dell' umido mortar settle equally throughout, when the
che mollifi⁶cò essa calcina. moisture that made the mortar soft evaporates.

⁷Per lo passato si prvova che la poca By what is said above it is proved that
quātità ⁸del muro nuovo interposta infra the small extent of the new wall between *A* and
A · n farà po⁹co calo rispetto alla quātità *n* will settle but little, in proportion to the
del medesimo mu¹⁰ro che s'interpone infra extent of the same wall between *c* and *d*.
c d, e tal fia la pro¹¹portione che ànno in- The proportion will in fact be that of
fra loro le raretà delle ¹²dette calcine qual' the thinness of the mortar in relation to
è la proportiōe delli ¹³nvmeri over delle the number of courses or to the quantity
quātità delle calcine interpo¹⁴ste nelle cōmes- of mortar laid between the stones above the
sure delle pietre murate so¹⁵pra le varie different levels of the old wall.
altezze delli muri vechi.

A. 53 *a*] **776.**

Questo · muro · si rōperà · sotto · l'arco *e* This wall will break under the arch *e f*,
· *f* perchè · i sette · quadrelli ²integri · nō sono because the seven whole square bricks are
· soffitiēti · a sostenere il piè · dell'arco sopra not sufficient to sustain the spring of the
postoli ³e rōperannosi questi · 7 · quadrelli · arch placed on them. And these seven
nel mezzo · apūto come · appare in · *a · b;* bricks will give way in their middle
⁴la ragione si è · che il quadrello · *a* · à sola- exactly as appears in *a b*. The reason
mēte · sopra · se · il peso *a · k* ⁵e l'ultimo · is, that the brick *a* has above it only
quadrello · sotto · l'arco · à sopra · se · il peso the weight *a k*, whilst the last brick under
c · d, x · a; ⁶*c · d* · pare che facci fare · for- the arch has above it the weight *c d x a*.

774. 2. sopra il vechio.
775. 1. chessi. 2. giūghano . . chalcina. 3. puetre. 4. chon . . chalcina. 8. cho . . chalcina. 7. la passata . . chella pocha.
9. pocho chalo risspecto. 10. chessinterpone . . ettal. 11. portione [di] che anno infralloro. 12. chalcine. 13. chal-
cine. 14. ste . . chōmesure.
776. 1. Quessto . . larcho [c] e . f. 2. assosstenere . . archo . . posstoli. 3. e rōperanosi . quesste . . mezo . . chome apare.
6. larcho. 7. cheffacci . . archo uerlasspalla. 8. archo. 9. chome . . dopio.

775. See Pl. CV, No. I. The top of the tower is wanting in this reproduction, and with it the
letter *n* which, in the original, stands above the letter *A* over the top of the tower, while *c* stands
perpendicularly over *d*.

za · all' arco · verso la spalla nel pūto · *p* ·, [7]ma il peso · *p* · *o* · lì fa resistētia ·, ōde tutto · il peso · ne va · nella radice dell' arco; [8]adū-

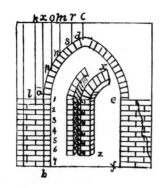

que fa · la radice delli archi · come · 7 · 6, ch'è · più · forte il doppio che · *x* · *z*.

c d seems to press on the arch towards the abutment at the point *p* but the weight *p o* opposes resistence to it, whence the whole pressure is transmitted to the root of the arch. Therefore the foot of the arch acts like 7 6, which is more than double of *x z*.

II.

ON FISSURES IN NICHES.

Br. M. 158 a] 777.

DELLE ROTTURE DELLI NICHI.

² L'arco fatto del semicircolo, il quale fia carico nelli ³ due oppisiti terzi della sua curvità, rōperà in ⁴ cinque lochi della sua curvità; provasi e sieno li pe⁵si *n m*, li quali rompono esso arco *a · b · f*., dico per lo ⁶ passato come *c a* stremi sono equalmēte aggravati dal peso *n*, ⁷ seguita per la 5^a che l'arco ronperà nella parte più remota dalle ⁸ due potentie che lo premono, il quale è il mezzo *e* ·, e altre⁹tanto intēdo aver detto dell'arco opposito *d g b*; adū¹⁰que *n m* pesi vēgono a discēdere, e discēder nō posso¹¹no per la 7^a che non si faccī più vicini, e avicinar nō si pos¹²sono, se l'arco che infra lor s'interpone non avicini li sua ¹³stremi, li quali nō si possono accostare sanza rottura del ¹⁴ suo mezzo; adū-que l'arco si ronperà in 2 lochi come fu primo ¹⁵ posto ecc.

¹⁶ Domāda del peso dato in *a*, che parte ne risponde ī · *n* · ¹⁷*f* linia, e cō che peso s'à a vinciere il peso posto in *f*.

ON FISSURES IN NICHES.

An arch constructed on a semicircle and bearing weights on the two opposite thirds of its curve will give way at five points of the curve. To prove this let the weights be at *n m* which will break the arch *a*, *b*, *f*. I say that, by the foregoing, as the extremities *c* and *a* are equally pressed upon by the thrust *n*, it follows, by the 5th, that the arch will give way at the point which is furthest from the two forces acting on them and that is the middle *e*. The same is to be understood of the opposite curve, *d g b*; hence the weights *n m* must sink, but they cannot sink by the 7th, without coming closer together, and they cannot come together unless the extremities of the arch between them come closer, and if these draw together the crown of the arch must break; and thus the arch will give way in two places as was at first said &c.

I ask, given a weight at *a* what counteracts it in the direction *n f* and by what weight must the weight at *f* be counteracted.

777. 1. rocture. 2. semil . . charicho. 3. churvita. 4. churvita prosi essieno. 5. ronpano . . archo . . per la. 6. passata chome ca"stremi" sono ecqualmēte agravati. 7. seguita "per la 5^a chellarcho." 8. chello priemano . . altrec. 9. archo ._. addū. 10. vēghano addisscēdere e disscēder nō possa. 12. sano dellarcho che infrallor. 13. achostare. 14. larcho . . chome fu pr"o" . ne rissponde. 17. chō . . possto.

Br. M. 141 *b*] **778.**

DELLA DIMINUITIONE DE' CORPI VMIDI [2]DI ON THE SHRINKING OF DAMP BODIES OF
GROSSEZZA O LARGHEZZA DIFFORME. DIFFERENT THICKNESS AND WIDTH.

[3]La finestra *a* è causa della rottura del The window *a* is the cause of the crack
b e questa tal rot[4]tura è aumētata dal peso at *b;* and this crack is increased by the
n m, il quale più si ficca ovvero penetra pressure of *n* and *m* which sink or penetrate
intra la ter[5]ra che ricieve il suo fondamēto, into the soil in which foundations are built
che nō fa la leuità del *b* ·, e ancora il fō- more than the lighter portion at *b*. Besides,
[6]damēto vechio che sta sotto *b* à fatto il the old foundation under *b* has already
calo, il che fatto non aveā li pi[7]lastri *n m* · settled, and this the piers *n* and *m* have not
e la parte *b* non disciēde perpendiculare, yet done. Hence the part *b* does not settle
anzi si gitta info[8]ri per obbliquo e non down perpendicularly; on the contrary, it is
si può per l'aversario gittare in dētro, thrown outwards obliquely, and it cannot
perchè tal parte disuni[9]ta dal tutto è più on the contrary be thrown inwards, be-
larga di fori che di dentro e li labri del cause a portion like this, separated from
rimanente [10]e della medesima figura, e se the main wall, is larger outside than inside
tal parte disunita avesse a ētrare in den- and the main wall, where it is broken, is of
tro, [11]il maggiore entrerebbe nel mi- the same shape and is also larger outside
nore, il che sarebbe inpossibile; adunque than inside; therefore, if this separate portion
[12]è cōcluso che per necessità la parte were to fall inwards the larger would have
di tale emiciclo si disuniscie dal tutto to pass through the smaller—which is impos-
col [13]gittarsi colla parte inferiore infori sible. Hence it is evident that the portion
e non indētro come vole [14]l'auersario of the semicircular wall when disunited
ecc. from the main wall will be thrust outwards,
 and not inwards as the adversary says.
[15]Quando le tribune intere o mezze When a dome or a half-dome is crushed
[16]sarā di sopra vinte da superchio peso, al- from above by an excess of weight the vault
[17]lora le sue volte si apirrāno [18]cō apritura will give way, forming a crack which dimi-
diminuitiva [19]dalla parte di sopra e larga nishes towards the top and is wide below,
di sot[20]to e stretta dalla parte di dentro e narrow on the inner side and wide outside;
[21]larga di fuori, a similitudine della [22]scorza as is the case with the outer husk of a
del pomo ovvero melarācia [23]divisa in molte pomegranate, divided into many parts length-
parti per la sua lūghez[24]za, chè quāto ella wise; for the more it is pressed in the
sarà premuta dal[25]le opposite parti della direction of its length, that part of the joints
sua lūghezza, [26]quella parte delle giūture will open most, which is most distant from
più si a[27]prirà, che fia più distāte alla causa the cause of the pressure; and for that reason
[28]che la prieme ·, e per questo mai si [29]deb- the arches of the vaults of any apse should
bono caricare li archi delle volte [30]di qual- never be more loaded than the arches of
unche emiciclo dalli archi dello [31]suo the principal building. Because that which
edifitio massimo, perchè quel che [32]più weighs most, presses most on the parts be-
pesa più prieme sopra ciò che li è di[33]sotto, low, and they sink into the foundations; but
e più disciende sopra li sua fon[34]damēti, il this cannot happen to lighter structures like
che interuenire nō può [35]alle cose più lieui the said apses.
come sono li emi[36]cicli predetti.

778. 1. chorpi. 2. "ollarghezza". 3. finesstra . . chausa . . roctura . . ecquesta . . roc. 4. ficha over . . intralla. 5. anchora
6. chessta ·. . affatto il chalo. 7. lasstri n . m . ella . . disscède per pēdichulare . . infor. 8. po. 9. eppiu largha . .
cheddi dentro [ess] elli. 10. fighura essettal . . avessi. 11. enterrebbe . . addunque. 12. e chōcluso . . disuniscie . . chol.
13. gittari [dap] cholla . . inferiore [di] inforienone . . chome. 15. trebune . . omeze. 17. apirrāno [chōta]. 18. [tama]
chō. 19. ellargha. 20. esstrēta . . dentro el. 21. largha . . assimilitudine. 22. over. 23. imolte parte. 24. sara permuta.
25. parte . . lūgheza. 26. quela. 27. pirra cheffia . . chausa. 28. chella . . quessto. 29. debbe charichare. 32. sopra chilli
edi. 33. disciende. 35. chose . . chome. 36. predecti. 37. quessti . . chubi. 38. ho. 39. chubo. 40. chubo b sosspeso. 41. in-

778. The figure on Pl. CV, No. 4 belongs to following. The sketch below of a pomegranate
the first paragraph of this passage, lines 1—14; refers to line 22. The drawing fig. 6 is, in the
fig. 5 is sketched by the side of lines 15—and original, over line 37 and fig. 7 over line 54.

[37]Qual di questi due cubi dimi[38]nuirà più vniformemēte, o [39]il cvbo *A* posato sopra il pavi[40]mēto, o'l cubo *b* sospeso [41]infra l'aria, essēdc l'uno [42]e l'altro cubo equali in peso [43]e in quantità e di terra mista [44]con equale vmidità? —

[45]Quel cubo che si posa sopra [46]il pavi-mēto più diminui[47]scie della sua altezza che per la [48]sua larghezza, il che [49]far nō può il cubo ch'è di [50]sopra e sospeso infra l'a-ria; [51]pruovasi così; il cubo po[52]sato so-pra questa medesima [53]sta meglio qui di sotto.

[54]Il fine delli dua cilindri di [55]terra fresca cioè *a b* sa[56]rà le figure piramidali di [57]sotto *c d* ‖ provasi co[58]sì : il cilindro *a,* posato [59]sopra il suo pavimēto per esse[60]re lui di terra assai mista [61]coll'umido, va ca-lādo me[62]diante il suo peso che da di se [63]alla sua basa, e tāto più ca[64]lerà e in-grossserà, quāto e'sa[65]rà colle sua parti più presso [66]alla sua basa, perchè lì si cari[67]ca il suo tutto ecc; E si[68]mile farà il peso *b,* il quale pi[69]ù s'astēderà, quāto elli à mag-gi[70]or peso sotto se, la qual maggiorità [71]è ne'cōfini del suo sostētaculo.

Which of these two cubes will shrink the more uniformly: the cube *A* resting on the pavement, or the cube *b* suspended in the air, when both cubes are equal in weight and bulk, and of clay mixed with equal quantities of water?

The cube placed on the pavement dimi-nishes more in height than in breadth, which the cube above, hanging in the air, cannot do. Thus it is proved. The cube shown above is better shown here below.

The final result of the two cylinders of damp clay that is *a* and *b* will be the pyramidal figures below *c* and *d.* This is proved thus: The cylinder *a* resting on block of stone being made of clay mixed with a great deal of water will sink by its weight, which presses on its base, and in proportion as it settles and spreads all the parts will be somewhat nearer to the base because that is charged with the whole weight, &c.; and the case will be the same with the weight of *b* which will stretch lengthwise in proportion as the weight at the bottom is increased and the greatest ten-sion will be the neighbourhood of the weight which is suspended by it.

frallaria essē luno. 44. ellaltro chub. 43. missta. 44. chon. 45. chubo chessi. 47. alteza. 48. [che] il che. 49. chubo. 50. essosspeso. 51. chosi il chubo. 54. chilindri. 55. fressca. 56. ra le. 57. socto . . cho. 58. chilindro. 60. missta. 61. chollumido va chalādo. 63. ettāto piu cha. 64. ēgrossera. 65. cholle . . parte. 66. chari. 67. cha . . Essi. 69. sas-stēdera . . magi. 70. laqqual magiorita. 71. cne chōfusi . sostētachulo.

III.

ON THE NATURE OF THE ARCH.

CHE COSA È ARCO.

[2]Arco non è altro che una fortezza · cavsata da due debolezze, ĩpero[3]chè l'arco negli edifiti è cõposto di 2 quarti · di circulo, i quali [4]quarti circuli, ciascuno debolissimo per se, desiderã cadere, e opponẽ[5]dosi alla ruina l'uno dell'altro de' due debolezze, si cõvertono in vni[6]ca fortezza.

WHAT IS AN ARCH?

The arch is nothing else than a force originated by two weaknesses, for the arch in buildings is composed of two segments of a circle, each of which being very weak in itself tends to fall; but as each opposes this tendency in the other, the two weaknesses combine to form one strength.

DELLA QUALITÀ DEL PESO DELLI ARCHI.

[8]Poichè l'arco fia · cõposto ·, quello · rimane in equilibrio, ĩpero[9]chè tãto spĩgie · l'uno · l'altro · quãto l'altro l'uno ·, e se pesa piv l'uno [10]quarto circulo · che l'altro ·, quivi fia leuata e negata la permanẽza, [11]imperochè 'l maggiore vĩcierà · il minore peso.

OF THE KIND OF PRESSURE IN ARCHES.

As the arch is a composite force it remains in equilibrium because the thrust is equal from both sides; and if one of the segments weighs more than the other the stability is lost, because the greater pressure will outweigh the lesser.

DEL CARICO DATO AGLI ARCHI.

[13]Dopo il peso equale de' quarti circuli è neciessario dare loro equale [14]peso di sopra, altremẽti si correrebbe nel sopra · detto errore.

OF DISTRIBUTING THE PRESSURE ABOVE AN ARCH.

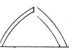

Next to giving the segments of the circle equal weight it is necessary to load them equally, or you will fall into the same defect as before.

779. 1. chosa e archo. 2. archo . . ĩ forteza . . deboleze. 3. larcho . . chõposto . . circhuli. 4. circhuli ciaschuno . debolisimo . . chadere eoponẽ. 5. debolezze . . chõuertano. 6. cha forteza. 7. dela . . deli. 8. chõposto quelo . . equilibra. 9. chettãto . . esse e pesa. 10. circhulo . . premanẽza. 11. magiore. 12. charicho dati ali. 13. circhuli. 14. chorerebe . . erore

DOVE L'ARCO SI RŌPE.

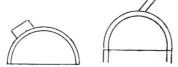

WHERE AN ARCH BREAKS.

[16]L'arco si rōperà j quella · parte che passa · il suo mezzo sotto il cietro.

An arch breaks at the part which lies below half way from the centre.

SECŌDO RŌPIMETO DELL ARCO.

SECOND RUPTURE OF THE ARCH.

[18]Se 'l superchio · peso · fia posto ī mezzo · l'arco nel pūto · a ·, quello desi[19]dera cadere · in · b ·, e ronpesi ne' ²/₃ della sua altezza in . c · e, [20]e tāto fia più potēte · g · e che e · a · quanto [21]m · o · entra in · m · n.

If the excess of weight be placed in the middle of the arch at the point a, that weight tends to fall towards b, and the arch breaks at ²/₃ of its height at c e; and g e is as many times stronger than e a, as m o goes into m n.

D'UN ALTRA CAGIONE DI RUINA.

ON ANOTHER CAUSE OF RUIN.

[23]L'arco verrà · ancora · meno · per essere sospīto da traverso, inpero[24]chè quā-do il carico nō si dirizza ai piè de-l'arco, [25]l'arco poco dura.

The arch will likewise give way under a transversal thrust, for when the charge is not thrown directly on the foot of the arch, the arch lasts but a short time.

A. 50 b] 780.

DELLA FORTEZZA DELL'ARCO.

ON THE STRENGTH OF THE ARCH.

[2]Il modo di fare l'arco permanēte si è a rienpiere i sua angoli · di buono ripieno [3]insino · al suo raso overo · culmine.

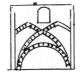

The way to give stability to the arch is to fill the spandrils with good masonry up to the level of its summit.

[4]DEL CARICARE SOPRA L'ARCO TŌDO.

ON THE LOADING OF ROUND ARCHES.

[5]DEL CARICARE L'ARCO · ACUTO BENE.

ON THE PROPER MANNER OF LOADING THE POINTED ARCH.

[6]DELLO INCŌVENIĒTE CHE SEGUITA A CA-RICARE [7]L'ARCO ACUTO SUL SUO MEZZO.

ON THE EVIL EFFECTS OF LOADING THE POINTED ARCH DIRECTLY ABOVE ITS CROWN.

15. larcho. 16. larcho . . mezo [da]. 17. sechōdo . . archo. 18. imezo larcho . . quelo. 19. chadere . . dela . . alteza. 20. [c . in n che in . e] g . e. 22. chagione. 23. larcho vera . anchora . . esserre. 24. charicho . . diriza . . archo. 25. larcho pocho.

780. 1. dela forteza delarcho. 2. larcho. 3. chulmine. 4. charichare . . larcho. 5. charichare larcho achuto. 6. delo inchō-veniēte . . charichare. 7. larcho achuto . . mezo. 8. dano . . larcho achuto. 9. charichato sopra a sua fiāchi. 10. larcho

8DEL DANNO CHE RICIEVE L'ARCO ACUTO
A ESSERE 9CARICATO SOPRA I SUOI FIÃCHI.

ON THE DAMAGE DONE TO THE POINTED
ARCH BY THROWING THE PRESSURE ON
THE FLANKS.

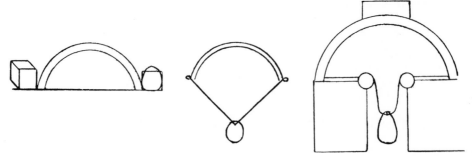

10L'arco · poco · curvo fia sicuro per se, 11ma se fia carico ·, le spalle · bisognia 12bene · armare; 13l'arco d'assai curvità fia per se debole, 14e piv forte se fia carico e farà poca noia 15alle sue spalle ·, e lui · rōperà · in o · p.

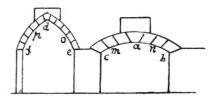

An arch of small curve is safe in itself, but if it be heavily charged, it is necessary to strengthen the flanks well. An arch of a very large curve is weak in itself, and stronger if it be charged, and will do little harm to its abutments, and its places of giving way are o p.

A. 51a] 781.

DEL RIPARO A TERREMOTI.

ON THE REMEDY FOR EARTHQUAKES.

2L'arco il quale mā3derà il peso per-pēdicu4lare alle sue radici 5farà il suo · ofitio

The arch which throws its pressure perpendicularly on the abutments will fulfil

per 6qualūque verso si stia, 7o rovescio, o a giacere, 8o ritto.

9¶L'arco · nō si rōperà · se la · corda del'arco di fori · nō toccherà l'arco di den-tro¶; 10Questo · appare per isperiēza, chè ogni · volta che la corda · a · o · n dell'arco 11di fori · n · r · a · toccherà · l'arco di dentro · x · b · y ·, l'arco darà prīcipio a sua 12debo-lezza ·, e tāto si farà · piv · debole · quāto l'arco · di dētro · rōperà dessa · corda.

13Quell'arco · il quale fia · carico dal'una de'lati, 14il peso si caricherà · sulla sōmità

its function whatever be its direction, upside down, sideways or upright.

The arch will not break if the chord of the outer arch does not touch the inner arch. This is manifest by experience, because whenever the chord a o n of the outer arch n r a approaches the inner arch x b y the arch will be weak, and it will be weaker in proportion as the inner arch passes beyond that chord. When an arch is loaded only on one side the thrust will press on the top of the other side and be transmitted

pocho . . sichuro. 11. charicho lesspali. 13. larcho . . churvita. 14. epiv seffia charicho effara . . 15. ellui.
781. 2. larcho. 3. perpēdichu. 6. Qulūque "r" so. 7. oadiacere. 9. larcho . . chorda delarcho . . tochera larcho. 10. apare chorda . . archo. 11. tochera larcho . . assua. 12. deboleza ettāto . . larcho . . chorda. 13. archo . . charicho. 14. chari-

780. Inside the large figure on the right is the note: *Da pesare la forza dell' archo.*

del'altro mezzo·, e pas¹⁵serà il peso·per īsino·al suo·fondamēto·, e rōperà·in quella ¹⁶parte che fia·piv·lontana·dai sua·stremi·e dalla sua corda.

to the spring of the arch on that side; and it will break at a point half way between its two extremes, where it is farthest from the chord.

H.¹ 35 b]

782.

La quātità cōtinua, che per forza in arco ²fia piegata, spīgie per la linia, ōde deside³ra tornare.

A continuous body which has been forcibly bent into an arch, thrusts in the direction of the straight line, which it tends to recover.

H.¹ 36 a]

783.

L'arco di quātità discreta fa forza ²per linia obliqua, cioè il triangulo ³c n b nō sēte peso.

In an arch judiciously weighted the thrust is oblique, so that the triangle c n b has no weight upon it.

S. K. M. II.² 67 b]

784.

Domando qui che ²pesi fieno quelli ³de'contrapesi a fa⁴re resistētia alla ru⁵ina· di ciascun arco?

I here ask what weight will be needed to counterpoise and resist the tendency of each of these arches to give way?

chera sula somita . . mezo e pa. 15. quela. 16. cheffia . . dala.
782. 1—3 R. 1. archo. 2. fie. **783.** 1—3 R. 1. larcho. **784.** 2. hce pesi. 3. affa. 4. resisētia.

784. The two lower sketches are taken from the MS. S. K. M. III, 10ᵃ; they have there no explanatory text.

Br. M. 158*b*] 785.

DELLA POTĒTIA DELL'ARCO NELL'ARCHI-TETTURA.

²La permanēza dell'arco fabbricato dallo architetto con³siste nella corda e nelle spalle sue.

DELLA SITUATIONE DELLA CORDA NEL SOPRA DETTO ARCO.

⁵La situatione della corda à equale necessità nel princi⁶pio dell'archo, e nel fine della rettitudine del pilastro ⁷dove si posa; pruovasi per la 2ª delli sostētaculi che dicie: ⁸Quella parte del sostentaculo manco resiste che è più remota dal fer⁹mamēto del suo tutto; adunque essendo la ¹⁰sōmità del pilastro vltima remotione dal suo fermamēto, e 'l si¹¹mile accadēdo nelli opposti stremi dell'arco, che sono vl¹²tima distantia dal mezzo, suo vero fermamēto, noi abbiā con¹³cluso, che tal corda *a b* di neciessità richiede la situatione delli ¹⁴sua opposti stremi infra li 4 opposti stremi predetti;

¹⁵Dicie l'auersario che tale arco vole essere più che mezzo ¹⁶tondo, e allora non avrà bisognio di corda perchè tali stremi ¹⁷nō spigneraño infuori, ma indentro, come si di-¹⁸mostra nello ecciesso *a · c · b · d*; Qui si risponde, tale ¹⁹inventione essere trista per 5 cause, e la prima è inquanto ²⁰alla fortezza, perchè è provato jl paralello cir-²¹culare, essendo cōposto di due semicirculi, · sol rōpersi dove ²²tali semicirculi insieme si congiūgono, come mo²³stra la figura *n m*; oltre a di questo seguita, ch'egli è mag-²⁴giore spatio infra li stremi del semicirculo che infra le pa²⁵rieti delli muri; terza è che 'l peso posto per cōtro alla fortezza ²⁶dell'arco diminuiscie tanto di peso, quāto le poste dell'arco ²⁷sono più larghe che detto spatio interposto infra li pilastri, 4ª è ²⁸che li pilastri indeboliscono per tāto quāto la parte loro

ON THE STRENGTH OF THE ARCH IN ARCHITECTURE.

The stability of the arch built by an architect resides in the tie and in the flanks.

ON THE POSITION OF THE TIE IN THE ABOVE NAMED ARCH.

The position of the tie is of the same importance at the beginning of the arch and at the top of the perpendicular pier on which it rests. This is proved by the 2nd "of supports" which says: that part of a support has least resistance which is farthest from its solid attachment; hence, as the top of the pier is farthest from the middle of its true foundation and the same being the case at the opposite extremities of the arch which are the points farthest from the middle, which is really its [upper] attachment, we have concluded that the tie *a b* requires to be in such a position as that its opposite ends are between the four above-mentioned extremes.

The adversary says that this arch must be more than half a circle, and that then it will not need a tie, because then the ends will not thrust outwards but inwards, as is seen in the excess at *a c, b d*. To this it must be answered that this would be a very poor device, for three reasons. The first refers to the strength of the arch, since it is proved that the circular parallel being composed of two semicircles will only break where these semicircles cross each other, as is seen in the figure *n m;* besides this it follows that there is a wider space between the extremes of the semicircle than between the plane of the walls; the third reason is that the weight placed to counterbalance the strength of the arch diminishes in proportion as the piers of the arch are wider than the space between the piers. Fourthly in proportion as the parts at *c a b d* turn outwards, the piers are weaker to support the arch above them. The 5th is that all the material and weight of the

785. 1. dellarcho. 2. premanēza dellarcho fabrichato . . architettoch \|\|\|\. 3. chorda. 4. chorda . . archo. 3. chorda allaq"a" neciessita. 6. rectitudine del pilasstro. 7. dovessi . . pella . . sostētachuli cheddicie. 8. sostentachulo mā. 9. tucto . . essendo [la somita delli] la. 10. somita . . pilasstro . . repotione. 11. achadēdo [nellarcho] nelli . . archo chessono . . chon. 13. chluso chettal chorda "a b" di. 14. infralli . . predecti. 15. chettale archo. 16. ara . . chorda. 17. nō [gitte-ranno] inspignierāno . . indrēto. 18. mosstra . . rispotale. 19. trissta per "5" [tre] chause ella . . e inq̄. 20. provato [larcho sol] jl. 21. chulare . . chōposto . . semice . . 22. semicirchuli . . chongiūghano . . mos. 23. fighura . . quessto . . ema. 24. infralli . . semics . . infralle. 25. riete . . posso perchōtro. 26. archo diminuisscie . . posste dellarcho. 27. e piu largha . . interposto infralli pilasstri \|\|\|\. 28. \|\|\| elli pilasstri indebolisschano. 29. larcho . . la 5ª he. 30. chettutta.

c a ²⁹*b d* si piegha indirieto nel ritienere sopra di se l'arco; la 5ª è ³⁰che tutta la spesa e 'l peso dell'arco che eccede il mezzo tondo ³¹è inutile e dañoso, ed è qui da notare, che il peso ³²sopra posto all'archo rōperà cō più facilità l'arco in *a b* trouā³³do la curuatura dell'ecciesso che al mezzo circulo s'agiugnie ³⁴che essendo dirieto il pilastro insino al cōtatto del semicirculo.

arch which are in excess of the semicircle are useless and indeed mischievous; and here it is to be noted that the weight placed above the arch will be more likely to break the arch at *a b*, where the curve of the excess begins that is added to the semicircle, than if the pier were straight up to its junction with the semicircle [spring of the arch].

LARCHO IL QUALE È CARICO SOPRA IL SUO MEZZO RŌPERÀ ³⁶NEL SUO QUARTO DESTRO E SINISTRO.

AN ARCH LOADED OVER THE CROWN WILL GIVE WAY AT THE LEFT HAND AND RIGHT HAND QUARTERS.

³⁷Prouasi per la 7ª di questo che dicie ³⁸¶le opposite stremità delli sostētaculi sono equalmēte agra³⁹vate dal peso che per lor si sospēde; adūque il peso dato in *f* si ⁴⁰sēte in *b c* cioè mezzo per ciascuno stremo, e per la terza che dicie: ⁴¹Quella parte del sostētacolo d'equal potētia più presto si rompe ⁴²che è più distante al suo ferma-mēto, ōde seguita che ⁴³per essere *d* equalmente distāte al *f e* ferma

This is proved by the 7ᵗʰ of this which says: The opposite ends of the support are equally pressed upon by the weight suspended to them; hence the weight shown at *f* is felt at *b c*, that is half at each extremity; and by the third which says: in a support of equal strength [throughout] that portion will give way soonest which is farthest from its attachment; whence it follows that *d* being equally distant from *f*, *e*

³⁵Se l'armadura dell'ar³⁶co nō cala in-sieme ³⁷col calo dell'arco, la cal³⁸cina nel seccarsi restri³⁹gnie in se medesima e ⁴⁰si spicca dall'ū de'matto⁴¹ni, alli quali ella per col⁴²legarli è interpo⁴³sta, e così li lascia dis⁴⁴legati, per la qual co⁴⁵sa la uolta resta disu⁴⁶nita e le pioggie in brie⁴⁷ve la ruinano.

If the centering of the arch does not settle as the arch settles, the mortar, as it dries, will shrink and detach itself from the bricks between which it was laid to keep them together; and as it thus leaves them disjoined the vault will remain loosely built, and the rains will soon destroy it.

A. 49*b*] **786.**

DELLA · FORTEZZA · E QUALITÀ · DELLI ARCHI, E DOVE SONO FORTI ²O DEBOLI · E COSÌ LE COLONNE.

ON THE STRENGTH AND NATURE OF ARCHES, AND WHERE THEY ARE STRONG OR WEAK; AND THE SAME AS TO COLUMNS.

¶³Quella · parte dell'arco che fia · piv · piana, farà minore resistētia ⁴al peso · so-pra · postoli. ¶

That part of the arch which is nearer to the horizontal offers least resistance to the weight placed on it.

archo . . eciede. 31. [dellarcho] e innutile. 32. possto . . larcho. 33. churuatura . . mezo circhulo. 34. pilasstro . . chō-tatto. 35. charicho . . mezo. 36. desstro essinisstro. 37. cheddicie. 18. sosstētachuli seno. 40. ciasscuno. 41. sosstē-tacholo . . si r\\\\\\\\\\. 42. disstante . . seghuita che\\\\\\\\\\. 43. deq distante al f e ferma\\\\\\\\\\\\\. 36. cho nō chala. 37. chol chalo dell archo. 38. secharsi. 40. sispicha. 41. chol. 42. legharsi. 43. e chosi. 44. leghati . . qual che. 45. la la . . ressta. 46. elle. 47. ve le.
786. 1. forteza. 2. chosi le cholone. 3. archo cheffia. 6. chalando chaccia. 7. ciaschuno ¹/2 archo. 8. echosi. 11. ciasschuno

[5]Quando · jl triāgolo · *a z n* [6]calando caccia indirieto · [7]j ²/₃ di ciascuno ¹/₂ arco [8]cioè *a.s.* e così *z · m*, ela [9]ragiō si è che *a* · piōba sopra · *b*, [10]e così *z* · sopra *f*.

When the triangle *a z n*, by settling, drives backwards the ²/₃ of each ¹/₂ circle that is *a s* and in the same way *z m*, the reason is that *a* is perpendicularly over *b* and so likewise *z* is above *f*.

[11]Ciascuno ¹/₂ · arco ·, sendo vinto · dal superchio · peso ·, si ronperà ne ²/₃ della [12]sua · altezza·, la quale · parte · risponde · per perpēdiculare · linia · sopra · il mezzo della sua [13]basa · come · appare · in · *a · b*; E questo accade chè'l pe o · desidera cadere [14]e passare pel · pūto · *r* ·; E s'egli desiderasse cōtra sua · natura cade[15]re dal pūto · *s* ·, l'arco · *n · s* · si rōperebbe · nel suo · mezzo · appūto [16]e se l'arco · *n · s* · fusse d'ū solo legnio, il peso posto in · *n* · desidereb[17]be cadere in · *m* · e ronperebbesi in mezzo ¹/₂ · all'arco *e · m* ·, altremēti si rōperà nel terzo [18]di sopra nel pūto [19]*a* ·, perchè da · *a · n* · [20]è l'arco · piv pia[21]no, che non è da · [22]*a · o* e che no[23]n è da *o · s*; [24]e tanto · quāto [25]*p · t* · è maggio[26]re che *t · n* · [27]tanto fia piv for[28]te · *a · o* · che [29]non è *a · n* ·; [30]e similmēte [31]tanto fia piv [32]forte · *s · o* · che [33]*o · a* · quāto · [34]*r · p* · fia maggi[35]ore · che *p t*.

[36]Quel arco · che fia · raddoppiato · nella quadratura della sua · grossezza [37]regierà · quattro · tanti · peso quanto · regieva · lo scēpio ·, tanto · piv · [38]quanto · il diamitro della · sua · grossezza · entra · mē numero · di uolte nella [39]sua · lunghezza, Cioè · se la · grossezza dell'arco sciēpio entra · 10 [40]volte nella sua · lūghezza, la grossezza · del arco dupplicato · ētrerà 5 volte [41]nella · sua · lūghezza ·; Adūque entrādo la metà meno la grossezza de [42]l'arco · dupplicato · nella sua · lunghezza · che nō fa quella de[43]l'arco · sciēpio · nella · sua ·, è ragionevol cosa che regga la metà piv [44]peso che nō gli toccherebbe, se fusse alla proportione dell'ar[45]co · sciēpio; Onde essendo quest'arco dupplicato per 4 volte la quā[46]tità del'arco sciēpio, parrebbe che dovesse regiere 4 tāti piv peso, [47]e la sopra detta regola dimostra che ne sostiene · 8 cotāti appūto.

Either half of an arch, if overweighted, will break at ²/₃ of its height, the point which corresponds to the perpendicular line above the middle of its bases, as is seen at *a b;* and this happens because the weight tends to fall past the point *r*.—And if, against its nature it should tend to fall towards the point *s* the arch *n s* would break precisely in its middle. If the arch *n s* were of a single piece of timber, if the weight placed at *n* should tend to fall in the line *n m*, the arch would break in the middle of the arch *e m*, otherwise it will break at one third from the top at the point *a* because from *a* to *n* the arch is nearer to the horizontal than from *a* to *o* and from *o* to *s*, in proportion as *p t* is greater than *t n*, *a o* will be stronger than *a n* and likewise in proportion as *s o* is stronger than *o a*, *r p* will be greater than *p t*.

The arch which is doubled to four times of its thickness will bear four times the weight that the single arch could carry, and more in proportion as the diameter of its thickness goes a smaller number of times into its length. That is to say that if the thickness of the single arch goes ten times into its length, the thickness of the doubled arch will go five times into its length. Hence as the thickness of the double arch goes only half as many times into its length as that of the single arch does, it is reasonable that it should carry half as much more weight as it would have to carry if it were in direct proportion to the single arch. Hence as this double arch has 4 times the thickness of the single arch, it would seem that it ought to bear 4 times the weight; but by the above rule it is shown that it will bear exactly 8 times as much.

¹/₂ . archo. 12. alteza . . risponde perpēdichulare . . mezo dela. 13. chome apare . . Ecquesto achade . . chadere. 14. Essegli desiderassi . . chōtra . . chade. 15. larcho . . rōperebe . . apūto. 16. esselarcho [in] fussi . . desidere. 17. be chadere eronprrebesi in 1/2 archo. 20. elarcho. 25. magio. 30. essimilmēte. 34. magi. 36. archo . cheffia radopiato . . grosseza. 37. lossciēpio . Ettanto. 38. grosseza. 39. lungeza . . sella grosseza dellarcho duplichato ētera. 40. volte ila . . lūgeza la grosseza . . archo duplichato ētera. 41. nela . . lūgeza . . grosseza. 42. larcho duplichato . . lungeza che nō fa che nō fa. 43. larcho . . chosa che rega. 44. peso [ap] che . . tocherebe [ali] sefuss·ssi ala. 45. cho . . archo duplichato. 46. archo . . parebe . . dovessi. 47. chōtāli apūto. 48. cheffia charicho . . diseghuale . . vera. 49. mācho. 50. cholona . . cha

QUEL PILASTRO CHE FIA CARICO DI PIV DI-SEGUALE [49]PESO VERRÀ PIV PRESTO AL MĀCO.

[50]La colonna $c \cdot b \cdot$ per l'essere carica d'equale · somma fia · piv · perma-nēte, [51]e l'altre · 2 di fori · àno bisognio di tāto peso dal loro ciētro infori [52]quāt'è · dal loro · ciētro indētro · cioè dal ciētro della colonna insino a mezzo l'arco.

[53]Li archi che stano per forza di catene nō fieno permanēti.

L'ARCO · FIA DI PIV LŪGA PERPETUITÀ ·, IL QUALE AVRÀ BONO CONTRARIO AL SUO SPĪGIERE.

[55]L'arco per se desidera cadere, e se l'ar-co fia 30 braccia e lo īteruallo ch'è infra i mvri [56]che lo so-stēgono sia · 20 ·, noi sap-piamo che 30 nō passerà per 20, se 20 nō si [57]fa ancora lui · 30 ·; ōde sendo vinto l'arco dal superchio · peso · si dirizza e i mvri [58]male resitēti l'aprono e dāno l'entrata in-fra loro spatio alla ruina del'arco; [59]Ma se tu nō uolessi mettere al-l'arco la sua corda di ferro, li debbi fare tali [60]spalle che facciano · resistētia al suo spingiere, la qual cosa · farai così : carica [61]li angoli $m \cdot n \cdot$ di pietre che le linie delle loro givnture se dirizzino al cientro [62]del circulo del'arco, E la ragione, che sarà l'arco permanēte, fia questa, Noi [63]sap-piamo chiaro che chi carica · l'arco nel quarto suo · $a \cdot b$ di superchio peso che'l [64]muro · $f \cdot g \cdot$ fia sospinto, perchè l'arco si uorrà dirizzare; E chi caricasse l'altro quarto [65]$b \cdot c \cdot$ ch'eli tirerebbe il mvro · $f \cdot g \cdot$ indētro, se nō fusse la linia delle pietre [66]$x\ y$ che fa sostegnio.

THAT PIER, WHICH IS CHARGED MOST UN-EQUALLY, WILL SOONEST GIVE WAY.

The column $c\ b$, being charged with an equal weight, [on each side] will be most durable, and the other two out-ward columns require on the part out-side of their centre as much pressure as there is inside of their centre, that is, from the centre of the co-lumn, towards the middle of the arch.

Arches which depend on chains for their support will not be very durable.

THAT ARCH WILL BE OF LONGER DURATION WHICH HAS A GOOD ABUTMENT OPPOSED TO ITS THRUST.

The arch itself tends to fall. If the arch be 30 braccia and the interval be-tween the walls which carry it be 20, we know that 30 cannot pass through the 20 unless 20 becomes likewise 30. Hence the arch being crushed by the excess of weight, and the walls offering insufficient resistance, part, and afford room between them, for the fall of the arch. But if you do not wish to strengthen the arch with an iron tie you must give it such abutments as can resist the thrust; and you can do this thus: fill up the spandrels $m\ n$ with stones, and direct the lines of the joints between them to the centre of the circle of the arch, and the reason why this makes the arch durable is this. We know very well that if the arch is loaded with an ex-cess of weight above its quarter as $a\ b$, the wall $f\ g$ will be thrust outwards because the arch would yield in that direction; if the other quarter $b\ c$ were loaded, the wall $f\ g$ would be thrust inwards, if it were not for the line of stones $x\ y$ which resists this.

S. K. M. II.2 66b]

787.

FONDAMĒTO.

[2]Qui si dimostra · come li archi [3]fatti ne' lati dell'ottāgolo spingo[4]no i pilastri delli

PLAN.

Here it is shown how the arches made in the side of the octagon thrust the piers

richa . . soma . . premanēte. 51. ano . . tādo . . daloro. 52. daloro . . cholona . . mezo. 53. stano . . chatene. 54. larcho . . ara . . chontrario. 55. larcho . . chadere Esselarcho . . 30 br . . īterualo. 56. sostēgano . . sapiano. 57. anora . . larcho . . diriza. 58. laprano edano . . ala . . archo. 59. Massettu . . archo . . chorda. 60. spale cheffacino . . chosa . . chari-cha. 61. chelle . . dele . . dirizino. 62. circhulo . . archo . larcho . . premanēte. 63. sapiano . . chariche larcho. 64. larcho si uora dirizare . . charichassi. 65. tirerebe . . fussi. 66. cheffa.
787. 2. dimosstra chome. 3. caciarlo.

angoli infori, ⁵come si dimostra nella linia · *h* · *c* ⁶e nella linia *t d* che spingono ⁷il pilastro · *m* · in fori, cioè si ⁸sforzano cacciarlo dal ciĕtro di tale ⁹ottangolo.

of the angles outwards, as is shown by the line *h c* and by the line *t d* which thrust out the pier *m*; that is they tend to force it away from the centre of such an octagon.

B. 27 a]

788.

La speriĕza · che vn peso posto sopra vno arco nō si carica tutto sopra alle sua colon²ne, anzi quāto è maggior peso fraposto sopra l'archi ·, tanto mē pesa ³l'arco il peso alle colōne; la sperienza siè questa: sia messo vn omo ⁴sopra le stadere in mezzo la trōba d'uno pozzo; fa dipoi che questo allarghi le mani ⁵e piedi infra le parieti di detto pozzo ·, vedrai questo pesare alla stadera mol⁶to meno ·; da li vno peso alle spalle, uedrai per speriĕza quāto maggior ⁷peso ti darà, maggiore forza farà in aprire le braccia e ganbe, e piv pō⁸dare nelle parieti, e piv mācare il pōdo alle stadere.

An Experiment to show that a weight placed on an arch does not discharge itself entirely on its columns; on the contrary the greater the weight placed on the arches, the less the arch transmits the weight to the columns. The experiment is the following. Let a man be placed on a steel yard in the middle of the shaft of a well, then let him spread out his hands and feet between the walls of the well, and you will see him weigh much less on the steel yard; give him a weight on the shoulders, you will see by experiment, that the greater the weight you give him the greater effort he will make in spreading his arms and legs, and in pressing against the wall and the less weight will be thrown on the steel yard.

788. 1. archo . . carica tu sopra . . colo. 2. magior. 3. larcho el . . cholone . . questa si mezzo. 4. imezo . . pozo. 5. **pozo** . . ala. 6. spalli . . isperieza . . magior. 7. darai magiore. 8. pariete . . māchare.

IV.

ON FOUNDATIONS, THE NATURE OF THE GROUND AND SUPPORTS.

Br. M. 138 a]

789.

La prima parte neciessarissima è la loro permanētia.

[2] Delli fondamēti che ànno le mēbrifica-tioni componi[3]trici delli tēpli e altri edi-fiti publici, tal proporti[4]one deve essere da profondità a profondità quale [5] è da peso a peso che scaricare si deve sopra essi mē[6]bri.

[7] Ogni parte della pro[8]fondità, che à la terra [9] per alquāto spatio, è [10] fatta a suoli, e [o11]gni suolo è cōposto di [12] parti, più grave [13] e piv leue l'una chel'al[14]tra; nel pro-fondarsi è più grave, e questo si prova, [15] perchè questi tali soli sō cō[17]posti dalle turbulentie [16] delle acque scaricate ī [18] mare dal corso de' fiumi, [19] che in quello ver-sano, [20] delle quali turbulentie [21] la parte più grave fu [22] quella che prima [23] si scaricò successiva[24]mēte, e questo fa l'ac[25]qua, dov' ella si ferma, le[26]vādo prima dove es[27]sa si move; E di que[28]sti tali soli di terra [29] si manifesta nelli lati [30] di fiumi che coi lor con[31]tinui corsi ànno secati [32] e partiti con grā pro[33]fondità di tagli l'ū mō[34]te dall'al-tro, doue per li [35] ghiajosi soli l'acque so[36]no scolate e per questo [37] la materia si è sec-

The first and most important thing is stability.

As to the foundations of the component parts of temples and other public buildings, the depths of the foundations must bear the same proportions to each other as the weight of material which is to be placed upon them.

Every part of the depth of earth in a given space is composed of layers, and each layer is composed of heavier or lighter materials, the lowest being the heaviest. And this can be proved, because these layers have been formed by the sedi-ment from water carried down to the sea, by the current of rivers which flow into it. The heaviest part of this sediment was that which was first thrown down, and so on by degrees; and this is the action of water when it becomes stagnant, having first brought down the mud whence it first flowed. And such layers of soil are seen in the banks of rivers, where their constant flow has cut through them and divided one slope from the other to a great depth; where in gra-velly strata the waters have run off, the ma-

789. 1. ella loro permanentia. 2. chean le mēbrificationi chonponi. 3. pubblici. 4. debbe . dapprofondita approfondita. 5. dap-peso . . chesscarichare si debbe. 8. alla. 9. spatiotio. 10. faetata assuoli. 11. chōpossto. 12. parte . . grave [opi]. 13. eppiv lievi luna chellal. 14. tra "nel grave" ecquesto si prove. 15. quessti. 16. turbbulentie. 17. scharichate. 21. fuc. 22. prim"a". 23. sisscharicho. 24. ecquesto fallac. 25. ferme. 29. manifessta. 30. cholor chon. 31. chorsi an seghati. 32. esspartiti. 34. dallaltre. 35. gliorosi. 37. se secha. 38. chōvertita. 40. fāgho. 41. ecquesto. 43. tereste. 45. chosi de chōverso.

cata 38 e coüertita in dura 39 pietra, e massime di 40 quel fāgo, che era più 41 sottile, e questo ci 42 fa cōcludere, che ogni par43te della terrestre superfitie fu 44 già ciētro della terra e 45 così de cōverso ecc.

terials have, in consequence, dried and been converted into hard stone, and this happened most in what was the finest mud; whence we conclude that every portion of the surface of the earth was once at the centre of the earth, and *vice versa* &c.

A. 50 a]

790.

¶Quella parte del fondamēto delli edifiti che piv pesa 2 piv si ficca · e lascia in alto il piv leggiero disunito da se; ¶ 3 ¶ E quel terreno ch'è piv · premvto, sendo poroso ·, piv acconsente; ¶ 4 Senpre tu · devi · fare i fondamēti che sportino egualmēte fori del 5 carico · de'lor mvri e pilastri come appare · in *m · a · b* ·, e se 6 farai · come · molti fanno, cioè di fare uno fondamēto d'equale 7 larghezza · in sino alla superfitie · della terra, e di sopra li danno diseguale 8 carico come

The heaviest part of the foundations of buildings settles most, and leaves the lighter part above it separated from it.

And the soil which is most pressed, if it be porous yields most.

You should always make the foundations project equally beyond the weight of the walls and piers, as shown at *m a b*. If you do as many do, that is to say if you make a foundation of equal width from the bottom up to the surface of the ground, and charge

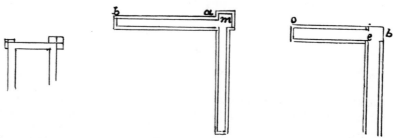

si dimostra in · *b · e* · e in *e · o*, la parte del fonda9mēto · *b · e*, perchè è piena dal pilastro del cātone ·, piv pesa e piv spīgie 10 in basso il suo fōdamēto che nō fa il muro · *e · o* che non occupa 11 interamēte il suo fōdamēto, e però meno spegnie e mē si ficca, 12 onde ficcādosi il pilastro *b · e* · e si diunisce e parte dal mv13ro · *e · o* · come si uede nel piv delli edifiti · che sono spicati intorno · a detti pilastri.

it above with unequal weights, as shown at *b e* and at *e o*, at the part of the foundation at *b e*, the pier of the angle will weigh most and thrust its foundation downwards, which the wall at *e o* will not do; since it does not cover the whole of its foundation, and therefore thrusts less heavily and settles less. Hence, the pier *b e* in settling cracks and parts from the wall *e o*. This may be seen in most buildings which are cracked round the piers.

A. 53 a]

791.

La finestra · *a* · sta bene sotto 2 la finestra *c* · e la finestra 3 · *b* · sta · male · sotto · lo spatio 4 · *d* ·, perchè detto · spatio · è sanza 5 sostegnio · e fondamēto, 6 si chè ricordati di nō rōpere 7 mai sotto · li spati · delle finestre.

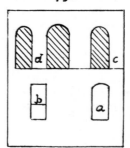

The window *a* is well placed under the window *c*, and the window *b* is badly placed under the pier *d*, because this latter is without support and foundation; mind therefore never to make a break under the piers between the windows.

790. 1. Quela. 2. ficha . ellasscia . . el . . legieri . dasse. 3. Ecquel tereno . . achōsēte. 4. debi . . chessportino. 5. pilasstri chome apare . . . esse. 6. chome . . ī fondamēto [equi] de quale. 7. largeza . . ala . . delatera . . dano. 8. charicho. 9. chātone. 10. baso . . none ochupa. 11. ficha. 12. fi[g] chādosi . . disunisscie. 13. chome . . chessono spichati. 14. pilasstri.
791. 2. ella. 3. sotto [la finestra] lo spatio. 5. effondamēto. 6. richordati.

A. 48b] 792.

DEL SOSTÈTACULO.

[2] Il pilastro moltiplicato per grossezza · crescierà tanto piv che la sua debita potētia [3] quāto · e' māca · della ragionevole altezza.

ESÈNPLO.

[5] Se uno pilastro · debe · essere · alto · 9 · grossezze·, cioè · che s'egli · sarà · grosso · uno braccio, la regola [6] lo pone di · 9 · braccia·; se ne collegherai · 100 · insieme · per grossezza · fia grosso braccia 10 e alto · 9, [7] e se il primo pilastro regieva 10000 libbre, perchè questo secōdo non è alto se non è circa [8] a una grossezza, e māchādoli · 8 parti della lunghezza · e' regierà · piv otto volte, [9] cioè ogni · pilastro collegato · li toccerà a regiere piv 8 volte che dislegato, cioè [10] che se prima regieva dieci mila libbre·, adesso ne sosterrà 90 mila.

OF THE SUPPORTS.

A pillar of which the thickness is increased will gain more than its due strength, in direct proportion to what its loses in relative height.

EXAMPLE.

If a pillar should be nine times as high as it is broad—that is to say, if it is one braccio thick, according to rule it should be nine braccia high—then, if you place 100 such pillars together in a mass this will be ten braccia broad and 9 high; and if the first pillar could carry 10000 pounds the second being only about as high as it is wide, and thus lacking 8 parts of its proper length, it, that is to say, each pillar thus united, will bear eight times more than when disconnected; that is to say, that if at first it would carry ten thousand pounds, it would now carry 90 thousand.

792. 1. sosstētachulo. 2. pilasstro mvltiplichato per grosseza cressciera . tanto "piv che". 3. mācha . . alteza. 5. Se î . . grosseze . . chesseli . . î br . [de] la. 6. 9 br . . cholegerai . . grosseza . br. 10. 7. esse . . lbr . . sechōdo . . circha. 8. a î grosseza e māchādoli . . dela lungeza. 9. cholegato . . tochera. 10. chesse . . mila lbr . . sostera.

V.

ON THE RESISTANCE OF BEAMS.

S. K. M. II.¹ 72a]

793.

²Quell'angolo sa³rà di piv resistē⁴tia che fia piv a⁵cuto e 'l piv ottu⁶so fia piv debole.

That angle will offer the greatest resistance which is most acute, and the most obtuse will be the weakest.

PALCO DOPPIO.

S. K. M. III.¹ 90b]

794.

Se i travi e'l peso *o* fia · 100 · libre, ²quāto · peso · sarà · in *a · b* · a fa³re resistētia · a esso · peso · che ⁴nō caggia in basso?

If the beams and the weight *o* are 100 pounds, how much weight will be wanted at *a · b* to resist such a weight, that it may not fall down?

A. 53a]

795.

DELLA LUNGHEZZA DELLE TRAVI.

ON THE LENGTH OF BEAMS.

²Quella · trave · che fia lūga · piv · che le 20 sua ³maggiori grossezze, fia poco permanēte e rōperasi in ¹/₂; ⁴e ricordati che

That beam which is more than 20 times as long as its greatest thickness will be of brief duration and will break in half; and

793. 4. cheffia. 5. piotu. **794.** 1—4 R. 2. affa. 3. resisstētia. 4. chaggio.

793. The three smaller sketches accompany the text in the original, but the larger one is not directly connected with it. It is to be found on fol. 89ª of the same Manuscript and there we read in a note, written underneath, *coverchio della perdicha del castello* (roof of the flagstaff of the castle).—Compare also Pl. XCIII, No. 1.

la parte ch'ētra nel mvro, sia penetrata
⁵di pece calda e fasciata d'asse di quercia,
ācor essa penetrata; ⁶Ogni trave vole pas-
sare i sua muri e esser ferma di là da essi
mv⁷ri cō soffitiēti catene, perchè spesso si
vēde per terremoti le tra-
vi usci⁸re de'mvri e rovi-
nare poi i mvri e solari;
dove, se sono īcatenate,
⁹terranno · i mvri · in · si-
eme fermi, e i mvri fermano · i solari.

remember, that the part built into the wall
should be steeped in hot pitch and filleted
with oak boards likewise so steeped. Each
beam must pass through its walls and be
secured beyond the walls with sufficient
chaining, because in con-
sequence of earthquakes
the beams are often seen
to come out of the walls
and bring down the walls
and floors; whilst if they are chained they will

¹⁰Ancora ti ricordo · che tu · nō faci mai
i smalti · sopra legni¹¹ame, imperochè nel
cresciere e discresciere · che fa il legname
¹²per l'umido · e secco, spesse volte cre-
pano detti solai e crepa¹³te le loro diuisioni
· a poco a poco si fāno in poluere e fāno
¹⁴brutta evidētia.

hold the walls strongly together and the
walls will hold the floors. Again I remind
you never to put plaster over timber.
Since by expansion and shrinking of
the timber produced by damp and dryness
such floors often crack, and once cracked
their divisions gradually produce dust and
an ugly effect. Again remember not to

¹⁵Ancora ti ricordo nō facci solari soste-
nvti da archi ¹⁶e travi, imperochè col tēpo il
solaro, ch'è sostenvto dalle tra¹⁷vi, cala al-
quāto in nel suo · mezzo, e quella parte
¹⁸del solaro, ch'è sostenuta dal arco, resta
nel suo loco, onde ¹⁹j solari che sono soste-
nvti da 2 varie nature di sostēta²⁰culi paiono
col tēpo fatti a còlli.

lay a floor on beams supported on arches;
for, in time the floor which is made on
beams settles somewhat in the middle
while that part of the floor which rests on
the arches remains in its place; hence, floors
laid over two kinds of supports look, in
time, as if they were made in hills [19].

795. 1. dela lungeza. 2. cheffia . . pivi . chele [10] 20. 3. magiori grosseze . . pocho. 4. richordoti. 5. chalda . . essa *is
wanting*. 7. chō soffitiēte chatene . . tremoti . . ussci. 8. īchatenate. 9. terano . . e e mvri. 10. Anchora ti richordo
chettu. 11. cresciere e disscresciere cheffa ilegname. 12. essecho . . isspesse . . detti soli e crep. 13. ti le . . apocho
apocho . . effano. 15. Anchora ti richordo nō faci. 16. ettrav . . chol . . dale. 17. chola . . inel . . mezo [che elp] equle
parte. 18. sostenta . . archo . . locho. 19. propositione J solari chessone. 20. ch chili paiano chol . . acholli. *The word*
propositione *written on the margin near line* 19 *has apparently nothing to do with this text, but M. Ravaisson, in his edition of
MS. A. has been misled by it to take* j solari (*line* 18) *for the beginning of a new paragraph.*

795. 19. M. RAVAISSON, in his edition of MS. A gives a very different rendering of this passage
translating it thus: *Les planchers qui sont soutenus par deux différentes natures de supports paraissent avec le
temps faits en voûte* [a cholli].

Remarks on the style of Leonardo's architecture.

A few remarks may here be added on the style of Leonardo's architectural studies. However incomplete, however small in scale, they allow us to establish a certain number of facts and probabilities, well worthy of consideration.

When Leonardo began his studies the great name of Brunellesco was still the inspiration of all Florence, and we cannot doubt that Leonardo was open to it, since we find among his sketches the plan of the church of Santo Spirito[1] and a lateral view of San Lorenzo (Pl. XCIV No. 1), a plan almost identical with the chapel Degli Angeli, only begun by him (Pl. XCIV, No. 3) while among Leonardo's designs for domes several clearly betray the influence of Brunellesco's Cupola and the lantern of Santa Maria del Fiore[2].

The beginning of the second period of modern Italian architecture falls during the first twenty years of Leonardo's life. However the new impetus given by Leon Battista Alberti either was not generally understood by his contemporaries, or those who appreciated it, had no opportunity of showing that they did so. It was only when taken up by Bramante and developed by him to the highest rank of modern architecture that this new influence was generally felt. Now the peculiar feature of Leonardo's sketches is that, like the works of Bramante, they appear to be the development and continuation of Alberti's.

[1] See Pl. XCIV, No. 2. Then only in course of erection after the designs of Brunellesco, though he was already dead; finished in 1481.

[2] A small sketch of the tower of the Palazzo della Signoria (MS. C. A. 309) proves that he also studied mediaeval monuments.

But a question here occurs which is difficult to answer. Did Leonardo, till he quitted Florence, follow the direction given by the dominant school of Brunellesco, which would then have given rise to his "First manner", or had he, even before he left Florence, felt Alberti's influence—either through his works (Palazzo Ruccellai, and the front of Santa Maria Novella) or through personal intercourse? Or was it not till he went to Milan that Alberti's work began to impress him through Bramante, who probably had known Alberti at Mantua about 1470 and who not only carried out Alberti's views and ideas, but, by his designs for St. Peter's at Rome, proved himself the greatest of modern architects. When Leonardo went to Milan Bramante had already been living there for many years. One of his earliest works in Milan was the church of Santa Maria presso San Satiro, Via del Falcone[1].

Now we find among Leonardo's studies of Cupolas on Plates LXXXIV and LXXXV and in Pl. LXXX several sketches which seem to me to have been suggested by Bramante's dome of this church.

The MSS. B and Ash. II contain the plans of S. Sepolcro, the pavilion in the garden of the duke of Milan, and two churches, evidently inspired by the church of San Lorenzo at Milan.

MS. B. contains besides two notes relating to Pavia, one of them a design for the sacristy of the Cathedral at Pavia, which cannot be supposed to be dated later than 1492, and it has probably some relation to Leonardo's call to Pavia June 21, 1490[2]. These and other considerations justify us in concluding, that Leonardo made his studies of cupolas at Milan, probably between the years 1487 and 1492 in anticipation of the erection of one of the grandest churches of Italy, the Cathedral of Pavia. This may explain the decidedly Lombardo-Bramantesque tendency in the style of these studies, among which only a few remind us of the forms of the cupolas of S. Maria del Fiore and of the Baptistery of Florence. Thus, although when compared with Bramante's work, several of these sketches plainly reveal that master's influence, we find, among the sketches of domes, some, which show already Bramante's classic style, of which the Tempietto of San Pietro in Montorio, his first building executed at Rome, is the foremost example[3].

On Plate LXXXIV is a sketch of the plan of a similar circular building; and the Mausoleum on Pl. XCVIII, no less than one of the pedestals for the statue of Francesco Sforza (Pl. LXV), is of the same type.

[1] *Evidence of this I intend to give later on in a Life of Bramante, which I have in preparation.*

[2] *The sketch of the plan of Brunellesco's church of Santo Spirito at Florence, which occurs in the same Manuscript, may have been done from memory.*

[3] *It may be mentioned here, that in 1494 Bramante made a similar design for the lantern of the Cupola of the Church of Santa Maria delle Grazie.*

The drawings Pl. LXXXIV No. 2, Pl. LXXXVI No. 1 and 2 and the ground floor of the building in the drawing Pl. XCI No. 2, with the interesting decoration by gigantic statues in large niches, are also, I believe, more in the style Bramante adopted at Rome, than in the Lombard style. Are we to conclude from this that Leonardo on his part influenced Bramante in the sense of simplifying his style and rendering it more congenial to antique art? The answer to this important question seems at first difficult to give, for we are here in presence of Bramante, the greatest of modern architects, and with Leonardo, the man comparable with no other. We have no knowledge of any buildings erected by Leonardo, and unless we admit personal intercourse—which seems probable, but of which there is no proof—, it would be difficult to understand how Leonardo could have affected Bramante's style. The converse is more easily to be admitted, since Bramante, as we have proved elsewhere, drew and built simultaneously in different manners, and though in Lombardy there is no building by him in his classic style, the use of brick for building, in that part of Italy, may easily account for it.

Bramante's name is incidentally mentioned in Leonardo's manuscripts in two passages (Nos. 1414 and 1448). On each occasion it is only a slight passing allusion, and the nature of the context gives us no due information as to any close connection between the two artists.

It might be supposed, on the ground of Leonardo's relations with the East given in sections XVII and XXI of this volume, that some evidence of oriental influence might be detected in his architectural drawings. I do not however think that any such traces can be pointed out with certainty unless perhaps the drawing for a Mausoleum, Pl. XCVIII.

Among several studies for the construction of cupolas above a Greek cross there are some in which the forms are decidedly monotonous. These, it is clear, were not designed as models of taste; they must be regarded as the results of certain investigations into the laws of proportion, harmony and contrast.

The designs for churches, on the plan of a Latin cross are evidently intended to depart as little as possible from the form of a Greek cross; and they also show a preference for a nave surrounded with outer porticos.

The architectural forms preferred by Leonardo are pilasters coupled (Pl. LXXXII No. 1) or grouped (Pl. LXXX No. 5 and XCIV No. 4), often combined with niches. We often meet with orders superposed, one in each story, or two small orders on one story, in combination with one great order (Pl. XCVI No. 2).

The drum (tamburo) of these cupolas is generally octagonal, as in the cathedral of Florence, and with similar round windows in its sides. In Pl. LXXXVII No. 2 it is circular like the model actually carried out by Michael Angelo at St. Peter's.

The cupola itself is either hidden under a pyramidal roof, as in the Baptistery of Florence, San Lorenzo of Milan and most of the Lombard churches (Pl. XCI No. 1 and Pl. XCII No. 1); but it more generally suggests the curve of Sta Maria del Fiore (Pl. LXXXVIII No. 5; Pl. XC No. 2; Pl. LXXXIX, M; Pl. XC No. 4, Pl. XCVI No. 2). In other cases (Pl. LXXX No. 4; Pl. LXXXIX; Pl. XC No. 2) it shows the sides of the octagon crowned by semicircular pediments, as in Brunellesco's lantern of the Cathedral and in the model for the Cathedral of Pavia.

Finally, in some sketches the cupola is either semicircular, or as in Pl. LXXXVII No. 2, shows the beautiful line, adopted sixty years later by Michael Angelo for the existing dome of St. Peter's.

It is worth noticing that for all these domes Leonardo is not satisfied to decorate the exterior merely with ascending ribs or mouldings, but employs also a system of horizontal parallels to complete the architectural system. Not the least interesting are the designs for the tiburio (cupola) of the Milan Cathedral. They show some of the forms, just mentioned, adapted to the peculiar gothic style of that monument.

The few examples of interiors of churches recall the style employed in Lombardy by Bramante, for instance in S. Maria di Canepanuova at Pavia, or by Dolcebuono in the Monastero Maggiore at Milan (see Pl. CI No. 1 [C. A. 181ᵇ; 546ᵇ]; Pl. LXXXIV No. 10).

The few indications concerning palaces seem to prove that Leonardo followed Alberti's example of decorating the walls with pilasters and a flat rustica, either in stone or by graffitti (Pl. CII No. 1 and Pl. LXXXV No. 14).

By pointing out the analogies between Leonardo's architecture and that of other masters we in no way pretend to depreciate his individual and original inventive power. These are at all events beyond dispute. The project for the Mausoleum (Pl. XCVIII) would alone suffice to rank him among the greatest architects who ever lived. The peculiar shape of the tower (Pl. LXXX), of the churches for preaching (Pl. XCVII No. 1 and pages 56 and 57, Fig. 1—4), his curious plan for a city with high and low level streets (Pl. LXXVII and LXXVIII No. 2 and No. 3), his Loggia with fountains (Pl. LXXXII No. 4) reveal an originality, a power and facility of invention for almost any given problem, which are quite wonderful.

In addition to all these qualities he propably stood alone in his day in one department of architectural study,—his investigations, namely, as to the resistance of vaults, foundations, walls and arches.

As an application of these studies the plan of a semicircular vault (Pl. CIII No. 2) may be mentioned here, disposed so as to produce no thrust on the columns on which it rests: volta ī botte e non ispignie īfori le colone. *Above the geometrical patterns on the same sheet, close to a circle inscribed in a square is the note:* la ragiō d'una volta cioè il terzo del diamitro della sua . . . del tedesco in domo.

There are few data by which to judge of Leonardo's style in the treatment of detail. On Pl. LXXXV No. 10 and Pl. CIII No. 3, we find some details of pillars; on Pl. CI No. 3 slender pillars designed for a fountain and on Pl. CIII No. 1 MS. B, is a pen and ink drawing of a vase which also seems intended for a fountain. Three handles seem to have been intended to connect the upper parts with the base. There can be no doubt that Leonardo, like Bramante, but unlike Michael Angelo, brought infinite delicacy of motive and execution to bear on the details of his work.

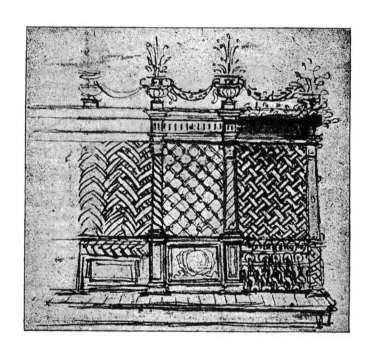

XIV.

Anatomy, Zoology and Physiology.

Leonardo's eminent place in the history of medicine, as a pioneer in the sciences of Anatomy and Physiology, will never be appreciated till it is possible to publish the mass of manuscripts in which he largely treated of these two branches of learning. In the present work I must necessarily limit myself to giving the reader a general view of these labours, by publishing his introductory notes to the various books on anatomical subjects. I have added some extracts, and such observations as are scattered incidentally through these treatises, as serving to throw a light on Leonardo's scientific attitude, besides having an interest for a wider circle than that of specialists only.

VASARI expressly mentions Leonardo's anatomical studies, having had occasion to examine the manuscript books which refer to them. According to him Leonardo studied Anatomy in the companionship of Marc Antonio della Torre "aiutato e scambievolmente aiutando."—This learned Anatomist taught the science in the universities first of Padua and then of Pavia, and at Pavia he and Leonardo may have worked and studied together. We have no clue to any exact dates, but in the year 1506 Marc Antonio della Torre seems to have not yet left Padua. He was scarcely thirty years old when he died in 1512, and his writings on anatomy have not only never been published, but no manuscript copy of them is known to exist.

This is not the place to enlarge on the connection between Leonardo and Marc Antonio della Torre. I may however observe that I have not been able to discover in Leonardo's manuscripts on anatomy any mention of his younger contemporary. The few quotations which occur from writers on medicine—either of antiquity or of the middle ages are printed in Section XXII. Here and there in the manuscripts mention is made of an anonymous "adversary" (avversario) whose views are opposed and refuted by Leonardo, but there is no ground for supposing that Marc Antonio della Torre should have been this "adversary".

Only a very small selection from the mass of anatomical drawings left by Leonardo have been published here in facsimile, but to form any adequate idea of their scientific

merit they should be compared with the coarse and inadequate figures given in the published books of the early part of the XVI. century.

William Hunter, the great surgeon—a competent judge—who had an opportunity in the time of George III. of seeing the originals in the King's Library, has thus recorded his opinion: "I expected to see little more than such designs in Anatomy as might be useful to a painter in his own profession. But I saw, and indeed with astonishment, that Leonardo had been a general and deep student. When I consider what pains he has taken upon every part of the body, the superiority of his universal genius, his particular excellence in mechanics and hydraulics, and the attention with which such a man would examine and see objects which he has to draw, I am fully persuaded that Leonardo was the best Anatomist, at that time, in the world . . . Leonardo was certainly the first man, we know of, who introduced the practice of making anatomical drawings" (Two introductory letters. London 1784*, pages* 37 *and* 39*).*

The illustrious German Naturalist Johan Friedrich Blumenbach esteemed them no less highly; he was one of the privileged few who, after Hunter, had the chance of seeing these Manuscripts. He writes: Der Scharfblick dieses grossen Forschers und Darstellers der Natur hat schon auf Dinge geachtet, die noch Jahrhunderte nachher unbemerkt geblieben sind" *(see Blumenbach's medicinische Bibliothek, Vol.* 3, *St.* 4, 1795, *page* 728*).*

These opinions were founded on the drawings alone. Up to the present day hardly anything has been made known of the text, and, for the reasons I have given, it is my intention to reproduce here no more than a selection of extracts which I have made from the originals at Windsor Castle and elsewhere. In the Bibliography of the Manuscripts, at the end of this volume a short review is given of the valuable contents of these Anatomical note books which are at present almost all in the possession of her Majesty the Queen of England. It is, I believe, possible to assign the date with approximate accuracy to almost all the fragments, and I am thus led to conclude that the greater part of Leonardo's anatomical investigations were carried out after the death of della Torre.

Merely in reading the introductory notes to his various books on Anatomy which are here printed it is impossible to resist the impression that the Master's anatomical studies bear to a very great extent the stamp of originality and independent thought.

I.

ANATOMY.

W. An. IV. 167a]

796.

Voglio far miraculi;—²abbi mē che li altri o³mini più quieti, e ⁴quelli che vogliono ar⁵ricchirsi in ū dì; vivi ⁶ nel lungo tēpo in ⁷grā povertà, co⁸me interviene e ⁹interverrà in etter¹⁰no alli alchimisti, ¹¹cercatori di cre¹²are oro e argēto, ¹³e all' īgegnieri che ¹⁴vogliono che l' a¹⁵cqua morta dia ¹⁶vita motiua ¹⁷a se medesima ¹⁸con cōtinuo ¹⁹moto, ²⁰e al sōmo stol²¹to negromante ²²e īcantatore.

²³E tu che dici, esser me²⁴glio il uedere fare ²⁵l'anatomia, che uede²⁶re tali disegni, dire²⁷sti bene, se fusse ²⁸possibile vedere tu²⁹tte queste cose che ³⁰in tal disegni si di³¹mostrano in una ³²sola figura, nella ³³quale con tutto il tu³⁴o ingenio nō vedra³⁵i, e non avrai la no³⁶titia, se nō d'alquā³⁷te poche vene, del³⁸le · quali io, per aver³⁹ne · vera · e piena ⁴⁰notitia, ò disfatti ⁴¹piv di dieci co⁴²rpi vmani, ⁴³di-

I wish to work miracles;—it may be that I shall possess less than other men of more peaceful lives, or than those who want to grow rich in a day. I may live for a long time in great poverty, as always happens, and to all eternity will happen, to alchemists, the would-be creators of gold and silver, and to engineers who would have dead water stir itself into life and perpetual motion, and to those supreme fools, the necromancer and the enchanter.

[23]And you, who say that it would be better to watch an anatomist at work than to see these drawings, you would be right, if it were possible to observe all the things which are demonstrated in such drawings in a single figure, in which you, with all your cleverness, will not see nor obtain knowledge of more than some few veins, to obtain a true and perfect knowledge of which I have dissected more than ten human bodies, destroying

A general introduction

796. 3. quieti ecq. 4. voliano a. 5. richire nūdi. 6. lungho. 9. intervera. 10. archimisti. 14. voglia. 15. cq"a" morta. 17. asse. 20. somo. 23. "e" ettu che di. 27. fussi. 31. mosstrano. 35. e non arai. 37. vene de. 43. destrugendo.

796. Lines 1—59 and 60—89 are written in two parallel columns. When we here find Leonardo putting himself in the same category as the Alchemists and Necromancers, whom he elsewhere mocks at so bitterly, it is evidently meant ironically. In the same way Leonardo, in the introduction to the Books on Perspective sets himself with transparent satire on a level with other writers on the subject.

Line 23 and the following seem to be directed against students of painting and young artists rather than against medical men and anatomists.

struggendo ogni [44]altri mēbri, consu[45]mando con minutis[46]sime particule [47]tutta la carne che [48]d'intorno a esse [49]vene si trovaua, [50]sanza insangui[51]narle, se non d'ī[52]sensibile insan[53]guinamēto delle vene capillari; [54]e vn sol corpo nō [55]bastava a tanto tēpo, che biso[56]gnava procedere di mano in mano [57]in tanti corpi, che si finisca la inte[58]ra cognitione; le qual repli[59]cai 2 volte per vedere le differentie.

[60]E se tu avrai l'amore a tal cosa, [61]tu sarai forse inpedito dallo [62]stomaco, e se questo nō ti inpedi[63]sce, tu sarai forse inpedito dal[64]la paura coll' abitare nelli tē-[65]pi notturni in cōpagnia di tali [66]morti squadrati e scorticati e [67]spaventevoli a vederli; e se que[68]sto nō t'īpedisce, forse ti māche[69]rà il disegnio bono, il quale s'appa[70]rtiene a tal figuratione; E [71]se tu avrai il disegnio e' nō sarà [72]accōpagnato dalla prospettiva, [73]e se sarà accōpagnato [74]e' ti mācherà l'ordine [75]delle dimostratiō [76]geometriche e l'ordine [77]delle calculation delle [78]forze e valimēto de' [79]muscoli; e forse ti [80]mācherà la patiētia che [81]tu nō sarai diligēte; Delle [82]quali se in me tutte queste [83]cose sono state o no, [84]i cēto 20 libri da me [85]conposti ne darà sentē-[86]tia del sì o del no, nelli [87]quali nō sono stato inpedi[88]to nè d'auaritia o negligētia, [89]ma sol dal tenpo ‖ vale.

all the other members, and removing the very minutest particles of the flesh by which these veins are surrounded, without causing them to bleed, excepting the insensible bleeding of the capillary veins; and as one single body would not last so long, since it was necessary to proceed with several bodies by degrees, until I came to an end and had a complete knowledge; this I repeated twice, to learn the differences [59].

And if you should have a love for such things you might be prevented by loathing, and if that did not prevent you, you might be deterred by the fear of living in the night hours in the company of those corpses, quartered and flayed and horrible to see. And if this did not prevent you, perhaps you might not be able to draw so well as is necessary for such a demonstration; or, if you had the skill in drawing, it might not be combined with knowledge of perspective; and if it were so, you might not understand the methods of geometrical demonstration and the method of the calculation of forces and of the strength of the muscles; patience also may be wanting, so that you lack perseverance. As to whether all these things were found in me or not[84], the hundred and twenty books composed by me will give verdict Yes or No. In these I have been hindered neither by avarice nor negligence, but simply by want of time. Farewell [89].

W. A. II. 36 a (21)] 797.

DELL'ORDINE DEL LIBRO. ### OF THE ORDER OF THE BOOK.

Plans and suggestions for the arrangement of materials (797—802). [2]Questa · opera · si deve prīcipiare alla · cōciettione · dell'omo ., e devi descriuere · il modo della matrice, [3]e come il putto · l'abita ·, e in che grado · lui risegga · ī quella ·, e 'l modo · dello vivificarsi e cibarsi, [4]e 'l suo · accrescimēto ·, e che · interuallo · sia ·

This work must begin with the conception of man, and describe the nature of the womb and how the foetus lives in it, up to what stage it resides there, and in what way it quickens into life and feeds. Also its growth and what interval there is between

44. consi. 45. minuti. 46. partichule. 53. capillar "e"(?). 54. e [altrettāte] e vn. 55. attanto tēpo che. 56. imano. 57. corpi che si finissimi la inte. 58. cognitione le qual [s] ripri. 59. cai [1] "2" volte . . diferentie. 60. essettu arai. 66. squartati. 68. nōtipedisce. 69. qual sapa. 70. attal. 71. settu arai. 72. acōpagnato. 73. esse . . acōpagnato. 76. geometrice. 79. efforse. 82. seime. 83. onno [lili]. 84. iccēto 20. 86. tia [di] del. 88. negli ētia. 89. d.l [dalla ve] tenpo. **797.** 2. debe. 2. e disscriuere. 3. chome il pucto . . risega . . uiuicharsi. 4. acresscimēto . . da ī grado da cresscimēto . a . ī.

84. Leonardo frequently, and perhaps habitually, wrote in note books of a very small size and only moderately thick; in most of those which have been preserved undivided, each contains less than fifty leaves. Thus a considerable number of such volumes must have gone to make up a volume of the bulk of the 'Codex Atlanticus' which now contains nearly 1200 detached leaves. In the passage under consideration, which was evidently written at a late

period of his life, Leonardo speaks of his Manuscript note-books as numbering 120; but we should hardly be justified in concluding from this passage that the greater part of his Manuscripts were now missing (see *Prolegomena*, Vol. I, pp. 5—7).

797. The meaning of the word *nervo* varies in different passages, being sometimes used for *muscolo* (muscle).

da · uno grado d'accrescimēto · a · uno · altro, e che cosa lo spigna fori ⁵del corpo · della madre ·, e per che · cagione qualche · uolta · lui · uēga fori · dal uētro di sua madre iñāti al debito ⁶tēpo.

⁷Poi discriuerai quali mēbra sieno · quelle · che crescono · poi · che'l putto è nato · piv che l'altre, ⁸e da la misura d'ū putto · d'un anno.

⁹Poi discrivi l'omo cresciuto e la fēmina · e sue · misure · e nature di complessione colore ¹⁰e fisonomie.

¹¹Di poi descrivi com'egli è cōposto · di uene ·, nerui ·, muscoli e ossa; Questo farai nell'ultimo del libro; ¹²di poi figura · in · 4 storie · quattro vniuersali casi delli omini, · cioè letitia con uari atti di ridere, ¹³e figura · la cagiō · del riso ·; piāto in vari modi colla · sua · cagione ·; cōtētione cō uari movi¹⁴mēti d'uccisione ·, fughe ·, pavre ·, ferocità ·, ardimēti, micidi · e tutte cose appartenēti a simil casi; ¹⁵di poi figura · vna fatica cō tirare, spiegniere · portare, fermare, sostenere e simili ¹⁶cose;

¹⁷Di poi discriui attitudine · e movimēto; ¹⁸di poi prospettiva · per l'ofitio e effetti dell'ochio e dell' udito,—dirai di mvsicha—e descrivi delli altri sēsi.

¹⁹Di poi discrivi la natura · de' sensi.

²⁰Questa figura strumētale dell'omo di-mostreremo in . . figure, delle ²¹quali le 3 prime saranno la ramificatione delle ossa, cioè vna dināzi · che ²²dimostri l'altitudine de' siti e figure delli ossi, la seconda sarà veduta in ²³proffilo e mostrerà la profondi-tà del tutto e delle parti e loro sito; La 3ª ²⁴figura fia dimostratrice delle ossa dalla parte dirieto; Di poi faremo ²⁵3 altre figure ne' simili aspetti colle ossa segate, nelle quali si vedranno le lor ²⁶grossezze e uacuità; 3 altre figure faremo dell' ossa in-tere e de' nerui che na²⁷scono dalla nuca, e in che mēbra ramificano; E 3 altre de'ossa e vene e do²⁸ve ramificano, poi 3 con muscoli e 3 con pelle, e figure propor-²⁹tionate, e 3 della femina per dimostrare matrice e vene mestruali, ³⁰che vanno alle poppe.

one stage of growth and another. What it is that forces it out from the body of the mother, and for what reasons it sometimes comes out of the mother's womb before the due time.

Then I will describe which are the mem-bers, which, after the boy is born, grow more than the others, and determine the propor-tions of a boy of one year.

Then describe the fully grown man and woman, with their proportions, and the nature of their complexions, colour, and physiognomy.

Then how they are composed of veins, tendons, muscles and bones. This I shall do at the end of the book. Then, in four draw-ings, represent four universal conditions of men. That is, Mirth, with various acts of laughter, and describe the cause of laughter. Weeping in various aspects with its causes. Contention, with various acts of killing; flight, fear, ferocity, boldness, murder and every thing pertaining to such cases. Then represent Labour, with pulling, thrusting, carry-ing, stopping, supporting and such like things.

Further I would describe attitudes and movements. Then perspective, concerning the functions and effects of the eye; and of hearing—here I will speak of music—, and treat of the other senses.

And then describe the nature of the senses.

This mechanism of man we will demon-strate in . . . figures; of which the three first will show the ramification of the bones; that is: first one to show their height and position and shape : the second will be seen in profile and will show the depth of the whole and of the parts, and their position. The third figure will be a demonstration of the bones of the backparts. Then I will make three other figures from the same point of view, with the bones sawn across, in which will be shown their thickness and hollow-ness. Three other figures of the bones com-plete, and of the nerves which rise from the nape of the neck, and in what limbs they ra-mify. And three others of the bones and veins, and where they ramify. Then three figures with the muscles and three with the skin, and their proper proportions; and three of woman, to illustrate the womb and the menstrual veins which go to the breasts.

altro . . chosu . . spiga. 5. chorpo . . chagione . . uega .. del. 7. cresscano ēnato. 9. ella . . essue . . chōprlessione chollore effisosomie. 11. desscrivi chom eli e chōposto . . musscoli. 12. chasi . . chouari. 13. effigura la chagiō . de riso . . cholla . . chagione . chōtetione cho. 14. ucisione . fuge . . ettutte chose apartenēti assimil chasi. 15. faticha chō . . sosstenere essimili. 16. chose. 18. lofitio effetti . . della uldito . . musicha . . sesi. 19. de . 2 . "sensi" sensi. 20. dimōsterreno. 22. effigure . . sechonda. 23. mossterra. 24. delle [ner] ossa . . faren. 20. asspetti . . segate . . uetra le. 26. gossese e uachuita . . fareno. 27. scā della nucha . . ramifichino. 28. ramifichino . . mvsscoli . . effigure. 29. tionati . . me-struale.

798.

ORDINE DEL LIBRO.

[2]Questa mia figuratione del corpo vmano ti sarà dimostra nō altre[3]menti, che se tu auessi l'omo naturale ināti, e la ragō si è, che se tu vuoi be[4]ne conoscere le parti dell'omo anatomizzato, tu lo vuoi ·— o l'o-chio tuo — per di[5]versi aspetti, quello cōside-rando di sotto, e di sopra, e dalli lati, vol-tando[6]lo e cercando l'origine di ciascū mēbro, e ī tal modo la notomia na[7]turale à soddisfatta alla tua notitia; Ma tu ài a intēdere, che tal noti[8]tia nō ti lascia sad-disfatto, cōciosiachè la grādissima confusione che [9]resulta della mistione di pañiculi misti cō uene, arterie, nerui, corde, [10]muscoli, ossi, sangue, il quale tignie di se ogni parte d'un medesimo colo[11]re, e le vene, che di tal sangue si votano non sono conosciute per la lor dimi[12]nutione, e la integrità delli pannicoli, nel cercare le parti che dentro a [13]loro s'includono, si viene a rompere, e la lor trasparētia, tinta di sangue, [14]nō ti lascia conoscere le parti coperte da loro per la similitu[15]dine del lor colore insanguinato, e nō puoi avere la notitia dell'ū che tu [16]nō cōfonda e distrugga l'altro; | adunque è necessario fare più notomie, [17]delle quali 3 te ne bisognia per auere piena notitia delle vene e arterie, [18]distruggēdo con sōma diligentia tutto il rimanēte, e altre 3 per auere la notitia [19]dèlli pannicoli, e 3 per le corde e muscoli e legamēti, e 3 per li ossi e car[20]tilagini, e 3 per la notomia delle ossa, le quali s'ànno a segare e dimo-[21]strare, quale è buso e quale no, quale è midolloso, quale è spugno[22]so, e quale è grosso dal fori al dentro, e quale è sottile, e alcuno à in al[23]cuna parte grā sottiglezza, e in alcuna è grosso, e in alcuna busa, o

THE ORDER OF THE BOOK.

This depicting of mine of the human body will be as clear to you as if you had the natural man before you; and the reason is that if you wish thoroughly to know the parts of man, anatomically, you—or your eye—require to see it from different aspects, considering it from below and from above and from its sides, turning it about and seeking the origin of each member; and in this way the natural anatomy is sufficient for your comprehension. But you must understand that this amount of knowledge will not continue to satisfy you; seeing the very great confusion that must result from the combination of tissues, with veins, ar-teries, nerves, sinews, muscles, bones, and blood which, of itself, tinges every part the same colour. And the veins, which dis-charge this blood, are not discerned by rea-son of their smallness. Moreover integrity of the tissues, in the process of the inves-tigating the parts within them, is inevitably destroyed, and their transparent substance being tinged with blood does not allow you to recognise the parts covered by them, from the similarity of their blood-stained hue; and you cannot know everything of the one with-out confusing and destroying the other. Hence, some further anatomy drawings be-come necessary. Of which you want three to give full knowledge of the veins and ar-teries, everything else being destroyed with the greatest care. And three others to dis-play the tissues; and three for the sinews and muscles and ligaments; and three for the bones and cartilages; and three for the anatomy of the bones, which have to be sawn to show which are hollow and which are not, which have marrow and which are spongy, and which are thick from the out-side inwards, and which are thin. And some are extremely thin in some parts and thick in others, and in some parts hollow or filled up with bone, or full of marrow, or spongy. And all these conditions are sometimes found

798. 2. Quessta. 3. chessettu .. ella .. chessettu. 4. conosscere le parte .. natomizate tu lo voĭi ollui ollochio. 5. asspetto. 6. ec-cerchando .. ciasscū. 7. turale ta sadisfatto .. chettal. 8. lasscia .. cōcosia chella .. chonfusione. 9. della .. pañi-chuli. 10. musscoli .. dumedesimo. 11. elle .. cognosscute. 12. nuitione ella .. pannichuli nel cierchare le parte .. al. 13. sincludano . si uēgano .. ella .. trassparētia. 14. lasscia cognossciere le parte [che son sotto a] coperte dalloro per almilitu. 15. poi .. chettu. 16. desstruggha .. natomie. 18. desstrugēdo .. soma. 19. pannichuli .. musscoli ellegamēti e 3 e 3. 20. e [ĭ] 3 per la natomia .. assegare e dimos. 21. quale he spugn"a''. 22. ecqua le he .. essottile .. innal. 23. chuna .. sottiglieza . alchuna .. alchuna. 24. osspugnosa e chosi .. sarano. 25. nūmēdesimo. 26. essuo. 28. as-

piena ²⁴d'osso, o midollosa, o spugnosa; e
così tutte queste cose sarāno alcuna volta
tro²⁵vate in un medesimo osso, e alcuno
osso fia che non à nessuna; e 3 te ne bisog-
²⁶na fare per la donna, nella quale è grā mis-
terio, mediante la · matrice e suo feto; ²⁷a-
dunque per il mio disegnio ti fia noto ogni
parte e ogni tutto mediante la di²⁸mostratione
di 3 diuersi aspetti di ciascuna parte, perchè
quando tu avrai vedu²⁹to alcun mēbro dalla
parte dinanzi con qualche neruo, corda, o
vena che ³⁰nasca dalla opposita parte, ti fia
dimostro il medesimo mēbro volto per lato
³¹o dirieto-; non altremēti che se tu auessi
in mano il medesimo mēbro e andas³²si lo
voltādo di parte in parte insino a tanto
che tu auessi piena notitia di quel³³lo che
tu desideri sapere, e così similmēte ti fia
posto inanti in tre o ³⁴4 dimostrationi di
ciascū mēbro per diuersi aspetti in modo che
tu resterai con³⁵vera e piena notitia di quello
che tu vuoi sapere della figura dell'omo.

³⁶Adunque qui con 12 figure intere ti
sarà mostrata la cosmografia del minor
³⁷mōdo col medesimo ordine che ināzi a
me fu fatto da Tolomeo nella sua cosmo-
³⁸grafia, e così diuidero poi quelle in
mēbra, come lui diuise il tutto in provin-
cie; ³⁹e ¦poi dirò l'ufitio delle parti per
ciascū verso, mettēdoti dināti alli ochi la
notitia ⁴⁰di tutta la figura e valitudine del-
l'omo inquāto a moto locale mediante le
sue parti, ⁴¹E così piacesse al nostro autore
che io potessi dimostrere la natura delli
omini e lo⁴²ro costumi nel modo che io
descrivo la sua figura.

⁴³E ricordoti che la notomia delli ner-
ui non ti darà la situatione della loro rami-
⁴⁴ficatione, nè in quali muscoli essi si rami-
ficano · mediante li corpi disfatti in acqua
⁴⁵corrēte, o in acqua di calcina, perchè,
ancorachè ti rimāga la origine de'lor nas-
scimenti ⁴⁶sanza tale acqua come coll' ac-
qua, le ramificationi loro pel corso del-
l'acqua si ⁴⁷vengono a vnire, non altremēti
che si fascia il lino o canapa pettinata per
filare, ⁴⁸tutto in vn fascio in modo che in-
possibile è a ritrovare in quali muscoli o
cō quale ⁴⁹o cō quāte ramificationi li nerui
s'infondino ne' predetti muscoli.

in one and the same bone, and in some
bones none of them. And three you must
have for the woman, in which there is
much that is mysterious by reason of the
womb and the foetus. Therefore by my
drawings every part will be known to you,
and all by means of demonstrations from
three different points of view of each part;
for when you have seen a limb from the
front, with any muscles, sinews, or veins
which take their rise from the opposite side,
the same limb will be shown to you in a
side view or from behind, exactly as if you
had that same limb in your hand and were
turning it from side to side until you
had acquired a full comprehension of all
you wished to know. In the same way there
will be put before you three or four demon-
strations of each limb, from various points
of view, so that you will be left with a true
and complete knowledge of all you wish to
learn of the human figure[35].

Thus, in twelve entire figures, you will
have set before you the cosmography of this
lesser world on the same plan as, before
me, was adopted by Ptolemy in his cosmo-
graphy; and so I will afterwards divide them
into limbs as he divided the whole world
into provinces; then I will speak of the func-
tion of each part in every direction, putting
before your eyes a description of the whole
form and substance of man, as regards his
movements from place to place, by means
of his different parts. And thus, if it
please our great Author, I may demonstrate
the nature of men, and their customs in the
way I describe his figure.

And remember that the anatomy of the
nerves will not give the position of their
ramifications, nor show you which muscles
they branch into, by means of bodies dis-
sected in running water or in lime water;
though indeed their origin and starting point
may be seen without such water as well as
with it. But their ramifications, when under
running water, cling and unite—just like flat
or hemp carded for spinning—all into a skein,
in a way which makes it impossible to trace
in which muscles or by what ramification the
nerves are distributed among those muscles.

spetti . . quanto . . arai. 30. parte [tu] eti . . per lalo. 31. chessettu . . imano. 32. attanto chettu. 33. llo chettu . .
possto. 34. asspetti . . chettu. 35. chettu voi. 36. mosstro la cossmografia. 37. fuffatto dattolomeo . . cossmo. 38. imēbra
. . province. 39. ciasscū. 40. lochale . . parte. 41. Eccosi piacessi . . altore . . dimosstrare. 42. cosstumi . . desscrivo.
43. cholla dilora. 44. facione . . musscoli . . ramifichino. 45. corēte o in acq"a" . . rimāgha. 46. tale acq "a" . .
ramificatione. 47. vengono chessi facci . . chanapa. 48. fasscio. 49. ramificatione . . mvsscoli.

798. 35. Compare Pl. CVII. The original drawing at Windsor is 28¹/₂ ✕ 19¹/₂ centimètres. The
upper figures are slightly washed with Indian ink. On the back of this drawing is the text No. **1140.**

W. 210] 799.

ORDINE DI NOTOMIA.

²Fa prima l'ossa come dire le braccia,
e poni il motore dalla spalla al ³gomito per
tutte le linie; Di poi dal gomito al braccio;
Di poi dal ⁴braccio alla mano e dalla mano
alli diti.

⁵E nel · braccio porrai li motori de'
diti che s'aprono, e ⁶questi nella lor di-
mostratione porrai soli; nella 2ᵃ dimo-
⁷stratione vestirai questi muscoli delli se-
condi motori de' diti, ⁸e così farai a
grado a grado per non confondere: ma
primo po⁹ni sopra dell' ossa quelli mu-
scoli che con essi ossa si congiungono,
¹⁰sanza altra confusione d'altri muscoli,
e con quelli porrai ¹¹li nerui e uene,
che li nutriscono, auendo prima fatto l'al-
bero delle ue¹²ne e nerui sopra delle sen-
plici ossa.

THE ARRANGEMENT OF ANATOMY.

First draw the bones, let us say, of the
arm, and put in the motor muscle from the
shoulder to the elbow with all its lines.
Then proceed in the same way from the
elbow to the wrist. Then from the wrist to
the hand and from the hand to the fingers.

And in the arm you will put the motors
of the fingers which open, and these you
will show separately in their demonstration.
In the second demonstration you will clothe
these muscles with the secondary motors of
the fingers and so proceed by degrees to
avoid confusion. But first lay on the bones
those muscles which lie close to the said
bones, without confusion of other muscles;
and with these you may put the nerves and
veins which supply their nourishment, after
having first drawn the tree of veins and
nerves over the simple bones.

W. An. IV, XXI] 800.

Comīcia la notomia alla testa e finis-
cila nella piāta del piede.

Begin the anatomy at the head and finish
at the sole of the foot.

W. An. II. 39b (o)] 801.

3 · uomini finiti, ²3 · con ossa e nerui,
³3 · con ossa senplici; ⁴Queste sono 12
dimo⁵strationi di figure ī⁶tere.

3 men complete, 3 with bones and ner-
ves, 3 with the bones only. Here we have
12 demonstrations of entire figures.

W. An. IV. 151a] 802.

Quādo · tu · ài · finito di ²crescere l'omo ·
tu ³farai · la statua · cō tu⁴tte · sue misure ·
⁵superfitiali.

When you have finished building up the
man, you will make the statue with all its
superficial measurements.

739. 2. le br e. 3. al br. 4. br alla. 5. nel br. porrai . . chessaperano. 6. cquesti. 7. musscoli. 9. musscoli . . chon . . chon-
 gunghano. 10. musscoli. 11. chelli notrisscano . . p "a" fatto. 12. ennerui.
800. effiniscila.
801. 1. homini. 2. chon. 3. ssenplici. 6. tiere. 802. 2. cressciere . . ettu. 3. lasstatua . chō.

802. *Cressciere l'omo.* The meaning of this ex-
pression appears to be different here and in the
passage C. A. 157ᵃ, 468ᵃ (see No. 526, Note 1. 2).
Here it can hardly mean anything else than
modelling, since the sculptor forms the figure by
degrees, by adding wet clay and the figure conse-
quently increases or grows. *Tu farai la statua* would

then mean, you must work out the figure in marble.
If this interpretation is the correct one, this pas-
sage would have no right to find a place in the
series on anatomical studies. I may say that it
was originally inserted in this connection under
the impression that *di cresciere* should be read *de-
scrivere.*

W. An. III, XXII]

803.

Farai tutti li moti dell' ossa [2]colle giunture loro dopo [3]la dimostratione delle pri[4]me tre figure dell' ossa, e[5]questo si deve fare nel primo [6]libro.

You must show all the motions of the bones with their joints to follow the demonstration of the first three figures of the bones, and this should be done in the first book.

Plans for the representation of muscles by drawings (803—809).

W. XXIII]

804.

Ricordoti che per farti certo del nascimento di qualunche muscolo, che tu tiri [2]la corda, partorita da esso muscolo, in modo che tu veda movere esso [3]muscolo e 'l suo nascimēto sopra delle · legature delli ossi.

Remember that to be certain of the point of origin of any muscle, you must pull the sinew from which the muscle springs in such a way as to see that muscle move, and where it is attached to the ligaments of the bones.

Notando.

[5]Tu non farai mai se nō confusione nella di[6]mostratione de' muscoli e lor siti, nascimēti [7]e fini, se prima non fai vna dimostratione di [8]muscoli sottili a uso di fila di refe, e così potrai [9]figurare l'un · sopra dell' altro, come li a situati la [10]natura, e così li potrai nominare secōdo il mēbro [11]al quale lor seruono, cioè il motore della pū[12]ta del dito grosso e del suo osso di mezzo o del primo ecc; [13]e dato che tu ài tale notitia, figurerai al lato a [14]questa · la uera forma e quātità e sito di ciascū muscolo; [15]ma ricordati di fare li fili, che insegniano li muscoli, neg[16]li medesimi siti che son le linie centrali di ciascū mu[17]scolo, e così tali fili dimostreranno la figura della ganba [18]e la loro distantia spedita e nota.

[19]Ho spogliato di pelle vno il quale per una mala[20]ttia s'era tanto diminuito che li muscoli erā [21]consumati e restati a uso di pellicola sottile, [22]in modo che le corde in scābio del conuertirsi [23]in muscolo si convertivano in larga pelle, [24]e quādo l'ossa erā uestite di pelle, poco acqui[25]stauā della lor naturale grossezza.

Note.

You will never get any thing but confusion in demonstrating the muscles and their positions, origin, and termination, unless you first make a demonstration of thin muscles after the manner of linen threads; and thus you can represent them, one over another as nature has placed them; and thus, too, you can name them according to the limb they serve; for instance the motor of the point of the great toe, of its middle bone, of its first bone, &c. And when you have the knowledge you will draw, by the side of this, the true form and size and position of each muscle. But remember to give the threads which explain the situation of the muscles in the position which corresponds to the central line of each muscle; and so these threads will demonstrate the form of the leg and their distance in a plain and clear manner.

I have removed the skin from a man who was so shrunk by illness that the muscles were worn down and remained in a state like thin membrane, in such a way that the sinews instead of merging in muscles ended in wide membrane; and where the bones were covered by the skin they had very little over their natural size.

803. 2. gunture. 3. dimosstratione. 4. ecq. 5. defare.
804. 1. nasscimēto . . chettu. 2. corta. 3. musscolo . . nasscimēto. 6. mosstratione . . musscoli ellor . . nasscimēti. 7. effini . . dimosstratione. 8. musscoli. 10. mēbr. 11. seruano coe . . motore [delluli]. 12. mezo. 13. chettu. 14. cquessta . . essito . . mussolo. 15. musscoli ne. 16. le medesimi . . chesson . . ciasscū. 17. dimosterā. 18. ella . . disstantia . . e note. 19. hosspogliato. 20. chelli musscoli. 21. cresstati. 22. chelle corde niscābio. 23: musscolo . . largha. 24. pocho. 25. grosseza.

804. The photograph No. 41 of Grosvenor Gallery Publications: a drawing of the muscles of the foot, includes a complete facsimile of the text of this passage.

W. An. I. 1 *b*]

805.

Quale nervo è cagione del moto dell'ochio a fare · che 'l moto dell'un ochio tiri l'altro.

²¶Del chiudere le ciglia, ³dello alzare le ciglia, ⁴dello abbassare le ciglia,¶ ⁵¶dello chiudere li ochi, ⁶dello aprire li ochi,¶ ⁷¶dello alzare le narici, ⁸del aprire le labra cō dēti · serrati, ⁹dello · appūtare · le labra, ¹⁰del ridere, ¹¹del maravigliarsi.

¹²A discriuere il principio dell'omo quãdo elli si cavsa · nella matrice, ¹³e perchè uno putto nō uiue · d'otto · mesi; ¹⁴che cosa è starnvto, ¹⁵che cosa è sbadiglio, ¹⁶malmaestro, ¹⁷spasimo, ¹⁸paralitico, ¹⁹tremito di freddo, ²⁰sudore, ²¹stãchezza, ²²fame, ²³sonno, ²⁴sete, ²⁵lussuria.

²⁶¶Del neruo · ch'è cagione del moto della spalla al gomito, ²⁷del moto che è dal gon ito alla mano, ²⁸dalla givntura · della · mano · al nascimēto de'diti, ²⁹dal nascimēto de'diti · al loro · mezzo ³⁰e dal mezzo all'ultimo nodo.¶

³¹Del neruo che è cagione del moto della coscia, ³²e dal ginochio al piè, e dalla givntura del piè ai diti ³³e così ai lor mezzi, ³⁴e del girare d'essa ganba.

Which nerve causes the motion of the eye so that the motion of one eye moves the other?

Of frowning the brows, of raising the brows, of lowering the brows,—of closing the eyes, of opening the eyes,—of raising the nostrils, of opening the lips, with the teeth shut, of pouting with the lips, of smiling, of astonishment.—

Describe the beginning of man when it is caused in the womb and why an eight months child does not live. What sneezing is. What yawning is. Falling sickness, spasms, paralysis, shivering with cold, sweating, fatigue, hunger, sleepiness, thirst, lust.

Of the nerve which is the cause of movement from the shoulder to the elbow, of the movement from the elbow to the hand, from the joint of the hand to the springing of the fingers. From the springing of the fingers to the middle joints, and from the middle joints to the last.

Of the nerve which causes the movement of the thigh, and from the knee to the foot, and from the joint of the foot to the toes, and then to the middle of the toes and of the rotary motion of the leg.

F. 95 *b*]

806.

ANATOMIA.

²Quali nerui over corde della mano sō ³quelle che accostano e discostano li ⁴diti della mano e de'piedi l'un dall'altro?

ANATOMY.

Which nerves or sinews of the hand are those which close and part the fingers and toes latteraly?

W. 238 *b*]

807.

Scuopri a grado a grado tutte le parti dinanti dell'omo ²nel fare la tua notomia, e così insino in sull'osso; ³descritione de' mēbra della vita e lor trauagliamēti.

Remove by degrees all the parts of the front of a man in making your dissection, till you come to the bones. Description of the parts of the bust and of their motions.

K.3 28 *a*]

808.

Fa la notomia della gā²ba insino al fiãco per ³tutti i versi e per tutti li ⁴atti e in

Give the anatomy of the leg up to the hip, in all views and in every action and in

805. 1. chagione . . affare. 7. anarise. 8. cho . . serati. 12. [facci] a desscrivere . . chausa. 13. î putto. 14. chosa esstarnuto. 15. chosa essbaviglio. 16. malmaesstro. 18. parleticho. 19. frede. 21. stãcheza. 26. chagione . . dalla. 28. nassimēto. 29. nassimēto . . mezo. 30. mezo. 31. chagione . . cosscia. 33. mezi.

806. 1. anotamia. 3. quelle che achostano e disscostano.

807. 1. parte. 3. discretiō de mēbr . . vite ellor.

808. 1—9 R. 2. fiãcho. 7. lle. 8. seghate . . gro.

808. A straightened leg in profile is sketched by the side of this text.

tutte le spoglie, ⁵vene, arterie, nerui, ⁶corde e mvscoli, pel⁷le e ossa, e poi dell'ossa ⁸segate per uedere la gros⁹sezza dell'ossa.

every state; veins, arteries, nerves, sinews and muscles, skin and bones; then the bones in sections to show the thickness of the bones.

W. A. II. *76 b*]

809.

Farai regola e misura di ciascun muscolo, ²e renderai ragione di tutti li loro vfiti, e in che mo³do s'adoperano e che li muove ecc.

⁴Farai prima la spina del dosso, di poi va vestendo ⁵a gradi l'un sopra dell'altro di ciascū di questi musco⁶li, e poni li nervi all'arterie e vene a ciascun ⁷muscolo per se, e oltre a di questo nota a quā⁸ti spondili si congiūgono, e che intestini sono ⁹loro a riscōtro e che ossi e altri strumēti orga-¹⁰nici ecc.

¹¹Le parti più alte de' magri son più alte nelli mu¹²scolosi, e similmēte ne'grassi; Ma la differētia, che è ¹³dalla figura de'muscoli che ànno li grossi a rispetto ¹⁴delli muscolosi, sarà qui di sotto descritta.

Make the rule and give the measurement of each muscle, and give the reasons of all their functions, and in which way they work and what makes them work &c.

[4] First draw the spine of the back; then clothe it by degrees, one after the other, with each of its muscles and put in the nerves and arteries and veins to each muscle by itself; and besides these note the vertebrae to which they are attached; which of the intestines come in contact with them; and which bones and other organs &c.

The most prominent parts of lean people are most prominent in the muscular, and equally so in fat persons. But concerning the difference in the forms of the muscles in fat persons as compared with muscular persons, it shall be described below.

On corpulency and leanness (809—811).

W. An IV. *7 (A. A)*]

810.

Descriui quali mu²scoli si perdono nello ī³grossare, e nel dimagra⁴re quali muscoli si sco⁵prono.

⁶E nota che quel loco del⁷la superfitie del grasso ⁸che sarà più cōcauata, ⁹quādo si disgrassa fìa ¹⁰più eleuato.

¹¹Doue li muscoli ¹²si separano l'ū dal-¹³l'altro, farai p¹⁴roffili, e doue s'¹⁵appiccano insieme . . .

Describe which muscles disappear in growing fat, and which become visible in growing lean.

And observe that that part which on the surface of a fat person is most concave, when he grows lean becomes more prominent.

Where the muscles separate one from another you must give profiles and where they coalesce . . .

W. 239 (= W. L. *131*)]

811.

DE FIGURA VMANA.

²Qual parte è quella nell'omo che nel suo ingrassa³re mai cresce carne?

⁴Quale è quella parte che nel dimagrare dell'omo ⁵mai nō dimagra con dimagratiō troppo sēsibile? ⁶infra le parti che ingrassano qual'è quella che più ⁷ingrassa?

OF THE HUMAN FIGURE.

Which is the part in man, which, as he grows fatter, never gains flesh?

Or what part which as a man grows lean never falls away with a too perceptible diminution? And among the parts which grow fat which is that which grows fattest?

809. 1. reghola . . ciasscū musscolo. 3. he chilli. 4. lasspina . . vavesstendo. 5. hagradi . . ciasscū di quessti. 6. ciasscū. 7. musscholo . . addi quessto . . acquā. 8. chongiūghano . . intesstini. 9. arrisscōtro . . orgha. 11. parte . . mus. 12. scho-losi essimilmēte . . Malla diferētia. 13. musscoli che āli . . aris specto. 14. musscholosi . . disoctō desscrcta.

810. 2. perdano. 4. musscoli. 5. prano. 6. que lochi. 7. lla. 8. chessara. 9. dissgrassa. 11. musscoli. 15. apichano.

811. 3. cressce. 4. ecquella. 6. infralle parte. 8. infralle parte . . chessi. 10. musscoli . . di ma. 11. gore grossezza. 12. affi-

809. The two drawings given on Pl. CVIII no. 1 come between lines 3 and 4. A good and very early copy of this drawing without the written text

exists in the collection of drawings belonging to Christ's College Oxford, where it is attributed to Leonardo.

[8] Infra le parti che dimagrano qual' è quella che si fa [9] più magra?

[10] Degli omini potēti in forze quali muscoli son di mag[11]giore grossezza e più eleuati?

[12] Tu ài a figurare nella tua anatomia tutti li gradi [13] delle mēbra dalla creatiō dell' omo insino alla sua [14] morte, e insino alla morte dell' osso, e qual parte d' esso [15] prima si cōsuma e qual più si cōserua.

[16] E similmente dall' ultima magrezza all' ultima grassezza.

Among those which grow lean which is that which grows leanest?

In very strong men which are the muscles which are thickest and most prominent?

In your anatomy you must represent all the stages of the limbs from man's creation to his death, and then till the death of the bone; and which part of him is first decayed and which is preserved the longest.

And in the same way of extreme leanness and extreme fatness.

S. K. M. III. 66a] 812.

NOTOMIA.

The divisions of the head (812. 813).

[2] I membri semplici · sono · vndici · cioè [3] cartilagine · ossi · nerui · vene, [4] arterie · pannicoli · legamēti e [5] corde, cotica e carne e grasso.

ANATOMY.

There are eleven elementary tissues:—

Cartilage, bones, nerves, veins, arteries, fascia, ligament and sinews, skin, muscle and fat.

DEL CAPO.

[7] Le parti del uaso del capo · sono 10: cioè [8] 5 · contenēti · e 5 · cōtenute; le contenēti [9] sono: capegli · cotica · carne [10] muscolosa · panniculo · grosso · e 'l [11] craneo · || le contenvte son queste : du[12]ra madre · pia madre · cieruello | diso[13]tto ritorna la pia e dura madre che dentro [14] a se rinchiudono il cieruello ·, poi la rete [15] mirabile · poi è l' osso, fondamēto del celabro [16] e donde · nascono li nerui.

OF THE HEAD.

The divisions of the head are 10, viz. 5 external and 5 internal, the external are the hair, skin, muscle, fascia and the skull; the internal are the dura mater, the pia mater, [which enclose] the brain. The pia mater and the dura mater come again underneath and enclose the brain; then the rete mirabile, and the occipital bone, which supports the brain from which the nerves spring.

S. K. M. III. 65b] 813.

a capelli
n cotica
c carne musculosa
m pañiculo · grosso
[5] o craneo cioè osso
b dura madre
d pia · madre
f cieruello
[10] r · pia madre · di sotto
t · dura · madre
l · rete mirabile
s · osso fondamēto.

a. hair
n. skin
c. muscle
m. fascia
o. skull i. e. bone
b. dura mater
d. pia mater
f. brain
r. pia mater, below
t. dura mater
l. rete mirablile
s. the occipitul bone.

gurare. 15. ecqual. 16. essimilmente . . magreza . . graseza.
812. 3. hossi. 4. pannichuli . . he. 5. codigahe. 8. he 5 cōtenute. 9. codiga. 10. musscolosa. 14. asse ringiugano. 15. ellosso. 16. nasscie.
813. 2. codiga. 6. [f cieruello].

813. See Pl. CVIII, No. 3.

W. An. II. 37 a] **814.**

Causa dell'alitare, ²causa del moto del core, ³causa del uomito, ⁴causa del discē-dere il ⁵cibo dallo stomaco, ⁶causa del votare li ī⁷testini;

⁸Causa del moto delle ⁹superfluità per le inte¹⁰stini;

¹¹Causa dello inghiottire, ¹²causa dello tossire, ¹³causa dello sbadigliare, ¹⁴causa dello starnuto, ¹⁵causa dell'adormētamē¹⁶to di diuerse mēbra;

¹⁷Causa del perdere il sēso ¹⁸ad alcū mēbro;

¹⁹Causa del solletico;

²⁰Causa della lussuria e al²¹tre necessità del corpo, ²²causa dell'orinare, ²³e così di tutte le lotioni natu²⁴rali del corpo.

Of the cause of breathing, of the cause of the motion of the heart, of the cause of vomiting, of the cause of the descent of food from the stomach, of the cause of emptying the intestines.

Of the cause of the movement of the superfluous matter through the intestines.

Of the cause of swallowing, of the cause of coughing, of the cause of yawning, of the cause of sneezing, of the cause of limbs getting asleep.

Of the cause of losing sensibility in any limb.

Of the cause of tickling.

Of the cause of lust and other appetites of the body, of the cause of urine and also of all the natural excretions of the body.

Physiological problems (814. 815).

W. An. III. 230 a (·S·)] **815.**

Le lagrime ²vengono dal ³core e nō dal ⁴ceruello.

⁵Difinisci tutte ⁶le parti di che si cō-⁷pone il corpo, co⁸minciādosi dalla ⁹cute colla sua so¹⁰praveste, la qual ¹¹è spesso spiccata ¹²mediante il sole.

The tears come from the heart and not from the brain.

Define all the parts, of which the body is composed, beginning with the skin with its outer cuticle which is often chapped by the influence of the sun.

814. 5. dello stomacho. 6. otare le ī. 7. testine. 9. super fruita. 10. stine. 11. delle ingiottire. 13. isbauiglare. 14. isstarnuto. 23. tutte lutioni.
815. 2. vengano. 5 difinisscitute. 6. parte. 8. mincādosi. 9. cutic. 10. pravessta. 11. spicha.

814. By the side of this text stands the pen and ink drawing reproduced on Pl. CVIII, No. 4; a skull with indications of the veins in the fleshy covering.

II.

ZOOLOGY AND COMPARATIVE ANATOMY.

816.

The divisions of the animal kingdom (816. 817).

Uomo | la descritione dell'omo, nella qual si contengono quelli che son qua²si di simile spetie come babbuino, scimmia e simili che sō molti.

³*Leone* | e suoi seguaci come pantieri, leonze, tigri, liopardi, lupi, cervie⁴ri, gatti di Spagna, gannetti e gatti comvni e simili.

⁵*Cavallo* e sua seguaci come mulo, asino e simili che ànno dēti sopra e di sotto.

⁶*Toro* | e sua seguaci cornvti e sanza denti di sopra come bufolo, ceruio, daino ⁷capriolo, pecore, capre, stambecchi, mvcheri, camozze, giraffe.

Man. The description of man, which includes that of such creatures as are of almost the same species, as Apes, Monkeys and the like, which are many,

The Lion and its kindred, as Panthers. Wildcats (?) Tigers, Leopards, Wolfs, Lynxes, Spanish cats, common cats and the like.

The Horse and its kindred, as Mule, Ass and the like, with incisor teeth above and below.

The Bull and its allies with horns and without upper incisors as the Buffalo, Stag Fallow Deer, Wild Goat, Swine, Goat, wild Goats Muskdeers, Chamois, Giraffe.

817.

Scrivi le varietà ²delli intestini de³lla spetie vma⁴na, scimie e si⁵mili; Di poi in ⁶che si uaria la spe⁷tie leonina, di ⁸poi la bovina, ⁹e vltimo li uccelli, ¹⁰e vsa tal descrit¹¹tione a uso di ¹²discorso.

Describe the various forms of the intestines of the human species, of apes and such like. Then, in what way the leonine species differ, and then the bovine, and finally birds; and arrange this description after the manner of a disquisition.

816. homo la . . contiene . . chesson. 2. essimili. 3. essua seguace . . tigre. 4. gannetti . . essimili. 5. chavallo . . [cervio] essimili cano. 6. essanza. 7. pechore . . stanbeche mvcheri
817. 2. delli intestini. 4. essi. 7. elonina. 9. ucielli. 10. discrip.

816. 3. *Leonza*—wild cat? "*Secondo alcuni, lo stesso che Leonessa; e secondo altri con più certezza, lo stesso che Pantèra.*" FANFANI, *Vocabolario* page 858.

W. A. IV. 153 b]

818.

Fa ti dare vna secōdina delli ²vitelli quādo nascono e nota ³la figura de' cotiledoni, se riser⁴vano li cotiledoni mas⁵chi o femminei.

Procure the placenta of a calf when it is born and observe the form of the cotyledons, if their cotyledons are male or female.

Miscellane-ous notes on the study of Zoology (818—821).

W. An. IV. 167 a]

819.

Scrivi la lingua del picchio ²e la ma-scella del cocodrillo.

Describe the tongue of the woodpecker and the jaw of the crocodile.

G. 64 b]

820.

Volare della 4ᵃ spetie ²di parpaglioni divo³ratori delle formiche alate; ⁴delle tre principali situationi ⁵che fanno l' ali delli vccielli che discēdono.

Of the flight of the 4ᵗʰ kind of butter-flies that consume winged ants. Of the three principal positions of the wings of birds in downward flight.

M. 67 a]

821.

Che modo fa la coda del pescie a so-spin²giere il pescie innāzi, e così l'anguilla, ³biscia e mignatta.

Of the way in which the tail of a fish acts in propelling the fish; as in the eel, snake and leech.

W. An. IV. 157 a (B)]

822.

DELLA MANO DI DENTRO.

OF THE PALM OF THE HAND.

²Farai poi vn discor³so delle mani di ciascu⁴n animale per mostrare ⁵in che si uariano, come nell' orso che ⁶agiugne la legatura de⁷lle corde de' diti del piè ⁸sopra il collo d' esso piè.

Then I will discourse of the hands of each animal to show in what they vary; as in the bear, which has the ligatures of the sinews of the toes joined above the instep.

Comparative study of the structure of bones and of the action of muscles (822—826).

W. XXIV ('55·)]

823.

Dimostratione secōda ²interposta infra l'anato³mia e 'l uiuo.
⁴Figurerai a questo p⁵aragone le gambe de' ra⁶nocchi, le quali ànno gran ⁷simili-tudine colle ganbe ⁸dell'omo si nell'ossa come ⁹ne' suoi muscoli; di poi ¹⁰seguirai le gābe dirieto ¹¹della lepre, le quali son ¹²molto muscolose e di ¹³muscoli spediti, perchè nō ¹⁴sono inpedite da grasse¹⁵zza.

A second demonstration inserted between anatomy and [the treatise on] the living being.
You will represent here for a comparison, the legs of a frog, which have a great resemblance to the legs of man, both in the bones and in the muscles. Then, in conti-nuation, the hind legs of the hare, which are very muscular, with strong active muscles, because they are not encumbered with fat.

818. 1. fatti. 2. nascano. 3. cotilidoni. 4. cotilidoni mass. 5. ci offeminine.
819. lingha . . pichio. 2. ella masscella. **820.** 5. cheffa . . discēda.
821. 1. pesscie assosspī. 2. pesscio . . languila. 3. bisscia e migmatta. **822.** 6. agugne la lecatura.
823. 4. acquessto. 6. nochi. 8. com"e". 9. musscoli. 12. molte.

820. 4. A passing allusion is all I can here permit myself to Leonardo's elaborate researches into the flight of birds. Compare the observations on this subject in the Introduction to section XVIII and in the Bibliography of Manuscripts at the end of the work.

821. A sketch of a fish, swimming upwards is in the original, inserted above this text.—Compare No. 1114.
823. This text is written by the side of a drawing in black chalk of a nude male figure, but there is no connection between the sketch and the text.

K.3 29 _b_] **824.**

Qui fo ricordo ²di dimostrare la dif-³ferentia ch'è dall'o⁴mo al cauallo, e simil-⁵mente delli altri ani⁶mali; e prima ⁷comin-cerò all'ossa, e proseguirò ⁸tutti li muscoli che sanza corde na⁹scono e finiscono nelle ossa, ¹⁰e poi di quelli che cō corda na-¹¹scono e finiscono nell'ossa, e poi di quelle ¹²che con una sola corda da v̄ can-to.

Here I make a note to demonstrate the difference there is between man and the horse and in the same way with other animals. And first I will begin with the bones, and then will go on to all the muscles which spring from the bones without tendons and end in them in the same way, and then go on to those which start with a single tendon at one end.

E. 16 _a_] **825.**

Nota delle piegatu²re delle giūtu³re, e in che mo⁴do cresce la ⁵carne sopra di ⁶loro nelli ⁷lor piegamē⁸tio e stendimē⁹ti; e di questa ¹⁰īportātissima ¹¹notitia fa uno ¹²particulare ¹³trattato | nel¹⁴la descritione ¹⁵de' movimēti ¹⁶delli animali ¹⁷di quattro pi¹⁸edi, infra li ¹⁹quali è l'omo ²⁰che ācora lui ²¹nella infātia ²²va cō 4 piedi.

Note on the bendings of joints and in what way the flesh grows upon them in their flexions or extensions; and of this most important study write a separate treatise: in the description of the movements of animals with four feet; among which is man, who likewise in his infancy crawls on all fours.

C. A. 292 _a_; 888 _a_] **826.**

DELLO · ANDARE DELL'OMO.

²L'andare dell'omo · è sempre a uso dell'universale andare delli animali di 4 piedi, imperochè siccome essi ³movono · i loro · piedi in croce a vso del trotto del cauallo, così l'omo in croce si move le sue 4 · mēbra, cioè ⁴se caccia · īnāti il piè destro per caminare, egli caccia ināzi cō quello il braccio · sinistro, e sempre così seguita.

OF THE WAY OF WALKING IN MAN.

The walking of man is always after the universal manner of walking in animals with 4 legs, inasmuch as just as they move their feet crosswise after the manner of a horse in trotting, so man moves his 4 limbs crosswise; that is, if he puts forward his right foot in walking he puts forward, with it, his left arm and vice versa, invariably.

824. 2. la di. 4. essimil. 6. e p"a". 7. epposseguiro. 8. musscoli. 9. scano effiniscano. 10. eppoi. 11. scano effinisscano . . he poi. 12. [q] che.

825. 1. "nota" delle pieghatu. 4. cressca. 5. charne. 7. pieghamē. 8. esstendimē. 9. quessta. 12. partichulare. 13. tractato. 14. lla desscritione. 18. infralli. 19. ellomo. 20. āchora.

826. 2. essenpre . . inperochessichome. 3. movano illoro . . chauallo . chosi. 4. chaccia . . desstro . . chaminare . . chaccia . chō . . sinisstro essepr.

824. See Pl. CVIII, No. 2.

III.

PHYSIOLOGY.

827.

Ho trovato nella compositione del corpo vmano che, come in tutte [2]le compositioni delli animali, esso è di piv ottusi e grossi sentimēti; [3]così è composto di strumēto manco ingegnoso e di lochi māco [4]capaci a ricevere la uirtù de' sensi; ò veduto nella spetie leoni[5]na il senso dell'odorato auere parte della sustantia del celabro, e discē-[6]dere li narici, capace ricettaculo contro al senso dello odorato, [7]il quale entra infra grā nvmero di saccoli cartilaginosi con assai [8]vie contro all'avenimento del predetto celabro.

[9]Li ochi della spetie leonina ànno gran parte della lor testa per lor [10]ricettacolo, e li nerui ottici inmediate congiugnersi col celabro; il che al[11]li omini si uede in contrario, perchè le casse delli ochi sono vna picco[12]la parte del capo, e li nerui ottici sono sottili e lunghi e deboli, e per debo-[13]le operatione si uede di loro il dì, e peggio la notte, e li predetti animali [14]vedono in nella notte che 'l giorno; [15]e 'l segno se ne vede, perchè predano di notte [16]e dormono il giorno come fāno ancora li uccelli notturni.

I have found that in the composition of the human body as compared with the bodies of animals the organs of sense are duller and coarser. Thus it is composed of less ingenious instruments, and of spaces less capacious for receiving the faculties of sense. I have seen in the Lion tribe that the sense of smell is connected with part of the substance of the brain which comes down the nostrils, which form a spacious receptacle for the sense of smell, which enters by a great number of cartilaginous vesicles with several passages leading up to where the brain, as before said, comes down.

The eyes in the Lion tribe have a large part of the head for their sockets and the optic nerves communicate at once with the brain; but the contrary is to be seen in man, for the sockets of the eyes are but a small part of the head, and the optic nerves are very fine and long and weak, and by the weakness of their action we see by day but badly at night, while these animals can see as well at night as by day. The proof that they can see is that they prowl for prey at night and sleep by day, as nocturnal birds do also.

Comparative study of the organs of sense in men and animals.

827. 1. ottrovato . . conpositone . . chome. 3. chosi e conpossto . . mancho . . mancho. 4. chapaci. 5. nel senso . . susstantia del celabro discē. 6. ricettachulo. 7. sachuli chartilaginosi. 9. tessta. 10. ricettachulo elli . . ottitti . . congugnersi. 11. lli . . chasse . . picho. 12. elli . . ellunghi. 13. eppeggo . . elli. 14. vegan inela . . gorno. 15. dormano il gorno . . fano . . ucelli.

H.2 38 *a*] **828.**

<table>
<tr><td>Advantages
in the struc-
ture of the
eye in cer-
tain animals
(828—831).</td></tr>
</table>

¶Tutte · le cose vedute parrāno ²maggiori · di mezza notte, che · di ³mezzo · dì · e maggiori di mattina che ⁴di mezzodì. ¶

⁵Questo · accade · perchè · la pupilla ⁶dell' ochio · è · minore · assai di mezzo ⁷dì · che di nessuno · altro tenpo.

⁸Tanto · quāto · è · maggiore · l'ochio ⁹over · pupilla del gufo a proportione ¹⁰dello · animale, che non è · quella · dell'o¹¹mo ·, tanto piv · lume vede di notte che ¹²nō · fa · l'omo; ōde di mezzo · dì nō vede ni¹³ente ·, se lui nō · diminuisce · sua · pupil¹⁴la ·, e similmēte · vede di notte le cose mag¹⁵giori · che di dì.

Every object we see will appear larger at midnight than at midday, and larger in the morning than at midday.

This happens because the pupil of the eye is much smaller at midday than at. any other time.

In proportion as the eye or the pupil of the owl is larger in proportion to the animal than that of man, so much the more light can it see at night than man can; hence at midday it can see nothing if its pupil does not diminish; and, in the same way, at night things look larger to it than by day.

G. 44 *a*] **829.**

DELLI OCHI DELLI ANIMALI.

²Li ochi di tutti li animali àño le ³lor popille, le quali per loro medesime cres-⁴cono e diminuiscono secōdo il mag⁵giore e minore lume del sole o altro ⁶chiarore; Ma nelli uccelli fa maggio⁷re differētia, e massima nelli nottur⁸ni, come gufi, barbagianni, e all'ochi ⁹che son di spetie di civetta; a questi cresce ¹⁰la popilla in modo che quasi occupa tut¹¹to l'ochio, e diminuisce insino alla grā¹²dezza d'ū grā di miglio e sempre osser¹³va figura circulare; Ma la spe¹⁴tie leonina come pātere, pardi, ¹⁵leōze, tigri, lupi, cieruieri, gatti di Spa¹⁶gnia e altri simili diminuiscono ¹⁷la lucie dal perfetto circulo ¹⁸alla figura biāgolare, cioè questa ¹⁹è come si dimostra in margine; Ma l'uomo ²⁰per avere più debole vista che nessuno altro a²¹nimale, meno è offeso dalla superchia luce, ²²e mē s'avmēta nelli lochi tenebrosi; ma ²³alli ochi delli detti animali notturni,—al ²⁴gufo vcciello cornuto, il quale è 'l ²⁵massimo nella spetie delli vccelli nottur²⁶ni: a questo s'aumēta tanto la uirtù vi²⁷siva, che nel minimo

OF THE EYES IN ANIMALS.

The eyes of all animals have their pupils adapted to dilate and diminish of their own accord in proportion to the greater or less light of the sun or other luminary. But in birds the variation is much greater; and particularly in nocturnal birds, such as horned owls, and in the eyes of one species of owl; in these the pupil dilates in such a way as to occupy nearly the whole eye, or diminishes to the size of a grain of millet, and always preserves the circular form. But in the Lion tribe, as panthers, pards, ounces, tigers, lynxes, spanish cats and other similar animals the pupil diminishes from the perfect circle to the figure of a pointed oval such as is shown in the margin. But man having a weaker sight than any other animal is less hurt by a very strong light and his pupil increases but little in dark places; but in the eyes of these nocturnal animals, the horned owl—a bird which is the largest of all nocturnal birds— the power of vision increases so much that in the faintest nocturnal light (which we call darkness) it sees

828. 1. tucte . le chose. 2. magiori . . meza. 3. mezo . . magiori. 4. mezo. 5. acchade. 6. mezo. 8. he magiore. 11. nocte. 12. mezo. 13. diminuiscce . . popi. 14. essimilmēte . . ma. 15. magiore.

829. 1. dell[o]i ochi[o]i. 3. popille le quali pe lor. 4. scano e diminvisschano . . il ma. 5. ēminore. 6. vcielli. 7. diferētia emassime neli. 8. ghufi. 9. chesson . . quessti crescie. 10. ochupa. 11. diminuisscie. 12. essenpre. 13. fighura circulare. M lla. 14. chome. 16. diminuiscano. 17. circhulo. 18. fighura biāghola . . quessta. 19. chome si dimosstra . . Mallom"o". 20. vissta. 21. luci"e". 23. notturniel. 24. ghupo . . chornuto. 25. vcielli. 26. acquessto. 28. quale noc dimādano . . ve

829. Compare No. 24, lines 8 and fol.

lume notturno (il ²⁸quale da noi dimādasi tenebre) vede assai cō ²⁹più vigore che noi nello splendore del ³⁰mezzo giorno, nel quale tali vccielli stā ³¹nascosti in lochi tenebrosi; e se pur ³²sō costretti u³³scire all'a³⁴ria allumina³⁵ta dal sole, elli' ³⁶diminuiscono ³⁷tāto la lor po³⁸pilla che la po³⁹tentia visiua ⁴⁰diminuisce ⁴¹insieme colla ⁴²quātità di tale ⁴³lucie.

⁴⁴Fa notomia ⁴⁵di vari ochi, ⁴⁶e vedi quali ⁴⁷sō li muscoli ⁴⁸ch'aprono e ⁴⁹serrano le pre⁵⁰dette popille ⁵¹delli ochi del⁵²li animali.

with much more distinctness than we do in the splendour of noon day, at which time these birds remain hidden in dark holes; or if indeed they are compelled to come out into the open air lighted up by the sun, they contract their pupils so much that their power of sight diminishes together with the quantity of light admitted.

Study the anatomy of various eyes and see which are the muscles which open and close the said pupils of the eyes of animals.

Br. M. 64 *b*] **830.**

a b n è il coperchio di sotto che chiude ²l'ochio di sotto in sù con coperchio oppaco, ³*c n b* chiude l'ochio dinanzi īdirieto ⁴con coperchio transparēte.

⁵Chiudesi sotto in sù ⁶perchè da alto disciē⁷de.

⁸Quando l'ochio delli uccelli si chiude ⁹colle sue due copriture, esso chiu¹⁰de prima la secondina la qual ¹¹chiude dal lagrimatoio alla co¹²da d'esso ochio, e la prima si chi¹³vde da basso in alto, e que-¹⁴sti due moti intersegati occupano ¹⁵in prima dal lacrimatoio, perchè già abbiamo veduto che ¹⁶dinanzi e di sotto si sono assicurati, e sol serba¹⁷no la parte di sopra per li pericoli delli uccielli ra¹⁸paci che discendono di sopra e dirieto; e sco-¹⁹prano prima il pannicolo di verso la coda, ²⁰perchè se 'l nemico viene dirieto, egli à la como²¹dità del fugire innāzi, e ancora tiene ²²il pannicolo detto secondino e traspa²³rente, perchè se non avesse tale scudo, e' nō ²⁴potrebbe tener li ochi aperti cōtro al ²⁵vēto che percuote l'ochio nel furo²⁶re del suo velocie volare; E la sua ²⁷popilla crescie e discrescie nel uedere ²⁸minore o maggiore lume cioè splēdore.

a b n is the membrane which closes the eye from below, upwards, with an opaque film, *c n b* encloses the eye in front and behind with a transparent membrane.

It closes from below, upwards, because it [the eye] comes downwards.

When the eye of a bird closes with its two lids, the first to close is the nictitating membrane which closes from the lacrymal duct over to the outer corner of the eye; and the outer lid closes from below upwards, and these two intersecting motions begin first from the lacrymatory duct, because we have already seen that in front and below birds are protected and use only the upper portion of the eye from fear of birds of prey which come down from above and behind; and they uncover first the membrane from the outer corner, because if the enemy comes from behind, they have the power of escaping to the front; and again the muscle called the nictitating membrane is transparent, because, if the eye had not such a screen, they could not keep it open against the wind which strikes against the eye in the rush of their rapid flight. And the pupil of the eye dilates and contracts as it sees a less or greater light, that is to say intense brilliancy.

H.3 61*a*] **831.**

¶L'ochio che di notte s'interporrà infra 'l lume e l'ochio ²della gatta, vedrà esso occhio parere di foco.¶

If at night your eye is placed between the light and the eye of a cat, it will see the eye look like fire.

assai chō. 29. vighore. 31. nasscosti inochi . . esseppur. 32. cosstretti vs. 33. allalla. 36. diminuiscā. 38. chella. 40. diminuissie. 41. cholla. 47. musscoli. 48. aprano es.

830. 2. socto . . oppacho. 4. chon choperchio transsparēte. 6. disciē. 7. da. 8. vcielli. 9. cholle . . chopriture. 12. ella. 13. di basso . . ecque. 14. interseghati ochupano. 15. dalacrimatoio . . giaā ueduto. 16. assichurati.¡ 17. pericholi. 18. dissciendono . . diriecto essco. 19. panitolo . . choda. 20. nemicho . . diriecto. 22. trāsspa. 23. auessi. 25. perchuote. 26. Ella. 27. cresscie e disscresscie. 28. magiore.

831. 1. ellochio. 2. vedera . . focho.

W. An. IV. 184*a* (7)] **832.**

La lingua è trouata auere 24
muscoli li quali rispondono alli
sei muscoli di che è ²conposta la
quātità della lingua che si move
per la bocca.

³E quando *a o v* si pronūtiano
con ⁴intelligibile e spedita pronū-
tia, egli è ⁵necessario che nella
continua lor ⁶pronūtiatione sanza
intermissiō di tēpo, che ⁷l'apritura
de' labri si uadi al cōtinuo restri-
⁸gnendo, cioè larghi sarāno nel
dire *a*, pi⁹ù stretti nel dire *o*,
e assai piv stretti nel pr¹⁰onun-
tiare *v*.

¹¹Prouasi come tutte le uo-
¹²cali son pronūtiate colla ¹³parte
ultima del pala¹⁴to mobile, il quale
copre l'e¹⁵piglotta.

a	*e*	*i*	*o*	*u*
ba	*be*	*bi*	*bo*	*bu*
ca	*ce*	*ci*	*co*	*cu*
da	*de*	*di*	*do*	*du*
fa	*fe*	*fi*	*fo*	*fu*
ga	*ge*	*gi*	*go*	*gu*
la	*le*	*li*	*lo*	*lu*
ma	*me*	*mi*	*mo*	*mu*
na	*ne*	*ni*	*no*	*nu*
pa	*pe*	*pi*	*po*	*pu*
qa	*qe*	*qi*	*qo*	*qu*
ra	*re*	*ri*	*ro*	*ru*
sa	*se*	*si*	*so*	*su*
ta	*te*	*ti*	*to*	*tu*

The tongue is found to have
24 muscles which correspond to
the six muscles which compose
the portion of the tongue which
moves in the mouth.

And when *a o u* are spoken
with a clear and rapid pronunciation,
it is necessary, in order to pronounce
continuously, without any pause be-
tween, that the opening of the lips
should close by degrees; that is,
they are wide apart in saying *a*,
closer in saying *o*, and much closer
still to pronounce *u*.

It may be shown how all the
vowels are pronounced with the
farthest portion of the false palate
which is above the epiglottis.

W. XXI] **833.**

Se tirerai il fiato pel na²so e lo vorrai
mādar fori ³per la bocca, tu sentirai il
sono ⁴che fa il tramezzo cioè il ⁵pānicolo
in ...

If you draw in breath by the nose and
send it out by the mouth you will hear the
sound made by the division that is the
membrane in[5] ...

C. A. 89*a*; 258*a*] **834.**

DELLA NATURA DEL UEDERE.

OF THE NATURE OF SIGHT.

²Dico · ʝl uedere · essere operato da tutti
li animali · mediāte · la luce; e se alcuno
cōtra questo ³allegherà · ʝl uedere · delli ·
animali notturni, dirò · questo · medesima-
mēte essere · sottoposto · a simile · natura;
ʝpero⁴chè · chiaro · si cōprēde ·, ʝ sensi ·
ricievēdo · le similitudini delle cose · nō mā-
dano · fori di loro alcuna virtù; ⁵anzi me-
diāte l'aria, che si trova īfra l'obietto e 'l
sēso ·, ʝncorpora · ʝ se le spetie delle · cose ·,
e per lo cōtatto, ⁶che à · col sēso, le porgie
a quello; se li obietti o per sono · o per
odore mādano le potētie spirituali all'orechio
⁷o al naso ·, qui nōn è neciessario nè si
adopera la luce ·; le forme delli obietti non

I say that sight is exercised by all ani-
mals, by the medium of light; and if any
one adduces, as against this, the sight of
nocturnal animals, I must say that this in
the same way is subject to the very same
natural laws. For it will easily be under-
stood that the senses which receive the
images of things do not project from them-
selves any visual virtue[4]. On the contrary
the atmospheric medium which exists be-
tween the object and the sense incorpo-
rates in itself the figure of things, and by
its contact with the sense transmits the ob-
ject to it. If the object—whether by sound
or by odour—presents its spiritual force
to the ear or the nose, then light is not
required and does not act. The forms of
objects do not send their images into

832. 1. musscole .. risspondano .. musscoli. 2. conposta .. boccha. 3. linghua chessi perbocha. 4. Essecquando .. cho.
 4. esspedita. 7. dellabri .. resstri. 8. coe. 12. chali. 13. lla. 15. piglotto.
833. 1. settirarai. 2. ello. 3. bocha tusscutirai. 4. cheffa il tramazzo. 5. pānicholo.
8̣34. 1. operato [mediāte la lu] dattutti .. esse. 3. alegera .. sotto . posti . assimile. 4. cōprēde . similitudine .. alchuna.
 5. āṇti .. chessi .. ʝnchorpora .. chōtatto. 6. chol . acquelo .. per [romore] "sono" per .. māda . per la. 7. nessi

833. 5. The text here breaks off. 834. 4. Compare No. 68. 8. See No. 58—67.

ētrano per similitudine j̄fra l'aria, [8]se quelli · nō sono · lvminosi ·; essēdo così l'ochio nō la può ricievere da quell'aria che nō l'à e che tocca la sua superfitie; [9]se tu volessi dire di molti animali · j quali · predano di notte ·, dico che quando in questi manca la poca luce [10]che basta · alla natura · de' loro · ochi ·, che questi s'aivtano colla · potētia dello · udito · e dello odorato, [11]i quali nō sono · j̄pediti · dalle tenebre ·, e de' quali avāzano di grā lūga · l'omo ·; Se porrai mēte · a una gatta [12]di giorno · saltare · j̄fra molte vasellamēti ·, vedrai · quelli rimanere salui, e se farai questo medesimo [13]di notte, ronperā ne · assai ·; li vccelli notturni · nō volano ·, se nō lucie · tutta o j̄ parte la luna, āzi si pasco[14]no j̄fra il coricare · del sole · e la · j̄tera oscurità della notte; —

[15]Nessuno corpo · si può · cōprendere sāza lume e ōbra; lume e ōbra sono causate dalla luce.

the air if they are not illuminated[8]; and the eye being thus constituted cannot receive that from the air, which the air does not possess, although it touches its surface. If you choose to say that there are many animals that prey at night, I answer that when the little light which suffices the nature of their eyes is wanting, they direct themselves by their strong sense of hearing and of smell, which are not impeded by the darkness, and in which they are very far superior to man. If you make a cat leap, by daylight, among a quantity of jars and crocks you will see them remain unbroken, but if you do the same at night, many will be broken. Night birds do not fly about unless the moon shines full or in part; rather do they feed between sun-down and the total darkness of the night.

No body can be apprehended without light and shade, and light and shade are caused by light.

G. 90 a]

835.

PERCHÈ NELLI OMINI ATTĒPATI [2]IL UEDERE È MEGLIO DISCOSTO.

WHY MEN ADVANCED IN AGE SEE BETTER AT A DISTANCE.

[3]Il uedere è meglio discosto che da pres[4]so in quelli omini, li quali s'attēpano, [5]perchè vna medesima cosa [6]māda di se minore inpressione nell'oc[7]chio, essendo remota che quādo li è vi[8]cina.

Sight is better from a distance than near in those men who are advancing in age, because the same object transmits a smaller impression of itself to the eye when it is distant than when it is near.

C. At. 89 a; 258 a]

836.

Il sēso comune è quello · che givdica · le cose · a · lui · date dalli altri sensi; [2]Li antichi · speculatori · àno · cōcluso · che quella · parte del giuditio · che è data all'omo, sia causata [3]da vno · strumēto ·, al quale referiscono · li altri 5 · mediāte la j̄pressiva, e a detto · strumēto · àno posto nome sēso · comvne, [4]e dicono questo sēso · essere situato · in mezzo · il capo j̄fra la j̄pressiva · e la memoria; E questo nome di sēso [5]comvne dicono solamēte ·, perchè è

The Common Sense, is that which judges of things offered to it by the other senses. The ancient speculators have concluded that that part of man which constitutes his judgment is caused by a central organ to which the other five senses refer everything by means of impressibility; and to this centre they have given the name Common Sense. And they say that this Sense is situated in the centre of the head between Sensation and Memory. And this name of Common Sense

The seat of the common sense.

. . lalluce. 8. nolla po . . dacquell . . aria "ce nola e" che tocha. 9. che qual"do" j̄ . . mancha la pocha. 10. allandatura chola . . delo · a[v]uldito. 11. porai mēte · ì̄ . gatta. 12. vedera . . esse. 13. vcielli . . pascā. 14. coricare . . ella. 15. po · chōplēdere . . e chausata.

835. 2. disscosto. 3. disscossto. 5. chosa.

836. 1. givdicha · le chose allui . . dali. 2. [J nosstri] li antich[e]i spechulatori . . choncluso checquella . . guditio . . chausata. 3. referischano . . 5. "mediāte la j̄prēsine" e a . . ano. 4. e dichano . . essere [situato] imezo [il chapo j̄ fralla j̄presiua ella . . Ecquestò. 5. dicano . . chomvne . . deli · . vldire tochare. 6. j̄prēsiua . . j̄mezo . . inprēsiua. 7. similitudine . .

comvne · judice · delli altri · 5 sēsi, cioè ve-
dere · udire · toccare · gustare e odorare;
[6]Il senso · comvne · si move mediāte la
īpressiva ch'è posta · ī mezzo jfra lui e i
sēsi; la inpressiua si move [7]mediāte le si-
militudini delle cose · a lei date · dalli stru-
mēti · superfitiali cioè sēsi, i quali sono posti
ī mezzo [8]jfra le cose esteriori e la īpres-
siva ·, e similmēte i sēsi si movono mediāte
li obietti; [9]le · circōstanti · cose · mādano le
loro · similitudini · ai sēsi; e i sensi le trās-
feriscono alla īpressiva; [10]la īpressiva le
māda al sēso comvne ·, e da quello · sono
stabilite nella memoria ·, e lì · sono · piv ·
o meno [11]retenute · secōdo la īportātia o
potētia della · cosa · data ·; Quello · senso ·
è piv veloce nel suo [12]ofitio, jl quale · è
piv · uicino · alla · impressiva ·, e l'ochio ·
superiore · è prīcipe · delli altri ·, [13]del quale
· solo · tratteremo e li altri lascieremo · per
nō ci · allūgare · dalla nostra · materia ·; dice
la speriēza [14]che l'ochio · s'astēde · j · 10 ·
varie nature · d' obietti · cioè · luce · e tenebre,
· l'una · cagione dell'altre 9 ·, e l'altra · priva-
tione: [15]colore · e corpo · figura · e sito ·
remotione · e propīquità · moto e quiete.

is given to it solely because it is the com-
mon judge of all the other five senses *i. e.*
Seeing, Hearing, Touch, Taste and Smell.
This Common Sense is acted upon by means
of Sensation which is placed as a medium
between it and the senses. Sensation is ac-
ted upon by means of the images of things
presented to it by the external instruments,
that is to say the senses which are the
medium between external things and Sen-
sation. In the same way the senses are
acted upon by objects. Surrounding things
transmit their images to the senses and
the senses transfer them to the Sen-
sation. Sensation sends them to the Com-
mon Sense, and by it they are stamped
upon the memory and are there more or
less retained according to the importance
or force of the impression. That sense is
most rapid in its function which is nearest
to the sensitive medium and the eye, being
the highest is the chief of the others. Of
this then only we will speak, and the
others we will leave in order not to make
our matter too long. Experience tells us that
the eye apprehends ten different natures of
things, that is: Light and Darkness, one
being the cause of the perception of the
nine others, and the other its absence:—
Colour and substance, form and place, dis-
tance and nearness, motion and stillness [15].

W. An. IV. 184*a* (7)] 837.

*On the ori-
gin of the
soul.*
 Ancorachè lo ingiegnio [2]vmano faccia
īuētioni va[3]rie, rispōdēdo cō uari [4]strumēti
a ū medesimo [5]fine, mai esso trove[6]rà
inuentione più [7]bella, nè più facile, nè [8]più
brieue della natu[9]ra, perchè nelle suē in-
[10]venzioni nulla mā[11]ca e nullo è superflu-
[12]o, e non va cō contra[13]pesi, quādo essa
fa le [14]mēbra atti al moto nel[15]li corpi delli
animali; [16]Ma ui mette dentro l'a[17]nima
d'esso corpo cōpo[18]nitore, cioè l'anima
del[19]la madre che prima [20]conpone nella
ma[21]trice la figura dell' o[22]mo; e al tempo
debito [23]desta l'anima, che di quel [24]deve
essere abitatore, [25]la qual prima restau[26]a
dormētata e in tutela [27]dell' anima della

 Though human ingenuity may make va-
rious inventions which, by the help of va-
rious machines answering the same end, it
will never devise any inventions more beau-
tiful, nor more simple, nor more to the pur-
pose than Nature does; because in her in-
ventions nothing is wanting, and nothing is
superfluous, and she needs no counterpoise
when she makes limbs proper for motion in
the bodies of animals. But she puts into
them the soul of the body, which forms them
that is the soul of the mother which first
constructs in the womb the form of the man
and in due time awakens the soul that is
to inhabit it. And this at first lies dormant

chose . . dali . . sēsiggugali . . mezo. 8. Infralle . . isteriori ella īpressia essimilemēte . . movano . . obietti le similitu-
dine. 9. delle chirchūstanti chose . . similitudine a sēsie sensi . . trāsferischano . . īprēsia. 10. īprēsia la . . dacquello . .
elli. 11. sechōdo. 12. uisino . ala inprēsia . . deli. 13. trattereno e laltri lasciereno . . dala. 14. chagne . . ellaltra.
15. chorpo . . essito . . ecquiete.
837. 1. chello. 2. vmano īīuētioni. 5. trover. 11. cha e nulla. 13. fa il. 14. mēbr. 16. coe. 23. dessta. 24. debbe. 25. resta[ui].

836. 15. Compare No. 23.

madre, [28]la quale la nutrisce e vivifi[29]ca per la vena ombelica[30]le, con tutti li sua mē[31]bri spirituali, e così segu[32]irà insino che tale ombe[33]lico lì è giunto colla se[34]condina e li cotilido[35]ni per la quale il figlo[36]lo si unisce colla madre; [37]e questi son causa che v[38]na volontà, vn sommo desi[39]derio, vna paura che [40]abbia la madre, o altro [41]dolor mētale à potēti[42]a più nel figliolo che nel[43]la madre, perchè spesse sono [44]le volte, che il figlio ne per[45]de la vita ecc.

[46]Questo discor[47]so nō ua qui, [48]ma si r[49]ichiede [50]nella cō[51]positiō [52]delli cor[53]pi anima[54]ti; — E il resto della difinitione dell' anima lascio nel[55]le mēti de' frati, padri de' popoli, li quali per inspira[56]tione sanno tutti li segreti.

[57]Lascio star le lettere incoronate, perchè sō sōma verità.

and under the tutelage of the soul of the mother, who nourishes and vivifies it by the umbilical vein, with all its spiritual parts, and this happens because this umbilicus is joined to the placenta and the cotyledons, by which the child is attached to the mother. And these are the reason why a wish, a strong craving or a fright or any other mental suffering in the mother, has more influence on the child than on the mother; for there are many cases when the child loses its life from them, &c.

This discourse is not in its place here, but will be wanted for the one on the composition of animated bodies—and the rest of the definition of the soul I leave to the imaginations of friars, those fathers of the people who know all secrets by inspiration.

[57]I leave alone the sacred books; for they are supreme truth.

W. An. II. 202 a (·B·)]

838.

COME · I · 5 SENSI · SONO · OFITIALI · DELL'ANIMA.

HOW THE FIVE SENSES ARE THE MINISTERS OF THE SOUL.

[2]L'anima · pare · risedere · nella parte juditiale, · e la · parte · juditiale pare essere [3]nel loco · doue · concorrono · tutti i sēsi ·, il quale è detto · senso comvne, e non è tutta [4]per tutto · il corpo ·, come molti · àño · creduto ·, anzi · tutto in nella · parte ·, inpercchè se ella [5]fusse · tutta per tutto · e tutta · in ogni · parte ·, non era · necessario · li stru[6]mēti · de'sensi fare infra loro · uno · medesimo cōcorso a uno · solo loco ·, anzi · basta[7]va · che · l'ochio operasse · l'ufitio · del sentimēto · sulla · sua superfitie · e nō mandare per la uia [8]delli nerui · ottici la similitudine · delle cose · vedute · al sēso ·, che · l'anima · alla · sopra [9]detta ragione le poteua comprēdere · in essa · superfitie del'o-

The soul seems to reside in the judgment, and the judgment would seem to be seated in that part where all the senses meet; and this is called the Common Sense and is not all-pervading throughout the body, as many have thought. Rather is it entirely in one part. Because, if it were all-pervading and the same in every part, there would have been no need to make the instruments of the senses meet in one centre and in one single spot; on the contrary it would have sufficed that the eye should fulfil the function of its sensation on its surface only, and not transmit the image of the things seen, to the sense, by means of the optic nerves, so that the soul—for the reason given above—may perceive it in the surface of the eye. In the same way as to the sense of hearing, it would have sufficed if the voice had mere-

On the relations of the soul to the organs of sense.

28. la qual nutrisscie vivifi. 29. cha . . vnbilica. 30. le sua. 32. chettale vnbi. 33. licho. 34. elli. 36. unisscie colla ma 37. ecquesti. 38. somo. 42. che ne. 43. spesse so. 45. della uita ecc. 54. dellania lasscio ne. 55. le mēte . . ispirita 56. tatione san. 57. Lascia *doubtful* . . soma. ·

838. 2. ella. 3. locho . . chonchorano . chomvne . . ettuta. 4. chorpo chome . . inela . . ssella. 5. fussi tutta [in ogni] per tutto . ettutta . . neciessario . fare li. 6. infralloro .î̃. . . chōchorso a . î̃ . . locho. 7. operassi . . del [suo] sentimēto. 8. ottiti [il] la . . chose . . chellanima. 9. conplēdere. 10. Essimilmēte il . . dellavldito . . risonassi . chōchaue. 11. cho-

837. 57. *lettere incoronate.* By this term Leonardo probably understands not the Bible only, but the works of the early Fathers, and all the books recognised as sacred by the Roman Church.

chio ·; ¹⁰E similmēte al sēso · dell' udito ·
bastaua solamēte · la uoce · risonasse nelle
cōcaue porosità ¹¹dell' osso · petroso · che
sta · dentro · all' orechio ·, e nō fare da esso ·
osso al sēso comune altro ¹²trāsito · dove ·
essa s'abbocca, e abbia a discorrere · al
comune givditio; ¹³Il senso dell' odorato ·
ācora lui si uede · essere dalla neciessità ·
costretto · a cōcorrere a detto ¹⁴juditio;
¹⁵Il tatto passa · per le corde forate,
ed è portato · a esso sēso ·; le quali corde
si uanno ¹⁶spargiēdo · con īfinita · ramifica-
tione · in nella pelle · che circūda · le corporee
mēbra ¹⁷e visciere ·; ¹⁸Le corde perforate
portano il comādamēto · e sentimēto alli
mēbri ofitiali, ¹⁹le quali · corde e nerui ·
infra · i muscoli · e lacierti ²⁰comādano · a
quelli · il mouimēto ·; quelli ubidiscono, e
tale: obediētia si ²¹mette in atto · collo sgō-
fiare ·, imperochè 'l gōfiare · raccorta · le loro
· lunghezze e tirasi dirieto · i nerui, ²²i quali
· si tessono per le particule de' mēbri; es-
sendo infusi nelli · stremi de' diti, ²³por-
tano · al sēso · la cagione del loro · cōtatto;
²⁴I nerui · coi loro · muscoli · servono ·
alle corde · come · i soldati · a cōdottieri ·, e
le corde ²⁵seruono · al senso comune · come
i cōdottieri al capitano ·; ²⁶adūque · la givn-
tura delli ossi · obbediscie · al neruo ·, e 'l
neruo · al muscolo e 'l muscolo alla corda,
²⁷e la corda al senso comune ·, e'l sēso
comune · è sedia · dell' anima ·, e la · memo-
ria è sua ²⁸munitione · e la · impressiva · è
sua · referēdaria; ²⁹come il senso · serve ·
all' anima · e nō l' anima al senso ·, e dove ·
māca · il senso ofitiale dell' anima ³⁰al-
l'anima ·, māca in questa vita · la totalità del-
l'ufitio · d'esso · sēso, come appare nel ³¹mvto
e l' orbo nato.

ly sounded in the porous cavity of the
indurated portion of the temporal bone which
lies within the ear, without making any
farther transit from this bone to the common
sense , where the voice confers with and
discourses to the common judgment. The
sense of smell, again, is compelled by ne-
cessity to refer itself to that same judg-
ment. Feeling passes through the perfo-
rated cords and is conveyed to this com-
mon sense. These cords diverge with infi-
nite ramifications into the skin which encloses
the members of the body and the viscera.
The perforated cords convey volition and
sensation to the subordinate limbs. These
cords and the nerves direct the motions of
the muscles and sinews, between which they
are placed; these obey, and this obedience
takes effect by reducing their thickness;
for in swelling, their length is reduced, and
the nerves shrink which are interwoven among
the particles of the limbs; being extended to
the tips of the fingers, they transmit to the
sense the object which they touch.

The nerves with their muscles obey the
tendons as soldiers obey the officers, and the
tendons obey the Common [central] Sense as
the officers obey the general. [27]Thus the
joint of the bones obeys the nerve, and the
nerve the muscle, and the muscle the tendon
and the tendon the Common Sense. And the
Common Sense is the seat of the soul[28],
and memory is its ammunition, and the im-
pressibility is its referendary since the sense
waits on the soul and not the soul on the sense.
And where the sense that ministers to the soul
is not at the service of the soul, all the func-
tions of that sense are also wanting in that man's
life, as is seen in those born mute and blind.

W. An. II. 202 b (·B·)] 839.

COME · I NERUI OPERANO QUALCHE UOLTA PER
LORO ²SANZA · COMĀDAMĒTO DELLI ALTRI
OFITIALI DELL' ANIMA.

HOW THE NERVES SOMETIMES ACT OF THEM-
SELVES WITHOUT ANY COMMANDS FROM THE
OTHER FUNCTIONS OF THE SOUL.

On involun-
tary mus-
cular action.

³Questo · chiaramēte · apparisce ·, inpero-
chè tu · vedrai · movere · ai paraletici e a

This is most plainly seen; for you will
see palsied and shivering persons move,

mvne. 12. essaboca · abbia dischorere · al chomune givditio [lodor]. 13. āchora . . chōstretto a chōchorrere. 14. jvditio [il]
gusto el tatto. 15. Il tutto nō passa elli per le chorde . . chorde si uano [di]. 16. sprgiēdo chōn . . ramifichatione inella
. . circhūda lẹ chorporee. 18. [j nervi] "le corde" . . portano [il sentimento] il chomādamēto ˙essentimēto. 19. chorde . .
musscoli. 20. acquelli . . queli obediscano [chollosco] ettale. 21. chollo schōfiare ipero chel . . rachorta . . lungeze ettirasi.
22. tessano . partichule. 23. chagione . . chōtatto. 24. choi . . mvsscoli . . servno . . chorde chome chōdottieri · elle
chorde. 25. seruano . . chomvne chome i chōdottieri al chapitano el sēso chomvne serve. 26. [adunque il neruo · serue
. al mvsscolo el mvsscolo]. 27. musscholo el mvsscolo . . chorda. 28. ella chorda . . chomvne . . chomvne essedia . . ella
. . essua. 29. amvnitione · ella inpresiua essua referēdaria [e il chore essuo]. 30. chome . . de all . . mācha. 31. mācha
. . apare. 32. ellorbo.
839. 1. chome. 2. chomādamēto. 3. aparisscie inperro · chettu vederai . . fredolleti. 4. chome. 5. chon . . essi . benbri . .

838. The peculiar use of the words *nervo, mus-*
colo, corda, senso comune, which are here literally ren-

dered by nerve, muscle cord or tendon and Common
Sense may be understood from lines 27 and 28.

freddolosi, 4e assiderati · le loro · tremāti · mēbra come · testa · e mani · sanza · liciēza · dell' anima ·, la quale 5anima cō tutte · sue · forze nō potrà · vietare a essi. menbri · che nō tremino; Questo medesimo 6accade nel malcaduco e ne' mēbra tagliati come code di lucierte; 7la idea · over imaginatiua · è · timone e briglia de' sensi ·, imperochè la cosa imaginata 8move il sēso; 9preimaginare · è lo imaginare le cose che saranno; 10post-imaginare è imaginare · le cose passate.

and their trembling limbs, as their head and hands , quake without leave from their soul and their soul with all its power cannot prevent their members from trembling. The same thing happens in falling sickness, or in parts that have been cut off, as in the tails of lizards. The idea or imagination is the helm and guiding-rein of the senses, because the thing conceived of moves the sense. Pre-imagining, is imagining the things that are to be. Post-imagining, is imagining the things that are past.

Tr. 14.

840.

4 sono le potentie : memoria · e intelletto, lascibili · e cōcupiscibili, 2le 2 prime son ragionevoli e l'altre sēnsuali; 3I 3 sensi vedere, udire, odorato sono di poca proibitione ·, tato e gusto4no; l'odorato · mena · con seco · il gusto · nel cane e altri · golosi animali.

There are four Powers: memory and intellect, desire and covetousness. The two first are mental and the others sensual. The three senses: sight, hearing and smell cannot well be prevented; touch and taste not at all. Smell is connected with taste in dogs and other gluttonous animals.

Miscellaneous physiological observations (840—842).

W. A. IV. 151*b*]

841.

Jo scopro alli omini l'origine 2della prima · o forse secōda cagione del loro essere.

I reveal to men the origin of the first, or perhaps second cause of their existence.

H.1 32*a*]

842.

Lussuria è cavsa della gienera2tione.
3Gola è mātenimēto della vita, 4pavra over timore è prolūga5mēto di uita e 6salvamēto dello strumē7to.

Lust is the cause of generation.
Appetite is the support of life. Fear or timidity is the prolongation of life and preservation of its instruments.

W. An. II. 43*b* (8)]

843.

Come il corpo dell'animale al continuo
2more e rinascie.

Il corpo di qualunche cosa la qual si nutrica, al con4tinuo muore e al continuo rinasce, perchè entrare 5non può nutrimēto se non in quelli lochi, dove il passato 6nutrimēto è spirato, e s'elli è spirato elli più nō à 7vita, e se tu nō li rendi nutrimēto equa8le al nutrimēto partito, allora

How the body of animals is constantly dying and being renewed.

The body of any thing whatever that takes nourishment constantly dies and is constantly renewed; because nourishment can only enter into places where the former nourishment has expired, and if it has expired it no longer has life. And if you do not supply nourishment equal to the nourishment

The laws of nutrition and the support of life (843—848).

trie mino Questo medessi. 6. achade . . mal chaducho . . mēbr . . chome chode. 7. e ētimone . . inpero chella chosa.
9. premaginare . . chose . chessaranno. 10. posimaginare . . chose.
840..1. lascibili e chōcupiscibili. 2. ellaltre. 3. de [2] 3 sensi . . vldire . . pocha . . tato. 4. chōseco . . chane . . golos.
841. 1. schopro. 2. della loro "prima offorse secōdo" sechonda chagione di loro.
842. 1—7 R. 1. chausa. 6. delo e saluamēto.
843. 1. chorpo . . chontinuo. 2. rinasscie. 3. chosa . . nutricha . . chon. 4. chontinuo rinasscie. 5. sēnon. 6. esspirato esselli
he . . nō[nu]. 7. [trusscie] vita essectu. 8. mancha. 9. valtudine essettulli . . tuc. 10. ressta desstructa Massettu. 11. des-

la vita manca di su⁹a valetūdine, e se tu li leui esso nutrimento, la uita in tut¹⁰to resta distrutta; Ma se tu ne rēdi tanto quanto si ¹¹ne distrugge alla giornata, allora tanto rinasce di ¹²uita, quanto se ne consuma a similitudine del lume ¹³della candela col nutrimēto datoli dall'omore ¹⁴d'essa candela, il quale lume ancora lui al con¹⁵tinuo con velocissimo socorso restaura di sotto, ¹⁶quāto di sopra se ne consuma morendo, e di splendi¹⁷da lucie si converte morēdo in tenebroso fumo, la qual ¹⁸morte è continua, siccome è cōtinuo esso fumo, e la cō¹⁹tinuità di tal fumo · è equale al cōtinuato nutrimēto, ²⁰e in instante tutto il lume è morto e tutto rigienerato insie²¹me col moto del nutrimento suo.

which is gone, life will fail in vigour, and if you take away this nourishment, the life is entirely destroyed. But if you restore as much is destroyed day by day, then as much of the life is renewed as is consumed, just as the flame of the candle is fed by the nourishment afforded by the liquid of this candle, which flame continually with a rapid supply restores to it from below as much as is consumed in dying above: and from a brilliant light is converted in dying into murky smoke; and this death is continuous, as the smoke is continuous; and the continuance of the smoke is equal to the continuance of the nourishment, and in the same instant all the flame is dead and all regenerated, simultaneously with the movement of its own nourishment.

W. An. III. 241a] **844.**

¶Come tu ài descritto il rè delli animali — ma io meglio direi dicēdo ²rè delle bestie · essendo tu la maggiore—perchè non li ài uccisi, acciò che possino poi darti ³li lor figlioli in benifitio della tua gola colla quale tu ài tē⁴tato farti sepultura di tutti li animali, e più oltre direi, se'l ⁵dire il uero mi fusse integramēte lecito; Ma non usciamo ⁶delle cose vmane, dicendo vna somma scelerata⁷gine, la qual non accade nelli animali terrestri, ⁸inperochè in quelli nō si trovano animali che māgino della loro ⁹spetie se nō per mācamēto di celabro (in poche infra loro, e de'ma¹⁰dri come infra li omini, bēchè nō sieno in tāto numero); ¹¹e questo non accade se nō nel¹²li

King of the animals—as thou hast described him—I should rather say king of the beasts, thou being the greatest—because thou hast spared slaying them, in order that they may give thee their children for the benefit of the gullet, of which thou hast attempted to make a sepulchre for all animals; and I would say still more, if it were allowed me to speak the entire truth[5]. But we do not go outside human matters in telling of one supreme wickedness, which does not happen among the animals of the earth, inasmuch as among them are found none who eat their own kind, unless through want of sense (few indeed among them, and those being mothers, as with men, albeit they be not many in number); and this happens only among the rapacious animals, as with the leonine species, and leo-

struggie . . rinasscie. 12. chonsuma assimilitudine. 13. socto della chandela chol. 14. chandela . . anchora . . chon. 15. chon velocissimo [vita] "sochorso" . . socto. 16. chonsuma. 17. chonverte . . tenebro. 18. chontinua sichome chontinuo . . ella. 19. chōtinuato. 20. e i ni state . . ettutto. 21. chol.

844. 1. isscritto . . ma i . . dirai. 2. bestie "essendo tu la magore" | perche no li ai uticcoche ti possin. 3. figloli . . ai te. 5. fussi . . none vsscīā. 6. disscendo . . soma issceleratagi. 7. gine . . soma issceleratagi . . achade . . terresti. 8. trova. 10. numero)e. 11. [alcvna volta] ecquesto none achade . . ne. 12. leonina [che sspessa]. 13. si māgia che] . . cerveri

844. We are led to believe that Leonardo himself was a vegetarian from the following interesting passage in the first of Andrea Corsali's letters to Giuliano de' Medici: *Alcuni gentili chiamati Guzzarati non si cibano di cosa alcuna che tenga sangue, nè fra essi loro consentono che si noccia ad alcuna cosa animata, come il nostro Leonardo da Vinci.*

5—18. Amerigo Vespucci, with whom Leonardo was personally acquainted, writes in his second letter to Pietro Soderini, about the inhabitants of

the Canary Islands after having stayed there in 1503: "*Hanno una scelerata libertà di viuere; si cibano di carne humana, di maniera che il padre māgia il figliuolo, et all'incontro il figliuolo il padre se.ondo che a caso e per sorte auiene. Io viddi vn certo huomo sceleratissimo che si vantaua, et si teneua a non piccola gloria di hauer mangiato più di trecento huomini. Viddi anche vna certa città, nella quale io dimorai forse ventisette giorni, doue le carni humane, hauendole salate, eran appicate alli traui, si come noi alli traui di cucina*

animali rapaci, come nella spetie leonina [13]e pardi, pardere, cervieri, gatte e simili, [14]li quali alcuna volta si māgiano i figlioli; ma tu oltre [15]alli figlioli ti māgi il padre, madre, fratelli e amici, e nō [16]ti basta questo, chè tu vai a caccia per le altrui isole, pi-[17]gliando li altri omini e questi mezzo nudi il mēbro e li testi[18]culi fai ingrassare e te li cacci giù per la tua gola; or [19]non produce la natura tāti senplici, che tu ti possa satia[20]re? e se nō ti cōtenti de' senplici, non puoi tu cō la mistiō [21]di quelli fare infiniti conposti, come scrisse il Platina [22]e li altri autori di gola? ¶

pards, panthers lynxes, cats and the like, who sometimes eat their children; but thou, besides thy children devourest father, mother, brothers and friends; nor is this enough for thee, but thou goest to the chase on the islands of others, taking other men and these half-naked, the and the thou fattenest, and chasest them down thy own throat[18]; now does not nature produce enough simples, for thee to satisfy thyself? and if thou art not content with simples, canst thou not by the mixture of them make infinite compounds, as Platina wrote[21], and other authors on feeding?

H.2 41 b] **845.**

Facciamo nostra vita coll' al[2]trui · morte. [3]In nella cosa morta rimā vi[4]ta dissensata, la quale ri[5]cōgiūta alli stomachi de' vi[6]ui ripiglia uita sēsitiva [7]e ītellettiva.

Our life is made by the death of others. In dead matter insensible life remains, which, reunited to the stomachs of living beings, resumes life, both sensual and intellectual.

S. K. M. III, 74a] **846.**

La natura pare qui in molti [2]o di molti animali stata più pre[3]sto crudele matrignia che ma[4]dre, e d'alcuni nō matrignia [5]ma pietosa madre.

Here nature appears with many animals to have been rather a cruel stepmother than a mother, and with others not a stepmother, but a most tender mother.

C. A. 75 b; 219 b] **847.**

L'omo e li animali sono propi trāsito e condotto di cibo, sepoltura · d'animali · albergo de' morti, facciēdo a se vna [2]dell'altrui morte guaina di corrutione!

Man and animals are really the passage and the conduit of food, the sepulchre of animals and resting place of the dead, one causing the death of the other, making themselves the covering for the corruption of other dead [bodies].

chatte essimili. 14. māgano i figlioli, mattu. 15. figloli. 16. bassta . . chaccia. 17. meznudi. 18. ettelli caccigu. 19. chettutti. 20. esse nō . . poi. 22. elli . . altori.
845. 1—7 R. 1. faciano nosstra . . choll. 3. jnella. 4. disensata. 5. stomaci. 7. ētellectiva.
846. 1. immolti. 5. piatosa.
847. 1. elli . . propi "trāsitoe" chondotto . . morti [animali] faciēdo asse. 2. morte [pigliando piacere dellaltri miserie] guaina di chorutione.

appicchiamo le carni di cinghali secche al sole o al fumo, et massimamente salsiccie, et altre simil cose: anzi si marauigliauano grādemēte che noi non māgiassimo della carne de nemici, le quali dicono muouere appetito, et essere di marauiglioso sapore, et le lodano come cibi soaui et delicati (Lettere due di Amerigo Vespucci Fiorentino drizzate al

magnifico Pietro Soderini, Gonfaloniere della eccelsa Republica di Firenze; various editions).

21. *Come scrisse il Platina* (Bartolomeo Sacchi, a famous humanist). The Italian edition of his treatise *De arte coquinaria*, was published under the title *De la honestra voluptate, e valetudine, Venezia* 1487.

848.

F. 1a]

La morte ne' vecchi sanza febre si causa dalle ²uene che uā dalla milza alla porta del fega³to e s'ingrossan tanto di pelle ch'elle si richi⁴udono e non danno più transito al san⁵gue che li nutrica.

⁶Il continuo corso che fa il sangue per le sue ⁷uene fa che tali vene s'ingrossano e fanno⁸si callose in tal modo che al fine si riserra⁹no e proibiscono il corso al sangue.

On the circulation of the blood (848—850).

Death in old men, when not from fever, is caused by the veins which go from the spleen to the valve of the liver, and which thicken so much in the walls that they become closed up and leave no passage for the blood that nourishes it.

[6]The incessant current of the blood through the veins makes these veins thicken and become callous, so that at last they close up and prevent the passage of the blood.

849.

Leic. 21b]

Raggirāsi l'acque con cōtinvo moto dall'infime profondità de' mari alle altissimę somità de' mōti, non osseruando ²la natura delle cose graui, e in questo caso fanno come il sangue delli animali che sempre si ³moue dal mare del core e scorre alla sōmità delle loro teste, e che quiui rōpōsi le uene ·, ⁴come si uede una vena rotta nel naso, che tutto il sangue da basso si leua alla altezza della rotta vena; — ⁵Quando l'aqua escie dalla rotta vena della terra essa osserua la natura delle altre cose piv ⁶graui che l'aria, onde senpre cerca i lochi bassi.

The waters return with constant motion from the lowest depths of the sea to the utmost height of the mountains, not obeying the nature of heavier bodies; and in this they resemble the blood of animated beings which always ·moves from the sea of the heart and flows towards the top of the head; and here it may burst a vein, as may be seen when a vein bursts in the nose; all the blood rises from below to the level of the burst vein. When the water rushes out from the burst vein in the earth, it obeys the law of other bodies that are heavier than the air since it always seeks low places.

850.

W. A. III. 226a (·M·)]

Come il sangue che torna indirieto, ²quādo il core si riapre, non è quel che ³riserra le porte del core.

That the blood which returns when the heart opens again is not the same as that which closes the valves of the heart.

851.

Bi. M. 147b]

Fattevi dare la difinitione e riparo del caso secondo ²..... e vedrete che omini son eletti per medici di mala³tie da loro non conosciute.

Some notes on medicine (851—855).

Make them give you the definition and remedies for the case . . . and you will see that men are selected to be doctors for diseases they do not know.

848. 1. vechi. 2. miza. 3. to singrossan. 4. vdano . . transitu. 5. chelli nutricha. 6. cheffa. 7. chettali . . effan. 8. risera. 9. proibisscano . . sanghue.

849. 1. Ragirāsi. 2. fa . . animati. 3. move [dal lago] "dal mare" del . . tesste . . echi quiui rōpasi. 4. chettutto . . alteza . . ve"na". 5. esscie. 6. grave chellaria . cercha.

850. 1. chettorna . . de porte.

851. 1. fatevi . . caso al scō e al. 2. laltro e vedrete. 3. dallor . . conossciute.

849. From this passage it is quite plain that Leonardo had not merely a general suspicion of the circulation of the blood but a very clear conception of it. Leonardo's studies on the muscles of the heart are to be found in the MS. W. An. III. but no information about them has hitherto been made public. The limits of my plan in this work exclude all purely anatomical writings, therefore only a very brief excerpt from this note book can be given here. WILLIAM HARVEY (born 1578 and Professor of Anatomy at Cambridge from 1615) is always considered to have been the discoverer of the circulation of the blood. He studied medicine at Padua in 1598, and in 1628 brought out his memorable and important work: *De motu cordis et sanguinis*.

W. XIII *b*]

852.

Medicina da grattature insegniomela l'araldo ²del rè di Frācia: oncie 4 ciera nova, ōcie 4, ³pece greca, ōcie 2 inciēso e ogni cosa ⁴stia separata, e fondi la ciera, e poi vi metti den⁵stro l'inciēso, e poi la pece; fa ne pe⁶verada e metti sopr' al male.

A remedy for scratches taught me by the Herald to the King of France. 4 ounces of virgin wax, 4 ounces of colophony, 2 ounces of incense. Keep each thing separate; and melt the wax, and then put in the incense and then the colophony, make a mixture of it and put it on the sore place.

Tr. 7]

853.

¶Medicina è ripareggiamēto de' disequali elemēti; ¶²malattia è discordanza d'elemēti īfusi nel uitale . corpo.

Medicine is the restoration of discordant elements; sickness is the discord of the elements infused into the living body.

Tr. 49]

854.

A chi da noia il uomito al nauicare debba bere sugo ²d'assētio.

Those who are annoyed by sickness at sea should drink extract of wormwood.

C. A. 77 *b*; 225 *b*]

855.

Se vuoi star sano esser a questa norma; ²nō māgiar sanza voglia ³mastica bene; e per quel che niēte ritiene, ⁴sia bē cotto e di semplice forma; ⁵chi medicina piglia mal s'informa.

To keep in health, this rule is wise: Eat only when you want and relish food. Chew thoroughly that it may do you good. Have it well cooked, unspiced and undisguised. He who takes medicine is ill advised.

W. An. III, XXV]

856.

Insegnioti di conse²rvare la sanità ³la qual cosa tanto ⁴più ti riuscirà, ⁵quāto più da fisici ⁶ti guarder⁷ai; ⁸perchè le sue cō ⁹positioni sō ¹⁰di spetie d'al¹¹chimia.

I teach you to preserve your health; and in this you will succed better in proportion as you shun physicians, because their medicines are the work of alchemists.

852. 4. sta seperata . . metti\\\\\\. 5. effane. 6. mal. 853. 1. riparegiamēto. 2. dischordanza.
854. al uomito il nauicare deba. 2. dasentio.
855. 1. uoi strasano. 2. voglia ecci\\\\ ellette. 3. masstica . . ecquel. 4. chotto.
856. 1. e ingegniati. 4. riusscira. 9. positione. 10. spetie dar. 12. ella. 13. qual. 14. nonemē. 15. numero. 16. de libri.
17. che sia dime. 18. dicina. *The meaning of these short lines 12—18 is doubtful.*

855. This appears to be a sketch for a poem.
856. This passage is written on the back of the drawing Pl. CVIII. Compare also No. 1184.

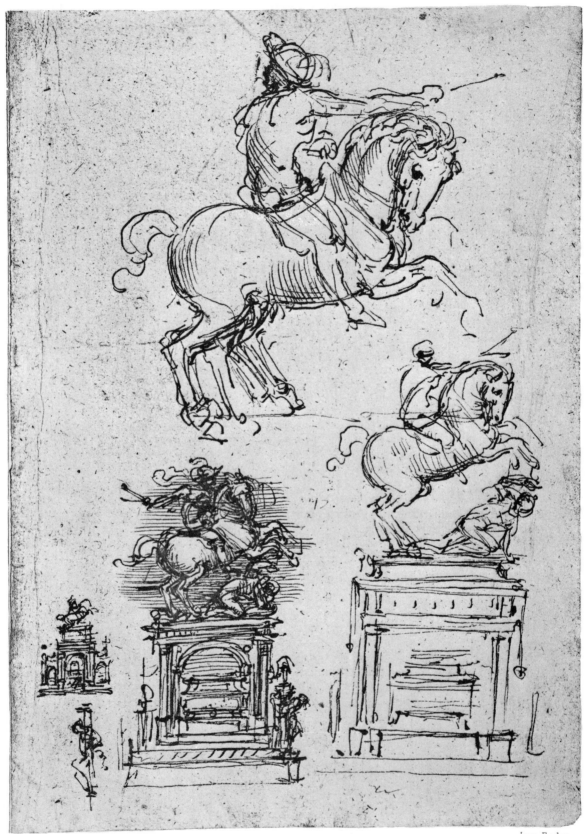

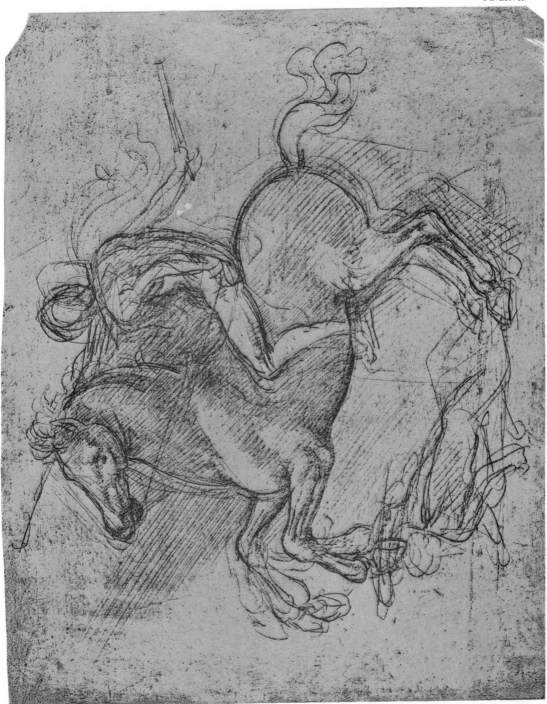

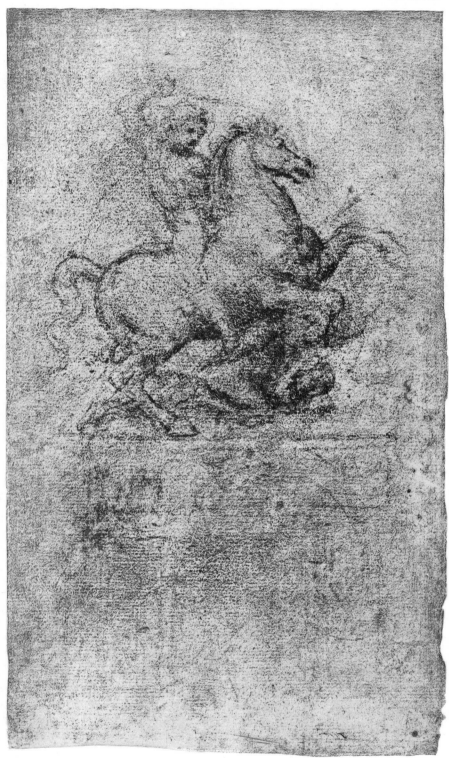

Héliog. Dujardin.

Imp. Eudes.

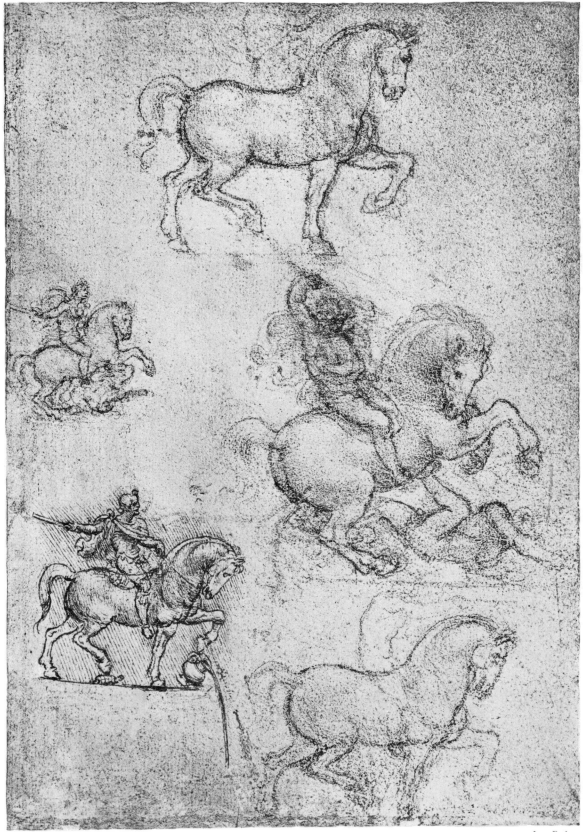

Héliog. Dujardin.

Imp. Eudes.

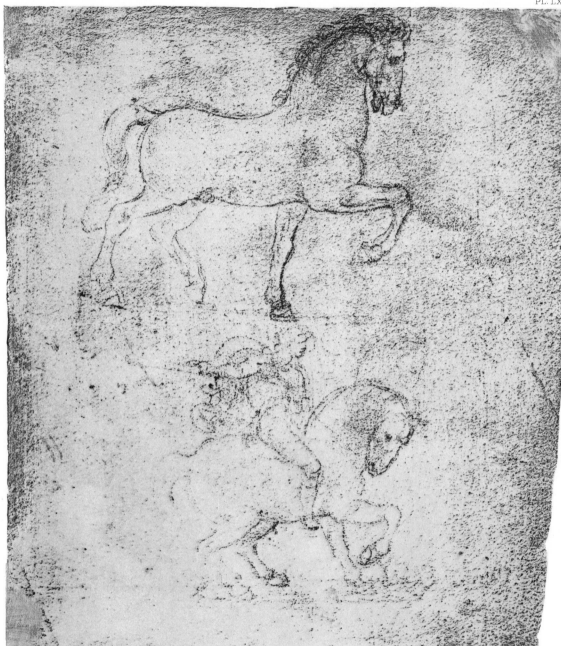

Heliog. Dujardin.

Imp. Eudes.

Héliog: Dujardin.

Imp. Eudes.

PL. LXXII.

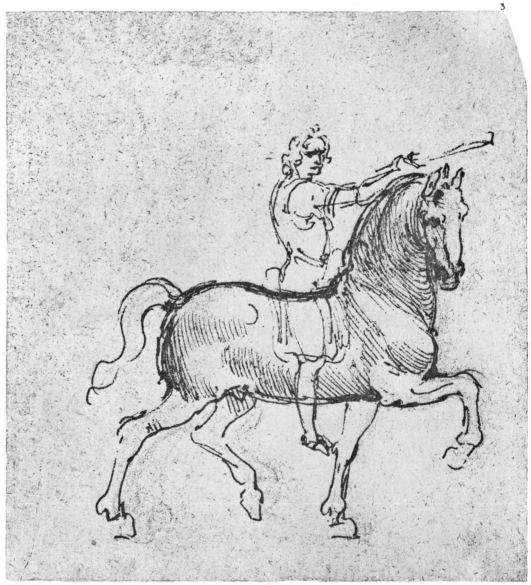

Héliog. Dujardin.

Imp. Eudes.

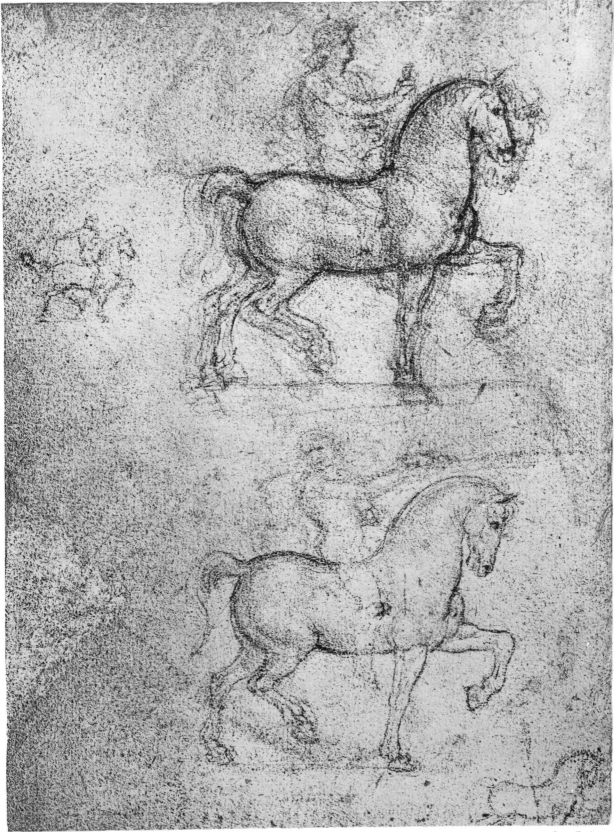

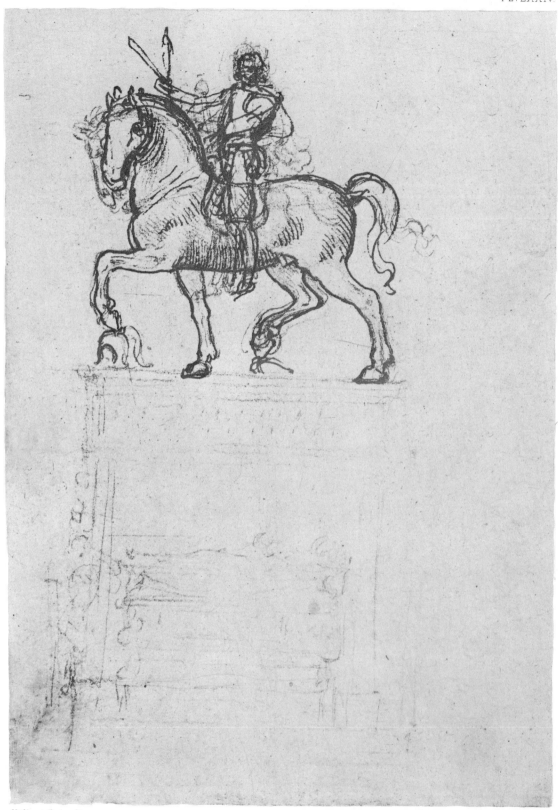

Héliog. Dujardin. Imp. Eudes.

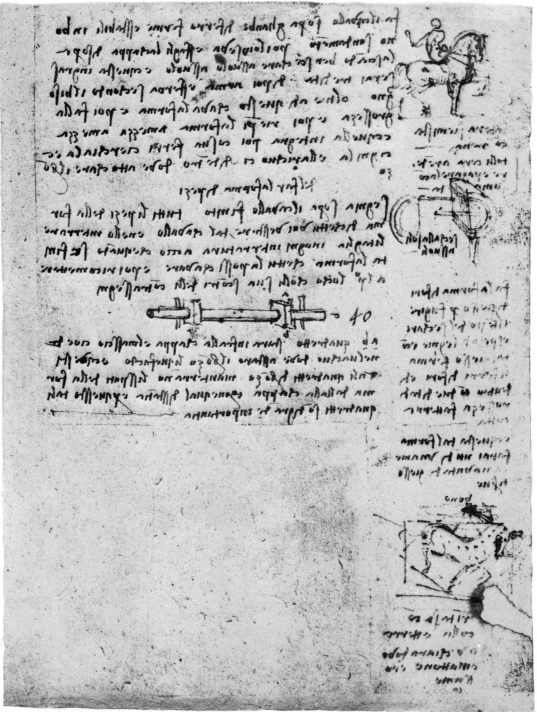

Héliog. Dujardin.

Imp. Eudes.

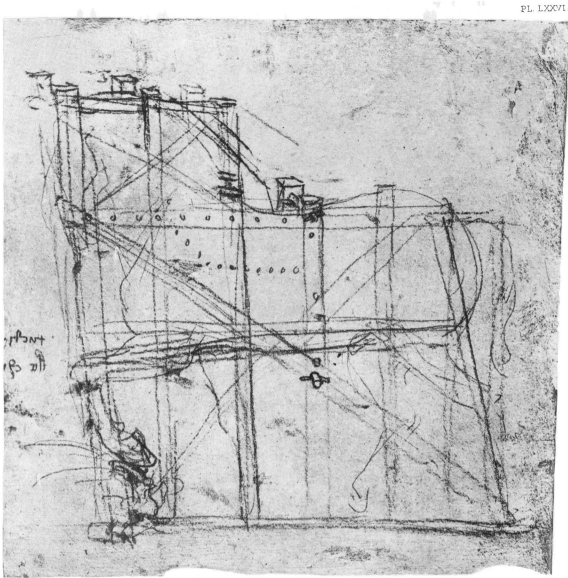

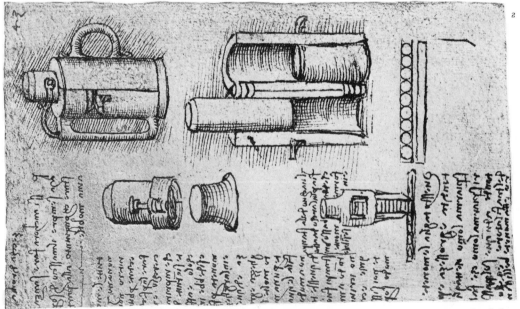

Héliog. Dujardin.

Imp. Eudes.

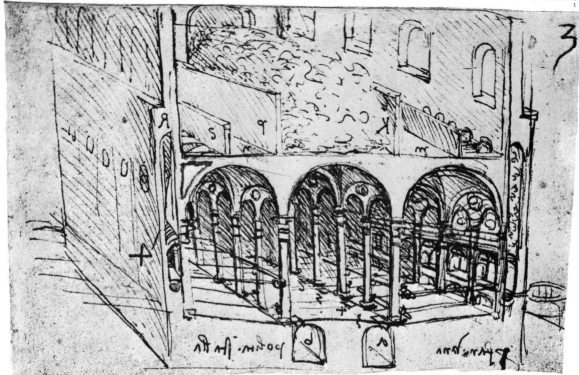

3

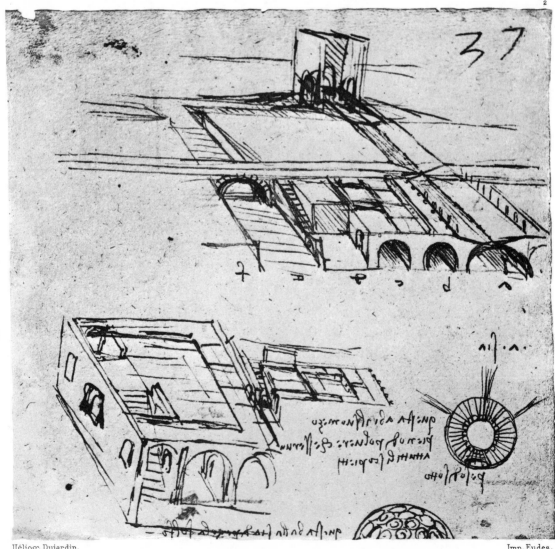

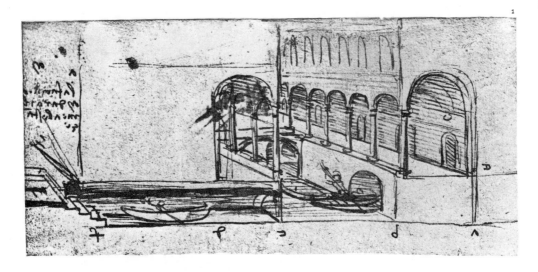

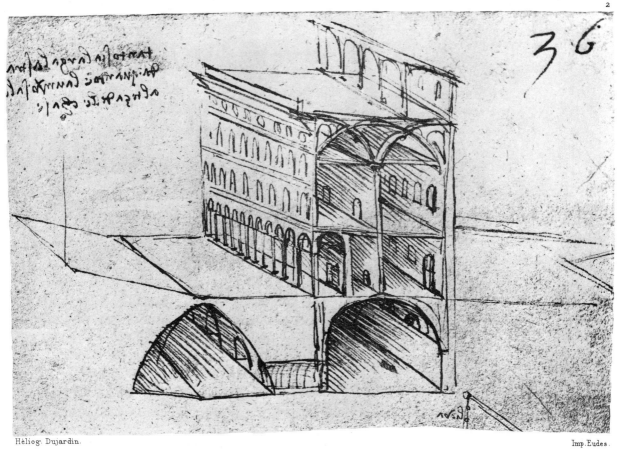

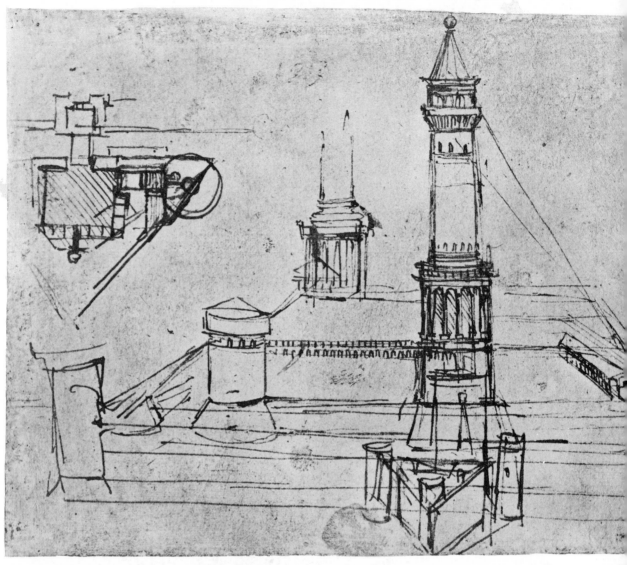

3

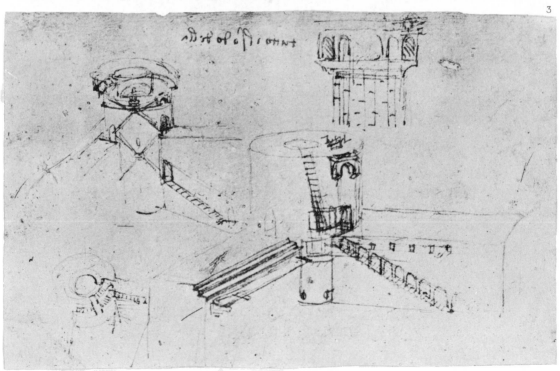

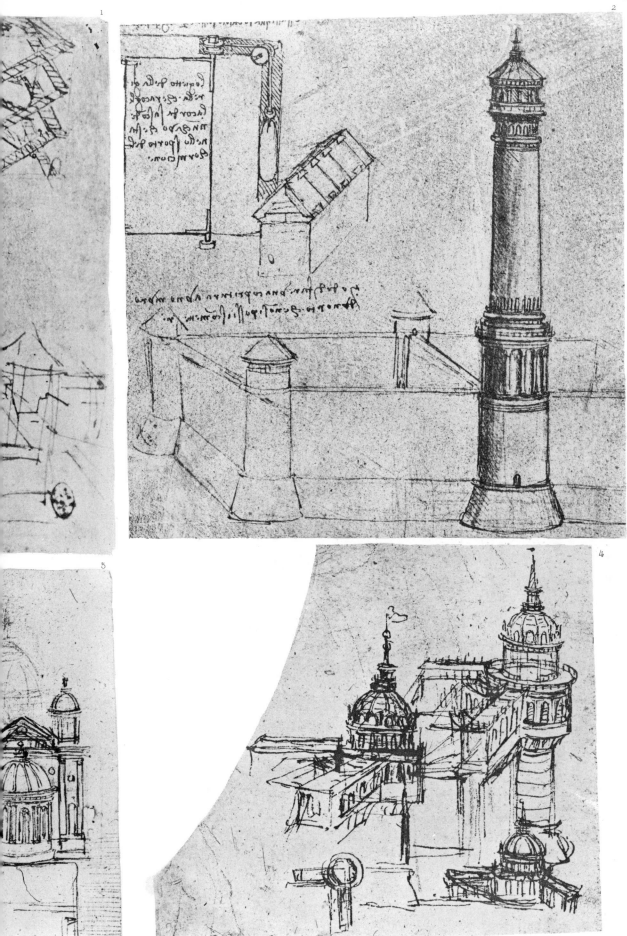

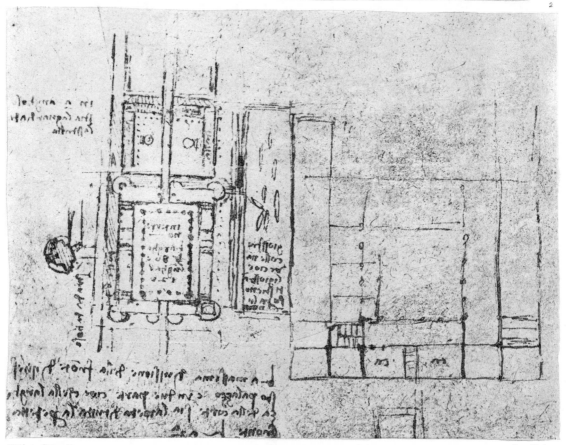

PL. LXXXIII.

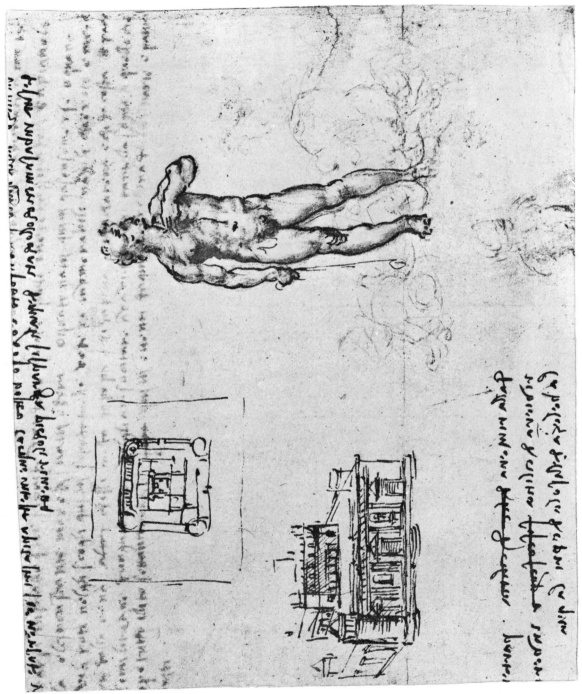

Héliog. Dujardin.

Plate LXXXII is reproduced on the following two pages.

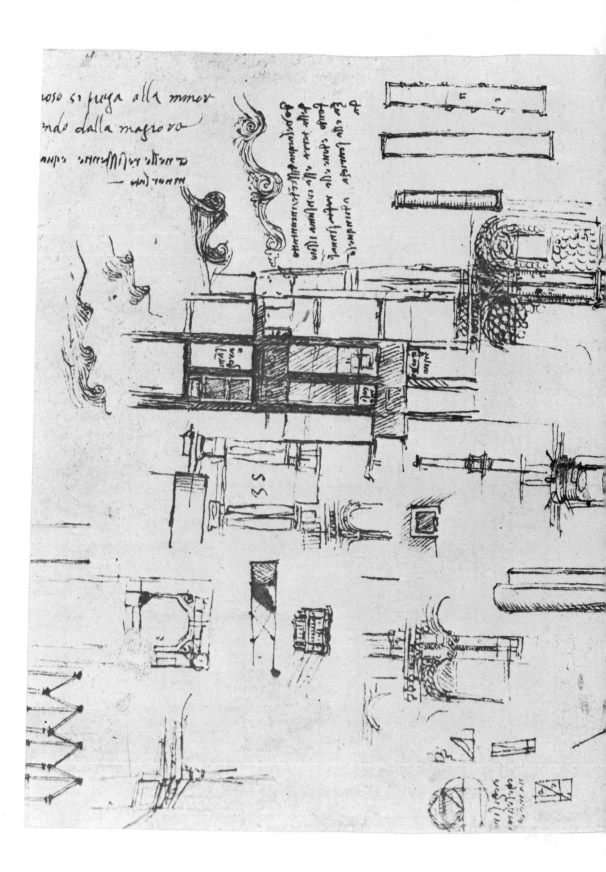

2

3

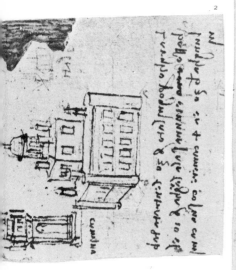

4

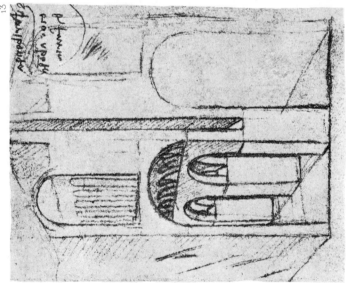

Hélio. Dujardin.

Imp. Eudes.

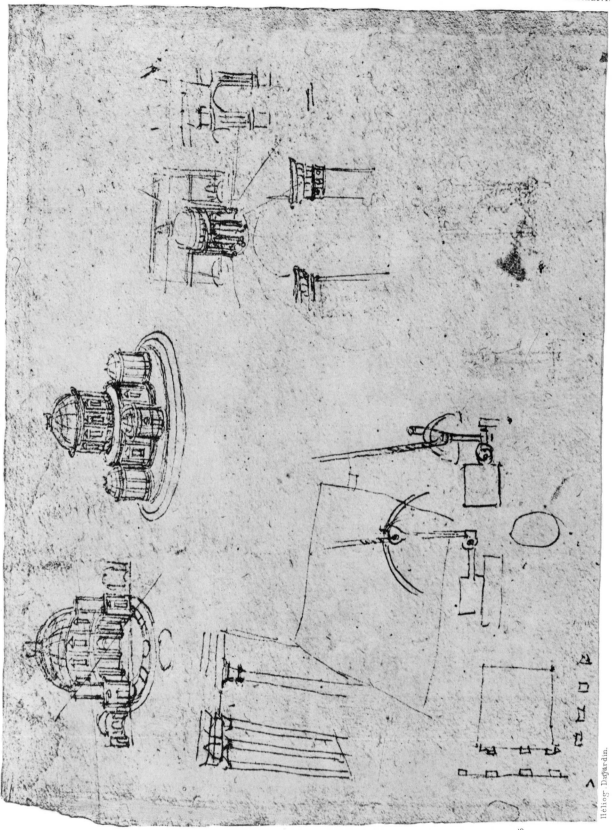

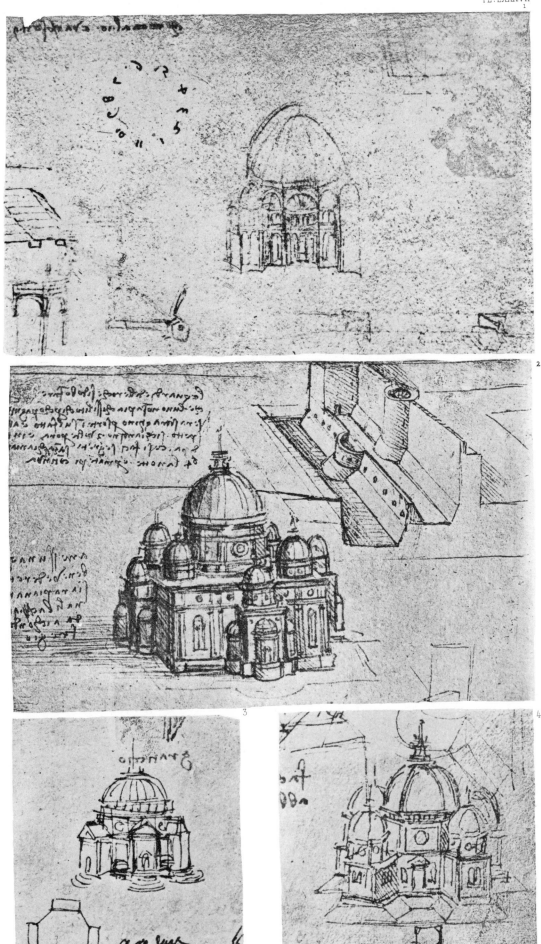

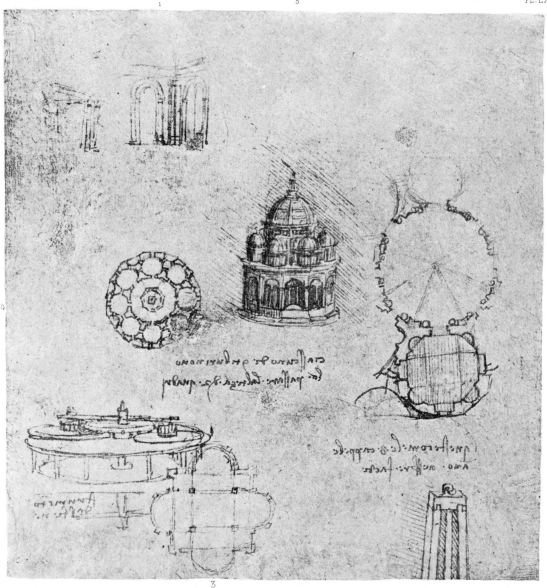

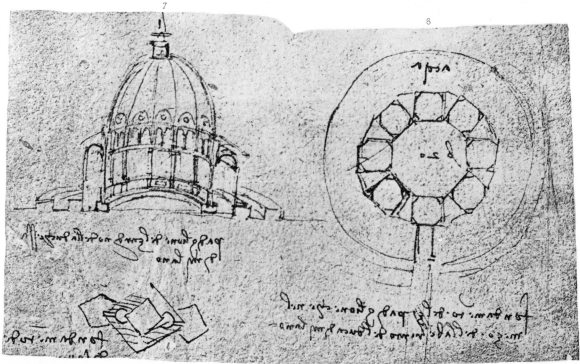

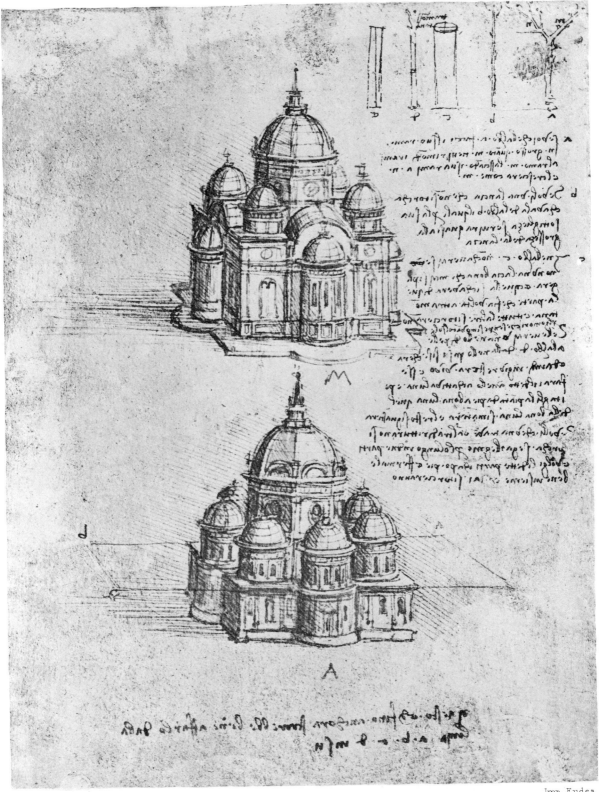

2

1

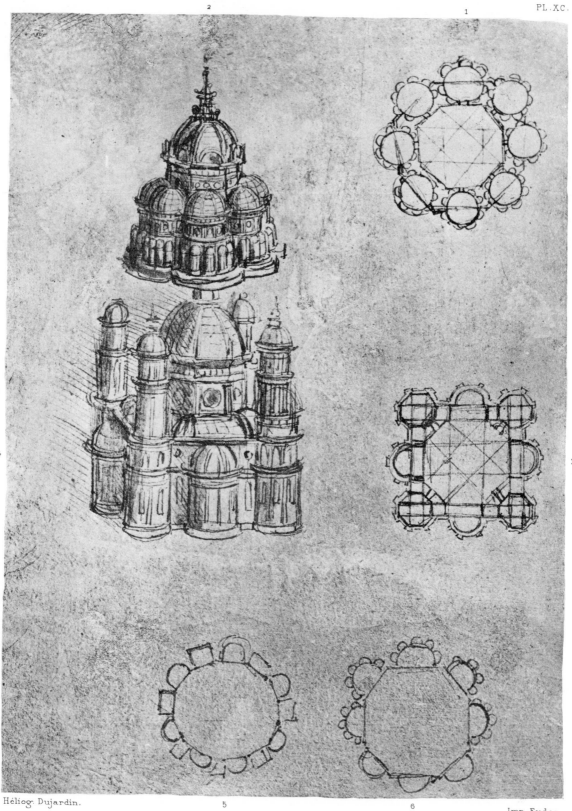

4

3

Héliog. Dujardin.

5

6

Imp. Eudes.

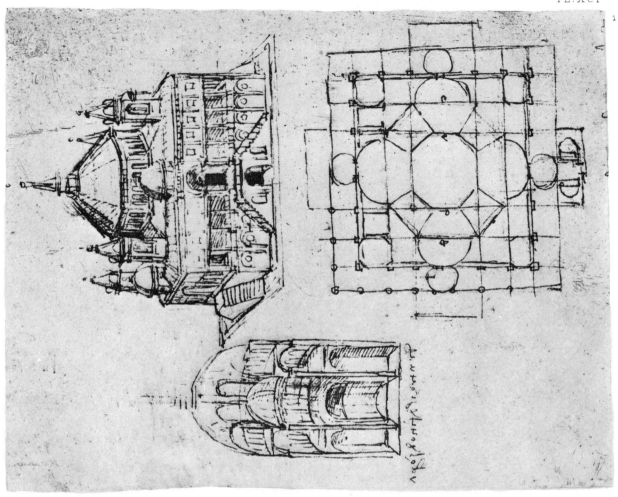

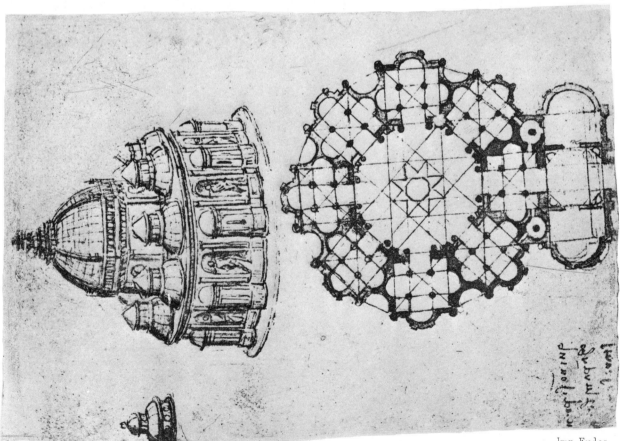

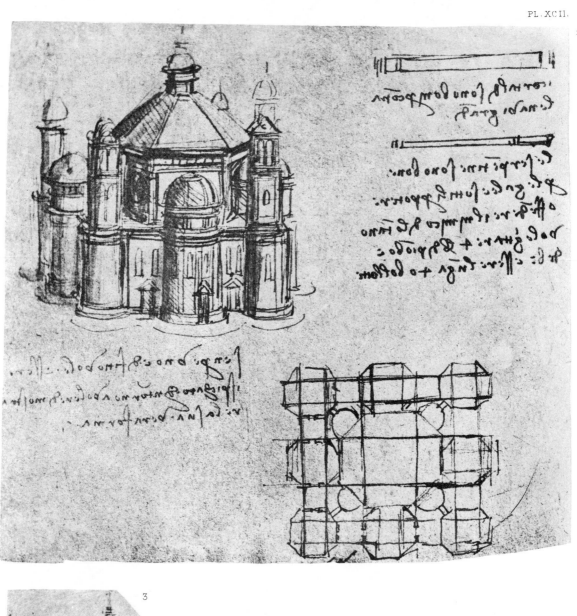

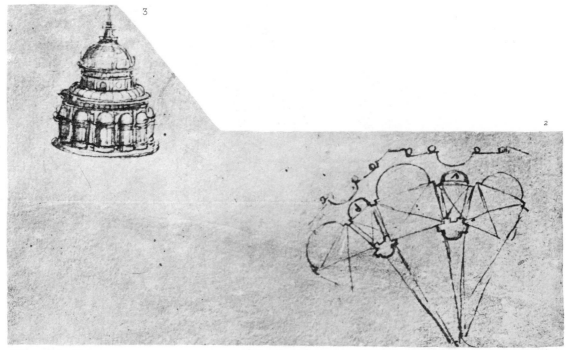

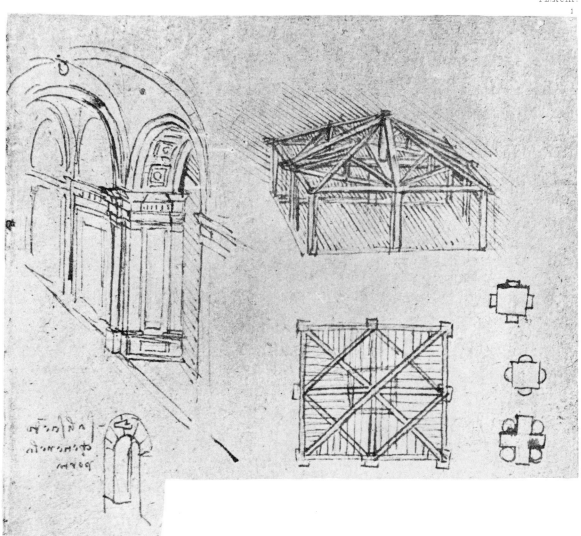

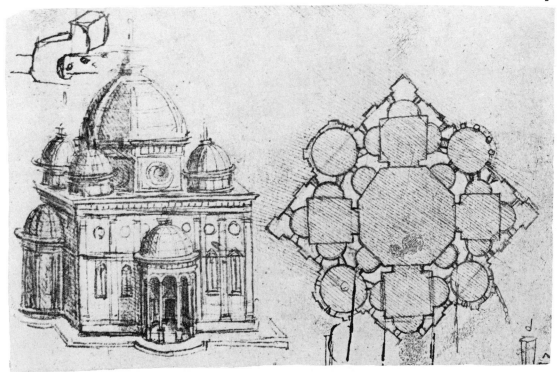

1

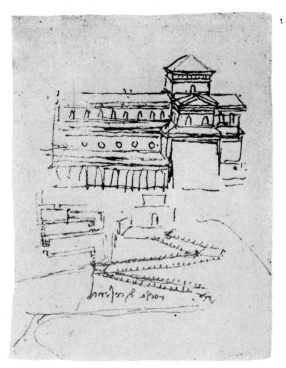

2

3

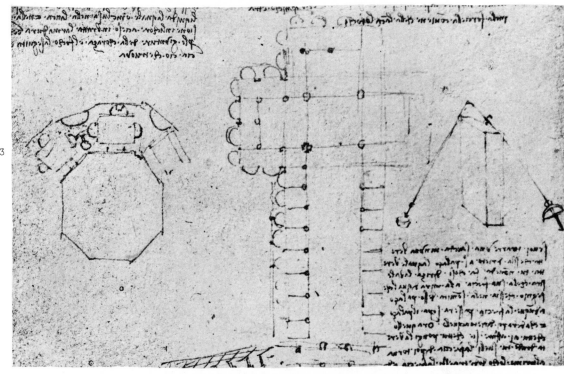

4

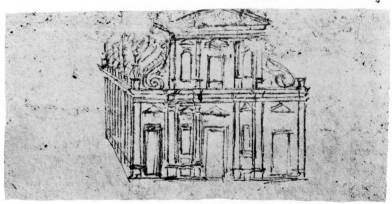

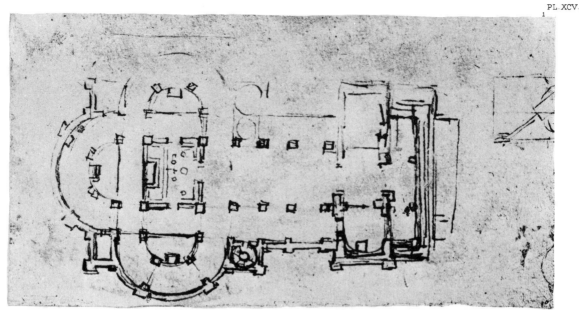

2

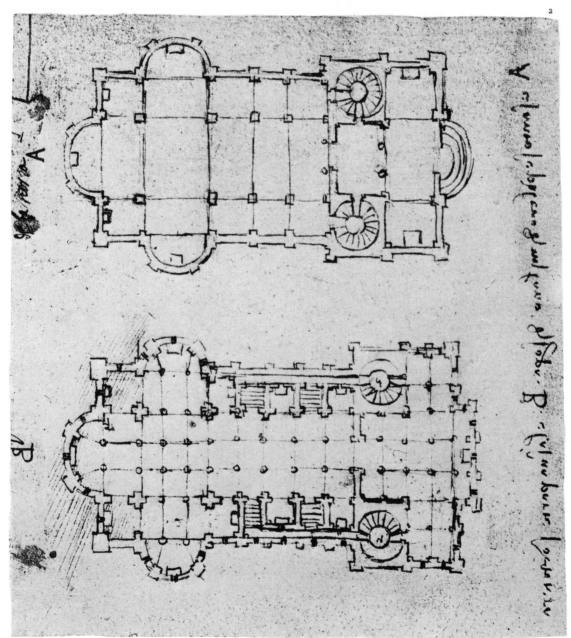

2

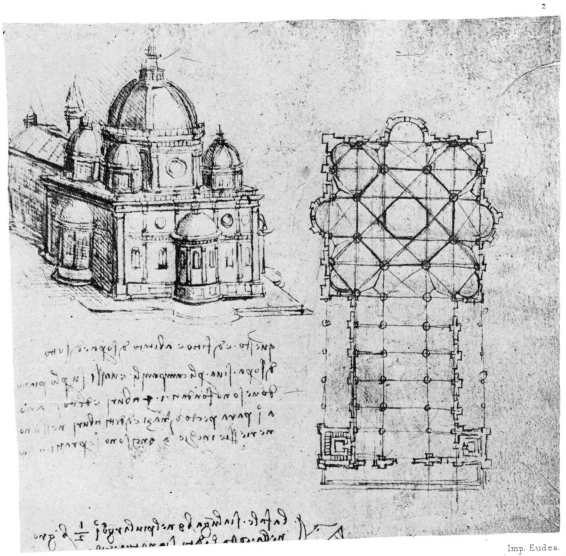

XV.

Astronomy.

*Ever since the publication by Venturi in 1797 and Libri in 1840 of some few passages of Leonardo's astronomical notes, scientific astronomers have frequently expressed the opinion, that they must have been based on very important discoveries, and that the great painter also deserved a conspicuous place in the history of this science. In the passages here printed, a connected view is given of his astronomical studies as they lie scattered through the manuscripts, which have come down to us. Unlike his other pure-ly scientific labours, Leonardo devotes here a good deal of attention to the opinions of the ancients, though he does not follow the practice universal in his day of relying on them as authorities; he only quotes them, as we shall see, in order to refute their arguments. His researches throughout have the stamp of independent thought. There is nothing in these writings to lead us to suppose that they were merely an epi-tome of the general learning common to the astronomers of the period. As early as in the XIV*th* century there were chairs of astronomy in the universities of Padua and Bologna, but so late as during the entire XVI*th* century Astronomy and Astrology were still closely allied.*

It is impossible now to decide whether Leonardo, when living in Florence, became acquainted in his youth with the doctrines of Paolo Toscanelli the great astronomer and mathematician (died 1482), of whose influence and teaching but little is now known, beyond the fact that he advised and encouraged Columbus to carry out his project of sailing round the world. His name is nowhere mentioned by Leonardo, and from the dates of the manuscripts from which the texts on astronomy are taken, it seems highly probable that Leonardo devoted his attention to astronomical studies less in his youth than in his later years. It was evidently his purpose to treat of Astronomy in a connected form and in a separate work (see the beginning of Nos. 866 and 892; compare also No. 1167). It is quite in accordance with his general scientific thoroughness that he should propose to write a special treatise on Optics as an introduction to Astronomy (see Nos. 867 and 877). Some of the chapters belonging to this Section bear the title

"Prospettiva" *(see Nos. 869 and 870), this being the term universally applied at the time to Optics as well as Perspective (see Vol. I, p. 10, note to No. 13, l. 10).*

At the beginning of the XVIth century the Ptolemaic theory of the universe was still universally accepted as the true one, and Leonardo conceives of the earth as fixed, with the moon and sun revolving round it, as they are represented in the diagram to No. 897. He does not go into any theory of the motions of the planets; with regard to these and the fixed stars he only investigates the phenomena of their luminosity. The spherical form of the earth he takes for granted as an axiom from the first, and he anticipates Newton by pointing out the universality of Gravitation not merely in the earth, but even in the moon. Although his acute research into the nature of the moon's light and the spots on the moon did not bring to light many results of lasting importance beyond making it evident that they were a refutation of the errors of his contemporaries, they contain various explanations of facts which modern science need not modify in any essential point, and discoveries which history has hitherto assigned to a very much later date.

The ingenious theory by which he tries to explain the nature of what is known as earth shine, the reflection of the sun's rays by the earth towards the moon, saying that it is a peculiar refraction, originating in the innumerable curved surfaces of the waves of the sea may be regarded as absurd; but it must not be forgotten that he had no means of detecting the fundamental error on which he based it, namely: the assumption that the moon was at a relatively short distance from the earth. So long as the motion of the earth round the sun remained unknown, it was of course impossible to form any estimate of the moon's distance from the earth by a calculation of its parallax.

Before the discovery of the telescope accurate astronomical observations were only possible to a very limited extent. It would appear however from certain passages in the notes here printed for the first time, that Leonardo was in a position to study the spots in the moon more closely than he could have done with the unaided eye. So far as can be gathered from the mysterious language in which the description of his instrument is wrapped, he made use of magnifying glasses; these do not however seem to have been constructed like a telescope—telescopes were first made about 1600. As LIBRI pointed out (Histoire des Sciences mathématiques III, 101) *Fracastoro of Verona (1473—1553) succeeded in magnifying the moon's face by an arrangement of lenses (compare No. 910, note), and this gives probability to Leonardo's invention at a not much earlier date.*

I.

THE EARTH AS A PLANET.

Br. M. 176*a*]

857.

Linia d'equalità, ²linia dell'orizzōte, ³linia giacēte, ⁴linia equigiacēte;
⁵Queste linie sō quelle ⁶che con sua stremi sō ⁷equidistanti al cē⁸tro del mondo.

The equator, the line of the horizon, the ecliptic, the meridian:
These lines are those which in all their parts are equidistant from the centre of the globe.

The earth's place in the universe (857. 858).

F. 41*b*]

858.

Come la terra non è nel mezzo del cerchio del ²sole, nè nel mezzo del mōdo, ma è ben nel mez³zo de' sua elemēti, conpagni e vniti cō lei, e chi ⁴stesse nella luna, quād'ella insieme col sole ⁵è sotto a noi, questa nostra terra coll'ele⁶mento dell'acqua parrebbe e farebbe ofitio tal ⁷qual fa la luna a noi.

The earth is not in the centre of the Sun's orbit nor at the centre of the universe, but in the centre of its companion elements, and united with them. And any one standing on the moon, when it and the sun are both beneath us, would see this our earth and the element of water upon it just as we see the moon, and the earth would light it as it lights us.

Br. M. 151*a*]

859.

La forza da carestia · o · douitia · è gienerata; ²questa è figliola del moto · materiale · e nepote ³del moto · spirituale ·, e madre e origine del peso; ⁴e esso peso è finito nell'elemēto dell'acqua e terra, ⁵e essa ·

Force arises from dearth or abundance; it is the child of physical motion, and the grand-child of spiritual motion, and the mother and origin of gravity. Gravity is limited to the elements of water and

The fundamental laws of the solar system (859—864).

857. 2. dorizōte. 6. che cho. 7. nequidistante.
858. 1. mezo. 2. mezo. 4. stessi. 5. essotto annoi . . nosta. 6. acq"a" parebbe effarebe. 7. annoi.
859. 1. odouitia. 2. effigliola . . enepo. 4. chesso . . heffinito . . ettera. 5. chessa . . he. 6. mouerebbe . . potessi. 7. hessa

859. Only part of this passage belongs, strictly speaking, to this section. The principle laid down in the second paragraph is more directly connected with the notes given in the preceding section on Physiology.

forza · è infinita, perchè con essa infiniti
[6]mōdi si mouerebbero ·, se strumēti farsi
potessero, [7]doue essa forza gienerare si
potesse.

[8]La forza col moto materiale e 'l peso
colla percussione [9]son le quattro accidētali
potētie, colle quali tutte l'opere [10]de' mor-
tali ànno loro essere e lor morte;

[11]La forza · dal moto · spirituale · à ori-
gine; il quale moto, [12]scorrēdo · per le mēbra
degli animali · sensibili ·, ingrossa [13]i muscoli
di quelli ·, onde ingrossati · essi muscoli si
uē[14]gono a raccortare e trarsi dirieto i nervi
che con essi [15]sō cōgiunti ·, e di qui si causa
la forza per le mēbra umane.

[16]La qualità e quātità delle forze · d'uno
uomo potrà [17]partorire · altra forza ·, la quale
sarà proportio[18]nevolmēte tanto maggiore
quāto essa sarà di piv [19]lūgo moto, l'una
che l'altra.

earth; but this force is unlimited, and
by it infinite worlds might be moved if
instruments could be made by which the
force could be generated.

Force, with physical motion, and gra-
vity, with resistance are the four exter-
nal powers on which all actions of mortals
depend.

Force has its origin in spiritual motion;
and this motion, flowing through the limbs
of sentient animals, enlarges their muscles.
Being enlarged by this current the muscles
are shrunk in length and contract the tendons
which are connected with them, and this is
the cause of the force of the limbs in man.

The quality and quantity of the force
of a man are able to give birth to other
forces, which will be proportionally greater
as the motions produced by them last
longer.

860.

Br. M. 175a]

Il peso · o · perchè non resta nel suo
sito? [2]non resta perchè non à resistētia;
e dō[3]de si moverà? Moverassi · inverso il
[4]centro; e perchè nō per altre linie? per-
chè [5]il peso, che non à resistentia, disciēn-
derà [6]in basso per la uia piv brieve, e 'l
più bas[7]so sito è il ciētro del mondo; e
perchè lo sa [8]così tal peso trovarlo con
tanta breuità? [9]perchè non va come insen-
sibile prima [10]vagando per diverse linie.

Why does not the weight o remain in its
place? It does not remain because it has no
resistance. Where will it move to? It will
move towards the centre [of gravity]. And
why by no other line? Because a weight
which has no support falls by the shortest
road to the lowest point which is the centre
of the world. And why does the weight know
how to find it by so short a line? Because it
is not independant and does not move about
in various directions.

861.

F. 22b]

Movasi la terra da che parte voglia,
[2]mai la superfitie dell'acqua uscirà fori
della [3]sua spera, ma senpre
sarà equidistante al [4]centro del
mondo;

[5]¶Dato che la terra · si ri-
movessi dal centro [6]del mon-
do, che farebbe l'acqua?¶

[7]Resterebbe intorno a esso
centro [8]con equal grossezza,
ma minore diami[9]tro, che
quando ella auea la terra in
corpo.

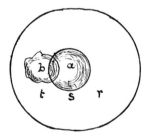

Let the earth turn on which side it may
the surface of the waters will never move
from its spherical form, but will
always remain equidistant from
the centre of the globe.

Granting that the earth might
be removed from the centre of
the globe, what would happen
to the water?

It would remain in a sphere
round that centre equally thick,
but the sphere would have a
smaller diameter than when it
enclosed the earth.

. . potessi. 9. quatro. 10. ellor. 12. scorēdo. 13. musscoli di quelle . . musscoli. 14. gano aracortare. 16. ecquātita
. . homo. 18. magiore. 19. luna cellaltra.
860. 4. cientro he. 8. chon. 9. perche nonva come [in gi] insensibile prima. 10. vagando per diuerse linie.
861. 2. acq"a" vsscirà. 5. chella. 6. cheffarebbe.

860. This text and the sketch belonging to it, 861. Compare No. 896, lines 48—64; and
are reproduced on Pl. CXXI. No. 936.

F. 11 b]

862.

Se la terra delli antipodi che sostiene ²l'oceano s'inalzasse, e si scoprisse assai ³fori d'esso mare, essendo quasi pia⁴na, in che modo sarebbe poi col tēpo ⁵a creare li mōti e le valli.

⁶E li sassi di diuerse falde?

Supposing the earth at our antipodes which supports the ocean were to rise and stand uncovered, far out of the sea, but remaining almost level, by what means afterwards, in the course of time, would mountains and vallies be formed?

And the rocks with their various strata?

Tr. 28]

863.

Ogni omo senpre si troua nel mezzo del mōdo e sotto il mezzo ²del suo · emisperio, e sopra il ciētro d'esso mōdo.

Each man is always in the middle of the surface of the earth and under the zenith of his own hemisphere, and over the centre of the earth.

Leic. 1 a]

864.

Ricordo come io ho in prima a dimo-²strare la distantia del sole dalla terra, ³e con ū de' sua razzi passati per ispi⁴racolo in loco oscuro ritrovare ⁵la sua quātità vera, e oltre a ⁶di questo per lo mezzo della spera del ⁷l'acqua ritrovare la grādezza della terra.¶

⁸Qui si dimostra come, quā⁹do il sole è nel mezzo del nostro ¹⁰emisperio, che li antipodi ¹¹orientali cogli occidentali ue¹²dono in un medesimo tenpo cias¹³cun per se spechiare il sole nelle ¹⁴loro acque, e 'l simile quelli del po¹⁵lo artico col antartico, se abi¹⁶tatori ui sono.

Mem.: That I must first show the distance of the sun from the earth; and, by means of a ray passing through a small hole into a dark chamber, detect its real size; and besides this, by means of the aqueous sphere calculate the size of the globe ...

Here it will be shown, that when the sun is in the meridian of our hemisphere [10], the antipodes to the East and to the West, alike, and at the same time, see the sun mirrored in their waters; and the same is equally true of the arctic and antarctic poles, if indeed they are inhabited.

C. A. 111 b; 345 b]

865.

Come la terra è una stella.

That the earth is a star.

How to prove that the earth is a planet (865—867).

F. 56 a]

866.

Tu nel tuo discorso ài a cōcludere ²la terra essere vna stella quasi si³mile alla luna, ⁴e la nobiltà del nostro mōdo;

⁵E così farai vn discorso delle grā⁶dezze di molte stelle, secōdo li autori.

In your discourse you must prove that the earth is a star much like the moon, and the glory of our universe; and then you must treat of the size of various stars, according to the authors.

862. 1. sella. 2. sinalzassi . . scoprissi essi. 5. elle. 6. elli.
863. 1. mezo . . essotto il mezo.
864. 1. chome . . in p"a" a dimō. 2. disstantia. 3. razi. 4. rachulo illocho oscuro. 6. mezo. 7. grādeza. 8. dimosstra chome. 9. mezo . . nosstro. 10. emissperio chelli antipodi di. 11. horientali. 12. gano nun. 13. scun. 14. acque . . quelgli. 15. articho chol antarticho.
865. R.
866. 1. tutto tuo discorsa a cō cludere. 3. luna [e cosi proverra]. 6. altori.

864. 10. 11. *Antipodi orientali cogli occidentali.* The word *Antipodes* does not here bear its literal sense, but—as we may infer from the simultaneous reference to inhabitants of the North and South— is used as meaning men living at a distance of 90 degrees from the zenith of the rational horizon of each observer.

F. 25 *b*] **867.**

ORDINE DEL PROVARE LA TERRA ESSERE
²VNA STELLA.

THE METHOD OF PROVING THAT THE EARTH
IS A STAR.

³Inprima definisci l'ochio, poi mostra come il bat⁴tere d'alcuna stella viene dall'ochio, e perchè il battere ⁵d'esse stelle è più nell'una che nell'altra, e come li ⁶razzi delle stelle nascono dall'ochio, e dì, che se 'l batte⁷re delle stelle fusse come pare nelle stelle, che tal bat⁸timēto mostra d'essere di tanta dilatatione, quāt'è ⁹il corpo di tale stella; essendo adūque maggiore della ter¹⁰ra che tal moto fatto in istante sarebbe troppo veloce ¹¹a raddoppiare la grādezza di tale stella; Di poi pro¹²va come la superfitie dell'aria ne' cō-fini del foco, e ¹³la superfitie del foco nel suo termine è quel¹⁴la, nella qual penetrādo li razzi solari portano la ¹⁵similitudine di corpi celesti grāde nel lor leua¹⁶re, e però è pic-cola, essendo esse nel mezzo del celo; ¹⁷sia la terra *a | n d m* sia ¹⁸la superfitie dell'aria che ¹⁹confina colla spera del ·²⁰foco; · *h f g* · sia il corso ²¹della luna o vuoi del sole; ²²dico che quādo il sole appari²³sce al'orizzōte *g*, che lì sono ueduti ²⁴li sua razzi passare per la superfitie ²⁵dell'aria infra āgoli inequali cioè *o m*, il che non è in *d k*, e ācora ²⁶passa per maggiore grossezza d'aria; tutto *e m* è aria più spessa.

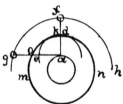

First describe the eye; then show how the twinkling of a star is really in the eye and why one star should twinkle more than another, and how the rays from the stars originate in the eye; and add, that if the twinkling of the stars were really in the stars —as it seems to be—that this twinkling appears to be an extension as great as the diameter of the body of the star; therefore, the star being larger than the earth, this motion effected in an instant would be a rapid doubling of the size of the star. Then prove that the surface of the air where it lies contiguous to fire, and the surface of the fire where it ends are those into which the solar rays penetrate, and transmit the images of the heavenly bodies, large when they rise, and small, when they are on the meridian. Let *a* be the earth and *n d m* the surface of the air in contact with the sphere of fire; *h f g* is the orbit of the moon or, if you please, of the sun; then I say that when the sun appears on the horizon *g*, its rays are seen passing through the surface of the air at a slanting angle, that is *o m*; this is not the case at *d k*. And so it passes through a greater mass of air; all of *e m* is a denser atmosphere.

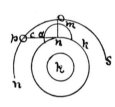

W. XXVI] **868.**

Infra 'l sole · e noi è tenebre, e però l'aria pare azzurra.

Beyond the sun and us there is darkness and so the air appears blue.

E. 15 *b*] **869.**

PROSPETTIVA.

PERSPECTIVE.

²Possibile è fare che l'ochio nō uedrà ³le cose remote molto diminuite, come fa

It is possible to find means by which the eye shall not see remote objects as much

867. 3. difinissci. 4. piene . . il bat. 6. razi . . nasscā . . e di chessel bate. 7. fussi . . tal ba. 9. magor. 10. istante sare trovo
veloce.· 11. radopiare la grādeza. 12. foco el. 15. lla superfitie . . focho . . ecquel. 14. razi . . portāta. 16. eppero e
pichole . . mezo. 20. foco. 21. della nuna ouoi. 22. apari. 23. orizōte g chele veduto. 24. razi. 25. coe o m il ce non
. . acora. 26. magore grosseza.

868. ettenebre . . azura.

869. 1. prosspettiva. 2. he fare chellochio . . uedera. 3. chome ffa. 4. pressspettiva naturale [le spe] le. 5. le diminuisschano.

868. Compare Vol. I, No. 301.

⁴la prospettiva naturale, le quali ⁵diminui-
scono mediante la curuità del⁶l'ochio, che
è costretto a tagliare sopra di ⁷se le pira-
midi di qualunche spetie che viene al ⁸ochio
·infra angoli retti sperici; Ma ⁹l'arte, che
io insegnio qui in margine, ta¹⁰glia
esse piramidi con angoli ret¹¹ti vi-
cino alla superfitie di tal popilla;
Ma ¹²la convessa popilla dell'occhio
piglia sopra ¹³di se tutto il nostro
emisperio, e que¹⁴sta mostrerà solo
una stella; ma doue ¹⁵molte pic-
cole stelle si ricevono per similitu¹⁶dine
nella superfitie della popilla, ¹⁷le quali
stelle son minime, questa di¹⁸mostrerà vna
sola stella, ma fia grāde; ¹⁹E così la luna
di maggiore grādezza, e le su²⁰e macule
di più nota figura; A questo ²¹nostro ochio
si debbe fare v̄ uetro pieno di ²²quell'acqua
di che si fa mētione ²³nel 4 del libro 113
delle cose naturali, ²⁴la quale acqua fa
parere spogliate di ²⁵vetro quelle cose
che son congielate nel²⁶le palle del uetro
cristallino.

DELL' OCHIO.

²⁸Infra li corpi minori della popilla del-
l'ochio ²⁹quella fia manco nota a essa po-
pilla, ³⁰la quale le sarà più vicina ‖ E con
questa ³¹speriētia ci si è fatto noto che la
virtù visiua nō ³²si riducie in pūto perchè
se la ecc.;

³³Leggi ī margine.

³⁴Quella cosa si ³⁵dimostra maggi³⁶ore,
che uiene ³⁷all'ochio cō più ³⁸grosso angolo.

³⁹Ma le spetie delli ob⁴⁰bietti, che cō-
cor⁴¹rono alla popilla ⁴²dell'ochio, si con-
par⁴³tono sopra tal popi⁴⁴lla nel medesimo
⁴⁵modo, ch'elle son cō⁴⁶partite infra l'aria;
⁴⁷e la prova di ques⁴⁸to è in se⁴⁹guito;
quādo noi ⁵⁰riguardiamo il ⁵¹cielo stellato
⁵²sanza por la ui⁵³sta più a una stel⁵⁴la
che all'altra, ⁵⁵che allora ci si mo⁵⁶stra il
cielo semina⁵⁷to di stelle, e sō pro⁵⁸portio-
nate nell'ochio ⁵⁹siccome lo sono in ⁶⁰cielo,
e così li loro ⁶¹spati fanno il simile.

diminished as in natural perspective, which
diminishes them by reason of the convexity
of the eye which necessarily intersects,
at its surface, the pyramid of every image
conveyed to the eye at a right angle on its
spherical surface. But by the method
I here teach in the margin[9] these
pyramids are intersected at right
angles close to the surface of the
pupil. The convex pupil of the eye
can take in the whole of our hemi-
sphere, while this will show only a
single star; but where many small stars trans-
mit their images to the surface of the pupil
those stars are extremely small; here only
one star is seen but it will be large. And
so the moon will be seen larger and its
spots of a more defined form[20]. You must
place close to the eye a glass filled with the
water of which mention is made in number
4 of Book 113 "On natural substances"[23];
for this water makes objects which are en-
closed in balls of crystalline glass appear
free from the glass.

OF THE EYE.

Among the smaller objects presented to
the pupil of the eye, that which is closest to
it, will be least appreciable to the eye. And
at the same time, the experiments here made
with the power of sight, show that it is not
reduced to speck if the &c.[32].

Read in the margin.

[34]Those objects are seen largest which
come to the eye at the largest angles.

But the images of the objects conveyed
to the pupil of the eye are distributed to
the pupil exactly as they are distributed in
the air: and the proof of this is in what
follows; that when we look at the starry sky,
without gazing more fixedly at one star than
another, the sky appears all strewn with stars;
and their proportions to the eye are the same
as in the sky and likewise the spaces between
them[61].

6. chosstretta attagliare. 7. piramide . . spetie viene. 8. llochio . . angholi. 10. lia [le] esse piramide chon angholi.
12. delloccio pigli. 13. mostro omissperio ecques. 14. mossterra. 15. pichole . . riciev. 16. popille [qu]. 17. stielle . .
quista e di. 18. mossterra . . maffia. 19. chosi . . magiore grādeza elle. 20. machule. 22. acqua [che] di . . mētione [de].
23. chose. 24. aqua. 25. chose chesson. 26. crisstallino. 28. Infralli chorpi. 29. mancho. 29. a essa [ochu] popilla.
30. chon questa [no]. 31. ci se . . chella. 32. sella. 33. [Quella u]. 34. chosa. 35. dimosstra magi. 37. chō. 38. grosse
anghole. 39. Malle setie. 40. biecto che chōchor. 41. rano. 42. chonpa"r". 43. tano. 45. chō. 46. infrallari"a". 47. ella.
48. sto [cm] ciē inse. 49. quasa quādo. 50. righuardiamo. 52. la ui. 53. ta. 58. ochi"o". 59. si chomelle. 60. chosi.

869. 9. 32. *in margine:* lines 34—61 are, in the
original, written on the margin and above them is
the diagram to which Leonardo seems to refer
here.

20 and fol. Telescopes were not in use till a
centu r later. Compare No. 910 and page 136.

23. *libro* 113. This is perhaps the number of a
book in some library catalogue. But it may refer,
on the other hand, to one of the 120 Books men-
tioned in No. 796. l. 84.

32. Compare with this the passage in Vol. I,
No. 52, written about twenty years earlier.

F. 60 *b*] **870.**

PROSPETTIVA.

[2] Delle cose remosse dall'ochio con e-
quale di[3]stantia, quella parrà esser mē dimin[4]vita che prima era più.

[5] Delle cose remosse dall'ochio con
equal di[6]stantia dal lor primo sito quella
mē diminuisce [7] che prima era più distante
da esso ochio; E tal [8] fia la proportione
della diminuitione, qual fù [9] la proportione
delle distantie ch'esse aveā da[10] l'ochio auanti
il loro moto.

[11] Come dire il corpo *t* e 'l corpo *e* e
[12] che la proportiō delle lor distantie dal-
l'ochio *a* [13] è quītupla; io rimovo ciascū
dal suo sito [14] e lo fo più distante dal-

PERSPECTIVE.

Among objects moved from the eye at
equal distance, that undergoes least diminution which at first was most remote.

When various objects are removed at equal
distances farther from their original position,
that which was at first the farthest from the eye
will diminish least. And the proportion of the
diminution will be in proportion to the
relative distance of the objects from the eye
before they were removed.

That is to say in the object *t* and the object *e*
the proportion of their distances from the eye *a* is
quintuple. I remove each from its place and set
it farther from the eye by one of the 5 parts

l'ochio vno d'essi 5' in che è [15] diuisa la
propositione; accade dūque che il più vicino
[16] all'ochio avrà doppiata la distantia, e per
la penulti[17]ma di questo esso è diminuto
la metà del suo tutto, [18] e 'l corpo *e* per
lo medesimo moto è diminuito [19] d'esso
suo tutto; adūque per la detta penultima
[20] è vero quel che in questa vltima s'è pro-
posto; [21] e questo dico per li moti de' corpi
celesti [22] in 3500 miglia di distātia che piv
essē[23] do in oriēte che sopra di noi, non
crescono o diminuiscono [24] con sensibile
dimostratione.

into which the proposition is divided. Henc[e]
it happens that the nearest to the eye ha[s]
doubled the distance and according to th[e]
last proposition but one of this, is diminished
by the half of its whole size; and the body
e, by the same motion, is diminished $1/5$ of
its whole size. Therefore, by that same
last proposition but one, that which is said
in this last proposition is true; and this I
say of the motions of the celestial bodies
which are more distant by 3500 miles when
setting than when overhead, and yet do not
increase or diminish in any sensible degree.

Br. M. 174 *b*] **871.**

a b è lo spiraculo donde [2] passa il sole,
e se tu po[3]tessi misurare la grossezza de'
[4] razzi solari in *n m*, tu po[5]tresti por bene
le uere linie [6] del concorso d'essi razzi solari,
[7] stante lo spechio in · *a b*, e [8] poi fare i

a b is the aperture through which the
sun passes, and if you could measure the
size of the solar rays at *n m*, you could
accurately trace the real lines of the conver-
gence of the solar rays, the mirror being at
a b, and then show the reflected rays at

870. 1. prespectiva. 2. remosse "dallochio" [dellor sito cone] quala di. 4. che p"a"era . . 5. chon . . dis. 6. p"o"sito qualla
. . diminuissce. 7. che p"a" . . Ettal. 10. iloro. 11. corpo e che e. 12. chella. 13. ciasscū del. 14. ellolofo . . inche.
15. la pro "ne" achade . . che piu. 16. ara dopiato. 20. preposto. 21. ecquesto . . celestiche. 22. [1500 in] 3500 . .
distātia cheli ā piv. 23. crescano o diminuiscano.
871. 1. ellosspiraculo. 2. essettu. 3. grossezza. 4. razi. 6. razi. 7. losspechio. 8. razi refressi. 10. chettu uoli poi torre

razzi reflessi infra āᵍgoli equali inuerso · *n m* · ¹⁰ma poi che tu vuoi torre in ¹¹*n m* · togli dentro allo spiracu¹²lo in *c d* che si possan misura¹³re nella percussione del razzo solare, ¹⁴e poi poni il tuo spechio nella distā¹⁵tia *a b* ·, e lì fa cadere i razzi *d b*, *c a*; poi ¹⁶risaltare infra angoli equali in uer¹⁷so *c d* · e questo è il uero modo; ¹⁸ma ti bisognia operare tale spe¹⁹chio nel medesimo mese e medesi²⁰mo dì e ora e pūto, e farà meglio ²¹che di nessū tempo, perchè in tal distantia ²²di sole si causò tal piramide.

equal angles to *n m*; but, as you want to have them at *n m*, take them at the inner side of the aperture at *c d*, where they may be measured at the spot where the solar rays fall. Then place your mirror at the distance *a b*, making the rays *d b*, *c a* fall and then be reflected at equal angles towards *c d*; and this is the best method, but you must use this mirror always in the same month, and the same day, and hour and instant, and this will be better than at no fixed time because when the sun is at a certain distance it produces a certain pyramid of rays.

G. 3 *b*] **872.**

a parte del corpo ō²broso *n* vede tutta la pa³rte dell'emisferio *b c d e f* ⁴e nō ui vede parte alcuna ⁵della oscurità della terra; ⁶e 'l simile accade nel punto *o*; adunque lo spatio *a* · *o* · è ⁷tutto d'una medesima chiarezza, in *s* vede sol 4 gra-⁸di dell'emisperio *d e f g h* ·, e vi vede tutta la terra ⁹*s h* che la fa più oscura quāto darà la calculatione.

a, the side of the body in light and shade *n*, faces the whole portion of the hemisphere *b c d e f*, and does not face any part of the darkness of the earth. And the same occurs at the point *o*; therefore the space *a o* is throughout of one and the same brightness, and *s* faces only four degrees of the hemisphere *d e f g h*, and also the whole of the earth *s h*, which will render it darker; and how much must be demonstrated by calculation.

A. 64 *b*] **873.**

<center>PRUOVA DELL'ACCRESCIMĒTO DEL SOLE ²IN NEL OCCIDĒTE.</center>

³Alcuni · matematici · dimostrano · il sole · cresciere nel ponēte ·, perchè l'ochio · sēpre lo uede per aria di maggiore grossezza, ⁴allegādo che le · cose uiste nella · nebbia e nel acqua pajono maggiori: ai quali · io rispōdo di no, inperochè le cose viste īfra la

<center>THE REASON OF THE INCREASED SIZE OF THE SUN IN THE WEST.</center>

Some mathematicians explain that the sun looks larger as it sets, because the eye always sees it through a denser atmosphere, alleging that objects seen through mist or through water appear larger. To these I reply: No; because objects seen through a mist are

11. allosspiracu. 12. chessi. 13. razo. 15. elli . . razi; *in the margin*: "d b" c a. 17. ecquesto. 18. matti. 20. effara.
872. 1. in a. 5. asscurita. 6. achade . . losspatio a . o . ed. 9. chella . . osscura.
873. 1. dellacresscimēto. 2. inel ocidēte. 3. raria . . magiore grosseza. 4. alegādo chelle chose . . nebia | "e nel acqᵇ" paro

872. This passage, which has perhaps a doubtful right to its place in this connection, stands in the Manuscript between those given in Vol. I as No. 117 and No. 427.

nebbia sō simi⁵li per colore alle lōtane·, e nōn essendo simili per diminvitione appariscono di maggiore grādezza; Ancora nessuna cosa ⁶crescie· in acqua·piana, e la pruova ne farai a lucidare vn asse mezza sotta l'acqua; Ma la ragione che 'l sol ⁷crescie· si è che | Ogni corpo luminoso quāto piv s'allōtana, piv pare grāde.

similar in colour to those at a distance; but not being similarly diminished they appear larger. Again, nothing increases in size in smooth water; and the proof of this may be seen by throwing a light on a board placed half under water. But the reason why the sun looks larger is that every luminous body appears larger in proportion as it is more remote.

874.

F. 94 *b*]

<div style="margin-left:2em">On the luminosity of the Earth in the universal space (874—878).</div>

Il libro mio s'astēde a mostrare, ²come l'oceā colli altri mari ³fa mediāte il sole splēde⁴re il nostro mōdo a modo ⁵di luna e a più remoti pa⁶re stella e questo provo;

⁷Dimostra prima come ogni lume remoto da⁸ll'ochio fa razzi, li quali pare che accrescino la figu⁹ra di tal corpo luminoso e di questo ne segui¹⁰ta che *2*

¹¹Luna frigida ¹²e vmida.

¹³L'acqua è frigi¹⁴da e vmida; ¹⁵tale influēti¹⁶a da il nostro ¹⁷mare alla lu¹⁸na qual la luna ¹⁹a noi.

In my book I propose to show, how the ocean and the other seas must, by means of the sun, make our world shine with the appearance of a moon, and to the remoter worlds it looks like a star; and this I shall prove.

Show, first that every light at a distance from the eye throws out rays which appear to increase the size of the luminous body; and from this it follows that *2* . .[10].

[11] The moon is cold and moist.

Water is cold and moist. Thus our seas must appear to the moon as the moon does to us.

875.

Br. M. 25 *a*]

L'onde dell'acqua crescono il simulacro della cosa che ²in lor si specchia.

³*a* sia il sole, *n m* sia l'acqua inōdata, *b* è 'l simulacro ⁴del sole, quando l'acqua nō fusse inondata; *f* sia l'ochio ⁵che uede esso simulacro in tutte l'onde che si rinchiudo⁶no nella basa del triangolo *c e f*; adunque il sole ⁷che nella superfitie sanza onde occupava l'acqua *c d*, ora ⁸nella superfitie inondata occupa tutta l'acqua *c e* (come è ⁹prouato nel 4

The waves in water magnify the image of an object reflected in it.

Let *a* be the sun, and *n m* the ruffled water, *b* the image of the sun when the water is smooth. Let *f* be the eye which sees the image in all the waves included within the base of the triangle *c e f*. Now the sun reflected in the unruffled surface occupied the space *c d*, while in the ruffled surface it covers all the watery space *c e* (as is proved in the 4th of my

magiore . . llechose . . nebia. 5. le per cholore ale . . esendo simile . . aparischano . . magiore grādeza Anchora nesuna chosa. 6. acq"a" . . meza . . lacq"a" Malla. 7. cresscie . . chorpo.

874. 1. libro mio (il *is wanting*). 5. e "a" piu. 6. ecquesto. 7. ōni lume. 8. razi . . acresscino. 11. fregida. 13. Lacq"a". 15. infruēti.

875. 1. aq"a" cresscano. 2. sisspechia. 3. lacq"a". 4. lacq"a" . . fussi. 5. chessi rinchiuda. 7. ocupava lacq"a" . . or"a".

873. Lines 5 and 6 are thus rendered by M. RAVAISSON in his edition of MS. A. "*De même, aucune chose ne croît dans l'eau plane, et tu en feras l'expérience* en calquant un ais sous l'eau."—Compare the diagrams in Vol. I, p. 114.

874. 10. Here the text breaks off; lines 11 and fol. are written in the margin.

875. In the original sketch, inside the circle in

the first diagram, is written *Sole* (sun), and to the right of it *luna* (moon). Thus either of these heavenly bodies may be supposed to fill that space. Within the lower circle is written *simulacro* (image). In the two next diagrams at the spot here marked *L* the word *Luna* is written, and in the last *sole* is written in the top circle at *a*.

della mia prospettiva), e tanto più occupe-
[10]rebbe d'acqua quanto esso simulacro fusse
più distäte dal'ochio.

[11]¶Il simulacro del sole si dimostrerà
piv lucido nell'onde mi[12]nute che nelle onde
grandi¶; E questo accade perchè le simili-
[13]tudini over simulacri del sole sono più
spesse nell'onde minute [14]che nelle grandi,
e li più spessi splendori rendono maggiore
[15]lume che li splendori più rari.

[16]L'onde intersegate a uso di scorza di
pigna rendono il si[17]mulacro del sole di
grandissimo splendore, [18]e questo accade
perchè tanto son li simulacri quanto son
li gio[19]ghi del'onde vedute dal sole, e

"Perspective") [9]and it will cover more of
the water in proportion as the reflected image
is remote from the eye[10].

The image of the sun will be more
brightly shown in small waves than in large
ones — and this is because the reflections or
images of the sun are more numerous in the
small waves than in large ones, and the more
numerous reflections of its radiance give a
larger light than the fewer.

Waves which intersect like the scales of
a fir cone reflect the image of the sun with
the greatest splendour; and this is the case
because the images are as many as the
ridges of the waves on which the sun

l'onbre che infra esse onde s'inter[20]pongono
sōn piccole e di poca oscurità, e li splen-
dori di tanti [21]simulacri insieme s'infondono
nelle similitudini che di lor [22]viene all'ochio,
in modo tale che esse ōbre sono insen-
sibili;¶

[23]Quel simulacro del sole occuperà
[24]più lochi nella superfitie dell'acqua, che
[25]sarà più distante dall'ochio che lo uede;

[26]a sia il sole, p q è il simulacro d'esso
[27]sole, a b è la superfitie dell'acqua doue
il sol [28]si spechia, r sia l'ochio che uede
esso si[29]mulacro nella superfitie dell'acqua
occupare [30]lo spatio o m; c è l'occhio
più remoto [31]da essa superfitie dell'acqua,
e così dal simulacro, onde esso simulacro
[32]occupa maggiore spatio d'acqua, — quāto
è lo spatio n o.

shines, and the shadows between these waves
are small and not very dark; and the radiance
of so many reflections together becomes
united in the image which is transmitted to
the eye, so that these shadows are imper-
ceptible.

That reflection of the sun will cover most
space on the surface of the water which is
most remote from the eye which sees it.

Let a be the sun, p q the reflection of
the sun; a b is the surface of the water, in
which the sun is mirrored, and r the eye
which sees this reflection on the surface of
the water occupying the space o m. c is the
eye at a greater distance from the surface
of the water and also from the reflection;
hence this reflection covers a larger space of
water, by the distance between n and o.

8. ochupa. 9. prosspectiva) ettanto . . ochupe. 10. dacq"a" . . fussi. 11. dimosterra. 12. achade chelle. 13. tudine.
14. elli . . rendan magore. 15. chelli. 16. disscorsa di pina rendano [loss] il si. 17. plendore [e chiareza]. 18. ecquesto
achade. 19. ellonbre. 20. pongono . . pichole . . pocha osscurita elli. 21. sinfondano . . similitudine. 23. sole [se]
ochupera. 25. chel uede. 27. ella. 28. sisspechia. 29. acq"a" ocupare. 30. Losspatio . . elloccio. 32. ochupa magore
. . ello.

9. *Nel quarto della mia prospettiva.* If this reference
is to the diagrams accompanying the text — as is
usual with Leonardo — and not to some particular
work, the largest of the diagrams here given

must be meant. It is the lowest and actually the
fifth, but he would have called it the fourth, for the
text here given is preceded on the same page of
the manuscript by a passage on whirlpools, with

Br. M. 28*a*]

876.

Ɉpossibile è ²che tan³to quāto il sole allumina ⁴dello spechio sperico, ⁵tāto d'esso spechio ab⁶bia a risplendere, ⁷se già esso spechio ⁸non fusse ōdāte o globulē⁹to;

¹⁰Vedi qui il so¹¹le allumina¹²re la luna, s¹³pecchio speri¹⁴co, e tan¹⁵to quāto es¹⁶so sole ne ¹⁷uede, tāto ne ¹⁸fa splēdere;

¹⁹Qui si concluderà che ciò che della luna ²⁰splende è acqua simile a quella deg-²¹li nostri mari, e così inōdata, ciò ²²che di lei non splende sone isole e ter²³ra ferma.

It is impossible that the side of a spherical mirror, illuminated by the sun, should reflect its radiance unless this mirror were undulating or filled with bubbles.

You see here the sun which lights up the moon, a spherical mirror, and all of its surface, which faces the sun is rendered radiant.

Whence it may be concluded that what shines in the moon is water like that of our seas, and in waves as that is; and that portion which does not shine consists of islands and terra firma.

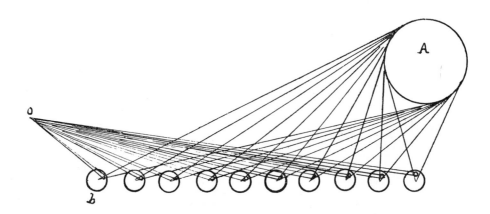

²⁴Questa dimostratione di tanti · corpi sperici interposti infra l'ochio ²⁵e 'l sole è fatta per mostrare che, siccome in ciascuno d'essi ²⁶corpi si uede il simulacro del sole, così si può vedere esso simulacro in cia-²⁷scuna globosità dell'onde del mare; come in molti di questi sperici si ²⁸uedono molti soli, così in molte onde si uedono molti lustri, li quali in molta ²⁹distanzia, ciascū lustro per se, si fanno grādi all' ochio e, così faciēdo ciascu³⁰na onda, si uengono a con-

This diagram, of several spherical bodies interposed between the eye and the sun, is given to show that, just as the reflection of the sun is seen in each of these bodies, in the same way that image may be seen in each curve of the waves of the sea; and as in these many spheres many reflections of the sun are seen, so in many waves there are many images, each of which at a great distance is much magnified to the eye. And, as this happens with each wave, the spaces

876. 1. he [chellol spechio]. 2. consperico possa] chettan. 4. spericho tā. 6. rissplendere. 7. ga. 8. fussi ōdate o globbule. 13. echio. 14. cho ettan. 19. che co che. 20. acqui .. acquella de. 21. ecco. 22. etter. 24. sperichi. 25. sole [nō] effatta per mosstrare [come] che si come in ciasscuno. 26. po .. in ca. 27. globbosita .. mare c . me. 28. uede .. uede lusstri. 29. ciasscū lusstro .. fa grande .. ciasscu. 30. lesspati .. infrallonde. 31. cagone. 32. elle parte onbro. 33. chettale .. none e .. in ese.

the diagram belonging to it also reproduced here. The words *della mia prospettiva* may therefore indicate that the diagram to the preceding chapter treating on a heterogeneal subject is to be excluded. It is a further difficulty that this diagram belongs properly to lines 9—10 and not to the preceding

sentence. The reflection of the sun in water is also discussed in the Theoretical part of the Book on Painting; see Vol. I, No. 206, 207.

876. In the original, at letter *A* in the diagram "*Sole*" (the sun) is written, and at *o* "*occhio*" (the eye).

sumare gli spati interposti infra l' onde, ³¹e per questa tal cagione e' pare tutto vn sole continuato nelli molti soli ³²spechiati nelle molte onde, e le parti onbrose miste colle spetie luminose ³³fan che tale splendore non è lucido come quel del sole in esse ōde spechia³⁴to.

interposed between the waves are concealed; and, for this reason, it looks as though the many suns mirrored in the many waves were but one continuous sun; and the shadows, mixed up with the luminous images, render this radiance less brilliant than that of the sun mirrored in these waves.

F. 77 *b*]

877.

Questa avrà ināzi a se il trattato de' ²onbra e lumi.

³Li stremi della luna sarā più alluminati e si dimostre⁴ran più luminosi, perchè in quelli non appare se nō le sō-⁵mità dell' ōde delle sue acque.

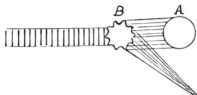

This will have before it the treatise on light and shade.

The edges in the moon will be most strongly lighted and reflect most light, because, there, nothing will be visible but the tops of the waves of the water[5].

W. X]

878.

Il sole parirà maggiore nell'acqua movente e ōdeggiāte ²che nella ferma: esemplo del lume visto sopra le corde ³del monocordo.

The sun will appear larger in moving water or on waves than in still water; an example is the light reflected on the strings of a monochord.

877. 1. ara . . asse. 2. ellumi. 3. dimoste. 4. apare.

878. 1. magiore . . ōdegiato. 2. essenplo . . chorde.

877. 5. I have thought it unnecessary to reproduce the detailed explanation of the theory of reflection on waves contained in the passage which follows this.

II.

THE SUN.

LAUDE DEL SOLE.

The question of the true and of the apparent size of the sun (879—884).

[2]Se guarderai le stelle sanza razzi (come si fa a veder[3]le per un piccolo foro fatto colla strema pūta da[4]la sottile aguglia, e questo posto quasi a toccare l'ochio), [5]tu uedrai esse stelle essere tanto minime che nul[6]la cosa pare essere minore, e ueramēte la lūga. di[7]stātia le fa ragionevolmente diminuire, ancorachè [8]molte vi sono che son moltissime volte maggiori che la [9]stella cioè la terra coll'acqua ·; ora pensa quel che par[10]rebbe essa nostra stella in tāta distantia, e conside[11]ra poi, quāte stelle si metterebbero e per longitudine e la[12]titudine infra esse stelle, le quali sono semina[13]te per esso spatio tenebroso; mai nō posso fare [14]ch'io non biasimi molti di quelli antichi, li quali disse[15]ro che 'l sole non avea altra grādezza che quella che [16]mostra, īfra quali fu Epicuro, e credo che caua[17]si tale ragione da vn lume posto in questa nostra a[18]ria, equidistāte al cētro; chi lo uede, non lo uede mai di[19]minuito di grādezza in nessuna distātia; e le ragi-

IN PRAISE OF THE SUN.

If you look at the stars, cutting off the rays (as may be done by looking through a very small hole made with the extreme point of a very fine needle, placed so as almost to touch the eye), you will see those stars so minute that it would seem as though nothing could be smaller; it is in fact their great distance which is the reason of their diminution, for many of them are very many times larger than the star which is the earth with water. Now reflect what this our star must look like at such a distance, and then consider how many stars might be added—both in longitude and latitude—between those stars which are scattered over the darkened sky. But I cannot forbear to condemn many of the ancients, who said that the sun was no larger than it appears; among these was Epicurus, and I believe that he founded his reason on the effects of a light placed in our atmosphere equidistant from the centre of the earth. Any one looking at it never sees it diminished in size at whatever distance; and the rea-

879. 1. lalde. 2. razi. 3. picholo. 4. acuchia ecque posto . . attocare. 6. lūgha dis. 7. stātia dalloro ragionevole diminuire ne anchora che. 8. magore chella. 9. coe . . aq"a" . . che pa. 11. metterebbe e per . . ella. 14. quali diso. 15. no chel sole . . grādeza. 16. mostra [alla] īfra. 18. noluede. 19. minuto . . grādeza inessuna . . elle.

879—882. What Leonardo says of Epicurus—who according to LEWIS, *The Astronomy of the ancients*, and MÄDLER, *Geschichte der Himmelskunde*, did not devote much attention to the study of ce-

lestial phenomena—, he probably derived from Book X of Diogenes Laertius, whose *Vitae Philosophorum* was not printed in Greek till 1533, but the Latin translation appeared in 1475.

F. 4*b*] 880.

oni della sua grandezza e virtù le riseruo
nel ²4° libro; ma bē mi maraviglio che
Socrate biasi³masse questo tal corpo, e che
dicesse quello esse⁴re a similitudine di pie-
tra infocata, e certo, chi ⁵l'oppose di tal
errore poco peccò; Ma io vorrei ⁶avere
vocabuli che mi seruissero a biasimare quel-
⁷li che vogliono laudare più lo adorare li
omini che ⁸tal sole, nō uedēdo nell'uniuerso
corpo ⁹di maggiore magnitudine e virtù di
quello; e 'l ¹⁰suo lume allumina tutti li corpi
celesti che per l'u¹¹niverso si cōpartono;
tutte l'anime discēdono da lui, ¹²perchè il
caldo ch'è in nelli animali viui viē dall'ani-
¹³me, e nessuno altro caldo nè lume è
nell'u¹⁴niverso, come mostrerò nel 4° libro,
e cier¹⁵to costoro che ànno voluto adorare
uomimi per i dei ¹⁶come Giove Saturno
Marte e simili ànno fatto grā¹⁷dissimo errore,
vedēdo che ancorachè l'omo fus¹⁸se grande
quāto il nostro mōdo, che parrebbe simi¹⁹le
a vna minima stella, la qual pare vn pūto
nell'uni²⁰verso, e ancora vedendo essi omini
mortali e ²¹putridi e corruttibili nelle lor
sepolture.

²²Luspera (?) ²³e Marcello ²⁴lauda cō
m²⁵olti altri ²⁶esso sole.

sons of its size and power I shall reserve
for Book 4. But I wonder greatly that Socra-
tes[2] should have depreciated that solar bo-
dy, saying that it was of the nature of incan-
descent stone, and the one who opposed him
as to that error was not far wrong. But I only
wish I had words to serve me to blame those
who are fain to extol the worship of men more
than that of the sun; for in the whole universe
there is nowhere to be seen a body of greater
magnitude and power than the sun. Its light
gives light to all the celestial bodies which are
distributed throughout the universe; and from
it descends all vital force, for the heat that is in
living beings comes from the soul [vital spark];
and there is no other centre of heat and light
in the universe as will be shown in Book 4; and
certainly those who have chosen to worship
men as gods—as Jove, Saturn, Mars and the
like—have fallen into the gravest error, seeing
that even if a man were as large as our earth,
he would look no bigger than a little star
which appears but as a speck in the universe;
and seeing again that these men are mortal,
and putrid and corrupt in their sepulchres.

Marcellus[23] and many others praise
the sun.

F. 6*a*] 881.

Forse Epicuro vide le ōbre delle colonne
ripercosse nelli an²tiposti muri essere equali
al diametro della colōna ³donde si partì a

Epicurus perhaps saw the shadows cast by
columns on the walls in front of them equal
in diameter to the columns from which the

880. 1. grandeza. 3. massi..dicessi. 4. assimilitudine. 5. loponi . . erore . . pecho. 6. seruissino abbiasimare que. 7. che vollō laldare. 9. magore. 11. cōpartano . . discēdā dallui. 12. inelli. 13. nellume enellu. 14. mosterro. 15. che an . . homini . . iddei. 16. gove saturno marte essimili an. 17. che anchorachellomo fu. 18. si grande . . parebe. 19. stela. 21. pitridi e curuttibili. *Lines 22—26 are written on the margin.* 22. luspera (?). 24. lalda.

881. 1. ripercose. 2. diametro 3. esendo . . paralella. 5. gudicare. 6. fussi. 8. colona . . sauide. 11. fussi . . lesstelle. 12. sarebō.

880. 2. *Socrates*; I have little light to throw on
this reference. Plato's Socrates himself declares on
more than one occasion that in his youth he had
turned his mind to the study of celestial pheno-
mena (Μετέωρα) but not in his later years (see G.
C. Lewis, *The Astronomy of the ancients*, page 109;
Mädler, *Geschichte der Himmelskunde*, page 41).
Here and there in Plato's writings we find inci-
dental notes on the sun and other heavenly bodies.
Leonardo may very well have known of these, since
the Latin version by Ficinus was printed as early
as 1491; indeed an undated edition exists which
may very likely have appeared between 1480—90.

There is but one passage in Plato, Epinomis
(p. 983) where he speaks of the physical properties
of the sun and says that it īs larger than the earth.

Aristotle who goes very fully into the subject
says the same. A complete edition of Aristotele's
works was first printed in Venice 1495—98, but a
Latin version of. the Books *De Coelo et Mundo* and
De Physica had been printed in Venice as early as
in 1483 (H. Müller-Strübing).

23. I have no means of identifying *Marcello* who
is named in the margin. It may be Nonius Mar-
cellus, an obscure Roman Grammarian of uncertain
date (between the II^nd and V^th centuries A. C.) the
author of the treatise *De compendiosa doctrina per
litteras ad filium* in which he treats *de rebus omni-
bus et quibusdam aliis*. This was much read in the
middle ages. The *editio princeps* is dated 1470 (H.
Müller-Strübing).

881. In the original the writing is across the diagram.

tale ōbra; essendo adunque il cōco⁴rso del-
l'ōbre paralello dall'suo nascimēto al suo
fine, ⁵li parue da giudicare che 'l sole an-
⁶cora lui fusse frōte di tal paralel⁷lo, e per
cōseguēza non essere piv gros⁸so di tal
colonna, e nō s'avvide che tal ⁹diminuitione

shadows were cast; and the breadth of the
shadows being parallel from beginning to
end, he thought he might infer that the sun
also was directly opposite to this parallel
and that consequently its breadth was not
greater than that of the column; not perceiv-
ing that the diminution in the shadow was

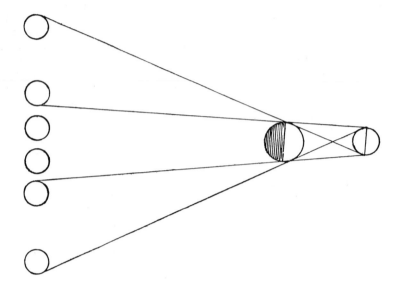

d'ōbra era insēsibile ¹⁰per la lunga distan-
tia del sole; ¹¹se 'l sole fusse minore della
terra, le stelle ¹²di grā parte del nostro
emisperio sarebbero sā¹³za lume; cōtro a
Epicuro che dice, tāto è ¹⁴grāde il sole,
quāto e' pare.

insensibly slight by reason of the remoteness
of the sun. If the sun were smaller than
the earth, the stars on a great portion of our
hemisphere would have no light, which is
evidence against Epicurus who says the sun
is only as large as it appears.

Dice Epicuro il sole essere tāto quāto
esso si dimostra; a²dunque e' pare essere
vn piè, e così l'abbiamo a tenere; ³segui-
rebbe che la luna quād'ella fa oscurare il
sole, il so⁴le non l'avāzerebbe di grādezza
come e' fa, onde, sendo ⁵la luna minor del
sole, essa luna sarebbe meno d'un piede,
⁶e per conseguēza quando il nostro mōdo
fa oscurare la lu⁷na, sarebbe minore a un
dito del piedi, conciò sia se 'l so⁸le è un
piede, e la nostra terra fa onbra piramidale
in⁹verso la luna, egli è necessario che sia
maggiore il lumi¹⁰noso, causa della pira-
mide ōbrosa, che l'opaco, causa d'essa ¹¹pi-
ramide.

Epicurus says the sun is the size it looks.
Hence as it looks about a foot across we
must consider that to be its size; it would
follow that when the moon eclipses the sun,
the sun ought not to appear the larger, as
it does. Then, the moon being smaller than
the sun, the moon must be less than a foot,
and consequently when our world eclipses
the moon, it must be less than a foot by a
finger's breadth; inasmuch as if the sun is a foot
across, and our earth casts a conical shadow
on the moon, it is inevitable that the lumi-
nous cause of the cone of shadow must be
larger than the opaque body which casts the
cone of shadow.

F. 10*b*]

883.

Misura quāti soli si metterebbero ²nel corso suo di 24 ore.

³Fa vn circulo e voltalo a mezzodì, come sō ⁴li orilogi da sole, e metti vna bacchetta in ⁵mezzo, in modo che la sua lūghezza si di⁶rizzi al cētro di tal cerchio, e nota l'on⁷bra che fa il sole d'essa bacchetta sopra la ⁸circūferentia di tale cerchio, che sarà ⁹l'onbra larga, diciamo tutto *a n*; ora ¹⁰misura quante volte tale ōbra entra in ¹¹tale circūferētia di cerchio, e tāte vol¹²te fia il numero che 'l corpo solare entrerà nel ¹³corso suo in 24 ore; e qui si potrà ¹⁴vedere, se Epicuro disse, che 'l sole era ¹⁵tanto grande quāto esso parea | che, pa-¹⁶rendo il diametro del sole vna misura ¹⁷pedale, e che esso sole entrasse mille ¹⁸volte nel suo corso di 24 ore, egli avre-¹⁹bbe corso mille piedi, cioè 300 braccia che ²⁰è vn sesto di miglio; ora ecco che 'l cor²¹so del sole infra dì e notte sarebbe ²²la sesta parte d'ū miglio, ²³e questa venerabile lumaca del sole av²⁴rebbe caminato 25 braccia per ora.

To measure how many times the diameter of the sun will go into its course in 24 hours.

Make a circle and place it to face the south, after the manner of a sundial, and place a rod in the middle in such a way as that its length points to the centre of this circle, and mark the shadow cast in the sunshine by this rod on the circumference of the circle, and this shadow will be—let us say—as broad as from *a* to *n*. Now measure how many times this shadow will go into this circumference of a circle, and that will give you the number of times that the solar body will go into its orbit in 24 hours. Thus you may see whether Epicurus was [right in] saying that the sun was only as large as it looked; for, as the apparent diameter of the sun is about a foot, and as that sun would go a thousand times into the length of its course in 24 hours, it would have gone a thousand feet, that is 300 braccia, which is the sixth of a mile. Whence it would follow that the course of the sun during the day would be the sixth part of a mile and that this venerable snail, the sun will have travelled 25 braccia an hour.

F. 0"]

884.

Possidonius cōpose libri della grādezza del sole.

Posidonius composed books on the size of the sun.

G. 34*a*]

885.

DELLA PROVA CHE 'L SOLE È CAL²DO PER NATURA E NŌ PER VIRTÙ.

OF THE PROOF THAT THE SUN IS HOT BY NATURE AND NOT BY VIRTUE.

³Che 'l sol sia in se caldo per natura e nō per vir⁴tù, si dimostra manifestamēte

That the heat of the sun resides in its nature and not in its virtue [or mode of

Of the nature of Sunlight.

883. 1. metterebbe. 3. mezodi. 4. dassole . . bachetta. 5. mezo . . chella. 5. lūgeza. 6. rizi. 7. cheffa. 8. cercio chessara. 9. largha. 11. ettāte. 12. il n"o" chel . . entera. 13. ecqui. 16. diamitro. 17. entrassi. 18. egliare. 19. coe 300 br . che. 20. miglo ora e che chel corso. 21. serebbela. 22. minato la sesta. 23. che questa . . lumacha delsole a. 24. rebe . . 25. br per.

885. 1—47 R. 1. grādeza. 4. manifestamēti. 5. sprendore. 6. po. 8. razi refre. 9. delli. 11. eldore chellochio nol possa

884. Poseidonius of Apamea, commonly called the Rhodian, because he taught in Rhodes, was a Stoic philosopher, a contemporary and friend of Cicero's, and the author of numerous works on natural science, among them: Φυσικὸς λόγος, περὶ κόσμου, περὶ μετεώρων.

Strabo quotes no doubt from one of his works, when he says that Poseidonius explained how it was that the sun looked larger when it was rising or setting than during the rest of its course (III, p. 135).

Kleomedes, a later Greek Naturalist also mentions this observation of Poseidonius' without naming the title of his work; however, as Kleomedes' Cyclia Theorica was not printed till 1535, Leonardo must have derived his quotation from Strabo. He probably wrote this note in 1508, and as the original Greek was first printed in Venice in 1516, we must suppose him to quote here from the translation by Guarinus Veronensis, which was printed as early as 1471, also at Venice (H. MÜLLER-STRÜBING).

per ⁵lo splendore del corpo solare, nel ⁶qual nō si può fermare l'ochio vmano, ⁷e oltre a di questo manifestissima⁸mēte lo dimostrano li sua razzi refle⁹ssi dalli spechi concavi, li quali, quā¹⁰do la lor percussione sarà di tāto sp¹¹lendore, che l'occhio non lo possa soppo¹²rtare, allora essa percussione ¹³avrà splendore simile al sole nel ¹⁴suo propio sito; e che sia vero, pro¹⁵vo che se tale spechio à la sua ¹⁶cōcavità tal qual si richiede alla ¹⁷generatione di tale razzo, allora ¹⁸nessuna cosa creata reggerà ¹⁹alla caldezza di tale percussione ²⁰di razzo reflesso d'alcuno spechio; ²¹e se tu dirai che lo spechio anco²²ra lui è freddo e gitta i razzi caldi, io ²³ti rispondo, che 'l razzo viē dal sole ed è ²⁴il razzo ²⁵dello spec²⁶chio conca²⁷vo, passa²⁸to ²⁹a traver-³⁰so della ³¹finestra.

action] is abundantly proved by the radiance of the solar body on which the human eye cannot dwell and besides this no less manifestly by the rays reflected from a concave mirror, which—when they strike the eye with such splendour that the eye cannot bear them—have a brilliancy equal to the sun in its own place. And that this is true I prove by the fact that if the mirror has its concavity formed exactly as is requisite for the collecting and reflecting of these ⎜rays, no created being could endure the heat that strikes from the reflected rays of such a mirror. And if you argue that the mirror itself is cold and yet send forth hot rays, I should reply that those rays come really from the sun and that it is the ray of the concave mirror after having passed through the window.

W. L. 132 a]

886.

Il sole nō si move.

The sun does not move.

Ash. I. 19 a]

887.

PRUOVA · COME QUĀTO PIV · SARAI PRESSO ALLA CAGI²ONE · DE'RAZZI DEL SOLE ·, PIV TI PARRÀ MAGGIORE IL SOLE ³SPECHIATO SUL MARE.

PROOF THAT THE NEARER YOU ARE TO THE SOURCE OF THE SOLAR RAYS, THE LARGER WILL THE REFLECTION OF THE SUN FROM THE SEA APPEAR TO YOU.

⁴Se il sole adopera il suo splendore col suo ciētro ⁵a fortificare la potētia di tutto il corpo, è ne⁶ciessario · che i sua razzi, quāto piv · s'alontanano da lui, piv si uadino ⁷aprēdo: se così è, tu che sei col ochio presso all'acqua · che spechia il sole, ⁸vedi una minima parte de' razzi del sole portare sulla superfitie ⁹del'acqua la forma d'esso sole spechiato ·, e se tu sarai presso al sole, ¹⁰come sarebbe quādo il sole è ī mezzodì e 'l mare sia per ponēte, ved¹¹rai il sole spechiarsi sù detto mare di grādis-

[4]If it is from the centre that the sun employs its radiance to intensify the power of its whole mass, it is evident that the farther its rays extend, the more widely they will be divided; and this being so, you, whose eye is near the water that mirrors the sun, see but a small portion of the rays of the sun strike the surface of the water, and reflecting the form of the sun. But if you were near to the sun—as would be the case when the sun is on the meridian and the sea to the westward—you would see the sun, mirrored in the

sopo. 12. percussione ar. 13. ara. 15. va chesse tale . . alla. 17. razo. 18. regiera. 20. refresso. 21. essettu . . chello. 22. fredo . . razi. 23. razo. 24. razo. 28. to [per il fo]. *Lines 32—47 are much effaced and some words remain doubtful:* 32. delle stan (?). 33. cedove. 34. sō tundu (?). 35. si\\\\\\\\\\. 36. non aqst (= *aquisterà*?). 37. caldeza ne. 38. ancora \\\\\\\\. 39. passādo per la. 40. spera del co. 41. simulacro. 42. alla su. 43. a cavsa e. 44. passi per ele. 45. mēto (?) pa. 46. sar si vo. 47. glia.
886. El sol.
887. 2. razi . . para magiore. 4. splendre. 5. a forzifichato dala . . chorpo. 6. razi. 7. che se chol . . preso. 8. vedi ĩ . parte [del sole] de razi . . sula. 9. esse tussarai. 10. sarebe . . mezodi . . vede. 12. razi. 13. perco . . magiore

886. This sentence occurs incidentally among mathematical notes, and is written in unusually large letters.
887. Lines 4 and fol. Compare Vol. I, Nos. 130, 131.

sima forma, perchè, [12] essēdo tu più presso al sole ·, l' ochio tuo, pigliādo i razzi presso al pūto, [13] ne piglia piv, e perciò ne resulta maggiore splēdore, e per questa ca[14]gione si potrebbe provare la luna essere mare che spe[15]chia · il sole ·, e quello che nō risplēde fia terra.

sea, of a very great size; because, as you are nearer to the sun, your eye taking in the rays nearer to the point of radiation takes more of them in, and a great splendour is the result. And in this way it can be proved that the moon must have seas which reflect the sun, and that the parts which do not shine are land.

Br. M. 78*b*]

888.

Togli la misura [2] del sole in solstitio [3] a mezzo giugnio.

Take the measure of the sun at the solstice in mid-June.

A. 64*a*]

889.

PERCHÈ · IL SOLE · PARE MAGGIORE NEL TRA[2]MŌTARE · CHE DI MEZZO GIORNO CHE CI È PRESSO.

[3] Ogni corpo ch' è visto per curvo mezzo [4] apparisce di maggiore forma, che non è.

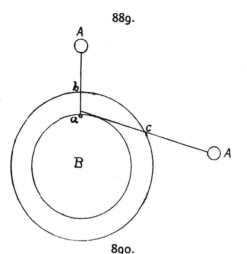

WHY THE SUN APPEARS LARGER WHEN SETTING THAN AT NOON, WHEN IT IS NEAR TO US.

Every object seen through a curved medium seems to be of larger size than it is.

C. A. 234*b*; 704*a*]

890.

Perchè l' ochio è piccolo, esso non può vedere [2] il sole in simvlacro, se nō piccolo; [3] Se l' occhio fusse equale al sole, esso vedrebbe [4] nell' acque, dato che le fussī [5] piane, il simulacro del sole equa[6]le al uero corpo del sole.

Because the eye is small it can only see the image of the sun as of a small size. If the eye were as large as the sun it would see the image of the sun in water of the same size as the real body of the sun, so long as the water is smooth.

Tr. 12]

891.

MODO DI VEDERE · IL SOLE ECLISSATO SANZA · PASSIONE · DELL' OCHIO.

A METHOD OF SEEING THE SUN ECLIPSED WITHOUT PAIN TO THE EYE.

[2] Tolli · vna carta · e falle busi con una agucchia, e per es[3]si busi · riguarda · il sole.

Take a piece of paper and pierce holes in it with a needle, and look at the sun through these holes.

· 14. potrebe. 15. ecquella.
888. 1. to la. 2. sostiṭio. 3. [a me] stitio a mezo gugnio.
889. 1. maggiore. 2. megogorno checepresso. 3. chorpo . . churvo mezo. 4. aparisscie di magiore.
890. 1. picholo . . po. 2. dere il . . picholo. 3. Sellochio fussi. 4. aque . . chelle.
891. 1. da vedere. 2. charta . . chon aguchia epere.

889. At A is written *sole* (the sun), at B *terra* (the earth).

III.

THE MOON.

892.

DELLA LUNA.

On the luminousity of the moon (892—901).

[2]Volendo io trattare della essentia della luna · è neciessario in prima [3]descriuere la prospettiva delli spechi piani, cōcaui e cō-uessi; [4]e prima che cosa è razzo luminoso, e come si piega per varie nature [5]di mezzi; Dipoi dove il razzo riflesso è più potēte,

OF THE MOON.

As I propose to treat of the nature of the moon, it is necessary that first I should describe the perspective of mirrors, whether plane, concave or convex; and first what is meant by a luminous ray, and how it is refracted by various kinds of media; then, when a reflected ray is most powerful, whether

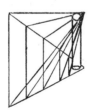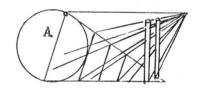

o nell' esser l'angolo [6]della incidentia acuto retto o ottuso, o nelle cōuessità o piano o [7]cōcavità, o da corpo dēso e trasparēte; Oltre a · questo, [8]come li razzi solari, che percuotono l'onde marine, si dimostrano al

when the angle of incidence is acute, right, or obtuse, or from a convex, a plane, or a concave surface; or from an opaque or a transparent body. Besides this, how it is that the solar rays which fall on the waves of the sea, are seen by the eye of the same

892. 2. tractare. 3. desscriuere . . presspectiva . . cōchaui e chōuissi [e che]. 4. chosa errazzo . . chome . . piegha. 5. mezi . . refresso eppiu potēte o nell esser lato. 6. achuta retta o hottusa ho . . pioni ho. 7. chōchavita adda chorpo . . ettras-parete . . addiquesto. 8. chome li razi . . perchotano. 9. llochio . . largheza . . āghol . . soma. 10. orizōte . . mācha chettale. 11. fresso . . fighura . . chosseghuē. 12. disstātia . . largheza āchora. 13. nosstro . . dimosstri parallela. 15. he

892. In the diagram Leonardo wrote *sole* at the place marked *A*.

⁹l'ochio in tanta larghezza nell'āgolo dell'ochio quanto nell'ultima somma ¹⁰dell'ōde all'orizzōte, e per questo nō māca che tale splendore solare ri¹¹flesso dall'ōde marittime nō sia di figura piramidale e per conseguē¹²za in ogni grado di distātia non acquisti gradi di larghezza ācorachè ¹³inquāto al nostro vedere si dimostri paralello.

¹⁴ 1 ᵃ ¶Nessū lievissimo ¹⁵è opaco;¶

¹⁶ 2 ᵃ ¶Nessū più lieve sta ¹⁷sotto al mē lieve;¶

¹⁸ 3 ᵃ ¶Se la luna à sito ¹⁹in mezzo ai sua ele²⁰mēti o no;

²¹ e s'ella non à sito ²²particulare co-²³me la terra nelli sua ²⁴elemēti, perchè nō ca²⁵de al cientro de' nostri ²⁶elemēnti?

²⁷ E se la luna non è ²⁸in mezzo alli sua elemē²⁹ti e nō discēde, ³⁰adūque ella è più ³¹lieve che altro elemē³²to;

³³E se la luna è più lie³⁴ve che altro elemēto, per³⁵chè è solida e nō traspare.

³⁶¶Delle cose di varie grādezze che, poste in varie distātie, ³⁷si mostrano e-quali, tal proportione fia da distātia a distā³⁸tia, qual fia da magnitudine a magnitudine. ¶

width at the angle nearest to the eye, as at the highest line of the waves on the horizon; but notwithstanding this the solar rays reflected from the waves of the sea assume the pyramidal form and consequently, at each degree of distance increase proportionally in size, although to our sight, they appear as parallel.

1st. Nothing that has very little weight is opaque.

2dly. Nothing that is excessively weighty can remain beneath that which is heavier.

3dly. As to whether the moon is situated in the centre of its elements or not.

And, if it has no proper place of its own, like the earth, in the midst of its elements, why does it not fall to the centre of our elements [26]?

And, if the moon is not in the centre of its own elements and yet does not fall, it must then be lighter than any other element.

And, if the moon is lighter than the other elements why is it opaque and not transparent?

When objects of various sizes, being placed at various distances, look of equal size, there must be the same relative proportion in the distances as in the magnitudes of the objects.

F. 93 a]

893.

DELLA LUNA E SE ELLA È PULITA E SPERICA.

²Il simulacro del sole in lei è potētemen³te luminoso ed è in piccola parte della su⁴a superfitie; E la prova vedrai a tor⁵re vna palla d'oro brunito, posta nel⁶le tenebre, con vn lume da lei remoto, ⁷il quale ancorachè esso allumini circa ⁸la metà d'essa palla, l'ochio non lo uede, se nō ⁹in piccola parte della sua superfitie, e tut¹⁰to il resto di tal superfitie spechia le tenebre ¹¹che la circūdano, e per questo in lei solo appa-¹²risce il simulacro del lume e tutto il re¹³sto rimane invisibile, stando l'ochio remo¹⁴to da tal palla; Questo medesimo interue-¹⁵rrebbe nella superfitie della luna, essendo po¹⁶lita, lustra e densa, come son corpi che spe¹⁷chiano;

OF THE MOON AND WHETHER IT IS POLISHED AND SPHERICAL.

The image of the sun in the moon is powerfully luminous, and is only on a small portion of its surface. And the proof may be seen by taking a ball of burnished gold and placing it in the dark with a light at some distance from it; and then, although it will illuminate about half of the ball, the eye will perceive its reflection only in a small part of its surface, and all the rest of the surface reflects the darkness which surrounds it; so that it is only in that spot that the image of the light is seen, and all the rest remains invisible, the eye being at a distance from the ball. The same thing would happen on the surface of the moon if it were polished, lustrous and opaque, like all bodies with a reflecting surface.

oppacho. 18. sella . . assito. 20. onno. 21. essella. 22. partichulare cho. 24. cha. 25. nosstri. 27. essella. 28. imezzo. 29. dissciēde. 30. eppiu. 33. essella . . eppiu. 35. solita . . trasspare. 36. delle chose . . grādezze [chessendo] posste. 37. disstātia adisstā.

893. 1. esselle. 2. illei. 3. pichola. 4. attor. 6. dallei. 8. noluede. 9. pichola . . ettu. 11. chella circūda . . illei . . apa. 12. ettutto. 14. dattal. 15. rebe. 16. lusstra . . chesspe. 19. settu. 21. inî. 24. pa. 27. cheffa. 30. col inel si. 34. po.

26. The problem here propounded by Leonardo was not satisfactorily answered till Newton in 1682 formulated the law of universal attraction and gravitation. Compare No. 902, lines 5—15.

¹⁸Prova tu ¹⁹come, se tu ²⁰stessi nella ²¹luna o in una ²²stella, ²³la nostra ²⁴terra ti par²⁵rà far l' u²⁶fitio col so²⁷le che fa la ²⁸luna;

²⁹E prova ³⁰come in nel si³¹mulacro ³²del sole nel ³³mare nō ³⁴può parere ³⁵vn sole co³⁶me pare in u³⁷no spechio pi³⁸ano.

Show how, if you were standing on the moon or on a star, our earth would seem to reflect the sun as the moon does.

And show that the image of the sun in the sea cannot appear one and undivided, as it appears in a perfectly plane mirror.

Ash. I. 19 a] 894.

Come l' onbre si cōfondono per lūnga distātia, ² si prvova nel' ōbra della luna che mai ³ si vede.

How shadows are lost at great distances, as is shown by the shadow side of the moon which is never seen.

Br. M. 28 a] 895.

O la luna à lume da se ²o no; s' ell' à lume da se, per³chè non risplende sanza ⁴l' aiuto del sole? e s' ella ⁵non à lume da se, ne-cies⁶sità la fa spe-chio sperico; ⁷e se ella è spechio, non è prova⁸to in prospettiua ¶ che 'l sim⁹ula-cro d' uno obbiet-to lumi¹⁰noso nō sarà mai equale alla ¹¹parte di quello specchio che da esso lu-minoso è ¹²allu-minato?¶e se così è, come ¹³mostra qui la figura in r s, dō¹⁴de uiē tanta quantità di splendo¹⁵re che à il plenilunio, che noi ve¹⁶diamo nella quinta deci-ma della ¹⁷luna?

Either the moon has intrinsic luminosity or not. If it has, why does it not shine without the aid of the sun? But if it has not any light in itself it must of neces-sity be a spherical mirror; and if it is a mirror, is it not proved in Per-spective that the image of a lumi-nous object will never be equal to the extent of sur-face of the reflec-ting body that it illuminates? And if it be thus [13], as is here shown at r s in the figure, whence comes so great an extent of radiance as that of the full moon as we see it, at the fifteenth day of the moon?

35. vn sole. 36. pare nū 37. no spechio. 38. anano.
894. 1. chōfondono. 2. dela.
895. 1. Olla . . allume dasse. 2. onno. 3. risplde. 4. essella. 6. dasse. 8. essello spechio, 9. prosspectiua. 13. parte "di quello spechio" che . . he. 13. esse.

894. Compare also Vol. I, Nos. 175—179.

895. 13. At A, in the diagram, Leonardo wrote *"sole"* (the sun), and at B *"luna o noi terra"* (the moon or our earth). Compare also the text of No. 876.

Br. M. 94*b*] 896.

DELLA LUNA.

[2]La luna non à lume da se, se nō quāto ne vede il sole tanto l'allumina, [3]della qual luminosità tanto ne vediamo quāto è quella che vede noi; [4]E la sua notte riciève tanto di splēdore, quāto è quello che li pre[5]stano le nostre acque nel refletterli il simulacro del sole, che in [6]tutte quelle che vedono il sole e la luna, si spechia; [7]La pelle over superfitie dell'acqua, di che si cōpone il mare della luna e il [8]mare della nostra terra, è senpre rugoso, [9]o poco o assai, o più, o meno, e tale rugosità è cavsa di dila[10]tare l'innumerabili simulacri del sole, che nei colli e cōcavità e la[11]ti e frōti delle innumerabili rughe si spechiano, cioè in tāti vari siti di ciascuna [12]ruga quāto son vari li siti che ànno li ochi che le vedono, jl che ac[13]cadere nō potrebbe, se la spera dell' acqua, che ī grā parte di se veste la [14]luna fusse d'uniforme spericità, perchè allora il simulacro del [15]sole sarebbe uno a ciascuno occhio, e la sua reflessione sarebbe particu[16]lare e senpre sarebbe splēdore sperico, come manifestamē[17]te ci assegnano le palle dorate, poste nelle sommità delli alti edifiti; Ma [18]se tali palle dorate fussino rugose o globulēti come son le mo[19]re, frutti neri conposti di minute globosità rotonde, allora ciascuna delle parti d'essa [20]globosità, vedute dal sole e dall'ochio, mostrerà a esso ochio il lustro [21]gienerato dal simulacro d'esso sole, e così in ū medesimo corpo si ue[22]drebbero molti minimi soli, li quali spesse sō le volte che per lunga distātia [23]si uniscono e paiono cōtinuati; E 'l lustro della luna nuova è più lucido e più [24]potēte che quādo è in plenilunio, e questo si ca[25]vsa perchè l'angolo della incidētia è molto più ottuso nella luna nuo[26]va che nella vecchia, doue tali angoli sono acutissimi; e l'onde della [27]luna spechiano il sole così nelle lor ualli come nelli colli, e li lati [28]restano oscuri ·; ma ne' lati della luna li fondi dell'onde non [29]vedono il sole, ma

OF THE MOON.

The moon has no light in itself; but so much of it as faces the sun is illuminated, and of that illumined portion we see so much as faces the earth. And the moon's night receives just as much light as is lent it by our waters as they reflect the image of the sun, which is mirrored in all those waters which are on the side towards the sun. The outside or surface of the waters forming the seas of the moon and of the seas of our globe is always ruffled little or much, or more or less—and this roughness causes an extension of the numberless images of the sun which are repeated in the ridges and hollows, the sides and fronts of the innumerable waves; that is to say in as many different spots on each wave as our eyes find different positions to view them from. This could not happen, if the aqueous sphere which covers a great part of the moon were uniformly spherical, for then the images of the sun would be one to each spectator, and its reflections would be separate and independent and its radiance would always appear circular; as is plainly to be seen in the gilt balls placed on the tops of high buildings. But if those gilt balls were rugged or composed of several little balls, like mulberries, which are a black fruit composed of minute round globules, then each portion of these little balls, when seen in the sun, would display to the eye the lustre resulting from the reflection of the sun, and thus, in one and the same body many tiny suns would be seen; and these often combine at a long distance and appear as one. The lustre of the new moon is brighter and stronger, than when the moon is full; and the reason of this is that the angle of incidence is more obtuse in the new than in the full moon, in which the angles [of incidence and reflection] are highly acute. The waves of the moon therefore mirror the sun in the hollows of the waves as well as on the ridges, and the sides remain in shadow. But at the sides

896. 2. dasse. 3. vedano .. ecquella .. vede. 4. Ella .. chelli pres. 5. nosstre acque .. refretterli. 6. vedano .. elluna si sspechia. 7. dichessi .. luna edel. 8. [la nostra luna] mare .. nosstra .. essenpre rughoso. 9. oppocho .. oppiu ōmeno ettale rughosita e chausa. 10. ine cholli e chōchavita ellati. 11. ti effrote "delle inumerabili" rughe sisspechiano .. ciasscuna. 12. rugha .. che āli .. chelle vedano. 13. chadere .. sella .. achq"a" ·, vesste. 14. luno fussi. 15. uno "accias cuno ochio" ella .. refressione .. partichu. 16. essenpre .. spericho chome. 17. asegnia. 18. ssettali .. rughose o globbulēti chome. 19. "neri" chonposti .. "rotonde" allora ciasscuna "delle parte". 20. globbosita .. mossterra. 21. chosi nūn .. chorpo. 22. derebbe .. lungha disstātia. 23. vnisschono eppaiano chōtinuati .. eppiu cido epiu. 24. pleniunnio ecquesto .. cha. 25. langholo. 26. vechia .. tale angholi .. achutissimi ellonde. 27. chosi .. chome .. cholli elli. 28. resstano osschuri. 29. vedano .. massolo vede .. quessto. 30. choll .. ettal. 31. elluminose chosi .. infussi venghano.

solo uedono le cime d'esse ōde, e per questo li simu[30]lacri son più rari e più misti coll'onbre delle valli, e tal mistione [31]delle spetie ōbrose e luminose, così insieme infuse, vengono all'o[32]chio cō poco splēdore, e nelli stremi sarā piv oscure per essere [33]la curuità de' lati di tale ōde insuffitiēte a riflettere all'ochio li ri[34]cievuti razzi; La luna nova per natura riflette li [35]razzi solari più inverso l'ochio per tali

of the moon the hollows of the waves do not catch the sunlight, but only their crests; and thus the images are fewer and more mixed up with the shadows in the hollows; and this intermingling of the shaded and illuminated spots comes to the eye with a mitigated splendour, so that the edges will be darker, because the curves of the sides of the waves are insufficient to reflect to the eye the rays that fall upon them. Now the new moon naturally reflects the solar rays more directly towards the eye from the

ōde streme, [36]che per nessuno altro loco, come mostra la figura della luna che [37]percuōtēdo con razzi *a* nell'onda *b* riflette in *b d*, dou' è situa[38]to l'ochio *d*; E questo accadere nō può nel plenilunio dove [39]il razzo solare, stando all'occidēte, percuote l'onde streme della [40]luna all'oriēte dal *n* in *m*, e non riflette inverso l'oc[41]chio occidētale, ma risalta all'oriēte, poco piegādo la rettitu[42]dine d'esso razzo solare, e così l'angolo della incidētia è grossissimo.

crests of the waves than from any other part, as is shown by the form of the moon, whose rays *a* strike the waves *b* and are reflected in the line *b d*, the eye being situated at *d*. This cannot happen at the full moon, when the solar rays, being in the west, fall on the extreme waters of the moon to the East from *n* to *m*, and are not reflected to the eye in the West, but are thrown back eastwards, with but slight deflection from the straight course of the solar ray; and thus the angle of incidence is very wide indeed.

[43]La luna è corpo opa[44]co e solido, e se per lo a[45]versario ella fusse trāspa[46]rente, ella nō ricieverebbe [47]il lume del sole.

[48]Il rossume over tuorlo dell'o[49]vo sta [50]in mezzo al suo al[51]bume sanza discēdere [52]d'alcuna parte, ed è pi[53]v lieve o più grave o equale d'esso [54]albume; e s'elli è più li[55]eve egli doverebbe surgie[56]re sopra tutto l'albume e [57]fermarsi in cōtatto del-

The moon is an opaque and solid body and if, on the contrary, it were transparent, it would not receive the light of the sun.

The yellow or yolk of an egg remains in the middle of the albumen, without moving on either side; now it is either lighter or heavier than this albumen, or equal to it; if it is lighter, it ought to rise above all the albumen and stop in contact with the shell

32. chō pocho . . osschure. 33. churuita . . arefrettere. ·34. razza da qual chosa la luna . . refrette. 35. razi . . tale. 36. locho . . mosstra la fighura. 37. percho tendo cho razi b e rēfrette. 38. Ecquesto achadere . . dove ∥ o. 39. razo solare [que] perchote stando allocidēte perchote lonte. 40. refrette. 41. pocho pieghādo. 42. chosi langholo. 43. chorpo. 44. cho essolido esse. 45. e fussi. 46. enō. 49. sta [in in al piu delle]. 50. [volte] in. 51. dissciēdere. 52. dalchuna. 53. greve "o equale" desso. 54. esselli. 55. eve edovere vesurgie. 57. chōtratto. 58. la [sua scho] schorza. 59. hovo

58la scorza d'es59so uovo, e s'elli è più 60grave doverebbe di61scièdere, e s'egli è equa62le così potrebbe stare 63nell'ū delli stremi, co64me in mezzo o disotto;

65L'īnvmerabili simulacri 66che dalle innumerabili onde del ma67re reflettono li sola68ri razzi, in esse onde percos69si, son causa di rē70dere cōtinuato e larghissi71mo splēdore sopra la superfitie 72 del mare.

of the egg; and if it is heavier, it ought to sink, and if it is equal, it might just as well be at one of the ends, as in the middle or below[54].

The innumerable images of the solar rays reflected from the innumerable waves of the sea, as they fall upon those waves, are what cause us to see the very broad and continuous radiance on the surface of the sea.

Br. M. 104a] **897.**

[Come nō si può spechiare il sole nel corpo 2della luna, essendo spechio colmo,

That the sun could not be mirrored in the body of the moon, which is a convex mirror,

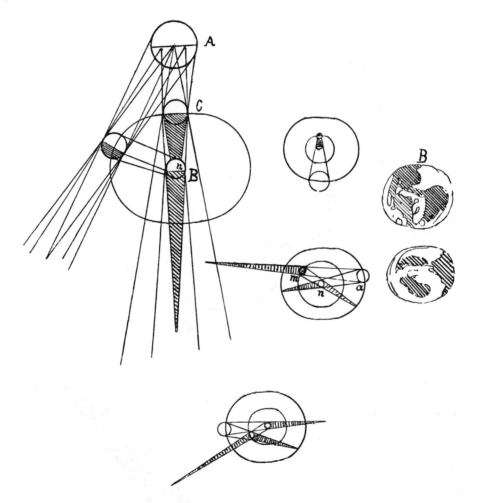

esselli. 60. dis. 61. esselli. 62. chosi. 63. cho. 64. dissotto. 66. cheddalle. 67. refrettano dalli. 68. razi . . perchos. 69. se son quelli chausa. 70. chōtinuato ellarghissi.

897. 1. po. 3. chettanto . . nalumina. 4. nesspechi. 5. avessi la superfitie che atta asspechiare. 6. cheffussi. 7. emmosso dal-

897. In the original diagrams *sole* is written at the place marked *A*; *luna* at *C*, and *terra* at the two spots marked *B*.

in mo³do che tanto quanto esso sol ne allumina, ⁴tanto essa luna ne specchia, se già tal luna ⁵non avesse la superfitie alta a specchiare, ⁶che fusse rugosa, a vso di superfitie di mare, ⁷quando in parte è mossa dal uento]·

⁸[L'onde dell' acqua crescono ⁹il simulacro della cosa ¹⁰in lei specchiata].

¹¹Quest'onde fanno per o¹²gni linia a similitu¹³dine della spoglia del¹⁴la pina.

¹⁵Queste son 2 figure sicchè¹⁶faraile l'una diversa dall' altra, ¹⁷coll' acqua ¹⁸ondeggiante e coll' acqua piana.

¹⁹Inpossibil'è ²⁰che per alcuna distantia il ²¹simulacro del sole, ²²fatto nella superfitie ²³del corpo sperico, occupi ²⁴la metà d'esso sperico;

²⁵Qui tu ài a provare, come la terra fa tutti ²⁶questi medesimi ofiti inverso la luna che ²⁷la luna inverso la terra;

²⁸Nō luce la luna col suo lume riflesso come ²⁹fa il sole, perchè il lume della luna non piglia ³⁰il lume del sole continuo in nel³¹la superfitie, ma in sù colmi e cavi del³²le onde delle acque, e per esser tal sole nella ³³luna cōfusamente spechiato per le mi³⁴stioni' delle onbre, che sono infra ³⁵l'onde che lustrano, perciò non è ³⁶il suo lume lucido e chiaro ³⁷com'è 'l sole.

³⁸Terra infra la luna in quīta decima e il sole; ³⁹Qui il sole è nel levante e la luna in ponente in quīta decima; ⁴⁰luna infra la terra in quīta decima e il sole; ⁴¹Qui è la luna che à il sole per ponēte e la terra per levāte.

in such a way as that so much of its surface as is illuminated by the sun, should reflect the sun unless the moon had a surface adapted to reflect it—in waves and ridges, like the surface of the sea when its surface is moved by the wind.

The waves in water multiply the image of the object reflected in it.

These waves reflect light, each by its own line, as the surface of the fir cone does [14].

These are 2 figures one different from the other; one with undulating water and the other with smooth water.

It is impossible that at any distance the image of the sun cast on the surface of a spherical body should occupy the half of the sphere.

Here you must prove that the earth produces all the same effects with regard to the moon, as the moon with regard to the earth.

The moon, with its reflected light, does not shine like the sun, because the light of the moon is not a continuous reflection of that of the sun on its whole surface, but only on the crests and hollows of the waves of its waters; and thus the sun being confusedly reflected, from the admixture of the shadows that lie between the lustrous waves, its light is not pure and clear as the sun is.

[38]The earth between the moon on the fifteenth day and the sun. [39]Here the sun is in the East and the moon on the fifteenth day in the West. [40]The moon on the fifteenth [day] between the earth and the sun. [41]Here it is the moon which has the sun to the West and the earth to the East.

A. 64a] **898.**

CHE COSA · È LA LUNA. WHAT SORT OF THING THE MOON IS.

²La luna non è · luminosa · per se, ma bene è atta · a ricievere la natura · della · luce ³a similitudine · dello · spechio · e dell'acqua · o altro · corpo·lucido ·, e crescie nell'oriēte ⁴e occidēte · come · il sole · e gli altri pianeti ·; E la ragione · si è · che ogni · corpo

The moon is not of itself luminous, but is highly fitted to assimilate the character of light after the manner of a mirror, or of water, or of any other reflecting body; and it grows larger in the East and in the West, like the sun and the other planets. And the reason is that every luminous body looks

uencto. 8. acq"a'' cresscano. 10. illei. 12. assimilitu. 13. spoglia de siche. 16. fara le luna disspersi. 17. acqua [ondosa] 18. ondegiante dallacq"a''. 21. siimularcro. 23. ochupi. 28. refresso. 32. acq"e''. 34. chessono. 35. lusstrano pero. 38. infralla . . decima il sole. 39. Ogni el . . "po''nente ella luna illeuante. 40. infralla . . decima il sole. 41. ella perleuāte ella terra per ponēte.

898. 1. chosa ella. 2. nōne. 3. assimilitudine . . acq"a'' . . cho"r''po . . ecresscie. 4. chome . . chorpo. 5. cresscie Chiaro . .

14. See the diagram p. 145.

38. This refers to the small diagram placed between *B* and *B*. — 39. See the diagram below the one referred to in the preceding note.

40. 41. Refers to the diagram below the others.

898. This text has already been published by LIBRI: *Histoire des Sciences*, III, pp. 224, 225.

· luminoso ⁵quāto piv . s'allontana · piv cresce ·; Chiaro · si può · cōprēdere · che · ogni pianeta e stel⁶la · è piv lontano · da noi nel ponēte che quādo · ciè · sopra · capo ·, circa · 3500, per la pruova se⁷gniata · da parte ·, e se uedi spechiare · il sole o la luna nell'acqua che ti sia · vicina, ⁸paratti in detta acqua della grādezza che ti · pare · in cielo; E se t'allontanerai·vno ⁹miglio · parrà maggiore 100 volte, e se lo vedrai spechiare · ī mare

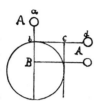

¹⁰nel tramōtare · il sole · spechiato · ti · parrà grāde · piv di · 10 · miglia, per¹¹chè occuperà · in detta spechiatione · piv · di 10 miglia · di marina ·, e se tu fussi ¹²dov'è la luna · parrebbe ti · esso · sole spechiarsi · in tāto · mare · quāto egli¹³n' allumina · alla giornata ·, e la terra · parrebbe infra detta · aqua come pajono · le ¹⁴macchie scure che sono · in nella · luna ·, la quale stādo in terra · si dimostra ta¹⁵le agli omini, qual farebbe agli omini che abitassino · nella luna il nostro ¹⁶mondo · appūto.

DELLA QUALITÀ · DELLA · LUNA.

¹⁸La luna quādo · è tutta · luminata · al nostro vedere, noi vediamo tutto il suo ¹⁹giorno, e allora per riflessione de' razzi del sole, percossi in lei e risaltati a noi, ²⁰l'ocieano · suo · ci gitta · meno vmidità, e quāto mē è luce piv noce.

Leic. 30 a]

DELLA LUNA.

²Dico che non avendo la luna lume da se, essendo luminosa, egl' è necessario che tale lume ³sia causato da altri.

larger in proportion as it is remote. It is easy to understand that every planet and star is farther from us when in the West than when it is overhead, by about 3500 miles, as is proved on the margin[7], and if you see the sun or moon mirrored in the water near to you, it looks to you of the same size in the water as in the sky. But if you recede to the distance of a mile, it will look 100 times larger; and if you see the sun reflected in the sea at sunset, its image would look to you more than 10 miles long; because that reflected image extends over more than 10 miles of sea. And if you could stand where the moon is, the sun would look to you, as if it were reflected from all the sea that it illuminates by day; and the land amid the water would appear just like the dark spots that are on the moon, which, when looked at from our earth, appears to men the same as our earth would appear to any men who might dwell in the moon.

OF THE NATURE OF THE MOON.

When the moon is entirely lighted up to our sight, we see its full daylight; and at that time, owing to the reflection of the solar rays which fall on it and are thrown off towards us, its ocean casts off less moisture towards us; and the less light it gives the more injurious it is.

899.

OF THE MOON.

I say that as the moon has no light in itself and yet is luminous, it is inevitable but that its light is caused by some other body.

chōplēdere . . este. 6. da "noi" . . chapo . circha. 7. esse . . oluna . . chetti. 8. acq"a" . . grādeza chetti . . Essettalontanera. 9. parira magiore . . essello vederai . . mare [il sole]. 10. [spe] nel . . para. 11. ochopera . . essettu. 12. parebbeti . . inquāto. 13. nalumina . . ellatera parebe . . achva chome pare. 14. mache schure chessono inella . . qual. 15. farebe alla. 16. acpūto. 19. refressione razi . . perchossi illei. 899. 2. dicho . . dasse . . chettale. 3. sie chausato.

Line 7 refers to the first diagram.—A = *sole* (the sun), B = *terra* (the earth), C = *luna* (the moon).

Leic. 36 b] **900.**

DELLA LUNA. ### OF THE MOON.

Tutte le cōtradizioni dell' auersario a All my opponent's arguments to say that
dir che nella lunā non è acqua. there is no water in the moon.

Leic. 1 b] **901.**

Risposta a maestro Andrea da Imola, Answer to Maestro Andrea da Imola, who
che disse come li razzi solari riflessi dal said that the solar rays reflected from a
corpo dello spechio convesso si confondono convex mirror are mingled and lost at a short
[2] e si consumano in brieue spatio, e che per distance; whereby it is altogether denied that
questo si negaua al tutto la parte luminosa the luminous side of the moon is of the
della luna non essere di natu[3]ra di spechio, nature of a mirror, and that consequently
e per consequenza non essere nato tale the light is not produced by the innumer-
lume dalla innvmerabile moltitudine del- able multitude of the waves of that sea,
l'onde di quel [4] mare, il quale io proponeuo which I declared to be the portion of the
essere quella parte della luna che s'allumi- moon which is illuminated by the solar
nava per li razzi solari; rays.

[5] o p · sia il corpo del sole, c n s sia la Let o p be the body of the sun, c n s the
luna, b sia l'ochio, che in sù la basa c n moon, and b the eye which, above the base
del cateto c n m vede spechia[6]re il corpo c n of the cathetus c n m, sees the body
del sole infra li equali angoli c n, e 'l simile of the sun reflected at equal angles c n; and
fa remouendosi l'ochio da b in a. the same again on moving the eye from b to a.

Leic. 2 a] **902.**

DELLA LUNA. ### OF THE MOON.

¶ [2] Nessun denso è piv̀ lieue che l'aria. No solid body is less heavy than the at-
 mosphere.

[3] Avendo noi provato come la parte Having proved that the part of the moon
della luna che risplende è acqua, che that shines consists of water, which mirrors
Explanation spechia il corpo del sole, [4] la quale ci rif- the body of the sun and reflects the radiance
of the lumen
cinereum in lette lo splendore da lui ricevuto; E come, it receives from it; and that, if these waters
the moon. se tale acqua fusse sanza ōde, ch'ella [5] pic- were devoid of waves, it would appear
cola si dimostrerebbe, ma di splendore small, but of a radiance almost like the sun;
quasi simile al sole; Al presente bisognia —[5] It must now be shown whether the
provare, se essa [6] luna è corpo grave o lieue, moon is a heavy or a light body: for, if it
inperochè se fusse grave, —confessando che were a heavy body—admitting that at every
dalla terra in sù in ogni grado d'altez[7]za grade of distance from the earth greater
s'acquista gradi di leuità, cōciosiachè levity must prevail, so that water is lighter
l'acqua è più lieue che la terra, e l'aria than the earth, and air than water, and fire
che l'acqua, e'l foco che l'aria, e così than air and so on successively—it would seem
[8] seguitando successiuamēte, —e'parrebbe che, that if the moon had density as it really has,
se la luna auesse densità com'ella à, ch'ella it would have weight, and having weight,
auesse gravità, e avēdo [9] gravità che lo that it could not be sustained in the space

900. 2. acqu"a".

901. 1. razi . . refressi . . chonvesso . . confondeano. 2. essi. 3. disspechio e per chonseguenza . . inumerabile. 4. chessa-
 luminava . . razi . . lochio di.

902. 2. chellaria. 3. chome . . rissplende. 4. refrette . . dallui ricevuti . . ssettale acq"a" fussi . . chel. 5. pichola . . dimoster-
 "r"ebe. 6. ollieve . . fussi . . dalte. 7. concosiachellacq"a" . . piv . . chella . . chellacq"a" . . focho chellaria. 8. eparebe
 chessella auessi . . chomella chella auessi . . avēdo. 9. chello . . ouessa . . nolla potessi sosstenere . . chon . . auessi a disscendere.

900. The objections are very minutely noted 902. 1. On the margin are the words *tola ro-*
down in the manuscript, but they hardly seem to *mantina*, *tola = ferro stagnato* (tinned iron);
have a place here. *romantina* is some special kind of sheet-iron no longer known
 901. The large diagram on the margin of page by that name.
161 belongs to this chapter.

spatio, ove essa si troua, non la potesse sostenere, e per conseguēza avesse a discendere [10]inverso il centro dell' universo, e congiugnersi colla terra, e se nō lei, al māco le sue acque aues[11]sino a cadere e spogliarla di se e cadere inverso il cētro e lasciar di se la luna spogliata e sanza lu[12]stro; ōde, nō seguitando quel che di lei la ragione ci promette, egli è manifesto segno che tal luna è vestita de' sua [13] elemēti, cioè acqua, aria e foco, e così in se, per se si sostenga in quello spatio come fa la nostra ter[14]ra coi sua elemēti in quest' altro spatio, e che tale ofitio faccino le cose gravi ne' sua elemē[15]ti, qual fanno l'altre cose gravi nelli elemēti nostri.

[16]Quando l'ochio in oriēte vede la luna in occidente vicina al tramōtato sole, esso la vede [17]colla sua parte onbrosa circundata da parte luminosa, del quale lume la parte laterale [18]e superiore deriua dal sole, e la parte inferiore deriva dallo oceano occidentale, il qual [19]ancora lui ricceue li razzi solari e li riflette nelli inferiori mari della luna, e ancora per [20]tutta la parte ōbrosa · della luna dà tanto di splendore, qual'è quel che dà la luna alla terra nella mez[21]zanotte, e perciò nō resta integralmēte scura, e di qui à alcuno creduto, che la [22]luna abbia in parte lume da se oltre a quel che gli è dato dal sole, il quale lume diriua dalla āti[23]detta causa delli nostri mari alluminati dal sole.

[24]Ancora si potrebbe dire che'l cerchio dello splendore

where it is, and consequently that it would fall towards the centre of the universe and become united to the earth; or if not the moon itself, at least its waters would fall away and be lost from it, and descend towards the centre, leaving the moon without any and so devoid of lustre. But as this does not happen, as might in reason be expected, it is a manifest sign that the moon is surrounded by its own elements: that is to say water, air and fire; and thus is, of itself and by itself, suspended in that part of space, as our earth with its element is in this part of space; and that heavy bodies act in the midst of its elements just as other heavy bodies do in ours[15].

When the eye is in the East and sees the moon in the West near to the setting sun, it sees it with its shaded portion surrounded by luminous portions; and the lateral and upper portion of this light is derived from the sun, and the lower portion from the ocean in the West, which receives the solar rays and reflects them on the lower waters of the moon, and indeed affords the part of the moon that is in shadow as much radiance as the moon gives the earth at midnight. Therefore it is not totally dark, and hence some have believed that the moon must in parts have a light of its own besides that which is given it by the sun; and this light is due, as has been said, to the above-mentioned cause,—that our seas are illuminated by the sun.

Again, it might be said that the circle of radiance

10. congugnersi . . esse . . mācho. 11. chadere . . ellasscia . spoglata essanza lus. 12. ragon . . "segno" chettal. 13. coe . . effocho echosi . . sostengha. 14. rra cosua . . chettale . . grave. 15. nosstri. 16. ochidento . . vede [la luna]. 17. circhundata . . luminoso. 18. essuperiore . . ella. 19. razzi . . elli refrette. 20. dissplendore . . nella me. 21. perco . . integralmēte [luminosa e di] "[onb]os" osscura . . alchuna . . chella. 22. parte di lume dasse . . accquel chelle. 23. chavsa nosstri. 24. Anchora si p"r"otrebbe . . cheff. 25. occidente . . dirivassi . . choll ochio essituato. 26. dimosstra. 27. Al-

15. This passage would certainly seem to establish Leonardo's claim to be regarded as the original discoverer of the cause of the ashy colour of the new moon (*lumen cinereum*). His observations

che fa la luna, quand'el'è col sole in ²⁵occidente, dirivasse dal sole integralmente·, quando essa col sole e coll' ochio è situata nel ²⁶modo che qui disopra si dimostra.

²⁷Alcuni potrebbero dire che l'aria, elemēto della luna, pigliando il lume del sole, come fa la no²⁸stra spera dell'aria, fusse quella che finisce il cerchio luminoso al corpo della luna.

²⁹Alcuni àn creduto che la luna abbia alquanto di lume da se, la quale ope³⁰nione è falsa, perchè l'ànno fondata sopra quel chiarore che si uede in mezzo ali ³¹corni quando la luna è nova, la quale alli confini dello splendore pare oscura, ³²e al confine della oscurità · del campo pare si chiara, che molti credono essere ³³vn cerchio di nouo splendore, che finisca di circundare, doue le punte de' corni ³⁴alluminati dal sole terminano il loro splendore; e questa varietà di campo nasce ³⁵perchè quella parte d'esso campo, che termina colla parte luminosa della luna, per tal ³⁶paragone di splendore si dimonstra piv oscura che non è, e quella parte di sopra, doue ³⁷pare vn pezzo di cerchio luminoso d'uniforme larghezza, nasce chè quiui la luna, essendo più chiara che ³⁸il mezzo over il campo, oue essa si troua, pel paragō di tale oscurità si dimostra in tale confine piv lu³⁹minosa che non è, la qual luminosità in tal tenpo nasce dal nostro oceano colli altri mediterrani ⁴⁰che in quel tēpo è alluminato dal sole che già è tramōtato, in modo che il mare allora fa tale ofitio alla ⁴¹parte oscura della luna, qual fa la luna in quīta decima a noi,

shown by the moon when it and the sun are both in the West is wholly borrowed from the sun, when it, and the sun, and the eye are situated as is shown above.

Some might say that the air surrounding the moon as an element, catches the light of the sun as our atmosphere does, and that it is this which completes the luminous circle on the body of the moon.

Some have thought that the moon has a light of its own, but this opinion is false, because they have founded it on that dim light seen between the hornes of the new moon, which looks dark where it is close to the bright part, while against the darkness of the background it looks so light that many have taken it to be a ring of new radiance completing the circle where the tips of the horns illuminated by the sun cease to shine[34]. And this difference of background arises from the fact that the portion of that background which is conterminous with the bright part of the moon, by comparison with that brightness looks darker than it is; while at the upper part, where a portion of the luminous circle is to be seen of uniform width, the result is that the moon, being brighter there than the medium or background on which it is seen by comparison with that darkness it looks more luminous at that edge than it is. And that brightness at such a time itself is derived from our ocean and other inland-seas. These are, at that time, illuminated by the sun which is already setting in such a way as that the sea then fulfils the same function to the dark side of the moon as the moon at its fifteenth day does to us when the

chuni potrebono . . chellaria . . piglando ilume. 28. fussi . . finissi. 29. alchuni . . chella . . dasse. 30. effalsa . . fondato . . chessi . . mezo. 31. quandella . . il quale alli . . osscuro. 32. osscurita . . molte credano . . 33. finissca di circhundare. 34. ecquesta . . canpo nassce. 35. chettermina. 36. hosscura . . nonne ecquella. 37. pezo . . largeza nassce. 38. mezo over chanpo. 39. nassce . . occeano coli . . mediterani. 40. ga. 41. osscura . . annoi quādel . . ettal. 42. dacquel pocho . .

however, having hitherto remained unknown to astronomers, Moestlin and Kepler have been credited with the discoveries which they made independently a century later.

Some disconnected notes treat of the same subject in MS. C. A. 239ᵇ; 718ᵇ and 719ᵇ: "*Perchè la luna cinta della parte alluminata dal sole in ponente, tra maggior splendore in mezzo a tal cerchio, che quando essa eclissava il sole. Questo accade perchè nell' eclissare il sole ella ombrava il nostro oceano, il qual caso non accade essendo in ponente, quando il sole alluma esso oceano.*" The editors of the "*Saggio*" who first published this passage (page 12) add another short

one about the seasons in the moon which I confess not to have seen in the original manuscript: "*La luna ha ogni mese un verno e una state, e ha maggiori freddi e maggiori caldi, e i suoi equinozii son più freddi de' nostri.*"

23. 24. The larger of the two diagrams reproduced above stands between these two lines, and the smaller one is sketched in the margin. At the spot marked *A* Leonardo wrote *corpo solare* (solar body) in the larger diagram and *Sole* (sun) in the smaller one. At *C luna* (moon) is written and at *B terra* (the earth).

34. See Pl. CVIII, No. 5.

quando il sol' è tramōtato, e tal propor-
[42]tione è da quel poco lume che à la parte
oscura della luna alla chiarezza della parte
alluminata, qual è dalla . . .

[43]Se uoi vedere [44]quanto la parte [45]on-
brosa della luna [46]sia più chiara che'l
[47]canpo, ove tal luna si [48]truova, occupa
col[49]la mano, o con altro [50]obietto più di-
stāte [51]all'oc[h]io, la parte lu[52]minosa della
luna.

sun is set. And the small amount of light
which the dark side of the moon receives
bears the same proportion to the light of
that side which is illuminated, as that . . . [42].

If you want to see how much brighter
the shaded portion of the moon is than the
background on which it is seen, conceal the
luminous portion of the moon with your
hand or with some other more distant ob-
ject.

F. 84a]

903.

MACULE DELLA LUNA.

[2]Alcuni dissero leuarsi da essa vapori
a modo di [3]nugoli e interporrsi infra la
luna e li ochi no[4]stri; il che, se così fusse,
mai tali macule sare[5]bbero stabili nè di
siti nè di figura, e vedendo la [6]luna in
diuersi aspetti, ancor che tal macule [7]nō
fossero variate, esse muterebbero figura
come [8]fa quella cosa che si vede per più
versi.

THE SPOTS ON THE MOON.

Some have said that vapours rise from On the spots
the moon, after the manner of clouds and in the moon
are interposed between the moon and our (903—907).
eyes. But, if this were the case, these spots
would never be permanent, either as to
position or form; and, seeing the moon
from various aspects, even if these spots did
not move they would change in form, as ob-
jects do which are seen from different sides.

F. 84b]

904.

DELLE MACHIE DELLA LUNA.

[2]Altri dissero che la luna era conposta
di parti più [3]o mē transparenti, come se
una parte fusse a modo [4]d'alabastro, e
alcuna altra a modo di cristallo o vetro,
[5]che ne seguirebbe che'l sole, ferēdo colli
sua razzi [6]nella parte mē transparēte, il
lume rimarrebbe in [7]superfitie, e così la
parte più densa resterebbe allu[8]minata, e
la parte transparēte mostrerebbe le [9]onbre
delle profondità sue oscure, e così si cōpo-
[10]ne la qualità della luna; e questa opini-
one è [11]piaciuta a molti filosofi, e massime
a Aristotele, e [12]pure ella è falsa opinione,
perchè ne' di[13]versi aspetti, che si trovano
spesso la luna e il so[14]le alli nostri occhi,
noi vedremmo variare tal ma[15]cule, e quando

OF THE SPOTS ON THE MOON.

Others say that the moon is composed
of more or less transparent parts; as though
one part were something like alabaster and
others like crystal or glass. It would
follow from this that the sun casting its rays
on the less transparent portions, the light
would remain on the surface, and so the
denser part would be illuminated, and the
transparent portions would display the shadow
of their darker depths; and this is their
account of the structure and nature of the
moon. And this opinion has found favour
with many philosophers, and particularly with
Aristotle, and yet it is a false view—for, in
the various phases and frequent changes of
the moon and sun to our eyes, we should
see these spots vary, at one time looking
dark and at another light: they would be
dark when the sun is in the West and the

alla . . osscura . . ciareza. 48. ochupi. 49. chon. 50. distāte ochu. 51. pì all.

903. 2. disse. 3. interprsi infralla . . elli . . nos. 4. fussi . . tal. 5. bon stabili. 6. chettal. 7. fusi variate . . muterebō.
8. chessi.

904. 2. chella . . parte. 3. transsparenti . . fussi. 5. cēne . . coli. 6. rimarebbe. 7. resterrebbe. 8. ella . . mosterrebbe.
9. osscure. 10. ecquesto openione. 11. piacuta . . massime aristotie e. 12. puere . . oppennione perche inne de. 13. asspetti
trauāno . . esso. 14. vederem. 15. ecquando . . farebono osscure ecquando. 16. in o. 17. ella . . mezo. 18. transparēte

42. Here the text breaks off; lines 43—52 are written on the margin.

si farebbono oscure, e quādo chi[16]are; scure
si farebbono, quādo il sole è in oc[17]cidēte
e la luna nel mezzo del celo, chè allora le
[18]cōcauità transparēti piglierebbono l'onbre
in[19]sino alle sommità de' labbri di tal cō-
cauità trās[20]parēti, perchè il sole nō potrebbe
penetrare li [21]sua razzi dentro alle boche
di tali cōcauità, [22]le quali parrebbono chiare
nel plenilunio, [23]doue la luna in oriēte
guarda il sole all'occidē[24]te; allora il sole
alluminerebbe insino ne' fō[25]di di tali trans-
parētie, e così, nō generādosi [26]onbre, la
luna non ci mostrerebbe in tal tenpo [27]le
predette machie, e così ora piv ora meno,
[28]secondo le mutatiō del sol dalla luna e
della lu[29]na dai lochi nostri, come di sopra
dissi.

moon in the middle of the sky; for then the
transparent hollows would be in shadow as
far as the tops of the edges. of those trans-
parent hollows, because the sun could not
then fling his rays into the mouth of the
hollows, which however, at full moon,
would be seen in bright light, at which time
the moon is in the East and faces the sun
in the West; then the sun would illuminate
even the lowest depths of these transparent
places and thus, as there would be no
shadows cast, the moon at these times
would not show us the spots in question;
and so it would be, now more and now
less, according to the changes in the position
of the sun to the moon, and of the moon
to our eyes, as I have said above.

F. 85 a] 905.

DELLE MACULE DELLA LUNA.

[2]Si è detto che le macule della luna
son create in essa luna, [3]da essere in se
di uaria rarità e dēsità, il che se così fusse,
[4]nell'eclissi della luna i razzi solari pene-
trebbono per [5]alcuna parte della predetta
rarità, e, nō si ueden[6]do tale effetto, detta
opinione è falsa;

[7]Altri dicono che la superfitie della luna,
essendo tersa [8]e pulita, che essa, a simili-
tudine di spechio, riceue in [9]se la simili-
tudine della terra; Questa openione [10]è
falsa, conciosiachè la terra, scoperta dal-
l'acqua, per diuer[11]si aspetti à diuerse
figure; adunque, quando la luna [12]è al-
l'oriēte, essa specchierebbe altre machie,
che quā[13]do essa ci è di sopra, o quādo
essa è in occidēte; però [14]le machie della
luna, come si uede nel pleni-
lunio, [15]mai si uariano nel
moto da lei fatto nel nostro
emi[16]sperio; 2ª ragione è, che
la cosa specchia[17]ta nella con-
vessità piglia piccola parte d'
es[18]so spechio, com'è provato
in prospettiua; 3ª ragione [19]li è, che nel
plenilunio la luna vede solo il mezzo [20]della

OF THE SPOTS ON THE MOON.

It has been asserted, that the spots on the
moon result from the moon being of varying
thinness or density; but if this were so, when
there is an eclipse of the moon the solar
rays would pierce through the portions which
were thin as is alleged [5]. But as we do
not see this effect the opinion must be false.

Others say that the surface of the moon
is smooth and polished and that, like a mirror,
it reflects in itself the image of our earth.
This view is also false, inasmuch as the
land, where it is not covered with water,
presents various aspects and forms. Hence
when the moon is in the East it would
reflect different spots from those it would
show when it is above us or in the West;
now the spots on the moon, as they are
seen at full moon, never vary
in the course of its motion over
our hemisphere. A second reason
is that an object reflected in a
convex body takes up but a small
portion of that body, as is pro-
ved in perspective [18]. The
third reason is that when the moon is full,
it only faces half the hemisphere of the

piglierebono. 19. somita delabri. 21. razi. 22. parebono. 23. ocidē. 24. alora. 26. mosterebbe. 28. ella lu.
905. 2. Essi detto chelle. 3. rareta . . chosi fussi. 4. razi . . peneterrebono. 5. rareta il ce nō. 6. to tale . . oppenione effalsa.
7. dicano chella. 8. assimilitudine disspechio. 10. concosiache . . acq"a". 11. asspecti. 12. spechierebe. 13. occquādo oci-
dēte il che. 14. plenilunio che. 16. he chella . . spechi. 17. pichola . . de. 18. ragone. 19. mezo. 21. locean . . rsplen-

905. 3—5. *Eclissi.* This word, as it seems to
me, here means eclipses of the sun; and the sense
of the passage, as I understand it, is that by the
foregoing hypothesis the moon, when it comes be-

tween the sun and the earth must appear as if
pierced,—we may say like a sieve.

18. *come è provato.* This alludes to the accom-
panying diagram.

spera della terra alluminata, nella quale
²¹ l'oceano colle altre acque risplendono, e
la terra ²² fa macule in esso splendore, e
così si uedrebbe ²³ la metà della nostra
terra cinta dallo splendo²⁴re del mare allu-
minato dal sole, e nella luna tal ²⁵ simili-
tudine sarebbe minima parte d'essa luna;
²⁶ 4ª è che la cosa splendida non si spechia
nell' al²⁷tra splendida; adunque il mare,
pigliando splendo²⁸re dal sole, siccome
fa la luna, e' nō si potrebbe in lei spe-
²⁹chiare tal terra, che ancora specchiar
non vi si vedesse ³⁰particularmēte il corpo
del sole e di ciascuna stel³¹la a lei op-
posta.

illuminated earth, on which only the ocean
and other waters reflect bright light, while
the land makes spots on that brightness;
thus half of our earth would be seen girt
round with the brightness of the sea lighted
up by the sun, and in the moon this
reflection would be the smallest part of that
moon. Fourthly, a radiant body cannot be
reflected from another equally radiant; there-
fore the sea, since it borrows its brightness
from the sun,—as the moon does—, could
not cause the earth to be reflected in it, nor
indeed could the body of the sun be seen
reflected in it, nor indeed any star opposite
to it.

Br. M. 19 a]

906.

Se terrai osseruate le particule delle
machie della luna, ²tu troverai in quelle
spesse uolte gran varietà, e di questo ³ò
fatto pruova io medesimo disegnādole; E
questo nasce da nuvo⁴li che si leuano dal-
l'acque d'essa luna, li quali s'interpongo-
⁵no infra 'l sole e essa acqua, e colla loro
onbra tolgo⁶no i razzi del sole a tale acqua,
onde essa acqua viene a ri⁷manere oscura,
per non potere spechiare il corpo solare.

If you keep the details of the spots of
the moon under observation you will often
find great variation in them, and this I myself
have proved by drawing them. And this
is caused by the clouds that rise from the
waters in the moon, which come between
the sun and those waters, and by their
shadow deprive these waters of the sun's rays.
Thus those waters remain dark, not being
able to reflect the solar body.

Leic. 5 a]

907.

Come le mac²chie della luna ³son va-
riate da ⁴quel che già fu⁵rō, per causa del
⁶corso delle sue ⁷acque.

How the spots on the moon must have
varied from what they formerly were, by
reason of the course of its waters.

C. A. 341 b; 1055 a]

908.

DE' CIERCHI DELLA LUNA.

²Jo · truouo · che quelli · cierchi ·, li quali
· par che di notte circūdino la luna · di uarie
grādezze e grossezze, ³sono · causati da ua-
rie · qualità di grossezze d'umori, i quali in
varie altezze infra la luna e li ochi ⁴nostri
sono situati ·; E quel cierchio maggiore è
mē rosso · ed è nella prima parte più bassa
di detti ⁵umori, il secondo minore è piv
alto, e pare piv rosso, perch'è visto per

OF HALOS ROUND THE MOON.

I have found, that the circles which at
night seem to surround the moon, of various
sizes, and degrees of density are caused by
various gradations in the densities of the vapours
which exist at different altitudes between the
moon and our eyes. And of these halos the
largest and least red is caused by the lowest of
these vapours; the second, smaller one, is
higher up, and looks redder because it is

On the moon's halo.

dano ellı. 24. aluminato. 25. luna c. 26. 4ª he chella .. splendita no si .. 27. splendita .. pigliando. 28. si come fa la
luna e nō .. illei. 29. speciar .. vedessi. 30. sole di ciasscuna. 31. allei opposita.
906. 1. Setterrai. 2. troverrai. 3. offatto .. "disegnādole" Ecquesto nascce da nugho. 4. chessi .. sinterponga. 5. cholla ..
tolgho. 6. razi .. attale .. arri. 7. osscura.
907. 4. ga.
908. 2. circhūdino .. grādeze e rosseza. 3. chausati .. grosseze domori .. alteze infralla .. elli. 4. nosstri .. Ecquel ..

2 umori·; e così quanto ⁶piv alti sieno, minori e piv rossi apparirāno, perchè infra l'ochio e quello fiā piv solidi umori, ⁷e per questo si pruova che doue apparisce maggiore rossore·lì è piv somma d'umori.

seen through two vapours. And so on, as they are higher they will appear smaller and redder, because, between the eye and them, there is thicker vapour. Whence it is proved that where they are seen to be reddest, the vapours are most dense.

W. XXVII] 909.

On instruments for observing the moon (909. 910).

Come tu vuoi prouare, la luna mostrarsi ²maggiore che essa non è, giugnendo all'orizzonte; ³tu torrai vn ochiale colmo da una superfitie ⁴e concauo dalla superfitie opposta, e tieni ⁵l'ochio dal concavo, e guarda l'obbietto fori ⁶della superfitie conuessa, e così ⁷avrai fatto vn vero simile ⁸all'aria, che si include in⁹fra la spera del foco e de¹⁰lla acqua, la quale aria è ¹¹concaua diuerso la terra e ¹²conuessa diuerso il foco.

If you want to prove why the moon appears larger than it is, when it reaches the horizon; take a lens which is highly convex on one surface and concave on the opposite, and place the concave side next the eye, and look at the object beyond the convex surface; by this means you will have produced an exact imitation of the atmosphere included beneath the sphere of fire and outside that of water; for this atmosphere is concave on the side next the earth, and convex towards the fire.

C. A. 187 a; 561 a] 910.

Fa ochiali da vedere ²la luna grande.

Construct glasses to see the moon magnified.

magiore . . edella prima. 5. omori . . sechondo . . vissto . . omori e chosi. 6. infrallochio ecquello . . solidomori. 7. apariscie magiore . . domori.

909. 1. volli . . mosstrare. 2. magore . . gngnendo. 4. conchauo . . ettieni. 6. chonuessa e chosi. 7. arai. 8. chessi. 9. fralla . . focho chede. 12. focho.

910. See the Introduction, p. 136, Fracastoro ays in his work Homocentres: *"Per dua specilla ocularia si quis perspiciat, alteri altero superposito, majora multo et propinquiora videbit omnia.—Quin imo* *quaedam specilla ocularia fiunt tantae densitatis, ut si per ea quis aut lunam, aut aliud siderum spectet, adeo propinqua illa iudicet, ut ne turres ipsas excedant"* (sect. II c. 8 and sect. III, c. 23).

VI.

THE STARS.

911.

Veggonsi le stelle di notte e nō di dì, per esser noi sotto ²la grossezza dell'aria, la quale è piena d'infinite particu³le d'umidità, le quali, ciascuna per se quādo è percossa ⁴dalli razzi del sole, rendono splendore, e così l'in⁵nvmerabili splēdori occupano esse stelle, e se ⁶tale aria nō fusse, il celo senpre ci mostrerebbe ⁷le stelle nelle sua tenebre.

The stars are visible by night and not by day, because we are beneath the dense atmosphere, which is full of innumerable particles of moisture, each of which independently, when the rays of the sun fall upon it, reflects a radiance, and so these numberless bright particles conceal the stars; and if it were not for this atmosphere the sky would always display the stars against its darkness.

On the light of the stars (911—913).

912.

SE LE STELLE ÀNNO LUME DAL SOLE O DA SE.

²Dicono di auere il lume da se, allegando ³che se Venere e Mercurio non avessino ⁴il lume da se, quādo essa s'interpone infra ⁵l'ochio nostro e 'l sole, esse oscurerebbero tan⁶to d'esso sole, quāto esse ne coprono al ochio ⁷nostro; E quest'è falso, perch'è prouato ⁸come l'onbroso, posto nel luminoso, è cinto e coper⁹to tutto da razzi laterali del rimanēte di tal lu¹⁰minoso, e così resta inuisibile, come si

WHETHER THE STARS HAVE THEIR LIGHT FROM THE SUN OR IN THEMSELVES.

Some say that they shine of themselves, alledging that if Venus and Mercury had not a light of their own, when they come between our eye and the sun they would darken so much of the sun as they could cover from our eye. But this is false, for it is proved that a dark object against a luminous body is enveloped and entirely concealed by the lateral rays of the rest of that luminous body and so remains invisible. As may be seen

911. 1. vegāsi lesselle. 2. grosseza. 3. ciasscuna..rende. 4. cossi. 5. ochupano.. esse. 6. fussi.. mosterrebbe. 7. lesstelle.
912. 1. ā lume. 2. dicano di havere.. dasse. 3. uenere e merchurio nōn auessi. 4. illume dasse.. infral. 5. oscurerebō.
6. coprano. 9. razi. 12. ilūga. 13. ochupano. 15. acade. 16. esieno.. non o. 18. nosstro. *Lines 19 and 20 are written*

911. See Vol. I, No. 296, which also refers to starlight.

912. From this and other remarks (see No. 902,

l. 34 &c.) it is clear that Leonardo was familiar with the phenomena of Irradiation.

di[11]mostra : quando il sole è veduto per la ra[12]mificatione delle piāte sanza foglie in lūga di[13]stantia, essi rami non occupano parte al[14]cuna d'esso sole alli ochi nostri; jl simile [15]accade a' predetti pianeti, li quali ancora [16]che da se sieno sanza luce, eglino non oc[17]cupano, com'è detto, parte alcuna del sole [18]all'ochio nostro.

when the sun is seen through the boughs of trees bare of their leaves, at some distance the branches do not conceal any portion of the sun from our eye. The same thing happens with the above mentioned planets which, though they have no light of their own, do not—as has been said—conceal any part of the sun from our eye[18].

SECONDA [20]PROVA.

SECOND ARGUMENT.

[21]Dicono le stelle nella notte parere lucidissime [22]quāto più ci sō superiori, e che, se esse nō auessino lume [23]da se, che l'ombra che fa la terra, che s'interpone [24]fra loro e 'l sole, verrebbe a scurarle, non vedē[25]do esse, nè sēdo vedute dal corpo solare; Ma [26]questi non ànno considerato, che l'onbra piramidale de[27]lla terra non aggiugne infra troppe stelle, e in [28]quelle ch'ella aggiugne, la piramide è tanto dimi[29]nuita, che poco occupa del corpo della stella; e 'l ri[30]manēte è alluminato dal sole.

Some say that the stars appear most brilliant at night in proportion as they are higher up; and that if they had no light of their own, the shadow of the earth which comes between them and the sun, would darken them, since they would not face nor be faced by the solar body. But those persons have not considered that the conical shadow of the earth cannot reach many of the stars; and even as to those it does reach, the cone is so much diminished that it covers very little of the star's mass, and all the rest is illuminated by the sun.

F. 60 a] 913.

Perchè li pianeti appariscono maggiori [2]in oriēte che sopra di noi, che dovrebbe [3]essere il contrario, essendo [4]3500 miglia più vicini a noi, essendo [5]nel mezzo del celo, che essendo al-l'o[6]rizzōte.

[7]Tutti li gradi delli elemēti, donde passa-[8]no le spetie de' corpi celesti, [9]che vengono all'ochio, sono [10]equali, e li angoli, [11]donde li penetra [12]la linia cētrale di tali spetie, sono [13]inequali, e la distantia è [14]maggiore, come mostra l'eccesso a b so[15]pra a d, e per la 9ª del 7° la grandezza [16]d'essi corpi celesti nell'orizzonte è provata.

Why the planets appear larger in the East than they do overhead, whereas the contrary should be the case, as they are 3500 miles nearer to us when in mid sky than when on the horizon.

All the degrees of the elements, through which the images of the celestial bodies pass to reach the eye, are equal curves and the angles by which the central line of those images passes through them, are unequal angles [13]; and the distance is greater, as is shown by the excess of a b beyond a d; and the enlargement of these celestial bodies on the horizon is shown by the 9th of the 7th.

on the margin. 20. pruoua. 21. Dicano. 22. superiore e chesselle nō auesino. 23. che obra cheffa . . chessinterpone. 24. le verebe asscurare. 25. nessēdo. 26. nōā . . chellonbra. 27. nōnagugne ·· stelle ege. 28. chellagugnie . . ettanto. 29. ochupa. 30. aluminato.

913. 1. apariscā magori. 2. douerebbe. 5. mezo. 6. rizōte. 7. gradi | ' delli elemēti''. 9. vengano. 10. cului elli angoli [della luna]. 11. [contra le di] donde li. 12. tale. 13. nequali ella. 14. magore . . ecesso. 15. grandeza. 16. orizonte.

913. l. 13. inequali, here and elsewhere does not mean unequal in the sense of not being equal to each other, but angles which are not right angles.

Br. M. 279*b*] **914.**

Per uedere la natura delli pi²aneti apri il tetto e mo³stra alla basa vn sol pia⁴neta, e 'l moto reflesso da ⁵tale basa dirà la comples⁶sione del predetto pianeta, ⁷ma fa che tal basa nō ne ⁸veda più d'uno per uolta.

To see the real nature of the planets open the covering and note at the base [4] one single planet, and the reflected movement of this base will show the nature of the said planet; but arrange that the base may face only one at the time.

Observations on the stars.

E. o'] **915.**

Tullius de Diuinatione ²ait Astrologiam fuisse ³adinuentā ante trojanum ⁴bellū Quingentis septua⁵ginta milibus añorum.
57000.

Cicero says in [his book] De Divinatione that Astrology has been practised five hundred seventy thousand years before the Trojan war.

57000.

On history of astronomy.

Br. M. 173*b* (190*b*)] **916.**

Benchè il tenpo · sia annumerato infra le continue ²quātità, esso, per essere inuisibile e sanza corpo, non cade integralmēte sotto la ³geometrica potentia, la quale lo diuide per figure e corpi d'infinita varietà, ⁴come continuo nelle cose uisibili e corporee far si uede; Ma sol co' sua primi ⁵principi si cōuiene ·, cioè col punto e colla linia ·; ʝl punto nel tempo è da ⁶essere equiparato · al suo instante, e la linia à similitudine colla lūghez⁷za d'una quantità d'un tempo, e siccome i pūti sō principio e fine della predet⁸ta linia ·, così li instanti

Although time is included in the class of Continuous Quantities, being indivisible and immaterial, it does not come entirely under the head of Geometry, which represents its divisions by means of figures and bodies of infinite variety, such as are seen to be continuous in their visible and material properties. But only with its first principles does it agree, that is with the Point and the Line; the point may be compared to an instant of time, and the line may be likened to the length of a certain quantity of time, and just as a line begins and terminates in a point, so such a space of time.

Of time and its divisions (916—918).

914. 4. refresso. 5. compless. 8. duna.
916. 1. anvmerato infralle 3. geometricha | "potentia" . . diuide . . chorpi difinita. 4. uisibile . . farsi e uede Massol. 5. coe . . cholla. 6. Ella . . "a" . . cholla lūggez. 7. "duna quantita" dun . . essicome . . effine. 8. instancti . . prcipio . . Esse.

914. 4. *basa.* This probably alludes to some instrument, perhaps the Camera obscura.

915. The statement that CICERO, *De Divin.* ascribes the discovery of astrology to a period 57000 years before the Trojan war I believe to be quite erroneous. According to ERNESTI, *Clavis Ciceroniana*, CH. G. SCHULZ (*Lexic. Cicer.*) and the edition of *De Divin.* by GIESE the word Astrologia occurs only twice in CICERO: *De Divin. II, 42. Ad Chaldæorum monstra veniamus, de quibus Eudoxus, Platonis auditor, in astrologia judicio doctissimorum hominum facile princeps, sic opinatur (id quod scriptum reliquit): Chaldæis in prædictione et in notatione cujusque vitæ*

ex natali die minime esse credendum." He then quotes the condemnatory verdict of other philosophers as to the teaching of the Chaldaeans but says nothing as to the antiquity and origin of astronomy. CICERO further notes *De oratore* I, 16 that Aratus was *"ignarus astrologiæ"* but that is all. So far as I know the word occurs nowhere else in CICERO; and the word *Astronomia* he does not seem to have used at all. (H. MÜLLER-STRÜBING.)

916. This passage is repeated word for word on page 190[b] of the same manuscript and this is accounted for by the text in Vol. I, No. 4. Compare also No. 1216.

sō termine e principio di qualūche dato spatio di tenpo;—e se [9]la linia è diuisibile in īfinito, lo spatio d'ū tenpo di tal diuisione non è alieno, [10]e se le parti diuise della linia sono proportionabili infra se, ancora le parti del tenpo [11]saraño proportionabili infra loro.

begins and terminates in an instant. And whereas a line is infinitely divisible, the divisibility of a space of time is of the same nature; and as the divisions of the line may bear a certain proportion to each other, so may the divisions of time.

Br. M. 176 a]

917.

Scriui la qualità del [2]tenpo, separata dalla [3]geometrica.

Describe the nature of Time as distinguished from the Geometrical definitions.

Br. M. 191 a]

918.

Fa che vn ora sia diui[2]sa in 3000 parti, e [3]questo farai coll'oriolo [4]alleggerēdo o aggravādo [5]il cōtrapeso.

Divide an hour into 3000 parts, and this you can do with a clock by making the pendulum lighter or heavier.

10. esselle parte. 11. infralloro.
917. 2. seperata. 3. geometricha. **918.** 3. cquesto. 4, allegerēdo o agravādo.

XVI.

Physical Geography.

Leonardo's researches as to the structure of the earth and sea were made at a time, when the extended voyages of the Spaniards and Portuguese had also excited a special interest in geographical questions in Italy, and particularly in Tuscany. Still, it need scarcely surprise us to find that in deeper questions, as to the structure of the globe, the primitive state of the earth's surface, and the like, he was far in advance of his time.

The number of passages which treat of such matters is relatively considerable; like almost all Leonardo's scientific notes they deal partly with theoretical and partly with practical questions. Some of his theoretical views of the motion of water were collected in a copied manuscript volume by an early transcriber, but without any acknowledgment of the source whence they were derived. This copy is now in the Library of the Barberini palace at Rome and was published under the title: "De moto e misura dell'acqua," by FRANCESCO CARDINALI, Bologna 1828. In this work the texts are arranged under the following titles: Libr. I. Della spera dell'acqua; Libr. II. Del moto dell'acqua; Libr. III. Dell'onda dell'acqua; Libr. IV. Dei retrosi d'acqua; Libr. V. Dell'acqua cadente; Libr. VI. Delle rotture fatte dall'acqua; Libr. VII Delle cose portate dall'acqua; Libr. VIII. Dell'oncia dell'acqua e delle canne; Libr. IX. De molini e d'altri ordigni d'acqua.

The large number of isolated observations scattered through the manuscripts, accounts for our so frequently finding notes of new schemes for the arrangement of those relating to water and its motions, particularly in the Codex Atlanticus: I have printed several of these plans as an introduction to the Physical Geography, and I have actually arranged the texts in accordance with the clue afforded by one of them which is undoubtedly one of the latest notes referring to the subject (No. 920). The text given as No. 930 which is also taken from a late note-book of Leonardo's, served as a basis for the arrangement of the first of the seven books—or sections—, bearing the title: Of the Nature of Water (Dell'acque in se).

As I have not made it any part of this undertaking to print the passages which refer to purely physical principles, it has also been necessary to exclude those practical researches which, in accordance with indications given in 920, ought to come in as Books 13, 14 and 15. I can only incidentally mention here that Leonardo—as it seems to me, especially in his youth—devoted a great deal of attention to the construction of mills. This is proved by a number of drawings of very careful and minute execution, which are to be found in the Codex Atlanticus. Nor was it possible to include his considerations on the regulation of rivers, the making of canals and so forth (No. 920, Books 10, 11 and 12); but those passages in which the structure of a canal is directly connected with notices of particular places will be found duly inserted under section XVII (Topographical notes). In Vol. I, No. 5 the text refers to canal-making in general.

On one point only can the collection of passages included under the general heading of Physical Geography claim to be complete. When comparing and sorting the materials for this work I took particular care not to exclude or omit any text in which a geographical name was mentioned even incidentally, since in all such researches the chief interest, as it appeared to me, attached to the question whether these acute observations on the various local characteristics of mountains, rivers or seas, had been made by Leonardo himself, and on the spot. It is self-evident that the few general and somewhat superficial observations on the Rhine and the Danube, on England and Flanders, must have been obtained from maps or from some informants, and in the case of Flanders Leonardo himself acknowledges this (see No. 1008). But that most of the other and more exact observations were made, on the spot, by Leonardo himself, may be safely assumed from their method and the style in which he writes of them; and we should bear it in mind that in all investigations, of whatever kind, experience is always spoken of as the only basis on which he relies. Incidentally, as in No. 984, he thinks it necessary to allude to the total absence of all recorded observations.

I.

INTRODUCTION.

Leic. 5a]

919.

Questi libri contēgono in ne' primi ² della natura dell' acqua in se ne' ³ sua moti, li altri contēgono delle ⁴ cose fatte dai sua corsi, ⁵ che mv⁶tano il mondo di centro e di figura.

These books contain in the beginning: Of the nature of water itself in its motions; the others treat of the effects of its currents, which change the world in its centre and its shape.

Schemes for the arrangement of the materials (919—928).

Leic. 15ᵇ]

920.

Diuisiō del libro.

Libro pᵒ dell' acque in se,
libro 2ᵒ del mare,
libro 3ᵒ delle uene,
⁵ libro 4ᵒ de' fiumi;
libro 5ᵒ delle nature de' fōdi,
libro 6 delli obbietti,
libro 7 delle ghiaje,
libro 8ᵒ della superfitie del' acqua,
¹⁰ libro 9 delle cose che in quella
son messe;
libro 10ᵒ de' ripari de' fiumi,
libro 11ᵒ delli condotti,
libro 12 de' canali,
libro 13 delli strumēti volti dall' acqua,
¹⁵ libro 14 del far mōtare l' acque,
libro 15 delle cose cōsumate dall' acque.

Divisions of the book.

Book 1 of water in itself.
Book 2 of the sea.
Book 3 of subterranean rivers.
Book 4 of rivers.
Book 5 of the nature of the abyss.
Book 6 of the obstacles.
Book 7 of gravels.
Book 8 of the surface of water.
Book 9 of the things placed
therein.
Book 10 of the repairing of rivers.
Book 11 of conduits.
Book 12 of canals.
Book 13 of machines turned by water.
Book 14 of raising water.
Book 15 of matters worn away by water.

919 .1. cōtēgano. 3. cōtēgano. 4. dae sua.
920. 8. giare. 9. delle . . acq"a". 10. quella. 16. dell cose . . acq"e".

Leic. 9 a] **921.**

Farai prima un libro ²che tratti de' lochi ³occupati dall'acque ⁴dolci, e 'l 2° dal⁵l'acque salse, e 'l ⁶3° come, per la par-⁷tita di quelle, queste ⁸nostre parti son ⁹fatte piv lieui, e ¹⁰per consequēza piv ¹¹remosse dal cen¹²tro del mōdo.

First you shall make a book treating of places occupied by fresh waters, and the second by salt waters, and the third, how by the disappearance of these', our parts of the world were made lighter and in consequence more remote from the centre of the world.

F. 87 b] **922.**

Descriui in prima tutta l'acqua in ciascuno suo moto, di poi ²descriui tutti li sua fondi e le lor materie, senpre al³legando le pro-positioni delle predette acque, e fia bu⁴ono ordine, che altrimēti l'opera sarebbe cō-fusa.

⁵Descriui tutte le figure che fa l'acqua dalla sua ⁶maggiore alla sua minore onda ·e le lor cause.

First write of all water, in each of its motions; then describe all its bottoms and their various materials, always referring to the propositions concerning the said waters; and let the order be good, for otherwise the work will be confused.

Describe all the forms taken by water from its greatest to its smallest wave, and their causes.

F. 88 a] **923.**

Libro 9 de' surgimenti accidentali del-l'acqua.

Book 9, of accidental risings of water.

F. 90 b] **924.**

ORDINE DEL LIBRO.

²Poni nel principio ciò che può fare vn fiume.

THE ORDER OF THE BOOK.

Place at the beginning what a river can effect.

Br. M. 35 a] **925.**

Libro d'abbattere li eserciti · col'impeto de' diluui fatti dall'acque disgorgate,

²Libro che l'acque cōducino a salua-mento li legniami tagliati ne' mōti,

³Libro delle barche condotte contro al-l'inpeto de' fiumi,

⁴Libro dell'alzare li gran ponti col sen-plice accrescimēto dell'acque,

⁵Libro del riparare all'inpeto de' fiumi che le città da quelli nō siē percosse.

A book of driving back armies by the force of a flood made by releasing waters.

A book showing how the waters safely bring down timber cut in the mountains.

A book of boats driven against the impetus of rivers.

A book of raising large bridges higher. Simply by the swelling of the waters.

A book of guarding against the impetus of rivers so that towns may not be damaged by them.

921. 1. p"a" vn libr. 3. ochupati. 7. quele. 8. parte.
922. 1. scriui in p"a" . . lacq"a" . . ciasscuno. 2. desscriui . . elle. 4.· altremēti. 5. cheffa lacq"a". 6. magore . . elle.
923. acq"a".
924. 2. co che po.
925. *The head of each line is marked by the letter* d *which is crossed out.* 1. dabatter . . chol inpito . . dilumi . . dellacq"a" discorghate. 2. chellacque . . assaluamento. 4. acresscimēto. 5. chelle cita dacquelli . . percossi.

Br. M. 35 *b*] 926.

Libro della dispositiō de' fiumi a cō-seruatiō dell'argine sue,

²Libro delli monti, che si spiccherāno, e fiā la terra sotto il nostro emisperio scoperta dall'acqua,

³Libro del terreno portato dal'acqua a riēpiere la grā profondità de' pelaghi,

⁴Libro de' modi che la fortuna per se netti li riēpiuti porti del mare,

⁵Libro dell'argine de' fiumi e lor permanentia,

⁶Libro del fare che li fiumi con lor corso tēgin netti li fondi loro per le città dōde passano,

⁷Libro del fare o rifondare li ponti sopra li fiumi,

⁸Libro di ripari che farsi debbō alli muri e argini de' fiumi percossi dall'acqua,

⁹Libro del generare li colli dall'arena o ghiaja sopra le gran profondità dell'acque.

A book of the ordering of rivers so as to preserve their banks.

A book of the mountains, which would stand forth and become land, if our hemisphere were to be uncovered by the water.

A book of the earth carried down by the waters to fill up the great abyss of the seas.

A book of the ways in which a tempest may of itself clear out filled up sea-ports.

A book of the shores of rivers and of their permanency.

A book of how to deal with rivers, so that they may keep their bottom scoured by their own flow near the cities they pass.

A book of how to make or to repair the foundations for bridges over the rivers.

A book of the repairs which ought to be made in walls and banks of rivers where the water strikes them.

A book of the formation of hills of sand or gravel at great depths in water.

Br. M. 122 *a*] 927.

L'acqua dà principio al moto suo,

²Libro liuellamenti d'acque per diuersi modi,

³Libro del discostare li fiumi dai lochi da loro offesi,

⁴Libro del dirizzar li fiumi che occupano superchio terreno,

⁵Libro del diuidere li fiumi in molti rami e farli guadabili,

⁶Libro dell'acque che cō diuersi moti passā pe' pelaghi loro,

⁷Libro del profondare li letti alli fiumi cō uari corsi d'acque,

⁸Libro di disporre li fiumi ī modo che li piccoli prīcipj de' sua danni non accrescino,

⁹Libro de' uari moti dell'acque che passan per diuerse figure di canali,

¹⁰Libro del fare che li piccoli fiumi non pieghino il maggiore percosso dalle loro acque,

¹¹Libro della maggior bassezza che trouar si possa nella corrēte della superfitie de' fiumi,

Water gives the first impetus to its motion.

A book of the levelling of waters by various means.

A book of diverting rivers from places where they do mischief.

A book of guiding rivers which occupy too much ground.

A book of parting rivers into several branches and making them fordable.

A book of the waters which with various currents pass through seas.

A book of deepening the beds of rivers by means of currents of water.

A book of controlling rivers so that the little beginnings of mischief, caused by them, may not increase.

A book of the various movements of waters passing through channels of different forms.

A book of preventing small rivers from diverting the larger one into which their waters run.

A book of the lowest level which can be found in the current of the surface of rivers.

926. 2. chessi spich[a] erāno effia la terra "sotto il nostro emisperio" scoperta dellacqua. 3. terē. 4. perse nettili riēpiuti porta del mare. 5. ellor premanentia. 6. chelli . . collor . . tēginetti . . fondi "lor". 7. orrifondare. 8. cheffarsi. 9. ghiara . . acq"e".

927. 1. \|\|\|\|\|\|\|\|\|\|\|\|\| gito dobliquita Lacq"a". 2—13. *Each line is headed by an* L, *meaning* Libro. 3. discosstare . . dalloro. 4. dirizar . . ce ochupan. 5. effarli. 6. chō. 7. chō . . chorsi. 8. di sporre . . chelli picholi . . accrescino. 9. acq"e" . . chanali. 10. chelli picholi . . magore perchosso. 11. dalla maggor basseza . . corēte. 12. pellalte.

¹²Libro dell' origine de' fiumi che versā per l'alte cime de' monti,

¹³Libro della uarietà de' moti dell' acque ne' lor fiumi.

A book of the origin of rivers which flow from the high tops of mountains.

A book of the various motions of waters in their rivers.

Br. M. 45*a*]

928.

[1] Della inequalità della concauità del nauilio,

²[1] Libro della inequalità della curuità de' lati de' nauili,

³[1] Libro della inequalità del sito del timone,

⁴[1] Libro della inequalità della carena de' nauili,

⁵[2] Libro della uarietà delli spiraculi donde l'acqua si uersa,

⁶[3] Libro dell'acqua inclusa ne' vasi insieme coll' aria e sua moti,

⁷[4] Libro del moto dell'acqua per le cicognole,

⁸[5] Libro delli scontri e concorsi dell'acque venute da diuersi aspetti,

⁹[6] Libro delle varie figure delli argini traversati dalli fiumi,

¹⁰[7] Libro delle uarie secche generate sotto le chiuse de' fiumi,

¹¹[8] Libro delle torture e pieghamēti delle corrēti de' fiumi,

¹²[9] Libro de' uari siti donde si de' trar l'acqua de' fiumi,

¹³[10] Libro delle figure dell'argini de' fiumi e lor permanētia,

¹⁴[11] Libro dell'acqua cadente perpēdicularmente sopra diuersi obbietti,

¹⁵[12] Libro del corso dell'acqua inpedito in diuersi siti,

¹⁶[12] Libro delle uarie figure delli obbietti che impediscono il corso del acque,

¹⁷[13] Libro delle concauità e globosità fatte dal fondo ītorno a vari obbietti,

¹⁸[14] Libro del condurre li canali navigabili sopra o sotto li fiumi che l'ītersegano,

¹⁹[15] Libro delli terreni che beono le acque de' canali e lor ripari,

²⁰[16] Libro della creatiō de' corsi de' fiumi che votano il letto de' fiumi riēpiuti di terreno.

[1] Of inequality in the concavity of a ship.

[1] A book of the inequality in the curve of the sides of ships.

[1] A book of the inequality in the position of the tiller.

[1] A book of the inequality in the keel of ships.

[2] A book of various forms of apertures by which water flows out.

[3] A book of water contained in vessels with air, and of its movements.

[4] A book of the motion of water through a syphon.

[5] A book of the meetings and union of waters coming from different directions.

[6] A book of the various forms of the banks through which rivers pass.

[7] A book of the various forms of shoals formed under the sluices of rivers.

[8] A book of the windings and meanderings of the currents of rivers.

[9] A book of the various places whence the waters of rivers are derived.

[10] A book of the configuration of the shores of rivers and of their permanency.

[11] A book of the perpendicular fall of water on various objects.

[12] A book of the course of water when it is impeded in various places.

[12] A book of the various forms of the obstacles which impede the course of waters.

[13] A book of the concavity and globosity formed round various objects at the bottom.

[14] A book of conducting navigable canals above or beneath the rivers which intersect them.

[15] A book of the soils which absorb water in canals and of repairing them.

[16] A book of creating currents for rivers, which quit their beds, [and] for rivers choked with soil.

928. 4. charena. 5. spirachuli . . lacq"a". 6. essua. 7. cicognuole. 8. acq"e" . . di . . asspetti. 9. delle . . traversate alli. 10. secche [fatte sotto] generate. 11. chorrēti. 12. lacque. 13. fighure dellargine . . ellor premanētia. 14. chadende perpēdichulare. 15. acq"a". 16. chenpedisscano . . aeq"e". 17. globbosita. 18. condure . . navichabili . . ossotto . . chellītersegano. 19. beano . . chanali ellor.

928. I. The first line of this passage was added subsequently, evidently as a correction of the following line. 7. *cicognole*, see No. 966, **11, 17.**

A. 55*b*]

929.

COMICIAMĒTO DEL TRATTATO DEL' ACQUA.

²L'omo è detto · da li antiqui · mōdo minore ·, e cierto la ditione · d'esso · nome è bene collocata, ³impero · chè, sicchome · l'omo · è cōposto · di terra ·, acqua ·, aria · e foco ·, questo corpo · della · terra ⁴è il simiglante ·; se l'omo · à in se · ossi, sostenitori e armadura · della carne ·, ꭮l mōdo à i sassi, ⁵sostenitori della · terra; se l'omo à in se il lago · del sangue, doue crescie · e discrescie il polmo⁶ne · nello · alitare ·, ꭮l corpo della terra à il suo oceano mare ·, il quale ancora · lui crescie ⁷e discrescie ogni · sei ore · per lo alitare · del mōdo ·; se dal detto · lago di sangue · diriuano ve⁸ne ·, che si vanno ramificãdo · per lo corpo · vmano ·, similmēte il mare oceano enpie ⁹il corpo della terra · d'infinite vene d'acqua; mancano al corpo della terra · i nerui, i quali nō ui ¹⁰sono ·, perchè i nervi sono fatti al proposito · del movimēto ·, e il mōdo sendo di perpetua stabilità, ¹¹non accade movimēto e, nō accadēdo movimēto, i nervi · nō ui sono · neciessari; Ma ī tutte ¹²l'altre · cose · sono · molto simili.

THE BEGINNING OF THE TREATISE ON WATER.

By the ancients man has been called the world in miniature; and certainly this name is well bestowed, because, inasmuch as man is composed of earth, water, air and fire, his body resembles that of the earth; and as man has in him bones the supports and framework of his flesh, the world has its rocks the supports of the earth; as man has in him a pool of blood in which the lungs rise and fall in breathing, so the body of the earth has its ocean tide which likewise rises and falls every six hours, as if the world breathed; as in that pool of blood veins have their origin, which ramify all over the human body, so likewise the ocean sea fills the body of the earth with infinite springs of water. The body of the earth lacks sinews and this is, because the sinews are made expressly for movements and, the world being perpetually stable, no movement takes place, and no movement taking place, muscles are not necessary.—But in all other points they are much alike.

General introduction.

929. 1. acq"a". 2. cholochata. 3. impero . chessi . chome . . chōposto di tera . acq"a" . . effocho . . chorpo . . tera. 4. sellomo . . osso . . charne. 5. ssisotenitori . . lacho. 6. tera . . occicano . . anchora . . cresscie. 7. diriua ve. 8. chessi vano ramifichãdo . . chorpo . . [C] similmēte . . occieano. 9. dacq"a" mancha . . tera. 11. achade . . achadēdo. 12. chose.

I.

OF THE NATURE OF WATER.

E. 12 a] 930.

ORDINE DEL PRIMO LIBRO DELLE ACQUE.

[2]Difinisci prima che cosa è altezza e bassezza anzi come sō situati [3]li elemēti l'ū'dentro all'altro; Di poi che cosa è gravità dē[4]sa e che è gravità liquida, ma prima che cosa è in se gravi[5]tà e leuità·; Di poi descrivi perchè l'acqua si move e perchè ter[6]mina il moto suo, poi perchè si fa più tarda o velocie, oltre [7]a questo come ella senpre disciēde, essendo in cōfine d'ari[8]a più bassa di lei | E come l'acqua si leua in aria mediante [9]il calore del sole e poi · ricade in pioggia·; ancora perchè l'acqua [10]surgie dalle cime de' monti e se l'acqua di nessuna vena più alta [11]che l'oceano mare può uersare acqua più alta che la superfitie [12]d'esso·oceano·; E come tutta · l'acqua che torna all'oceano è più alta [13]della spera dell'acqua | e come l'acqua delli mari equinotiali è più alta [14]che le acque settētrionali, ed è più alta sotto il corpo del sole [15]che in nessuna parte del circulo equinotiale | come si speri[16]mēta sotto il calore dello stizzo infocato, l'acqua che mediā[17]te tale stizzo bolle e l'acqua circustāte al ciētro di tal bol[18]lore senpre

The arrangement of Book I.

THE ORDER OF THE FIRST BOOK ON WATER.

Define first what is meant by height and depth; also how the elements are situated one inside another. Then, what is meant by solid weight and by liquid weight; but first what weight and lightness are in themselves. Then describe why water moves, and why its motion ceases; then why it becomes slower or more rapid; besides this, how it always falls, being in contact with the air but lower than the air. And how water rises in the air by means of the heat of the sun, and then falls again in rain; again, why water springs forth from the tops of mountains; and if the water of any spring higher than the ocean can pour forth water higher than the surface of that ocean. And how all the water that returns to the ocean is higher than the sphere of waters. And how the waters of the equatorial seas are higher than the waters of the North, and higher beneath the body of the sun than in any part of the equatorial circle; for experiment shows that under the heat of a burning brand the water near the brand boils, and the water surrounding this ebullition always sinks with

930. 1. p"o" libro. 2. p"a" che chosa he . . ebbasseza. 3. chosa. 4. chosa. 5. elleuita. 7. addi questo chomella . . cōtino. 8. chome. 9. chalore . . eppoi richade . . anchora. 10. delle cime . . essellacqua. 11. chelloccieano . . chella. 12. occieano . . chome . . chettorna . . accieano eppiu. 13. [desso] della . . chome . . equinotiali eppiu. 14. chelle. 15. inessuna . . circhulo . . sissperi. 16. chalore . . infochato. 17. talle . . ellacqua circhustāte. 18. dissciende . . circhulare e chome.

disciende con onda circulare e come l'acque
¹⁹settētrionali son piv basse che li altri
mari e tāto più, quā²⁰to esse son piv fredde,
insin che si convertono in ghiaccio.

a circular eddy. And how the waters of the
North are lower than the other seas, and
more so as they become colder, until they
are converted into ice.

C 26 b (4)]

931.

CHE COSA È ACQUA.

²Acqua è infra i quatro elemēti il se-
cōdo mē grave e di seconda volubilità.·

OF WHAT IS WATER.

Among the four elements water is the
second both in weight and in instability.

Definitions
(931. 932).

I.² 24 a and b]

932.

PRINCIPIO DEL LIBRO DELL'ACQUE.

²Pelago è detto quello, il quale à figura
larga ³e profōda; ⁴nel quale l'acque stanno
con poco moto.

THE BEGINNING OF THE BOOK ON WATER.

Sea is the name given to that water
which is wide and deep, in which the waters
have not much motion.

Leic. 34 b]

933.

Li centri della spericità dell'acqua sono
due: l'uno è della vniuersale acqua, l'altro
è particulare; ²l'vniversale è quello, il
quale serue a tutte l'acque sanza moto, che
sono in se in grā quātità, ³come canali,
fossi, viuai, fonti, pozzi, fiumi morti, laghi,
paduli, stagni e mari, li quali, ancoraché
sieno di uarie altezze ciascuno per se, àño
li termini delle lor superfitie equi⁴distanti
al centro del mondo, come sono i laghi
posti nelle cime delli alti mōti come sopra
⁵Pietra Pana e Lago della Sibilla a Norcia,
e tutti li laghi che dā principio a grandi
fiumi, come Tesino ⁶dal Lago Maggiore,
Adda dal lago di Como, Mincio dal lago
di Garda e Reno dal lago di Costan⁷tia |
e di Coira e dal lago di Lucerne, e come
Tigron, il quale passa per la Minore Asia,
il quale ne porta ⁸con seco l'acqua di 3
paduli, l'un dopo l'altro, di uarie altezze,
de' quali il piv alto è Munace, el mezzano
è Pallas ⁹e 'l più basso è Triton; ancora
el Nilo diriua da 3 altissimi paduli in Eti-
opia.

The centres of the sphere of water are
two, one universal and common to all water,
the other particular. The universal one is
that which is common to all waters not in
motion, which exist in great quantities. As
canals, ditches, ponds, fountains, wells, dead
rivers, lakes, stagnant pools and seas, which,
although they are at various levels, have
each in itself the limits of their superficies
equally distant from the centre of the earth,
such as lakes placed at the tops of high moun-
tains; as the lake near Pietra Pana and
the lake of the Sybil near Norcia; and all
the lakes that give rise to great rivers, as
the Ticino from Lago Maggiore, the Adda
from the lake of Como, the Mincio from
the lake of Garda, the Rhine from the lakes
of Constance and of Chur, and from the lake of
Lucerne, like the Tigris which passes through
Asia Minor carrying with it the waters of three
lakes, one above the other at different heights
of which the highest is Munace, the middle one
Pallas, and the lowest Triton; the Nile again
flows from three very high lakes in Ethiopia.

Of the sur-
face of the
water in rela-
tion to the
globe
(933—936).

19. chelli . . ettāto. 20. chessi chonvertano in diaccio.
931. 1. chosa . . sechōdo. 2. grieve . . sechonda. **932.** 2. pellago . . affigura.
933. 1. Lli centri . . acq"a" . . partichulare. 2. deluniversale . . attutte lacque . . chessono. 3. cannali fossi "viuai fonti pozi'
fiumi . . quali "ancorche sieno di uarie alteze ciascun per se" ano. 4. distante . . illaghi. 5. pietra pana ellago . . sibilla
a norca ettutti. 6. [adda da] dal . . magore . . lagho . como [adice] "menzo" dal lagho . . erreno . . gostan. 7. eurio
lacho . . Trigon . . minore africha il quane ne. 8. consecholacq"a" . . alteze . . mezano he. 9. di.

932. Only the beginning of this passage is here
given, the remainder consists of definitions which
have no direct bearing on the subject.

933. 5. *Pietra Pana*, a mountain near Florence. If
for Norcia, we may read Norchia, the remains of

the Etruscan city near Viterbo, there can be no doubt
that by '*Lago della Sibilla*'—a name not known else-
where, so far as I can learn—Leonardo meant
Lago di Vico (Lacus Ciminus, Aen. 7).

A. 58 *b*] **934.**

DEL CIĒTRO DELL OCIEANO · MARE. OF THE CENTRE OF THE OCEAN.

²Il ciētro della spera · dell'acqua · è il The centre of the sphere of waters is
centro · vero · della rotōdita del nostro mōdo, the true centre of the globe of our world,
· il quale si cōpone ³infra · acqua e terra · which is composed of water and earth,
in forma · rotōda ·; Ma se tu · volessi trovare having the shape of a sphere. But, if you
· il ciētro dello · elemēto della ⁴terra ·, questo want to find the centre of the element of
· è cōtenuto · per equidistāte · spatio · dalla the earth, this is placed at a point equidi-
superfitie · dell'oceano · mare ·, e nō dalla stant from the surface of the ocean, and
⁵equidistante · superfitie · della · terra ·, perchè not equidistant from the surface of the earth;
chiaro · si comprende · questa palla · della · for it is evident that this globe of earth has
terra non ⁶avere · niente · di perfetta · rotō- nowhere any perfect rotundity, excepting in
dità ·, se non è · in quella · parte dou' è mare places where the sea is, or marshes or other
· o paduli o altre acque mor⁷te, · e qualun- still waters. And every part of the earth
que · parte · d'essa · terra che escie · fori · that rises above the water is farther from
d'esso mare, s'allontana · dal suo · ciētro. the centre.

E. 4 *b*] **935.**

DEL MARE CHE MUTA ²IL PESO DELLA TERRA. OF THE SEA WHICH CHANGES THE WEIGHT OF
 THE EARTH.

³Li nichi, ostrighe e altri simili animali, The shells, oysters, and other similar ani-
⁴che nascono nelli fanghi marini, ci testifi- mals, which originate in sea-mud, bear wit-
⁵cano la mutatiō della terra intorno al ness to the changes of the earth round the
⁶ciētro de' nostri elemēti; pruovasi così: centre of our elements. This is proved
⁷Li fiumi reali senpre corrono con torbidu- thus: Great rivers always run turbid, being
⁸me, tinto dalla terra, che per lor si leua coloured by the earth, which is stirred by the
mediāte la cō⁹fregatiō delle sue acque sopra friction of their waters at the bottom and on
il fondo e nelle sue ¹⁰riue, e tal cōsumati- their shores; and this wearing disturbs the face
one scopre le fronti de' gradi ¹¹fatti a' suoli of the strata made by the layers of shells,
di quelli nichi, che stan nella superfitie which lie on the surface of the marine mud,
¹²del fango marino, li quali in tal sito na- and which were produced there when the
scierono, quā¹³do l'acque salse li copriuano, salt waters covered them; and these strata
e questi tali gradi erano ri¹⁴coperti di tenpo were covered over again from time to time,
in tenpo dalli fanghi di uarie grossez¹⁵ze o with mud of various thickness, or carried down
condotti al mare dalli fiumi cō diluvi di di- to the sea by the rivers and floods of more or
verse grā¹⁶dezze; e così tali fāghi furono less extent; and thus these layers of mud became
composti in tāta altezza, che dal fondo si raised to such a height, that they came up
¹⁷scopriua all'aria; Ora questi tali fondi from the bottom to the air. At the present time
sono in tāta ¹⁸altezza che son fatti colli, these bottoms are so high that they form hills
o alti mōti, e li fiumi, ¹⁹consuma²⁰tori de' or high mountains, and the rivers, which
lati ²¹d'essi monti, ²²scoprono ²³li gradi wear away the sides of these mountains, un-
d'es²⁴si nichi, e co²⁵sì il leni²⁶ficato lato cover the strata of these shells, and thus the
²⁷della terra ²⁸al cōtinuo ²⁹s'inalza, e ³⁰li softened side of the earth continually rises and
antipo³¹di s'accosta³²no più al ³³ciētro del the antipodes sink closer to the centre of the
³⁴mondo, ³⁵e li anti³⁶chi fondi del ³⁷mare earth, and the ancient bottoms of the seas
son fatti ³⁸gioghi di monti. have become mountain ridges.

934. 1. eccicono. 2. dellacq"a" . . retōdita . . nosstro . . qualle . . chōpone. 3. acq"a" ecterra . . retōda Massettu . . elle-
mēto. 4. quessto e chōtenuto . . equidisstante . . occieano. 5. equidisstanto . . chonplende questa . . nōna. 6. retōdita.
7. ecqualumque . . terra esscie.
935. 3. osstrighe. 4. nasschano . . tessti. 5. chano. 6. nosstri. 7. senpre [stanno] corā torbidi. 8. medinte la terra. 9. fre-
ghatiō . . accque . . nelle sine. 10. rive ettal . . sconpre . . fronte. 11. assuoli . . chesstan. 12. fangho . . nasscicrono.
13. ecquessti . . era ri. 14. grosse. 15. indotti. 16. faghi conpossti . . alteza. 17. quessti. 18. alteza . . elli fiumi.
22. scoprano. 24. echo. 25. si [l] illeni. 26. fichato. 29. el sacosstā. *Lines 19—38 are written on the margin.*

Leic. 10*b*]

936.

Faccia mutatiō la terra colla sua gravezza, quāte farsi ²voglia, che mai la superfitie della spera dell'acqua nō si partirà dalla sua equidistātia col centro del mōdo.

Let the earth make whatever changes it may in its weight, the surface of the sphere of waters can never vary in its equal distance from the centre of the world.

Leic. 35*b*]

937.

SE LA TERRA È MĒ CHE L'ACQUA.

WHETHER THE EARTH IS LESS THAN THE WATER.

²Dicono alcuni esser vero, che la terra, ch'è scoperta dalle acque, sia molto minore che quella che da esse acqu'è coperta; ³Ma che considerando la grossezza di 7000 miglia di diametro, che à·essa terra, e' si può concludere l'acqua essere di ⁴poca profondità.

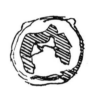

Some assert that it is true that the earth, which is not covered by water is much less than that covered by water. But considering the size of 7000 miles in diameter which is that of this earth, we may conclude the water to be of small depth.

Of the proportion of the mass of water to that of the earth (937. 938).

Leic. 36*a*]

938.

DELLA TERRA IN SE.

OF THE EARTH.

²L'alzarsi tanto le cime de' monti sopra la spera dell'acqua può esser diriuato, perchè il loco grandissimo ³della terra, il quale

The great elevations of the peaks of the mountains above the sphere of the water may have resulted from this that: a very

era ripieno d'acqua, cioè la grandissima cauerna, douette cadere ⁴assai della sua volta inuerso il centro del mondo, trovandosi ispiccata mediante il corso de⁵lle uene che al continuo consumano il loco donde passano.

⁶Profondamēto di paesi ⁷come nel Mare Morto di So⁸ria cioè Sodoma e Gomorra.

⁹È necessario che l'acqua sia più che la terra, e la parte scoperta del mare nō

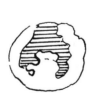

large portion of the earth which was filled with water that is to say the vast cavern inside the earth may have fallen in a vast part of its vault towards the centre of the earth, being pierced by means of the course of the springs which continually wear away the place where they pass.

Sinking in of countries like the Dead Sea in Syria, that is Sodom and Gomorrah.

It is of necessity that there should be more water than land, and the visible portion of

936. 1. facia . . graveza. 2. dellacq"a".
937. 1. Sella . . chellacq"a". 2. dicano . . chella. 3. groseza . . diamitro . . po con chludere lacqua per essere. 4. pocha.
938. 2. lasspera . . ilocho. 3. coe. 4. isspichata. 5. iloco. 8. coe soddoma e gamora. 9. chellacq"a" . . chella terra ella . . dell . . dimosstra.

938. The small sketch below on the left, is placed in the original close to the text referring to the Dead Sea.

lo dimostra, onde bisognia che [10]molta acqua sia dentro alla terra, sanza quella ch'è infusa nella bassa aria e che scorre [11]per li fiumi e uene.

the sea does not show this; so that there must be a great deal of water inside the earth, besides that which rises into the lower air and which flows through rivers and springs.

F. 27 a] 939.

FIGURA D'ELEMĒTI.

THE FIGURES OF THE ELEMENTS.

The theory of Plato. [2]Della figura delli elemēti, e prima contro a chi nega [3]l'opinione di Platone, che dicono che se essi elemēti vestis[4]sero l'un l'altro, colle figure che mette Platone, che si ca[5]vserebbe vacuo infra l'uno e l'altro; e non è vero, e [6]qui lo provo, ma prima bisognia proporre alcuna cō[7]clusione: Non è neciessario che nessuno ele[8]mento, che veste l'ū l'altro, sia d'equ l grossezza in tu[9]tta la sua quantità infra la parte che ueste e quel[10]la ch'è uestita; Noi uediamo la spera dell'acqua ma[11]nifestamēte essere di uarie grossezze dalla sua [12]superfitie al fondo, e che, nō che essa vestisse [13]la terra

Of the figures of the elements; and first as against those who deny the opinions of Plato, and who say that if the elements include one another in the forms attributed to them by Plato they would cause a vacuum one within the other. I say it is not true, and I here prove it, but first I desire to propound some conclusions. It is not necessary that the elements which include each other should be of corresponding magnitude in all the parts, of that which includes and of that which is included. We see that the sphere of the waters varies conspicuously in mass from the surface to the bottom, and that, far

quando fusse di figura cuba cioè di 8 angoli come [14]vole Platone, essa veste la terra che à innumerabili [15]angoli di scogli coperti dall'acqua e varie globosità e cō[16]cavità, e non si genera vacuo infra l'acqua e la terra; Ancora l'aria veste la spera dell'acqua [17]insieme colli monti e valli che superano essa spera, e nō [18]rimane vacuo infra la terra e l'aria, sicchè, chi disse [19]generarsi vacuo, ebbe tristo discorso.

from investing the earth when that was in the form of a cube that is of 8 angles as Plato will have it, that it invests the earth which has innumerable angles of rock covered by the water and various prominences and concavities, and yet no vacuum is generated between the earth and water; again, the air invests the sphere of waters together with the mountains and valleys, which rise above that sphere, and no vacuum remains between the earth and the air, so that any one who says a vacuum is generated, speaks foolishly.

[20]A Platō si rispōde che la superfitie [21]delle figure che avrebbero li elemēti, [22]che lui pone, non potrebbero sta[23]re.

But to Plato I would reply that the surface of the figures which according to him the elements would have, could not exist.

A. 58 b] 940.

PRUOVA · COME · LA TERRA · NON È · TŌDA, [2]E, NON ESSENDO TŌDA, NŌ PUÒ AVER COMVNE · CETRO.

PROVES HOW THE EARTH IS NOT GLOBULAR AND NOT BEING GLOBULAR CANNOT HAVE A COMMON CENTRE.

That the flow of rivers proves the slope of the land. [3]Noi · vediamo · il Nilo · partirsi dalle · meridiane · regioni · e rigare · diuerse provincie, corrēdo [4]inverso · settentrione · per

We see the Nile come from Southern regions and traverse various provinces, running towards the North for a distance of

939. 1. p"a" contro . . niegha. 3. lopēnione . . dicano chesse . . vessti. 4. sm lūlaltro cholle. 5. vserebe . . ellaltro ilenone vere. 6. sna p"a". 8. grosseza. 9. infralla . . ecquel. 10. lasspera dellacq"a". 11. grosseze. 12. vestissi [il cubo] 13. quande fussi . . cubo "cee di 8 angoli" come. 14. esse . . inunbili. 15. acq"a". 16. cavita "e non sigenera vacuo infra lacqua ella terra" Ancora laria che veste. 17. cholli. 18. ellaria siche. 20. chella. 21. arebō. 22. chellui . . potrebono.

940. 1. chome . . tera . . po avr chomune. 3. vedemo . . delle . . chorēdo. 4. settantrione . . isspatio . . miglia "e vessare

ispatio · di 3000 · miglia e versare nelle mediterrane ōde ai liti d'Egitto, e se noi · vogliamo · dare a questo · di calo quelle ⁵dieci · braccia per miglio ·, le quali comvnalmēte · si concede · alla · vniversalità · del corso · de' fiumi, ⁶noi troveremo · il Nilo · avere il suo · fine piv basso · che 'l prīcipio · miglia dieci ·; ⁷Ancora · vediamo il Reno, Rodano e Danvbio · partirsi dalle germaniche · parti, quasi ciētro ⁸d'Evropa ·, e l'uno a Oriēte, l'altro a settētrione ·, e l'ultimo · a meridiani mari fa suo corso; ⁹se tu cōsiderai · bene tutto, vedrai le pianvre d'Europa fare vno cōcorso molto ¹⁰piv · elevato ·, che nō sono · l'alte cime de' marittimi mōti; or pēsa, quāto le loro cime ¹¹si trovano · piv · alte · che liti marini.

3000 miles and flow into the Mediterranean by the shores of Egypt; and if we will give to this a fall of ten braccia a mile, as is usually allowed to the course of rivers in general, we shall find that the Nile must have its mouth ten miles lower than its source. Again, we see the Rhine, the Rhone and the Danube starting from the German parts, almost the centre of Europe, and having a course one to the East, the other to the North, and the last to Southern seas. And if you consider all this you will see that the plains of Europe in their aggregate are much higher than the high peaks of the maritime mountains; think then how much their tops must be above the sea shores.

A. 55 b]

941.

DEL CALDO CHE NEL MŌDO · È.

²Dov'è · vita lì è calore ·, e dou'è · calore · vitale, quiui è mouimēto · d'umori; ³Questo · si pruoua, · inperochè si uede · per effetto · che · il caldo · dello elemēto · del foco · senpre · tira · a se ⁴li umidi · vapori · e folte nebbie e spessi · nuvoli ·, i quali · spiccano da' mari e altri · paduli · e fiumi e vmide ⁵valli, e quelle tirādo · a poco a poco · insino · alla · fredda · regione, quella prima parte si ferma, ⁶perchè · il caldo · e vmido nō si affà · col freddo · e secco; onde · ferma la prima parte lì assetta l'altre ⁷parti, e così, aggiugniēdosi parte cō parte ·, si fa · spesse · e oscure nvbole ·; e spesso sono ⁸remosse e portate da vēti d'una · in altra regione; dove per la densità loro fanno sì spessa gravezza, ⁹che cadono · cō spessa · pioggia ·; e se 'l caldo · del sole s'aggivgnie · alla potētia dello elemēto ¹⁰del foco ·, i nvuoli fieno tirati piv · alti e trovano · piv freddo, in nel quale sì ghiacciano e cavsasi ¹¹tēpestosa · grādine ·; Ora · quel medesimo · caldo ·, che tiene · sì grā peso · d'acqua ·, come si uede ¹²piovere de' nvvoli, sveglie l'acque di basso · in alto · dalle base delle mōtagnie, e cōduciele, e tienle ¹³dētro · alle · cime delle mōtagnie,—le quali, trovādo qualche fessura, al · continuo vsciēdo, ¹⁴causā i fiumi.

OF THE HEAT THAT IS IN THE WORLD.

Where there is life there is heat, and where vital heat is, there is movement of vapour. This is proved, inasmuch as we see that the element of fire by its heat always draws to itself damp vapours and thick mists as opaque clouds, which it raises from seas as well as lakes and rivers and damp valleys; and these being drawn by degrees as far as the cold region, the first portion stops, because heat and moisture cannot exist with cold and dryness; and where the first portion stops the rest settle, and thus one portion after another being added, thick and dark clouds are formed. They are often wafted about and borne by the winds from one region to another, where by their density they become so heavy that they fall in thick rain; and if the heat of the sun is added to the power of the element of fire, the clouds are drawn up higher still and find a greater degree of cold, in which they form ice and fall in storms of hail. Now the same heat which holds up so great a weight of water as is seen to rain from the clouds, draws them from below upwards, from the foot of the mountains, and leads and holds them within the summits of the mountains, and these, finding some fissure, issue continuously and cause rivers.

Theory of the elevation of water within the mountains.

nelle mediterane ōde a liti e se . . degitto acquessto di cholo qualle. 5. dieci br . . quale chomvnemēte . . chonciede. 6. no trovrremo . . prēcipio . . . diecip. 7. vedemo . . delle. 8. elluno . . assettātrione . . chorso. 9. settu chōsiderai . be verai [levr] le . . deropia . . chōchorso. 10. cime.

941. 1. chaldo. 2. vita | "li" e chalore . . quiue . . domori [Esse l chaldo move lumido "il freddo lo ferma". 3. chaldo . . focho . . asse. 4. effolte nebie esspessi nuboli . . spicha de . . effiumi. 5. quele . . apocho apocho . . freda regione [i] e. 6. chaldo . . chol . . essecho . . li assetta laltre. 7. chosi agiugnēdo . . chō . . osschure . . esspesso sono [portale]. 8. fano . graueza. 9. chadano chōispessa piogia esselchaldo . . sagivgne. 10. focho . . fredo inel . . diacciano e chavsasi. 11. chaldo chettiene . . chome. 12. nvboli [tienē] disuelle . . delle mōtagnie e chōducie le ettielle. 13. mōtagnie le quali . . li chontinui vssciēdo. 14. chausano i fiumi.

F. 73 *a*] **942.**

DEL MARE CHE A MOLTI ²SENPLICI PAR PIÙ
ALTO ³CHE LA TERRA CHE GLI FA LITI.

OF THE SEA, WHICH TO MANY FOOLS APPEARS
TO BE HIGHER THAN THE EARTH WHICH FORMS
ITS SHORE.

The relative height of the surface of the sea to that of the land (942—945).

⁴*b d* è vna pianvra, donde corre ⁵vn fiume al mare, la qual pianu⁶ra à per termine esso mare; e per⁷chè in vero essa terra scoperta nõ ⁸è nel sito dell'e-qualità,—perchè, se co⁹sì fusse, il fiume non avrebbe mo¹⁰to---,onde, moven-dosi, questo sito ¹¹à piutosto da essere detto spiagg¹²ia che pianvra; e così essa pia¹³nura *d b* termina in tal modo ¹⁴colla spera dell' acqua che, chi la produ¹⁵cesse in continua rettitudine in *b a*, ¹⁶essa entrerebbe sotto il mare, e ¹⁷di qui nasce che 'l mar *a c b* pare più alto che la terra discoperta.

¹⁸Naturalmēte nes¹⁹suna parte della ²⁰terra discoperta da ²¹l'acqua fia mai ²²più bassa che la ²³superfitie della ²⁴spera d'essa acqua.

b d is a plain through which a river flows to the sea; this plain ends at the sea, and since in fact the dry land that is un-covered is not perfectly level—for, if it were, the river would have no motion—as the river does move, this place is a slope rather than a plain; hence this plain *d b* so ends where the sphere of water begins that if it were extended in a continuous line to *b a* it would go down beneath the sea, whence it follows that the sea *a c b* looks higher than the dry land.

Obviously no portions of dry land left uncovered by water can ever be lower than the surface of the watery spherė.

A. 58 *b*] **943.**

D'ALCUNI CHE DICONO · L'ACQUA ESSERE · PIV
· ALTA · CHE LA TERRA · SCOPERTA.

OF CERTAIN PERSONS WHO SAY THE WATERS WERE
HIGHER THAN THE DRY LAND.

²Cierto · non poca · ammiratione · mi da · la comvne · opinione fatta cõtro · al uero dallo vniversale ³cõcorso · de' givditi · delli omini ·, e questo · è che tutti · s'accordano · che la superfitie · del mare ⁴sia · piv · alta · che l'altissime · cime delle · mõtagnie ·, alle-gãdo molte · vane e puerili · ragioni, ⁵cõtro ai quali · io n'allegherò · solo · vna · senplie e brieve ragione ·; Noi vediamo chiaro, che ⁶se si toglie · via · l'argine · al mare ·, che lui · vestirà · la terra e faralla di per-fetta rotõdità; ⁷or cõsidera · quãta · terra si leuerebbe a fare che l'õde marine coprissino ⁸il mõdo; adūque ciò, che si leuasse, sarebbe piv · alto · che la riua del mare.

Certainly I wonder not a little at the common opinion which is contrary to truth, but held by the universal consent of the judgment of men. And this is that all are agreed that the surface of the sea is higher than the highest peaks of the mountains; and they allege many vain and childish reasons, against which I will allege only one simple and short reason: We see plainly that if we could remove the shores of the sea, it would invest the whole earth and make it a perfect sphere. Now, consider how much earth would be carried away to enable the waves of the sea to cover the world; there-fore that which would be carried away must be higher than the sea-shore.

942. 2. senpici par pu. 3. chella . . chelli. 4. a d e vna. 5. lacqual. 6. essesso. 9. fussi . . arebbe. 14. dellacq"a". 15. cessi. 16. enterebbe. 17. nassce. *On the margin is written:* cella tera
di scoperta.
 Lines 18—24 *are also written on the margin.* 18. ne. 22. chella. 24. acq"a".
943. 1. dichano lacq"a" . . chella. 2. pocha amiratione . . chomvne oppenione fatto chõtra. 3. chõchorso . . ecquesto e chet-tutti sachordano chella. 4. chellaltissime . . ragione. 5. nalegero . . vedemo. 6. tolglie . . chellui vesstira effaralla . . retõdita. 7. chõsidera [vn pocha] . . affare chellõde . . choprissino. 8. chessi leuassi . . chella.

A. 56 a]　　　　　　　　　　　**944.**

OPINIONE D'ALCUNI · CHE DICONO · CHE L'AC-
QUA D' ALCUNI ²MARI È PIV ALTA CHE LE PIV
ALTE SOMMITÀ DE'MŌTI, ³E PERÒ · SIA SOSPĪTA
L'ACQUA · A ESSE SŌMITÀ.

THE OPINION OF SOME PERSONS WHO SAY THAT
THE WATER OF SOME SEAS IS HIGHER THAN THE
HIGHEST SUMMITS OF MOUNTAINS; AND NEVER-
THELESS THE WATER WAS FORCED UP TO
THESE SUMMITS.

⁴L'acqua nō si moverà · da loco a loco
· se la bassezza · non la tira; E per corso
⁵naturale · nō potrà · mai · ritornare · a altezza
· simile · al primo loco, do⁶ve
nel uscire de'mōti si mostrò
· al cielo ·; E quella · parte
del mare ·, che ⁷cō falsa ·
imaginatione · tu · diciesti · es-
sere si alta ·, che uersaua ·
per le cime · de⁸li alti · mōti,
· per tāti seculi · sarebbe · cō-
sumata · e uersata per l'uscita
d'esse ⁹mōtagnie; Tu puoi
bene pēsare · che tāto tēpo
che Tigris ed Eufrates

Water would not move from place to
place if it were not that it seeks the lowest
level and by a natural consequence it never
can return to a height like that
of the place where it first on
issuing from the mountain
came to light. And that por-
tion of the sea which, in your
vain imagining, you say was
so high that it flowed over the
summits of the high mountains,
for so many centuries would be
swallowed up and poured out
again through the issue from
these mountains. You can well imagine that
all the time that Tigris and Euphrates

A. 56 b]　　　　　　　　　　**945.**

ànno · versato · per le · sommità de' mōti
· Armeni ·, che si può · credere · che tutta
l'acqua dell'ocieano ²sia · moltissime · volte
· passata · per dette · bocche ·; or non cre-
di tu che 'l Nilo · abbi messo · piv ³acqua ·
ī mare · che non è · al presente tutto lo ele-
mēto · dell'acqua ·? cierto · sì; · e se detta ·
acqua ⁴fusse · caduta fori di questo · corpo
· della terra ·, questa machina · sarebbe già
lūgo tēpo ⁵stata sāza acqua, sichè si può
cōcludere · che l'acqua vadi dai fiumi al
mare e dal mare ⁶ai fivmi, senpre così
raggirādo e voltādosi, e che tutto · il mare
· e i fivmi sieno passati per la bocca del
Nilo infinite volte.

have flowed from the summits of the
mountains of Armenia, it must be believed
that all the water of the ocean has passed
very many times through these mouths.
And do you not believe that the Nile must
have sent more water into the sea than at
present exists of all the element of water?
Undoubtedly, yes. And if all this water
had fallen away from this body of the earth,
this terrestrial machine would long since
have been without water. Whence we may
conclude that the water goes from the rivers
to the sea, and from the sea to the rivers, thus
constantly circulating and returning, and that
all the sea and the rivers have passed through the
mouth of the Nile an infinite number of times.

944. 1. Opeuione dalchuni che dichano chellacqua dalchuni. 2. alta [che alchu] chelle . . somita. 4. Lacq"a" . . dalocho al-
locho sella bassezza . . chorso. 5. alteza . . locho. 6. usscire . . Ecquella. 7. chō . . dicievi. 8. tāte sechuli sarebe chō
sumata . . lusscita. 9. mōtāgnia . . chettāto . . chettigris.

945. 1. mōti ermini che si po . . che | "tutta"llacq"a". 2. boche . . abi. 3. imare . . e "al presēte" tutto . . esse. 4. fussi
chaduta . . chorpo . . tera . . sarebe. 5. chōchiudere. 6. ragirādo . . chettutto . . sia pasato . . bocha; *the last two words*
infinite volte *are written on the margin.*

945. *Mōti Armeni, Ermini* in the original, in M.
RAVAISSON's transcript *"monti ernini [le loro ruine?]"*.
He renders this *"Le Tigre et l'Euphrate se sont dé-
versés par les sommets des montagnes [avec leurs eaux
destructives?] on peut cro're"* &c. Leonardo always
writes *Ermini, Erminia,* for *Armeni, Armenia* (Arabic:

Irminiah). M. RAVAISSON also deviates from the
original in his translation of the following pas-
sage: *"Or tu ne crois pas que le Nil ait mis plus
d'eau dans la mer qu'il n'y en a à présent dans tout
l'élément de l'eau. Il est certain que si cette eau était
tombée"* &c.

II.

ON THE OCEAN.

G. 48 b]

946.

PERCHÈ L'ACQUA È SALSA.

Refutation of Pliny's theory as to the saltness of the sea (946. 947).

²Dicie Plinio nel 2° suo libro, al 103 ca³pitolo, che l'acqua del mare è salata per- chè ⁴l'ardore del sole secca l'umi⁵do e quello succia, e questo al mare, che ⁶molto s'allarga, dà sapore di sale; ⁷Ma questo nō si cōciede, perchè se la salsedine ⁸del mare avesse cavsa dallo ardore del sole, ⁹e' non è dubbio che tanto maggiormente li laghi, stagni e paduli ¹⁰sarebbono più insalati, quāto ¹¹le loro acque son manco mobili e di ¹²minore profondità, e la esperiēzia ci mo¹³stra il contrario; tali paduli ci mostrā ¹⁴le loro acque essere al tutto private di sal¹⁵sedine; Ancora s'assegnia da Plinio nel medesimo¹⁶capitolo che tal salsedine

WHY WATER IS SALT.

Pliny says in his second book, chapter 103, that the water of the sea is salt because the heat of the sun dries up the moisture and drinks it up; and this gives to the wide stretching sea the savour of salt. But this cannot be admitted, because if the saltness of the sea were caused by the heat of the sun, there can be no doubt that lakes, pools and marshes would be so much the more salt, as their waters have less motion and are of less depth; but experience shows us, on the contrary, that these lakes have their waters quite free from salt. Again it is stated by Pliny in the same chapter that this saltness might originate,

946. 1. essalsa. 2. ᵃ103 capitoli. 3. chellacqua . . essalata. 4. [li razi solari] Lardore . . secha "abrōzre e (?)" lumi. 5. ecquello . . ecquesto. 6. sallargha . . sale | [Qui]. 7. Macquesto . . sella. 8. avessi chausa dello. 9. chelli "tanto magiormente" laghi. 10. [dove lacque] sarebbono. 11. [le] le . . mancho . . eddi. 12. ella . . mos. 13. in chontrario . . mosstrā. 14. tucto. 15. Acora sasegnia [nel me]. 16. chapitolo chettal. 17. nassciere . . leuato | "ne ogni" porte. 18. dolcie [dellacqᵘa" ressta lasspra]

946. See PLINY, Hist. Nat. II, CIII [C]. *Itaque Solis ardore siccatur liquor: et hoc esse masculum sidus accepimus, torrens cuncta sorbensque. (cp. CIV.) Sic mari late patenti saporem incoqui salis, aut quia exhausto inde dulci tenuique, quod facillime trahat vis ignea, omne asperius crassiusque linquatur: ideo summa aequorum aqua dulciorem profundam; hanc esse veriorem causam, quam quod mare terrae sudor sit aeternus: aut quia plurimum ex arido misceatur illi vapore: aut quia terrae natura sicut medicatas aquas inficiat . . (cp. CV): altis-* *simum mare XV. stadiorum Fabianus tradit. Alii n Ponto coadverso Coraxorum gentis (vocant Βαθέα Ponti) trecentis fere a continenti stadiis immensam altitudinem maris tradunt, vadis nunquam repertis. (cp. CVI [CIII]) Mirabilius id faciunt aquae dulces, juxta mare, ut fistulis emicantes. Nam nec aquarum natura a miraculis cessat. Dulces mari invehuntur, leviores haud dubie. Ideo et marinae, quarum natura gravior, magis invecta sustinent. Quaedam vero et dulces inter se supermeant alias.*

¹⁷potrebbe nasciere, perchè, leuatone ogni
¹⁸dolce e sottile ¹⁹parte, la qual facilmēte
il caldo a se ti²⁰ra, rimane la parte più
aspra e più ²¹grossa, e per questo l'acqua,
che è nella su²²perfitie, è più dolcie che
nel fōdo; ²³a questa si cōtradice colle me-
desime ²⁴sopradette ragioni, cioè che il
medesimo ac²⁵caderebbe alli paduli e_altre
acque che per il cal²⁶do s'asciugano; Acora
fu detto che ²⁷la salsedine del mare è
sudore della terra; ²⁸a questo si rispōde
che tutte le uene dell'acque ²⁹che pene-
trano la terra, sarebbono insalate; Ma ³⁰si
cōclude la salsedine del mare esser nata
³¹dalle molte vene d'acqua le quali nel
³⁴penetrare la ter³⁵ra trovano ³⁶le mini-
³⁷ere del sale, e ³⁸quelle in parte ³⁹si sol-
uono e por⁴⁰tā seco all' o⁴¹cieano e li altri
⁴²mari, d'ō⁴³de mai ¶li nuvo⁴⁴li, seminatori
⁴⁵d'elli fiumi¶ ⁴⁶lo leuano; ed e' sarebbe
⁴⁷più salato il ma⁴⁸re alli nostri tē⁴⁹pi che
mai per ⁵⁰alcun altro tē⁵¹po fusse, e se
per ⁵²l'auersario si di⁵cesse, che il tenpo
⁵⁴infinito secchereb⁵⁵be over cōgielereb⁵⁶be
il mare in sa⁵⁷le, a questo ⁵⁸si risponde,
che ⁵⁹tal sale si rē⁶⁰de alla terra ⁶¹colla
liberatione ⁶²d'essa terra, che ⁶³s'inalza col
suo ⁶⁴acquistato sale, ⁶⁵e li fiumi lo rendo-
⁶⁶no alla sōmersa terra.

because all the sweet and subtle portions which the heat attracts easily being taken away, the more bitter and coarser part will remain, and thus the water on the surface is fresher than at the bottom [22]; but this is contradicted by the same reason given above, which is, that the same thing would happen in marshes and other waters, which are dried up by the heat. Again, it has been said that the saltness of the sea is the sweat of the earth; to this it may be answered that all the springs of water which penetrate through the earth, would then be salt. But the conclusion is, that the saltness of the sea must proceed from the many springs of water which, as they penetrate into the earth, find mines of salt and these they dissolve in part, and carry with them to the ocean and the other seas, whence the clouds, the begetters of rivers, never carry it up. And the sea would be salter in our times than ever it was at any time; and if the adversary were to say that in infinite time the sea would dry up or congeal into salt, to this I answer that this salt is restored to the earth by the setting free of that part of the earth which rises out of the sea with the salt it has acquired, and the rivers return it to the earth under the sea.

G. 49a]

947.

Terza e vlti²ma ragione di³remo, il sale ⁴essere in tutte ⁵le cose create ⁶e questo c' ī⁷segniano ⁸le acque passa⁹te per tutte le ci¹⁰eneri e calci¹¹ni delle cose ¹²bruciate, e le ¹³orine di qua¹⁴lūche anima¹⁵le e le super¹⁶fluità usci¹⁷te de' lor cor¹⁸pi e le terre, ¹⁹nelle quali si ²⁰cōuertono ²¹le cor-rutioni ²²di tutte le cose.

²³Ma a dire meglio, essendo dato il mōdo eterno, egli è neciessario ²⁴che li sua popoli sieno ācora loro eterni; ōde ²⁵eternalmēte fu e sarebbe la spetie vmana cōsu²⁶matricie del sale; e se tutta la massa

For the third and last reason we will say that salt is in all created things; and this we learn from water passed over the ashes and cinders of burnt things; and the urine of every animal, and the superfluities issuing from their bodies, and the earth into which all things are converted by corruption.

But,—to put it better,—given that the world is everlasting, it must be admitted that its population will also be eternal; hence the human species has eternally been and would be consumers of salt; and if all the mass of the earth were to be turned into salt, it

22. Compare No. 948.

della terra fas²⁷si sale, non basterebbe alli cibi vmani, per la qual ²⁸cosa ci bisognia confessare, o che la spetie del sale ²⁹sia eterna īsieme col mōdo, o che quella ³⁰mora e rinasca insieme cogli omini d'essa di³¹voratori; Ma se la esperiēza c'insegnia quel ³²non avere morte come per il foco si manife³³sta, il qual non la cōsuma, e per l'acqua che di tāto si ³⁴sala di quāto ella in se ne risolue, evaporādo l'a³⁵qua, sempre il sale resta nella prima quātità; ³⁶deve passare per li corpi vmani che in orina, ³⁷o sudore, o altre superfluità fia ritrovato, e ques³⁸to è il sale che ogni anno si porta alle città; adūque ³⁹cavasi il sale de' lochi, dov'è piscia;—li porci e li vēti marini sō salati;—

⁴⁰Diremo che la ⁴¹pioggia pene⁴²tratrice della ⁴³terra sia que⁴⁴lla, ch'è sotto ⁴⁵alli fonda⁴⁶mēti delle cit⁴⁷tà e popoli, ⁴⁸e sia quella che ⁴⁹per li meati del⁵⁰la terra rē-⁵¹da la salsedi⁵²ne leuata dal ⁵³mare, e che ⁵⁴la mutatiō ⁵⁵del mare, sta⁵⁶to sopra tutti ⁵⁷li monti, lo la⁵⁸sci per le minie⁵⁹re ritrovate ⁶⁰in essi monti ecc.

would not suffice for all human food [27]; whence we are forced to admit, either that the species of salt must be everlasting like the world, or that it dies and is born again like the men who devour it. But as experience teaches us that it does not die, as is evident by fire, which does not consume it, and by water which becomes salt in proportion to the quantity dissolved in it,—and when it is evaporated the salt always remains in the original quantity—it must pass through the bodies of men either in the urine or the sweat or other excretions where it is found again; and as much salt is thus got rid of as is carried every year into towns; therefore salt is dug in places where there is urine.— Sea hogs and sea winds are salt.

We will say that the rains which penetrate the earth are what is under the foundations of cities with their inhabitants, and are what restore through the internal passages of the earth the saltness taken from the sea; and that the change in the place of the sea, which has been over all the mountains, caused it to be left there in the mines found in those mountains, &c.

Leic. 21 b]

948.

The characteristics of sea water (948. 949).

L'acque de' mari salati son dolci nelle sua grā profondità.

The waters of the salt sea are fresh at the greatest depths.

G. 38 a]

949.

COME L'OCEANO NŌ PE²NETRA INFRA LA TERRA.

THAT THE OCEAN DOES NOT PENETRATE UNDER THE EARTH.

³L'oceano nō penetra infra la terra, e que⁴sto c'insegniano le molte e varie vene d'acque dol⁵ci, le quali in diuersi lochi d'esso oceano pene⁶trano dal fondo alla sua superfitie; Ancora il me⁷desimo dimostrano li pozzi fatti dopo lo spa⁸tio d'ū miglio remoti dal detto ocieano, ⁹li quali s'enpiano d'acqua dolcie, e questo ac¹⁰cade perchè l'acqua dolcie è più sottile che l'ac-¹¹qua salata, e per cōseguēza più penetra-¹²tiva.

¹³Qual pesa più, ¹⁴o l'acqua ghiac¹⁵ciata o la nō ¹⁶ghiacciata?

The ocean does not penetrate under the earth, and this we learn from the many and various springs of fresh water which, in many parts of the ocean make their way up from the bottom to the surface. The same thing is farther proved by wells dug beyond the distance of a mile from the said ocean, which fill with fresh water; and this happens because the fresh water is lighter than salt water and consequently more penetrating.

Which weighs most, water when frozen or when not frozen?

chella. 29. etterna . . chol . . checquella. 30. rinascca . . chogli. 31. Massella essperiēza. 32. focho. 33. nolla. 35. sepre . . ressta. 36. ne vale passare. 37. ritrorato ecq"a". 38. ōni. 39. pisscia. 40. direno chelle. 41. piogie. 42. tratrici. 43. sien. 44. lla. 46. delli ci. 48. sie quella che. 49. de. 60. nessi.

949. loccieano. 2. infralla. 3. loccieano . . infralla . . ecques. 4. cinsegnia . . euuarie. 5. occieano "pe" nene. 7. dimostrano li pozi . . losspa. 8. miglio [li quali] remōti. 9. ecquessto. 10. chade . . chellac. 11. piu [soct] penetra. *Lines* 13—16 *are written on the margin.* 14. diac. 15. olla. 16. diacciata. 17. dole. 18. chella. 20. chellacqua . . chōtro.

947. l. 27. That is, on the supposition that salt, once consumed, disappears for ever.

PIÙ PENETRA L'ACQUA DOLCIE CŌTRO [18]AL-
L'ACQUA SALSA, CHE LA SALSA CŌTRO AL[19]LA
DOLCIE.

[20]Che l'acqua dolcie penetri più cōtro
all' ac[21]qua salsa, che essa salsa cōtro alla
dolcie, ci [22]lo manifesta vna sottil tela asci-
utta e [23]vechia, pendente con equal bas-
sezza [24]colli sua oppositi stremi nelle due
varie [25]acque, delle quali le lor superfitie
siē [26]d'equal bassezza, e allor si vedrà ele-
var[29]si in alto infra essa pezza tanto più
l'acqua [28]dolcie, che la salsa, quanto la
dolcie è più [29]lieve che essa salsa.

FRESH WATER PENETRATES MORE AGAINST SALT
WATER THAN SALT WATER AGAINST FRESH
WATER.

That fresh water penetrates more against
salt water, than salt water against fresh is
proved by a thin cloth dry and old,
hanging with the two opposite ends equally
low in the two different waters, the surfaces
of which are at an equal level; and it will
then be seen how much higher the fresh
water will rise in this piece of linen than the
salt; by so much is the fresh lighter than
the salt.

C. A. 157b; 466a]

950.

Tutti li mari mediterrani e li [2]golfi
d'essi mari sō fatti da fi[3]vmi che versano
in mare.

All inland seas and the gulfs of those On the for-
seas, are made by rivers which flow into mation of
Gulfs
the sea. (950. 951).

C. A. 83b; 240b]

951.

QUI SI RENDE RAGIONE DELLI EFFETTI FATTI
DALLE ACQUE NEL PROPOSITO SITO.

[2]Tutti li laghi e tutti li golfi del mare
e tutti li mari mediterrani nascono dalli
fiumi, che in quelli spā[3]dono le loro acque,
e dalli impedimēti della loro declinatione
[4]nel Mare Mediterrano, diuisore d'Africa
dall' Europa, e dell' Europa dall' Asia, me-
diāte il Nilo e Tanai che in [5]lui versano
le loro acque; Si domāda, quale inpedi-
mēto è maggiore a proibire il corso delle
sue acque, che nō si renda all' oceano.

HERE THE REASON IS GIVEN OF THE EFFECTS
PRODUCED BY THE WATERS IN THE ABOVE MEN-
TIONED PLACE.

All the lakes and all the gulfs of the sea
and all inland seas are due to rivers which
distribute their waters into them, and from im-
pediments in their downfall into the Mediter-
ranean—which divides Africa from Europe
and Europe from Asia by means of the Nile
and the Don which pour their waters into it.
It is asked what impediment is great en-
ough to stop the course of the waters
which do not reach the ocean.

Ash. III. 25a]

952.

DE ONDA.

[2]L'onda del mare
senpre ruina [3]dinan-
ti alla sua basa, e
quella par[4]te del col-
mo si troverà più
bassa che [5]prima era
più alta.

OF WAVES.

A wave of the On the en-
croachments
sea always breaks in of the sea on
the land and
front of its base, vice versa
(952—954).
and that portion of
the crest will then be
lowest which before
was highest.

21. dolcie cie. 22. assciuta eo. 23. pendente [cholli] chon. 24. cholli. 26. vedra mē eleua "r". 27. si [eleua] in . . tantu.
28. chella . . he piu.
950. 1. elli. 2. gholfi.
951. 1. effecti .. delle. 2. ettuttili gholfi . . etti ttutti . . nasschano. 3. Dano le . . ed dalli la pedimēti. 4. mediterano . . ettanai
che il. 5. domāde . . occieano.
952. 2. Londa [delle] del. 3. ecquella. 4. cholmo. 5. alta sara poi piu bas.

952. The page of FRANCESCO DI GIORGIO'S
Trattato, on which Leonardo has written this remark,
contains some notes on the construction of dams,
harbours &c.

Leic. 20 a] 953.

Come le riue del ma²re al continvo acquistano terreno inuerso il mezzo del mare; Come li scogli e promontori ³de' mari al continvo ruinano e si consumano; Come i mediterrani scopriranno i lor fondi all'aria e sol ri⁴serberanno il canale al maggior fiume, che dentro vi metta, il quale correrà all'oceano e iui uerse⁵rà le sue acque insieme con quelle di tutti i fiumi, che cō seco s'accōpagnano.

That the shores of the sea constantly acquire more soil towards the middle of the sea; that the rocks and promontories of the sea are constantly being ruined and worn away; that the Mediterranean seas will in time discover their bottom to the air, and all that will be left will be the channel of the greatest river that enters it; and this will run to the ocean and pour its waters into that with those of all the rivers that are its tributaries.

Leic. 27 b] 954.

Come il fiume del Po in brieve tenpo secca il mare Adriano nel ²medesimo modo ch'elli asseccò grā parte di Lonbardia.

How the river Po, in a short time might dry up the Adriatic sea in the same way as it has dried up a large part of Lombardy.

C. A. 162 b; 482 a] 955.

The ebb and flow of the tide (955—960)

¶Dove è maggior quātità d'acqua, ²quivi è maggior flusso e riflusso; e 'l ³contrario fa nelle acque strette.¶
⁴Guarda se 'l mare è nella soma cresciē⁵te quādo la luna è nel mezzo del tuo emi⁶sphero.

Where there is a larger quantity of water, there is a greater flow and ebb, but the contrary in narrow waters.
Look whether the sea is at its greatest flow when the moon is half way over our hemisphere [on the meridian].

Leic. 17 b] 956.

Se 'l flusso e riflusso nasce dalla luna o sole, overo è l'ali²tare di questa terrestre machina; Come il flusso e riflusso è vario in diuersi paesi e mari.

Whether the flow and ebb are caused by the moon or the sun, or are the breathing of this terrestrial machine. That the flow and ebb are different in different countries and seas.

Leic. 5 a] 957.

Libro 9º delli scontri de' fiumi e lor flusso e riflusso; e la medesima ²causa lo crea nel mare per causa dello stretto di Gibiltar, e ancora accade per le uoragini.

Book 9 of the meeting of rivers and their flow and ebb. The cause is the same in the sea, where it is caused by the straits of Gibraltar. And again it is caused by whirlpools.

953. 2. acquisstano . . mezo . . liscogli. 3. essi chonsumano Come e . . scopiranno . . essol. 4. magor. 5. cōsecho sacōpagnano.
954. 1. secha. 2. assecho.
955. 1. he magior. 2. frusso e refrusso. 4. gharda. 5. mezo.
956. 1. frusso e refrusso nassce. 2. tereste . . frusso e refrusso.
957. 1. isscontri . . ellor frusso e refrusso ella. 2. chausa . . strett[i] o di gibiltar . . achade . . voragine.

956. 1. Allusion may here be made to the mythological explanation of the ebb and flow given in the Edda. Utgardloki says to Thor (Gylfaginning 48): "When thou wert drinking out of the horn, and it seemed to thee that it was slow in emptying a wonder befell, which I should not have believed possible: the other end of the horn lay in the sea, which thou sawest not; but when thou shalt go to the sea, thou shalt see how much thou hast drunk out of it. And that men now call the ebb tide."
Several passages in various manuscripts treat of the ebb and flow. In collecting them I have been guided by the rule only to transcribe those which named some particular spot.

Leic. 6 b] **958.**

DEL FLUSSO E RIFLUSSO.

[2] Tutti li mari ànno il lor flusso e ri-
flusso in v̄ medesimo tempo, ma pare va-
riarsi, perchè li giorni nō co[3]minciano in
vn medesimo tenpo in tutto l'universo, cō-
ciosiachè, quādo nel nostro emisperio è
mezzo [4]giorno, nell'opposito emisperio è
mezzanotte·, e nelle congiuntioni oriētali
dell'uno e del'altro emispe[5]rio comincia la
notte che corre dirieto al giorno, e nelle
congiūtioni occidentali d'essi emisperi co-
mincia [6]il giorno che seguita la notte dalla
sua opposita parte·; adunque è conchiuso
che, ancora che 'l [7]detto accrescimēto
e diminvitione delle altezze de' mari sien
fatte in vn [8]medesimo tenpo, essi mostrano
variarsi per le già dette cagioni; sono adun-
que sōmerse le acque [9]nelle uene partite
dai fondi de' mari, le quali ramificano dentro
al corpo della terra, e rispondono [10]al na-
scimento de' fiumi·, i quali al continvo tol-
gono dal fondo il mare al mare andato;
è tolto innvme[11]rabili volte nella superfitie
un mare al mare; E se tu volessi, che la
luna, apparendo all'orientale parte [12]del
Mare Mediterrano, comīciasse ad attrarre a
se l'acque del mare, ne seguirebbe che in-
mediate [13]se ne vedrebbe la speriēza al
fine oriētale di tal mare predetto; Ancora
essendo il Mar Medi[14]terrano circa alla
ottava parte della circūferenza della spera
dell acqua, per essere lui [15]lungo 3 mila
miglia, e 'l flusso e riflusso nō fa se nō 4
volte in 24 ore, e' nō s'accorderebbe tale
[16]effetto col tenpo d'esse 24 ore, se esso
Mare Mediterrā nō fusse lungo semila miglia,
perchè [17]se lo spogliamēto di tanto mare
avesse a passare per lo stretto di Gibiltar
nel correr dietro [18]alla luna, e' sarebbe si
grāde il corso delle acque per tale stretto,
e s'alzerebbe in tāta altezza, [19]che dopo
esso stretto farebbe tal corso, che per molte
miglia infra l'oceano farebbe inōdatione e
bolli[20]menti grandissimi, per la qual cosa
sarebbe inpossibile passarui, e dopo questo
· subito l'ocea[21]no rēderebbe colla medesima
furia l'acque ricevute, dōde esso le riceve;

OF THE FLOW AND EBB.

All seas have their flow and ebb in the
same period, but they seem to vary because
the days do not begin at the same time
throughout the universe; in such wise as that
when it is midday in our hemisphere, it is
midnight in the opposite hemisphere; and at
the Eastern boundary of the two hemispheres
the night begins which follows on the day,
and at the Western boundary of these hemi-
spheres begins the day, which follows the
night from the opposite side. Hence it is
to be inferred that the above mentioned swelling
and diminution in the height of the seas,
although they take place in one and the
same space of time, are seen to vary from
the above mentioned causes. The waters are
then withdrawn into the fissures which start from
the depths of the sea and which ramify in-
side the body of the earth, corresponding to
the sources of rivers, which are constantly
taking from the bottom of the sea the water
which has flowed into it. A sea of water is
incessantly being drawn off from the surface of
the sea. And if you should think that the moon,
rising at the Eastern end of the Mediterranean
sea must there begin to attract to herself the
waters of the sea, it would follow that we
must at once see the effect of it at the Eas-
tern end of that sea. Again, as the Mediter-
ranean sea is about the eighth part of the cir-
cumference of the aqueous sphere, being
3000 miles long, while the flow and ebb only
occur 4 times in 24 hours, these results
would not agree with the time of 24 hours,
unless this Mediterranean sea were six
thousand miles in length; because if such a
superabundance of water had to pass through
the straits of Gibraltar in running behind the
moon, the rush of the water through that
strait would be so great, and would rise
to such a height, that beyond the straits it
would for many miles rush so violently
into the ocean as to cause floods and
tremendous seething, so that it would be
impossible to pass through. This agitated
ocean would afterwards return the waters it

958. 1. frusso e refiusso. 2. frusso e refrusso n̄v . . gorni nō cho- 3. mincano. 3. concosia . . nosstro · . mez. 4. gorno . .
oposito . . mezanotte . . conguntioni . . emissspe. 5. cominca . . gorno . . congūtioni ocidentali . . comica. 6. gorno . . opo-
sita. 7. acresscimēto . . dellellalteze demari ancora chelle . . nvn. 8. mostra . . chagoni . . somerse. 9. defondi ramifichano
. . rispondano. 10. nasscimento De . . tolgano "·del fondo" [e rendano] il . . andato "e tolto" invmerabili volte "nella
superfitie" umare . . Essettu . . chella . . aparendo. 12. mediterano comicassi . . asse. 13. lassperiēza . . mare "predetto".
14. terano circha . . acqu"a". 15. lungho . . frusso e refrusso . . sacorderebe. 16. mediterā fussi lungho. 17. sello . .
avessi . . dirie. 18. sarebe . . essalzerebe. 19. hesso . . infrall . . ebbolli. 21. rederebbe . . riceve . . echoche. 22. passerebe . .

ecco che adūque mai si [22]passerebbe per tale stretto·, e la speriēza mostra che d'ogni ora vi si passa, saluo che quādo il uento [23]viē per la linia della corrēte, allora il riflusso forte s'aumēta·; Il mare non alza l'acqua nelli [24]stretti che ànno vscita ma ben s'ingorga e si ritarda dināti a quelli·, onde con furioso moto [25]poi ristora il tempo del suo ritardamēto insino al fin del suo moto riflesso.

had received with equal fury to the place they had come from, so that no one ever could pass through those straits. Now experience shows that at every hour they are passed in safety, but when the wind sets in the same direction as the current, the strong ebb increases[23]. The sea does not raise the water that has issued from the straits, but it checks them and this retards the tide; then it makes up with furious haste for the time it has lost until the end of the ebb movement.

Leic. 13 a]

959.

Come jl flusso e riflusso non è generale, perchè [2]in riuiera di Genova non fa niēte, a Vinegia due braccia, tra la Inghilterra e Fiandra fa 18 braccia; [3]Come per lo stretto di Sicilia la corrēte è grādissima, perchè di lì passā tutte l'acque de' fiumi che uersā [4]nel Mare Adriatico.

That the flow and ebb are not general; for on the shore at Genoa there is none, at Venice two braccia, between England and Flanders 18 braccia. That in the straits of Sicily the current is very strong because all the waters from the rivers that flow into the Adriatic pass there.

Leic. 35 a]

960.

Nelle parti occidentali·, appresso alla Fiandra, il mare cresce e māca ogni 6 ore circa 20 braccia, [2]e 22 quādo la luna è in suo fauore, ma le 20 braccia è il suo ordinario, il quale ordinario manifestamēte si uede [3]non essere per cavsa della luna; Questa varietà del crescere e discrescere del mare ogni 6· ore può [4]accadere per le ringorgationi delle acque, le quali son condotte nel Mare Mediterrano da quella quantità de' fiu[5]mi dell'Africa Asia ed Evropa, che in esso mare versano le loro acque, le quali per lo stretto di Gibiltar infra Abila

In the West, near to Flanders, the sea rises and decreases every 6 hours about 20 braccia, and 22 when the moon is in its favour; but 20 braccia is the general rule, and this rule, as it is evident, cannot have the moon for its cause. This variation in the increase and decrease of the sea every 6 hours may arise from the damming up of the waters, which are poured into the Mediterranean by the quantity of rivers from Africa, Asia and Europe, which flow into that sea, and the waters which are given to it by those rivers; it pours them to the ocean

ella . . ora usi passa. 23. refrusso . . lacq"a". 24. vsscita [ne in quelli] ma ben siningorgha "essiritarda . . acquelli onde poi con. 25. tenpo [cheche] del . . refresso.
959. 1. frusso e refrusso. 2. genva . . uinegia due br tralla ingilterra . . 18 br. 3. cicilia lacorēte. 4. adriatico.
960. 1. parte hoccidentale . . cressce "e mācha . . circha 20 bra. 2. 20 br quale "ordinario". 3. chavsa . . cressciere e discrescere . . ore po. 4. achadere . . mediterano da "quella". 5. africha . . versano "le loro acque" le . . abile e calpe.

958. 23. In attempting to get out of the Mediterranean, vessels are sometimes detained for a considerable time; not merely by the causes mentioned by Leonardo but by the constant current flowing eastwards through the middle of the straits of Gibraltar.

959. A few more recent data may be given here to facilitate comparison. In the Adriatic the tide rises 2 and $1/2$ feet, at Terracina $1^1/4$. In the English channel between Calais and Kent it rises from 18 to 20 feet. In the straits of Messina it rises no more than $2^1/2$ feet, and that only in stormy weather, but the current is all the stronger. When Leo-

nardo accounts for this by the southward flow of all the Italian rivers along the coasts, the explanation is at least based on a correct observation; namely that a steady current flows southwards along the coast of Calabria and another northwards, along the shores of Sicily; he seems to infer, from the direction of the fiist, that the tide in the Adriatic is caused by it.

960. 5. *Abila*, Lat. *Abyla*, Gr. Ἀβύλη, now *Sierra Ximiera* near Ceuta; *Calpe*, Lat. *Calpe.* Gr. Κάλπη, now Gibraltar. Leonardo here uses the ancient names of the rocks, which were known as the Pillars of Hercules.

e Calpe ⁶promōtori rende all'occeano le acque che da essi fiumi li son date, jl quale oceano, astendendosi ⁷infra le isole d'Inghilterra e l'altre più settētrionali, si uiene a ringorgare e tenere in collo per diuersi golfi, ⁸li quali, essendo tali mari discostatisi colla lor superfitie dal centro del mōdo ·, ànno acquistato peso, il quale, ⁹poichè supera la potentia dell'avenimēto delle acque che lo cavsauano, essa acqua ripiglia im¹⁰peto in contrario al suo avenimēto, e fa impeto contro alli stretti, che li davano l'acque e massime fa ¹¹contra lo stretto di Gibiltar, il quale per alquāto spatio di tenpo rimā ringorgato e viene a riseruarsi tut¹²te l'acque che di novo in tal tenpo li sō date dalli già detti fiumi, e questa mi pare una delle ragioni che ¹³si potrebbe assegnare della causa d'esso flusso e riflusso, come nella 21ª del 4ª della mia teori¹⁴ca è provato.

through the straits of Gibraltar, between Abila and Calpe[5]. That ocean extends to the island of England and others farther North, and it becomes dammed up and kept high in various gulfs. These, being seas of which the surface is remote from the centre of the earth, have acquired a weight, which as it is greater than the force of the incoming waters which cause it, gives this water an impetus in the contrary direction to that in which it came and it is borne back to meet the waters coming out of the straits; and this it does most against the straits of Gibraltar; these, so long as this goes on, remain dammed up and all the water which is poured out meanwhile by the aforementioned rivers, is pent up [in the Mediterranean]; and this might be assigned as the cause of its flow and ebb, as is shown in the 21st of the 4th of my theory.

6. asslendendosi. 7. infralle isola digilterra ellaltre . . settātrionali . . ettenere. 8. cholla . . del mō . ano. 9. chello . . ripiglia ē. 10. peto . . inpito . . chelli. 12. ta lacq"a" . . ga detti . . ecquesti . . chausa . . frusso e refrusso comi. 14. cha e.

III.

SUBTERRANEAN WATER COURSES.

C. A. 157*b*; 466*a*]

961.

Theory of the circulation of the waters (961. 962).

Grādissimi fiumi corrono ²sotto terra.

Very large rivers flow under ground.

Leic. 31*a*]

962.

Qui s'à a īmagina²re la terra ³segata pel mez⁴zo, e vedrannosi ⁵le profondità ⁶del mare e della ⁷terra; ⁸le uene si partono ⁹da' fondi de' ma¹ºri e tessono la ¹¹terra, e si leua¹²no alla sommità ¹³de' mōti, e riuer¹⁴sano per li fiumi e ¹⁵ritornano al ma¹⁶re.

This is meant to represent the earth cut through in the middle, showing the depths of the sea and of the earth; the waters start from the bottom of the seas, and ramifying through the earth they rise to the summits of the mountains, flowing back by the rivers and returning to the sea.

Leic. 21*b*]

963.

Observations in support of the hypothesis (963—969).

Raggirasi l'acqua con cōtinvo moto dall'infime profondità de' mari alle altissime somità de' mōti, non osseruando ²la natura delle cose graui, e in questo caso fanno come il sangue delli animali, che sempre si ³moue dal mare del core e scorre alla sōmità delle loro teste, e quiui rōponsi le uene, come si uede ⁴una vena rotta nel naso, che tutto il sangue da basso si leua

The waters circulate with constant motion from the utmost depths of the sea to the highest summits of the mountains, not obeying the nature of heavy matter; and in this case it acts as does the blood of animals which is always moving from the sea of the heart and flows to the top of their heads; and here it is that veins burst—as one may see when a vein bursts in the nose, that all the blood

961. 1. corā.

962. 4. uedrassi. 7. [e come]. 8. partā. 10. ettessano. 11. essi.

963. 1. Rogirāsi. 2. fa . . animati. 3. move [dal lago] "dal mare" del . . tesste . . e chi quiui rōpasi. 4. chettutto . . àlteza

963. The greater part of this passage has been given as No. 849 in the section on Anatomy.

alla altezza della rotta vena; ⁵Quando l'acqua escie della rotta vena della terra, essa osserua la natura dell'altre cose piv gravi ⁶che l'aria, onde senpre cerca i lochi bassi. ⁷Vaño ⁸le uene scorrēdo con īfinita ramificatione pel corpo della terra.

from below rises to the level of the burst vein. When the water rushes out of a burst vein in the earth it obeys the nature of other things heavier than the air, whence it always seeks the lowest places. [7]These waters traverse the body of the earth with infinite ramifications.

Br. M. 233 b]

964.

Quella cavsa, che move li umori in tutte le spetie de' corpi · animati e che cō quelle soccorre a ogni lesione, ²move l'acqua·dall'infima profōdità del mare alla soña altezza de' mōti, ³e come l'acqua si leua dalle ⁴inferiori parti della vite all'alte tagliature.

The same cause which stirs the humours in every species of animal body and by which every injury is repaired, also moves the waters from the utmost depth of the sea to the greatest heights.

Br. M. 236 b]

965.

L'acqua è proprio quella che per vitale umore ²di questa · arida terra · è dedicata·, e ³quella cavsa che la move · per le sue rami⁴ficate vene · cōtro al natural corso del-⁵le cose gravi·, è proprio quella che mo⁶ve · li umori · in tutte le spetie de' corpi ⁷animati; Ma quella, con sōma āmi⁸ratiō de' sua contemplanti, dall'infima pro⁹fondità del mare · all'altissime soñità ¹⁰de' mōti si leua, e per le rotte · vene ver¹¹sando · al basso mare · ritorna, · e di novo ¹²con celerità · sormōta, e all' · āti-detto de¹³sceso · ritorna·, così dalle parti intrī¹⁴siche · all'esteriori ·, così dalle infime alle ¹⁵superiori, voltādo · quādo con naturale cor¹⁶so ruina·, così insieme cōgiunta, cō ¹⁷cōtinua revolutione, ¹⁸per li terrestri meati si ua raggirādo.

It is the property of water that it constitutes the vital human of this arid earth; and the cause which moves it through its ramified veins, against the natural course of heavy matters, is the same property which moves the humours in every species of animal body. But that which crowns our wonder in contemplating it is, that it rises from the utmost depths of the sea to the highest tops of the mountains, and flowing from the opened veins returns to the low seas; then once more, and with extreme swiftness, it mounts again and returns by the same descent, thus rising from the inside to the outside, and going round from the lowest to the highest, from whence it rushes down in a natural course. Thus by these two movements combined in a constant circulation, it travels through the veins of the earth.

G. 70 a]

966.

SE L'ACQUA PUÒ MŌTARE DAL MARE ²ALLE CIME DELLI MONTI.

WHETHER WATER RISES FROM THE SEA TO THE TOPS OF MOUNTAINS.

³Il mare oceano nō può penetrare ⁴dalle radici alle cime de' mōti che con lui ⁵con-

The water of the ocean cannot make its way from the bases to the tops of the mountains

. . ve "ne". 5. esscie. 6. grave chellaria . . cercha.

964. 1. socore . . lesione. 2. frofōdita . . alteza. 3. come [il sangue] lacq"a". 4. tagliature de. *here the text breaks off*.

965. 1. lacq"a" . . omore. 2. quessta . . dedichata. 4. chōtro . de. 5. chose. 6. omori . . lesspetie. 7. che chōsōma ami. 8. contenplanti | "e che" dall. 10. rocte. 12. cono celerita . . dis. 13. scienso. 15. cho. 17. cōtinua revoluitione siua [ragirādo]. 18. teresti . . ragirādo.

966. 1. sellacq"a" mōtare. 3. occieano. 4. radicie . . collui. 5. sul si leua quato la seccita. 6. Esse. 7. cheppienetra.

finano, ma solo si leua quādo la secchità ⁶del mōte ne tira; E se per l'aversario la ⁷pioggia, che penetra dalla cima del monte ⁸alle radici sua, che col mare confinano, discē⁹de e mollifica la spiaggia opposta del me¹⁰desimo monte e tira al continuo, si come ¹¹fa la cicogniola che versa per il suo lato più lū¹²go, fusse quella che tira in alto l'acqua del ¹³mare; come se *s n* fusse la pelle del ma¹⁴re, e la pioggia discende dalla cima del mō¹⁵te *a* allo *n* da vn lato e dall'altro lato di¹⁶scēde da *a* allo *m*, sanza dubbio que¹⁷sto sarebbe il modo dello stillare a feltro o ¹⁸come si fa per la canna detta cico¹⁹gniola, e senpre l'acqua che à mollificato ²⁰il monte per la gran pioggia, che discende dal²¹li due opposti lati, tirerebbe a sè al lato ²²più lūgo la pioggia *a n* insieme coll' acqua ²³del mare perpetuamēte, se il lato del mōte ²⁴*a m* fusse più lūgo che l'altro *a n*, il che essere ²⁵nō può, perchè nessuna parte di terra che nō ²⁶sia sōmersa dall' oceano sarà più bassa ²⁷d'esso oceano ecc.

which bound it, but only so much rises as the dryness of the mountain attracts. And if, on the contrary, the rain, which penetrates from the summit of the mountain to the base, which is the boundary of the sea, descends and softens the slope opposite to the said mountain and constantly draws the water, like a syphon[11] which pours through its longest side, it must be this which draws up the water of the sea; thus if *s n* were the surface of the sea, and the rain descends from the top of the mountain *a* to *n* on one side, and on the other sides it descends from *a* to *m*, without a doubt this would occur after the manner of distilling through felt, or as happens through the tubes called syphons[17]. And at all times the water which has softened the mountain, by the great rain which runs down the two opposite sides, would constantly attract the rain *a n*, on its longest side together with the water from the sea, if that side of the mountain *a m* were longer than the other *a n*; but this cannot be, because no part of the earth which is not submerged by the ocean can be lower than that ocean.

A. 55*b*] **967.**

Delle vene del' acqua sopra · le cime delle mōtagnie.

Of springs of water on the tops of mountains.

²Chiaro · apparisce · che tutta la · superfitie dell' ocieano ·, quādo non à fortuna ·, è di pari distātia ³al ciētro · della · terra ·, e che le cime delle mōtagnie sono tanto piv lontane · da esso ⁴ciētro · quāto · elle s'alzano · sopra alla superfitie d'esso · mare ·; Adūque se 'l corpo della ⁵terra non avesse similitudine · coll' omo, sarebbe · inpossibile · che l'acqua · del mare, essendo tāto ⁶piv · bassa · che le mōtagnie ·, ch'ella potesse · di sua natura · salire · alle · sommità · d'esse mōtagnie; ⁷Onde · è da credere · che quella · cagione ·, che tiene il sangue · nella · sōmità della · testa · dell' omo, ⁸quella · medesima · tenga l'acqua · nella · sommità · de' monti.

It is quite evident that the whole surface of the ocean—when there is no storm—is at an equal distance from the centre of the earth, and that the tops of the mountains are farther from this centre in proportion as they rise above the surface of that sea; therefore if the body of the earth were not like that of man, it would be impossible that the waters of the sea—being so much lower than the mountains—could by their nature rise up to the summits of these mountains. Hence it is to be believed that the same cause which keeps the blood at the top of the head in man keeps the water at the summits of the mountains.

8. chol . . chonfina disscie̅. 9. mollifiche. 10. ettira. 12. gho fussi . . chettira. 13. chome . . fusse. 14. ella . . disciende alla. 15. da ullato. 16. disciēde . . dubbio che. 17. affeltro. 18. chome . . lla channa [decta]. 19. essenpre . . mollifichato. 20. cheddissciēde. 21. asse il lato. 22. lūgho . . chollacq"a". 23. sellatto. 24. fussi . . lūgho chellaltro. 26. ọ̈ccieano. 27. occieano.

967. 1. acq"a". 2. aparisscie . . chella "tutta". 3. tera e chelle . . mōtagni "e" . . esso [mare]. 4. sopa . . ̣chorpo. 5. tera . . avessi . . choll . . chellacqua. 7. che̟cquella chagione . chettiene . . somita. 8. lacq"a".

966. 11, 17. Cicognola, Syphon. See Vol. I, Pl. XXIV, No. 1.

967. 968. This conception of the rising of the blood, which has given rise to the comparison, was recognised as erroneous by Leonardo himself at a later period. It must be remembered that

A. 56 a]

968.

DELLA CÔFERMATIONE PERCHÈ L'ACQUA È NELLE · SOMITÀ DE' MÔTI.

²Dico · che siccome · il naturale · calore · tiene il sāgue nelle uene · alla sommità dell'omo, ³e quādo lo · omo · è morto, esso sangue · freddo · si riduce ⁴ne' lochi · bassi ·, e, quādo · il sole · riscalda · la testa all'omo, ⁵ moltiplica · e sopraviene tāto sangue con omori ·, che forzādo · le uene ⁶gienera · spesso · dolori · di testa ·, similemēte le uene ·, che vanno ramificādo ⁷per il · corpo · della · terra · e per lo · naturale · calore, · ch'è sparso per tutto · il côti⁸nēte · corpo ·, l'aqua · sta · per le uene · eleuate · all'alte cime de' mōti; E quel⁹la · acqua ·, che passasi · per uno · condotto mvrato · nel corpo d'essa · mōtagnia, ¹⁰come · cosa · morta · non uscirà · dalla · sua · prima · bassezza ·, perchè non è ¹¹riscaldata · dal uitale · calore della · prima · vena ·; ancora · il calore ¹²dell'emēto del fuoco ·, e il giorno · il caldo del sole ·, ànno potētia di suegliere ¹³l'umidità · de' bassi lochi · de' mōti e tirare in alto · nel medesimo · modo ch'ella ¹⁴tira . i nvvoli · e sueglie · la loro · vmidità · dal letto del mare.

IN CONFIRMATION OF WHY THE WATER GOES TO THE TOPS OF MOUNTAINS.

I say that just as the natural heat of the blood in the veins keeps it in the head of man,—for when the man is dead the cold blood sinks to the lower parts—and when the sun is hot on the head of a man the blood increases and rises so much, with other humours, that by pressure in the veins pains in the head are often caused; in the same way veins ramify through the body of the earth, and by the natural heat which is distributed throughout the containing body, the water is raised through the veins to the tops of mountains. And this water, which passes through a closed conduit inside the body of the mountain like a dead thing, cannot come forth from its low place unless it is warmed by the vital heat of the spring time. Again, the heat of the element of fire and, by day, the heat of the sun, have power to draw forth the moisture of the low parts of the mountains and to draw them up, in the same way as it draws the clouds and collects their moisture from the bed of the sea.

Leic. 11 a]

969.

Come molte vene d'acqua salata si trovano fortemēte distanti dal ²mare, e questo potrebbe accadere, perchè tal uena passasse per qualche miniera di sale come quella d'Ungheria, che si caua ³il sale per le grandissime cave, come quasi cavano le pietre.

That many springs of salt water are found at great distances from the sea; this might happen because such springs pass through some mine of salt, like that in Hungary where salt is hewn out of vast caverns, just as stone is hewn.

968. 1. chôfermatione . . lacq"a". 2. dicho chessichome . . chalore tie "il sāgue" leuene . ala somita. 3. [cho] e quādo [esso] "lo" omo . . fredo. 4. bassi [chosi] echauàdo il . . risschalda [il n] la. 5. molti pricha essopraviene . . chon . . chefforzādo. 6. vano ramifichādo. 7. lochorpo . . tera . . chalori chessparso . . chōti. 8. chorpo . . elleuate . . Ecque. 9. per i̅ chondotto . . chorpo. 10. chome chosa . . vsscira della . . basseza . nōne. 11. rischaldata . . chalore anchora il chalore. 12. focho . . chaldo . sole a . dissuegliere. 13. lochi "de mōti" ettirare. 14. nvboli essueglie . . delletto.

969. 1. trova . . distante . . da. 2. ecquesto . . achadere . . passasi . . chessi. 3. quasi caua.

the MS. *A*, from which these passages are taken, was written about twenty years earlier than the MS. Leic. (Nos. 963 and 849) and twenty-five years before the MS. W. An. IV.

There is, in the original a sketch with No. 968 which is not reproduced. It represents a hill of the same shape as that shown at No. 982. There are veins, or branched streams, on the side of the hill, like those on the skull Pl. CVIII, No. 4.

969. The great mine of Wieliczka in Galicia, out of which a million cwt. of rock-salt are annually dug out, extends for 3000 mètres from West to East, and 1150 mètres from North to South.

IV.

OF RIVERS.

Leic. 33*b*] **970.**

DELLE DIRIUATIONI DE' FIUMI.

On the way in which the sources of rivers are fed.

[2]Il corpo della terra, a similitudine de' corpi deli animali, è tessuto di ramificationi di uene, le quali son tutte insieme cōgiunte, [3]e son constituite a nvtrimento e viuificatione d'essa terra e de' sua creati ·; partano dalle profondità del mare, e a quelle dopo molta revolutio[4]ne ànno a tornare per li fiumi creati dalle alte rotture d'esse uene; e se tu volessi dire, le pio[5]ve il uerno o la resolutione della neue l'estate essere causa del nascimento de' fiumi, e' si ti potrebbe allegare [6]li fiumi, che ànno origine ne' paesi focosi dell' Africa, nella quale non piove e meno nevica, perchè il superchio [7]caldo senpre risolue in aria tutti li nuvoli, che da uēti in là son sospinti; e se tu dicessi che tali fiumi, che uē[8]gono grossi il Luglio e 'l Agosto, son delle nevi che si risoluono il Maggio e 'l Giugnio per l'appressamēto del sole alle ne[9]ui delle montagnie di Scitia, e che tali resolutioni si riducono in certe valli e fanno laghi, doue poi entrano per le [10]vene e caue sotterane, le

OF THE ORIGIN OF RIVERS.

The body of the earth, like the bodies of animals, is intersected with ramifications of waters which are all in connection and are constituted to give nutriment and life to the earth and to its creatures. These come from the depth of the sea and, after many revolutions, have to return to it by the rivers created by the bursting of these springs; and if you chose to say that the rains of the winter or the melting of the snows in summer were the cause of the birth of rivers, I could mention the rivers which originate in the torrid countries of Africa, where it never rains—and still less snows—because the intense heat always melts into air all the clouds which are borne thither by the winds. And if you chose to say that such rivers, as increase in July and August, come from the snows which melt in May and June from the sun's approach to the snows on the mountains of Scythia[9], and that such meltings come down into certain valleys and form lakes, into which they enter by springs and subter-

970. 1. assimi . . ettessudi di ramifichatione . . cōgunte. 3. consstit ite "a nvtrimento" e viuifichatione . . terra | "e de sua creati" essi partano delle . . acquelle. 4. ano attornare . . essettu. 5. olla . lastate . . chausa . . nasscimento . . portrebbe. 6. fochosi africha . . nevicha. 7. chaldo . . nvoli . . illa . . sosspinte . . essettu . . chettali. 8. gano . . ellagosto . . chessi . . lapressamēto . . mago . . gugnio. 9. disscitia . . riduchano . . effano lagh. 10. riescano . . effalso inperochelle . . las. 11. chellorigine . . concosia chella.

970. 9. Scythia means here, as in Ancient Geography, the whole of the Northern part of Asia as far as India.

quali riescono poi all' origine del Nilo, questo è falso, inperochè è piv bassa la [11]Scitia che l' origine del Nilo, conciosiachè la Scitia è presso al mare di Pōto a 400 miglia, e l' origine del Nilo è [12]remoto 3000 miglia dal mare d' Egitto, ove versā le sue acque.

ranean caves to issue forth again at the sources of the Nile, this is false; because Scythia is lower than the sources of the Nile, and, besides, Scythia is only 400 miles from the Black sea and the sources of the Nile are 3000 miles distant from the sea of Egypt into which its waters flow.

Leic. 5 *a*]

971.

Libro 9° delli scontri de' fiumi e lor flusso e riflusso, e la medesima [2]causa lo crea nel mare per causa dello stretto di Gibilterra, e ancora accade per le uoragini;

[3]Se due fiumi insieme si scontrano per vna medesima linia, la qual sia retta, poi infra 2 angoli retti [4]pigliano insieme lor corso, e' seguirà il flusso e riflusso · ora a l' uno fiume, ora all' altro, avanti [5]che sieno · vniti e massime, se l' uscita nella loro vnitione nō sarà piv veloce, che quād' erā disuniti; [6]Qui accadono 4 casi.

Book 9, of the meeting of rivers and of their ebb and flow. The cause is the same in the sea, where it is caused by the straits of Gibraltar; and again it is caused by whirlpools. *The tide in estuaries.*

[3] If two rivers meet together to form a straight line, and then below two right angles take their course together, the flow and ebb will happen now in one river and now in the other above their confluence, and principally if the outlet for their united volume is no swifter than when they were separate. Here occur 4 instances.

Leic. 15 *a*]

972.

Quando il fiume minore versa le sue acque nel maggiore, il quale maggiore corra dall' opposita [2]riua, allora il corso del fiume minore piegherà il suo corso inverso l' auenimēto del fiume [3]maggiore; e questo accade perchè, quando esso maggiore fiume enpie d' acqua tutto il suo letto, e' [4]glì viene a fare ritroso sotto la bocca di tal fiume, e così spingnie cō seco l' acqua versata dal fi[5]vme minore; Quando il fiume minore versa le sue acque nel fiume maggiore, il quale [6]abbia la corrente alla foce del minore, allora le sue acque si piegheranno inverso la fu[7]ga del fiume maggiore.

When a smaller river pours its waters into a larger one, and that larger one flows from the opposite direction, the course of the smaller river will bend up against the approach of the larger river; and this happens because, when the larger river fills up all its bed with water, it makes an eddy in front of the mouth of the other river, and so carries the water poured in by the smaller river with its own. When the smaller river pours its waters into the larger one, which runs across the current at the mouth of the smaller river, its waters will bend with the downward movement of the larger river. *On the alterations, caused in the courses of rivers by their confluence (972—974).*

971. 1. isscontri . . ellor frusso e refrusso alta. 2. chausa . . strett [i] o di gibiltar . . achade . . uoragine. 3. retta e poi. 4. piglino . . refrusso. 5. chessieno . . lusscita nedella. 6. achade 4 chasi.

972. 1. magore il cqual "magore" corra "dall oposita riua" [remoto dalla sua]. 2. piegera. 3. magore ecquesto acchade . . magor . . letto el. 4. affare retroso . . bocha. 5. magore. 6. minor [fiume] allora . . piegeranno. 7. magore.

971. The first two lines of this passage have already been given as No. 957. In the margin, near line 3 of this passage, the text given as No. 919 is written.

972. In the original sketches the word *Arno* is written at the spot here marked *A*, at *R. Rifredi*, and at *M. Mugnone*.

Leic. 16*b*] **973.**

Quando le piene de' fiumi sō ²diminuite·, allor li angoli acuti, che si generā nelle congiuntioni de' sua rami, si fanno piv cor³ti nelli lor lati e più grossi nelle lor punte, come sia la corrente *a n*, e la corrente *d n*, ⁴le quali si congiunghino insieme in · *n*, quando il fiume è nelle sue gran piene; dico che, quando sia ⁵nella predetta dispositione·, che se *d n* avanti la piena era piv basso che *a n*, che nel tempo della piena ⁶*d n* sarà piē di rena e fango, il quale nel calare delle acque *d n* porterà uia il fango e rimar⁷rà col fondo basso, e 'l canale *a n*, trovandosi alto, scolerà le sue acque nel basso *d n* e consumerà tutta ⁸la punta del renaio *b c n*, e così rimarrà l'angolo *a c d* piv grosso che l'angolo *a n d*, e di lati più corti, come ⁹prima dissi.

When the fulness of rivers is diminished, then the acute angles formed at the junction of their branches become shorter at the sides and wider at the point; like the current *a n* and the current *d n*, which unite in *n* when the river is at its greatest fulness. I say, that when it is in this condition if, before the fullest time, *d n* was lower than *a n*, at the time of fulness *d n* will be full of sand and mud. When the water *d n* falls, it will carry away the mud and remain with a lower bottom, and the channel *a n* finding itself the higher, will fling its waters into the lower, *d n*, and will wash away all the point of the sand-spit *b n c*, and thus the angle *a c d* will remain larger than the angle *a n d* and the sides shorter, as I said before.

G. 48*a*] **974.**

AQUA.

DEL MOTO D'Ū SUBITO ENPITO FATTO ³DA UN FIUME SOPRA IL SUO LETTO ASCIUTTO.

⁴Tanto è più tardo o velocie il corso dell'acqua, ⁵data dallo isboccato lago al secco fivme, quā⁶to esso fiume fia più largo o piv stretto, over ⁷più piano o cupo in un loco che in un altro, ⁸per quel che è proposto: il flusso e ri⁹flusso del mare che dallo oceano entra nel Me¹⁰diterraneo Mare e de' fiumi, che giostrano ¹¹con lui, alzano tanto più o meno le loro acque, ¹²quanto tal mare è piv o meno stretto.

WATER.

OF THE MOVEMENT OF A SUDDEN RUSH MADE BY A RIVER IN ITS BED PREVIOUSLY DRY.

In proportion as the current of the water given forth by the draining of the lake is slow or rapid in the dry river bed, so will this river be wider or narrower, or shallower or deeper in one place than another, according to this proposition: the flow and ebb of the sea which enters the Mediterranean from the ocean, and of the rivers which meet and struggle with it, will raise their waters more or less in proportion as the sea is wider or narrower.

C. A. 362*b*; 1134*b*] **975.**

Whirlpools. Voragine, cioè caverne, ²cioè residui d'acque pre³cipitose.

Whirlpools, that is to say caverns; that is to say places left by precipitated waters.

973. 2. conguntione. 3. corente . . ella corente. 4. congunghino . . dicho. 5. predecta disspositione chesse. 6. effango . . rima. 8. cori rimara lanolo . . groso.

974. 3. da u . . assciucto. 4. eppiu . . chorpo . . acq"a". 5. isbochato lagho . . secho. 6. largho . . strecto. 7. ochupo nū locho che inu. 8. propossto . . e re. 9. frusso . . dello occieano. 10. mediterano . . giosstrano. 11. chō. 12. eppiu . . strecto.

975. 2. coe residii. 3. cipitosa.

973. Above the first sketch we find, in the original, this note: "*Sopra il pōte rubaconte alla torricella*"; and by the second, which represents a pier of a bridge, "*Sotto l'ospedal del ceppo.*"

974. In the margin is a sketch of a river which winds so as to form islands.

G. 49*b*]

976.

DELLA VIBRATIONE DELLA TERRA.

²Li corsi sotterranei ³delle acque, sicome quelli che son fatti infra ⁴l'aria e la terra, son quelli che al continuo ⁵cōsumano e profondano li letti del⁶li lor corsi.

OF THE VIBRATION OF THE EARTH.

The subterranean 'channels of waters, like those which exist between the air and the earth, are those which unceasingly wear away and deepen the beds of their currents.

On the alterations in the channels of rivers.

Leic. 6*b*]

977.

Il fiume che esce de' mōti pone gran quātità di sassi grossi in nel suo ghiareto, i quali fatti sono ancora ²con parte de' sua angoli e lati, e nel processo del corso conduce pietre minori con angoli piv cōsumati, cioè le grā ³pietre fa minori, e piv oltre pō ghiaia · grossa, e poi minvta ·, e seguita rena grossa, e poi minvta, dipoi procede ⁴litta grossa, e poi piv sottile, e così seguēdo giugne al mare l'acqua turba di rena e di litta; la rena scarica sopra de' ⁵liti marini per il rigurgitamēto dell' ōde salse, e segue la litta di tanta sottilità che par di natura d'acqua, la qual non si fer⁶ma sopra de' marī liti, ma ritorna indietro coll'acqua per la sua leuità, perch'è nata di foglie marcie e d'altre cose leuissime, si ⁷che, essendo quasi, com'è detto, di natura d'acqua, essa poi in tenpo di bonaccia si scarica e si ferma sopra del ⁸fondo del mare, ove per la sua sottilità si condensa e resiste all'onde che sopra vi passano per la sua lubricità, e ⁹qui stanno i nichi e quest'è terra bianca da far boccali.

A river that flows from mountains deposits a great quantity of large stones in its bed, which still have some of their angles and sides, and in the course of its flow it carries down smaller stones with the angles more worn; that is to say the large stones become smaller. And farther on it deposits coarse gravel and then smaller, and as it proceeds this becomes coarse sand and then finer, and going on thus the water, turbid with sand and gravel, joins the sea; and the sand settles on the sea-shores, being cast up by the salt waves; and there results the sand of so fine a nature as to seem almost like water, and it will not stop on the shores of the sea but returns by reason of its lightness, because it was originally formed of rotten leaves and other very light things. Still, being almost—as was said—of the nature of water itself, it afterwards, when the weather is calm, settles and becomes solid at the bottom of the sea, where by its fineness it becomes compact and by its smoothness resists the waves which glide over it; and in this shells are found; and this is white earth, fit for pottery.

The origin of the sand in rivers (977. 978).

Leic. 31*b*]

978.

Tutte l'uscite dell'acque dal monte nel mare portā cō seco li sassi del monte in es²so mare, e per la inōdatione dell'acque marine contro alli sua monti, esse pietre erā ributta³te inverso il mōte, e nell'ādare e nel ritornare indietro delle acque al mare, le pietre insieme cō quel⁴la tornavano, e nel ritornare li angoli loro insieme si percuoteano, e come parte men ⁵resistente alle percosse si cōsumavano e facean le pietre sanza angoli, in figu⁶ra rotonda ·, come ne' liti dell'Elsa si dimostra, e quelle rimanevā piv grosse, che manco sarā remosse ⁷dal lor

All the torrents of water flowing from the mountains to the sea carry with them the stones from the hills to the sea, and by the influx of the sea-water towards the mountains; these stones were thrown back towards the mountains, and as the waters rose and retired, the stones were tossed about by it and in rolling, their angles hit together; then as the parts, which least resisted the blows, were worn off, the stones ceased to be angular and became round in form, as may be seen on the banks of the Elsa. And those remained larger which were less removed

976. 1. viberatio. 2. supterrani [e super accquelli]. 3. so fatti infral. 4. ella. 6. chorsi.

977. 1. essce . . inel. 2. ellati . . agoli . . coe. 3. grosa e po . . grosa prociede. 4. lita . . gugne . . lita . . scaricha. 5. per e . ricitramēto . . lita . . dachq"a". 6. indirieta collo per . . marce. 7. bonacca . . scaricha essi. 9. ecquest . biancha daffar bochali.

978. 1. lusscite dellacq"e" . . secho . . in e. 2. rebutta. 3. mōde "e nellādare" e . . indirieto. 4. toravano . . perchoteano. 5. perchose . . effacean. 6. ritonda "come ne liti dellebba si dimosstra" ecquella rimanē . . mancho. 7. nasscimēto. 8. locho

nascimēto; e così quella si facea minore, che piv si rimouea dal predet⁸to loco, in modo che nel procedere ella si cōuerte in ghiaja minvta, e poi in rena ⁹e in vltimo in fango ·; dipoi che 'l mare si discosta dalli predetti monti·, la salsedine lascia¹⁰ta dal mare con altro umore della terra à fatta vna collegatione a essa ghiaja e rena, che la ¹¹ghiaja in sasso e la rena in tufo s'è convertita; E di questo si uede l'esenplo ¹²in Adda all'uscire de' monti di Como e in Tesino, Adige, Oglio dall'alpi de' Tedeschi, e il si¹³mile d'Arno dal monte Albano intorno a Mōte Lupo e Capraia, doue li sassi grandissimi son tutti ¹⁴di ghiaja cōgelata di diuerse pietre e colori.

from their native spot; and they became smaller, the farther they were carried from that place, so that in the process they were converted into small pebbles and then into sand and at last into mud. After the sea had receded from the mountains the brine left by the sea with other humours of the earth made a concretion of these pebbles and this sand, so that the pebbles were converted into rock and the sand into tufa. And of this we see an example in the Adda where it issues from the mountains of Como and in the Ticino, the Adige and the Oglio coming from the German Alps, and in the Arno at Monte Albano [13], near Monte Lupo and Capraia where the rocks, which are very large, are all of conglomerated pebbles of various kinds and colours.

. . procedere in si . . giara. 9. fangho . . disscosste . . lasscia. 10. ta del . . altromore . . affatto . . giara errena chella. 11. giara . . ella . . chonvertita. 12. inada . .. adice oglio e adriano dell alpi . . tedesci el si . . 13. darno del. 14. cholori.

978. 13. At the foot of *Monte Albano* lies Vinci, the birth place of Leonardo. Opposite, on the other bank of the Arno, is *Monte Lupo*.

V.

ON MOUNTAINS.

C. A. 157 b; 466 a]

979.

¶Li mōti son fatti dalli cor²si de’ fiumi;¶
³¶Li mōti son disfatti dalli cor⁴si de’ fiumi.¶

Mountains are made by the currents of rivers.
Mountains are destroyed by the currents of rivers.

The formation of mountains (979—983).

Leic. 10 a]

980.

Come le ²radici settentrionali di qualunche alpe · non sono ancora petrificate; e questo si vede ma³nifestamente doue i fiumi, che le tagliano, corrano inverso settentrione, li quali tagliā ⁴ nell’ altezze de’ mōti le falde delle pietre viue, e nell’ congiugniersi colle pianure le predette falde ⁵ son tutte di terra da fare boccali ·, come si dimostra in Val di Lamona al fiume Lamona nel⁶l’uscire del Mōte Appenino fargli le predette cose nelle sue rive;
Come li fiumi ànno tutti segati ⁷ e diuisi li menbri delle grand’ alpi l’uno dall’altro, e questo si manifesta per lo ordine delle ⁸ pietre faldate, chè dalla sommità del monte insino al fiume si vedono le corrispōdenze delle falde essere ⁹ così da l’un de’ lati del fiume come dall’altro; Come

That the Northern bases of some Alps are not yet petrified. And this is plainly to be seen where the rivers, which cut through them, flow towards the North; where they cut through the strata in the living stone in the higher parts of the mountains; and, where they join the plains, these strata are all of potter’s clay; as is to be seen in the valley of Lamona where the river Lamona, as it issues from the Appenines, does these things on its banks.
That the rivers have all cut and divided the mountains of the great Alps one from the other. This is visible in the order of the stratified rocks, because from the summits of the banks, down to the river the correspondence of the strata in the rocks is visible on either side of the river. That the

979. 3. dissfacti . . chor.
980. 2. radice . . petrifichate ecquesto. 3. chelle . . chorrane . . settantrione. 4. alteze . . congugnersi cholle. 5. daffare bochali . . lumona fare al. 6. lusscire . . farli . . fiumi an. 7. alpe . . ecquesto. 8. somita . . vede . . conrisspōdenze. 9. tutti

979. Compare 789.

le pietre faldate de' monti · son tutti i gradi [10]de' fanghi posati l'un sopra l'altro per le inōdationi de' fiumi; Come le diuerse grossezze delle falde del[11]le pietre son create da diuerse inondationi de' fiumi, cioè maggiore ondatione o minore.

stratified stones of the mountains are all layers of clay, deposited one above the other by the various floods of the rivers. That the different size of the strata is caused by the difference in the floods—that is to say greater or lesser floods.

L. 76 a] 981.

Le sommità de' monti per [2]lungo tenpo senpre s'i[3]nalzano;

[4]I lati opposti de' mō[5]ti senpre s'auicinano; [6]le profondità delle ualli, [7]le quali son sopra la [8]spera dell'acqua, per lungo [9]tenpo senpre [10]s'appropinquano al cē[11]tro del mondo;

[12]In equal tēpo molto pi[13]v si profondano le ual[14]li che non s'alzano i mō[15]ti;

[16]Le base de' monti senpre [17]si fanno piv strette;

[18]Quanto [19]la ualle piv si pro[20]fonda, piv si consu[21]ma ne' sua lati in [22]più brieue tenpo.

The summits of mountains for a long time rise constantly.

The opposite sides of the mountains always approach each other below; the depths of the valleys which are above the sphere of the waters are in the course of time constantly getting nearer to the centre of the world.

In an equal period, the valleys sink much more than the mountains rise.

The bases of the mountains always come closer together.

In proportion as the valleys become deeper, the more quickly are their sides worn away.

Br. M. 30 b] 982.

In ogni concauità delle cime de' monti senpre si trouer[2]anno li piegamēti delle falde delle pietre.

In every concavity at the summit of the mountains we shall always find the divisions of the strata in the rocks.

C. A. 124 b; 383 a] 983.

DEL MARE CHE CIGNE LA TERRA.

[2]Jo truouo il sito della terra essere ab antico · nelle sue pianure tutto [3]occupato e coperto dall'acque salse ecc.

OF THE SEA WHICH ENCIRCLES THE EARTH.

I find that of old, the state of the earth was that its plains were all covered up and hidden by salt water.

e gradi. 10. gosseze. 11. coe magore . . ōminore.
981. 1. somita. 7. la 5. 8. acq"a". 9. senpre [sabb]. 17. strecte. 20. consū. 21. made sua.
982. 2. ra li.
983. 1. ce cignie. 2. abbanticho . . tucto. 3. ochupato e choperto.

983. This passage has already been published by Dr. M. JORDAN: *Das Malerbuch des L. da Vinci*, *Leipzig* 1873, p. 86. However, his reading of the text differs from mine.

Leic. 31 *a*] **984.**

Perchè molto sō ²piv antiche le ³cose che le lette⁴re, non è maravi⁵glia, se alli nostri ⁶giorni non appari⁷sce scrittura de-⁸lli predetti ma⁹ri essere occupa¹⁰tori di tanti pa¹¹esi; ¹²e se pure alcuna ¹³scrittura apparia, ¹⁴le guerre, l'incēdi, li diluvi dell'acque ¹⁵le mutationi delle ¹⁶lingue e delle leggi ¹⁷ànno cōsumato ¹⁸ogni antichità, ma ¹⁹a noi bastano le testi²⁰monianze delle co-²¹se nate nelle acque ²²salse ritrouarsi ²³nelli alti mōti, ²⁴lontani dalli mari ²⁵d'allora.

Since things are much more ancient than letters, it is no marvel if, in our day, no records exist of these seas having covered so many countries; and if, moreover, some records had existed, war and conflagrations, the deluge of waters, the changes of languages and of laws have consumed every thing ancient. But sufficient for us is the testimony of things created in the salt waters, and found again in high mountains far from the seas.

The authorities for the study of the structure of the earth.

984. 3. chelle. 6. gorni non aparis. 7. sciptura del. 9. ocupa. 11. [esi essettu]. 12. esse. 15. "li diluui dellacque" le mutationi. 16. legi. 19. basta. 20. monātie. 26. talor.

VI.

GEOLOGICAL PROBLEMS.

Leic. 3 a]

985.

In questa tua opera tu ài ɉn prima a provare, come li nichi in mille braccia d'altura nō ui furō [2]portati dal diluuio, perchè si uedono a ū medesimo liuello, e si vedono auāzare assai mōti sopra [3]esso liuello, e a dimādare se 'l ɗiluvio fù per piogga o per ringorgamēto di mare, e poi ài [4]a mostrare, che nè per pioggia che ingrossi i fiumi, nè per rigonfiamēto d'esso mare; li nichi, come cosa [5]grave, non sono sospinti dal mare alli mōti, nè tirati a se dalli fiumi cōtro al corso delle [6]loro acque.

In this work you have first to prove that the shells at a thousand braccia of elevation were not carried there by the deluge, because they are seen to be all at one level, and many mountains are seen to be above that level; and to inquire whether the deluge was caused by rain or by the swelling of the sea; and then you must show how, neither by rain nor by swelling of the rivers, nor by the overflow of this sea, could the shells—being heavy objects—be floated up the mountains by the sea, nor have carried there by the rivers against the course of their waters.

C. A. 152 a; 452 a]

986.

Doubts about the deluge.

Dubitatione.

[2]Mouesi qui vn dubbio e questo è, se 'l [3]diluvio, venuto al tenpo di Noè, fù vni-[4]versale o no; E qui parrà di no, per le

A doubtful point.

Here a doubt arises, and that is: whether the deluge, which happened at the time of Noah, was universal or not. And it would

985. 1. quessta . . br daltura. 2. perchessi uedano . . e uedesi. 4. mosstrare . . piogga chengrossi . . chome. 5. sosspinti . . asse . . chorso. 6. accq"e".

986. 2. ecquesso. 4. onno. 5. chessi . . abbian "nella bibbia. 6. chonpossto. 7. nocte . . pio. 8. chettal piogg. 9. ghomiti.

985. The passages, here given from the MS. Leic., have hitherto remained unknown. Some preliminary notes on the subject are to be found in MS. F 80a and 80b; but as compared with the fuller treatment here given, they are, it seems to me, of secondary interest. They contain nothing

that is not repeated here more clearly and fully. Libri, *Histoire des Sciences mathématiques III*, pages 218—221, has printed the text of *F* 80a and 80b, therefore it seemed desirable to give my reasons for not inserting it in this work.

⁵ragioni che si assegnieranno; Noi abbiamo nella bibbia, ⁶che il predetto diluvio fù conposto di 40 ⁷dì e 40 notti di continua e vniversa piog⁸gia, e che tal pioggia alzò dieci ⁹gomiti sopra al più alto mōte dell'univer¹⁰so; E se così fù, che la pioggia fusse vniver¹¹sale, ella vestì di se la nostra ter¹²ra di figura sperica; È la superfi¹³tie sperica in ogni sua parte equalmen¹⁴te distante dal ciētro della sva spe¹⁵ra, onde la spera del'acqua, trovandosi ¹⁶nel modo della detta conditione, elli è ¹⁷inpossibile, che l'acqua sopra di lei si mova, ¹⁸perchè l'acqua in se non si move, s'ella non ¹⁹disciēde; addunque l'acqua di tanto dilu²⁰vio come si partì, se qui è provato, non a²¹ver moto? e s'ella si partì, come si mosse, ²²se ella non ādava allo insù? e qui ne mācano²³ le ragiō naturali, ōde bisognia per soccor²⁴so di tal dvbitatione chiamare il mira²⁵colo per aiuto, o dire che ²⁶tale acqua fu vaporata dal calore del sole.

seem not, for the reasons now to be given: We have it in the Bible that this deluge lasted 40 days and 40 nights of incessant and universal rain, and that this rain rose to ten cubits above the highest mountains in the world. And if it had been that the rain was universal, it would have covered our globe which is spherical in form. And this spherical surface is equally distant in every part, from the centre of its sphere; hence the sphere of the waters being under the same conditions, it is impossible that the water upon it should move, because water, in itself, does not move unless it falls; therefore how could the waters of such a deluge depart, if it is proved that it has no motion? and if it departed how could it move unless it went upwards? Here, then, natural reasons are wanting; hence to remove this doubt it is necessary to call in a miracle to aid us, or else to say that all this water was evaporated by the heat of the sun.

Leic. 8 *b*] **987.**

DEL DILUUIO E DE'NICHI MARINI.

²Se tu dirai che li nichi, che per li confini d'Italia lontano dalli mari in tāta altezza si ueggono ³alli nostri tempi, siano stati per causa del diluuio che lì li lasciò, io ti rispōdo che, credendo tu che ⁴tal diluuio superasse il piv alto monte 7 cubiti, come scrisse chi li misurò, tali nichi che senpre ⁵stanno vicini ai liti del mare, e' doueano restare sopra tali mōtagnie, e nō si poco sopra le radi⁶ci de' monti per tutto a vna medesima altezza a suoli a suoli; E se tu dirai che, essendo tali ⁷nichi vaghi di stare vicini alli liti marini e che, crescēdo in tāta altezza, che li nichi si ⁸partirono da esso lor primo sito e seguitarono l'accresciimēto delle acque insino alla lor ⁹soma altezza, Qui si risponde che, sendo il nichio anima-

OF THE DELUGE AND OF MARINE SHELLS.

If you were to say that the shells which are to be seen within the confines of Italy now, in our days, far from the sea and at such heights, had been brought there by the deluge which left them there, I should answer that if you believe that this deluge rose 7 cubits above the highest mountains— as he who measured it has written—these shells, which always live near the sea-shore, should have been left on the mountains; and not such a little way from the foot of the mountains; nor all at one level, nor in layers upon layers. And if you were to say that these shells are desirous of remaining near to the margin of the sea, and that, as it rose in height, the shells quitted their first home, and followed the increase of the waters up to their highest level; to this I answer, that the cockle is an animal of not more rapid movement than the snail is out of water, or even somewhat

That marine shells could not go up the mountains.

10. chosi . . chella piggia fussi. 12. fighura spericha Ella. 13. spericha nogni. 14. disstante al. 16. chonditione. 17. chellacqua . . mov "a". 20. chome. 21. essella . . chome. 22. ecquimāca. 23. sochor. 25. cholo [per sochorso] per . . oddire. 26. chalar.
987. 1. 8 del. 2. settu . . chelli . . luntano dali . . alteza si uegghano. 3. nosstri tenpi sia stato . . chausa . . lasscio . . rispōde. 4. diluio superassi . . chessenpre. 5. aliti del mare doueano . . pocho . . li radi. 6. ce de . . assuoli assuoli Essettu. 7. crescēdo . . alteza chelli. 8. partirano . . lor p⁴o" sito esseguitorno lacresscimēto. 9. alteza . . chessendo. 10. chessi

¹⁰le di non più veloce moto, che si sia la lumaca, fori dell'acqua, e qualche cosa più tarda perchè nō nota, ā¹¹zi si fa vn solco per l'arena mediante i lati di tal solco ove s'appoggia, caminerà il dì dalle 3 alle 4 . braccia; ¹²adunque questo cō tale moto nō sarà caminato dal mare Adriano insino in Mōferrato di Lon¹³bardia, chè v'è 250 miglia di distantia, in 40 giorni, come disse chi tenne cōto d'esso tenpo; e se tu dici che ¹⁴l'onde ve li portarono, essi per la lor gravezza non si reggono, se nō sopra il suo fondo·; e se questo nō mi ¹⁵concedi, cō-fessami al meno ch'elli aueano a rimanere nelle cime de' piv alti mōti e ne' laghi che in¹⁶fra li mōti si serrano, come lago di Lario o di Como, e 'l Maggiore, e di Fiesole, e di Perugia, e simili;

¹⁷E se tu dirai che li nichi son ¹⁸por-tati dall'onde, essēdo voti e morti, io dico che, dove andauano li morti, poco si rimo-veuano da'uiui, e in que¹⁹ste montagnie sono trovati tutti i uiui che si cognoscono che sono colli gusci appaiati, e sono ²⁰in vn filo doue non è nessun de' morti, e poco piv alto è trovato doue eran gittati dall'ō²¹de tutti li morti colle loro scorze separate, apresso a dove li fiumi cascavano in ²²mare in grā profondità; come Arno, che cadea dalla Gonfolina apresso a ²³Mōte Lupo e quiui lasciaua la ghiaja, la quale ancor si uede, che si è insieme ricōgielata e di pie²⁴tre di uari paesi nature e colori e durezze se n'è fatto vna sola congelatione, e poco più oltre la congelatione dell'are²⁵na s'è fatta tufo, dou'ella s'agiraua inverso Castel Fiorētino, più oltre si scaricava il fango, ²⁶nel quale abitavano i nichi, il quale s'inalzava a gradi, secondo che le piene d'Arno torbido ²⁷in quel mare versauano, e di tempo in tenpo s'inalzaua il fondo al mare, ɉl quale a gradi ²⁸producea essi nichi, come si mostra nel taglio di Colle Gonzoli, dirupato dal fiume d'Arno, ²⁹che il suo piede consuma, nel qual taglio si

slower; because it does not swim, on the contrary it makes a furrow in the sand by means of its sides, and in this furrow it will travel each day from 3 to 4 braccia; therefore this creature, with so slow a motion, could not have travelled from the Adriatic sea as far as Monferrato in Lombardy [13], which is 250 miles distance, in 40 days; which he has said who took account of the time. And if you say that the waves carried them there, by their gravity they could not move, excepting at the bottom. And if you will not grant me this, confess at least that they would have to stay at the summits of the highest mountains, in the lakes which are enclosed among the mountains, like the lakes of Lario, or of Como and il Maggiore [16] and of Fiesole, and of Perugia, and others.

And if you should say that the shells were carried by the waves, being empty and dead, I say that where the dead went they were not far removed from the living; for in these mountains living ones are found, which are recognisable by the shells being in pairs; and they are in a layer where there are no dead ones; and a little higher up they are found, where they were thrown by the waves, all the dead ones with their shells separated, near to where the rivers fell into the sea, to a great depth; like the Arno which fell from the Gonfolina near to Monte Lupo [23], where it left a deposit of gravel which may still be seen, and which has agglomerated; and of stones of various districts, natures, and colours and hardness, making one single conglomerate. And a little beyond the sand-stone conglomerate a tufa has been formed, where it turned towards Castel Florentino; farther on, the mud was deposited in which the shells lived, and which rose in layers according to the levels at which the turbid Arno flowed into that sea. And from time to time the bottom of the sea was raised, depositing these shells in layers, as may be seen in the cutting at Colle Gonzoli, laid open by

. . lumacha . . ecqualche . . tarda. 11. solcho . . sapogia chaminera . . 4 br. 12. chaminato . . i mōferato. 13. gorni . . tene . . essettu di che. 14. portorono . . regano. 15. cedi. 16. fralli . . magore . . peruga. 17. Esse tu dirai dirai chelle. 18. dicho . . andaua . . pocho. 19. cognoscano . . cholli gussci . . essono. 20. in vnn . . pocho. 21. cholle . . chassca-vano. 22. gra . . chadea della Golfolina. 23. giara . . chesse insieme . ricōgielata. 24. nari "paesi" nature "e colorie du-reze" se ne fatto . . gongelatione . . pocho. 25. seffatto . . invero chastel . . scharichava il fango. 26. abitava . . chelle

987. 13. *Monferrato di Lombardia.* The range of hills of Monferrato is in Piedmont, and Casale di Monferrato belonged, in Leonardo's time, to the Marchese di Mantova.

16. *Lago di Lario.* Lacus Larius was the name given by the Romans to the lake of Como. It is evident that it is here a slip of the pen since the

the words in the MS. are: "*Come Lago di Lario o 'l Magore e di Como.*" In the MS. after line 16 we come upon a digression treating of the weight of water; this has here been omitted. It is 11 lines long.

23. *Monte Lupo,* compare 970, 13; it is between Empoli and Florence.

uedono manifestamēte li predetti gradi de' nichi in ³⁰ fango azzureggiante, e ui si trova di uarie cose marine; E si è alzata la terra del nostro ³¹ emisperio per tanto più che nō solea, per quāto ella si fece più lieue delle acque, che le manca³²rono per il taglio di Calpe e d'Abila, e altrettanto piv s'è alzata, perchè il peso dell'acque, che di qui mā³³carono, s'aggiunsero · alla terra volta all'altro emisperio, E se li nichi fussero stati ³⁴portati dal Torbido diluuio, essi si sarebbero misti, separatamente l'un dal'altro, infra 'l fango e non ³⁵con ordinati gradi a suoli, come alli nostri tenpi si vede.

the Arno which is wearing away the base of it; in which cutting the said layers of shells are very plainly to be seen in clay of a bluish colour, and various marine objects are found there. And if the earth of our hemisphere is indeed raised by so much higher than it used to be, it must have become by so much lighter by the waters which it lost through the rift between Gibraltar and Ceuta; and all the more the higher it rose, because the weight of the waters which were thus lost would be added to the earth in the other hemisphere. And if the shells had been carried by the muddy deluge they would have been mixed up, and separated from each other amidst the mud, and not in regular steps and layers— as we see them now in our time.

Leic. 9 a]

988.

Di quelli che dicono che i nichi sono per molto spatio e nati remoti dalli mari · per la natura del sito e de' cieli, ²che dispone e influiscie tal loco a simile creatione d'animali ·; a costor si risponderà che, se tale influētia ³ d'animali nō potrebbe accadere in vna sola linia, se nō animali di medesima sorte e età, e non il uechio col gio⁴vane, e nō alcun col coperchio e l'altro essere sanza sua copritura, e nō l'uno esser rotto e l'altro intero, ⁵e nō l'uno ripieno di rena marina e rottame minvto e grosso d'altri nichi dentro alli nichi ⁶interi, che lì son rimasti aperti, e nō le boche de' granchi sanza il rimanēte del suo tutto, e non li ni⁷chi d'altre spetie appiccati con loro in forma d'animale che sopra di quelli si mouesse, perchè ancora resta ⁸il uestigio del suo andamento sopra la scorza che lui già, a uso di tarlo sopra il legname, andò cōsumādo; ⁹nō si troverebbero infra loro ossa e denti di pescie, li quali alcuni dimandano saette e altri lingue di ser¹⁰penti,

As to those who say that shells existed for a long time and were born at a distance from the sea, from the nature of the place and of the cycles, which can influence a place to produce such creatures—to them it may be answered: such an influence could not place the animals all on one line, except those of the same sort and age; and not the old with the young, nor some with an operculum and others without their operculum, nor some broken and others whole, nor some filled with sea-sand and large and small fragments of other shells inside the whole shells which remained open; nor the claws of crabs without the rest of their bodies; nor the shells of other species stuck on to them like animals which have moved about on them; since the traces of their track still remain, on the outside, after the manner of worms in the wood which they ate into. Nor would there be found among them the bones and teeth of fish which some call arrows and others serpents' tongues, nor would so many

The marine shells were not produced away from the sea.

piane. 27. quell · · versaua. 28. deripato. 29. piede · · taglo si vede. 30. fangho azuregante · · Essi alzato · · nosstro. 31. emissperio · · mancho. 32. perl · · calpe dattile · · perche[la] il. 33. chorono sagunsono · · emissperio Esselli · · futtino. 34. portadi · · essi saren misti · · fangho ennō. 35. assuoli.

98). 1. dicano che michi. 2. infruisscie · · locho assimile · · risodera chesse · · infruētia. 3. po achadere · · enone il · · col go. 4. ellaltro esere colla sua · · ellaltro. 6. chelli · · rimassti · · rimanē dal · · e none. 7. colloro apichati · · mouessi. 8. lasscorza chellui ga. 9. troverra infrallaro · · pesscie. 10. troverra. 11. auebe · · stano · · elle cose. 12. sariano · · alteza · · ga a

988. 1. Scilla argued against this hypothesis, which was still accepted in his days; see: *La vana Speculazione, Napoli* 1670.

e nō si troverebbero tanti mēbri di diuersi animali insieme vniti se lì da liti marini gittati nō fussino, [11]e 'l diluuio lì nō gli avrebbe portati, perchè le cose gravi più del'acqua nō stanno a galla sopra l'acqua, e le cose pre[12]dette nō sariano in tanta altezza, se già a nuoto ivi sopra dell'acque portate non furono, la qual cosa è inpossi-[13]bile per la lor gravezza; Dove le uallate non riсievono le acque salse del mare, quiui i nichi mai non si [14]vedono, come manifesto si uede nella gran valle d'Arno di sopra alla Gonfolina, sasso per antico vnito [15]con Monte Albano in forma d'altissimo argine, il quale tenea ringorgato tal fiume in modo che prima che versasse nel mare, [16]il quale era dopo ai piedi di tal sasso, conponea 2 grandi laghi, de' quali il primo è, dove oggi si uede fiorire la città di Fiorē[17]ze insieme con Prato e Pistoia, e Monte Albano seguiva il resto dell'argine insin doue oggi è posto Serravalle·; dal Val d'Arno [18]di sopra insino Arezzo si creava vno secondo lago, il quale nell'ati-detto lago versaua le sue acque, [19]chiuso circa dove oggi si uede Girone, e occupaua tutta la detta valle di sopra per ispatio di 40 miglia [20]di lūghezza; questa valle riceue sopra il suo fondo tutta la terra portata dall'acqua da quella intorbidata, la quale [21]ancora si uede a' piedi di Prato Magno restare altissima, doue li fiumi nō l'ànno consumata, e infra essa terra si uedono le pro[22]fonde segature de' fiumi che quiui son passati, li quali discēdono dal grā mōte di Prato Magno, nelle quali [23]segature nō si uede vestigio alcuno di nichi e di terra marina; questo lago si congiugnea col lago di Perugia;

[24]Gran somma di nichi si uede doue li fiumi versano in mare, perchè in tali siti l'acque non so[25]no tante salse per la mistion dell'acque dolci che con quelle s'uniscono·, e 'l segnio di ciò si vede doue per antico li Mo[26]nti Appenini versauano li lor fiumi nel mare Adriano, li quali in gran parte mostrano infra li mōti grā [27]somma di nichi insieme coll azzurigno terreno di mare,

portions of various animals be found all together if they had not been thrown on the sea shore. And the deluge cannot have carried them there, because things that are heavier than water do not float on the water. But these things could not be at so great a height if they had not been carried there by the water, such a thing being impossible from their weight. In places where the valleys have not been filled with salt sea water shells are never to be seen; as is plainly visible in the great valley of the Arno above Gonfolina; a rock formerly united to Monte Albano, in the form of a very high bank which kept the river pent up, in such a way that before it could flow into the sea, which was afterwards at its foot, it formed two great lakes; of which the first was where we now see the city of Florence together with Prato and Pistoia, and Monte Albano. It followed the rest of its bank as far as where Serravalle now stands. From the Val d'Arno upwards, as far as Arezzo, another lake was formed, which discharged its waters into the former lake. It was closed at about the spot where now we see Girone, and occupied the whole of that valley above for a distance of 40 miles in length. This valley received on its bottom all the soil brought down by the turbid waters. And this is still to be seen at the foot of Prato Magno; it there lies very high where the rivers have not worn it away. Across this land are to be seen the deep cuts of the rivers that have passed there, falling from the great mountain of Prato Magno; in these cuts there are no vestiges of any shells or of marine soil. This lake was joined with that of Perugia [23].

A great quantity of shells are to be seen where the rivers flow into the sea, because on such shores the waters are not so salt owing to the admixture of the fresh water, which is poured into it. Evidence of this is to be seen where, of old, the Appenines poured their rivers into the Adriatic sea; for there in most places great quantities of shells are to be found, among the mountains, together

noto . . inposi. 13. graveza. 14. vidone . . vale. 15. "con monte albano" in forma . . daltissima argine [il quale] tenea . . versassi nel ma. 16. apiedi . . il p"o"e dove ogi si uide "fruire" la. 17. ze "insieme con" prato . . il re"sto" . . ogi . . ualdarno. 18. arezo . . lagho . . ati detto. 19. chircha . . ochupaua. 20. di lūgeza . 20 tera porta dallacque di. 21. acora . . al "tissima" . . nō lan. 22. si uede . . disscēdano. 23. alchuno . . terra [azurigma come] "marina" questo . . congugnea collacho di peruga. 24. soma. 25. suniscano . . dicosi . . anticho. 26. nti appenini . . moti. 27. chollazurigno terē . .

23. See Pl. CXIII.

e tutti li sassi, che di tal loco si cauano, son pieni di nichi; ^{28}Il medesimo si conoscie auere fatto Arno, quando cadea dal sasso della Gonfolina nel mare, ^{29}che dopo quella non troppo basso si trovaua, perchè a quelli tempi superaua l'altezza di San Miniato al Tedesco, ^{30}perchè nelle somme altezze di quello si uedono le ripe piene di nichi e ostriche dentro alle sue mvra; non si distesero li ni^{31}chi inverso Val di Nievole, perchè l'acque dolci d'Arno in là non si astendeano;

Come li nichi nō si ^{32}partirono dal mare per diluuio, perchè l'acque, che di uerso la terra veniuano, ācora che esse tirassino il mare ^{33}inverso la terra, esse erā quelle che percuoteano il suo fondo, perchè l'acqua, che viene diuerso la terra, à ^{34}più corso che quella del mare, e per cōseguenza è piv potente, entra sotto l'altra acqua del mare ^{35}e rimove il fondo e accompagnia con seco tutte le cose mobili che in quella trova, come son i predetti ^{36}nichi e altre simili cose, e quanto l'acqua, che viē di terra, è piv torbida che quella del mare, tā^{37}to piv si fa potente e grave che quella; adunque io nō ci vedo modo di tirare i predetti nichi tanto in^{38}fra terra, se quiui nati nō fussino; se tu mi dicessi, il fiume Loira, che passa per la Francia, ^{39}nell'accrescimēto del mare si copre piv di ottanta miglia di paese, perchè è loco di grā pia^{40}nvra, e 'l mare s'alza circa braccia 20, e nichi si uengono a trovare in tal pianvra, disco^{41}sta dal mare essa 80 miglia, qui si rispōde che 'l flusso e reflusso ne' nostri mediterrani ^{42}mari nō fanno tanta varietà, perchè in Genovese nō uaria nvlla, a Vinegia poco, in A^{43}frica poco, e dove poco varia, poco occupa di paese;

Senpre la corrēte dell'acqua de' fiumi ^{44}s'inōda sopra del loco doue li è inpedito il corso ·; ancora doue essa si ristrignie per passare sotto ^{45}li archi de' ponti.

with bluish marine clay; and all the rocks which are torn off in such places are full of shells. The same may be observed to have been done by the Arno when it fell from the rock of Gonfolina into the sea, which was not so very far below; for at that time it was higher than the top of San Miniato al Tedesco, since at the highest summit of this the shores may be seen full of shells and oysters within its flanks. The shells did not extend towards Val di Nievole, because the fresh waters of the Arno did not extend so far.

That the shells were not carried away from the sea by the deluge, because the waters which came from the earth although they drew the sea towards the earth, were those which struck its depths; because the water which goes down from the earth, has a stronger current than that of the sea, and in consequence is more powerful, and it enters beneath the sea water and stirs the depths and carries with it all sorts of movable objects which are to be found in the earth, such as the above-mentioned shells and other similar things. And in proportion as the water which comes from the land is muddier than sea water it is stronger and heavier than this; therefore I see no way of getting the said shells so far in land, unless they had been born there. If you were to tell me that the river Loire [38], which traverses France, covers when the sea rises more than eighty miles of country, because it is a district of vast plains, and the sea rises about 20 braccia, and shells are found in this plain at the distance of 80 miles from the sea; here I answer that the flow and ebb in our Mediterranean Sea does not vary so much; for at Genoa it does not rise at all, and at Venice but little, and very little in Africa; and where it varies little it covers but little of the country.

The course of the water of a river always rises higher in a place where the current is impeded; it behaves as it does where it is reduced in width to pass under the arches of a bridge.

ettutti. 28. conosscie . . fatto [il ual darno] arno . . chadea del . . golfolina. 29. tropo . . acquelli tenpi . . lalteza di saminiato. 30. some alteze . . uede . . osstrighe . . distesono. 31. nievole per lacque . . asstendeano. 32. partirō del . . lache che diuerso terra veniuano al mare ancora e esse. 33. inverso terra . . peroteano . . vie diuersō tera | a. 34. checquella . . acq"a" . . 35. aconpagnia consecho . . mobile . . son e prede. 36. ecquanto . . checquella. 37. adunque i nō ci vego . . e predetti. 38. fi atterra . . settu . . era . . franca. 39. acresscimēto . . ellocho. 40. circha br 20 e . . uengano attrorare . . discos. 41. sto dal . . esse . . risspōde . . frusso e refrusso . . medi terani. 42. nola . . pocho. 43. pocho . . pocho . . pocho schupa . . correte. 44. locho douele . . corso. | anchora.

38. Leonardo has written Era instead of Loera or Loira—perhaps under the mistaken idea that Lo was an article.

Leic. 9 *b*]　　　　　　　　　　　　　　,989.

Further researches (989—991).

CONFUTATIONE CH'È CONTRO COLOR CHE DI-
CONO, I NICHI ESSER PORTATI PER MOLTE GIOR-
NATE DISTANTI DALLI MARI PER CAUSA DEL
DILUUIO [2]TANT'ALTO CHE SUPERASSE TALE
ALTEZZA.

[3]Dico che il diluuio non potè portare
le cose nate dal mare alli mōti, se già il
mare gonfiando nō creasse inōdazione [4]in-
sino alli lochi sopradetti, la qual gonfia-
tione accadere nō può, perchè si darebbe
vacuo, e se tu diciessi l'aria quiui [5]riem-
pierebbe ·, noi abbiamo concluso il grave
non si sostenere sopra il lieue, onde per
neciessità si cō[6]clude, esso diluuio essere
cavsato dall'acque piovane, e se così è,
tutte esse acque corrono al mare, [7]e nō
corre il mare alle montagnie, e se elle cor-
rono al mare, esse spingono li nichi dal
lito del mare, e nō le [8]tirano a se; E se
tu dicessi, poichè 'l mare alzò per l'acque
piovane, portò essi nichi a tale altezza,
[9]già abbiamo detto che le cose piv gravi
dell'acqua nō notā sopra di lei, ma stāno
nei fondi, dalle quali nō si [10]rimovono, se
nō per cavsa di percussiō d'onda ·; E se tu
dirai che l'onde le portassino in tali lochi
alti, noi abbiamo [11]prouato che l'onde nelle
grā profondità tornano in contrario nel
fondo al moto di sopra, la qual cosa [12]si
manifesta per lo intorbidare del mare dal
terreno tolto vicino alli liti; Muovesi la
cosa piv lieue che l'[13]acqua insieme colla
sua onda, ed è lasciata nel piv alto sito
della riva dalla piv alta onda; Muouesi la
cosa [14]più grave che l'acqua ·, sospinta
dalla sua ōda nella superfitie e dal fondo
suo ‖ e per queste due conclusioni, che ai
lochi [15]sua · sarā provate a pieno, noi con-
cludiamo che l'onda superfitiale nō può
portare nichi, per essere più grievi che
[16]l'acqua;
　　[17]Quando il diluuio auesse avto a por-
tare li nichi trecento e quattro cento mi-
[18]glia distanti dalli mari, esso li avrebbe
portati misti con diuerse nature insieme
ammontati, e noi vediamo in [19]tal distantie
l'ostriche tutte insieme, e le conchilie, e li
pesci calamai, e tutti li altri nichi, che
stanno insieme a congre[20]gatione, essere

A CONFUTATION OF THOSE WHO SAY THAT
SHELLS MAY HAVE BEEN CARRIED TO A DISTANCE
OF MANY DAYS' JOURNEY FROM THE SEA BY THE
DELUGE, WHICH WAS SO HIGH AS TO BE ABOVE
THOSE HEIGHTS.

I say that the deluge could not carry objects,
native to the sea, up to the mountains, unless
the sea had already increased so as to create
inundations as high up as those places; and
this increase could not have occurred because
it would cause a vacuum; and if you were
to say that the air would rush in there, we
have already concluded that what is heavy
cannot remain above what is light, whence of
necessity we must conclude that this deluge
was caused by rain water, so that all these
waters ran to the sea, and the sea did not run
up the mountains; and as they ran to the sea,
they thrust the shells from the shore of the sea
and did not draw them towards themselves. And
if you were then to say that the sea, raised
by the rain water, had carried these shells
to such a height, we have already said that
things heavier than water cannot rise upon
it, but remain at the bottom of it, and do
not move unless by the impact of the waves.
And if you were to say that the waves had
carried them to such high spots, we have
proved that the waves in a great depth move
in a contrary direction at the bottom to the
motion at the top, and this is shown by the
turbidity of the sea from the earth washed
down near its shores.　　Anything which is
lighter than the water moves with the waves,
and is left on the highest level of the highest
margin of the waves.　　Anything which is
heavier than the water moves, suspended in
it, between the surface and the bottom; and
from these two conclusions, which will be
amply proved in their place, we infer that the
waves of the surface cannot convey shells,
since they are heavier than water.
　　If the deluge had to carry shells three
hundred and four hundred miles from the
sea, it would have carried them mixed with
various other natural objects heaped together;
and we see at such distances oysters all
together, and sea-snails, and cuttlefish, and
all the other shells which congregate together,

989. 1. dicano . . gornate . . chausa. 2. tantalta . . superassi. 3. Dicho che diluuio no po | "te" . . cose "nate" del . . creassi
. . achadere . . po . . dare vachuo. 5. rienpierebe . . abiā . . greve. 6. esse chosi . . corrano. 7. esselle corrano . . del
lito. 8. asse Esse . . attale alteza. 9. abiā . . chelle . . grav . stano in fondo delle 10. removano . . . Essettu . . abiā.
11. chellonde . . provondita. 12. del terē . . chella. 13. acq"a" . . lassciata. 14. chellacqua . sospinte . . e del. 15. che-
llonda . . po. 17. auesse. 18. disstanti . . arebbe . . chon . . amōtati. 19. losstriche . . elli conchili elli . . chalamai

trovati tutti insieme morti, e li nichi sole-
tari trovarsi distanti l'uno dall'altro, come
ne' liti marittimi ²¹tutto il giorno vediamo;
E se noi troviamo l'ostriche insieme appa-
rētate grādissime, infra le quali assai vedi
quelle ²²che ànno ancora il coperchio con-
giunto, a significare che qui furono lasciate
dal mare, che ancor viveano quando fù
²³tagliato lo stretto di Gibilterra; Vedesi
in nelle montagnie di Parma e Piacētia le
moltitudini di nichi e coralli ²⁴intarlati, an-
cora appiccati alli sassi, de' quali, quand'io
facevo il grā cavallo di Milano, me ne fù
portato vn grā sacco ne²⁵lla mia fabbrica
da certi villani, che in tal loco furō trovati,
fralli quali ve n'era assai delli conseruati
nella prima bōtà;

²⁶Truovāsi sotto terra e sotto li pro-
fondi cavamenti de' lastroni li legniami
delle traui lauorati, fatti già neri, li qua²⁷lì
furō trovati a mio tenpo in quel di Castel
Fiorētino ·, e questi in tal loco profondo
v'erano prima che la litta gittata ²⁸dall'Arno
nel mare, che quiui copriva, fusse abban-
donata in tant' altezza, e che le pianvre del
Casentino fussī tanto abbassate ²⁹dal terrē
che ànno al continuo di lì sgonberato;

³⁰E se tu dicessi, tali ³¹nichi essere
crea³²ti e creano a cō³ tinvo in simili lochi
per la natura del ³⁴sito e de' cieli, che
qui³⁶vi influisce, questa ³⁷tale openione non
³⁸sta in cervelli di trop³⁹po discorso, perchè
qui⁴⁰vi s'envmerā li anni ⁴¹del loro accre-
scimento ⁴²sulle loro scorze, e se ne ⁴³ve-
dono piccoli e grādi, ⁴⁴i quali sanza cibo nō
cre⁴⁵scerebbero e non si cibarebbero sā⁴⁶za
moto, e quivi mouere nō si po⁴⁷teano.

all to be found together and dead; and the
solitary shells are found wide apart from each
other, as we may see them on sea-shores every
day. And if we find oysters of very large shells
joined together and among them very many
which still have the covering attached, indi-
cating that they were left here by the sea, and
still living when the strait of Gibraltar
was cut through; there are to be seen, in
the mountains of Parma and Piacenza, a
multitude of shells and corals, full of holes,
and still sticking to the rocks there. When
I was making the great horse for Milan, a
large sack full was brought to me in my
workshop by certain peasants; these were
found in that place and among them were
many preserved in their first freshness.

Under ground, and under the foundations
of buildings, timbers are found of wrought
beams and already black. Such were found in
my time in those diggings at Castel Fiorentino.
And these had been in that deep place before
the sand carried by the Arno into the sea,
then covering the plain, had been raised to
such a height; and before the plains of Casen-
tino had been so much lowered, by the earth
being constantly carried down from them.

[30]And if you were to say that these
shells were created, and were continually
being created in such places by the nature
of the spot, and of the heavens which might
have some influence there, such an opinion
cannot exist in a brain of much reason;
because here are the years of their growth,
numbered on their shells, and there are large
and small ones to be seen which could not
have grown without food, and could not
have fed without motion—and here they could
not move[47].

Leic. 10 a] **990.**

Come ²nelle falde, infra l'una e l'altra
si trovano ancora li andamēti delli lonbrici,
che caminavano infra esse ³quādo non erano
ancora asciutte; Come tutti li fanghi ma-
rini ritengono ancora de' nichi ⁴ed è petri-
ficato il nichio insieme col fango; della

That in the drifts, among one and another,
there are still to be found the traces of the
worms which crawled upon them when they
were not yet dry. And all marine clays
still contain shells, and the shells are petri-
fied together with the clay. From their
firmness and unity some persons will have
it that these animals were carried up to

ettutti. 20. elli trovare . . lunoall. 21. gorno . . Esse . . losstriche . . aparētadi grādissimi infralle quale. 22. anchora
. . congunto . . assignificare . . lasssciate . . ancoravveano. 23. losstretto di gibiltar . . inelle . . moltitudine de. 24. apichati
. . ne nefu . . sachone. 25. fabricha . . nella p"a" bōta. 26. essotto . . ga neri. 27. ecquesti . . profondor "o"no . .
chella lita gitta. 28. copria fussi abondata . . alteza e chelle . . tante abassate. 29. del . . sgonbera 30. essettu. 31. niche.
33. nvo. 36. infruisscie. 37. none. 38. di tro. 41. deloro acresscimento. 42. sule. 43. vede picoli. 45. bono e non si
ciborō. 47. trono.

990. 2. infralluna allaltra . . trova anchora. 3. neuera . . asscutta . . fangh . . ritengano. 4. essenplicita . . uogliano chettal.

989. 30—47. These lines are written in the margin.

stoltitia e senplicità di quelli, che uogliono che ta⁵li animali fussino alli lochi distanti dai mari portati dal diluvio; Come altra setta d'ignoranti ⁶affermano la natura, o i celi auerli in tali lochi creati · per īflussi celesti, come in quelli ⁷nō si trovassino l'ossa de' pesci cresciuti cō lūghezza di tenpo, come nelle scorze de' nichi e lumache nō si potesse ⁸annvmerare li anni o i mesi della lor uita, come nelle corna de' buoi e de' castroni e nella ramificatione de⁹lle piante, che nō furō mai tagliate in alcuna parte; E auendo con tali segni dimostrato e la lunghezza della lor uita ¹⁰essere manifesta, ecco bisognio confessare, che tali animali nō uiuino sanza moto per cercare ¹¹il loro cibo e in loro non si uede strumēto da penetrare la terra e 'l sasso, ove si trovano rinchiusi·; ¹²Ma in che modo si potrebbe trovare in vna grā lumaca i rottami e parte di molt'altre sorti di nichi di uarie na¹³ture, se ad essa, sopra de' liti marini già morta, non li fussino state gittate dalle onde del mare, come dell'al¹⁴tre cose lieui, che esso gitta a terra? Perchè si truova tanto rottame e nichi interi fra falda e falda di pie¹⁵tra, se già quella sopra del lito nō fusse stata ricoperta da una terra rigittata dal mare, la qual poi si uenne pe¹⁶trificando? E se 'l diluvio predetto li auesse in tali siti dal mare portato, tu troveresti essi nichi in nel termi¹⁷ne d'una sola falda, e non al termine di molte; deuonsi poi annvmerare le uernate delli ā¹⁸ni, che 'l mare mvltiplicaua le falde dell'arena e fango, portatoli da fiumi vicini, e ch'elli scaricava in sui liti sua, e se ¹⁹tu volessi dire, che piv diluui fussino stati a produrre tali falde e nichi infra loro, e' bisognierebbe, ²⁰che ancora tu affermassi ogni āno essere vn tal diluuio accaduto; Ancora infra li rot²¹tami di tal nichi si prosume in tal sito essere spiaggia di mare, doue tutti i nichi son gittati rotti e diuisi e nō ²²mai appaiati, come infra 'l mare viui si trovano con due gusci, che fan coperchio l'uno all'altro; E infra ²³le falde della riuiera e de' liti marittimi son trovati de' rottami; E dentro alli termini delle pietre son trovati ²⁴rari e appaiati de' gusci, come quelli che furō lasciati dal mare sotterrati viui dentro al fango, il qual ²⁵poi si seccò e col tenpo petrificò.

places remote from the sea by the deluge. Another sect of ignorant persons declare that Nature or Heaven created them in these places by celestial influences, as if in these places we did not also find the bones of fishes which have taken a long time to grow; and as if, we could not count, in the shells of cockles and snails, the years and months of their life, as we do in the horns of bulls and oxen, and in the branches of plants that have never been cut in any part. Besides, having proved by these signs the length of their lives, it is evident, and it must be admitted, that these animals could not live without moving to fetch their food; and we find in them no instrument for penetrating the earth or the rock where we find them enclosed. But how could we find in a large snail shell the fragments and portions of many other sorts of shells, of various sorts, if they had not been thrown there, when dead, by the waves of the sea like the other light objects which it throws on the earth? Why do we find so many fragments and whole shells between layer and layer of stone, if this had not formerly been covered on the shore by a layer of earth thrown up by the sea, and which was afterwards petrified? And if the deluge before mentioned had carried them to these parts of the sea, you might find these shells at the boundary of one drift but not at the boundary between many drifts. We must also account for the winters of the years during which the sea multiplied the drifts of sand and mud brought down by the neighbouring rivers, by washing down the shores; and if you chose to say that there were several deluges to produce these rifts and the shells among them, you would also have to affirm that such a deluge took place every year. Again, among the fragments of these shells, it must be presumed that in those places there were sea coasts, where all the shells were thrown up, broken, and divided, and never in pairs, since they are found alive in the sea, with two valves, each serving as a lid to the other; and in the drifts of rivers and on the shores of the sea they are found in fragments. And within the limits of the separate strata of rocks they are found, few in number and in pairs like those which were left by the sea, buried alive in the mud, which subsequently dried up and, in time, was petrified.

5. fossi inali .. diluio. ī frussi. 7. trovassi .. cressciuti .. lugeza .. pote. 8. anvmerare .. casstroni .. del. 9. signi dimostro o la lungeza. 10. ecci bisognia chettali. 11. illor nosi. 12. nvna gra lumacha .. altre sotte. 13. ture e essa sopa de .. morta nolli .. comellā. 14. esso .. atterra. 15. fussi .. uno. 16. trifichando . Essel diluio .. auessi .. troverresti hessi .. inel. 17. nōne .. di [qualunche falda] "di molte" deuensi po anvmerare [li ani] le uernate. 18. del [fango] "larena effangho" portatoli .. insu liti .. esset. 19. ennichi infralloro. 20. ongni .. tatal .. acaduto [e che tenessi] Ancora infralii. 21. spiagia. 22. apaiati .. gussci cheffan .. infralle. 24. apaiati di gussci .. lassciati sollerati. 25. secho .. petrificho.

Leic. 10 b] 991.

E se tu vuoi dire che tale diluuio fuquello che portò tali nichi fuor de' mari cētinaia di miglia·, questo nō può acca²dere, essendo stato esso diluuio per cause di pioggie, perchè naturalmente le pioggie spingono i fiumi insieme colle cose da loro ³portate inuerso il mare, e nō tirano inverso de' mōti le cose morte dai liti marittimi., e se tu dicessi che'l diluvio poi s'al⁴zò colle sue acque sopra de' mōti, il moto del mare fù si tardo col camino suo contro al corso de' fiumi, che non avrebbe ⁵sopra di se tenvto a noto le cose piv gravi di lui, e se pur l'auesse sostenute, esso nel calare l'avrebbe lasciate in diversi ⁶lochi seminate; Ma come accomoderemo noi li coraIli, li quali inverso Mōte Ferrato di Lonbardia esser si tutto⁷dì trovati intarlati appiccati alli scogli, scoperti dalle corrēti de'fiumi? e li detti scogli sono tutti coperti di parentadi ⁸e famiglie d'ostriche, le quali noi sappiamo che nō si movono, ma stā senpre appiccate col' ū de' gusci al sasso, e l'altro apro⁹no per cibarsi d'animaluzzi, che notā per l'acque, li quali, credendo trovar bona pastura, diuentano cibo del predetto nichio; non si ¹⁰trova l'arena mista coll'aliga marina essersi petrificata, poichè l'aliga, che la ramezzaua, venne meno; e di questo ¹¹scopre tutto il giorno il Po nelle ruine delle sue ripe.

And if you choose to say that it was the deluge which carried these shells away from the sea for hundreds of miles, this cannot have happened, since that deluge was caused by rain; because rain naturally forces the rivers to rush towards the sea with all the things they carry with them, and not to bear the dead things of the sea shores to the mountains. And if you choose to say that the deluge afterwards rose with its waters above the mountains, the movement of the sea must have been so sluggish in its rise against the currents of the rivers, that it could not have carried, floating upon it, things heavier than itself; and even if it had supported them, in its receding it would have left them strewn about, in various spots. But how are we to account for the corals which are found every day towards Monte Ferrato in Lombardy, with the holes of the worms in them, sticking to rocks left uncovered by the currents of rivers? These rocks are all covered with stocks and families of oysters, which as we know, never move, but always remain with one of their halves stuck to a rock, and the other they open to feed themselves on the animalcules that swim in the water, which, hoping to find good feeding ground, become the food of these shells. We do not find that the sand mixed with seaweed has been petrified, because the weed which was mingled with it has shrunk away, and this the Po shows us every day in the debris of its banks.

Leic. 20 a] 992.

Perchè sono trovate l'ossa ²de' grā pesci e le ostriche e coralli e altri diuersi nichi e chiocciole sopra l'alte cime de' mōti ma³rittimi nel medesimo modo che si trovā ne' bassi mari?

Why do we find the bones of great fishes and oysters and corals and various other shells and sea-snails on the high summits of mountains by the sea, just as we find them in low seas? Other problems (992—994).

Leic. 36 a] 993.

Tu ài ora a provare come li nichi nō nascono, se nō in acque salse, quasi tutte le sorte, e che ²li nichi di Lonbardia ànno

You now have to prove that the shells cannot have originated if not iu salt water, almost all being of that sort; and that the shells in Lombardy are at four levels,

991. 1. Essettu volli . . chettale . . for . . po acha. 2. chause di piogie . . piogie spingano . . dallor. 3. morte de liti . . esse . . diluui. 4. sittardo . . arebe [te]. 5. esse . . lauesi sosstenvte . . larebe lassciate. 6. acomodereno. 7. ildi . . "intarlati" apichati alli scolgli . . elli . . scolgli . . parendadi e. 8. sapiano . . movano . . apichate cholū degussci . . apra. 9. danimaluzi . . diuenta. 10. trova egli larena . . cholla . . poichellaliga chella framezaua. 11. gorno.

992. 2. pessci elle osstriche . . cioccole. 993. 1. nasscano. 3. chessabochano.

4 liuelli, e così è per tutti, li quali sono fatti in piv tēpi, e questi ³sono per tutte le ualli che sboccano alli mari.

and thus it is everywhere, having been made at various times. And they all occur in valleys that open towards the seas.

Br. M. 156*b*] **994.**

Per le 2 linie de' nicchi bisognia dire che la terra per sdegno ²s'attufasse sotto il mare, e fece il primo suolo, poi il diluuio ³fece il secondo.

From the two lines of shells we are forced to say that the earth indignantly submerged under the sea and so the first layer was made; and then the deluge made the second.

994. 1. nicch . . chellatera. 2. sattu fassi sottollmare effe. 3. fe il sechondo.

994. This note is in the early writing of about 1470—1480. On the same sheet are the passages No. 1217 and 1219. Compare also No. 1339. All the foregoing chapters are from Manuscripts of about 1510. This explains the want of connection and the contradiction between this and the foregoing texts.

VII.

ON THE ATMOSPHERE.

Leic. 20 a] **995.**

Come la chiarezza dell' aria na²scie dall' acqua che in quella s' è resoluta e fattasi in īsēsibili graniculi, li quali, preso il lume del sole dall' op³posita parte, rēdono la chiarezza che in essa aria si dimonstra, e l' azzurro, che in quella apparisce, nascie ⁴dalle tenebre, che dopo essa aria si nascondono.

That the brightness of the air is occasioned by the water which has dissolved itself in it into imperceptible molecules. These, being lighted by the sun from the opposite side, reflect the brightness which is visible in the air; and the azure which is seen in it is caused by the darkness that is hidden beyond the air.[4]

Constituents of the atmosphere.

Leic. 22 b] **996.**

Come i retrosi de' uēti a certe ²boche di ualli percuotino sopra delle acque e quelle concauino cō grā cauamēto, e portino ³l' acqua in aria in forma colunnale in color di nugola, e il medesimo vid' io già fare sopra ⁴vn arenaio d' Arno, nel quale fu concauato l' arena più d' una statura d' uomo, e ⁵di quella fu remossa la ghiaja e gittata in disparte per lūgo spatio, e parea per l' aria in forma ⁶di grādissimo canpanile, e crescieva la sommità come i rami di gran pino, e si piegaua ⁷poi nel contatto del retto uēto che passaua sopra li mōti.

That the return eddies of wind at the mouth of certain valleys strike upon the waters and scoop them out in a great hollow, whirl the water into the air in the form of a column, and of the colour of a cloud. And I saw this thing happen on a sand bank in the Arno, where the sand was hollowed out to a greater depth than the stature of a man; and with it the gravel was whirled round and flung about for a great space; it appeared in the air in the form of a great bell-tower; and the top spread like the branches of a pine tree, and then it bent at the contact of the direct wind, which passed over from the mountains.

On the motion of air (996—999).

995. 1. chiareza. 2. sscie . . effattasi . . presi. 3. rēdano la ciareza . . dimosstra ellazurro . . apparisce nasscie . . nasscondano.
996. 1. accerte. 2. percotino . . ecquelle . . chauamēto. 3. colunale . . vidio cia. 4. duome he. 5. giara e gittatta. 6. ecresscieva lasomita . . rāmi di girapino essi.

995. 4. Compare Vol. I, No. 300.

Leic. 23a] **997.**

L'onda dell'aria fa il me²desimo vfitio infra l' elemēto del fuoco ·, che fa l'onda dell'acqua infra l'aria, o l' onda dell'a³rena, cioè terra, infra l'acqua, e sono i lor moti in tal proportione qual è quella de' lor mo⁴tori infra loro.

The element of fire acts upon a wave of air in the same way as the air does on water, or as water does on a mass of sand —that is earth; and their motions are in the same proportions as those of the motors acting upon them.

S. K. M. II.² 19b] **998.**

DE MOTO.

Domādo, se 'l uero moto ²de' nuvoli si può conosciere ³per lo moto delle sue ombre, ⁴e similemēte del moto ⁵del sole.

OF MOTION.

I ask whether the true motion of the clouds can be known by the motion of their shadows; and in like manner of the motion of the sun.

H.3 52a] **999.**

Per cognosciere ²meglio i vēti.

To know better the direction of the winds.

Leic. 34a] **1000.**

The globe an organism.
Nessuna cosa nasce in loco doue nõ sia vita sensitiua, vegetatiua e rationale; nascono le penne sopra li uccelli, e si mv-tano ogni anno; nascono ²li peli sopra li animali, e ogni anno si mvtano, saluo al-cuna parte, come li peli delle barbe de' lioni e gatte e simi³li; nascono l'erbe sopra li prati e le foglie sopra li alberi, e ogn'āno in grā parte si rinovano; adunque potremo dire, ⁴la terra avere anima vegetatiua, e che la sua carne sia la terra, li sua ossi sieno li ordini delle collegationi de' sas⁵si,

Nothing originates in a spot where there is no sentient, vegetable and rational life; feathers grow upon birds and are changed every year; hairs grow upon animals and are changed every year, excepting some parts, like the hairs of the beard in lions, cats and their like. The grass grows in the fields, and the leaves on the trees, and every year they are, in great part, renewed. So that we might say that the earth has a spirit of growth; that its flesh is the soil, its bones the arrangement and connection of the rocks of

997. 2. infrallelemēto . . focho . cheffa. 3. coe . . infrallacqua essono . . quele quella delor.
998. 2. nvvoli spo. 3. obre. 4. essimile.nēte.
999. 1—2 R. 1. cōgnosciere. 2. e vēti.
1000. 1. nassce . . locho . . vita "sensitiua [intellettiua] vigitatiua e ra tïonale] nassce le pene . . essi . . nassce. 2. alchuna . .
 essimi. 3. nassce . . elle . . potren. 4. vigitatiua e chella . . collegatione. 5. comogano. 6. occeano . . cresscere e dis-

999. In connection with this text I may here mention a hygrometer, drawn and probably invented by Leonardo. A facsimile of this is given in Vol. I, p. 297 with the note: '*Modi di pesare l' arie eddi sa-pere quando s'à arrompere il tēpo*' (Mode of weighing the air and of knowing when the weather will change); by the sponge "*Spugnea*" is written.

1000. Compare No. 929.

di che si compongono le mōtagnie, il suo tenerume sono li tufi, il suo sangue sono le uene delle acque, il lago [6]del sangue, che sta dintorno al core, è il mare oceano, il suo alitare e 'l crescere e discrescere del sangue [7]pelli polsi, e così nella terra è il flusso e riflusso del mare, e 'l caldo dell' anima del mondo è il fuoco, [8]ch' è infuso per la terra, e la residenza dell' anima vegetativa sono li fochi, che per diuersi lochi della [9]terra spirano in bagni, e in miniere di solfi, e in vulcani, e Mō Gibello di Sicilia, e altri lochi assai.

which the mountains are composed, its cartilage the tufa, and its blood the springs of water. The pool of blood which lies round the heart is the ocean, and its breathing, and the increase and decrease of the blood in the pulses, is represented in the earth by the flow and ebb of the sea; and the heat of the spirit of the world is the fire which pervades the earth, and the seat of the vegetative soul is in the fires, which in many parts of the earth find vent in baths and mines of sulphur, and in volcanoes, as at Mount Ætna in Sicily, and in many other places.

scresscere. 7. frusso e refrusso . . focho. 8. ella reside dell . . vigitativa. 9. in vulgano . . cicilia.

XVII.

Topographical Notes.

A large part of the texts published in this section might perhaps have found their proper place in connection with the foregoing chapters on Physical Geography. But these observations on Physical Geography, of whatever kind they may be, as soon as they are localised acquire a special interest and importance and particularly as bearing on the question whether Leonardo himself made the observations recorded at the places mentioned or merely noted the statements from hearsay. In a few instances he himself tells us that he writes at second hand. In some cases again, although the style and expressions used make it seem highly probable that he has derived his information from others— though, as it seems to me, these cases are not very numerous—we find, on the other hand, among these topographical notes a great number of observations, about which it is extremely difficult to form a decided opinion. Of what the Master's life and travels may have been throughout his sixty-seven years of life we know comparatively little; for a long course of time, and particularly from about 1482 to 1486, we do not even know with certainty that he was living in Italy. Thus, from a biographical point of view a very great interest attaches to some of the topographical notes, and for this reason it seemed that it would add to their value to arrange them in a group by themselves. Leonardo's intimate knowledge with places, some of which were certainly remote from his native home, are of importance as contributing to decide the still open question as to the extent of Leonardo's travels. We shall find in these notes a confirmation of the view, that the MSS. in which the Topographical Notes occur are in only a very few instances such diaries as may have been in use during a journey. These notes are mostly found in the MSS. books of his later and quieter years, and it is certainly remarkable that Leonardo is very reticent as to the authorities from whom he quotes his facts and observations: For instance, as to the Straits of Gibraltar, the Nile, the Taurus Mountains and the Tigris and Euphrates. Is it likely that he, who declared that in all scientific research, his own experience should be the foundation of his statements (see XIX Philosophy No. 987—991) should here have made an exception to this rule without mentioning it?

As for instance in the discussion as to the equilibrium of the mass of water in the Mediterranean Sea—a subject which, it may be observed, had at that time attracted the interest and study of hardly any other observer. The acute remarks, in Nos. 985—993, on the presence of shells at the tops of mountains, suffice to prove—as it seems to me—that it was not in his nature to allow himself to be betrayed into wide generalisations, extending beyond the limits of his own investigations, even by such brilliant results of personal study.

Most of these Topographical Notes, though suggesting very careful and thorough research, do not however, as has been said, afford necessarily indisputable evidence that that research was Leonardo's own. But it must be granted that in more than one instance probability is in favour of this idea.

Among the passages which treat somewhat fully of the topography of Eastern places by far the most interesting is a description of the Taurus Mountains; but as this text is written in the style of a formal report and, in the original, is associated with certain letters which give us the history of its origin, I have thought it best not to sever it from that connection. It will be found under No. XXI (Letters).

That Florence, and its neighbourhood, where Leonardo spent his early years, should be nowhere mentioned except in connection with the projects for canals, which occupied his attention for some short time during the first ten years of the XVIth century, need not surprise us. The various passages relating to the construction of canals in Tuscany, which are put together at the beginning, are immediately followed by those which deal with schemes for canals in Lombardy; and after these come notes on the city and vicinity of Milan as well as on the lakes of North Italy.

The notes on some towns of Central Italy which Leonardo visited in 1502, when in the service of Cesare Borgia, are reproduced here in the same order as in the note book used during these travels (MS. L., Institut de France). These notes have but little interest in themselves excepting as suggesting his itinerary. The maps of the districts drawn by Leonardo at the time are more valuable (see No. 1054 note). The names on these maps are not written from right to left, but in the usual manner, and we are permitted to infer that they were made in obedience to some command, possibly for the use of Cesare Borgia himself; the fact that they remained nevertheless in Leonardo's hands is not surprising when we remember the sudden political changes and warlike events of the period. There can be no doubt that these maps, which are here published for the first time, are original in the strictest sense of the word, that is to say drawn from observations of the places themselves; this is proved by the fact—among others—that we find among his manuscripts not only the finished maps themselves but the rough sketches and studies for them. And it would perhaps be difficult to point out among the abundant contributions to geographical knowledge published during the XVIth century, any maps at all approaching these in accuracy and finish.

The interesting map of the world, so far as it was then known, which is among the Leonardo MSS. at Windsor (published in the 'Archaeologia' Vol. XI) cannot be attributed to the Master, as the Marchese Girolamo d'Adda has sufficiently proved; it has not therefore been reproduced here.

Such of Leonardo's observations on places in Italy as were made before or after his official travels as military engineer to Cesare Borgia, have been arranged in alphabetical order, under Nos. 1034—1054. The most interesting are those which relate to the Alps and the Appenines, Nos. 1057—1068.

Most of the passages in which France is mentioned have hitherto remained unknown, as well as those which treat of the countries bordering on the Mediterranean, which come at the end of this section. Though these may be regarded as of a more questionable importance in their bearing on the biography of the Master than those which mention places in France, it must be allowed that they are interesting as showing the prominent place which the countries of the East held in his geographical studies. He never once alludes to the discovery of America.

I.

ITALY.

C. A. 45 a; 140 a]

1001.

CANALE DI FIREZE.

²Facciasi alle Chiane d'Arezzo · tali · cateratte che, māchando · acqua l'estate in Arno ·, il canale nō rimāga · arido; ³e facciasi esso canale · largo · in fōdo braccia 20 ·, e 30 in bocca, e braccia 2 · s · per l'acqua o 4 ·, perchè dua d' esse braccia reca ⁴alli mvlini e li prati ·; questo · bonificherà il paese ·, e Prato, Pistoia e Pisa insieme cō Firēze, faranno l'anno di meglio ⁵dugiēto mila ducati ·, e porgieranno le mani e spesa a esso · aivtorio, e i Lucchesi il simile, perchè il lago di Sesto fia navicabile; ⁶fo lo · fare · la uia di Prato · e Pistoia e tagliare Serravalle . e uscire nel lago ·, perchè nō bisognia conche o sostegni i qua⁷li · nō sono · eterni, anzi senpre si sta in esercitio · a operarli e mantenerli.

⁸E sappi che se, cauādo · il canale ·, doue esso è profondo · 4 braccia, si · dā 4 dinari per braccio quadro, in doppia profondità · si ⁹dā · 6 dinari, se fai 4 ¹⁰braccia e' sono

CANAL OF FLORENCE.

Sluices should be made in the valley of la Chiana at Arezzo, so that when, in the summer, the Arno lacks water, the canal may not remain dry: and let this canal be 20 braccia wide at the bottom, and at the top 30, and 2 braccia deep, or 4, so that two of these braccia may flow to the mills and the meadows, which will benefit the country; and Prato, Pistoia and Pisa, as well as Florence, will gain two hundred thousand ducats a year, and will lend a hand and money to this useful work; and the Lucchese the same, for the lake of Sesto will be navigable; I shall direct it to Prato and Pistoia, and cut through Serravalle and make an issue into the lake; for there will be no need of locks or supports, which are not lasting and so will always be giving trouble in working at them and keeping them up.

And know that in digging this canal where it is 4 braccia deep, it will cost 4 dinari the square braccio; for twice the depth 6 dinari, if you are making 4 braccia

Canals in connection with the Arno (1001—1008).

1001. 2. alle chiane darezo . . chateratte . . māchando . acqua \ lastate innarno. 3. effacciasi . . br. 20 . . boccha e br. 2 . 5 . per qua . . dua desse br. rua (?) . 4. elli . . quessto . . pistoia . . chō . . fia lano dimeglio. 5. porgierano le mani "esspesa" . . sessto. 6. folli fare . . ettagliare esscire. 7. etterni. *Lines* 8—15 br. *stands always for* braccia. 8. Essapi chesse chauādo il chanale . . dopia. 9. dinari [onsi in . 7 . si da il doppio . perche . quelle . sechonde 4 br. il tereno e giassmosso e poi perche] seffai 4. 10. dellabri . . ellaltro. 11. esse fussi. 12. cresse solo . î . bancho . . cresscie. 13. viene dinari sei

1001. This passage is illustrated by a slightly sketched map, on which these places are indicated from West to East: Pisa, Luccha, Lago, Seravalle, Pistoja, Prato, Firenze.

solamēte · 2 · banchi ·, cioè · vno dal fondo · del fosso · alla superfitie de' labri del fosso ·, e l'altro da essi labri ¹¹alla · soṁità del mōte · della · terra che d'in sulla · riva · dell'argine · si leua ·; e se fusse di ḋoppia profondità ·, esso argine ¹²cresce solo · uno banco, cioè braccia · 4 ·, che crescie · la metà della · prima spesa, cioè che, dove prima in 2 banchi · si da¹³và · dinari · 4 · in 3, si viene a dare · sei · a 2 dinari · per banco, essendo il fosso in fondo braccia · 16; ancora se'l fosso fusse largo braccia 16 ¹⁴e profōdo · 4 ·, venēdo · a · 4 L · per opera ·, dinari 4 · Milanesi · il braccio quadro ·; il fosso · che in fondo sarà braccia ¹⁵32, verrà a stare dinari · 8 il · braccio quadro.

and there are but 2 banks; that is to say one from the bottom of the trench to the surface of the edges of it, and the other from these edges to the top of the ridge of earth which will be raised on the margin of the bank. And if this bank were of double the depth only the first bank will be increased, that is 4 braccia increased by half the first cost; that is to say that if at first 4 dinari were paid for 2 banks, for 3 it would come to 6, at 2 dinari the bank, if the trench measured 16 braccia at the bottom; again, if the trench were 16 braccia wide and 4 deep, coming to 4 lire for the work, 4 Milan dinari the square braccio; a trench which was 32 braccia at the bottom would come to 8 dinari the square braccio.

L. 1 a]

1002.

Dal muro d'Arno della ²Giustitia all'argine d'Ar³no di Sardigna, dove sono ⁴i muri alle mulina, è braccia ⁵7400, cioè migla 2 ⁶e braccia 1400, ⁷e'l di là d'Arno è braccia 5500.

From the wall of the Arno at [the gate of] la Giustizia to the bank of the Arno at Sardigna where the walls are, to the mills, is 7400 braccia, that is 2 miles and 1400 braccia and beyond the Arno is 5500 braccia.

C. A. 284 a; 865 a]

1003.

Dirizzare Arno ²di sotto e di sopra; ³s'auanzerà vn tesoro, ⁴a tanto per stajoro ⁵a chi lo vole.

By guiding the Arno above and below a treasure will be found in each acre of ground by whomsoever will.

Br. M. 273 b]

1004.

Il muro dalle ²Casaccie si ³dirizza alla por⁴ta di san Niccolò.

The wall of the old houses runs towards the gate of San Nicolo.

. . bancho "essendo il fosso in fondo braccia 16" anchora . . fusi largho. 14. [e al] e profōdo. 15. verɪa dinari.
1002. 2. gusstitia. 4. e br. 5. [8000] 7400 coe. 6. br. 7. br.
1003. 1. dirizare arnno. 4. attanto perisstaioro. 1004. 1. mro d lle. 2. casace [con]. 3. diriza. 4. nicolo.

1002. 2. *Giustizia.* By this the Porta della Giustizia seems to be meant; from the XVth to the XVIth centuries it was also commonly known as Porta Guelfa, Porta San Francesco del Renaio, Porta Nuova, and Porta Reale. It was close to the Arno opposite to the Porta San Niccolò, which still exists.

1004. By the side of this text there is an indistinct sketch, resembling that given under No. 973. On the bank is written the word *Casace.* There then follows in the original a passage of 12 lines in which the consequences of the windings of the river are discussed. A larger but equally hasty diagram on the same page represents the shores of the Arno inside Florence as in two parallel lines. Four horizontal lines indicate the bridges. By the side these measures are stated in figures: 1. (at the Ponte alla Carraja): 230—*largho br. 12 e 2 di spōda e 14 di pile e a 4 pilastri;* 2. (at the Ponte S. Trinità): 188—*largho br. 15 e 2 di spōde he 28 di pilastri for delle spōde e pilastri sō 2;* 3. (at the Ponte vecchio); *pōte lung br. 152 e largo;* 4. (at the Ponte alle Grazie): 290 *ellargo 12 e 2 di spōde e 6 di pili.*

There is, in MS. W. L. 212[b], a sketched plan of Florence, with the following names of gates: *Nicholo—Saminiato—Giorgo—Ghanolini—Porta San Fredian—Prato—Faenza—Ghallo—Pinti—Giustitia.*

Br. M. 274 a]

1005.

640 braccia è il muro rotto, [2]e 130 è il muro rimanēte, [3]col mulino [4]300 braccia à rotto dal Bisarno in 4 anni.

The ruined wall is 640 braccia; 130 is the wall remaining with the mill; 300 braccia were broken in 4 years by Bisarno.

W. L. 226 a]

1006.

Nō sanno, perchè Arno [2]non starà mai in ca[3]nale; perchè [4]i fiumi che vi mettono, [5]nella loro entrata pō[6]gono terreno, e dalla oppo[7]sita parte leuano e [8]pieganvi il fiume; [9]6 miglia si fa per Ar[10]no dalla Caprona a Li[11]vorno, e 12 si fa per li [12]stagni che s'avāzano 32 [13]miglia, e 16 dalla Caprona [14]in sù, che fā 48 [15]per Arno da Firenze, [16]avanzasi 16 miglia; a Vico miglia 16, [17]e'l canale à 5; [18]da Firenze a Fucechio miglia 40 per [19]acqua d'Arno.

[20]Miglia 56 · per Arno [21]da Firēze a Vico, [22]e pel canale di Pistoia [23]è miglia 44 · adū[24]que è piv corta 12 [25]miglia per canale che per Arno.

They do not know why the Arno will never remain in a channel. It is because the rivers which flow into it deposit earth where they enter, and wear it away on the opposite side, bending the river in that direction. The Arno flows for 6 miles between la Caprona and Leghorn; and for 12 through the marshes, which extend 32 miles, and 16 from La Caprona up the river, which makes 48; by the Arno from Florence beyond 16 miles; to Vico 16 miles, and the canal is 5; from Florence to Fucechio it is 40 miles by the river Arno.

56 miles by the Arno from Florence to Vico; by the Pistoia canal it is 44 miles. Thus it is 12 miles shorter by the canal than by the Arno.

Leic. 18 b]

1007.

Cōcauità fatta da Mēsola, quādo Arno è basso e Mē-sola grossa.

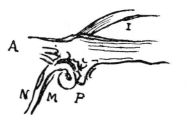

The eddy made by the Mensola, when the Arno is low and the Mensola full.

1005. 1. 6400 bre. 2. moro.
1006. 2. nōnistara. 4. mettano. 6. gā terreno e dallopo. 10. caprona alli. 12. savāza. 17. ecanale. 19. acq"a". 24. chorta.

1006. This passage is written by the side of a map washed in Indian ink, of the course of the Arno; it is evidently a sketch for a completer map.

These investigations may possibly be connected with the following documents. *Francesco Guiducci alla Balìa di Firenze. Dal Campo contro Pisa 24 Luglio 1503* (*Archivio di Stato, Firenze, Lettere alla Balìa;* published by J. GAYE, *Carteggio inedito d'Artisti, Firenze* 1840, *Tom. II,* p. 62): *Ex Castris, Franciscus Ghuiduccius,* 24. *Jul.* 1503. *Appresso fu qui hieri con una di V. Signoria Alexandro degli Albizi insieme con Leonardo da Vinci et certi altri, et veduto el disegno insieme con el ghovernatore, doppo molte discussioni et dubii conclusesi che l'opera fussi molto al proposito, o si veramente Arno volgersi qui, o restarvi con un canale, che almeno vieterebbe che le colline da nemici non potrebbono essere offese; come tucto referiranno loro a V. S.*

And, *Archivio di Stato, Firenze, Libro d'Entrata e Uscita di cassa de' Magnifici Signori di luglio e agosto*

1503 *a* 51 *T.: Andata di Leonardo al Campo sotto Pisa. Spese extraordinarie dieno dare a di XXVI di luglio L. LVI sol. XIII per loro a Giovanni Piffero; e sono per tanti, asegnia avere spexi in vetture di sei chavalli a spese di vitto per andare chon Lionardo da Vinci a livellare Arno in quello di Pisa per levallo del lito suo.* (Published by MILANESI, *Archivio Storico Italiano, Serie III, Tom. XVI.*) VASARI asserts: *(Leonardo) fu il primo ancora, che giovanetto discorresse sopra il fiume d'Arno per metterlo in canale da Pisa a Fiorenza* (ed. SANSONI, IV, 20).

The passage above is in some degree illustrated by the map on Pl. CXII, where the course of the Arno westward from Empoli is shown.

1007. *Mensola* is a mountain stream which falls into the Arno about a mile and a half above Florence.

A=Arno, I=Isola, M=Mvgone, P=Pesa, N=Mesola.

1008.

Come il fiume, che s'a à piegare d'uno in altro loco, debbe essere lusin²gato e nō con uiolenza aspreggiato, e a questo fare si de' cauare infra'l fiume alquāto ³di pescaia, e poi di sotto gittarne vna piv ināti, e così si faccia colla 3ª 4ª e 5ª, in modo che'l ⁴fiume inbocchi col canale datoli, o che per tal mezzo si scosti dal loco da lui danneggiato, come ⁵fu fatto in Fiādra, dettomi da Niccolò di Forzore;

Come si de' vestire di riparo vn argine percosso ⁶dal'acqua, come sotto l'isola de' Cocomeri.

That the river which is to be turned from one place to another must be coaxed and not treated roughly or with violence; and to do this a sort of floodgate should be made in the river, and then lower down one in front of it and in like manner a third, fourth and fifth, so that the river may discharge itself into the channel given to it, or that by this means it may be diverted from the place it has damaged, as was done in Flanders—as I was told by Niccolò di Forsore.

How to protect and repair the banks washed by the water, as below the island of Cocomeri.

Fig. 1.

Fig. 2.

Fig. 3.

Fig. 4.

⁷Pōte Rubaconte (Fig. 1); ⁸sotto il Bisticci ⁹e Canigiani (Fig. 2); ¹⁰sopra la pescaia de¹¹lla Givstitia (Fig. 3); ¹²a b è vna secca ¹³a riscōtro doue fi¹⁴niscie l'isola de' Coco¹⁵meri in mezzo d'Ar¹⁶no (Fig. 4).

Ponte Rubaconte (Fig. 1); below [the palaces] Bisticci and Canigiani (Fig. 2). Above the flood gate of la Giustizia (Fig. 3); a b is a sand bank opposite the end of the island of the Cocomeri in the middle of the Arno (Fig. 4).

1009.

Canals in the Milanese (1009—1013).

Navilio di san Cristoforo di Milano fatto a dì 3 di maggio 1509.

The canal of San Cristofano at Milan made May 3rd 1509.

1010.

DEL CANALE DI MARTESANA.

OF THE CANAL OF MARTESANA.

²Facēdo il canale di Martesana e'si diminuisce ³l'acqua all'Adda, la qual è destribuita in mol⁴ti paesi al seruitio de' prati; Ecco vn rime⁵dio, e questo è di fare molti

By making the canal of Martesana the water of the Adda is greatly diminished by its distribution over many districts for the irrigation of the fields. A remedy for this

1008. 1. chessa . . locho. 2. asspreggato e acquessto. 4. inbochi . . mezo si scossti dal locho dallui damegato. 5. nicholo . . percossa. 8. bestticci. 9. camigagani. 10. pesscaja. 11. giosstitia. 15. imezo.

1009. crisstofano . . facto addi . . maggo.

1010. 1. martigana. 2. martigana . . diminuissce. 3. imol. 4. Ecci. 5. ecquesto . . checq. 6. beuta datta terra. 8. nessono

1008. The course of the river Arno is also discussed in Nos. 987 and 988.

1009. This observation is written above a washed pen and ink drawing which has been published as Tav. VI in the „Saggio." The editors of that work explain the drawing as *"uno Studio di bocche per estrazione d'acqua."*

1010. *"el navilio di Martagano"* is also mentioned

in a note written in red chalk, MS. H² 17ᵃ Leonardo has, as it seems, little to do with Lodovico il Moro's scheme to render this canal navigable. The canal had been made in 1460 by Bertonino da Novara. Il Moro issued his degree in 1493, but Leonardo's notes about this canal were, with the exception of one (No. 1343), written about sixteen years later.

fontanili, chè q⁶uell'acqua, che è bevuta dalla terra nō fa ser⁷uitio a nessuno, nè ancora danno, perchè a ⁸nessuno è tolta, e facēdo tali fontanili, l'acqua, ⁹che prima era perduta, ritorna di nouo a rifa¹⁰re seruitio e vtile alli omini.

would be to make several little channels, since the water drunk up by the earth is of no more use to any one, nor mischief neither, because it is taken from no one; and by making these channels the water which before was lost returns again and is once more serviceable and useful to men.

Leic. 18 a]

1011.

Nessuno canale, che esca fori de' fiumi, sarà durabile, se l'acqua del fiume, donde ²nascie, non è integralmēte rinchiusa come il canal di Martisana e quel ch'escie di Tesino.

No canal which is fed by a river can be permanent if the river whence it originates is not wholly closed up, like the canal of Martesana which is fed by the Ticino.

C. A. 139 b; 421 b]

1012.

Dal principio del navilio al mo²lino.
³Dal prīcipio del navilio di Briuio al ⁴molino del Travaglia è trabochi 2794, ⁵cioè · braccia 11176, che son più di 3 miglia ⁶e due terzi, e quiui truovo più alto il ⁷navilio che la pelle dell'acqua di

From the beginning of the canal to the mill.
From the beginning of the canal of Brivio to the mill of Travaglia is 2794 trabochi, that is 11176 braccia, which is more than 3 miles and two thirds; and here the canal is 57 braccia higher than the surface

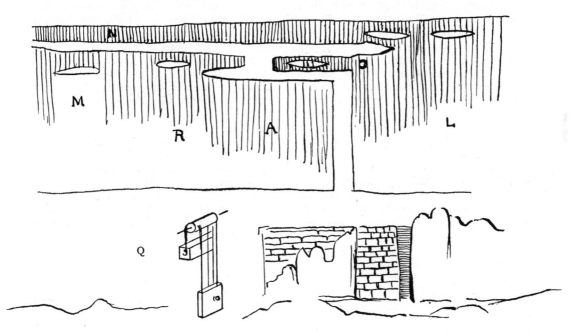

ettolta effacēdo . . lacq"a". 9. primo. 10. omini E . *there the text breaks off*.
1011. 1. chanale . . essca . . sellacqua. 2. nasscie . . rinciusa . . tessino.
1012. marligana ecquel . . esscie. 5. br. 11176. 6. ecquini. 7. chella . . dellacq"a' . . br. 57. 8. chalo.

1012. The following are written on the sketches: At the place marked *N: navilio da dacquiue* (canal of running water); at *M: molin del Travaglia* (Mill of Travaglia); at *R: rochetta ssanta maria* (small rock of Santa Maria); at *A: Adda*; at *L: Lagho di Lecho ringorgato alli 3 corni in Adda,—Concha perpetua* (lake

Adda · braccia 57, [8]a dare due ōcie di calo per ogni cētō trabochi, [9]e in tal sito

of the water of the Adda, giving a fall of two inches in every hundred trabochi; and

disegniamo torre la bocha [10]del nostro navilio.

at that spot we propose to take the opening of our canal.

C. A. 233 *a*; 700 *a*]

1013.

¶Se nō ui si da fama che questo sia canale pu²blico, e' sarà necessario pagare il terreno, [3]e lo pagherà il rè col lasciare li dazi d'un āno.

If it be not reported there that this is to be a public canal, it will be necessary to pay for the land; and the king will pay it by remitting the taxes for a year.

H.² 43 *a*]

1014.

NAVILIO.

CANAL.

Estimates and preparatory studies for canals (1014. 1015).

[2]Jl navilio · che sia · largo in fōdo [3]braccia 16 · e in bocca · 20 ·, si potrà dire [4]in soma · tutto · largo braccia 18 ·, e se sarà [5]profondo · 4 · braccia ·, a 4 · dinari il quadretto ·, [6]costerà · il miglio · cavatura · sola [7]duc . 900 ·, essendo · i quadreti · di [8]comune · braccio, ma se le · braccia saranno [9]a vso di misura · di terra ·, che ogni [10]4 . son 4 . e ¹/₂, e se il miglio s'ī[11]tēde di tre mila braccia comuni, a tornar · [12]in braccia · di · terra · le sua 3000 · braccia tor[13]nano · māco ¹/₄, che restano · braccia · [14]2250, che a 4 dinari il · braccio, mōta [15]il miglio ducati 675; a 3 dina[16]ri il quadretto mōta il miglio ducati [17]506 ¹/₄, che la cavatura di 30 mi[18]glia di navilio mōta ducati 15187 · ¹/₂.

The canal which may be 16 braccia wide at the bottom and 20 at the top, we may say is on the average 18 braccia wide, and if it is 4 braccia deep, at 4 dinari the square braccia; it will only cost 900 ducats, to excavate by the mile, if the square braccio is calculated in ordinary braccia; but if the braccia are those used in measuring land, of which every 4 are equal to 4 ¹/₂, and if by the mile we understand three thousand ordinary braccia; turned into land braccia, these 3000 braccia will lack ¹/₄; there remain 2250 braccia, which at 4 dinari the braccio will amount to 675 ducats a mile. At 3 dinari the square braccio, the mile will amount to 506 ¹/₄ ducats so that the excavation of 30 miles of the canal will amount to 15187 ¹/₂ ducats.

1013. 2. necesario. 3. ello pagera . . lidāti.
1014. 2. chessia. 3. br. 16 . . boccha . . portrà di. 4. tucto . . br. 18 essessara. 5. 4 br. a 4 . di. 6. chosstera. 7. quadrecti. 8. br. massellebr. sarano. 10. ¹/₂ M sseil. 11. mila br. 12. br. di . . comunitornar. 12. 3000 br. 13. restaño br. 14. il {br. 16. duc. 17. chella. 18. colasciare duc.

of Lecco overflowing at Tre Corni, in Adda,— a permanent sluice). Near the second sketch, referring to the sluice near *Q: qui la chatena ttalie d'ū peso* (here the chain is in one piece). At *M* in the lower sketch: *molʳ del travaglia, nel cavare la concha il tereno ara chōtrapeso cō cassa d'acqua* (Mill of Travaglia, in digging out the sluice the soil will have as a counterpoise a vessel of water).

1013. 3. *il rè*. Louis XII or Francis I of France. It is hardly possible to doubt that the canals here spoken of were intended to be in the Milanese. Compare with this passage the rough copy of a letter by Leonardo, to the *"Presidente dell' Ufficio regolatore dell' acqua"* on No. 1350. See also the note to No. 745, l. 12.

Br. M. 149 a]　　　　　　　**1015.**

Per fare il grā ²canale, fa prima ³il
piccolo e dalli ⁴l'acqua, che colla ⁵rota farà
il grāde.

To make the great canal, first make the
smaller one and conduct into it the waters
which by a wheel will help to fill the great one.

C. A. 72 b; 211 b]　　　　　　　**1016.**

¶Poni il uero mezzo di Milano.¶

Indicate the centre of Milan.

Mōforte—porta rēsa—porta nova—strada nova—navilio—porta cumana—barco—porta _{Notes on}
giovia—porta vercellina—porta sco Anbrogio—porta Tesinese—torre dell'Imperatore—_{buildings at}
porta Lodovica—acqua.

Notes on
buildings at
Milan
(1016—1019).

I.¹ 32 b]　　　　　　　**1017.**

A

Rifosso di Mila²no;

³Canale ⁴largo 2 ⁵braccia;

⁶Castello ⁷con fossi ingor-
gati;

⁸Ingorgatione ⁹de'fossi del
¹⁰castello di Milā.

The moat of Milan.

Canal 2 braccia wide.

The castle with the moats
full.

The filling of the moats of
the Castle of Milan.

I.¹ 34 a]　　　　　　　**1018.**

BAGNO.

²Per iscaldare l'acqua della stufa della
³duchessa torrai 3 parti d'acqua cal¹¹da
sopra 4 parti d'acqua fredda.

THE BATH.

To heat the water for the stove of the
Duchess take four parts of cold water to
three parts of hot water.

1015. 1—5 R. 3. picholo. 4. lachq"a" che cholla.
1016. 1. mezo; — barcho — tore delomperatore — porta lodovicha.
1017. 7. co fossi.　　　　　**1018.** 2. lacq"a". 3. torai . . parte dacq"a" chal. 4. dacq"a".

1016. See Pl. CIX. The original sketch is here
reduced to about half its size. The gates of the
town are here named, beginning at the right hand
and following the curved line. In the bird's eye
view of Milan below, the cathedral is plainly recog-
nisable in the middle; to the right is the tower of San
Gottardo. The square, above the number 9147, is
the Lazzaretto, which was begun in 1488. On the
left the group of buildings of the *'Castello'* will be

noticed. On the sketched Plan of Florence (see
No. 1004 note) Leonardo has written on the margin
the following names of gates of Milan: Vercel-
lina — Ticinese — Ludovica — Romana — Orientale —
Nova—Beatrice—Cumana.—Compare too No. 1448,
ll. 5, 12.

1018. *Duchessa di Milano*, Beatrice d'Este, wife of
Ludovico il Moro to whom she was married, in
1491. She died in June 1497.

L. 15 a] **1019.**

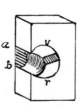

In domo alla car-
ruco²la del chiodo
della croce;
 ³item.
 ⁴Da mettere il
⁵corpo *v r* ⁶nello

In the Cathedral at
the pulley of the nail
of the cross.
 Item.
 To place the mass
v r in the ...

E. 1 a] **1020.**

DELLA POTENTIA DEL UACUO ²GIENERATO IN
ISTĀTE.

OF THE FORCE OF THE VACUUM FORMED IN
A MOMENT.

³Vidi a Milano v̄a saetta percuotere la
⁴torre della Credenza da quella parte ⁵che
risguarda tramōtana e disciese ⁶con tardo
moto per esso lato, e inmediate ⁷si divise
da essa torre, ⁸e si ualse d'esso ⁹muro uno
spa¹⁰tio di 3 braccia per o¹¹gniv̄o e pro-
¹²fondo due, e ¹³questo muro ¹⁴era grosso
4 braccia, ¹⁵ed era mura¹⁶to di sottili e
¹⁷minuti matto¹⁸ni antichi, ¹⁹e questo fu
ti²⁰rato dal uacu²¹o, che la ²²fiāma della
²³saetta lasciò ²⁴di se ecc.

I saw, at Milan, a thunderbolt fall on
the tower della Credenza on its Northern
side, and it descended with a slow motion
down that side, and then at once parted from
that tower and carried with it and tore away
from that wall a space of 3 braccia wide
and two deep; and this wall was 4 braccia
thick and was built of thin and small old
bricks; and this was dragged out by the
vacuum which the flame of the thunderbolt
had caused, &c.

Leic. 28 a] **1021.**

Remarks on natural phenomena in and near Milan (1021. 1022).

Io sono già stato a vedere tal mvltipli-
catione (di arie) e già ²sopra a Milano in-
verso lago Maggiore vidi vna nvuola in

I have already been to see a great
variety (of atmospheric effects). And lately
over Milan towards Lago Maggiore I saw a

1019. 1. charucho. 2. ciodo. 6. nello s *here the text breaks off.*
1020. 1. uachuo. 2. isstāte. 3. perchotere. 4. dacquella. 5. rissghuarda mōtana e dissciesse. 7. torre e porto chonsecho.
8. essiulse. 10. 3. br. 13. cquesto. 14. 4 br. 18. antichi ec. 19. ecquessto. 20. uachu. 21. chella. 23. lasscio.
1021. 1. mvltiplicatione e ga. 2. magore . . mōtaggnia . . scoli. 3. infochati . . razi . . ga . . orizonte . . rossegaua . .

1019. On this passage AMORETTI remarks (*Memorie Storiche* chap. IX): *Nell' anno stesso lo veggiamo formare un congegno di carucole e di corde, con cui trasportare in più venerabile e più sicuro luogo, cioè nell'ultima arcata della nave di mezzo della metropolitana, la sacra reliquia del Santo Chiodo, che ivi ancor si venera. Al fol. 15 del codice segnato Q. R. in 16, egli ci ha lasciata di tal congegno una doppia figura, cioè una di quattro carucole, e una di tre colle rispettive corde, soggiugnandovi: in Domo alla carucola del Chiodo della Croce.*
AMORETTI's views as to the mark on the MS. and the date when it was written are, it may be

observed, wholly unfounded. The MS. L, in which
it occurs, is of the year 1502, and it is very unlikely that Leonardo was in Milan at that time;
this however would not prevent the remark, which
is somewhat obscure, from applying to the Cathedral
at Milan.

1020. With reference to buildings at Milan see
also Nos. 751 and 756, and Pl. XCV, No. 2 (explained on p. 52), Pl. C (explained on pages 60—62).
See also pages 25, 39 and 40.

1021. *di arie* is wanting in the original but may
safely be inserted in the context, as the formation
of clouds is under discussion before this text.

forma di grandissima mōtagnia, piena di scogli ³infocati, perchè li razzi del sole, che già era all'orizzonte che rosseggiava, la tigneano del suo colore, e questa tal nugola ⁴attraeva a se tutti li nvgoli piccoli che intorno li stavano, e la nugola grāde nō si mouea di suo loco, anzi ri⁵seruò nella sua sommità il lume del sole insino a una ora e mezzo di notte, tant'era la sua immēsa grādezza; ⁶e infra due ore di notte gienerò si gran vēto che fu cosa stupēda e inavdita.

cloud in the form of an immense mountain full of rifts of glowing light, because the rays of the sun, which was already close to the horizon and red, tinged the cloud with its own hue. And this cloud attracted to it all the little clouds that were near while the large one did not move from its place; thus it retained on its summit the reflection of the sunlight till an hour and a half after sunset, so immensely large was it; and about two hours after sunset such a violent wind arose, that it was really tremendous and unheard of.

W. XXVIII.]

1022.

A dì 10 di diciembre a ore 15 ²fu appicato il fuoco;
³A dì 18 di dicembre 1511 a ore 15 fu fatto questo ⁴secondo incendio da Suizzeri a Milano ⁵al luogo detto DCXC.

On the 10th day of December at 9 o'clock a. m. fire was set to the place.
On the 18th day of December 1511 at 9 o'clock a. m. this second fire was kindled by the Swiss at Milan at the place called DCXC.

B. 58 a]

1023.

Camini del castello di Pauia, ²àño 6 gradi di busi; è dall'uno ³all'altro uno braccio.

The chimneys of the castle of Pavia have 6 rows of openings and from each to the other is one braccio.

Note on Pavia.

ecquesta. 4. asse . . picholi . . locho. 5. somita . . mezo . . imēsu grādeza. 6. stupēte inavldita.
1022. 1—5 (R). 2. apicato . . fuocho. 3. Lore. 4. suizeri. 5. alloguo dicto.
1023. 2. buse. 3. î br.

1022. With these two texts, (l. 1—2 and l. 3—5 are in the original side by side) there are sketches of smoke wreaths in red chalk.

1023. Other notes relating to Pavia occur on p. 43 and p. 53 (Pl. XCVIII, No. 3). Compare No. 1448, 26.

H.² 17 *b*] **1024.**

Notes on the
Sforzesca
near Vige-
vano
(1024—1028).

A dì 2 di febraro 1494 alla ²Sforzesca ritrassi scalini 25 ³di ²/₃ di braccio l'uno, larghe braccia 8.

On the 2nd day of February 1494. At Sforzesca I drew twenty five steps, ²/₃ braccia to each, and 8 braccia wide.

H.¹ 38 *a*] **1025.**

Vignie di Vigevano ²a dì 20 di marzo 1494.

The vineyards of Vigevano on the 20th day of March 1494.

H.¹ 1 *a*] **1026.**

Da serrare in chiave vno · īcastro ²a Vigievano.

To lock up a butteris at Vigevano.

Leic. 21 *a*] **1027.**

Ancora se la infima parte dell'argine trauersalmēte opposto al cor²so delle acque sarà fatto in potenti e larghi gradi a uso di scala, l'acque ³che nell'abassamento del lor corso sogliono perpendicularmente cadere dal ter⁴mine di tale loco in infima sua bassezza e scalzare i fondamēti d'esso argine, non po⁵tran più discendere con colpo di troppa valitudine; e lo esenpio dico fu a me quella ⁶scala, onde cadea l'acqua de'prati della Sforzesca di Vigeuano, sulla quale ui cadea ⁷l'acqua corrēte in 50 braccia d'altezza.

Again if the lowest part of the bank which lies across the current of the waters is made in deep and wide steps, after the manner of stairs, the waters which, in their course usually fall perpendicularly from the top of such a place to the bottom, and wear away the foundations of this bank can no longer descend with a blow of too great a force; and I find the example of this in the stairs down which the water falls in the fields at Sforzesca at Vigevano over which the running water falls for a height of 50 braccia.

Leic. 32 *a*] **1028.**

Scala di Vigevano ²sotto la Sforzesca di 130 ³scaglioni, alti ¹/₄ e lar⁴ghi ¹/₂ braccio, per la qual ⁵cade l'acqua e non ⁶consuma niēte nell'ul⁷tima percussione, e per ⁸tale scala è disceso ⁹tanto terreno che a¹⁰ssecò vn padule, cio¹¹è riempì, e se n'è fat¹²to praterie da padu¹³le di grā profondità.

Stair of Vigevano below La Sforzesca, 130 steps, ¹/₄ braccio high and ¹/₂ braccio wide,

down which the water falls, so as not to wear away anything at the end of its fall; by these steps so much soil has come down that it has dried up a pool; that is to say it has filled it up and a pool of great depth has been turned into meadows.

1024. 1—3 R. 1. allas. 2. sforzesscha . . schalini. 3. di br . . large br.
1025. 1—2 R. 1. vigieuine. **1026** 1—2 R. 1. asserare. 2. auigieuine.
1027. 1. sella . . pare . . oposto. 2. fatti . . ellarghi . . disscala lacqua. 3. 2 . delor soglian . . chadere. 4. tale infima . . basseza e dissalzare . . desse. 5. disscendere . tropa . . ello . . foame colla. 6. pradi . . sforzessca di uigieuine la qual ui cadea su. 7. corēte . . br. dalteza.
1028. 1. schala di uigieuine. 2. sforzessa di [100] 130. 3. ellar. 4. ¹/₂ br . . 5. chade. 7. perchussione. 8. dissceso. 10. secho . . co. 11. rienpiuto essene. 12. di padu.

1024. See Pl. CX, No. 2. The rest of the notes on this page refer to the motion of water. On the lower sketch we read: 4 *br.* (four braccia) and *giara* (for *ghiaja*, sand, gravel).

1025. On one side there is an effaced sketch in red chalk.

Leic. 11 δ] **1029.**

Come in molti lochi si trovano ve²ne
d'acqua che sei ore crescono e sei ore
calano, e io per me n'ò veduto vna in sul
lago di Como, detta fonte Pli³niana, la
quale fa il predetto cresciere e diminuire
in modo che, quando uersa, macina due
mulini, e quãdo mãca, ⁴ cala sì ch' egli è
come guardare l'acqua in vn profondo
pozzo.

In many places there are streams of water which swell for six hours and ebb for six hours; and I, for my part, have seen one above the lake of Como called Fonte Pliniana, which increases and ebbs, as I have said, in such a way as to turn the stones of two mills; and when it fails it falls so low that it is like looking at water in a deep pit.

Notes on the North Italian lakes (1029—1033).

C. A. 211 a; 619 a] **1030.**

LAGO DI COMO · ²VAL DI CHIAUENNA.

³Sù pel lago di Como, diuerso la Magnia,
è valle Chiauenna doue la Mera fiume
mette in esso ⁴lago; qui si truovano mõ-
tagnie · sterili e altissime · con grãdi scogli ·;
j̄ queste mõtagnie ⁵li uccielli · d'acqua sono
detti marãgoni; qui nascono abeti, larici
e pini·, daini, stãbecchi, camoz⁶zi · e terribili
· orsi ·; nõ ci si può mõtare ·, se non è a
4 piedi ·; vannoci · i villani a'tẽpi delle
⁷nevi cõ grãdi · ingegni · per fare trabocare
gli orsi giv · per esse · ripe; queste ⁸mõtagnie
strette mettono in mezzo · il fiume ·, sono
a destra e a sinistra per spatio ⁹di miglia
20 . tutte a detto modo ·; truovãsi di miglio
in miglio bone · osterie ·; su¹⁰per detto fiume
· si truovano · cadute · d'acqua di 400 braccia,
le quali fanno bel vedere; ¹¹e c'è bõ uiuere
· a 4 soldi per scotto ·; per esso fiume si
cõduce assai · legniame.

LAKE OF COMO. VALLEY OF CHIAVENNA.

Above the lake of Como towards Germany is the valley of Chiavenna where the river Mera flows into this lake. Here are barren and very high mountains, with huge rocks. Among these mountains are to be found the water-birds called gulls. Here grow fir trees, larches and pines. Deer, wild-goats, chamois, and terrible bears. It is impossible to climb them without using hands and feet. The peasants go there at the time of the snows with great snares to make the bears fall down these rocks. These mountains which very closely approach each other are parted by the river. They are to the right and left for the distance of 20 miles throughout of the same nature. From mile to mile there are good inns. Above on the said river there are waterfalls of 400 braccia in height, which are fine to see; and there is good living at 4 soldi the reckoning. This river brings down a great deal of timber.

VAL SASINA.

¹³Val Sasina · viene diuerso · la Italia .;
questa è quasi di simile forma e natura;
¹⁴nascie vi assai mappello ·, e ci sono grã
ruine e cadute d'acque.

VAL SASINA.

Val Sasina runs down towards Italy; this is almost the same form and character. There grow here many *mappello* and there are great ruins and falls of water[14].

1029. 1. imolti . . trova. 2. cresscano essei . . chalano . . veduta . . sulago di chomo . . fonte pri. 3. cresciere macina piv
mulina . . mãcha. 4. chalisi . . lacqua non . . pozo.

1030. 2. ciauenna. 3. super . . diuer . . ciauenna . . "fiume" mette. 4. truova mõtagni . . chon. 5. dacqua dette . . nasscie . . larice
eppini . . stã becche chamo. 6. ze . . teribili . . po . . delli. 7. chõ grãde ingiẽgri . . trabochare. 8. metano . . mezo . . des-
stra e assinistra . . isspatio. 9. imiglio. 10. truova chadute . . br. le quale. 11. uci bõ . . ischotto per ess . . chõduce.
14. nasscievi . . ecci grã . . ecchadute. 15. valle ditrozzo. 16. ellarici. 17. tessta . . Voltolina elle . . leorme. 18. sepre

1029. 2. 3. The fountain is known by this name to this day: it is near Torno, on the Eastern shore of Como. The waters still rise and fall with the flow and ebb of the tide as Pliny described it (Epist. IV, 30; Hist. Nat. II, 206).

1030. 1031. From the character of the handwriting we may conclude that these observations were made in Leonardo's youth; and I should infer from their contents, that they were notes made in anticipation of a visit to the places here described, and derived from some person (unknown to us) who had given him an account of them.

14. The meaning of *mappello* is unknown.

Valle d'introzzo.

[16]Questa valle · produce assai abeti pini e larici ·, è doue Anbrogio Fereri fa [17]venire · il suo legniame ·; in testa · della Valtellina sono le mōtagnie di Bormio, [18]terribili · e piene sēpre di neve; qui nascono ermellini.

A bellaggio.

[20]A riscontro · a Bellaggio · castello è il fiume Latte ·, el quale · cade da alto [21]piv che braccia · 100 dalla vena ·, donde nascie, a piōbo nel lago · cō inestimabile strepito [22]e romore ·; questa vena versa solamēte agosto e settēbre.

Valtellina.

[24]Valtellina ·, com'è detto, valle circūdata d'alti e terribili · mōti, fa [25]vini potēti · e assai ·, e fa tanto bestiame · che da paesani · è concluso · nascierui [25]piv latte che uino ·; questa è la ualle · doue passa Adda, la quale prima corre [27]piv che 40 miglia per la Magnia ·; questo fiume fa il pescie temolo, il quale [28]vive d'argiēto ·, del quale · se ne truoua · assai per la sua rena; [29]j questo paese ognivno · può vēdere pane . e vino, e'l uino vale al piv uno soldo [30]il boccale · e la libra della uitella uno soldo, e'l sale 10 dinari, e'l simile il burro, [31]ed è la loro libbra 30 ōcie e l'oua uno soldo la soldata.

Valley of introzzo.

This valley produces a great quantity of firs, pines and larches; and from here Ambrogio Fereri has his timber brought down; at the head of the Valtellina are the mountains of Bormio, terrible and always covered with snow; marmots (?) are found there.

Bellaggio.

Opposite the castle Bellaggio there is the river Latte, which falls from a height of more than 100 braccia from the source whence it springs, perpendicularly, into the lake with an inconceivable roar and noise. This spring flows only in August and September.

Valtellina.

Valtellina, as it is called, is a valley enclosed in high and terrible mountains; it produces much strong wine, and there is so much cattle that the natives conclude that more milk than wine grows there. This is the valley through which the Adda passes, which first runs more than 40 miles through Germany; this river breeds the fish *temolo* which live on silver, of which much is to be found in its sands. In this country every one can sell bread and wine, and the wine is worth at most one soldo the bottle and a pound of veal one soldo, and salt ten dinari and butter the same and their pound is 30 ounces, and eggs are one soldo the lot.

C. A. 211*b*; 619*b*] **1031.**

A Bormio.

[2]A Bormio sono . i bagni ·;—sopra Como otto miglia · è la Pliniana, [3]la quale · crescie e discrescie ogni 6 · ore, e'l suo cresciere fa [4]acqua per 2 mvlina e n'avanza, e'l suo calare fa asciugare la fonte; [5]più su 2 miglia · è Nesso · terra, dove cade uno fiume cō grāde [6]enpito per una grādissima fessura di mōte ·; Queste gite sō da [7]fare nel mese di maggio; E i maggior sassi scoperti che si truouano [8]in questi paesi · sono le mōtagnie di Mādello, vicine alle mōtagnie di [9]Lecco e di Gravidona inverso Bellin-

At Bormio.

At Bormio are the baths;—About eight miles above Como is the Pliniana, which increases and ebbs every six hours, and its swell supplies water for two mills; and its ebbing makes the spring dry up; two miles higher up there is Nesso, a place where a river falls with great violence into a vast rift in the mountain. These excursions are to be made in the month of May. And the largest bare rocks that are to be found in this part of the country are the mountains of Mandello 'near to those of Lecco, and

nascie. 19. abbellagio. 20. arischontro abbellagio . chastello . . fiume lacci"o" el. 21. nascie a piōbo ne gallo chō inistimabile strepido. 22. erromore. 23. valtolina. 24. chome . . circhūdata . . etteribili. 25. vni . . effa . . besstiame . . paessani . . nasscier ui. 26. ella . . ada . . chore. 27. pesciō temere il. 29. po . . î soldo. 30. bochale ella . . î soldo ell . . burlo. 31. lbra . . elloua.

1031. abormi. 2. abormi . . ella priniana. 3. cresscie e disseresscie ōgni . . cresciere. 4. asciugare. 5. piussu . . tera . . î fiume chō. 7. del . . magio . . magior . . schoperti chessi truovno. 8. visine. 9. leche e di gravidonia . . mglia allecho

zona, a 30 miglia da Lecco, ¹⁰e quelle di ualle di Chiavenna ·, ma la maggiore è quella di Mādello, ¹¹la quale · à nella · sua basa vna buca diuerso il lago, la quale va sotto ¹²200 scalini ·, e qui d'ogni tēpo è ghiaccio · e vēto.

of Gravidona towards Bellinzona, 30 miles from Lecco, and those of the valley of Chiavenna; but the greatest of all is that of Mandello, which has at its base an opening towards the lake, which goes down 200 steps, and there at all times is ice and wind.

IN VALSASINA.

¹⁴Ī Valsasina infra · Vimognio et · Introbbio ·, a man destra entrādo per uia di ¹⁵Lecco, si trova la Troggia fiume ·, che cade da uno sasso · altissimo e cadēdo entra ¹⁶sotto terra · e lì finisce · il fiume ·; 3 · miglia · piv là si truovano li edifiti ¹⁷della · vena · del rame · e dello argēto ·, presso a una terra · detta Prato Santo Pietro, ¹⁸e vene di ferro, e cose fantastiche ·; la Grignia è piv alta · mōtagnia ch'abbino ¹⁹questi paesi ed è pelata.

IN VAL SASINA.

In Val Sasina, between Vimognio and Introbbio, to the right hand, going in by the road to Lecco, is the river Troggia which falls from a very high rock, and as it falls it goes underground and the river ends there. 3 miles farther we find the buildings of the mines of copper and silver near a place called Pra' Santo Pietro, and mines of iron and curious things. La Grigna is the highest mountain there is in this part, and it is quite bare.

C. A. 270 a; 821 a] **1032.**

Il lago di Pusiano ²versa in nel lago ³di Segrino e d'Annone ⁴e di Sala; ⁵Il lago d'Añone ha 22 braccia più alta la pelle ⁶della sua acqua che la pelle dell'acqua ⁷del lago di Lecco, e 20 braccia è più alto ⁸il lago di Pusiano che'l lago d'Añone, ⁹le quali, giūte colle braccia 22 dette, fan braccia 42, ¹⁰e quest è la maggiore altezza che abbia la pe¹¹lle del lago di Pusiāno sopra la pelle del la¹²go di Lecco.

The lake of Pusiano flows into the lake of Segrino [3] and of Annone and of Sala. The lake of Annone is 22 braccia higher at the surface of its water than the surface of the water of the lake of Lecco, and the lake of Pusiano is 20 braccia higher than the lake of Annone, which added to the aforesaid 22 braccia make 42 braccia and this is the greatest height of the surface of the lake of Pusiano above the surface of the lake of Lecco.

G. 1 a] **1033.**

A Santa Maria nella valle ²di Ravagnate, ne' mōti Briātia sō le pertiche ³di castagne di 9 braccia e di 14 l'u²no in 100.

⁵A Varallo di Ponbia presso a Sesto ⁶sopra Tesino sono li cotogni biāchi grā-⁷di e duri.

At Santa Maria in the Valley of Ravagnate in the mountains of Brianza are the rods of chestnuts of 9 braccia and one out of an average of 100 will be 14 braccia.

At Varallo di Ponbia near to Sesto on the Ticino the quinces are white, large and hard.

10. ecquelle . . edavenna malla magiore ecquella. 11. busa. 12. schalini . . diaggio. 14. ualsasina ifra . . desstra. 15. leccho . . trosa . . chade . . da ī . . chadēdo. 16. elli finissce . . pivlla si truova. 17. arzēto . . prascto petro. 18. fero . . chabbi. 19. edie.

1032. 1. ilago di pusiā. 2. inel lagho. 3. di serio e danō. 5. lagho danō . . br . . alto. 6. chella. 7. lagho . . br. eppiu. 8. he il lagho. 8. pustā . . danō br. 20. 9. gute . . br. 22 . . br. 42. 10. ecqueste la magore alteza . . la pel . . Pusiā. 12. gho di lecho.

1033. 1. maria \\\o nella. 2. di ranvagnā . . briātia. 3. 9 br. e di 14 [et] 7 (?) lu. 4. re (? = no) in 100 di 9 br. 5. a voral di ponbio presso assesto. 6. licatɔni. 7. edduri.

1032. This text has in the original a slight sketch to illustrate it.—3. The statement about the lake Segrino is incorrect; it is situated in the Valle Assina, above the lake of Pusiano.

1033. 2. *Ravagnate* (Leonardo writes *Ravagnā*) in the Brianza is between Oggiono and Brivio, South of the lake of Como. M. Ravaisson avails himself of this note to prove his hypothesis

L. 6 *a*] **1034.**

Colōbaia a Urbino a dì 30 ²di luglio Pigeon-house at Urbino, the 30th day
1502. of July 1502.

L. 6 *b*] **1035.**

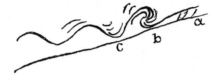

Fatta al mare di Piō- Made by the sea at
bino. Piombino.

L. 10 *b*] **1036.**

Acquapendente è a Oruieto. Acquapendente is near Orvieto.

L. 15 *b*] **1037.**

Rocca di Cesena. The rock of Cesena.

L. 19 *b*] **1038.**

Siena ²*a b* braccia ³4, ⁴*a c* braccia ⁵10; Siena, *a b* 4 braccia, *a c* 10 braccia.
⁶Scale d'Urbino. Steps at [the castle of] Urbino.

L. 33 *b*] **1039.**

Campana · di Siena, cioè ²il modo del The bell of Siena, that is the manner of
suo moto ³e sito della dinodatura ⁴del its movement, and the place of the attachment
battaglio suo. of the clapper.

1034. 1. du vrbino. 2. luglio 1402. **1035.** Aquapendente. **1037.** rocha. **1038.** 2. br. 3. br.
1039. 1. coe. 3. essito.

that Leonardo paid two visits to France. See
Gazette des Beaux Arts, 1881 pag. 528:

*Au recto du même feuillet, on lit encore une note
relative à une vallée "nemonti brigātia"; il me semble
qu'il s'agit bien des monts de Briançon, le Brigantio des
anciens. Briançon est sur la route de Lyon en Italie.
Ce fut par le mont Viso que passèrent, en août 1515,
les troupes françaises qui allaient remporter la victoire de
Marignan.*

*Léonard de Vinci, ingénieur de François I^{er}, comme
il l'avait été de Louis XII, aurait-il été pour quelque
chose dans le plan du célèbre passage des Alpes, qui eut
lieu en août 1515, et à la suite duquel on le vit
accompagner partout le chevaleresque vainqueur? Aurait-
il été appelé par le jeune roi, de Rome où l'artiste était
alors, dès son avénement au trône?*

5. Varallo di Ponbia, about ten miles South of
Arona is distinct from Varallo the chief town in the
Val di Sesia.

1034. An indistinct sketch is introduced with
this text, in the original, in which the word
Scolatoro (conduit) is written.

1035. Below the sketch there are eleven lines
of text referring to the motion of waves.

1036. *Acquapendente* is about 10 miles West of
Orvieto, and is to the right in the map on Pl. CXIII,
near the lake of Bolsena.

1037. See Pl. XCIV No. 1, the lower sketch.
The explanation of the upper sketch is given on p. 29.

1038. See Pl. CX No. 3; compare also No. 765.

1039. The text is accompanied by an indistinct
sketch.

L. 36ᵇ]

1040.

El dì di Sāta Maria mezz'agosto ²a Cesena 1502.

On St. Mary's day in the middle of August, at Cesena, 1502.

L. 40ᵃ]

1041.

Scale del cōte d'Urbino, saluatiche.

Stairs of the [palace of the] Count of Urbino,—rough.

L. 46ᵇ]

1042.

Alla fiera di Scō ²Lorenzo a Cesena, ³1502.

At the fair of San Lorenzo at Cesena. 1502.

L 47ᵃ]

1043.

Finestre da Cesena.

Windows at Cesena.

L. 66ᵇ]

1044.

Porto Cesenatico a dì 6 di set²tenbre 1502, a ore 15; ³In che modo debbono ⁴uscire bastioni fori delle ⁵mura delle terre per potere ⁶difendere l'argini di fori, ⁷aciò nō sieno battuti coll' artiglieria.

At Porto Cesenatico, on the 6ᵗʰ of September 1502 at 9 o'clock a. m. The way in which bastions ought to project beyond the walls of the towers to defend the outer talus; so that they may not be taken by artillery.

L. 67ᵃ]

1045.

La rocca del porto di Cesena sta a Ce²sena per la 4ᵃ di libeccio.

The rock of the harbour of Cesena is four points towards the South West from Cesena.

L. 72ᵃ]

1046.

In Romagnia, capo d'ogni grossezza ²d'ingegno, vsano i carri di 4 rote, de qua-³li ○ n'àño 2 dinanzi basse e due alte ⁴dirieto, la qual cosa è in gran dis⁵fauore di moto, perchè in sulle ⁶rote dinanzi si scarica piv peso, che ⁷in su quelle dirieto, come mostrai ⁸nella prima del 5° delli elemēti.

In Romagna, the realm of all stupidity, vehicles with four wheels are used, of which ○ the two in front are small and two high ones are behind; an arrangement which is very unfavourable to the motion, because on the fore wheels more weight is laid than on those behind, as I showed in the first of the 5ᵗʰ on "Elements".

1040. 1. mezagossto. 2. [4] 502. 1044. 4. vsscire basstioni . . delle.
1045. 1. rocha. 2. pla . . libecco. 1046. 1. grosseza. 2. rote equa. 7. mostai.

1040. See Pl. CX, No. 4.
1041. The text is accompanied by a slight sketch.

1043. There are four more lines of text which refer to a slightly sketched diagram.
1044. An indistinct sketch, accompanies this passage.

L. 77 a] **1047.**

Uve portate ²a Ciesena; Thus grapes are carried at Cesena.
³Il numero de' cavatori ⁴de' fossi è The number of the diggers of the ditches
piramidale. is [arranged] pyramidically.

L. 78 a] **1048.**

¶Fassi vn armonia colle diuerse cadute There might be a harmony of the different
²d'acqua, come vedesti alla fonte di falls of water as you saw them at the
³Rimini; come vedesti a dì 8 d'agosto fountain of Rimini on the 8ᵗʰ day of Au-
⁴1502.¶ gust, 1502.

L. 78 b] **1049.**

Fortezza d'Urbino. The fortress at Urbino.

L. 88 b] **1050.**

Imola vede Bologna a ⁵/₈ di ponente Imola, as regards Bologna, is five points
inverso ²maestro con ispatio di 20 mi- from the West, towards the North West,
glia; at a distance of 20 miles.
³Castel san Piero è ueduto da Imola Castel San Piero is seen from Imola at
in ¹/₂ ⁴infra ponente e maestro · con ispatio four points from the West towards the North
di ⁵7 miglia; West, at a distance of 7 miles.
⁶Faenza sta con Imola tra leuāte e Faenza stands with regard to Imola be-
scirocco ⁷in mezzo giusto a 10 miglia di tween East and South East at a distance of
spatio; ⁸Forlì sta cō Faenza infra scirocco ten miles. Forli stands with regard to Faenza
e leuā⁹te in mezzo giusto con ispatio di 25 between South East and East at a distance of
miglia ¹⁰da Imola e 10 da Faēza; 20 miles from Imola and ten from Faenza.
¹¹Forlimpopoli fa il simile a 25 mi¹²glia Forlimpopoli lies in the same direction
da Imola; at 25 miles from Imola.
¹³Bertinoro sta con Imola a ⁵/₈ infra Bertinoro, as regards Imola, is five points
leuā¹⁴te e scirocco a 27 miglia. from the East towards the South East, at 27 miles.

1047. 1. vue. 1048. 1. chadute. 3. addi. 1049. forteza.
1050. 1. inver. 2. maesstro conisspatio . . migla. 4. maesstro. 6. faenta . . esscirocho. 7. mezo gussto . . disspatio. 8. furli
 . . scirocho alleuā. 9. mezo gussto. 11. furinpopoli. 13. bertonora. 14. esscirocho.

1047. A sketch, representing a hook to which two bunches of grapes are hanging, refers to these
first two lines. Cesena is mentioned again Fol. 82 a: *Carro da Cesena* (a cart from Cesena).
 1049. In the original the text is written inside the sketch in the place here marked *n.*

W. L. 229 a] **1051.**

Imola uede Bologna a ⅝ di po²nente ·
inuerso maestro con di³stantia · di miglia · 20;
⁴Castel · San Piero · è veduto · da Imo⁵la
in mezzo infra ponente e mae⁶stro · in di-
stantia di miglia · 7.
⁷Faenza · è veduto da Imola infra leuante
⁸e scirocco in mezzo apunto in distantia
⁹di migla · 10, e 'l simile fa · Forlì con Imo-
¹⁰la con distantia di miglia · 20, e Forlimpo-
¹¹poli · fa il simile con Forlì con distantia
di ¹²miglia 25;
¹³Bertinoro si uede da Imola a ⅛ di
leuante ¹⁴inverso scirocco con distantia di
27 miglia.

Imola as regards Bologna is five points
from the West towards the North West at a di-
stance of 20 miles.
Castel San Pietro lies exactly North West
of Imola, at a distance of 7 miles.
Faenza, as regards Imola lies exactly
half way between the East and South East at
a distance of 10 miles; and Forli lies in the
same direction from Imola at a distance of
20 miles; and Forlimpopolo lies in the same
direction from Forli at a distance of 25 miles.
Bertinoro is seen from Imola two points
from the East towards the South East at a
distance of 27 miles.

L. 94 b] **1052.**

Da Bōcon²vento alla ³Casa Nova ⁴mi-
glia 10, ⁵dalla Casa No⁶va a Chiusi ⁷miglia
· 9 ·, ⁸da Chiusi a Pe⁹rugia, da Peru¹⁰gia a
Santa ¹¹Maria degli ¹²Angeli, e poi ¹³a
Fuligno.

From Bonconventi to Casa Nova are
10 miles, from Casa Nova to Chiusi 9 miles,
from Chiusi to Perugia, from Perugia to Santa
Maria degli Angeli, and then to Fuligno.

L. 0"] **1053.**

Dì primo d'agosto 1502 ²in Pesaro la
libreria.

On the first of August 1502, the library
at Pesaro.

1051. *written from left to right.* 1. blogna. 2. inuer maesstro con dis. 4. Chastel. 5. mezo . . emaes. 6. indisstantia . . migla
7. veduta. 7. esscirrocho in mezo apunto in disstantia. 9. furli. 10. chon disstantia di migla . . furlinpo. 11. furli .
disstantia. 12. migla. 13. Bernotoro. 14. inver scilocho . . disstantia . . migla.
1052. 1. bōchon. 8. aper. 10. assanta.
1053. 1. di p"o".

1051. Leonardo inserted this passage on the
margin of the circular plan, in water colour, of
Imola—see Pl. CXI No. 1.—In the original the
fields surrounding the town are light green; the
moat, which surrounds the fortifications and the
windings of the river Santerno, are light blue. The
parts, which have come out blackish close to the
river are yellow ochre in the original. The dark
groups of houses inside the town are red. At the
four points of the compass drawn in the middle
of the town Leonardo has written (from right to
left): *Mezzodì* (South) at the top; to the left *Scirocho*
(South east), *levante* (East), *Greco* (North East), *Septan-
trione* (North), *Maesstro* (North West), *ponente* (West)
Libecco (South West). The arch in which the plan
is drawn is, in the original, 42 centimètres across.

At the beginning of October 1502 Cesare Borgia
was shut up in Imola by a sudden revolt of the
Condottieri, and it was some weeks before he could
release himself from this state of siege (see Grego-
rovius, *Geschichte der Stadt Rom im Mittelalter*,
Vol. VII, Book XIII, 5, 5).
Besides this incident Imola plays no important
part in the history of the time. I therefore think
myself fully justified in connecting this map, which
is at Windsor, with the siege of 1502 and with
Leonardo's engagements in the service of Cesare
Borgia, because a comparison of these texts, Nos.
1050 and 1051, raise, I believe, the hypothesis to
a certainty.
1052. Most of the places here described lie
within the district shown in the maps on Pl. CXIII.

L. 21 *a*] **1054.**

PICTURA. OF PAINTING.

²Scorta sulle sommità e in su' lati ³de' On the tops and sides of hills foreshorten
colli le figure de' terreni e le sue ⁴diuisi- the shape of the ground and its divisions,

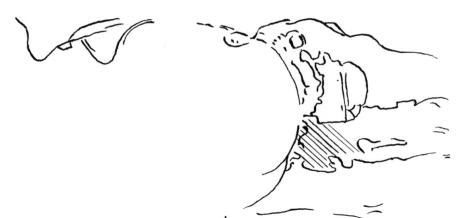

oni, e nelle cose uolte a te ⁵fa le in pro- but give its proper shape to what is turned
pia forma. towards you.

Leic. 9*b*] **1055.**

 In Candia di Lonbardia · presso Ales- At Candia in Lombardy, near Alessandria
_{Alessandria} sandria della Paglia, facendosi per ²messer della Paglia, in making a well for Messer
_{in Piedmont} Gualtieri di Candia vno pozzo, fu trovato Gualtieri of Candia, the skeleton of a very
_{(1055. 1056).} vno principio di navilio grandissimo sotto large boat was found about 10 braccia
terra, circa a braccia 10, e perchè ³il leg- underground; and as the timber was black
name era nero e bello, parue a esso messer and fine, it seemed good to the said Messer
Gualtieri di fare allungare tal bocca di pozzo Gualtieri to have the mouth of the well
in forma che i termini ⁴di tal navilio si lengthened in such a way as that the ends
scoprissino. of the boat should be uncovered.

1054. 3. essere. 4. atte. 5. falle.
1055. 2. pozo . . circha a br. 3. ebbello . . meser . . bocha di pozo. 4. navili si scoprissi.

 1054. This passage evidently refers to the By the side of this text we find, in the original,
making of maps, such as Pl. CXII, CXIII, and a very indistinct sketch, perhaps a plan of a posi-
CXIV. There is no mention of such works, it is tion. Instead of this drawing I have here inser-
true, excepting in this one passage of MS. L. But ted a much clearer sketch of a position from the
this can scarcely be taken as evidence against same MS., L. 82 b and 83 a. They are the only
my view that Leonardo busied himself very exten- drawings of landscape, it may be noted, which
sively at that time in the construction of maps; occur at all in that MS.
and all the less since the foregoing chapters **1055.** 2. *Messer Gualtieri*, the same probably as is
clearly prove that at a time so full of events Leo- mentioned in Nos. 672 and 1344.
nardo would only now and then commit his obser-
vations to paper, in the MS. L.

1056.

Leic. 10 *b*]

Alessandria della Paglia in Lombardia non à altre pietre ²da far calcina, se nō miste con infinite cose nate in mare, la quale oggi è remota dal mare piv di 200 miglia.

At Alessandria della Paglia in Lombardy there are no stones for making lime of, but such as are mixed up with an infinite variety of things native to the sea, which is now more than 200 miles away.

1057.

G. 1 *b*]

Monbracco, sopra Saluzzo,—²sopra la Certosa vn miglo, al piè di mō Viso,— ³à vna miniera di pietra ⁴faldata, la quale è biāca ⁵come marmo di Carrara, sanza ⁶macvle, ch' è della durez⁷za del porfido o più; ⁸della quale il conpare ⁹mio, maestro Benedet¹⁰to scultore, à in pro¹¹messo di darmene una ¹²tavoletta per li colori, ¹³a dì 2 di genaro 1511.

At Monbracco, above Saluzzo,—a mile above the Certosa, at the foot of Monte Viso, there is a quarry of flakey stone, which is as white as Carrara marble, without a spot, and as hard as porphyry or even harder; of which my worthy gossip, Master Benedetto the sculptor, has promised to give me a small slab, for the colours, the second day of January 1511.

The Alps (1057—1062).

1058.

Leic. 11 *b*]

Come son uene che per terremoti o altri accidenti subito nasco²no e subito mācano; E questo accade in vna mōtagnia in Sauoia, doue certi boschi sprofondarono e lasciarono vno ³baratro profondissimo · e lontano circa 4 miglia di lì s'aperse il terreno in certa spiaggia di mōte, e gittò vna ⁴subita inōdatione grossissima d'acqua, la quale nettò tutta vna vallata di terreni lauorativi, vignie e case, e fece ⁵grādissimo danno ovunque discorse.

That there are springs which suddenly break forth in earthquakes or other convulsions and suddenly fail; and this happened in a mountain in Savoy where certain forests sank in and left a very deep gap, and about four miles from here the earth opened itself like a gulf in the mountain, and threw out a sudden and immense flood of water which scoured the whole of a little valley of the tilled soil, vineyards and houses, and did the greatest mischief, wherever it overflowed.

1059.

C. A. 86 *b*; 250 *b*]

Riuiera d'Arua presso a Ginevra; ² ¼ di miglio in Sauoia, doue si fa la fiera ³ in San Giovanni nel uillaggio di san Gervagio.

The river Arve, a quarter of a mile from Geneva in Savoy, where the fair' is held on midsummerday in the village of Saint Gervais.

1056. Alesandria . . illonbardia. 2. mista . . il quale.
1057. *Lines* 1, 3—13 *R*. 1. monbracho . . saluzo, 2. a pie . . uiso. 4. biācha. 5. carra"ra"sa. 6. machvle . . dure. 7. obpiu.
 8. delle quali. 9. maesstro benedec. 11. messo con darmene.
1058. 1. nasca. 2. essubito . . Ecquesto acade nvna . . bosci profondorono ellasciorono. 3. baladro . . circha . . spiagga.
 4. terē . . effece. 5. ovunche.
1059. 2. miglo. 3. batte in san govanni . . uilago . . cervagio.

1057. *Saluzzo* at the foot of the Alps South of Turin.

9. 10. *Maestro Benedetto scultore;* probably some native of Northern Italy acquainted with the place here described. Hardly the Florentine sculptor Benedetto da Majano. Amoretti had published this passage, and M. Ravaisson who gave a French translation of it in the *Gazette des Beaux Arts* (1881, pag. 528), remarks as follows: *Le maître sculpteur que Léonard appelle son "compare" ne serait-il pas Benedetto da Majano, un de ceux qui jugèrent avec lui de la place à donner au David de Michel-Ange, et de qui le Louvre a acquis récemment un buste d'après Philippe Strozzi?*

To this it may be objected that Benedetto da Majano had already lain in his grave fourteen years, in the year 1511, when he is supposed to have given the promise to Leonardo. The colours may have been given to the sculptor Benedetto and the stone may have been in payment for them. From the description of the stone here given we may conclude that it is repeated from hearsay of the sculptor's account of it. I do not understand how, from this observation, it is possible to conclude that Leonardo was on the spot.

1059. An indistinct sketch is to be seen by the text.

Leic. 4 a] **1060.**

E questo vedrà come vid'io, chi ādrà
so pra Mōboso, giogo dell'Alpi che diuidono
la Francia dalla Italia, la qual montagnia
à la sua basa che parturisce ³li 4 fiumi
che rigā per 4 aspetti contrari tutta l'Europa,
e nessuna montagnia à le sue base in si-
mile al⁴tezza; questa si leua in tanta altura
che quasi passa tutti li nuuoli e rare volte
vi cade neue, ma sol grādi⁵ne d'istate
quando li nuuoli sono nella maggiore al-
tezza, e questa grandine vi si cōserua in
modo, che se nō ⁶fusse la retà del caderui
e del montarui nuuoli, che non accade 2
volte in vna età, egli ui sarebbe altissima
quātità di ghiaccio inalzato dali gradi della
grādine, il qua⁷le di mezzo luglio vi trouai
grossissimo ·, e vidi l'aria sopra di me tene-
brosa e 'l sole che percotea la mōta⁸gnia
essere piv luminoso quiui assai che nelle
basse pianure, perchè minor grossezza d'aria
s'interpone in⁹fra la cima d'esso monte
e 'l sole.

And this may be seen, as I saw it, by
any one going up[5] Monbroso, a peak of
the Alps which divide France from Italy.
The base of this mountain gives birth to the
4 rivers which flow in four different directions
through the whole of Europe. And no
mountain has its base at so great a height
as this, which lifts itself above almost all the
clouds; and snow seldom falls there, but
only hail in the summer, when the clouds
are highest. And this hail lies [unmelted]
there, so that if it were not for the absorp-
tion of the rising and falling clouds, which
does not happen more than twice in an age, an
enormous mass of ice would be piled up there
by the layers of hail, and in the middle of July
I found it very considerable; and I saw the
sky above me quite dark, and the sun as it
fell on the mountain was far brighter here
than in the plains below, because a smaller
extent of atmosphere lay between the summit
of the mountain and the sun.

Leic. 9 b] **1061.**

Truouasi nelle montagnie di Verona la
sua pietra rossa mista tutta di nichi con-
vertiti ²in essa pietra ·, dalli quali, per la
loro bocca, era gommata la materia d'essa
pietra, ed erano in alcuna parte restati
separati dall'altra massa del sasso che
li circundava; perchè la scorza del nichio
s'era interposta, e nō li auea ⁴lasciati
congiugniere; E in alcun altra parte tal
gomma auea petrificate le invecchiate e
quasi la scorza.

In the mountains of Verona the red marble
is found all mixed with cockle shells turned
into stone; some of them have been filled
at the mouth with the cement which is the
substance of the stone; and in some parts
they have remained separate from the mass
of the rock which enclosed them, because
the outer covering of the shell had inter-
posed and had not allowed them to unite
with it; while in other places this cement had
petrified those which were old and almost strip-
ped the outer skin.

C. A. 231 b; 696 a] **1062.**

Ponte di Goritia ²Vilpago.

Bridge of Goertz—Wilbach (?).

1060. 1. ecquesto. 2. gogo . . diuitano la franca . . alla . . parturissce. 3. alle. 4. nuuoli . . chade. 5. magore . . ecquesta
 . . ĩmodo chesse. 6. fussi "la reta del caderui e del montarui nuuoli" che non achade [del s] . . eta e. 7. mezo . .
 grossimo . . tenenebrosa ellsole. 8. luminosi . . grosseza.
1061. 2. delli . . era gornata . . edera. 3. masa . . chelli circhundava . . lasscorza. 4. lassciati congugniere . . goma . . pe-
 trificata le invegiate e quasi scorzo.
1062. vilpagho.

1060. I have vainly enquired of every available
authority for a solution of the mystery as to what
mountain is intended by the name Mom boso (Comp.
Vol. I Nos. 300 and 301). It seems most obvious
to refer it to Monte Rosa. *Rosa* is derived from the
Keltic *ros* which survives in Breton and in Gaelic,
meaning, in its first sense, a mountain spur, but which
also—like *Horn*—means a very high peak; thus
Monte Rosa would mean literally the High Peak.

6. *in una età.* This is perhaps a slip of the pen
on Leonardo's part and should be read *estate* (summer).

1062. There is a slight sketch with this text,
Leonardo seems to have intended to suggest, with
a few pen-strokes, the course of the Isonzo and
of the Wipbach in the vicinity of Gorizia (Goerz).
He himself says in another place that he had been
in Friuli (see No. 1077 l. 19).

Leic. 10 a]

1063.

Quella parte della terra s'è piv alienata dal centro ² del mōdo, la qual s'è fatta piv lieve·; E quella parte della terra s'è fatta piv lieve, per la quale ³ è passato maggior concorso · d'acque, E si è adūque fatta piv lieue quella parte, donde sco⁴la piv numero di fiumi, come l'alpi, che diuidono la Magnia e la Francia dalla Italia, delle quali ⁵escie il Rodano a mezzodì, e il Reno a tramōtana ·, ʝl Danubio over Danoia a greco, e 'l Po a leuā⁶te con īnvmerabili fiumi che con loro s'accōpagnano, i quali senpre corrono torbidi, dalla terra ⁷da loro portata, al mare;

Mouōsi al continvo i liti marittimi inverso il mezzo del mare e lo ⁸scacciā dal suo primo sito; Riseruerassi la piv bassa parte del Mediterrano per letto e cor⁹so del Nilo, fiume massimo, che versa in esso mare, E con lui s'accompagnieranno tutti li fiumi sua ¹⁰aderēti, che prima in esso mare le loro acque versar soleano, come far si uede al Po colli aderēti ¹¹sua, li quali prima versauā nel mare · che infra l'Appennino e le Germaniche alpi si era vnito ¹²col Mare Adriatico;

Come le alpi galliche son la piv alta parte dell' Evropa.

That part of the earth which was lightest remained farthest from the centre of the world; and that part of the earth became the lightest over which the greatest quantity of water flowed. And therefore that part became lightest where the greatest number of rivers flow; like the Alps which divide Germany and France from Italy; whence issue the Rhone flowing Southwards, and the Rhine to the North. The Danube or Tanoia towards the North East, and the Po to the East, with innumerable rivers which join them, and which always run turbid with the soil carried by them to the sea.

The shores of the sea are constantly moving towards the middle of the sea and displace it from its original position. The lowest portion of the Mediterranean will be reserved for the bed and current of the Nile, the largest river that flows into that sea. And with it are grouped all its tributaries, which at first fell into the sea; as may be seen with the Po and its tributaries, which first fell into that sea, which between the Appenines and the German Alps was united to the Adriatic sea.

That the Gallic Alps are the highest part of Europe.

The Appenins (1063—1068).

E. 1 b

1064.

E di questi ò ri²trovato nelli ³sassi dell'alto ⁴Appenino e ⁵massime nel ⁶sasso della Ver⁷na.

And of these I found some in the rocks of the high Appenines and mostly at the rock of La Vernia.

E. 80 a]

1065.

A Parma alla ²Cāpana a dì 25 ³di settēbre 1514.

At Parma, at 'La Campana' on the twenty-fifth of October 1514.

1063. 2. lequella . . seffatta. 3. magor choncorso . . Essi adūque. 4. diuidano . . ella franca . . della qual. 5. attramōtana . . danubbio . . tanoia a grecho . . alleu. 6. chon . . cholloro sacōpagniano . . corrā. 7. dallo portata . . movāsi . . mezo . . ello. 8. scaccā del . . mediterano. 9. ineso . . sachonpagniera. 10. solano . . colli aderē. 11. apenino elle . . serava. 12. chol . . adriaticho . . le alpe le . . pivolta.
1064. 1. quessti. 2. trovati. 7. nia.

1064. 6. *Sasso della Vernia*. The frowning rock between the sources of the Arno and the Tiber, as Dante describes this mountain, which is 1269 mètres in height.

This note is written by the side of that given

as No. 1020; but their connection does not make it clear what Leonardo's purpose was in writing it.

1065. 2. *Cāpana*, an Inn.

A note on the petrifactions, or fossils near Parma will be found under No. 989.

C. A. 137a; 414a]　　　　　　　　1066.

Modo di seccare il padule [2]di Piom-
bino.

A method for drying the marsh of
Piombino.

K.[1] 2a]　　　　　　　　1067.

Fanno li pastori [2]in quel di Roma[3]gnia
nelle radici [4]dell' Appēnino certe [5]gran con-
cauità ne[6]l monte a uso di cor[7]no e da
parte commet[8]tono vn corno, e q[9]uello
piccol corno di[10]uēta vn medesimo col[11]la
già fatta concauità, ō[12]de fa grādissimo
suono.

The shepherds in the Romagna at the
foot of the Apennines make peculiar large
cavities in the mountains in the form of
a horn, and on one side they fasten a horn.
This little horn becomes one and the same
with the said cavity and thus they produce
by blowing into it a very loud noise.

Leic. 31 b]　　　　　　　　1068.

Vedesi vna vena surgere in Sicilia, la
[2]quale a certi tenpi dell' anno versa foglie
di castagno in moltitudine, e in Sicilia nō
na[3]scono castagnie, è adūque necessario
che tal uena esca d'alcū pelago dell' Italia
e va[4]da poi sotto il mare e sbocchi poi in
Sicilia.

A spring may be seen to rise in Sicily
which at certain times of the year throws
out chesnut leaves in quantities; but in
Sicily chesnuts do not grow, hence it is
evident that that spring must issue from some
abyss in Italy and then flow beneath the sea
to break forth in Sicily.

1066. 1. sechare.
1067. 3. radice. 4. apēnino. 5. chonchauita. 7. pare come. 8. tano vn chorno ecq. 9. pichol. 10. chol. 11. ga. 12. sono.
1068. 1. cicilia. 2. accerti . . ano. 3. chasstagno . . moltitudile 3. scie chastagnie . . chettal esscha dalchū pellagho.
　　　　4. día poi essbochi . . cicilia.

1066. There is a slight sketch with this text
in the original. — Piombino is also mentioned in
Nos. 609, l. 55—58 (compare Pl. XXXV, 3, below).
Also in No. 1035.

1067. As to the Romagna see also No. 1046.
1046. The chesnut tree is very common in Si-
cily. In writing *cicilia* Leonardo meant perhaps
Cilicia.

II.

FRANCE.

C. A. 353 *b*; 1105 *b*] **1069.**

ALEMAGNIA.	FRANCIA.	GERMANY.	FRANCE.
[2] a. Austria,	a. Picardia,	a. Austria.	a. Picardy.
[3] b. Sassonia,	b. Normandia,	b. Saxony.	b. Normandy.
[4] c. Norimberga,	c. Delfinato;	c. Nuremberg.	c. Dauphiné.
[5] d. Fiandra;	d.	d. Flanders.	

	SPAGNIA.		SPAIN.
	[7] a. Biscaglia,		a. Biscay.
	[8] b. Castiglia,		b. Castille.
	[9] c. Galitia,		c. Galicia.
	[10] d. Portogallo,		d. Portugal.
	[11] e. Tarragona,		e. Taragona.
	[12] f. Granada.		f. Granada.

C. A. 358 *b*; 1124 *b*] **1070.**

Perpigniana;	Perpignan.
[2] Roana,	Roanne.
[3] Lione,	Lyons.
[4] Parigi,	Paris.
[5] Guāto,	Ghent.
[6] Brugia,	Bruges.
[7] Olanda.	Holland.

1069. *In the original the three columns are parallel.* 1. alamania franca — spognia. 4. nolinberg — dalfinato. 5. flandra. 7. bisscaglia. 8. casstiglia. 11. taragona. 12. granata.

1070. 3. lioñe.

 1069. Two slightly sketched maps, one of Europe the other of Spain, are at the side of these notes.

 1070. *Roana* does not seem to mean here Rouen in Normandy, but is probably Roanne (Rodumna) on the upper Loire, Lyonnais (Dép. du Loire). This town is now unimportant, but in Leonardo's time was still a place of some consequence.

Leic. 27 b]　　　　　　　　　　1071.

Come in Bordea presso a Guascognia
alza il mare circa a 40 braccia pel suo
reflus²so, e 'l suo fiume ringorga l'acque
salze piv di cento cinquāta miglia, e li
nauili, che ³si debbono calafatare, restano
alti sopra vn alto collo sopra dello abassato
mare.

At Bordeaux in Gascony the sea rises
about 40 braccia before its ebb, and the
river there is filled with salt water for more
than a hundred and fifty miles; and the
vessels which are repaired there rest high
and dry on a high hill above the sea at
low tide.

Leic. 34 b]　　　　　　　　　　1072.

El Rodano esce dal lago di Ginevra e
corre prima ²a ponente, e poi a mezzodì,
con corso di 400 miglia, e versa le sue
acque nel mare mediterrano.

The Rhone issues from the lake of
Geneva and flows first to the West and then
to the South, with a course of 400 miles
and pours its waters into the Mediterranean.

K.3 20 a]　　　　　　　　　　1073.

c d giardino di Bles;
²a b è il cōdotto di
Bles, fatto ī ³Frācia
da Fra Giocōdo, b c
è il ⁴mācamēto dell'al-
tezza di tal cō⁵dotto,
c d è l'altezza del
giar⁶dino di Bles, e f
è la caduta ⁷della ci-
cognola, b c, e f, f g
⁸è dove tal cicognola
versa nel ⁹fiume.

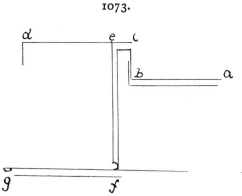

c d is the garden at
Blois; a b is the con-
duit of Blois, made in
France by Fra Gioco-
do, b c is what is want-
ing in the height of
that conduit, c d is the
height of the garden at
Blois, e f is the siphon
of the conduit, b c, e
f, f g is, where the si-
phon discharges into the
river.

1071. 1. guasscogna . . circha a 40 br . . refru. 2. elli. 3. deano . . chollo.
1072. 1. essce del lagho. 2. mezodi . . mediterano.

1071. 2. This is obviously an exaggeration
founded on inaccurate information. Half of 150
miles would be nearer the mark.

1073. The tenor of this note (see lines 2 and 3)
seems to me to indicate that this passage was not
written in France, but was written from oral infor-
mation. We have no evidence as to when this
note may have been written beyond the circumstance
that Fra Giocondo the Veronese Architect left France
not before the year 1505. The greater part of the
magnificent Château of Blois has now disappeared.
Whether this note was made for a special purpose is
uncertain. The original form and extent of the
Château is shown in Androvet, *Les plus excellents
Bastiments de France, Paris MDCVII*, and it may be
observed that there is in the middle of the
garden a Pavilion somewhat similar to that shown
on Pl. LXXXVIII No. 7.

See S. DE LA SAUSSAYE, *Histoire du Château de Blois
4ème édition Blois et Paris* p. 175: *En mariant sa
fille aînée à François, comte d'Angoulême, Louis XII lui
avait constitué en dot les comtés de Blois, d'Asti, de Coucy,
de Montfort, d'Etampes et de Vertus. Une ordonnance
de François I. lui laissa en 1516 l'administration du
comté de Blois.*

*Le roi fit commencer, dans la même année, les travaux
de cette belle partie du château, connue sous le nom
d'aile de François I, et dont nous avons donné la
description au commencement de ce livre. Nous trouvons
en effet, dans les archives du Baron de Joursanvault,
une pièce qui en fixe parfaitement la date. On y lit:
"Je, Baymon Philippeaux, commis par le Roy à tenir le
compte et fair le payement des bastiments, ediffices et
reparacions que le dit seigneur fait faire en son chastu
de Blois, confesse avoir eu et reçeu . . . la somme de
trois mille livres tournois le cinquième jour de
juillet, l'an mil cinq cent et seize. P. 24: Les jardins
avaient été décorés avec beaucoup de luxe par les différents
possesseurs du château. Il ne reste de tous les bâtiments
qu'ils y élevèrent que ceux des officiers chargés de l'ad-*

Br. M. 269*a*]　　　　　　　　　1074.

Loira fiume ²d'Ambosa.

³Il fiume è più ⁴alto dentro al⁵l'argine *b d* che ⁶fuori d'essa ar⁷gine;

⁸Isola dove è ⁹vna parte ¹⁰d'Anbuosa.

¹¹Il fiume Loira che passa per Anbosa passa per *a b, c d,* e poichè è passato il pōte, ¹²ritorna contro al suo avenimento per il canale *d e, b f* in contatto dell'argine ¹³che si interpone infra li due moti contrari del predetto fiume *a b, c d, d e, b f;* ¹⁴di poi si riuolta in giù per il canale *f l, g h, n m,* e si ricongiugnie col fiume dōde ¹⁵prima si diuise, che passa per *k n,* che fa *k m, r t;* ma quādo il fiume è ¹⁶grosso, allora elli corre tutto per uno solo verso, passādo l'argine *b d.*

The river Loire at Amboise.

The river is higher within the bank *b d* than outside that bank.

The island where there is a part of Amboise.

This is the river that passes through Amboise; it passes at *a b c d,* and when it has passed the bridge it turns back, against the original current, by the channel *d e, b f* in contact with the bank which lies between the two contrary currents of the said river, *a b, c d,* and *d e, b f.* It then turns down again by the channel *f l, g h, n m,* and reunites with the river from which it was at first separated, which passes by *k n,* which makes *k m, r t.* But when the river is very full it flows all in one channel passing over the bank *b d.*

Br. M. 269*b*]　　　　　　　　　1075.

L'acque sieno rin²gorgate sopra ³il termine di Ro⁴morontino in tā⁵ta altezza, ch'elle ⁶faccino poi nel ⁷loro disciēso mol⁸te molina;

The water may be dammed up above the level of Romorantin to such a height, that in its fall it may be used for numerous mills.

1073. 1. gardino. 4. alteza. 5. ellalteza del gar. 6. ella.

1074. 1. Loera. 2. dā[n]bosa. 3. gocōdo. 3. eppiu. 8. fiume era che. 13. chessi . . infralli . . controri . . predecto. 14. ess richongiugnie. 15. diuise [eppa] che . . cheffa.

1075. 1. Lacqua sia rio. 2. ghorghata. 5. alteza. 7. uo disscieso. 9. uilla. 10. francha. 11. docto a romolō. 12. del

ministration et de la culture des jardins, et un pavillon carré en pierre et en brique flanqué de terrasses à chacun de ses angles. Quoique défiguré par des mesures élevées sur les terrasses, cet édifice est très-digne d'intérêt par l'originalité du plan, la décoration architecturale et le souvenir d'Anne de Bretagne qui le fit construire. Félibien describes the garden as follows: Le jardin haut était fort bien dressé par grands compartimens de toutes sortes de figures, avec des allées de meuriers blancs et des palissades de coudriers. Deux grands berceaux de charpenterie separoient toute la longueur et la largeur du jardin, et dans les quatres angles des allées, où ces berceaux se croissent, il y auoit 4 cabinets, de mesme charpenterie ... Il y a pas longtemps qu'il y auoit dans ce mesme jardin, à l'endroit où se croissent les allées du milieu, un édifice de figure octogone, de plus de 7 thoises de diamètre et de plus de neuf thoises de haut; avec 4 enfoncements en forme de niches dans les 4 angles des allées. Ce bastiment estoit de charpente mais d'un extraordinairement bien travaillé. On y voyait particulièrement la cordilière qui regnait tout autour en forme de cordon. Car la Reyne affectait de la mettre non-seulement à ses armes et a ses chiffres mais de la faire représenter en divers manières dans tous les ouvrages qu'on lui faisait pour elle ... le bastiment estait couvert en forme de dôme qui dans son milieu avait encore un plus petit dôme, ou lanterne vitrée au-dessus de laquelle estait une figure dorée représentant Saint Michel. Les

deux dômes estoient proprement couvert d'ardoise et de plomb doré par dehors; par dedans ils estoient lambrissés d'une menuiserie très delicate. Au milieu de ce Salon il y avait un grand bassin octogone de marbre blanc, dont toutes les faces estoient enrichies de differentes sculptures, avec les armes et les chiffres du Roy Louis XII et de la Reine Anne. Dans ce bassin il y en avait un autre posé sur un piédestal lequel auoit sept piedz de diamètre. Il estait de figure ronde à godrons, avec des masques et d'autres ornemens très sçauamment taillez. Du milieu de ce deuxiesme bassin s'y levoit un autre petit piédestal qui portait un troisiesme bassin de trois pieds de diamètre, aussy parfaitement bien taillé; c'estoit de ce dernier bassin que jallissoit l'eau qui se répendoit en suitte dans les deux autres bassins. Les beaux ouvrages faits d'un marbre egalement blanc et poli, furent brisez par la pesanteur de tout l'édifice, que les injures de l'air renversèrent de fond en comble.

1074. See Pl. CXV. Lines 1—7 are above, lines 8—10 in the middle of the large island and the word *Isola* is written above *d* in the smaller island; *a* is written on the margin on the bank of the river above l. 1; in the reproduction it is not visible. As may be seen from the last sentence, the observation was made after long study of the river's course, when Leonardo had resided for some time at, or near, Amboise.

[9]Il fiume di Villa[10]franca sia cō[11]dotto a Romorō[12]tino, e sia fatto dal suo [13]popolo, e li legni[14]ami, che conpō[15]gono le lor case, [16]siē per barche cō[17]dotte a Romorō[18]tino; e 'l fiume [19]sia ringorga[20]to in tāta altez[21]za, che l'acqua [22]si possa cō co[23]modo discie[24]so riduciere [25]a Romorōtino.

The river at Villefranche may be conducted to Romorantin which may be done by the inhabitants; and the timber of which their houses are built may be carried in boats to Romorantin[18]. The river may be dammed up at such a height that the waters may be brought back to Romorantin with a convenient fall.

Br. M. 269*b*] **1076.**

S'elli è meglio che l'acqua [2]vada tutta in alto in una so[3]la volta, o veramēte in due?

[4]Rispōdesi che in vna sola vol[5]ta la rota nō potreb[6]be sostenere tutta l'acqua [7]ch'ella leua in due volte, per[8]chè nella mezza volta della [9]rota leuerebbe 100 libbre, [10]e nō più, e s'ell' auesse a leua[11]re le 200 libbre la uolta inte[12]re, non le leuerebbe, se [13]tal rota nō raddoppiasse il dia[14]metro, e raddoppiando tal [15]diametro raddoppie reb[16]be il tenpo; adūque è meglio [17]e più comodità di spesa a fare [18]tal rota sub 2ᵃ che 2 la ecc.

[19]Il desciēso del mozzo non s'ab[20]bassa insino alla pelle dell'acqua, [21]perchè toccādo l'acqua diminuireb[22]be il peso suo.

[23]E se per l'aversario [24]s'ingrossasse il [25]fugatore dell'ac[26]qua dieci tan[27]ti più, che la [28]canna dell'[29]acqua fuggiē[30]te d'essi, se li [31]dieci tanti [32]men moto [33]che a questo, [34]che vfitio sareb[35]be il suo? Ri[36]spōdesi per la [37]9ᵃ di questo [38]che dice, che l'acqua [39]s'alzerebbe [40]la decima parte di quel che prima s'alzava [41]nell'altezza di quella canna donde prima sur[42]gieua.

As to whether it is better that the water should all be raised in a single turn or in two?

The answer is that in one single turn the wheel could not support all the water that it can raise in two turns, because at the half turn of the wheel it would be raising 100 pounds and no more; and if it had to raise the whole, 200 pounds in one turn, it could not raise them unless the wheel were of double the diameter and if the diameter were doubled, the time of its revolution would be doubled; therefore it is better and a greater advantage in expense to make such a wheel of half the size (?) &c.

The going down of the nave of the wheel must not be so low as to touch the surface of the water, because by touching the water its momentum will be lessened.

And if on the contrary the conduit for the water were ten times the size of the pipe for the water escaping from it, and if it had ten times less motion, what would be its office? This is answered by the 9th of this which says that the water would rise in the pipe whence it first flow, to a tenth part of its original height.

Br. M. 270*b*] **1077.**

Se'l fiume *m n*, ramo del fiume Loira, si manda nel [2]fiume di Romorontino colle sua acque torbide, esso i[3]grasserà le can-

If the river *m n*, an affluant of the river Loire, were turned with its muddy waters, into the river of Romorantin, this would fatten

13. elli. 14. conpo. 15. ghano. 17. aremolō. 19. ringhorgha. 21. chellacqua. 23. disscie. 25. romolōtino.
1076. 1. selli . . chellacq"a". 2. alto nuna. 4. nvna. 6. bono sosstenere . . lacq"a". 7. chella. 8. meza. 10. essellauessi alleua. 12. nolle leuerebbe [se el] se. 13. raddopiassi. 14. mitro [e in] e. 15. [tempo] diamitro radoppiereb. 17. affare. 19. disscieso . . mozzo nossab. 20. acqu"a". 21. tochādo lacqu"a". 23. Esse. 24. singrossassi. 25. fughatore. 27. chella. 28. channa della. 30. te dessi se li. 31. dieci tanta. 32. men moto. 33. che acque sto. 34. che vfitio sareb. 35. be il suo Ris. 37. quessto. 38. chellacqua. 40. che p"a". 41. channa donde p"a" sue. 42. giena.
1077. 1. fiume [era] Era | si. 2. romolontino . . torbite. 3. essesso. 5. effara chanale navichabile e merchātile. 11. Quella.

1075. 18. Compare No. 744.
1076. The topographical interest of this passage arises from the circumstance that it is written on the reverse of the sheet on which we find the text relating to Romorantin, No. 1074.

pagnie sopra le quali esso adaque⁴rà, e rēderà il paese fertile da nutrire li a⁵bitatori, e farà canale navicabile e mercātile.

⁶Modo che 'l fiume ⁷col suo corso ⁸netti il fondo del ⁹fiume.

¹⁰Per la nona del 3°; ¹¹Quello ch'è più velo¹²cie, più cōsuma il ¹³suo fondo, e per la cō-¹⁴versa: l'acqua ch'è più ¹⁵tarda piv lascia ¹⁶di quel che la intorbi¹⁷da;

¹⁸E facciasi il serraglio mobile, che io or¹⁹dinai nel Friuli, del quale, aperto vna cāterat²⁰ta, l'acqua che di quella vsciua cavò il fondo; ²¹addunque nelli diluui de' fiumi si debbono aprire le cate²²ratte de' molini, acciochè tutto il corso del fiume si renda per ca²³teratta in ciascū molino; sieno molte, acciochè ²⁴si faccia maggiore īpeto, e così netterà tutto il fiume; ²⁵e infra le due poste de' moli²⁶ni sia vna delle dette caterat²⁷te; sia vna d'esse poste di tal cate²⁸ratte infra l'uno e l'al²⁹tro molino.

the land which it would water and would render the country fertile to supply food to the inhabitants, and would make navigable canals for mercantile purposes.

The way in which the river in its flow should scour its own channel.

By the ninth of the third; the more rapid it is, the more it wears away its channel; and, by the converse proposition, the slower the water the more it deposits that which renders it turbid.

And let the sluice be movable like the one I arranged in Friuli [19], where when one sluice was opened the water which passed through it dug out the bottom. Therefore when the rivers are flooded, the sluices of the mills ought to be opened in order that the whole course of the river may pass through falls to each mill; there should be many in order to give a greater impetus, and so all the river will be scoured. And below the site of each of the two mills there may be one of the said sluice falls; one of them may be placed below each mill.

C. A. 329b; 993a] **1078.**

Vno trabocco è quattro braccia e vno miglio è tre mila d'esse braccia; E 'l braccio si diuide in 12 ōcie; ²e l'acqua de' canali à di calo in ogni cēto trabocchi 2 delle dette oncie; adūque 14 oncie ³di calo son neciessarie a due mila ottocēto braccia di moto ne'detti canali; seguita che 15 oncie ⁴di calo danno debito moto alli corsi dell'acque dei predetti canali, cioè uno braccio e ¹/₂ ⁵per miglio; E per questo cōcluderemo che l'acqua che si toglie dal fiume di Villa

A trabocco is four braccia, and one mile is three thousand of the said braccia. Each braccio is divided into 12 inches; and the water in the canals has a fall in every hundred trabocchi of two of these inches; therefore 14 inches of fall are necessary in two thousand eight hundred braccia of flow in these canals; it follows that 15 inches of fall give the required momentum to the currents of the waters in the said canals, that is one braccio and a half in the mile. And from this it may be concluded that the water taken from the river of Ville-

14. cheppiu. 15. lasscia. 16. chella. *Lines 6—17 are written in the margin.* 18. effaciasi. 19. nel frigholi del. 20. lacq-"a"che . . vssciua cav"o". 21. si debbe apr‖‖‖‖‖‖‖‖. 22. ratte demolini . . del fiume si‖‖‖‖‖‖‖‖‖‖. 23. ciasscū . . . accioche‖‖‖‖‖‖‖‖. 24. sapra effacci magiore . . tutto if‖‖‖‖‖‖‖‖. 25. infralle . . posste. 27. posste. 28. rate molini infralluna ellal. *Lines 25—29 stand in the original above line 18.*
1078. 1. traboccho. 2. br. e î . . El br. [s] si . . ōcie‖‖‖‖‖. 2. ellacqua . . addi chalo . . trabochi . . 14 ō di. 3. di chalo . . adumila . . br. di moto [de de] ne . . 15 ō di. 4. di chalo . . corsi [de detti o] dell . . de . . cioe î br. 5. quesso

1077. 19. This passage reveals to us the fact that Leonardo had visited the country of Friuli and that he had stayed there for some time. Nothing whatever was known of this previously.

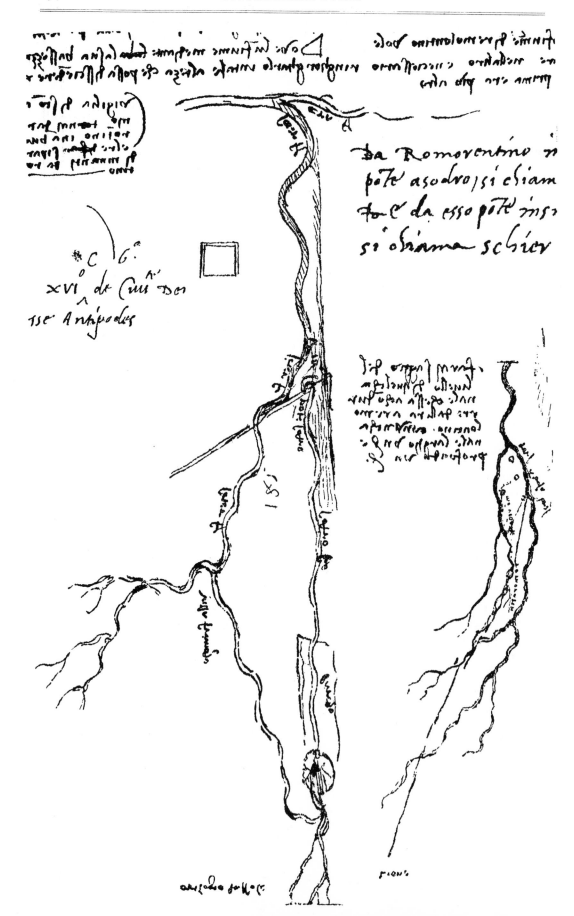

Franca e si ⁶presta al fiume di Romoron-
tino vuole . . . Dove l'ū fiume mediante la
sua bassezza nō ⁷può entrare nell' altro, è
neciessario ringorgarlo in tale altezza che
possa disciēdere ⁸in quel che prima era
piv alto.

⁹¶Vigilia di Sco Anto¹⁰nio tornai da
Romo¹¹rōtino in Ābuosa,¶ ¹²e 'l rè si partì
due ¹³dì innanti da Romorō¹⁴tino.

¹⁵Da Romorontino insino al ¹⁶pōte a
Sodro | si chiama Soudro; ¹⁷e da esso pōte
insino a Tours ¹⁸si chiama Schier.

¹⁹Farai saggio del ²⁰liuello di quel ca-
²¹nale che si à a cōdur²²re dalla Loira a
Romo²³lontino con vn ca²⁴nale largo vn
braccio e ²⁵profondo vn braccio.

franche and lent to the river of Romorantin
will Where one river by reason of its
low level cannot flow into the other, it will
be necessary to dam it up, so that it may
acquire a fall into the other, which was
previously the higher.

The eve of Saint Antony I returned from
Romorantin to Amboise, and the King went
away two days before from Romorantin.

From Romorantin as far as the bridge at
Saudre it is called the Saudre, and from that
bridge as far as Tours it is called the Cher.

I would test the level of that channel
which is to lead from the Loire to Romo-
rantin, with a channel one braccio wide and
one braccio deep.

Br. M. 263*b*] **1079.**

STRADA D'ORLEANS.

² Alla quarta di mezzodì verso scirocco;
³alla terza di mezzodì verso scirocco;
⁴alla quarta di mezzodì verso scirocco;
⁵alla quinta di mezzodì verso scirocco;
⁶Tra libeccio e mezzodì; ⁷a leuante par-
ticipando di mezzodì; ⁸tra mezzo giorno
verso leuante ¹/₈; ⁹Da poi verso ponente;
¹⁰tra mezzodì e libeccio; ¹¹a mezzodì.

THE ROAD TO ORLEANS.

At ¹/₄ from the South to the South East.
At ¹/₃ from the South to the South East.
At ¹/₄ from the South to the South East.
At ¹/₅ from the South to the South East.
Between the South West and South, to the East
bearing to the South; from the South towards
the East ¹/₈; thence to the West, between the
South and South West; at the South.

cōcludereno chellacqua chessi . . francha essi. 6. pressta . . remolontino vole mediante [la ba] la sua.
7. ringhorgharlo . . alteza . . dissciēdere \\\\\\\ . 12. el re [di fran] si. 13. innanti . *Lines* 15—18 *are written
from left to right.* 15. Romorantino. 17. [po] e da. 20. cha. 21. chessa a chōdur. 22. rre dalliraa remo. 23. cha.
24. largho vn br. 25. vn br.
1079. *written from left to right:* 1. dorléons. 2. de mezo syroccho. 3. de mezo . . syroccho. 4. mezo . . syrocco. 5. mezo
. . syrocco. 6. lybeccio e mezodi. 6. mezo. 7. mezo. 8. ponte. 9. mezo . . lybeccio. 10. mezo.

1078. Lines 6—18 are partly reproduced in the
facsimile on p. 254, and the whole of lines 19—25.

The following names are written along the rivers
on the larger sketch. *era f* (the Loire) *scier f* (the
Cher) three times. *Pōte Sodro* (bridge of the Soudre).
Villa francha (Villefranche) *banco* (sandbank) *Sodro*
(Soudre). The circle below shows the position of
Romorantin. The words '*orologio del sole*' written
below do not belong to the map of the rivers.
The following names are written by the side of the
smaller sketch-map:—*tors* (Tours), *Abosa* (Amboise)
bres—for Bles (Blois) *mō rica* \\\\ (Montrichard). *Lione*
(Lyons). This map was also published in the
'Saggio' (Milano, 1872) Pl. XXII, and the editors
remark: *Forse la linia retta che va da Amboise a
Romorantin segna l'andamento proposto d'un Canale, che
poi sembra prolungarsi in giù fin dove sta scritto Lione.*

M. Ravaisson has enlarged on this idea in the
Gazette des Beaux Arts (1881 p. 530): *Les traces de
Léonard permettent d'entrevoir que le canal commençant
soit auprès de Tours, soit auprès de Blois et passant par
Romorantin, avec port d'embarquement à Villefranche,
devait, au delà de Bourges, traverser l'Allier au-dessous
des affluents de la Dore et de la Sioule, aller par
Moulins jusqu' à Digoin; enfin, sur l'autre rive de la
Loire, dépasser les monts du Charolais et rejoindre la
Saône auprès de Mâcon.* It seems to me rash, however,
to found so elaborate an hypothesis on these sket-
ches of rivers. The slight stroke going to *Lione* is
perhaps only an indication of the direction. — With
regard to the Loire compare also No. 988. l. 38.

1079. The meaning is obscure; a more important
passage referring to France is to be found under
No. 744.

B. 61*a*] **1080.**

On the
Germans
(1080. 1081).

Modo come i Tedeschi ingarbugliano e tessano, serādosi īsieme, ²le loro targhe lunghe cōtro a nemici·, abassandosi e mettēdo ³vna delle teste a terra, tenēdo il resto·in mano.

The way in which the Germans closing up together cross and interweave their broad leather shields against the enemy, stooping down and putting one of the ends on the ground while they hold the rest in their hand.

B. 63*b*] **1081.**

Vsano i Germani·annegare·castellani cō fumo di pivma, solfo ²e risagallo·, e fanno durare detti fumi 7 e 8 ore; ācora la ³pula del frumēto fa assai e durabil fumo; e letame secco ancor lui, ⁴ma fa sia mischiato colla sāsa, cioè vliue tratte nel' olio, o vuoi morchia ⁵d'olio.

The Germans are wont to annoy a garrison with the smoke of feathers, sulphur and realgar, and they make this smoke last 7 or 8 hours. Likewise the husks of wheat make a great and lasting smoke; and also dry dung; but this must be mixed with olive husks, that is olives pressed for oil and from which the oil has been extracted.

Leic. 1*b*] **1082.**

The
Danube.

Come le ualli furō già coperte in grā parte da laghi, inperochè senpre il suo terreno fece argine a fiumi, e da mari, i quali poi colla perseueratione de' fiumi ²segarono li monti, e li fiumi coi lor vagabundi corsi portarono via le altre pianvre incluse dalli mōti, e le segature de' mōti so³no note per le falde delle pietre, che si corrispondono nelle lor taglia-ture fatte dalli detti corsi de' fiumi; ⁴Il Monte Emus che riga la Tratia e la Dardaria e si congiugne col Monte Sardonius, el quale, seguendo ⁵a ponēte, muta il nome di Sardus in | Rebi nel toccare la Dalmatia, poi se-guendo a ponēte riga li Illirici ⁶oggi detta Schiavonia, e mvta nome di | Rebi in | Al-banus, e seguendo pure a ponēte si muta nel Mōte Ocra ⁷a tramōtana, e a mezzodì sopra all'Istria si nomina | Caruancas e si congiugne a ponēte sopra l'Italia col Mōte

That the valleys were formerly in great part covered by lakes the soil of which always forms the banks of rivers,—and by seas, which afterwards, by the persistent wearing of the rivers, cut through the mountains and the wandering courses of the rivers carried away the other plains enclosed by the mountains; and the cutting away of the mountains is evident from the strata in the rocks, which correspond in their sections as made by the courses of the rivers [4]. The Hæmus moun-tains which go along Thrace and Dardania and join the Sardonius mountains which, going on to the westward change their name from Sardus to Rebi, as they come near Dalmatia; then turning to the West cross Illyria, now called Sclavonia, changing the name of Rebi to Albanus, and going on still to the West, they change to Mount Ocra in the North; and to the South above Istria they are named Caruancas; and to the West above Italy they join the Adula, where the Danube rises [8], which stretches to the East and has a

1080. 2. chome i tedeschi ingarigliano ettessano. 2. large lunge. 3. dele . . attera . . imano.
1081. 1. anegare chastelani. 2. risalgalo effano. 3. elletame secho. 4. ovoi morcha.
1082. 1. laghi "inperche senpre il suo terreno fece argine afiumi" e da mari. 2. segorono . . elli fiumi co . . portorono . . mōti elle. 3. chessi conrisspondano. 4. emus . . tratia ella dardaria essi congvgne . . monte [scardus] sardonius. 5. nel cottare la. 6. sciavonia . . ponente [segue] si muta. 7. attramōtana e mezodi . . isstria . . essi congugne. 8. nasscie il reno

1080. Above the text is a sketch of a few lines crossing each other and the words *de ponderibus.* The meaning of the passage is obscure.

1081. There is with this passage a sketch of a round tower shrouded in smoke.

1082. 4. *Emus,* the Balkan; *Dardania,* now Servia.

Adula, [8]doue nascie il Danubio, il quale s'astende a leuante con corso di 1500 mi-glia, e la sua linia breuissima è circa [9]mille miglia, e altrettanto o circa è'l ramo del Monte Adula mutato ne'predetti nomi di mōti; sta a tramon[10]tana il monte | Carpatus, il quale termina la larghezza della valle del Danubio, la qual, come dissi, s'astende [11]a leuāte cō lunghezza di circa mille miglia, ed è larga doue 200 e doue 300 miglia; questa si mette pel [12]mezzo il Danvbio, primo fiume d'Europa per magni-tudine, il qual Danvbio si lascia per mezzo di [13]Austria e Albania e per tramōtana Bauaria, Polonia, Ungheria, Valachia e Bosnia; versaua adunque il Danubio | over | Da[14]noia nel mare di Ponto, il quale s'astendea insino vicino all'Austria e occu-paua tutta la pianvra che oggi [15]discorre esso Danvbio, e'l segno dico ne mostrano l'ostriche e li nichi e bovoli e cappe e ossa di grā pesci, che an[16]cora in molti lochi si trouano nell'alte coste de'predetti mōti; ed era tale mare fatto per la ringorgatione delli ra[17]mi del Monte Adula, che s'asten-deano a leuante e si congiugneano colli rami del Mōte Tauro, che s'astendono a po[18]nēte, e circa alla Bitinia versauā l'acque d'esso Mare di Pōto nel Propontico, ca-dendo nel Mare Egeo cioè [19]Mar Mediter-rano, doue poi il lungo corso spiccò li rami del Mōte Adula dalli rami del Mōte Tauro; li Mare [20]di Pōto s'abassò e scoperse la Val di Danubio colle prenominate provincie, e tutta l'Asia Minore di là dal monte Ta-[21]vro per tramōtana e la pianvra ch'è da Mōte Caucasso al mare di Ponto per ponēte, e la pianura del Ta[22]nai dentro alli monti Rifei cioè a' piedi loro; Ecco che 'l mare di Ponto abbassò circa a braccia 1000 [23]nello scoprire di tanta pianura.

course of 1500 miles; its shortest line is about 1000 miles, and the same or about the same is that branch of the Adula mountains changed as to their name, as before mentioned. To the North are the Carpathians, closing in the breadth of the valley of the Danube, which, as I have said extends eastward, a length of about 1000 miles, and is some-times 200 and in some places 300 miles wide; and in the midst flows the Danube, the principal river of Europe as to size. The said Danube runs through the middle of Austria and Albania and northwards through Bavaria, Poland, Hungary, Wallachia and Bos-nia and then the Danube or Donau flows into the Black Sea, which formerly extended almost to Austria and occupied the plains through which the Danube now courses; and the evidence of this is in the oysters and cockle shells and scollops and bones of great fishes which are still to be found in many places on the sides of those mountains; and this sea was formed by the filling up of the spurs of the Adula mountains which then extended to the East joining the spurs of the Taurus which extend to the West. And near Bithynia the waters of this Black Sea poured into the Propontis [Marmora] falling into the Ægean Sea, that is the Mediterranean, where, after a long course, the spurs of the Adula mountains became separated from those of the Taurus. The Black Sea sank lower and laid bare the valley of the Danube with the above named coun-tries, and the whole of Asia Minor beyond the Taurus range to the North, and the plains from mount Caucasus to the Black Sea to the West, and the plains of the Don this side—that is to say, at the foot of the Ural mountains. And thus the Black Sea must have sunk about 1000 braccia to uncover such vast plains.

il quale .. alleuante conchorso .. ella .. circha. 9. circha .. attramon. 10. largeza. 11. alleuāte cō lungeza .. largha [dalle do] doue. 12. mezo .. danvbbio .. danvbbio si lasscia per mezo. 13. vngeria .. ebboxnia .. danubbio over da. 14. sasstendea .. ochupaua. 15. disscorre .. losstriche elli .. e bovoli e chappe .. pessci. 17. chessastendeano alleuante essi congugneano.. taruro chessastendanoal. 18. circha allabettima versauā .. propontticho chadendo .. egeocoe. 19. mediterano. spicho. 20. esscoperse la ual di danv | "bbio" .. province ettutta .. minore dala dal. 21. ella ... cha-vcaso .. ella. 22. coe .. Ecchochel .. circha a br. 1000. 23. isscoprire.

8. *Danubio*, in the original *Reno;* evidently a mistake as we may infer from *come dissi* l. 10 &c.

III.

THE COUNTRIES OF THE WESTERN END OF THE MEDITERRANEAN.

A. 57 a]

1083.

PERCHÈ IL MARE FA LA CORRĒTE NELLO STRETTO DI SPAGNIA PIV CH'ALTROVE.

The straits of Gibraltar (1083—1085).

²¶ Il fiume · d'equal profondità · avrà · tanto · piv · fuga · nella · minore · larghezza ³ che nella · maggiore ·, quanto · la maggiore · larghezza · avanza · la minore; ¶

⁴ Questa · propositione · si pruova . chiaramēte per ragione cōferma ⁵dalla sperienza ·, jnperochè, quando · per uno canale · d'uno miglio · di larghezza passe⁶rà uno miglio · di lūghezza d'acqua, dove · il fiume · fia · largo 5 migli, ciascuno ⁷de 5 migli quadri metterà ¹/₅ · di se · per ristaurare il mi⁸glio · quadro d'acqua mācato · nello pelago, ⁹e dove il fivme · fia · lar¹⁰go · 3 · miglia ·, ciascu¹¹no · d'essi migli quadri ¹²metterà di se lo terzo ¹³di sua quātità per lo mā¹⁴care che fecie il mi¹⁵glio quadro dello stret¹⁶to ·, come si dimo¹⁷stra · in · $f \cdot g \cdot h$ · ¹⁸per lo miglio · n.

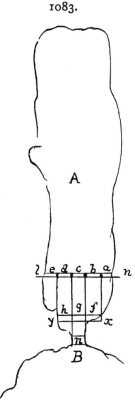

WHY THE SEA MAKES A STRONGER CURRENT IN THE STRAITS OF SPAIN THAN ELSEWHERE.

A river of equal depth runs with greater speed in a narrow space than in a wide one, in proportion to the difference between the wider and the narrower one.

This proposition is clearly proved by reason confirmed by experiment. Supposing that through a channel one mile wide there flows one mile in length of water; where the river is five miles wide each of the 5 square miles will require ¹/₅ of itself to be equal to the square mile of water required in the sea, and where the river is 3 miles wide each of these square miles will require the third of its volume to make up the amount of the square mile of the narrow part; as is demonstrated in $f g h$ at the mile marked n.

1083. 1. chorēte . . chaltro"ve". 2. ara . . fugha . . largheza. 3. chenella . . quancto . . largheza. 4. [perissperienza] per . . chōferma. 5. dallissperienza . . per î chanale. 6. ra î miglio di lūgezza dacq"a" . . ciaschuno. 7. ciasscun "de 5" migli[o] quadr[o] i mettera [per ristaurare il mā] ¹/₅ . di se. 8. dacq"a" māchato . . pelago 4. 9. 4 e dove. 10. gho . . ciaschu. 14. chare cheffecie. 15. stre. 16. chome. *Lines 9–18 are written in the margin.*

1083. In the place marked A in the diagram *Mare Mediterano* (Mediterranean Sea) is written in the original. And at B, *stretto di Spagna* (straits of Spain, *i. e.* Gibraltar). Compare No. 960.

C. A. 212 b; 626 b]

1084.

PERCHÈ È MAGGIORE SĒPRE LA CORRĒTE DI SPAGNIA INVERSO PONĒTE · CHE PER LEUĀTE.

²La ragiō si è ·, che se tu · metterai · insieme · le boche · de'fiumi · che mettono · in questo · Mare Mediterrano, tu tro³verai · essere · maggiore · soṁa d'acqua · ch'è · quella · che uersa · esso · mare per lo stretto in nell'oceano mare; ⁴tu vedi · l'Africa scaricare · i sua fiumi · che corrono · a tramō tana · inesso mare īfra i quali ⁵è · il Nilo ·, che riga · 3000 miglia dell'Africa ·, e vi è · il · fiume Bagrada, · e 'l Mavretano, e altri simili; ⁶l'Europa vi versa il Tanai e 'l Danvbio ·, il Po e 'l Rodano, Arno e Teuere, sichè chiaramente questi fivmi insieme co⁷n īfiniti fivmi di minor fama · fanno · maggiore · larghezza ε profōdità · e corso ·, e non è il mare stretto 18 miglia ⁸che nel ultima terra di ponēte · diuide · l'Europa dal' Africa.

WHY THE CURRENT OF GIBRALTAR IS ALWAYS GREATER TO THE WEST THAN TO THE EAST.

The reason is that if you put together the mouths of the rivers which discharge into the Mediterranean sea, you would find the sum of water to be larger than that which this sea pours through the straits into the ocean. You see Africa discharging its rivers that run northwards into this sea, and among them the Nile which runs through 3000 miles of Africa; there is also the Bagrada river and the Schelif and others. Likewise Europe pours into it the Don and the Danube, the Po, the Rhone, the Arno, and the Tiber, so that evidently these rivers, with an infinite number of others of less fame, make its great breadth and depth and current; and the sea is not wider than 18 miles at the most westerly point of land where it divides Europe from Africa.

Leic. 10 b]

1005.

Il ²seno mediterrano come pelago ricevea l'acque regali del'Africa, Asia ed Europa, che a esso erano volte, ³e le sue acque veniano alle piaggie de'monti, che le circūdavano, e lì faceano argine, e le cime ⁴dello Apennino stauano in esso mare in forma d'isole, circūdate dalle acque salse, ⁵e ancora l'Africa dentro al suo Mōte Atalante non mostraua al celo scoperta la terra delle sue grā pianvre cō circa ⁶a 3000 miglia di lunghezza, e Mēfi risedeua in sul lito di tal mare, e sopra le pianvre della Italia, doue oggi ⁷volā li ucielli a turme, soleano discorrere i pesci a grādi squadre.

The gulf of the Mediterranean, as an inland sea, received the principal waters of Africa, Asia and Europe that flowed towards it; and its waters came up to the foot of the mountains that surrounded it and made its shores. And the summits of the Apennines stood up out of this sea like islands, surrounded by salt water. Africa again, behind its Atlas mountains did not expose uncovered to the sky the surface of its vast plains about 3000 miles in length, and Memphis[6] was on the shores of this sea, and above the plains of Italy, where now birds fly in flocks, fish were wont to wander in large shoals.

Leic. 27 b]

1086.

Co²me sopra Tunisi è il maggior riflusso che faccia il Mare Mediterrano che son circa 2 braccia ³e ½, e a Venezia cala 2 braccia; e in tutto il resto di tal Mare Mediterrano cala poco o ni⁴ente.

The greatest ebb made anywhere by the Tunis. Mediterranean is above Tunis, being about two and a half braccia and at Venice it falls two braccia. In all the rest of the Mediterranean sea the fall is little or none.

1084. magiore . . chɔrēte . . inver. 2. settu . . mettano. 3. magiore . . dacq"a" . . inell. 4. lafricha scharichare . . chorano attramōtana . . equali. 5. dellafricha . ini . il fiume bagrada. 6. levropia . . siche ciaro . . cho. 7. fano magiore largeza . . chorso . . moglia. 8. nelūtimatera . . leeropa . . africha.

1085. 1. nel. 2. seno [mediterano] mediterano il quale come pelagho . . regali [di circha 300 fiumi regali] "delafrica asia edeuropa, che acso erano volte". 3. e cholle . . acque veniano ale piagge . . chello . . elli faceano . . elle cime. 4. apennino [in forma di sole] stauano in eso . . circhūdate. 5. lafricha [non mos] dentro . . attalante no mostraua . . celo "scoperta la terra de" le sue . . circha. 6. lungeza e mēfi . . sulito . . mare "e sopra" le. 7. [disorā] volā . . atturme solea . . pessci a grāde.

1086. 2. tuniti . . magor . . refrusso . . mediterano . . circha 2 br. 3. vinegia chala . . meditera . . pocho.

1084. 5. *Bagrada* (Leonardo writes Bragada) in Tunis, now Medscherda; *Mavretano*, now Schelif.
1085. 6. *Mēfi.* Leonardo can only mean here the citadel of Cairo on the Mokattam hills.

F. 61 *a*] 1087.

Libya.

Descriui li mōti de' flessibili aridi, cioè della ²creatione dell'onde della rena portate dal uē³to, e de'sua mōti e colli, come accade nella Li⁴bia; l'esenplo ne vedrai sulli grā renaj ⁵di Po o di Tesino o altri grā fiumi.

Describe the mountains of shifting deserts; that is to say the formation of waves of sand borne by the wind, and of its mountains and hills, such as occur in Libya. Examples may be seen on the wide sands of the Po and the Ticino, and other large rivers.

B. 82 *b*] 1088.

Majorca.

Circūfulgore · è vna macchina navale ·, fu invētione di quelli di Majolica.

Circumfulgore is a naval machine. It was an invention of the men of Majorca.

Ash. II. 12 *a*] 1089.

The
Tyrrhene
Sea.

Alcuni·nel Mare Tirreno · vsarono questo modo, cioè ²appiccauano vn ācora a l'una delle stremità dell'āteña, ³e dall'altra vna · corda che ī basso s'appiccava a vn ācora, ⁴e nel pugniare attacavano detta · ācora ai remeggi dell'o⁵posito navilio, e per forza d'argano quello mādavano alla bāda ⁶e gittavano sapon tenero e stoppa īpeciata īfocata sulla ⁷prima bāda dou'era l'ācora attaccata, acciochè, per fugir detto ⁸foco, i difenditori d'esso navilio avessino a fugire da l'op⁹posita bāda, e faciēdo così facievano avmēto · allo spugnia¹⁰tore, perchè la galera piv facilmēte per lo cōtrapeso ¹¹andava alla bāda.

Some at the Tyrrhene sea employ this method; that is to say they fastened an anchor to one end of the yard, and to the other a cord, of which the lower end was fastened to an anchor; and in battle they flung this anchor on to the oars of the opponent's boat and by the use of a capstan drew it to the side; and threw soft soap and tow, daubed with pitch and set ablaze, on to that side where the anchor hung; so that in order to escape that fire, the defenders of that ship had to fly to the opposite side; and in doing this they aided to the attack, because the galley was more easily drawn to the side by reason of the counterpoise.

1087 1. desscriui . . fressibili. 3. cholli . . 1088. maccina . . macolica.
1089. 1. tireno. 2. apichauano nācora [chorda che ībaso sapienvavācora] "aluna delle stremita dellatena". 3. chorda . . sapi-
cava. 4. decta āchora ai remigi. 5. ala. 6. stopa īpegolata . . sula. 7. bōda lācoratachata acio. 8. affugire dallo.
9. effaciēdo. 10. galea.

1088. The machine is fully described in the MS. and shown in a sketch.

1089. This text is illustrated in the original by a pen and ink sketch.

IV.

THE LEVANT.

1090.

Truovāsi nelle riue del Mare Mediter-
rano versare fiumi 300, [2] e porti 40 mila 200,
e esso mare è di lunghezza miglia 3000;
Molte volte s'è accozza[3]to l'accrescimēto
de'mari del riflusso suo e'l soffiare delli
venti occidē[4]tali al diluuio del Nilo, ed alli
fiumi che uersā dal mare di Pōto, ed auere
alzato tanto li mari che sō [5]cō grādissimi di-
luui discorsi per molti paesi, · e questi di-
luui accadono nel tenpo, che 'l sole [6]distrugie
le neui delli alti mōti d'Etiopia che si le-
uano alla fredda regiō dell'aria, e si[7]mil-
mēte fa l'appressamēto del sole alli mōti
della Sarmatia Asiatica e quella d'Europa,
[8]in modo che l'accozzamēto di queste 3
dette cose sono, e sono state cagione di
grā[9]dissimi diluui, cioè il riflusso del mare,
e li uenti occidentali, e la distrutiō delle
nevi; è ogni cosa [10]ringorgata nella Siria,
Samaria, la Giudea infra Sinai e il Libano,
e 'l resto della Siria infra [11]il Libano e Mōte

On the shores of the Mediterranean 300 rivers flow, and 40, 200 ports. And this sea is 3000 miles long. Many times has the increase of its waters, heaped up by their backward flow and the blowing of the West winds, caused the overflow of the Nile and of the rivers which flow out through the Black Sea, and have so much raised the seas that they have spread with vast floods over many countries. And these floods take place at the time when the sun melts the snows on the high mountains of Ethiopia that rise up into the cold regions of the air; and in the same way the approach of the sun acts on the mountains of Sarmatia in Asia and on those in Europe; so that the gathering together of these three things are, and always have been, the cause of tremendous floods: that is, the return flow of the sea with the West wind and the melting of the snows. So every river will overflow in Syria, in Samaria, in Judea between Sinai and the Lebanon, and in the rest of Syria between the Lebanon and the Taurus mountains, and in Cilicia, in the Armenian mountains, and in Pamphilia and in Lycia within the hills,

The Lavantine Sea

1090. 1. mediterano. 2. porti [5] 40 mila 200 . . langeza . . seacoza. 3. lacresscimēto . . refrusso. 4. del mare . . ponto aveuere.
5. luui disscorsi . . ecquesti . . achagiano. 6. le neue . . chessi . . freda . . essi. 7. lapressamēto . . asiaticha ecquella.
8. chellacogamēto . . chagione. 9. coe il refrusso . . ocidentali ella. 10. soria someria la gudea . . sinai e e libano . .
soria. 11. elibano . . ella cilicia . . mōtermini ella . . litia dentrali. 12. ellegitto . . attalante . . lagho . . chade·

Tauro, e la Cilicia dentro alli mõti Armeni e la Pamfilia e Licia dentro alli mõticelli [12] e l'Egitto insino al mõte Atlante; Il seno di Persia, che già fu lago grãdissimo del Tigris e cade[13]a nel mare d'India, ora à consumato il mõte · che li facea argine, e si è ragguagliato coll'altezza [14] dello Occeano Indico; E se 'l Mare Mediterrano sequiva il moto suo nel sẽ d'Arabia, ãcor facieva il simile, [15]cioè che si ragguagliava l'altezza Mediterranea colla altezza d'esso Mare Indico.

and in Egypt as far as the Atlas mountains. The gulf of Persia which was formerly a vast lake of the Tigris and discharged into the Indian Sea, has now worn away the mountains which formed its banks and laid them even with the level of the Indian ocean. And if the Mediterranean had continued its flow through the gulf of Arabia, it would have done the same, that is to say, would have reduced the level of the Mediterranean to that of the Indian Sea.

Leic. 31 a] **1091.**

The Red Sea. (1091. 1092).

Versò l'acqua Mediterrana lungamente pel Mare Rosso, el quale è [2]largo cento miglia e lungo mille cinque cento; è tutto pieno di scogli, e à consumato li la[3]ti del Mõte Sinai, la qual cosa testifica, nõ da inõdatione del Mar d'India, che in tali liti percuo[4]tesse, ma da una ruina d'acqua, la qual portaua con seco tutti li fiumi che soprabbon[5]dauano al Mare Mediterrano, e oltre a questo il riflusso del mare; [6]e poi, essendo tagliato nel ponente, 3 mila miglia remoto da questo loco, il mõte Calpe è s[7]piccato dal Mõte Abila, e fu tal taglio fatto bassissimo nelle pianure che si trouauã infra Abila [8]e l'oceano a piè del monte in loco basso, aiutato dal concauamẽto di qualche vallata fatta [9]da alcun fiume che quiui passasse; venne Ercole ad aprire il mare nel ponẽte, e allora [10]l'acque marine cominciarono a uersare nell'oceano occidentale, e per la grã bassezza, il Mare [11]Rosso rimase piv alto, onde l'acque ànno abbandonato il corso di quiui; senpre ànno poi versa[12]to l'acque per lo Stretto di Spagna.

For a long time the water of the Mediterranean flowed out through the Red Sea, which is 100 miles wide and 1500 long, and full of reefs; and it has worn away the sides of Mount Sinai, a fact which testifies, not to an inundation from the Indian sea beating on these coasts, but to a deluge of water which carried with it all the rivers which abound round the Mediterranean, and besides this there is the reflux of the sea; and then, a cutting being made to the West 3000 miles away from this place, Gibraltar was separated from Ceuta, which had been joined to it. And this passage was cut very low down, in the plains between Gibraltar and the ocean at the foot of the mountain, in the low part, aided by the hollowing out of some valleys made by certain rivers, which might have flowed here. Hercules came to open the sea to the westward and then the sea waters began to pour into the Western Ocean; and in consequence of this great fall, the Red Sea remained the higher; whence the water, abandoning its course here, ever after poured away through the Straits of Spain.

C. A. 321 b; 971 a] **1092.**

La superfitie del Mare Rosso è in liuello coll'oceano.

The surface of the Red Sea is on a level with the ocean.

13. chelli . argine edessi ragualgliato . . alteza. 14. indicho Esse . . mediterano. 15. coe chesi racualgliaua laltezza mediteranea . . alteza . . indicho.

1091. 1. mediterana lunghamente. 2. largho . . ellungho . . cinquecento tutto. 3. de mõti sinai . . liti percho. 4. tessi . . consecho . . soprabon. 5. dauono . . mediterano e oltre adĩquesto il refrusso. 6. chalpe es. 7. pichato . . abile effu . . chessĩ trovaua . . abile. 8. ellocceano . . locho . . chonchauamẽto. 9. passassi . . erchole. 10. comincorono . . occeano . . perlla . . basseza. 11. lacque anbandonato.

1092. 1. mare [so] rosso e illiuello. 2. chaduta . . esserrato [el] la bocha. 3. mediterano. 4. rĩghorghato. 5. fralli . . ghade-

1091. 9. Leonardo seems here to mention to the reader an allusion to the legend of the pillars Hercules half jestingly and only in order to suggest of Hercules.

²Può esser caduta vna mōtagnia e, serrato la bocca ³del Mare Rosso, e proibito l'esito al Mediterrano, e co⁴sì rīgorgato tal mare abbia per esito il trāsito ī⁵fra li gioghi Gadetani, perchè similmente abbiā ⁶veduti alli nostri tēpi cadere v̄ monte di sette ⁷miglia e serrare vna valle e farne lago, e così sō ⁸fatti la maggior parte de'laghi da mōti come Lago di ⁹Garda di Como e Lugano, e 'l lago Maggiore; ¹⁰il Mediterrano poco s'abbassò per il taglio Gaditano ne¹¹li cōfini della Siria e assai in esso taglio, perchè pri¹²ma che tal taglio si creassè, esso mare versaua per scirocco, ¹³e poi s'ebbe a fare la calata, che corresse a tal Gaditano.

¹⁴In *a* cadea l'acqua ¹⁵del Mediterrano nel oce¹⁶ano.

¹⁷¶Tutte le pianure che son ¹⁸dalli mari · alli mōti, sono ¹⁹già state coperte dall'acque salse;¶

²⁰¶Ogni valle è fatta dal suo fiu²¹me e tal proportione è da valle a val²²le, quale è da fiume a fiume;¶

²³¶Il massimo fiume del nostro mōdo è ²⁴il Mediterrano fiume,¶

²⁵¶che si move dal principio ²⁶del Nilo all'Oceano occidē²⁷tale,¶

²⁸e la sua suprema altezza ²⁹è nella Mavretania este³⁰riore, e à di corso 10 mila ³¹miglia, prima chè si ripatrii ³²col suo Oceano, padre del³³le acque,

³⁴Cioè 3000 il Mediterrano, 3000 ³⁵il Nilo scoperto, e 3000 il Nilo ³⁶che corre a oriēte ecc.

A mountain may have fallen and closed the mouth of the Red Sea and prevented the outlet of the Mediterranean, and the Mediterranean Sea thus overfilled had for outlet the passage below the mountains of Gades; for, in our own times a similar thing has been seen[6]; a mountain fell seven miles across a valley and closed it up and made a lake. And thus most lakes have been made by mountains, as the lake of Garda, the lakes of Como and Lugano, and the Lago Maggiore. The Mediterranean fell but little on the confines of Syria, in consequence of the Gaditanean passage, but a great deal in this passage, because before this cutting was made the Mediterranean sea flowed to the South East, and then the fall had to be made by its run through the Straits of Gades.

At *a* the water of the Mediterranean fell into the ocean.

All the plains which lie between the sea and mountains were formerly covered with salt water.

Every valley has been made by its own river; and the proportion between valleys is the same as that between river and river.

The greatest river in our world is the Mediterranean river,

which moves from the sources of the Nile to the Western ocean.

And its greatest height is in Outer Mauritania and it has a course of ten thousand miles before it reunites with its ocean, the father of the waters.

That is 3000 miles for the Mediterranean, 3000 for the Nile, as far as discovered and 3000 for the Nile which flows to the East, &c.

tani . . simile abbiā. 6. veduta. 7. serare . . effarne lagho. 8. magiore laghi de mōti . . lagho. 9. gharda [lac] di co:no ellughano ellagho magiore. 10. mediterano pocho sabasso . . ghaditano. 11. soria. 12. chettal . . scirocho. 13. affare . . choressi . . Gadetano. 14. chadea. 15. mediterraneo nel. 17. chesson. 19. dallacq. 20. effatta. 21. ettal pro"ne". 22. he daffiume affiume. 23. del "nostro" mōde he. 24. mediterano [fatto] fiume. 25. [di] chessi . . occieano. 28. ella . . supprema. 29. he . . esste. 32. occieano. 34. mediterano. 36. chorre [da] a oriēte.

1092. See Pl. CXI 2, a sketch of the shores of the Mediterranean Sea, where lines 11 to 16 may be seen. The large figures 158 are not in Leonardo's writing. The character of the writing leads us to conclude that this text was written later than the foregoing. A slight sketch of the Mediterranean is also to be found in MS. I', 47ª.

6. Compare also No. 1336, ll. 30, 35 and 36.— Paolo Giovio, the celebrated historian (born at Como in 1483) reports that in 1513 at the foot of the Alps, above Bellinzona, on the road to Switzerland, a mountain fell with a very great noise, in consequence of an earthquake, and that the mass of rocks, which fell on the left (Western) side blocked the river Breno (T. I p. 218 and 345 of D. Sauvage's French edition, quoted in ALEXIS PERCY, *Mémoire des tremblements de terre de la péninsule italique; Académie Royale de Belgique.* T. XXII).—

C. A. 94*b*; 276*a*]　　　　　　　　**1093.**

The Nile (1093—1098).

Adūque cōcluderemo quelle · mōtagnie · essere di maggiore altura, ²sopra · delle . quali · fioccando · l' origine · del Nilo · dai nuvoli · casca.

Therefore we must conclude those mountains to be of the greatest height, above which the clouds falling in snow give rise to the Nile.

B. 61*b*]　　　　　　　　**1094.**

Gli Egiziani, gli Etiopi · e gli Arabi · nel passare il Nilo vsano ai cameli ²appiccare ai lati del busto 2 baghe cioè otri ī questa forma di sotto.

³In queste 4 maglie di re⁴te mettono i piè i cameli ⁵di carriaggi.

The Egyptians, the Ethiopians, and the Arabs, in crossing the Nile with camels, are accustomed to attach two bags on the sides of the camel's bodies that is skins in the form shown underneath.

In these four meshes of the net the camels for baggage place their feet.

Leic. 34*b*]　　　　　　　　**1095.**

Il Tigri passa per l' Asia Minore, il quale ne porta ²con seco l' acqua di 3 paduli, l' un dopo l' altro di uarie altezze, de' quali il piv alto è Munace, e 'l mezzano è Pallas, ³e 'l più basso è Triton; ancora el Nilo diriua di 3 altissimi paduli in Etiopia, il quale cor⁴re a tramōtana e versa nel mare d' Egitto con corso di 4000 miglia, e la sua breuissima e diritta linia ⁵è 3000 miglia; di quel che s' à notitia escie de' mōti della luna con diuersi e incogniti prīcipi, e tro⁶vāsi li detti laghi alti sopra la spera dell' acqua circa a 4000 braccia cioè vn miglio e ¹/₃, a dare ⁷vn braccio di caduta al Nilo per ogni miglio.

The Tigris passes through Asia Minor and brings with it the water of three lakes, one after the other of various elevations; the first being Munace and the middle Pallas and the lowest Triton. And the Nile again springs from three very high lakes in Ethiopia, and runs northwards towards the sea of Egypt with a course of 4000 miles, and by the shortest and straightest line it is 3000 miles. It is said that it issues from the Mountains of the Moon, and has various unknown sources. The said lakes are about 4000 braccia above the surface of the sphere of water, that is 1 mile and ¹/₃, giving to the Nile a fall of 1 braccia in every mile.

Leic. 21*b*]　　　　　　　　**1096.**

Moltissime volte il Nilo e gli altri fiumi di grā ma²gnitudine ànno · versato tutto l' elemēto dell' acqua · e rēduto al mare.

Very many times the Nile and other very large rivers have poured out their whole element of water and restored it to the sea.

1093. 1. [adūque chōcluderemo quelle mōtagnie essere di magiore altura]. 2. [sopra delle quali lorigine del nilo dai nvvoli fiochando cade]. 3. sopra delle quali | "fiochando del nilo . dai nvvoli . cade". 4. chōcuderano . . magiore 5. fiochando . . nvuoli casscha.

1094. 1. egiti. 2. apichare . . bage. 4. mettano. 5. cariagi.

1095. 1. come trigon il quale passa per la minore africha il quane ne. 2. consecho lacq"a" . . alteze . . mezano. 4. attramōtana . . ella sua . . ediritti. 5. he 3000 . . quel chessa notitio esscie. 6. vasi . . soppra lasspera dellacq"a" circha 4000 br. coe. 7. vn br. di.

1094. Unfortunately both the sketches which accompany this passage are too much effaced to be reproduced. The upper represents the two sacks joined by ropes, as here described, the other shows four camels with riders swimming through a river.

1095. 5. *Incogniti principio.* The affluents of the lakes are probably here intended. Compare, as to the Nile, Nos. 970, 1063 and 1084.

Leic. 22 a] **1097.**

Perchè il Nilo inōda l'estate e viē da Why does the inundation of the Nile occur
paesi focosi? in the summer, coming from torrid countries?

Leic. 32 b] **1098.**

Nō si nega che 'l ²Nilo al continvo It is not denied that the Nile is con-
³ non ētri torbido ⁴nel mare d'Egitto, ⁵e stantly muddy in entering the Egyptian sea
che tal turbulē⁶tia non sia ca⁷vsata dal and that its turbidity is caused by soil
terrē, ⁸che esso fiume le⁹ua al continvo that this river is continually bringing from
da' ¹⁰lochi, onde passa, ¹¹ il qual terrē ¹²mai the places it passes; which soil never
ritorna in ¹³dirieto nel ma¹⁴re che lo ricieue, returns in the sea which receives it, unless
¹⁵se nō lo ributta al¹⁶li sua liti; vedi ¹⁷il it throws it on its shores. You see the
mare areno¹⁸so dirieto al mō¹⁹te Atlante, sandy desert beyond Mount Atlas where
doue già ²⁰fu coperto d'acqua ²¹salsa. formerly it was covered with salt water.

B. 61 b] **1099.**

Gli Assiri e quelli di Evbea vsano ai The Assyrians and the people of Euboea Customs of
loro cavalli ²portare sacchi da potere a lor accustom their horses to carry sacks which Asiatic Nations
posta · ēpiere di uēto, ³i quali portano in they can at pleasure fill with air, and which (1099. 1100).
scābio di bandella della sella di sopra ⁴e in case of need they carry instead of the
d'accanto, e bene è coperta di piastre girth of the saddle above and at the side,
di corame cotto, ⁵acciochè 'l saettame and they are well covered with plates of cuir
non le fora, si che non àño in cvore la bouilli, in order that they may not be perforated
⁶fuga sicura che la uittoria īcierta; vno by flights of arrows. Thus they have not on
cavallo ⁷così fatto passa 4 e 5 omini a v̄ their minds their security in flight, when the
bisognio. victory is uncertain; a horse thus equipped
 enables four or five men to cross over at need.

B. 62 b] **1100.**

 Navicula. Small boats.

²Le navicule · apresso · ali Assiri furono The small boats used by the Assyrians
fatte di uirghe sottili di salice ³e tessute were made of thin laths of willow plaited
sopra pertiche pur di salice, ridotte ī forma over rods also of willow, and bent into the
di barchetta, ilotate ⁴di poluere sottile in- form of a boat. They were daubed with fine
beuerata d'olio, o di tremētina · ridotta ī mud soaked with oil or with turpentine, and
natura ⁵di fango, la qual facieva resistētia reduced to a kind of mud which resisted the
al' acqua, e perchè il pino n'isfendea per ⁶senpre water and because pine would split; and always
stava fresca ci essere vesti detta sorte di navi- remained fresh; and they covered this sort
cule · di pelle bouine ⁷nel passare Sicuris ·, of boats with the skins of oxen in safely
fiume di Spagnia, secōdo ne testifica Lu- crossing the river Sicuris of Spain, as is
cano; reported by Lucan[7].

1097. lāstade . . dipaesi.
1098. 1. negha. 5. chettal. 6. cha. 9. de. 11. equal. 14. re lo. 15. nollo rebutta. 19. attalante. 20. dacq"a".
1099. 1. ecquelli . . cavagli. 3. schābio. 4. dacanto. 5. acciochel saettumel fora si che non ano inēcare (?) la.
 6. uettoria.
1100. 1. navichula. 2. navichula . . sali \|\|\|\|. 3. ettessute. 4. o di tue mētina ridotta. 5. alacqua e pechel pinōnis fede aper.
 6. fresca ci essere vesti detta sorte di navicule . di pele bouine. 8. lissciti elli . . voliono. 9. aligano li grātici . . bage

1100. 7. See Lucan's Pharsalia IV, 130: His ratibus transjecta manus festinat utrimque
 Utque habuit ripas Sicoris camposque reliquit, *Succisam cavare nemus &c.*
 Primum cana salix madefacto vimine parvam Caesar (de bello civ. I, 54) has the same remark
 Texitur in puppim, calsoque inducto juvenco about the Britanni (confirmed by Pliny, hist. nat.
 Vectoris patiens tumidum supernatat amnem. IV, 15) which Leonardo here makes about the
 Sic Venetus stagnante Pado, fusoque Britannus Assyrians.—This and the foregoing text are illu-
 Navigat oceano, sic cum tenet omnia Nilus, strated by slight sketches.
 Conseritur bibula Memphitis cymbo papyro.

⁸L'Ispani ·, li Sciti · e li Arabi ·, quãdo vogliono fare vn subito pōte, ⁹alligano · li graticci fatti di salice sopra le baghe overo otri di pelli bouine, ¹⁰e così passā sicuramente.

The Spaniards, the Scythians and the Arabs, when they want to make a bridge in haste, fix hurdlework made of willows on bags of ox-hide, and so cross in safety.

Leic. 10 *b*]

1101.

Rhodes 1101. 1102).
Nello ottanta 9 fu vno terremoto nel mar di Atalia presso a Rodi, il quale aperse il mare cioè il fondo, ²nella qual apritura si sommerse tanto diluuio d'acque, che per piv di 3 · ore si scoperse il fondo del mare dall'acque, che ³di quiui si spogliarono, e poi si richiuse al primo grado.

In [fourteen hundred and] eighty nine there was an earthquake in the sea of Atalia near Rhodes, which opened the sea—that is its bottom—and into this opening such a torrent of water poured that for more than three hours the bottom of the sea was uncovered by reason of the water which was lost in it, and then it closed to the former level.

L. 0']

1102.

Rodi à dētro 5000 case.

Rhodes has in it 5000 houses.

W. XVII*a*]

1103.

PEL SITO DI VENERE.

SITE FOR [A TEMPLE OF] VENUS.

Cyprus 1103. 1104).
²Farai le scale da 4 faccie, per le quali si pervenga a un prato fatto dalla natura sopra vn sasso, ³il quale sia fatto vuoto e sostenvto dinanzi con pilastri, e sotto traforato con magno portico, nel⁴li quali uada

You must make steps on four sides, by which to mount to a meadow formed by nature at the top of a rock which may be hollowed out and supported in front by pilasters and open underneath in a large portico,

ovrotri . . pelle. 10. passa.
1101. 1. mare disatalia preso . . aperse "il mare co" el fondo [del mare]. 2. somerse tane diluuio . . mare dellacqua. 3. spogliorono.
1103. 2. lesscale . . pervena . . prato [for] fatto [sopr] dalla. 3. voto essoslenvta . . pilasstrĩ essotto . . conmagnio porticho, ne.

1101. *Nello ottanto* 9. It is scarcely likely that Leonardo should here mean 89 A D. Dr. H. MÜLLER-STRÜBING writes to me as follows on this subject: "With reference to Rhodes Ross says (*Reise auf den Griechischen Inseln, III* 70 *ff.* 1840), that ancient history affords instances of severe earthquakes at Rhodes, among others one in the second year of the 138th Olympiad=270 B. C.; a remarkably violent one under Antoninus Pius (A. D. 138—161) and again under Constantine and later. But Leonardo expressly speaks of an earthquake "*nel mar di Atalia presso a Rodi*", which is singular. The town of Attalia, founded by Attalus, which is what he no doubt means, was in Pamphylia and more than 150 English miles East of Rhodes in a straight line. Leake and most other geographers identify it with the present town of Adalia. Attalia is rarely mentioned by the ancients, indeed only by Strabo and Pliny and no earthquake is spoken of. I think therefore you are justified in assuming that Leonardo means 1489"?' In the elaborate catalogue of earthquakes in the East by Selale Dshelal eddin Sayouthy

(an unpublished Arabic MS. in the possession of Prof. SCHEFER, (Membre de l'Institut, Paris) mention is made of a terrible earthquake in the year 867 of the Mohamedan Era corresponding to the year 1489, and it is there stated that a hundred persons were killed by it in the fortress of Kerak. There are three places of this name. Kerak on the sea of Tiberias, Kerak near Tahle on the Libanon, which I visited in the summer of 1876—but neither of these is the place alluded to. Possibly it may be the strongly fortified town of Kerak=Kir Moab, to the West of the Dead Sea. There is no notice about this in ALEXIS PERCY, *Mémoire sur les tremblements de terres ressentis dans la péninsule turco-héllenique et en Syrie (Mémoires couronnés et mémoires des savants étrangers, Académie Royale de Belgique, Tome XXIII).*

1103. See Pl. LXXXIII. Compare also p. 33 of this Vol. The standing male figure at the side is evidently suggested by Michael Angelo's David. On the same place a slight sketch of horses seems to have been drawn first; there is no reason for

l'acqua in diuersi vasi di graniti porfidi e serpētini, dentro a emicicli, e spā⁵da l'acqua in se medesimi, e dintorno a tal portico inverso tramōtana sia un lago · con vna isoletta ⁶in mezzo, nella quale sia vn folto e ōbroso bosco; l'acque in testa ai pilastri siē uersate in uasi ai piè ⁷de' sua inbasamēti, de' quali si spargano piccoli riuetti;

⁸Partendosi dalla ⁹riviera di Cilitia inverso meridio si scopre ¹⁰la bellezza dell'isola di Cipri.

in which the water may fall into various vases of granite, porphyry and serpentine, within semi-circular recesses; and the water may overflow from these. And round this portico towards the North there should be a lake with a little island in the midst of which should be a thick and shady wood; the waters at the top of the pilasters should pour into vases at their base, from whence they should flow in little channels.

Starting from the shore of Cilicia towards the South you discover the beauties of the island of Cyprus.

W. XVII*b*]

1104.

Dalli meridionali lidi di Cilitia si uede per australe la bell'isola ²di Cipri, la qual fu regnio della dea Venere, e molti incitati dalla sua bellezza ³ànno rotte le loro navili e sarte infra li scogli circundati dalle vertiginose ōde; ⁴quiui la bellezza del dolce colle invita i vagabundi navicanti a re⁵crearsi infra le sue fiorite verdure, fralle quali i uēti ragiorādosi enpiono l'i⁶sola e 'l circūstante mare di suaui odori; o quāte naui quiui già son sommerse! o quanti ⁷navili rotti negli scogli! quiui si potrebbero vedere invmerabili navili; chi è rotto e mezzo ⁸coperto dall'arena, chi si mostra da poppa, e chi da prua, e chi da carena e chi da costa, e parà ⁹a similitudine d'un giudizio, che voglia risuscitare navili morti; tant'è la somma di quelli, che ¹⁰copre tutto il lito settentrionale; quiui i uenti d'aquilone resonādo fan uari e paurosi ¹¹soniti.

From the shore of the Southern coast of Cilicia may be seen to the South the beautiful island of Cyprus, which was the realm of the goddess Venus, and many navigators being attracted by her beauty, had their ships and rigging broken amidst the reefs, surrounded by the whirling waters. Here the beauty of delightful hills tempts wandering mariners to refresh themselves amidst their flowery verdure, where the winds are tempered and fill the island and the surrounding seas with fragrant odours. Ah! how many a ship has here been sunk. Ah! how many a vessel broken on these rocks. Here might be seen barks without number, some wrecked and half covered by the sand; others showing the poop and another the prow, here a keel and there the ribs; and it seems like a day of judgment when there should be a resurrection of dead ships, so great is the number of them covering all the Northern shore; and while the North gale makes various and fearful noises there.

The Caspian Sea (1105. 1106).

C. A. 256*a*; 773*a*]

1105.

Scriui a Bartolomeo turco del flusso e ²riflusso del mar di Ponto, e che intenda, ³se tal flusso e riflusso è nel Mare Ircano ⁴over Mare Caspio.

Write to Bartolomeo the Turk as to the flow and ebb of the Black sea, and whether he is aware if there be such a flow and ebb in the Hyrcanean or Caspian sea.

4. vada lacque in diuersi [5] vasi . . esspā. 5. attal . . si lago. 6. mezo . . testa a pilastri . . uasi a pie. 7. sparga picholi riuetti. 8. dalla riuiera [di lic di cilitia] partendosi. 9. cilitia [si scopr] inver meridio si co. 10. beleza . . cipri la qua.

1104. 1. dalla riuiera dalli. 2. della sa belleza. 3. an rotte lor navili essarte . . delle ruertinali ōde. 4. belleza del del dolce callo invita [invita] i. 5. infralle . . fral . . enpiano. 6. adori . . ga son somerse. 7. roti nelgli . . potrebe . . roto e mezo 8. arena [altri] chissi . . popa . . charena e qui. 9. assimilitudine dun giudizi che volglia risucitare nvavili . . tantella soma. 10. varie. 11. chopre . . settantironale [sopra] quiui e uenti . . pauro.

1105. 1. turcho . . frusso. 2. refrusso. 3. settal frusso e refrusso. 4. casspio.

assuming that the text and this sketch, which have no connection with each other, are of the same date.

Sito di Venere. By this heading Leonardo appears to mean Cyprus, which was always considered by the ancients to be the home and birth place of Aphrodite (Κύπρις in Homer).

1105. The handwriting of this note points to a late date.

F. 50 a] **1106.**

PERCHÈ L'ACQUA ²È IN SU MŌ³TI.

⁴Dallo stretto di Gibilterra al Tanai è migli⁵a 3500, edè alto vn miglio e ¹/₆, dando vn braccio ⁶per miglio di cala a ogni acqua che si move me⁷diocremēte, e il Mar Caspio è assai più al⁸to; e nessū de' mōti d'Europa si leua vn ⁹miglio sopra la pelle delli nostri mari; adū¹⁰que si potrebbe dire, che l'acqua ch'è nelle ¹¹cime de' nostri mōti, venisse dall'altezza d'essi ¹²mari e de' fiumi che vi versano, che sō più alti.

WHY WATER IS FOUND AT THE TOP OF MOUNTAINS.

From the straits of Gibraltar to the Don is 3500 miles, that is one mile and ¹/₆, giving a fall of one braccio in a mile to any water that moves gently. The Caspian sea is a great deal higher; and none of the mountains of Europe rise a mile above the surface of our seas; therefore it might be said that the water which is on the summits of our mountains might come from the height of those seas, and of the rivers which flow into them, and which are still higher.

F. 68 a] **1107.**

The sea of Azov.

Qui seguita che 'l Mare della Tana, che ²confina col Tanai, è la più alta parte ³che abbia il Mare Mediterrano, il qua⁴le è remoto dallo Stretto di Gibilterra ⁵3500 miglia, come mostra la carta da ⁶nauicare; e à di calo 3500 braccia, cioè uno ⁷miglio e ¹/₆; e è più alto adunque que⁸sto mare che mōte che abbia l'occidēte.

Hence it follows that the sea of Azov is the highest part of the Mediterranean sea, being at a distance of 3500 miles from the Straits of Gibraltar, as is shown by the map for navigation; and it has 3500 braccia of descent, that is, one mile and ¹/₆; therefore it is higher than any mountains which exist in the West.

Leic. 31 b] **1108.**

The Dardanelles.

In nello stretto di Tratia il Mare di Pō²to senpre versa nel Mare Egeo, e mai l'Egeo in lui, e questo diriua, che 'l Mare Caspio, che cō 400 miglia sta per leuāte colli ³fiumi che ī lui versano, senpre versa per cave sotterrane in esso Mar di Pōto, e 'l simile fa il Tanai ⁴col Danvbio, in modo che senpre esse acque Pōtiche son piv alte che quelle dello Egeo, ⁵e per ciò le piv alte senpre discendono nelle basse, e nō mai le basse nelle alte.

In the Bosphorus the Black Sea flows always into the Egean sea, and the Egean sea never flows into it. And this is because the Caspian, which is 400 miles to the East, with the rivers which pour into it, always flows through subterranean caves into this sea of Pontus; and the Don does the same as well as the Danube, so that the waters of Pontus are always higher than those of the Egean; for the higher always fall towards the lower, and never the lower towards the higher.

1106. 1. lacq"a". 5. 3500 coe on miglio . . vn br. 6. acq"a" chessi. 7. e mar casspio. 9. pele. 10 chellacqua. 11. venissi . . alteza. 12. vivsano.

1107. 2. ella. 3. mediterano. 5. mosstra. 6. navicare che . . 3500 br. coe î. 7. e ¹/₆ che e piu.

1108. 2. ecquestō . . caspio "che cō [3] 400 (?) mili sta per leuāte" colli. 3. cave socterrane. 4. danvbbio . . chessenprᵉ ⁵. perco le . . dissēdano.

1107. The passage before this, in the original, treats of the exit of the waters from Lakes in general.

L. 66 a]　　　　　　　**1109.**

Ponte da Pera a Costantinopoli · largo
²40 braccia, alto dall'acqua braccia 70,
lungo ³braccia 600, cioè 400 sopra del
mare, e 200 ⁴posa in terra, faciendo di se
spalle a se ⁵medesimo.

The bridge of Pera at Constantinople, Constan-
40 braccia wide, 70 braccia high above the tinople.
water, 600 braccia long; that is 400 over
the sea and 200 on the land, thus making
its own abutments.

Leic. 28 a]　　　　　　**1110.**

Se si volterà il fiu²me alla rottura piv
³ināti, mai ritorne⁴rà nel corpo della ⁵terra,
come fa l'Eu⁶frates fiume, e co⁷sì faccia, a
chi a Bo⁸lognia rīcresce li ⁹sua fiumi.

If the river will turn to the rift farther The
on it will never return to its bed, as the Euphrates.
Euphrates does, and this may do at Bologna
the one who is disappointed for his rivers.

C. A. 94 b; 276 a]　　　　　**1111.**

Mons Caucasus · Comedorum · e Paro-
panisi insieme cōgiv̄ti, ² che tra Batriana e
India nascono Oxus fiume ·, che in essi mōti
nascie ³e corre 500 miglia a tramōtana e
altrettāte a ponēte e versa le sue acque
nel Mare Ircano ⁴e cō seco s'accōpagnia ·
Osus ·, Daagodos ·, Arthamis ·, Xariaspis,
Dragamaim ·, Ocus ·, Margus, ⁵fiumi grā-
dissimi; dall'opposita parte uerso mezzodì
· nasce · jl grā fiume · Indo · il quale di⁶rizza
le sue ōde per 600 miglia · inverso meridio,
e per questa linia s'accōpagnia cō seco i
fiumi Xaradrus ·, Bibasis ·, ⁷Vadris ·, Vanda-
bal ·, Bislaspus · per leuāte ·, Suastus · e Coe
per ponēte ·, e incorporati tali fiumi colle
⁸sue acque si uolta · corrēdo miglia 800 per
ponēte ·, e ribattēdosi ne' Mōti Arbeti uno
gomito, e' si volta ⁹a mezzodì, per la quale
linia · infra 500 miglia truova il mare d'In-

Mounts Caucasus, Comedorum, and Paro- Centrae
pemisidae are joined together between Bactria Asia.
and India, and give birth to the river Oxus
which takes its rise in these mountains and
flows 500 miles towards the North and as
many towards the West, and discharges its
waters into the Caspian sea; and is accom-
panied by the Oxus, Dargados, Arthamis, Xari-
aspes, Dargamaim, Ocus and Margus, all very
large rivers. From the opposite side towards
the South rises the great river Indus which
sends its waters for 600 miles Southwards
and receives as tributaries in this course the
rivers Xaradrus, Hyphasis, Vadris, Vandabal
Bislaspus to the East, Suastes and Coe to
the West, uniting with these rivers, and with
their waters it flows 800 miles to the West;
then, turning back by the Arbiti mountains
makes an elbow and turns Southwards, where

1109. 1. gostantinopoli. 2. 40 br . . br. 70. 3. br. 600 coe. 4. spalle asse.
1111. 1. mō caucassus comedorū. 2. nasscano [oduss] oxus . . nasscie. 3. e chōsecho sacōpagnia. 4. attramōtana. 5. dallo-
posita parte [nass] uer mezodi nasscie. 6. riza . . inver . . sachōpagnia. 7. biilasspus . . suasstus hecoe per . . incho-
porate. 8. chorrendo . . arbeti [assali] í gomito. 9. mezodi . . somergie. 10. nasscie. 11. mezodi. 12. sscirocho . . he
13. sarabas diaravna (?) e so as esscilo. 14. mare | "indo" per molte boche.

1109. See Pl. CX No. 1. In 1453 by order of
Sultan Mohamed II. the Golden Horn was crossed
by a pontoon bridge laid on barrels (see Joh. Dukas'
History of the Byzantine Empire XXXVIII p. 279).
—The biographers of Michelangelo, Vasari as well
as Condivi, relate that at the time when Michel-
angelo suddenly left Rome, in 1506, he entertained
some intention of going to Constantinople, there to
serve the Sultan, who sought to engage him, by
means of certain Franciscan Monks, for the purpose
of constructing a bridge to connect Constantinople
with Pera. See VASARI, *Vite* (ed. Sansoni VII, 168):
*Michelangelo, veduto questa furia del papa, dubitando di
lui, ebbe, secondo che si dice, voglia di andarsene in
Gostantinopoli a servire il Turco, per mezzo di certi frati*

*di San Francesco, che desiderava averlo per fare un ponte
che passassi da Gostantinopoli a Pera.* And CONDIVI,
Vita di M. Buonaroti chap. 30: *Michelangelo allora
vedendosi condotto a questo, temendo dell'ira del papa,
pensò d'andarsene in Levante; massimamente essendo
stato dal Turco ricercato con grandissime promesse per
mezzo di certi frati di San Francesco, per volersene servire
in fare un ponte da Costantinopoli a Pera ed in altri
affari.* Leonardo's plan for this bridge was made
in 1502. We may therefore conclude that at about
that time the Sultan Bajazet II. had either announced
a competition in this matter, or that through his
agents Leonardo had first been called upon to carry
out the scheme.

dia doue per sette · rami · in quello si som-
mergie.

[10] Nell' aspetto del medesimo mōte nascie
il magnio [11] Gāgie, il quale fiume corre per
mezzodì miglia 500 [12] e per scirocco · mille
· e · Sarabas · Diarnvna e Soas [13] e Scilo ·
Cōdranvnda · li faño cōpagnia; [14] versa in
mare Indo per molte bocche.

after a course of about 100 miles it finds the
Indian Sea, in which it pours itself by seven
branches. On the side of the same mountains
rises the great Ganges, which river flows
Southwards for 500 miles and to the South-
west a thousand . . . and Sarabas, Diarnuna,
Soas and Scilo, Condranunda are its tributaries.
It flows into the Indian sea by many mouths.

C. A. 384 *b*; 1189 *b*]

1112.

<div style="margin-left:2em">On the
natives of hot
countries.</div>

Li omini nati in [2] paesi caldi
amano [3] la notte, perchè li rīfre[4]sca,
e àño in odio la [5] luce, perchè li ri-
scal[6]da, e però sono del co[7]lore della
notte cio[8]è neri | e ne' paesi [9] freddi
ogni cosa è [10] per l' opposito.

Men born in hot countries love
the night because it refreshes them and
have a horror of light because it burns
them; and therefore they are of the
colour of night, that is black. And in
cold countries it is just the contrary.

1112. 2. chaldi amaño. 3. perche le. 6. perosino. 9. cosa he.

1112. The sketch here inserted is in MS. H3 55 [h].

XVIII.

Naval Warfare.—Mechanical Appliances.—Music.

Such theoretical questions, as have been laid before the reader in Sections XVI and XVII, though they were the chief subjects of Leonardo's studies of the sea, did not exclusively claim his attention. A few passages have been collected at the beginning of this section, which prove that he had turned his mind to the practical problems of navigation, and more especially of naval warfare. What we know for certain of his life gives us no data, it is true, as to when or where these matters came under his consideration; but the fact remains certain both from these notes in his manuscripts, and from the well known letter to Ludovico il Moro (No. 1340), in which he expressly states that he is as capable as any man, in this very department.

The numerous notes as to the laws and rationale of the flight of birds, are scattered through several note-books. An account of these is given in the Bibliography of the manuscripts at the end of this work. It seems probable that the idea which led him to these investigations was his desire to construct a flying or aerial machine for man At the same time it must be admitted that the notes on the two subjects are quite unconnected in the manuscripts, and that those on the flight of birds are by far the most numerous and extensive. The two most important passages that treat of the construction of a flying machine are those already published as Tav. XVI, No. 1 and Tav. XVIII in the "Saggio delle opere di Leonardo da Vinci" (Milan 1872). The passages—Nos. 1120—1125—here printed for the first time and hitherto unknown—refer to the same subject and, with the exception of one already published in the Saggio— No. 1126—they are, so far as I know, the only notes, among the numerous observations on the flight of birds, in which the phenomena are incidentally and expressly connected with the idea of a flying machine.

The notes on machines of war, the construction of fortifications, and similar matters which fall within the department of the Engineer, have not been included in this work, for the reasons given on page 26 of this Vol. An exception has been made in favour of the passages Nos. 1127 and 1128, because they have a more general interest, as bearing on

the important question: whence the Master derived his knowledge of these matters. Though it would be rash to assert that Leonardo was the first to introduce the science of mining into Italy, it may be confidently said that he is one of the earliest writers who can be proved to have known and understood it; while, on the other hand, it is almost beyond doubt that in the East at that time, the whole science of besieging towns and mining in particular, was far more advanced than in Europe. This gives a peculiar value to the expressions used in No. 1127.

I have been unable to find in the manuscripts any passage whatever which throws any light on Leonardo's great reputation as a musician. Nothing therein illustrates VASARI'S well-known statement: Avvenne che morto Giovan Galeazzo duca di Milano, e creato Lodovico Sforza nel grado medesimo anno 1494, fu condotto a Milano con gran riputazione Lionardo al duca, il quale molto si dilettava del suono della lira, perchè sonasse; e Lionardo portò quello strumento ch'egli aveva di sua mano fabbricato d'argento gran parte, in forma d'un teschio di cavallo, cosa bizzarra e nuova, acciocchè l'armonia fosse con maggior tuba e più sonora di voce; laonde superò tutti i musici che quivi erano concorsi a sonare.

The only notes on musical matters are those given as Nos. 1129 and 1130, which explain certain arrangements in instruments.

DEL MOTO DEL MOBILE,—[2]DEL COGNOSCERE QUĀTO [3]IL NAVILIO SI MOVE PER ORA.

[4]Ànno li nostri antichi vsato diuersi in-[5]giegni per vedere che viaggio faccia v̄ navilio per ci[6]ascuna ora, infra li quali Vitruvio ne po[7]ne vno nella sua opera d'Architettura, il qua[8]le modo è fallace insieme cogli altri; e que[9]sto è vna rota da mulino tocca dall' onde [10]marine nelle sue stremità, e mediante le [11]intere sue revolutioni si descrive vna linia [12]retta che rappresenta la linia circ̄uferē[13]tiale di tal rota ridotta in rettitudine; [14]Ma questa tale inventione non è valida, [15]se nō nelle superfitie piane e immobili de' [16]laghī; Ma se l'acqua si move insieme col [17]navilio con equal moto, allora tal rota re[18]sta inmobile, e se l'acqua è di moto più o mē [19]velocie che 'l moto del nauilio, ancora tal ro[20]ta non à moto equale a quel del navilio, in [21]modo che tale inventione è di poca valitudine; [22]Ecco vn altro modo fatto colla speriētia d'uno [23]spatio noto da una isola a vn altra, e questo si [24]fa con un asse o lieua percossa dal uēto, che la percuote o più o [25]men velocie, e questo è in Battista Alberti;

ON MOVEMENTS;—TO KNOW HOW MUCH A SHIP ADVANCES IN AN HOUR.

The ancients used various devices to ascertain the distance gone by a ship each hour, among which Vitruvius [6] gives one in his work on Architecture which is just as fallacious as all the others; and this is a mill wheel which touches the waves of the sea at one end and in each complete revolution describes a straight line which represents the circumference of the wheel extended to a straightness. But this invention is of no worth excepting on the smooth and motionless surface of lakes. But if the water moves together with the ship at an equal rate, then the wheel remains motionless; and if the motion of the water is more or less rapid than that of the ship, then neither has the wheel the same motion as the ship so that this invention is of but little use. There is another method tried by experiment with a known distance between one island and another; and this is done by a board or under the pressure of wind which strikes on it with more or less swiftness. This is in Battista Alberti[25].

The ship's logs of Vitruvius, of Alberti and of Leonardo

1113. 2. cogniossciere. 4. nosstri. 6. asscuna . . infralli . . vetruvio. 7. darchitectura. 8. effallacie . . ecque. 9. tocha dallonde. 11. desscrive. 12. circh̄uferē. 13. diridotta. 14. Macquessta. 15. inmobile. 16. Massellacqua. 17. rota res. 18. essellacqua. 19. anchora. 20. noña . . acquel. 21. chettale . . pocha. 22. Ecci . . cholla. 23. ecquesto. 24. fa vasse lieua perchossa . . chella perchote eppiuō. 25. ecquesto . . balissta abrti. 26. batissa. 27. albertiche effat. 28. lassperi. 31. issola.

1113. 6. See VITRUVIUS, *De Architectura lib. X.* C. 14 (p. 264 in the edition of Rose and Müller-Strübing). The German edition published at Bale in 1543 has, on fol. 596, an illustration of the contrivance, as described by Vitruvius.

25. LEON BATTISTA ALBERTI, *De Architectura lib. V.,* c. 12 treats '*de le navi e parti loro*', but there is no

reference to the machine, mentioned by Leonardo. Alberti says here: *Noi abbiamo trattato lungamente in altro luogo de' modi de le navi, ma in questo luogo ne abbiamo detto quel tanto che si bisogna.* To this the following note is added in the most recent Italian edition: *Questo libro è tuttora inedito e porta il titolo, secondo Gesnero di 'Liber navis'.*

²⁶Il modo di Battista ²⁷Alberti è fat²⁸to sopra la speri²⁹entia d'uno spa³⁰tio noto da vn³¹a isola a un altra; ³²Ma tale inventi³³one nō riesce, ³⁴se nō a vn navi-³⁵lio simile a quel ³⁶dove è fatto tale ³⁷sperietia, ma ³⁸bisognia che sia ³⁹col medesimo ⁴⁰carico, e me⁴¹desima vela, ⁴²e medesima situ⁴³atiō di vela, e ⁴⁴medesime grā⁴⁵dezze d'onde; ma ⁴⁶il mio modo ser⁴⁷ve a ogni navi⁴⁸lio, si di remi co⁴⁹me vela, e sia pi-⁵⁰ccolo o grāde, ⁵¹o lūgo e alto, ⁵²o basso, sēpre serve.

Battista Alberti's method which is made by experiment on a known distance between one island and another. But such an invention does not succeed excepting on a ship like the one on which the experiment was made, and it must be of the same burden and have the same sails, and the sails in the same places, and the size of the waves must be the same. But my method will serve for any ship, whether with oars or sails; and whether it be small or large, broad or long, or high or low, it always serves [52].

Leic. 22 b] 1114.

Methods of staying and moving in water

Come con otricoli l'esercito debbe pas-²sare i fiumi a noto; ... Del modo del notare de' pesci; del modo ³ del lor saltare fori delle acque, come far si uede a delfini, che par cosa marauigliosa for⁴mare salto sopra la cosa che non aspetta, anzi si fugge; Del notare delli animali di lū⁵ga figura, come anguille e simili; Del modo del notar contro alle corēti e grā ⁶cadute de' fiumi; Del modo come notino li pesci di retōda figura; Come li animali ⁷che non ànno lunga fessa non sā notare; Come tutti li altri animali naturalmente sā⁸no notare, auendo li piedi colle dita, saluo che l'omo; In che modo l'omo debbe inpara⁹re a notare; Del modo del riposarsi sopra delle acque; Come l'omo si debbe difen¹⁰dere dalle revertigini over retrosi delle acque che lo tirano in fondo; Come l'omo ti¹¹rato in fondo abbia a cercare del moto riflesso, che lo gitti fori della profondità; Co¹²me si debe passeggiare colle · braccia; come si debbe notare river-scio; Come, e come non ¹³si può star sotto l'acque ·, se non quando si può ritenere lo alitare; Come molti stie¹⁴no con istrumēto alquāto sotto l'acque; Come e perchè io non scrivo il mio modo di ¹⁵star sotto l'acqua, quāto io posso star sanza man-giare, e questo nō publico o diuolgo per le ma¹⁶le nature delli omini, li quali vse-rebbero li assasinamēti ne' fondi de' mari

How an army ought to cross rivers by swimming with air-bags . . . How fishes swim [2]; of the way in which they jump out of the water, as may be seen with dolphins; and it seems a wonderful thing to make a leap from a thing which does not resist but slips away. Of the swimming of animals of a long form, such as eels and the like. Of the mode of swimming against currents and in the rapid falls of rivers. Of the mode of swimming of fishes of a round form. How it is that animals which have not long hind quartres cannot swim. How it is that all other animals which have feet with toes, know by nature how to swim, excepting man. In what way man ought to learn to swim. Of the way in which man may rest on the water. How man may protect himself against whirlpools or eddies in the water, which drag him down. How a man dragged to the bottom must seek the reflux which will throw him up from the depths. How he ought to move his arms. How to swim on his back. How he can and how he can-not stay under water unless he can hold his breath [13]. How by means of a certain ma-chine many people may stay some time under water. How and why I do not describe my method of remaining under water, or how long I can stay without eating; and I do not publish nor divulge these by reason of the evil nature of men who would use them as

32. Mattale. 33. riesscie. 35. acquel. 36. effatto. 37. essperiētia. 38. chessia. 39. chol. 40. charicho. 45. deze . . M"a". 47. a "o"gni. 48. cho. 49. essia. 50. c"j"colo ogrande stār. 51. do ollūgho. 52. obbasso.
1114. 1. otricolli lessercito . . pa. 2. pessci. 3. adalfini. 4. fuge. 5. essimili De. 6. pessci. 7. nonā. 8. cōlle chellomo riposarsi lomo sopra. 10. delle revertigini. 10. chelli tirano. 11. refresso . . che gitti. 12. passegare colle br . . Come e non. 13. si postar . . quanto si po. 14. isscrivo. 15. quāto iposso . . magare ecquesto. 16. vserebono. 17. son-

52. Leonardo does not reveal the method in-vented by him.

1114. 2. Compare No. 821.
L. 13—19 will also be found in Vol. I No. 1.

col ronpere [17]i navili in fondo, e sommer-
gierli insieme colli omini che ui son dentro,
e bēchè io insegni [18] delli altri, quelli nō
son di pericolo, perchè di sopra all'acqua
apparisce la bocca della canna, [19] onde
alitano, posta sopra li otri o sughero.

means of destruction at the bottom of the sea,
by sending ships to the bottom, and sinking
them together with the men in them. And
although I will impart others, there is no
danger in them; because the mouth of the
tube, by which you breathe, is above the
water supported on bags or corks[19].

Ash. II. 4 *b*] **1115.**

Se sarā in pugnia · naui · e · galee ·, es-
sendo vincitori le naui per le loro alte
gaggie, [2]si de' tirare l'antena · per īsino
quasi alla sommità
dell'albero, [3] e abbi
nella stremità di detta
ātena, cioè quella ch'è
sporta sopra [4] il nemi-
co, appiccato v̄a gag-
gietta fasciata, e di
sotto e dītorno uno
[5] grosso materasso
pieno di bābagia, ac-

Supposing in a battle between ships and
galleys that the ships are victorious by reason
of the high of their tops, you must haul the yard
up almost to the top
of the mast, and at
the extremity of the
yard, that is the end
which is turned tow-
ards the enemy, have
a small cage fastened,
wrapped up below and
all round in a great
mattress full of cotton

On naval
warfare
(1115. 1116).

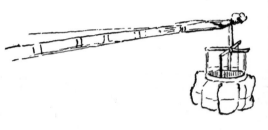

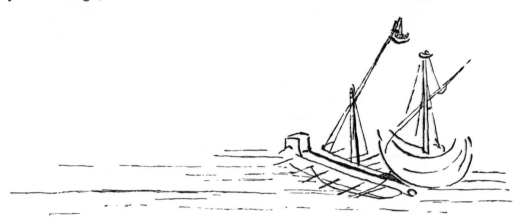

ciò nō sia offesa dalle bōbardelle, [6]poi tira
col'argano ī basso l'opposita parte d'essa
antena, e la gaggia [7]opposita andrà tāto
· in alto ·, ch'ella di grā luga av̄azerà la
gaggia del[8]la nave, e potrassi facilmēte
cacciare li omini che dētro ui sono; [9]ma
bisognia che gli omini che sono nella galea
· vadino dall'opposita banda, [10]acciò · fac-
cino · contrapeso al carico delli omini posti
dētro · alla gaggia [11]della antēna.

so that it may not be injured by the bombs;
then, with the capstan, haul down the oppo-
site end of this yard and the top on the oppo-
site side will go up so high, that it will be far
above the round-top of the ship, and you will
easily drive out the men that are in it. But
it is necessary that the men who are in the
galley should go to the opposite side of it so
as to afford a counterpoise to the weight of
the men placed inside the cage on the yard.

mergierli . . ebēce. 18. aparissce la bocha. 19. ossugero.
1115. 1. sara . . gagie. 2. si de [mettere] tirare . . somita. 3. abi . . ītena . . che [apichata] sporta. 4. apichato v̄a gagietta
fassciatta . . dītorno dino. 6. chol . . ella gagia. 7. oposita andera . . gagia de. 8. chaciare. 9. chessono . . ghalea . .
daloposita. 10. chontrapeso . . charicho . . gagia. 11. antena.

Se vuoli fare vna · armata marittima, vsa di questi navili per sfondare le navi, [2]cioè fa navili · di 100 piè, e larghi piedi 8, ma fa che i remi sinistri abino i loro [3]motori nel lato destro del navilio, e così i destri nel sinistro come appare in M, acciochè lo lieve de' remi [4]sia piv lūgo ·, e detto navilio sia grosso piè uno e ¹/₂ · cioè fatto

If you want to build an armada for the sea employ these ships to ram in the enemy's ships. That is, make ships 100 feet long and 8 feet wide, but arranged so that the left hand rowers may have their oars to the right side of the ship, and the right hand ones to the left side, as is shown at M, so that the leverage of the oars may be longer. And the

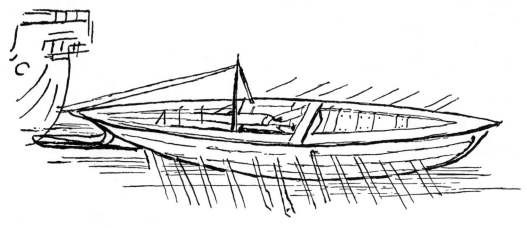

di travi fermi di [5]fuori e di dētro con asse con cōtrari liniamēti; e questo navilio avrà,

said ship may be one foot and a half thick, that is made with cross beams within and without,

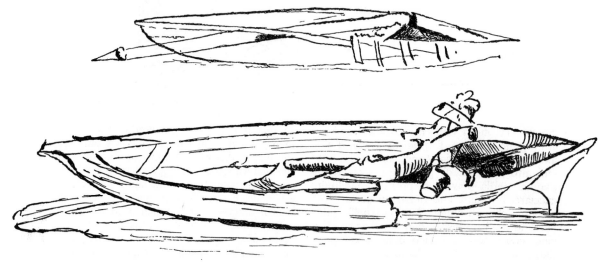

sotto [6]l'acqua vn piede, appiccato vno spūtone ferrato di peso e grossezza d'un

with planks in contrary directions. And this ship must have attached to it, a foot below the

1116. 1. isfondare. 2. cheremi . . ilor. 3. nelato . . sinistro "come apare in M" aciochelo. 4. sieno piv lūge . . pie î e . . facto di trav ferm. 5. fori . . chon asse chō cōtrari . . navilio avc sotto. 6. lacq"a" vn piedi apuchato . . ferato adi

ācudi⁷ne· e questo per forza di remi potrà, dato il primo colpo, tornare īdirietro, ⁸e cō furia ricacciarsi ināti e dare il colpo secōdo, e poi il terzo, e tāti che rōpa detto navilio.

water, an iron-shod spike of about the weight and size of an anvil; and this, by force of oars may, after it has given the first blow, be drawn back, and driven forward again with fury give a second blow, and then a third, and so many as to destroy the other ship.

B. 81*b*] **1117.**

MODO DI SALUARSI · IN VNA · TEPESTA E NAVFRAGIO · MARITTIMO.

Bisognia · avere v̄a vesta ² di corame ch'abbi doppio i labri del petto per spatio d'vno · dito, e così sia doppio ³dalla cītura īsino al ginocchio ·, e sia corame sicuro dallo · esalare ·; E quādo ⁴bisognasse saltare ī mare ·, sgō-fia · per li labri del petto le code del tuo vestito, ⁵e salta in mare ·, e lasciati guidare all'onde ·; quādo nō vedi vi-cina riva, ⁶ne abbi notitia · del mare ·, e ti ni sempre · ī bocca la canna dell'aria che va nel vestito, ⁷e quādo per una volta o 2 ti bisognasse trare dell'aria comvne, e la schiuma t'inpedisce, ⁸tira per bocca di quella del vestito.

A METHOD OF ESCAPING IN A TEMPEST AND SHIPWRECK AT SEA.

Have a coat made of leather, which must *The use of* be double across the breast, that is having a *swimming* hem on each side of about a finger breadth. *belts.* Thus it will be double from the waist to the knee; and the leather must be quite air-tight. When you want to leap into the sea, blow out the skirt of your coat through the double hems of the breast; and jump into the sea, and allow yourself to be carried by the waves; when you see no shore near, give your attention to the sea you are in, and always keep in your mouth the air-tube which leads down into the coat; and if now and again you require to take a breath of fresh air, and the foam prevents you, you may draw a breath of the air within the coat.

S. K. M. III. 25*b*] **1118.**

Se 'l mare si pesa sul suo fondo, ²vn omo, che giacesse sopra esso ³fondo e avesse 1000 braccia d'acqua ⁴a dosso, n'avrebbe a scoppiare.

If the weight of the sea bears on its bottom, *On the gra-* a man, lying on that bottom and having *vity of* 1000 braccia of water on his back, would *water.* have enough to crush him.

C. A. 7*a*; 19*a*] **1119.**

D'andar sotto acqua;
²Modo di caminare ³sopra l'acqua.

Of walking under water. *Diving appa-*
Method of walking on water. *ratus and*
 Skating
 (1119—1121).

peso . . grosseza. 7. ecquesto . . forza adi remi . . īdirieto. 8. richaciarsi.
1117. 2. dopio . . p̄eto perispatio dono . . dopio. 3. aginochio essia sicuro dello. 4. biscognassi . . schōfia. 5. essalta imare ellassciati . .
 visina. 6. abi . . ettieni . . bocha la cana. 7. per î . . bisognassi trare dellaria *partly indistinct;* sciuma tīpedissi. 8. boca.
1118. 2. diaciessi. 3. avessi 1000 br dacu 4 asscopiare. **1119.** 2. chomin. 3. sop acq"a".

1117. AMORETTI, *Memorie Storiche*, Tav. II. B. Fig. 5, gives the same figure, somewhat altered. 6. *La canna dell' aria.* Compare Vol. I. No. 1. Note.

1119. The two sketches belonging to this passage are given by AMORETTI, *Memorie Storiche*. Tav. II, Fig. 3 and 4.

Ash. II. 5 b] **1120.**

Siccome per lo fivme ghiacciato uno omo corre ²sanza mvtatione di piedi·, così vn carro fia ³possibile fare che corra per se.

Just as on a frozen river a man may run without moving his feet, so a car might be made that would slide by itself.

S. K. M. III. 46 b] **1121.**

Definitione perchè vno ²che sdrucciola sopra il ghiaccio ³nõ cade.

A definition as to why a man who slides on ice does not fall.

Mz. 3 a (6)] **1122.**

On Flying machines (1122—1126).

L'uomo ne' volatili à a stare libero dalla cintura insù ²per potersi bilicare, come fa in barca acciò che 'l cē³tro della grauità di lui e dello strumēto si possa ⁴bilicare e trasmutarsi, dove necessità il dimāda ⁵alla mutatione del centro della sua resistētia.

Man when flying must stand free from the waist upwards so as to be able to balance himself as he does in a boat so that the centre of gravity in himself and in the machine may counterbalance each other, and be shifted as necessity demands for the changes of its centre of resistance.

Mz. 12 a (16)] **1123.**

Ricordati siccome ɟl tuo vccello non debbe imitare ²altro che 'l pipistrello per cavsa che i pannicoli fāno ³armadura over collegatione alle armadure, cioè ma⁴estre delle ali;

Remember that your flying machine must imitate no other than the bat, because the web is what by its union gives the armour, or strength to the wings.

⁵E se tu imitassi l'alie delli vccelli pennvti, esse ⁶son di piv potēte nervatura, per essere esse ⁷traforate cioè che le lor penne sō disunite e passa⁸te dall'aria; Ma il pipistrello è aivtato dal panni⁹culo che lega il tutto, e non è traforato.

If you imitate the wings of feathered birds, you will find a much stronger structure, because they are pervious; that is, their feathers are separate and the air passes through them. But the bat is aided by the web that connects the whole and is not pervious.

1120. 1. sichome . . diacciato ĩ omo core. 2. chosi vn charo. 3. possiuile. 3. chora.
1121. 1. definition. 2. strusi . . diaccio.
1122. 1. volatili asstare. 2. barcha. 4. bilichare e strassmutarsi. 5. ressistētia.
1123. 1. sichome. 2. pipísstrello . . chavsa che panichuli. 3. chollegacione . . coe. 4. esstre . . alie. 5. essettu. 6. enervatura
 7. coe chelle . . eppassa. 9. chulo chellega.

1120. The drawings of carts by the side of this text have no direct connection with the problem as stated in words.—Compare No. 1448, l. 17.

1121. An indistinct sketch accompanies the passage, in the original.

Mz. 9 *b* (13)]　　　　　　　　　　**1124.**

PER FUGIRE IL PERICOLO DELLA RUINA.

²Può accadere la ruina di tali strumēti per · 2 · modi, de' quali ³il primo · è del ronpersi lo strumēto, secondario fia quā⁴do lo strumento si uoltasse per taglio o vicino a esso taglio, ⁵perchè senpre debbe discendere per grande obbliquità e quasi ⁶per la linia dell'equalità; In quanto al primo, ⁷del ronpersi lo strumēto, si riparerà col farlo di somma for⁸tezza, per qualunche linia esso si potesse voltare, e assai distante l'un centro dall'altro, cioè nel⁹lo strumēto di 30 braccia di lunghezza essi centri sieno distanti 4 braccia l'un dall'altro.

TO ESCAPE THE PERIL OF DESTRUCTION.

Destruction to such a machine may occur in two ways; of which the first is the breaking of the machine. The second would be when the machine should turn on its edge or nearly on its edge, because it ought always to descend in a highly oblique direction, and almost exactly balanced on its centre. As regards the first—the breaking of the machine—,that may be prevented by making it as strong as possible; and in whichever direction it may tend to turn over, one centre must be very far from the other; that is, in a machine 30 braccia long the centres must be 4 braccia one from the other.

Mz. 13 *a*]　　　　　　　　　　**1125.**

Baghe dove l'omo in 6 braccia ²d'altezza cadendo nō si faccia male, ³cadendo così in acqua come ⁴in terra; e queste baghe le⁵gate a vso di paternostri s'avvol⁶gino altrui addosso.

Bags by which a man falling from a height of 6 braccia may avoid hurting himself, by a fall whether into water or on the ground; and these bags, strung together like a rosary, are to be fixed on one's back.

C. A. 372 *b*; 1158 *b*]　　　　　　　　**1126.**

Tāta forza si fa colla cosa īcōtro all'aria, quāto l'aria alla cosa; ²Vedi l'alie percosse cōtro all'aria fanno sostenere la pesante aquila sulla suprema sottile aria ³vicina all'elemēto del fuoco; Ancora vedi la mossa aria sopr'al mare ripercossa ⁴nelle gōfiate vele far correr la carica e pesāte nave; sichè per queste demostra⁵tive e assegnate ragioni potrai conosciere l'uomo colle sua cōgiegniate e grādi ale, ⁶facciēdo forza cōtro alla resistēte aria, vincēdo poterla soggiogare a le⁷varsi sopra di lei.

An object offers as much resistance to the air as the air does to the object. You may see that the beating of its wings against the air supports a heavy eagle in the highest and rarest atmosphere, close to the sphere of elemental fire. Again you may see the air in motion over the sea, fill the swelling sails and drive heavily laden ships. From these instances, and the reasons given, a man with wings large enough and duly connected might learn to overcome the resistance of the air, and by conquering it, succeed in subjugating it and rising above it.

1124. 1. pericholo. 2. achadere . . tale. 3. sechondario. 4. losstrumento si uoltassi. 4. vicico. 5. disscendere. 7. losstrumēto. 8. teza. 8. potessi . . disstante . . coe. 9. br di lungeza·. . 4 br lū.
1125. 1. 6 br. 2. dalteza . . facca. 3. chedendo. 4. ecqueste. 5. paternosstri savol. 6. glino . . adosso.
1126. 1. [vo] tāta . . cholla chosa ī chōtro . . chosa. 2. perchosse chōtro·. . fassosstenere . . sulla "suplema" sottile. 3. fuocho Anchora . . riperchossa. 4. ghōfiate . . chorrer la charicha . . qste [asse] demosstra. 5. chonossciere . . cholle . . chōgiegniate. 6. chōtro . . resisstēte aria [potersi e] e vincēdo poterla sogiogare alle.

1124. Compare No. 1428.
1126. A parachute is here sketched, with an explanatory remark. It is reproduced on Tav. XVI in the *Saggio*, and in: *Leonardo da Vinci* *als Ingenieur etc., Ein Beitrag zur Geschichte der Technik und der induktiven Wissenschaften, von Dr. Hermann Grothe, Berlin* 1874, p. 50.

Ash. II. 4*a*] **1127.**

Of mining.
Se tu · vuoi sapere · doue · una caua faccia suo · corso, metti vno tāburo ²in tutti quelli lochi, dove tu sospetti si facci la cava ·, e sopra detto tābu³ro · metti vno pajo di dadi ·, e quādo sarai apresso · al loco dove si caua, i dadi risal⁴teranno alquāto sopra del tāburo · per lo colpo che si da sotto terra nel cavare.

If you want to know where a mine runs, place a drum over all the places where you suspect that it is being made, and upon this drum put a couple of dice, and when you are over the spot where they are mining, the dice will jump a little on the drum at every blow which is given underground in the mining.

⁵Sono alcuni che per auere comodità d'ū fiume o di padule ⁶alle lor terre, ànno fatto apresso di quel loco, doue sospettano si faccia ⁷la cava, vno grā riserbo d'aqua, e cauato · in cōtra il nemi⁸co e, quel trouato, ànno sboccato il bottino e annegato nella ⁹cava grā popolo.

There are persons who, having the convenience of a river or a lake in their lands, have made, close to the place where they suspect that a mine is being made, a great reservoir of water, and have countermined the enemy, and having found them, have turned the water upon them and destroyed a great number in the mine.

Tr. 48] **1128.**

FUOCO GRECO.

Of Greek fire.
²Tolli · carbon di salcio, e sale nitro, e acquavite, e sulfore, ³pegola con īciēso, e cāfora, e lana etiopica e fa bollire ⁴ogni cosa īsieme; questo fuoco · è di tanto desi-

GREEK FIRE.

Take charcoal of willow, and saltpetre, and sulphuric acid, and sulphur, and pitch, with frankincense and camphor, and Ethiopian wool, and boil them all together. This

1127. 1. settu vuoli . . î cha faccia . . chorso. 2. tussosspetti . . essopra. 3. vno pa di. 4. terano . . chessi da . . tera. 5. chomodita. 6. tere . . facci. 7. riserbo daqᵘᵃ" e chauato. 8. ano isboccato . . anegatti.
1128. 1. fuocho grecho. 2. charbon di salco essale . . essulfore. 3. chāfera elana etiopicha effa. 4. onichosa . . focho . . dessi-

derio di bru⁵ciare, che seguita il legniame sin sotto l'acque; ⁶e se aggivgnierai in essa conpositione vernice liquida, ⁷e olio petrolio, e tremētina, e acieto forte, mischia ⁸ogni cosa īsieme, e secca al sole o nel forno quādo n'è trat⁹to'l pane, e poi volta intorno alla stoppa di canapa o altra, ¹⁰riduciēdola in forma rotonda, e ficcati da ogni pa¹¹rte i chiodi acutissimi, solamēte lascia ī detta palla vn ¹²buco come razzo; poi la copri di colofonio e di solfo;

¹³Ancora questo foco appiccato in sommità d'una lunga asta, ¹⁴la quale abbi uno braccio di pūta di ferro acciò nō sia bruciato da det¹⁵to foco, è bono per evitare e proibire īfra le naui ostili, per ¹⁶non essere soprafatti da īpito;

¹⁷Ācora gittati vasi di uetro pieni di pegola sopra ¹⁸li aversi navili, — ītendenti li omini di quelli alla battaglia, — ¹⁹e poi gittato dirieto simili palle accese ànno potēza a brucia²⁰re ogni navilio.

fire is so ready to burn that it clings to the timbers even under water. And add to this composition liquid varnish, and bituminous oil, and turpentine and strong vinegar, and mix all together and dry it in the sun, or in an oven when the bread is taken out; and then stick it round hempen or other tow, moulding it into a round form, and studding it all over with very sharp nails. You must leave in this ball an opening to serve as a fusee, and cover it with rosin and sulphur.

Again, this fire, stuck at the top of a long plank which has one braccio length of the end pointed with iron that it may not be burnt by the said fire, is good for avoiding and keeping off the ships, so as not to be overwhelmed by their onset.

Again throw vessels of glass full of pitch on to the enemy's ships when the men in them are intent on the battle; and then by throwing similar burning balls upon them you have it in your power to burn all their ships.

Br. M. 175a] **1129.**

Tanburo di tacche, fregate ²da rote di molle;

A drum with cogs working by wheels with springs [2]. Of Music (1129. 1130).

derio. 5. sare che seghuita ilegniame . . lacq"e". 6. esse agivg . . chonpositione. 7. emiscia. 8. oni . . essechai . . ne forno quādo ne tra. 9. e po volta . . ala stopa. 10. retonda efficchati da ongni. 11. achutissimi lassa īdetta balla. 12. buso chomaraza poi . . colofonia. 13. quessto . . appichato in somita . . asste. 14. abi ī br di . . fero acio . . brusato da de 15. eviare . . ne nave. 17. gittate. 18. ītenti . . queli ala. 19. gitato . . simile . . acese ano potēza a brusa. 20. ōni.

1129. 2. molle. 5. cholla. 8. coe. 9. sicome. 10. fa boci. 13. quesste. 16. uoce. 17. tassti . . esserrano bichi di grā disstātie

1128. Venturi has given another short text about the Greek fire in a French translation (Essai § XIV). He adds that the original text is to be found in MS. B. 30 (?). Libri speaks of it in a note as follows (*Histoire des sciences mathématiques en Italie Vol. II* p. 129): *La composition du feu grégeois est une des choses qui ont été les plus cherchées et qui sont encore les plus douteuses. On dit qu'il fut inventé au septième siècle de l'ère chrétienne par l'architecte Callinique (Constantini Porphyrogenetae opera, Lugd. Batav. 1617,—in-8 ᵛᵒ; p. 172, de admin. imper. exp. 48), et il se trouve souvent mentionné par les Historiens Byzantins. Tantôt on le lançait avec des machines, comme on lancerait une bouche, tantôt on le soufflait avec de longs tubes, comme on soufflerait un gaz ou un liquide enflammé (Annae Comnenae Alexias, p. 335, lib. XI.—Aeliani et Leonis, imperatoris tactica, Lugd.-Bat. 1613, in-4. part. 2ᵃ, p. 322, Leonis tact. cap. 19.—Joinville, histoire du Saint Louis collect. Petitot tom. II, p. 235). Les écrivains contemporains disent que l'eau ne pouvait pas éteindre ce feu, mais qu'avec du vinaigre et du sable on y parvenait.*

Suivant quelques historiens le feu grégeois était composé de soufre et de résine. Marcus Graecus (Liber ignium, Paris, 1804, in-4º) donne plusieurs manières de le faire qui ne sont pas très intelligibles, mais parmi lesquelles on trouve la composition de la poudre à canon. Léonard de Vinci (MSS. de Léonard de Vinci, vol. B. f. 30) dit qu'on le faisait avec du charbon de saule, du salpêtre, de l'eau de vie, de la résine, du soufre, de la poix et du camphre. Mais il est probable que nous ne savons pas qu'elle était sa composition, surtout à cause du secret qu'en faisaient les Grecs. En effet, l'empereur Constantin Porphyrogénète recommande à son fils de ne jamais en donner aux Barbares, et de leur répondre, s'ils en demandaient, qu'il avait été apporté du ciel par un ange et que le secret en avait été confié aux Chrétiens (Constantini Porphyrogennetae opera, p. 26—27, de admin. imper., cap. 12).

1129. This chapter consists of explanations of the sketches shown on Pl. CXXI. Lines 1 and 2 of the text are to be seen at the top at the left hand side of the first sketch of a drum. Lines 3—5 refer to the

³Tanburo quadro, del quale ⁴si tira e allenta la sua car⁵ta colla lieua *a b*;

⁶Tanburo a cōsonāza;

⁷Vna tabella a cōsonā⁸za, cioè 3 tabelle insieme;

⁹Siccome vn medesimo ¹⁰tanburo fa voci ¹¹graui e acute, ¹²secondo le carte più o mē ¹³tirate, così queste carte, ¹⁴variamente tirate sopra ¹⁵vn medesimo corpo di tā-¹⁶buro, farā uarie uoci;

¹⁷Tasti stretti e serrano; bicchi di grā distātie infra loro, ¹⁸e sono al proposito della tronba prossima di sopra;

¹⁹*a* entri in loco dell'ordinarie posite ²⁰che ànno i partici ne' lor busi de' zufoli.

A square drum of which the parchment may be drawn tight or slackened by the lever *a b*[5].

A drum for harmony[6].

[7] A clapper for harmony; that is, three clappers together.

[9] Just as one and the same drum makes a deep or acute sound according as the parchments are more or less tightened, so these parchments variously tightened on one and the same drum will make various sounds[16].

Keys narrow and close together; (bicchi) far apart; these will be right for the trumpet shown above.

a must enter in the place of the ordinary keys which have the in the openings of a flute.

Br. M. 136*a*] **1130.**

Tanpani sona²ti come il mo³nacordo ⁴o voi dolze⁵mele;

⁶Qui si fa una rota di canne a vso ⁷di tabelle con vn circulo mvsicale det⁸to canone, che si canta a quattro e ⁹ciascū cantore canta tutta la rota, e però ¹⁰fo io qui vna rota cō 4 denti che ogni ¹¹dente per se fa l'ofitio d'un cantore.

Tymbals to be played like the monochord, or the soft flute.

[6] Here there is to be a cylinder of cane after the manner of clappers with a musical round called a Canon, which is sung in four parts; each singer singing the whole round. Therefore I here make a wheel with 4 teeth so that each tooth takes by itself the part of a singer.

B. 4*a*] **1131.**

Of decorations.

Pañi biāchi e cielesti, ²tessuti a scacchi ³per fare uno apparecchio;

⁴Pañi tirati ⁵in *a · b · c · d · e · f · g · h · i · k ·*, ⁶da fa⁷re uno ciclo a uno ap⁸parecchio.

White and sky-blue cloths, woven in checks to make a decoration.

Cloths with the threads drawn at *a b c d e f g h i k*, to go round the decoration.

infrallo. 19. illoco . . posste. **1130.** 6. channe . . circul. 7. chon. 8. chessi . . acquattro he.

1131. 2. schachi. 3. î aparechio. 6. daffa. 7. re î cielo a î a. 8. parechio.

sketch immediately below this. Line 6 is written as the side of the seventh sketch, and lines 7 and 8 at the side of the eighth. Lines 9—16 are at the bottom in the middle. The remainder of the text is at the side of the drawing at the bottom.

1130. In the original there are some more sketches, to which the text, from line 6, refers. They are studies for a contrivance exactly like the cylinder in our musical boxes.

XIX.

Philosophical Maxims. Morals. Polemics and Speculations.

Vasari indulges in severe strictures on Leonardo's religious views. He speaks, among other things, of his "capricci nel filosofar delle cose naturali" *and says on this point:* "Per il che fece nell'animo un concetto si eretico che e' non si accostava a qualsi voglia religione, stimando per avventura assai più lo esser filosofo che cristiano" *(see the first edition of* 'Le Vite'*). But this accusation on the part of a writer in the days of the Inquisition is not a very serious one—and the less so, since, throughout the manuscripts, we find nothing to support it.*

Under the heading of "Philosophical Maxims" I have collected all the passages which can give us a clear comprehension of Leonardo's ideas of the world at large. It is scarcely necessary to observe that there is absolutely nothing in them to lead to the inference that he was an atheist. His views of nature and its laws are no doubt very unlike those of his contemporaries, and have a much closer affinity to those which find general acceptance at the present day. On the other hand, it is obvious from Leonardo's will (see No. 1566) that, in the year before his death, he had professed to adhere to the fundamental doctrines of the Roman Catholic faith, and this evidently from his own personal desire and impulse.

The incredible and demonstrably fictitious legend of Leonardo's death in the arms of Francis the First, is given, with others, by Vasari and further embellished by this odious comment: "Mostrava tuttavia quanto avea offeso Dio e gli uomini del mondo, non avendo operato nell'arte come si conveniva." *This last accusation, it may be remarked, is above all evidence of the superficial character of the information which Vasari was in a position to give about Leonardo. It seems to imply that Leonardo was disdainful of diligent labour. With regard to the second, referring to Leonardo's morality and dealings with his fellow men, Vasari himself nullifies it by asserting the very contrary in several passages. A further refutation may be found in the following sentence from*

the letter in which Melzi, the young Milanese nobleman, announces the Master's death to Leonardo's brothers: Credo siate certificati della morte di Maestro Lionardo fratello vostro, e mio quanto optimo padre, per la cui morte sarebbe impossibile che io potesse esprimere il dolore che io ho preso; e in mentre che queste mia membra si sosterranno insieme, io possederò una perpetua infelicità, e meritamente perchè sviscerato et ardentissimo amore mi portava giornalmente. È dolto ad ognuno la perdita di tal uomo, quale non è più in podestà della natura, ecc.

It is true that, in April 1476, we find the names of Leonardo and Verrocchio entered in the "Libro degli Uffiziali di notte e de' Monasteri" *as breaking the laws; but we immediately after find the note* "Absoluti cum condizione ut retamburentur" (Tamburini *was the name given to the warrant cases of the night police). The acquittal therefore did not exclude the possibility of a repetition of the charge. It was in fact repeated, two months later, and on this occasion the Master and his pupil were again fully acquitted. Verrocchio was at this time forty and Leonardo four-and-twenty. The documents referring to this affair are in the State Archives of Florence; they have been withheld from publication, but it seemed to me desirable to give the reader this brief account of the leading facts of the story, as the vague hints of it, which have recently been made public, may have given to the incident an aspect which it had not in reality, and which it does not deserve.*

The passages here classed under the head "Morals" reveal Leonardo to us as a man whose life and conduct were unfailingly governed by lofty principles and aims. He could scarcely have recorded his stern reprobation and unmeasured contempt for men who do nothing useful and strive only for riches, if his own life and ambitions had been such as they have so often been misrepresented.

At a period like that, when superstition still exercised unlimited dominion over the minds not merely of the illiterate crowd, but of the cultivated and learned classes, it was very natural that Leonardo's views as to Alchemy, Ghosts, Magicians, and the like should be met with stern reprobation whenever and wherever he may have expressed them; this accounts for the argumentative tone of all his utterances on such subjects which I have collected in Subdivision III of this section. To these I have added some passages which throw light on Leonardo's personal views on the Universe. They are, without exception, characterised by a broad spirit of naturalism of which the principles are more strictly applied in his essays on Astronomy, and still more on Physical Geography.

To avoid repetition, only such notes on Philosophy, Morals and Polemics, have been included in this section as occur as independent texts in the original MSS. Several moral reflections have already been given in Vol. I, in section "Allegorical representations, Mottoes and Emblems". Others will be found in the following section. Nos. 9 to 12, Vol. I, are also passages of an argumentative character. It did not seem requisite to repeat here these and similar passages, since their direct connection with the context is far closer in places where they have appeared already, than it would be here.

I.

PHILOSOPHICAL MAXIMS.

S. K. M. III. 64 b]

1132.

Io t'ubidisco, Signore, prima per l'a-²more che ragionevolmente portare ³ti debo, secōdariamente chè tu sai ⁴abbreviare o prolungare le uite ⁵ali omini.

I obey Thee Lord, first for the love I ought, in all reason to bear Thee; secondly for that Thou canst shorten or prolong the lives of men.

Prayers to God (1132. 1133).

W. An. IV. 172 a]

1133.

¶ORATIO.

²Tu o Iddio ci vendi ³tutti li beni per prez⁴zo di fatica.¶

A PRAYER.

Thou, O God, dost sell us all good things at the price of labour.

A. 24 a]

1134.

O mirabile givstitia di te, primo motore, · tu · non · ài · voluto · mācare · a nessuna ²potētia l'ordine e qualità de' sua · neciessari effetti.

O admirable impartiality of Thine, Thou first Mover; Thou hast not permitted that any force should fail of the order or quality of its necessary results.

The powers of Nature (1134—1139).

S. K. M. III. 49 a]

1135.

La neciessità · è · maestra ²e tutrice · della · natura;
³La neciessità è tema e in⁴ventrice · della natura ⁵e freno e regola eterna.

Necessity is the mistress and guide of nature.
Necessity is the theme and the inventress, the eternal curb and law of nature.

1132. 3. sechondaria. 4. abrieviere. **1133.** 2. "tu" | o idio [che] ci vende. 3. per pre. 4. faticha.
1134. 1. māchare a nessuna [creata chosa]. 2. "equalita" de sua.
1135. 1. he maesstra. 2. ettutrice. 3. ettema. 5. effrno.

Tr. 75] **1136.**

Molte volte una medesima cosa · è tirata da 2 violētie, ²cioè · neciessità · e potentia ·; l'acqua piove, la terra l'assorbisce, ³per neciessità d'omore ·, e 'l sole la sveglie nō per neciessità, ma per potētia.

In many cases one and the same thing is attracted by two strong forces, namely Necessity and Potency. Water falls in rain; the earth absorbs it from the necessity for moisture; and the sun evaporates it, not from necessity, but by its power.

S. K. M. II.² 43a] **1137.**

La gravità, la forza · · e'l moto · accidentale · insieme col²la percussione · son · le quatro · accidentali · potentie, ³colle · quali · tutte · l'euidenti · opere de' mortali ⁴ànno · loro · essere · e loro morte.

Weight, force and casual impulse, together with resistance, are the four external powers in which all the visible actions of mortals have their being and their end.

Tr. 70] **1138.**

¶Il corpo nostro è sottoposto al cielo, e lo cielo è sottoposto allo spirito.¶

Our body is dependant on heaven and heaven on the Spirit.

H.3 93a] **1139.**

Il moto è causa d'ogni vita.

The motive power is the cause of all life.

W. XXIX] **1140.**

Psychology (1140–1147).

E tu uomo, che consideri in questa ²mia fatica l'opere mirabili della ³natura, se giudicherai essere cosa ⁴nefanda il distruggerla, or pēsa ⁵essere cosa nefandissima il torre la ⁶vita all' omo, del quale, se questa ⁷sua cōpositione ti pare di marauiglio⁸so artifitio, pensa questa essere ⁹nulla rispetto all' anima che in ¹⁰tale architettura abita, e vera¹¹mente, quale · essa si sia, ella è ¹²cosa diuina, sicchè lascia ¹³la abitare nella sua opera a suo be¹⁴neplacito, e nō volere che la tua ¹⁵ira o malignità distrugga ¹⁶una tāta vita, chè ve¹⁷ramēte, chi non la ¹⁸stima, non la ¹⁹merita.

And you, O Man, who will discern in this work of mine the wonderful works of Nature, if you think it would be a criminal thing to destroy it, reflect how much more criminal it is to take the life of a man; and if this, his external form, appears to thee marvellously constructed, remember that it is nothing as compared with the soul that dwells in that structure; for that indeed, be it what it may, is a thing divine. Leave it then to dwell in His work at His good will and pleasure, and let not your rage or malice destroy a life—for indeed, he who does not value it, does not himself deserve it[19].

1136. 1. volte va medesima chosa ettirata. 2. losorbisscie. 3. sole lassuele.
1137. 1. chol. 3. cholli . . tucte. 4. elloro.
1138. 1. essottoposto. 2. ello . . essottoposto.
1139. R. chausa.
1140. 1, quessta. 3. gudicherai. 4. desstrugerla. 7. sua cō [sa] positione. 12. diuina [sig] che [si] lasscia. ' 13. assuo. 14. chella. 15. distrugha. 17. chi nolla. *The last seven lines are very indistinct.* 20. si pa"r"te dal. 21. corpo e ben. 22. reto chol su. 23. o pianto e ch. 24. ore nō sia. 25. anza [g] ca. 26. one.

1140. This text is on the back of the drawings reproduced on Pl. CVII. Compare No. 798, 35 note on p. 111: Compare also No. 837 and 838.
19. In MS. I¹ 15a is the note: *chi nō stima la vita, non la merita.*

1141.

Tr. 78]

L'anima mai si può corrōpere · nella corruttiō del corpo, ma fa nel corpo ²a similitudine del uēto che cavsa il suono del organo, ³chè guastādosi vna canna, nō resultava per quella del uēto ⁴buono effetto.

The soul can never be corrupted with the corruption of the body, but is in the body as it were the air which causes the sound of the organ, where when a pipe bursts, the wind would cease to have any good effect.

1142.

C. A. 58 a; 180 a]

Ogni parte à inclinatiō ²di ricōgiugnersi al suo ³tutto per fugire dalla ⁴sua inperfettione;

⁵L'anima desidera stare ⁶col suo corpo, perchè sanza ⁷li strumēti organici di tal ⁸corpo nulla può operare ⁹nè sētire.

The part always has a tendency to reunite with its whole in order to escape from its imperfection.

The spirit desires to remain with its body, because, without the organic instruments of that body, it can neither act, nor feel anything.

1143.

C. A. 75 a; 219 a]

Chi vuole vedere come l'anima abita nel suo ²corpo, guardi come esso corpo vsa la ³sua cotidiana abitatione, cioè se quella ⁴è sanza ordine e confusa, disordina⁵to e cōfuso fia il corpo tenvto dalla sua anima.

If any one wishes to see how the soul dwells in its body, let him observe how this body uses its daily habitation; that is to say, if this is devoid of order and confused, the body will be kept in disorder and confusion by its soul.

1144.

Br. M. 278 b]

Perchè vede piv certa la cosa l'ochio ne' sogni ²che colla imaginatione, stando desto?

Why does the eye see a thing more clearly in dreams than with the imagination being awake?

1145.

Tr. 65]

I sensi sono terrestri, la ragione sta ²fuor di quelli, quādo cōtenpla.

The senses are of the earth; Reason, stands apart in contemplation.

1146.

Tr. 70]

Ogni attione bisognia che s'esercita ²per moto;

³¶Cogniosciere e volere sō 2 operationi ⁴vmane;¶

⁵Discernere, givdicare, cōsigliare ⁶sono atti vmani.

Every action needs to be prompted by a motive.

To know and to will are two operations of the human mind.

Discerning, judging, deliberating are acts of the human mind.

1141. 1. chorrōpere . . curuttiō . . maffa. 2. assimilitudine . . chavsa del sono. 3. guasstādosi . . chana.
1142. 3. tutto [fa] per. 4. inperfectione. 6. chol. 7. orghanici.
1143. 1. vole . . chome. 2. chorpo . . chome esso chorpo. 3. chotidiana . . secquella. 4. chonfusa. 5. chōfuso . . chorpo.
1144. 2. dessto.
1145. 1. teresti. 2. for di queli . . chōtempla.
1146. 1. chessesercita. 3. cogniossciere . . operatione. 5. dissciernere . . chōsigliare.

1141. Compare No. 845.
1145. Compare No. 842.

Tr. 45] **1147.**

Ogni nostra cognitione prīcipia da sen-
timēti.

All our knowledge has its origin in
our preceptions.

Tr. 51] **1148.**

Sciētia—notitia delle cose che sono pos-
Science, its sibili, presēti e preterite; ² presciētia—notitia
principles
and rules delle cose che possī uenire, ³però lento.
(1148—1161).

Science is the observation of things pos-
sible, whether present or past; prescience is
the knowledge of things which may come
to pass, though but slowly.

C. A. 85 a; 247 a] **1149.**

La speriēza, ²interprete infra ³l'artifi-
tiosa natu⁴ra e la umana spe tie, ne insegnia
ciò ⁶che essa natura infra ⁷mortali ado-
pera, ⁸da neciessità co⁹stretta non altri-
¹⁰mēti operarsi po¹¹ssa · che la ragiō, suo
timone, ¹²operare le asse¹³gni.

Experience, the interpreter between forma-
tive nature and the human race, teaches how
that nature acts among mortals; and being
constrained by necessity cannot act otherwise
than as reason, which is its helm, requires
her to act.

S. K. M. III. 80 b] **1150.**

La sapiētia è figliola della ²speriētia.

Wisdom is the daughter of experience.

I.¹ 18 a] **1151.**

La natura è piena d'infinite ragioni ²che
nō furō mai in isperiētia.

Nature is full of infinite causes that have
never occured in experience.

M. 58 b] **1152.**

¶La verità fu sola fi²gliola del tenpo.¶

Truth was the only daughter of Time.

C. A. 151 a; 449 a] **1153.**

La speriēza nō falla mai, ma sol fallano
i vostri giuditi, promettendosi di quella
²efetti · tali che ne' uostri esperimēti
causati nō sono;
³La speriēza nō falla ·, ma sol fallano i
vostri giuditi, promettēdosi di lei cose, che
nō ⁴sono in sua potestà; ⁵a torto si lamen-
tano li omini della speriēza, cō somme
rampogne quella ⁶accusano esser fallace,

Experience never errs; it is only your
judgments that err by promising themselves
effects such as are not caused by your
experiments.
Experience does not err; only your
judgments err by expecting from her what
is not in her power. Men wrongly com-
plain of Experience; with great abuse they
accuse her of leading them astray but they set

1147. 1. prēcipia.
1148. 1. notiti delle chessono possibile presente. 2. cose che pesi uine che posī uenire. 3. penvlente.
1149. 1. lassperiēza. 4. ella. 5. ninsegna. 8. cō. 11. chella ragiō "suotimone". 12. hoperare. 12. asegni.
1150. 1 dela. 2. speriētia la quale speri. 3. ēza *here the text breaks off.*
1151. 2. inisperiētia.
1152. 1. verita sola fu fi. 2. glola.
1153. 1. vosstri guditi. 2. [tale] effetto | "tale" che ine uosstri . . chausati. 3. essperiēza . . massol . . vosstrigiuditi [i quali sa]
 prometa "desi". 5. attorto si lamenta . . della ["innocēte" issperieza la quale con some ranpogne. 7. Ma lasciāno.

[7]ma lasciano stare essa speriētia, [8]voltati dalle lamentationi contro alla nostra ignoranza, la quale ui [9]fa trascorrere con uostri vani e stolti desideri a inprometterui di quella cose che nō sono [10]in sua potētia, [11]dicendo quella esser fallace; [12]a torto si lamētan li omini della innocente sperientia ⋅, quella spesso accusando [13]di fallacia e di bugiarde [14]dimostrationi.

Experience aside, turning from it with complaints as to our ignorance causing us to be carried away by vain and foolish desires to promise ourselves, in her name, things that are not in her power; saying that she is fallacious. Men are unjust in complaining of innocent Experience, constantly accusing her of error and of false evidence.

1154.

Mz. 1 a (3)

¶ La scientia strumentale over machinale [2]è nobilissima e sopra tutte l'altre vtilissima, [3]cōciosiachè mediante quella tutti li corpi ani[4]mati, che ànno moto, fanno tutte loro operationi, i quali moti [5]nascono dal centro della lor grauità che è posto [6]in mezzo a parte di pesi disequali, e à questo [7]carestia e dovitia di muscoli, ed etiā lie-[8]va e contralieua. ¶

Instrumental or mechanical science is of all the noblest and the most useful, seeing that by means of this all animated bodies that have movement perform all their actions; and these movements are based on the centre of gravity which is placed in the middle deviding unequal weights, and it has dearth and wealth of muscles and also lever and counter-lever.

1155.

E. 8 b]

DELLA MECCANICA.

[2]La meccanica è il paradiso delle sciētie matema[3]tiche, perchè cō quella si viene al frutto matematico.

OF MECHANICS.

Mechanics are the Paradise of mathematical science, because here we come to the fruits of mathematics.

1156.

Br. M. 191 a]

A ciascuno strumēto si richiede [2]esser fatto colla speriēza.

Every instrument requires to be made by experience.

1157.

W. An. III. 241 a]

Chi biasima la soma certezza della [2]matematica, si pasce di confusione [3]e mai porrà silentio [4]alle contraditioni delle soffi-[5]stiche sciētie, colle quali [6]s'inpara vno eterno gridore.

The man who blames the supreme certainty of mathematics feeds on confusion, and can never silence the contradictions of sophistical sciences which lead to an eternal quackery.

1158.

G. 95 b]

Nessuna certezza delle sciētie è, do[2]ve nō si può applicare [3]vna delle sciētie matema[4]tiche e che non sono v[5]nite con esse matematiche.

There is no certainty in sciences where one of the mathematical sciences cannot be applied, or which are not in relation with these mathematics.

8. evoltati . . lamentatione . . ingnoranza. 9. transcorrere co uosstre "vani e" in stolti . . "di quella" chose. 10. in "sua" potētia. 12. attorto . . della "inocente" essperientia . . achusando. 13. bugarde. 14. dimōstratione. Ma *here the text breaks off.*

1154. 1. Lasscientia. 2. essopra. 3. conco sia che. 4. mati "che annomoto" fanno . . ecquali. 5. nasscano . . possto. 6. mezo apparte . . acquesto. 7. charesstia e douitia di mvsscoli.

1155. 1. dela mechanicha. 2. mechanicha. 3. perchche chō . . matema"ticho".

1156. 1. ciasscuno. 2. cholla essperiēza.

1157. 1. certeza delle. 2. matematiche si passce. 3. [e mati] e mai.

1158. 1. certezza "dele sciētie" e do. 2. po applichare.

1155. Compare No. 660, ll. 19—22 (Vol. I., p. 332).

C. A. 75 a; 219 a]　　　　　　　　　1159.

Chi disputa allegādo l'autorità, non adopera ²lo ingiegno, ma pivtosto · la memoria; ³le buone · lettere son nate da vn bono naturale, ⁴e perchè si de' piv laudare la cagiō che l' effetto, ⁵piv lauderai vn buon naturale sanza lettere, ⁶che vn bon letterato sanza naturale.

Any one who in discussion relies upon authority uses, not his understanding, but rather his memory. Good culture is born of a good disposition; and since the cause is more to be praised than the effect, I will rather praise a good disposition without culture, than good culture without the disposition.

I.2 82 a]　　　　　　　　　1160.

La sciētia è il capitano, e la pratica sono i soldati.

Science is the captain, and practice the soldiers.

G. 8 a]　　　　　　　　　1161.

DELL'ERRORE DI QUELLI CHE VSANO ²LA PRATICA SANZA SCIĒTIA.

³Quelli che s'inamorā di pratica ⁴sāza sciētia sō come 'l nocchiere che ē⁵stra navilio sanza timone e bussola, ⁶chè mai à certezza dove si vada.

OF THE ERRORS OF THOSE WHO DEPEND ON PRACTICE WITHOUT SCIENCE.

Those who fall in love with practice without science are like a sailor who enters a ship without a helm or a compass, and who never can be certain whither he is going.

1159. 1. laturita. 2. longiegno. 3. sonate. 4. laldare la chagiō chelle fetto. 5. lalderai vn bo. 6. literato.
1160. 1. ella pratica.
1161. 1—6 R. 1. erore. 2. praticha. 3. chessinnamorā di praticha. 4. nochieri. 5. ebbussola. 6. cierteza.

II.

MORALS.

Br. M. 156 b]

1162.

Or vedi la sperāza e'l desiderio del ripatriarsi ²e ritornare nel primo caso fa a similitudine della farfalla al lume, e l'uomo ³che cō cōtinvi desideri sēpre cō festa aspetta la nvova ⁴primavera, sempre la nvova state, sempre e nvovi mesi, ⁵e nvovi anni, parēdogli che le desiderate cose, venēdo, ⁶sieno troppe tarde, E' non s'avede che desidera la sua disfazi⁷one; ma questo desiderio è la quītessenza, spirito degli ele³menti, che trovādosi rīchivsa per l'anima dallo vmano corpo ⁹desidera senpre ritornare al suo mandatario; ¹⁰E uo' che sappi che questo medesimo desiderio è quella quītessēza, ¹¹cōpagnia della natura, e l'uomo è modello dello mōdo.

Now you see that the hope and the desire of returning home and to one's former state is like the moth to the light, and that the man who with constant longing awaits with joy each new spring time, each new summer, each new month and new year—deeming that the things he longs for are ever too late in coming—does not perceive that he is longing for his own destruction. But this desire is the very quintessence, the spirit of the elements, which finding itself imprisoned with the soul is ever longing to return from the human body to its giver. And you must know that this same longing is that quintessence, inseparable from nature, and that man is the image of the world.

What is life? (1162. 1163).

C. A. 70 a; 207 a]

1163.

O tēpo, consumatore delle cose, ²e o invidiosa antichità, tu distruggi tutte le cose, ³e consumi tutte le cose da duri dēti ⁴della vecchiezza a poco a poco cō lēta ⁵morte! Elena quando si specchiaua, vedēdo ⁶le vizze grinze del suo viso, fatte per la vecchi⁷ezza, piagnie e pēsa seco, perchè fu rapita ⁸due volte.

O Time! consumer of all things; O envious age! thou dost destroy all things and devour all things with the relentless teeth of years, little by little in a slow death. Helen, when she looked in her mirror, seeing the withered wrinkles made in her face by old age, wept and wondered why she had twice been carried away.

1162. 1. *On the margin:* pro, *meaning probably* propositione. 2. lassperāza [del suo] el desidero 2. chas"o" . . assimilitudine ·"dela farfalla alume" dell uomo. 3. chō chōtinvi . . chō fessta asspetta. 5. chose. 6. dissfazi. 7. Desidero e ne i [q] la quīte essenza. 8. peranima dello chorpo. 10. chessapi . . quīta esēza. 11. chōpagnia . . elluomo.

1163. 1. chonsumatore . . chose. 2. disstruggi . . chose. 3. chonsumate . . chose. 4. vecchieza appocho appocho chō. 5. elena . . sisspecchiaua. 6. leuzze grinze. 7. eppēsa secho. 8. da volte. 9. chonsumatore . . chose. 10. lesono chonsumate.

⁹O tēpo consumatore delle · cose ·, e o invidiosa · antichi¹⁰tà, per la quale tutte le cose sono consumate!

O Time! consumer of all things, and O envious age! by which · all things are all devoured.

H 2 33*b*]

1164.

Death.

Ogni danno lascia dispiacere ²nella ricordatione, saluo ³che'l sommo dāno, cioè la morte, che ⁴uccide essa ricordatione īsieme ⁵colla vita.

Every evil leaves behind a grief in our memory, except the supreme evil, that is death, which destroys this memory together with life.

C. A. 75*b*; 219*b*]

1165.

How to spend life (1165—1179).

¶O dormiēte · che cosa · è sonno? ȷl sōno à similitudine · colla morte; O perchè non fai · adunque tale opera, che dopo la morte ²tu abbi similitudine di perfetto viuo, che uiuendo · farsi col sonno simile ai tristi morti?¶

O sleepers! what a thing is slumber! Sleep resembles death. Ah why then dost thou not work in such wise as that after death thou mayst retain a resemblance to perfect life, when, during life, thou art in sleep so like to the hapless dead?

G. 89*a*]

1166.

L'un caccia l'al²tro.
³Per questi quadretti ⁴s'intende la uita ⁵e li studi umani.

One pushes down the other. By these square-blocks are meant the life and the studies of men.

C. A. 365*b*; 1141*b*]

1167.

¶La cognitiō del tēpo preterito ²e del sito della terra è orna³mēto e cibo delle mēti vmane.¶

The knowledge of past times and of the places on the earth is both an ornament and nutriment to the human mind.

Mz. 8*a* (12)

1168.

È di tāto vilipēdio la bugia, che s'ella dicesse bene già ²cose di Dio, ella toglie gratia a sua deità, ed è di tāta eccellē³tia la uerità, che s'ella laudasse cose minime elle si faño nobili;
⁴Sanza dubbio tal proportione è dalla verità alla bugia, qual è ⁵dalla luce alle tenebre, ed è essa verità in se di tanta eccellē⁶tia che, ancora ch'ella s'estenda sopra vmili e basse materie, ⁷sanza comparatione ella eccede le incertezze e bugie

To lie is so vile, that even if it were in speaking well of godly things it would take off something from God's grace; and Truth is so excellent, that if it praises but small things they become noble.

Beyond a doubt truth bears the same relation to falsehood as light to darkness; and this truth is in itself so excellent that, even when it dwells on humble and lowly matters, it is still infinitely above uncertainty and lies, disguised in high and

1164. 1. dāv lasscia disspiacere. 3. somo. 4. viede.
1165. 1. chosa . . assimilitudine cholla. 2. abi . . chol sono. **1166.** 5. elli.
1167. 1. chognitiō. 3. eccibo . . vma"ne".
1168. 1. ede di . . chessella dicessi. 2. dio ella to di gratia assua. 3. chessella laldassi. 5. verita "in se" di. 6. anchora sastende. 7. comperatione ellaccede . . esstese. 8. pra [le altissime] li . disscorsi. 9. nosstra anchora. 10. no resta . .

1165. Compare No. 676, Vol. I. p. 353.

estese so⁸pra li magni e altissimi discorsi, perchè la mē⁹te nostra, ancora ch'ell'abbia la bugia pel quīto elemēto, ¹⁰non resta però che la verità delle cose nō sia di sommo no¹¹trimento delli intelletti fini, ma non di uaga¹²bundi ingegni;

¹³Ma tu che ¹⁴viui di sogni, ¹⁵ti piaciono più le ¹⁶ragioni soffistiche ¹⁷e barerie de' ¹⁸pallaji nelle ¹⁹cose grādi ²⁰e incerte, che ²¹le certe ²²naturali e ²³nō di tāta al²⁴tura.

lofty discourses; because in our minds, even if lying should be their fifth element, this does not prevent that the truth of things is the chief nutriment of superior intellects, though not of wandering wits.

But you who live in dreams are better pleased by the sophistical reasons and frauds of wits in great and uncertain things, than by those reasons which are certain and natural and not so far above us.

S. K. M. III. 36*b*] **1169.**

⁜ Fuggi quello · studio · del quale ²la resultante opera more insie³me coll' operante d'essa.

Avoid studies of which the result dies with the worker. ✳

C. A. 75*a*; 219*a*] **1170.**

A torto si lamētā li omini della fuga del tenpo, ²incolpando quello di troppa velocità, nō s'accorgiēdo ³quello essere di bastevole trāsito, ma bona me⁴moria·, di che la natura ci à dotati, ci fa che ⁵ogni cosa lungamēte passata ci pare essere presente.

Men are in error when they lament the flight of time, accusing it of being too swift, and not perceiving that it is sufficient as it passes; but good memory, with which nature has endowed us, causes things long past to seem present.

C. A. 111*a*; 345*a*] **1171.**

Acquista cosa nella tua giovētù ²arresta il danno della tua ve³cchiezza; — ⁴e se tu intēdi ⁵la vechiezza aver per suo cibo la sa⁶piētia, adoperati in tal modo in giovē⁷tù che tal uecchiezza nō māchi il nu⁸trimēto.

Learning acquired in youth arrests the evil of old age; and if you understand that old age has wisdom for its food, you will so conduct yourself in youth that your old age will not lack for nourishment.

C. A. 223*b*; 671*b*] **1172.**

¶L'acquisto di qualūche cognitione ²è sēpre vtile allo intelletto, perchè potrà ³scacciare da se le cose inutili è riserva⁴re lè buone;¶

⁵¶perchè nessuna cosa si può amare ne odiare, ⁶se prima nō si à cognitiō di quella.¶

The acquisition of any knowledge is always of use to the intellect, because it may thus drive out useless things and retain the good.

For nothing can be loved or hated unless it is first known.

Tr. 32] **1173.**

¶Siccome · vna · giornata · bene spesa dà lieto dormire, così vna vita · bene · vsata · dà lieto morire.¶

As a day well spent procures a happy sleep, so a life well employed procures a happy death.

chella . . chose . . somo. 12. ingegni ingeni. 13. mattu. 15. piace. 16. ragō soffistice. 18. palari. 21. delle certe.
1169. 3. choll.
1170. 2. incholpando . . tropa . . sachorgiēdo. 4. ci fa [parere] "che". 5. chosa.
1171. 1. chosa . . goventu. 2. cheresta il. 3. chieza [ovr o chettu masstulli la tu]. 4. [a vechiezza]—essettu. 6. govē.
7. chettal vecheza.
1172. 1. chognitione. 3. schacciare dasse le chose inutile. 4. re le. 5. chosa. 6. chognitiō.
1173. 1. sicchome . . dallieto.

Tr. 68]　　　　　　　　　1174.

L'acqua che tochi de' fivmi, è l'ulti²ma di quella · che ādò, e la prima ³di quelle · che viene; così il tēpo ⁴presēte;
⁵La vita bene spesa lunga è.

The water you touch in a river is the last of that which has passed, and the first of that which is coming. Thus it is with time present. Life if well spent, is long.

W. XII.]　　　　　　　　1175.

Siccome māgiare · sanza voglia si cōuerte ²ī fastidioso · notrimento ·, così lo studio sā³za desiderio · guasta la ⁴memoria, col ⁵nō ritenere cosa ch'ella pigli.

Just as food eaten without caring for it is turned into loathsome nourishment, so study without a taste for it spoils memory, by retaining nothing which it has taken in.

Ash. I. 1 b]　　　　　　　1176.

Siccome il mangiare · sanza · voglia fia dañoso · alla salute, ²così lo studio sanza · desiderio guasta · la memoria, e nō ritiē cosa · ch'ella pigli.

Just as eating against one's will is injurious to health, so study without a liking for it spoils the memory, and it retains nothing it takes in.

C. A. 284 b; 865 b]　　　　　　1177.

Ti ghiacciano le parole · in bocca, ²e faresti gielatina ī Mōgibello;
³Siccome il ferro s'arruginiscie sanza ⁴esercitio, e l'acqua si putrefa e nel freddo ⁵s'agghiaccia ·, così l'ingiegnio sanza e⁶sercitio si guasta;
⁷Mal fai se lodi ·, e peggio se tu riprēdi ⁸la cosa ·, quādo bene · tu nō la intēdi;
⁹Quādo fortuna viē, prēdi l'a mā salua ¹⁰dināti, perchè retro · è · calua.

On Mount Etna the words freeze in your mouth and you may make ice of them[2].
Just as iron rusts unless it is used, and water putrifies or, in cold, turns to ice, so our intellect spoils unless it is kept in use.
You do ill if you praise, and still worse if you reprove in a matter you do not understand.
When Fortune comes, seize her in front with a sure hand, because behind she is bald.

W. An. II. 203 a] (24)　　　　1178.

Nō mi | pare che li omini grossi e di ²tristi costumi e di poco discorso meritino si bello stru³mēto, nè tanta varietà di machinamēti quanto li omini speculatiui e ⁴di grā discorsi, ma solo vn sacco doue si ri-

It seems to me that men of coarse and clumsy habits and of small knowledge do not deserve such fine instruments nor so great a variety of natural mechanism as men of speculation and of great knowledge; but merely a

1174. 1. chettochi. 2. ādo ella. 3. quelli.
1175. 1. sichome . . chōuerte. 2. losstudio. 3. za [disspositione] desiderio quassta. 4. memoria [chol nō pigliare alchuna]. 5. e nō ritenere chosa chclla pigli.
1176. 1. sichome . . voglia [da danno] fia. 2. chosi losstudio . . chosa.
1177. 1. diaciano . . bocha. 2. effaresti. 3. si chome il fero sa . ruginissce. 4. ellacq"a" . . fredo. 5. sagiacia chosi. 7. pegio istu. 8. nolantēdi. 10. dinātico . perche reto e chalua.
1178. 1. chelli . . grosi. 2. trissti chorstumi "e di pocho disscorso" meritino. 3. nettanta . . spechulatiui e di. 4. disscorsi.

1177. 1. 2. There is no clue to explain this strange sentence.

ceua il cibo, e donde esso ⁵ esca, chè in vero altro che un transito di cibo non sō da essere giudicati, ⁶ perchè niente mi pare che essi participino di spetie vmana altro, che la voce ⁷ e la figvra, e tutto il resto è assai manco che bestia.

sack in which their food may be stowed and whence it may issue, since they cannot be judged to be any thing else than vehicles for food; for it seems to me they have nothing about them of the human species but the voice and the figure, and for all the rest are much below beasts.

S. K. M. III. 17 a] **1179.**

Ecco alcuni che non altramente che trā²sito di cibo e avmētatori di ster³co e rienpitori di destri chiamarsi debono, perchè per ⁴ loro non altro nel mōdo o pure alcuna virtù in opera si ⁵ mette, perchè di loro altro ⁶ che pieni destri non resta.

Some there are who are nothing else than a passage for food and augmentors of excrement and fillers of privies, because through them no other things in the world, nor any good effects are produced, since nothing but full privies results from them.

C. A. 153 b; 455 b] **1180.**

Il massimo ingāno delli omini ² è nelle loro oppinioni.

The greatest deception men suffer is from their own opinions.

On foolishness and ignorance (1180—1182).

Tr. 56] **1181.**

La stoltitia è scudo della vergogna, come la imprōtitudine ² della povertà glorificata.

Folly is the shield of shame, as unreadiness is that of poverty glorified.

Tur. 17 b] **1182.**

La ciecca igniorāza così ci cōduce ² cō effetto de' lascivi sollazzi
 ³ {per nō conosciere la uera luce.
 ⁴ {per nō conosciere qual sia la uera luce.
 ⁵ E'l uano splendor ci toglie l'esser
⁶;¶vedi che per lo splendor nel fuoco andiamo, ⁸ come ciecca jgnorāza ci cōduce.
 ¹⁰ O miseri mortali aprite li occhi.

Blind ignorance misleads us thus and delights with the results of lascivious joys.
{Because it does not know the true light.
{Because it does not know what is the true
 light.
Vain splendour takes from us the power of being behold! for its vain splendour we go into the fire, thus blind ignorance does mislead us. That is, blind ignorance so misleads us that ...
O! wretched mortals, open your eyes.

Ash. I. 1 a] **1183.**

Nō si dimāda · richezza · quello · che si può perdere; ² la uirtù · è vero · nostro · bene ed è vero premio ³ del suo · possessore ·; lei nō si può · perdere ·, lei ⁴ nō ci abandona ·,

That is not riches, which may be lost; virtue is our true good and the true reward of its possessor. That cannot be lost; that never deserts us, but when life leaves us. As

On riches (1183—1187).

5. sacho [da cibo] doue. 6. essca . . gudicati. 7, chella voce. 18. ella . . ettutto erresto . . mancho che besstia.
1179. 1. ecci . . che altro chettrā. 3. cho | "e rienpitori ʃdi desstri" chiamarsi. 4. loro | "altro nel mōdo o pure" alchuna.
 6. pieni e desstr.
1180. 2. he nelloro oppennione.
1181. 1. esschudo . . chome. 2. grorifichato.
1182. 1. ciccha . . chosi ci chōduce. 2. e chō . . lasscivi sollazzi. 3. chonossciere. 4. chonossciere. 6. b |\\\\ ¶ vedi fucho andiano. 7. ¶ ciecha īgnorāza . . intal modo chōduce. 8. coe chome ciecha jgnorāza ci chōduce. 9. che.
1183. 1. richeza . . chessi. 4. lasscia. 5. elle esterne. 6. isspeso lassciano choniscorno. 7. essbeffato iloro.

se prima la uita nō ci lascia; ⁵le robe e le esterne diuitie · senpre le tieni ⁶cō timore; spesso lasciano · con scorno ⁷e sbeffato · il loro possessore perdēdo lor possessione.

to property and external riches, hold them with trembling; they often leave their possessor in contempt, and mocked at for having lost them.

F. 96*b*] **1184.**

Ogni omo desidera far capitale per ²dare a medici destruttori di uite, adūque debono essere richi;

³L'uomo à grande discorso, del quale la più parte ⁴è vana e falsa, li animali l'ànno piccolo, ma è vti⁵le e vero, e meglio è la piccola certezza che la grā ⁶bugia.

Every man wishes to make money to give it to the doctors, destroyers of life; they then ought to be rich[2].

Man has much power of discourse which for the most part is vain and false; animals have but little, but it is useful and true, and a small truth is better than a great lie.

C. A. 108*b*; 338*b*] **1185.**

Chi piv possiede piv debbe ²temere di nō perdere.

He who possesses most must be most afraid of loss.

W. XIII] **1186.**

Chi uuole essere ricco in v̄ dì ²e impiccato in vn anno.

He who wishes to be rich in a day will be hanged in a year.

S. K. M. III. 77*a*] **1187.**

E questo uomo à vna somma ²pazzia cioè che sēpre stēta per ³non stētare, e la uita a lui ⁴fugie sotto sperāza di gode⁵re i beni con somma fatica ac⁶quistati.

That man is of supreme folly who always wants for fear of wanting; and his life flies away while he is still hoping to enjoy the good things which he has with extreme labour acquired.

B. 3*b*] **1188.**

Se tu · avessi · il corpo secōdo la virtù ·, tu . nō carpesti ²in questo mōdo;

³Tu cresci ī reputatione come il pane ī mano a' putti.

Rules of Life (1188—1202).

If you governed your body by the rules of virtue you would not walk on all fours in this world.

You grow in reputation like bread in the hands of a child.

Tr. 2] **1189.**

Saluatico è quel che si salua.

Savage he is who saves himself.

1184. 2. medici "destruttori di iute" aduque . . esse. 4. picholo. 5. verso . . ella pichola certeza.
1185. 1. ci piv posiede. 2. no.
1186. 1. richo nv̄di. 2. empichato nvn.
1187. 1. uomo . . soma. 2. pazia . . chessēpre. 3. istētare ella uita seli. 5. soma faticha a. 6. quisstati
1188. 1. settu . . capresti. 3. cressci.

1184. 2. Compare No. 856.
1188. The first sentence is obscure. Compare Nos. 825. 826.

E. 31*b*]

1190.

Non si debbe desiderare lo inpossibile.

We ought not to desire the impossible.

H.3 70*b*]

1191.

Dimāda cōsiglio a chi bē si corregge;
²Givstitia vuol potētia, intelligē³tia e volontà, e si assomi⁴glia al rè delle api;
⁵Chi nō puniscie il male, co⁶māda che si facci;
⁷Chi piglia la biscia per la coda ⁸quella poi lo morde;
⁹Chi cava la fossa, quella ¹⁰gli ruina adosso.

Ask counsel of him who rules himself well.
Justice requires power, insight, and will; and it resembles the queen-bee.
He who does not punish evil commands it to be done.
He who takes the snake by the tail will presently be bitten by it.
The grave will fall in upon him who digs it.

H.3 71*a*]

1192.

¹Chi nō rafrena la uoluttà ·, colle bestie ²s'acōpagni;
³Nō si può avere maggior nè minor signio⁴ria che quella di se medesimo;
⁵Chi poco pēsa, molto erra;
⁶Più facilmēte si cōtesta al prīcipio, ⁷che al fine;
⁸Nessuno cōsiglio è piv leale che ⁹quello che si da alle navi che so¹⁰no in pericolo;
¹¹Aspetti danno quel che si regie per ¹²giovane sconsigliato.

The man who does not restrain wantonness, allies himself with beasts.
Yon can have no dominion greater or less than that over yourself.
He who thinks little, errs much.
It is easier to contend with evil at the first than at the last.
No counsel is more loyal than that given on ships which are in peril: He may expect loss who acts on the advice of an inexperienced youth.

Tr. 39]

1193.

Dov'è piv sentimēto, lì è piv martirio; grā martire.

Where there is most feeling, there is the greatest martyrdom;—a great martyr.

H.1 16*b*]

1194.

La memoria de' benifitj apres²so l'īgratitudine è fragile;
³Reprēdi l'amico ī segre⁴to, e laudalo ī paleso;
⁵Non essere bugiardo del ⁶preterito.

The memory of benefits is a frail defence against ingratitude.
Reprove your friend in secret and praise him openly.
Be not false about the past.

1190. 1. debba.
1191. 1–10 R. 1. ach bē si corege. 2. vol. 3. essi. 4. gia are delleave. 5. punisscie. 9. cicava. 10. glruina.
1192. 1—12 R. 1. cholle. 3. po . . magior. 5. ci poco. 6. a prīcipio. 8. nesuno chōsiglio. 9. chessi da dalle. 10. pericholo. 11. dano. 12. giovane scōsiglo.
1193. piv ne martiri. 1194. 1—6 R. 1. benifiti apre. 4. ellaldalo. *Two lines between l. 4 and l. 5 are effaced.*

1190. The writing of this note, which is exceedingly minute, is reproduced in facsimile on Pl. XLI No. 5 above the first diagram.

C. A. 115*b*; 357*b*]

1195.

CŌPERATIONE DELLA PATIĒTIA.

²La patiētia fa cōtra alle ingiurie non altramēti che si faccino i panni ³contra del freddo, jnperochè se ti mvltiplicherai li pañi secondo la mvl⁴tiplicatione · del freddo ·, esso freddo · nocere nō · potrà ·; similmēte alle ⁵grādi ingivrie · cresci la patiētia, · e esse ingiurie offendere nō ti po⁶tranno la tua mēte.

A SIMILE FOR PATIENCE.

Patience serves us against insults precisely as clothes do against the cold. For if you multiply your garments as the cold increases, that cold cannot hurt you; in the same way increase your patience under great offences, and they cannot hurt your feelings.

S. K. M. II.² 24*a*]

1196.

Tanto è a dire bē d'ū tristo, ²quanto a dire male d'ū bono.

To speak well of a base man is much the same as speaking ill of a good man.

H.² 12*b*]

1197.

La invidia offēde colla fitta ²infamia, cioè col detrarre, ³la qual cosa spavēta la virtù.

Envy wounds with false accusations, that is with detraction, a thing which scares virtue.

L. 0″]

1198.

Decipimur votis et tempore fallimur et mos ²deridet curas; anxia vita nihil.

We are deceived by promises and time disappoints us[2] . . .

L. 90*b*]

1199.

¶La pavra nascie piv tosto ²che altra cosa. ¶

Fear arises sooner than any thing else.

C. A. 75*b*; 219*b*]

1200.

Siccome l'animosità è pericolo di uita · così la paura · è sicurità di quella;

²Le minaccie sol sono ³arme dello minacciato;

⁴¶Dov'entra la uētura, la invidia · vi pone lo assedio e lo cōbatte, e dond'ella si parte, vi lascia il dolore e pētimēto;

⁵¶Raro cade chi ben camina;

Just as courage imperils life, fear protects it.

Threats alone are the weapons of the threatened man.

Wherever good fortune enters, envy lays siege to the place and attacks it; and when it departs, sorrow and repentance remain behind.

He who walks straight rarely falls.

1195. 2. allengiurie: altremēti . . chessi. 3. fredo jnpero chessetti . . sechondo. 4. esso fredo. 5. grāde . . cressci . . essa ingiuria.
1196. 1. trissto.
1197. 1—3 R. 1. lanvidia . . cholla. 2. chol. 3. spavēte.
1198. 1. et mos. 2. nhil.
1199. 1—2 R. 1. nasscie. 2. chosa.
1200. 1. sichome . . pericholo . . chosi . . sichurita. 3. iminacciato. 4. lanvidia . . essedio ello chōbatte E . . lasscia il "dolore he" piētimēto. 5. chade . . chamina. 6. laldi e pegio . . chosa dicho . . tu nolla. 7. laldi e pegio è tu . . tu nollātēdi.

1198. 2. The rest of this passage may be rendered in various ways, but none of them give a satisfactory meaning.

⁶¶Mal'è se laudi e peggio se riprēdi la cosa, dico se bene tu non la intēdi;

⁷¶Mal fai se laudi e peggio se tu ri-prēdi ‖ la cosa quādo bene tu non la intendi.

It is bad if you praise, and worse if you reprove a thing, I mean, if you do not under-stand the matter well.

It is ill to praise, and worse to reprimand in matters that you do not understand.

G. 49 a] 1201.

Senpre le parole che nō soddisfaño all'orechio dello ¦²auditore, li danno tedio over rincrescimēto, e'l segnio di ³ciò vedrai, spesse uolte tali auditori essere ⁴copiosi di sbadigli; addūque tu, che parli dināti a omini ⁵di chi tu·cierchi benivolētia, quādo tu vedi·tali pro⁶digi di rīcrescimēto, abre-uia il tuo parlare, o tu mu⁷ta ragionamēto, e se tu altramēti farai, allora in lo⁸co della desiderata gratia tu acquisterai odio ⁹e nimicitia;

¹⁰E se vuoi vedere di quel⁻che vn si diletta sanza u¹¹dirlo parlare, parla a lui mutādo diuersi ragio¹²namēti, e quel dove tu lo vedi stare intēto sanza ¹³sbadiglia-mēti o storcimēti di ciglia o altre varie ¹⁴azione, sia cierto che quella cosa, di che si parla, ¹⁵è quella di che lui si diletta, ecc.

Words which do not satisfy the ear of the hearer weary him or vex him, and the symptoms of this you will often see in such hearers in their frequent yawns; you there-fore, who speak before men whose good will you desire, when you see such an excess of fatigue, abridge your speech, or change your discourse; and if you do otherwise, then instead of the favour you desire, you will get dislike and hostility.

And if you would see in what a man takes pleasure, without hearing him speak, change the subject of your discourse in talk-ing to him, and when you presently see him intent, without yawning or wrinkling his brow or other actions of various kinds, you may be certain that the matter of which you are speaking is such as is agreeable to him &c.

Tr. 11] 1202.

Mvouesi l'amante per la cosa amata come il senso·e lo sensibile, e cō seco s'uniscie ²e fassi vna cosa medesima; ³l'opera è la prima cosa che nasce dal-l'unione; ⁴se la cosa amāta è vile·, l'amāte si fa vile;

⁵Quando·la cosa vnita è cōueniēte al suo ⁶vnitore·, li seguita·dilettatione·e pia-cere e soddisfatione;

⁷Quādo l'amāte è giv̄to all' amato, lì si riposa; ⁸quādo·il peso·è posato·lì si riposa.

The lover is moved by the beloved object as the senses are by sensible objects; and they unite and become one and the same thing. The work is the first thing born of this union; if the thing loved is base the lover becomes base.

When the thing taken into union is per-fectly adapted to that which receives it, the result is delight and pleasure and satisfaction.

When that which loves is united to the thing beloved it can rest there; when the burden is laid down it finds rest there.

C. A. 64 b; 197 b] 1203.

La prima fama si fa etterna insieme colli abitatori ²della città da lui edificata o accresciuta;

There will be eternal fame also for the inhabitants of that town, constructed and enlarged by him.

Politics (1203. 1204).

1201. 1. saddisfaño. 2. alditore . . rincresscimēto. 3. uolte [alli] ttali vlditore. 4. chopiosi di sbavigli. 6. rīcresscimēto . . ottu. 7. essettu altremēti . . allora illo. 8. cho. 9. ennimicitia. 10. Esse voi . . sanza vl. 11. allui. 12. ecquel . . tullo. 13. sbadigliamēti osstorcimeti. 14. azione . . di chessi. 15. ecquella . . lui si di che lui si diletta.

1202. 1. lamata per la cosamato ·. . senso ella sensibile e chōsecho. 2. effassi. 3. ella . . chosa . . nasscie dell. 4. sella. 5. chosa . . chōueniēte . . essadisfatione. 8. lì si riposato. 9. la cosasa chogni usscivta chol nostro intelletto.

1203. 2. dallui . . acressciuta. 3. obbediscano esso mossi . . collogano co signiori "e costringano. 4. sagvinita . . roba sang-

1203. These notes were possibly written in preparation for a letter. The meaning is obscure.

[3] Tutti i popoli · obbediscono e sō mossi da lor magniati ·, e essi magniati · si collegano e costringono coi signori [4] per 2 · vie: o per sanguinità ·, o per roba: sanguinità, quādo · i lor figlioli sono a similitudine [5] di statichi; sicurtà è pegnio della lor dubitata · fede; roba, quādo · tu farai a ciascū d'essi [6] murare vna casa o 2 dentro alla tua città, della quale lui ne tragga qual[7] ch'entrate · e trarrà . . . 10 città · cinque mila · case · cō trenta [8] mila abitatori ·, e digregerai tanta cōgregatione di popolo che a similitudine di capre l'ū [9] adosso all' altro stanno, ēpiēdo ogni parte di fetore e si fanno semēza di pestilēte [10] morte;

[11] E la città si fà di bellezza cōpagnia del suo nome e a te vtile di dati e fama etterna del suo crescimēto.

All communities obey and are led by their magnates, and these magnates ally themselves with the lords and subjugate them in two ways: either by consanguinity, or by fortune; by consanguinity, when their children are, as it were, hostages, and a security and pledge of their suspected fidelity; by property, when you make each of these build a house or two inside your city which may yield some revenue and he shall have . . .; 10 towns, five thousand houses with thirty thousand inhabitants, and you will disperse this great congregation of people which stand like goats one behind the other, filling every place with fetid smells and sowing seeds of pestilence and death;

And the city will gain beauty worthy of its name and to you it will be useful by its revenues, and the eternal fame of its aggrandizement.

Ash. II. 13 a] **1204.**

Per mātenere il dono prīcipal [2] di natura cioè libertà, trovo modo [3] da offēdere e difēdere stāte assediati [4] dali ābitiosi tirañi, e prima dirò del si[5]to mvrale, e ācora per che i popoli possino [6] mātenere i loro boni e giusti signiori.

To preserve Nature's chiefest boon, that is freedom, I can find means of offence and defence, when it is assailed by ambitious tyrants, and first I will speak of the situation of the walls, and also I shall show how communities can maintain their good and just Lords.

uinata sanguinita . . assimilitudine. 5. tuffarai aciasscū. 6. casa [de] o 2 . . traga. 7. ettrrarra 1 br 10 citta . . mila casse. 8. edigregierai tanto . . assimilitudine. 9. allalstano . . oni . . fetore si fano . . pessilēte. 11. ella . . atte . . dati effama . . cresscimēto.

1204. 1. īstādo assediati.

1204. Compare No. 1266.

III.

POLEMICS.—SPECULATION.

G. 47 a]

1205.

O speculatore del²le cose, nō ti laudare ³di conosciere le cose ⁴che ordinariamē⁵te per se medesima la ⁶natura ⁷conduce; ⁸Ma rallegrati di co⁹nosciere il fine ¹⁰di quelle cose che ¹¹son disegniate dalla ¹²mēte tua.

Oh! speculators on things, boast not of knowing the things that nature ordinarily brings about; but rejoice if you know the end of those things which you yourself devise. ^{Against Speculators (1205. 1206).}

S. K. M. II.² 67 a]

1206.

O speculatori · dello continvo moto, quā²ti vani disegni in simile cerca avete creati! ³accōpagniatevi colli cercatori dell'oro.

Oh! speculators on perpetual motion how many vain projects of the like character you have created! Go and be the companions of the searchers for gold.

C. A. 75 b; 219 b]

1207.

J bugiardi · interpreti di natura · affermano l'argiēto viuo · essere comvne semēza a tutti i metalli ·, nō si ricordādo che la ²natura varia le semēze · secōdo la diuersità delle cose che essa vole produrre al mōdo.

The false interpreters of nature declare that quicksilver is the common seed of every metal, not remembering that nature varies the seed according to the variety of the things she desires to produce in the world. ^{Against alchemists (1207. 1208).}

1205. 1. hosspechulatori. 2. chose . . laldare. 3. conossciere. 6. per sua [natu] "[ordine]". 7. [ralmēte] chonducie. 8. dicho. 9. nossciere. 10. chose.
1206. 1. spechulatori. 2. ciercha ave creati. 3. acōpagniatevi . . cierchator.
1207. 1. interpetri . . chomvne . . attutti . . richordādo chella. 2. sechōdo . . chose . . produre.

1206. Another short passage in MS. I, referring also to speculators, is given by LIBRI (*Hist. des Sciences math.* III, 228): *Sicchè voi speculatori non vi fidate delli autori che ànno sol col immaginatione voluto farsi inter-* *preti tra la natura e l'omo, ma sol di quelli che non coi cienni della natura, ma cogli effetti delle sue esperienze ànno esercitati i loro ingegni.*

F. 5 b]　　　　　　　　　　**1208.**

E molti ²fecero bot³tega cōn ī⁴ganni e ⁵miraculi ⁶finti, ingan⁷nādo la sto⁸lta molti-⁹tudine.

And many have made a trade of [de-lusions and false miracles, deceiving the stupid multitude.

Against friars.

Tr. 68]　　　　　　　　　　**1209.**

¶ Farisei ·, frati · santi vol dire. ¶

Pharisees—that is to say, friars.

Against writers of epitomes.

W. An. III. 241]　　　　　　　　　　**1210.**

I abbreuiatori delle opere · fanno ingiu-ria ²alla cognitione e allo amore, ³con-ciosiachè l' amore di qualūche cosa è figli-uolo ⁴d'essa cognitione; l' amore ⁵è tanto più feruēte, quanto la ⁶cognitione è più certa, la qual ⁷certezza nasce dalla cogni-tione ⁸integrale di tutte quelle par⁹ti le quali, essendo insieme vnite, ¹⁰conpongono il tutto di quelle co¹¹se che debbono essere amate; ¹²che vale a quel, che per abbre-uiare ¹³le parti di quelle cose che lui fa ¹⁴professione di darne integral no¹⁵titia, che lui lascia indietro la ¹⁶maggior parte delle cose, di che il tutto ¹⁷è cōposto? egli è vero che la inpa¹⁸tientia, madre della stoltitia, è que¹⁹lla · che lauda la breuità; come se ²⁰questi tali non avessino tāto di uita, ²¹ch'elli seruisse a potere avere vna ²²intera notitia d'un sol particulare co²³me è vn corpo vmano! e poi vogli²⁴ono ab-bracciare la mēte di dio nella ²⁵quale s'in-clude l' universo cara²⁶tando e minuzzando quella in īfinite ²⁷parti, come se l' avessino a anatomizzare;

²⁸O stoltitia vmana nō ²⁹t'avedi tu che tu sei stato con teco ³⁰tutta la tua età, e non ài ancora ³¹notitia di quella cosa che tu più possie³²di, cioè della tua pazzia? e vuoi po³³i colla moltitudine de' soffistichi ingannare ³⁴te e altri, sprezzando le mate-matiche sciē³⁵zie, nelle qual si contiene la uerità, no³⁶titia delle cose che in lor si cōtē-gono; e vuoi ³⁷poi scorrere ne' miracoli e scrivere ch'ài ³⁸notitia di quelle cose, di che la mēte vmana ³⁹non è capace, e non si possono dimostrare per ne⁴⁰ssuno esenplo naturale, e ti pare avere ⁴¹fatto miraculi,

Abbreviators do harm to knowledge and to love, seeing that the love of any thing is the offspring of this knowledge, the love being the more fervent in pro-portion as the knowledge is more certain. And this certainty is born of a complete knowledge of all the parts, which, when com-bined, compose the totality of the thing which ought to be loved. Of what use then is he who abridges the details of those matters of which he professes to give thorough information, while he leaves behind the chief part of the things of which the whole is composed? It is true that impatience, the mother of stupidity, praises brevity, as if such persons had not life long enough to serve them to acquire a complete knowledge of one single subject, such as the human body; and then they want to comprehend the mind of God in which the universe is included, weighing it minutely and mincing it into infinite parts, as if they had to dissect it!

Oh! human stupidity, do you not per-ceive that, though you have been with yourself all your life, you are not yet aware of the thing you possess most of, that is of your folly? and then, with the crowd of so-phists, you deceive yourselves and others, despising the mathematical sciences, in which truth dwells and the knowledge of the things included in them. And then you occupy yourself with miracles, and write that you possess information of those things of which the human mind is incapable and which cannot be proved by any instance from nature. And you fancy you have wrought miracles when you spoil a work of some

1208. 2. fecē bot. 6. inga. 10. ne sāsi foperia cognoscitore de loro ingāni essigli poniano.

1210. 1. abbreuiatori . . opre . f . fanno ingiuia. 2. cognitione [concosia che] e allo. 3. concosia chellamore . . effilol. 4. ella [cogni] more. 5. ettanto. 7. feruēde certeza nascie. 8. i integrale . . pa. 9. te le. 10. conpongano . . quella. 11. sa che. 12. abreuiare. 13. parte. 15. chellui lassci indirieto. 16. magor. 17. chella. 19. chellalda . . chomesse. 21. chelli ser-uissi. 22. da "sol" parlicutare. 24. ano abracciare . . nelle. 26. minvzando. 27. parte . . lavessino anatomizare. 28. [e delle chose che] o. 29. tu [chett] chettu se. 31. chettu. 32. coe . . pazzia [vole] e volli. 33. i conlla . . inganare. 34. splezando. 35. ze nella. 36. cōtēgano e voi. 39. posso. 40. naturale letti. 41. tu gnasto. 42. spechulativo. 43. chettu.

1209. Compare No. 837, ll. 54—57, No. 1296 (p. 363 and 364), and No. 1305 (p. 370).

quãdo tu ài quastato vna [42]opera d'alcuno
ingegnio speculativo, e nõ [43]t'avedi che tu
cadi nel medesimo errore, [44]che fa quello
che denuda la piãta dell'orna[45]mento de' sua
rami, pieni di fronde, miste co[46]li odoriferi
fiori o frutti, [48]come fece Giv[49]stino,
abbreuiatore delle storie scritte da Trogo
[50]Põpeo, il quale scrisse ornatamente tutti
[51]li eccellẽti fatti delli sua antichi, li quali
e[52]rã pieni di mirabilissimi ornamẽti; e così
[53]conpose vna cosa ignuda, ma sol degna
d'in[54]gegni inpatiẽti, li quali pare lor perder
[55]tanto di tenpo, quãto quello è che è ado-
perato vtil[56]mẽte, cioè nelli studi delle opere
di nature e delle [57]cose vmane; Ma stieno
questi tali in conpa[58]gnia delle bestie; Nelli
lor cortigiani sieno cani e [59]i altri animali
piẽ di rapina e accompagniansi [60]con loro
correndo sempre dietro, e seguita-
[61]no l' inocẽti animali che cõ la fame alli
tem[62]pi delle grã nevi ti uengono alle case,
dimanda[63]tori limosina come lor tutore.

speculative mind, and do not perceive that
you are falling into the same error as that
of a man who strips a tree of the ornament
of its branches covered with leaves mingled
with the scented blossoms or fruit
[48] as Justinus did, in abridging the histories
written by Trogus Pompeius, who had
written in an ornate style all the worthy
deeds of his forefathers, full of the most
admirable and ornamental passages; and so
composed a bald work worthy only of
those impatient spirits, who fancy they are
losing as much time as that which they
employ usefully in studying the works of
nature and the deeds of men. But these
may remain in company of beasts; among
their associates should be dogs and other
animals full of rapine and they may hunt
with them after, and then follow helpless
beasts, which in time of great snows come
near to your houses asking alms as from
their master

C. A. 187 *b*; 562 *b*]　　　　　　　　1211.

O matematici fate lume a tale er[2]rore!
[3]Lo spirito non à voce, perchè dov'è
voce [4]è corpo, e dove è corpo è occupa-
tiõ di lo[5]co, il quale inpediscie all'ochio il
ue[6]dere delle cose poste dopo tale loco;
[7]adunque tal corpo enpie di se tutta [8]la
circustante aria, cioè colle sua s[9]petie.

O mathematicians shed light on this error. On spirits (1211—1213).
The spirit has no voice, because where
there is a voice there is a body, and where
there is a body space is occupied, and this
prevents the eye from seeing what is placed
behind that space; hence the surrounding air
is filled by the body, that is by its image.

B. 4 *b*]　　　　　　　　　　1212.

Nõ può essere voce, dove non è movi-
mẽto e percussione d'aria; [2]nõ può essere
percussione d'essa aria, doue non è stru-
mẽto; [3]nõ può essere strumẽto incorporeo;
essẽ[4]do così, vno spirito nõ può avere nè
voce nè forma nè forza, [5]e se piglierà
corpo, non potrà penetrare nè [6]entrare
doue li usci sono serrati; [7]e se alcuno di-
ciesse: per aria cõgregata [8]e ristretta ĩsieme
lo spirito piglia i corpi [9]di uarie · forme ·, e

There can be no voice where there is no
motion or percussion of the air; there can
be no percussion of the air where there is
no instrument, there can be no instrument
without a body; and this being so, a spirit
can have neither voice, nor form, nor strength.
And if it were to assume a body it could
not penetrate nor enter where the passages
are closed. And if any one should say
that by air, compressed and compacted

44. cheffa. 45. misto. 46. offrutti sopra dimostra. 47. que en quella piãta esser da fare [bene]. 48. di [molte] lun se
tavole come fece givs. 49. abreuiatore . . da troc. 50. põpeo il . . tuti. 51. eceletti. 53. inuda . . degnia di. 55. quel-
loche. 56. coe . . dele. 57. questi. 58. cortigani sie. 59. a altri . . rapina e aconpagniasi. 60. senpre dirieto ach fuge.
61. alli ten. 62. uengano . . casi. 63. lor tutore essnull *here the text breaks off.*
1211. 1. attale. 4. e do e corpo e ochupatiõ. 5. cho. 6. posste . . locho. 7. dal. 8. coe.
1212. 1. nõ po. 2. nõ po. 3. nõ po. 4. nõ po . . voce "| ne forma" ne forza. 5. esse. 6. sera "ti". 7. esse . . diciessi perr.
8. chorpi. 9. quelo. 10. Acquesta . . dicho. 11. none nerui e ossa non po. 12. operrata inessuno. 14. fugi. 15. isperiẽza.

1210. 48. *Givstino*, Marcus Junianus Justinus,
a Roman historian of the second century, who com-
piled an epitome from the general history written

by Trogus Pompeius, who lived in the time of
Augustus. The work of the latter writer no longer
exist.

per quello strumēto parla [10]e move cō forza, a questa parte dico, [11]che doue non sono nerui e ossa, non può esse[12]re forza · operata in nessuno movimēto [13]fatto dagl' imaginati spiriti;

[14]fuggi i precetti · di quelli · speculatori, chè le loro [15]ragioni · nō son · confermate · dalla · speriēza.

together, a spirit may take bodies of various forms and by this means speak and move with strength—to him I reply that when there are neither nerves nor bones there can be no force exercised in any kind of movement made by such imaginary spirits.

Beware of the teaching of these speculators, because their reasoning is not confirmed by experience.

W. An. II. 242 b (·N·)] 1213.

Delli discorsi vmani stoltissimo è da essere riputato quello, il qual s'astēde al[2]la credulità della negromātia, sorella della alchimia, partoritricie del[3]le cose senplici e naturali; Ma è tanto più degnia di riprensio[4]ne che l'alchimia, quāto ella non partorisce alcuna cosa se nō simile a se, [5]cioè bugia; il che non interviene nella alchimia, la quale è ministra[6]tricie de'senplici prodotti della natura, il quale vfitio fatto esser nō può [7]da essa natura, perchè in lei non sono strumēti organici colli quali essa possa operare quel [8]che adopera l'uomo mediante le mani, che in tale vfitio [9]à fatti i vetri ecc.; ma essa negromātia, stendardo ovvero bandiera [10]volante, mossa dal vēto, è guidatricie della stolta moltitudine, la quale [11]al continuo testimonia collo abbaiamēto d'infiniti effetti di tale [12]arte; e uāno ēpiuti i libri, affermando che l'incāti e spiriti adoperino [13]e sanza lingua parlino, e sanza strumēti organici, sāza i quali [14]parlar nō si può, parlino, e portino gravissimi pesi, facino tēpestare [15]e piovere, e che li omini si cōvertino il gatte, lupi e altre bestie, [16]benchè in bestia prima ētrā quelli che tal cosa affermano;

[17]E cierto, se tale negromātia fusse in essere, come dalli bassi ingiegni è creduto, [18]nessuna cosa è sopra la terra che al danno e seruitio dell'omo fusse di tanta valitudine, perchè se fus[19]se vero, che in tale arte si avesse potētia di far turbare la trāquilla serenità dell'ari[20]a, convertendo quella in notturn aspetto, e far le corruscationi o venti con spa[21]vētevoli toni e folgori scorrēti infra le tenebre, e' con īpetuosi venti ruinare

Of all human opinions that is to be reputed the most foolish which deals with the belief in Necromancy, the sister of Alchemy, which gives birth to simple ànd natural things. But it is all the more worthy of reprehension than alchemy, because it brings forth nothing but what is like itself, that is, lies; this does not happen in Alchemy which deals with simple products of nature and whose function cannot be exercised by nature itself, because it has no organic instruments with which it can work, as men do by means of their hands, who have produced, for instance, glass &c. but this Necromancy the flag and flying banner, blown by the winds, is the guide of the stupid crowd which is constantly witness to the dazzling and endless effects of this art; and there are books full, declaring that enchantments and spirits can work and speak without tongues and without organic instruments — without which it is impossible to speak — and can carry heaviest weights and raise storms and rain; and that men can be turned into cats and wolves and other beasts, although indeed it is those who affirm these things who first became beasts.

And surely if this Necromancy did exist, as is believed by small wits, there is nothing on the earth that would be of so much importance alike for the detriment and service of men, if it were true that there were in such an art a power to disturb the calm serenity of the air, converting it into darkness and making coruscations or winds, with terrific thunder and lightnings rushing through the darkness, and with violent

1213. *Above the text is the note*: seguita quel che mācha dirieto alla facia del pie. 1. Ma dalli dìsscorsi . . essere [tenuto] "re putato" . . sasstēde 2. archimia. 3. lle chose [naturali] senplici . . ettanto . . ripresi. 4. chellarchimia . . partorissce . . chosa . . asse. 5. [parole] "cioe bugia" il che nonē . . archimia . . e [vfit] ministra. 6. dalla. 7. illei none . . orghanici [da poter] "cholli quali" essa. 8. lomo [il quale] mediante. 9 affatti e vetri . . stendar "do" over. 10. vēto guidatricie. 11. chontinuo e tesstimonia chollo. 12. ēpiute . . chellinchāti esspiriti. 13. essanza . . essanza . . saza. 14. po . . tēpesstare. 15. chelli . . ghatte. 16. che dattal chosa. 17. ecciercto settale . . fussi . . chome. 18. chosa essopra . . al "danno e" seruitio . . fussi . . tanta [vtilita] "valitudine" perchesse fu. 19. si . . arte [fussi] si avessi . . turbare [laria] la. 2. chonvertendo . . inotturnasspetto effarle corrusscationi . . chon isspa. 21. effolgo"ri" . . infralle . . e chonnī petuosi. 22. dira-

²²li alti edifiti, e diradicare le selue, e con quelle percuotere li eserciti, e quelli ²³ronpēdo e atterrādo, e oltr' a questo le dannose tenpeste, privando li cultori ²⁴del premio delle lor fatiche,—o qual modo di guerra può essere, che con tanto dan²⁵no possa offendere il suo nemico di aver potestà di privarlo delle sue raccolte? qual bat²⁶taglia marittima può essere che si assomigli a quella? dico lui che comāda alli vēti ²⁷e fa le fortune ruvinose e sommergitrici di qualunche armata,—cierto quel che ²⁸co māda a tali inpetuosi potētie sarà signore delli popoli, e nessuno vma²⁹no ingiegnio potrà resistere alle sue dannose forze; Li occulti tesori e ³⁰giemme, riposte nel corpo della terra, fieno a costui tutti manifesti; nessun ³¹serrame o fortezza inespugnabili sarā quelle che saluar possino al³²cuno sanza la voglia di tal negromāte; Questo si farà portare per l'aria dal³³l'oriente all'occidēte e per tutti li opposti aspetti dell'universo; Ma per³⁴chè mi voglio più oltre estendere? quale è quella cosa che per ta³⁵le arteficie far nō si possa? quasi nessuna, eccietto il levarsi la morte; ad³⁶dunque è concluso in parte il danno e la vtilità che in tale arte si contiene, essē³⁷do vera; e s'ella è vera, perchè non è restata infra li omini che tanto la deside³⁸rano, non avēdo riguardo a nessuna deità? e so, che infiniti ce n'è, che per soddisfare ³⁹a vn suo appetito, ruinerebbero Iddio cō tutto l'universo; e s'ella non è rimasto infra ⁴⁰li omini, essendo a lui tanto neciessaria, essa nō fu mai, nè mai è per dovere essere, ⁴¹per la difinitiō dello spirito, il quale è invisibile in corpo; e dentro alli elemē⁴²ti non sono cose incorporee, perchè doue non è corpo, è vacuo, e il uacuo nō si da dē⁴³tro alli elemēti, perchè subito sarebbe dall'elemēto riēpiuto; ‖ volta carta.

storms overthrowing high buildings and rooting up forests; and thus to oppose armies, crushing and annihilating them; and, besides these frightful storms may deprive the peasants of the reward of their labours. — Now what kind of warfare is there to hurt the enemy so much as to deprive him of the harvest? What naval warfare could be compared with this? I say, the man who has power to command the winds and to make ruinous gales by which any fleet may be submerged,—surely a man who could command such violent forces would be lord of the nations, and no human ingenuity could resist his crushing force. The hidden treasures and gems reposing in the body of the earth would all be made manifest to him. No lock nor fortress, though impregnable, would be able to save any one against the will of the necromancer. He would have himself carried through the air from East to West and through all the opposite sides of the universe. But why should I enlarge further upon this? What is there that could not be done by such a craftsman? Almost nothing, except to escape death. Hereby I have explained in part the mischief and the usefulness, contained in this art, if it is real; and if it is real why has it not remained among men who desire it so much, having nothing to do with any deity? For I know that there are numberless people who would, to satisfy a whim, destroy God and all the universe; and if this necromancy, being, as it were, so necessary to men, has not been left among them, it can never have existed, nor will it ever exist according to the definition of the spirit, which is invisible in substance; for within the elements there are no incorporate things, because where there is no body, there is a vacuum; and no vacuum can exist in the elements because it would be immediately filled up. Turn over.

W. An. II. 242 *a*] **1214.**

DELLI SPIRITI.

²Abiāo insin qui dirieto a questa faccia detto, ³come la difinitiō dello spirito ⁴è vna potentia congiunta al corpo, perchè per se

OF SPIRITS.

We have said, on the other side of this page, that the definition of a spirit is a power conjoined to a body; because it cannot

dichare le piante "selue" e chon . . perchotere . . ecquelli. 23. oltradiquesto . . tenpesste . . chultori. 24. ghuerra po . . chon. 25. nemicho aver potessta . . richolte . . ba. 26. po . . chessi . . acquella dicho . . chomāda. 27. effa . . essomergitrici. 28. chomāda attali. 29. resissstere . . ocholti. 30. gieme . . chorpo . . achosstu . . nessu. 31. fortezza [chef] inepugrabili . . chessalvar. 32. chuno. 33. lloriente . . oposti asspetti. 34. mi voio piu oltre asslendendo . . chosa che pera. 36. choncluso "in parte" il ella . . chontiene. 37. essella . . none e resstata infralli . . chetta deside. 38. essol che infiniti ciene . . saddisfare. 39. ruinerebono . . chō . . essella. 40. allui tanta (?) . . mai nemmai. 41. chorpo. 42. none chose inchorporee . . chorpo e vachuo . . vachuo.
1214. 2. acquesta . . decto. 3. chome . . spirito [e vn ome nōch]. 4. chongiunta. 5. alchuna . . lochale. 6. essettu . . reggha

medesimo ⁵reggiere nō si può, nè pigliare alcuna sorte di moto locale, ⁶e se tu dirai che per se si regga, questo essere non può ⁷dentro alli elemēti, perchè se lo spirito è quātità incor⁸porea, questa tal quantità è detta vacuo, e il ua⁹cuo non si da in natura; e dato che si desse, subito sa-¹⁰rebbe riempiuto dalla ruina di quello elemento nel ¹¹qual il uacuo si gienerasse; adunque per la difinition del pe¹²so che dicie, la grauità è vna potētia accidentale creata ¹³d'alcuno elemento tirato o sospinto nell'altro, seguita, che ¹⁴nessuno elemēto, non pesando nel medesimo elemēto, e' pe-¹⁵sa nell'elemēto superiore ch'è più lieve di lui; come si uede ¹⁶la parte dell'acqua non à gravità o leuità più che l'altra ¹⁷acqua, ma se tu la tirerai nell'aria, allora ella acqui¹⁸sterà gravezza, e se tu tirerai l'aria ¹⁹sotto l'acqua, allora l'acqua, che si trova sopra tale ²⁰aria, acquista gravezza, la qual gravezza per se sostener ²¹non si può, onde lì è neciessario la ruina, e così cade infra ²²l'acqua in quel loco ch'è vacuo d'essa acqua; tale ac²³caderebbe nello spirito, stando infra li elemēti, chè al ²⁴continuo gienererebbe vacuo in quel tale elemēto, dove ²⁵lui si trovasse, per la qual cosa lì sarebbe neciessario la con²⁶tinua fuga inverso il cielo, insinche vscito fusse di tali ²⁷elemēti.

SE LO SPIRITO TIENE CORPO INFRA LI ²⁹ELE-MĒNTI.

³⁰Abbiā provato, come lo spirito non può per se stare infra li ³¹elementi sanza corpo, nè per se si può mouere per moto vo³²lontario, se non è allo in sù; Ma al presente diremo co³³me, pigliando corpo d'aria tale spirito, è necies³⁴sario che s'infonda infra essa aria, perchè, s'elli stesse vnito, ³⁵e' sarebbe separato e caderebbe alla gieneratiō del uacuo, ³⁶come di sopra è detto; adunque è neciessario che, a volere ³⁷restare infra l'aria, che esso s'infonda in una quātità d'aria; e ³⁸se si mista coll'aria, elli seguita due inconvenienti, cioè ³⁹che elli leuifica quella quātità dell'aria dove esso si mista, e ⁴⁰per la qual cosa l'aria leuificata per se uola in alto,

move of its own accord, nor can it have any kind of motion in space; and if you were to say that it moves itself, this cannot be within the elements. For, if the spirit is an incorporeal quantity, this quantity is called a vacuum, and a vacuum does not exist in nature; and granting that one were formed, it would be immediately filled up by the rushing in of the element in which the vacuum had been generated. Therefore, from the definition of weight, which is this—Gravity is an accidental power, created by one element being drawn to or suspended in another—it follows that an element, not weighing anything compared with itself, has weight in the element above it and lighter than it; as we see that the parts of water have no gravity or levity compared with other water, but if you draw it up into the air, then it would acquire weight, and if you were to draw the air beneath the water then the water which remains above this air would acquire weight, which weight could not sustain itself by itself, whence collapse is inevitable. And this happens in water; wherever the vacuum may be in this water it will fall in; and this would happen with a spirit amid the elements, where it would continuously generate a vacuum in whatever element it might find itself, whence it would be inevitable that it should be constantly flying towards the sky until it had quitted these elements.

AS TO WHETHER A SPIRIT HAS A BODY AMID THE ELEMENTS.

We have proved that a spirit cannot exist of itself amid the elements without a body, nor can it move of itself by voluntary motion unless it be to rise upwards. But now we will say how such a spirit taking an aerial body would be inevitably melt into air; because if it remained united, it would be separated and fall to form a vacuum, as is said above; therefore it is inevitable, if it is to be able to remain suspended in the air, that it should absorb a certain quantity of air; and if it were mingled with the air, two difficulties arise; that is to say: It must rarefy that portion of the air with which it mingles; and for this cause the rarefied air must fly up of itself and will not

. . po. 7. perchessello . . inchor. 8. quantita [se] e decta vachuo. 9. chuo . . dato che se dessi subita. 10. reimpiuto ellemento. 11. uachuo si gienerassi. 13. ossosspinto. 14. ellemēto . . chome. 16. olleuita ellaltra. 17. massetti. 18. essettu. 19. chessi. 20. sosstener. 21. po onde le neciessario: chosi chade. 22. locho. 23. chaderebbe . . infralli. 24. chontinuo gienerrebbe. 25. trovassi . . chosa . ·. chon. 26. fugha . . vsscito fussi. 27. [adunque di reno]. 28. sello . . chorpo infralli. 30. losspirito . . infralli. 31. chorpo . . po. 32. sennon . . direno cho. 33. chorpo daria chettale. 34. chessinfonda . . perchesselli. 35. seperato e chadrebbe . . uachuo. 36. Chome . . decto. 37. resstare . . nuna. 38. ssesi . . chollaria . . coe. 39. leuificha . . missta. 40. chosa . . leuifichata . . ressta. 41. infrallaria . . a di questo. 42. disunisscie.

e non resta [41]infra l'aria più grossa di lei; e oltre a questo tal uirtù [42]spirituale sparsa si disuniscie e altera suà natura, per la qual [43]cosa esso māca della prima virtù; aggiugnesi vn 3° incō[44]veniente, e questo è, che tal corpo d'aria, preso dallo spirito, è [45]sottoposto alla penetratiō de' venti, li quali al continuo disu[46]niscono e stracciano le parti vnite dell'aria, quelle rivolgiē[47]do e raggirando infra l'altra aria; adunque lo spirito, in tale

remain among the air that is heavier than itself; and besides this the subtle spiritual essence disunites itself, and its nature is modified, by which that nature loses some of its first virtue. Added to these there is a third difficulty, and this is that such a body formed of air assumed by the spirits is exposed to the penetrating winds, which are incessantly sundering and dispersing the united portions of the air, revolving and whirling amidst the rest of the atmosphere; therefore the spirit which is infused in this

W. An. II. 201 b (M)] 1215.

aria infuso, sarebbe smēbrato overo sbranato e [2]rotto insieme collo sbranamēto dell' aria, nella qual s'infuse.

air would be dismembered or rent and broken up with the rending of the air into which it was incorporated.

SE LO SPIRITO, AVĒDO PRESO CORPO [4]D'ARIA, SI PUÒ PER SE MOVERE O NO.

[5]Inpossibile è che lo spirito, infuso a una quātità d'aria, [6]possa movere essa aria; e questo si manifesta per la passa[7]ta dove dice ¶ lo spirito leuifica quella quātità dell'aria, [8]nella quale esso s'infonde; adunque tale aria [9]si leuerà in alto sopra l'altra aria, e sarà moto fatto dell'a[10]ria per la sua leuità e nō per moto volontario dello spirito, e [11]se tale aria si scontra nel uēto per la 3ª di questo, essa [12]aria sarà mossa dal uēto e nō dallo spirito in lei infuso.

AS TO WHETHER THE SPIRIT, HAVING TAKEN THIS BODY OF AIR, CAN MOVE OF ITSELF OR NOT.

It is impossible that the spirit infused into a certain quantity of air, should move this air; and this is proved by the above passage where it is said: the spirit rarefies that portion of the air in which it incorporates itself; therefore this air will rise high above the other air and there will be a motion of the air caused by its lightness and not by a voluntary movement of the spirit, and if this air is encountered by the wind, according to the 3rd of this, the air will be moved by the wind and not by the spirit incorporated in it.

SE LO SPIRITO PUÒ PARLARE O NO.

[14]Volendo mostrare, se lo spirito può parlare o no, è necies[15]sario in prima definire che cosa e uocie, e come si giene[16]ra; e diremo in questo modo: la vocie è movimē[17]to d'aria confricata in corpo denso, e 'l corpo denso [18]confricato nell'aria che è il medesimo, la qual cō[19]fricatione di denso con raro condensa il raro e fassi resis[20]tētia, e ancora il uelocie raro nel tardo raro si condensa[21]no l'uno e l'altro ne' contatti, e fanno suono e grandissimo [22]strepito; e il suono ovvero mormorio fatto dal raro [23]che si move nel raro cō medi-

AS TO WHETHER THE SPIRIT CAN SPEAK OR NOT.

In order to prove whether the spirit can speak or not, it is necessary in the first place to define what a voice is and how it is generated; and we will say that the voice is, as it were, the movement of air in friction against a dense body, or a dense body in friction against the air,—which is the same thing. And this friction of the dense and the rare condenses the rare and causes resistance; again, the rare, when in swift motion, and the rare in slow motion condense each other when they come in contact and make a noise and very great uproar;

43. chosa . . mācha . . agiugnecisi. 44. ecquesto he chettal. 45. sottopossto . . venetratiō . . chontinuo. 46. nisscano esstracciano le parte. 47. ragirando infrallaltra . . losspirito in tale ·/.
1215. 1. issmēbrato . . sbranato er. 2. chollassbranamēto. 3. sello . . avēto . . chorpo . . po per . . onno. 5. Inpossibile che chello. 6. ecquesto. 7. losspirito leuificha. 9. essara. 11. essettale . . quessto. 13. sello sspirito po . . onno. 14. mosstrare sello. 15. chosa . . chome. 16. quessto mōdo. 17. confrighata in chorpo . . chorpo. 18. chonfrighato. 19. freghatio . . chon . . chondensa . . effassi. 20. stēti e anchora. 21. ellaltro . . chontatti effanno sono. 22. sono over . . facto . . raro [nel ra]. 23. [ro] chessi . . chō . . chome. 24. fiama . . soni infrallaria. 25. rarro cō raro ecquando.

ocre movimēto, come [24]la grā fiamma gieneratricie di suoni infra l'aria; è 'l grandissi-[25]mo strepito fatto di raro cō raro, e quando il uelocie ra[26]ro penetra in mobile raro, come la fiaña del foco vsci[27]ta dalla bōbarda, e percossa infra l'aria, e ancora la fiamma [28]vscita dal nuvolo percuote l'aria nella gieneratiō delle saette; [29]Addunque diremo che lo spirito non possa gienerar vocie sanza [30]movimento d'aria, e aria in lui non è, nè la può cacciare da se [31]se elli nō l'à, e se uol movere quella, nella quale lui è infuso, [32]egli è neciessario che lo spirito multiplichi, e multiplicar nō [33]pvò se lui non à quātità; e per la 4ª che dicie: nessuno raro [34]si move se non à loco stabile, donde lui pigli il movimēto, e [35]massimamēte auendosi a mouere lo elemento nello elemēto [36]il quale nō si move da se, se nō per vaporacione vniforme al ciētro della [37]cosa vaporata, come accade nella spugnia ristretta [38]in nella mano che sta sotto l'acqua, dalla qual l'acqua fuggie per qua[39]lunche verso con equal movimēto per le fessure interposte infra [40]le dita della man che dentro a se la strīgnie;

[41]Se lo spirito à vocie articulata, [42]e se lo spirito può essere audito, [43]e che cosa è audire e vedere; [44]l'ōda della vocie va [45]per l'aria come le spetie delli [46]obbietti vanno all'ochio.

and the sound or murmur made by the rare moving through the rare with only moderate swiftness, like a great flame generating noises in the air; and the tremendous uproar made by the rare mingling with the rare, and when that air which is both swift and rare rushes into that which is itself rare and in motion, it is like the flame of fire which issues from a big gun and striking against the air; and again when a flame issues from the cloud, there is a concussion in the air as the bolt is generated. Therefore we may say that the spirit cannot produce a voice without movement of the air, and air in it there is none, nor can it emit what it has not; and if desires to move that air in which it is incorporated, it is necessary that the spirit should multiply itself; and that cannot multiply which has no quantity. And in the 4th place it is said that no rare body can move, if it has not a stable spot, whence it may take its motion; much more is it so when an element has to move within its own element, which does not move of itself, excepting by uniform evaporation at the centre of the thing evaporated; as occurs in a sponge squeezed in the hand held under water; the water escapes in every direction with equal movement through the openings between the fingers of the hand in which it is squeezed.

As to whether the spirit has an articulate voice, and whether the spirit can be heard, and what hearing is, and seeing; the wave of the voice passes through the air as the images of objects pass to the eye.

Br. M. 131 a] **1216.**

Nonentity. Ogni quātità continva intellettualmē[2]te è diuisibile in infinito;

[3][Infra le · grandezze · delle · cose · che sono infra noi [4]l'essere · del nulla tiene · il principato ·, e 'l suo · ofitio [5]s'estende · infra le · cose · che non àno · l'essere ·, e la sua

Every quantity is intellectually conceivable as infinitely divisible.

[Amid the vastness of the things among which we live, the existence of nothingness holds the first place; its function extends over all things that have no existence, and

26. chome . . focho vssci. 27. della . . perchossa infrallaria e anchora la fiama. 28. vsscita del nugholo e perchote. 29. direno chello. 30. nella puo chaccia ra dasse. 31. esse uol. 32. chello. 33. sellui . . nessuna. 34. locho. 36. move dasse se. 37. chome acondo nella . . risstretta. 38. inella . . chessta . . lacq"a" della. 39. chon . interpossse. 40. della ma che . . asse lasstrīgnie. 41. sello . . artichulata. 42. essello . . po . . vldito. 43. chosa. 44. e [chon] lōda. 45. echome. **1216.** 3. Infralle grandeze . . chose chessono infrannoi. 5. sastende infralle chose . . ella. 8. alla sua. 9. soma. 11. somare . .

1216. Compare No. 916.

⁶essentia · risiede · apresso · del tenpo · infra
'l preterito ⁷e 'l futuro, e nulla possiede
del presente; Questo nulla ⁸à la · sua · parte
equale · al tutto ·, e 'l tutto · alla parte, ⁹e
'l diuisibile · allo indiuisibile ·; e tal somma ·
produce nella ¹⁰sua partitione come nella
multiplicatione, ¹¹e nel suo sommare · quanto
nel sottrare, come si dimostra ¹²apresso
delli aritmetici dello suo 10° carattere che
rap¹³presenta esso nvllo; E la podestà
sua non si estende infra ¹⁴le cose di natura.]

¹⁵[Quello che è · detto · niēte, · si ritrova
solo nel tenpo · e nelle ¹⁶parole; nel tenpo
si trova · infra 'l preterito · e 'l futuro, ¹⁷e
nulla ritiene del presente ·, e così infra le ·
parole delle co¹⁸se che si dicono · che non
sono . o che sono impossibili.]

¹⁹Apresso · del tenpo e' nulla · risiede
infra 'l preterito e 'l futuro, ²⁰e niente pos-
siede del presente, e apresso di natura e'
s'ac²¹conpagnia infra le cose inpossibili ·,
onde per quel ch'è ²²detto · e' non à l'es-
sere; ²³Inperochè doue fusse ²⁴il nvlla, sa-
rebbe dato il uacuo.

its essence, as regards time, lies precisely
between the past and the future, and has
nothing in the present. This nothingness
has the part equal to the whole, and the
whole to the part, the divisible to the in-
divisible; and the product of the sum is the
same whether we divide or multiply, and in
addition as in subtraction; as is proved by
arithmeticians by their tenth figure which
represents zero; and its power has not exten-
sion among the things of Nature.]

[What is called Nothingness is to be
found only in time and in speech. In time
it stands between the past and future and
has no existence in the present; and thus in
speech it is one of the things of which we
say: They are not, or they are impossible.]

With regard to time, nothingness lies
between the past and the future, and has
nothing to do with the present, and as to its
nature it is to be classed among things impos-
sible: hence, from what has been said, it has
no existence; because where there is nothing
there would necessarily be a vacuum.

Br. M. 156 a]　　　　　　　　**1217.**

ESEMPLO DELLA SAETTA FRA NUVOLI.

²[O potente e già animato strumento
dell'artificiosa natura, ³a te nō valēdo le
tue grā forze ti cōuiene abbādonare la
trāquilla vita e obbedire alla legie, ⁴che Iddio
e 'l tēpo diede alla gienitrice natura.]

⁷O quāte volte furono vedute le īpav-
rite schiere ⁸de' delfini e de' grā tonni fu-
gire dal inpia tua furia, ⁹e tu, che . . .
¹⁰fulminando gienerasti nel mare subita tē-
pesta con grā busse e sommersione di navili
cō grā¹¹de ōdamēto, ēpiēdo gli scoperti liti
degli īpavriti e sbigo¹²ttiti pesci, togliē-
dosi a te per lasciato mare rimasi in loco
divenivano soperchia e ¹³abbondante preda
de' vicini popoli;

EXAMPLE OF THE LIGHTNING IN CLOUDS.

[O mighty and once living instrument of Reflections
formative nature. Incapable of availing thy- on Nature
self of thy vast strength thou hast to abandon (1217—1219).
a life of stillness and to obey the law which
God and time gave to procreative nature.]

Ah! how many a time the shoals of terri-
fied dolphins and the huge tunny-fish were
seen to flee before thy cruel fury, to escape;
whilst thy fulminations raised in the sea a
sudden tempest with buffeting and submer-
sion of ships in the great waves; and filling the
uncovered shores with the terrified and desperate
fishes which fled from thee, and left by the sea,
remained in spots where they became the abun-
dant prey of the people in the neighbourhood.

sottrare. 12. arismetrici della sua 10ᵃ caratta che re. 13. Ella . . nosistende. 15. Quello chche. 16. preterito hel.
17. infralle. 18. chessi dicono . . chessono impossibile. 20. posiede . . apresso. 21. infralle . . impossibile. 23. fussi.
1217. 1. essēplo . . nvuolli. 2. chōuene "abādonare la trāquila vita" obedire. 3. chel che . . die. 4. natura a tette nō ualse.
5. [\\\\\\\\\ haghagli arbri schiene cholle quali tu seghuitādo la tua]. 6. [pleda aprivis sol chavi "chonvetro" aprendo chō
tē pes]. 8. dalfini . . tua] "tua" furia e cchupare. 9. ettu che chol veloce tramvre lalie cholla forci elluti choda. 10. fu-
minando gienerai nel . . chō . . somersione . . chō. 11. schoperti . . essbigho. 12. pessci . . atte . . loccho . . diveni-
vano superchava (?). 13. bodante pleda. 14. o tēpo chonsumatore delle chose āteri volgiēdole. 15. dai [lo] alle tratte

1217—1219. The character of the handwriting
points to an early period of Leonardo's life. It has

become very indistinct, and is at present exceedingly
difficult to decipher. Some passages remain doubtful.

¹⁴O tēpo, velocie predatore ¹⁵delle create cose, quāti rè, quāti popoli ài tu disfatti, e quā¹⁶te mutazioni di stati e vari casi sono seguite dopo che la mara¹⁷vigliosa forma di questo pescie qui morì ¹⁸per le caverne e ritorte interiora; ¹⁹ora disfatto dal tēpo patiēte giacci ī questo chiuso loco; colle spolpate e ignivde ossa ²⁰ài fatto armadura e sostegnio al sopra posto mōte.

O time, swift robber of all created things, how many kings, how many nations hast thou undone, and how many changes of states and of various events have happened since the wondrous forms of this fish perished here in this cavernous and winding recess. Now destroyed by time thou liest patiently in this confined space with bones stripped and bare; serving as a support and prop for the superimposed mountain.

Br. M. 155 b] 1218.

Rimase lo elemēto dell'acqua rīchiuso īfra li crescivti argini de' fiumi, e si vede 'l mare ²īfra la crescivta terra ³e la circundatricie aria, avēdo a fasciare e circon-⁴scrivere la moltificata machina della terra, e la sua ⁵grossezza, che staua fra l'acqua e lo elemēto del fuoco, ⁶rimāga molto ristretta e privata dalla bisogniosa acqua; i fivmi ⁷rimarrāno senza le loro acque, la fertile terra nō māderà piv leggieri ⁸frōde, nō fieno piv i cāpi adornití dalle ricascati piāte; tutti ⁹li animali nō trovādo da pasciere le fresche erbe, morranno, e mā-¹⁰cherà il cibo ai rapaci lioni e lupi e altri animali che vivono ¹¹di ratto, e agli omini dopo molti ripari cōverrà abādonare ¹²la loro vita, e mācherà la gienerazione vmana; a questo modo la fertile e fruttuosa terra ¹³abandonata rimarrà arida e sterile e per rīchivso omo¹⁴re della acqua, rīchivsa nel suo ventre, e per la vivace natura osserve-¹⁵rà alquāto dello suo accrescimēto, tāto che passata la fredda e so¹⁶ttile aria fia costretta a terminare collo elemēto del fuoco; ¹⁷allora la sua superfice rimarrà in riarsa cienere, e questo fia il termine ¹⁸della terrestre natura.

The watery element was left enclosed between the raised banks of the rivers, and the sea was seen between the uplifted earth and the surrounding air which has to envelope and enclose the ·complicated machine of the earth, and whose mass, standing between the water and the element of fire, remained much restricted and deprived of its indispensable moisture; the rivers will be deprived of their waters, the fruitful earth will put forth no more her light verdure; the fields will no more be decked with waving corn; all the animals, finding no fresh grass for pasture, will die and food will then be lacking to the lions and wolves and other beasts of prey, and to men who after many efforts will be compelled to abandon their life, and the human race will die out. In this way the fertile and fruitful earth will remain deserted, arid and sterile from the water being shut up in its interior, and from the activity of nature it will continue a little time to increase until the cold and subtle air being gone, it will be forced to end with the element of fire; and then its surface will be left burnt up to cinder and this will be the end of all terrestrial nature.

Br. M. 156 b] 1219.

Perchè la natura non ordinò che l'uno animale nō uivesse ²dalla morte dell'altro? ³la natura, essēdo vaga e pigliādo piacere

Why did nature not ordain that one animal should not live by the death of another? Nature, being inconstant and

vite nvuove e varie abitazioni [o quante]. 16. tēpo [vīcitore] velocie pledatore. 17. chleate chose . . dissfatti. 10. disstati e vari chasi sono seghuite poche la mara. 19. vgliosa forma di questo pesscie qui mòri. 20. per lechavernole e ritorte interiora. 21. ora "disfato dal tēpo" pazēte dicei . . locho cholle jsspogliate "spolpate". 22. sosstegnio . . possto.

1218. 1. dela acq"a" . . cresscivte argine. 2. jnfralla cressciuta tera. 3. chotra che la circhīatricie . . affasciare e circho. 4. moltifichata . . terra chella. 5. grosseza chesstaua . . fralla aqua . . fuocho. 6. rimāgha . . dela . . aqua. 7. rimarrāno . . acq. 8. chāpi adornide delle richasschati biade tuti. 9. morano. 10. cher il cibo a . . ellupe . . vano. 11. rato . . chō prvra. 12. vita | "e māchera la gieneraziode vmana" a . . modo [la tera] fertile e frutuosa tera. 13. rimara alida essterile. 14. "acq" . . per la la. 15. fredda esso. 16. chosstretta . . cholo . . fuocho 17. ri nara īnriarsa (?) cienere. 18. teresstre.

1219. 1. chō ¶ perche . . chelluno . . uivessi. 3. pro ¶ la . vagha . . del "creare e fare" "[fare]" chōtinv. 4. efforme [mette

1217. 1218. Compare No. 1339, written on the same sheet.

del creare e fare cōtin⁴ue vite e forme, per- | taking pleasure in creating and making con-

del creare e fare cōtin⁴ue vite e forme, per-
chè cogni⁵oscie che sono accrescimēto della
sua terrestre materia, ⁶è volonterosa e piv
presta col suo creare che 'l tēpo col cō-
⁷sumare; e però à ordinato che molti ani-
mali sieno cibo l'uno del⁸l'altro; e nō sod-
disfaciēdo questo a simile desiderio, e' spesso
⁹māda fuora cierti avelenati e pestilēti
vapori sopra le grā moltipli¹⁰cazioni e cō-
gregazioni d'animali, e massime sopra gli
omini, che fanno ¹¹grāde accrescimēto, per-
chè altri animali ¹²nō si cibano di loro, e
tolte via le cagioni mācherānno li effetti;
¹³adūque questa terra cierca di mācare di
sua vita, desiderādo ¹⁴la continva moltipli-
cazione; per la tua assegniata e demon-
strata ¹⁵ragione spesso li effetti sommigliano
le loro cagioni; gli animali so¹⁶no esēplo
della vita mōdiale.

taking pleasure in creating and making con-
stantly new lives and forms, because she knows
that her terrestrial materials become thereby
augmented, is more ready and more swift in
her creating, than time in his destruction; and
so she has ordained that many animals shall be
food for others. Nay, this not satisfying her de-
sire, to the same end she frequently sends forth
certain poisonous and pestilential vapours upon
the vast increase and congregation of ani-
mals; and most of all upon men, who in-
crease vastly because other animals do not
feed upon them; and, the causes being remo-
ved, the effects would not follow. This earth
therefore seeks to lose its life, desiring only
continual reproduction; and as, by the argu-
ment you bring forward and demonstrate, like
effects always follow like causes, animals
are the image of the world.

piv vite sopra la terra che] perchę. 5. oſscie chessono accresscimēto. 6. pressta chol . . chol chō. 8. sosdisfaciēdo qussto
assimile . . esspesso. 9. vapori "e pestilētie chontinva pessta" sopra. 10. chazioni e chō greghazioni . . fano. 11. accres-
scimēto . . altr. 12. chagione. 13. chō ¶ adūque . . ciercha . . māchare. 14. chóntinva moltiplichazione . . emosstra.
15. somigliano . . chagioni. 16. dela.

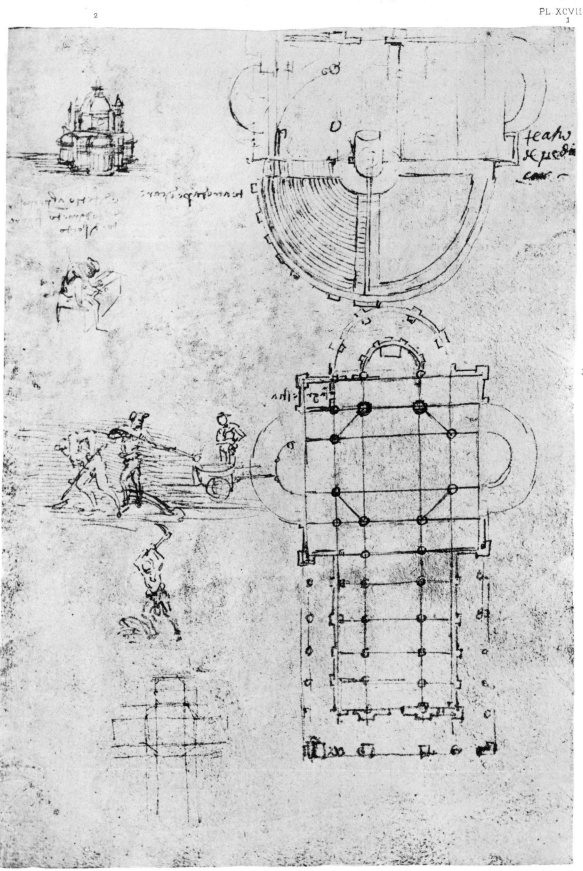

Héliog. Dujardin.

Imp. Eudes.

Imp. Eudes.

Héliog. Dujardin.

2

1

3

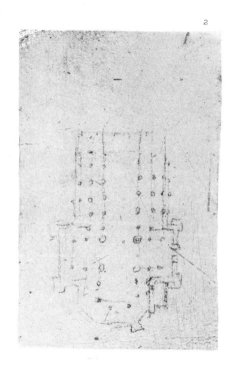

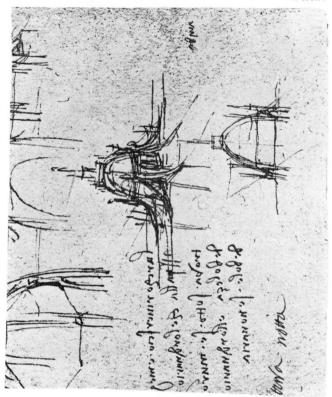

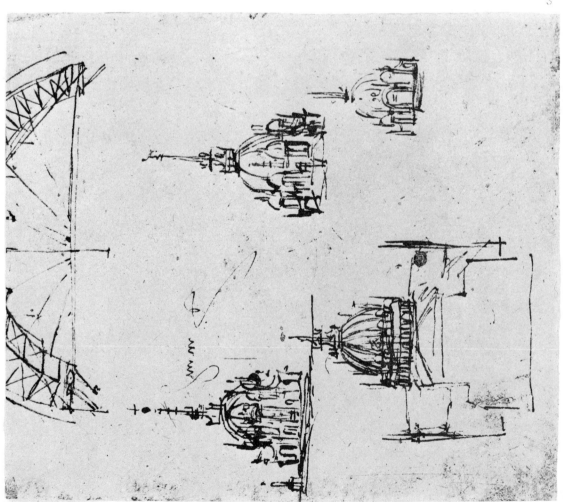

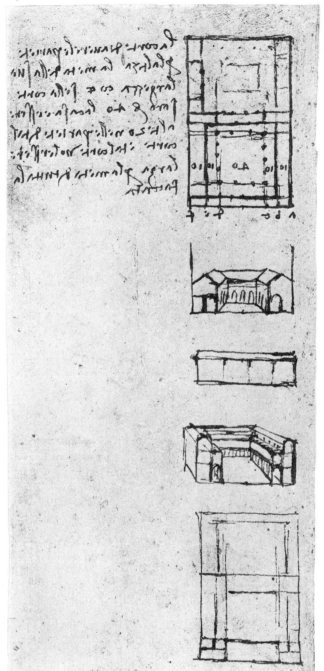

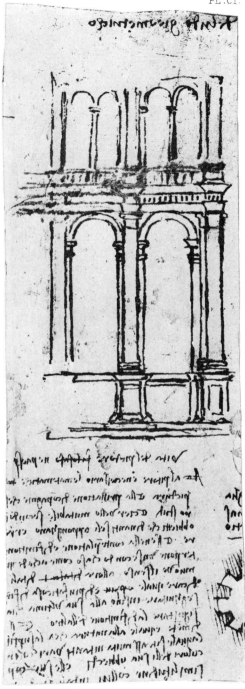

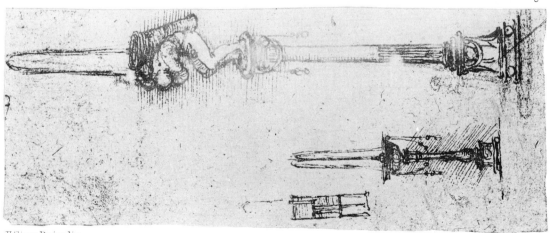

Plate C is reproduced on the following two pages.

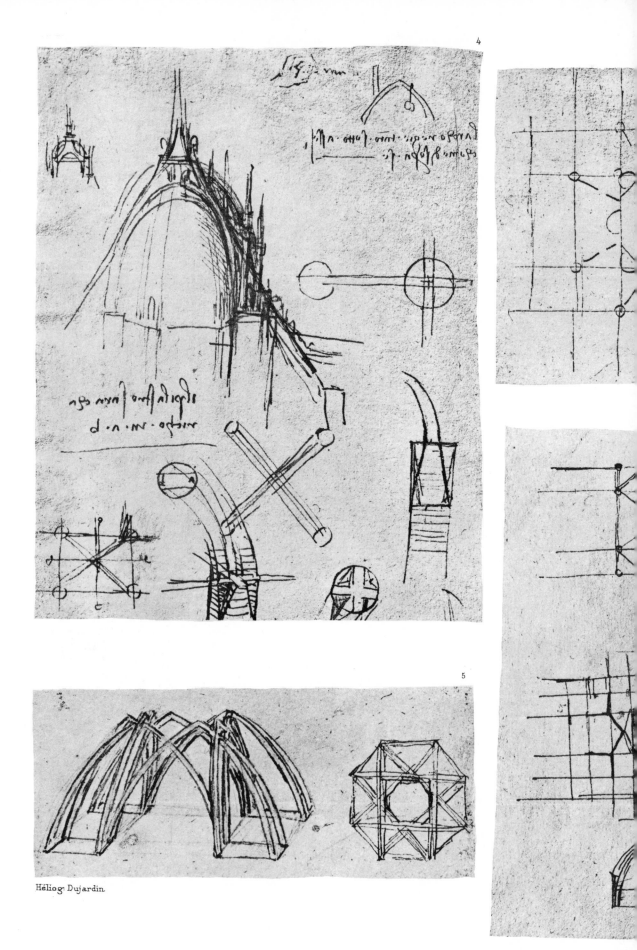

Héliog. Dujardin.

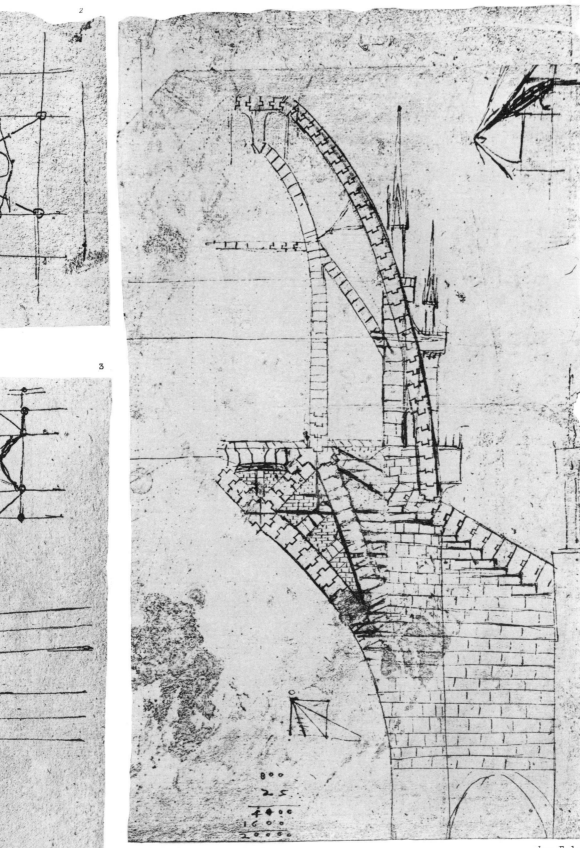

2

3

8 0 0
2 5
4 0 0 0
1 6 0 0 0
2 0 0 0 0

Imp. Eudes.

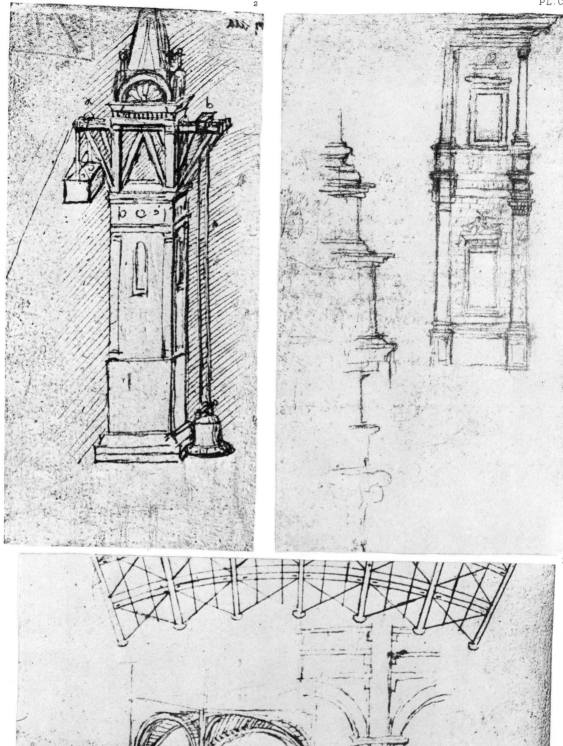

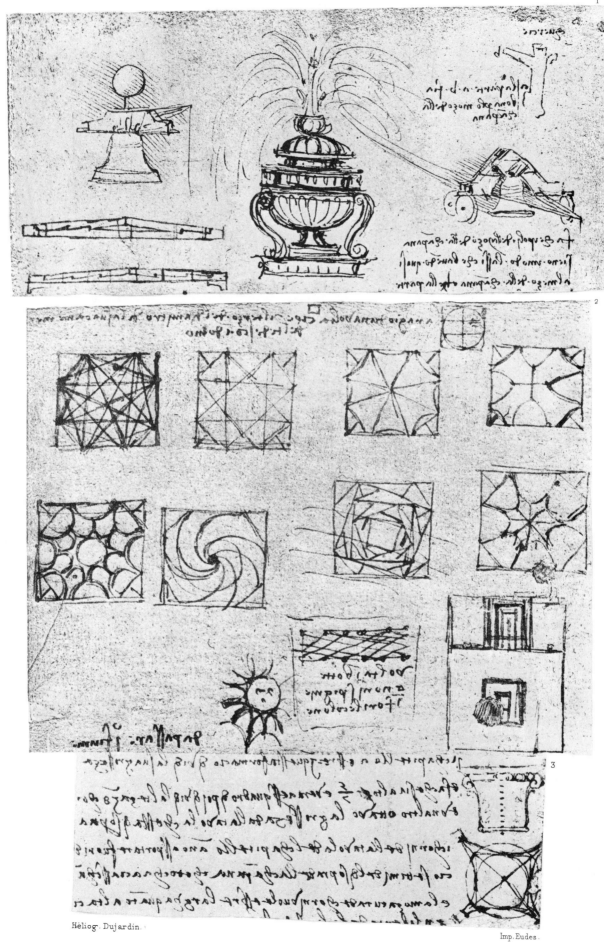

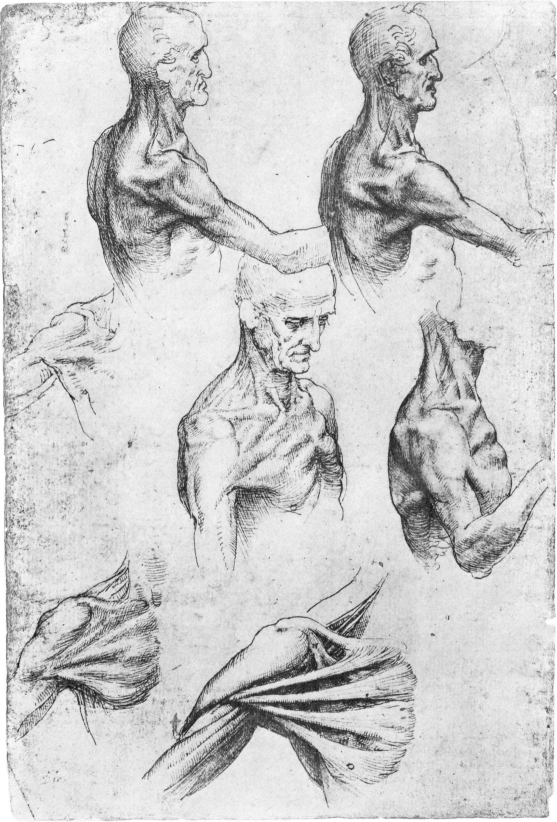

1

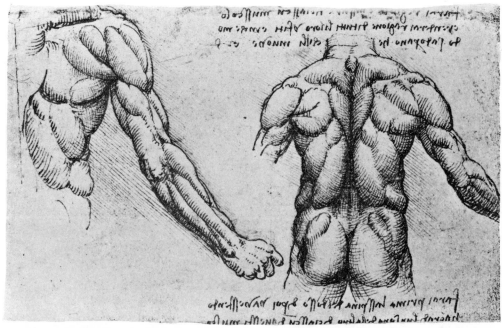

2

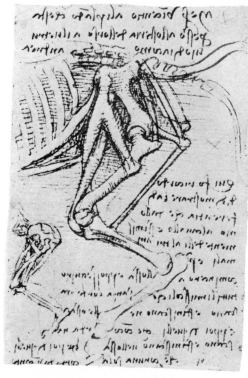

5

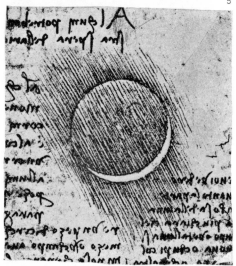

4

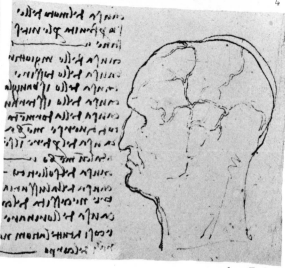

3

Héliog. Dujardin.

Imp. Eudes.

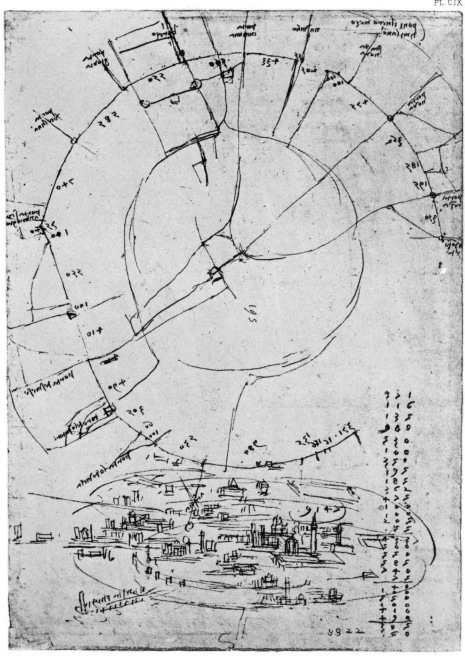

Héliog. Dujardin.

Imp. Eudes.

Plate CX will be found following Plate CXIV.

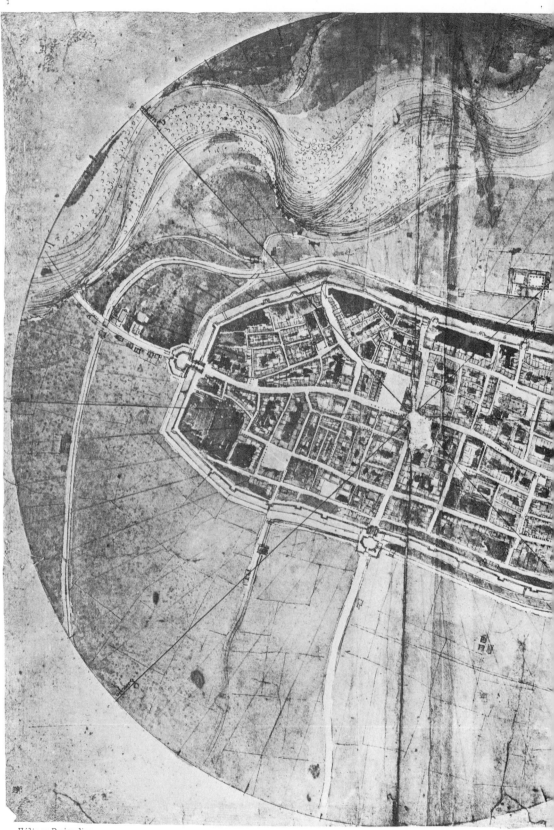

2.

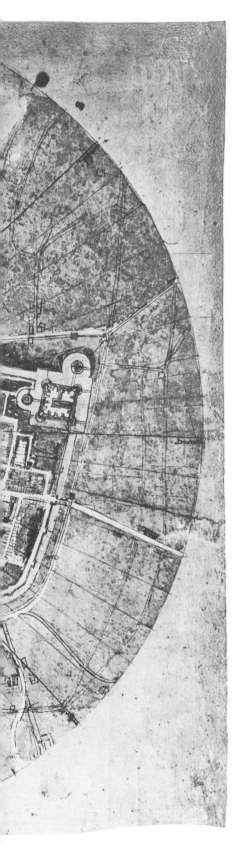

Imp. Eudes.

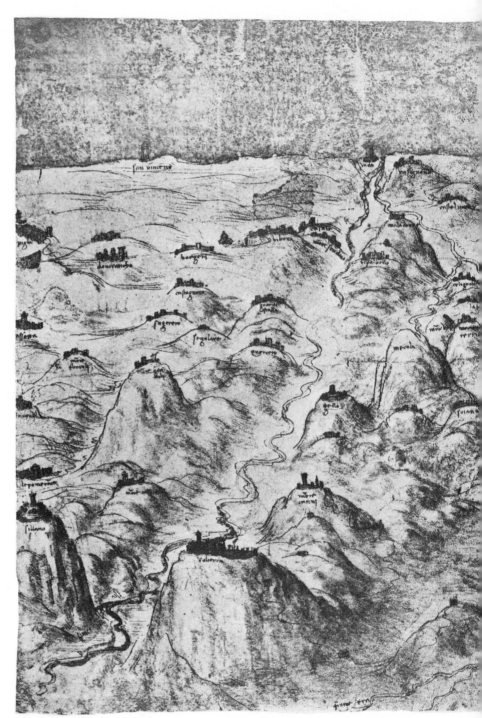

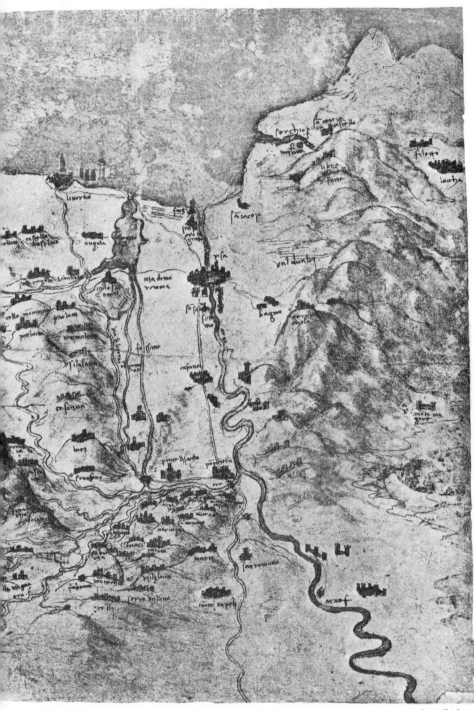

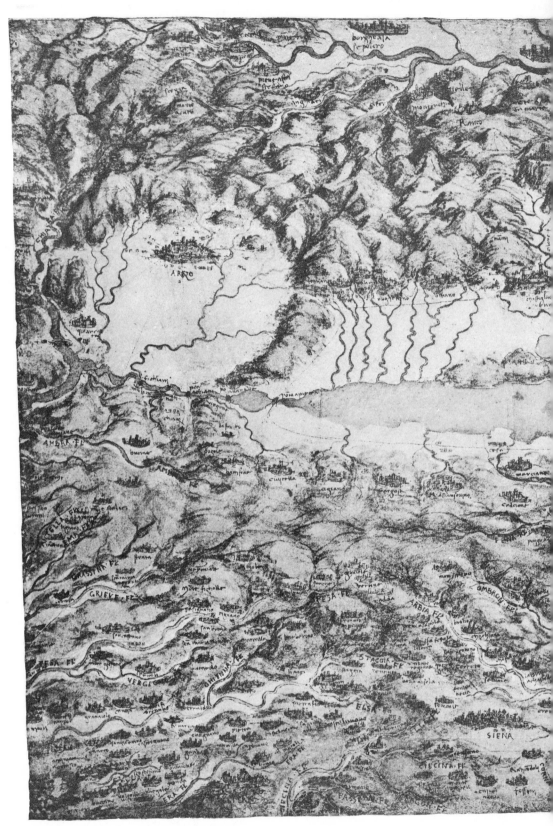

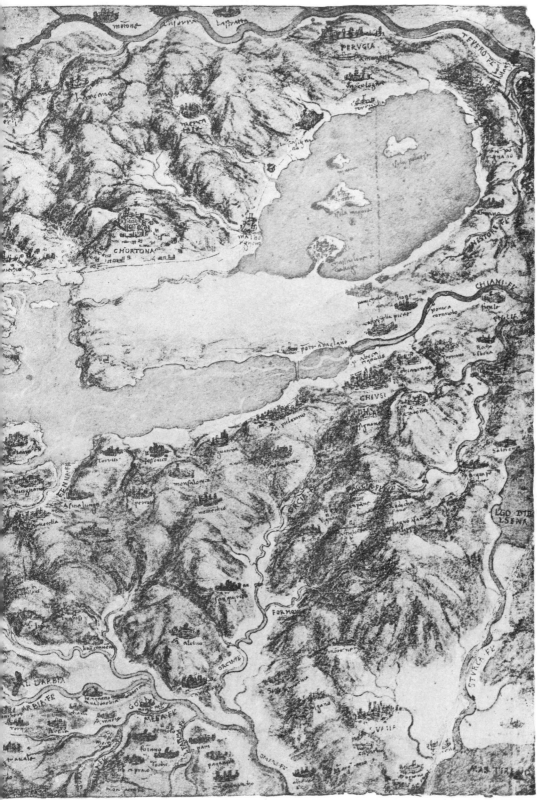

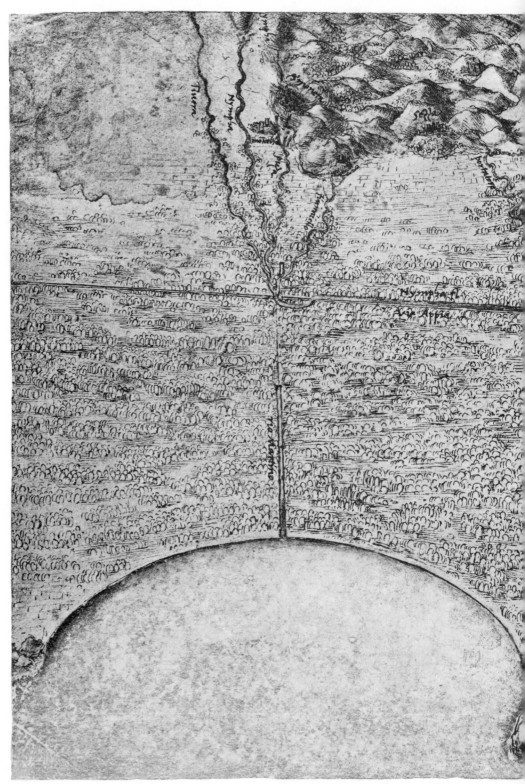

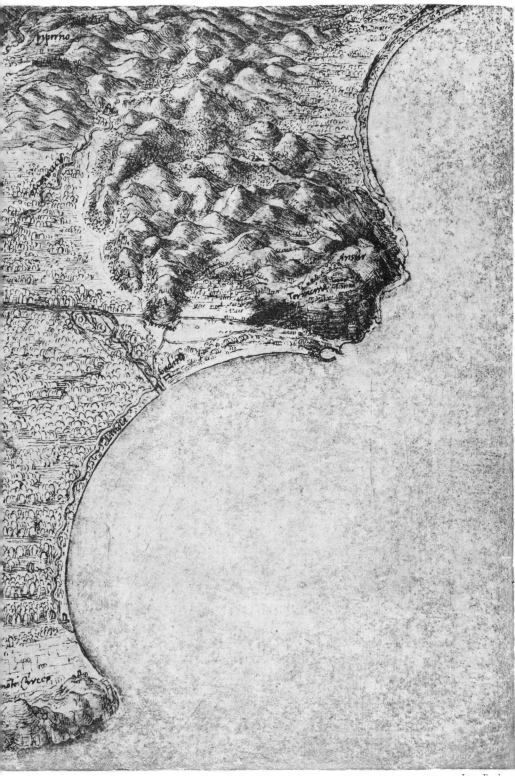

3

4

Héliog. Dujardin.

Imp. Eudes.



Héliog. Dujardin.

Imp. Eudes.

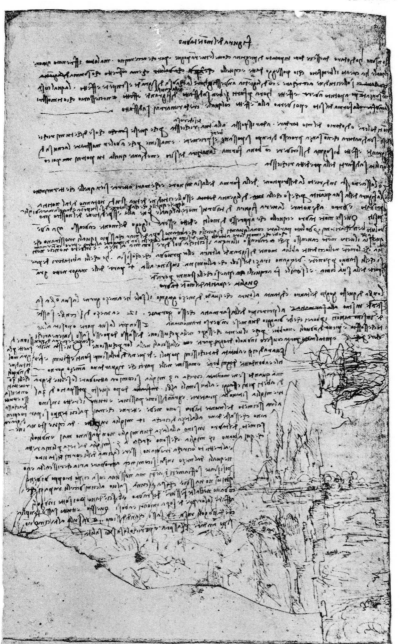

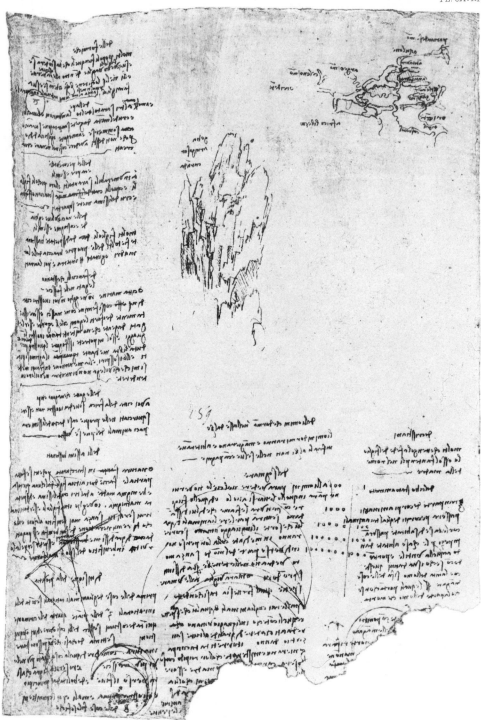

Héliog. Dujardin.

Imp. Eudes.

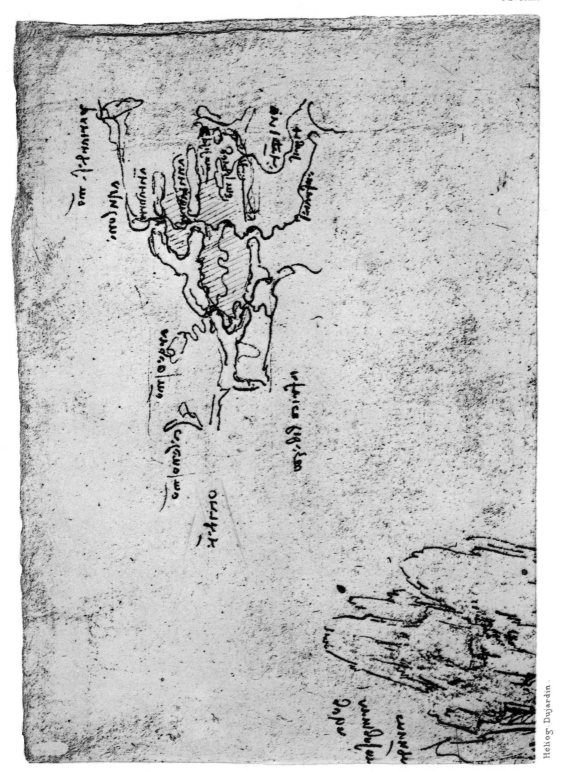

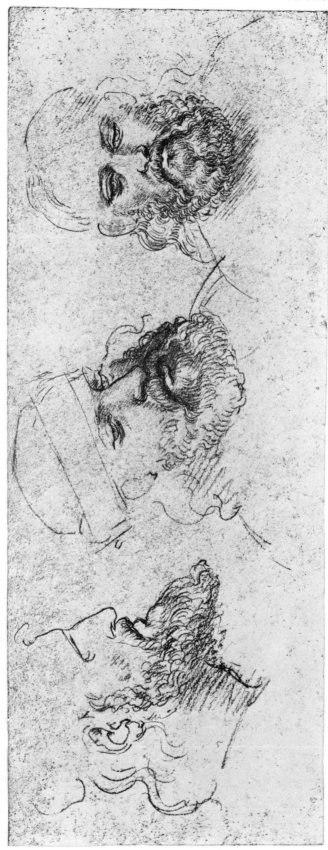

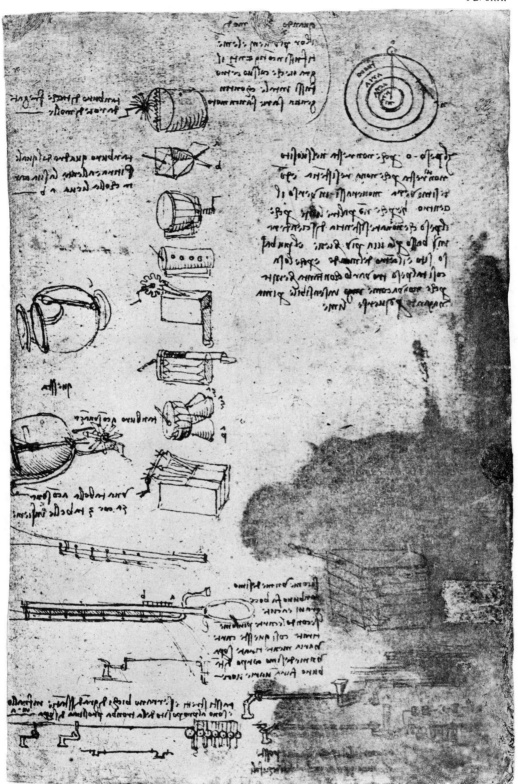

Héliog. Dujardin.

Imp. Eudes.

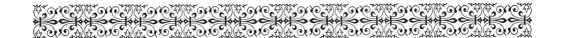

XX.

Humorous Writings.

Just as Michaelangelo's occasional poems reflect his private life as well as the general disposition of his mind, we may find in the writings collected in this section, the transcript of Leonardo's fanciful nature, and we should probably not be far wrong in assuming, that he himself had recited these fables in the company of his friends or at the court festivals of princes and patrons. Era tanto piacevole nella conversazione — *so relates Vasari —* che tirava a sè gli animi delle genti. *And Paulus Jovius says in his short biography of the artist:* Fuit ingenio valde comi, nitido, liberali, vultu autem longe venustissimo, et cum elegantiae omnis deliciarumque maxime theatralium mirificus inventor ac arbiter esset, ad lyramque scito caneret, cunctis per omnem aetatem principibus mire placuit. *There can be no doubt that the fables are the original offspring of Leonardo's brain, and not borrowed from any foreign source; indeed the schemes and plans for the composition of fables collected in division V seem to afford an external proof of this, if the fables themselves did not render it self-evident. Several of them— for instance No. 1279—are so strikingly characteristic of Leonardo's views of natural science that we cannot do them justice till we are acquainted with his theories on such subjects; and this is equally true of the 'Prophecies'.*

I have prefixed to these quaint writings the 'Studies on the life and habits of animals' which are singular from their peculiar aphoristic style, and I have transcribed them in exactly the order in which they are written in MS. H. This is one of the very rare instances in which one subject is treated in a consecutive series of notes, all in one MS., and Leonardo has also departed from his ordinary habits, by occasionally not completing the text on the page it is begun. These brief notes of a somewhat mysterious bearing have been placed here, simply because they may possibly have been intended to serve as hints for fables or allegories. They can scarcely be regarded as preparatory for a natural history; rather they would seem to be extracts. On the one hand the names

of some of the animals seem to prove that Leonardo could not here be recording obser-
vations of his own; on the other hand the notes on their habits and life appear to me
to dwell precisely on what must have interested him most—so far as it is possible to
form any complete estimate of his nature and tastes.

In No. 1293 lines 1—10, we have a sketch of a scheme for grouping the Prophe-
cies. I have not however availed myself of it as a clue to their arrangement here
because, in the first place, the texts are not so numerous as to render the suggested
classification useful to the reader, and, also, because in reading the long series, as they
occur in the original, we may follow the author's mind; and here and there it is
not difficult to see how one theme suggested another. I have however regarded
Leonardo's scheme for the classification of. the Prophecies as available for that of the
Fables and Jests, and have. adhered to it as far as possible.

Among the humourous writings I might perhaps have included the 'Rebusses', of
which there are several in the collection of Leonardo's drawings at Windsor; it seems
to me not likely that many or all of them could be solved at the present day and the
MSS. throw no light on them. Nor should I be justified if I intended to include in
the literary works the well-known caricatures of human faces attributed to Leonardo—
of which, however, it may be incidentally observed, the greater number are in my
opinion undoubtedly spurious. Two only have necessarily been given owing to their
presence in text, which it was desired to reproduce: Vol. I page 326, and Pl. CXXII.
It can scarcely be doubted that some satirical intention is conveyed by the drawing on
Pl. LXIV (text No. 688).

My reason for not presenting Leonardo to the reader as a poet is the fact that
the maxims and morals in verse which have been ascribed to him, are not to be found
in the manuscripts, and Prof. Uzielli has already proved that they cannot be by him.
Hence it would seem that only a few short verses can be attributed to him with any
certainty.

I.

STUDIES ON THE LIFE AND HABITS OF ANIMALS.

1220.

AMORE DI UIRTÙ.

²Cardellino · è · vno · vcciello · jl quale ³si dice · che, essendo · esso · portato · dinanzi ⁴a vno · infermo · che, se 'l detto · infermo · de⁵be morire, questo · ucciello · li uolta · la te⁶sta per lo · cōtrario · e mai · lo riguarda ·, e se ⁷esso infermo · debe · scampare ·, questo ⁸vcciello · mai · l'abandona · di uista, anzi ⁹è causa · di leuarli · ogni · malattia;

¹⁰Similmēte è · l'amore · di uirtù ·; nō guar¹¹da · mai · cosa · vile ·, nè · trista; anzi di¹²mora · senpre · in cose oneste · e uirtuo-¹³se ·, e rimpatria in cor giētile a si¹⁴militudine degli uccielli nelle uerdi selue ¹⁵sopra · i fioriti rami ·; e si dimostra piv ¹⁶esso amore nelle auersità che nelle prosperi¹⁷tà, faciēdo come il lume che piv risplēde ¹⁸doue truoua piv tenebroso · sito.

THE LOVE OF VIRTUE.

The gold-finch is a bird of which it is related that, when it is carried into the presence of a sick person, if the sick man is going to die, the bird turns away its head and never looks at him; but if the sick man is to be saved the bird never loses sight of him but is the cause of curing him of all his sickness.

Like unto this is the love of virtue. It never looks at any vile or base thing, but rather clings always to pure and virtuous things and takes up its abode in a noble heart; as the birds do in green woods on flowery branches. And this Love shows itself more in adversity than in prosperity; as light does, which shines most where the place is darkest.

1221.

INVIDIA.

²Del nibbio · si leggie ·, che quādo esso uede ³i sua figlioli nel nido esser di troppa gra⁴ssezza, che per invidia egli becca loro le coste e tiē⁵gli sanza māgiare.

ENVY.

We read of the kite that, when it sees its young ones growing too big in the nest, out of envy it pecks their sides, and keeps them without food.

1220. 2. callendrino e uno. 4. chessel. 5. quessto. 6. esse. 7. isschanpare quessto. 9. chausa . . hogni. 11. trissta. 12. honeste he. 13. ripatria [senpre] in . . assi. 15. essi . . prossperi. 17. comelume . . rissplēde.

1221. 2. nibio si legie. 4. ssezza che "per inuidia" egli gli beccha . . cosste ettiē. 6. allegreza. 7. lalegreza e apropriata.

ALLEGREZZA.

⁷L'allegrezza · è appropriata · al gallo · che ⁸d'ogni piccola · cosa · si rallegra e cā-⁹ta · con vari e scherzāti mouimēti.

TRISTEZZA.

¹¹La tristezza · s'assomiglia al corbo, il quale, ¹²quādo uede i sua nati figlioli esser biā¹³chi, che per lo grāde dolore si parte cō tristo ¹⁴rammarichio, gl'abādona e nō gli pascie · ¹⁵īsino che non gli vede alquāte poche pēne ¹⁶nere.

CHEERFULNESS.

Cheerfulness is proper to the cock, which rejoices over every little thing, and crows with varied and lively movements.

SADNESS.

Sadness resembles the raven, which, when it sees its young ones born white, departs in great grief, and abandons them with doleful lamentations, and does not feed them until it sees in them some few black feathers.

H.1 6a] 1222.

PACE.

²Del castoro si legge che, quādo è perse³guitato ·, cōnosciēdo · essere · per la virtù ⁴de' sua medicinali · testiculi, esso nō po⁵tēdo piv fuggire, si ferma, e per auere ⁶pace coi cacciatori coi sua tagliēti ⁷dēti si spicca i testiculi e li lascia a sua ⁸nimici.

IRA.

¹⁰Dell'orso si dice che · quādo va alle case ¹¹delle api per torre loro il mele, esse ¹²api cōminciando a pūgierlo, che lui lasci¹³a il mele e corre alla vendetta, e volē-¹⁴dosi cō tutte quelle che lo mordono vē-¹⁵dicare, cō nessuna si uēdica, in modo che la ¹⁶sua ira si cōuerte in rabbia, e gittatosi ¹⁷in terra colle mani e coi piedi inasprādo ¹⁸indarno da quelle si difende.

PEACE.

We read of the beaver that when it is pursued, knowing that it is for the virtue [contained] in its medicinal testicles and not being able to escape, it stops; and to be at peace with its pursuers, it bites off its testicles with its sharp teeth, and leaves them to its enemies.

RAGE.

It is said of the bear that when it goes to the haunts of bees to take their honey, the bees having begun to sting him he leaves the honey and rushes to revenge himself. And as he seeks to be revenged on all those that sting him, he is revenged on none; in such wise that his rage is turned to madness, and he flings himself on the ground, vainly exasperating, by his hands and feet, the foes against which he is defending himself.

H.1 6b] 1223.

GRATITUDINE.

²La virtù · della gratitudine si dice ³essere piv nelli uccielli detti upupa, ⁴i quali, conosciēdo il benificio della ⁵ricievuta vita e nvtrimēto dal pa⁶dre e dalla lor madre, quādo li uedo⁷no vechi fanno loro vno nido e li ⁸covano e li nutriscono, e cavā loro ⁹col becco le vechie e triste penne, e ¹⁰cō cierte erbe li rēdano la uista, ¹¹in modo che ritornano in prospertà.

GRATITUDE.

The virtue of gratitude is said to be more [developed] in the birds called hoopoes which, knowing the benefits of life and food, they have received from their father and their mother, when they see them grow old, make a nest for them and brood over them and feed them, and with their beaks pull out their old and shabby feathers; and then, with a certain herb restore their sight so that they return to a prosperous state.

8. pichola chosa . . echā. 9. coūari esscerzati. 10. tristeza. 11. tristeza sasomiglia al corb. 14. ramarichio. 15. nogli . . poce.

1222. 2. he. 3. cōnossciēdo. 5. fugire. 7. sisspicha . . elli lasscia assua. 11. ave. 12. ave lo cōmiciato a pūgiere o di lui lassci. 13. core. 14. chello mordano. 15. imodo chella. 17. tero cholle mani eco . . inaspādo. 18. dacquelle.

1223. 1. [miscericordia] over graditudine. 3. detti upica. 4. conossciēdo . . nvtrimēdo. 6. ueda. 7. fano . . elli. 8. elli notrisscano. 9. becho . . trisste. 10. chō . . rēdano. 11. imodo. 13. rosspo si passcie . . essenpre.

AVARITIA.

[13] Il rospo si pascie di terra e senpre [14] sta macro, perchè nō si satia; tant' è [15] il timore che essa terra nō li manchi.

AVARICE.

The toad feeds on earth and always remains lean; because it never eats enough:— it is so afraid lest it should want for earth.

INGRATITUDINE.

[2] I colonbi sono assimigliati alla [3] ingratitudine, inperochè quādo [4] sono in età che non abbino piv biso[5]gnio d'essere cibati, cominciano a [6] cōbattere col padre; e nō finisce [7] essa pugnia insino a tāto che [8] caccia il padre e togli la moglie [9] faciendose la sua.

INGRATITUDE.

Pigeons are a symbol of ingratitude; for when they are old enough no longer to need to be fed, they begin to fight with their father, and this struggle does not end until the young one drives the father out and takes the hen and makes her his own.

CRUDELTÀ.

[11] Il basilisco · è di tanta crudeltà che, [12] quādo colla sua venenosa vista nō può [13] occidere li animali, si volta all'erbe [14] e le piāte, e fermādo in quelle la sua [15] vista le fa seccare.

CRUELTY.

The basilisk is so utterly cruel that when it cannot kill animals by its baleful gaze, it turns upon herbs and plants, and fixing its gaze on them withers them up.

LIBERALITÀ.

[2] Dell'aquila si dice che non à mai si grā [3] fame ·, che non lasci parte della sua [4] preda · a quelli vcciegli che gli son [5] dintorno ·, i quali, nō potēdosi per se [6] pasciere, è neciessario che sieno cor[7]teggiatori d'essa aquila, perchè in tal [8] modo si cibano.

GENEROSITY.

It is said of the eagle that it is never so hungry but that it will leave a part of its prey for the birds that are round it, which, being unable to provide their own food, are necessarily dependent on the eagle, since it is thus that they obtain food.

CORETTIONE.

[10] Quādo il lupo · va asentito intorno [11] a qualche stallo di bestiame, e che per caso [12] esso pōga il piede in fallo in modo facci [13] strepito, egli si morde il piè per correg[14]giere se da tale errore.

DISCIPLINE.

When the wolf goes cunningly round some stable of cattle, and by accident puts his foot in a trap, so that he makes a noise, he bites his foot off to punish himself for his folly.

LUSINGHE OVER SIRENE.

[2] La sirena si dolcemēte cāta [3] che adormēta i marinari, e essa [4] mōta sopra i navili e occide li a[5]dormētati marinari.

FLATTERERS OR SYRENS.

The syren sings so sweetly that she lulls the mariners to sleep; then she climbs upon the ships and kills the sleeping mariners.

1224. 4. abino. 5. comiciano. 6. finissce. 7. attāto. 8. cacia . . toli. 9. rafaciendosela. 11. basalisscio. 12. vissta nōpo. 14. elle . . effermādo . . lassua. 15. sechare.

1225. 3. nollassci. 4. acquelli . chelle. 6. passciere . . chessieno. 7. tegiatori. 9. corettione. 10. assentito. 11. acqualche. 12. imodo faci. 13. strepido . . percore. 14. tatale.

1226. 1. lusingeover s\\\\\\e. 8. vcidē. 9. semēza. 10. pascano. 13. caciatori 'vesta. 14. core. 15. cho gra . . v̄iciodale cordi.

Prudētia.

[7]La formica per naturale cōsiglio [8]provede la state per lo uerno, uccidē[9]do le racolte semēze, perchè nō ri[10]nascino, e di quelle al tenpo si pascono.

Pazzia.

[12]Il bo saluatico avēdo in odio il co-[13]lore rosso, i cacciatori vestono di rosso [14]il pedal d'una piāta, e esso bo corre a [15]quella e cō gran furia v'inchioda le corti-[16]ne, ōde i cacciatori l'uccidono.

Prudence.

The ant, by her natural foresight provides in the summer for the winter, killing the seeds she harvests that they may not germinate, and on them, in due time she feeds.

Folly.

The wild bull having a horror of a red colour, the hunters dress up the trunk of a tree with red and the bull runs at this with great frenzy, thus fixing his horns, and forthwith the hunters kill him there.

H.[1] 8b]. 1227.

Givstitia.

[2]E' si può · assimigliare la uirtù della giusti[3]tia allo rè delle api, il quale ordina [4]e dispone ogni cosa cō ragione, impero-[5]chè alcune api sono ordinate anda[6]re per fiori, altre ordinate a lavora[7]re, altre a cō-battere colle vespe, [8]altre a leuare le sporcitie, altre [9]a accōpagnare e corteggiare il loro rè; e quā[10]do è vecchio e sāza ali, esse lo portano, [11]e se ui vna māca di suo ofi-tio, sāza [12]alcuna remissione è punita.

Verità.

[14]Benchè le pernici rubino l'oua l'una all'al[15]tra, nōdimeno i figlioli nati d'esse ova [16]senpre ritornano alla lor uera madre.

Justice.

We may liken the virtue of Justice to the king of the bees which orders and arranges every thing with judgment. For some bees are ordered to go to the flowers, others are ordered to labour, others to fight with the wasps, others to clear away all dirt, others to accompagny and escort the king; and when he is old and has no wings they carry him. And if one of them fails in his duty, he is punished without reprieve.

Truth.

Although partridges steal each other's eggs, nevertheless the young born of these eggs always return to their true mother.

H.[1] 9a] 1228.

Fedeltà over lealtà.

[2]Le grù son tanto fedeli e leali al loro rè [3]che la notte, quādo lui dorme, alcune vā[4]no dintorno al prato per guardare da lū[5]ga ·; altre ne stanno dapresso e tengono [6]vno sasso ciascuna in piè, che se 'l son[7]no le uincesse, essa pietra caderebbe e fa[8]rebbe tal romore, ch'essi ridesterebbero; e [9]altre vi sono che insieme intorno al rè dor[10]mono, e ciò fanno ogni notte scābiādosi, [11]acciò chè loro rè nō uogliono mācare.

Fidelity, or Loyalty.

The cranes are so faithful and loyal to their king, that at night, when he is sleeping, some of them go round the field to keep watch at a distance; others remain near, each holding a stone in his foot, so that if sleep should overcome them, this stone would fall and make so much noise that they would wake up again. And there are others which sleep together round the king; and this they do every night, changing in turn so that their king may never find them wanting.

16. iccaciatori loccidano.
1227. 2. delagusti. 3. ave. 4. chosa . . ipero. 5. alchuna ave. 6. allauora. 7. chōbottere cholle vesspe. 8. spurcitie. 9. acō-pagnare e cortegiare loree. 10. essāza. 11. esse . . māca. 14. benchelle.
1228. 1. lialta. 2. allorere. 3. chella. 5. ettengano. 6. sasso [per] ciascuna . . chesselso. 7. vinciessi . . chaderebe effa. 8. rebe . . ridesterebono. 9. chensieme . . are. 10. mano . . fano. 11. acio chollorore nō uē gli a māchare. 13. torma dissga.

FALSITÀ.

[13]La uolpe quãdo vede alcuna torma di sgar[14]ze o taccole o simili uccielli, subito si gitta in ter[15]ra in modo colla bocca aperta che par morta, [16]e essi uccielli le uogliono beccare la lingua, e essa [17]gli piglia la testa.

FALSEHOOD.

The fox when it sees a flock of herons or magpies or birds of that kind, suddenly flings himself on the ground with his mouth open to look as he were dead; and these birds want to peck at his tongue, and he bites off their heads.

H.¹ 9ð] **1229.**

BUGIA.

[2]La talpa · à li ochi molto · piccoli ·, e senpre [3]sta · sotto · terra · e tanto · viue ·, quanto essa [4]sta occulta ·, e come · viene alla luce [5]subito · more · perchè si fa nota; così la bugia.

LIES.

The mole has very small eyes and it always lives under ground; and it lives as long as it is in the dark but when it comes into the light it dies immediately, because it becomes known;—and so it is with lies.

FORTEZZA.

[7]Il lione · mai · teme ·, anzi · cõ forte animo [8]pugna cõ fiera battaglia contra la mol-[9]titudine de' cacciatori ·, senpre ciercãdo [10]offendere · il primo · che l'offese.

VALOUR.

The lion is never afraid, but rather fights with a bold spirit and savage onslaught against a multitude of hunters, always seeking to injure the first that injures him.

TIMORE OVER UILTÀ.

[12]La lepre senpre teme ·, e le foglie che ca[13]dono dalle piãte · per autunno senpre la tẽ[14]gono in timore, e 'l piv delle volte in fuga.

FEAR OR COWARDICE.

The hare is always frightened; and the leaves that fall from the trees in autumn always keep him in terror and generally put him to flight.

H.¹ 10a] **1230.**

MAGNIANIMITÀ.

[2]Il falcone nõ preda · mai ·, se non uc-celli [3]grossi., e prima si lascierebbe morire che [4]si cibasse de' piccoli, o che mangiasse car[5]ne fetida.

MAGNANIMITY.

The falcon never preys but on large birds; and it will let itself die rather than feed on little ones, or eat stinking meat.

VANA GLORIA.

[7]In questo vitio si legge del pavone es-ser[8]li più che altro animale sottoposto, [9]perchè senpre contempla in nella bellezza [10]della sua coda, quella allargãdo in for[11]ma di rota e col suo grido trae a se [12]la uista de'circustãti animali;

[13]E questo · è l'ultimo vitio che si possa [14]vinciere.

VAIN GLORY.

As regards this vice, we read that the peacock is more guilty of it than any other animal. For it is always contemplating the beauty of its tail, which it spreads in the form of a wheel, and by its cries attracts to itself the gaze of the creatures that surround it.

And this is the last vice to be conquered.

14. tacole ossimili . . sibito . . inte. 15. imodo . .. bocha. 16. occielli . . uoglia becare . . e ess.
1229. 1. busia. 2. picioli essenpre. 3. ettonto. 4. occhulta e chome. 6. forteza. 7. ilione . . chõ. 8. puglia. 9. caciatori. 10. chellofese. 12. elle . . che cha. 13. giano delle . . altunno. 14. gano.
1230. 2. senone ucieli. 3. lasscierebe. 4. chessicibassi de picholi. 5. feteda. 6. groria. 7. legie del pagone. 9. chontenpra inella belleza. 10. chol . . asse.

H.I 10 *b*] **1231.**

CONSTANTIA.

[2]Alla costantia · s'assimiglia · la fenice, [3]la quale intēdēdo per natura la sua re-[4]novatione ·, è costante a sostenere le cuo-centi [5]fiamme · le quali la cōsumano, e poi [6]di novo rinascie.

CONSTANCY.

Constancy may be symbolised by the phoenix which, knowing that by nature it must be resuscitated, has the constancy to endure the burning flames which consume it, and then it rises anew.

INCŌSTANTIA.

[8]Il rondone si mette per la incostantia, [9]il quale senpre sta in moto per nō sop-porta[10]re alcuno minimo disagio.

INCONSTANCY.

The swallow may serve for Inconstancy, for it is always in movement, since it cannot endure the smallest discomfort.

TĒPERĀZA.

[12]Il camello è il piv · lussurioso animale [13]che sia, e andrebbe mille miglia dirieto a vna [14]camella ·, e se vsasse cōtinvo cō la madre o so[15]relle, mai le tocca; tāto si sa bē tēperare.

CONTINENCE.

The camel is the most lustful animal there is, and will follow the female for a thousand miles. But if you keep it constantly with its mother or sister it will leave them alone, so temperate is its nature.

H.I 11 *a*] **1232.**

INTĒPERANZA.

[2]Il liocorno overo vnicorno · per la sua intē[3]perāza e nō sapersi uīciere per lo di-letto che à [4]delle donzelle · dimētica la sua ferocità [5]e saluatichezza; ponēdo da cāto ogni sospetto [6]va alla sedente donzella e se le adormē[7]ta · in grēbo ·, e i cacciatori in tal modo [8]lo pigliano.

INCONTINENCE.

The unicorn, through its intemperance and not knowing how to control itself, for the love it bears to fair maidens forgets its ferocity and wildness; and laying aside all fear it will go up to a seated damsel and go to sleep in her lap, and thus the hunters take it.

VMILITÀ.

[10]Dell'umilità si uede somma speriētia nello [11]agnello, il quale si sottomette a ogni ani[12]male; e quādo per cibo son dati ai incarcerati [13]leoni ·, a quelli si sottomet-tono come alla [14]propria madre, in modo che spesse volte [15]si è vis.o i lioni non li volere occidere.

HUMILITY.

We see the most striking example of humility in the lamb which will submit to any animal; and when they are given for food to imprisoned lions they are as gentle to them as to their own mother, so that very often it has been seen that the lions forbear to kill them.

H.I 11 *b*] **1233.**

SUPERBIA.

[2]Il falcone per la sua alterigia e super-bia [3]vole signioreggiare · e soprafare tutti li al[4]tri vccielli · che sono di rapina, e sempre [5]desidera · essere solo, e spesse volte si è [6]veduto il falcone assaltare l'aquila, [7]regina delli vccielli.

PRIDE.

The falcon, by reason of its haughtiness and pride, is fain to lord it and rule over all the other birds of prey, and longs to be sole and supreme; and very often the falcon has been seen to assault the eagle, the Queen of birds.

1231. 2. sasomiglia. 3. intēdedo. 4. sosstene lecocē 5. ti fiame. 6. ti fiame rinasscie. 8. incosstantia. 9. imoto , . soporta. 13. chessia e ādebe. 14. esse vsassi . . osso. 15. tocha . . teprare.

1232. 2. lalicorno. 4. dimēticha. 5. saluaticheza . . sospeto. 6. essele. 7. chaciatori. 10. soma. 12. dati [ai dimessti] alin-carcerati. 13. cileoni . . sottomettano. 14. imodo chesspesse. 15. se visto . . noli.

1233. 2. essuperbia. 3. signioregiare essopra. 4. chesso di rapina essē. 5. esspesse voltese. 8. asstinentia. 9. assino. 10. et-

ASTINENTIA.

[9]Il saluatico · asino · quãdo · va alla [10]fonte · per bere · e trova · l'acqua intor[11]bidata, non avrà mai si grã sete, che nõ [12]s'astẽga di bere, e aspetti ch'essa acqua [13]si richiari.

ABSTINENCE.

The wild ass, when it goes to the well to drink, and finds the water troubled, is never so thirsty but that it will abstain from drinking, and wait till the water is clear again.

GOLA.

[15]Il vulture · è tanto sottoposto alla gola [16]che andrebbe mille miglia per mãgiare [17]d'una carognia, e per questo seguita li eserciti.

GLUTTONY.

The vulture is so addicted to gluttony that it will go a thousand miles to eat a carrion [carcase]; therefore is it that it follows armies.

H.1 12a]

1234.

CASTITÀ.

[2]La tortora nõ fa mai fallo al suo cõpagnio, [3]e se l'uno more, l'altro osserua perpetua ca[4]stità e non si posa mai su ramo verde e nõ [5]beue mai acqua chiara.

CHASTITY.

The turtle-dove is never false to its mate; and if one dies the other preserves perpetual chastity, and never again sits on a green bough, nor ever again drinks of clear water.

LUSSURIA.

[7]Il pipistrello per la sua sfrenata lussu[8]ria non osserua alcuno vniversale mo[9]do di lussuria, anzi maschio cõ maschio, [10]femina cõ femina, siccome a caso si tro[11]vano insieme, vsano il lor coito.

UNCHASTITY.

The bat, owing to unbridled lust, observes no universal rule in pairing, but males with males and females with females pair promiscuously, as it may happen.

MODERANZA.

[13]L'ermellino per la sua moderãtia nõ mãgia [14]se non vna sola volta il dì, e prima si lascia pi[15]gliare dai cacciatori che volere fugire [16]nella infangata tana, [17]per nõ maculare la sua giẽtilezza.

MODERATION.

The ermine out of moderation never eats but once in the day; it will rather let itself be taken by the hunters than take refuge in a dirty lair, in order not to stain its purity.

H.1 12b]

1235.

AQUILA.

[2]L'aquila, quãdo è vechia, vola tãto [3]in alto, che abbrucia le sue penne, e na[4]tura cõsente che si rinoui in giovẽtù, [5]cadendo nella poca acqua;

[6]E se i sua nati nõ possono tenere la uista [7]nel sole—; nõ li pascie di nessuno uccello, [8]che nõ uole morire; non s'accostano

THE EAGLE.

The eagle when it is old flies so high that it · scorches its feathers, and Nature allowing that it should renew its youth, it falls into shallow water [5]. And if its young ones cannot bear to gaze on the sun [6]—; it does not feed them with any bird, that does not wish to die. Animals which much fear

truova. 11. non ara . . sede. 12. asspetti . . acqa. 13. sirisciari. 15. la voltore ettanto sotto possto. 16. andrebe mile miglia [all] per. 17. per que seguita.

1234. 1. casstita. 3. esselluno. 4. enosi. 7. palpisstrello . . isfrenata. 9. masscio cõ masscio. 10. sichome achaso. 14. senvna . . lasscia. 15. gliare a caciatori. 17. giẽtileza.

1235. 3. abrucia . . pene. 4. chessi. 5. cadẽ nella poca acqua. 6. esse . . nõ posso tene. 7. pascie nessuno uciel . . morire

1235. 5. 6. The meaning is obscure.

al suo ⁹nido gli animali che forte la tema¹⁰no, ma essa a lor nō noce, senpre ¹¹lascia rimanēte della sua preda.

LUMERPA,—FAMA.

¹³Questa nascie nell'Asia Maggiore, e splē¹⁴de si forte che toglie le sue ōbre, e morendo ¹⁵nō perde esso lume, e mai li cadono giù le ¹⁶penne, e la penna che si spicca piv nō ¹⁷luce.

it do not approach its nest, although it does not hurt them. It always leaves part of its prey uneaten.

LUMERPA,—FAME.

This is found in Asia Major, and shines so brightly that it absorbs its own shadow, and when it dies it does not lose this light, and its feathers never fall out, but a feather pulled out shines no longer.

H.I 13a]

1236.

PELICANO.

²Questo porta grāde amore a sua nati, ³e trouādo quelli nel nido morti dal ⁴serpēte, si pūgie a riscōtro al core e, col ⁵suo piovente sangue bagniādoli, li tor⁶na in vita.

THE PELICAN.

This bird has a great love for its young; and when it finds them in its nest dead from a serpent's bite, it pierces itself to the heart, and with its blood it bathes them till they return to life.

SALAMĀDRA.

⁸Questo · non à mēbra passive, e nō si ⁹cura d'altro cibo che di foco, e spesso in ¹⁰quello rinova la sua scorza. ¹¹La salamādra nel foco ¹²rinova la sua scorza; — ¹³per la ¹⁴vir¹⁵tù.

THE SALAMANDER.

This has no digestive organs, and gets no food but from the fire, in which it constantly renews its scaly skin. The salamander, which renews its scaly skin in the fire,—for virtue.

CAMELEO.

¹⁶Questo viue d'aria, e ī quella sta su¹⁷bietto a tutti li uccielli, e per stare piv ¹⁸saluo vola sopra le nvvole; e truova ¹⁹aria tāto sottile, che nō può sostenere ²⁰vcciello che lo seguiti. ²¹A questa altezza nō va, se nō a chi da cieli ²²è dato, cioè dove vola il cameleone.

THE CAMELEON.

This lives on air, and there it is the prey of all the birds; so in order to be safer it flies above the clouds and finds an air so rarefied that it cannot support the bird that follows it. At that height nothing can go unless it has a gift from Heaven, and that is where the chameleon flies.

H.I 13b]

1237.

ALEPO PESCIE.

²Alepo nō uive fori dell'acqua.

THE ALEPO, A FISH.

The fish *alepo* does not live out of water.

STRUZZO.

⁴Questo cōuerte il ferro in suo ⁵nutrimēto; cova l'uova colla vista; ⁶¶per l'arme ⁷de' capitani.¶

THE OSTRICH.

This bird converts iron into nourishment, and hatches its eggs by its gaze;—Armies under commanders.

nossacosti. 9. chefforte la tena. 11. lasscia. 12. P. fama; — lumerpa fama (?). 13. nasscie . . magiore essplē. 14. chettoglie. 15. li cade piv le. 16. ella pena chessi spicha.
1236. 4. risscōtro. 9. esspesso. 12. rafeua la. 17. bietta attutti . . istare. 18. nvbe. 19. po. 20. chello. 21. acquesta. 22. cameleone. *Lines 11—15 are written on the margin near the title-line.*
1237. 1. alep[o] pescie. [4. suo "nutrimēto". 5. cova lava. *Lines 6 and 7 are written on the margin near the title-line.*

CIGNO.

[9]Cignio è candido sanza alcuna [10]macchia, e dolcemēte canta nel mo[11]rire, il qual cāto termina · la uita.

THE SWAN.

The swan is white without any spot, and it sings sweetly as it dies, its life ending with that song.

CICOGNIA.

[13]Questa, beuēdo la salsa acqua, [14]caccia da se il male; se truova la cō[15]pagnia in fallo, l'abandona; e quādo [16]è vechia, i sua figlioli la covano e pa[17]scono, infinchè more.

THE STORK.

This bird, by drinking saltwater purges itself of distempers. If the male finds his mate unfaithful, he abandons her; and when it grows old its young ones brood over it, and feed it till it dies.

H.1 14a] **1238.**

CICALA.

[2]Questa col suo canto fa tacere [3]il cucco, more nell'olio, e resucita [4]nello aceto, cāta per li ardēti caldi.

THE GRASSHOPPER.

This silences the cuckoo with its song. It dies in oil and revives in vinegar. It sings in the greatest heats

PIPISTRELLO.

[6]Questo dov'è piv luce piv si fa [7]orbo, e come piv guarda il sole [8]più s'acciecca; [9]pel uitio che nō può [10]stare do[11]v'è la vir[12]tù.

THE BAT.

The more light there is the blinder this creature becomes; as those who gaze most at the sun become most dazzled.—For Vice, that cannot remain where Virtue appears.

PERNICE.

[14]Questa si trasmuta di femina i maschio, [15]e dimētica il primo sesso, e fura per īuidia [16]l'oua al'altre, e le coua, ma i nati segui[17]tano la uera madre.

THE PARTRIDGE.

This bird changes from the female into the male and forgets its former sex; and out of envy it steals the eggs from others and hatches them, but the young ones follow the true mother.

RŌDINE.

[19]Questa colla celidonia lumina i sua [20]ciecchi nati.

THE SWALLOW.

This bird gives sight to its blind young ones by means of celandine.

H.1 14b] **1239.**

OSTRIGA.—PEL TRADIMĒTO.

[2]Questa, quādo la luna è piena, s'apre tutta, [3]e quādo il grācio la vede, dētro le gietta [4]qualche sasso o festuca, e questa nō si [5]può riserrare, ōde è cibo d'esso grāchio; [6]così fa, chi apre la bocca a dire il suo segreto, [7]chè si fa preda dello indiscreto auditore.

THE OYSTER.—FOR TREACHERY.

This creature, when the moon is full opens itself wide, and when the crab looks in he throws in a piece of rock or seaweed and the oyster cannot close again, whereby it serves for food to that crab. This is what happens to him who opens his mouth to tell his secret. He becomes the prey of the treacherous hearer.

8. cinguo. 10. cānta. 14. cacia dasse. 15. ecquādo. 16. issua. 17. scano.

1238. 1. cichala. 3. cucho. 5. palpistrello. 8. sacieca. 9. po. 14. trassmuta . . masscio. 15. iprimo. 16. elle cova. 19. collaccelidonia. 20. cieci.

1239. 1. hosstriga. 2. quasta. 3. ecquādo. 4. qualchessasso offistuca ecquesta. 5. po riserare. 6. faciaprla bocha . . sigreto. 7. chessi . . vlditore. 8. bavalissco. 9. effugito dettutti . . la do. 10. mezo. 11. essi. 12. ¶rua per la virtù¶·

Basiliscio.—Crudeltà.

[9]Questo è fugito da tutti i serpēti; la don[10]nola per lo mezzo della ruta cōbatte con essi [11]e si l'uccide.

L'aspido.

[14]Questo porta ne'dēti la subita morte [15]e per nō sentire l'incāti, colla coda si [16]stoppa li orechi.

H.1 15a] 1240.

Drago.

[2]Questo lega le gābe al liofante [3]e quel li cade adosso, e l'uno e l'al[4]tro more, e morēdo fa sua vēdetta.

Vipera.

[6]Questa nel suo accoppiare apre la bocca, e nel fine [7]strīgnie dēti e amazza il marito, poi [8]i figlioli in corpo crescivti straccia[9]no il uētre e occidono la madre.

Scorpione.

[11]La saliua sputa a digivno · sopra dello scor[12]pione e l'occide; à similitudine dell'a-[13]stinētia della gola, che togle via e cura [14]le malatie che da essa gola dipēdono, e a[15]pre la strada alle virtù.

H.1 17a] 1241.

Coccodrillo. Ipocresia.

[2]Questo · animale piglia l'o[3]mo e subito l'uccide poichè l'à morso [4]con lamētevole voce e molte lacrime [5]lo piāge ·, e finito il lamēto crudel[5]mēte lo diuora ·; così fa l'ipocrito [7]che per ogni lieue cosa s'enpie il uiso [8]di lagrime; mostrādo un cor di tigro e'ral[9]legrasi nel core dell'altrui male cō [10]piātoso volto.

Botta.

[12]La botta fugie la luce del sole, e se pure [13]per forza v'è tenvta, si gōfia tāta, che s'ascon[14]de la testa in basso, e privasi d'essi razzi; [15]così fa chi è nimico della chiara e luciē[16]te virtù, che nō può se nō con gōfiato [17]animo forzatamēte starle davāti.

The Basilisk.—Cruelty.

All snakes flie from this creature; but the weasel attacks it by means of rue and kills it.

The Asp.

This carries instantaneous death in its fangs; and, that it may not hear the charmer it stops its ears with its tail.

The Dragon.

This creature entangles itself in the legs of the elephant which falls upon it, and so both die, and in its death it is avenged.

The Viper.

She, in pairing opens her mouth and at last clenches her teeth and kills her husband. Then the young ones, growing within her body rend her open and kill their mother.

The Scorpion.

Saliva, spit out when fasting will kill a scorpion. This may be likened to abstinence from greediness, which removes and heals the ills which result from that gluttony, and opens the path of virtue.

The Crocodile. Hypocrisy.

This animal catches a man and straightway kills him; after he is dead, it weeps for him with a lamentable voice and many tears. Then, having done lamenting, it cruelly devours him. It is thus with the hypocrite, who, for the smallest matter, has his face bathed with tears, but shows the heart of a tiger and rejoices in his heart at the woes of others, while wearing a pitiful face.

The Toad.

The toad flies from the light of the sun, and if it is held there by force it puffs itself out so much as to hide its head below and shield itself from the rays. Thus does the foe of clear and radiant virtue, who can only be constrainedly brought to face it with puffed up courage.

16. stopa.

1240. delluno ellal. 6. suo coperbocha. 7. stīgnie dēti e amaza. 8. cresscivti. 11. la sciliua . . dellosschor. 12. pione locide assimilitudine. 13. chettole viaconde. 14. l |\\\| mal |\\\\\\\| che |\\| a. *Lines* 14 *and* 15 *are very indistinct and nearly effaced.*

1241. 1. cocodrillo. 2. animale [essendo]. 3. poichella morto. 4. collamētevole. 8. mostrādo īcor di tigro e ra. 12. esse. 13. scofia chessasco. 14. baso. 15. cosi facie nemico . . ciara. 16. po . . con |\\\\\| cōfiati. 17. |\\| animo . . stale.

H.I 17b]

1242.

BRUCO.—DELLA VIRTÙ IN GIENERALE.

³Il bruco·, che mediante l'esercitato studio ⁴di tessere con mirabile artifitio e sottile lauoro ⁵intorno a se fa la nova abitatione, escie ⁵poi fori di quella colle dipinte e belle ⁷ali, cō quelle leuādosi inverso il cielo.

RAGNIO.

⁹Il ragnio·partoriscie fori di se l'ar¹⁰tifitiosa e maestrevole tela, la quale ¹¹gli rēde per benifitio la presa preda.

THE CATERPILLAR.—FOR VIRTUE IN GENERAL.

The caterpillar, which by means of assiduous care is able to weave round itself a new dwelling place with marvellous artifice and fine workmanship, comes out of it afterwards with painted and lovely wings, with which it rises towards Heaven.

THE SPIDER.

The spider brings forth out of herself the delicate and ingenious web, which makes her a return by the prey it takes.

H.I 18a]

1243.

LIONE.

²Questo animale col suo tonāte grido ³desta i sua figlioli dopo il terzo giorno ⁴nati, aprēdo a quelli tutti li adormēta⁵ti sēsi, e tutte le fiere, che ⁶nella selua sono, fuggono.

⁷Puossi assimigliare a figlioli della ⁸virtù·, che mediāte il grido delle lode ⁹si suegliano·e crescono per li studi onorevoli ¹⁰che senpre piv gli inalza, e tutti i tristi ¹¹a esso grido fuggono ciessādosi dai ¹²vertuosi.

¹³Ancora il leone copre le sue pedate, ¹⁴perchè nō s'intenda il suo viaggio ¹⁵per i nimici; questo sta bene al capitano ¹⁶a cielare i segreti del suo animo, acciochè ¹⁷il nimico nō cogniosca i sua tratti.

THE LION.

This animal, with his thundering roar, rouses his young the third day after they are born, teaching them the use of all their dormant senses and all the wild things which are in the wood flee away.

This may be compared to the children of Virtue who are roused by the sound of praise and grow up in honourable studies, by which they are more and more elevated; while all that is base flies at the sound, shunning those who are virtuous.

Again, the lion covers over its foot tracks, so that the way it has gone may not be known to its enemies. Thus it beseems a captain to conceal the secrets of his mind so that the enemy may not know his purpose.

H.I 18b]

1244.

TARĀTA.

²Il morso della tarāta mātiene l'omo ³nel suo proponimēto, cioè quello che ⁴pensano quādo fu morso.

DUGO E CIVETTA.

⁶Questi gastigano i loro schernitori ⁷privādoli di uista, chè così à ordina⁸to la natura, perchè si cibino.

THE TARANTULA.

The bite of the tarantula fixes a man's mind on one idea; that is on the thing he was thinking of when he was bitten.

THE SCREECH-OWL AND THE OWL.

These punish those who are scoffing at them by pecking out their eyes; for nature has so ordered it, that they may thus be fed.

1242. 3. la sercitato. 4. comirabile | "artificio" essottile. 5. asse la . . escie. 6. chelle dipinte lauādosi. 10. maesstre vole tella. 11. rēdende.

1243. 4. aprēda acquelli. 5. ettutti [li anima] le. 6. sona. 8. delle lalde. 9. sissuegliano e crescano li studi. 10. chessenpre piv glinalza ettutti. 11. esse . . fugano. 13. ileoni co. 14. viagio. 15. ai capitani.

1244. 4. persano. 5. duco. 7. diuita. 8. to natura.

1242. Two notes are underneath this text. The first: '*nessuna chosa e da ttemere piu che lla sozza fama*' is a repetition of the first line of the text given in Vol. I No. 695.

The second: *faticha fugga cholla fama in braccio quasi ochultata c* is written in red chalk and is evidently an incomplete sentence.

LEOFANTE.

²Il grāde elefante·à per natura quel ³che raro negli omini si truova, cioè ⁴probità, prudētia, equità e osser⁵vātia e religione, inperochè, quādo ⁶la luna·si rinova·, questi vanno ai fi⁷vmi e quivi purgādosi solennemēte ⁸si lauano, e così salutato il pianeta ⁹ritornano alle selue; E quādo ¹⁰sono ammalati, stando supini, gitta¹¹no l'erbe verso il cielo, quasi com'esse ¹²sacrificare volessino; ¶ sotterrano li dē¹³ti quādo per vecchiezza gli cadono; ¶ de' ¹⁴sua due dēti l'uno adopera a cauare ¹⁵le radici per cibarsi; all'altro cōserua ¹⁶la pūta per cōbattere; Quādo sono ¹⁷superati da cacciatori, e chè la stāchezza ¹⁸gli uīcie per cotali dēti l'elefanti, quelle trattesi, con esse si ricomprano.

THE ELEPHANT.

The huge elephant has by nature what is rarely found in man; that is Honesty, Prudence, Justice, and the Observance of Religion; inasmuch as when the moon is new, these beasts go down to the rivers, and there, solemnly cleansing themselves, they bathe, and so, having saluted the planet, return to the woods. And when they are ill, being laid down, they fling up plants towards Heaven as though they would offer sacrifice.—They bury their tusks when they fall out from old age.—Of these two tusks they use one to dig up roots for food; but they save the point of the other for fighting with; when they are taken by hunters and when worn out by fatigue, they dig up these buried tusks and ransom themselves.

Sono di leni menti e conoscono i pericoli; ²¶e se esso trova·l'omo solo e smarito, ³piacievolmēte lo rimette nella perduta ⁴strada, se truova le pedate dell'omo ⁵prima che veda l'omo; ⁶¶esso teme tradimēto, ōde si ferma ⁷e soffia, mostrādolo ali altri elefanti, ⁸e fanno schiera e vanno assentitamēte.

⁹Questi vanno senpre a schiere, e 'l più ¹⁰vechio va ināzi, e 'l secōdo d'età resta ¹¹l'ultimo, e così chiudono la schiera; ¹²temono vergognia, non vsano il co¹³ito se nō di notte di nascosto, e nō tor¹⁴nano dopo il coito alli armēti, se prima ¹⁵nō si lauano nel fiume; nō cōbattono ¹⁶le femine, come gli altri animali; ¹⁷¶ed è tāto clemēte, che mal uolōtieri per na¹⁸tura nō noce ai mē potenti di se, e scō¹⁹trādosi nella sua via e greggi delle pecore

They are merciful, and know the dangers, and if one finds a man alone and lost, he kindly puts him back in the road he has missed, if he finds the footprints of the man before the man himself. It dreads betrayal, so it stops and blows, pointing it out to the other elephants who form in a troop and go warily.

These beasts always go in troops, and the oldest goes in front and the second in age remains the last, and thus they enclose the troop. Out of shame they pair only at night and secretly, nor do they then rejoin the herd but first bathe in the river. The females do not fight as with other animals; and it is so merciful that it is most unwilling by nature ever to hurt those weaker than itself. And if it meets in the middle of its way a flock of sheep

colla sua mano le pone da parte ²per non le pestare, coi piedi, nè mai noce ³se nō sono provocati; quādo son ca⁴duti nella fossa, gli altri cō rami, ⁵terra e sassi riēpiono la fossa, ⁶in modo che alzano il fondo,

it puts them aside with its trunk, so as not to trample them under foot; and it never hurts any thing unless when provoked. When one has fallen into a pit the others fill up the pit with branches, earth and stones, thus

1245. 2. ellefante. 4. he equita e osser. 6. quessti vano. 9. Ecquādo. 10. amalati . . suppini. 12. volessino (sotterali. 13. uechieza gli cagiano (de. 16. Quā sono. 17. caciatori e chella stācheza. 18. dēti le lepāte ecquele (?). 19. lelefante . . traitosi \\\\\\ nessosiricōprano. *These two last lines are much effaced.*

1246. 1. sono elemēti e conosschano. 2. esse . . sole essmarito. 7. essoffia mosstrādola. 8. effano sciera e vano. 9. vano . . assciere. 11. civdano lassciera. 12. temano. 13. nasscosto. 15. nocōbattano. 16. me femine. 18. essō. 19. nella m . "gregi" diria delle.

1247. 1. cholla . . pone de [parte. 2. per nolle pestare co. 5. essassi riēpiano. 6. imolalzano . . cheso. 7. rimō \\\\\\\\ temano.

che esso facil[7]mēte rimōti; temono forte [8]lo stridore de' porci e fugono indiri[9]eto; e nō fa māco danno poi coi piedi a sua [10]che a nimici; dilettāsi de' fiumi, [11]e sempre vāno vagabūdi intorno [12]quelli, ¶ e per lo grā peso nō possono [13]notare; diuorano le pietre, e trō[14]chi delli alberi sono loro gratissimo cibo; [15]ànno in odio i ratti; le mosche si dilettano [16]del suo odore e posādosi li adosso, quello [17]arraspa la pelle, e fa le pieghe strette, e l'uccide.

raising the bottom that he may easily get out. They greatly dread the noise of swine and fly in confusion, doing no less harm then, with their feet, to their own kind than to the enemy. They delight in rivers and are always wandering about near them, though on account of their great weight they cannot swim. They devour stones, and the trunks of trees are their favourite food. They have a horror of rats. Flies delight in their smell and settle on their back, and the beast scrapes its skin making its folds even and kills them.

H.[1] 20 b] 1248.

Quādo passano i fiumi, mādano [2]i figlioli diuerso il calar dell'acqua, [3]e stando loro inverso l'erta ronpono [4]il rapido corso dell'acqua, aciochè 'l cor[5]so non le menasse via; il drago [6]se li gitta sotto il corpo, colla [7]coda l'annoda le gābe, coll'alie [8]e colle braccia anche li tignie le coste [9]e coi denti lo scanna, el liofante [10]li cade adosso o il drago scoppia, [11]e così colla sua morte del nemico [12]si uēdica.

When they cross rivers they send their young ones up against the stream of the water; thus, being set towards the fall, they break the united current of the water so that the current does not carry them away. The dragon flings itself under the elephant's body, and with its tail it ties its legs; with its wings and with its arms it also clings round its ribs and cuts its throat with its teeth, and the elephant falls upon it and the dragon is burst. Thus, in its death it is revenged on its foe.

IL DRAGONE.

THE DRAGON.

[14]Questi s'accōpagniano insieme e si tessa[15]no a uso di radici, e colla testa leuata [16]passano i paduli, e notano dove trouano [17]migliore pastura, e se così non si vnissero,

These go in companies together, and they twine themselves after the manner of roots, and with their heads raised they cross lakes, and swim to where they find better pasture; and if they did not thus combine

H.[1] 21 a] 1249.

annegherebbero; così fa la unitione.

they would be drowned, therefore they combine.

SERPĒTE.

THE SERPENT.

[3]Il serpēte, grādissimo animale, [4]quādo vede alcuno ucciello per l'aria, [5]tira a se si forte il fiato, che si tira [6]gli uccielli in bocca; Marco, [7]Regulo, consule dello esercito Roma[8]no, fu col suo esercito da un simile [9]animale assalito e quasi rotto, il qua[10]le animale, essēdo morto per una machina [11]mvrale, fu misurato 123 piedi, cio[12]è 64 braccia e $\frac{1}{2}$; avāzava colla testa tutte [13]le piāte d'una selua.

The serpent is a very large animal. When it sees a bird in the air it draws in its breath so strongly that it draws the birds into its mouth too. Marcus Regulus, the consul of the Roman army was attacked, with his army, by such an animal and almost defeated. And this animal, being killed by a catapult, measured 123 feet, that is $64\frac{1}{2}$ braccia and its head was high above all the trees in a wood.

9. dano poico piedi. 10. diletāsi fiuvmi. 11. essēpre . . intorna. 12. quelgli . . possā. 14. abberi soloro. 15. ano. 17. arapa . . effaale piege strette lucide.

1248. 4. lunito (?) corso dellacua. 6. nolle menasse via | il . . cholla. 7. lanoda . . chollalie. 8. cholle bre anche. 9. e cho denti. 10. drago sciopa. 14. sacōpagnian . . essi. 15. ratici. 16. troua. 17. essecosino si vnisser.

1249. 1. anegerebono. 3. grādisimo. 5. asse . . chessi. 6. bochaa. 7. cūsuloi 8. ma fu chol . . da vsimili. 10. macin"a".

Boie.

[15]Questa e grā biscia, la quale cō se mede[16]sima si aggruppa alle ganbe della vacca in mo[17]do nō si mova, poi la tetta in modo che quasi [18]la dissecca; di questa spetie a tēpo di Claudio [19]īperatore nel mōte Vaticano ne fu morta

The Boa (?)

This is a very large snake which entangles itself round the legs of the cow so that it cannot move and then sucks it, in such wise that it almost dries it up. In the time of Claudius the Emperor, there was killed, on the Vatican Hill,

H.1 21 *b*] 1250.

vna che avea vno putto intero in corpo [2]il quale avea trāghiottito

one which had inside it a boy, entire, that it had swallowed.

Macli. ¶Pel sonno è giūto.

[4]Questa bestia nascie in Scādinavia isola; [5]à forma di grā cavallo, se nō che la [6]grā lūghezza dello collo e delli orechi lo vari-[7]ano; pascie l'erba allo indietro, perchè à si [8]lūgo il labro di sopra che pasciēdo inā[9]zi coprirebbe l'erba; à le gābe d'ū pezzo; [10]per questo, quādo vuol dormire s'appoggia [11]a vno albero, e i cacciatori, ātivedēdo [12]il loco vsato a dormire, segā quasi tutta [13]la piāta, e quādo questo poi vi s'appoggia [14]nel dormire·, per lo sonno cade, e i cac-ciato[15]ri così lo piglano, e ogni altro modo di pi[16]glarlo è vano, perchè è d'incredibile velocità [17]nel correre.

The Macli.—Caught when asleep.

This beast is born in Scandinavia. It has the shape of a great horse, excepting that the great length of its neck and of its ears make a difference. It feeds on grass, going backwards, for it has so long an upper lip that if it went forwards it would cover up the grass. Its legs are all in one piece; for this reason when it wants to sleep it leans against a tree, and the hunters, spying out the place where it is wont to sleep, saw the tree almost through, and then, when it leans against it to sleep, in its sleep it falls, and thus the hunters take it. And every other mode of taking it is in vain, because it is incredibly swift in running.

H.1 22 *a*] 1251.

Bonaso noce Colla fuga.

[2]Questo nascie·in Peonia; à collo [3]cō crini simile al cauallo, in tutte [4]l'altre parti è simile·al toro, saluo [5]che le sue corna sono in modo piegate [6]indētro, che nō può cozzare, e per questo [7]non à altro scanpo· che la fuga·, nella [8]quale·getta sterco per spatio di 400 [9]braccia del suo corso·, il quale, dove to[10]cca, abbrucia come foco.

The Bison which does injury in its flight.

This beast is a native of Paeonia and has a neck with a mane like a horse. In all its other parts it is like a bull, excepting that its horns are in a way bent inwards so that it cannot butt; hence it has no safety but in flight, in which it flings out its excrement to a distance of 400 braccia in its course, and this burns like fire wherever it touches.

Leoni, Pardi, Pātere, Tigri.

[12]Questi tēgono·l'ūgie nella guaina, e mai [13]le sfoderanno, se non è adosso alla preda o ne[14]mico.

Lions, Pards, Panthers, Tigers.

These keep their claws in the sheath, and never put them out unless they are on the back of their prey or their enemy.

12. e 64 brē ½. 15. bisscie. 16. sagluppa . . della vecha imo. 17. imodo. 18. ladiseza. 19. īperadore . . morta.

1250. 2. trāgiottito. 3. macli pel sonno egiūto. 4. iniscandinavia. 5. chella. 6. lūgeza. 7. passie . . allōdirieto . . assi. 8. passiēdo. 9. ci copirebe . . ha le . . pezo. 10. vol . . sapogia. 10. ecchaciatori. 13. sapogia. 14. ecaciato.

1251. 2. nasscie. 4. essimile. 5. chelle sie . . imodo. 6. pocozare. 7. chella. 8. gīta stercho per ispatio. 9. bracia. 10. tocha abrucia. 12. tēgano. 13. lessfoderano. 17. caciatori. 19. accioche | "per"ella . . nō siē"o".

LEONESSA.

[16]Quãdo la leonessa difẽde i figli[17]oli dalle mã de'cacciatori, per nõ si spauẽ[18]tare dalli spiedi, abbassa li ochi a terra [19]accioche, per la sua fuga i figli nõ sieno [20]prigioni.

THE LIONESS.

When the lioness defends her young from the hand of the hunter, in order not to be frightened by the spears she keeps her eyes on the ground, to the end that she may not by her flight leave her young ones prisoners.

1252.

H.[1] 22 b]

LEONE.

[2]Questo · si terribile animale niẽte teme [3]piv che lo strepido delle vuote carrette [4]e simile · il cãto de'galli, · e teme a[5]ssai nel uederli e con pauroso a[6]spetto riguarda la sua cresta; [7]e forte inuilisce, quãdo à coper[8]to · il uolto.

THE LION.

This animal, which is so terrible, fears nothing more than the noise of empty carts, and likewise the crowing of cocks. And it is much terrified at the sight of one, and looks at its comb with a frightened aspect, and is strangely alarmed when its face is covered.

PÃTERE IN AFRICA.

[10]Questo à forma di leonessa, ma è [11]piv alta di gãbe, e piv sottile, e lũga; [12]è tutta biãca e punteggiata di ma[13]chie nere a modo di rosette, e di que[14]sta si dilettano · tutti li animali di [15]vedere ·, e senpre le starebbero dintorno, [16]se nõ fusse la terribilità · del suo viso,

THE PANTHER IN AFRICA.

This has the form of the lioness but it is taller on its legs and slimmer and long bodied; and it is all white and marked with black spots after the manner of rosettes; and all animals delight to look upon these rosettes, and they would always be standing round it if it were not for the terror of its face;

1253.

H.[1] 23 a]

onde essa, questo conosciẽdo, ascõ[2]de il uiso, e li animali circũstãti [3]s'assicurano e fannosi vicini per me[4]glio potere fruire tãta bellezza, õ[5]de questa subito piglia il piv uici[6]no e subito lo diuora.

therefore knowing this, it hides its face, and the surrounding animals grow bold and come close, the better to enjoy the sight of so much beauty; when suddenly it seizes the nearest and at once devours it.

CAMELLI.

[8]Quegli Battriani ànno 2 gobbi, [9]gli Arabi uno solo; sono veloci in battagla [10]e vtilissimi a portare le some; [11]questo animale à regole e misura [12]oseruãtissima, perchè nõ si move se à [13]piv carico che l'usato, e se fa piv [14]uiaggio fa il simile, subito si ferma, [15]õde lì bisognia a mercatãti allog[16]giare.

CAMELS.

The Bactrian have two humps; the Arabian one only. They are swift in battle and most useful to carry burdens. This animal is extremely observant of rule and measure, for it will not move if it has a greater weight than it is used to, and if it is taken too far it does the same, and suddenly stops and so the merchants are obliged to lodge there.

1254.

H.[1] 23 b]

TIGRO.

[2]Questa nascie in Ircania, la qua[3]le è simile alquãto alla pãtera per le [4]diuerse machie della sua pelle, ed è ani[5]male di

THE TIGER.

This beast is a native of Hyrcania, and it is something like the panther from the various spots on its skin. It is an animal

1252. 2. teribile. 3. chello .. · vote carette. 4. essimile .. etteme. 6. cressta. 7. efforte inuilissce. 11. ellũga. 12. ettutta biãcha e punegiata. 15. starebõ ditorno. 16. fussi .. teribilita.

1253. 1. conossciẽdo asscõ. 2. elli. 3. sasicurano e fanosi. 4. belleza. 8. batriani. 9. arabi î solo. 13. chellusato esse. 14. uiagio .. sibito. 15. alo. 16. ciare.

1254. 2. na·scie. 3. lehe simile. 5. cacia. 6. truoua. [la sua ta] i sua. 8. leua [ecque] essubito. 10. tera. 12. cholle . .

spauōtevole velocità; il caccia[6]tore quādo truoua i sua figli, [7]li rapiscie subito, ponēdo spechi nel [8]loco donde li leua, e subito sopra [9]veloce cauallo si fugie; la pantera tor[10]nādo truoua li spechi fermi in terra, ne [11]quali vedēdosi, li pare vedere li sua fi[12]glioli, e raspādo colle zāpe scuopre [13]l'inganno, ōde mediāte l'odore de' figli [14]seguita il cacciatore, e quādo esso caccia[15]tore vede la tigra, lascia vno de'figlioli, [16]e questa lo piglia, e portalo al nido; [17]subito rigivgne esso cacciatore, e fa

of terrible swiftness; the hunter when he finds its young ones carries them off hastily, placing mirrors in the place whence he takes them, and at once escapes on a swift horse. The panther returning finds the mirrors fixed on the ground and looking into them believes it sees its young; then scratching with its paws it discovers the cheat. Forthwith, by means of the scent of its young, it follows the hunter, and when this hunter sees the tigress he drops one of the young ones and she takes it, and having carried it to the den she immediately returns to the hunter and does

H.I 24 *a*] **1255.**

il simile insino a tāto ch'esso mōta [2]in barca.

the same till he gets into his boat.

CATOPLEA.

[4]Questa nascie · in Etiopia · vicino al fonte [5]Nigricapo; è animale nō troppo · grande ·, è [6]pigra · in tutte le mēbra ·, e al capo di tāta grā[7]dezza · che malagievolmēte · lo porta ·, in modo che [8]senpre · sta · chinato · inverso · la terra ·, altri[9]menti · sarebbe · di sōma · peste · alli omini, [10]perchè qualunque è veduta da sua · ochi [11]subito · more.

CATOBLEPAS.

It is found in Ethiopia near to the source Nigricapo. It is not a very large animal, is sluggish in all its parts, and its head is so large that it carries it with difficulty, in such wise that it always droops towards the ground; otherwise it would be a great pest to man, for any one on whom it fixes its eyes dies immediately.

BASILISCO.

[13]Questo · nascie · nella provincia · Cirenaica [14]e nō è · maggiore · che · 12 · dita e à · in capo [15]vna machia bianca a similitudine di diadema; [16]col fischo · caccia · ogni serpēte ·, a similitudi[17]ne di serpe, ma nō si move cō torture, anzi [18]manritto · dal mezzo · innāzi ·; diciesi che vno

THE BASILISK.

This is found in the province of Cyrenaica and is not more than 12 fingers long. It has on its head a white spot after the fashion of a diadem. It scares all serpents with its whistling. It resembles a snake, but does not move by wriggling but from the centre forwards to the right. It is said that one

H.I 24 *b*] **1256.**

di questi, essendo · morto · con vn aste da vno che [2]era · a cavallo, che 'l suo veneno discorrendo [3]super l'aste ·, e nō che l'omo · ma il cavallo morì; [4]guasta · le piāte e nō solamēte quelle [5]che tocca ·, ma quelle · doue · soffia ·; secca l'er[6]be, spezza · i sassi.

of these, being killed with a spear by one who was on horse-back, and its venom flowing on the spear, not only the man but the horse also died. It spoils the wheat and not only that which it touches, but where it breathes the grass dries and the stones are split.

schuopre. 13. langono. 14. essocacia. 15. lasscia. 17. r | givgnieso caciatore effa.
1255. 1. imile . . attāto. 4. nasscie. 6. tucte. 7. deza . . imodo. 8. altre. 9. pesste. 10. he veduta. 13. nasscie. 14. magiore . . he a in. 16. fisscio . . assimilitudi. 18. marito dal mezio.
1256. 2. chavallo. 2. discorendo. 3. chellomo. 4. [colio] guassta le biande. 5. chettoccha macquelle . . secha. 6. belola.

1255. Leonardo undoubtedly derived these remarks as to the Catoblepas from Pliny, Hist. Nat. VIII. 21 (al. 32): *Apud Hesperios Aethiopas fons est Nigris* (different readings), *ut plerique existimavere, Nili caput* — — — *Juxta hunc fera appellatur catoblepas, modica alioquin, ceterisque membris iners, caput tantum praegrave aegre ferens; alias internecio humani generis, omnibus qui oculos ejus videre, confestim morientibus.* Aelian, *Hist. An.* gives a far more minute description of the creature (τὸ χατώβλεπον), but he says that it poisons beasts not by its gaze, but by its venomous breath. Athenaeus 221 B, mentions both. If Leonardo had known of these two passages, he would scarcely have omitted the poisonous breath. (H. MÜLLER-STRÜBING.)

DONNOLA OVER BELLULA.

[8]Questa · trovãdo · la tana · del basilisco, coll'o[9]dore della · sua · sparsa · orina l'uccide; l'o[10]dore della quale orina · ãcora spesse volte [11]essa donola occide.

CERASTE.

[13]Queste · ànno quattro · piccoli corni mobili; [14]onde quãdo si uogliono · cibare, nascõda[15]no sotto · le foglie tutta la persona, sal[16]vo · esse cornicina ·, le quali movēdo pare [17]agli ucielli quelli essere piccoli uermini [18]che scherzino, õde subito si calano per beccar[19]li; e questa subito s'avviluppa loro in cier[20]chio, e esse lì diuora.

H.I 25 a]

AMPHESIBENE.

[2]Questa · à · due teste ·, l'una nel suo loco, l'al[3]tra nella · coda ·, come se nõ bastasse che [4]da uno solo loco gittasse il ueneno.

IACULO.

[6]Questa · sta sopra · le piãte ·, e si lancia · come [7]dardo; e passa a trauerso le fere, e l'uccide.

ASPIDO.

[9]Il morso · di questo · animale · non à · rimedio, [10]se nõ di subito · tagliare · le parti morse; Questo [11]si pestifero · animale · à tale affetione nella [12]sua cõpagnia · che sempre vanno accõpagniati, [13]chè se per disgratia · l'uno di loro è morto ·, l'al[14]tro con incredibile velocità seguita l'ucci[15]ditore, ed è tãto attēto e sollecito alla vēdetta, [16]che vīcie · ogni difficultà ·; passando ogni eser[17]cito, solo il suo nemico cierca · offendere; [18]e passa ogni spatio, e nõ si può schifarlo, se nõ [19]col passare l'acque · e cõ velocissima fuga; [20]à li ochi īdētro e grãdi orechi, e piv lo move l'udito che 'l uedere.

H.I 25 b]

ICNEUMONE.

[2]Questo · animale · è mortale nemico all'aspido; [3]nascie · in Egitto ·, e quãdo · vede presso al [4]suo · sito alcuno · aspido ·, subito corre [5]alla litta over fango · del Nilo, e cõ quello [6]tutto · s'infanga, e poi, risecco dal

1257.

THE WEASEL.

This beast finding the lair of the basilisk kills it with the smell of its urine, and this smell, indeed, often kills the weasel itself.

THE CERASTES.

This has four movable little horns; so, when it wants to feed, it hides under leaves all of its body except these little horns which, as they move, seem to the birds to be some small worms at play. Then they immediately swoop down to pick them and the Cerastes suddenly twines round them and encircles and devours them.

THE AMPHISBOENA.

This has two heads, one in its proper place the other at the tail; as if one place were not enough from which to fling its venom.

THE IACULUS.

This lies on trees, and flings itself down like a dart, and pierces through the wild beast and kills them.

THE ASP.

The bite of this animal cannot be cured unless by immediately cutting out the bitten part. This pestilential animal has such a love for its mate that they always go in company. And if, by mishap, one of them is killed the other, with incredible swiftness, follows him who has killed it; and it is so determined and eager for vengeance that it overcomes every difficulty, and passing by every troop it seeks to hurt none but its enemy. And it will travel any distance, and it is impossible to avoid it unless by crossing water and by very swift flight. It has its eyes turned inwards, and large ears and it hears better than it sees.

1258.

THE ICHNEUMON.

This animal is the mortal enemy of the asp. It is a native of Egypt and when it sees an asp near its place, it runs at once to the bed or mud of the Nile and with this makes itself muddy all over, then it dries

7. donola. 8. basilssco. 12. cerasste. 13. quattro pichorni mobili. 14. uogliano. 14. nasscõda. 17. picholi. 18. ce serzino . . becar. 19. ecquesta . . sauilupa. 20. cio esseli diuora.

1257. 1. amphesibene. 2. tesste. 3. basstassi. 4. da î solo locho. 6. essi· 7. attrauero le fiere elluccide. 11. attale. 12 ce senpre . . acõpagniati. 13. chesseper. 14. luci. 15. essollecito. 16. dificulta. 18. scifarlo. 20. laldito.

1258. 1. ichneumone. 3. nasscie. 4. asspido 5. lita . . echõ. 6. riseccho. 7. cosi sēchãda lū. 8. assimilitudine. 9. coraza . .

sole, di no⁷vo di fango s'inbratta; e così se-
guitando l'ū do⁸po l'altro si fa tre o 4 veste
a similitudine ⁹di corazza·, e dipoi assalta
l'aspido, e bē cō¹⁰testa cō quello in modo
che, tolto il tēpo, ¹¹se li caccia in·gola e
l'annega.

CROCODILLO.

¹³Questo nascie nel Nilo, à 4 piedi, vi¹⁴ve
in terra e in acqua, nè altro terrestre ¹⁵ani-
male si truova sanza lingua che questo;
¹⁶e solo morde movēdo la mascella di
sopra; ¹⁷crescie insino in 40 piedi, è un-
ghiato, ¹⁸armato di corame, atto a ogni colpo;
el dì ¹⁹sta in terra, e la notte in acqua;
questo, ²⁰cibato di pesci, s'adormēta sulla
riua del ²¹Nilo colla bocca aperta e l'uc-
ciello detto

itself in the sun, smears itself again with
mud, and thus, drying one after the other,
it makes itself three or four coatings like a
coat of mail. Then it attacks the asp, and fights
well with him, so that, taking its time it
catches him in the throat and destroys him.

THE CROCODILE.

This is found in the Nile, it has four feet
and lives on land and in water. No other
terrestrial creature but this is found to have
no tongue, and it only bites by moving its
upper jaw. It grows to a length of forty feet
and has claws and is armed with a hide that
will take any blow. By day it is on land
and at night in the water. It feeds on fishes,
and going to sleep on the bank of the Nile
with its mouth open, a bird called

H.I 26a] **1259.**

trochilo, piccolissimo vcciello·, subito
li ²corre alla bocca e, saltatoli fra denti
³dentro·, e' fora·leva beccando il rimaso
⁴cibo·; e così stuzzicādolo cō dilettevole
⁵voluttà lo inuita aprire tutta la bocca, ⁶e
così s'adormēta; questo veduto ⁷dal icneu-
mone·subito si li slācia·in bocca, ⁸e fora-
toli lo stomaco e le budelle finalmēte ⁹l'uc-
cide.

DELFINI.

¹¹La natura à dato tal cognitione alli·
ani¹²mali che, oltre allo conosciere la lor co-
¹³modità, conoscono·la incomodità del ni-
¹⁴mico·; onde intēde il delfino·quāto ¹⁵va-
glia·il taglio delle sue·penne, posteli ¹⁶sulla
schiena, e quāto sia tenera la pācia ¹⁷del
cocodrillo·; onde·nel lor cōbattere se li
¹⁸caccia sotto e tagliali la pācia, e così
¹⁹l'uccide.
²⁰Il cocodrillo è terribile a chi fuggie, e
vilis²¹simo a chi lo caccia.

trochilus, a very small bird, runs at once
to its mouth and hops among its teeth
and goes pecking out the remains of the
food, and so inciting it with voluptuous
delight tempts it to open the whole of its
mouth, and so it sleeps. This being observed
by the ichneumon it flings itself into its
mouth and perforates its stomach and
bowels, and finally kills it.

THE DOLPHIN.

Nature has given such knowledge to
animals, that besides the consciousness of
their own advantages they know the disad-
vantages of their foes. Thus the dolphin
understands what strength lies in a cut from
the fins placed on his chine, and how tender
is the belly of the crocodile; hence in
fighting with him it thrusts at him from be-
neath and rips up his belly and so kills him.
The crocodile is a terror to those that flee,
and a base coward to those that pursue him.

H.I 26b] **1260.**

IPPOPOTAMO.

²Questo·quando si sente aggravato·va
³ciercando le spine, o dove siā i rima-
nē⁴ti de'tagliati canneti, e lì tāto frega vna

THE HIPPOPOTAMUS.

This beast when it feels itself over-full
goes about seeking thorns, or where there
may be the remains of canes that have been

lasspido. 10. tasta .. imodo chettolto. 11. cacia .. ella niega. 13. nasscie .. piedi nvc vi. 14. ce in terra e in acq"a"
[e sua] ne .. tereste. 15. checquesto. 16. massciella. 17. cresscie .. vngliato. 18. [vestito] "armato" di .. atto ogni.
18. ella notte. 19. pessci. 20. bocha .. elluciello.
1259. 1. trocilo picholissimo vciello. 2. bocha essaltatoli. 3. effora liva bechando. 4. cibo e e cosi stuzzicādolo. 5. lonuita ..
boccha. 7. daleleumone .. si linācia in boccha. 8. elle. 9. luccide [essimile al ramarro vergezzo]. 12. alo nasscire.
13. cogniosscano. 15. pene. 16. sula sciena .. pāca. 17. nellor. 18. ettagliali. 20. etteribile acci‡ fuggie e vili
21. accilo.
1260. 1. hippotamo. 2. agravato. 3. cierchando .. sia. 4. caneti elli. 5. chauato .. chelli .. cola lita. 6. risaldala. 7. lūgia. 8. cīglare

ve⁵na che la taglia, e cauato il sangue, che li ⁶bisognia, colla litta s'infanga, e risalta alla ⁷piaggia; à forma quasi come cavallo; l'ūghia, ⁸fessa, coda torta, e dēti di cīghiale; collo cō ⁹crini la pelle; nō si può passare·, se nō si ba¹⁰gnia·; pasciesi di piāte ne' cāpi, entravi ¹¹allo dirieto, acciochè pare ne sia uscito.

split, and it rubs against them till a vein is opened; then when the blood has flowed as much as he needs, he plasters himself with mud and heals the wound. In form he is something like a horse with long haunches, a twisted tail and the teeth of a wild boar, his neck has a mane; the skin cannot be pierced, unless when he is bathing; he feeds on plants in the fields and goes into them backwards so that it may seem, as though he had come out.

IBIS.

¹³Questo à similitudine colla cicognia, e quan¹⁴do si sente ammalato, ēpie il gozzo d'acqua, ¹⁵e col becco si fa vn clistero.

THE IBIS.

This bird resembles a crane, and when it feels itself ill it fills its craw with water, and with its beak makes an injection of it.

CIERUI.

¹⁷Questo quando si sente morso dal ragno ¹⁸detto falangio·māgia de' grāchi, e si libera ¹⁹di tale veneno.

THE STAG.

These creatures when they feel themselves bitten by the spider called father-long-legs, eat crabs and free themselves of the venom.

H.¹ 27ᵃ]

1261.

LUCERTE.

²Questa quādo cōbatte colle serpi ³mangia la cicierbita; e sō libere.

THE LIZARD.

This, when fighting with serpents eats the sow-thistle and is free.

RONDINE.

⁵Questa rende il uedere alli orbiti ⁶figlioli col sugo della celidonia.

THE SWALLOW.

This [bird] gives sight to its blind young ones, with the juice of the celandine.

BELLULA.

⁸Questa quando caccia ai ratti, māgia ⁹prima·della·ruta.

THE WEASEL.

This, when chasing rats first eats of rue.

CINGHIALE.

¹¹Questo medica·i sua·mali mangiādo ¹²della edera.

THE WILD BOAR.

This beast cures its sickness by eating of ivy.

SERPE.

¹⁴Questa quādo si uol renovare, gitta il ¹⁵vechio scoglio, comīciādosi dalla testa; ¹⁶mvtasi in vn dì e vna notte.

THE SNAKE.

This creature when it wants to renew itself casts its old skin, beginning with the head, and changing in one day and one night.

PARTERA.

¹⁸Questa, poichè le sono·uscite l'interiora, ¹⁹ancora conbatte coi cani e cacciatori.

THE PANTHER.

This beast after its bowels have fallen out will still fight with the dogs and hunters.

9. si po passare. 10. passciesi . . biāde. 11. vsscito. 13. assimilitudine . . ciguognia ecq"ā". 14. amalato . . il cozo dacque. 15. e chol becho . . cristero. 18. falange . . grāci essi.
1261. 2. colle [lucerte] serp. 3. essō. 5. alli vnorbiti. 6. chol. 7. belola. 16. mvtasi nvndi . . nocte. 18. poichelle sono vsscite lenteriora.

H.I 27 b] **1262.**

CAMELEONTE.

²Questo · piglia · senpre il colore della cosa ³dove si posa · ; onde insieme colle frōdi ⁴dove si posano, spesso dali elefanti sō diuorati.

CORBO.

⁶Questo quando à ucciso el cameleonte ⁷si purga coll'alloro.

THE CHAMELEON.

This creature always takes the colour of the thing on which it is resting, whence it is often devoured together with the leaves on which the elephant feeds.

THE RAVEN.

When it has killed the Chameleon it takes laurel as a purge.

H.I 48 b] **1263.**

¶Moderanza raffrena tutti i vitj.
²L'ermelino prima morire che imbrat-³tarsi.

Moderation checks all the vices.
The ermine will die rather than besmirch itself.

DELL'ANTIUEDERE.

⁵Il gallo nō cāta, se prima 3 volte nō batte ⁶l'alie; il papagalo nel mutarsi pe'rami ⁷nō mette i piè, doue non à prima ⁸messo il becco; ⁹¶il uoto nascie quādo la sperāza more.
¹⁰Il moto seguita il ciētro del peso.

OF FORESIGHT.

The cock does not crow till it has thrice flapped its wings; the parrot in moving among boughs never puts its feet excepting where it has first put its beak. Vows are not made till Hope is dead.
Motion tends towards the centre of gravity.

H.3 53 a] **1264.**

MAGNANIMITA.

Il falcone nō pi²glia se nō vccelli grossi, e prima ³more che māgiare carne di nō bono odore.

MAGNANIMITY.

The falcon never seizes any but large birds and will sooner die than eat [tainted] meat of bad savour.

1262. 6. quessto . . cameleont. 7. pugra choll alloro.
1263. 2. cheēbra. 8. becho. 9. nasscie. 10. mot seguita.

1264. 2. vcielli. 3. chare.

II.

FABLES.

H.² 3b]

1265.

FAVOLA.

²Sendo l'ostrica insieme colli altri ³pesci in casa del pescatore scarica⁴ta vicino al mare ·, priega il ratto, ⁵che al mare la cōduca; il ratto fatto ⁶disegnio di māgiarla la fa aprire, ⁷e mordēdola questa li serra la testa ⁸e si lo ferma; viene la gatta e l'uccide.

A FABLE.

An oyster being turned out together with other fish in the house of a fisherman near the sea, he entreated a rat to take him to the sea. The rat purposing to eat him bid him open; but as he bit him the oyster squeezed his head and closed; and the cat came and killed him.

Fables on animals (1265—1270).

C. A. 115a; 357a]

1266.

FAVOLA.

²I tordi si rallegrarono forte, vedēdo che l'omo prese la ciuetta ³e le tolse la libertà, quella legando con forti legami ai sua piedi; la ⁴qual ciuetta fu poi mediante il uischio causa nō di far perdere ⁵la libertà ·ai tordi, ma la loro propia vita ·; detta per quelle ⁶terre che si rallegrā di uedere perdere la libertà ai loro maggio⁷ri, mediante i quali poi perdono il soccorso, e rimāgono lega⁸ti in potētia del loro nemico ·, lasciādo la libertà e spesse volte la uita.

A FABLE.

The thrushes rejoiced greatly at seeing a man take the owl and deprive her of liberty, tying her feet with strong bonds. But this owl was afterwards by means of bird-lime the cause of the thrushes losing not only their liberty, but their life. This is said for those countries which rejoice in seeing their governors lose their liberty, when by that means they themselves lose all succour, and remain in bondage in the power of their enemies, losing their liberty and often their life.

1265. 2. lostriga . . colli al. 5. ce al mare . . fato. 7. sera. 8. essilo . . ellucide.
1266. 2. rallegrorono . . chellomo. 3. elle . . choforti. 4. uiscio. chausa . . far perde. 5. malla. 6. chessi ralegrā . . mgai. 7. perdano il sochorso. 8. nemicho . . esspesse.

C. A. 117 a; 361 a] **1267.**

FAVOLA.

²Dormēdo · il cane · sopra la pelle · d' un castrone, vna delle sua ³pulci ·, sentēdo · l'odore · della vnta · lana ·, givdicò quello ⁴dovesse essere · loco di migliore · vita e piv sicura da denti e unghie del cane, che pascier⁵si del cane ·; e sanza altri pensieri abbandonò il cane, e lì entrata ⁶infra la folta lana ·, cominciò cō somma fatica · a volere ⁷trapassare alle radici de' peli ·; la quale inpresa dopo molto ⁸sudore trovò esser uana ·, perchè tali peli erano tanto spessi che ⁹quasi si toccavano, e nō u'era spatio dove la pulcie potesse saggiare ¹⁰tal pelle ·; ōde · dopo lūgo travaglio e fatica cominciò a vole¹¹re ritornare al suo cane ·, il quale essendo già partito, fu ¹²costretta dopo lūgo pētimēto e amari piāti a morirsi di fame.

A FABLE.

A dog, lying asleep on the fur of a sheep, one of his fleas, perceiving the odour of the greasy wool, judged that this must be a land of better living, and also more secure from the teeth and nails of the dog than where he fed on the dog; and without farther reflection he left the dog and went into the thick wool. There he began with great labour to try to pass among the roots of the hairs; but after much sweating had to give up the task as vain, because these hairs were so close that they almost touched each other, and there was no space where fleas could taste the skin. Hence, after much labour and fatigue, he began to wish to return to his dog, who however had already departed; so he was constrained after long repentance and bitter tears, to die of hunger.

C. A. 66 a; 200 a] **1268.**

FAVOLA.

²Non si cōtentando · il uano · e vagabūdo parpaglione ³di potere · comodevolmēte · volare · per l'aria, ⁴vinto · dalla dilettevole · fiamma · della cādela, deli⁵berò · volare in quella ·; e 'l suo · giocōdo · movimē⁶to · fu cagione di subita · tristitia ·, inperochè in detto ⁷lume si consumarono · le sottili ali · che 'l parpa⁸glione · misero caduto · tutto bruciato a piè del ⁹candeliere ·; dopo · molto · pianto e pētimē¹⁰to · si rascivgò · le lagrime dai bagniati ochi, ¹¹e levato · il uiso in alto · disse · : o falsa luce, ¹²quāti · come me debi tu · avere · ne passa¹³ti tenpi · avere · miserabilmēte · ingañati! e se ¹⁴pure volevo · vedere · la luce ·, nō doveu' · io cono¹⁵sciere il sole · dal falso · lume dello spurco sevo?

A FABLE.

The vain and wandering butterfly, not content with being able to fly at its ease through the air, overcome by the tempting flame of the candle, decided to fly into it; but its sportive impulse was the cause of a sudden fall, for its delicate wings were burnt in the flame. And the hapless butterfly having dropped, all scorched, at the foot of the candlestick, after much lamentation and repentance, dried the tears from its swimming eyes, and raising its face exclaimed: O false light! how many must thou have miserably deceived in the past, like me; or if I must indeed see light so near, ought I not to have known the sun from the false glare of dirty tallow?

FAVOLA.

¹⁷Trovando la scimia vno nidio di piccoli ¹⁸vccelli ·, tutta · allegra · appressatasi a quelli, e quali essē¹⁹do già da volare, ne potè solo pigliare il minore; essē²⁰do pieno d'allegrezza con esso · in mano, se n'ādò al suo ²¹ricetto; e comīciato a cōsiderare

A FABLE.

The monkey, finding a nest of small birds, went up to it greatly delighted. But they, being already fledged, he could only succeed in taking the smallest; greatly delighted he took it in his hand and went to his abode; and having begun to look at the

1267. 2. chastrone. 4. dovessi . . locho . . sichura "da denti e vnglia del cane" che passcier. 5. essanza . . abandono. 6. infralla . . soma faticha. 7. molta [fa]. 9. to chauano . . potessi sagiare. 10. faticha cōmincio. 12. pētimēto amari.
1268. 2. chōtentando. 3. chomodamēte . . laria [dilibero dischore]. 4. revinto . . fiama . . chādela dili . . giochōdo. 6. chagione . . inperochēdetto . . 7. chonsumorono . . sottile ali . [ch]el . . brusato. 9. chandelieri. 11. dise. 12. chome . . pasa. 13. essi. 14. chome. 17. scimia [inp] vno . . di [lusi] di picioli. 18. vcielli . . appressatasi a queli. 20. dalegreza chon eso imano . . 21. ricieto e chomīciato a chōsiderare . . vcielletto. 22. issuecerato. 23. essirinse chellagli tolsi.

questo vccelletto, ²²lo comīciò a baciare; e
per lo sviscerato · amore tanto ²³lo baciò,
e rivolse, e strinse · ch' ella gli tolse la uita;
²⁴ è detta per quelli che per nō gastigare
i figlioli capita²⁵no male.

little bird he took to kissing it, and from
excess of love he kissed it so much and
turned it about and squeezed it till he killed
it. This is said for those who by not punish-
ing their children let them come to mischief.

C. A. 66 *b*; 200 *b*]

1269.

FAVOLA.

²Stando il topo assediato · in vna piccola
sua abitatione ³dalla donnola ·, la quale cō
cōtińva vigilantia attēdea ⁴alla sua disfatione,
· e' per uno · piccolo spiraculo riguarda⁵va
il suo grā pericolo; infrattanto · venne la
gatta, ⁶e subito prese essa donnola, e ime-
diate l' ebbe diuorata; ⁷allora il ratto ·,
fatto sacrificio a Giove d' alquāte sua noc-
⁸ciole ·, ringratiò sommamēte la sua deità, e
uscito fori dalla ⁹sua buca a possedere la
già persa libertà, della quale subito in¹⁰sieme
colla vita fu dalle feroci unghie de' denti
della ¹¹gatta privato.

A FABLE.

A rat was besieged in his little dwelling
by a weasel, which with unwearied vigi-
lance awaited his surrender, while watching
his imminent peril through a little hole.
Meanwhile the cat came by and suddenly
seized the weasel and forthwith devoured
it. Then the rat offered up a sacrifice to
Jove of some of his store of nuts, humbly
thanking His providence, and came out
of his hole to enjoy his lately lost liberty.
But he was instantly deprived of it, together
with his life, by the cruel claws and teeth
of the lurking cat.

C. A. 66 *b*; 201 *b*]

1270.

FAUOLA.

²La formica · trovato vno · grano di
³miglio ·, jl grano sētendosi preso da quel-
⁴la gridò: se mi fai tāto piacere di ⁵lasci-
armi fruire il mio desiderio del ⁶nasciere ·,
io ti rēderò · ciēto me medesimi; ⁷e così
fu fatto.

⁸Trovato il ragnio vno grappolo · d' uue,
⁹il quale per la sua dolcezza era · molto ·
visitato · da avi e diuerse ¹⁰qualità · di mo-
sche ·, li parue · avere trouato ¹¹loco · molto
· comodo · al suo · inganno ·; e cala¹²tosi giù
· per lo suo · sottile · filo, e ētrato · nella no-
¹³va · abitatione · lì ogni · giorṇo ¹⁴faciēdosi
alli spiraculi ·, fatti dalli ¹⁵interualli · de' grani
· dell' uue ·, assaltaua come ¹⁶ladrone i miseri
animali · che da lui non si ¹⁷guardauano; e
passati · alquanti · giorni · il ¹⁸uendemiatore ·
colse · essa uua e, messa coll' al¹⁹tre · insieme,
con quelle · fu pigiata ·; e così ²⁰l' una · fu
laccio e inganno · dello ingañatore ²¹ragnio ·,
come · delle · ingannate mosche.

²²Addormētatosi · l' asino · sopra il ghi-
accio ²³d' ū profondo · lago ·, il suo · calore
dissolue ²⁴esso ghiaccio ·, e l' asino · sot-
t' acqua a mal suo ²⁵danno si destò · e su-
bito · annegò.

A FABLE.

The ant found a grain of millet. The
seed feeling itself taken prisoner cried out
to her: "If you will do me the kindness to
allow me accomplish my function of repro-
duction, I will give you a hundred such as
I am." And so it was.

A Spider found a bunch of grapes which
for its sweetness was much resorted to by
bees and divers kinds of flies. It seemed
to her that she had found a most convenient
spot to spread her snare, and having settled
herself on it with her delicate web, and
entered into her new habitation, there, every
day placing herself in the openings made by
the spaces between the grapes, she fell like
a thief on the wretched creatures which were
not aware of her. But, after a few days
had passed, the vintager came, and cut away
the bunch of grapes and put it with others,
with which it was trodden; and thus the
grapes were a snare and pitfall both for the
treacherous spider and the betrayed flies.

An ass having gone to sleep on the ice
over a deep lake, his heat dissolved the ice
and the ass awoke under water to his great
grief, and was forthwith drowned.

1069. 2. stanto . . pichola. 3. della donora. 4. per î pichola spirachulo ragnarda. 5. perichulo . vene. 6. donola. 7. dalquata
sua no. 8. rigratio somamente . . vsscito . della. 9. busa . . dela. 10. ungha. 11. privata.

1070. formicha. 4. lagrodo. 5. lassciarmi. 6. nasscicre . . redero. 9. il quale "per la sua dolceza" era. 10. mossche. 11. locho
. . chomodo . . cholla. 12. gu. 13. giorno [con ingani]. 14. [chonduci] faciēdosi. 15. chome. 16. dalli. 17. chon.
18. colta . . vua e messe. 20. laccio ēnganno. 21. chome . . mossche. 22. adormentatosi . . diaccio. 23. disolue.
24. diaccio ellasino sottacqa. 25. dessto. 26. soportare chō. 27. nasschōdere cheffallanitra. 28. sottacqa. 29. pene.

²⁶Il falcone ·, nō potendo sopportare cō patiētia ²⁷il nascōdere che fa l'anitra, fugiēdo se le dināzi ²⁸e entrādo sotto · acqua · volle, come quelle, sott' acqua ²⁹seguitare, e bagnatosi le penne rimase in essa ³⁰acqua; e l'anitra, leuatasi in aria ·, scherne ³¹il falcone che annegava.

³²Il ragnio ·, volendo · pigliare · la mosca cō sue ³³false · reti ·, fu · sopra · quelle · dal calabrone ³⁴crudelmēte morto.

³⁵Volendo · l'aquila · schernire · il gufo, rimase ³⁶coll' alie · inpaniata ·, e fu dall'omo · presa e morta.

A falcon, unable to endure with patience the disappearance of a duck, which, flying before him had plunged under water, wished to follow it under water, and having soaked his feathers had to remain in the water while the duck rising to the air mocked at the falcon as he drowned.

The spider wishing to take flies in her treacherous net, was cruelly killed in it by the hornet.

An eagle wanting to mock at the owl was caught by the wings in bird-lime and was taken and killed by a man.

S. K. M. III. 93 b] **1271.**

Fables on lifeless objects (1271—1274).

Trovandosi l'acqua nel superbo mare, suo elemē²to, le veñe voglia di mōtare sopra ³l'aria, e cōfortata dal foco elemēto, releuatasi ī sottile vapore, ⁴quasi parea della sottigliezza dell'ari⁵e; mōtata in alto givnse īfra l'a⁶ria piv sottile e fredda, dove fu abādona⁷ta dal foco, e i piccoli granicoli, ⁸sendo ristretti, già s'uniscono e fā⁹nosi pesanti, ove cadēdo la superbia ¹⁰si cōuerte in fuga, e cade dal cielo, ¹¹ōde poi fu beuuta dalla secca terra, ¹²dove lūgo tēpo incarcierata ¹³fece penitētia del suo peccato.

The water finding that its element was the lordly ocean, was seized with a desire to rise above the air, and being encouraged by the element of fire and rising as a very subtle vapour, it seemed as though it were really as thin as air. But having risen very high, it reached the air that was still more rare and cold, where the fire forsook it, and the minute particles, being brought together, united and became heavy; whence its haughtiness deserting it, it betook itself to flight and it fell from the sky, and was drunk up by the dry earth, where, being imprisoned for a long time, it did penance for its sin.

C. A. 172 b; 516 b] **1272.**

FAUOLA.

²Vsciendo vn giorno il rasojo · di quel manico, col quale si fa gvaina a se medesimo, ³e postosi al sole ·, vide il sole spechiarsi nel suo corpo; della qual cosa prese somma gloria, ⁴e rivolto col pensiero · indirieto · cominciò cō seco medesimo · a dire: Or tornerò io ⁵piv a quella bottega della quale novamēte uscito · sono ·? cierto · no ·; nō piaccia alli Dei che ⁶si splendida bellezza caggia in tāta viltà d'animo! che pazzia sarebbe quella, la qual mi cō⁷ducesse a radere le insaponate barbe de' rustici villani · e fare mecaniche operationi! ⁸è questo corpo da simili eserciti? cierto

A FABLE.

The razor having one day come forth from the handle which serves as its sheath and having placed himself in the sun, saw the sun reflected in his body, which filled him with great pride. And turning it over in his thoughts he began to say to himself: "And shall I return again to that shop from which I have just come? Certainly not; such splendid beauty shall not, please God, be turned to such base uses. What folly it would be that could lead me to shave the lathered beards of rustic peasants and perform such menial service! Is this body destined for such work? Certainly not. I will hide myself in some retired spot and

30. ellanitra . . schernia. 31. anegava. 32. cosua. 33. rete. 35. schenire. 36. inpaniate eff.

1271. 1. lacq"a" . . superbo "mare" suo. 3. laria "e cōfortata dal foco elemēto" eleuatosi. 4. sittiglieza. 5. infralla. 6. sottile "effreda" dove. 7. focho e picoli. 8. restretti . . suniscano effā. 9. la superb. 10. del cielo. 11. bevute . . sechatera. 13. fe . . pechato.

1272. 2. vssciendo . . rasoro . . manicho chol . . giaina asse. 3. isspechiarsi . . chorpo . . chosa . . soma groria. 4. chol . . chomincio chōsecho. 5. acquella . . vsscito · . piacia alli de . la e. 6. belleza chagia . pazia . . sarebe . . michō. 7. duciessi . . russtrichi vilani effare smechaniche operatione. 8. or questo orpo da . . vogli naschondere. 9. ochulto locho

no; Io mi voglio nascondere in qualche [9]oculto loco, e lì cō trāquillo riposo passare mia vita ·; E così nascosto per alquāti mesi, [10]vn giorno ritornato all'aria e uscito fori della sua guaina, vide se essere fatto a si[11]militudine d'una rugginēte sega, e la sua superfitie non ui spechiare piv lo splendiēte sole; [12]cō vano pētimēto indarno piāse lo inriparabile danno, con seco diciēdo: o quanto [13]meglio era esercitare col barbiere il mio perduto taglio di tāta sottilità; dov'è la lustrante [14]superfitie? certo la fastitiosa e brutta ruggine l'à consumata!

[15]Questo medesimo · accade nelli ingiegni · che in scābio dello esercitio si danno · all'otio; [16]I quali · a similitudine del sopra detto · rasojo · perdono la tagliente sua sottilità, [17]e la rugine della ignioranza guasta la sua forma.

there pass my life in tranquil repose." And having thus remained hidden for some months, one day he came out into the air, and issuing from his sheath, saw himself turned to the similitude of a rusty saw while his surface no longer reflected the resplendent sun. With useless repentance he vainly deplored the irreparable mischief saying to himself: "Oh! how far better was it to employ at the barbers my lost edge of such exquisite keenness! Where is that lustrous surface? It has been consumed by this vexatious and unsightly rust."

The same thing happens to those minds which instead of exercise give themselves up to sloth. They are like the razor here spoken of, and lose the keenness of their edge, while the rust of ignorance spoils their form.

FAUOLA.

[19]Vna · pietra novamēte per l'acque scoperta di bella grādezza si staua sopra vn cierto loco rilevato, [20]dove terminava un dilettevole boschetto sopra vna sassosa strada in cō[21]pagnia d'erbe, di uari fiori di diuersi colori ornate, e vedea [22]la grā somma delle pietre che nella a se sotto [23]posta strada collocate · erano ·; le uenne · desiderio di là giv lasciarsi ca[24]dere, diciēdo · cō seco: che fo io qui · cō queste erbe? io voglio cō que[25]ste mie sorelle in cōpagnia abitare; e giv lasciatosi cadere infra [26]le desiderate cōpagnie finì suo volubile corso ·; e stata alquāto co[27]miciò a essere dalle rote de' carri ·, dai piè de' ferrati cavalli, e de [28]viandāti · a essere in continvo travaglio ·; chi la volta, quello la pesta[29]va; alcuna volta se leuava alcuno pezzo, quādo stava coperta da fā[30]go o sterco di qualche animale ·, e in vano riguardava il loco dō-[31]de partita s'era in nel loco della solletaria e trāquilla pace;

[32]Così accade a quelli che dalla vita soletaria cōtenplativa voglio[33]no venir abitare nelle città infra i popoli pieni d'infiniti mali.

A FABLE.

A stone of some size recently uncovered by the water lay on a certain spot somewhat raised, and just where a delightful grove ended by a stony road; here it was surrounded by plants decorated by various flowers of divers colours. And as it saw the great quantity of stones collected together in the roadway below, it began to wish it could let itself fall down there, saying to itself: "What have I to do here with these plants? I want to live in the company of those, my sisters." And letting itself fall, its rapid course ended among these longed for companions. When it had been there sometime it began to find itself constantly toiling under the wheels of the carts the iron-shoed feet of horses and of travellers. This one rolled it over, that one trod upon it; sometimes it lifted itself a little and then it was covered with mud or the dung of some animal, and it was in vain that it looked at the spot whence it had come as a place of solitude and tranquil place.

Thus it happens to those who choose to leave a life of solitary comtemplation, and come to live in cities among people full of infinite evil.

elli chō · · chosi naschosto. 10. gorno . . . vsscito . . fatto assi. 11. ruginēte . ella . . noui spechiare. 12. cho . . dano cho secho . . o qua. 13. chol . . il mi . . lusstante. 14. fasstidiosa . . rugine. 15. chenisschābio. 16. assimilitudine . . decto nasoro perde . . suttilita. 17. ella . . guassta. 19. pietra | "novamēte per lacque scoperta" di bella grādeza . . locho. 20. vdidi lettevole bosschetto . . īchō. 21. derbettedi uari . . cholori ornata. 22. soma . . asse. 23. chollochate · · uene · · lassciarsi cha. 24. chōsecho · · chō · · chō. 25. sorelle · · chōpagnia · · lassatosi chadere. 26. chōpagnie · · cho. 27. dale · · charri · · defferati chavalli. 28. chontinvo · · quale la. 29. alchuna · · alchuno pezo · choperta. 30. osstercho · · locho. 31. partata · · inel locho. 32. acade acquelli che della · · chōtenplativa voglia.

C. A. 66 *a*; 201 *a*] **1273.**

²Le fiamme · già · aveano durato nella fornace ³de' bichieri, e veduto a se avicinarsi vna ⁴candela in vn bello e lustrante cãdeliere, con gran deside⁵rio si forzauano · accostarsi a quella; infra le qua⁶li vna, lasciato el suo naturale ⁷corso e tiratasi dentro · a vno · voto stizzo, dove ⁸ si pascieva · e vsscita fori d'una piccola fessura ⁹alla cãdela, che vicina l'era, si ¹⁰gittò · e cõ somma · gelosìa · e ingordigia quella ¹¹diuorando · quasi · a fine la condusse ·; e volendo ripa¹²rare · al prolungamẽto · della sua vita, indar¹³no tẽtò tornare alla fornace ·, donde partita s'era, ¹⁴perchè fu costretta · morire, le mazze insieme ¹⁵colla cãdela, õde al fine cõ piãto e pẽtimẽto ¹⁶· in fastidioso fumo si convertì, lasciãdo ¹⁷tutte le sorelle in splendente e lũga vita e bellezza.

Some flames had already lasted in the furnace of a glass-blower, when they saw a candle approaching in a beautiful and glittering candlestick. With ardent longing they strove to reach it; and one of them, quitting its natural course, writhed up to an unburnt brand on which it fed and passed at the opposite end out by a narrow chink to the candle which was near. It flung itself upon it, and with fierce jealousy and greediness it devoured it, having reduced it almost to death, and, wishing to procure the prolongation of its life, it tried to return to the furnace whence it had come. But in vain, for it was compelled to die, the wood perishing together with the candle, being at last converted, with lamentation and repentance, into foul smoke, while leaving all its sisters in brilliant and enduring life and beauty.

C. A. 66 *b*; 201 *b*] **1274.**

Trovandosi · alquanta · poca neve ²appiccata alla sommità · d'un sasso, il quale ³era collocato sopra la strema · al⁴tezza d'una · altissima · mõtagnia, · e raccol⁵to · in se · la imaginatione, comiciò · con quella ⁶a considerare e infra se · dire: Or nõ son io ⁷da essere · giudicata · altera . e superba, avere ⁸ me piccola · dramma · di neve · posto · in si al⁹to loco? e sopportare che tanta quãtità di neve, ¹⁰quanta · di qui · per me · essere veduta può, stia ¹¹piv bassa di me? cierto · la mia poca quãti¹²tà non merita · questa · altezza, chè bene posso per ¹³testimonãza · della mia · piccola · figura conoscie¹⁴re quello che 'l sole fecie · ieri alle mia con¹⁵pagnie, · le quali in poche · ore · dal sole furo¹⁶no · disfatte ·; e questo interuenne per essersi ¹⁷posto piv alto · che a loro nõ si richiedea ·; io vo¹⁸glio fugire · l'ira · del sole, e abbassarmi, e trovare ¹⁹loco · cõueniẽte · alla mia parua quãtità; ²⁰e gittatasi in baso e comĩciata a disciẽdere rottãdo ²¹dall'alte spiaggie · super l'altra neve, quãto piv ciercò ²²loco · basso ·, piv · crebbe · sua · quãtità in

A small patch of snow finding itself clinging to the top of a rock which was lying on the topmost height of a very high mountain and being left to its own imaginings, it began to reflect in this way, saying to itself: "Now, shall not I be thought vain and proud for having placed myself—such a small patch of snow—in so lofty a spot, and for allowing that so large a quantity of snow as I have seen here around me, should take a place lower than mine? Certainly my small dimensions by no means merit this elevation. How easily may I, in proof of my insignificance, experience the same fate as that which the sun brought about yesterday to my companions, who were all, in a few hours, destroyed by the sun. And this happened from their having placed themselves higher than became them. I will flee from the wrath of the sun, and humble myself and find a place befitting my small importance." Thus, flinging itself down, it began to descend, hurrying from its high home on to the other snow; but the more it sought a low place

1273. 1. [lo ingordo fochosapiglia nelle legnie]. 2. [il focho] "le fiame" gia vno . ꞇ e durato nella. 3. de bichieri . . asse. 4. chandela . . bello chandeliere "ellusstrante" chon gra. 5. achostarsi a chuella infralle. 6. vna [falcara] laciato. 7. stizo. 8. vsscita | "dal oposita" fori. 9. [alume che lara] alla cãdela. 10. chõ soma . . ingordigia [di] quella. 11. fine chõ dule e volento. 13. tonare. 14. chostretta . . le mazare. 15. cholla . . chõ. 16. [si cõ uerti] in . . lumo si . . lascĩa. 17. issplendevole ellũga . . belleza.

1274. 1. pocha. 2. apichata . . somita. 3. chollochato soprapra lasstrema. 4. teza . . rachol. 5. lamaginatione chomĩcio chon. 6. chonsiderare. 7. givdichata. 8. picciola droma. 9. locho essopportare che tante. 10. quanto . . veduta po stia. 11. pocha. 12. nomerta questa alteza. 13. pichola . . chonosscie . . chon. 16. disfacte ecquesto interuene. 17. alora. 18. abastarmi. 19. chõueniẽte. 20. chomĩciata . . rottãto. 21. dell . . spiagie . . quato. 22. imodo. 23. sopra ĩ

modo ²³che, terminato · il suo · corso · sopra · uno colle, si trouò ²⁴di nō quasi minor grādezza · che 'l colle che essa sostenea; ²⁵e fu · l'ultima · che in quella · state · dal sole disfatta ²⁶fusse ·; detta · per quelli · che s'umiliano,-son esaltate.

the more its bulk increased, so that when at last its course was ended on a hill, it found itself no less in size than the hill which supported it; and it was the last of the snow which was destroyed that summer by the sun. This is said for those who, humbling themselves, become exalted.

C. A. 75 a; 219 a]　　　　　　　**1275.**

Avēdo ȷl ciedro desiderio di fare uno bello e grāde frutto ²in nella sommità · di se lo mise in essecutione cō tutte le ³forze del suo omore ·; ȷl quale frutto cresciuto · fu cagione ⁴di fare declinare la eleuata e diritta cima.

⁵Il persico avēdo · ȷvidia alla grā quātità de' fru⁶tti visti fare al noce suo vicino, deliberato fare ⁷il simile ·, si caricò de' sua in modo tale che 'l peso ⁸di detti frutti lo tirò diradicato e rotto alla piana ⁹terra.

The cedar, being desirous of producing a fine and noble fruit at its summit, set to work to form it with all the strength of its sap. But this fruit, when grown, was the cause of the tall and upright tree-top being bent over. *Fables on plants (1275—1279).*

The peach, being envious of the vast quantity of fruit which she saw borne on the nut-tree, her neighbour, determined to do the same, and loaded herself with her own in such a way that the weight of the fruit pulled her up by the roots and broke her down to the ground.

ciedro (*cedar*).　　persico (*peach-tree*).　　noce (*nut-tree*).　　fico (*fig-tree*).　　fico (*fig-tree*).　　olmo (*elm-tree*).

¹⁰Il noce mostrādo se per vna strada ai viādanti ¹¹la richezza de' sua frutti, ogni omo lo lapidaua.

¹²Il fico stādo sanza frutti, nessuno lo riguardava; ¹³volendo col fare essi frutti essere laudato dali o¹⁴mini ·, fu da quelli piegato · e rotto.

¹⁵Stando il fico vicino all'olmo ·, e riguardando i sua ¹⁶rami essere · sanza frutti e avere ardimēto ¹⁷di tenere il sole · a sua · acerbi fichi cō rā¹⁸pognie gli disse: o olmo ·, non ài tu vergognia a ¹⁹starmi dināzi? ma aspetti · che mia figlioli sieno ²⁰in matura · età, e vedrai dove ti troverai! i quali ²¹figlioli poi maturati, capitādovi una squadra ²²di soldati, fu da quelli per torre i sua fichi tutto lacera²³to · e diramato e

The nut-tree stood always by a road side displaying the wealth of its fruit to the passers by, and every one cast stones at it.

The fig-tree, having no fruit, no one looked at it; then, wishing to produce fruits that it might be praised by men, it was bent and broken down by them.

The fig-tree, standing by the side of the elm and seeing that its boughs were bare of fruit, yet that it had the audacity to keep the Sun from its own unripe figs with its branches, said to it: "Oh elm! art thou not ashamed to stand in front of me. But wait till my offspring are fully grown and you will see where you are!" But when her offspring were mature, a troop of soldiers coming by fell upon the fig-tree and her

cole. 24. grādeza. 25. effu. 26. chessa umiliano. 26. esaltate.
1275. 2. inella somita . . mise aseguitione chō tuttelle. 3. frutto "crescivto" fu chagione. 5. persicho. 6. diliberato. 7. charicho . . imodo. 8. diradichato. 9. tera. 10. mostādo se per. 11. richeza . . frutto. 12. ficho. 13. chol . . frutte . . laldato. 15. ficho. 17. acerbi [fra] fichi chō. 18. dise hoholmo . . ha. 19. asspetta. 20. imatura . . vederai. 21. chapitādovi sguadra. 22. queli pertore i sua. 23. chosi. 25. do h"o" ficho. 26. queli.

rotto; il quale stādo poi così ²⁴storpiato delle sue mēbra·, l'olmo lo dimādò diciē²⁵do: o fico quāto. era il meglio a stare sanza figlioli ²⁶che per quelli venire in si miserabile stato!

figs were all torn off her, and her boughs cut away and broken. Then, when she was thus maimed in all her limbs, the elm asked her, saying: "O fig-tree! which was best, to be without offspring, or to be brought by them into so miserable a plight!"

S. K. M. III. 45[a]

1276.

La piāta si dole del palo ²secco e vechio che se l'era ³posto al lato e de' pali ⁴secchi che la circūdano;
⁵L'ū lo mātiene diritto, ⁶l'altro lo guarda dalla ⁷triste cōpagnia.

The plant complains of the old and dry stick which stands by its side and of the dry stakes that surround it.
One keeps it upright, the other keeps it from low company.

C. A. 66 a; 200 a]

1277.

FAVOLA.

²Trovādosi la noce essere della cornacchia ³portata · sopra vn alto · campanile, e' per ⁴vna fessura, doue caddè, fu liberata · dal mortale ⁵suo becco; pregò · esso muro · ⁶per quella · gratia che Dio li aveva dato · del essere tanto ⁷eminēte · e magnio · e ricco di si belle cāpane e di tā⁸to · onorevole · suono · ch'ella douesse soccorrere, ⁹poi ch'ella non avea potuta cadere sotto ¹⁰i verdi rami del suo vechio · padre·, e essere nella gras-¹¹sa terra, ricoperta dalle sue cadēti foglie·, che non la ¹²volesse lui abandonare·, jnperoch'ella, trovādosi ¹³nel becco della · fiera corua, ¹⁴votò, che scappādo da essa voleua finire la ui¹⁵ta · sua · in un piccolo buco; alle quali parole ¹⁶il mvro·, mosso. a cōpassione, · fu cōtento riciettar¹⁷la nel loco ov' era caduta·; e infra poco tēpo ¹⁸la noce cominciò aprirsi e mettere le radici infra ¹⁹le fessure delle pietre·, e quelle allargare, e gitta²⁰re i rami fori della sua · caverna·; e quegli ²¹in brieve leuati sopra lo edifitio, e ingrossate le ²²ritorte radici, cominciò aprire i mvri e ca²³uare le antiche pietre de' loro · uechi lochi; allo²⁴ra il muro · tardi e indarno pianse · la cagione del suo danno; ²⁵e in breve aprì e rovinò grā parte delle sua mēbra.

A FABLE.

A nut, having been carried by a crow to the top of a tall campanile and released by falling into a chink from the mortal grip of its beak, it prayed the wall by the grace bestowed on it by God in allowing it to be so high and thick, and to own such fine bells and of so noble a tone, that it would succour it, and that, as it had not been able to fall under the verdurous boughs of its venerable father and lie in the fat earth covered up by his fallen leaves it would not abandon it; because, finding itself in the beak of the cruel crow, it had there made a vow that if it escaped from her it would end its life in a little hole. At these words the wall, moved to compassion, was content to shelter it in the spot where it had fallen; and after a short time the nut began to split open and put forth roots between the rifts of the stones and push them apart, and to throw out shoots from its hollow shell; and, to be brief, these rose above the building and the twisted roots, growing thicker, began to thrust the walls apart, and tear out the ancient stones from their old places. Then the wall too late and in vain bewailed the cause of its destruction and in a short time, it wrought the ruin of a great part of it.

1276. 2. secho. 3. ede pa\\\\\\. 4. sechi chello.
277. 2. della chornachia. 3. [essere] portato . . chan panile. 4. chade . . liberato. 5. [becho] suo becho pregho . . mvro [chella ricicua]. 7. richo . . chāpane. 8. honorevole sono . . douessi sochorere. 9. perche poichela non era pututa chadere 10. nella gra. 11. tera richoperto delle , . chadēti . . nola. 12. volessi. 13. nel fiero becho . . chorua chia chella si. 14. vot. [v] che schāpādo. 15. nvn piciolo buso. 16. chōpassione . . chōtento. 17. nelocho . . chaduta . . pocho. 18. chomīcio. 19. ecquelle. 20. chaverna. 21. ingrosate. 24. tardi | "e indarno" pianse . . dano. 25. brieve apero rovino.

C. A. 66 *a*; 200 *a*]

1278.

Favola.

[2] Il rovistico ·, sendo stimolato nelli sua sottili · rami ripieni di novelli [3] frutti dai pugnięti artigli e becco · delle inportune merle, si do[4]leva cō pietoso · rammarichio · īuerso essa · merla, pregando quella [5] che, poichè lei li toglieva · e sua diletti · frutti, il merlo non le privasse [6] delle foglie, le quali lo difendevano · dai cocięti · razzi del sole, e che coll'a[7]cute vnghie non la scorticasse e suestisse della · sua tenera · pelle; [8] Alla quale la merla con vilani rāpognie rispose: o taci salua[9]tico · sterpo ·! nō sai che la natura t'à fatto produrre · questi frutti [10] per mio notrimēto? nō uedi che sei al mōdo per servirmi di tale cibo? [11] nō sai, vilano ·, che tu · farai in nella prossima īuernata notri[12]mēto e cibo del fuoco ·? le quali parole ascoltate dal albero [13] patiētemēte, nō sanza lacrime ·, jnfra poco tenpo il merlo preso [14] dalla ragnia, e colti de' rami per fare gabbia per īcarcerare esso merlo [15] toccò infra l'altri rami al sottile rovistico a fare legni minimi [16] della gabbia, le quali vedēdo essere causa della persa libertà del merlo, [17] rallegratasi mosse tale parole: O merlo · io sono qui non ācora [18] consumata, come dicievi, dal foco; prima vedrò te prigione, che tu me brugiata.

Favola.

[20] Veduto · il lavro · e mirto · tagliare il pero ·, con alta voce [21] gridarono: O pero ·, ove vai · tu? ov'è la superbia che aveui quādo [22] aveui · i tua · maturi · frutti? ora nō ci farai · tu ōbra [23] colle tue · folte chiome ·; Allora · il pero · rispose: io ne ve[24]do l'agricola che mi taglia e mi porterà alla bottega d'ottimo [25] scultore, il quale mi farà con su' arte pigliare la forma [26] di Giove · Idio ·, e sarò dedicato nel tenpio · e dagli omini [27] adorato · invece di Giove; e tu ti metti ī pūto a rimanere [28] spesso storpiata · e pelata de' tua rami, i quali mi sieno [29] dali omini per onorarmi poste d'intorno.

A Fable.

The privet feeling its tender boughs loaded with young fruit, pricked by the sharp claws and beak of the insolent blackbird, complained to the blackbird with pitious remonstrance entreating her that since she stole its delicious fruits she should not deprive it of the leaves with which it preserved them from the burning rays of the sun, and that she should not divest it of its tender bark by scratching it with her sharp claws. To which the blackbird replied with angry upbraiding: "O, be silent, uncultured shrub! Do you not know that Nature made you produce these fruits for my nourishment; do you not see that you are in the world [only] to serve me as food; do you not know, base creature, that next winter you will be food and prey for the Fire?" To which words the tree listened patiently, and not without tears. After a short time the blackbird was taken in a net and boughs were cut to make a cage, in which to imprison her. Branches were cut, among others from the pliant privet, to serve for the small rods of the cage; and seeing herself to be the cause of the Blackbird's loss of liberty it rejoiced and spoke as follows: "O Blackbird, I am here, and not yet burnt by fire as you said. I shall see you in prison before you see me burnt."

A Fable.

The laurel and the myrtle seeing the pear tree cut down cried out with a loud voice: "O pear-tree! whither are you going? Where is the pride you had when you were covered with ripe fruits? Now you will no longer shade us with your mass of leaves." Then the pear-tree replied: "I am going with the husbandman who has cut me down and who will take me to the workshop of a good sculptor who by his art will make me take the form of Jove the god; and I shall be dedicated in a temple and adored by men in the place of Jove, while you are bound always to remain maimed and stripped of your boughs, which will be placed round me to do me honour.

1278. Irovesstrice. 3. pugięti . . becho. 4. chō . . ramarichio. 5. poichellei . . mero nolle [togliessi] privasse. 6. dele . . razi . . cholla. 7. chute . . non ischortichasse dissuestissi . . pella. 8. Ala . . chon vilani rāgognie. 9. tichostrepo . . fatti produre. 10. chesse. 11. inela. 12. foco . . quali [dopo pi] parole ascoldate. 13. pocho. 14. dala . . cholti . . gabia . . īchacierare. 15. stocho . . rouiserico affare lenimini. 16. dela gabia . . chaua. 17. ralegratasi . . i sono . . āchora. 18. chonsumata chome . . focho . . vedero chettu. 20. chon. 22. hora. 23. chole . . focie. 24. cholagrichola. 25. chon. 26. essaro dedichato. 27. ettu. 28. ispeso. 31. chastagno. ficho. 32. "in verso se" i sua . . isspichava . frutti quelli i quali.

FAVOLA.

³¹Vedēdo jl castagnio · l'vomo · sopra · il fico, il quale piegava ³²inverso se i sua rami e di quelli spiccava · i maturi frutti · i quali mette³³va nell' aperta bocca difaciē-doli e diserrādoli coi duri dēti, crollā³⁴do · i lunghi rami, e' cō spregevole mormorio disse: ³⁵O fico · quāto sei tu mē di me obbligato alla natura · ! vedi come ³⁶in me ordinò · serrati · i mia dolci figlioli ·, prima vestiti di sottile ca³⁷micia, sopra la quale è posta la dura e foderata pelle ·, e nō cō-³⁸tētandosi di tanto benificarmi · ch'ell'à fatto loro la forte abi³⁹tatione, e sopra quella fondò acute · e folte · spine ·, aciochè le ⁴⁰mani dell'omo · nō mi possino nvocere ·; Allora il fico comī⁴¹ciò insieme coi sua figlioli a ridere, e ferme le risa disse: ⁴²co-nosci l'omo essere di tale ingiegnio che lui ti sappi col⁴³le pertiche e pietre e sterpi, tratti infra i tua rami, farti povero ⁴⁴de' tua frutti, e quelli caduti posta coi piedi o coi sassi, a modo ⁴⁵che i frutti tua escino stra-ciati e storpiati fora dall'armata ⁴⁶casa; e io sono cō diligiēza tocco dalle mani, e nō come te da bastoni e da sasso.

A FABLE.

The chesnut, seeing a man upon the fig-tree, bending its boughs down and pulling off the ripe fruits, which he put into his open mouth destroying and crushing them with his hard teeth, it tossed its long boughs and with a noisy rustle exclaimed: "O fig! how much less are you protected by nature than I. See how in me my sweet offspring are set in close array; first clothed in soft wrappers over which is the hard but softly lined husk; and not content with taking this care of me, and having given them so strong a shelter, on this she has placed sharp and close-set spines so that the hand of man cannot hurt me." Then the fig-tree and her offspring began to laugh and having laughed she said: "I know man to be of such ingenuity that with rods and stones and stakes flung up among your branches he will bereave you of your fruits; and when they are fallen, he will trample them with his feet or with stones, so that your offspring will come out of their armour, crushed and maimed; while I am touched carefully by their hands, and not like you with sticks and stones."

C. A. 66 a; 201 a] **1279.**

Il mischio · salice trovādosi nō potere fruire ²il piacere di uedere i sua · sottili · rami · fare over ³cōdurre · alla · desiderata · grandezza e dirizzarsi al cielo per cagione · della ⁴vite · e di qualunche piāta · li era uicina ·, senpre elli ⁵era · storpiato · e dira-mato; e guasto; e raccolte · in se tutti li spiri⁶ti · e' con quelli apre e' spalanca · le parti alla ⁷imaginatione ·; e stando · in cō-tinva · cogitatione ·, e ricier⁸cando · con quella · l'universo · delle piāte, cō quale ⁹di quelle · esso collegare · si potesse che · non avesse bi-so¹⁰gnio · dell' aivto · de' sua · legami-; essendo stato · alquanto · in questa ¹¹nutritiva · ima-ginatione ·, cō subito assa¹²limēto li corse · nel pensiero · la zucca ·, e crollato tutti i ra-¹³mi · per grāde · allegrezza · pare li · avere trovato cōpa¹⁴gnia · al suo · desiato · propo-sito, imperochè quella è piv atta ¹⁵a le-gare · altri che essere · legata; ¹⁶e fatta tal

The hapless willow, finding that she could not enjoy the pleasure of seeing her slender branches grow or attain to the height she wished, or point to the sky, by reason of the vine and whatever other trees that grew near, but was always maimed and lopped and spoiled, brought all her spirits together and gave and devoted itself entirely to imagina-tion, standing plunged in long meditation and seeking, in all the world of plants, with which of them she might ally herself and which could not need the help of her withes. Having stood for some time in this prolific imagination, with a sudden flash the gourd presented itself to her thoughts and tossing all her branches with extreme delight, it seemed to her that she had found the com-panion suited to her purpose, because the gourd is more apt to bind others than to need binding; having come to this conclusion

33. bocha . . choi. 34. chōtemultevole. 35. ficho. 36. settu . . obrigato . . chome. 37. ime . . serati . . cha . . chō. 38. benificharmi . . la [spinosa] abi. 39. achute effolte . . aciochelle. 40. aloro il ficho chomī. 41. choi . . dise. 42. cho chonosci . . sapicho. 44. queli chaduti posta cho . . chosassi. 45. chefrutti . . straciati . . dell. 46. chasa . . chō . . tocho . . chome te "da bastōni e" dassesso e.
1279. 1. miscio . . trovādosi [ognino] nō. 2. pia ure d[a]i. 3. condure . . grandeza | "e dirizarsi al cielo" per chagione. 4. vite. [d]e . . visina. 5. diramato | "e guasto" e racholte . . lisspi. 6. chon . . esspalancha . . parte. 7. chōtinva. 8. chando chon . . chō. 9. di qule . . chollegare si potessi [la quale] "che" non avessi. 10. gni . . esse "do" alquanto. 11. [imagi-natione] notritiva. 12. zucha e chrollato. 13. allegreza . . chōpa. 14. disiato . . iperochecquella. 15. allegare . . legata [e per ato la sschaza]. 16. [chelli piāti di] effatte . . diliberatione | "ricca sua rami iuerso il cielo" attēde asspettare

diliberatione rizza sua rami in uerso il cielo aspettando [17]qualche amichevole · vcciello, che li fusse al disiderio mezzano; [18]jfra quali · veduta · a se vicina · la sgarza disse inverso [19]di quella : o giētile vcciello ·, per quello · soccorso [20]che a questi giorni da mattina · ne' mia rami trovasti, [21]quādo · l' affamato, crudele e rapace falcone ti voleva diuorare, [22]e per quelli · riposi che sopra me spesso ài [23]vsato · quādo · [24]l' ali tue · a te · riposo chiedeano ·, e per quelli piacie[25]ri che infra detti mia rami scherzādo colle tue cōpagnie [26]ne' · tua · amoreggiamenti ài vsato, jo ti priego · che tu truovi, [27]la zucca ·, e inpetri da quella alquāte delle sue semēze; [28]e dì a quelle · che, nate · ch' elle · fieno ·, ch'io le tratterò no[29]n altramēte · che se del mio corpo · gienerate l' auessi; [30]e similmēte vsa tutte quelle parole, che di simile intē[31]tione persuasiue · sieno, benchè a te, maestra de' linguag[32]gi, insegniare · non bisognia ·; e se questo [33]farai, io sono · cōtēta di ricieuere il tuo nidio sopra [34]il nascimēto de' mia · rami · insieme colla tua fa[35]miglia sanza pagamēto d'alcū fitto ·; allora la sgar[36]za fatto · e fermato alquāti capitoli di novo col salice, e mas[37]sima che biscie o faine sopra se mai non accettasse, [38]alzato la coda e bassato · la testa e gittatasi dal ramo [39]rēde il suo · peso · all' ali, e quelle battēdo sopra [40]la fugitiva · aria ·, ora qua, ora in là curiosamēte col timō della coda [41]dirizzādosi ·, peruen͂e · a vna zucca ·, e cō bel saluto [42]e alquāte bone parole inpetrò le dimandate semēze; [43]e condottele al salice fu con lieta ciera ricevuta; [44]e raspato alquāto coi piè il terreno vicino al salicie, [45]col becco in cierchio a esso essi · grani · piātò ·, li quali [46]in brieve tēpo · crescēdo · comīciarono collo accrescimēto · e aprimēto de' sua [47]rami · a occupare · tutti · i rami del salice, e colle sue [48]grā foglie · a tog/lierle · la bellezza del sole e del cielo ·; e nō [49]bastādo · tāto male, seguēdo le zucche comīciarono, per discō[50]cio preso, a tirare le cime de' teneri rami inverso la te[51]rra con strane torture e disagio di quelli.

she awaited eagerly some friendly bird who should be the mediator of her wishes. Presently seeing near her the magpie she said to him: "O gentle bird! by the memory of the refuge which you found this morning among my branches, when the hungry cruel, and rapacious falcon wanted to devour you, and by that repose which you have always found in me when your wings craved rest, and by the pleasure you have enjoyed among my boughs, when playing with your companions or making love—I entreat you find the gourd and obtain from her some of her seeds, and tell her that those that are born of them I will treat exactly as though they were my own flesh and blood; and in this way use all the words you can think of, which are of the same persuasive purport; though, indeed, since you are a master of language, I need not teach you. And if you will do me this service I shall be happy to have your nest in the fork of my boughs, and all your family without payment of any rent." Then the magpie, having made and confirmed certain new stipulations with the willow,—and principally that she should never admit upon her any snake or polecat, cocked his tail, and put down his head, and flung himself from the bough, throwing his weight upon his wings; and these, beating the fleeting air, now here, now there, bearing about inquisitively, while his tail served as a rudder to steer him, he came to a gourd; then with a handsome bow and a few polite words, he obtained the required seeds, and carried them to the willow, who received him with a cheerful face. And when he had scraped away with his foot a small quantity of the earth near the willow, describing a circle, with his beak he planted the grains, which in a short time began to grow, and by their growth and the branches to take up all the boughs of the willow, while their broad leaves deprived it of the beauty of the sun and sky. And not content with so much evil, the gourds next began, by their rude hold, to drag the ends of the tender shoots down towards the earth, with strange twisting and distortion.

17. chelli fussi . . mezano. 18. asse . . lassgaza disse iver. 19. vcciello [jo ti priego] per . . sochorso. 20. acquesssti . . ine. 21. lafamato falchone | "crudeele he" rapacte. 22. [etti priego] "e" per . . sopra [inparani] speso. 23. quādo [i nervi "e move \\\\\\\\\\ telle tua" issacho nō poteano piv menare]. 24. [le tue alie] lalie | "tue" atte. 25. re che . . cholle . . chōpagnie. 26. amorigia . . chettu. 27. zucha . . inpretri dacquella. 28. ediacquelle . . lettrattero. 29. altremēti chesse . . chorpo . . lanessi [essi]. 30. essimilmēte. 31. atte . . lingua. 32. ne bisognia essecquesto [seruitio ni]. 33. chōtēta. 34. nasscimēto . . cholla. 35. lassga. 36. fatto "effermi" alquāti . . novo \\\ chol . . e ma. 37. bissce offaine . . acciettassi. 38. del rarmo. 39. ecquelle. 40. ora illa "curiosamēte" cho. 41. dirizādosi . . zucha echo . . dimadate. 43. chondottele . . cho lieto ciera. 44. rasspatò . . copie il tereno. 45. chol becho iciercho [al salice ¶ esse] "a esse" graui . . le. 46. cresscēdo . . chollo "accrescimēto he a" primēto. 47. ochupare . . cholle. 48. attorle la belleza. 49. bastāto . . zuche comīcie per discō. 50. attirare . . inver la. 51. chon istrane. Lines 52—54 are written on the margin. 52. scon

[52]Allora scontēdosi, e indarno crollan-dosi per fare da se esse zuche cadere, e indarno [53]vaneggiando alquāti giorni · in simile inganno ·, perchè la bona e forte collegatione tal [54]pēsiero negava, vedēdo passare il uēto ·, a quello racomādādosi, e quello soffiò forte; allora s'a[55]perse il uechio e voto gābo del salice in 2 parti insino [56]alle sue radici; e caduto in 2 parti indarno pianse se me[57]desimo, e conobbe che era nato per non aver mai bene.

Then, being much annoyed, it shook itself in vain to throw off the gourd. After raving for some days in such plans vainly, because the firm union forbade it, seeing the wind come by it commended itself to him. The wind flew hard and opened the old and hollow stem of the willow in two down to the roots, so that it fell into two parts. In vain did it bewail itself recognising that it was born to no good end.

tēdossi . . crolladosi . . dasse . . chadere. 53. vanegiāto . . ingano . . efforte chollegatione. 54. acquello . . ecquello 56. radice. 57. conobe.

III.

JESTS AND TALES.

C. A. 117a; 361a]

1280.

FACIETIA.

²Andādo vn prete per la sua parrochia il sabato santo, dādo ³come vsanza l'acqua benedetta per le case, capitò nella stāza ⁴d'ū pittore, doue spargiēdo essa acqua sopra alcuna sua pittu⁵ra esso pittore voltosi indirieto, alquāto crucciato; dis⁶se perchè faciesse tale spargimēto sopra le sue pitture? allora ⁷il prete disse, essere così vsanza, e ch'era suo debito il fare ⁸così, e che facieva bene, e chi fa bene debbe aspettare be⁹ne e meglio, chè così promettea Dio, e che d'ogni bene, che si ¹⁰facieva in terra, se n'avrebbe di sopra per ogni vn 100; allora ¹¹il pittore, aspettato ch'egli uscisse fori, se li fecie di sopra ¹²alla finestra, e gittò vn grā sechione d'acqua adosso a esso ¹³prete, diciēdo: ecco che di sopra ti uiene per ogni v̄ 100, come ¹⁴tu diciesti·, che accaderebbe del bene che mi facievi colla ¹⁵tua acqua santa, colla quale m'ài guasto mezze le mie ¹⁶pitture.

A JEST.

A priest, making the rounds of his parish on Easter Eve, and sprinkling holy water in the houses as is customary, came to a painter's room, where he sprinkled the water on some of his pictures. The painter turned round, somewhat angered, and asked him why this sprinkling had been bestowed on his pictures; then said the priest, that it was the custom and his duty to do so, and that he was doing good; and that he who did good might look for good in return, and, indeed, for better, since God had promised that every good deed that was done on earth should be rewarded a hundred-fold from above. Then the painter, waiting till he went out, went to an upper window and flung a large pail of water on the priest's back, saying: "Here is the reward a hundred-fold from above, which you said would come from the good you had done me with your holy water, by which you have damaged my pictures."

S. K. M. III. 73b]

1281.

Il uino cōsumato dallo ²ubriaco, esso vino col beuitore si vēdica.

When wine is drunk by a drunkard, that wine is revenged on the drinker.

1280. 4. hessa acq. 5. scrucciato di. 6. si . . faciessi. 8. asspettare. 9. chessi. 10. narebbe. 11. asspettato chelli vsscissi. 13. echo. 14. achaderebbe. 15. cholla . . meze.
1281. 1. chōsumato. 2. ubriacho . . chol . . vendicha.

C. A. 66a; 201a]　　　　　　　　　　1282.

⁸Trovādosi il uino, divino licore dell'uua, in vna ⁹avrea · e ricca tazza sopra la tavola di Ma¹⁰vmetto, e mōtato · in gloria di tā¹¹to onore, subito fu assaltato · da vna · cōtraria ¹²cogitatione · diciēdo · a se · medesimo: che fo, e di che ¹³mi rallegro · io? non m'avvedo · essere vicino alla ¹⁴mia morte? e lasciare l'aurea abitazione de¹⁵lla tazza · e entrare in nelle brutte e fetide caverne ¹⁶del corpo vmano · e lì trasmvtarmi di odorife¹⁷ro e suave · licore · in brutta e trista orina? e nō ¹⁸bastādo tāto male · ch'io ancora deba si lūga¹⁹mēte · giacere · ne' brutti ricettacoli coll'altra ²⁰fetida e corrotta materia, vscita dalle vmane inte²¹riora? gridò inverso · il cielo, chiedēdo ²²vēdetta di tanto danno, ²³e che si ponesse ora mai fine a tāto dispreggio, ²⁴chè, poichè quello paese producea le piv belle ²⁵e migliori · vue di tutto · l'altro mōdo, che al meno ²⁶esse non fussino · in vino cōdotte; allora Giove fece ²⁷che 'l bevto · vino · da Mavmetto eleuò l'anima sua ²⁸inverso · il cielabro ·, e quello · in modo cōtaminò che ²⁹lo fecie · matto ·, e partorì tanti errori che, torna³⁰to in se, fecie legge che nessuno · Asiatico bevesse ³¹vino ·; e furono lasciate poi libere le uiti coi sua frutti.

³²Già il uino, ³³entrato nel³⁴lo stomaco, co³⁵mincia a bo³⁶llire e sgōfia³⁷re; già l'ani-³⁸ma di quello ³⁹comincia a abā⁴⁰donare il cor⁴¹po; già si volta ⁴²inverso il cie⁴³lo; trova il cie⁴⁴labro ·, cagione ⁴⁵della diuisione ⁴⁶dal suo corpo; ⁴⁷già lo comincia ⁴⁸a cōtaminare ⁴⁹e farlo furia⁵⁰re a modo di ma-⁵¹tto; già fa in⁵²riparabili erro⁵³ri, ammazzādo i su⁵⁴a amici.

Wine, the divine juice of the grape, finding itself in a golden and richly wrought cup, on the table of Mahomet, was puffed up with pride at so much honour; when suddenly it was struck by a contrary reflection, saying to itself: "What am I about, that I should rejoice, and not perceive that I am now near to my death and shall leave my golden abode in this cup to enter into the foul and fetid caverns of the human body, and to be transmuted from a fragrant and delicious liquor into a foul and base one. Nay, and as though so much evil as this were not enough, I must for a long time lie in hideous receptacles, together with other fetid and corrupt matter, cast out from human intestines." And it cried to Heaven, imploring vengeance for so much insult, and that an end might henceforth be put to such contempt; and that, since that country produced the finest and best grapes in the whole world, at least they should not be turned into wine. Then Jove made that wine drunk by Mahomet to rise in spirit to his brain; and that in so deleterious a manner that it made him mad, and gave birth to so many follies that when he had recovered himself, he made a law that no Asiatic should drink wine, and henceforth the vine and its fruit were left free.

As soon as wine has entered the stomach it begins to ferment and swell; then the spirit of that man begins to abandon his body, rising as it were skywards, and the brain finds itself parting from the body. Then it begins to degrade him, and make him rave like a madman, and then he does irreparable evil, killing his friends.

S. K. M. III. 58a]　　　　　　　　　　1283.

Vno · artigiano andando ²spesso a visitare vno signiore ³sanza · altro · proposito dimādare ⁴al quale, jl signore domandò ⁵quello · che · andava faciēdo? ⁶questo · disse che veniua lì ⁷per avere · de' piaceri che

An artizan often going to visit a great gentleman without any definite purpose, the gentleman asked him what he did this for. The other said that he came there to have a pleasure which his lordship could not have;

1282. 1. Il uino vedendosi "nelle partimaumettane" ogni giorno . dai beuitori. 2. essere messo . . inelle fasstidiose . . brudella e chōller. 3. tito in urina e diaciere "lu gamēte" poire nei brutti e pu. 4. zalenti lochi . dilibero adoperare [i sua spiriti]. 5. [u] ogni sua . . forza [ara] al riparo di tāta. 6. nefanda vilta . e trovādosi sopra la tavola di. 7. mavmetto . . nvna richa e bella]. 8. trovādosi [il] il uino. 9. richacha taza. 10. groria. 11. honore. 12. cheffo i di che. 13. nomavedo. 14. ellasciare. 15. taza. 15. inelle . . effetide chaverne. 16. ellisstrassmvtarmi. 17. essuave . . ettrista. 18. basstādo. 18. anchora. 19. diasiere ine . . riciettacholi choll. 20. fitidae chor "o''tta . . vsscita delle. 22. danno [allora giove fecie]. 23. ponessi . . attāto disspregio. 24. paesse. 25. migliore . . il meno. 26. elle non . . chōdotte. 27. beuto. 28. ecquello imodo. 29. chettorna. 30. legie . . assiaticho beessi. 31. effunassciato . . libere . . cosua. 34. o stomaco. 36. esscōfia. 47. cia lo comincia a. 49. effarlo. 52. cro. 53. amazādo.

1283. 6. quesso. 7. chellui. 8. perochello. 9. ĩvollentieri. 11. fano.

lui ⁸aver nō potea; perochè ⁹volentieri vedeua omi¹⁰ni piv potenti di lui, come ¹¹fanno i popolani, ma che 'l si¹²gnore non potea · vedere se ¹³non omini di mē possa di lui; ¹⁴per questo i signori māca¹⁵vano d' esso piacere.

since to him it was a satisfaction to see men greater than himself, as is the way with the populace; while the gentleman could only see men of less consequence than himself; and so lords and great men were deprived of that pleasure.

C. A. 147 *b*; 439 *a*]

1284.

Vsano i frati minori a cierti tempi alcune loro quaresime, nelle quali essi non māgiano carne ne' lor cōuēti, ²ma in viaggio, perchè essi viuono di limosine ·, ànno liciētia di māgiare · ciò che è posto loro innāzi; ōde abattē³dosi in detti viaggi una copia d' essi frati a vn osteria · in cōpagnia d' ū cierto · mecantuolo ·, il quale essendo ⁴a vna medesima mēsa, alla quale · nō fu portato per la pouertà dell' ostiero altro che vn pvllastro cotto; ōde es⁵so mercatucolo, vedendo questo essere poco per lui, si uolse a essi frati e disse: se io ho bē ⁶di ricordo ·, voi nō māgiate in tali dì ne' vostri cōuēti · d' alcuna maniera di carne; alle quali parole i fra⁷ti furono costretti per la regola sanza altre cavillationi · a dire ciò essere la ueritā ·; ōde il mercatello ⁸ebbe il suo desiderio, e così māgiò essa polastra, e i frati fecero il meglio poterono ·; ove dopo tale desinare ⁹questi cōmēsari si partirono tutti e 3 di conpagnia ·, e dopo alquanto di uiagio, trovati vn fiume di bona ¹⁰larghezza e profondità ·, essendo tutti 3 a piedi, i frati per pouertà e l' altro per auaritia ·, fu neciessario per l' uso ¹¹della cōpagnia che vno de' frati, essendo scalzi ·, passasse sopra i sua omeri esso mercātucolo ·; onde datoli ¹²il frate al servo i zoccoli, si caricò di tale uomo; onde accade, che trovandosi esso frate in mezzo del ¹³fiume ·, esso ancora si ricordò della sua · regola ·, e fermatosi a vso di San Cristoforo alzò la testa ¹⁴inverso quello che l' aggravava, e disse: diīni vn poco ·, ài tu nessū dinari adosso? bē sai, rispose que¹⁵sto; come credete voi ch' a mia pari mercatāte andasse altramēti attorno ·? oimè, disse il frate, la nostra ¹⁶regola vieta che noi nō possiano portare danari adosso ·! e subito lo gittò nell' acqua; la qual cosa conosciuta ¹⁷dal mercatāte facetamēte la già fatta ingíuria essere vēdicata ·, cō piacievole uiso pacificamēte, ¹⁸mezzo arossito per vergogna, la uēdetta sopportò.

Franciscan begging Friars are wont, at certain times, to keep fasts, when they do not eat meat in their convents. But on journeys, as they live on charity, they have license to eat whatever is set before them. Now a couple of these friars on their travels, stopped at an inn, in company with a certain merchant, and sat down with him at the same table, where, from the poverty of the inn, nothing was served to them but a small roast chicken. The merchant, seeing this to be but little even for himself, turned to the friars and said: "If my memory serves me, you do not eat any kind of flesh in your convents at this season." At these words the friars were compelled by their rule to admit, without cavil, that this was the truth; so the merchant had his wish, and eat the chicken and the friars did the best they could. After dinner the messmates departed, all three together, and after travelling some distance they came to a river of some width and depth. All three being on foot—the friars by reason of their poverty, and the other from avarice—it was necessary by the custom of company that one of the friars, being barefoot, should carry the merchant on his shoulders: so having given his wooden shoes into his keeping, he took up his man. But it so happened that when the friar had got to the middle of the river, he again remembered a rule of his order, and stopping short, he looked up, like Saint Christopher, to the burden on his back and said: "Tell me, have you any money about you?"—"You know I have", answered the other, "How do you suppose that a Merchant like me should go about otherwise?" "Alack!" cried the friar, "our rules forbid as to carry any money on our persons," and forthwith he dropped him into the water, which the merchant perceived was a facetious way of being revenged on the indignity he had done them; so, with a smiling face, and blushing somewhat with shame, he peaceably endured the revenge.

1284. 1. fratti . . tenpi. 2. uiagio . . viuano . . che hi posto. 3. viagi una "copia" dessi . . mecantuolo. 4. ostieri . . polostro . . ōdehe. 5. merchantuolo. 5. hessere pocho. 7. alte gavillationi a direco essere. 8. ebe . . chosisi . . frati fraone il meglio poterone . oue dopo. 9. chonpagnia. 10. largeza . . tutte . . ellaltro. 11. discalzi passassi . . mercātuolo. 12. asserbo zocholi . . charicho . . homo . . imezo. 13. hesso . . richordo dela . . effermatosi . . cristofano. 14. chellagravava . . pocho . . rissponse . . merchatāte andassi altre. 16. chēnoi . . conossciuta. 17. merchatate facietamēte . . vīdichata . . pacifichamēte. 18. mezo . . soporto.

M. 58*b*] **1285.**

FACETIA.

[2]Vno volendo provare colla autorità [3]di
Pitagora, come altre volte lui era [4]stato al
mōdo, e vno nō li lasciava [5]finire il suo
ragionamēto, allor costui [6]disse a questo
tale: è per tale segniale che [7]io altre volte
ci fussi stato, io mi ricor[8]do che tu eri
mvlinaro; allora costui [9]sentēdosi mordere
colle parole gli [10]confermò essere vero, che
per questo cō[11]trassegnio lui si ricordava
che questo [12]tale era stato l'asino che gli
portava la [13]farina.

FACETIA.

[15]Fu dimādato vn pittore perchè, fac-
ciēdo [16]lui de' figure si belle che erā cose
morte, [17]per che causa esso avesse fatti i
figlioli [18]si brutti; allora il pittore rispose
che le [19]pitture le fecie di dì, e i figlioli
di notte.

A JEST.

A man wishing to prove, by the authority
of Pythagoras, that he had formerly been in
the world, while another would not let him
finish his argument, the first speaker said to
the second: "It is by this token that I
was formerly here, I remember that you
were a miller." The other one, feeling him-
self stung by these words, agreed that it was
true, and that by the same token he remem-
bered that the speaker had been the ass that
carried the flour.

A JEST.

It was asked of a painter why, since
he made such beautiful figures, which were
but dead things, his children were so ugly;
to which the painter replied that he made
his pictures by day, and his children by
night.

C. A. 12*a*; 42*a*] **1286.**

Vno · vede vna grāde · spada al lato · a
vn altro, e' dice: o poverello ell'è grā tēpo
ch'io [2]t'ò veduto · legato a questa · arme ·,
perchè · nō ti disleghi, avēdo le māni di-
sciolte, [3]e possiedi libertà? al qual · costui
rispose: questa è cosa · nō tua, anzi · è
vecchia; [4]questo sentēdosi mordere · rispose:
io · ti conosco · sapere si poche cose in
questo [5]mōdo · ch'io credevo · che ogni di-
ualgata · cosa · a te · fusse · per nova.

A man saw a large sword which another
one wore at his side. Said he "Poor fellow,
for a long time I have seen you tied to that
weapon; why do you not release yourself
as your hands are untied, and set yourself
free?" To which the other replied: "This is
none of yours, on the contrary it is an old
story." The former speaker, feeling stung,
replied: "I know that you are acquain-
ted with so few things in this world, that I
thought anything I could tell you would
be new to you."

C. A. 300*b*; 914*a*] **1287.**

Vno lasciò lo usare con uno · suo · amico,
[2]perchè · quello · spesso · li diciena · male ·
delli [3]amici · sua ·; Il quale · lasciato · amico ·
[4]vn dì dolendosi collo amico e dopo il
molto [5]dolersi lo pregò, ch'elli · dicesse
quale fusse [6]la cagione, che lo auesse · fatto
dimēticare · [7]tanta amicitia; al quale esso ·
rispose: jo [8]non voglio più usare · con teco

A man gave up his intimacy with one
of his friends because he often spoke ill of
his other friends. The neglected friend one
day lamenting to this former friend, after
much complaining, entreated him to say
what might be the cause that had made
him forget so much friendship. To which
he answered: "I will no longer be in-

1285. 2. cholla alturita. 3. pictagora. 4. lassciava . . chostui. 6. acquesto. 7. cifussi. 8. chettu . . chosstui. 9. cholle.
11. richordaua. 12. chelli. 15. pictore. 17. chausa . . auessi. 18. risspose chelle. 19. figlio.

1286. 2 acquesta . . disslegi [e sta liber] avēdo . . disscolte. 3. cosstui rissose. 4. risspuose . . conossco . . chose . .
quessto. 5. chosa atte fussi.

1287. 1. lasscio . . amicho. 2. isspesso. 3. lasscato amicho [si do]. 4. cholla amicho. 5. diciessi . . fussi. 6. chagione chello
auessi . . dimētichare. 7. risspose. 8. no . . chontecho. 9. nōno. 10. amicho. 11. abbia chome me affare trissta.

per ⁹ch'io · ti uoglio bene ·, e non uoglio che, diciē¹⁰do tu male ad altri di me ·, tuo amico ·, che al¹¹tri abbiano, come me, a fare trista impressione ¹²di te ·, diciendo tu a quelli male di me, tuo amico; ¹³ōde, non vsando noi piv insieme, parrà che noi ¹⁴siamo fatti nimici, e per il dire tu male di me, com'è ¹⁵tua vsanza ·, non sarai tanto da essere biasi¹⁶mato ·, come se noi usassimo · insieme.

timate with you because I love you, and I do not choose that you, by speaking ill of me, your friend, to others, should produce in others, as in me, a bad impression of yourself, by speaking evil to them of me, your friend. Therefore, being no longer intimate together, it will seem as though we had become enemies; and in speaking evil of me, as is your wont, you will not be blamed so much as if we continued intimate.

C. A. 75 b; 219 b]

1288.

Vno disputādo e vantādosi · di sapere fare molti vari · e belli · giochi ·, vn altro de' circonstanti ⋮ disse: jo so fare ²vno giocco · il quale · farà · trarre le brache · a chi a me parirà; il primo vantatore, trovandosi sanza brache, ³disse · che a me non le sarai trarre e vo' dare vn pajo di calze; il proponitore d'esso gioco accettato ⁴lo invito · in pro mvto piv paja di brache, e trassele nel uolto · al mettitore delle calze, e vinse il pegnio.

⁵Vno disse a vn suo conosciēte: tu ài · tutti · li ochi · trasmutati · in strano · colore; Quello · li ripose interuenirli ⁶spesso, ma tu nō ci ài posto cura;—e quādo t'adiuiē questo?—rispose l'altro: ogni volta, che mia · ochi vedono jl tuo viso ⁷strano ·, per la violenza ricievuta da si grā dispiaciere · subito s'impallidiscono · e mvtano in istrā colore;

⁸Vno disse a un altro: tu ài tutti li occhi mutati in istrā colore; Quello li rispose egli è perchè i mia ochi vedono ⁹il tuo viso strano.

¹⁰Vno disse che in suo paese · nascievano le piv strane cose del mōdo ·; l'altro rispose : tu che sei vi na¹¹to, confermi ciò esser uero · per la stranezza della tua brutta presenza.

A man was arguing and boasting that he knew many and various tricks. Another among the bystanders said: "I know how to play a trick which will make whomsoever I like pull off his breeches." The first man— the boaster—said: "You won't make me pull off mine, and I bet you a pair of hose on it." He who proposed the game, having accepted the offer, produced breeches and drew them across the face of him who bet the pair of hose and won the bet [4].

A man said to an acquaintance: "Your eyes are changed to a strange colour." The other replied: "it often happens, but you have not noticed it." "When does it happen?" said the former. "Every time that my eyes see your ugly face, from the shock of so unpleasing a sight they suddenly turn pale and change to a strange colour."

A man said to another: "Your eyes are changed to a strange colour." The other replied: "It is because my eyes behold your strange ugly face."

A man said that in his country were the strangest things in the world. Another answered: "You, who were born there, confirm this as true, by the strangeness of your ugly face."

Tr. 78]

1289.

Dispreggiādo uno vecchio publicamēte vn giovane mostrādo auda²cemēte nō temer quello, ònde il giovane li rispuose che la ³sua lūga età li facieva migliore scudo che la lingua ⁴o la forza.

An old man was publicly casting contempt on a young one, and boldly showing that he did not fear him; on which the young man replied that his advanced age served him better as a shield than either his tongue or his strength.

12. acquegli. 13. noi | "piv" insieme para. 14. siano .. tire tu .. chome. 15. tu. 16. chome.
1288. 1. dissputādo .. circhustanti 2. giocho trarae. 3. che no disse .. nole sarai .. parodi chalze.. giocho aciettato. 4. ettras-sele .. chalze. 4. chonossciēte .. trassmutati in insstrano cholore. 6. chura ecquādo .. oni .. vegano. 7. sinpalidis cano .. cholore. 8. ellgie .. vegano. 10. nasscieva .. chose .. ui sena. 11. chonfermi .. straneza.
1289. dispregiādo î vecchio .. mostrādo alda. 3. schudo chella lingha.

1288. The joke turns, it appears, on two meanings of *trarre* and is not easily translated.

S. K. M. II.² 44 *a*] **1290.**

FACIETIA.

²Sendo uno infermo in articulo ³ di
morte, esso sentì battere la porta, ⁴e domā-
dato vno de' sua serui chi era ⁵che batteva
l'uscio, esso seruo rispose ⁶esser vna che
si chiamava madoña ⁷Bona; allora l'in-
fermo alzato le ⁸braccia al cielo ringraziò
Dio con al⁹ta voce; poi disse ai serui che
lasci¹⁰assino venire presto questa, accio-
¹¹chè potesse vedere vna donna ¹²bona
iñazi che esso morisse, ¹³imperochè in sua
vita mai ne vide nessuna.

A JEST.

A sick man finding himself in *articulo
mortis* heard a knock at the door, and asking
one of his servants who was knocking, the
servant went out, and answered that it was
a woman calling herself Madonna Bona. Then
the sick man lifting his arms to Heaven
thanked God with a loud voice, and told the
servants that they were to let her come in
at once, so that he might see one good
woman before he died, since in all his life
he had never yet seen one.

S. K. M. II.² 43 *b*] **1291.**

FACIETIA.

²Fu detto a vno che si levasse ³dal
letto, perchè già era leva⁴to il sole; E lui
rispose: se ⁵io avessi a fare tanto viaggio
⁶e facende quanto lui, ancora io sarei ⁷già
levato, e però avendo a fa⁸re si poco ca-
mino, ancora non ⁹mi voglio levare.

A JEST.

A man was desired to rise from bed,
because the sun was already risen. To which
he replied: "If I had as far to go, and as
much to do as he has, I should be risen by
now; but having but a little way to go, I
shall not rise yet."

Fo'] **1292.**

Vno vedendo vna femina parata a tener
ta²vola in giostra guardò il tavolaccio
e gridò ³vedendo la sua lancia: oimè
quest'è troppo pic⁴col lavorante a si grā
bottega.

A man, seeing a woman ready to hold
up the target for a jousting match, exclaimed,
looking at the shield, and considering his
spear: "Alack! this is too small a workman
for so great a business."

1290. lusscie . . rispose. 6. eser . . chessi chiamav. 8. rigrazio. 9. chellasci. 11. potessi. 12. hessomorissi. 13. iperoche
. . ma ne.
1291. chessi levassi. 3. del . . hera. 4. Ellui. 5. affare . . viago. 6. "e facende" quanto. 7. av̄do affa. 8. anchora no. 9. mi
vo levare.
1292. 2. ingostra . . tavolacco. 3. lassua . . tropo pi. 4. assi . . bottegha.

IV.

PROPHECIES.

C. A. 143*a*; 426*a*]

1293.

DIUISIONE DELLA PROFETIA.

²Prima delle cose degli animali; secōda delli ³irrationali; 3ª delle piāte, quarta delle cerimonie; ⁴quīta de' costumi; sesta delli casi overo editti, over qui⁵stioni; settima de' casi che nō possono stare ⁶in natura, come dire di quella cosa, quāto piv ne le-⁷vi piv crescie; e riserua i grādi casi ⁸inverso il fine, e deboli dà dal principio, ⁹e mostra prima i mali, e poi le punitioni ¹⁰delle cose filosofiche.

❴ Delle formiche. ❵

¹²Molti popoli fien quelli che nascōderā se ¹³i figlioli e le sue vettovaglie dentro alle oscure caverne, ¹⁴e lì nelli lochi tenebrosi ciberā se e sua ¹⁵famiglia per molti mesi sanza altro lume accidentale o naturale.

THE DIVISION OF THE PROPHECIES.

First, of things relating to animals; secondly, of irrational creatures; thirdly of plants; fourthly, of ceremonies; fifthly, of manners; sixthly, of cases or edicts or quarrels; seventhly, of cases that are impossible in nature [paradoxes], as, for instance, of those things which, the more is taken from them, the more they grow. And reserve the great matters till the end, and the small matters give at the beginning. And first show the evils and then the punishment of philosophical things.

❴ Of Ants. ❵

These creatures will form many communities, which will hide themselves and their young ones and victuals in dark caverns, and they will feed themselves and their families in dark places for many months without any light, artificial or natural.

1293. 3. inrationali . . cirimonie. 4. sessta. 5. chasi. 6. inatura. 7. cresscie . . chasi. 9. emali. 12. queli . . nasscōderā. 13. e sue | "figloli" e . . dētro alle "osscure" caverne. 14. elli nelli. 15. famiglia "per molti mesi" sanza . . acidentale.

1293. Lines 1—51 are in the original written in one column, beginning with the text of line 11. At the end of the column is the programme for the arrangement of the prophecies, placed here at the head: Lines 56—79 form a second column, lines 80—97 a third one (see the reproduction of the text on the facsimile Pl. CXVIII).

Another suggestion for the arrangement of the prophecies is to be found among the notes 55—57 on page 357.

❡ Dell' api. ❡

¹⁷E a molti altri sarā tolte le mvnitioni e lor cibi, ¹⁸e crudelmēte da giēte sanza ragione saranno ¹⁹sommerse e annegate; o giustitia di Dio ²⁰perchè nō ti desti a vedere così malmenare e tua ²¹creati?

❡ Delle pecore vacche ²³e capre e simili. ❡

²⁴A innumerabili saran tolti i loro piccoli figlio²⁵li e quelli scarnati ²⁶e crudelissimamēti squartati.

❡ Delle noci e vliue e ghiā²⁸de e castagnie e simili. ❡

²⁹Molti figlioli da spietate bastona³⁰te fieno tolti dalle propie braccia delle lor ³¹madri e gittati in terra e poi lacerati.

❡ De'fanciulli che stanno ³³legati nelle fascie. ❡

³⁴O città marine, io vedo in uoi i uostri citta³⁵dini così femine come maschi stret-³⁶tamente dai forti legami colle braccia e ganbe esser le³⁷gati da gente che non ītenderanno i uostri lī³⁸guaggi, e sol ui potrete sfogare li vostri dolori e per³⁹duta libertà mediante i lagrimosi piā⁴⁰ti e li sospiri e lamentatione infra uoi mede⁴¹simi, chè chi vi lega, non v'intenderà, nè voi loro in⁴²tenderete.

❡ Delle gatte che māgiano i topi. ❡

⁴⁴A voi città dell'Africa si uedrà i uostri nati essere ⁴⁵squarciati nelle propie case de' crudelissimi e ra⁴⁶paci animali del paese vostro.

❡ Delli asini bastonati. ❡

⁴⁸O natura, perchè ti sei fatto ⁴⁹partiale, facciēdoti ai tua figli d'alcuna pietosa ⁵⁰e benignia madre, ad'altri crudelissima e spieta⁵¹ta matrignia? io vedo i tua figlioli esser dati in al⁵²trui seruitù sanza mai benifitio alcuno, e in lo⁵³co di remuneratione de' fatti benifitj esser pagati ⁵⁴di grādissimi martiri, e spēdere senpre la lo⁵⁵r vita in benifitio del suo mal fattore.

❡ Of Bees. ❡

And many others will be deprived of their store and their food, and will be cruelly submerged and drowned by folks devoid of reason. Oh Justice of God! Why dost thou not wake and behold thy creatures thus ill used?

❡ Of Sheep, Cows, Goats and the like. ❡

Endless multitudes of these will have their little children taken from them ripped open and flayed and most barbarously quartered.

❡ Of Nuts, and Olives, and Acorns, and Chesnuts, and such like. ❡

Many offspring shall be snatched by cruel thrashing from the very arms of their mothers, and flung on the ground, and crushed.

❡ Of Children bound in Bundles. ❡

O cities of the Sea! In you I see your citizens—both females and males—tightly bound, arms and legs, with strong withes by folks who will not understand your language. And you will only be able to assuage your sorrows and lost liberty by means of tearful complaints and sighing and lamentation among yourselves; for those who will bind you will not understand you, nor will you understand them.

❡ Of Cats that eat Rats. ❡

In you, O cities of Africa your children will be seen quartered in their own houses by most cruel and rapacious beasts of your own country.

❡ Of Asses that are beaten. ❡

[48] O Nature! Wherefore art thou so partial; being to some of thy children a tender and benign mother, and to others a most cruel and pitiless stepmother? I see children of thine given up to slavery to others, without any sort of advantage, and instead of remuneration for the good they do, they are paid with the severest suffering, and spend their whole life in benefitting those who ill treat them.

16. ape. 17. e amolti | "[era]" altri . . toltolte la. 18. ragone sarano. 19. gustitia. 20. dessti. 22. vache. 23. essimili. 24. invmerabili . . elloro picholi. 25. ecquelli [crudelissimamēte] scannati [essqua]. 28. essimili. 29. dispietate. 30. fietolti delle. 32 fanculli chesstano. 33. fasscie. 34. veggho . . uosstri. 35. dini [esse] cossi . . massci essere isstre. 36. dei . . cole br. 38. essol . . issfogare li uosstri "dolori e" eper. 39. mediante [i gran pian] i lagrimosi. 40. elle i sosspiri ellamentatione. 43. māgano e topi. 44. uosstri. 46. vosstro. 47. basstonati. 48. O natura [sanza] in stacchurata perchetti seffatta. 49. dalchuna. 50. disspieta. 51. vegho. 52. alchuno eillo. 53. cho. 54. da [ere] di grādissime [bastonate]

48. Compare No. 845.

⟦Delli omini che dormono nell'asse d'alberi.⟧

⟦Of Men who sleep on boards of Trees.⟧

57 Li omini dormiranno e māgieranno e abiterāno 58 infra li alberi nelli selue e cāpagnie.

Men shall sleep, and eat, and dwell among trees, in the forests and open country.

⟦Del sogniare.⟧

⟦Of Dreaming.⟧

60 Alli omini parrā vedere nel cielo nove rui⁶¹ne; parrā in quello leuarsi a uolo, e di quello fuggi⁶²re cō penvria le fiamme che di lui discē⁶³dono; sentirā parlare li animali di qua⁶⁴lūche sorte in linguaggio vmano; scorre⁶⁵ranno inmediate colla lor persona ⁶⁶in diverse parti del mōdo sanza mo⁶⁷to; vedrāno nelle tenebre grādissimi ⁶⁸splēdori; o maraviglia della vmana ⁶⁹spetie qual frenesia t'ā si condotto! ⁷⁰parlerai cogli animali di qualūche spetie, ⁷¹e quelli cō teco in linguaggio vmano, ⁷²vedrāti cadere di grande alture san⁷³za tuo danno; i torrēti t'accompa⁷⁴gneranno e mischieranno col lor rapido corso . . .

Men will seem to see new destructions in the sky. The flames that fall from it will seem to rise in it and to fly from it with terror. They will hear every kind of animals speak in human language. They will instantaneously run in person in various parts of the world, without motion. They will see the greatest splendour in the midst of darkness. O! marvel of the human race! What madness has led you thus! You will speak with animals of every species and they with you in human speech. You will see yourself fall from great heights without any harm and torrents will accompany you, and will mingle with their rapid course.

⟦De' cristiani.⟧

⟦Of Christians.⟧

81 Molti che tengono la fede del figlio-82lo e sol fan tenpli nel nome 83 della madre.

Many who hold the faith of the Son only build temples in the name of the Mother.

⟦Del cibo stato animato.⟧

⟦Of Food which has been alive.⟧

84 Gran parte de' corpi animati 85 passerà pe' corpi degli altri animali, 86 cioè le case disabitate passerā 87 in pezzi per le case abitate, dan88do a quella vtile, e portā89do cō seco i sua danni; 90 cioè la uita dell'omo si fa dalle cose 91 māgiate·, le quali portā con se92co la parte dell'omo ch'è morta....

[84] A great portion of bodies that have been alive will pass into the bodies of other animals; which is as much as to say, that the deserted tenements will pass piecemeal into the inhabited ones, furnishing them with good things, and carrying with them their evils. That is to say the life of man is formed from things eaten, and these carry with them that part of man which dies . . .

C. A. 143*b*; 426*b*] **1294.**

⟦Delli ufitj funerali ²e processioni e lumi ³e cäpane e cōpagnia.⟧

⟦Of Funeral Rites, and Processions, and Lights, and Bells, and Followers.⟧

⁴Agli omini saran fatti grandissimi ⁵onori e ponpe sanza lor saputa.

The greatest honours will be paid to men, and much pomp, without their knowledge.

"martiri" esspēder. 56. dormā nellasse. 57. māgierano. 60. para. 61. parā . . fugi. 62. penvra . . fiame . . disscē. 63. dano. 64. ilinguaggo. 66. parte. 68. sprēdori . . delle vmane. 69. tasi chondotto. 71. ecqueli cōtecho . . liguagio vmano [cha]. 72. chadere. 73. tataconpa. 74. gierano e miscerate chollor rapidŏ corso. 75. ||||| sera car |||||||||||||||||| madressore. 76. |||||||||||||||||| erai cholli a. 77. ||||||||||| ādis. 78. ||||||||||||||||||| anime. 79. |||||||||||||||||||||||||||| le penne. 80. crisstiani. 81. chettengo. 82. essol. 86. coe. 87. pezi . . chase. 88. acquella vntile. 89. cōsecho . . danni queste. 90. coe . . delle. 91. māgate [e] le . . chon se. 92. cho. 93. |||||||||||||||||||||||||||||| te cō ponitu. 94. |||||||||||||||||| elle māgano. 95. |||||||||||||||||||||| morte rifara. 96. ||||||||||||||||||| ma nōne. 97. |||||||||||||||||| [case].

1294. 2. ellumi. 4. sara.

84 and following; compare No. 846.

1294. A facsimile of this text is on Pl. CXVI below on the right, but the writing is larger than the other notes on the same sheet and of a somewhat different style. The ink is also of a different hue, as may be seen on the original sheet at Milan.

C. A. 362 a; 1143 a] 1295.

❲Dell auaro.❳

[2]Molti fieno quelli che con ogni studio e sollecitudine seguiranno [3]con furia quella cosa che senpre li à spauētati, nō conosciendo la sua [4]malignità.

❲Delli omini che, quāto piv inuechiano, piv [6]si fanno avari, chè auēdosi a star poco dovrebbero farsi liberali.❳

[7]Vedansi a quelli, che son giudicati di piv speriētia e giuditio, quanto [8]egli' ànno mē bisognio delle cose, cō piv auidità cercarle e riseruarle.

❲Della fossa.❳

[11]Starā molti occupati in esercitio a leuare di quella cosa che tanto crescierà, quan[12]to se ne leuò.

❲Del peso posto sul piumaccio.❳

[14]E a molti corpi nel vedere da lor leuar la testa, si uedrà manifesta[15]mente cresciere, e rendendo loro la leuata testa · immediatamente [16]diminviscono la grādezza.

❲Del pigliare de' pidocchi.❳

[18]E saran molti cacciatori d'animali che, quanto piv ne piglierāno [19]māco n'avranno, e così de conuerso piv n'avrā, quāto men ne piglie[20]ranno.

❲Dello tignere l'acqua colle 2 sechie a vna sola corda.❳

[22]E rimaranno occupati molti che quāto piv [23]tirerāno in giù la cosa, essa piv se ne fugirà in contrario [24]modo.

❲Le lingue de' porci e vitelli nelle budelle.❳

[28]O cosa spurca, che si vedrà l'uno animale aver la lingua [29]in culo all'altro.

❲De' crivelli fatti di pelle d'animali.❳

[31]Vedrassi il cibo degli animali passar dentro alle [32]lor pelli per ogni parte salvo che per la bocca, e penetra[33]re dall'opposita parte insino alla piana terra.

❲Of the Avaricious.❳

There will be many who will eagerly and with great care and solicitude follow up a thing, which, if they only knew its malignity, would always terrify them.

❲Of those men, who, the older they grow, the more avaricious they become, whereas, having but little time to stay, they should become more liberal.❳

We see those who are regarded as being most experienced and judicious, when they least need a thing, seek and cherish it with most avidity.

❲Of the Ditch.❳

Many will be busied in taking away from a thing, which will grow in proportion as it is diminished.

❲Of a Weight placed on a Feather-pillow.❳

And it will be seen in many bodies that by raising the head they swell visibly; and by laying the raised head down again, their size will immediately be diminished.

❲Of catching Lice.❳

And many will be hunters of animals, which, the fewer there are the more will be taken; and conversely, the more there are, the fewer will be taken.

❲Of Drawing Water in two Buckets with a single Rope.❳

And many will be busily occupied, though the more of the thing they draw up, the more will escape at the other end.

❲Of the Tongues of Pigs and Calves in Sausage-skins.❳

Oh! how foul a thing, that we should see the tongue of one animal in the guts of another.

❲Of Sieves made of the Hair of Animals.❳

We shall see the food of animals pass through their skin everyway excepting through their mouths, and penetrate from the outside downwards to the ground.

1295. 2. fien"o" . . essollecitudine seguirano. 3. chessenpre. 6. fano asstar . . doberebō. 7. vedanssi acquelli chesson gudichati . . guditio. 9. della fossa ¶ della informa di frenesia o farnetico. 10. dinsania di ceruello. ¶ 11. molti "ochupati" in . . alleua"r" di . . chosa cresscier. 12. ta se ne leuo [ecquāto piv se ne pone piv gressere diminissce]. 13. piumacco. 14. moti corpi . . dallor . . manit ||||||||. 15. cresscière . . imediate. 16. diminvissean. 17. pidochi. 18. essaran. 19. naranno . . narā. 21. dellottignier lacq"a". 22. ochupati . . piv [tirerano]. 23. trireroña in gu. 25. la salsiccia che mu nelle budelle. 26. molti si farā casa "e abiterano nelle" delle propie. 27. linguie de porci "e vitelli" nelle. 28. spurcha. 32. bocha. 33. oposita. 34. feroce . . possenti . . difendera. 38. voltatili. 40. zocholi. 41. chelli. 45. delli "grandi"

⟦Delle lanterne.⟧

³⁵Le feroci corna de' possenti tori difenderan³⁶no la luce notturna dall'inpetuoso furor di uēti.

⟦Delle piume ne' letti.⟧

³⁸Li animali volatili sosterrā l'omini colle lor propie ³⁹penne.

⟦Li animali che uā sopra li alberi, ādando in zoccoli.⟧

⁴¹Sarā si grāde i fanghi che li omini andranno sopra l'al⁴²beri de' lor paesi.

⟦Delle sola delle scarpe che son di bue.⟧

⁴⁴E si uedrà in gran parte del paese caminare sopra le pelli ⁴⁵delli grandi animali.

⟦Del nauicare.⟧

⁴⁷Saranno gran venti, per li quali le cose oriētali si faranno occiden⁴⁸tali, e quelli di mezzodì in grā parte miste col corso de' uē⁴⁹ti seguirānolo per lunghi paesi.

⟦Delle pitture ne' santi adorati.⟧

⁵¹Parleranno li omini alli omini che non sentiranno; avrā gli occhi ⁵²aperti e nō uedranno; parleranno a quelli e nō fia loro risposta; ⁵³chiederà gratie a chi avrà orecchi e non ode; farā lume a chi ⁵⁴è orbo.

⟦De' segatori.⟧

⁵⁹Saranno molti che si moverā l'uno ⁶⁰contra dell'altro, tenendo in mano il tagliente ferro; Questi nō si ⁶¹faranno infra loro altro nocimēto che di stāchezza, perchè quā⁶²to l'uno si caccierà inanti, tanto l'altro si ritirerà indirieto; ⁶³ma tristo che s'inframetterà in mezzo, perchè al fine rimarrà ta⁶⁴gliato in pezzi.

⟦Il filatoio da seta.⟧

⁶⁶Sentirassi le dolenti grida, le alte strida, ⁶⁷le rauce e infoccate vocie di quei che fieno con tormento spogliati e al fine ⁶⁸lasciati ignudi e sanza moto; e questo fia per cavsa del motore che tutto volge.

⟦Of Lanterns.⟧

[35]The cruel horns of powerful bulls will screen the lights of night against the wild fury of the winds.

⟦Of Feather-beds.⟧

Flying creatures will give their very feathers to support men.

⟦Of Animals which walk on Trees—wearing wooden Shoes.⟧

The mire will be so great that men will walk on the trees of their country.

⟦Of the Soles of Shoes, which are made from the Ox.⟧

And in many parts of the country men will be seen walking on the skins of large beasts.

⟦Of Sailing in Ships.⟧

There will be great winds by reason of which things of the East will become things of the West; and those of the South, being involved in the course of the winds, will follow them to distant lands.

⟦Of Worshipping the Pictures of Saints.⟧

Men will speak to men who hear not; having their eyes open, they will not see; they will speak to these, and they will not be answered. They will implore favours of those who have ears and hear not; they will make light for the blind.

⟦Of Sawyers.⟧

There will be many men who will move one against another, holding in their hands a cutting tool. But these will not do each other any injury beyond tiring each other; for, when one pushes forward the other will draw back. But woe to him who comes between them! For he will end by being cut in pieces.

⟦Silk-spinning.⟧

Dismal cries will be heard loud, shrieking with anguish, and the hoarse and smothered tones of those who will be despoiled, and at last left naked and motionless; and this by reason of the mover, which makes everything turn round.

❨Del mettere e trarre il pan dalla bocca del forno.❩

70 Per tutte le città e terre e castelli e case si uedrà, per desiderio di māgiare, trarre il 71 propio cibo di bocca l'uno all' altro sanza poter fare difesa alcuna.

❨Le terre lauorate.❩

73 Vedrassi voltare la terra sotto sopra e risguardare l'opositi 74 emisperii e scoprire le spelonche a ferocissimi animali.

❨Del seminare.❩

76 Allora in grā parte delli omini, che resterā uiui, gitterā 77 fori delle lor case le serbate vettovaglie in libera preda delli 78 vcelli e animali terrestri sanza curarsi d'essi in parte alcuna.

❨Delle pioggie che fanno che fiumi intorbidati 80 portan via le terre.❩

81 Verrà diuerso il cielo chi trasmuterà gran parte dell' Africa 82 che si mostra a esso cielo inverso l'Europa, e quella di Euro 83 pa inverso l'Africa·, e quelle delle provincie Scitiche si mischieranno in 84 sieme con grā revolutione.

❨De legniami che bruciano.❩

87 Li alberi e arbusti delle grā selue si convertiranno in cenere.

❨Delle fornaci di mattoni e calcina.❩

89 Al fine la terra si farà rossa per lo infocamēto di molti giorni, 90 e le pietre si convertiranno in cenere.

❨I pesci lessi.❩

92 Li animali d'acqua moriranno nelle bollenti acque.

❨L'uliue che cadono dagli uliui dannoci l'olio che fa lume.❩

94 Discenderà con furia diuerso la terra, chi ci darà notrimēto e luce.

❨Of putting Bread into the Mouth of the Oven and taking it out again.❩

In every city, land, castle and house, men shall be seen, who for want of food will take it out of the mouths of others, who will not be able to resist in any way.

❨Of tilled Land.❩

The Earth will be seen turned up side down and facing the opposite hemispheres, uncovering the lurking holes of the fiercest animals.

❨Of Sowing Seed.❩

Then many of the men who will remain alive, will throw the victuals they have preserved out of their houses, a free prey to the birds and beasts of the earth, without taking any care of them at all.

❨Of the Rains, which, by making the Rivers muddy, wash away the Land.❩

[81] Something will fall from the sky which will transport a large part of Africa which lies under that sky towards Europe, and that of Europe towards Africa, and that of the Scythian countries will meet with tremendous revolutions [84].

❨Of Wood that burns.❩

The trees and shrubs in the great forests will be converted into cinder.

❨Of Kilns for Bricks and Lime.❩

Finally the earth will turn red from a conflagration of many days and the stones will be turned to cinders.

❨Of boiled Fish.❩

The natives of the waters will die in the boiling flood.

❨Of the Olives which fall from the Olive trees, shedding oil which makes light.❩

And things will fall with great force from above, which will give us nourishment and light.

.. cheffieno | "con tormento" ispogliati. 68. lassciati ingnudi | "e sanza moto" ecquesto .. chausa .. chettutto. 69. ettrarre .. della bocha. 70. etterre e chastelle e chase "per desiderio di māgiare" trarre. 71. [cibo] propio .. bocha "luno all altro" sanza .. alchuna. 73. rissguardare. 74. esschoprire .. spilonche. 76. allor [li omini] in. 77. chase. 78. terresti .. churarsi. 79. piove chenfanche. 81. africha. 82. chessi mosstra a .. ecquella di curo. 83. lafricha . ecquelle .. simichieranno. 84. chon .. revolutione [al fine si fermeranno e mvterano natura di novi frutti]. *Lines 86—88 come in the original after lines 89 and 90, but Leonardo directs us to invert the order by writing 2ᵃ at the beginning of the former passage and 1ᵃ at the head of the latter one.* 86. bruca no. 87. albusti .. cᴜnvertirano. 89. gorni. 90. elle .. convertiranno [in polvere] "in cenere". 91. epessci. 92. morirano .. acq"e". 93. che chagiō deli uliui chadioci lolio. 94. diuerso il celo chicci .. elluce. 95. guficōchessuecella alla parra. 96. tessta essaltera .. li ochin. 97. tessta .. danimali [vssciti delle]

81—84. Compare No. 945.

⟦Delle ciuette e gufi; ciò che succhiella alla parra.⟧

⁹⁶Molti periranno · di fracassamento di testa e salteranno loro li ochi in grā par-⁹⁷te della testa · per causa · d'animali pavrosi vsciti dalle tenebre.

⟦Del lino che fa la cura de' giēti.⟧

⁹⁹Sarā reveriti e onorati e cō reuerētia e amore ascoltati, li sua precetti ¹⁰⁰di chi prima fusse legato, stratiato o martorizato da molte e diuerse battitoje.

⟦De' libri che insegnano precetti.⟧

¹⁰²I corpi sanz'anima ci daranno con lor sententie precietti vtili al ben morire.

⟦De' battuti e scoreggiati.⟧

¹⁰⁴Li omini si nasconderanno · sotto le scorze delle scorticate erbe, e quiui gri-¹⁰⁵dando si darā martiri con battimēti di menbra a se medesimi.

⟦Delle maniche de' coltegli fatte di corna ¹¹¹di castrone.⟧

¹¹²Nelle corna delli animali si vedranno tagliēti ¹¹³ferri colli quali si torna la uita a molti della loro ¹¹⁴spetie.

⟦Della notte che nō si conosce ¹¹⁶alcun colore.⟧

¹¹⁷Verrà a tanto che non si conoscierà diferenza infra ¹¹⁸colori, anzi si faran tutti di nera qualità.

⟦Delle spade e lance che per se ¹²⁰mai nuocono a nessuno.⟧

¹²¹Chi per se è māsueto e sanza alcuna offensione, si farà ¹²²spauentevole e feroce mediante le triste cōpa¹²³gnie, e torrà la vita crudelissimamēte ¹²⁴a molte genti; e piv n'ucciderebbe, se corpi sā¹²⁵z'anima e usciti dalle spelonche non li difendessino, ¹²⁶cioè le corazze di ferro.

⟦De' lacciuoli e trappole.⟧

¹²⁸Molti morti si moverā con furia e piglierāno e legheranno ¹²⁹i vivi, e serviranno gli a lor nemici circa ¹³⁰la lor morte e distrutione.

⟦Of Owls and screech owls and what will happen to certain birds.⟧

Many will perish of dashing their heads in pieces, and the eyes of many will jump out of their heads by reason of fearful creatures come out of the darkness.

⟦Of flax which works the cure of men.⟧

That which was at first bound, cast out and rent by many and various beaters will be respected and honoured, and its precepts will be listened to with reverence and love.

⟦Of Books which teach Precepts.⟧

Bodies without souls will, by their contents give us precepts by which to die well.

⟦Of Flagellants.⟧

Men will hide themselves under the bark of trees, and, screaming, they will make themselves martyrs, by striking their own limbs.

⟦Of the Handles of Knives made of the Horns of Sheep.⟧

We shall see the horns of certain beasts fitted to iron tools, which will take the lives of many of their kind.

⟦Of Night when no Colour can be discerned.⟧

There will come a time when no difference can be discerned between colours, on the contrary, everything will be black alike.

⟦Of Swords and Spears which by themselves never hurt any one.⟧

One who by himself is mild enough and void of all offence will become terrible and fierce by being in bad company, and will most cruelly take the life of many men, and would kill many more if they were not hindered by bodies having no soul, that have come out of caverns-that is, breastplates of iron.

⟦Of Snares and Traps.⟧

Many dead things will move furiously, and will take and bind the living, and will ensnare them for the enemies who seek their death and destruction.

pavrosi vssciti delle. 98. cheffa . . de cēti. 99. reverita e onorata . . asscoltata 100. . . . diuerse battitare. 101. chensegnā. 103. scoregiati. 104. lessconze delle isscorticate. 105. asse. 106. della lusuria. 107. essinfurieranno dellecose piu belle "a cercare" possedere e operare le parte lor piv brutte. 108. doue poi con danno e penitentia ritornati nellorsentimento arā grāde amira. 109. tiō di se stessi. 111. chastrone. 112. uedra. 113. feri cholli. 115. cognosscie. 117. vera attanto . cognossciera. 119. ellance. 120. nocano añessuno. 121. perse | "he suā sueto" e . . alchuna. 122. si fara spauentevole "e feroce" mediante le trisste. 123. ettorra. 124. nuceiderebe. 125. vssciti delle splilonche noli. 126. coe le corazze. 127. lacioli. 128. chon furia "e piglierāno" e legerano. 129. e vivi esserberā . . circha. 132. vsscira delle . . ettenebrose.

❡ De' metalli. ❡

[132] Uscirà dalle oscure e tenebrose [133] spelonche · che metterà tutta l'umana spe[134]tie in grandi affanni, pericoli e mor- [135] te ·; a molti segua[136] ci lor, dopo molti affanni, darà [137] diletto; ma chi nō fia suo partigiano morrà [138] con stento e calamità; questo commette[139] rà infiniti tradimēti, questo avmēte[140] rà e persuaderà li omini tristi alli assassinamēti [141] e latrocini · e le perfidie ·; questa darà [142] sospetto · a i sua partigiani ·; questo torrà [143] lo stato alle città libere; questo torrà [144] la uita a molti; questo travaglierà [145] li omini infra loro con molte arti, [146] inganni e tradimēti; o animal mo[147]struoso! quāto sarebbe meglio agli omini [148] che tutti tornassero nell'inferno! per costui [149] rimarrā diserte le grā selue delle lor [150] piāte; per costui infiniti animali perderanno la ui[151]ta.

❡ Del fuoco. ❡

[153] Nascierà di piccolo principio, [154] chi si farà cō prestezza grande; que[155]sto non stimerà alcuna creata [156] cosa, anzi colla sua potētia [157] quasi il tutto avrà in potentia [158] di transformare di suo essere [159] in vn altro.

❡ De' navili che annegano. ❡

[161] Vedrannosi grandissimi [162] corpi sanza vita por[163]tare con furia moltitu[164]dine d'omini alla distrutti[165]one di lor uita.

❡ De' boi che si māgiano. ❡

[167] Māgieranno i padrō delle posses- [168] sioni i lor propi lauoratori.

❡ De' battere il letto per rifarlo. ❡

[170] Veranno li omini in tanta ingratitudine, [171] che, chi darà loro albergo sanza alcū prezzo, [172] sarà carico di bastonate, in modo che [173] gran parte delle interiora si spignerā[174]no dal loco loro e s'andranno rivoltando pel [175] suo corpo.

❡ Delle cose che si māgiano [177] che prima s'uccidono. ❡

[178] Sarà morto da loro il loro nutritore e flag[179]giellato cō spietata morte.

❡ Of Metals. ❡

That shall be brought forth out of dark and obscure caves, which will put the whole human race in great anxiety, peril and death. To many that seek them, after many sorrows they will give delight, and to those who are not in their company, death with want and misfortune. This will lead to the commission of endless crimes; this will increase and persuade bad men to assassinations, robberies and treachery, and by reason of it each will be suspicious of his partner. This will deprive free cities of their happy condition; this will take away the lives of many; this will make men torment each other with many artifices deceptions and treasons. O monstrous creature! How much better would it be for men that every thing should return to Hell! For this the vast forests will be devastated of their trees; for this endless animals will lose their lives.

❡ Of Fire. ❡

One shall be born from small beginnings which will rapidly become vast. This will respect no created thing, rather will it, by its power, transform almost every thing from its own nature into another.

❡ Of Ships which sink. ❡

Huge bodies will be seen, devoid of life, carrying, in fierce haste, a multitude of men to the destruction of their lives.

❡ Of Oxen, which are eaten. ❡

The masters of estates will eat their own labourers.

❡ Of beating Beds to renew them. ❡

Men will be seen so deeply ungrateful that they will turn upon that which has harboured them, for nothing at all; they will so load it with blows that a great part of its inside will come out of its place, and will be turned over and over in its body.

❡ Of Things which are eaten and which first are killed. ❡

Those who nourish them will be killed by them and afflicted by merciless deaths.

134. pericholi. 135. molti [al sin darano piacere] sequa. 136. ci lor [darā diletto] dopo. 137. partigano. 138. chonisstento e chalamita . . comette. 139. infinita. 140. omini "tristi" alli. 14. elle peruita questa terra in. 142. partigani. 145. lor comolte [f] balde ingan. 146. ingani. 147. sare meglioli. 148. chettutti tornassi . . cosstui. 149. rimarā. 150. perda laui. 152. fuocho. 153. nassciera di pichole. 154. presteza. 155. isstimera. 156. sua potē. 157. tutto fara in. 160. navili canegano. 161. vedrassi. 162. chorpi. 166. chessimāgano. 167. e padrō . . posse. 168. e lor. 171. che che . . prezo. 172. charicho di basstonate. 173. spigerā. 174. del locho. 175. essandrano. 175. chorpo. 176. chose chessi. 177. succidano. 178. sarmorto dalloro . . effra. 179. disspietata. 182. vederassi. 187. chol suo e alticōciascūo. 188. vedrassi. 189. trans [mutarsi] "correre" ora.

❡ Dello spechiare le mura [181] delle città nel-
l'acqua de' lor fossi. ❩

[182] Vedrannosi l'alte mvra delle grā città
sotto sopra ne' lo [183] ro fossi.

❡ Dell'acqua che corre torbida [185] e mista
cō terra, e della polue [186] re e nebbia mista
coll'aria, e del [187] foco misto col suo e altri
cō ciascūo. ❩

[188] Vedrassi tutti li elementi insieme
misti con grā re [189] volutione trascorrere ora
inverso il centro del mō [190] do, ora inverso
il celo, e quādo dalle parti meri [191] dionali
scorrere cō furia inverso il fred [192] do set-
tentrione, qualche volta dall'oriēte inverso
[193] l'occidente, e così di questo in quell'al-
tro emisperio.

❡ In ogni punto si può fare diuisio [195] ne de'
2 emisperi. ❩

[196] Li omini tutti scābieranno emisperio
immediate.

❡ In ogni pūto è diuisione da o [198] riente a
occidente. ❩

[199] Moverannosi tutti li animali da oriēte
a occidente, e così [200] da aquilone a meriggio
scanbievolmēte, e così de' cōuerso.

❡ Del moto dell'acque che portano [202] i
legniami che son morti. ❩

[203] Corpi sanz'anima · per se medesimi
si moveranno e porterā [204] cō seco innume-
rabile generatione di morti, toglien [205] do le
richezze a circūstanti viuēti.

❡ Dell'oua che sendo māgiate nō possono
[207] fare e pulcini. ❩

[208] O quanti fiē quegli, ai quali sarà pro-
ibito il nascere!

❡ De' pesci che si māgiano non nati. ❩

[210] Infinita gieneratione si perderà per
la morte delle grauide.

❡ Del piāto fatto il venerdì santo. ❩

[220] In tutte le parti d'Europa sarà piāto
da grā popoli per la morte d'ū [221] solo omo
morto in oriēte.

❡ Of the Reflection of Walls of Cities in the
Water of their Ditches. ❩

The high walls of great cities will be
seen up side down in their ditches.

❡ Of Water, which flows turbid and mixed
with Soil and Dust; and of Mist, which is
mixed with the Air; and of Fire which is
mixed with its own, and each with each. ❩

All the elements will be seen mixed to-
gether in a great whirling mass, now borne
towards the centre of the world, now to-
wards the sky; and now furiously rushing
from the South towards the frozen North,
and sometimes from the East towards the
West, and then again from this hemisphere
to the other.

❡ The World may be divided into two Hemi-
spheres at any Point. ❩

All men will suddenly be transferred into
opposite hemispheres.

❡ The division of the East from the West
may be made at any point. ❩

All living creatures will be moved from
the East to the West; and in the same way
from North to South, and vice versa.

❡ Of the Motion of Water which carries
wood, which is dead. ❩

Bodies devoid of life will move by them-
selves and carry with them endless genera-
tions of the dead, taking the wealth from
the bystanders.

❡ Of Eggs which being eaten cannot form
Chickens. ❩

Oh! how many will they be that never
come to the birth!

❡ Of Fishes which are eaten unborn. ❩

Endless generations will be lost by the
death of the pregnant.

❡ Of the Lamentation on Good Friday. ❩

Throughout Europe there will be a lamen-
tation of great nations over the death of
one man who died in the East.

190 delle parte. 191. scorēra . . il fre. 192. to settantrione acua. 193. emissperio. 194. po. 196. inmediate. 199. mo-
veròsi. 200. meridio. 201. acqua. 202. e legniami chesson. 204. invmerabile . . morti [dondo et] toglē. 206. chessendo
māgiata . . possā. 207. e pulcini. 208. nassciere. 209. pessci chessi māgano onato. 211. delli animali che si castrano. 212. a
gran parte della spetie masachina pell esser tolti loro e tes 213. tichuli fia proibito el generare. 214. delle bestie chef-
fano il caco. 215. illate fia tolto ai pichioli figlioli. 216. delle som mate fatte delle croie. 217. a grā parte delle femine
letine fia tolto ettagliato lor le retto. 218. insieme cholla irta [ello avendo ipicholi figloletti in corpo]. 219. venerdi scō.
220. popoli la. 221. homo. 224. chō. 226. chessi chollomo. 227. vedrassi . . effigure. 228. chesse guiranno. 229. dun-

⟦Del sogniare.⟧

²²³Andranno li omini e nō si moveranno, ²²⁴parleranno cō chi nō si trova, senti²²⁵rāo chi nō parla.

⟦Dell' onbra che si move coll' uomo.⟧

²²⁷Vedrannosi forme e figure d' uomini ²²⁸e d' animali, che seguiranno essi ani²²⁹mali e omini dovunque fugiranno; ²³⁰e tal fia il moto di lui qual è del²³¹l' altro, ma parrà cosa mirabile delle ²³²varie grandezze in che essi si tras²³³mutano.

⟦¶Dell' ombra del sole e dello spechiarsi ²³⁵nell' acqua in un medesimo tēpo.¶⟧

²³⁶Vedrassi molte volte l' uno uomo ²³⁷diuentare 3, e tutti lo seguo²³⁸no, e spesso l' uno, il piv certo, l' abandona.

⟦Delle casse che riseruano ²⁴⁰molti tesori.⟧

²⁴¹Troverrassi dentro a de' noci e deli alberi ²⁴²e altre piante tesori grādissimi, i quali ²⁴³lì stanno occulti e ben guardati.

⟦Dello spegnere el lume a chi ²⁴⁵va al letto.⟧

²⁴⁶Molti per mandare fori il fiato ²⁴⁷con troppa prestezza perderanno il ue²⁴⁸dere e in brieue tutti i sentimēti.

⟦Delle canpanelle de' muli ²⁵⁰che stanno presso ai loro orechi.⟧

²⁵¹Sentirassi in molte parti dell' Europa · stru²⁵²mēti di uarie magnitudini far diuerse ²⁵³armonie con grandissime fatiche di chi ²⁵⁴piv presso l' ode.

⟦Delli asini.⟧

²⁵⁶Le molte fatiche saran remvnerate di ²⁵⁷fame, di sete, di disagio, e di mazzate, e di pū²⁵⁸ture, e bestemie, e grā uillanie.

⟦De' soldati a cauallo.⟧

²⁶⁰Molti sarā veduti portati da grādi ani²⁶¹mali con veloce corso alla ruina della sua ²⁶²vita e prestissima morte.
²⁶³Per l' aria e per la terra saranno veduti ani²⁶⁴mali di diuersi colori portarne cō fu²⁶⁵rore li omini alla destrutione di lor vita.

⟦Delle stelle delli sproni.⟧

²⁶⁷Per causa delle stelle · si uedranno li omini ²⁶⁸esser velocissimi al pari di qualūche ²⁶⁹animal ueloce.

⟦Of Dreaming.⟧

Men will walk and not stir, they will talk to those who are not present, and hear those who do not speak.

⟦Of a Man's Shadow which moves with him.⟧

Shapes and figures of men and animals will be seen following these animals and men wherever they flee. And exactly as the one moves the other moves; but what seems so wonderful is the variety of height they assume.

⟦Of our Shadow cast by the Sun, and our Reflection in the Water at one and the same time.⟧

Many a time will one man be seen as three and all three move together, and often the most real one quits him.

⟦Of wooden Chests which contain great Treasures.⟧

Within walnuts and trees and other plants vast treasures will be found, which lie hidden there and well guarded.

⟦Of pùtting out the Light when going to Bed.⟧

Many persons puffing out a breath with too much haste, will thereby lose their sight, and soon after all consciousness.

⟦Of the Bells of Mules, which are close to their Ears.⟧

In many parts of Europe instruments of various sizes will be heard making divers harmonies, with great labour to those who hear them most closely.

⟦Of Asses.⟧

The severest labour will be repaid with hunger and thirst, and discomfort, and blows, and goadings, and curses, and great abuse.

⟦Of Soldiers on horseback.⟧

Many men will be seen carried by large animals, swift of pace, to the loss of their lives and immediate death.
In the air and on earth animals will be seen of divers colours furiously carrying men to the destruction of their lives.

⟦Of the Stars of Spurs.⟧

By the aid of the stars men will be seen who will be as swift as any swift animal.

che. 230. ettal . . dellui quate del. 231. para. 232. grandeze trans. 234. delleobr. 235. nvn. 237. ettutti. 238. esspesso luno piu. 243. ochulti . . guarda. 245. valletto. 246. molti [per soi] per. 247. prèsteza. 248. tutti e sentimēti. 250. chesta . . aloro. 251. sentirasi. 252. magnitudine. 257. disago. 258. besstemie. 259. acchauallo. 260. portare. 263. sara. 265. disstrutione. 267. chausa . . uedra. 272. piāto cō. 273. dellessca. 274. chon. 275. ra visibile.

[Il bastone ch'è morto.]

[271]Il movimēto de' morti farà fugire [272]cō dolore e piāto e cō grida molti viui.

[Dell' esca.]

[274]Cō pietra e con ferro si rende[275]ranno visibili le cose che prima nō [276]si vedeano.

[Of a Stick, which is dead.]

The motions of a dead thing will make many living ones flee with pain and lamentation and cries.

[Of Tinder.]

With a stone and with iron things will be made visible which before were not seen.

C. A. 362 *b*; 1134 *b*]

1296.

[Del navicare.]

[2]Vedrassi li alberi delle grā selue di Tavrus, [3]e di Sinai, Apenino, e Atlante scorrere per l'aria [4]da oriēte a occidēte, da aquilone a meridi[5]e, e porteranno per l'aria grā moltitudine [6]d'omini; o quāti voti! o quāti mòr[7]ti! o quanta seperatiō d'amici e di parēti! o quā[8]ti fiē quelli che nō rivedranno piv̀ le lor pro[9]vincie nè le lor patrie, e che moriranno sanza se[10]poltura colle lor ossa sparse in diuersi [11]siti del mōdo!

[Dello sgomberare l'ogni santi.]

[13]Molti · abandoneranno le propie abitationi, e por[14]terā cō seco tutti e sua valsenti, e andran[15]no abitare in altri paesi.

[Del dì de' morti.]

[17]E quāti fiē quelli che piāgeranno i lor [18]antichi morti portādo lumi a quelli.

[De' frati che spēdendo parole; [20]riceuono di grā ricchezze e danno [21]il paradiso.]

[24]¶Le invisibili monete farā triōfare molti spē[25]ditori di quelle.¶

[Degli archi fatti [27]colli corni de' boi.]

[28]Molti fiē quelli che per causa delle bouine cor[29]na moriranno di dolente morte.

[Dello scriver lettere da \n [31]pàese a vn altro.]

[32]Parleransi li uomini di remotissimi paesi l'uno all'altro e rispōderāsi.

[Degli emisperi che sono infiniti [34]e da infinite linie son diuisi, in mo[35]do che senpre ciascuno uomo n'à [36]vna d'esse linie infra l'ū de' piedi e l'altro.]

[37]Parleransi e coccheransi e abbraccieransi li omini stanti da l'uno al'[38]altro emisperio, e tenderansi i loro linguaggi.

[Of going in Ships.]

We shall see the trees of the great forests of Taurus and of Sinai and of the Appenines and others, rush by means of the air, from East to West and from North to South; and carry, by means of the air, great multitudes of men. Oh! how many vows! Oh! how many deaths! Oh! how many partings of friends and relations! Oh! how many will those be who will never again see their own country nor their native land, and who will die unburied, with their bones strewn in various parts of the world!

[Of moving on All Saints' Day.]

Many will forsake their own dwellings and carry with them all their belongings and will go to live in other parts.

[Of All Souls' Day.]

How many will they be who will bewail their deceased forefathers, carrying lights to them.

[Of Friars, who spending nothing but words, receive great gifts and bestow Paradise.]

Invisible money will procure the triumph of many who will spend it.

[Of Bows made of the Horns of Oxen.]

Many will there be who will die a painful death by means of the horns of cattle.

[Of writing Letters from one Country to another.]

Men will speak with each other from the most remote countries, and reply.

[Of Hemispheres, which are infinite; and which are divided by an infinite number of Lines, so that every Man always has one of these Lines between his Feet.]

Men standing in opposite hemispheres will converse and deride each other and embrace each other, and understand each other's language.

⟦De' preti che dicono messe.⟧

⁴⁰Molti fien quelli che per esercitare la lor arte si uestirā richissi⁴¹mamente e questo parrà esser fatto secōdo l'uso de grēbiali.

⟦De' frati confessori.⟧

⁴³Le suēturate donne di propia volontà ⁴⁴andranno a palesare agli omini ⁴⁵tutti le loro lussurie e opere ⁴⁶vergognose e segretissime.

⟦Delle chiese e abitatiō de' frati.⟧

⁵³Assai saranno che lascieranno ⁵⁴li eserciti e le fatiche ⁵⁵e povertà di uita e di roba, e andranno abitare nelle ⁵⁶richezze e triōfanti edifiti mostrando questo esser ⁵⁷il mezo di farsi amico a Dio.

⟦Del uendere il paradiso.⟧

⁶¹Infinita moltitudine venderanno publicamente e pacificamēte ⁶²cose di grandissimo prezzo sanza licenza del padrone di quelle, ⁶³e che mai nō furō loro nè in lor potestà, e a questo nō prove⁶⁴drà la giustitia vmana.

⟦De' morti che si uanno a sotterrare.⟧

⁶⁶I senplici popoli porterā gran quantità di lumi per far lumi ⁶⁷ne' viaggi a tutti quelli che integralmente ànno perso la uirtù ⁶⁸visiua.

⟦Delle doti delle fanciulle.⟧

⁷¹E doue prima la gioventù feminina nō si potea difendere dal⁷²la lussuria e rapina de' maschi, nè per guardie di parenti nè fortezze di mvra, ⁷³verrà tenpo che bisognierà che padri e parēti d'esse fanciulle ⁷⁴le paghino di grā prezzi chi voglia dormire con loro, ancorachè es⁷⁵se sien ricche, nobili, e bellissime; certo è, par qui che la ⁷⁶natura voglia spegniere la umana spetie come cosa invtile al mondo, ⁷⁷e guastatrice di tutte le cose create.

⟦Della crudeltà dell'omo.⟧

⁷⁹Vedrannosi animali sopra della terra, i quali senpre conbatteranno infra ⁸⁰loro e

⟦Of Priests who say Mass.⟧

There will be many men who, when they go to their labour will put on the richest clothes, and these will be made after the fashion of aprons [petticoats].

⟦Of Friars who are Confessors.⟧

And unhappy women will, of their own free will, reveal to men all their sins and shameful and most secret deeds.

⟦Of Churches and the Habitations of Friars.⟧

Many will there be who will give up work and labour and poverty of life and goods, and will go to live among wealth in splendid buildings, declaring that this is the way to make themselves acceptable to God.

⟦Of Selling Paradise.⟧

An infinite number of men will sell publicly and unhindered things of the very highest price, without leave from the Master of it; while it never was theirs nor in their power; and human justice will not prevent it.

⟦Of the Dead which are carried to be buried.⟧

The simple folks will carry vast quantities of lights to light up the road for those who have entirely lost the power of sight.

⟦Of Dowries for Maidens.⟧

And whereas, at first, maidens could not be protected against the violence of Men, neither by the watchfulness of parents nor by strong walls, the time will come when the fathers and parents of those girls will pay a large price to a man who wants to marry them, even if they are rich, noble and most handsome. Certainly this seems as though nature wished to eradicate the human race as being useless to the world, and as spoiling all created things.

⟦Of the Cruelty of Man.⟧

Animals will be seen on the earth who will always be fighting against each other

39. dicā. 41. ecquesto . . grēbivli. 42. chonfessore. *Lines* 43—46 *are written on the margin parallel to lines* 47—51. 44. andrano [a dire] "palesare" ali omini [dalor. 47. [assai fien quelli che vorranno sapere co che ffannole le femmi. 48. ne nelle lor lussurie chon se e cogli altri omini elle messcine. 19. cōverra che palesino tutte le loro ochulte opere vergognose. 40. e premiare li asscoltatori di lor miserie e [infamie sce]. 51. [Ierate infamie]. 53. sarano [chea] lasscieranno "le" [la lor povera vital]. 54. elle. 56. ettriō fanti . . mosstrando quessto. 57. il mezo [di seruire] di farsi addio [effarsi allui benivolo]. 59. [infinita moltitudine venderanno publichamēte "chosa di grādissima valuta" quel che. 60. mai nō fu loro ne i lor podesta eancho]. 61. publica e pacifichamēte. 62. chose . . prezo. 63. illor . . acquesto. 64. dera. 65. chessiuanno assotterrare. 67. quelli cintera "gralm" mēte an. 68. visiua o ometti ne sciocheza o viue pazzo questedue. 69. piteti onno nel prīcipio della prepositione. 70. fanculle. 72. lla . . massci . . guardie | "di parenti" ne. 73. vera . . fanculle. 74. paghi . . plezzi . . colloro. 75. sien [belli] riche . . chella. 77. guasstatrice . . chose. 79. vedrassi. 80. chon

con danni grandissimi e spesso morte di ciascuna delle [81] parti; questi non avrà termine nelle lor malignità; per le fiere mē-[82]bra di questi uerranno a terra grā parte delli alberi delle gran selue dell'u[83]niverso, e poi ch'essi avranno pasciuto, il nutri-mēto de' loro desideri sa[84]rà, di dar morte e affanno e fatiche e guerre e furie a qua-lūche cosa animata; e per la loro smisurata superbia questi si vor[85]ranno leuare inverso il cielo, ma la superchia gravezza delle lor membra gli porrà [86]in basso; nulla cosa resterà sopra la terra o sotto la terra e l'acqua che nō [87]sia perseguitata ·, remossa o guasta ·, e quella dell'ū paese remossa nell'altro; [88]e 'l corpo di questi si farà sepultura e transito di tutti i già da lor morti cor[89]pi animati; o mōdo, come è che nō t'apri a precipitarlo nell'alte fessure de' tua [90]grā baratri e spelonche, e non mostrare più al cielo si crudele e spie[91]tato mōstro!

with the greatest loss and frequent deaths on each side. And there will be no end to their malignity; by their strong limbs we shall see a great portion of the trees of the vast forests laid low throughout the universe; and, when they are filled with food the satisfaction of their desires will be to deal death and grief and labour and wars and fury to every living thing; and from their immoderate pride they will desire to rise towards heaven, but the too great weight of their limbs will keep them down. Nothing will remain on earth, or under the earth or in the waters which will not be persecuted, disturbed and spoiled, and those of one country removed into another. And their bodies will become the sepulture and means of transit of all they have killed.

O Earth! why dost thou not open and engulf them in the fissures of thy vast abyss and caverns, and no longer display in the sight of heaven such a cruel and horrible monster.

Br. M. 42 b] 1297.

PROFETIE.

[2]Molte fien quelle che cresce[3]rā nelle lor ruine.

(La palla della neue [5]rotolādo sopra la [6]neue.)

[7]Molta turba fie quella [8]che, dimēticato loro esse[9]re e nome, staran come [10]morti sopra le spoglie [11]deli altri morti.

(Il dormire sopra [13]le piume dell'uccielli.)

[14]Vedrannosi le parti oriēta[15]li discorrere [16]nell'occidentali e le me[17]ridionali in settentri[18]one, avviluppando[19]si per l'universo con grande [20]strepito e tremore o furore.

(Il uento d'oriēte che [22]scorreua in ponente.)

[23]I razzi solari accende[24]rāno il foco in te[25]rra coll' quale s'in[26]focherà ciò ch'è sotto [27]il cielo, e ripercossi [28]nel suo inpedimē-[29]to ritorneranno [30]in basso.

(Lo spechio cavo [32]acciēde il foco, col [33]quale si scalda il [34]forno che à il fō[35]do che sta sotto il suo [36]cielo.)

PROPHECIES.

There will be many which will increase in their destruction.

(The Ball of Snow rolling over Snow.)

There will be many who, forgetting their existence and their name, will lie as dead on the spoils of other dead creatures.

(Sleeping on the Feathers of Birds.)

The East will be seen to rush to the West and the South to the North in confusion round and about the universe, with great noise and trembling or fury.

(In the East wind which rushes to the West.)

The solar rays will kindle fire on the earth, by which a thing that is under the sky will be set on fire, and, being reflected by some obstacle, it will bend downwards.

(The Concave Mirror kindles a Fire, with which we heat the oven, and this has its foundation beneath its roof.)

. . esspesso . . ciasscuna. 81. parte . . arā. 82. atterra, 83. poichessarā passcuti . . dellor. 84. affanno "e fatiche e guerre e furi" accqualūche cossa animata "e per la loro issisurata superbia" questi. 85. malla . . gravezza "delle lor menvra" gli tera. 86. resstera . . ossotto ellacqua. 87. quassta ecquella. 88. ettransito . . iga da. 89. chome me nō tapri e precipita nellaltre fessure. 90. palatri esspelonche e no . . disspia.

1297. 2. cressce. 3. dimēticato. 10. lesspoglie de. 13. dellucie. 14. vedrassi le parte. 15. li [trans] discorrere. 16. ochidentallelle me. 17. settantri. 18. siavilupando. 19. cogra. 20. strepido e tremore "o furore". 23. razi. 25. si. 26. coche. 27. riperchossi. 29. nto ritorneran. 31. pechio. 32. aciēde. 33. 36. celo. 38. o si fugira. 39. soto . . celo. 40. rtorno

[37]Gran parte del mare [38]si fuggirà inverso il [39]cielo e per molto tēpo nō fa-[40]rà ritorno; ❲Cioè pe' nuvoli.❳

A great part of the sea will fly towards heaven and for a long time will not return. ❲That is, in Clouds.❳

[41]Restaci · il moto che separa [42]il motore dal mobile.

There remains the motion which divides the mover from the thing moved.

[43]Sarà annegato chi fa il lume [44]al culto diuino. ‖ ❲Le ape che [45]faño la cera delle candele.❳

Those who give light for divine service will be destroyed. ❲The Bees which make the Wax for Candles.❳

[46]I morti uscirāno di sotto terra [47]e coi loro fieri mouimēti cac[48]cieranno dal mondo · innumera[49]bili creature umane.

Dead things will come from underground and by their fierce movements will send numberless human beings out of the world.

❲Il ferro uscito di sot[51]to terra è morto, [52]e se ne fa l'arme che [53]ammorti tanti uomini.❳

❲Iron, which comes from under ground is dead but the Weapons are made of it which kill so many Men.❳

[54]Le grandissime montagnie [56]ācorachè sieno remo[57]te da marini liti, scaccieraño [58]il mare dal suo sito.

The greatest mountains, even those which are remote from the sea shore, will drive the sea from its place.

❲Questo sono li fiumi [60]che portanno le terre, [61]da loro leuate dalle mō[62]tagnie, e le scarica[63]no ai marini · liti, [64]e doue entra [65]la terra si fuggie il [66]mare.❳

❲This is by Rivers which carry the Earth they wash away from the Mountains and bear it to the Sea-shore; and where the Earth comes the sea must retire.❳

[67]L'acqua caduta dai nuvoli ancora in moto sopra le spiaggie de' mōti si ferme-[68]rà per lūgo spatio di tempo sanza [69]fare alcū moto, e questo accade[70]rà in molte e diuerse provincie.

The water dropped from the clouds still in motion on the flanks of mountains will lie still for a long period of time without any motion whatever; and this will happen in many and divers lands.

❲La neve che fiocca [72]che è acqua.❳

❲Snow, which falls in flakes and is Water.❳

[73]I gran sassi de' monti gitterā [74]fuoco tale che brucieranno il le[75]gname di molte e grādissime selue [76]e molte fere saluatiche e dimestiche.

The great rocks of the mountains will throw out fire; so that they will burn the timber of many vast forests, and many beasts both wild and tame.

❲La pietra del fucile, [78]che fa foco che consu[79]ma tutte le some del[80]le legnie con che si [81]disfā le selve; [82]E cuocierassi con esse [83]la carne delle bestie.❳

❲The Flint in the Tinder-box which makes a Fire that consumes all the loads of Wood of which the Forests are despoiled and with this the flesh of Beasts is cooked.❳

[84]O quanti grandi edifitj fieno ruinati [85]per causa del fuoco!

Oh! how many great buildings will be ruined by reason of Fire.

❲Del fuoco delle bonbarde.❳

❲The Fire of great Guns.❳

[87]I buoi fieno in gran parte cavsa delle ruine [88]delle città, e similmēte cavalli e bufoli

Oxen will be to a great extent the cause of the destruction of cities, and in the same way horses and buffaloes

❲Tirā le bonbarde.❳

❲by drawing Guns❳.

coe pe nvgoli. 41. Resstaci chessepera. 43. anegato chiffa ilume. 46. vsscirāno. 47. hecholoro . . ca. 48. del . . invmera. 50. usscito diso. 51. momorto. 52. esse. 53. amorti. 54. montagnie per. 55. [lunga remotione fia an]. 56. anchorachessieno che sieno. 58. del. 61. dallor . . delle. 62. elle scarica. 63. noa. 67. de nvgoli | "ancora in moto sopra le spiage de mōti sua natura che" si ferme. 69. acade. 70. imolte . . prouince. 71. fiocha. 73. gra. 74. focho . . ile. 76. fierc. 79. some de. 81. disfa. 82. e cocierassicon eso. 83. della besttie. 85. chausa del focho. 87. boi. 86. focho. 88. essinilmēte cavgli. 83. tira.

I.² 15 a] 1298.

¶ Vedrassi la spetie leonina · colle unghiate ²branche aprire la terra · e nelle fatte ³spelonche · seppellire · se insieme co⁴li altri animali a se sottoposti.¶

¶⁵Usciranno dalla terra · animali · vestiti di tenebre, ⁶i quali con maravigliosi assalti ⁷assaliranno l'umana generatione, e quella ⁸da feroci morsi · fia con confusion di sā⁹gue da essi · diuorata.¶

¹⁰Ācora scorrerà per l'aria · la nefāda spetie volatile, ¹¹la quale · assalirà · li omini e li a¹²nimali, e di quelli si ciberanno cō grā ¹³gridore; empierāno i loro vētri di vermiglio sangue.

The Lion tribe will be seen tearing open the earth with their clawed paws and in the caves thus made, burying themselves together with the other animals that are beneath them.

Animals will come forth from the earth in gloomy vesture, which will attack the human species with astonishing assaults, and which by their ferocious bites will make confusion of blood among those they devour.

Again the air will be filled with a mischievous winged race which will assail men and beasts and feed upon them with much noise— filling themselves with scarlet blood.

I.² 15 b] 1299.

Vedrassi il sangue uscire dalle · stracciate carni, ²rigare le superfitiali parti delli omini;

¶³Verrà alli omini · tal crudele mala⁴tia, che colle propie vnghie · si strac⁵cieranno le loro carni || ❨sarà la rognia;❩¶

¶⁶Vedrannosi le piāte rimanere sanza foglie, ⁷e i fiumi fermare i loro corsi;¶

¶⁸L'acqua del mare si leuẹrà sopra l'alte cime de' mōti ⁹verso il cielo, e ricaderà sopra alle a¹⁰bitationi delli omini || ❨cioè per nuvoli;❩¶

¶¹¹Vedrannosi i maggiori alberi delle selue essere ¹²portati dal furor de' venti dall'oriēte ¹³all'occidente || ❨cioè per mare;❩¶

¶¹⁴Li omini gitterāo via le propie vettovaglie ❨¹⁵cioè seminādo.❩¶

Blood will be seen issuing from the torn flesh of men, and trickling down the surface.

Men will have such cruel maladies that they will tear their flesh with their own nails. ❨The Itch.❩

Plants will be seen left without leaves, and the rivers standing still in their channels.

The waters of the sea will rise above the high peaks of the mountains towards heaven and fall again on to the dwellings of men. ❨That is, in Clouds.❩

╲ The largest trees of the forest will be seen carried by the fury of the winds from East to West. ❨That is across the Sea.❩

Men will cast away their own victuals. ❨That is, in Sowing.❩

I.² 26 a] 1300.

¶Verrà a tale la gieneratione vmana ²che nō si intēderà il parlare · l'uno dell'altro; ³cioè un tedesco con un turco.¶

¶⁴Vedrassi ai padri donare le lor figliole ⁵a lussuria delli omini e premiare e abbādonare ogni ⁶passata guardia || ❨quādo si maritano le pùtte.❩¶

¶⁷Uscirāno li omini dalle sepulture cōuertiti ⁸in vccelli ·, e assaliranno li altri omini togliendo ⁹loro il cibo dalle propie mani e mēse || ❨le mosche.❩¶

Human beings will be seen who will not understand each other's speech; that is, a German with a Turk.

Fathers will be seen giving their daughters into the power of man and giving up all their former care in guarding them. ❨When Girls are married.❩

Men will come out their graves turned into flying creatures; and they will attack other men, taking their food from their very hand or table. ❨As Flies.❩

1298. 1. vederassi . . colle vngliate. 2. b \\\\ ache. 3. secho . . cho. 4. asse sottopossti. 5. vsscira della . . animali "vestitidi tenebr[oso]" di osscuro. 6. [colore] i quali cho. 7. gienerationa ecq. 8. quela da . . fia confusion. 10. laria [vcielli] "la nefāda specie volati". 11. assalira . . ellia. 13. enperāno . . sange.

1299. 1. usscire delle. 4. cholle . . si stra. 6. vedrassi. 8. leuera "sopra lalte cime de mōti" [molte ˈmiglia]. 10. bitatione . . nvgoli. 11. vedera . . magiori. 13. coe.

1300. 1. verano attale. 3. vtedesco con v̄ turco. 5. ebādonare "e premiare" ogni. 7. vsscirāno . . delle. 8. vcielli e assalirano . . tolendo. 9. delle . . le mosche [ecc]. 10. arove. 11. scierano. 12. quelli [che osseruerano] "che presterāno orechi" | le . . legere.

¶ [10] Molti fien quegli che scorticādo la madre li arrove [11] scieranno la sua pelle · adosso; ‖ ⟪i lavoratori della terra.⟫¶

¶ [12] Felici fiē quelli che presterāno orechi alle parole de' morti; | ⟪leggere [13] le bone opere e osseruarle.⟫¶

Many will there be who, flaying their mother, will tear the skin from her back. ⟪Husbandmen tilling the Earth.⟫

Happy will they be who lend ear to the words of the Dead. ⟪Who read good works and obey them.⟫

I.2 16 b]

1301.

¶ Le penne leuerāno li omini siccome gli uccielli inverso il cielo; [2] ⟪cioè per le lettere · fatte da esse pēne.⟫¶

[3] ¶ L'umane opere fieno cagione di lor morte; | ⟪le spade e lācie.⟫¶

¶ [4] Li omini perseguirāno quella cosa della qual piv temono, ¶ [5] cioè | ⟪sarā miseri per nō venire ī miseria.⟫¶

¶ [6] Le cose disunite · s'unirāno · e ricieverāno in se [7] tal uirtù, che rēderanno la persa memoria alli omi [8] ni ·, cioè i papiri · che sō fatti di peli disuniti [9] e tēgono memoria delle cose e fatti delli omini.¶

¶ [10] Vedrannosi l'ossa de' morti cō veloce moto tratta [11] re la fortuna del suo motore; ⟪i dadi.⟫¶

¶ [12] I buoi colle lor corna difenderā [13] no il foco dalla · sua · morte; ‖ ⟪la lāterna.⟫¶

¶ [14] Le selue partorirāno figlioli che fiano causa della [15] lor morte; ‖ ⟪il manico della scura.⟫¶

Feathers will raise men, as they do birds, towards heaven ⟪that is, by the letters which are written with quills.⟫

The works of men's hands will occasion their death. ⟪Swords and Spears.⟫

Men out of fear will cling to the thing they most fear. ⟪That is they will be miserable lest they should fall into misery.⟫

Things that are separate shall be united and acquire such virtue that they will restore to man his lost memory; that is papyrus [sheets] which are made of separate strips and have preserved the memory of the things and acts of men.

The bones of the Dead will be seen to govern the fortunes of him who moves them. ⟪By Dice.⟫

Cattle with their horns protect the Flame from its death. ⟪In a Lantern [13].⟫

The Forests will bring forth young which will be the cause of their death. ⟪The handle of the hatchet.⟫

I.2 17 a]

1302.

¶ Li omini batteranno aspramēte · chi fia causa [2] di lor uita; ‖ ⟪batterāno · il grano.⟫¶

¶ [3] Le pelli delli animali · removerāno li omini con gran [4] gridori e bestemie dal lor silentio; | ⟪le balle da giuocare.⟫¶

[5] Molte volte la cosa disunita fia causa di grāde unitione; [6] ⟪cioè il pettine fatto dalla disunita canna unisce · le [7] fila · nella seta.⟫

¶ [8] Il uēto passato per le pelli delli animali farà saltare [9] li omini; ‖ ⟪cioè la piva che fa lo saltare.⟫¶

Men will deal bitter blows to that which is the cause of their life. ⟪In thrashing Grain.⟫

The skins of animals will rouse men from their silence with great outcries and curses. ⟪Balls for playing Games.⟫

Very often a thing that is itself broken is the occasion of much union. ⟪That is the Comb made of split Cane which unites the threads of Silk.⟫

The wind passing through the skins of animals will make men dance. ⟪That is the Bag-pipe, which makes people dance.⟫

1301. 1. sichome. 2. faete. 3. lesspade he lāce. 4. chosa . . temano. 7. rēderaūno. 8. palpiri chessō. 9. tēgano . . cosse effatti. 10. vederassi . . chō. 12. [le corna delle] i boi. 14. cheffia chausa.

1302. 1. batterano asspramēte cheffia chausa. 3. pelle . . con gā. 4. besstemie . . giucare. 5. chausa. 6. della . . vnisscie. 9. cheffa \\\\\\\ are.

1301. 13. See note page 357.

I.2 17 *b*] **1303.**

⟦De' noci battuti.⟧

[2]Quelli che avranno · fatto meglio, sa-ranno [3]piv battuti e i sua figlioli tolti [4]e scorticati overo spogliati e rotte e fra[5]cas-sate le sue ossa.

⟦Delle scolture.⟧

[7]Oimè, che vedo il saluatore di novo crocifisso.

⟦Della bocca dell' omo ch'è sepoltura.⟧

[9]Usciranno grā romori dalle sepolture di [10]quelli che sō finiti da cattiva e uiolēte morte.

⟦Delle pelli delli animali [12]che tengono il senso del tatto [13]che v'è sulle scritture.⟧

[14]Quāto piv si parlerà · colle pelli, veste del [15]sentimento, tanto piv s'acquisterà sa-piētia.

⟦De' preti che tengono l'ostia [17]in corpo.⟧

[18]Allora tutti quasi i tabernaculi dove sta il [19]corpus domini si vedraño manifesta-mēte [20]per se stessi andare per diuerse strade del mōdo.

⟦Of Walnut trees, that are beaten.⟧

Those which have done best will be most beaten, and their offspring taken and flayed or peeled, and their bones broken or crushed.

⟦Of Sculpture.⟧

Alas! what do I see? The Saviour cru-cified anew.

⟦Of the Mouth of Man, which is a Sepulchre.⟧

Great noise will issue from the sepul-chres of those who died evil and violent deaths.

⟦Of the Skins of Animals which have the sense of feeling what is in the things written.⟧

The more you converse with skins cove red with sentiments, the more wisdom will-you acquire.

⟦Of Priests who bear the Host in their body.⟧

Then almost all the tabernacles in which dwells the Corpus Domini, will be plainly seen walking about of themselves on the various roads of the world.

I.2 18 *a*] **1304.**

¶ E quelli che pascono l'erbe [2]farā della notte [3]giorno; ‖ ⟦sevo.⟧ ¶

¶ [4]E molti terrestri e acquatici [5]animali mōterāno fralle [6]stelle; | ⟦cioè pianeti.⟧ ¶

¶ [7]Vedrassi i morti portare [8]i vivi; ‖ ⟦i carri e navi in diuerse parti.⟧ ¶

[10]A molti fia tolto il cibo di bocca; ⟦Ai forni.⟧

¶ [12]E quelli che si inboccheranno, per l'altrui [13]mani fia lor tolto il cibo di bo-[14]cca; ⟦il forno.⟧ ¶

And those who feed on grass will turn night into day ⟦Tallow.⟧

And many creatures of land and water will go up among the stars ⟦that is Planets.⟧

The dead will be seen carrying the living ⟦in Carts and Ships in various places.⟧

Food shall be taken out of the mouth of many ⟦the oven's mouth.⟧

And those which will have their food in their mouth will be deprived of it by the hands of others ⟦the oven.⟧

I.2 18 *b*] **1305.**

⟦De' crocifissi vēduti.⟧

[2]Io vedo di novo vēduto e crocifisso Cristo [3]e marterizzare i sua sāti.

⟦I medici che uiuono de' malati.⟧

[5]Verrāno li omini in tanta viltà, che avrā di gra[6]tia, che altri triōfino sopra i loro mali [7]ovvero della perduta lor uera ricchezza, cioè la sanità.

⟦Of Crucifixes which are sold.⟧

I see Christ sold and crucified afresh, and his Saints suffering Martyrdom.

⟦Of Physicians, who live by sickness.⟧

Men will come into so wretched a plight that they will be glad that others will derive profit from their sufferings or from the loss of their real wealth, that is health.

1303. 2. aranno. 3. e e sua. 4. esscorticha . . effra. 5. chassate. 7. ome . . saluadore. 8. dela bocha. 9. vsscira . . delle . . de. 10. queli chesso finiti de. 11. belle. 12. tengano. 13. che vesule. 14. cholle pelleveste del. 16. chettengano. 19. vederaño. 20. stesse.

1304. 1—14 R. 1. ecqueli che pascā lere. 2. [cholla] farā. 4. teresti e aquatici. 6. stelle e pianeti. 8. i carri "e navi." 10. amoli fia . . bocha. 11. a. 12. ecque chessi. 14. bocha.

1305. 2. i vedo. 3. marterizare. 4. uiuā. 5. verāno . . arā. 6. triōfi . . ilor. 7. ovedella . . richeza coe. 8. delle religiō.

⟪Della religione de' frati ⁹che vivono per li loro sā¹⁰ti, morti per assai tēpo.⟫

¹¹Quelli che saranno morti dopo mille anni ¹²fien quelli che daranno le spese a molti ¹³vivi.

⟪De' sassi cōvertiti in calcina, ¹⁵de' quali si murano le prigioni.⟫

¹⁶Molti che fieno disfatti dal fuoco ¹⁷innāzi a questo tenpo, torrāno la libertà a mol¹⁸ti uomini.

⟪Of the Religion of Friars, who live by the Saints who have been dead a great while.⟫

Those who are dead will, after a thousand years be those who will give a livelihood to many who are living.

⟪Of Stones converted into Lime, with which prison walls are made.⟫

Many things that have been before that time destroyed by fire will deprive many men of liberty.

I.² 19a]

1306.

⟪De' putti che tettano.⟫

²Molti Francescani, Domenicani, e Bene-³dettini mangieranno quel che da altri ⁴altre volte vicinamēte è stato māgia⁵to, che staranno molti mesi avanti ⁶che possino parlare.

⟪De' nichi e chiocciole che sono rebuttati ⁸dal mare che marciscono dētro ai lor gusci.⟫

⁹O quanti fiē quelli che, poichè fiē morti, mar¹⁰ciranno nelle lor propie case, ēpiēdo le ¹¹circūstāte parti piene di fetulēte puzzo!

⟪Of Children who are suckled.⟫

Many Franciscans, Dominicans and Benedictines will eat that which at other times was eaten by others, who for some months to come will not be able to speak.

⟪Of Cockles and Sea Snails which are thrown up by the sea and which rot inside their shells.⟫

How many will there be who, after they are dead, will putrefy inside their own houses, filling all the surrounding air with a fetid smell.

L. 91a]

1307.

⟪De' mvli che portano le ricche some ²dell'argiēto e oro.⟫

³Molti tesori e grā ricchezze · saranno appre⁴sso alli animali di 4 piedi, i quali le por⁵teranno in diversi lochi.

⟪Of Mules which have on them rich burdens of silver and gold.⟫

Much treasure and great riches will be laid upon four-footed beasts, which will convey them to divers places.

K.² 1b]

1308.

⟪Dell'onbra che fa l'omo di not²te col lume.⟫

³Appariranno grandissime figure in forma ⁴vmana, le quali quanto piv le ti fa⁵rai vicine, più diminuiranno la ⁶loro immensa magnitudine.

⟪Of the Shadow cast by a man at night with a light.⟫

Huge figures will appear in human shape, and the nearer you get to them, the more will their immense size diminish.

9. vivano. 11. chessarano. 15. mure. 16. cheffieno . . foco [dopo molti]. 17. ināzi acquesto. 18. homini.
1306. 1. chettattaño. 2. franciessci domenichi. 3. detta mangierano. 7. chesson. 8. marciscano . . a lor. 10. cirano. 11. puzo.
1307. 1. riche. 2. he oro. 3. richeze . . apre. 5. terano.
1308. 1. dino. 2. chol. 4. sitifa. 5. ra vicino . . diminvirano. 6. inmensa.

1307. It seems to me probable that this note, which occurs in the note book used in 1502, when Leonardo, in the service of Cesare Borgia, visited Urbino, was suggested by the famous pillage of the riches of the palace of Guidobaldo, whose treasures Cesare Borgia at once had carried to Cesena (see GREGOROVIUS, *Geschichte der Stadt Rom im Mittelalter*. XIII, 5, 4).

C. A. 127 *b*; 390 *a*] **1309.**

⦅Delle biscie portate dalle cicognie.⦆

² Vedrannosi in grandissima altezza dell'aria lūghissimi serpenti ³ conbattere colli uccielli.

⦅Delle bōbarde ch'escono dalla fossa e dalla forma.⦆

⁵ Uscirà di sotto terra chi con spauētevoli grida stordirà ⁶ i circonstanti vicini e col suo fiato farà morire li omini ⁷ e ruinare le città e castella.

⦅Of Snakes, carried by Storks.⦆

Serpents of great length will be seen at a great height in the air, fighting with birds.

⦅Of great guns, which come out of a pit and a mould.⦆

Creatures will come from underground which with their terrific noise will stun all who are near; and with their breath will kill men and destroy cities and castles.

Br. M. 212 *b*] **1310.**

⦅Del grāo e altre semēze.⦆

² Gitteranno li omini fori delle lor propie case quelle uettovalglie, le quali ³ erā dedicate a sostētare la lor uita.

⦅Delli alberi che nutriscono i nesti.⦆

⁵ Vedrannosi i padri e le madri fare molto piv giovamento ai figliastri che ai lor ueri ⁶ figlioli.

⦅Del turibolo dell'incēso.⦆

⁸ Quelli che cō uestimēti bianchi andranno con arrogante movimēto minacciā⁹do con metallo e fuoco, che nō facieva lor detrimēto alcuno.

⦅Of Grain and other Seeds.⦆

Men will fling out of their houses those victuals which were intended to sustain their life.

⦅Of Trees, which nourish grafted shoots.⦆

Fathers and mothers will be seen to take much more delight in their step-children then in their own children.

⦅Of the Censer.⦆

Some will go about in white garments with arrogant gestures threatening others with metal and fire which will do no harm at all to them.

S. K. M. II.2; 35 *b*] **1311.**

⦅Del segare dell'erbe.⦆

² Spegnieransi innumerabili viti ³ e farassi sopra la terra innumera⁴bili buchi.

⦅Della vita delli omini ⁶ che ogni aõo si mv⁷tano di carne.⦆

⁸ Li omini passerā morti per le ⁹ sue propie budelle.

⦅Of drying Fodder.⦆

Innumerable lives will be destroyed and innumerable vacant spaces will be made on the earth.

⦅Of the Life of Men, who every year change their bodily substance.⦆

Men, when dead, will pass through their own bowels.

1309. 1. bissce. 2. vedrassi . . alteza . . lūgisimi serpe. 3. combatere. 4. escan della . . della. 5. vsscira . . conispauēteuoli. 6. circustanti . . fiato.

1310. 2. chase. 3. assossētare. 4. notriscano e nesti. 5. vedrassi . . elle . . govameto . . figliasstri. 7. tuibile. 8. uestimēte biāche . . arogante . . minaciā. 9. comͤetallo effoco chi.

1311. 2. spēgineransi inumerabili. 3. invmera. 6. aͣi. 8. paserā. 9. gudelle. 10. de vai. 11. [molti animali].

S. K. M. II.2; 3a] **1312.**

❡ I calzolari. ❱

[2] Li omini vedranno cō piacere [3] disfare e rōpere l'opere loro.

❡ Shoemakers. ❱

Men will take pleasure in seeing their own work destroyed and injured.

S. K. M. II.2; 69a] **1313.**

❡ De capretti. ❱

[2] Ritornerà [3] il tēpo d'Erode, perchè [4] l'innocēti figliuoli sarā [5] tolti alle loro [6] balie, e da cru[7]deli omini di gran ferite moriranno.

❡ Of Kids. ❱

The time of Herod will come again, for the little innocent children will be taken from their nurses, and will die of terrible wounds inflicted by cruel men.

1312. 1—3 R. 2. vederā chō. 3. diffare.
1313. 2. [sarāno tolti] ritornera. 3. perche [i pi]. 4. li nocēti figuoli. 7. gra.

V.

DRAUGHTS AND SCHEMES FOR THE HUMOROUS WRITINGS.

Br. M. 42*b*]

1314.

FAUOLA.

[2]El granchio stā[3]do sotto il sasso per piglia[4]re pesci che sotto a quel[5]lo entrauano, vene la pi[6]ena con rovinoso precipita[7]mento di sassi, e col loro rotolare [8]si fraciellò tal grāchio.

QUEL MEDESIMO.

[10]Il ragnio, stante infra [11]l'uue, pigliaua le mosche [12]che in su tali uve si pasci[13]evano; venne la vēdemmi[14]a e fu pestato, il ragno in[15]sieme coll'uue.

[16]La uite invecchiata sopra l'al[17]bero vecchio · cade insi[18]eme colla ruina d'esso al[19]bero, e fu per la trista conpagnia a mancare insieme [21]con quella.

[22]Il torrēte portò tanto [23]di terra e pietre nel [24]suo letto, che fu costre[25]tto a mutar sito.

[26]La rete che soleua pigliare [27]li pesci fu presa e portata [28]via dal furor de' pesci.

[29]La palla della neue quan[30]to piv rotolando disciese [31]dalle mōtagnie della neue [32]tāto piv multiplicò la sua [33]magnitudine.

[34]Il salice che per li sua lun[35]ghi giermi à a mente e uol [36]cresciere da superare ciascuna [37]altra piāta, per avere fatto [38]cō-pagnia colla vite che o[39]gni anno si potta, fu ancora [40]lui senpre storpiato.

A FABLE.

The crab standing under the rock to catch the fish which crept under it, it came to pass that the rock fell with a ruinous downfall of stones, and by their fall the crab was crushed.

Schemes for fables, etc. (1314—1323).

THE SAME.

The spider, being among the grapes, caught the flies which were feeding on those grapes. Then came the vintage, and the spider was cut down with the grapes.

The vine that has grown old on an old tree falls with the ruin of that tree, and through that bad companionship must perish with it.

The torrent carried so much earth and stones into its bed, that it was then constrained to change its course.

The net that was wont to take the fish was seized and carried away by the rush of fish.

The ball of snow when, as it rolls, it descends from the snowy mountains, increases in size as it falls.

The willow, which by its long shoots hopes as it grows, to outstrip every other plant, from having associated itself with the vine which is pruned every year was always crippled.

C. A. 66 *b*; 201 *b*] **1315.**

Fauola della lingua morsa dai dēti.
²Il ciedro insuperbito dalla sua bellezza
³dubita delle piāte che li sō dītorno, e fat-
⁴tole si torre dinanzi; il uēto poi non es-
sē⁵do interrotto ·, lo gittò per terra · diradi-
cato.
⁶La uitalba · non stādo cōtēta nella sua
⁷siepe ·, commīciò . a passare coi sua · rami la
⁸comvne strada · e appicarsi all' opposita
siepe; ⁹onde da uiādanti · poi · fu · rotta.

Fable of the tongue bitten by the teeth.
The cedar puffed up with pride of its
beauty, separated itself from the trees around
it and in so doing it turned away towards
the wind, which not being broken in its fury,
flung it uprooted on the earth.
The traveller's joy, not content in its
hedge, began to fling its branches out over the
high road, and cling to the opposite hedge,
and for this it was broken away by the passers by.

H.2 15 *b*] **1316.**

Il calderugio dà la vittouaglia ²ai figliuoli
ingabbiati; — pri³ma morte che perdere li-
bertà.

The goldfinch gives victuals to its caged
young. Death rather than loss of liberty.

S. K. M. II2; 12 *a*] **1317.**

⟦Delle baghe.⟧
²Le capre cōdur³rāno il uino alle ⁴città.

⟦ Of Bags. ⟧
Goats will convey the wine to the city.

I.1 39 *b*] **1318.**

Tutte le cose che nel uerno fiē ²nascoste
sotto la neve rimaranno sco³perte e palesi
nell' estate; ⟦detta per la ⁴bugia che nō può
stare occulta.⟧

All those things which in winter are
hidden under the snow, will be uncovered
and laid bare in summer. ⟦for Falsehood,
which cannot remain hidden⟧.

H.1 44 *a*] **1319.**

FAVOLA.

²Il giglio si pose sopra la ripa di Te-
sino, ³e la corrēte tirò la ripa īsieme col
lilio.

A FABLE.

The lily set itself down by the shores
of the Ticino, and the current carried away
bank and the lily with it.

H.2 14 *b*] **1320.**

FACETIA.

²Perchè li Ungheri tēgono la croce ‡
dvppia.

A JEST.

Why Hungarian ducats have a double
cross on them.

1315. 2. della . . belleza. 3. chelli . . effa. 4. tore. 5. interotto. 5. pertera . . diradichato. 6. istādo. 7. comīcio . . cosua.
8. apicharsi . . oposita.
1316. 1. calderigio da il arouialio. 2. a figlioli ingabiati.
1317. 1. bage. 2. chapre cōdu. 3. ale.
1318. 1. cose. 2. remarāo. 3. palese nella stade. 4. ochulta.
1319. 2. iligio si pose. 3. ella corēte. **1320.** 1—2 R. 2. perchelli ūgeri tēgā.

1316. Above this text is another note, also referring to liberty; see No. 694.

Tr. 73.] **1321.**

CŌPARATIONE. A SIMILE.

¶ ²Vn vaso crudo rotto si può riformare, ³ma il cotto no.¶

A vase of unbaked clay, when broken, may be remoulded, but not a baked one.

S. K. M. III. 66 b] **1322.**

Vedēdosi la carta tutta macchiata ²dalla oscura negrezza dell'īchiostro, ³di quello si duole; il quale mostra a essa ⁴che per le parole che sono sopra lei cōposte ⁵essere cagione della cōseruatione di ⁶quella.

Seeing the paper all stained with the deep blackness of ink, it he deeply regrets it; and this proves to the paper that the words, composed upon it were the cause of its being preserved.

L. o'] **1323.**

¶Neciessaria cōpagnia à la penna col tenperatoio, ²e similemēte vtile cōpagnia, perchè l'ū sanza l'altro nō ³vale troppo.¶

The pen must necessarily have the pen-knife for a companion, and it is a useful companionship, for one is not good for much without the other.

S. K. M. III. 48 a] **1324.**

Il coltello, accidētale armatura, caccia dall'omo le sua ²unghie, armatura naturale;

³Lo spechio signoria forte tenē⁴do · dentro · a se spechiata la re⁵gina ·, e partita quella le spe⁶chio riman in le ...

The knife, which is an artificial wea-pon, deprives man of his nails, his natural weapons.

The mirror conducts itself haughtily holding mirrored in itself the Queen. When she departs the mirror remains there ...

Schemes for prophecies (1324—1329).

L. 72 b] **1325.**

El lino è dedicato a morte e cor²rutione de'mortali, a morte pe'lac³ciuoli delli vccelli, ⁴animali e pesci, ⁵a corrutione per le tele line dove s'in⁶vogliano i morti, che si sotterrano, ⁷quali si corrōpono in tali tele; ⁸E ancora esso lino nō si spicca dal suo ⁹festuco, se esso nō comīcia a macerar¹⁰si e coronpersi, e questo è quello ¹¹collo quale si debbe incoronare e or¹²nare li ufiti funerali.

Flax is dedicated to death, and to the corruption of mortals. To death, by being used for snares and nets for birds, animals and fish; to corruption, by the flaxen sheets in which the dead are wrapped when they are buried, and who become corrupt in these winding sheets.— And again, this flax does not separate its fibre till it has begun to steep and putrefy, and this is the flower with which garlands and decorations for funerals should be made.

I.2 91 a] **1326.**

〖De'villani in camiscia che lavorano.〗

²Verranno tenebre diuerso · l'oriēte, le qua³li con tāta oscurità tignieranno il ⁴cielo che copre l'Italia.

〖De' barbieri.〗

⁶Tvtti li omini si fuggiranno in Africa.

〖Of Peasants who work in shirts〗

Shadows will come from the East which will blacken with great colour darkness the sky that covers Italy.

〖Of the Barbers.〗

All men will take refuge in Africa.

1321. 2. rotto crudorottosi po.
1322. 1. charta . . machiata. 2. osscura negreza. 3. dole el . . mostra a ess. 4. parolle chesso sopra lei chōpone. 5. chagione.
1323. 1. ha la. 2. essimilemēte.
1324. 1. coltello | "accidētale armatura" cacia. 2. ungie. 3. losspechio. 4. asse. 5. losspe. 6. rimāinle.
1325. 1. morte e cu. 2. pela. 3. vcielli. 4. pessci. 5. currutione pe le. 6. volgano . . chessi. 7. corrōpano. 8. spicha. 10. choronpersi ecquesto ecquello. 11. colla.
1326. 1—6 R. 1. camica chellavorano. 2. verra tienbre. 3. codioscurita . . tignierano.

G. 89 a] **1327.**

Per il pannilino che si [2]tiē colla mano nel co[3]rso dell'acqua corrē[4]te, nella quale acqua [5]il panno lascia [6]tutte le sue bruttu[7]re, significa [8]questo ecc.

[9]Per lo spino inscrito[10]li sopra boni fru[11]tti significa que[12]llo che per se non e[13]ra disposto a vir[14]tù, ma median[15]te l'aiuto dei pr[16]ecettori da di se [17]vn fassi nome vi[18]rtù.

The cloth which is held in the hand in the current of a running stream, in the waters of which the cloth leaves all its foulness and dirt, is meant to signify this &c.

By the thorn with inoculated good fruit is signified those natures which of themselves were not disposed towards virtue, but by the aid of their preceptors they have the repudation of it.

C. A. 36 a; 116 b] **1328.**

COMUNE.

[2]Vn meschino sarà soiato e essi soiatori [3]senpre sien sua ingannatori e rubatori [4]e assassini d'esso meschino.

[5]La percussione della spera del sole [6]apparirà cosa che, chi la crederà coprire, sa[7]rà coperto da lei.

❬De' danari e oro.❭

[9]Uscirà dalle cavernose spelonche, chi farà [10]con sudore affaticare tutti i popoli del mōdo, [11]cō grādi affanni, ansieta, sudori per essere [12]aivtato da lui.

❬Della paura della pouertà.❭

[14]La cosa maluagia e spauēteuole darà di se tāto [15]timore appresso a delli omini che come [16]matti, credendo fugirla, concorreranno cō [17]veloce moto alle sue smisurate forze.

❬Del consiglio.❭

[19]E colui che sarà piv neciessario a chi avrà bi[20]sogno di lui sarà sconosciuto, cioè piv sprezzato.

A COMMON THING.

A wretched person will be flattered, and these flatterers are always the deceivers, robbers and murderers of the wretched person.

The image of the sun where it falls appears as a thing which covers the person who attempts to cover it.

❬Money and Gold.❭

Out of cavernous pits a thing shall come forth which will make all the nations of the world toil and sweat with the greatest torments, anxiety and labour, that they may gain its aid.

❬Of the Dread of Poverty.❭

The malicious and terrible [monster] will cause so much terror of itself in men that they will rush together, with a rapid motion, like madmen, thinking they are escaping her boundless force.

❬Of Advice.❭

The man who may be most necessary to him who needs him, will be repaid with ingratitude, that is greatly contemned.

W. XXX.] **1329.**

❬Delle ape.❭

[2]Vivono a popoli insieme, [3]sono annegate per torli il mele; [4]molti e grandissimi popoli sarā [5]annegati nelle lor propie case.

❬ Of Bees.❭

They live together in communities, they are destroyed that we may take the honey from them. Many and very great nations will be destroyed in their own dwellings.

1327. 1—18 R. 1. panolino chessi. 3. acq"a". 5. pano lasscia. 7. significha. 9. losspino insidito. 11. significha. 13. disposto. 15. ti laiuto del. 17. vnlissinome.

1328. 1. vcomune. 2. mescino. 4. messcino. 5. percusione. 6. aparira . . crederra. 7. dallei. 9. vsscira delle. 10. effattichare . . pololi. 11. affani. 12. dallui. 14. la maluagia es spauēteuole. 15. apresso a delli omini che coli ali come. 16. cocoreranno. 17. moto le le sua isspermisurate. 19. cholui . . ara. 20. sara \\\\\\ conosciuto \\\\\\ cioe piv sprezato.

1329. 2. vivano apopoli ensieme. 3. anegate. 5. [no] gati nelle lororo propie 6. [si some] sarā se.

F. 47 a]　　　　　　　　**1330.**

PERCHÈ LI CANI ODORĀ VOLENTIERI IL CULO L'UNO AL²L'ALTRO.

Questo animale à in odio i po³veri, perchè e' māgiano tristi cibi, e ama li richi, ⁴perchè essi àn' bone vivāde e massime di car⁵ne; E lo sterco delli animali senpre ri-⁶tiene della virtù della sua origine, come mo⁷strano le feccie

¹⁰Ora i cani ànno si sottilissimo odo¹¹rato che col naso sentono la uirtù rima¹²sta in tali feccie; e che sie uero, se le trovā ¹³per le strade odorano, e se vi sentono dentro ¹⁴vi¹rtù di carne o d'altro, essi le pigliano, e ¹⁵se nò, le lasciano; e per tornare al quesito di¹⁶co, che se conoscono il cane mediante tali ¹⁷odori essere ben pasciuto, essi lo riguar¹⁸dano, perchè stimano quello avere potēte e ricco pa¹⁹drone, e se nō sentono tale odore cō uirtù, essi sti²⁰mano tal cane essere da poco, e avere povero ²¹e tristo padrone, e però mordono tali cani come fare²²bbero il suo padrone.

WHY DOGS TAKE PLEASURE IN SMELLING AT EACH OTHER.

This animal has a horror of the poor, because they eat poor food, and it loves the rich, because they have good living and especially meat. And the excrement of animals always retains some virtue of its origin as is shown by the faeces. . . .

Now dogs have so keen a smell, that they can discern by their nose the virtue remaining in these faeces, and if they find them in the streets, smell them and if they smell in them the virtue of meat or of other things, they take them, and if not, they leave them: And to return to the question, I say that if by means of this smell they know that dog to be well fed, they respect him, because they judge that he has a powerful and rich master; and if they discover no such smell with the virtue of meet, they judge that dog to be of small account and to have a poor and humble master, and therefore they bite that dog as they would his master.

C. A. 68 b; 203 b]　　　　　**1331.**

Sono li moti della terra ²circulari assai vtili, ³cōciosiachè¹ mai li o⁴mini si fermano; e fa⁵si in piv modi, de' qua⁶li nell'uno li omini por⁷tano la terra in spal⁸la, l'altro, colli bau⁹li, e altri col carret¹⁰to; Quel che la porta ¹¹in spalla si fa prima ¹²enpiere il uassoio in ter¹³ra·, e perde tēpo a metterselo ¹⁴in spalla; Quel dello bau¹⁵le non perde tenpo.

The circular plans of carrying earth are very useful, inasmuch as men never stop in their work; and it is done in many ways. By one of these ways men carry the earth on their shoulders, by another in chests and others on wheelbarrows. The man who carries it on his shoulders first fills the tub on the ground, and he loses time in hoisting it on to his shoulders. He with the chests loses no time.

Tr. 2]　　　　　　　　**1332.**

Se'l Petrarca amò si forte il lauro, ²fu perch'egli è buon fralla salsiccia e tonno; ³io nō posso di lor ciancie far tesauro.

If Petrarch was so fond of bay, it was because it is of a good taste in sausages and with tunny; I cannot put any value on their foolery. Irony (1332).

1330. 1. adorā. 5. Ello stercho. 7. stra leuetie miseraice strebute insin ne. 8. le ultima basseza delle intestine. 9. per trarre asse desse fecce la uirtu cheue. 10. rimasa ora i cani ā si. 11. sentano. 12. sa in tale fecce. 13. strade [elle] odorano esse uīsentā dentro. 14. esse le. 15. lassciano. 16. cognoscano. 17. odore . . passiuto. 18. richo. 19. esse nō setā. 21. mordā. 22. bono.

1331. 3. cōcosia. 4. effa. 6. po"r". 7. inispal. 8. colleban. 9. le e . . carre. 10. chella. 11. inispalla. 14. inispalla . . della baul. 15. la non.

1332. 1. petrarcha . . ilaur \\\\\. 2. ·percheglie e bō . . e ton \\\\\. 3. i nō . . giāce.

1331. The subject of this text has apparently no connection with the other texts of this section.

1332. Conte Porro has published these lines in the *Archivio Stor. Lombarda* VIII, IV; he reads the concluding line thus: *I nò posso di loro già (sic) co' far tesauro.*—This is known to be by a contemporary poet, as Senatore Morelli informs me.

Br. M. 129 a]　　　　　　　　　　**1333.**

Tricks
(1333—1335).

Noi siamo due fratelli, chè ciascuno di noi [2]à vn fratello; qui il modo del dire pare che [3]2 fratelli diuētino 4.

We are two brothers, each of us has a brother. Here the way of saying it makes it appear that the two brothers have become four.

C. 19 b]　　　　　　　　　　**1334.**

GIOCHI DI PARTITO.

[2]Mettiti in 2 mani equali numeri ·; metti 4 della mā [3]destra nella sinistra ‖ gitta via il rimanēte ‖ gitta via altrettā[4]to della man sinistra ‖ metti vi sopra · 5 ·; ora tu ti trovi [5]in quella mano 13 ‖ cioè io vi ti feci mettere 4 dalla destra nel[6]la sinistra, e gĭttar uia il rimanēte; ora qui la mā destra à piv 4 che là [7] nō sonovi; io ti fo poi gittare via altrettanto dalla destra quāto tu [8]gittasti dalla sinistra, che gittando dalle 2 mani due quātità e[9]quali, il rimanente fia equale; ora e'ti resta 4 e 4, che fa 8, [10]e perchè il giocco nō sia conosciuto io vi ti feci mettere sopra 5 [11]che fece · 13.

TRICKS OF DIVIDING.

Take in each hand an equal number; put 4 from the right hand into the left; cast away the remainder; cast away an equal number from the left hand; add 5, and now you will find 13 in this [left] hand; that is—I made you put 4 from the right hand into the left, and cast away the remainder; now your right hand has 4 more; then I make you throw away as many from the right as you threw away from the left; so, throwing from each hand a quantity of which the remainder may be equal, you now have 4 and 4, which make 8, and that the trick may not be detected I made you put 5 more, which made 13.

GIOCHI DI PARTITO.

[13]Togli da 12 in giù che numero ti piace; togli poi tāti de' mia che [14]tu finisca il numero di 12 ·, e quel che rimane a me è [15]il numero che tu aveui prima; perchè quādo io ti dissi to[16]gli da 12 in giù qual numero ti piace, io mi missi in mano [17]12, e di questo mio 12 tu togliesti tale numero, che tu [18]faciesti il tuo numero 12; ecco che tu cresciesti al tuo nu[19]mero che tu togliesti al mio; cioè che se tu aveui 8, a andare insino [20]in 12, tu togliesti del

TRICKS OF DIVIDING.

Take any number less than 12 that you please; then take of mine enough to make up the number 12, and that which remains to me is the number which you at first had; because when I said, take any number less than 12 as you please, I took 12 into my hand, and of that 12 you took such a number as made up your number of 12; and what you added to your number, you took from mine; that is, if you had 8 to go as far as to 12, you took of my 12, 4; hence this

1333. 1. nosiamo . . ciasscu. 2. qui el.
1334. 3. desstra. 4. tutti trovi. 5. coe . . . della desstra. 6. chella. 7. soneva . . desstra. 8. gittasti . . sinisstra. 9. ressta . . cheffa. 10. gocho . . cognossciuto . . fesi. 11. cheffece. 12. givochi di part "to". 13. polāti. 14. ttu finissca . . ecquel . . anmehe. 15. chettu prima tu perche. 16. ingu. 17. quesso mi 12 tu togliessti . . chettu. 18. faciessti . . chettu cressciessti. 19. mero tu togliessti . . coessettu. 8, andare. 20. togliessti. 21. atte . . ressta. 22. e he quale . . chello faciessi.

1334. G. Govi *says in the* 'Saggio' *p.* 22: *Si dilettò Leonarda di giuochi di prestigi e molti*(?) *ne descrisse, che si leggono poi riportati dal Paciolo nel suo libro:* de Viribus Quantitatis, *e che, se non tutti, sono certo in gran parte invenzioni del Vinci.*

mio 12 vn · 4; onde quel 4 trasmu²¹tato da me a te fa che'l mio 12 resta 8, e'l tuo 8 si fa 12; ²²adunque il mio 8 è equale al tuo 8 innāzi, che lo facesse 12.

4 transferred from me to you reduced my 12 to a remainder of 8, and your 8 became 12; so that my 8 is equal to your 8, before it was made 12.

C. A. 75*b*; 219*b*]

1335.

Se tu vuoi insegnia²re a vno · vna cosa ³che tu · nō sappia, falli ⁴misurare la lunghezza ⁵d'una cosa a te incogni⁶ta ·, e lui saprà la mi⁷sura che tu prima nō sā-⁸peui; — maestro Gi⁹ovanni da Lodi.

If you want to teach someone a subject you do not know yourself, let him measure the length of an object unknown to you, and he will learn the measure you did not know before;—Master Giovanni da Lodi.

1335. 1 settu volli insegni. 3. chettu sapia. 4. lungeza. 5. atte. 6. ellui. 7. chettu. 8. maesstro. 9. dallodi.

Letters. Personal Records. Dated Notes.

When we consider how superficial and imperfect are the accounts of Leonardo's life written some time after his death by Vasari and others, any notes or letters which can throw more light on his personal circumstances cannot fail to be in the highest degree interesting. The texts here given as Nos. 1351—1353, set his residence in Rome in quite a new aspect; nay, the picture which irresistibly dwells in our minds after reading these details of his life in the Vatican, forms a striking contrast to the contemporary life of Raphael at Rome.

I have placed foremost of these documents the very remarkable letters to the Defterdar of Syria. In these Leonardo speaks of himself as having staid among the mountains of Armenia, and as the biographies of the master tell nothing of any such distant journeys, it would seem most obvious to treat this passage as fiction, and so spare ourselves the onus of proof and discussion. But on close examination no one can doubt that these documents, with the accompanying sketches, are the work of Leonardo's own hand. Not merely is the character of the handwriting his, but the spelling and the language are his also. In one respect only does the writing betray any marked deviation from the rest of the notes, especially those treating on scientific questions; namely, in these observations he seems to have taken particular pains to give the most distinct and best form of expression to all he had to say; we find erasures and emendations in almost every line. He proceeded, as we shall see, in the same way in the sketches for letters to Giuliano de' Medici, and what can be more natural, I may ask, than to find the draft of a letter thus altered and improved when it is to contain an account of a definite subject, and when personal interests are in the scale? The finished copies as sent off are not known to exist; if we had these instead of the rough drafts, we might unhesi-

tatingly have declared that some unknown Italian engineer must have been, at that time, engaged in Armenia in the service of the Egyptian Sultan, and that Leonardo had copied his documents. Under this hypothesis however we should have to state that this unknown writer must have been so far one in mind with Leonardo as to use the same style of language and even the same lines of thought. This explanation might—as I say—have been possible, if only we had the finished letters. But why should these rough drafts of letters be regarded as anything else than what they actually and obviously are? If Leonardo had been a man of our own time, we might perhaps have attempted to account for the facts by saying that Leonardo, without having been in the East himself, might have undertaken to write a Romance of which the scene was laid in Armenia, and at the desire of his publisher had made sketches of landscape to illustrate the text.

I feel bound to mention this singular hypothesis as it has actually been put forward (see No. 1336 note 5); and it would certainly seem as though there were no other possible way of evading the conclusion to which these letters point, and their bearing on the life of the master,—absurd as the alternative is. But, if, on a question of such importance, we are justified in suggesting theories that have no foundation in probability, I could suggest another which, as compared with that of a Fiction by Leonardo, would be neither more nor less plausible; it is, moreover the only other hypothesis, perhaps, which can be devised to account for these passages, if it were possible to prove that the interpretation that the documents themselves suggest, must be rejected a priori; viz may not Leonardo have written them with the intention of mystifying those who, after his death, should try to decipher these manuscripts with a view to publishing them? But if, in fact, no objection that will stand the test of criticism can be brought against the simple and direct interpretation of the words as they stand, we are bound to regard Leonardo's travels in the East as an established fact. There is, I believe nothing in what we know of his biography to negative such a fact, especially as the details of his life for some few years are wholly unknown; nor need we be at a loss for evidence which may serve to explain—at any rate to some extent—the strangeness of his undertaking such a journey. We have no information as to Leonardo's history between 1482 and 1486; it cannot be proved that he was either in Milan or in Florence. On the other hand the tenor of this letter does not require us to assume a longer absence than a year or two. For, even if his appointment (offitio) as Engineer in Syria had been a permanent one, it might have become untenable—by the death perhaps of the Defterdar, his patron, or by his removal from office—, and Leonardo on his return home may have kept silence on the subject of an episode which probably had ended in failure and disappointment.

From the text of No. 1379 we can hardly doubt that Leonardo intended to make an excursion secretly from Rome to Naples, although so far as has hitherto been known, his biographers never allude to it. In another place (No. 1077) he says that he had worked as an Engineer in Friuli. Are we to doubt this statement too, merely because no biographer has hitherto given us any information on the matter? In the geographical notes Leonardo frequently speaks of the East, and though such passages

afford no direct proof of his having been there, they show beyond a doubt that, next to the Nile, the Euphrates, the Tigris and the Taurus mountains had a special interest in his eyes. As a still further proof of the futility of the argument that there is nothing in his drawings to show that he had travelled in the East, we find on Pl. CXX a study of oriental heads of Armenian type,—though of course this may have been made in Italy.

If the style of these letters were less sober, and the expressions less strictly to the point throughout, it might be possible to regard them as a romantic fiction instead of a narrative of fact. Nay, we have only to compare them with such obviously fanciful passages as No. 1354, Nos. 670—673, and the Fables and Prophecies. It is unnecessary to discuss the subject any further here; such explanations as the letter needs are given in the foot notes.

The drafts of letters to Lodovico il Moro are very remarkable. Leonardo and this prince were certainly far less closely connected, than has hitherto been supposed. It is impossible that Leonardo can have remained so long in the service of this prince, because the salary was good, as is commonly stated. On the contrary, it would seem, that what kept him there, in spite of his sore need of the money owed him by the prince, was the hope of some day being able to carry out the project of casting the 'gran cavallo'.

1336.

AL DIODARIO DI SIRIA LOCOTENĒTE DEL SACRO SOLTANO ²DI BABILONIA.	TO THE DEVATDAR OF SYRIA, LIEUTENANT OF THE SACRED SULTAN OF BABYLON.

³Il nvouo accidēte accaduto in queste nostre parti settentrionali, il quale sō certo che nō solamēte a te ma a tutto l'universo

[3] The recent disaster in our Northern parts which I am certain will terrify not you alone but the whole world, which

Drafts of Letters and Reports referring to Armenia (1336. 1337).

1336. 1. sorio. 3. [eaca n] "duto" [vono] "il nvouo" accidēte | "achaduto" in queste . . parte settantrionali [le quali so] "il

1336. Lines 1—52 are reproduced in facsimile on Pl. CXVI.

1. *Diodario*. This word is not to be found in any Italian dictionary, and for a long time I vainly sought an explanation of it. The youthful reminiscences of my wife afforded the desired clue. The chief town of each Turkish Villayet, or province—such as Broussa, for instance, in Asia Minor, is the residence of a Defterdar, who presides over the financial affairs of the province. *Defterdar hane* was, in former times, the name given to the Ministry of Finance at Constantinople; the Minister of Finance to the Porte is now known as the *Malliè-Nazri* and the *Defterdars* are his subordinates. A *Defterdar*, at the present day is merely the head of the finance department in each Provincial district. With regard to my suggestion that Leonardo's *Diodario* might be identical with the Defterdar of former times, the late M. C. DEFRÉMERIE, Arabic Professor, and Membre de l'Institut de France wrote to me as follows: *Votre conjecture est parfaitement fondée; diodario est l'equivalent de dévadar ou plus exactement dévâtdâr, titre d'une importante dignité en Egypte, sous les Mamlouks.*

The word however is not of Turkish, but of Perso-Arabic derivation. دفتر دار, دواة دار literally *Defter* (Arabic) meaning *folio;* for *dar* (Persian) Bookkeeper or holder is the English equivalent; and the idea is that of a deputy in command. During

the Mamelook supremacy over Syria, which corresponded in date with Leonardo's time, the office of Defterdar was the third in importance in the State.

Soltano di Babilonia. The name of Babylon was commonly applied to Cairo in the middle ages. For instance BREIDENBACH, *Itinerarium Hierosolyma* p. 218 says: "At last we reached Babylon. But this is not that Babylon which stood on the further shore of the river Chober, but that which is called the Egyptian Babylon. It is close by Cairo and the twain are but one and not two towns; one half is called Cairo and the other Babylon, whence they are called together Cairo-Babylon; originally the town is said to have been named Memphis and then Babylon, but now it is called Cairo." Compare No. 1085, 6.

Egypt was governed from 1382 till 1517 by the Borgite or Tcherkessian dynasty of the Mamelook Sultans. One of the most famous of these, Sultan Kaït Bey, ruled from 1468—1496 during whose reign the Gama (or Mosque) of Kaït Bey and tomb of Kaït Bey near the Okella Kaït Bey were erected in Cairo, which preserve his name to this day. Under the rule of this great and wise prince many foreigners, particularly Italians, found occupation in Egypt, as may be seen in the 'Viaggio di Josaphat Barbaro', among other travellers. "Next to Leonardo (so I learn from Prof. Jac. Burckhardt of Bâle) Kaït Bey's most helpful engineer was a German

farà ⁴terrore; il quale successiuamente ti sarà detto per ordine mostrando primo l'effetto e poi la causa . .

⁵Ritrovandomi · io in queste parti d'Erminia · a dare con amore e sollecitudine opera a quello vfitio, pel quale tu mi mãdasti, e nel ⁶dare principio in quelle parti che a me pareano esser · piv al proposito

shall be related to you in due order, showing first the effect and then the cause[4] . .

Finding myself in this part of Armenia[5] to carry into effect with due love and care the task for which you sent me[6]; and to make a beginning in a place which seemed to me to be most to our purpose, I entered into

quale [ere] sõ cierto" che . . atte mattutto . . dara. 4. terrore [e ca] il . . causa [e du]. 5. dare | "con amore essollecitudine" opera acquello [pe] vfitio . . mãdassti. 6. parte [chontingne ne a noi] che . . pareano | "eser" piv . . nosstro. 7. cita

who in about 1487 superintended the construction of the Mole at Alexandria. Felix Fabri knew him and mentions him in his *Historia Suevorum*, written in 1488."

3. *Il nuovo accidente accaduto*, or as Leonardo first wrote and then erased, *è accaduto un nuovo accidente*. From the sequel this must refer to an earthquake, and indeed these were frequent at that period, particularly in Asia Minor, where they caused immense mischief. See No. 1101 note.

4. The text here breaks off. The following lines are a fresh beginning of a letter, evidently addressed to the same person, but, as it would seem, written at a later date than the previous text. The numerous corrections and amendments amply prove that it is not a copy from any account of a journey by some unknown person; but, on the contrary, that Leonardo was particularly anxious to choose such words and phrases as might best express his own ideas.

5. *Parti d'Erminia.* See No. 945, note. The extent of Armenia in Leonardo's time is only approximately known. In the XVth century the Persians governed the Eastern, and the Arabs the Southern portions. Arabic authors—as, for instance Abulfeda—include Cilicia and a part of Cappadocia in Armenia, and Greater Armenia was the tract of that country known later as Turcomania, while Armenia Minor was the territory between Cappadocia and the Euphrates. It was not till 1522, or even 1574 that the whole country came under the dominion of the Ottoman Turks, in the reign of Selim I.

The Mamelook Sultans of Egypt seem to have taken a particular interest in this, the most Northern province of their empire, which was even then in danger of being conquered by the Turks. In the autumn of 1477 Sultan Kaït Bey made a journey of inspection, visiting Antioch and the valleys of the Tigris and Euphrates with a numerous and brilliant escort. This tour is briefly alluded to by *Moodshireddin* p. 561; and by WEIL, *Geschichte der Abbasiden* V, p. 358. An anonymous member of the suite wrote a diary of the expedition in Arabic, which has been published by R. V. LONZONE ('*Viaggio in Palestina e Soria di Kaid Ba XVIII sultano della II dinastia*

mamelucca, fatto nel 1477. *Testo arabo. Torino* 1878', without notes or commentary). Compare the critique on this edition, by J. GILDEMEISTER in *Zeitschrift des Deutschen Palaestina Vereins* (Vol. III p. 246—249). Lanzone's edition seems to be no more than an abridged copy of the original. I owe to Professor Schéfer, Membre de l'Institut, the information that he is in possession of a manuscript in which the text is fuller, and more correctly given. The Mamelook dynasty was, as is well known, of Circassian origin, and a large proportion of the Egyptian Army was recruited in Circassia even so late as in the XVth century. That was a period of political storms in Syria and Asia Minor and it is easy to suppose that the Sultan's minister, to whom Leonardo addresses his report as his superior, had a special interest in the welfare of those frontier provinces. Only to mention a few historical events of Sultan Kaït Bey's reign, we find that in 1488 he assisted the Circassians to resist the encroachments of Ala-eddoulet, an Asiatic prince who had allied himself with the Osmanli to threaten the province; the consequence was a war in Cilicia by sea and land, which broke out in the following year between the contending powers. Only a few years earlier the same province had been the scene of the so-called Caramenian war in which the united Venetian, Neapolitan and Sclavonic fleets had been engaged. (See CORIALANO CIPPICO, *Della guerra dei Veneziani nell'Asia dal* 1469—1474. Venezia 1796, p. 54) and we learn incidentally that a certain Leonardo Boldo, Governor of Scutari under Sultan Mahmoud,—as his name would indicate, one of the numerous renegades of Italian birth—played an important part in the negotiations for peace.

Tu mi mandasti. The address *tu* to a personage so high in office is singular and suggests personal intimacy; Leonardo seems to have been a favourite with the Diodario. Compare lines 54 and 55.

I have endeavoured to show, and I believe that I am also in a position to prove with regard to these texts, that they are draughts of letters actually written by Leonardo; at the same time I must not omit to mention that shortly after I had discovered

nostro ·, entrai nella 7 città · di Calindra, vicina ai nostri confini; questa città è posta nelle spiaggie di quel8la parte del mŏte Tavro, che è diuisa dall' Eufrates e riguarda i corni del grā Mŏte Tav9ro per ponēte ·; Questi corni · son di tanta altura che par che tocchino il cielo, chè nell' universo non è parte terre10stre piv alta della sua cima ·; e senpre 4 ore inanzi dì è per-

the city of Calindra[7], near to our frontiers. This city is situated at the base of that part of the Taurus mountains which is divided from the Euphrates and looks towards the peaks of the great Mount Taurus[8] to the West[9]. These peaks are of such a height that they seem to touch the sky, and in all the world there is no part of the earth, higher than its summit[10], and the rays of

di chalindra . . confini [e] questa . . ispiegge [del m] di quel. 8. diuisa [dal lago] dalleufrates [essa per le] e riguarda i [grā] corni del "grā". 9. altura [che lo per me non credo] "che par chettochino il celo" che nell universo [sia] "none" parte. 10. ste piv al della . . essenpre . . di [allu] e perchossa . . sole [che allei si mostra]. 11. lesere . . petra biāchissima

these texts in the Codex Atlanticus and published a paper on the subject in the *Zeitschrift für bildende Kunst* (*Vol. XVI*), Prof. GOVI put forward this hypothesis to account for their origin:

"*Quanto alle notizie sul monte Tauro, sull'Armenia e sull'Asia minore che si contengono negli altri frammenti, esse vennero prese da qualche geografro o viaggiatore contemporaneo. Dall'indice imperfetto che accompagna quei frammenti, si potrebbe dedurre che Leonardo volesse farne un libro, che poi non venne compiuto. A ogni modo, non è possibile di trovare in questi brani nessun indizio di un viaggio di Leonardo in oriente, nè della sua conversione alla religione di Maometto, come qualcuno pretenderebbe. Leonardo amava con passione gli studi geografici, e ne' suoi scritti s'incontran spesso itinerarî, indicazioni, o descrizioni di luoghi, schizzi di carte e abbozzi topografici di varie regioni, non è quindi strano che egli, abile narratore com'era, si fosse proposto di scrivere una specie di Romanzo in forma epistolare svolgendone l'intreccio nell'Asia Minore, intorno alla quale i libri d'allora, e forse qualche viaggiatore amico suo, gli avevano somministrato alcuni elementi più o meno fantastici.* (See *Transunti della Reale Accademia dei Lincei* Vol. V Ser. 3).

It is hardly necessary to point out that Prof. Govi omits to name the sources from which Leonardo could be supposed to have drawn his information, and I may leave it to the reader to pronounce judgment on the anomaly which is involved in the hypothesis that we have here a fragment of a Romance, cast in the form of a correspondence. At the same time, I cannot but admit that the solution of the difficulties proposed by Prof. Govi is, under the circumstances, certainly the easiest way of dealing with the question. But we should then be equally justified in supposing some more of Leonardo's letters to be fragments of such romances; particularly those of which the addresses can no longer be named. Still, as regards these drafts of letters to the *Diodario*, if we accept the Romance theory, as proposed by Prof. Govi, we are also compelled to assume that Leonardo purposed from the first to illustrate his tale; for it needs only a glance at the

sketches on Pl. CXVI to CXIX to perceive that they are connected with the texts; and of course the rest of Leonardo's numerous notes on matters pertaining to the East, the greater part of which are here published for the first time, may also be somehow connected with this strange romance.

7. *Città de Calindra* (*Chalindra*). The position of this city is so exactly determined, between the valley of the Euphrates and the Taurus range that it ought to be possible to identify it. But it can hardly be the same as the sea port of Cilicia with a somewhat similar name Celenderis, Kelandria, Celendria, Kilindria, now the Turkish Gulnar. In two Catalonian Portulans in the Bibliothèque Nationale in Paris—one dating from the XVth century, by Wilhelm von Soler, the other by Olivez de Majorca, in 1584—I find this place called Calandra. But Leonardo's Calindra must certainly have lain more to the North West, probably somewhere in Kurdistan. The fact that the geographical position is so carefully determined by Leonardo seems to prove that it was a place of no great importance and little known. It is singular that the words first written in l. 8 were *divisa dal lago* (Lake Van?), altered afterwards to *dall'Eufrates*.

Nostri confini, and in l. 6 *proposito nostro*. These refer to the frontier and to the affairs of the Mamelook Sultan. Lines 65 and 66 throw some light on the purpose of Leonardo's mission.

8. *I corni del grā mŏte Tauro*. Compare the sketches Pl. CXVI—CXVIII. So long as it is impossible to identify the situation of Calindra it is most difficult to decide with any certainty which peak of the Taurus is here meant; and I greatly regret that I had no foreknowledge of this puzzling topographical question when, in 1876, I was pursuing archaeological enquiries in the Provinces of Aleppo and Cilicia, and had to travel for some time in view of the imposing snow-peaks of Bulghar Dagh and Ala Tepessi.

9—10. The opinion here expressed as to the height of the mountain would be unmeaning, unless it had been written before Leonardo moved to Milan, where Monte Rosa is so conspicuous an

cossa dai razzi del sole ¹¹in oriēte·; e per essere lei di pietra biāchissima, essa forte risplende, e fa l'ufitio a questi Ermini come farebbe vn bel lume ¹²di luna·nel mezzo delle tenebre; e per la sua grande altura essa passa la somma altezza de' nuvoli per spatio di 4 miglia; e per linia retta ¹³questa cima è ueduta di grā parte dell'occidente alluminata dal sole dopo il suo tramontare ¹⁴insino alla 3ᵃ parte della notte; ed è quella che appresso di voi ne' tempi sereni abbiamo già giudicato essere vna cometa, e pare a noi nelle ¹⁵tenebre della notte mvtarsi in varie figure, e quādo diuidersi in due o in 3 parti, e quādo lūga e quādo corta; e questo nascie per li ¹⁶nuvoli che nel orizzonte del cielo s'interpongono infra parte d'esso monte e il sole, e per tagliare l'uno essi raz¹⁷zi solari·, il lume del monte è interrotto con vari spati di nvvoli, e però è di figvra uaria¹⁸bile nel suo splendore.

the sun always fall upon it on its East side, four hours before day-time, and being of the whitest stone[11] it shines resplendently and fulfils the function to these Armenians which a bright moon-light would in the midst of the darkness; and by its great height it outreaches the utmost level of the clouds by a space of four miles in a straight line. This peak is seen in many places towards the West, illuminated by the sun after its setting the third part of the night. This it is, which with you[14] we formerly in calm weather had supposed to be a comet, and appears to us in the darkness of night, to change its form, being sometimes divided in two or three parts, and sometimes long and sometimes short. And this is caused by the clouds on the horizon of the sky which interpose between part of this mountain and the sun, and by cutting off some of the solar rays the light on the mountain is intercepted by various intervals of clouds, and therefore varies in the form of its brightness.

DIVISIONE DEL LIBRO.

²⁰La predica e persuasione di fede;
²¹¶La subita inōdatione insin al ²²fine suo;¶
²³¶La ruina della città;
²⁴¶La morte del popolo ²⁵e disperatione;¶
²⁶¶La cerca del predica²⁷tore e la sua liberatione e benivo²⁸lentia;¶
²⁹¶Descritione della cavsa di tal ³⁰ruina del mōte;¶
³¹¶Il danno ch'ella fece;

THE DIVISIONS OF THE BOOK[19].

The praise and confession of the faith[20].
The sudden inundation, to its end.
[23]The destruction of the city.
[24]The death of the people and their despair.
The preacher's search, his release and benevolence[28].
Description of the cause of this fall of the mountain[30].
The mischief it did.

[essa] "essa forte rissplende e" fa . . acquesti . . chome. 12. luna "nel mezzo delle tenebre" e per . . le [magnie] somme" alteza de nugoli per [piv di 4 miglia] "per isspatio di 4 miglia" a | per. 13. ueduta [prima per] di . . dell ochcidente [pi] allumi. 14. e "jnsino alla 3 parte della notte" de cquella che apresso div[n]oi . . tenpi . . abiā ga gudicato . . cumeta . . annoi. 15. mvtarsi varie . . ecquādo . . parti "e equādo lūga ecquādo corta" ecquesto nasscie. 16. nvoli . . orizonte . . celo sinterpongano . . elsole . . essira. 17. ellume . . monte he . . varri [e] spati . . nvgoli. 24. popolo [el suo piāto]. 26. la [cōfermatio] la cerca. 27. ella . . venivo. 35. alagamēto . . parte. 40. profeta [mostra]; che *is wanting.*

object in the landscape. 4 *ore inanzi* seems to mean, four hours before the sun's rays penetrate to the bottom of the valleys.

11. *Pietra bianchissima.* The Taurus Mountains consist in great part of limestone.

14. *Appresso di voi.* Leonardo had at first written *noi* as though his meaning had been: This peak appeared to us to be a comet when you and I observed it in North Syria (at Aleppo? at Aintas?). The description of the curious reflection in the evening, resembling the "Alpine-glow" is certainly not an invented fiction, for in the next lines an explanation of the phenomenon is offered, or at least attempted.

19. The next 33 lines are evidently the contents of a connected Report or Book, but not of one

which he had at hand; more probably, indeed, of one he purposed writing.

20. *Persuasione di fede*, of the Christian or the Mohammedan faith? We must suppose the latter, at the beginning of a document addressed to so high a Mohammedan official. *Predica* probably stands as an abbreviation for *predicazione* (lat. *praedicatio*) in the sense of praise or glorification; very probably it may mean some such initial doxology as we find in Mohammedan works. (Comp. l. 40.)

26. 28. The phraseology of this is too general for any conjecture as to its meaning to be worth hazarding.

30. *Ruina del monte.* Of course by an earthquake. In a catalogue of earthquakes, entitled *kechf aussal-ssalèb an auasf ezzel-zelèh*, and written by Djelal eddin

[32] ¶ Ruina di neve;

[33] ¶ Trovata del profeta;

[34] ¶ La profetia sua;

[35] ¶ Allagamēto delle parti basse [36] di ‖ Erminia occidentale, [37] li scolamēti delle quali era[38]no per la tagliata di mōte Tav-[39]ro; ¶

[40] Come il novo profeta mostra che [41] questa ruina è fatta [42] al suo proposito;

[43] Descritione del mōte Tavro [44] e del fiume Evfrates;

[45] Perchè il monte risplende nella sua cima [46] la metà o'l 3° della notte, e pare vna [47] cometa a quelli di ponente dopo la [48] sera, eināti dì a quelli di leuāte.

[49] Perchè essa cometa par di uariabile [50] figura in modo che ora è tonda or [51] lunga e or diuisa in 2 or in 3 parti, e [52] ora vnita, e quādo si riuede.

FIGURA DEL MŌTE TAVRO.

[54] Non sono, o Diodario, da essere da te inputato di pigritia come le tue rāpogne · par che accennino ·, ma lo isfrenato amore, [55] il quale ha creato il benifitio ch'io posseggo da te, è quello, che mi à costretto cō somma [56] sollecitudine a cercare e cō diligiētia a investigare la cavsa di si grāde e stupēdo effetto ·; la qual cosa [57] nō sanza tēpo à potuto avere effetto; ora, per farti ben satisfatto della causa di si grande effetto, è neciessario ch'io ti mostri [58] la forma del sito, e poi verrò allo effetto col quale credo rimarrai satisfatto;

[32] Fall of snow.
The finding of the prophet [33].
His prophesy.

[35] The inundation of the lower portion of Eastern Armenia, the draining of which was effected by the cutting through the Taurus Mountains.

How the new prophet showed [40] that this destruction would happen as he had foretold.

Description of the Taurus Mountains [43] and the river Euphrates.

Why the mountain shines at the top, from half to a third of the night, and looks like a comet to the inhabitants of the West after the sunset, and before day to those of the East.

Why this comet appears of variable forms, so that it is now round and now long, and now again divided into two or three parts, and now in one piece, and when it is to be seen again.

OF THE SHAPE OF THE TAURUS MOUNTAINS [53].

I am not to be accused, Oh Devatdar, of idleness, as your chidings seem to hint; but your excessive love for me, which gave rise to the benefits you have conferred on me [55] is that which has also compelled me to the utmost painstaking in seeking out and diligently investigating the cause of so great and stupendous an effect. And this could not be done without time; now, in order to satisfy you fully as to the cause of so great an effect, it is requisite that I should explain to you the form of the place, and then I will proceed to the effect, by which I believe you will be amply satisfied.

41. [disc] questa . . effatta. 45. rissplende. 47. cometa [in] acquelli di. 48. acquelli. 50. ettondo. 51. lungho . . diuiso. 54. ho diodaro . . datte . . piegritia chome . . lo [tuo] isfrenato. 55. datte ecquello che [apv "a" chavoluto] che ma cō-stretto chō somma [dieligiētia]. 56. [cerchare ei] sollecitudine a cerchare . . anvessthighare la chavsa . . stupēte. 57. hora . . sadisfatto di si grande "della causa [effetto] e . . mosstri. 58. la [cavsa ella] forma . . rimarai satisfatto. 59. rissposta

Syouthy, the following statement occurs: "In the year 889 (1484 A.D.) there were six shocks of earthquake at Aleppo. They were excessively violent and threw the inhabitants into consternation." I owe this communication to the kindness of Prof. Ch. Schéfer, Membre de l'Institut, to whom this unpublished Arabic MS. belongs. The foregoing entries refer to two earthquakes in Cairo, in 1476 and 1481: the following ones indicate a time at which Leonardo was, certainly, living in Milan.

36. *Tagliata di Monte Tauro.* The Euphrates flows through the Taurus range near the influx of the Kura Shai; it rushes through a rift in the wildest cliffs from 2000 to 3000 feet high and runs on for 90 miles in 300 falls or rapids till it reaches Telek, near which at a spot called Gleikash, or the Hart's leap, it measures only 35 paces across. Compare the map on Pl. CXIX and the explanation fo it on p. 391.

40. *Novo profeta,* l. 33, *profeta.* Mohammed. Leonardo here refers to the Koran:

In the name of the most merciful God.—When the earth shall be shaken by an earthquake; and the earth shall cast forth her burdens; and a man shall say, what aileth her? On that day the earth shall declare her tidings, for that thy Lord will inspire her. On that day men shall go forward in distinct classes, that they may behold their works. And whoever shall have wrought good of the weight of an ant, shall behold the same. And whoever shall have wrought evil of the weight of an ant, shall behold the same. (The Koran, translated by G. Sale, Chapter XCIX, p. 452).

53—94. The facsimile of this passage is given on Pl. CXVII.

54. The foregoing sketch of a letter, lines 5. 18, appears to have remained a fragment when Leonardo received pressing orders which caused

59 Nō ti dolere, o Diodario, del mio tardare · a dar risposta alla tua desiderosa richiesta, perchè queste cose, di che tu mi richie60desti, son di natura che nō sanza processo di tenpo si possono bene esprimere, e massime perchè, a voler mostrare la causa di 61 si grande effetto, bisognia descrivere cō bona forma la natura del sito, e mediante quella tu potrai poi cō 62 facilità satisfarti della predetta richiesta;

63 Jo lascierò indietro la descritione della forma dell'Asia Minore, e che mari o terre sien quelle che terminono 64 la figura della sua quātità, perchè so che la diligentia e sollecitudine de' tua studi non t'ànno di tal notitia 65 privato; e verrò a denotare la vera figura di Tavrus Mōte, il quale è quello ch'è cavsatore di si stupenda e dannosa maraviglia, la quale · serue alla espeditione del nostro pro66posito; Questo monte Tavro è quello che appresso di molti è detto essere il giogo del Monte Cavcaso, ma, avēdo 67 voluto ben chiarirmi ·, ò voluto parlare con alquanti di quelli che abitano sopra del Mar Caspio, i quali mostrano che 68 quel sia il uero Mōte Caucaso, che, benchè i mōti loro abbino il medesimo nome, questi son di maggiore altura, e però cōfermano, perchè Caucaso in lingua Scitica vuol dire somma altezza ·, e in vero non ci è noti69tia che l'oriēte nè l' occidente abbia monte di si grande altura ·; e la pruova, che così sia ·, è che li abitatori de' pae70si, che gli stanno per ponēte, vedono i razzi del sole che allumina insino alla 4ª parte delle maggior notti grā 71 parte della sua cima ·, e'l simile fa a quelli paesi che gli stanno per oriēte.

QUALITÀ E QUĀTITÀ DEL MŌTE TAVRO.

73 L'onbra di questo giogo del Tauro è di tanta altura che, quādo di mezzo giugno il sole è a mezzo giorno, la sua ōbra s'a-

[59] Do not be aggrieved, O Devatdar, by my delay in responding to your pressing request, for those things which you require of me are of such a nature that they cannot be well expressed without some lapse of time; particularly because, in order to explain the cause of so great an effect, it is necessary to describe with accuracy the nature of the place; and by this means I can afterwards easily satisfy your above-mentioned request[62].

I will pass over any description of the form of Asia Minor, or as to what seas or lands form the limits of its outline and extent, because I know that by your own diligence and carefulness in your studies you have not remained in ignorance of these matters[65]; and I will go on to describe the true form of the Taurus Mountain which is the cause of this stupendous and harmful marvel, and which will serve to advance us in our purpose[66]. This Taurus is that mountain which, with many others is said to be the ridge of Mount Caucasus; but wishing to be very clear about it, I desired to speak to some of the inhabitants of the shores of the Caspian sea, who give evidence that this must be the true Caucasus, and that though their mountains bear the same name, yet these are higher; and to confirm this in the Scythian tongue Caucasus means a very high[68] peak, and in fact we have no information of there being, in the East or in the West, any mountain so high. And the proof of this is that the inhabitants of the countries to the West see the rays of the sun illuminating a great part of its summit for as much as a quarter of the longest night. And in the same way, in those countries which lie to the East.

OF THE STRUCTURE AND SIZE OF MOUNT TAURUS.

[73] The shadow of this ridge of the Taurus is of such a height that when, in the middle of June, the Sun is at its meridian, its

tua . . "desiderosa" richiessta queste [son cho] chose di che. 60. possano "bene" espriemere . . mosstrare. 61. disscrivere. 62. sadisfarti. 63. lassciero [sta] indirieto la desscriptione . . etterre . . chetterminino. 64. chella [tua] diligentia [de tua] essollecitudine . . notanno. 65. mōte | "il quel equello che chavsatore di si stupenda e danosa maraviglia" la quale . . esspeditione . . nosstro. 66. ecquello . . gogo . . cavcasso ma avē . . chasspio . . mosstrano. 68. caucaso "che beche i moti loro abbino il medesimo nome e questi son di magore altura e pero cōfermano" perche [a] cavcasso illingua isciticha vol . . alteza. 69. nelloccidente . . ella . . chosi . . he chelli. 70. chelli . . veggano i razi . . magor notto. 71. acquelli . .

him to write immediately and fully on the subject mentioned in line 43.

59—62. This passage was evidently intended as an improvement on that immediately preceding it. The purport of both is essentially the same, but the first is pitched in a key of ill-disguised annoyance

which is absent from the second. I do not see how these two versions can be reconciled with the romance-theory held by Prof. Govi.

68. Caucasus; Herodot Καύκασις; Armen. Kaukaz.

73—75. The statements are of course founded on those of the 'inhabitants' spoken of in l. 67.

74 stende insino al principio della Sarmatia, che sō giornate · 12, e a mezzo dicembre s'astē75de insino ai mōti Iperborei, che è viaggio d'un mese inverso tramontana; E senpre la sua parte opposita al uē76to che soffia è priva di nuvoli e nebbie, perchè il uento, che s'apre nella percussione del sasso, dopo esso sasso si uiene a richi-77vdere, e in tal moto porta con seco i nvvoli da ogni parte, e lasciali nella lor percussione; e senpre è piena di percussione di saette per la grā moltitudine di nvvoli che lì sō ricettati, onde il sasso è tutto fracassato e pien di grā ruine; Questo nelle 78sua radici è abitato da richissimi popoli, ed è pieno di bellissimi fonti e fiumi; è fer79tile e abondante d'ogni bene e massime nelle parti che riguardano a mezzo giorno; — 80ma quando se n'è montato circa 3 miglia, si comīcia a trovare le selue de' grā81di abeti, pini e faggi e altri simili alberi; dopo questi per spatio di 3 al82tre miglia si trovano praterie e grādissime pasture, e tutto il resto, insino 83al nascimēto del Monte Tavro, sono nevi

shadow extends as far as the borders of Sarmatia, twelve days off; and in the middle of December it extends as far as the Hyperborean mountains, which are at a month's journey to the North[75]. And the side which faces the wind is always free from clouds and mists, because the wind which is parted in beating on the rock, closes again on the further side of that rock, and in its motion carries with it the clouds from all quarters and leaves them where it strikes. And it is always full of thunderbolts from the great quantity of clouds which accumulate there, whence the rock is all riven and full of huge débris[77]. This mountain, at its base, is inhabited by a very rich population and is full of most beautiful springs and rivers, and is fertile and abounding in all good produce, particularly in those parts which face to the South. But after mounting about three miles we begin to find forests of great fir trees, and beech and other similar trees; after this, for a space of three more miles, there are meadows and vast pastures; and all the rest, as far as the beginning of the Taurus, is eternal snows

chelli. 73. gogho . . mezo gugnio . . he a mezo gorno. 74. insino [alla sarmatia] al . . chessō gornate . . mezo di[s]. cenbre sasste. 75. he viaggio Essenpre . . oposita. 76. chessoffia . . nvuoli ennebbie . . chessapre . . perchussione. 77. vedere [perche] e in . . nvuoli . . parte [e ne] ellasscia . . perchussione. *The text between the words* perchussione *and* Questa *has subsequently been added and is written on the margin in* 13 *short lines* . nugoli chelli . . ettutto frachassato 78. abitata . . piena . . effiumi. 79. mezo gorno. 80. montata circha . . comīca attrovare. 81. effaggi . . alberi [infrallo] dopo . . questo isspatio. 82. trova . . passture ettutto il retto. 83. nasscimēto . . neve etterne. 84. tano chessaste-

77. Sudden storms are equally common on the heights of Ararat. It is hardly necessary to observe that Ararat cannot be meant here. Its summit is formed like the crater of Vesuvius. The peaks sketched on Pl. CXVI—CXVIII are probably views of the same mountain, taken from different sides. Near the solitary peak, Pl. CXVIII these three names are written *goba*, *arnigasar*, *carūda*, names most likely of different peaks. Pl. CXVI and CXVII are in the original on a single sheet folded down the middle, 30 centimètres high and 43½ wide. On the reverse of one half of the sheet are notes on *peso* and *bilancia* (weight and balance), on the other are the 'prophecies' printed under Nos. 1293 and 1294. It is evident from the arrangement that these were written subsequently, on the space which had been left blank. These pages are facsimilied on Pl. CXVIII. In Pl. CXVI—CXVIII the size is smaller than in the original; the map of Armenia, Pl. CXVIII, is on Pl. CXIX slightly enlarged. On this map we find the following names, beginning from the right hand at the top: *pariardes mō* (for Paryadres Mons, Arm. Parchar, now Barchal or Kolai Dagh; Trebizond is on its slope).

Aquilone—North, *Antitaurus Antitaurus* \\\\ *psis mō* (probably meant for Thospitis = Lake Van, Arm. Dgov Vanai, Tospoi, and the Mountain range to the South); *Gordis mō* (Mountains of Gordyaea), the birth place of the Tigris; *Oriente*—East; *Tigris*, and then, to the left, *Eufrates*. Then, above to the left *Argeo mō* (now Erdshigas, an extinct volcano, 12000 feet high); *Celeno mō* (no doubt Sultan Dagh in Pisidia). Celeno is the Greek town of Κελαιναί—see Arian 1, 29, 1—now the ruins of Dineir); *oriente*—East; *africo libezco* (for libeccio—South West). In the middle of the Euphrates river on this small map we see a shaded portion surrounded by mountains, perhaps to indicate the inundation mentioned in l. 35. The affluent to the Euphrates shown as coming with many windings from the high land of 'Argeo' on the West, is the Tochma Su, which joins the main river at Malatie. I have not been able to discover any map of Armenia of the XVth or XVIth century in which the course of the Euphrates is laid down with any thing like the correctness displayed in this sketch. The best I have seen is the Catalonian Portulan of Olivez de Majorca, executed in 1584, and it is far behind Leonardo's.

eterne che mai per alcū tenpo si par[84]tono, che s'astendono all'altezza di circa 14 miglia in tutto; da questo na[85]scimēto del Tavro insino all'altezza d'vn miglio non passano mai i nuvoli; [86]che qui abbiamo 15 miglia, che sono circa a 5 · miglia d'altezza per linia retta, [87]e altrettanto o circa troviamo essere la cima delli corni del Tauro, [88]ne' quali dal mezzo in su si comincia a trovare aria che riscalda e nō [89]vi si sente soffiamēti de' uēti, ma nessuna cosa ci può troppo vivere; [90]quiui nō nascie cosa alcuna, saluo alcuni vccelli rapaci che [91]covano nell'alte fessure del Tavro, e disciēdono poi sotto i nuvoli [92]a fare le lor prede sopra i monti erbosi; Questo è tutto sasso senplice, [93]cioè da' nuvoli insù, ed è sasso candidissimo · e in sulla alta cima nō [94]si può andare per l'aspra e pericolosa sua salita.

which never disappear at any time, and extend to a height of about fourteen miles in all. From this beginning of the Taurus up to the height of a mile the clouds never pass away; thus we have fifteen miles, that is, a height of about five miles in a straight line; and the summit of the peaks of the Taurus are as much, or about that. There, half way up, we begin to find a scorching air and never feel a breath of wind; but nothing can live long there; there nothing is brought forth save a few birds of prey which breed in the high fissures of Taurus and descend below the clouds to seek their prey. Above the wooded hills all is bare rock, that is, from the clouds upwards; and the rock is the purest white. And it is impossible to walk to the high summit on account of the rough and perilous ascent.

C. A. 211*b*; 621*a*]

1337.

Avēdoti · io più volte fatto · con mia lettere partecipe · delle cose che di qua · sono · accadute ·, no m'è paruto tacere a [2]vna nova · accaduta · ne'giorni passati · la quale

[3]Avēdoti io piv volte

[4]Essendomi io più volte con lettere rallegrato · teco della tua prospera fortuna ·, al presente so che come amico ti cōtristerai · con meco [5]del misero · stato nel quale mi trovo; ¶e questo è che ne'giorni · passati · sono stato · in tāti affanni, [6]pavre, pericoli e danno · insieme con questi miseri paesani, che avevamo d'avere invidia ai morti, e cierto · io nō credo · [7]che, poichè gli elemēti con lor separatione · disfeciono · il grā caos, che essi riunissino · lor forza, anzi rabbia ·,

Having often made you, by my letters, acquainted with the things which have happened, I think I ought not to be silent as to the events of the last few days, which—[2]. . .

Having several times—

Having many times rejoiced with you by letters over your prosperous fortunes, I know now that, as a friend you will be sad with me over the miserable state in which I find myself; and this is, that during the last few days I have been in so much trouble, fear, peril and loss, besides the miseries of the people here, that we have been envious of the dead; and certainly I do not believe that since the elements by their separation reduced the vast chaos to order, they have ever combined their force and fury to do so much mischief to man. As far as regards

dano all alteza . . circha . . da cquesto. 85. alteza . . mai e nvuoli. 86. abiamo . . chessono circha . . dalteza. 87. circha troviano. 88. cominca attrovare . . risscalda. 89. cipo. 90. nasscie chosa. 91. disciēdano . . nvgoli. 92. affare . . Quessto ettutto. 93. coe . . nvgoli . . chandidissimo. 94. si po . . lasspra e pericholosa.

1337. 1. avēdoti "io" piu . . commia . . participe . . che didi qua . . achadute. 2. achaduta. 4. chollettere . . techo . . so "che chome amico" ti . . comecho. 5. ecquesto he. 6. pericholi . . chō . . avno | "davere" invidia . . inō credo. 7. collor . . che el

1337. On comparing this commencement of a letter l. 1—2 with that in l. 3 and 4 of No. 1336 it is quite evident that both refer to the same event. (Compare also No. 1337 l. 10—12 and 17 with No. 1336 l. 23, 24 and 32.) But the text No. 1336, including the fragment l. 3—4, was obviously written later than the draft here reproduced. The *Diodario* is not directly addressed—the person addressed indeed is not known—and it seems to me highly probable that it was written to some other patron and friend whose name and position are not mentioned.

a fare tanto nocimēto alli omini ⁸quāto al presente da noi · s'è veduto · e provato, in modo ch'io nō posso imaginare · che cosa si possin ⁹piv accresciere a tanto male, il quale noi provammo in spatio di dieci ore; In prima fummo assaliti e comba¹⁰ttuti dall'impeto · e furore de' vēti e a questo s'aggiunsero le ruine delli grā mōti di neve, i quali ànno ripieno tutte questi valli ¹¹e cōquassato grā parte della nostra città; E nō si cōtentādo di questo, la fortuna ¹²cō subiti diluvi d'acque ebbe a sommergere tutta la parte bassa di questa città; oltre di questo s'aggiunse vna subita piog¹³gia ·, anzi ruinosa tēpesta piena d'acqua, sabbia, fango e pietre, insieme avviluppati cō radici sterpi e ciocchi di uarie piāte; ¹⁴e ogni cosa scorrendo per l'aria discēdea sopra di noi ·; e in vltimo vno inciēdio di fuoco parea cōdotto nō che da vēti ma da 10 milia diavoli, che'l portassino, il quale à abbruciato e disfatto tutto questo ¹⁵paese, e ancora non vi è cessato; E que' pochi, che siamo restati, siamo rimasti · cō tanto sbigottimēto ¹⁶e tāta pavra che appena come balordi abbiamo ardire di parlare · l'uno coll' altro ·; avēdo · abbandonato ogni · nostra cura, ci stiamo insieme vniti ¹⁷jn cierte ruine di chiese insieme misti maschi e femine, piccoli e grādi, a modo di ¹⁸torme di capre; ¶ i vicini per pietà ci ànno soccorso di uettovaglie, i quali erā prima nostri

us here, what we have seen and gone through is such that I could not imagine that things could ever rise to such an amount of mischief, as we experienced in the space of ten hours. In the first place we were assailed and attacked by the violence and fury of the winds[10]; to this was added the falling of great mountains of snow which filled up all this valley, thus destroying a great part of our city[11]. And not content with this the tempest sent a sudden flood of water to submerge all the low part of this city[12]; added to which there came a sudden rain, or rather a ruinous torrent and flood of water, sand, mud, and stones, entangled with roots, and stems and fragments of various trees; and every kind of thing flying through the air fell upon us; finally a great fire broke out, not brought by the wind, but carried as it would seem, by ten thousand devils, which completely burnt up all this neighbourhood and it has not yet ceased. And those few who remain unhurt are in such dejection and such terror that they hardly have courage to speak to each other, as if they were stunned. Having abandoned all our business, we stay here together in the ruins of some churches, men and women mingled together, small and great[17], just like herds of goats. The neighbours out of pity succoured us with victuals, and they had previously been our enemies. And if

rivnissino . . rabie affare. 8. dannoi . . imodo . . chosa. 9. accressciere attanto male "il ˉquale" noi prevamo . . ore [Nori abbiamo] jn . . furno "assaliti". 10. ttutti . . effurore . . vēti [e in breue] acquesto sagivnse . . neve i quli ano ripieno . . valle. 11. parte [di questa] "della nostra" citta [e morte molte giēte] E nō si cōtentā di. 12. dilui . . assomergiere . . questa [terra] citta oltre a di questo sagivnse . . pio. 13. dacq "a" sabia . . avilupati cō radici "sterpi" ezzochi. 14. cosa | "scorendo per laria" discēdea . . focho il quala [a disfatto e] parea cōdotto nō chè da vēti ma da 10 milia diavoli chel portassino" a abruciato e difatto. 15. ancora [nō da sire al suo cōsumare] "noui e cessato" E que . . chessiano . . si ano rimasi . . esbigottimēto. 16. appena | "come balordi" abiamo advre . . abandonato. 17. ciese . . massci effemine picoli. *The text between the words* capre *and* Ora *is written on the margin.* *The words:* i vicini . . nostri nimici *are written in six short lines on the right side and the following words* esse nō . . di fame *are written in eleven lines on the opposite side:* i vicini |

11. *Della nostra città* (Leonardo first wrote *di questa città*). From this we may infer that he had at some time lived in the place in question wherever it might be.

17. *Certe ruine di chiese.* Either of Armenian churches or of Mosques, which it was not unusual to speak of as churches.

Maschi e femmini insieme unite, implies an infringement of the usually strict rule of the separation of the sexes.

18. *I vicini, nostri nimici.* The town must then have stood quite close to the frontier of the country. Compare 1336. L. 7. *vicini ai nostri confini.* Dr. M. JORDAN has already published lines 4—13 (see *Das Malerbuch, Leipzig,* 1873, p. 90:—his reading differs from mine)

under the title of "Description of a landscape near Lake Como". We do in fact find, among other loose sheets in the Codex Atlanticus, certain texts referring to valleys of the Alps (see Nos. 1030, 1031 and note p. 237) and in the arrangement of the loose sheets, of which the Codex Atlanticus has been formed, these happen to be placed close to this text. The compiler stuck both on the same folio sheet; and if this is not the reason for Dr. JORDAN's choosing such a title (Description &c.) I cannot imagine what it can have been. It is, at any rate, a merely hypothetical statement. The designation of the population of the country round a city as "the enemy" (*nemici*) is hardly appropriate to Italy in the time of Leonardo.

nimici;¶ e se nō fussero cierti popoli che ci ànno soccorso di uettovaglia, tutti saremmo morti di fame; Ora vedi come ci ¹⁹troviamo ·; E tutti questi mali son niēte · a cōparatione di quelli che in breve tēpo ne son promessi;

²⁰So che come amico ti cōtristerai del mio · male · come già con lettere ti mostrai con effetto rallegrarmi del tuo bene...

it had not been for certain people who succoured us with victuals, all would have died of hunger. Now you see the state we are in. And all these evils are as nothing compared with those which are promised to us shortly.

I know that as a friend you will grieve for my misfortunes, as I, in former letters have shown my joy at your prosperity . . .

F. 37*b*]

1338.

LIBRO 43 DEL MOTO DELL' ARIA INCLUSA SOTTO L' ACQUA.

BOOK 43. OF THE MOVEMENT OF AIR ENCLOSED IN WATER.

Notes about events observed abroad (1338. 1339).

.... Ho veduto mov³imēti d' aria tanto furiosi, che ànno ac⁴conpagniati e misti col corso suo li ⁵grandissimi alberi delle selue e li tetti in⁶teri de grā palazzi, e questa medesima ⁷furia fare vna buca con moto reuer⁸tiginoso e cavare vn ghiareto e portare ghi⁹ara, rena, acqua più d' ū mezzo miglio in¹⁰aria.

I have seen motions of the air so furious that they have carried, mixed up in their course, the largest trees of the forest and whole roofs of great palaces, and I have seen the same fury bore a hole with a whirling movement digging out a gravel pit, and carrying gravel, sand and water more than half a mile through the air.

Br. M. 155*a*]

1339.

A similitudine d' uno ritrosito vento che scorra in un a²renosa e cavata valle che pel suo velocie corso scac³cia al cētro tutte quelle cose che s' oppōgono al suo furi⁴oso corso....

Like a whirling wind which rushes down a sandy and hollow valley, and which, in its hasty course, drives to its centre every thing that opposes its furious course

⁵Non altramēti il settētrionale aquilone ripercuote ⁶colla sua tēpesta....

No otherwise does the Northern blast whirl round in its tempestuous progress

"per pieta" ci a sochorso . . esse nō fussi socorso di uttovaglia . . saremo. 19. Ettitti .⌐. chē brieve . . ne promesso. 20. chome . . cōtrissterai . . chome . . collettere timosstra . . ralegrarmi. 1338. 1. lacq"a". 3. anno a. 5. elli. 6. palazi ecquesta. 7. bucha. 8. giareto e portare gia. 9. mezo miglo. 10. naria. 1339. 1. chesschorranuna. 2. chavata . . chorso scha. 3. qlle chose chessoppōghono. 4. chorso. 5. altremēti . . settātrione . . riperchuote. 6. cholla. 7. mvglia il [sellantrionale] tēpesstoso. 8. [mosso chō grā furia da] quādo . . settātrionale.

1338. The first sixteen lines of this passage which treat of the subject as indicated on the title-line have no place in this connexion and have been omitted.

2. *Ho veduto movimenti* &c. Nothing of the kind happened in Italy during Leonardo's lifetime, and it is therefore extremely probable that this refers to the natural phenomena which are so fully described in the foregoing passage. (Compare too, No. 1021.) There can be no doubt that the descriptions of the Deluge in the Libro di Pittura (Vol. I, No. 607—611), and that of the fall of a mountain No. 610, l. 17—30 were written from the vivid impressions derived from personal experience. Compare also Pl. XXXIV—XL.

1339. It may be inferred from the character of the writing, which is in the style of the note in facsimile Vol. I, p. 297, that this passage was written between 1470 and 1480. As the figure *6* at the end of the text indicates, it was continued on another page, but I have searched in vain for it. The reverse of this leaf is coloured red for drawing in silver point, but has not been used for that purpose but for writing on, and at about the same date. The passages are given as Nos. 1217, 1218, 1219, 1162 and No. 994 (see note page 218). The text given above is obviously not a fragment of a letter, but a record of some personal experience. No. 1379 also seems to refer to Leonardo's journeys in Southern Italy.

[7]Nō fa si grā mugghio il tēpestoso mare, [8]quādo il settētrionale aquilone [9]lo ripercuote colle scivmose onde fra Scilla e Cariddi, nè Stronboli o Mō[10]gibello, quando le solfuree fiaͫe, essendo rīchiuse, [11]per forza ronpēdo e aprēdo il grā mōte, fulminādo [12]per l'aria pietre terra īsieme coll'uscita e vomitata fiaͫa . . .

[13]Nè quādo le infocate caverne di Mōgibello rivomitādo il male tenuto elemēto, spigniendolo [14]alla sua regione, cō furia cacciādo īnāzi qualūche ostacolo [15]s'interpone alla sua īpetuosa furia. . . .

[16]E tirato dalla mia bramosa voglia, vago di uedere la gran cō . . . [17]delle varie e strane forme fatte dalla artifiziosa natura, ragiratomi [18]alquāto ĵfra gli ōbrosi scogli pervenni all' ētrata d'una [19]grā caverna dinanzi alla quale restato alquāto [20]stupefatto,—e ĵgniorante di tal cosa piegato le mie rene [21]in arco e ferma la stāca mano sopra il ginocchio e colla destra mi feci tenebra [22]alle abbassate e chivse ciglia; e spesso piegādomi in qua e in là per ve[23]dere dētro vi discernessi alcuna cosa, e questo vietatomi per [24]la grāde oscurità, che là entro era, e stato alquāto, subito si destarono [25]in me 2 cose, pavra e desiderio; paura · per la minaccio[26]sa oscura spilonca, desiderio per vedere se là ētro fusse alcuna [27]miracolosa cosa. . . .

Nor does the tempestuous sea bellow so loud, when the Northern blast dashes it, with its foaming waves between Scylla and Charybdis; nor Stromboli, nor Mount Etna, when their sulphurous flames, having been forcibly confined, rend, and burst open the mountain, fulminating stones and earth through the air together with the flames they vomit.

Nor when the inflamed caverns of Mount Etna, rejecting the ill-restrained element vomit it forth, back to its own region, driving furiously before it every obstacle that comes in the way of its impetuous rage

Unable to resist my eager desire and wanting to see the great of the various and strange shapes made by formative nature, and having wandered some distance among gloomy rocks, I came to the entrance of a great cavern, in front of which I stood some time, astonished and unaware of such a thing. Bending my back into an arch I rested my left hand on my knee and held my right hand over my down-cast and contracted eye brows: often bending first one way and then the other, to see whether I could discover anything inside, and this being forbidden by the deep darkness within, and after having remained there some time, two contrary emotions arose in me, fear and desire—fear of the threatening dark cavern, desire to see whether there were any marvellous thing within it

C. A. 382 *a*; 1182 *a*] **1340.**

Auēdo, signore mio illustrissimo, uisto e considerato oramai a sufficiētia le proue di tutti quelli · che si [2]reputano maestri e

Most illustrious Lord, Having now sufficiently considered the specimens of all those who proclaim themselves skilled contrivers

Drafts of Letters to Lodovico il Moro (1340—1345).

9. riperchuote "chole scivmose onde frassilla echaridbi nesstronboli. 10. zolfurę. 12. cholluscita "e vomitata" fiaͫa. 13. lēfochate chaverne "di mōgibello" ri vomitādo "il male tenuto elemento" spigniendolo. 14. chō . . chacciādo . . osstacholo. 16. vagho . . la gra chō\\\\\. 17. varie "e strane" forme . . ragiratom\\\\. 18. schogli pervenni [alla b] all. 19. chavena [nella quale] dinanzi . . resstato. 20. chosa [chomīciato] pieghato . . ren\\\. 21. archo [e colla] "e ferma la" stāca mano [su] "sopra il" ginocchio e cholla desstra . . feci ten\\\\. 22. ecchiuse . . essspesso pieghādomi in qua e illa per\\\\\. 23. vdissciernessi alchuna chosa . . vietatom\\\\\. 24. osschurta . . esstato allquāto subitose. 25. le īme 2 [chōtrarie] chose . . la mina. 26. ce osscura spiloncha . . alchu\\\. 27. mirachalosa chosa . *6.*

1340. 1—36 *written from left to right.* 1. Hauēdo S "re" mio ĵll. . . horamai ad. 2. che le . . di dicti. 3. alieni dal cœ . . ex-

13. *Mongibello* is a name commonly given in Sicily to Mount Etna (from Djebel, Arab.=mountain). Fr. FERRARA, *Descrizione dell' Etna con la storia delle eruzioni* (Palermo, 1818, p. 88) tells us, on the authority of the *Cronaca del Monastero Benedettino di Licordia*, of an eruption of the Volcano with a great flow of lava on Sept. 21, 1447. The next records of the mountain are from the years 1533 and 1536. A. Percy neither does mention any eruptions of Etna during the years to which this note must probably refer (*Mémoire des tremblements de terre de la péninsule italique*, Vol. XXII des Mémoires

couronnées et Mémoires des savants étrangers. Académie Royale de Belgique).

A literal interpretation of the passage would not, however, indicate an allusion to any great eruption; particularly in the connection with Stromboli, where the periodical outbreaks in very short intervals are very striking to any observer, especially at night time, when passing the island on the way from Naples to Messina.

1340. The numerous corrections, the alterations in the figures (l. 18) and the absence of any signature prove that this is merely the rough draft of a

compositori di instruměti bellici ·, et che la inuětione di operatione di detti 3 instruměti nō sono niente aliene dal commune vso: Mi forzerò, nō derogando a nessuno altro, 4 farmi ītendere da Vostra Eccellentia, aprě-

of instruments of war, and that the invention and operation of the said instruments are nothing different to those in common use: I shall endeavour, without prejudice to any one else, to explain myself to your Excellency

do a quella li secreti · mei ·, e appresso offerendoli ad ogni suo piacimento 5 ī tempi opportuni operare cũ effetto ancora tutte quelle cose · che sub breuità in parte saranno qui disotto 6 notate.

showing your Lordship my secrets, and then offering them to your best pleasure and approbation to work with effect at opportune moments as well as all those things which, in part, shall be briefly noted below.

forzero . . altº. 4. ītende"re" da v. ex"tia" . . qlla . . ap̄psso . . ad ōi . . piacim̄to. 5. oportuni . . cũ . . āca . . bre-
uita "ī pâte" saranno. 6. notate [e anchora ī molte piu secōdo le occurrětie de diuěsi casi s]. 7. acti . . qlli. 8. uolta

letter to Lodovico il Moro. It is one of the very few manuscripts which are written from left to right—see the facsimile of the beginning as here reproduced. This is probably the final sketch of a document the clean of which copy was written in the usual manner. Leonardo no doubt very rarely wrote so, and this is probably the reason of the conspicuous dissimilarity in the handwriting, when he did. (Compare Pl. XXXVIII.) It is noteworthy too that here the orthography and abbreviations are also exceptional. But such superficial peculiarities are not enough to stamp the document as altogether spurious. It is neither a forgery nor the production of any artist but Leonardo himself. As to this point the contents leave us no doubt as to its authenticity, particularly l. 32 (see No. 719,

where this passage is repeated). But whether the fragment, as we here see it, was written from Leonardo's dictation—a theory favoured by the orthography, the erasures and corrections — or whether it may be a copy made for or by Melzi or Mazenta is comparatively unimportant. There are in the Codex Atlanticus a few other documents not written by Leonardo himself, but the notes in his own hand found on the reverse pages of these leaves amply prove that they were certainly in Leonardo's possession. This mark of ownership is wanting to the text in question, but the compilers of the Codex Atlanticus, at any rate, accepted it as a genuine document.

With regard to the probable date of this projected letter see Vol. II, p. 3.

1. [7]Ho modi di ponti leggierissimi e forti, e atti ad portare facilissimamēte, et cō quelli seguire [8]e alcuna uolta fuggire li inimici, e altri securi e īoffensibile da foco [9]e battaglia ·, facili e comodi da leuare e ponere ·; Et modi di ardere e disfare quelli dell'inimico.

[10]2. So ī la ossidione di una terra togliere uia l'acqua de' fossi ·; e fare īfiniti pōti: gatti e scale [11]e altri īstrumenti pertinēti a detta speditione.

[12]3. Itē se per altezza di argine o per · fortezza di loco e di sito nō si potesse ī la ossidione di [13]vna terra usare l'officio delle bombarde: ho modi di ruinare omni rocca o altra fortezza, [14]se già nō fusse fondata ī su el sasso ecc.

[15]4. Ho ancora modi di bombarde comodissime e facili a portare: Et con quelle buttare minuti sassi [16]a similitudine quasi di tempesta ·; E con il fumo di quella dando grāde spauēto al'inimico [17]con graue suo danno e confusione ecc.

[18]9. Et quādo accadesse essere ī mare, ho modi di molti īstrumenti attissimi da offendere e difendere: [19]et nauili che faranno resistentia al trarre di omni grossissima bōbarda: e poluere e fiumi.

[20]5. Itē ho modi: per caue e uie secrete distorte fatte senza alcuno strepito per uenire disegnato [21]... ancora che bisogniasse passare sotto fossi o alcuno fiume.

[22]6. Item farò carri coperti e sicuri īoffensibili ·, i quali ētrādo ītra li inimici con sue artiglierie:, nō è si grāde multi[23]tudine di gente d'arme che nō rompessino: E dietro a questi potranno seguire fāterie assai illesi e sēza [24]alcuno īpedimēto.

[25]7. Item occorrendo di bisogno, farò bōbarde, mortari et passauolanti di bellissime e utili forme fuori del comune uso;

[26]8. Doue mācasse la operatione · delle bōbarde comporrò briccole, māgani | trabuchi e altri īstrumenti di mirabile [27]efficacia e fuori del' usato: Et ī soma secondo la uarietà de' casi cōporrò uarie e īfinite cose da offēdere e di ...

1) I have a .sort of extremely light and strong bridges, adapted to be most easily carried, and with them you may pursue, and at any time flee from the enemy; and others, secure and indestructible by fire and battle, easy and convenient to lift and place. Also methods of burning and destroying those of the enemy.

2) I know how, when a place is besieged, to take the water out of the trenches, and make endless variety of bridges, and covered ways and ladders, and other machines pertaining to such expeditions.

3) Item. If, by reason of the height of the banks, or the strength of the place and its position, it is impossible, when besieging a place, to avail oneself of the plan of bombardment, I have methods for destroying every rock or other fortress, even if it were founded on a rock, &c.

4) Again I have kinds of mortars; most convenient and easy to carry; and with these can fling small stones almost resembling a storm; and with the smoke of these causing great terror to the enemy, to his great detriment and confusion.

9) [8]And when the fight should be at sea I have kinds of many machines most efficient for offence and defence; and vessels which will resist the attack of the largest guns and powder and fumes.

5) Item I have means by secret and tortuous mines and ways, made without noise to reach a designated [spot], even if it were needed to pass under a trench or a river.

6) Item. I will make covered chariots, safe and unattackable which, entering among the enemy with their artillery, there is no body of men so great but they would break them. And behind these, infantry could follow quite unhurt and without any hindrance.

7) Item. In case of need I will make big guns, mortars and light ordnance of fine and useful forms, out of the common type.

8) Where the operation of bombardment should fail, I would contrive catapults, mangonels, *trabocchi* and other machines of marvellous efficacy and not in common use. And in short, according to the variety of cases, I can contrive various and endless means of offence and defence.

[secondo le occurrētie] fuggire. 9. de ād̄e . . qlli. 10. obsidione de . . togle"r" uia laqua, et . . ghatti. 11. ad dicta expeditione. 12. de āgine . . de loco . . pottesse . . obsidione de. 13. dele . . omni [forte] o | "rocca" (?) altra. 14. saxo. 15. anchora . . de bombāde . . facile ad . . Et cū q̄lle . . minuti [saxi]. 16. a [disimilitudine quasi] di . . cūel . . q̄lla. 17. cū. 18. accadessi de . .ı strumti actissimi . . offend̄e e defend̄e. 19. de . . g"o"ssissima . . polue. 20. facte . . uenire [ad uno ce"r"to] e diseg"a"to. 21. \\\\\\\\ anchora . . coperti "e sicuri" e . . cq"a"li ītrādo ītra [in] li inimica cū . . si [grosso] grande. 23. darme . . Et . . poteranno inlesi. 24. alchuno. 25. occurendo di bi soḡ . . mōtari . . utile forma fora del cōe. 26. mācassi . . de le componero . . māgliani. 27. fora . . sēdo . . cōpoñro . . ed \\\\\\\. 28. credo satisfare . . ō̄ . . edifitii e p. 29. et pvati . .

²⁸10. Jn tēpo di pace credo di soddis-
fare benissimo al paragone di ogni altro in
architettura, ī compositione di edifitii e pu-
blici ²⁹e privati: e ī cōdurre acqua da uno
loco ad uno altro.

³⁰Jtē cōdurrò ī scultura, di marmore,
di bronzo e di terra: simile ī pictura ciò
che si possa fare ³¹a paragone di ogni altro
e sia chi vuole.

³²Ancora si potrà dare opera al cauallo
di bronzo, che sarà gloria īmortale e
eterno onore della ³³felice memoria del
signore vostro padre e dela īclyta casa
Sforzesca;

³⁴E se alcuna delle sopradette cose a al-
cuno paressino īpossibili e īfattibili, mi offro
³⁵paratissimo a farne esperimento ī parco
uostro, o ī qual loco piacerà a vostra Ecel-
lenza, al³⁶la quale umilmente quanto più
posso, mi raccomando ecc.

10) In time of peace I believe I can give
perfect satisfaction and to the equal of any other
in architecture and the composition of buil-
dings public and private; and in guiding
water from one place to another.

Item: I can carry out sculpture in marble,
bronze or clay, and also in painting whatever
may be done, and as well as any other, be
he whom he may.

[32]Again, the bronze horse may be taken
in hand, which is to be to the immortal glory
and eternal honour of the prince your father
of happy memory, and of the illustrious house
of Sforza.

And if any one of the above-named things
seem to any one to be impossible or not
feasible, I am most ready to make the ex-
periment in your park, or in whatever place
may please your Excellency—to whom I com-
mend myself with the utmost humility &c.

S. K. M. III. 28 b] 1341.

Al mio Illustrissimo Signore Lodouico,
 Duca di Bari·/.
Leonardo Da · Vinci
 Fiorentino ·
⁵Leonardo.

To my illustrious Lord, Lodovico,
 Duke of Bari,
Leonardo da Vinci
 of Florence—
Leonardo.

S. K. M. III. 23 b] 1342.

Vi piace vedere uno · modello · del quale
²risulterà · vtile · a uoi e a me ·, e vtili³tà
· a quelli che fieno · cagione · di no⁴stra
vtilità.

You would like to see a model which
will prove useful to you and to me, also
it will be of use to those who will be the
cause of our usefulness.

cōducē aqua . . alto [acto ad offendē e difendē. 30. cōducero. 31. ad . . deōni . . uole. 32. Anchora si potera . . honore
dela. 33. s"r"vost"o" patre e dela. 34. Et se alchunọ dele sop"r" dicte . . alchuno . . īpossibile e infactibile me offer.
35. ad farene esperimento . . q"al" . . vost ex"tia" ad. 36. humilm̄te . . me recomādo de.
1341. *Written from left to right.* 1. Ill"mo" Sig"re". 2. bari.
1342. 1. vedere î modello. 2. am̄e. 3. acquelli cheffieno chagione.

1341. Evidently a note of the superscription of a
letter to the Duke, and written, like the foregoing
from left to right. The manuscript containing it
is of the year 1493. Lodovico was not proclaimed
and styled Duke of Milan till September 1494.
The Dukedom of Bari belonged to the Sforza
family till 1499.

1342. 1343. These two notes occur in the same

not very voluminous MS. as the former one and
it is possible that they are fragments of the same
letter. By the *Modello*, the equestrian statue is
probably meant, particularly as the model of
this statue was publicly exhibited in this very
year, 1493, on the occasion of the marriage
of the Emperor Maximilian with Bianca Maria
Sforza.

S. K. M. III. 79*b*] **1343.**

Ecco · signor · molti · giētil omini ²che faranno infra loro · questa · spesa, ³lasciādo loro · godere l'entrata dell'acque, ⁴mvlina e passaggio di navili, e quādo ⁵e' sarà vēduto · loro il prezzo loro rēderā⁶no il navilio di Martigiana . . .

There are here, my Lord, many gentlemen who will undertake this expense among them, if they are allowed to enjoy the use of admission to the waters, the mills, and the passage of vessels and when it is sold to them the price will be repaid to them by the canal of Martesana.

C. A. 308*b*; 939*a*] **1344.**

Assai mi rincrescie d'essere ī neciessità ·, ma piv mi dole ²che quella · sia causa · dello interrōpere il desiderio mio, il ³quale · è senpre disposto a vbidir uostra Eccellentia; ⁴forse che uostra Eccellēntia ⁵nō commise altro a messer Gual⁶tieri, credēdo che io avessi dina⁷ri

I am greatly vexed to be in necessity, but I still more regret that this should be the cause of the hindrance of my wish which is always disposed to obey your Excellency.

Perhaps your Excellency did not give further orders to Messer Gualtieri, believing that I had money enough.

⁸E mi rincrescie assai che tu m'abbi ri⁹trovato in neciessità, e che l'auere io ¹⁰a guadagniare il uitto,-m'abbi ¹¹a interronpere...

I am greatly annoyed that you should have found me in necessity, and that my having to earn my living should have hindered me. . . .

¹²Assai mi rincresce che l'auere a guadagnia¹³re il uitto · m'abbia forzato interrōpere l'opera e di soddis¹⁴fare ad alcuni piccoli,- del seguitare l'o¹⁵pera che già vostra Signoria mi commise; Ma spero in bre¹⁶ue avere guadagniato · tanto che potrò · soddisfare ¹⁷ad animo riposato · a vostra Eccielenza, alla quale ¹⁸mi raccomādo, e se uostra Signoria credesse ch'io ¹⁹avessi · dinari, quella s'ingannerebbe; ò tenvto · 6 · boche 56 mesi, e ò avuto 50 ducati.

[12] It vexes me greatly that having to earn my living has forced me to interrupt the work and to attend to small matters, instead of following up the work which your Lordship entrusted to me. But I hope in a short time to have earned so much that I may carry it out quietly to the satisfaction of your Excellency, to whom I commend myself; and if your Lordship thought that I had money, your Lordship was deceived. I had to feed 6 men for 56 months, and have had 50 ducats.

C. A. 328*b*; 983*b*] **1345.**

E se mi dato piv alcuna commissione d'alcuna . . .
²del premio del mio seruitio ·, perchè nō sō da essere da . . .
³cose assegniatiori, perchè loro ànno intante di pe . . .
⁴tie che bene possono assettare piv di me . . .
⁵nō la mia arte, la quale voglio mvtare ed . . .
⁶dato qualche vestimēto si oso vna somma . . .

And if any other comission is given me by any . . .
of the reward of my service. Because I am not [able] to be . .
things assigned because meanwhile they have . . . to them
. . which they well may settle rather than I . .
not my art which I wish to change and
given some clothing if I dare a sum

1343. 1. Ecci. 2. fa ranno infralloro. 3. lassciādo. 4. passagio. 5. prezo lor rēdevā.

1344. 1. rincrescie. 2. chausa . . interōpere . . il q. 3. ecellentia. 5. chomise altro [al] meser qual. 8. rineresscie . . chettu mabbi ri\\\\\\. 9. echellauere. 10. guadagnare [il pane] il uicto mabi. 11. anteronpere. 12. rincressce chellauere. 13. uicto mabia interōpere [lopera de il sadis]. 14. fare ad alcuni picioli di el seguitare [aluna] lo. 15. smi chomisse. 16. podṛo sadisfare. 17. eccieleza. 18. \\\\\\\\racomādo esse uostra S si. 19. \\\\\\\\ssi dinari quella quella singanerebe.

1345. 1. esse . . comesione. 3. tante di pe. 4. possano. 6. sioso vna soma. 7. uosstra . . ochupa. 8. vosstra . . mi | "pichol

1345. The paper on which this is written is torn down the middle; about half of each line remains.

⁷Signiore ·, conosciēdo · io · la mēte · di uo-
stra · Ecciellentia · essere · occupa · · ·
⁸il ricordare · a vostra Signioria · le mie
piccole e l'arti messe in silētio ...
⁹che 'l mio . taciere fusse causa · di fare ·
isdegniare vostra Signori ...
¹⁰la mia vita ai uostri seruiti · mi tiē con-
tinvamēte parato · a vbidire ...
¹¹del cauallo nō dirò niēte, perchè cognio-
sco · i tēpi ...
¹²a vostra Signoria com' io restai avere · il
salario di 2 · anni · del ...
¹³cō due . maestri · i quali cōtinvo · stettero ·
a mio salario e spesa ...
¹⁴che al fine mi trovai · avanzato detta
opera · circa 15 lire · mo ...
¹⁵opere di fama per le quali io potessi
mostrare a quelli che ueranno ch'io sono sta...
¹⁶sa per tutto · ma io nō so, doue io po-
tessi spēdere le mia opere a per ...

¹⁷l'auere io · atteso a guadagniarmi la
uita ...

¹⁸per non essere informato io che essere
io mi trova ...
¹⁹si ricorda · della commissione del dipigniere
· i camerini ...
²⁰portavo a vostra Signoria · solo richiedēdo
a quella ...

My Lord, I knowing your Excellency's
mind to be occupied
to remind your Lordship of my small matters
and the arts put to silence
that my silence might be the cause of making
your Lordship scorn . .
my life in your service. I hold myself ever
in readiness to obey . . .
[11]Of the horse I will say nothing because
I know the times [are bad]
to your Lordship how I had still to receive
two years' salary of the
with the two skilled workmen who are con-
stantly in my pay and at my cost
that at last I found myself advanced the
said sum about 15 lire
works of fame by which I could show to
those who shall see it that I have been
everywhere, but I do not know where I
could bestow my work [more] . . .

[17] I, having been working to gain my
living

I not having been informed what it is, I find
myself
[19]remember the commission to paint the
rooms
I conveyed to your Lordship only requesting
you

C. A. 316ᵇ; 958ᵇ]　　　　　　　1346.

Draft of letter to be sent to Pia-cenza (1346. 1347).

Magnifici · fabbricieri ·, intēdendo io vostre
magni²ficēze avere · preso · partito · di fare
cierte · magnie opere di bronzo; delle quali
· io vi ³darò · alcuno · ricordo · prima · che voi
nō siate · tanto . veloci · e tanto · presti a fare
essa allocatione ⁴chè per essa cielerità sia
tolto · la uia del potere · fare bona eletione
d'opere e maestri; e qualche omo che
per la · sua · insofficiētia abbia apresso a
vostri ⁵successori · a vituperare, se · ella vo-

Magnificent Commissioners of Buildings
I, understanding that your Magnificen-
cies have made up your minds to make
certain great works in bronze, will remind you
of certain things: first that you should not be
so hasty or so quick to give the commission,
lest by this haste it should become impossible
to select a good model and a good master;
and some man of small merit may be chosen,
who by his insufficiency may cause you to

ellarcimesse. 9. fussi chausa. 10. mi tiē. 11. [ia dinaro. 12. chomio . . ave"re" el. 13. maessti . . cōtinovo stettono . .
salario esspe. 14. avnzato ditta . . circha. 15. opere | "di fama" per elle . . acqelli che uerano. 16. opere [in piv] a per.
18. trovo [come e mi]. 19. richorda della comessione . . acquella.
1346. 1. [venerabili] e m²gnifici fabricieri [parēdo amme fare in parte]. 2. ficiēze [volere] avere. 3. richordo . . ettanto presst
a "affare essa allocatione" [pigliare partito]. 4. tolto "la uia del potere fare bona elletione dopere e maesstro" qualche
homo [di picho] | che . . abia . . vosstri.´ 5. suciessori . . ella vosstra eta "erchettalia siasi ui ciedi boni īgiegni"\|\|\|\|\|\| vdi-

11. See No. 723, where this passage is repeated.
17. See No. 1344 l. 12.
19. In April, 1498, Leonardo was engaged in
painting the Saletta Nigra of the Castello at Milan.
(See G. MONGERI, *l'Arte in Milano*, 1872, p. 417.)
1346. 1347. Piacenza belonged to Milan. The
Lord spoken of in this letter, is no doubt Lodovico
il Moro. One may infer from the concluding sen-
tence (No. 1346, l. 33. 34 and No. 1347), that
Leonardo, who no doubt compiled this letter,
did not forward it to Piacenza himself, but gave
it to some influential patron, under whose name
and signature a copy of it was sent to the Com-
mission.

stra · età givdicādo che questa · età fusse
mal fornita d'omini ⁶di bon givditio · e
di boni · maestri, vedendo le altre città, e
massime la città de' Fiorentini, · quasi ne'
medesimi tēpi, essere ⁷dotata di si belle e
magnie opere di bronzo, intra le quali le
porte del loro Battisterio ·; la qual Fiorētia ·,
si come Piaciētia, ⁸è terra di passo · doue ·
cōcorrono assai forestieri ., i quali vedendo
le opere belle o bone, belle fanno a se
⁹medesimi inpressioni: quella città · essere
fornita di degni abitatori, vedendo l' opere
testimonie d' essa opinione; e per lo contra-
rio di¹⁰co, vedendo · tanta spesa di metallo
operata si tristamēte, che mē uergognia
alla città ¹¹sarebbe che esse porte fussino
di senplice legniame ·, perchè la poca spesa
della materia ¹²nō parebbe meriteuole di
grāde · spesa di magisterio ·, ōde che . .

¹³La principale parte che per le città · si
ricierchi · si sono · i domi, ai quali appres-
satisi, le prime · cose, ¹⁴che all' ochio ap-
pariscono, · sono · le porte donde in esse
chiese passare si possa.

¹⁵Guardate ·, signiori · fabbricieri ·, che la ·
troppa celerità del uolere voi con tāta ¹⁶pre-
stezza · dare · speditione alla locatione · di
tanta magnia opera, quanto io sento che
per uoi ¹⁷s'è ordinata, non sia cagione che
quello ·, che per onore · di dio · e delli omini
si fa ·, non torni in grā ¹⁸disonore de' uostri
giuditi e della vostra città, doue, per essere
terra degnia e di passo, è concorso · d' in-
numera¹⁹bili forestieri ·; e questo disonore
accaderebbe ·, quādo per le · uostre · indili-
giētie ²⁰voi · prestasti · fede · a qualche van-
tatore che per le · sue frasche o per fauore ·,
che di qua · dato li fusse, ²¹da uoi auesse
a inpetrare · simile opera ·, per la quale · a
se e a uoi avesse a partorire lunga ²²e
grādissima infamia ·; Chè non posso · fare ·
che io non mi crucci · a ripensare quali
omini ²³sieno quelli che abbino · conferito ·
volere · in simile inpresa ētra²⁴re sanza pen-
sare alla loro sofitiēzia, sanza dirne altro ·;
chi è maestro · di boccali ·, chi di corazze

be abused by your descendants, judging that
this age was but ill supplied with men of
good counsel and with good masters; seeing
that other cities, and chiefly the city of the
Florentines, has been as it were in these very
days, endowed with beautiful and grand works
in bronze; among which are the doors of
their Baptistery. And this town of Florence,
like Piacenza, is a place of intercourse, through
which many foreigners pass; who, seeing that
the works are fine and of good quality, carry
away a good impression, and will say that that
city is well filled with worthy inhabitants, seeing
the works which bear witness to their opinion;
and on the other hand, I say seeing so much
metal expended and so badly wrought, it were
less shame to the city if the doors had been of
plain wood; because, the material, costing so
little, would not seem to merit any great
outlay of skill . . .

Now the principal parts which are sought
for in cities are their cathedrals, and of these
the first things which strike the eye are the
doors, by which one passes into these churches.

Beware, gentlemen of the Commission, lest
too great speed in your determination, and so
much haste to expedite the entrusting of so great
a work as that which I hear you have ordered,
be the cause that that which was intended for
the honour of God and of men should be turned
to great dishonour of your judgments, and of
your city, which, being a place of mark, is
the resort and gathering-place of innumerable
foreigners. And this dishonour would result
if by your lack of diligence you were to put
your trust in some vaunter, who by his
tricks or by favour shown to him here
should obtain such work from you, by
which lasting and very great shame would
result to him and to you. Thus I cannot
help being angry when I consider what men
those are who have conferred with you
as wishing to undertake this great work
without thinking of their sufficiency for it,
not to say more. This one is a potter,
that one a maker of cuirasses, this one is a

cādo . . heta fussi. 6. givditio che di . . maesstri vedendo | "nellaltre citta e massime" nella cita. 7. magnie | "opere di bronzo intrall
quali le" porte . . batissterio. 8. he tera . . cōcorre . . fano asse. — *On the margin near line* 1 *is the note:* piaciētia he terra
di passo come fiorenza. 9. inpressione . . essere [ben] fornita . . abitatori | "vedendo lopere testimonie desso oppenione" e
per lo contra di. 10. ovedendo trisstamēte. 11. sarebe . . perchella pocha. 12. parebe. 13. la principale "parti" chosa delle citta
per] che . . domi di quelle delle quali apresatosi le . . chose . . porte [per le quali] "donde" in ese ciese. 15. chella . .
ciclerita [e pressteza] del . . chon. 16. pressteza . . isspeditione . . omini "si fa" non. 18. disonore de uostri inditi e"
della vosstra cita . . chonchorso dinumera. 19. foresstieri ecquesto . . achaderebe . . perlle uosstre. 20. presstassi . .
acqualche vantato . . frape . favorare . fussi. 21. auessi . . asse e auoi auessi appartorire. 22. grādissima [vergognia] infamia . . nomi
isscrucci a "ri" | pēsare quali | "[sieno li] [quelgli]" omini. 23. quelli [dai quali io sia] ce ōme [cho] abbino chonferito.
24. sanza | "sanza pensare alla loro sofitiēzia" dir ne . . maessro . . bochali . . coraze . . chanpanaro. 25. sonaglieri [in-

chi canpanaro, alcuno [25]sonagliere, E insino bonbardiere, fra i quali vno Delsigniore s'è uātato · che tra l'essere [26]lui conpare de Messere · Anbrosio Ferrere—chi a qualche commissione—dal quale lui à buone promessioni ·; e se quello nō basterà [27]che mōterà · a cavallo · e andrà dal signiore e impetrerà tali lettere, [28]che per uoi mai simile opera nō gli sarà dinegata ·; o guardate dove i maestri, [29]atti a simili opere, sono ridotti quādo con simili omini ànno a gareggiare; [30]aprite li ochi · e vogliate bē uedere che i vostri dinari nō si spēdino [31]in conprare · le uostre · vergognie ·; jo vi so annvntiare che di questa terra voi nō [32]trarete se non è · opere di sorte e di vili e grossi magisteri; nō ci è uomo che vaglia; [33]e credetelo a me, saluo Leonardo Fiorē-tino, che fa il cauallo del duca Frācesco di brōzo, che non è bisognio fare stima, [34]perchè à che fare il tenpo di sua vita ·, e dubito che per l'essere si grāde opera che non la finirà mai.

[35]I miseri [36]studiosi [41]con che spe-[42]ranza e' posso[43]no aspettare pre[44]mio di lor virtù?

bell-founder, another a bell ringer, and one is even a bombardier; and among them one in his Lordship's service, who boasted that he was the gossip of Messer Ambrosio Ferrere [26], who has some power and who has made him some promises; and if this were not enough he would mount on horseback, and go to his Lord and obtain such letters that you could never refuse [to give] him the work. But consider where masters of real talent and fit for such work are brought when they have to compete with such men as these. Open your eyes and look carefully lest your money should be spent in buying your own disgrace. I can declare to you that from that place you will procure none but average works of inferior and coarse masters. There is no capable man,—[33]and you may believe me,—except Leonardo the Florentine, who is making the equestrian statue in bronze of the Duke Francesco and who has no need to bring himself into notice, because he has work for all his life time; and I doubt, whether being so great a work, he will ever finish it[34].

The miserable painstakers with what hope may they expect a reward of their merit?

C. A. 316a; 958a] 1347.

Ecco vno il quale il signiore ·, per fare questa sua opera à tratto di Firenze [2]che è degnio maestro, ma à tāta faciēda che non la finirà mai; [3]e credete voi che diffe-rētia · sia a vedere vna cosa bella da una brutta; [4]allega Plinio.

There is one whom his Lordship invited from Florence to do this work and who is a worthy master, but with so very much business he will never finish it; and you may imagine that a difference there is to be seen between a beautiful object and an ugly one. Quote Pliny.

1348.

Illmo ac Rͫo Dͫo Meo Unico.
D . Hip . Car .˜li Estensi D . meo Colͫo.
Ferrarie.
Illͫ ac R . me D . ne mi hu . co . men.

Letter to the Cardinal Ippolito d'Este.
Pochi giorni sono ch'io venni da Milano, et trovando che uno mio fratello maggiore

Most Illustrious and most Reverend Lord.
The Lord Ippolito, Cardinal of Este
at Ferrare.
Most Illustrious and most Reverend Lord.
I arrived from Milan but a few days since and finding that my elder brother refuses to

sino] E insino [a vna] bonbardiere | "frai quali vno del" del . . trallessere. 26. ferere "ce a qualce comessione" dal. . esse. 27. che [vel sara] mōtera a cchavallo e andra [attrovare] del signiore e [che vi portera] inpetera" tale. 28. gli sa dinegata mo . . dove [i maesstri dibono ingiegnio]. 29. agimile garegiare. 30. voliate . . uedere [in] che [modo] i vosstri dinari [si debbono spendere] nō . . le uostre le uosstre vergogni . . anvntiare . . tera. 32. none e hopere di sorte [e vili dib] e di vile . . homo. 33. saluo [quel] leonar fiorētino" cheffa il chauallo . . frāc° "di brōzo" che . . lesere. 34. nolla. 36. studiosi dif—. 37. [li uirtu che cō]. 38. [tanti studi sono]. 39. [venvti in qual]. 40. [cō grado di dise]. 41. [gnio] chon che spie. 42. possa. 43. asspettare.

1347. 1. Eci . . attratto di firenze. 2. tāta faciēda nolla. 3. diferētia da ı̈ brutta.

1346. 26. Messer Ambrogio Ferrere was Farmer of the Customs under the Duke. Piacenza at that time belonged to Milan.

1348. This letter addressed to the Cardinal

Ippolito d'Este is here given from Marchese G. CAMPORI's publication: *Nuovi documenti per la Vita di Leonardo da Vinci. Atti e Memorie delle R. R. Deputazioni di Storia patria per la provincie modenosi e par-*

non mi vuol servare uno testamento facto da 3 anni in qua che è morto nostro padre; ancor che la ragione sia per me, non dimeno per non mancare a me medesimo in una cosa che io stimo assai, non ho voluto ommettere di richiedere la R.^{ma} V. S. di una I.^{ra} commendatizia et di favore, qui a el S.^{or} Raphaello Jheronymo, che è al presente uno de n.^{ri} excelsi Sig.^{ri}, ne quali questa mia Causa si agita et particularmente è suta dal Ex.^{tia} del gonfaloniere rimessa nel pren.^{to} S.^{or} Raphaello et sua S.^{ia} la ha a decidere et terminare prima venga la festa di tutti e sancti. Et però Mons.^{or} mio io prego quanto più so e posso V. R. S. che scriva una I.^{ra} qui al decto S.^{or} Raphaello in quel dextro et affettuoso modo che lei saprà, raccomandandoli Leonardo Vincio sviisceratissimo Ser.^{re} suo, come mi appello, et sempre voglio essere: ricercandolo, e gravandolo mi voglia fare non solo ragione, ma expeditione favorevole, et io non dubito punto per molte relationi mi son facte che, sendo el S.^{or} Raphaello a V. S. Affectionatissimo, la cosa mi succederà ad votū. Il che attribuirò a la I.^{ra} di V. R. S. a la quale iterum mi racomando. Et bene valeat.

Florentie XVIII.^a 7bris 1507
E V. R. D.
S.^{tor} Humil.
Leonardus Vincius pictor.

carry into effect a will, made three years ago when my father died—as also, and no less, because I would not fail in a matter I esteem most important—I cannot forbear to crave of your most Reverend Highness a letter of recommendation and favour to Ser Raphaello Hieronymo, at present one of the illustrious members of the Signoria before whom my cause is being argued; and more particularly it has been laid by his Excellency the Gonfaloniere into the hands of the said Ser Raphaello, that his Worship may have to decide and end it before the festival of All Saints. And therefore, my Lord, I entreat you, as urgently as I know how and am able, that your Highness will write a letter to the said Ser Raphaello in that admirable and pressing manner which your Highness can use, recommending to him Leonardo Vincio, your most humble servant as I am, and shall always be; requesting him and pressing him not only to do me justice but to do so with despatch; and I have not the least doubt, from many things that I hear, that Ser Raphaello, being most affectionately devoted to your Highness, the matter will issue *ad votum*. And this I shall attribute to your most Reverend Highness' letter, to whom I once more humbly commend myself. *Et bene valeat.*

Florence XVIII^a 7bris 1507.
E. V. R. D.
your humble servant
Leonardus Vincius, pictor.

C. A. 310*a*; 944*a*] 1349.

Jo ho sospetto che la poca mia remuneratione de'gran benifiti che io ho riceuuti da nostra Eccelētia ²non l'abbino al-

I am afraid lest the small return I have made for the great benefits, I have received from your Excellency, have not made you

Draft of
Letter to the
Governor of
Milan.

1348. *Written from left to right.*
1349. 1. sosspecto chella poche.. uosstra. 2. nonabbino isdegnare conmecho ecquesto.. uosstra [ecci]. 3. auto risspossta..cossti..

menesi, *Vol. III. It is the only text throughout this work which I have not myself examined and copied from the original. The learned discoverer of this letter—the only letter from Leonardo hitherto known as having been sent— dds these interesting remarks:* Codesto Cardinale nato ad Ercole I. nel 1470, arcivescovo di Strigonia a sette anni, poi d'Agra, aveva conseguito nel 1497 la pingue ed ambita cattedra di Milano, là dove avrà conosciuto il Vinci, sebbene il poco amore ch'ei professava alle arti lasci credere che le proteste di servitù di Leonardo più che a gratitudine per favori ricevuti e per opere a lui allogate, accennino a speranza per un favore che si aspetta. Notabile è ancora in questo prezioso documento la ripetuta signatura del grande artista 'che si scrive Vincio e Vincius, non da Vinci come si tiene comunemente, sebbene l'una e l'altra possano valere

a significare così il casato come il paese; restando a sapere se il nome del paese di Vinci fosse assunto a cognome della famiglia di Leonardo nel qual supposto più propriamento avrebbe a chiamarsi Leonardo Vinci, o Vincio (latinamente Vincius) com'egli stesso amò segnarsi in questa lettera, e come scrissero parecchi contemporanei di lui, il Casio, il Cesariano, Geoffroy Tory, il Gaurico, il Bandello, Raffaelle Maffei, il Paciolo. Per ultimo non lascerò d'avvertire come la lettera del Vinci è assai ben conservata, di nitida e larga scrittura in forma pienemente corrispondente a quella dei suoi manoscritti, vergata all'uso comune da sinistra a destra, anzichè contrariamente come fu suo costume; ma indubbiamente autentica e fornita della menzione e del suggello che fresca ancora conserva l'impronta di una testa di profilo da un picciolo antico cammeo. (Compare No. 1368, note.)

quāto fatto sdegniare con meco, e questo è che da tante lettere che io ho scritte a uostra ³Signoria io non ò mai avuto risposta; hora io mando costì Salai per fare intendere a uostra Signoria ⁴come io sono quasi al fine del mio letigio che io ho· co'mia fratelli, come io credo trouarmi costì in questa ⁵pasqua e portare con meco due quadri di due nostre donne di uarie grandezze, Le quali son fatte ⁶pel cristianissimo nostro rè, e perchè a uostra Signoria piacerà, jo avrei ben caro di sapere alla mia ⁷tornata di costa, doue io auessi a stare per stanza, perchè non uorrei dare più noia a uostra Signoria, e ⁸ancora, auendo io lauorato pel cristianissimo rè, se la mia prouisione è per correre o no; jo scriuo ⁹al presidente di quella acqua che mi donò il·rè·, della quale non fui messo in possessione, perchè in quel tēpo u'era ¹⁰carestia nel nauilio per causa de'gran secchi, e perchè i sua bocchelli non erano moderati; ma bē mi promise che, ¹¹fatta tal moderatione, io ne sarei messo in possessione; sicchè io prego uostra Signoria · che non le incresca, ¹²che ora che tali bochelli son moderati, di fare ricordare al presidente la mia espeditione cioè di darmi la ¹³possessione d'essa acqua, perchè alla uenuta mia spero farui su strumēti e cose che sarà di grā piacere al ¹⁴nostro cristianissimo rè; Altro non mi accade; sono senpre a uostri comandi.

somewhat angry with me, and that this is why to so many letters which I have written to your Lordship I have never had an answer. I now send Salai to explain to your Lordship that I am almost at an end of the litigation I had with my brother; that I hope to find myself with you this Easter, and to carry with me two pictures of two Madonnas of different sizes. These were done for our most Christian King, or for whomsoever your Lordship may please. I should be very glad to know on my return thence where I may have to reside, for I would not give any more trouble to your Lordship. Also, as I have worked for the most Christian King, whether my salary is to continue or not. I wrote to the President as to that water which the king granted me, and which I was not put in possession of because at that time there was a dearth in the canal by reason of the great droughts and because [10]its outlets were not regulated; but he certainly promised me that when this was done I should be put in possession. Thus I pray your Lordship that you will take so much trouble, now that these outlets are regulated, as to remind the President of my matter; that is, to give me possession of this water, because on my return I hope to make there instruments and other things which will greatly please our most Christian King. Nothing else occurs to me. I am always yours to command.

C. A. 364ᵇ; 1138ᵇ] 1350.

Drafts of Letters to the Superintendent of Canals and to Fr. Melzi.

Magnifico presidēte, io mando costì Salai mio discepolo, il quale ²di questa sia aportatore e da lui intenderete a bocca la causa del mio tanto sopra (sedere)...

Magnificent President, I am sending thither Salai, my pupil, who is the bearer of this, and from him you will hear by word of mouth the cause of my ...

uosstra. 4. lettigio .. fratelgli .. cossti in quessta. 5. passqua epportare commecho .. nosstre .. quale. 6. crisstinissimo .. nosstra .. arei. 7. cossta .. asstare per isstanza .. uosstre he. 8. re sella , . he per .. onno. 9. posessione. 10. sechi .. bochelli non era .. promisse. 11. posessione siche io priegho uosstra .. nolle incressca. 12. expeditione coe di darnela. 33. posessione .. isspero .. chessarà. 14. nomi acade.

1350. 1. Magni"co" presidēte [questa sol per condare] io .. quale [di questa sia]. 2. [la porta] di questa .. abocha sopra. 3. Ma-

1349. Charles d'Amboise, Maréchal de Chaumont, was Governor of Milan under Louis XII. Leonardo was in personal communication with him so early as in 1503. He was absent from Milan in the autumn of 1506 and from October 1510—when he besieged Pope Julius II. in Bologna—till his death, which took place at Correggio, February 11. 1511. Francesco Vinci, Leonardo's uncle, died—as Amoretti tells us—in the winter of 1510—11 (or according to Uzielli in 1506?), and Leonardo remained in Florence for business connected with his estate. The letter written with reference to this affair, No. 1348, is undoubtedly earlier than the letters Nos. 1349 and 1350. Amoretti tells us, *Memorie*

Storiche, ch. II, that the following note existed on the same leaf in MS. C. A. I have not however succeeded in finding it. The passage runs thus: *Jo sono quasi al fine del mio letigio che io ò con miè' fratetgli Ancora ricordo a V. Excia la facenda che ò cum Ser Juliano mio Fratello capo delli altri fratelli ricordandoli come se offerse di conciar le cose nostre fra noi fratelli del comune della eredità de mio Zio, e quelli costringa alla expeditione, quale conteneva la lettera che lui me mandò.*

10. Compare Nos. 1009 and 1010.

Leonardo has noted the payment of the pension from the king in 1505.

³Magnifico presidēte io.

Magnificent President, I . . .

⁴Magnifico presidente, essendomi io piv volte ricordato delle proferte fattemi da uostra Eccellētia più volte, ò preso sicurtà ⁵di scriuere e di ricordare a questa la promessa fattami à l'ultima partita, cioè la possessione di quel⁶le 12 once d'acqua donatemi dal cristianissimo rè; vostra Signoria sa che io non ētrai in essa ·possessione, perchè in quel ⁷tempo, ch'ela mi fu donata, era carestia d'acqua nel navilio, si pel grā secco come pel non essere ancora moderati li sua bochelli; ma ⁸mi fu promesso da uostra Eccellentia che fatta tal moderatione io avrei l'inttento mio; di poi, intendendo essere acconcio il navilio, io scrissi più volte a vo⁹stra signoria e a Messer Girolamo da Cusano, che à apresso di se la carta di tal donazione, e così scrissi al Corigero, e ¹⁰mai ebbi risposta; Ora io mādo costì Salai, mio discepolo, aportatore di questa, al quale vostra Signoria potrà ¹¹dire a bocca tutto quel ch'è seguito, della qual cosa io prego vostra Ecciellenza; ¹²Jo credo esser costì in questa pasqua per esser presso al fine del mio piateggiare, e porterò cō meco due quadri di nostra ¹³donna che io ò commīciate, e ò le ne' tempi, che mi sono avāzati, condotte in assai bō porto; Altro nō mi accade.

Magnificent President:—Having ofttimes remembered the proposals made many times to me by your Excellency, I take the liberty of writing to remind your Lordship of the promise made to me at my last departure, that is the possession of the twelve inches of water granted to me by the most Christian King. Your Lordship knows that I did not enter into possession, because at that time when it was given to me there was a dearth of water in the canal, as well by reason of the great drought as also because the outlets were not regulated; but your Excellency promised me that as soon as this was done, I should have my rights. Afterwards hearing that the canal was complete I wrote several times to your Lordship and to Messer Girolamo da Cusano, who has in his keeping the deed of this gift; and so also I wrote to Corigero and never had a reply. I now send thither Salai, my pupil, the bearer of this, to whom your Lordship may tell by word of mouth all that happened in the matter about which I petition your Excellency. I expect to go thither this Easter since I am nearly at the end of my lawsuit, and I will take with me two pictures of our Lady which I have begun, and at the present time have brought them on to a very good end; nothing else occurs to me.

¹⁴Magnifico Signore mio, l'amore che uostra Eccellētia m'à senpre dimostro, e' benefiti ch'io ò riceuuti da quella al continuo ¹⁵mi sō dināzi
¹⁶Io ò sospetto che la poca remuneratiō de' grā benifiti ch'io ho riceuuto da uostra Eccellentia non l'abbi¹⁷no fatto alquāto turbare con meco, e questo è che di piv lettere che io ò scritte a vostra Eccellentia io non ò mai ¹⁸avuta risposta ·, ora io mando costì Salai per fare intendere a vostra signoria, come io son quasi al fine del mio ¹⁹letigio coi mia fratelli, e come io credo essere costì in questa pasqua e portare con meco due quadri doue sono ²⁰due Nostre ·donne di varie grādezze, le quali io ò comīciato pel cristianissimo rè, o per chi a uoi piacerà; avrei ben caro di sa²¹pere

My Lord the love which your Excellency has always shown me and the benefits that I have constantly received from you I have hitherto . . .
I am fearful lest the small return I have made for the great benefits I have received from your Excellency may not have made you somewhat annoyed with me. And this is why, to many letters which I have written to your Excellency I have never had an answer. I now send to you Salai to explain to your Excellency that I am almost at the end of my litigation with my brothers, and that I hope to be with you this Easter and carry with me two pictures on which are two Madonnas of different sizes which I began for the most Christian King, or for whomsoever you please. I should be very glad to

gni"co" [mio] presidēte [avē] io. 4. presidēde esendomi . . uostra [se] ecciellētia. 5. a [vostra signoria] "acquesta" la . . fattami [alla partita mia di costa] a . . coe "la posessione" di. 6. dacq"a" donatomi . . cristianissimo . . posessione. 7. tempo "che la mi fa donata" era . . dacq"a" . . secho. 7. moderato. 8. ecellentia cheffatta . . arei lattento . . poi | "intendendo essere à conco il navilio" io. 9. donagone. 10. bocha . . Quel . . ipriegho vosstra. 12. passqua . . piategare nosta. 13. commīcate e olle acade poe. 14. M"o"signore [antonio maria] "mio" lamore "labeit" che uostra [signoria] "ecellētia" ma senpre di . . chio o"chi" . . riceuuti dacquella mi al. 16. ossospetto . . pocha remuneratiō [de benifitich] de . . manibi abi. 17. conmecho ecquesto . . osscritte avosstra . . inōno. 18. vta risspetta hora . . vosstra. 19. letigo comia . . cossti . . passqua . . comecho . . doue su. 20. grādeze . . comīcate . . arei . . asstare . . istantia. 21. uorei [piu] . . uosstra.

alla mia tornata di costà, dove io ò a stare per stanza, perchè nō uorrei dare più noia a uostra Signoria, e ā²²cora, auendo io lauorato pel cristianissimo Rè, se la mia prouisione è per correre o no; io scriuo al presidē²³te di quell' acqua che mi donò il rè, della quale nō fui messo in possessione per esserne carestia nel nauilio per ca²⁴usa de' grā secchi, e perchè i sua bocchelli non erā moderati; ma bē mi promise che, fatta tal moderatione, i' ne sarei ²⁵messo in possessione, sichè io vi prego che, scontrandovi in esso presidente, nō ui incresca che ora, che tali bochelli sō ²⁶moderati, di ricordare a detto presidente di farmi dare la possessione d'essa acqua, che mi parue intēdere che in grā par²⁷te staua a lui; altro non mi accade; sono senpre a uostri comādi.

²⁸Buō dì, messer Francesco ·, può lo fare Iddio che di tante lettere ch'io v'ò scritte · che mai voi non m'abbiate risposto; Or aspettate ²⁹ch'io venga costà, per Dio, ch'io vi farò tanto scrivere che forse vi rincrescerà.

³⁰Caro mio, messer Francesco, io mādo costì Salai per intendere dalla magnificentia del presidente che fine à auuta quella ³¹moderatione dell'acque che alla mia partita fu ordinata per li bochelli del nauilio, perchè el magnifico presidēte mi promi³²se che subito fatta tal moderatione, io sarei spedito; Ora egli è più tenpo che io intesi che il nauilio s'accō³³ciaua, e similmente i sua bochelli, e inmediate scrissi al presidente e a uoi, e poi replicai, e mai ebbi ³⁴risposta; adūque voi degnerete di rispōdermi quel ch'è seguito, e non essendo per spedirsi nō u'īcresca per mio a³⁵more di sollecitarne vn poco il presidente e così messer Girolamo da Cusano, al quale uoi mi racomādere³⁶te e offeriretemi a sua magnificētia.

know where, on my return from this place, I shall have to reside, because I do not wish to give more trouble to your Lordship; and then, having worked for the most Christian King, whether my salary is to be continued or not. I write to the President as to the water that the king granted me of which I had not been put in possession by reason of the dearth in the canal, caused by the great drought and because its outlets were not regulated; but he promised me certainly that as soon as the regulation was made, I should be put in possession of it; I therefore pray you that, if you should meet the said President, you would be good enough, now that the outlets are regulated, to remind the said President to cause me to be put in possession of that water, since I understand it is in great measure in his power. Nothing else occurs to me; always yours to command.

Good day to you Messer Francesco. Why, in God's name, of all the letters I have written to you, have you never answered one. Now wait till I come, by God, and I shall make you write so much that perhaps you will become sick of it.

Dear Messer Francesco. I am sending thither Salai to learn from His Magnificence the President to what end the regulation of the water has come since, at my departure this regulation of the outlets of the canal had been ordered, because His Magnificence the President promised me that as soon as this was done I should be satisfied. It is now some time since I heard that the canal was in order, as also its outlets, and I immediately wrote to the President and to you, and then I repeated it, and never had an answer. So you will have the goodness to answer me as to that which happened, and as I am not to hurry the matter, would you take the trouble, for the love of me, to urge the President a little, and also Messer Girolamo Cusano, to whom you will commend me and offer my duty to his Magnificence.

22. crisstianisimo . . sella . . onno. 23. acq"a" . . ı e [la quale] della . . caresstia. 24. sechi . . bochelgli . . promisse. 25. priegho chesscontrandosi. 26. posesione . . acq"a". 27. allui . . nomi achade [se nō di racoman]. 28. meser . . puollo . . idio . . vosscritte . . nomabiate rissposto. 29. vengha . . chefforse vi rincresscera. 30. charo . . meser francessco . . cheffine a uta. 31. della cq"a" . . partia . . che nauilio sacō. 33. caua essimilmente . . scrissi [io auoi e] al . . ripricai. 34. rissposta . . risspodermi . . isspedirsi. 35. pocho. 36. offererete assua mgnificētia.

1350. 28—36. Draft of a letter to Francesco Melzi, born 1493—a youth therefore of about 17 in 1510. Leonardo addresses his young friend as "Messer", as being the son of a noble house.　　Melzi practised art under Leonardo as a dilettante and not as a pupil, like Cesare da Sesto and others (See LERMOLIEFF, *Die Galerien &c.*, p. 476).

C. A. 243*b*; 729*b*]　　　　　　**1351.**

[Jllustrissimo mio Signore, ² Assai mi ral-legro, illustrissimo mio signiore ·, del uostro].

³ Tanto mi son rallegrato, o illustrissimo mio signore, del desiderato acquisto di vostra sanità che io quasi ho [riavuto la sanità mia]—[sono all' ultimo del mio male]—e'l male mio da me s'è fuggito — — della quasi reintegrata sanità di vostra Eccellenza; ⁴ Ma assai mi rincrescie il nō auere io po-tuto integralmēte satisfare alli desideri di uostra Ecciellentia mediā⁵te la malignità di cotesto ingannatore, al quale non ò las-ciato indirieto cosa alcuna colla quale ⁶ io li abbia potuto giovare che per me non li sia stata fatta e prima la sua provision inanzi al tēpo li era pagata, la quale io credo che volentieri ⁷ negherebbe, se io non avessi la scritta e testificata da me e dallo interprete, e vedendo io che per me nō si lauorava, se nō quādo ⁸ i lavori d'altri si mācavano, de' quali lui era sollecito in-vestigatore, jo lo preghai che dovesse mangia⁹re con meco, e lauorare indi ap-

[Most illustrious Lord. I greatly rejoice at your . . .]

I was so greatly rejoiced, most illustrious Lord, by the desired restoration of your health, that it almost had the effect that [my own health recovered]—[I have got through my illness]— my own illness left me — —of your Excellency's almost restored health. But I am extremely vexed that I have not been able completely to satisfy the wishes of your Excellency, by reason of the wickedness of that deceiver, for whom I left nothing undone which could be done for him by me and by which I might be of use to him; and in the first place his allowances were paid to him before the time, which I believe he would willingly deny, if I had not the writing signed by myself and the interpreter. And I, seeing that he did not work for me unless he had no work to do for others, which he was very careful in solliciting, invited him to dine with me, and to work afterwards near me, because, besides the saving of expense, he

1351. 1. Illusimo permio signiore e vett. 2. rallego [della] illustrissimo. 3. del [famoso] desiderato . . uosstra . . che ĩ quasi ho sfatto "[riavta la sanita mia]" "[son sono allultimo del mio male]" "el mal mio dame se fuggito" [del grāde acquisto] della . . reīntegrata . . uosstra eccielleca. 4. [chel mia . . rincresscie [della malignita] il . . auere | "io" potuto "integral-mēte" sadisfare . . uosstra s. te [Illustr] te la malignita [de] di cossto . . lassciato indirieto [nessuna] cosa "alcuna" colle. 6. giovare | "che per me non li sia stata fatta" e . li sua [danari] provisione "inanzi al tēpo" immediate . . paghata. 7. ne-gherebbe "neghata" se . . avesi lasscritta ettesticata di me dello interpete. 8. daltri [erā finiti] "si mācavano" de . . sol-lecito cerchatore "investighatore" jo [lo uolsi e] lo [feci] "lo" pregha "i"che do"ve" ssi. 9. comecho "ellauorare di lindi apresso di me perche oltre alcōto .\· — *Here on the margin is the note in three lines* .\· bē lopere elli acquisterebbe il

1351. 1353. It is clear from the contents of this notes that they refer to Leonardo's residence in Rome in 1513—1515. Nor can there be any doubt that they were addressed to Leonardo's patron at the time: Giuliano de' Medici, third son of Lorenzo the Magnificent and brother of Pope Leo X (born 1478). In 1512 he became the head of the Florentine Republic. The Pope invited him to Rome, where he settled; in 1513 he was named patrician with much splendid ceremonial. The medal struck in honour of the event bears the words MAG. IVLIAN. MEDICES. Leonardo too uses the style "Magnifico", in his letter. Compare also No. 1377.

GINO CAPPONI (*Storia della Repubblica di Firenze*, Vol. III, p. 139) thus describes the character of Giuliano de' Medici, who died in 1516: *Era il migliore della famiglia, di vita placida, grande spenditore, tenendo intorno a sè uomini ingegnosi, ed ogni nuova cosa voleva provare.*

See too GREGOROVIUS, *Geschichte der Stadt Rom*, VIII (book XIV. III, 2): *Die Luftschlösser fürstlicher Grösse, wozu ihn der Papst hatte erheben wollen zerfielen.*

Julian war der edelste aller damaligen Medici, ein Mensch von innerlicher Richtung, unbefriedigt durch das Leben, mitten im Sonnenglanz der Herrlichkeit Leo's X. eine dunkle Gestalt die wie ein Schatten vorüberzog. Giuliano lived in the Vatican, and it may be safely inferred from No. 1352 l. 2, and No. 1353 l. 4, that Leonardo did the same.

From the following unpublished notice in the Vatican archives, which M. Eug. Müntz, librarian of the Ecole des Beaux arts, Paris, has done me the favour to communicate to me, we get a more accurate view of Leonardo's relation to the often named GIORGIO TEDESCO:

Nota delle provisione (sic) *a da pagare per me in nome del nostro ill. S. Bernardo Bini e chompᵃ di Roma, e prima della illᵐᵃ sua chonsorte ogni mese d.* 800.

A Lᵈᵒ da Vinci per sua provisione d. XXXIII, e più d. VII al detto per la provisione di Giorgio tedescho, che sono in tutto d. 40.

From this we learn, that seven ducats formed the German's monthly wages, but according to No. 1353 l. 7 he pretended that eight ducats had been agreed upon.

presso di me, perchè oltre al conto elli acquisterebbe il linguaggio italiano; [lui senpre lo promise e mai lo volle fare]; E questo facievo ancora, perchè quel Giovā tedesco che fa li spechi ogni dì lì era in bottega, e volleua vedere e intendere ciò che si facieva e publicava per la ... forte biasimando; e perchè lui māgiava cō quelli [10] della guardia del papa, e poi se n'ādava in conpagnia colli scoppietti, amazādo vccielli per queste anticaglie e così seguitava da dopo desinare a sera; E se io mandavo Lorēzo [11] a sollecitarli il lavoro lui si cruciava e dicieva che nō volea tanti maestri sopra capo, e che il lauorar suo era [12] per la guardaroba di vostra Ecciellētia, e passò dua mesi e così seguitava e indi, trovādo Giannicolò della [13] guardaroba, domādailo s' el Tedesco avea finito l' opere del magnifico, e lui mi disse non esser vero, ma che so [14] lamēte li avea dato a nettar dua scoppiette; di poi faciēdolo io sollecitare lui lasciò la bettega, e comīciò a lavorare ī came [15] ra, e perde assai tēpo nel fare vn altra morsa e lime e altri strumēti a vite; e quiui lavorava mulinelli da torcere seta, [16] li quali nascōdeva, quādo vn de' mia v'ētrava, e con mille bestemie e rimbrotti, in modo che nessū de mia voleva piv entrare.

[17] Tanto mi sō rallegrato, jllustrissimo mio Signore, del desiderato acquisto di vostra sanità che quasi il male mio da me [18] s' è fugito; Ma assai mi rincrescie il non avere io potuto integralmēte satisfare alli desideri di uostra Eccellenza [19] mediante la malignità di cotesto ingānatore tedesco, per il quale non ò lasciato indireto cosa alcuna, [20] colla quale io abbia creduto farli piaciere; e secondariamente invitarlo ad abitare e vivere con meco, per la qual cosa io ve [21] drei al continuo l' opera che lui faciesse, e cō facilità ricorreggierei li errori ·; e oltre di questo inparerebbe la lingua italiana, [22] mediante la quale lui cō facilità potrebbe parlare sanza interprete; e li sua danari li

would acquire the Italian language. He always promised, but would never do so. And this I did also, because that Giovanni, the German who makes the mirrors, was there always in the workshop, and wanted to see and to know all that was being done there and made it known outside ... strongly criticising it; and because he dined with those of the Pope's guard, and then they went out with guns killing birds among the ruins; and this went on from after dinner till the evening; and when I sent Lorenzo to urge him to work he said that he would not have so many masters over him, and that his work was for your Excellency's Wardrobe; and thus two months passed and so it went on; and one day finding Gian Niccolò of the Wardrobe and asking whether the German had finished the work for your Magnificence, he told me this was not true, but only that he had given him two guns to clean. Afterwards, when I had urged him farther, he left the workshop and began to work in his room, and lost much time in making another pair of pincers and files and other tools with screws; and there he worked at mills for twisting silk which he hid when any one of my people went in, and with a thousand oaths and mutterings, so that none of them would go there any more.

I was so greatly rejoiced, most Illustrious Lord, by the desired restoration of your health, that my own illness almost left me. But I am greatly vexed at not having been able to completely satisfy your Excellency's wishes by reason of the wickedness of that German deceiver, for whom I left nothing undone by which I could have hope to please him; and secondly I invited him to lodge and board with me, by which means I should constantly see the work he was doing and with greater ease correct his errors while, besides this, he would learn the Italian tongue, by means of which be could with more ease talk without an interpreter; his moneys were always given him in advance of the

linghagio italiano . . lui senpre [lo promisse e mai lo volle fare] .\· Ecque"sto" faciev̄o¦. *On the margin in twelve short lines:* ¦ ecquesto facievo ancora perche que . . tedescho . . ongni . . ibottegha . . cio chessi e publicava per la for biasimando \||||||||\ aro quel \||||||||\ ndea

Here ends the note on the margin. perche lui māgiava [colli tedessci che so] cō quel. 10. nādava "in conpagnia" cholli schopietti . . antichaglie "ecosi segutava da dopo desinare assera" Esse. 11. [a richordarli] a solecitarli . . lui "si scruciava e" dicieva . . maesstri . . chapo eche [la] cche se [la] e i lauorare. 12. ghuarderoba [del s] di . . e [chosi] passo . . seghuita ve [se no] e vndi [li] trovādo. 13. ghuarderoba [del s] domādalo selli [ave] sel tedessco . . magnificho ellui . . Mace. 14. scoppiette . . solecitare . . lassio . . bottegha e comōcio allavorare. ellime . . llavorava mulenelli dattorciere. 16. loi quali nasscōdeva . . nesun de mia vēdrava . . comile . . rinbrotti . . nesū. 17. vosstra . . che | "quasi" il [mio] male. 18. rincresscie . . sadifare . . uosstra. 19. ingānatore [tedesco il quale] tedesco . . lasscciato . . chosa. 20. cholle . . e "p" prima | "secondariamente" invitarlo . . vi"ve"re comecho. 21. chellui faciessi. 22. ricoregiere . . oltre

furō ²³sēpre dati ināzi al tēpo ·; Dipoi la richiesta di costui fu di avere li modelli ²⁴finiti di legniame, com' ellino aveano a essere di ferro, e' quali volea portare nel suo paese; La qual cosa io li negai diciē-²⁵doli ch' io li darei in disegnio la larghezza, lunghezza e grossezza e figura di ciò ch'elli avesse a fare, e così restammo mal volētieri.

²⁶La secōda cosa fu, che si fecie vn altra bottega e morse e strumenti, dove dormiua, e quivi lavorava per altri, dipoi andava a desi²⁷nare coi Suizzeri della guardia, dove sta giēte sfacciēdata, della qual cosa lui tutti li uīcieva; e'l piv ²⁸delle v̟olte se n'andauano due o tre di loro, colli scoppietti; ammazzavā vccielli per le anticaglie, e questo durava insino a sera;
²⁹Al fine ò trovato come ³⁰questo maestro Giovā³¹ni delli Spechi è quello ³²che à fatto il tutto per ³³due cagioni; e la prima ³⁴perchè lui à avuto a dire che ³⁵la venuta mia qui ³⁶li à tolto la cōuersa³⁷tione e'l favore di uostra ³⁸Signoria, che senpre ve . . . ³⁹L'altra è ⁴⁰che la stātia ⁴¹di questo fereui ⁴²disse cōuenirsi a lui per ⁴³lavorare li spechi, e ⁴⁴di questo n'à fatto dimostra⁴⁵tione chè, oltre al farmi ⁴⁶costui nimico, li à fatto vē⁴⁷dere ogni suo e lasciare ⁴⁸a lui la sua bot⁴⁹tega, nella qual lavora ⁵⁰cō molti lavorāti assai spe⁵¹chi per mādare alle fiere.

time when due. Afterwards he wanted to have the models finished in wood, just as they were to be in iron, and wished to carry them away to his own country. But this I refused him, telling him that I would give him, in drawing, the breadth, length, height and form of what he had to do; and so we remained in ill-will.

The next thing was that he made himself another workshop and pincers and tools in his room where he slept, and there he worked for others; afterwards he went to dine with the Swiss of the guard, where there are idle fellows, in which he beat them all; and most times they went two or three together with guns, to shoot birds among the ruins, and this went on till evening.

At last I found how this master Giovanni the mirror-maker was he who had done it all, for two reasons; the first because he had said that my coming here had deprived him of the countenance and favour of your Lordship which always . . . The other is that he said that his iron-workers' rooms suited him for working at his mirrors, and of this he gave proof; for besides making him my enemy, he made him sell all he had and leave his workshop to him, where he works with a number of workmen making numerous mirrors to send to the fairs.

C. A. 278 a; 850 a] **1352.**

Tanto mi son rallegrato, illustrissimo mio signiore, del desiderato acquisto di uostra sanità, che quasi il male mio da me ²s'è fuggito; dico iddio ne sia laudato, Ma assai mi rincresce il non avere io potuto integralmēte satisfare alli desideri di uostra Eccellenza ³mediante la malignità di cotesto ingānatore tedesco, per il quale non ò lasciato indirieto cosa alcuna, ⁴colla quale io abbia creduto farli piacere, e secondariamente invitarlo ad abitare e vivere con meco, per la qual cosa ⁵io farei piantare

I was so greatly rejoiced, most Illustrious Lord, by the wished for recovery of your health, that my own ills have almost left me; and I say God be praised for it. But it vexes me greatly that I have not been able completely to satisfy your Excellency's wishes by reason of the wickedness of that German deceiver, for whom I left nothing undone by which I could hope to please him; and secondly I invited him to lodge and board with me, by which means I should see constantly the work he was doing,

a di questo . . taliana . . interprete [e ottre a di questo] "e prima" li sua. 23. ināzi [al mese] al tēpo allcuttofu Di . . riciessta . . modelli [finiti di legniane]. 24. fin [iti di pūto] di . . chomelli . . neghai. 25. darei [di] in . . luneza e grosseza . . avessi affare . . restamo. 26. bottegha "emvro (?) e morse esstrumēti" [nella camera] dove. 27. nare [colla ghuardi] co suizeri . . ghardia . . uīcieva dissene vssciva el piv . . 28. senadaua . . ottre . . scopietti amazava . . antichaglie ecquesto . . assera. 30. maesstro. 33. ella. 34. lui avuto. 35. mia [ari] qui. 36. tolto [il s] la. 37. uosstra. 38. Signoria che senpre ve. 39. [nēdo] Laltra e che. 40. [faciendoli] chella. 41. di questo [mini] fereui. 42. disscie cōuenirsi allui. 43. lisspechi. 47. ellassciare. 48. allui . . boc. 49. tecca. 51. chi pe.

1352. 2. seffuggito "dicho idio ne sia laldato" Ma . . rincre. *Here the text breaks off.* 2. *The text from lines* 1—4: Ma assai etc. . . *to* ad abitare e vivere *is an exact copy of lines* 18—20 *No.* 1349. 4. comecho . . chosa io vedrei .\· *Here follow six short lines on the margin:* farei piantare vn dessco . . quesste . . potessi . . di sot fabrichare e chosi. *The marginal note ends here.* — faciessi e chō . . ricorregierebe.

vn desco a' piedi d'una di queste finestre, dove lui potesse lauorar di lima, e finire le cose di sotto fabricate, e così io vedrei al continuo l'opera che lui facesse e con facilità si ricorreggierebbe.

for which purpose I would have a table fixed at the foot of one of these windows, where he could work with the file and finish the things made below; and so I should constantly see the work he might do, and it could be corrected with greater ease.

C. A. 179*b*; 541*b*] 1353.

Draft of letter written at Rome.

Questo altro m'à īpedito l'anatomia [2]col papa biasiamādola, e così all'o[3]spedale, e ēpie di botteghe da spechi [4]tutto questo Beluedere o di lavorā[5]ti; e così à fatto nella stātia di ma[6]estro Giorgio; [7]disse che otto du[8]cati li furon promes[9]si ogni mese, comī[10]ciādo il primo dì [11]che si mise in via, [12]o il più tardo quā[13]do e' ui parlò, e che [14]voi l'acciettaste;

[15]Vedēdo io costui rare volte sta[16]re a bottega e che cōsumava assai, Jo [17]li feci dire che se li piacea che io farei [18]con lui mercato di ciascuna cosa che [19]lui facesse, e a stima tānto li darei [20]quāto noi fussimo d'accordo; elli [21]si cōsigliò col uicino e lasciò lì la stā[22]tia, vendendo ogni cosa, e venne a trovare. . .

This other hindered me in anatomy, blaming it before the Pope; and likewise at the hospital; and he has filled [4]this whole Belvedere with workshops for mirrors; and he did the same thing in Maestro Giorgio's room. He said that he had been promised [7]eight ducats every month, beginning with the first day, when he set out, or at latest when he spoke with you; and that you agreed.

Seeing that he seldom stayed in the workshop, and that he ate a great deal, I sent him word that, if he liked I could deal with him separately for each thing that he might make, and would give him what we might agree to be a fair valuation. He took counsel with his neighbour and gave up his room, selling every thing, and went to find . . .

C. A. 304*a*; 925*a*] 1354.

Miscellaneous Records (1354. 1355).

Caro Benedetto de' Pertarti. [2]Caduto Jl fier gigāte per la cagione della Jsaguinata [3]e fangosa terra, parve che cadesse vna mōtagnia; [4]onde la cāpagnia guassata di terremoto, e spavēto [5]a Plutone Jfernale; e per la grā percossa ristette [6]sulla piana terra alquāto stordito; e subito [7]il popolo, credēdo fusse morto di qualche saetta,—[8]tornato la gran turba, a guisa di formiche che scorrono a [9]furia, quando per il corpo del caduto robore (?); così questi [10]scorrēdo per l'ampie membra e le ravrādo con spesse [11]ferite; onde

Dear Benedetto de' Pertarti. When the proud giant fell because of the bloody and miry state of the ground it was as though a mountain had fallen so that the country shook as with an earthquake, and terror fell on Pluto in hell. From the violence of the shock he lay as stunned on the level ground. Suddenly the people, seeing him as one killed by a thunderbolt, turned back; like ants running wildly over the body of the fallen oak, so these rushing over his ample limbs them with

1353. 2. chosi. 3. dasspechi. 4. ollavrā. 5. affatto. 6. esstro giorgo. 8. fu. 9. sa. 11. misse. 16. abottegha . . asai. 17. chesseli piacea che i farei. 18. collui merchato . . casscuna. 19. facessi e asstima attato. 20. dachordo. 21. ellasciolli 22. vendeda ogni cosa e vene attrovare.

1354. 1. benedeto prtarli. 2. dela. 3. tera . . cadessi. 4. gussa di tere moto. 5. plutone Jfernale . . percosa. 6. sula . . tera . . stordito on sobito. 7. il popo Jrededo fusi. 8. gra turba . . scorano. 9. furi o\\\\\ndo per olcorpo del caduto uogore cosi. 10. per larpie mebra e lera vrādo conispese. 11. ferie. 12. dale . . señdesi. 13. vmuglio. 14. fusi . . le + (4 ?)

1354. A puzzling passage, meant, as it would seem, for a jest. Compare the description of Giants in Dante, *Inf.* XXI and XXII. Perhaps Leonardo had the Giant Antaeus in his mind. Of him the myth relates that he was a son of Gê, that he fed on lions; that he hunted in Libya and killed the inhabitants. He enjoyed the peculiarity of

renewing his strength whenever he fell and came in contact with his mother earth; but that Hercules lifted him up and so conquered and strangled him. Lucan gives a full account of the struggle. Pharsalia IV, 617. The reading of this passage, which is very indistinctly written, is in many places doubtful.

risentito jl gigāte e sētēdosi ¹²quasi coperto dalla moltitudine, subito sentesi cuo¹³cere per le pūture; mise un mugghio che parve ¹⁴fusse vno spavētoso tono, e posto le sue mani in ¹⁵terra, e levatosi il pavroso volto, e postosi ¹⁶vna delle mani j̄ capo trovò selo ¹⁷pieno ¹⁸d'uomini appiccati e canna-¹⁹glia a similitudine de' mi²⁰nvti animali, che fra que ²¹gli sogliono nascere; ²²onde scuotendo jl capo gli o²³mini lācia non altramēti per l'aria che si facia ²⁴la grādine, quādo va cō furor di vēti, e trovossi molti ²⁵di questi vomini esser morti da quegli che gli stavano so²⁶pra ritti; coi piedi calpestādo . . .

²⁷E tenēdosi a capegli ēgiegniādosi nascōdere tra quegli, facievano ²⁸a similitudine de' marinai quādo è fortuna, che corrono super le corde ²⁹per abbassar la a poco vēto.

³⁰Nuove delle cose ³¹di levāte; ³²sappi come ³³nel mese ³⁴di givgnio ³⁵è apparito ³⁶vn gigāte che viē dalla ³⁷deserta Libia, ³⁸a similitudine delle ³⁹formiche furiā⁴⁰do ⁴¹abbatuto dall ⁴²rigido villano.

⁴³Questo gigāte era nato nel Mōt'Atalate, ed era ⁴⁴un eroe, e ebbe cōtrastare cogli Egiti e Arabi ⁴⁵Medi e Persi; viveva j̄ mare delle bale⁴⁶ne de' grā capidogli e de' navili.

⁴⁷Marte, temēdo della ⁴⁸vita, s'era fugito sotto le ⁴⁹ di Giove.

⁵⁰¶E per la grā caduta parve la provīcia ⁵¹tutta tremasse.¶

frequent wounds; by which, the giant being roused and feeling himself almost covered by the multitude, he suddenly perceives the smarting of the stabs, and sent forth a roar which sounded like a terrific clap of thunder; and placing his hands on the ground he raised his terrible face: and having lifted one hand to his head he found it full of men and rabble sticking to it like the minute creatures which not unfrequently are found there; wherefore with a shake of his head he sends the men flying through the air just as hail does when driven by the fury of the winds. Many of these men were found to be dead; stamping with his feet.

And clinging to his hair, and striving to hide in it, they behaved like sailors in a storm, who run up the ropes to lessen the force of the wind [by taking in sail].

News of things from the East.

Be it known to you that in the month of June there appeared a Giant, who came from the Lybian desert . . . mad with rage like ants struck down by the rude.

This great Giant was born in Mount Atlas and was a hero and had to fight against the Egyptians and Arabs, Medes and Persians. He lived in the sea on whales, grampuses and ships.

Mars fearing for his life took refuge under the . . . of Jove.

And at the great fall it seemed as though the whole province quaked.

W. XXXI.] 1355.

Il quale spirito ritrova · il cerebro, dōde partito s'era ·, con alta vocie cō tali parole mosse . . .

²E se alcuno uomo bēchè abbi discretione o bōtà, dalli altri omini ³ e peggio se da esso son remote.

This spirit returns to the brain whence it had departed, with a loud voice and with these words, it moved . . .

And if any man though he may have wisdom or goodness

ma"ni"j̄. 15. tera elevatosia. 16. dele. 17. pieno [di minvti animali]. 18. apicati e cane. 19. glia similitudine. 20. animali cheraquē. 21. gli. 22. ode scutēdo jl cap glio. 23. mini faciano non altremēti. 24. trovosi. 25. morti da quegli che gli tepesta vonātoso. 26. parito co pie di. 27. e atenēdo a capegli ēgiegniādosi nascōdere tra. 28. quāde fortuna cecorono. 29. abasarla à poco. 30. nuove dell cose quā. 32. sapi. 33. del. 35. aparito. 36. gigāte ce viē dila. 37. diserta. 38. dele. 40. do orgnarlo super lorgero. 41. abatuto dale sura del. 42. rigido vilano. 44. ueroe debe cōtro atuserse cogli egiti e arabi. 47. dela. 49. rodi di ove. 51. tuta tremassi.

1355. 1. El quale . . cierbio . . chon . . vo cie [ne] cotali. 2. alchuno homo . . bota di nolmē li che me dalli altri omini tr||||||so||||||| 3. la settu||||||| e peggiose do esso son remote. 4. spiritoche dōde me partisti joho . . homo"a"male . .

1355. This passage, very difficult to decipher, is on the reverse of a drawing at Windsor, Pl. CXXII, which possibly has some connection with it. The drawing is slightly reduced in this reproduction; the original being 25 cm. high by 19 cm. wide.

⁴O felice; o avēturato spirito, dōde partisti! jo ho questo uomo a male mio grado bē cono⁵scivto ·; Questo è ricietto · di villania ·, questo è propio · ammonitione di somma ingratitudine, ⁶in cōpagnia di tutti i viti ·; ma che mi vo io cō parole indarno affaticādomi? la somma de' peccati ⁷solo in lui trovati sono; E se alcuno infra loro si trova, che alcuna bontà possegga, non altri⁸mēti come che me dalli altri uomini trattati sono ·, e in effetto io ho questa cōclusione ch'è ⁹male s'eli sono nimici e peggio s'eli son amici.

O blessed and happy spirit whence comest thou? Well have I known this man, much against my will. This one is a receptacle of villainy; he is a perfect heap of the utmost ingratitude combined with every vice. But of what use is it to fatigue myself with vain words? Nothing is to be found in them but every form of sin . . And if there should be found among them any that possesses any good, they will not be treated differently to myself by other men; and in fine, I come to the conclusion that it is bad if they are hostile, and worse if they are friendly.

H.³ 89 a] **1356.**

Miscellaneous drafts of letters and personal records (1356—1368).

Tutti i mali che sono ²e che furono, ⁶essēdo messi in opera da costui ⁷nō satisfarebbero al deside⁸rio del suo iniquo animo; ⁹io nō potrei con lunghezza di tēpo ¹⁰descriverui la natura di costu¹¹i, ma bē cōchivdo ohe . . .

All the ills that are or ever were, if they could be set to work by him, would not satisfy the desires of his iniquitous soul; and I could not in any length of time describe his nature to you, but I conclude . . .

C. A. 380 a; 1179 b] **1357.**

Io ho uno · che per auersi di me promesso cose assai · mē che debite, ²essendo rimasto ingañato del suo prosontuoso desiderio, à tē³tato di tormi tutti li amici e perchè li à trouati saui e non leggi⁴eri al suo volere mi à minaciato che trouate le annūtiationi ⁵che mi torrà i benefattori; ōde io ho di questo informato ⁶vostra Signoria accio [che, volendo questo seminare li usati ⁷scādoli, non troui terreno atto a seminare pensieri e li ⁸atti della sua mala natura]; ⁹che, tentādo lui fare di uostra signoria strumēto · della sua iniqua e maluagia natura ¹⁰rimāga ingannato di suo desiderio.

I know one who, having promised me much, less than my due, being disappointed of his presumptuous desires, has tried to deprive me of all my friends; and as he has found them wise and not pliable to his will, he has menaced me that, having found means of denouncing me, he would deprive me of my benefactors. Hence I have informed your Lordship of this, to the end [that this man who wishes to sow the usual scandals, may find no soil fit for sowing the thoughts and deeds of his evil nature] so that he, trying to make your Lordship, the instrument of his iniquitous and maliceous nature may be disappointed of his desire.

W. An. III. 241 a] **1358.**

E in questo caso io so che io ne acquisterò non pochi nemici, conciosia²chè nessū crederà ch'io possa dire di lui, perchè pochi

And in this case I know that I shall make few enemies seeing that no one will believe what I can say of him; for they are but

chono. 5. uilania . . amv nitione. 6. chōpagnia . . voi chō . . affatichādomi lassoma de pechati. 7. solo nello trovati sono Esse alchuno . . alchuna . . possega. 8. chome . . omini . . effetti . . chōclusione. 9. male seli sonimiche e pegio seli son irattatiamicho.

1356. 1. chessono. 2. furono [nō sodisfare]. 3. [bono al a ssere messi]. 4. in opera [allo iniquo desiderio]. 5. [di questo homo]. 7. nō sadissfarebono. 9. inō . . chollungeza dite. 11. cōciudo.

1357. 1. huno . . promesse chose. 2. desiderio attē. 3. sauieno legi. 4. nia minaciato . . tronata le anutione. 5. torra e benifactori. 6. vosstra . . le usate. 7. chādali . . tereno . . asseminare "[aricievere]" in pensicrei elli. 9. [accioche nō ui faccia] "che tentādo lui fare di uosstra signoria [ecciellencia] strumēti.

1358. 1. chaso iso . . acquistero pochi . . concosia. 2. crederra . . poci. 3. disspiacino . . sol queli . . dispiaca. 4. attali . . odiano. 6. vole.

1358. Below this text we read *gusstino* = Giustino and in another passage on the same page Justin is

quoted (No. 1210, l. 48). The two have however no real connection.

son quelli ³a chi i sua viti dispiacino; anzi solamente a quelli omini li dispiacio⁴no che son di natura cōtraria a tali uitj; e molti odiano li ⁵padri e guastan le amicitie, represōri de' sua viti e non ⁶vogliono esenpli contrari a essi, nè nessuno vmā consiglio.

⁷E se alcuno si ne trova virtuoso e bono, non lo scacciate ⁸da voi; fatteli onore, acciò che non abbia a fugirsi da ⁹voi e ridursi neli eremi, o spelonche, o altri lochi soleta¹⁰ri, per fugirsi dalle vostre insidie, e se alcun di questi ¹¹tali si trova, fatteli onore, perchè questi sono li uostri Iddei ¹²terrestri, questi meritā da uoi le statue e li simulacri; ma ¹³bē ui ricordo che li lor simulacri nō siē da uoi mā¹⁴giati come ācora in alcuna regione del India; ¹⁵chè quādo li simulacri operano alcuno mi¹⁶raculo secondo loro, li sacerdoti li tagliano in pezzi, essen¹⁷do di legno, e ne danno a tutti quelli del paese nō ¹⁸sanza premio, e ciascū raspa sottilmēte la sua parte ¹⁹e mette sopra la prima vivanda che māgiano; e così tē²⁰gono per fede aversi māgiato il suo santo, e credono che lui li ²¹guardi poi da tutti li pericoli ‖ che ti pare, uomo, qui della ²²tua spetie? sei tu così sauio, come tu ti tieni? son ²³queste cose da esser fatte da omini?

few whom his vices have disgusted, and he only dislikes those men whose natures are contrary to those vices. And many hate their fathers, and break off friendship with those who reprove their vices; and he will not permit any examples against them, nor any advice.

If you meet with any one who is virtuous do not drive him from you; do him honour, so that he may not have to flee from you and be reduced to hiding in hermitages, or caves or other solitary places to escape from your treachery; if there is such an one among you do him honour, for these are our Saints upon earth; these are they who deserve statues from us, and images; but remember that their images are not to be eaten by you, as is still done in some parts of India [15], where, when the images have according to them, performed some miracle, the priests cut them in pieces, being of wood, and give them to all the people of the country, not without payment; and each one grates his portion very fine, and puts it upon the first food he eats; and thus believes that by faith he has eaten his saint who then preserves him from all perils. What do you think here, Man, of your own species? Are you so wise as you believe yourselves to be? Are these things to be done by men?

C. A. 4b; 11b] **1359.**

Come io vi dissi ne' dì passati, voi sapete ²che io sono sanza alcuno...
³Francesco d'Antonio
⁴Bernardo di Maestro Jacopo.

As I told you in past days, you know that I am without any. . . .
Francesco d'Antonio.
Bernardo di Maestro Jacopo.

C. A. 38b; 124a] **1360.**

Dimmi come le cose sono passate.

Tell me how the things happened.

.. esse. 7. esse . vertuoso . nollo scaccia de. 8. da voi[m] fatteli . . abia | affugirsi. 9. ermi . . saleta. 10. vosstre . . esse. 11. fate . . onore che "perche" questi. 12. statue elli onori "simulacri" ma. 13. chelli. 14. gati chome āchora. 16. lo tagliano . . pezi esse. 17. attutti . . paese [el qa]nō. 18. rasspa. 19. viuada che māgano. 20. gā per fede avrsimāgato . . credā. 21. dattutti pericoli ‖ chettitti pare omo. 22. settu . . tuttiti eni.
1359. 1—4. *Written from left to right.* 1. Chome iovi disi. 2. alchuno. 3. [franī dantonio]. 4. [brn brnado di m"o" iachopo].
1360. 1. chome le cose.

L. 15. In explanation of this passage I have received the following communication from Dr. G. W. LEITNER of Lahore: "So far as Indian customs are known to us, this practice spoken of by Leonardo as 'still existing in some parts of India' is perfectly unknown; and it is equally opposed to the spirit of Hinduism, Mohammedanism and Sikhism. In central Thibet the ashes of the dead, when burnt, are mixed with dough, and small figures—usually of Buddha—are stamped out of them and some are laid in the grave while others are distributed among the relations. The custom spoken of by Leonardo may have prevailed there but I never heard of it." Possibly Leonardo refers here to customs of nations of America.

C. A. 17 b; 67 b] **1361.**

J̄ lorēzo‖ ²inbiadali‖‖ ³inferri de‖‖ ⁴in lorēzo‖‖ ⁵[inno abuil]‖‖ ⁶in acōcatu‖‖ ⁷per la sella‖‖ ⁸colte di lor‖‖ ⁹v̄ cavallott‖‖ ¹⁰el uiagg‖‖ ¹¹al‖‖ ¹²a lurēz‖‖ ¹³in biada‖‖ ¹⁴inferri‖‖ ¹⁵abusso‖‖ ¹⁶in viagg‖‖ ¹⁷alorēz‖‖

W. An. IV. 174 a] **1362.**

E così piacesse al nostro autore che io potessi dimostrare la natura delli omini ²e loro costumi nel modo che io descrivo la sua figura.

And so may it please our great Author that I may demonstrate the nature of man and his customs, in the way I describe his figure.

C. A. 65 b; 199 b] **1363.**

Questo scriuersi distintamēte del nibbio ²par che sia mio destino, perchè nella prima ³ricordatione della mia infantia e' mi ⁴parea che, essendo io in culla, che vn ⁵nibbio venisse a me e mi aprisse la ⁶bocca colla sua coda, e molte volte ⁷mi percuotesse cō tal coda dentro alle ⁸labra.

This writing distinctly about the kite seems to be my destiny, because among the first recollections of my infancy, it seemed to me that, as I was in my cradle, a kite came to me and opened my mouth with its tail, and struck me several times with its tail inside my lips.

C. A. 248 a; 737 a] **1364.**

[Quādo io feci bene, essendo putto, voi mi mettesti in prigione, ²ora s'io lo fo grāde, voi mi farete peggio.]

[When I did well, as a boy you used to put me in prison. Now if I do it being grown up, you will do worse to me.]

Br. M. 251 b] **1365.**

Dimmi se mai fu fatto alcuna cosa.

Tell me if anything was ever done.

Br. M. 253 a] **1366.**

Dimmi · se mai fece ²cosa che mi di....

Tell me if ever I did a thing which me.....

S. K. M. III. 85 a] **1367.**

¶Non iscoprire se libertà ²t'è cara, chè 'l uolto mio ³è carciere d'amore.¶

Do not reveal, if liberty is precious to you; my face is the prison of love.

1362. 1. piacessi . . altore. 2. desscrivo.
1363. 1. nibio. 2. nela. 5. venissin me e mi aprissi. 6. bocha chola. 7. perchotessi.
1364. 1. feci bensenedo (*doubtful*) putto. 2. forāde . . pegio.
1365. P. — di mi semmai . . facto alchuna chosa. 1366. 1. semmai. 2. chosa chemmi dit.
1367. 1. nonisscoprire selliberta. 2. te chara. 3. charciere.

1361. This seems to be the beginning of a letter, but only the first words of the lines have been preserved, the leaf being torn down the middle. No translation is possible.

1362. A preparatory note for the passage given as No. 798, ll. 41—42.
1363. This note probably refers to the text No. 1221.
1367. This note seems to be a quotation.

C. A. 188 *b*; 564 *b*] **1368.**

Maestro Leonardo Fiorentino. Maestro Leonardo of Florence.

Flor. Uff.] **1369.**

Dì di Sca Maria della Neve, ²a dì 2 d'agosto 1473.

The day of Santa Maria *della Neve* [of the Snows] August the 2^nd 1473.

Notes bearing Dates (1369—1378).

W. An. I. 1 *a*] **1370.**

A dì 2 d'aprile 1489 libro titolato de figura vmana.

On the 2^nd of April 1489, book entitled 'Of the human figure'.

C. A. 103 *a*; 325 *a*] **1371.**

A dì primo d'agosto 1499 · scrissi qui de moto · e peso.

On the 1^st of August 1499, I wrote here of motion and of weight.

1368. m"o". **1369.** 2. addi 2 daggossto. **1370.** 1489 [del] libro. **1371.** adi p"o" dagosto.

1368. So Leonardo writes his name on a sheet with sundry short notes, evidently to try a pen. Compare the signature with those in Nos. 1341, 1348 and 1374 (see also No. 1346, l. 33). The form "Lionardo" does not occur in the autographs. The Portrait of the Master in the Royal Library at Turin, which is reproduced—slightly diminished—on Pl. I, has in the original two lines of writing underneath; one in red chalk of two or three words is partly effaced: *lionardo it . . . lm* (or *lai?*); the second written in pencil is as follows: *fatto da lui stesso assai vecchio.* In both of these the writing is very like the Master's, but is certainly only an imitation.

1369. This date is on a drawing of a rocky landscape. See *Chronique des Arts* 1881 no. 23: *Léonard de Vinci a-t-il été au Righi le 5 août 1473?* letter by H. de Geymüller. The next following date in the MSS. is 1478 (see No. 663).

1370. While the letters in the MS. notes of 1473 and 1478 are very ornate, this note and the texts on anatomy on the same sheet (for instance No. 805) are in the same simple hand as we see on Pl. CXVI and CXIX. No 1370 is the only dated note of the years between 1480 and 1489, and the characters are in all essential points identical with those that we see in the latest manuscripts written in France (compare the facsimiles on Pl. CXV and

p. 254), so that it is hardly possible to determine exactly the date of a manuscript from the style of the handwriting, if it does not betray the peculiarities of style as displayed in the few notes dated previous to 1480.—Compare the facsimile of the manuscripts 1479 on Pl. LXII, No. 2; No. 664, note, Vol. I p. 346. This shows already a marked simplicity as compared with the calligraphy of 1478.

The text No. 720 belongs to the year 1490; No. 1510 to the year 1492; No. 1459, No. 1384 and No. 1460 to the year 1493; No. 1463, No. 1517, No. 1024, 1025 and 1461 to the year 1494; Nos. 1523 and 1524 to the year 1497.

1371. *Scrissi qui.* Leonardo does not say where; still we may assume that it was not in Milan. Amoretti writes, *Memorie Storiche*, chap. XIX: *Sembra pertanto che non nel* 1499 *ma nel* 1500, *dopo il ritorno e la prigionia del duca, sia da qui partito Lionardo per andare a Firenze; ed è quindi probabile, che i mesi di governo nuovo e incerto abbia passati coll' amico suo Francesco Melzi a Vaprio, ove meglio che altrove studiar potea la natura, e soprattutta le acque, e l'Adda specialmente, che già era stato l'ogetto delle sue idrostatiche ricerche.* At that time Melzi was only six years of age. The next date is 1502; to this year belong No. 1034, 1040, 1042, 1048 and 1053. The note No. 1525 belongs to the year 1503.

Br. M. 272 *a*] **1372.**

A dì 9 di luglio 1504, mercoledì a ore 7 morì Ser ²Piero da Vinci, notaio al Palazzo del Podestà, mio padre, a ore 7, era d'età d'anni 80, lasci³ò 10 figlioli ma⁴schi e 2 femmine.

On the 9th of July 1504, Wednesday, at seven o'clock, died Ser Piero da Vinci, notary at the Palazzo del Podestà, my father, —at seven o'clock, being eighty years old, leaving behind ten sons and two daughters.

C. A. 70 *b*; 208 *b*] **1373.**

Mercoledì a ore 7 ²morì Ser Piero da Vinci a dì 9 ³di luglio 1504.

On Wednesday at seven o'clock died Ser Piero da Vinci on the 9th of July 1504.

S. K. M. I.¹ 1 *b*] **1374.**

Principiato da me Leonardo ²da Vīci a dì 12 di luglio 1505.

Begun by me, Leonardo da Vinci, on the 12th of July 1505.

F. 1 *a*] **1375.**

Comīciato a Milano a dì 12 di settēbre 1508.

Begun at Milan on the 12th of September 1508.

W. An. III. 217. *a*] **1376.**

A dì 9 di giennaro 1513.

On the 9th of January 1513.

1372. *Written from left to right:* 1. addi . . luglio 1504 en mercholedi. 2. palago . . lasc. 4. sci et.
1373. 3. luglo. **1374.** 2. uīci addi. **1375.** comīcato . . addi. **1376.** addi.

1372. This statement of Ser Piero's age contradicts that of the *Riassunto della portata di Antonio da Vinci* (Leonardo's grandfather), who speaks of Ser Piero as being thirty years old in 1457; and that of the *Riassunto della portata di Ser Piero e Francesco*, sons of Antonia da Vinci, where Ser Piero is mentioned as being forty in 1469. These documents were published by G. UZIELLI, *Ricerche intorno a L. da Vinci, Firenze,* 1872, pp. 144 and 146. Leonardo was, as is well known, a natural son. His mother 'La Catarina' was married in 1457 to Acchattabriga di Piero del Vaccha da Vinci. She died in 1519. Leonardo never mentions her in the Manuscripts. In the year of Leonardo's birth Ser Piero married Albiera di Giovanni Amadoci, and after her death at the age of thirty eight he again married, Francesca, daughter of Ser Giovanni Lanfredi, then only fifteen. Their children were Leonardo's half-brothers, Antonio (b. 1476), Ser Giuliano (b. 1479), Lorenzo (b. 1484), a girl, Violante (b. 1485), and another boy Domenico (b. 1486); Domenico's descendants still exist as a family. Ser Piero married for the third time Lucrezia di Guglielmo Cortigiani by whom he had six children: Margherita (b. 1491), Benedetto (b. 1492), Pandolfo (b. 1494), Guglielmo (b. 1496), Bartolommeo (b. 1497), and Giovanni) date of birth unknown). Pierino da Vinci the sculptor (about 1520—1554) was the son of Bartolommeo, the fifth of these children. The dates of their deaths are not known, but we may infer from the above passage that they were all still living in 1505.

1373. This and the previous text it may be remarked are the only mention made by Leonardo of his father; Nos. 1526, 1527 and No. 1463 are of the year 1504.

1374. Thus he writes on the first page of the MS. The title is on the foregoing coversheet as follows: *Libro titolato disstrafformatione coe* (cioè) *d'un corpo nvn* (in un) *altro sanza diminuitione e acresscemento di materia.*

1375. No. 1528 and No. 1529 belong to the same year. The text Vol. I, No. 4 belongs to the following year 1509 (1508 old style); so also does No. 1009.— Nos. 1022, 1057 and 1464 belong to 1511.

1376. No. 1465 belongs to the same year. No. 1065 has the next date 1514.

G. o']

1377.

Partissi il magnifico Giuliano de' [2]Medici a dì 9 di giennaio 1515 [3]in sull'aurora da Roma per ādare [4]a sposare la moglie in Sovoia; [5]e in tal dì ci fu la morte del rè di Francia.

The Magnifico Giuliano de' Medici left Rome on the 9th of January 1515, just at daybreak, to take a wife in Savoy; and on the same day fell the death of the king of France.

C. A. 245a; 731a]

1378.

A 24 di giugnio il dì di san Giovanni [2]1518 in Ābosa nel palazzo del clli.

On the 24th of June, St-John's day, 1518 at Amboise, in the palace of . . .

1377. 1. magnificho. 2. addi. 3. darroma. 4. assposare. 5. dere.

1378. 1. a 24 digugnio. 2. palazzo dell clli.

1377. Giuliano de Medici, brother to Pope Leo X.; see note to Nos. 1351—1353. In February, 1515, he was married to Filiberta, daughter of Filippo, Duke of Savoy, and aunt to Francis I, Louis XII's successor on the throne of France. Louis XII died on Jan. 1st, and not on Jan. 9th as is here stated.— This addition is written in paler ink and evidently at a later date.

1378. *Castello del clli.* The meaning of this word is obscure; it is perhaps not written at full length.

XXII.

Miscellaneous Notes.

The incidental memoranda scattered here and there throughout the MSS. can have been for the most part intelligible to the writer only; in many cases their meaning and connection are all the more obscure because we are in ignorance about the persons with whom Leonardo used to converse nor can we say what part he may have played in the various events of his time. Vasari and other early biographers give us a very superficial and far from accurate picture of Leonardo's private life. Though his own memoranda, referring for the most part to incidents of no permanent interest, do not go far towards supplying this deficiency, they are nevertheless of some importance and interest as helping us to solve the numerous mysteries in which the history of Leonardo's long life remains involved. We may at any rate assume, from Leonardo's having committed to paper notes on more or less trivial matters on his pupils, on his house-keeping, on various known and unknown personages, and a hundred other trifles—that at the time they must have been in some way important to him.

I have endeavoured to make these 'Miscellaneous Notes' as complete as possible, for in many cases an incidental memorandum will help to explain the meaning of some other note of a similar kind. The first portion of these notes (Nos. 1379—1457), as well as those referring to his pupils and to other artists and artificers who lived in his house (1458—1468) are arranged in chronological order. A considerable proportion of these notes belong to the period between 1490 and 1500, when Leonardo was living at Milan under the patronage of Lodovico il Moro, a time concerning which we have otherwise only very scanty information. If Leonardo did really—as has always been supposed,—spend also the greater part of the preceding decade in Milan, it seems hardly likely that we should not find a single note indicative of the fact, or referring to any event of that period, on the numerous loose leaves in his writing that exist. Leonardo's life in Milan between 1489 and 1500 must have been comparatively uneventful. The MSS. and memoranda of those years seem to prove that it was a tranquil period of intellectual and artistic labour rather than of bustling court life. Whatever may

have been the fate of the MSS. and note books of the foregoing years—whether they were destroyed by Leonardo himself or have been lost—it is certainly strange that nothing whatever exists to inform us as to his life and doings in Milan earlier than the consecutive series of manuscripts which begin in the year 1489.

There is nothing surprising in the fact that the notes regarding his pupils are few and meagre. Excepting for the record of money transactions only very exceptional circumstances would have prompted him to make any written observations on the persons with whom he was in daily intercourse, among whom, of course, were his pupils. Of them all none is so frequently mentioned as Salai, but the character of the notes does not—as it seems to me—justify us in supposing that he was any thing more than a sort of factotum of Leonardo's (see 1519, note).

Leonardo's quotations from books and his lists of titles supply nothing more than a hint as to his occasional literary studies or recreations. It was evidently no part of his ambition to be deeply read (see Nrs. 10, 11, 1159) and he more than once expressly states (in various passages which will be found in the foregoing sections) that he did not recognise the authority of the Ancients, on scientific questions, which in his day was held paramount. Archimedes is the sole exception, and Leonardo frankly owns his admiration for the illustrious Greek to whose genius his own was so much akin (see No. 1476). All his notes on various authors, excepting those which have already been inserted in the previous section, have been arranged alphabetically for the sake of convenience (1469—1508).

The passages next in order contain accounts and inventories principally of household property. The publication of these—often very trivial entries—is only justifiable as proving that the wealth, the splendid mode of life and lavish expenditure which have been attributed to Leonardo are altogether mythical; unless we put forward the very improbable hypothesis that these notes as to money in hand, outlay and receipts, refer throughout to an exceptional state of his affairs, viz. when he was short of money.

The memoranda collected at the end (No. 1505—1565) are, in the original, in the usual writing, from left to right. Besides, the style of the handwriting is at variance with what we should expect it to be, if really Leonardo himself had written these notes. Most of them are to be found in juxtaposition with undoubtedly authentic writing of his. But this may be easily explained, if we take into account the fact, that Leonardo frequently wrote on loose sheets. He may therefore have occasionally used paper on which others had made short memoranda, for the most part as it would seem, for his use. At the end of all I have given Leonardo's will from the copy of it preserved in the Melzi Library. It has already been printed by Amoretti and by Uzielli. It is not known what has become of the original document.

Truova ingol e digli che tu l'aspetti
amor a e che tu andrai cō seco ilopan a;
²fatti fare enoiganod al; e tolli il libro di
Vitolone, e le misure · delli edifiti ³ publici ·;
fa fare 2 casse coperte da mvlattiere, ma
meglio fia · le coperte da letto, che ⁴ son 3,
delle quali lascierai una a Vinci; togli le
fodere (?) delle grattugie (?) da Gio⁵vā
Lonbardo il telajuolo di Verona ·; cōpra
delle tovaglie · e mātili scarpini,
⁶calze 4 para, vn giubbone di cimoza e
pelli per fare ne de' novi; il tornio d'Ales-
⁷sandro ·; vendi quel che nō si può portare;
piglia da Gian di Paris il modo de colorire
⁸a secco ·, el modo del sale bianco e del
fare le carte inpastate; folie in mol⁹ti doppi;

Find Longhi and tell him that you wait
for him at Rome and will go with him to
Naples; make you pay the donation [2] and
take the book by Vitolone, and the measure-
ments of the public buildings. [3] Have two
covered boxes made to be carried on mules,
but bed-covers will be best; this makes three,
of which you will leave one at Vinci. [4] Obtain
the from Giovanni Lom-
bardo the linen draper of Verona. Buy hand-
kerchiefs and towels, and shoes, 4 pairs
of hose, a jerkin of . . . and skins, to
make new ones; the lake of Alessandro. [7]
Sell what you cannot take with you. Get
from Jean de Paris the method of painting
in tempera and the way of making white

Memoranda
before 1500
(1379—1413).

1379. 1. truova ingol edilli chettu . . chettu . . ilopana. 2. fare la eno iganodal ettolli . . elle. 3. faffare . . coperte dalletto.
4. lascierai ĩ a uinci . . le fochere delle gratuto dago. 5. lonbardo il teraajo (?) di uerona . . mātili bretre (?) scarpīni.
6. gubbone di ci moza . . tornio dale. 7. si po . . piglia dāgandiparis. 8. assecho . . folie in mol. 9. ti doppi ella sua

1379. The mysterious looking words, quite dis-
tinctly written, in line 1: *ingol, amor a, ilopan a* and
on line 2: *enoiganod al* are obviously in cipher and
the solution is a simple one; by reading them back-
wards we find for *ingol*: logni—probably *longi*, evi-
dently the name of a person; for *amor a*: *a Roma*,
for *ilopan a*: *a Napoli*. Leonardo has done the same
in two passages treating on some secrets of his art
Nos. 641 and 729, the only other places in which
we find this cipher employed; we may therefore
conclude that it was for the sake of secrecy that
he used it.

There can be no doubt, from the tenor of this
passage, that Leonardo projected a secret excursion
to Naples. Nothing has hitherto been known of
this journey, but the significance of the passage will
be easily understood by a reference to the following
notes, from which we may infer that Leonardo really

had at the time plans for travelling further than
Naples. From lines 3, 4 and 7 it is evident that
he purposed, after selling every thing that was not
easily portable, to leave a chest in the care of his
relations at Vinci. His luggage was to be packed
into two trunks especially adapted for transport by
mules. The exact meaning of many sentences in
the following notes must necessarily remain obscure.
These brief remarks on small and irrelevant affairs
and so forth are however of no historical value. The
notes referring to the preparations for his journey
are more intelligible.

2. Libro di Vitolone see No. 1506 note.

7 and fol. It would seem from the text that
Leonardo intended to have instructions in painting
on paper. It is hardly necessary to point out
that the Art of illuminating was quite separate from
that of painting.

e la sua cassetta de' colori; inpar la tem-
pera delle carnagioni, inpara [10]a disoluere
la lacca gommata, lin del seme, de
. . . e dele . . . biãche, [11]delli agli da
Piacẽtia, togli 'De Põderibus;' tolli l'opere
di Leonardo cremo[12]nese; leua il fornello
[13]. della [14]semẽza de ligli [15]e
dell'erba stella, [16]delle zuche marine, [17]vẽdi
l'asse della sosta, [18]fatti dare la
[19]a chi la rubò, pi[20]glia il liuellare, [21]quãto
terreno può [22]cauare l'omo in un dì.

salt, and how to make tinted paper; sheets
of paper folded up; and his box of co-
lours; learn to work flesh colours in tem-
pera, learn to dissolve gum lac, linseed
. white, of the garlic of Pia-
cenza; take '*de Ponderibus*'; take the works of
Leonardo of Cremona. Remove the small fur-
nace seed of lilies and of . . . Sell the
boards of the support. Make him who stole it,
give you the learn levelling and how
much soil a man can dig out in a day.

C. 19*b*] **1380.**

Questo fecie Lione in piazza
[2]di castello con v̄ vincolo e vna
[3]saetta.

This was done by Leone in the
piazza of the castle with a chain
and an arrow.

B. 50*b*] **1381.**

[2]Callias Rodiano, [3]Epimaco Ateniense,
[4]Diogine filosofo Rodiano, [5]Calcedonio di
Tracia, [6]Febar di Tiria, [7]Callimaco architetto,
maestro di fochi.

Callias of Rhodes, Epimachus the Athe-
nian, Diogenes, a philosopher, of Rhodes,
Calcedonius of Thrace, Febar of Tyre, Calli-
machus the architect, a master of fires.

Ash. II. 13*b*] **1382.**

A maestro Lodovico chiedi li cõdotti
d'acqua.

Ask maestro Lodovico for 'the conduits
of water'.

Fl. Uff.] **1383.**

. . . ɉ Pistoja[2]; Fiorauante di Domenico
ɉ Firenze è cõpare [3]amantissimo, quant' è
mio . . .

. . . at Pistoja, Fioravante di Domenico at
Florence is my most beloved friend, as though
he were my [brother].

. . cornage inpara. 10. lacha gommatalli del seme de fotteragi e delle gniffe biãche. 11. delli algli da piacẽtia . . leonardo
chermo. 13. diganni noto della. 14. semẽza deli gli. 15. e dellerba stella. 16. delle zuche marine. 17. dalla. 18. fatti
dare la fochera. 19. tereno po. 20. lomo nũdi.
1380. 1. questa . . piaza. 2. casstello chon v̄ uĩcho e vna.
1381. 3. acte niense. 4. filosafo. 6. febar di tiria. 7. challimacho architecto.
1382. mastro lodvvicho ciedi . . dacq"a".
1383. \\\ e echopa ɉ pisstoja. 2. domenicho . . cõpere. 3. mio jjrsuiosssam (?). 4. jnde nom. 5. amante quanto.

11. *De Ponderibus.* A large number of Leonardo's
notes bear this superscription. Compare No. 1436, 3.

1380. This note must have been made in Milan;
as we know from the date of the MS.

1381. Callias, Architect of Aradus, mentioned
by Vitruvius (X, 16, 5).—Epimachus, of Athens, in-
vented a battering-enginee for Demetrius Poliorketes
(Vitruvius X, 16, 4).—Callimachus, the inventor of
the Corinthian capital (Vitr. IV, 1, 9), and of the

method of boring marble (Paus. I, 26, 7), was also
famous for his casts in bronze (Plin. XXXIV,
8, 19). He invented a lamp for the temple of
Athene Polias, on the Acropolis of Athens (Paus.
I, 26, 7).—The other names, here mentioned, cannot
be identified.

1382. *Condotti d'acqua.* Possibly a book, a MS. or
a map.

1383. On the same sheet is the text No. 663.

S. K. M. III. 1*b*]　　　　　**1384.**

A dì 16 di luglio.
[2]Caterina venne a dì 16 [3]di luglio 1493.
[4]Morel Fiorētino di messer Mariolo, cavallo [5]grosso à bel collo e assai bella testa.
[6]Rōzone biāco del falconiere à belle coscie, [7]dirieto sta in Porta Comasina.
[8]Cauallo grosso del Chermonino del signor Givlio.

On the 16th day of July.
Caterina came on 16th day of July, 1493.
Messer Mariolo's Morel the Florentin, has a big horse with a fine neck and a beautiful head.
The white stallion belonging to the falconer has fine hind quarters; it is behind the Comasina Gate.
The big horse of Cermonino, of Signor Giulio.

S. K. M. III. 30*a*]　　　　　**1385.**

DELLO STRUMĒTO.

[2]Chiūque spēde uno ducato per paro [3]pigli lo strumēto, e non spē[4]derà · se non v̄ mezzo per premi[5]nētia allo invētore dello strum[6]ēto, e vno grosso per l'operatore [7]ogni año; non uoglio sottovfiti [8]all.

OF THE INSTRUMENT.

Any one who spends one ducat may take the instrument; and he will not pay more than half a ducat as a premium to the inventor of the instrument and one grosso to the workman every year. I do not want sub-officials.

S. K. M. III. 55*a*]　　　　　**1386.**

Maestro Givliano da Mar[2]liano a v̄ bello erbolaro; [3]sta a riscōtro alli Strami [4]legnamieri.

Maestro Giuliano da Marliano has a fine herbal. He lives opposite to Strami the Carpenters.

S. K. M. III. 94*a*]　　　　　**1387.**

Cristofano da Castiglio[2]ne sta alla Pietà, à bona [3]testa.

Christofano da Castiglione who lives at the Pietà has a fine head.

C. A. 328*a* 980*a*]　　　　　**1388.**

Opera di [2]della stalla di G[3]aleazzo; [4]per la via di Brera; [5]benefitio dello Stanghe; bene[6]fitio della por[7]ta nova; [8]benefitio di Mon[9]sa—; [10]errore dell' Inta[11]co—; [12]dì prima li benefitj; [13]e poi l'opere e poi [14]le ingratudini [15]e poi le īdegni e la[16]mētationi e . . .

Work of . . . of the stable of Galeazzo; by the road of Brera[4]; benefice of Stanghe[5]; benefice of Porta Nuova; benefice of Monza; Indaco's mistake; give first the benefices; then the works; then ingratitude, indignity and lamentations.

H.3 47*b*]　　　　　**1389.**

Chiliarco, capo di mille,
[2]Prefetti—capitani,
[3]Legione, semila 63.

Chiliarch—captain of 1000.
Prefects—captains.
A legion, six thousand and sixty three men.

1384. 1. R. 2. catelina. 4. chaval. 5. chollo eassa. 6. rōcino. 8. R. chauallo . . del chermanino.
1385. 2. chiūq spēde ī ducato . . paro. 3. lustrumēto . . ispē. 4. mezo. 6. ēto e ī grosso. 7. oñ año uoglio.
1386. 3. alli strami. 4. legiamieri.　　　　**1387.** 1. cristofano da chasstiglio.
1388. 1. Opera di roma. 2. dich. 5. benefitio . . beni. 8. benefitio. 9. cia. 10. crore. 11. cho. 12. benefiti. 14. ingralitūdine. 16. mētatione.　　　**1389.** 1—3 R.

1384. Compare Nos. 1522 and 1517. Caterina seems to have been his housekeeper.

1385. Refers perhaps to the regulation of the water in the canals.

1386. Compare No. 616, note. 4. *legnamiere* (milanese dialect) = legnajuolo.

1388. 4. *Brera*, see No. 1448, 11, 13; 5. *Stanghe*, see No. 1509.

H.² 14 b] 1390.

Vna monica sta alla Colōba ²in Cre- A nun lives at La Colomba at Cremona;
mona che lavora bē ³cordoni di paglia, e she works good straw plait, and a friar of
vno frate ⁴di Scō Francesco. Saint Francis.

H.² 46a] 1391.

Aguglia,—Niccolao,—²refe,—³Ferrādo, Needle,—Niccolao,—thread,—Ferrando,
—⁴iacopo ādrea,—⁵tela,—⁶pietra,—⁷colo- —Iacopo Andrea,—canvas,—stone,—co-
ri,—⁸penella,—⁹tavoletta da colori,—¹⁰spū- lours,—brushes,—pallet,—sponge,—the panel
ga,—¹¹tavola del Duca. of the Duke.

S. K. M. II.² 7 a] 1392.

Messer Giā Domenico ²Mezzabarba, e Messer Gian Domenico Mezzabarba and
messer ³Giovā Francesco Mezzabarba, ⁴al Messer Giovanni Franceso Mezzabarba. By
lato a messer Piero d' Anghie⁵ra. the side of Messer Piero d'Anghiera.

S. K. M. II.² 7 b] 1393.

Cōte Francesco Torello. Conte Francesco Torello.

S. K. M. II.² 12 a] 1394.

Givliā Trōbetta,—²Antonio di Ferrara, Giuliano Trombetta,—Antonio di Ferrara,
—³olio di bolla. —Oil of

S. K. M. II 2 20 a] 1395.

Paolo fu ratto in cielo. Paul was snatched up to heaven.

S. K. M. II.² 22 a] 1396.

Givliā da Maria, medico ²à vn massajo Giuliano da Maria, physician, has a stew-
sāza mano. ard without hands.

S. K. M. II.² 27 a] 1397.

Fatti mādare spighe di ²grā grosso da Have some ears of corn of large size sent
Firēze. from Florence.

1390. 1—4 R. 2. chermona chellavora. 3. chordoni. 4. franc"o".
1391. 1—11 R. 1. agngia niccholao. 3. ferādo.
1392. 1. domenicho. 2. meza . . meser. 3. franc"o" meza. 4. Piero dagale. 5. ra sotto il coperio debe lacq"a".
1393. franc"o". 1394. 1. trobebetta. 2. ferra. 3. dibola. 1395. R. pagolo.
1396. 1. mariamēdicho. 2. avmazaro. 1397. 1. spīge.

1390. _La Colomba_ is to this day the name of a small house at Cremona, decorated with frescoes.
1394. Near this text is the sketch of a head drawn in red chalk.
1395. See the facsimile of this note on Pl. XXIII No. 2.

S. K. M. II.2 52 *a*] **1398.**

Vedi la lettiera a Scā Maria;
² Segreta.

See the bedstead at Santa Maria.
Secret.

S. K. M. II.2 53 *a*] **1399.**

¶ Arrigo de' avere ² ducati 11 d'oro; ¶
³ Arrigo de' avere ⁴ ducati 4 d'oro ⁵ a
mezzo Agosto.

Arrigo is to have 11 gold Ducats.
Arrigo is to have 4 gold ducats in the
middle of August.

S. K. M. II.2 63 *a*] **1400.**

Da al patrone lo esēplo ² del capitano,
che nō lui vī³cie, ma li soldati mediāte ⁴ il
suo cōsilio, e pur merita il saldo.

Give your master the instance of a
captain who does not himself win the vic-
tory, but the soldiers do by his counsels;
and so he still deserves the reward.

S. K. M. II.2 68 *b*] **1401.**

Messer Pier Antonio.

Messer Pier Antonio.

S. K. M. II.2 69 *a*] **1402.**

Olio,—² giallo,—³ Ambrosio,—⁴ la boc-
ca,—⁵ la masseria.

Oil,—yellow,—Ambrosio,—the mouth,—
the farmhouse.

S. K. M. II.2 75 *b*] **1403.**

Alessandro carissimo, ² da Parma per la
mā di . . .

My dear Alessandro from Parma, by the
hand of . . .

S. K. M. II.2 78 *b*] **1404.**

Giovannina, viso fantastico, ² sta a Scā
Caterina, all' ospedale.

Giovannina, has a fantastic face,—is at
Santa Caterina, at the Hospital.

I.2 11 *a*] **1405.**

24 tavole fanno una pertica;
² 4 trabochi fanno una tavola;
³ 4 braccia e mezzo fanno uno trabocco;
⁴ vna pertica è 1936 braccia ☐,
⁵ ovvero 1944.

24 tavole make 1 perch.
4 trabochi make 1 tavola.
4 braccia and a half make a trabocco.
A perch contains 1936 square braccia,
or 1944.

1399. 1. arigo. 3. arigo. 5. mezo. **1400.** 1. padrone. **1401.** meser pier ātō chodi. 2. diga.
1402. 3. abrosio. 4. bocha. 5. masera. **1403.** 1. charissi no. 2. [si] da . . mā di[l]p.
1404. 1. fantasticho. 2. chaterina.
1405. 1—5. R. 1. fā î perticha. 2. fa î. 3. br e mezo fa î trabocho. 4. perticha he . . br. 5. ovr.

1404. Compare the text on the same page: No. 667.

I.2 70 b] 1406.

La strada di messer Mariolo è braccia The road of Messer Mariolo is 13 $^1/_4$ brac-
13 $^1/_4$, ^2la casa di Vāgelista è 75; cia wide; the House of Evangelista is 75.
^3Entra braccia 7 e $^1/_2$ ^4nella casa di It enters 7 $^1/_2$ braccia in the house of Ma-
Mariolo. riolo.

I.2 72 b] 1407.

Domando in che parte del suo moto I ask at what part of its curved motion
curvo ^2la cavsa, che move, lascierà la cosa the moving cause will leave the thing
mossa ^3e mobile. moved and moveable.

^4Parla cō Pietro Mōti di questi tali Speak to Pietro Monti of these methods
^5modi di trarre i dardi. of throwing spears.

I.2 87 a] 1408.

Antonio de' Risi sta al cō^2siglio di Antonio de' Risi is at the council of
Givstitia. Justice.

I.1 28 a] 1409.

Disse Paolo che nessuno strumento Paolo said that no machine that moves
^2che move vn altro..... another

1406. 1. meser . . he br. 2. vāgelissta he. 3. br 7 e 1/2. 1409. 1. pagolo.

1406. On this page and that which faces it, here given, deals with questions in mechanics.
MS. I² 71ᵃ, are two diagrams with numerous reference The instances in which Leonardo quotes the opi-
numbers, evidently relating to the measurements of nions of his contemporaries on scientific matters
a street. are so rare as to be worth noticing. Compare
 1409. The passage, of which the beginning is No. 901.

W. P. 7.] **1410.**

 Caravaggio. Caravaggio.

W. A. II. 5 *b*] **1411.**

 Carrucole, — [2]chiodi, — [3]corda, — [4]mercu- Pulleys, —nails,—rope,—mercury,—cloth,
rio, — [5]tela, — [6]lunedì. Monday.

W. A. II. 202 *b*] **1412.**

 RICORDO. MEMORANDUM.

 [2]Maghino Speculus di maestro Giovanni Maghino, Speculus of Master Giovanni
Frãciese; [3]Galieno de vtilità. the Frenchman; Galenus on utility.

W. X.] **1413.**

 Presso al Corduso · sta Pier Antonio da Near to Cordusio is Pier Antonio da
Fossano [2]e Serafino · suo fratello. Tossano and his brother Serafino.

L. o'] **1414.**

 Paolo di Vannoccio in Siena. Paul of Vannochio at Siena Memoranda
 [3]La saletta di sopra per li apostoli; The upper chamber for the apostles. after 1500
 [4]Buildings by Bramante. (1414—1434)
 [4]Edifiti di Bramãte; The governor of the castle made a
 [5]Il castellano fatto prigione; prisoner,
 [6]Il Visconte strascinato e poi morto il [6]Visconti carried away and his son
figliuolo; killed.
 [7]Gian della Rosa toltoli i danari; Giovanni della Rosa deprived of his money.
 [8]Borgonzo principiò e nol volle, e però [8]Borgonzio began ; and moreover
fuggì le fortune; his fortunes fled.
 [9]Il duca perso lo stato e la roba e li- The Duke has lost the state, property
ertà, [10]e nessuna sua opera si finì per lui. and liberty and none of his entreprises was
 carried out by him. [10].

1410. carovagio. 1411. 1. carruchole. 4. merchurio, 7. idomoodi (?).
1412. 1. richordo. 2. maghino spechulus di m"o". 1413. 1. chorduso . . daffossano. 2. essera fino.
1414. 1. pagolo di uannocco. 2. codi rõcho . — domenico chia umo. 5. prigone. 6. bissconte strascinato . . el figlolo. 7. gan
 della rosa tollto li e danari. 8. borgonzo . . pro. 9. ella roba elliberta.

1410. *Caravaggio,* a village not far from the Adda
between Milan and Brescia, where Polidoro and Michel-
angelo da Caravaggio were born. This note is given
in facsimile on Pl. XIII, No. 1 (above, to the left).
On Pl. XIII, No. 2 above to the right we read
cerovazo.

1413. This note is written between lines 23 and
24 of the text No. 710. Corduso, Cordusio (*curia
ducis*) = Cordus in the Milanese dialect, is the name
of a Piazza between the Via del Broletto and the
Piazza de' Mercanti at Milan. . In the time of il
Moro it was the centre of the town. The persons
here named were members of the noble Milanese
family de'Fossani; Ambrogio da Fossano, the con-
temporary painter, had no connection with them.

 1414. l. 4—10. This passage evidently refers to
events in Milan at the time of the overthrow of
Ludovico il Moro. Amoretti published it in the
'*Memorie Storiche*' and added copious notes.

 6. *Visconti. Chi fosse quel Visconte non sapremmo in-
dovinare fra tanti di questo nome. Arluno narra che
allora atterrate furono le case de' Viconti, de' Castiglioni,
de' Sanseverini, e de' Botta e non è improbabile che ne
fossero insultati e morti i padroni. Molti Visconti annovera lo
stesso Cronista che per essersi rallegrati del ritorno del
duca in Milano furono da' Francesi arrestati, e strascinati
in Francia come prigionieri di stato; e fra questi Messer
Francesco Visconti, e suo figliuolo Battista.* (AMORETTI,
Mem. Stor. XIX.)

 8. *Borgonzio o Brugonzio Botta fu regolatore delle du-
cali entrate sotto il Moro, alla cui fuga la casa sua fu
pur messa a sacco da' partitanti francesi.* (AMORETTI, l. c.)

L. 1 a] **1415.**

²1 A̅brosio Petri,—³Sc̄o Marco,—⁴4
assi per la finestra,—⁵2 guasparistrame—
⁶3 i sa̅ti di capelle,—⁷5 a casa li Gienovesi.

Ambrosio Petri, St. Mark, 4 boards for
the window, 2, 3 the saints of
chapels, 5 the Genoese at home.

L. 1 b] **1416.**

Panno d'arazzo,—²seste,—³libro di Ma-
so,—⁴libro di Giovanni Be̅cj,—⁵cassa in
dogana,—⁶tagliare la vesta,—⁷cintura della
spada,—⁸rinpedulare li stivaletti,—⁹cappello
legieri,—¹⁰canne delle casaccie,—¹¹il de-
bito della touagla,—¹²baga da notare,—
¹³libro di carte bianche per disegnare,—
¹⁴carboni. ¹⁵¶qua̅to è uno fiorino ¹⁶di su-
gello?¶ ¹⁷¶vn guarda¹⁸cuore di pelle.¶

Piece of tapestry,—pair of compasses,—
Tommaso's book,—the book of Giovanni
Benci,—the box in the custom-house,—to cut
the cloth,—the sword-belt,—to sole the boots,
—a light hat,—the cane from the ruined
houses,—the debt for the table linen,—swim-
ming-belt,—a book of white paper for draw-
ing,—charcoal.—How much is a florin,
a leather bodice.

L. 2 a] **1417.**

Borges ti farà avere Archimede del
²vescouo di Padova, e Vitellozzo quello
dal Borgo a San Sepolcro.

Borges shall get for you the Archimedes
from the bishop of Padua, and Vitellozzo the one
from Borgo a San Sepolcro.

L. 30 b] **1418.**

Tabella di Marzocco.

Marzocco's tablet.

L. 0″] **1419.**

Marcello sta in casa di Giacomo da
Me̅²gardino.

Marcello lives in the house of Giacomo
da Mengardino.

Br. M. 202 b] **1420.**

Dou'è Valentino?—²stiuali,—³casse in
dogana,—⁴. . . .,—⁵frate del Carmine,—
⁶squadre,—⁷Piero Martelli,—⁸Salui Bor-
gherini,—⁹rimanda le sache,—¹⁰sostētaculo
delli ochiali,—¹¹lo igniudo del Sangallo,—
¹²la cappa.
 ¹³Porfido,—¹⁴gruppi,—¹⁵squadra,—
¹⁶Pandolfino.

Where is Valentino?—boots,—boxes in
the custom-house,. . . .,—[5] the monk at the
Carmine,—squares,—[7] Piero Martelli,—
[8] Salvi Borgherini,—send back the bags,—
a support for the spectacles,—[11] the nude
study of San Gallo,—the cloak.
 Porphyry,—groups,—square,—[16] Pan-
dolfino.

1415. 1. 10 omria (?). 4. aose. 5. quas paris trame. 7. chasa legienovesi.
1416. 1. darazo. 6. taglare lavessta. 8. lissti valetti. 10. dalle cassacce. 15. e i̅ fi. 18. core. **1417.** 2. vesscovo. 2. vitellozo.
1418. marzoccho. **1419.** 1. chasa diachomo. **1420.** 4. falleri. 8. borgerini. 11. lognudo.

1417. *Borges.* A Spanish name.
3. Borgo a San Sepolcro, where Luca Paciolo, Leonardo's friend, was born.
1420. *Valentino.* Cesare Borgia is probably meant. After being made Archbishop of Valence by Alexander VI he was commonly called Valentinus or Valentino. With reference to Leonardo's engagements by him see pp. 224 and 243, note.

5. *Carmine.* A church and monastery at Florence.
7. 8. *Martelli, Borgherini;* names of Florentine families. See No. 4.
11. *San Gallo;* possibly Giuliano da San Gallo, the Florentine architect.
16. *Pandolfini,* see No. 1544 note.

F. o'] **1421.**

¶Spechi cōcavi; ¶filosofia d'Aristotile, ²¶libri d'Auicenna; ¶messer Ottaviā Palavi-³¶vocabolista vul- cino pel suo Vetruuio;¶ ⁴gare e latino.¶ ⁵¶Coltelli di Boemia; ¶Va ogni sabato alla ⁶Vetruuio;¶ stufa e vedrai delli nudi;¶ ⁷¶Meteora; ⁸¶Archimede, de cē- ¶Fa gōfiare il polmō ⁹tro grauitatis.¶ d'ū porco, e guarda ¹⁰¶Anotomia, Alessā- se cresce in larghezza ¹¹dro Benedetto;¶ e ī lūghezza, over in larghezza e māco in ¹²¶Il Dāte di Niccolò del- lūghezza.¶ ¹³la Croce.¶

¹⁴Al Bertuccio il Marliano de calcula-tione, ¹⁵Alberto de celo e mūdo · [da fra Bernardino]; ¹⁶Oratio scrisse della velocità del cielo.

Concave mirrors; philosophy of Aristotle; [2] the books of Avicenna; Messer Ottaviano Italian and Latin vocabu-Palavicino for his lary; Vitruvius[3]. bohemian knives; go every Saturday to the Vitruvius;[6] hot bath where you will see naked men; 'Meteora'[7]. Archimedes, on the centre Inflate the lungs of gravity; [9] of a pig and ob-anatomy [10] Alessandro serve whether they Benedetto; increase in width The Dante of Niccolò and in length, or della Croce; in width dimini-shing in length. [14] Marliano, on Calculation, to Bertuccio. Albertus, on heaven and earth[15], [from the monk Bernardino]. Horace has written on the movements of the heavens.

F. 27 b] **1422.**

De' 3 corpi regolari cōtro alcū comēta-²tori che biasimā li ātichi īvētori dōde na-quero le gramatiche e le scientie . . .

Of the three regular bodies as opposed to some commentators who disparage the An-cients, who were the originators of grammar and the sciences and . . .

W. An. III. 217 a ('G·')] **1423.**

Camera de²lla Torre da ³Vaneri.

The room in the tower of Vaneri.

1421. 2. dauinega. 3. vocabolissta . — sino pel. 4. ellatino. 5. buemia . . alla. 6. vederai. 7. meteura. 9. trugrauitatis . — dū porcho. 10. alesā . — cresse in largeza. 11. lūgeza . . largeza. 12. nicolo de . — e mācha in lūgeza. 14. bertucco. 16. oratio . . del celo. *These six word*s *are written in four short lines on the margin near line* 1—4. **1422.** 2. nascerō le gramatiche elle. **1423.** 1. chamera.

1421. *Filosofia d'Aristotele* see No. 1481 note.

2. *Avicenna* (Leonardo here writes it Avinega) the Arab philosopher, 980—1037, for centuries the un-impeachable authority on all medical questions. Leonardo possibly points here to a printed edition: *Avicennae canonum libri V, latine* 1476 *Patavis*. Other editions are, Padua 1479, and Venice 1490.

3. 6. *Vitruvius.* See Vol. I, No. 343 note.

7. *Meteora.* See No. 1448, 25.

9. The works of Archimedes were not printed during Leonardo's life-time.

10. Compare No. 1494.

14. *Johannes Marliani sua etate philosophorum et me-dicorum principis et ducalis phisic. primi de proportione motuum velocitate questio subtilissima incipit ex ejusdem Marliani originali feliciter extracta, M(ilano)* 1482.

Another work by him has the title: *Marlianus mediolanensis. Questio de caliditate corporum humanorum tempore hiemis ed estatis et de antiparistasi ad celebrem philosophorum et medicorum universitatem ticinensem.* 1474.

15. See No. 1469, l. 7.

1423. This note is written inside the sketch of a plan of a house. On the same page is the date 1513 (see No. 1376).

W. 232*b* (.F.)] **1424.**

Riserua all'ultimo dell'ōbre le figure
[2]che cōpariranno nello scrittoio di Gerar[3]do
miniatore a Sā Marco in Firēze.

[4][Va per il Melso, [5]e allo Ambasciatore
[6]e a maestro Bernardo.]

The figures you will have to reserve for
the last book on shadows that they may appear
in the study of Gerardo the illuminator at San
Marco at Florence.

[Go to see Melzo, and the Ambassador,
and Maestro Bernardo].

M. 0'] **1425.**

Ermete [2]filosofo.

Hermes the philosopher.

M. 8*a*] **1426.**

Suisset cioè calculatore, — [2]Tisber, —
Angelo Fossobrō, — [4]Alberto.

Suisset, viz. calculator, — Tisber, — An-
gelo Fossobron, — Alberto.

M. 53*b*] **1427.**

Modo del pōte leuatojo che mi mostrò
Donnino, [2]e perchè *c* · e *d* spingano in basso.

The structure of the drawbridge shown me
by Donnino, and why *c* and *d* thrust downwards.

Mz. 0''] **1428.**

Piglerà il primo volo il grāde vccello; —
sopra del dosso del suo [2]magnio cecero, —
empiēdo l'universo di stupore, — em [3]piēdo
di sua fama tutte le scritture e gloria et-
terna al loco [4]dove nacque.

The great bird will take its first flight; —
on the back of his great swan, — filling
the universe with wonders; filling all writings
with his fame and bringing eternal glory to
his birthplace.

Tr. 22] **1429.**

Questo inganno fu vsato dai Ga[2]lli ·
contro · a' Romani, e seguì [3]ne tal morta-
lità che tutta [4]Roma · si vestì · a bruno.

This stratagem was used by the Gauls
against the Romans, and so great a mortality
ensued that all Rome was dressed in mourn-
ing.

1424. serua. 2. ceparirano scriptoio [del] di gera. 3. marcho. 5. ībassciatore. 6. maesstro.
1425. 2. filosafo. **1426.** 1. coe chalculatore. 3. fossabrō. **1427.** 1. leuato i che. 2. c he d spingano.
1428. 1. il p''o'' volto [leverassi delge] il. 2. cecero c enpiēdo. 3. groria . . alaido. 4. [dore] doue.
1429. 2. chontro . . essegui. 3. chettutta. 4. vessti.

1424. L. 1—3 are in the original written between
lines 3 and 4 of No. 292. But the sense is not clear
in this connection. It is scarcely possible to de-
vine the meaning of the following sentence.

2. 3. *Gherardo* Miniatore, a famous illuminator,
1445—1497, to whom Vasari dedicated a section of
his Lives (Vol. II pp. 237—243, ed. Sansoni 1879).

5. *Bernardo*, possibly the painter Bernardo Ze-
nale.

1427. The sketch on the same page as this text
represents two poles one across the other. At the
ends of the longest are the letter *c* and *d*. The
sense of the passage is not rendered any clearer.

1428. This seems to be a speculation about the
flying machine (compare p. 271).

1429. Leonardo perhaps alludes to the Gauls under
Brennus, who laid his sword in the scale when the
tribute was weighed.

K.² 27 *b*]

1430.

Alberto da Imola;—algebra cioè dimostratione come una cosa s'agguaglia a un altra.

Alberto da Imola;—Algebra, that is, the demonstration of the equality of one thing to another.

K.3 48 *b*]

1431.

Joannes Rubicissa e Robbia.

Johannes Rubicissa e Robbia.

W. A. III. 152 *a*]

1432.

Dimāda la moglie di Bia²gio Crivelli come il cappone ³allieva e cova l'oua della ⁴gallina, essendo lui inbri⁵acato.

Ask the wife of Biagio Crivelli how the capon nurtures and hatches the eggs of the hen,—he being drunk.

W. A. IV. 153'*a*]

1433.

Libro dell'acque a messer Marco Antonio.

The book on Water to Messer Marco Antonio.

W. An. IV. 167]

1434.

Fa tradurre Avicenna; de' giovamēti;— ²ochiali col cartone, ³acciajuolo e forchetta e;—⁴carbone, asse e fogli e lapis e biāchetto e cera;—⁵tanagle e . . . da vetri, sega da osso di sottil dētatura, scarpello, ⁶calamaro de, 3 erbe, e Agnol Benedetto, ⁷fa d'avere vn teschio, noce, mostarda;
⁸Stivali,—guāti,—⁹calcetti,—¹⁰pettine, papiri,—¹¹ ,—¹²camisce, . . .,—¹³stringhe, carbori,—¹⁴scarpe, —¹⁵tēperatoio,—¹⁶penne,—¹⁷vna pelle al petto.

Have Avicenna's work on useful inventions translated; spectacles with the case, steel and fork and, charcoal, boards, and paper, and chalk and white, and wax; for glass, a saw for bones with fine teeth, a chisel, inkstand, three herbs, and Agnolo Benedetto. Get a skull, nut,—mustard.

Boots,—gloves, socks, combs, papers, towels, shirts, shoe-tapes, — shoes, penknife, pens. A skin for the chest.

W. L. 141 *b*]

1435.

Libro di Piero Crescēzio,—²i nvdi di Giouañj Ambrosio,—³compasso,—⁴libro di Gian Jacomo,—

The book of Piero Crescenzo,—studies from the nude by Giovanni Ambrosio,—compasses,—the book of Giovanni Giacomo.

Undated memoranda (1435—1457).

1430. 2. alcibra coe mostra come. 3. n"o" e cosa sagualglia alla cosa.
1431. 1. ioanēs "erobbia" rupicissa. 1432. 2. gi cri velli . . cuppone. 4. ghallina.
1433. 1. dellacq"e" . . marcho ant.
1434. 1. avicena de govamēti. 3. accarolo . . egamavr (*or* gamaut). 4. ellapis e biācetto. 5. tauaglie "e topo da vetri" segha "da osso" di. 6. calimano de aperataio. 7. tesscio . . mostada. 10. palpiri. 11. scugaco da scarte. 12. camisce coci. 13. curbori. 1435. 1. crescciēzo.

1433. Possibly Marc-Antonio della Torre, see p. 97.

1434. 4. *Lapis.* Compare Condivi, *Vita di ¹Michelagnolo Buonarotti*, Chap. XVIII.: *Ma egli* (Michelangelo) *non avendo che mostrare, prese una penna (perciochè in quel tempo il lapis non era in uso) e con tal leggiadria gli dipinse una mano ecc.* The incident is of the year 1496.—*Lapis* means pencil, and chalk (*matita*). Between lines 7 and 8 are the texts given as Nos. 819 and No. 7.

W. L. 141 a] **1436.**

RICORDO.

²Andare in provisione per il mio giar-dino,—³Giordano 'de pōderibus',—⁴el cō-ciliatore, de flusso e reflusso del mare,—⁵far fare due casse da soma,—⁶vedi il tor-nio del Beltraffio e falli trarre vna pietra,—⁷Lascia il libro a messere Andrea tedesco, ⁸fa vna bilancia d'una freccia e pesa la cosa īfocata e poi la ripesa fredda; ⁹Lo spechio di maestro Luigi,—¹⁰A b flusso e reflusso dell'acque, provato al molino di Vaprio,—¹¹beretta.

MEMORARDUM.

To make some provisions for my garden, —Giordano, *De Ponderibus* [3],—the peace-maker, the flow and ebb of the sea,—have two baggage trunks made, look to Beltraffio's [6] lathe and have taken the stone,—out leave the books belonging to Messer Andrea the German,—make scales of a long reed and weigh the substance when hot and again when cold. The mirror of Master Luigi; *A b* the flow and ebb of the water is shown at the mill of Vaprio,—a cap.

W. L. 212 a] **1437.**

Giovanni Fabre,—²Lazaro del Volpe,—³comune, ⁴Ser Piero.—

Giovanni Fabre,—Lazaro del Volpe,—the common,—Ser Piero. |

W. L. 203 a] **1438.**

[Lattantio] ²[libro di Benozzo], ³gruppi,—⁴legare il libro,—⁵Lucerna,—⁶Ser Pe-cantino,—⁷Pandolfino,—⁸[Rosso],—⁹squa-dra,—¹⁰coltellini,—¹¹carrozze,—¹²stregghia ¹³[cavallina],—¹⁴tazza.

[Lactantius], [the book of Benozzo], groups,—to bind the book,—a lantern,—Ser Pecantino,—Pandolfino.—[Rosso]—a square, —small knives,—carriages,—curry combs—cup.

C. A. 11 b; 37 b] **1439.**

Quadrāte di Carlo Marmocchi,—²mes-ser Francesco Araldo,—³Ser Benedetto d'Accie perello,—⁴Benedetto, del abbaco, —⁵maestro Pagolo medico,—⁶Domenico di Michelino,—⁷el caluo deli Alberti,—⁹messer Giovanni Argimboldi.

Quadrant of Carlo Marmocchi,—Messer Francesco Araldo,—Ser Benedetto d'Accie perello,—Benedetto on arithmetic,—Maestro Paulo, physician,—Domenico di Michelino,—. of the Alberti,—Messer Giovanni Argimboldi.

1436. 1. Richordo. 2. provitione. 4. frusso e refrusso. 5. dassoma. 6. effalli. 7. lasscia . . messere andrea tedesscho. 8. īfo-chata eppoi. 9. losspechio . . maesstro. 10. frusso e refrusso . . di uavrio.
1437. 1. govanni. 2. lazero . . elulpe.
1438. 8. careze. 9. streglia. 10. [cavalino.]
1439. 1. charlo. 2. franc"o". 3. benedetto daccieperello. 4. abbacho. 5. maesstro pagholo medicho. 6. domenicho. 7. chaluo. 8. meser argirobolto.

1436. 3. *Giordano.* Jordanus Nemorarius, a mathe-matician of the beginning of the XIIIth century. No particulars of his life are known. The title of his principal work is: *Arithmetica decem libris de-monstrata*, first published at Paris 1496. In 1523 ap-peared at Nuremberg: *Liber Jordani Nemorarii de ponderibus, propositiones XIII et earundem demonstra-*

tiones, multarumque rerum rationes sane pulcherrimas complectens, nunc in lucem editus.

6. *Beltraffio*, see No. 465, note 2.

There are sketches by the side of lines 8 and 10.

1437. These names are inserted on a plan of plots of land adjoining the Arno.

C. A. 19 *b*; 72 *b*] **1440.**

Colore,— [2] formulario,— [3] Archimede, —
[6] Marcanto [7] nio ;
[8] Ferro stagnato, — [9] ferro traforato.

Colours, formula,—Archimedes,—Mar-
cantonio.
Tinned iron,—pierced iron.

C. A. 27 *a*; 89 *a*] **1441.**

Vedi la bottega che fu di [2] Bartolomeo
cartolaio.

See the shop that was formerly Barto-
lommeo's, the stationer.

C. A. 70 *a*; 207 *a*] **1442.**

Primo libro è di Michele di Francesco
di Nabini, è di scientia.

The first book is by Michele di Francesco
Nabini; it treats on science.

C. A. 113 *a*; 349 *a*] **1443.**

Messer Francesco, medico Lucchese a-
presso il Cardinale Farnese.

Messer Francesco, physician of Lucca,
with the Cardinal Farnese.

C. A. 118 *a*; 366 *a*] **1444.**

Libro del Pandolfino,— [2] coltelli,— [3] pen-
na da rigare,— [4] tignere la uesta,— [5] libreria
di Scō Marco,— [6] libreria di Sco Spirito,—
[7] Lattantio de' Daldi,— [8] Antonio Couoni,—
[9] libro di maestro Paolo Infermieri,— [10] sti-
ualetti, scarpe e calze,— [11] lacca,— [12] gar-
zone che mi facci il modello,— [13] gramatica
di Lorenzo de' Medici,— [14] Giouanni del
Sodo, — [15] Sansouino, — [16] riga, — [17] coltello
sottilissimo, — [18] occhiali,— [19]—
[20] rifare,— [21] libro di Maso,—
[22] catenuzza di Michelagnolo,— [23] ¶impara
la multiplicatione [24] delle radici da maestro
Luca ¶ [25] el mio mappamōdo che à Giovanni
Bēci, [26] calcetti,— [27] vesta dal gabellotto,—
[28] cordovano rosso,— [29] mappamōdo di Gio-
vanni Benci,— [30] paesi di Milano in istāpa,
— [31] libro di mercato,—

Pandolfino's book [1],— knives,— a pen
for ruling,— to have the vest dyed,— The
library at St.-Mark's,—The library at Santo
Spirito,—Lactantius of the Daldi [7],—Anto-
nio Covoni,— A book by Maestro Paolo In-
fermieri,—Boots, shoes and hose,—(Shell)lac,
—An apprentice to do the models for me.
Grammar, by Lorenzo de Medici,—Giovanni
del Sodo,—Sansovino, [15]—a ruler,— a very
sharp knife, — Spectacles,—fractions ,
—repair,—Tomaso's book,—
Michelagnolo's little chain; Learn the multi-
plication of roots from Maestro Luca;—my
map of the world which Giovanni Benci
has [25];— Socks,—clothes from the custom-
house-officier,—Red Cordova leather,—The
map of the world, of Giovanni Benci,—a
print, the districts about Milan—Market book.

1440. 4. cochino. 5. aioditti. **1441.** 1. bottegha cheffu. 2. bartol.

1442. p"o" libro . . franc"o" eddi sua disciē.

1444. 2. coltegli. 3. darrigare. 5. marcho. 9. pagolo infermieri. 17. sotilissimo. 19. rotti fisici. 20. rifare lalbernuscio. 22. ca-
tenuza. 23. ipara. 24. radice . . maesstro. 27. vesta di gā bellotto. 29. govanni.

1441. 6. *Marc Antonio*, see No. 1433.

1443. *Alessandro Farnese*, afterwards Pope Paul III
was created in 1493 Cardinal di San Cosimo e San
Damiano, by Alexander VI.

1444. 1. *Pandolfino, Agnolo,* of Florence. It is to
this day doubtful whether he or L. B. Alberti was
the author of the famous work *'Del Governo della
Famiglia'*. It is the more probable that Leonardo
should have meant this work by the words *il libro*,
because no other book is known to have been
written by Pandolfino. This being the case this al-
lusion of Leonardo's is an important evidence in

favour of Pandolfino's authorship (compare No. 1454,
line 3).

7. The works of Lactantius were published
very often in Italy during Leonardo's lifetime. The
first edition published in 1465 *"in monastero
sublacensi"* was also the first book printed in
Italy.

15. *Sansovino, Andrea*—the *sculptor;* 1460—1529.

25. Leonardo here probably alludes to the map,
not executed by him (See p. 224), which is with the
collection of his MSS. at Windsor, and was publi-
shed in the *Archaeologia* Vol. XI (see p. 224).

C. A. 145 a; 432 a] **1445.**

¶ Di quel di Pavia si lauda · piv · il movi-
mēto · che nessun altra cosa;—

¶ ²L'imitatione · delle cose · antiche · è
piv laudabile · che quella delle · moderne;—

¶ ³Nō può essere bellezza · e vtilità ·
come appare nelle fortezze ⁴e nelli omini; ¶

¶ ⁵Il trotto · è quasi di qualità di cavallo
libero;—

⁶Doue · manca · la uiuacità naturale, bi-
sognia farne una accidētale. ¶

In that at Pavia the movement is more
to be admired than any thing else.

The imitation of antique work is better
than that of the modern things.

Beauty and utility cannot exist together,
as seen in fortresses and in men.

The trot is almost the nature of the free
horse.

Where natural vivacity is lacking it must
be supplied by art.

C. A. 176 b; 532] **1446.**

Saluadore materassaio ²sta in sulla pi-
azza di Sco An³drea; entra da pellicciai . . .

Salvadore, the matress maker, lives on the
Piazza di Sant' Andrea, you enter by the furrier's.

C. A. 185 b; 557 b] **1447.**

Mōsignor de' Pazzi,— ²ser Ātonio Pacini.

Monsignore de' Pazzi,—Ser Antonio Pacini.

C. A. 222 a; 664 a] **1448.**

Algibra ch'è apresso i Marliani fatta
dal loro padre,—

²Dell'osso, de' Marliani,

³Dell'osso che fora, Gian Giacomo da
Bellinzona, e tirare fori il chiodo cō faci-
lità,—

⁴Misura di Boccalino,—

⁵Misura di Milano e borghi,—

⁶Libro che tratta di Milano e sua
chiese, che à l'ultimo cartolaio īuerso il
Corduso,—

⁷Misura della corte vechia,—

⁸Misura del castello,—

⁹Fatti mostrare al maestro · d'abbaco ·
riquadrare · uno,—

¹⁰Fatti mostrare a messer Fatio 'di pro-
portione',—

An algebra, which the Marliani have,
written by their father, [1]—

On the bone, by the Marliani,—

On the bone which penetrates, Gian Gia-
como of Bellinzona, to draw out the nail with
facility,—

The measurement of Boccalino,—

The measurement of Milan and the sub-
urbs, [5]—

A book, treating of Milan and its chur-
ches which is to be had at the last statio-
ner's on the way to Corduso [6],—

The measurement of the Corte Vecchia,—

The measurement of the Castle,—

Get the master of arithmetic to show you
how to square a,—

Get Messer Fazio to show you [the book]
on proportion,—

1445. 1. lalda . . chosa. 2. chose . . laldabile chelle. 3. pro essere belleza . . chome apare. 5. trocto . . chavallo. 6. mancha
. . fare î accidētale.
1446. 2. piaza di sco\\\\\\. 3. pelliccai\\\\\\. 4. detare a franc° paio\\\\\\. 5. î di lenzola e per so\\\\\\.
1447. pazi.
1448. 1. alcibra. 3. cheffora giaiachomo da belinchona ettirare . . ciodo chō. 4. bochalino. 6. chettatta . . essa . . chartolaio
. . chorduso. 7. chorte. 8. chastello. 9. dabbacho . . riquadrare î magloto (?). 11. mosstrare . . fratte. 13. fraffillippo.

1445. *Quel di Pavia.* *Pavia* is possibly a clerical
error for *Padua*, and if so the meaning of the pas-
sage is easily arrived at: *Quel di Padua* would be
the bronze equestrian statue of Gattamelata, on the
Piazza del Santo at Padua executed by Donatello in
1443 (see pp. 2 and 3).

2. See No. 487 note. Vol. I p. 244.

1448. 1. 2. *Marliani*, an old Milanese family, now
extinct.

5. 21. See Pl. CIX and No. 1016.

6. *Corduso*, see No. 1413, note.

[11] Fatti mostrare · al frate di Brera 'de pōderibus',—

[12] Della misura di Sco Lorenzo,—

[13] A fra Filippo di Brera prestai · cierti gruppi,—

[14] Ricorda a Giouanino bonbardieri · del modo, come si mvrò la torre di Ferrara · sāza buche,—

[15] Dimāda · maestro Antonio, come · si piantā bōbarde e bastioni di dì o di notte,—

[16] Domanda Benedetto Portinari in che modo si corre per lo ghiaccio · in Fiādra,—

[17] Le proportioni · d'Alchino colle cōsiderationi del Marliano da messer Fatio,—

[18] La misura del sole promessami da maestro Giovanni frāzese,—

[19] Balestra di maestro Gianetto,—

[20] Il libro di Giovanni Taverna che · à · messer Fatio,—

[21] Ritrarai Milano,—

[22] Misura di navilio, conche e sostegnio e barche maggiori e spesa,—

[23] Milano ī fondamēto,—

[24] Gruppi di Bramāte,—

[25] Meteora d'Aristotile vulgare,—

[26] Fa d'avere Vitolone ch' è nella libreria di Pauia che tratta della matematica,— [27] teneva uno maestro d'acqua, e fatti dire i riparo d'essa, e quello che costa [28] vn riparo, e una · conca ·, e uno navilio, e uno molino alla lonbarda,

[29] Un nipote · di Gian Āgelo · dipītore à uno libro d'acque che fu del padre;

[30] Paolino Scarpellino ·, detto Assiolo ·, è bono · maestro d'acque.

Get the Friar di Brera to show you [the book] '*de Ponderibus*' [11],—

Of the measurement of San Lorenzo,—

I lent certain groups to Fra Filippo de Brera, [13]—

Memorandum: to ask Maestro Giovannino as to the mode in which the tower of Ferrara is walled without loopholes, —

Ask Maestro Antonio how mortars are placed on bastions by day or by night,—

Ask Benedetto Portinari how the people go on the ice in Flanders,—

On proportions by Alchino, with notes by Marliano, from Messer Fazio,—

The measurement of the sun, promised me by Maestro Giovanni, the Frenchman,—

The cross bow of Maestro Gianetto,—

The book by Giovanni Taverna that Messer Fazio,—

You will draw Milan [21],—

The measurement of the canal, locks and supports, and large boats; and the expense,—

Plan of Milan [23],—

Groups by Bramante [24],—

The book on celestial phenomena by Aristoteles, in Italian [25],—

Try to get Vitolone, which is in the library at Pavia [26] and which treats of Mathematics,—He had a master [learned] in waterworks and get him to explain the repairs and the costs, and a lock and a canal and a mill in the Lombard fashion.

A grandson of Gian Angelo's, the painter has a book on water which was his fathers.

Paolino Scarpellino, called Assiolo has great knowledge of water works.

C. A. 313*b*; 950*b*] 1449.

Francesco d'Antonio j̄ Firenze. Francesco d'Antonio at Florence.

14. richorda a govanni . . cho ṇe . . tore di ferara. 15. chome. 16. chore . . diacio di fiādra. 17. cholle chōsideratione. 18. promissami . . maestro. 22. chōche esso stegnio . . magiori esspesa. 26. tratte delle matematice. 27. teneva ī maestro dacq"a" effatti . . ecquelle che chosta. 26. e ī choncha e ī . . e ī. 29. vnipote . . giānāgelo . . a ī libro. 30. pagolino scharpellino . . maesstro.

1449. 1. franc"o" dant"o" j̄ffirence (*early writing*).

11. 13. *Brera*, now *Palazzo delle Scienze ed Arti*. Until 1571 it was the monastery of the order of the Umiliati and afterwards of the Jesuits.

De ponderibus, compare No. 1436, 3.

12. *Sco Lorenzo.* A church at Milan, see pp. 39, 40 and 50.

13. 24. *Gruppi.* See Vol. I p. 355, No. 600, note 9.

16. The *Portinari* were one of the great merchant-families of Florence.

23. *Fondamento* is commonly used by Leonardo to mean ground-plan. See for instance p. 53.

25. *Meteora.* By this Leonardo means no doubt the four books τὰ μετεωρολογικά. He must refer here to a MS. translation, as no Italian translation is known to have been published (see No. 1477 note).

26. *Vitolone* see No. 1506, note.

Libreria di Pavia. One of the most famous of Italian libraries. After the victory of Novara in April 1500, Louis XII had it conveyed to France, '*come trofeo di vittoria*'!

C. A. 358*b*; 1124*b*] 1450.

Givliano Gōdi, —²Tomaso Ridolfi, —
³Tom̄aso·Paganelli, —⁴Niccolò·del Nero, —
⁵Simō·Guasti, —⁶Nasi, —⁷erede di Lionardo
Manelli, —⁸Guglielmo di Ser Martino, —
⁹Bartolomeo · del Tovaglia, — ¹⁰Andrea ·
Arrigucci, —¹¹Niccolo·Capponi, —¹²Giovan
Portinari.

Giuliano Gondi[1], — Tomaso Ridolfi, —
Tomaso Paganelli, —Nicolò del Nero, —Simone
Zasti, — Nasi, —the heir of Lionardo Ma-
nelli, —Guglielmo di Ser Martino, —Barto-
lomeo del Tovaglia, —Andrea Arrigucci, —
Nicolò Capponi, —Giovanni Portinari.

Br. M. 48*a*] 1451.

Pandolfino.

Pandolfino.

Br. M. 132*b*] 1452.

Il Vespuccio mi vol dare un libro di
geometria.

Vespuccio will give me a book of Geo-
metry.

Br. M. 150*a*] 1453.

Marcantonio Colonna ²in S͞co Apostolo.

Marcantonio Colonna at Santi Apostoli.

Br. M. 191*a*] 1454.

Cassa,	gabbia,—	A box,	a cage,—
²Liuello,	far l'uccello,—	A square,	to make the bird [2],—
³Libro del Pandolfino,	grasselino,—	Pandolfino's book,	mortar [?],—
⁴Coltellini,—	Venieri per la	Small knives,	Venieri for the

1450. 1—12 R. 4. nicholo. 5. zasti. 7. rede di. 11. nicholo.
1453. marchātonio cholonna.
1454. 1. chassa. 4. pella. 5. darrizare . . metaura. 8. casa e pazi. 9. maesstro pa"lo". 10. esscarpe. 11. lacha, — trai 2 aguti.

1452. 1. el vespucco . . dare î libro di giometria.

1450. 1. *Guiliano Gondi.* Ser Piero da Vinci, Leonardo's father, lived till 1480, in a house belonging to Giuliano Gondi. In 1498 this was pulled down to make room for the fine Palazzo built on the Piazza San Firenze by Giuliano di San Gallo, which still exists. In the *Riassunto del Catasto di Ser Piero da Vinci*, 1480, Leonardo is not mentioned; it is evident therefore that he was living elsewhere. It may be noticed incidentally that in the *Catasto di Giuliano Gondi* of the same year the following mention is made of his four eldest sons:

Lionardo mio figliuolo d'età d'anni 29, non fa nulla,
Giovambatista d'età d'anni 28 in Ghostantinopoli,
Billichozo d'età d'anni 24 a Napoli,
Simone d'età d'anni 23 in Ungheria.

He himself was a merchant of gold filigree (*facciamo lavorare una bottegha d'arte di seta . . . facciamo un pocho di trafico a Napoli*). As he was 59 years old in 1480, he certainly would not have been alive at the time of Leonardo's death. But Leonardo must have been on intimate terms with the family till the end of his life, for in a letter dated June 1. 1519, in which Fr. Melzi, writing from Amboise, announces

Leonardo's death to Giuliano da Vinci at Florence (see p. 284), he says at the end *"Datemene risposta per i Gondi"* (see UZIELLI, *Ricerche*, passim).

Most of the other names on the list are those of well-known Florentine families.

1452. See No. 844, note, p. 130.

1453. In July 1506 Pope Julius II gave Donna Lucrezia della Rovere, the daughter of his sister Lucchina, in marriage to the youthful Marcantonio Colonna, who, like his brothers Prospero and Fabrizio, became one of the most famous Captains of his family. He gave to him Frascati and made him a present of the palazzo he had built, when Cardinal, near the church of Santi Apostoli which is now known as the Palazzo Colonna (see GREGOROVIUS, *Gesch. der Stadt Rom.* Vol. VIII, book XIV 1, 3. And COPPI, *Mem. Colonnesi* p. 251).

1454. Much of No. 1444 is repeated in this memorandum.

2. Vasari states that Leonardo invented mechanical birds which moved through the air. Compare No. 703.

⁵Penna da rizzare, pietra,—stella,— Pen for ruling, stone,—star,—
⁶Tignere la uesta, la tazza d' Alfieri,— To have the vest dyed, Alfieri's tazza,—
⁷Librerie, la Meteora,— The Libraries, the book on celestial phenomena,—

⁸Lattantio de' Daldi, va a casa de' Pazzi,— Lactantius of the Daldi,— go to the house of the Pazzi,
⁹Libro di maestro Paolo Infermieri,— cassetta,— Book from Maestro Paolo Infermieri,— small box,—
¹⁰Stiualetti, calze e scarpe, suchiellino,— Boots, shoes and hose, small gimlet,—
¹¹Lacca, Lac, ,—
¹²Garzone pe' modelli, An apprentice for models, ,—
¹³Gramatica di Lorēzo de' Medici,— la valuta del Grammar of Lorenzo de' Medici, the amount of the . . .
¹⁴Giouanni del Sodo per Giovanni del Sodo for . . . ,—the broken
¹⁵Sansauino, valuta del . . .,— Sansovino, the
¹⁶Pier di Cosimo, . . . per l' alie,— Piero di Cosino [16], the wings,—
¹⁷Filippo e Lorenzo,— ¹⁸riga,— ¹⁹ochiali, —²⁰rifare la,—²¹libro di Maso,— ²²catena di Michelagnolo,— ²³mvltiplicatione di radici,— ²⁴di corda e arco,— ²⁵mappamōdo de' Benci,— ²⁶calcetti,— ²⁷vesta dal gabellotto,— ²⁸cordovano,— ²⁹libri di mercato,—³⁰acque del Cronaca,—³¹acque del Tanaglino,— ³².,—³³le berrette,— ³⁴spechio del Rosso vederlo fare,—³⁵ ¹/₃ di che n'ò ⁵/₆,— ³⁶Meteora d' Aristotele,— ³⁷casse di Lorēzo di Pier Francesco,—³⁸maestro Piero dal Borgo,—³⁹legare il mio libro,— ⁴⁰¶mostra al Serigatto il libro,—⁴¹e fatti dare la regola dell' orilogio, anello, ¶— ⁴²noce muscato,— ⁴³gomma,— ⁴⁴squadra,— ⁴⁵Giouā Batista a la piazza de' Mozzi,— ⁴⁶Giovanni Benci il libro mio, e' diaspri, ⁴⁷ottone per li ochiali. Filippo and Lorenzo [17],— A ruler,—Spectacles,—to do the again,—Tomaso's book,—Michelagnolo's chain,— The multiplication of roots,— Of the bow and strinch,—The map of the world from Benci,—Socks,—The clothes from the custom-house officier,— Cordova leather,—Market books,—waters of Cronaca,—waters of Tanaglino . . ., —the caps,—Rosso's mirror; to see him make it,—¹/₃ of which I have ⁵/₆ ,—on the celestial phenomena, by Aristotle [36],—boxes of Lorenzo di Pier Francesco [37],—Maestro Piero of the Borgo,—To have my book bound,—Show the book to Serigatto,—and get the rule of the clock [41],—ring,—nutmeg,—gum,—the square,—Giovan' Batista at the piazza de' Mozzi,— Giovanni Benci has my book and jaspers,—brass for the spectacles.

Br. M. 192a] **1455.**

Cerca in Firenze della Search in Florence for

12. dali antelessi. 14. per rotti fisici vatro. 15. del ca. 16. fetto per lalie. 20. la bruncio (?). 24. archo. 25. mapamōdo. 27. di ganbelletto. 30. clomica. 32. moncatto. 35. n"o". 36. metaura. 38. maesstro. 41. effatti. 42. misscado. 45. govā batissta . . piaza de mozi. 46. govanni . . ellibro mio e dia ispriottone.
1455. 1. cerchi . . dellaramōdina.

7. 36. *Meteora.* See No. 1448, 25.
16. *Pier di Cosimo* the well known Florentine painter 1462—1521. See VASARI, *Vite* (Vol. IV, p. 134 ed. Sansoni 1880) about Leonardo's influence on Piero di Cosimo's style of painting.
17. *Filippo e Lorenzo;* probably the painters Filippino Lippi and Lorenzo di Credi. L. di Credi's pictures and Vasari's history of that painter bear ample evidence to his intimate relations with Leonardo.

37. *Lorenzo di Pier Francesco* and his brother *Giovanni* were a lateral branch of the *Medici* family and changed their name for that of Popolani.
41. Possibly this refers to the clock on the tower of the Palazzo Vecchio at Florence. In February 1512 it had been repaired, and so arranged as to indicate the hours after the French manner (twelve hours a. m. and as many p. m.).

Mi. A.]

1456.

Bernardo da Pŏte...²Val di Lugā al fiē disce...³ e questo e mostr...⁴molte vene per l'anotomia.

Bernardo da Ponte . . . Val di Lugano . . . many veins for anatomical demonstration.

Br. M. P.]

1457.

Paolo da Tavechia, per ²vedere le machie de³lle pietre tedesche.

Paolo of Tavechia, to see the marks in the German stones.

C. 15 b (1)]

1458.

Notes on pupils (1458—1468.)

Jacomo venne a stare · con meco ɉl dì della Maddalena nel mille 490, d'età d'anni 10; ²Il secondo dì li feci tagliare 2 camicie, uno pajo di calze e vn giubbone, e quā-do mi posi i dinari al lato per pagare dette cose lui mi *lire* 4 ³detti dinari dalla scarsella, e mai fu possibile farli le confessare, bench'io n'avessi vera ciertezza;—ladro, bugiardo, ostinato, ghiotto. — ⁴Il dì seguente andai a ciena con Iacomo, Andrea e detto Iaçomo ·; cienò per 2 e fece male per 4, inperochè rupe 3 ampolline, ⁵versò il uino, e dopo questo venne a ciena doue me... ⁶Itē a dì 7 di settēbre · rubò uno grafio di valuta di 22 soldi a Marco che staua con meco, ɉl quale era *lire* 4 ⁷d'argiēto e tolse gli lo dal suo studiolo, e poi che detto Marco n'ebbe assai ciercato, lo trovò na⁸scosto in nella cassa di detto Iacomo *lire* 4.

Giacomo came to live with me on St.-Mary Magdalen's[1] day, 1490, aged 10 years. The second day I had two shirts cut out for him, a pair of hose, and a jerkin, and when I put aside some money to pay for these things he stole 4 *lire* the money out of the purse; and I could never make him confess, though I was quite certain of the fact.—Thief, liar, obstinate, glutton. The day after, I went to sup with Giacomo Andrea, and the said Giacomo supped for two and did mischief for four; for he brake 3 cruets, spilled the wine, and after this came to sup where I Item: on the 7th day of September he stole a silver point of the value of 22 soldi from Marco[6] who was living with me, 4 *lire* this being of silver; and he took it from his studio, and when the said Marco had searched for it a long while he found it hidden in the said Giacomo's box 4 *lire*.

1456. 1. pŏte\\\\\. 2. al fiē dis\\\\\. 3. ecquesto e mostr\\\\. 4. la not\\\\\. 5. paroffa di sā posā\\\\\.
1457. 1. pagol. 3. tedessce.
1458. 1. Iachomo vene . . chomecho . . madalena . . dani. 2. sechondo . . chamice î paro di chalze . . gibone ecquādo . . chose 3. della scharsella . . farlie le chonfessare . . cierteza . — ladro . . ghiotto *these four words are written on the margin.* 4. chon iachomo . . 3 amole. 5. vene. 6. graffio . . ualluta . . marcho . . chomecho . . era [di ua] lire. 7. [luto di] durgiēto ettolse glielo del . . marcho [glielebe] nebe assai cierco lo tro na. 8. schosto inella chassa . . iachomo lire 4².

1456. This fragmentary note is written on the margin of a drawing of two legs.

1457. This note occurs on a pen and ink drawing made by Leonardo as a sketch for the celebrated large cartoon in the possession of the Royal Academy of Arts, in London. This cartoon is commonly supposed to be identical with that described and lauded by Vasari, which was exhibited in Florence at the time and which now seems to be lost. Mr. Alfred Marks, of Long Ditton, in his valuable paper (read before the Royal Soc. of Literature, June 28, 1882) "On the St. Anne of Leonardo da Vinci", has adduced proof that the cartoon now in the Royal Academy was executed earlier at Milan. The note here given, which is written on the sheet containing the study for the said cartoon, has evidently no reference to the drawing on which it is written but is obviously of the same date. Though I have not any opening here for discussing this question of the cartoon, it seemed to me important to point out that the character of the writing in this note does not confirm the opinion hitherto held that the Royal Academy cartoon was the one described by Vasari, but, on the contrary, supports the hypothesis put forward by Mr. Marks.

1458. *Il dì della Maddalena.* July 22.

6. *Marco*, probably Leonardo's pupil Marco d'Oggionno; 1470 is supposed to be the date of his birth and 1540 of his death.

Che stava con meco. We may infer from this that he left the master shortly after this, his term of study having perhaps expired.

9 Item a dì 26 di gienaro seguēte, essendo io in casa di messer Galeazzo da San Severino a ordinare la festa 10 della sua giostra, e spogliandosi cierti staffieri per prouarsi alcune vesti d'omini saluatici ch'a detta *lire 2 S 4*

11 festa accadeano, Giacomo s'accosto alla scarsella d'uno di loro, la qual era ī sul letto con altri panni, 12 e tolse quelli dinari che dētro vi trovò.

13 Itē essendomi da maestro Agostino da Pauia donato in detta casa una pelle turchesca da fare uno *lire 2.*

14 pajo di stiualetti ·, esso Giacomo infra uno mese me la rubò, e vendè la a uno conciatore di 15 scarpe per 20 soldi, de' quali danari secondo che lui propio mi cōfessò, ne cōprò anici cōfetti;

16 Itē ancora a dì 2 d'aprile, lasciādo Giā Ātonio uno grafio d'argiēto sopra uno suo disegno, 17 esso Giacomo gli lo rubò, il qual era di ualuta di soldi 24 *lira* 1 ª *S* 4.

18 Il primo 19 anno
20 v̄ mātello, lire 2
21 camicie 6, lire 4
22 3 givboni, lire 6
23 4 paja di calze lire, 7 S 8
24 vestito foderato, lire 5
25 24 paja di scarpe, lire 6 · S 5
26 vna baretta, lire 1
27 strīghe lire, 1.

Item: on the 26th January following, I, being in the house of Messer Galeazzo da San Severino [9], was arranging the festival for his jousting, and certain footmen having undressed to try on some costumes of wild men for the said festival, Giacomo went to the purse of one of them which lay on the bed with other clothes, 2 *lire* 4 *S*, and took out such money as was in it.

Item: when I was in the same house, Maestro Agostino da Pavia gave to me a Turkish hide to have *2 lire.* a pair of short boots made of it; this Giacomo stole it of me within a month and sold it to a cobbler for 20 soldi, with which money, by his own confession, he bought anise comfits.

Item: again, on the 2nd April, Giovan Antonio[16] having left a silver point on a drawing of his, Giacomo stole it, and this was of the value of 24 soldi 1 *lira* 4 *S.*

The first year—
A cloak, 2 lire,
6 shirts, 4 lire,
3 jerkins, 6 lire,
4 pairs of hose, 7 lire 8 soldi,
1 lined doublet, 5 lire,
24 pairs of shoes, 6 lire 5 soldi,
A cap, 1 lira,
laces, 1 lira.

1459.

A dì penvltimo di settèmbre;
2 giobia, a dì 27 di settēbre, 3 tornò maestro Tõmaso, 4 lavorò per se insino a dì penvltimo di febraio; 5 a dì 18 di marzo 1493 6 venne Iulio tedesco 7 a stare meco; Lucia,—Piero,—Lionard.
9 A dì 6 d'ottobre.

On the last day but one of September; Thursday the 27th day of September Maestro Tommaso came back and worked for himself until the last day but one of February. On the 18th day of March, 1493, Giulio, a German, came to live with me,—Lucia, Piero, Leonardo.
On the 6th day of October.

9. Ite adi . . esendo . . chasa . . galeazo dassanseverino ardina la. 10. alchune veste . . saluatichi. 11. achadeano j iachomo sachosto allasscharsella . . chon. 13. chasa. 14. paro . . iachomo infra ī mese. 15. de qua dinari sechondo . . chōfessone chōpre . . chōfetti. 16. anchora . . lassciādo . . ātonio ī graffio. 17. iachomo glielo. 18—27. R. 21. camice. 23. para di chalze. 24. li 5. 25. para . . scarpeli. 27. incīti strīge.

1459. 1. R. 2. grobia. 3. maesstro. 4. addi. 6. tedessco. 7. asstare mecho. 9. R. *The words* lucia piero lionard *are written on the margin.*

9. *Galeazzo.* See No. 718 note.
16. *Giovan Antonio*, probably Beltraffio, 1467 to 1516.
Leonardo here gives a detailed account not only of the loss he and others incurred through Giacomo

but of the wild tricks of the youth, and we may therefore assume that the note was not made merely as a record for his own use, but as a report to be forwarded to the lad's father or other responsible guardian.

H.3 58 b] **1460.**

1493.

²A dì primo di novēbre facemmo ³cō-
to; Givlio restava a rimettere mesi ⁴4 ‖ e
maestro Toṁaso mesi 9; ⁵maestro Toṁaso
fece di poi 6 cādellie⁶ri ·, dì 10 ·; Givlio in
cierte molli ⁷dì 15; lavorò poi per se in-
⁸sino a dì 27 di maggio, e lavorò ⁹per me
uno martinello insino a dì 18 ¹⁰di luglio,
poi per se insino a dì 7 ¹¹d'agosto, e
questo uno mezzo dì per una donna; ¹²di
poi per me in 2 serrature ¹³insino a dì ·
20 d'agosto.

1493.

On the 1ˢᵗ day of November we settled
accounts. Giulio had to pay 4 months;
and Maestro Tommaso 9 months; Maestro
Tommaso afterwards made 6 candlesticks,
10 days' work; Giulio some fire-tongs
15 days work. Then he worked for himself
till the 27ᵗʰ May, and worked for me at a
lever till the 18ᵗʰ July; then for himself till
the 7ᵗʰ of August, and for one day, on the
fifteenth, for a lady. Then again for me at
2 locks until the 20ᵗʰ of August.

H.1 41 a] **1461.**

¶A dì 23 d'agosto lire 12 da Pulisona;¶
²a dì 14 di marzo 1494 ³venne Galeazzo
a stare con meco ⁴cō patto di dare 5 lire
il mese ⁵per le sue spese, pagādo ogni 14
⁶dì de' mesi.
⁷Dettemi suo padre fiorini 2 di Reno;
⁸A dì 14 di luglio ebbi da Galeazzo
fio⁹rini 2 di Reno.

On the 23ʳᵈ day of August, 12 lire from
Pulisona. On the 14ᵗʰ of March 1494, Ga-
leazzo came to live with me, agreeing to
pay 5 lire a month for his cost paying on
the 14ᵗʰ day of each month.
His father gave me 2 Rhenish florins.
On the 14ᵗʰ of July, I had from Galeazzo
2 Rhenish florins.

H.3 57 a] **1462.**

A dì 15 di ²settēbre Gi³vlio comī⁴ciò
la serratu⁵ra del mio ⁶studiolo 14⁷94.

On the 15ᵗʰ day of September Giulio began
the lock of my studio 1494.

Br. M. 271 b] **1463.**

Sabato mattina a dì 3 d'agosto · 1504
venne Iacopo ²tedesco a stare con meco
in casa; convennesi con me³co che io
li facessi le spese per uno carlino ⁴il dì.

Saturday morning the 3ʳᵈ of August 1504
Jacopo the German came to live with me
in the house, and agreed with me that I should
charge him a carlino a day.

G. 0″] **1464.**

1511.
A dì 26 di settēbre Antonio ²si rupe
la gāba, à a stare 40 dì.

1511.
On the 26ᵗʰ of September Antonio broke
his leg; he must rest 40 days.

1460. 1—7 R. 4. seratu. 11. mezzo uno di.
1461. 1—13 R. 2. facemo. 8. magio. 9. me î. 11. mezo î di per î dona. 13. addi 20.
1462. 1—7 R. 3. galeazo asstare comecho. 4. chō pacto. 7. padre f. 2 di rē. 8. galeazo.
1463. *Written from left to right.* 1. addi . . iachopo. 2. tedesscho asstare chome cho in chasa chonvennesi choṁe. 3. choche
 . . lesspese . . charlino.
1464. 2. addi . . setēbre 2 ruppe.

1464. This note refers possibly to Beltraffio.

E. 1a]　　　　　　　　　　　　**1465.**

Parti da Milano per Roma a dì 24 ²di settēbre 1513 cō Giovā, Francesco ³de' Melsi, Salai, Lorēzo e il Fāfoia.

I left Milan for Rome on the 24th day of September, 1513, with Giovanni[2], Francesco di Melzi[3], Salai, Lorenzo and il Fanfoia.

C. A. 67 a; 202 a]　　　　　　　**1466.**

A dì 3 di gienajo.

²Benedetto veñe a 17 d'ottobre; ³è stato con meco due mesi e 13 dì ⁴dell'anno passato, nel qual tēpo à me⁵ritato li 38 e S 18 di 8; ⁶ne à avuto lire 26 e S 8, resta a ⁷avere per l'anno passato lire 12 S 10.

⁸Joatti venne · a dì 8 di settēbre ⁹a 4 ducati al mese, è stato con me ¹⁰mesi · 3 e dì 24; à meritato · li. ¹¹59 S 14 e · 8, ne à avuto li¹²re 43 S 4; ¹³restà a auere lire 16 ¹⁴per 10 di 8.

¹⁵Benedetto grossoni 24.

On the 3rd day of January.

Benedetto came on the 17th of October; he stayed with me two months and 13 days of last year[4], in which time he earned 38 lire, 18 soldi and 8 dinari; he had of this 26 lire and 8 soldi, and there remains to be paid for the past year 12 lire 10 soldi.

Giodatti (?) came on the 8th day of September, at 4 soldi a month, and stayed with me 3 months and 24 days, and earned 59 lire 14 soldi and 8 dinari; he has had 43 lire, 4 soldi, there remains to pay 16 lire, 10 soldi and 8 dinari.

Benedetto, 24 grossoni.

C. A. 260 a; 793 a]　　　　　　**1467.**

³Giā Maria 4
⁴Benedetto 4
⁵Gian Pietro 3
⁶Salai 3
⁷Bartolomeo 3
⁸Gherardo 4.

Gian Maria 4,
Benedetto 4,
Gian Pietro[5] 3,
Salai 3,
Bartolomeo 3,
Gherardo 4.

1465. 1. addi. 2. sectēbe . . frāciesscho.
1466. *Written from left to right.* 1. gienaro . dottobre a di 4 elm. 3. asstato cho mecho. 4. dellano . . tēpo ame. 5. vitato li 38 e. 6. anneauto. 8. joatti (?) venne . . settēbr. 9. stato come. 11. ane aun li.
1467. 1. \\\\\nco. 2. \\\\\\\iberdo. 5. gian petro.

1465. 2. *Giovan;* it is not likely that Leonardo should have called Giovan' Antonio Beltraffio at one time Giovanni, as in this note and another time Antonio, as in No. 1464 while in No. 1458 l. 16 we find *Giovan' Antonio,* and in No. 1436, l. 6 *Beltraffio.* Possibly the Giovanni here spoken of is Leonardo's less known pupil Giovan Pietrino (see No. 1467, 5).

2. 3. *Francesco de' Melzi* is often mentioned, see Nos. 1350.

3. *Salai.* See No. 1519 note.

4. *Lorenzo.* See No. 1351, l. 10 (p. 408). Amoretti gives the following note in *Mem. Stor. XXIII:* 1505. *Martedi—sera a dì 14 d'aprile. Venne Lorenzo a stare con mecho: disse essere d'età d'anni* 17 . . *a dì* 15 *del detto aprile ebbi scudi* 25 *d'oro dal chamerlingo di Santa Maria nuova.* This, he asserts is derived from a MS. marked S, in quarto. This MS. seems to have vanished and left no trace behind; Amoretti himself had not seen it, but copied from a selection of

extracts made by Oltrocchi before the Leonardo MSS. were conveyed to Paris on the responsibility of the first French Republic. Lorenzo, by this, must have been born in 1487. The sculptor Lorenzetto was born in 1490. Amoretti has been led by the above passage to make the following absurd observations:

Cotesto Lorenzo, che poi gli fu sempre compagno, almeno sin che stette in Italia, sarebb' egli Lorenzo Lotto bergamasco? Sappiamo essere stato questo valente dipintore uno de' bravi scolari del Vinci (?).

Il Fāfoia, perhaps a nickname. Cesare da Sesto, Leonardo's pupil, seems to have been in Rome in these years, as we learn from a drawing by him in the Louvre.

1466. This seems to be an account for two assistants. The name of the second is scarcely legible. The year is not given. The note is nevertheless of chronological value. The first line tells us the date when the note was registered, January 3^d, and the

C. A. F. *279a; 855a*] **1468.**

Salai lire 20	Salai, 20 lire,
² Bonifacio lire 2	Bonifacio, 2 lire,
³Bartolomeo lire 4	Bartolomeo, 4 lire,
⁴Arrigo lire 15.	Arrigo [Harry], 15 lire.

C. A. *207a; 609a*] **1469.**

<table>
<tr><td colspan="2">L' Abbaco,</td><td>Fiore di Virtù,.</td><td>Book on Arithmetic,[1]</td><td>'Flowers of Virtue',</td></tr>
<tr><td>Quotations and notes on books and authors (1469—1508).</td><td>²Plinio,</td><td>Vita de' Filosofi,</td><td>Pliny, [2]</td><td>'Lives of the Philosophers',</td></tr>
<tr><td></td><td>³Bibbia,</td><td>Lapidario,</td><td>The Bible, [3]</td><td>'Lapidary',</td></tr>
<tr><td></td><td>⁴De re militari,</td><td>Pistole del Filelfo,</td><td>'On warfare' [4]</td><td>'Epistles of Filelfo',</td></tr>
</table>

1468. 2. prefacio. 4. arigo.
1469. 1—25 R. 1. dabacho. 2. filosafi. 3. bibia. 4. pistole. 5. decha. 6. decha . — ciecho dasscholi. 7. decha . — magnio.

observations that follow refer to events of the previous month 'of last year' (*dell' anno passato*). Leonardo cannot therefore have written thus in Florence where the year was, at that period, calculated as beginning in the month of March (see Vol. I, No. 4, note 2). He must then have been in Milan. What is more important is that we thus learn how to date the beginning of the year in all the notes written at Milan. This clears up Uzielli's doubts: *A Milano facevasi cominciar l'anno ab incarnatione, cioè il 25 Marzo e a nativitate, cioè il 25 Decembre. Ci sembra probabile che Leonardo dovesse prescegliere lo stile che era in uso a Firenze.* (*Ricerche*, p. 84, note.)

1467. 5. See No. 1465, 2.

1469. The late Marchese Girolamo d'Adda published a highly valuable and interesting disquisition on this passage under the title: *Leonardo da Vinci e la sua Libreria, note di un bibliofilo* (*Milano* 1873. *Ed. di soli 75 esemplari*; privately printed). In the autumn of 1880 the Marchese d'Adda showed me a considerable mass of additional notes prepared for a second edition. This, as he then intended, was to come out after the publication of this work of mine. After the much regretted death of the elder Marchese, his son, the Marchese Gioachino d'Adda was so liberal as to place these MS. materials at my disposal for the present work, through the kind intervention of Signor Gustavo Frizzoni. The following passages, with the initials G. d'A. are prints from the valuable notes in that publication, the MS. additions I have marked*. I did not however think myself justified in reproducing here the acute and interesting observations on the contents of most of the rare books here enumerated.

1. "*La nobel opera de arithmethica ne la qual se tracta tute cosse amercantia pertinente facta & compilata per Piero borgi da Veniesia*", *in-4°. In fine:* "*Nela inclita cita di Venetia a çorni* . 2 *augusto* . 1484 .*fu imposto fine ala presente opera.*" *Segn. a—p . quaderni. V'ha però*

un' altra opera simile di Filippo Calandro, 1491. *È da consultarsi su quest' ultimo, Federici: Memorie Trevigiane, Fiore di virtù : pag.* 73. "*Libricciuolo composto di bello stile verso il* 1320 *e più volte impresso nel secolo XV (ristampato poi anche più tardi). Gli accademici della Crusca lo ammettono nella serie dei testi di lingua. Vedasi Gamba, Razzolini, Panzer, Brunet, Lechi, ecc.* (G. D'A.)

2. "*Historia naturale di C. Plinio Secondo, tradocta di lingua latina in fiorentina per Christophoro Laudino & Opus Nicolai Jansonis gallici imp. anno salutis M.CCCC.LXXVI.Venetiis*" *in-fol.—Diogene Laertio. Incomincia:* "*El libro de la vita de philosophi etc.: Impressum Venetiis per Bernardinum Celerium de Luere,* 1480", *in-4°* (G. D'A.).

3. "*La Bibia volgare historiata (per Nicolò di Mallermi) Venecia M.CCCC.LXXI in kalende di Augusto (per Vindelino de Spira)*" 2 *vol. in-fol. a 2 col. di 50 lin.; od altra ediz. della stessa versione del Mallermi, Venetia* 1471, *e sempre:* "*Venecia per Gabriel de Piero* 1477," *in-fol.;* 2 *vol.; Ottavio Scotto da Modoetia* 1481," "*Venetia* 1487 *per Joan Rosso Vercellese,*" "1490 *Giovanni Ragazo di Monteferato a instantia di Luchanthonio di Giunta, ecc.*"— *Lapidario Teofrasto? Mandeville:* "*Le grand lapidaire," versione italiana ms.?* . . . *Giorgio Agricola non può essere, perchè nato nel* 1494, *forse Alberto Magno: de mineralibus.* * *Potrebbe essere una traduzione del poema latino (Liber lapidum seu de gemmis) di Marbordio Veterio di Rennes (morto nel* 1123) *da lui stesso tradotto in francese dal greco di Evao rè d'Arabia celebre medico che l'aveva composto per l'imperatore Tiberio. Marbodio scrisse il suo prima per Filippo Augusto rè di Francia. Vi sono anche traduzioni in prosa.* "*Il lapidario o la forza e la virtu delle pietre preziose, delle Erbe e degli Animali.*" (G. D'A.)

4. *Il Vegezio?* . . . *Il Frontino?* . . . *Il Cornazzano?* . . . *Noi crediamo piuttosto il Valturio. Questo libro doveva essere uno de'favoriti di Leonardo poichè libro di scienza e d'arte nel tempo stesso.*

[5] Deca prima,	Della cōseruatiō della sanità,	The first decade, [5]	'On the preservation of health',
[6] Deca terza,	Ciecco d'Ascoli,	The third decade, [6]	Ciecho d'Ascoli,
[7] Deca quarta,	Alberto Magno,	The fourth decade, [7]	Albertus Magnus,
[8] Guidone,	Retorica nova,	Guido, [8]	New treatise on rhetorics,
[9] Piero Cresciētio,	Cibaldone,	Piero Crescentio, [9]	Cibaldone,
[10] Quadriregio,	Esopo,	'Quadriregio', [10]	Æsop,

8. gidone . — rettoricha. 9. zibaldone. 10. de 4 regi ⁝ — isopo. 12. imortalita. 15. petrarcha. 17. [deg] de. 19. de-

Le edizioni a stampa sono le seguenti: La prima: "Roberti Valturii de re militari, libri XII ad Sigismundum Pandulfum Malatestam . . . Johannes ex Verona oriundus: Nicolai cyrugiae medici filius: Artis impressorie magister: hunc de re militari librum elegantissimum; litteris, & figuratis signis sua in patria primus impressit. An. M. CCCCLXXII." in-fol. senza numerazione.

La seconda edizione è di Bologna, 1483, ristampata a Parigi nel 1532, e poi nuovamente nel 1533. Paolo Ramusio la volgeva in italiano e la pubblicava di nuovo in Verona coi tipi del Paganino, sempre in-fol., 1483 (le stampe di formato più piccolo), e Luigi Meigret la traduceva in lingua francese nel 1555 a Parigi.

"Mediolani per Leon. Pachel & Ulric. Scinzenzeler 1484" in-4º—.

5—7. *Abbiamo varie versione delle Deche di Tito Livio, impresse nel secolo XV. Il "Tito Livio volgarizzato (da Ruggiero Ferario) Roma Uldarico Gallo nel 1476," un tom. in 3 vol. in-fol. "Bologna per maestro Antonio da Bologna 1478," piccolo in-fol. "Venetia Octaviano Scoto 1481," pic. in-fol. Venetia Bartholomeo de Alexandria & Andrea de Asula 1485. Bartholomeo de Zanis, 1490, ecc." Vedasi il Manuel del Brunet o meglio il Repertorium dell' Hain ed il Panzer.* (G. D'A.)

5. *"Arnaldi de Villanova & Johannis Mediolanensis Regimen sanitatis Salernitanum, 1480," in-4º ovvero "Tractato utilissimo circa la conservatione de la sanitate, ecc. composto per il clarissimo ed excellente philosopho & doctore di medicina messer Ugo Benzo di Siena, ecc.", in-4º, caratteri gotici senza numeri e senza nome di tipografo. In fine: "Exactum est hoc opus Mli (Mediolani) cura & diligentia Petri de Corneno Mediolanensis, 1481. pridie kalendas Junias . Johanne Galeatio Sforcia Vicecomite principe nostro invictissimo dominante." V. Sassi-Argelati. Parte I, vol. I, p. DLXXV.* (G. D'A.)

6. *L'Acerba (da acervus, cumulo), il noto poema di Francesco Stabili, astrologo nemico dell' Alighieri. Numerose edizioni del secolo XV e XVI. È una vera enciclopedia in versi, ripiena di idee arditissime e che valsero all' infelice pensatore il rogo nel 1347. In questo poema trovansi delineate le origini di molti trovati moderni, ed in particolare della circolazione del sangue, due secoli prima del Michele Serveto. Della prima edizione di Brescia Ferrandus s. a. in-fol. · non si conosce che un solo esemplare nella Spenceriana. V. Dibdin.* (G. D'A.)

7. *"Incomenza el libro chiamato della vita ecc., cōposto per Alberto magno filosofo excellentissimo ecc. Neapoli*

Bernardini de gerardinis de Amelia, 1478," in-4º. Altra edizione di "Bologna per Bazalino di Bazaliero, 1493," in-4º got. (G. D'A.)

8. *Forse "Guido dalle Colonne" detto anche "da Cauliaco." "Guidonis de Cauliaco Cyrurgia. Turra de Castello recepta atque balnei de Porecta ecc. Venetiis mandato & expensis Octaviani Scoti cura & arte Boneti Locatelli, 1498" in-fol. got.: rarissimo trattato di chirurgia. Ebbe traduzioni francesi parecchie e nel secolo XV anche una versione italiana s. l. n. a. ed un altra in lingua castigliana nel 1498. Vedi: Brunet, Panzer, Hain e Mendez. —L. Guil. de Saona rhetorica nova, S. Albano, in-4º 1480 (Laurentius Guilelmus). È libro de' più rari (Brunet, Tomo V, col. 137). S. Albans, Albani Villa, Verulantium, Borgo inglese nella contea di Hertfordshire, la patria di Bacone Francesco.* (G. D'A.)

9. *De agricultura. "Il libro della agricultura di Pietro Crescentio," prima edizione di questa versione italiana scritta nel trecento e testo di lingua citato dall' Accademia della Crusca. "Florentie per me Nicholaum Laurentii alemanum diocesis uratislaviensis anno M.CCCC.L.XXVIII." in-fol. — Cibdone: Le materie trattate in questo singolarissimo libretto sono: dei frutti, delle erbe, della flebotomia, della medicina, della luxuria, del bagno, ecc. Almansor-ebn-Isahck fu governatore del Chorassan ed al suo nome intitolava Raze i suoi dodici libri di medicina, che in compendio contengono tutto il sistema medico degli Arabi. Quest'ultima edizione in-4º. Brescia per d. Bapt. de Farfengo, si compone di sei carte s. n. 2. o seg. caratteri semigotici a 2 col.* (G. D'A.)

10. *Quadriregio (libro chiamato il) di Federigo Frezzi domenicano. È poema religioso-morale-scientifico in terzine. Fra gli imitatori della Divina Comedia è dei migliori "non indegno di gir dietro a Dante" dice il Quadrio. Questo poema è in oggi ingiustamente negletto e quasi sconosciuto, ancorchè in tempi da noi lontani fosse stato nobilmente stampato più volte. Ebbe almeno sette edizioni dal 1481 al 1515, e contiene bellezze di primo ordine. *L'edizione che con molta probabilità era fra i libri di Leonardo riteniamo quello di Milano 1488 Zaroto. Un esemplare all' Ambrosiana fra i quattrocentisti donati da G. Porro, — forse più rara che molte altre.*

"Fabulae de Esopo historiate," in-4º fig. senza nota di tempo e di luogo; o l'edizione di Venezia per Manfredo da Monferrato, in-4º fig. 1481 e 1490; od anche: "Brescia per Boninum de Boninis 1487," in-4º con 67 belle figure silografiche; "Roma, Silber 1483," Venetia Manfredo Bo-

[11]Donato,	Salmi,	Donato, [11]	Psalms,
[12]Ivstino,	De Immortalità d'a-	Justinus, [12]	'On the immortality of
	nima,		the soul,
[13]Guidone,	Burchiello,	Guido [13]	Burchiello,
[14]Dottrinale,	Driadeo,	'Doctrinale' [14]	Driadeo,
[15]Morgāte,	Petrarca,	Morgante [15]	Petrarch.
[16]Giovā di Mādiuilla,		John de Mandeville [16]	
[17]De onesta voluttà,		'On honest recreation' [17]	
[18]Māganello,		Manganello, [18]	
[19]Cronica d'Isidoro,		The Chronicle of Isidoro, [19]	
[20]Pistole d'Ouidio,		The Epistles of Ovid, [20]	
[21]Pistole del Filelfo,		Epistles of Filelfo, [21]	
[22]Spera,		Sphere, [22]	

nello da Streno, 1497, in-4°, ecc., o più probabilmente:
"Aesopi" vita & fabulæ latine cum versione italica &
allegoriis Fr. Tuppi impressæ, Napoli, 1483," in-fol., rara
edizione ornata di belle vignette incise in legno. Questo
Esopo è anche libro di novelle. Nel Catalogo Cicognara
abbiamo una minuta descrizione di questo rarissimo vo-
lume. (G. D'A.)

11. *"Donatus latine & italice: Impressum Venetiis im-*
pensis Johannis Baptistae de Sessa anno 1499, in-4°".—
"El Psalterio de David in lingua volgare (da Malermi
Venetia nel M.CCCC.LXXVI," in-fol. s. n. (G. D'A.)

12. *Compare No. 1210, 48.—La versione di Girolamo*
Squarzafico: "Il libro di Justino posto diligentemente in
materna lingua. Venetia ale spese (sic) di Johañe de Colonia
& Johañe Gheretzē . . . 1477," in-fol.— "Marsilii Ficini, Theo-
logia platonica, sive de animarum immortalitate, Florentine,
per Ant. Misconimum 1482," in-fol., ovvero qualche ver-
sione italiana di questo stesso libro, ms. (G. D'A.)

13. *Forse "la Historia Trojana Guidonis," od il "mani-*
pulus" di "Guido da Monterocherii," ma più probabilmente
"Guido d'Arezzo," il di cui libro: "Micrologus, seu disci-
plina artis musicae" poteva da Leonardo aversi ms.; di
questi ne esistono in molto biblioteche, e fu poi impresso
nel 1784 dal Gerbert.

Molte sono le edizione dei sonetti di Burchiello Fioren-
tino, impresse nel secolo XV. La prima e più rara e
recercata: " Incominciano li sonetti, ecc. (per Christoforo
Arnaldo)", in-4° senza numeri, richiami o segnature, del
1475, e fors' anche del 1472, secondo Morelli e Dibdin, ecc.
(G. D'A.)

14. *Versione italiana det "Doctrinal de Sapience"*
di Guy de Roy, e fors' anche l'originale in lingua
francese.—

Di Pulci Luigi, benchè nell' edizione: "Florentiae 1479"
in-4° si dica: "Il Driadeo composto in rima octava per
Lucio Pulcro," Altre ediz. del secolo XV, "Florentie Misco-
mini 1481, in-4°, Firenze, apud S. Jacob. de Ripoli, 1483,"
in-4° e "Antoni de Francesco, 1487," in-4° e Francesco
di Jacopo 1489," in-4° ed altre ancora di Venezia e senza
alcuna nota ecc. (G. D'A.)

15. *Una delle edizioni del Morgante impresse nel se-*
colo XV, ecc.—

Quale delle opere di Francesco Petrarca, sarebbe ma-
lagevole l'indovinare, ma probabilmente il Canzoniere.
(G. D'A.)

16. *Sono i viaggi del cavaliere "Mandeville," gentil-*
uomo inglese. Scrisse il suo libro in lingua francese.
Fu stampato replicatamente nel secolo XV in francese, in
inglese ed in italiano, ed in tedesco; del secolo XV ne*
annoverano forse più di 27 edizioni, di cui ne conosciamo
8 in francese, quattro in latino, sei in tedesco e molte altre
in volgare. (G. D'A.)

17. *Il Platina (Bartolomeo Sacchi) la versione italiana*
"de la honesta voluptate, & valetudine (& de li obsonnii)
Venetia (senza nome di tipografo) 1487," piccolo in-4°
gotico. (G. D'A.) – *Compare No. 844, 21.*

18. *Il Manganello: Satira eccessivamente vivace contro*
le donne ad imitazione della Sesta di Giovenale. Manga-
nello non è soltanto il titolo del libricino, sua ben anche
il nome dell' autore ch' era un "milanese". Di questo li-
bercolo rarissimo, che sembra impresso a Venezia dallo
Zoppino (Nicolò d'Aristotile detto il), senza data, ma dei
primissimi anni del secolo XVI, e forse più antico, come
vedremo in appresso, non se ne conoscono fra biblioteche
pubbliche e private che due soli esemplari in Europa.
(G. D'A.)

19. *"Cronica desidero", sembra si deggia leggere piut-*
tosto "cronico disidoro"; ed in questo caso s'intenderebbe la
"cronica d'Isidoro" tanto in voga a quel tempo "Comenza
la Cronica di Sancto Isidoro menore con alchune additione
cavate del testo & istorie de la Bibia & del libro di Paulo
Oroso Impresso in Ascoli in casa del reverendo
misser Pascale per mano di Guglielmo de Linis
de Alamania M.CCCC.LXXVII" in-4° di 157 ff. È il
primo libro impresso ad Ascoli e l'edizione principe di
questa cronica in oggi assai rara. Non lo è meno l'edi-
zione di Cividal del Friuli, 1480, e quella ben anche di
Aquila, 1482, sempre in-4°. Vedasi Panzer, Hain, Brunet
e P. Dechamps. (G. D'A.)

20. *"Le pistole di Ovidio tradotte in prosa. Napoli*
Sixt. Riessinger", in-4°, oppure: "Epistole volgarizzate
1489," in-4° a due col. "impresse ne la cita (sic) di Bressa
per pre: Baptista de Farfengo," (in ottave) o: "El libro
dele Epistole di Ovidio in rima volgare per messere Do-
minico de Monticelli toschano. Brescia Farfengo," in-4°
got. (in rima volgare), 1491, ed anche la versione di Luca
Pulci. Firenze, Mischomini, 1481, in-4°. (G. D'A.)

21. *See l. 4.*

22. *"Jo: de Sacrobusto," o "Goro Dati," o "Tolosano da*
Colle" di cui molteplici edizioni del secolo XV. (G. D'A.)

²³Facietie di Poggio,
²⁴De chiromātia,
²⁵Formulario di pistole.

The Jests of Poggio[23]
Chiromancy, [24]
Formulary of letters,[25]

S. K. M. III. 87 *b*] **1470.**

Nonio Marciello, ²Festo Pōpeo, ³Marco Varrone.

Nonius Marcellus, Festus Pompeius, Marcus Varro.

F. o"] **1471.**

Piāta d'Elefante d'India che à Antonello Merciaio ²da maestro Maffeo; perchè 7 anni la ter³ra alza e 7 abbassa;—⁴cerca di Vetruvio ⁵fra cartolaj.

Map of Elephanta in India which Antonello Merciaio has from maestro Maffeo;—there for seven years the earth rises and for seven years it sinks;—Enquire at the stationers about Vitruvius.

Leic. 13 *a*] **1472.**

Vedi de naui messer Battista ²e Frontino de' aquidotti.

See 'On Ships' Messer Battista, and Frontinus 'On Acqueducts' [2].

. A. 376 *b*; 1168 *a*] **1473.**

Anasagora; ²ogni cosa viē da ogni cosa, —ed ogni cosa si fa ogni cosa, ³e ogni cosa torna in ogni cosa; perchè ciò ch'è nelli elemē⁴ti è fatto da essi elemēti.

Anaxagoras: Every thing proceeds from every thing, and every thing becomes every thing, and every thing can be turned into every thing else, because that which exists in the elements is composed of those elements.

sidero. 23. pogio.
1470. 3. marcho. **1471.** dellefau\\\\ dindia chella. 2. mafeo . . annila tera . . abassa.
1472. 1. meser batista.
1473. 1. anasaghora. 2. chosa viē. 3. chogni . . ogni chosa. 4. effatto.

23. *Tre edizioni delle facezie del Poggio abbiamo in lingua italiana della fine del secolo XV, tutte senza data. "Facetie de Poggio fiorentino traducte de latino in vulgare ornatissimo," in-4°, segn. a—e in caratteri romani; l'altra: "Facetie traducte de latıno in vulgare," in-4°, caratteri gotici, ecc.* (G. D'A.)

24. *"Die Kunst Cyromantia etc. in tedesco. 26 ff. di testo e figure il tutte esequito sù tavole di legno verso la fine del secolo XV da Giorgio Schapff". Dibdin, Heinecken, Sotheby e Chatto ne diedero una lunga descrizione; i primi tre accompagnati da fac-simili. La data 1448 che si legge alla fine del titolo si riferisce al periodo della composizione del testo, non a quello della stampa del volume benche tabellario. Altri molti libri di Chiromanzia si conoscono di quel tempo e sarebbe opera vana il citarli tutti.* (G. D'A.)

25. *Miniatore Bartolomeo. "Formulario de epistole vulgare missive e responsive, & altri flori de ornati parlamenti al principe Hercule d'Esti ecc. composto ecc. Bologna per Ugo di Rugerii," in-4°, del secolo XV. Altra edizione di "Venetia Bernardino di Novara," 1487" e "Milano per Joanne Angelo Scinzenzeler 1500," in-4°.* (G. D'A.)

Five books out of this list are noted by Leonardo in another MS. (Tr. 3): *donato, — lapidario, — plinio, — abacho, — morgante.*

1470. Nonius Marcellus and Sextus Pompeius Festus were Roman grammarians of about the fourth century A. D. Early publications of the works of Marcellus are: *De proprietate sermonis, Romae* (about 1470), and 1471 (place of publication unknown). *Compendiosa doctrina, ad filium, de proprietate sermonum.* Venice, 1476. BRUNET, *Manuel du libraire* (IV, p. 97) notes: *Le texte de cet ancien grammairien a été réimprimé plusieurs fois à la fin du XVᵉ siècle, avec ceux de Pomponius Festus et de Terentius Varro. La plus ancienne édition qui réunisse ces trois auteurs est celle de Parme,* 1480 . . . *Celles de Venise,* 1483, 1490, 1498, *et de Milan,* 1500, *toutes in-fol., ont peu de valeur.*

1472. 1. Compare No. 1113, 25.

2. *Vitruvius de Arch., et Frontinus de Aquedoctibus.* Florence, 1513.—This is the earliest edition of Frontinus.—The note referring to this author thus suggests a solution of the problem of the date of the Leicester Manuscript.

L. 94*b*]　　　　　　　　　　**1474.**

Archimede del uescouo ³di Padoua.

The Archimedes belonging to the Bishop of Padua.

W. 191*a*]　　　　　　　　　　**1475.**

Archimede à dato la ²☐ra d'una figura late³rata e nō del cerchio; ¶ ⁵adunque Ar-⁶chimede non ⁷quadrò mai figu⁸ra di lato curuo; ¶ ⁹cioè quadrò il cer¹⁰chio meno una portio¹¹ne tanto minima quā¹²to lo intelletto possa immaginare, cioè quanto il pūto visibile.

Archimedes gave the quadrature of a polygonal figure, but not of the circle. Hence Archimedes never squared any figure with curved sides. He squared the circle minus the smallest portion that the intellect can conceive, that is the smallest point visible.

Br. M. 279*b*]　　　　　　　　　　**1476.**

Chi auesse trovato l' ultima vali²tudine della bōbarda in tutte ³sua varietà, e pre-sētato tale ⁴segreto alli Romani, cō ⁵qual prestezza avrebbero conquista⁶to ogni terra e superato ogni ese⁷rcito, e qual premio era, ⁸che potesse equipararsi a tanto ⁹benifitio! Archimede ā¹⁰corachè lui auesse grādemēte dan¹¹neggiati li Romani alla spugna¹²tione di Siracusa, nō li fu mai ¹³mācato l' offerta di grādissimi pre¹⁴mi da essi Romani, e nella pre¹⁵sa di Siracusa fu cercato dilige¹⁶temēte d'esso Archime-mide, e tro¹⁷vato morto; ne fu fatto maggiore ¹⁸lamētatione nel senato e ¹⁹popolo Romano, che s' egli' auessi²⁰no perso tutto il loro esercito, e non ²¹mancarono d'ono-rarlo di sepoltu²²ra e di statua, della quale fu capo ²³Marco Marcello; e dopo la seconda ²⁴ruina di Siragusa fu ritrouato ²⁵da Catone la sepoltura d'esso Archi²⁶mede nel²⁷le ruine d'un tenpio; onde Catone fe-²⁸cie rifare il tēpio e la sepoltura ²⁹onora-tissima . . . ³⁰e di questo si scriue ³¹auere detto Catone ³²non si gloriar di ³³nessuna cosa tan³⁴to, quanto d' auere ³⁵onorato esso Archi³⁶mede d'esso orna³⁷mēto.

If any man could have discovered the utmost powers of the cannon, in all its various forms and have given such a secret to the Romans, with what rapidity would they have conquered every country and have vanquished every army, and what reward could have been great enough for such a service! Archimedes indeed, although he had greatly damaged the Romans in the siege of Syracuse, nevertheless did not fail of being offered great rewards from these very Romans; and when Syracuse was taken, diligent search was made for Archimedes; and he being found dead greater lamentation was made for him by the Senate and people of Rome than if they had lost all their army; and they did not fail to honour him with burial and with a statue. At their head was Marcus Marcellus. And after the second destruction of Syracuse, the sepulchre of Archimedes was found again by Cato [25], in the ruins of a temple. So Cato had the temple restored and the sepulchre he so highly honoured Whence it is written that Cato said that he was not so proud of any thing he had done as of having paid such honour to Archimedes.

1474. uescouo.　　　　　1475. 1. data. 3. rato. 6. chimenide. 10. cio meno Ĩ. 11. tanta. 12. inmaginare coe q"u"to.
1476. 1. auessi trovata. 4. romani [qual] cō. 5. presteza arebero conquisa. 7. ecqual. 8 potessi . . attanto. 10. chellui auessi grādemēte da. 11. negati . . allasspugna. 12. serausa. 13. lo fere li grādissimi. 15 serausa fu cerco dilige. 17. magore. 18. nel [ꝑo] senato. 19. romane chessegli. 20. e no. 21. mancorono. 22. distaua. 23. dopo la 2ª. 24. seragosa. 25. catone. 26. mede e [esso catone la retro] ne. 28. ella. 29. onoratissimar\|\|\|\. 30. scriu\|\|\|\. 31. cat\|\|\|\. 32. signoriar\|\|\|\. 33. cosa t\|\|\|\. 34. daue\|\|\|\. 35. ar\|\|\|\. 36. orn\|\|\|\.

1474. See No. 1421, l. 3, 6 and Vol. I, No. 343.
1475. Compare No. 1504.
1476. Where Leonardo found the statement that Cato had found and restored the tomb of Archimedes, I do not know. It is a merit that Cicero claims as his own (Tusc. V, **23**) and certainly with a full right to it. None of Archimedes' biographers—not even the diligent Mazzucchelli, mentions any version in which Cato is named. It is evidently a

slip of the memory on Leonardo's part. Besides, according to the passage in Cicero, the grave was not found '*nelle ruine d'un tempio*'—which is highly improbable as relating to a Greek—but in an open spot (H. MÜLLER - STRÜBING).—See too, as to Archimedes, No. 1417.

Leonardo says somewhere in MS. C.A.: *Architronito è una macchina di fino rame, invenzion d' Archimede* (see '*Saggio*', p. 20).

I.2 82 *b*]

1477.

Aristotele 3° della fisica, e Alberto e Tomaso, ²e li altri de risaltatione, ȷ 7ª della fisica, ³de cielo e mv̄do.

Aristotle, Book 3 of the Physics, and Albertus Magnus, and Thomas Aquinas and the others on the rebound of bodies, in the 7th on Physics, on heaven and earth.

M. 62 *a*]

1478.

Dice Aristotile che se vna potentia move v̄ ²¶ corpo vn tanto spatio in tanto tēpo, la me³desima potentia moverà la metà di quel ⁴corpo due tanti di spatio nel medesimo tēpo.¶

Aristotle says that if a force can move a body a given distance in a given time, the same force will move half the same body twice as far in the same time.

C. A. 284 *b*; 865 *b*]

1479.

Aristotile nel terzo dell' etica: ²l' uomo è degnio di lode e di uituperio solo ³nelle · cose · che sono ȷ sua potestà ⁴di fare e di nō fare.

Aristotle in Book 3 of the Ethics: Man merits praise or blame solely in such matters as lie within his option to do or not to do.

C. A. 121 *a*; 375 *a*]

1480.

¹Dicie · Aristotele · che ogni cosa desidera mātenere la sua natura.

Aristotle says that every body tends to maintain its nature.

K.² 3 *b*]

1481.

De incremēto ²Nili, opera d' Ari³stotile piccola.

On the increase of the Nile, a small book by Aristotle.

W. A. IV. 151 *b*]

1482.

Avicenna vole ²che l' anima partorisca ³l' anima, e 'l corpo il corpo, ⁴e ogni mēbro per rata.

Avicenna will have it that soul gives birth to soul as body to body, and each member to itself.

F. 0″]

1483.

Avicenna de' liquidi.

Avicenna on liquids.

1477. 1. fisicha. 2. elli . . fisicha. **1478.** 1. chesse. 4. dua tanti spatio.
1479. 1. eticha. 3. imai (?) nelle chose chessono.
1480. 2. la gravita per essere etc. etc. **1481.** 3. pichola. **1482.** 1. aviciena. 2. chellanima partorischa.
1483. 1. avicena.

1481. *De inundatione Nili*, is quoted here and by others as a work of Aristotle. The Greek original is lost, but a Latin version of the beginning exists (Arist. Opp. IV p. 213 ed. Did. Par.).

In his quotations from Aristotle Leonardo possibly refers to one of the following editions: *Aristotelis libri IV*

de coelo et mundo; de anima libri III; libri VIII physicorum; libri de generatione et corruptione; de sensu et sensato ... omnia latine, interprete Averroe. Venetiis 1483 (first Latin edition). There is also a separate edition of *Liber de coelo et mundo*, dated 1473.

1482. *Avicenna,* see too No. 1421, l. 2.

Br. M. 71 *b*] **1484.**

Rugiero Bacone fatto in istanpa. Roger Bacon, done in print.

C. A. 139 *b*; 419 *b*] **1485.**

Cleomete filosofo. Cleomedes the philosopher.

Tr. 4] **1486.**

CORNELIO CELSO.

² Il somo · bene · è la sapiēza ·; il somo
male · è il dolore · del corpo; jmperochè,
essēdo ³ noi conposti · di 2 cose, cioè · d' a-
nima · e di corpo, ⁴ delle quali la prima · è
migliore ·, la peggiore · è il corpo; la sapi-
ētia è ⁵ della miglior parte ·; il sommo male
è della peggior parte e pessima; Ottima
cosa è nell' animo la sapiēza, così è pessima
⁶ cosa nel corpo il dolore; ⁷ adūque, sicome
il sommo male è 'l corporal dolore, così la
sapiētia è dell' animo ⁸ il somo bene, cioè
dell' uomo sagio, e nissvna altra cosa è da
cōparare a questa.

CORNELIUS CELSUS.

The highest good is wisdom, the chief
evil is suffering in the body. Because, as
we are composed of two things, that is soul
and body, of which the first is the better,
the body is the inferior; wisdom belongs
to the better part, and the chief evil belongs
to the worse part and is the worst of all.
As the best thing of all in the soul is
wisdom, so the worst in the body is suf-
fering. Therefore just as bodily pain is the
chief evil, wisdom is the chief good of the
soul, that is with the wise man; and nothing
else can be compared with it.

Tr. 57] **1487.**

Demetrio solea dire non essere differē-
tia · dalle parole e voci dell' inperiti ignio-
rāti, ² che sia da suoni e strepiti · cavsati dal
ventre ripieno di superfluo vēto; ³ e questo
nō senza cagiō dicea, īperochè lui nō re-
putava esser differētia da qual parte ⁴ costoro
mādassino · fuora la voce, o dalle parti
īferiori o dalla bocca, ⁵ che l' una e l' altra
era di pari valimēto e sustātia.

Demetrius was wont to say that there was
no difference between the speech and words
of the foolish and ignorant, and the noises
and rumblings of the wind in an inflated
stomach. Nor did he say so without reason,
for he saw no difference between the parts
whence the noise issued; whether their lower
parts or their mouth, since one and the
other were of equal use and importance.

1484. 1. Rugieri bachō. **1485.** 1. filosafo.
1486. 2. ella sapiēza . . iperoche. 3. corp\|\| [lanima e meliore cel corpo. 4. pegiore . . chorpo. 5. somo . . pegior. 7. somo
. . choporal . . chosi. 8. delonsagio enīvna . . chosa e da a questa cōparare.
1487. 1. diferētia . . evoce. 2. chessia da soni e strepidi. 3. ecquesto. 3. īperochellui . . diferētia. 4. parte . . bocha. 5. chel-
luna ellaltra.

1484. The earliest printed edition known to Brunet
of the works of Roger Bacon, is a French trans-
lation, which appeared about fourty years after Leo-
nardo's death.

1485. *Cleomede.* A Greek mathematician of the
IVth century B. C. We have a Cyclic theory of Me-
teorica by him. His works were not published before
Leonardo's death.

1486. *Aulus Cornelius Celsus*, a Roman physician,
known as the Roman Hippocrates, probably contem-
porary with Augustus. Only his eight Books 'De
Medicina', are preserved. The earliest editions are:
Cornelius Celsus, de medicina libr. VIII., Milan 1481
Venice 1493 and 1497.

1487. Compare Vol. 1, No. 10.

S. K. M. III. 93*a*]

1488.

Maestro Stefano ²Caponi, medico, ³sta alla piscina, ⁴à Euclide 'de pō⁵deribus'.

Maestro Stefano Caponi, a physician, lives at the piscina, and has Euclid *De Ponderibus*.

K.² 2*a*]

1489.

5° Euclide. ²Prima definitione ¶parte è quantità di quantità ³minore della maggiore, cōciosia⁴chè la minore numeri la mag⁵giore;
⁶Parte propriamēte detta è quella ⁷ch'è moltiplicatiua, cioè che, multi⁸plicata per alcuno numero, ricōpo⁹ne il suo tutto con precisione;
¹⁰Parte comune aggregatiua è que¹¹lla, la quale, quantunche volte si pi¹²glia più o meno del suo tutto, ¹³ond'è neciessario che coll'ajuto d'al¹⁴tra quantità diuersa rifaccia il suo ¹⁵tutto, e perciò è detta aggregatiua.
¹⁶Seconda definitione. ¶La multiplicità è maggiore della mi¹⁷nore, quando la minore misura qu¹⁸ella;
¹⁹Di sopra difinimmo il minore estremo, ²⁰e qui si difinisce il maggiore; La parte

5th Book of Euclid. First definition: a part is a quantity of less magnitude than the greater magnitude when the less is contained a certain number of times in the greater.
A part properly speaking is that which may be multiplied, that is when, being multiplied by a certain number, it forms exactly the whole. A common aggregate part

Second definition. A greater magnitude is said to be a multiple of a less, when the greater is measured by the less.
By the first we define the lesser [magnitude] and by the second the greater is defined. A part is spoken

K.² 2*b*]

1490.

relatiuamente è detta al tutto, ²e in questi due estremi sta tutta ³la relatione di quegli, e chiamā⁴si mvltiplici.

of in relation to the whole; and all their relations lie between these two extremes, and are called multiples.

S. K. M. III. 16*b*]

1491.

Dice Ippocrate che la origine della ²nostra semenza diriua dal cielabro · e dal ³polmone · e' testiculi di nostri gie⁴nitori ·, dove si fa l'ultima decotione; ⁵e tutti li altri mēbri porgono · per sudatio⁶ne la loro sustātia a esso seme, per⁷chè non si dimostra alcuna via, ⁸che a essa semēza peruenire possino.

Hippocrates says that the origin of men's sperm derives from the brain, and from the lungs and testicles of our parents, where the final decocture is made, and all the other limbs transmit their substance to this sperm by means of expiration, because there are no channels through which they might come to the sperm.

1488. 3. pesscina. 4. a heuclide.
1489. 2. pᵃ difinitione *is written on the margin.* 3. magore concosia. 4. chella. 5. gore. 6. ditta ecque. 7. che moltiplichatiua coe. 10. cumune agreghatiua cqu"e". 12. plia [ma fa] piu . . tutt"o". 13. chollaiuto. 14. rifacea. 15. pero e detto agregatiua. 16. 2ᵃ difinitione *is written on the margin.* La multiplici e magore. 19. difinimo . . extremo. 20. ecqui si difinisce il maggiore.
1490. 2. quessti duextremi. 4. mvltiplici.
1491. 1. ipocrate chella. 2. nosstra senza. 3. ettestichuli di nosstri. 4. dovessi . . dechotione. 5. ettutti . . porgano. 6. susstātia. 7. dimosstra alchuna.

1491. The works of Hippocrates were printed first after Leonardo's death.

Ash. II. 11*b*] **1492.**

Lucretio nel terzo · delle cose · naturali ‖ le mani, vnghie e dēti furono ²le armi · deli ātichi_ (165);

³Acora vsano per stēdardo · di vno fasciculo d'erba · legato a vna pertica (167).

Lucretius in his third [book] 'De Rerum Natura'. The hands, nails and teeth were (165) the weapons of ancient man.

They also use for a standard a bunch of grass tied to a pole (167).

Tr. 2] **1493.**

Ammiano Marcellino afferma, essere abbruciati ²7 cēto mila volumi di libri nella pugnia Alessādrina ³al tēpo di Givlio Cesare.

Ammianus Marcellinus asserts that seven hundred thousand volumes of books were burnt in the siege of Alexandria in the time of Julius Cesar.

W. XXIII.] **1494.**

Dice Mōdino che li muscoli che alza²no li diti del piede stanno nella parte ³siluestra della coscia, e poi soggiugne ⁴che 'l dosso del piede non à muscoli, ⁵perchè la natura li volle fare legieri ac⁶ciochè fussino facili al movimēto, per⁷chè se fussino carnosi, sarebber più ⁸gravi; e qui la speriētia mostra . . .

Mondino says that the muscles which raise the toes are in the outward side of the thigh, and he adds that there are no muscles in the back [upper side] of the feet, because nature desired to make them light, so as to move with ease; and if they had been fleshy they would be heavier; and here experience shows . . .

G. 8*a*] **1495.**

Del'error di quelli che vsano ²la pratica sanza sciētia;—³vedi primo ⁴la poetica ⁵d'Oratio.

Of the error of those who practice without knowledge;—[3] See first the 'Ars poetica' of Horace [5].

1492. 1. naturale. 3. istēdare diono.
1493. 1. amiano . . abrusiati. 2. 7 cēto M"a" [di] volumi . . nela [spu] pugnia. 3. ivlio.
1494. 1. chelli mussccoli. 2. piedi. 3. cosscia . . sogugne. 4. piedi . . musscoli. 5. le volle . . legieri a. 6. coche fussi facile.
 7. fussi carnose sarebbe. 8. grave.
1495. 1—5 R. 1. cror. 4. poetria.

1492. *Lucretius, de rerum natura libri VI* were printed first about 1473, at Verona in 1486, at Brescia in 1495, at Venice in 1500 and in 1515, and at Florence in 1515. The numbers 165 and 167 noted by Leonardo at the end of the two passages seem to indicate pages, but if so, none of the editions just mentioned can here be meant, nor do these numbers refer to the verses in the poems of Lucretius.

1493. *Ammiani Marcellini historiarum libri qui extant XIII,* published at Rome in 1474.

1494. "*Mundini anatomia. Mundinus, Anothomia* (sic). *Mundini praestantissimorum doctorum almi studii ticiensis* (sic) *cura diligentissime emendata. Impressa Papiae per magistrum Antonium de Carcano* 1478," *in-fol.;* ristampata: "*Bononiae Johan. de Noerdlingen,* 1482," *in-fol.;* "*Padova*

per Mattheum Cerdonis de Vuindischgretz, 1484," *in-*4°; "*Lipsia,* 1493," *in-*4°; "*Venezia,* 1494," *in-*4° *e ivi* "1498," *con fig. Queste figure per altro non sono, come si è preteso, le prime che fossero introdotte in un trattato di Notomia. Nel 'fasciculus Medicinae' di Giovanni Ketham, che riproduce l' 'Anatomia' del Mundinus, impresso pure a Venezia da J. e G. de Gregoriis,* 1491, *in-fol., contengonsi intagli in legno (si vogliono disegnati non già incisi da Andrea Mantegna) di grande dimensione, e che furono più volte riprodotti negli anni successivi. Quest' edizione del "fasciculus" del* 1491, *sta fra nostri libri e potrebbe benissimo essere il volume d' Anatomia notato da Leonardo.* (G. D'A.)

1495. A 3—5 are written on the margin at the side of the title line of the text given, entire as No. 19

S. K. M. III. 3*b*]　　　　　　　**1496.**

¶Eredi di maestro Giovā ²Ghirīgallo ànno opere del Pe³lacano. ¶

The heirs of Maestro Giovanni Ghiringallo have the works of Pelacano.

B. 8*a*]　　　　　　　**1497.**

Catapulta, come dice Nonio e Plinio, è vno strumēto ritrovato da quelli ecc.

The catapult, as we are told by Nonius and Pliny, is a machine devised by those &c.

Ash. II. 12*b*]　　　　　　　**1498.**

Ò ritrovato nele Storie delli Spagnioli · come · nelle guerre da loro ²avute colli Inglesi fu Archimede Siracusano, il quale ī quel tēpo ³dimorava ī cōpagnia di Ecliderides, rè de' Cirodastri; Il quale nella ⁴pugnia marittima ordinò ·, che i navili fussino con lunghi arbori, ⁵e sopra le lor gaggie ⁶collocò · vna · antennetta di lūghezza di 40 piè, e ¹/₃ ⁷piè di grossezza; nel' una stremità era vna ancora picciola, nel' al⁸tra · vn contrapeso; al' ancora era appiccato 12 piedi ⁹di catena · e dopo essa catena tāta corda ¹⁰che perveniua dalla catena al nascimēto della gaggia ch'era attaccata con una cordella; ¹¹da esso nascimēto mādaua ī basso īsino al nascimēto dell'arbore, ¹²dou'era collocato vn argano fortissimo, e lì era fermo ¹³il nascimēto d'essa corda; Ma per tornare all'ufitio d'essa machina ¹⁴dico che sotto a detta ācora era vno foco, il quale con sommo stre¹⁵pito gittava ī basso i sua razzi e pioggia di pegola īfocata, li qua¹⁶li piovēdo sopra alla gaggia costrignievano li omini, che lì erano, a ¹⁷abbādonare detta gaggia, ōde calato l'ancora colle acut ¹⁸quella cauaua ai labri della gaggia; e subito era tagliata la corda posta ¹⁹al nascimēto della gaggia a sotenere quella corda ch'ādaua ²⁰dal'ācora al'argano, e tirādo il navilio . . .

I have found in a history of the Spaniards that in their wars with the English Archimedes of Syracuse who at that time was living at the court of Ecliderides, King of the Cirodastri. And in maritime warfare he ordered that the ships should have tall masts, and that on their tops there should be a spar fixed[6] of 40 feet long and one third of a foot thick. At one end of this was a small grappling iron and at the other a counterpoise; and there was also attached 12 feet of chain; and, at the end of this chain, as much rope as would reach from the chain to the base of the top, where it was fixed with a small rope; from this base it ran down to the bottom of the mast where a very strong spar was attached and to this was fastened the end of the rope. But to go on to the use of his machine; I say that below this grappling iron was a fire[14] which, with tremendous noise, threw down its rays and a shower of burning pitch; which, pouring down on the [enemy's] top, compelled the men who were in it to abandon the top to which the grappling-iron had clung. This was hooked on to the edges of the top and then suddenly the cord attached at the base of the top to support the cord which went from the grappling iron, was cut, giving way and drawing in the enemy's ship; and if the anchor—was cast . . .

1496. 1. maesstro jovā. 2. ghirīgallo ano. 3. lachano.
1498. 1. chome . . guere dalloro. 2. ingilesi fu darchimede. 4. cholunghi albori. 5. essopra . . gagie. 6. chollocho . . antenetta di lūgezza. 7. grosseza. 8. vcontrapeso . . era apicato. 9, e[ttā]dopo . . chorda. 10. anassimēto . . gagia. *The following words are written on the margin:* chera attaca etacata cōnuna cordella. 11. nasimēto . . nasimēto delo albore. 12. vn [albore] rgano. 13. nassimēto. 14. chon somo. 15. pido . . sua raza e piogia. 16. ala gagia chostrignieva. 17. abādonare . . gagia . . chalato lancora chole achuti rāpo (?). 18. gagia essubito. 19. [assostenere] a noscimēto dela gagia . . quela chorda. 20. navilio demi (?) essi (?) poneva (?) dancora (?).

1497. *Plinius*, see No. 946.
1498. Archimedes never visited Spain, and the names here mentioned cannot be explained. Leonardo seems to quote here from a book, perhaps by some questionable mediæval writer. Prof. C. Justi writes to

me from Madrid, that Spanish savants have no knowledge of the sources from which this story may have been derived.
　6. Compare No. 1115.
　14. Compare No. 1128.

Leic. 14 *b*] **1499.**

Teofrasto, del flusso e riflusso ²e delle vortici e de' acque.

Theophrastus on the ebb and flow of the tide, and of eddies, and on water.

Ash. II. 11 *b*] **1500.**

Trifone Alessādrino, il quale duceua sua età in Apolonia città d' Albania (163).

Tryphon of Alexandria, who spent his life at Apollonia, a city of Albania (163).

K.3 29 *b*] **1501.**

Messer Vīcentio Aliprādo, che sta ²presso all' osteria dell' Orso, à il Vetru³uio di Iacomo Andrea.

Messer Vincenzio Aliprando, who lives near the Inn of the Bear, has Giacomo Andrea's Vitruvius.

L. 53 *b*] **1502.**

Dice Vetruvio che i modelli piccoli ²non sono in nessuna operatione confor³mi all' effetto de' grandi; la qual co⁴sa qui disotto intendo dimostra⁵re tale conclusione · essere falsa, ⁶e massimamente allegando quelli me⁷desimi termini, coi quali lui cō⁸clude tale · sententia, cioè colla ⁹sperientia · della triuella, per la qua le ¹⁰lui mostra essere fatto dalla po¹¹tentia dell' omo vno buso di cier-¹²ta quantità di diametro, e che poi ¹³vn buso di dupplicato diametro nō ¹⁴sarà fatto da dupplicata potentia ¹⁵di detto uomo, ma da molto piv; all¹⁶a qual cosa si può molto ben rispō¹⁷dere, allegando che il trivello

Vitruvius says that small models are of no avail for ascertaining the effects of large ones; and I here propose to prove that this conclusion is a false one. And chiefly by bringing forward the very same argument which led him to this conclusion; that is, by an experiment with an auger. For he proves that if a man, by a certain exertion of strength, makes a hole of a given diameter, and afterwards another hole of double the diameter, this cannot be made with only double the exertion of the man's strength, but needs much more. To this it may very well be answered that an auger

L. 53 *a*] **1503.**

di dupplicata figura non può ²essere mosso da dupplicata po³ten-tia, conciosiachè la superfitie ⁴ d'ogni corpo di figura simile è di dup⁵plicata quantità alla superfitie, di ⁶quadrupli-cata quātità l' una ⁷all' altra, come mostrano le due ⁸figure · *a* · e · *n*.

of double the diameter cannot be moved by double the exertion, because the superficies of a body of the same form but twice as large has four times the extent of the superficies of the smaller, as is shown in the two figures *a* and *n*.

1499. teofrassto de frusso e rifrusso. 2. vertigine.
1501. aliplādo. 2. .uetru.
1502. 1. picho. 2. inessuna. 3. dall effecto. 4. ḍisocto . . dimosstra. 6. que me. 8. coe colla. 9. essperiētia . . trinella la qua.
 10. mosstra. 11. fatto. 12. diamitro. 13. diametro. 14. potenti"a". 15. homo. 16. si po . . risspo. 17. trivell"o".
1503. 1. duplichata . . non po. 3. concosia chella. 4. e di du. 6. quadruplata. 7. mosstrā le due.

1499. The Greek philosophers had no opportunity to study the phenomenon of the ebb and flow of the tide and none of them wrote about it. The move-ment of the waters in the Euripus however was to a few of them a puzzling problem.

1500. Tryphon of Alexandria, a Greek Gram-marian of the time of Augustus. His treatise πάθη λέξεως appeared first at Milan in 1476, in Constantin Laskaris's Greek Grammar.

G. 95 a] **1504.**

DELLA □ᵃ DEL CIRCULO, E CHI FU IL PRIMO
CHE LA ²TROVÒ A CASO.

³Vetruvio, misurando le miglia colle molte intere revolutioni ⁴delle rote che movono i carri, distese nelli suoi stadi molte linie ⁵circūferētiali del circolo di tali rote; Ma lui le inparò dalli ani⁶mali motori di tali carri; Ma nō conobbe quello essere il mezzo ⁷a dare il □ᵗᵒ equale a vn circolo, il quale prima per Archimede Siragusano ⁸fu trovato: chè la multiplicatione del semidiamitro d'un circolo colla ⁹metà della sua circūferētia facieva vn quadrilatero rettilinio, ¹⁰equale al circolo.

OF SQUARING THE CIRCLE, AND WHO IT WAS
THAT FIRST DISCOVERED IT BY ACCIDENT.

Vitruvius, measuring miles by means of the repeated revolutions of the wheels which move vehicles, extended over many Stadia the lines of the circumferences of the circles of these wheels. He became aware of them by the animals that moved the vehicles. But he did not discern that this was a means of finding a square equal to a circle. This was first done by Archimedes of Syracuse, who by multiplying the second diameter of a circle by half its circumference produced a rectangular quadrilateral equal figure to the circle[10].

Ash. II. 10 b] **1505.**

Virgilio dicie era lo scudo biāco e sanza laude, perchè apresso ²a li Attici le uere laude cōfermate da testimoni da

Virgil says that a blank shield is devoid of merit because among the people of Athens the true recognition confirmed by testimonies . . .

B. 58 a] **1506.**

J̄ Vjtolone sono 805 · conclusioni in prospettiva.

In Vitolone there are 805 conclusions [problems] in perspective.

Br. M. 79 b] **1507.**

Vitolone in Sā Marco.

Vitolone, at Saint Mark's.

1504. 1. de □ᵃ del ce chi . . chella. 2. achaso. 3. cholle. 4. movano i charri . . nelle sue stadi. 5. circūferētiali del c. di . . mallui. 6. charri . . chonobbe . . mezo. 7. a vn c il quale p"a" per . . siraghusaro. 8. chella . . dun c. cholla. 9. circhūferētia. 10. al c.
1505. 1. sanza lalde. 2. atici lalde chōfermate ta testimoni da\\\\\noma. 3. colegati ētraversati e per molificatiō cōgiv̄te (?).
1506. uitolone he 805 chonchisioni in prosspettiva. **1507.** marcho.

1504. *Vitruvius,* see also Nos. 1113 and 343.
10. Compare No. 1475.
1505. The end of the text cannot be deciphered.
1506. (*Witelo, Vitellion, Vitellon*) *Vitellione.* È da vedersi su questo ottico prospettico del secolo XIII Luca Pacioli, Paolo Lomazzo, Leonardo da Vinci, ecc. e fra i moderni il Graesse, il Libri, il Brunet, e le Memorie pubblicate dal principe Boncompagni, e 'Sur l'orthographe du nom et sur la patrie de Witelo (Vitellion) note de Maximilien Curtze, professeur à Thorn', ove sono descritti i molti codici esistenti nelle biblioteche d'Europa. Bernardino Baldi nelle sue 'Vite de' matematici', manoscritto presso il principe Boncompagni, ha una biografia del Vitellione. Questo scritto del Baldi reca la data 25 agosto 1588. Discorsero poi di lui Federigo Risnerio e Giovanni di Monteregio nella prefazione dell' Alfagrano, Giovanni Boteone, Girolamo Cardano, 'De subtilitate', che nota gli errori di Vitellione. Visse, secondo il Baldi, intorno all' anno 1269, ma secondo il Reinoldo fioriva nel 1299, avendo dedicata la sua opera ad un frate Guglielmo di Monteca, che visse di que' tempi.
Intorno ad un manoscritto dell' ottica di Vitellione, citato da Luca Pacioli v' ha un secondo esemplare del Kurtz,

con aggiunte del principe Boncompagni, e le illustrazioni del cav. Enrico Narducci. Nel 'Catalogo di manoscritti posseduti da D. Baldassare de' principi Boncompagni, compilato da esso Narducci, Roma, 1862, sotto al n. 358, troviamo citato: Vitellio, 'Perspectiva', manoscritto del secolo XIV. La 'Prospettiva di Vitelleone' (sic) Thuringo-poloni è citata due volte da Paolo Lomazzo nel Trattato dell' arte della pittura. Vitellio o Vitelo o Witelo. Il suo libro fu impresso in foglio a Norimberga nel 1535; la secondo edizione è del 1551, sempre di Norimberga, ed una terza di Basilea, 1572. (See *Indagini Storiche . . . sulla Libreria-Visconteo-Sforzesca del Castello di Pavia . . . per cura* di G. D'A., Milano 1879. P. I. Appendice p. 113. 114).
1507. Altro codice di cotesta 'Prospettiva' del Vitolone troviamo notato nel 'Canone bibliographico di Nicolò V', conservato alla Magliabecchiana, in copia dell' originale verosimilmente inviato dal Parentucelli a Cosimo de' Medici (Magliab. cod. segn. I VII, 30 carte da 193 a 198). Proviene dal Convento di San Marco e lo aveva trascritto frate Leonardo Scruberti fiorentino, dell' ordine dei predicatori che fu anche bibliotecario della Medicea pubblica in San Marco (See *Indagini Storiche . . . per cura* di G. D'A. Parte I, p. 97).

K.² 12*b*] **1508.**

Come Xenofonte pro²pose il falso.
³Se a cose disequali si leuano cose ⁴dis-
equali, le quali sieno nella mede⁵sima pro-
portione ecc.

How this proposition of Xenophon is false.
If you take away unequal quantities from
unequal quantities, but in the same propor-
tion, &c.

B. 4 *a*] **1509.**

Inventories
and accounts A dì 28 d'aprile ebbi da Marchesino ·
(1509—1545). lire 103 e S. 12.

On the 28th day of April I received from
the Marchesino 103 lire and 12 dinari.

Ash. I. 1 *a*] **1510.**

A dì 10 di luglio 1492 ī fiorī di rē
 135 l. 445
²ī dinari di 6 S l. 112 S. 16
³ī dinari di · S 5 e ¹/₂ l. 29 S. 13
⁴ī dinari 9 d'oro e scudi 3 l. 53
⁵ ────────────────
 l. 811 ī somma.

On the 10th day of July 1492 in 135 Rhe-
nish florins l. 445
in dinari of 6 soldi l. 112 S 16
in dinari of 5¹/₂ soldi l. 29 S 13
9 in gold and 3 scudi l. 53
 ────────────────
 l. 811 in all.

S. K. M. III. 47 *a*] **1511.**

A dì · primo · di febraio · lire 1200.

On the first day of February, lire 1200.

S. K. M. III. 43 *a*] **1512.**

126 passi è la sala ²di corte, larga
braccia 27.

The hall towards the court is 126 paces
long and 27 braccia wide.

H.3 77 *a*] **1513.**

La gronda stretta sopra la sala ²lire 30;
³le grōde sotto · a di questa ·; siēno,
ciascuno ⁴quadro per se, lire · 7, e di spesa
tra azzurro, ⁵oro, biacca ·, giesso, indaco e
colla · lire 3; ⁶di tēpo giornate . 3 ;
⁷le storie sotto a esse grōde coi suoi
⁸pilastri lire 12 per ciascuna;
⁹stimo la spesa fra smalto, azzurro e
oro, ¹⁰e altri colori · lire una e ¹/₂ ;
¹¹le giornate stimo 3 · tralla investigati-
one ¹²del cōponimēto, pilastrello e altre
cose.

The narrow cornice above the hall lire 30.
The cornice beneath that, being one for
each picture, lire 7, and for the cost of blue,
gold, white, plaster, indigo and glue 3 lire;
time 3 days.
The pictures below these mouldings with
their pilasters, 12 lire each.
I calculate the cost for smalt, blue and
gold and other colours at 1¹/₂ lire.
The days I calculate at 3, for the inven-
tion of the composition, pilasters and other
things.

1508. ·1. zenofonti. 3. si leua. 4. qual sieno. 6. sima pro"ne". **1509.** addi.
1510. 2. dinar. 3. dinari. 4. ī di 9 doroesscudi. 5. soma.
1512. 1. ella. 2. larga br 27.
1513. 1. strecta. 3. socto a di quessta. 4. azzurro. 5. oro br biache . . indacho echolla. 7. grōda chosua. 8. pilastre . .
 ciasschuna. 9. azuro e a oro. 10. lire ī e 1/2. 11. invesstichatiō.

1508. Xenophon's works were published several
times during Leonardo's lifetime.

1509 Instead of the indication of the year there

is a blank space after *d'aprile*.—Marchesino Stange
was one of Lodovico il Moro's officials. — Campare
No. 1388.

H.3 76b] **1514.**

Itē per ciascuna volta · sola · lire 7
²di spesa tra azzurro e oro · lire · 3 ¹/₂
³di · tēpo · giorni 4.
⁴per le finestre lire 1ᵃ e ¹/₂
⁵il cornicione sotto alle finestre S 16 il
 braccio
⁶item per 24 storie romane lire 14 l'una
⁷i filosofi lire 10
⁸i pilastri, vn ōcia d'azzurro soldi 10
⁹in oro soldi 15
¹⁰sono lire 2 e ¹/₂.

Item for each vault 7 lire
outlay for blue and gold 3¹/₂
time, 4 days
for the windows 1¹/₂
The cornice below the windows 16 soldi
per braccio
item for 24 pictures of Roman history
 14 lire each
The philosophers 10 lire
the pilasters, one ounce of blue 10 soldi
for gold 15 soldi
Total 2 and ¹/₂ lire.

H.3 81b] **1515.**

Grōda di sopra lire 30
²grōda di sotto lire 7
³le storie l'una per l'altra lire 13.

The cornice above lire 30
The cornice below lire 7
The compositions, one with another lire 13

H.3 94b] **1516.**

Salai lire 6 ... ³soldi 4 ... ⁶soldi 10 in
⁷vna ca⁸tena;
 ⁹14 di marzo ò avuto lire 13 ¹⁰S 4,
resta lire 16.

Salai, 6 lire ... 4 soldi ... 10 soldi for
a chain; —
On the 14th of March I had 13 lire S. 4;
16 lire remain.

H.² 16b] **1517.**

Quāte braccia è alto il piā delle
mvra?
 ²123 braccia
 ³Quāt'è larga la sala?
 ⁴Quāt'è larga la ghirlanda?
 ⁵30 ducati.
 ⁶A dì 29 di gienaro 1494.
 ⁷Panno per calze lire 4 S 3
 ⁸soppaño S 16
 ⁹fattura S 8
 ¹⁰Salai S 3
 ¹¹anello di diaspro S 13
 ¹²pietra stellata S 11
 ¹³Caterina S 10
 ¹⁴Caterina S 10.

How many braccia high is the level of
the walls?—
123 braccia
How large is the hall?
How large is the garland?
30 ducats.
On the 29th day of January, 1494
cloth for hose lire 4 S 3
lining S 16
making S 8
to Salai S 3
a jasper ring S 13
a sparkling stone S 11
to Caterina S 10
to Caterina S 10

1514. 1. chiasscuna voltaiola lire. 2. azuro. 5. cornicone .. il br. 6 ite. 7. i filosafi. 8. ipila vnōcia dazuro. 10. simolire.
1515. 3. perllaltra.
1516. 1—10 R. 1. 6 in vna. 2. rev(?). 3. soldi 4 nv. 4. varco eli. 5. goni. 7. nona. 9. mazo.
1517. 1. br e. 2. R. — 122 br. 4. girlando. 5—14 R. — 6. addi. 7. chalze. 11. di diasspis.

H.² 33a] **1518.**

La rota	lire 7		The wheel	lire 7
²labro	li 10		the tire	lire 10
³scudo	li 4		the shield	lire 4
⁴carello	li 8		the cushion	lire 8
⁵poli del'albero	li 2		the ends of the axle-tree	lire 2
⁶letto e telajo	li 30		bed and frame	lire 30
⁷canale	li 10.		conduit	lire 10

S. K. M. II.² 4a] **1519.**

Petrosemolo	parti 10	Parsley	10 parts
²mēta	parte 1	mint	1 part
³serpillo	parte 1	thyme	1 part
⁴aceto e sale poco;		Vinegar . . . and a little salt two pieces	
⁵canavaccio 2 pezzi per Salai.		of canvas for Salai.	

S. K. M. II.¹ 0'] **1520.**

Martedì si cōprò il uino da mattina, ²venerdì a dì 4 di settēbre il simile.

On Tuesday I bought wine for morning [drinking]; on Friday the 4ᵗʰ day of September the same.

S. K. M. II.¹ 94b] **1521.**

Piscina all' ospedale, — ²ducati 2,— ³fave, — ⁴melica biāca,— ⁵melica rossa,— ⁶panico,— ⁷miglio,— ⁸fagiuoli,— ⁹fave,— ¹⁰pisegli.

The cistern at the Hospital, — 2 ducats, — beans, — white maize, — red maize, — millet, — buckwheat, — kidney beans, — beans, — peas.

S. K. M. II.¹ 95a] **1522.**

SPESE PER LA SOTTERATURA DI CATERINA. EXPENSES OF THE INTERMENT OF CATERINA.

²Libbre 3 di cera	S 27		For the 3 lbs of tapers	27 S
³per lo cataletto	S 8		For the bier	8 S
⁴palio sopra il cataletto	S 12		A pall over the bier	12 S
⁵portatura · e portura di croce	S 4		For bearing and placing the cross	4 S
⁶per la postatura · del morto	S 8		For bearing the body	8 S
⁷per 4 preti e 4 cherici	S 20		For 4 priests and 4 clerks	20 S
⁸canpana ·, libri, spūga	S 2		Bell, book and sponge	2 S
⁹per li sotteratori	S 16		For the gravediggers	16 S
¹⁰all' ātiano	S 8		To the senior	8 S
¹¹per la liciētia · ali ufitiali	S 1		For a license from the authorities	1 S
	106			106 S
¹²il medico	S 2		The doctor	2 S
¹³zucchero e cādele	S 12		Sugar and candles	12 S
	120			120 S

1518. 1—7 R. 6. ettelaro.
1519. 1. petrose milo parte. 3. srpilo pa. 4. aceto peneo essale. 5. canovacci 2 prsi.
1521. 1. pisciṅ damozania(?) allospedadi. 4. meliga. 5. meliga. 8. fagioli.
1522. 1. socteratura. 2. In libr. 3. 3. catalecto. 4. sopra catalecto. 7. cerici. 8. libr. 9. socteratori.\ 10. allātiano. 12. in
 medico. 13. zuchero.

1519. This note, of about the year 1494, is the earliest mention of Salai, and the last is of the year 1513 (see No. 1465, 3). From the various notes in the MSS. he seems to have been Leonardo's assistant and keeper only, and scarcely himself a painter. At any rate no signed or otherwise authenticated picture by him is known to exist. Vasari speaks somewhat doubtfully on this point.

1520. This note enables us to fix the date of the Manuscript, in which it is to be found. In 1495 the 4th of September fell on a Friday; the contents of the Manuscript do not permit us to assign it to a much earlier or later date (Compare No. 1522, and Note).

1522. See Nos. 1384 and 1517.

L. 94 a]　　　　　　　　**1523.**

La cappa di Salai a dì 4 d'aprile 1497.

[2] 4 braccia di panno argiētino	l. 15	S	4
[3] velluto verde per ornare	l. 9	S	
[4] bindelli	l.	S	9
[5] magliette	l.	S	12
[6] manifattura	l. 1	S	5
[7] bindello · per dināzi	li · S		5
[8] pūta			
[9] ecco di suo grossoni · 13	li 26	S	5
[10] Salai ruba li soldi.			

Salai's cloak, the 4th of April 1497.

4 braccia of silver cloth	l. 15	S	4
green velvet to trim it	l. 9	S	—
binding	l. —	S	9
loops	l. —	S	12
the making	l. 1	S	5
binding for the front	l. —	S	5
stitching			
here are 13 grossoni of his	l. 26	S	5
Salai stole the soldi.			

I.² 1 b]　　　　　　　　**1524.**

Lunedì cōprai braccia 4 di tela, lire 13 S 14 [2] e ¹/₂, a dì 17 di ottobre 1497.

On Monday I bought 4 braccia of cloth lire 13 S 14¹/₂ on the 17th of, October 1497.

Br. M. 229 b]　　　　　　　　**1525.**

Ricordo come a dì 8 d'aprile 1503 io Leonardo da Vinci prestai a Vāte mi[2]niatore ducati 4 d'oro in oro; portògli Salai e li dette in sua propia [3] mano; disse rendermile infra lo spatio di 40 giorni;

[4] Ricordo come nel sopradetto giorno io rēdei a Salai ducati 3 d'oro, i quali [5] disse volersene fare vn paio di calze rosate co' sua fornimēti, e li restai a dare [6] ducati 9 ·, posto che lui ne de' dare a me ducati 20, cioè 17 prestai li a Milano e 3 a Venezia;

[7] Ricordo come io diedi a Salai braccia 21 di tela da fare camicie, a S. 10 il braccio, [8] le quali li diedi a dì 20 d'aprile 1503.

Memorandum. That on the 8th day of April 1503, I, Leonardo da Vinci, lent to Vante, miniature painter 4 gold ducats, in gold. Salai carried them to him and gave them into his own hand, and he said he would repay within the space of 40 days.

Memorandum. That on the same day I paid to Salai 3 gold ducats which he said he wanted for a pair of rose-coloured hose with their trimming; and there remain 9 ducats due to him—excepting that he owes me 20 ducats, that is 17 I lent him at Milan, and 3 at Venice.

Memorandum. That I gave Salai 21 braccia of cloth to make a shirt, at 10 soldi the braccio, which I gave him on the 20th day of April 1503.

C. A. 70 b; 208 b]　　　　　　　　**1526.**

La mattina di S͞c͞o Pietro a dì 29 di giugno 1504 [2] tolsi ducati 10, de' quali ne diedi uno a Tomaso, mio [3] famiglio, per spēdere;

On the morning of San Peter's day, June 29th, 1504, I took 10 ducats, of which I gave one to Tommaso my servant to spend.

1523. 2. 4 br di. 9. ecci di suo. 10. P.　　　**1524.** 1. br 4.
1525. 1. chome. 2. innoro . . elli detti. 3. losspatio . . gorni. 4. assalai. 5. elliresstai addare. 6. duchati 9 possto chellui . . amme . . coe 1 [6] 7 prestali . . e [4] 3 a vinegia. 7. assalai br 21 . . daffare camice a S 10 il bracco. 8. la queli . . addi.
1526. 1—22. *Written from left to right.* 1. pitro addi . . gugno. 2. î attomaso. 3. isspēdere. 4. fr î assalai . . isspendere in

1525. With regard to Vante or Attavante, the miniature painter (not Nanni as I formerly deciphered this name, which is difficult to read; see *Zeitschrift für Bild. Kunst*, 1879, p. 155), and Vasari, Lives of Frate Giovanni da Fiesole, of Bartolommeo della Gatta, and of Gherardo, *miniatore.* He, like Leonardo, was one of the committee of artists who, in 1503, considered the erection and placing of Michel Angelo's David. The date of his death is not known; he was of the same age as Leonardo. Further details will be found in '*Notizie di Attavante miniatore, e di alcuni suoi lavori*' (Milanese's ed. of Vasari, III, 231—235).

⁴lunedì mattina fiorino uno a Salai per spendere in casa,

⁵martedì tolsi fiorino uno per mio spendere,

⁶mercoledì sera fiorino uno a Tomaso, ināti cena,

⁷sabato mattina fiorino uno a Tomaso,

⁸lunedì mattina fiorino uno māco S 10,

⁹giouedì a Salai fiorino uno māco S 10,

¹⁰pel giubbone fiorino uno,

¹¹pel giubbone } fr. 2,
¹²e per berretta }

¹³al calzaiolo fr. 1°,

¹⁴a Salai fr. 1°;

¹⁵Venerdì mattina a dì 19 di luglio fiorino uno māco S 6, restò mi fr. 7 e 22 in cassa;

¹⁶martedì a dì 23 di luglio fiorino uno a Tomaso,

¹⁷lunedì mattina a Tomaso fiorino uno,

¹⁸[mercoledì mattina fiorino uno a Tomaso]

¹⁹giouedì mattina a dì p° d'agosto fiorino uno a Tomaso,

²⁰domenica 4 d'agosto fiorino uno;

²¹venerdì a dì 9 d'agosto 1504 ²²tolgo ducati 10 dalle casse.

On Monday morning 1 florin to Salai to spend on the house.

On Thursday I took 1 florin for my own spending.

Wednesday evening 1 florin to Tommaso, before supper.

Saturday morning 1 florin to Tommaso.

Monday morning 1 florin less 10 soldi.

Thursday to Salai 1 florin less 10 soldi.

For a jerkin, 1 florin.

For a jerkin } 2 florins.
And a cap }

To the hosier, 1 florin.

To Salai, 1 florin.

Friday morning, the 19th of July, 1 florin, less 6 soldi. I have 7 fl. left, and 22 in the box.

Tuesday, the 23th day of July, 1 florin to Tommaso.

Monday morning, to Tommaso 1 florin.

[Wednesday morning 1 fl. to Tommaso.]

Thursday morning the 1st day of August 1 fl. to Tommaso.

Sunday, the 4th of August, 1 florin.

Friday, the 9th day of August 1504, I took 10 ducats out of the box.

Br. M. 271*b*] **1527.**

1504.

²Venerdì a dì 9 d'agosto 1504 tolsi fiorini 10 d'oro ³.... venerdì a dì 9 d'agosto grossoni quindici cioè fr. 5 S 5 ⁴.... dato a me fr. 1° d'oro a dì 12 d'agosto, ⁵.... a dì 14 d'agosto grossoni 32 a Tomaso, ⁶e a dì 18 del detto grossoni 5 a Salai, ⁷a dì 8 di settēbre grossoni 6 al fattore ⁸per spendere cioè il dì della donna; ⁹a dì 16 di settembre detti grossō 4 ¹⁰a Tomaso in domenica.

1504.

On the 9th day of August, 1504, I took 10 florins in gold[2] [3] on Friday the 9th day of August fifteen grossoni that is fl. 5 S 5 given to me 1 florin in gold on the 12th day of August[4] on the 14th of August, 32 grossoni to Tommaso. On the 18th of the same 5 grossoni to Salai. On the 8th of September 6 grossoni to the workman to spend; that is on the day of our Lady's birth. On the 16th day of September I gave 4 grossoni to Tommaso: on a Sunday.

chasa. 5. fr î. 6. mercholedi. 6. fr î attomaso . . cene. 7. fr î attomaso. 8. fr î mācho. 9. gonedi assalai fr î mācho. 10. gubone fr î. 11. gubone. 14. assalai. 15. vene "rdi" [sabato] mattina "a di 19 di luglio" fr 1° mācho. 16. luglio fr 1° attomaso. 17. attomaso fr 1°. 18. [mercholedi mattin . . fr 1° attomaso]. 19. govedi "mattina" addi . . fr 1° attomaso. 20. domenicha . . fr 1°. 21. addi. 22. tolgho.

1527. *Written from left to right.* 3. anne dato [addi] venerdi . . coe. 4. m|\|\|\ dato ame fri doro addi 12 d'agosto. 5. an|\|\|\to addi . . 3 (?) atto maso. 6. addi . . assalai. 8. isspendere coe. 9. addi. 10. attomaso indomenicha.

1527. In the original, the passage given as No. 1463 is written between lines 2 and 3 of this text, and it is possible that the entries in lines 3 and 4 refer to the payments of Jacopo Tedesco, who is there mentioned. The first words of these lines are very illegible.

7. *Al fattore.* Il Fattore, was, as is well known,

the nick-name of Giovanni Franceso Penni, born in Florence in 1486, and subsequently a pupil of Raphael's. According to Vasari he was known by it even as a boy. Whether he is spoken of in this passage, or whether the word Fattore should be translated literally, I will not undertake to decide. The latter seems to me more probably right.

F. o″] **1528.**

A dì d'ottobre 1508 ebbi scudi 30; [2] 13 ne prestai a Salai per cōpiere la dota alla [3] sorella, e 17 ne restò a me.

On the day of October, 1508, I had 30 scudi; 13 I lent to Salai to make up his sister's dowry, and 17 I have left.

C. A. 189a; 565a] **1529.**

Ricordo de' danari che io ho avuto dal rè per mia prouisione dal luglio 1508 insino [2] aprile prossimo 1509: prima scudi 100·, poi 70, e poi 50, e poi [3] 20, e poi 200 fiorini a 48 S. per l'uno.

Memorandum of the money I have had from the King as my salary from July 1508 till April next 1509. First 100 scudi, then 70, then 50, then 20 and then 200 florins at 48 soldi the florin.

C. A. 76a; 223a] **1530.**

Sabato a dì 2 di marzo [2] ebbi da Scā Maria Nova [3] ducati 5 d'oro, restò [4] ve ne 450, de' quali 2 ne [5] detti il medesimo dì a Salai, [6] che me li avea prestati.

Saturday the 2nd day of March I had from Santa Maria Novella 5 gold ducats, leaving 450. Of these I gave 2 the same day to Salai, who had lent them to me.

C. A. 253b; 748a] **1531.**

¶ Giovedì, a dì 8 di givgnio [2] tolsi grossoni 17 S 18;¶ [3] giovedì detto da mattina a Salai [4] per spendere S 22.

Thursday, the eighth day of June, I took 17 grossoni, 18 soldi; on the same Thursday in the morning I gave to Salai 22 soldi for the expenses.

W. XXXII.] **1532.**

A Salai grossoni 4, e 1 braccio [2] di velluto 5 lire, e ½, [3] sapere S · 10, maglie d'argiēto; [4] Salai S 14 per bindelli, [5] fattura della cappa S 25.

To Salai 4 grossoni, and for one braccio of velvet, 5 lire, and ½; viz. 10 soldi for loops of silver; Salai 14 soldi for binding, the making of the cloak 25 soldi.

C. A. 17b; 67b] **1533.**

¶ Detti a Salai lire [2] 93 · S 6; [3] ò ne avuti lire 67, [4] resta dare 26 · S 6.¶

I gave to Salai 93 lire 6 soldi, of which I have had 67 lire and there remain 26 lire 6 soldi.

1528. 2. assalai. 3. amme.
1529. 1. Richordo de dinari . . da dal luglo. 1530. 5. assalai.
1531. 1. giove. 3. assalai. 4. perisspēdere.
1532. 1. assalai . . 4 e e 1 br. 2. br 5 lire he ½. 3. velluto br 5 lire he ½. 3. sapr.
1533. 1. assalai. 3. one auiti.

1529. Compare No. 1350 and 1561.
1530. See 'Conto corrente di Leonardo da Vinci con lo Spedale di S. Maria Nuova' [1500 a 1507, 1513—1520] published by G. UZIELLI, Ricerche intorno a Leonardo

da Vinci, Firenze, 1872, pp. 164, 165, 218 and 219. The date here given by Leonardo does not occur in either of the accounts.
1532. Compare No. 1523.

C. A. 312 *b*; 949 *b*]　　　　　　**1534.**

A Salai	S 42		To Salai	S 42
[2] dozzine 2 di stringe	S 8		2 dozen of laces	S 8
[3] in fogli	S 3 d. 8		for papers	S 3 d 8
[4] vn pajo di scarpe	S 14		a pair of shoes	S 14
[5] in veluto	S 14		for velvet	S 14
[6] spada e coltello	S 21		a sword and knife	S 21
[7] in barbiere	S 11		to the barber	S 11
[8] a Paolo per una....	S 20		to Paolo for a....	S 20
[9] per dire la uentura	S 6		For having his fortune told	S 6

Br. M. 272 *b*]　　　　　　**1535.**

Venerdì mattina	in pane	S..d	On Friday morning,	bread	S..d
[2] fiorino uno a Salai	in uino	S..d	one florin to Salai to	wine	S..d
per spē[3]dere; avuto	in oua	S..d	spend; 3 soldi re-	grapes	S..d
S 3	[4] in funghi	S..d	ceived	mushrooms	S..d
	[5] in frutti	S..d		fruit	S..d
	[6] in crusca	S..d		[6] bran	S..d
	[7] in barbiere	S..d		at the barber's	S..d
	[8] in scarpe	S..d		for shoes	S..d

C. A. 116 *b*; 395 *a*]　　　　　　**1536.**

Giovedi mattina fiorino uno.

On Thursday morning one florin.

C. A. 212 *b*; 627 *b*]　　　　　　**1537.**

¶ Dì di Scō Ambrosio S 36 da mattina in giovedò. ¶

On Saint Ambrose's day from the morning to Thursday 36 soldi.

C. A. 258 *a*; 784]　　　　　　**1538.**

I danari ch'io ò avuto da Ser Matteo: [2] prima grossoni 20, poi 13 volte 3 f., e di poi grossoni 61, [3] e poi 3, di poi 3 · 3 ·; S 46 grossoni 12.

The moneys I have had from Ser Matteo; first 20 grossoni, then on 13 occasions 3 f. and then 61 grossoni, then 3, and then 3 · 3; 46 soldi 12 grossoni.

E. o″]　　　　　　**1539.**

Ī carta	S 18		For paper	S 18
[2] ī tela	S 30		for canvas	S 30
[3] i carta	S 10 d 19		for paper	S 10 d 19
[4] somma	73		Total	S 73

1534. 1. assalai. 2. dozine o . . string. 4. pa disscarpe 8 apago[o pr"a" croetta.
1535. 1—8. *Written from left to right.* 2. fr. ī assalai perispē. 3. auta, — innova. 5. frutte. 6. crussca. 8. iniscarpe.
1536. 1. govedi . . fr ī.　　　**1537.** abrósio.
1538. 1. chio auuto. 2. pr grossoni.

1535. 6. Compare Nos. 1545, l. 4 and 5, with similar entries for horse's fodder.

Br. M. 227 a] **1540.**

Libbre · 20 · d'azzurro di
Magnia, vn ducato la libbra l. 80 S d
²libbre · 60 di biacca S . .
la libbra lire 15 S d
 ³libbre 1¹/₂ S. 4 la libbra lire 06 S d
 ⁴cinabro libbre 2, S 18
la libbra lire 01 S 16 d
 ⁵verde libbre 6, S 12
la libbra lire 03 S 12 d
 ⁶giallo libbre 4, a S 12
la libbra lire 02 S 08 d
 ⁷minio libbra una, a
S 8 la libbra lire 00 S 08 d
 ⁸aiorica libbre 4, S 2
la libbra lire 00 S 08 d
 ⁹oguria libbre sei, a S
uno la libbra lire 00 S 06 d
 ¹⁰nero in pietra S 2 la
libbra per 20 lire 02 S 00 d
 ¹¹ciera per fare le stelle
libbre 29 a S la libbra lire S d
 ¹²olio per dipingere
libbre 4 a soldi 5 la libbra lire 10 S d
 ¹³in somma lire 120:
S 18 sanza l'oro 18
 ¹⁴stagnio per appiccare l'oro 120 18
 58

20 pounds of German
blue, at one ducat the pound lire 80 S d
60 pounds of white, S . .
the pound lire 15 S d
 1¹/₂ pound at 4 S the pound lire 6 S d
 2 pounds of cinnabar at
S 18 the pound lire 1 S 16 d
 6 pounds of green at S 12
the pound lire 3 S 12 d
 4 pounds of yellow at S 12
the pound lire 2 S 8 d
 1 pound of minium at S 8
the pound lire 0 S 8 d
 4 pounds of at S 2
the pound lire 0 S 8 d
 6 pounds of ochre at S 1
the pound lire 0 S 6 d
black . . . at S 2 the pound
for 20 lire 2 S 0 d
wax to make the stars
29 pounds at S—the pound lire 0 S 0 d
40 pounds of oil for paint-
ing at 5 soldi the pound lire 10 S 0 d
Altogether lire 120 d 18
without the gold. 18
tin for putting on the gold 120 18
 58

Br. M. 42 b] **1541.**

Due scuri grandi e vna piccina, 8 cuc-
chiai d'ottone; ²4 touaglie, 2 guardanappe,
15 tovagliolini, 2 tovagliole, canava 2, ³2
invoglie, 3 paia di lenzuola, 2 paie nove
e uno vecchio.

Two large hatchets and one very small
one, 8 brass spoons, 4 tablecloths, 2 towels,
15 small napkins, 2 coarse napkins, 2 coarse
cloths, 2 wrappers, 3 pairs of sheets, 2 pairs
new and 1 old.

Br. M. 212 a] **1542.**

Letto	7 0 S.	Bed	7 0 S
²anello	7 0	ring	7 0
³stovigli	2 5	crockery	2 5
⁴ortolano	1 2	gardener	1 2
⁵mainardo	2 8	2 8
⁶fachini	2 1	porters	2 1
⁷bichieri	1 0	glasses	1
⁸ in ferri da foco	3 6	fuel	3 6
⁹in serrature	1	a lock	1

1540. 1—14. *Written from left to right.* 1. libra, libre *throughout for* libbra; libbre dazurro. 2. biaccha S. [6] [7] o la libra.
 4. libr "2" 22 "4". 7. libre î a. 8. [aivricha] "aioricha". 9. aquiria libr sei a î la. 12. dipigniere libre 4 o [per] soldi.
 13. insoma. 14. apichare.
1541. 1. scure grande . . chuchiai. 2. tovagli . . guardanape 14 "15" tovaglolini 2 tovaglole canava. 3. nove e î vechio.
1542. 5. mainard "o". 8. inferi da focho.

H.3 89 b] **1543.**

Peltro novo,	3 · paji di lēzuola	New tin-ware	3 pairs of sheets
²6 · scodellini,	di 4 teli l'uno,	6 small bowls,	each of 4 breadths,
³6 scodelle	2 lenzoli piccoli	6 bowls,	2 small sheets,
⁴2 piattegli grandi	2 tovaglie e ¹/₂	2 large dishes,	2 tablecloths and ¹/₂,
⁵2 piattegli mezzani,	16 mātili	2 dishes medium size,	16 coarse cloths,
⁶2 piatteletti,	8 camicie	2 small ones	8 shirts,
⁷peltro vechio	9 pannetti	Old tin-ware	9 napkins,
⁸3 scodellini	2 sciugatoj	3 small bowls,	2 hand-towels.
⁹4 scodelle		4 bowls,	
¹⁰3 quadretti		3 square stones,	
¹¹2 scodellini		2 small bowls,	
¹²uno scodellone		1 large bowl,	
¹³uno piattello		1 platter,	
¹⁴4 cādellieri		4 candlesticks,	
¹⁵1 candelliere piccolo.		1 small candlestick.	

C. A. 132 a; 402 a] **1544.**

Calze	S 40	Hose	S 40
²paglia	S 60	straw	S 60
³biada	S 42	wheat	S 42
⁴vino	S 54	wine	S 54
⁵pane	S 18	bread	S 18
⁶carne	S 54	meat	S 54
⁷uova	S 5	eggs	S 5
⁸salata	S 3	salad	S 3
⁹barbiere	S 2 d 6	the Barber	S 2 d 6
¹⁰cavalli	S 1.	horses	S 1

C. A. 26 a; 87 a] **1545.**

Domenica		Sunday	
²carne	S 10 d	meat	S 10 d
³vino	S 12 d	wine	S 12 d
⁴crusca	S 5 d 4	bran	S 5 d 4
⁵erba	S 10 d	herbs	S 10 d
⁶ricotta	S 4 d 4	buttermilk	S 4 d 4
⁷melone	S 3 d	melon	S 3 d
⁸pane	S 3 d 1	bread	S 3 d 1
⁹lunedì ¶	9 8	Monday	S 9 8
¹⁰....le	S 6 d	S 6 d
¹¹vino	S 12 d	wine	S 12 d
¹²crusca	S 9 d 4	bran	S 9 d 4
¹³ricotta	S 4 d 4	buttermilk	S 4 d 4
¹⁴erba	S 8 d	herbs	S 8 d

1543. 1. para. 3. picolo. 6. piattelecti. 8. sciugatto. 12. î. 13. î. 15. picolo.
1544. 7. hova.
1545. 1—25 P. 1. domenic S. 6. ricote. 7. mcloroi(?). 13. ricote. 23. melonne. 24. cruvsca.

[15]martedì	...	S		d		Tuesday	S		d	
[16]carne	S	o	d	8		meat	S	o	d	8
[17]vino	S	12	d			wine	S	12	d	
[18]pane	S	3	d			bread	S	3	d	
[19]crusca	S	5	d	4		meal	S	5	d	4
[20]erba	S	8	d			herbs	S	8	d	
[21]mercoledì						Wednesday				
[22]vino	S	5	d			wine	S	5	d	
[23]melone	S	2	d			melon	S	2	d	
[24]crusca	S	5	d	4		meal	S	5	d	4
[25]erba	S	8.				vegetables	S	8.		

Ash. I. 18 *b*] **1546.** Notes by unknown persons among the MSS. (1546—1565).

Miseracione divina sacro sancte Romane ecclesie tituli n · cardinalis [2]wulgarit[er] nuncupatus venerabili religioſo fratri Johanni Mair d'Nustorf [3]ordinis praedicatorum provintie teutonie (?) conventus Wiennensis capellano [4]nostro commensali salutem in dño sempiternam Religione zelus rite ac in [ferite?] [5]honestas aliarumque laudabilium probitatis et virtutum merita quibus apud nos fide [6]digno commendationis testimonio Magistri videlicet ordinis felicis recordacionis Leonardi de [7]Mansuetis de Perusio sigillo suo us dans tibi ad..... opera virtutum comen(salem)? [8]locum et tempus success(ores) cujus similiter officium ministratus qui praedecessoris sui donum (?) [9]confirmavit et de novo dedit aliorumque plurima [laudatis] qui opera tua laudant [10]nos inducunt ut tibi (?) reddamus ad gratiam liberalem hinc est quod nos cupientes.

W. XII *b*] **1547.**

Johannes · Antonius · di Johannes Ambrosius de Bolate; [2]Chi perde il tempo e' virtù non aquista; [3]quanto più pensa l'animo più s'attrista; [4]Virtù non ha in potere lo auere; chi lascia onore per acquistare auere; [5]Non vale fortuna a chi non s'affatica; [6]Colui si fa felice, che Christum vestiga; [7]perfetto dono nō s'à sanza gran pena; [8]Passano nostri triumfi, nostre pompe; [9]la gola · e 'l sonno · e l'otiose · piume Anno · dal mondo · ogni virtù sbandita, [10]tal · che dal corso · suo · quasi · smarita; Nostra · natura · è vinta dal costume; [11]Ormai · convien · così · che tu ti spoltri; Disse il maestro che segiendo · in piuma, [12]in fama · non si viene, nè sotto coltri, Sanza la qual · chi sua · vita · consuma [13]tal · uestigia · in terra di se lascia ·, Qual · fumo · in aria · o nell'acqua la schiuma.

Johannes Antonius di Johannes Ambrosius de Bolate. He who lets time pass and does not grow in virtue, the more I think of it the more I grieve. No man has it in him to be virtuous who will give up honour for gain. Good fortune is valueless to him who knows not toil. The man becomes happy who follows Christ. There is no perfect gift without great suffering. Our glories and our triumphs pass away. Foul lust, and dreams, and luxury, and sloth have banished every virtue from the world; so that our Nature, wandering and perplexed, has almost lost the old and better track. Henceforth it were well to rouse thyself from sleep. The master said that lying in down will not bring thee to Fame; nor staying beneath the quilts. He who, without Fame, burns his life to waste, leaves no more vestige of himself on earth than wind-blown smoke, or the foam upon the sea.

1546—1566. *All these texts are written in the ordinary way from left to right.*
1547. 1. Ambrossius. 3. pensse . . satrista. 4. lassa honore . . aquistare havere. 5. safaticha. 5. coluy . . Xstum. 7. perfecto donnōsa. 8. pasano. 9. ellotiose . . del. 10. chorso . . issmarita . . chostume. 11. chonvien chosi chettutti spoltri . . maesstro chessiegiendo. 12. si uen nessotto choltri. 12. chissua . . chonsuma. 13. uesstigia . . lasscia . . onnellacqua lasschiuma.

1546. The meaning of this document, which is very difficult to decipher, and is written in unintelligible Latin, is, that Leonardo di Mansuetis recommends the Rev. Mair of Nusdorf, chaplain at Vienna, to some third person; and says also that something, which had to be proved, has been proved. The rest of the passages on the same leaf are undoubtedly in Leonardo's hand. (Nos. 483, 661, 519, 578, 392, 582, 887 and 894.)

1547. From the last sentence we may infer that this text is by the hand of a pupil of Leonardo's.— On the same sheet are the notes Nos. 1175 and 715 in Leonardo's own handwriting.

Br. M. 148 a] **1548.**

La mattina de santo Zanobio a dì 29 de maggio nel 1504 ²ebbi da Lionardo Vinci dvcati 15 d'oro, e cominciai a spendere

On the morning of Santo Zanobio the 29th of May 1504, I had from Lionardo Vinci 15 gold ducats and began to spend them.

Italian				English			
³a mona Margarita	S	62	d 4	to Mona Margarita	S	62	d 4
⁴a rifare · l'anello	S	19	d 8	to remake the ring	S	19	d 8
⁵panni	S	13	d	clothes	S	13	
⁶bon bove	S	4		good beef	S	4	
⁷uova	S	6	d	eggs	S	6	
⁸al banco debito	S	7	d	debt at the bank	S	7	
⁹velluto	S	12		velvet	S	12	
¹⁰vino	S	6	d 4	wine	S	6	d 4
¹¹carne	S	4	d	meat	S	4	
¹²more	S	2	d 4	mulberries	S	2	d 4
¹³funghi	S	3	d 4	mushrooms	S	3	d 4
¹⁴insalata	S	1	d	salad	S	1	
¹⁵frutta	S	1	d 4	fruit	S	1	d 4
¹⁶candele	S	3	d	candles	S	3	
¹⁷.	S	1	d	S	1	
¹⁸farina	S	2	d	flour	S	2	
¹⁹domenica	198	·	8	Sunday	198		8
²⁰pane	S	6	d	bread	S	6	
²¹vino	S	9	d 4	wine	S	9	d 4
²²carne	S	7	d	meat	S	7	
²³minestra	S	2	d	soup	S	2	
²⁴frutta	S	3	d 4	fruit	S	3	d 4
²⁵candele	S	3	d 0	candles	S	3	d
²⁶Lvnedì	31			Monday	31		
²⁷pane	S	6	d 4	bread	S	6	d 4
²⁸carne	S	10	d 8	meat	S	10	d 8
²⁹vino	S	9	d 4	wine	S	9	d 4
³⁰frutta	S	4	d	fruit	S	4	
³¹minestra	S	1	d 8	soup	S	1	d 8
	32				32		

Br. M. 148 b] **1549.**

Martedì				Tuesday		
²pane	S	6	d	bread	S	6
³carne	S	11	d	meat	S	11
⁴vino	S	7	d	wine	S	7
⁵frutta	S	9	d	fruit	S	9
⁶minestra	S	2	d	soup	S	2
⁷insalata	S	1	d	salad	S	1

1548. 1. matina . . ganobi . . mago. 2. ebi . . comincai. 3. magarita. 4. arefaere. 6. bonbove. 7. hove. 9. veleto. 13. fonghi. 15. frvte. 17. poniti. 19. domenega. 24. frute. 25. candel. 30. frvte.
1549. 1. martedi *here Leonardo notes in his usual handwriting* ¹/₂ *a grecho.* 5. frvte.

1548. 1549. On the same sheet is the text No. 1015 in Leonardo's own handwriting.

Br. M. 149 b]　　　　　　　　　**1550.**

A Mona Margarita	d 5				To Monna Margarita	S 5			
[2] a Tomaso		S 14			to Tomaso		S 14		
[3] a mona Margarita	di 5	S 2			to Monna Margarita	d 5	S 2		
[4] el dì di san Zanobi					on the day of San Zanobi				
[5] resta					left after				
[6] de pagamento	di 13	S 2	d 4		payment	d 13	S 2	d 4	
[7] di mona Margarita					of Monna Margarita				
[8] in somma	[9] d 14	S 5 · 4			altogether	d 14	S 5	d 4	

Br. M. 271 a]　　　　　　　　　**1551.**

Il · lvnedì a dì 13 di febraio prestai lire S 7 a Lionardo per spendere [2] venerdì d 7.

On Monday, the 13th of February, I lent lire S 7 to Lionardo to spend, Friday d 7.

Br. M. 274 a]　　　　　　　　　**1552.**

¶ Stephano, Chigi, Canonico [3] famigliare del chiarissimo [4] Conte Grimani; [5] a Santo Apostolo. ¶

Stephano Chigi, Canonico, servant of the honorable Count Grimani at S. Apostoli.

C. A. 4 a; 11 a]　　　　　　　　　**1553.**

Essendomi sollecitato; [2] d'amor non ne che · dvnque . . . [3] Bernardo · di Simone, [4] Siluestro di Stefano ·, [5] Bernardo · di Jacopo, [6] Francesco di Matteo Bonciani, [7] Antonio di Giovanni Ruberti; [8] Antonio da Pistoia, Antonio; [9] chi tenpo à e tenpo aspetta [10] perde l' amico · e' danari.

Having become anxious Bernardo di Simone, Silvestro di Stefano, Bernardo di Jacopo, Francesco di Matteo Bonciani, Antonio di Giovanni Ruberti, Antonio da Pistoia Antonio; He who has time and waits for time, will lose his friends and his money.

C. A. 34 b; 109 a]　　　　　　　　**1554.**

Reverendissimo maestro domino Giouañi come fratello jo parlai a maestro Zacaria di quella [2] facenda et l'ho fatto esser contento di quella ordinatione ch'io ho uoluto, [3] cioè in quãto alla comissione ch'io ho dalle parti, et dico che tra noi nõ ha [4] a correre denari inquanto alli quadri della . . .

Reverend Maestro, Domino Giovanni, I spoke to Maestro Zacaria as · a brother about this business, and I made him satisfied with the arrangement that I had wished; that is, as regards the commission that I had from the parties and I say that between us there is no need to pay money down, as regard the pictures of the . . .

1550. 1. margerita d 5½(?) 5. 4. ganobi. 5. resta se mïo da iord. 6. de. 7. di cai(?)li mona malgarita. 8. soma. 10. [a mone margerita S. 7.]

1551. 1. el lvnedi . . prestaio . . perispende. 2. vermadi d. 7 nel 1. 3. di poi imponi di chossto nõnebbi mi se nüoperepochi soldimi forõ.

1552. 2. de dn. c (?) cegno. 3. kᶜᶜmo".

1553. 3. br bernardo. 4. saluesstro. 5. dia chopo. 6. francᶜᶜo". 7. antᶜᶜo". 8. pistoia ghagha diche. 9. asspetta. 10. lamicho e danari nvna. 11. chiasmo e accierbi o esser surado (?).

1554. R "do" mstr dõ . . como frãllo mro. 3. dicochtra. 4. denari inquato . . guadri. *Here the texts breaks off.*

1551. This note is followed by an account very like the one given as No. 1549.
1552. Compare No. 674, 21–23.

C. A. 75 *a*; 220 *a*] **1555.**

Delle cose vedute infra la nebbia quella parte che sarà più ²uicina alli estremi, sarà manco uisibile, e tanto meno ³quāto sō più remote.

Of things seen through a mist that which is nearest its farthest limit will be least visible, and all the more so as they are more remote.

Cod. A. 77 ; *b* 225 *b*] **1556.**

Teodoricus Rex ²semper Augustus.

Theodoricus Rex Semper Augustus.

C. A. 94 *b*; 271 *b*] **1557.**

Πρωομιάσαι ὦ ἄνθρωπος 'Αθῆνας.
²Aut Hesperia sola dicis et significat Italiā, ³aut addis vltima et significat Ispaniā; ⁴Vmbria par Tuscie.

Either you say Hesperia alone, and it will mean Italy, or you add ultima, and it will mean Spain. Umbria, part of Tuscany.

C. A. 121 *b*; 376 *b*] **1558.**

Πάντων ἀντιαμφλίων δυὸ εὐθεῖαι ἐπισταύρονται; ²πρωομιάσαι ὦ ἄνθρωπος 'Αθῆνας τοῖς θεοῖς δέχομαι.

C. A. 130 *a*; 397 *a*] **1559.**

Canonica di a dì 5 di Luglio 1507. ²Cara mia diletta madre, e mie sorelle, e mio cognato, avisovi come ³sono per la grazia di dio di quella spada che io . . . portatela ⁴alla piazza delli Strozzi (?) a Maso della . . . e spedirò la facenda ⁵di Piero in modo che

Canonica of on the 5ᵗʰ of July 1507; my dearly beloved mother, sisters and cousin I herewith inform you that thanks to God I am about the sword which I bring it to Maso at the piazza and I will settle the business of Piero so that

C. A. 164 *b*; 490 *b*] **1560.**

Ut bene respondet Naturae ars docta! dedisset
Vincius, ut tribuit cetera · sic animam ·
Noluit ut similis magis haec foret: altera sic est:
Possidet illius Maurus amans animam.

1555. 1. prte. 2. extremi . . ettanto.
1556. Teodoricus R. 1557. 3. sig "cas" ispaniā.
1559. 1. canonica ?) didio (?) adi. 2. dileta . . sorele . . chome. 4. istro"a"zi . . maso della violē.

1557. The notes in Greek, Nos. 1557, 1558 and 1562 stand in close connection with each other, but the meaning of some words is very doubtful, and a translation is thus rendered impossible.
1559. AMORETTI, *Mem. Stor. XXIV*, quotes the first three lines of this letter as by Leonardo. The character of the writing however does not favour this hypothesis, and still less the contents. I should regard it rather a rough draft of a letter by young

Melzi. I have not succeeded in deciphering completely the 13 lines of this text. Amoretti reads at the beginning *Canonica di Vaprio*, but *Vaprio* seems to me a very doubtful reading.
1560. These three epigrams on the portrait of Lucrezia Crivelli, a picture by Leonardo which must have been lost at a very early date, seem to have been dedicated to Leonardo by the poet. Leonardo used the reverse of the sheet for notes on geometry.

Hujus quam cernis nomen Lucretia, Divi
Omnia cui larga contribuere manu.
Rara huic forma data est; pinxit Leonardus, amavit
Maurus, pictorum primus hic, ille ducum.

Naturam, ac superas hac laesit imagine Divas
Pictor: tantum hominis posse manum haec doluit,
Illae longa dari tam magnae tempora formae,
Quae spatio fuerat deperitura brevi.

C. A. 171 b; 515 b] **1561.**

Egidius Romanus de formatione corporis humani in vtero matris.
²A Mons. le Vintie,-des chevaux (?) ³de l'escuyer du Roy...; ⁴laissez payement continuer a Ms. ⁵Lyonard Paintre du Roy. Amboyse.

Egidius Romanus on the formation of the human body in the mother's womb[1].
[2]To Monsieur le Vinci,-the horses of the king's equerry Continue the payment to Ms. Lyonard, Painter to the King.
[6]Amboise.

C. A. 175 a; 526 a] **1562.**

Πρωομιάσαι ὦ ἄνθρωπος τοῖς θεοῖς δέχομαι.

C. A. 227 b; 685 a] **1563.**

Memoria a maestro Lionardi di avere lo stato di Firenze

Memorandum to Maestro Lionardo to have . . . the state of Florence.

C. A. 334 b; 1017 b] **1564.**

Ricordo a Vostra Eccellentia come Ridolfo ²Manini · condusse a Firenze una somma ³di cristallo..... altre pietre come sono · · ·

To remind your Excellency that Ridolfo Manini brought to Florence a quantity of crystal besides other stones such as are . . .

1561. 1. informatione. 2. des cheuaux a(?). 3. de l'escuyeres(?). 5. peintre(?) du Roi P. 6. Amboyse Amboyse. 7. Amboyse Amboyse.
1563. 1. a m "r o" Lionardo dihavere p'sto lo nolo stato.
1564. 1. vra ELL"tia". 2. Manini [porte] conduse . . som î. 3. cristillo inporse (?) altre.

1561. 1. *Liber magistri Egidii de pulsibus matrice compositus* (*cum commentario Gentilis de Fulgineo*) published in 1484 at Padova, in 1494 and in 1514 at Venice, and in 1505 at Lyons.
2. This text appears to be in a handwriting different from that in the note, l. 1. Here the reading is not so simple as AMORETTI gave it, *Mem. Stor. XXV: A Monsieur Lyonard Peintre du Roy pour Amboyse*. He says too that this address is of the year 1509, and Mr. Ravaisson remarks: "*De cette suscription il semble qu'on peut inférer que Léonard était alors en France, à la cour de Louis XII . . . Pour conclure je crois qu'il n'est pas prouvé que Léonard de Vinci n'ait pas fait un voyage de quelques mois en France sous Louis XII, entre le printemps de 1509 et l'automne de 1510.*"—I must confess that I myself have not succeeded in deciphering completely this French writing of which two words remain to me doubtful. But so much seems to be quite evident that this is not an address of a letter at all, but a certificate or note. *Amboise* [l. 6] I believe to be the signature of Charles d'Amboise the Governor of Milan. If this explanation is the right one, it can be easily explained by the contents of Nos. 1350 and 1529. The note, line 1, was perhaps added later by another hand; and Leonardo himself wrote afterwards on the same sheet some geometrical explanations. I must also point out that the statement that this sheet belongs to the year 1509 has absolutely no foundation in fact. There is no clue whatever for giving a precise date to this note.

C. A. 329*b*; 993*a*]

1565.

XVI° C. 6 de Ciuitate Dei, [2]se Antipodes.

Bibl. Melzi]

1566.

Leonardo's Will.

Sia manifesto ad ciaschaduna persona presente et aduenere, che nella corte del Re nostro signore in Amboysia avanti de noy personalmente constituito messer Leonardo de Vince pictore del Re, al presente comorante nello locho dicto du Cloux appresso de Amboysia, el qual considerando la certezza dela morte e l'incertezza del hora di quella, ha cognosciuto et confessato nela dicta corte nanzi de noy nela quale s'è somesso e somette circa ciò havere facto et ordinato per tenore dela presente il suo testamento et ordinanza de ultima volontà nel modo qual se seguita. Primeramente el racomanda l'anima sua ad nostro Signore Messer Domine Dio, alla gloriosa Virgine Maria, a Monsignore Sancto Michele, e a tutti li beati Angeli Santi e Sante del Paradiso.

Item el dicto Testatore vole essere seppelito drento la giesia de sancto Florentino de Amboysia et suo corpo essere portato li per li capellani di quella.

Item che il suo corpo sia accompagnato dal dicto locho fin nela dicta giesia de sancto Florentino per il colegio de dicta giesia cioè dal Rectore et Priore, o vero dali Vicarii soy et Capellani della giesia di sancto Dionisio d'Amboysia, etiam li Fratri Minori del dicto locho, et avante de essere portato il suo corpo nela dicta chiesia, esso Testatore, vole siano celebrate ne la dicta chiesia di sancto Florentino tre grandi messe con diacono et sottodiacono, et il dì che se diranno dicte tre grandi messe che se dicano anchora trenta messe basse de Sancto Gregorio.

Item nella dicta chiesia de Sancto Dionisio simil servitio sia celebrato come di sopra.

Item nella chiesia de dicti Fratri et religiosi minori simile servitio.

Item el prefato Testatore dona et concede ad Messer Francesco da Melzo, Gentilomo da Milano, per remuneratione de' servitii ad epso grati a lui facti per il pas-

Be it known to all persons, present and to come that at the court of our Lord the King at Amboise before ourselves in person, Messer Leonardo da Vinci painter to the King, at present staying at the place known as Cloux near Amboise, duly considering the certainty of death and the uncertainty of its time, has acknowledged and declared in the said court and before us that he has made, according to the tenor of these presents, his testament and the declaration of his last will, as follows. And first he commends his soul to our Lord, Almighty God, and to the Glorious Virgin Mary, and to our lord Saint Michael, to all the blessed Angels and Saints male and female in Paradise.

Item. The said Testator desires to be buried within the church of Saint Florentin at Amboise, and that his body shall be borne thither by the chaplains of the church.

Item. That his body may be followed from the said place to the said church of Saint Florentin by the *collegium* of the said church, that is to say by the rector and the prior, or by their vicars and chaplains of the church of Saint Denis of Amboise, also the lesser friars of the place, and before his body shall be carried to the said church this Testator desires, that in the said church of Saint Florentin three grand masses shall be celebrated by the deacon and sub-deacon and that on the day when these three high masses are celebrated, thirty low masses shall also be performed at Saint Gregoire.

Item. That in the said church of Saint Denis similar services shall be performed, as above.

Item. That the same shall be done in the church of the said friars and lesser brethren.

Item. The aforesaid Testator gives and bequeaths to Messer Francesco da Melzo, nobleman, of Milan, in remuneration for services and favours done to him in the past, each

1565. 1. XVI° "6°" de Ciu"ite" Dei. 2. esse.

1565. A facsimile of this note, which refers to a well known book by St. Augustin, is given on page 254.
1566. See page 420.

sato, tutti et ciaschaduno li libri, che il dicto Testatore ha de presente et altri Instrumenti et Portracti circa l'arte sua et industria de Pictori.

Item epso Testatore dona et concede a sempre mai perpetuamente a Battista de Vilanis suo servitore la metà zoè medietà de uno iardino, che ha fora a le mura de Milano et l'altra metà de epso iardino ad Salay suo servitore nel qual iardino il prefato Salay ha edificata et constructa una casa, la qual sarà e resterà similmente a sempremai perpetudine al dicto Salai, soi heredi et successori, et ciò in remuneratione di boni et grati servitii, che dicti de Vilanis et Salay dicti suoi servitori lui hano facto de quì inanzi.

Item epso Testatore dona a Maturina sua fantescha una veste de bon pan negro foderata de pelle, una socha de panno et doy ducati per una volta solamente pagati: et ciò in remuneratione similmente de boni servitii a lui facti epsa Maturina de quì inanzi.

Item vole che ale sue exequie siano sexanta torchie, le quali seranno portate per sexanta poveri, ali quali seranno dati danari per portarle a discretione del dicto Melzo le quali torzi seranno divise nelle quattro chiesie sopradicte.

Item el dicto Testatore dona ad ciascheduna de dicte chiesie sopradicte diece libre cera in candele grosse che saranno messe nelle dicte chiesie per servire al dì che se celebreranno dicti servitii.

Item che sia dato ali poveri del ospedale di Dio alli poveri de Sancto Lazaro de Amboysia, e per ciò fare sia dato et pagato alli Tesorieri d'epsa confraternità la summa et quantità de soysante dece soldi tornesi.

Item epso Testatore dona et concede al dicto Messer Francesco Melce presente et acceptante il resto della sua pensione et summa de' danari qual a lui sono debiti del passato fino al dì della sua morte per il recevoir, ovvero, Tesaurario general M. Johan Sapin, et tutte et ciaschaduna summe de' danari che ha recepto dal p.º Sapin de la dicta sua pensione, e in caxo chel decede inanzi al prefato Melzo, e non altramente li quali danari sono al presente nella possessione del dicto Testatore nel dicto loco de Cloux come el dice. Et similmente el dona et concede al dicto de Melze tucti et ciaschaduni suoi vestimenti quali ha al presente ne lo dicto loco de Cloux tam per remuneratione de boni et

and all of the books the Testator is at present possessed of, and the instruments and portraits appertaining to his art and calling as a painter.

Item. The same Testator gives and bequeaths henceforth for ever to Battista de Vilanis his servant one half, that is the moity, of his garden which is outside the walls of Milan, and the other half of the same garden to Salai his servant; in which garden aforesaid Salai has built and constructed a house which shall be and remain henceforth in all perpetuity the property of the said Salai, his heirs and successors; and this is in remuneration for the good and kind services which the said de Vilanis and Salai, his servants have done him in past times until now.

Item. The said Testator gives to Maturina his waiting woman a cloak of good black cloth lined with fur, a of cloth and two ducats paid once only; and this likewise is in remuneration for good service rendered to him in past times by the said Maturina.

Item. He desires that at his funeral sixty tapers shall be carried which shall be borne by sixty poor men, to whom shall be given money for carrying them; at the discretion of the said Melzo, and these tapers shall be distributed among the four above mentioned churches.

Item. The said Testator gives to each of the said churches ten lbs. of wax in thick tapers, which shall be placed in the said churches to be used on the day when those said services are celebrated.

Item. That alms shall be given to the poor of the Hotel-Dieu, to the poor of Saint Lazare d'Amboise and, to that end, there shall be given and paid to the treasurers of that same fraternity the sum and amount of seventy soldi of Tours.

Item. The said Testator gives and bequeaths to the said Messer Francesco Melzo, being present and agreeing, the remainder of his pension and the sums of money which are owing to him from the past time till the day of his death by the receiver or treasurer-general M. Johan Sapin, and each and every sum of money that he has already received from the aforesaid Sapin of his said pension, and in case he should die before the said Melzo and not otherwise; which moneys are at present in the possession of the said Testator in the said place called Cloux, as he says. And he likewise gives and bequeaths to the said Melzo all and each of his clothes which he at present possesses at the said place of Cloux, and all in

grati servitii, a lui facti da qui inanzi, che per li suoi salarii vacationi et fatiche chel potrà avere circa la executione del presente Testamento, il tutto però ale spese del dicto Testatore.

Ordina et vole, che la summa de quattrocento scudi del sole che ha in deposito in man del Camarlingo de Sancta Maria de Nova nela città de Fiorenza, siano dati ali soy fratelli carnali residenti in Fiorenza con el profitto et emolumento che ne po essere debito fino al presente da prefati Camarlinghi al prefato Testatore per casone de dicti scudi quattrocento da poi el dì che furono per el prefato Testatore dati et consignati alli dicti Camarlinghi.

Item vole et ordina dicto Testatore che dicto Messer Francisco de Melzo sia et remana solo et in sol per il tutto executore del Testamento del prefato Testatore, et che questo dicto Testamento sortisca suo pleno et integro effecto, et circa ciò che è narrato et decto havere tenere guardare et observare epso Messer Leonardo de Vince Testatore constituto ha obbligato et obbliga per le presente epsi soy heredi et successori con ogni soy beni mobili et immobili presenti et advenire et ha renunciato et renuncia per la presente expressamente ad tucte et ciaschaduna le cose ad ciò contrarie. Datum nelo dicto loco de Cloux ne la presencia de magistro Spirito Fleri Vicario nela chiesia de Sancto Dionisio de Amboysia, M. Gulielmo Croysant prete et capellani, magistro Cipriane Fulchin, Fratre Francesco de Corton et Francesco da Milano religioso del convento de fratri minori de Amboysia, testimonii ad ciò ciamati et vocati ad tenire per il iudicio de la dicta Corte in presentia del prefato M. Francesco de Melze acceptante et consentiente il quale ha promesso per fede et sacramento del corpo suo per lui dati corporalmente ne le mane nostre di non mai fare venire, dire, ne andare in contrario. Et sigillato a sua requesta dal sigillo regale statuito a li contracti legali d'Amboysia, et in segno de verita.

Dat·a dì XXIII de Aprile MDXVIII avanti la Pasqua.

Et a dì XXIII d'epso mese de Aprile MDXVIII ne la presentia di M. Gulielmo Borian notario regio ne la corte de Baliagio d'Amboysia il prefato M. Leonardo de Vince ha donato et concesso per il suo testamento et ordinanza de ultima voluntà supradicta al dicto M. Baptista de Vilanis presente et acceptante il dritto de laqua

remuneration for the good and kind services done by him in past times till now, as well as in payment for the trouble and annoyance he may incur with regard to the execution of this present testament, which however, shall all be at the expense of the said Testator.

And he orders and desires that the sum of four hundred scudi del Sole, which he has deposited in the hands of the treasurer of Santa Maria Nuova in the city of Florence, may be given to his brothers now living in Florence with all the interest and usufruct that may have accrued up to the present time, and be due from the aforesaid treasurer to the aforesaid Testator on account of the said four hundred crowns, since they were given and consigned by the Testator to the said treasurers.

Item. He desires and orders that the said Messer Francesco de Melzo shall be and remain the sole and only executor of the said will of the said Testator; and that the said testament shall be executed in its full and complete meaning and according to that which is here narrated and said, to have, hold, keep and observe, the said Messer Leonardo da Vinci, constituted Testator, has obliged and obliges by these presents the said his heirs and successors with all his goods moveable and immoveable present and to come, and has renounced and expressly renounces by these presents all and each of the things which to that are contrary. Given at the said place of Cloux in the presence of Magister Spirito Fleri vicar, of the church of Saint Denis at Amboise, of M. Guglielmo Croysant priest and chaplain, of Magister Cipriane Fulchin, Brother Francesco de Corton, and of Francesco da Milano, a brother of the Convent of the Minorites at Amboise, witnesses summoned and required to that end by the indictment of the said court in the presence of the aforesaid M. Francesco de Melze who accepting and agreeing to the same has promised by his faith and his oath which he has administered to us personally and has sworn to us never to do nor say nor act in any way to the contrary. And it is sealed by his request with the royal seal apposed to legal contracts at Amboise, and in token of good faith.

Given on the XXIIIrd day of April MDXVIII, before Easter.

And on the XXIIIrd day of this month of April MDXVIII, in the presence of M. Guglielmo Borian, Royal notary in the court of the bailiwick of Amboise, the aforesaid M. Leonardo de Vinci gave and bequeathed, by his last will and testament, as aforesaid, to the said M. Baptista de Vilanis, being present and agreeing, the right of water which

che qdam bone memorie Re Ludovico XII ultimo defuncto ha alias dato a epso de Vince suxo il fiume del naviglio di Sancto Cristoforo ne lo Ducato de Milano per gauderlo per epso De Vilanis a sempre mai in tal modo et forma che dicto Signore ne ha facto dono in presentia di M. Francesco da Melzo Gentilhomo de Milano et io.

Et a dì prefato nel dicto mese de Aprile ne lo dicto anno MDXVIII epso M. Leonardo de Vinci per il suo testamento et ordinanza de ultima volunta sopradecta ha donato al prefato M. Baptista de Vilanis presente et acceptante tutti et ciaschaduni mobili et utensili de caxa soy de presente ne lo dicto loco du Cloux, in caxo però che el dicto de Vilanis surviva al prefato M. Leonardo de Vince, in presentia del prefato M. Francesco da Melzo et io Notario etc. Borean.

the King Louis XII, of pious memory lately deceased gave to this same de Vinci, the stream of the canal of Santo Cristoforo in the duchy of Milan, to belong to the said Vilanis for ever in such wise and manner that the said gentleman made him this gift in the presence of M. Francesco da Melzo, gentleman, of Milan and in mine.

And on the aforesaid day in the said month of April in the said year MDXVIII the same M. Leonardo de Vinci by his last will and testament gave to the aforesaid M. Baptista de Vilanis, being present and agreeing, each and all of the articles of furniture and utensils of his house at present at the said place of Cloux, in the event of the said de Vilanis surviving the aforesaid M. Leonardo de Vinci, in the presence of the said M. Francesco Melzo and of me Notary &c. Borean.

REFERENCE TABLE TO THE NUMERICAL ORDER OF THE CHAPTERS.

	IV. ON FOUNDATIONS, THE NATURE OF THE GROUND AND SUPPORTS.
789.	Br. M. 138 a.
790.	A. 50 a.
791.	A. 53 a.
792.	A. 48 b.
793.	S. K. M. II.¹ 72 a.
794.	S. K. M. III.¹ 91 a.
795.	A. 53 a.

XIV.

ANATOMY, ZOOLOGY AND PHYSIOLOGY.

I. ANATOMY.

796.	W. An. IV. 167 a.
797.	W. An. II. 36 a (21).
798.	W. An. IV. 157 a (B).
799.	W. 210 a.
800.	W. An. IV. XXI.
801.	W. An. II. 39 b (o).
802.	W. An. IV. 151 a.
803.	W. An. IV. XXII.
804.	W. XXIII.
805.	W. An. I. 1 b.
806.	F. 95 b.
807.	W. 238 b.
808.	K.³ 28 a.
809.	W. An. II. 76 b.
810.	W. An. IV. 7 (AA).
811.	W. 239 a (= W. L. 131).
812.	S. K. M. III. 66 a.
813.	S. K. M. III. 65 b.
814.	W. An. II. 37 a.
815.	W. An. III. 230 a.

II. ZOOLOGY AND COMPARATIVE ANATOMY.

816.	W. An. IV. 173 b.
817.	W. An. II. 206 b (I).
818.	W. An. IV. 153 b.
819.	W. An. IV. 167 a.
820.	G. 64 b.
821.	M. 67 a.
822.	W. An. IV. 157 a (B).
823.	W. XXIV (·55·)
824.	K.³ 29 b.
825.	E. 16 a.
826.	C. A. 292 a; 888 a.

III. PHYSIOLOGY.

827.	W. An. IV. 173 a.
828.	H.² 38 a.
829.	G. 44 a.
830.	Br. M. 64 b.
831.	H.³ 61 a.

832.	W. An. IV. 184 a (7).
833.	W. XXI.
834.	C. A. 89 a; 258 a.
835.	G. 90 a.
836.	C. A. 89 a; 258 a.
837.	W. An. IV. 184 a (7).
838.	W. An. 202 a (·B·)
839.	W. An. II. 202 b (·B·)
840.	Tr. 14.
841.	W. An. IV. 151 b.
842.	H.¹ 32 a.
843.	W. An. II. 43 b (8).
844.	W. An. III. 241 a.
845.	H.² 41 b.
846.	S. K. M. III. 74 a.
847.	C. A. 75 b; 219 b.
848.	F. 1 a.
849.	Leic. 21 b.
850.	W. An. III. 226 a (·M·)
851.	Br. M. 147 b.
852.	W. XIII.
853.	Tr. 7.
854.	Tr. 49.
855.	C. A. 77 b; 225 b.
856.	W. An. III., XXV.

XV.

ASTRONOMY.

I. THE EARTH AS A PLANET.

857.	Br. M. 176 a.
858.	F. 41 b.
859.	Br. M. 151 a.
860.	Br. M. 175 a.
861.	F. 22 b.
862.	F. 11 b.
863.	Tr. 28.
864.	Leic. 1 a.
865.	C. A. 111 b; 345 b.
866.	F. 56 a.
867.	F. 25 b.
868.	W. XXVI.
869.	E. 15 b.
870.	F. 60 b.
871.	Br. M. 174 b.
872.	G. 3 b.
873.	A. 64 b.
874.	F. 94 b.
875.	Br. M. 25 a.
876.	Br. M. 28 a.
877.	F. 77 b.
878.	W. X.

II. THE SUN.

879.	F. 5 a.
880.	F. 4 b.
881.	F. 6 a.

882.	F. 8 b.
883.	F. 10 a.
884.	F. o″.
885.	G. 34 a.
886.	W. L. 132 a.
887.	Ash. I. 19 a.
888.	Br. M. 78 b.
889.	A. 64 a.
890.	C. A. 234 a; 704 a.
891.	T. 12.

III. THE MOON.

892.	Br. M. 94 a.
893.	F. 93 a.
894.	Ash. I. 19 a.
895.	Br. M. 28 a.
896.	Br. M. 94 b.
897.	Br. M. 103 a.
898.	A. 64 a.
899.	Leic. 30 a.
900.	Leic. 36 b.
901.	Leic. 1 b.
902.	Leic. 2 a.
903.	F. 84 a.
904.	F. 84 b.
905.	F. 85 a.
906.	Br. M. 19 a.
907.	Leic. 5 a.
908.	C. A. 341 b; 1055 a.
909.	W. XXVII.
910.	C. A. 187 a; 561 a.

IV. THE STARS.

911.	F. 5 b.
912.	F. 57 a.
913.	F. 60 a.
914.	Br. M. 279 b.
915.	E. o′.
916.	Br. M. 173 b and 190 b.
917.	Br. M. 176 a.
918.	Br. M. 191 a.

XVI.

PHYSICAL GEOGRAPHY.

INTRODUCTION.

919.	Leic. 5 a.
920.	Leic. 15 b.
921.	Leic. 9 a.
922.	F. 87 b.
923.	F. 88 a.
924.	F. 90 b.
925.	Br. M. 35 a.
926.	Br. M. 35 b.
927.	Br. M. 122 a.
928.	Br. M. 45 a.
929.	A. 55 b.

III. THE COUNTRIES OF THE WESTERN END OF THE MEDITERRANEAN.

1083. A. 57 a.
1084. C. A. 212 b; 626 b.
1085. Leic. 10 b.
1086. Leic. 27 b.
1087. F. 61 a.
1088. B. 82 b.
1089. Ash. II. 12 a.

IV. THE LEVANT.

1090. Leic. 31 a.
1091. Leic. 31 a.
1092. C. A. 321 b; 971 a.
1093. C. A. 94 b; 276 a.
1094. B. 61 b.
1095. Leic. 34 b.
1096. Leic. 21 b.
1097. Leic. 22 a.
1098. Leic. 32 b.
1099. B. 61 b.
1100. B. 62 b.
1101. Leic. 10 b.
1102. L. o'.
1103. W. XVII a.
1104. W. XVII b.
1105. C. A. 256 a; 773 a.
1106. F. 50 a.
1107. F. 68 a.
1108. Leic. 31 b.
1109. L. 66 a.
1110. Leic. 28 a.
1111. C. A. 94 b; 276 a.
1112. C. A. 384 b; 1189 b.

XVIII. NAVAL WARFARE.—MECHANICAL APPLIANCES.—MUSIC.

1113. G. 54 a.
1114. Leic. 22 b.
1115. Ash. II. 4 b.
1116. Ash. II. 6 a.
1117. B. 81 b.
1118. S. K. M. III. 25 b.
1119. C. A. 7 a; 19 a.
1120. Ash. II. 5 b.
1121. S. K. M. III. 46 b.
1122. Mz. 3 a. (6)
1123. Mz. 12 a. (10)
1124. Mz. 9 b. (13)
1125. Mz. 13 a.
1126. C. A. 372 b; 1156 b.
1127. Ash. II. 4 a.
1128. Tr. 48.
1129. Br. M. 175 a.
1130. Br. M. 136 a.
1131. B. 4 a.

XIX. PHILOSOPHICAL MAXIMS.—MORALS, POLEMICS AND SPECULATION.

I. PHILOSOPHICAL MAXIMS.

1132. S. K. M. III. 64 b.
1133. W. An. IV. 172 a.
1134. A. 24 a.
1135. S. K. M. III. 49 a.
1136. Tr. 75.
1137. S. K. M. II.¹ 43 a.
1138. Tr. 40.
1139. H.3 93 a.
1140. W. XXIX.
1141. Tr. 78.
1142. C. A. 58 a; 180 a.
1143. C. A. 75 a; 219 a.
1144. Br. M. 278 b.
1145. Tr. 65.
1146. Tr. 70.
1147. Tr. 45.
1148. Tr. 51.
1149. C. A. 85 a; 247 a.
1150. S. K. M. III. 80 b.
1151. I.¹ 18 a.
1152. M. 58 b.
1153. C. A. 151 a; 449 a.
1154. Mz. 1 a.
1155. E. 8 b.
1156. Br. M. 191 a.
1157. W. An. III. 241 a.
1158. G. 95 b.
1159. C. A. 75 a; 219 a.
1160. I.² 82 a.
1161. G. 8 a.

II. MORALS.

1162. B. M. 156 b.
1163. C. A. 70 a; 207 a.
1164. H.² 33 b.
1165. C. A. 75 b; 219 b.
1166. G. 89 a.
1167. C. A. 365 b; 1141 b.
1168. Mz. 8 a (12).
1169. S. K. M. III.; 36 b.
1170. C. A. 75 a; 219 a.
1171. C. A. 111 a; 345 a.
1172. C. A. 223 b; 671 b.
1173. Tr. 32.
1174. Tr. 68.
1175. W. XII.
1176. Ash. I. 1 b.
1177. C. A. 284 b; 885 b.
1178. W. An. II. 203 a (24).
1179. S. K. M. III. 17 a.
1180. C. A. 153 b; 455 b.
1181. Tr. 57.
1182. Tur. 17 b.

1183. Ash. I. 1 a.
1184. F. 96 b.
1185. C. A. 108 b; 338 b.
1186. W. XIII.
1187. S. K. M. II. 77 a.
1188. B. 3 b.
1189. Tr. 2.
1190. E. 31 b.
1191. H.3 70 b.
1192. H.3 71 a.
1193. Tr. 39.
1194. H. 16 b.
1195. C. A. 115 b; 357 b.
1196. S. K. M. II.² 24 a.
1197. H.² 12 b.
1198. L. o".
1199. L. 90 b.
1200. C. A. 75 b; 219 b.
1201. G. 49 a.
1202. Tr. 11.
1203. C. A. 64 b; 197 b.
1204. Ash. II. 13 a.

III. POLEMICS.—SPECULATION.

1205. G. 47 a.
1206. S. K. M. II.² 67 a.
1207. C. A. 75 b; 219 b.
1208. F. 5 b.
1209. Tr. 68.
1210. W. An. III. 241.
1211. C. A. 187 b; 562 b.
1212. B. 4 b.
1213. W. An. II. 242 b. (N)
1214. W. An. II. 242 a.
1215. W. An. II. 201 b.
1216. Br. M. 131 a.
1217. Br. M. 156 a.
1218. Br. M. 155 b.
1219. Br. M. 156 b.

XX. HUMOROUS WRITINGS.

I. STUDIES ON THE LIFE AND HABITS OF ANIMALS.

1220. H.¹ 5 a.
1221. H.¹ 5 b.
1222. H.¹ 6 a.
1223. H.¹ 6 b.
1224. H.¹ 7 a.
1225. H.¹ 7 b.
1226. H.¹ 8 a.
1227. H.¹ 8 b.
1228. H.¹ 9 a.
1229. H.¹ 9 b.
1230. H.¹ 10 a.
1231. H.¹ 10 b.
1232. H.¹ 11 a.
1233. H.¹ 11 b.

1234.	H.¹ 12 a.
1235.	H.¹ 12 b.
1236.	H.¹ 13 a.
1237.	H.¹ 13 b.
1238.	H.¹ 14 a.
1239.	H.¹ 14 b.
1240.	H.¹ 15 a.
1241.	H.¹ 17 a.
1242.	H.¹ 17 b.
1243.	H.¹ 18 a.
1244.	H.¹ 18 b.
1245.	H.¹ 19 a.
1246.	H.¹ 19 b.
1247.	H.¹ 20 a.
1248.	H.¹ 20 b.
1249.	H.¹ 21 a.
1250.	H.¹ 21 b.
1251.	H.¹ 22 a.
1252.	H.¹ 22 b.
1253.	H.¹ 23 a.
1254.	H.¹ 23 b.
1255.	H.¹ 24 a.
1256.	H.¹ 24 b.
1257.	H.¹ 25 a.
1258.	H.¹ 25 b.
1259.	H.¹ 26 a.
1260.	H.¹ 26 b.
1261.	H.¹ 27 a.
1262.	H.¹ 27 b.
1263.	H.¹ 48 b.
1264.	H.³ 53 a.

II. FABLES.

1265.	H.² 3 b.
1266.	C. A. 115 a; 357 a.
1267.	C. A. 117 a; 361 a.
1268.	C. A. 66 a; 200 a.
1269.	C. A. 66 b; 200 b.
1270.	C. A. 66 b; 201 b.
1271.	S. K. M. III. 93 b.
1272.	C. A. 172 b; 516 b.
1273.	C. A. 66 a; 201 a.
1274.	C. A. 66 b; 201 b.
1275.	C. A. 75 a; 219 a.
1276.	S. K. M. III. 45 a.
1277.	C. A. 66 a; 200 a.
1278.	C. A. 66 a; 200 a.
1279.	C. A. 66 a; 201 a.

III. JESTS AND TALES.

1280.	C. A. 117 a; 361 a.
1281.	S. K. M. III. 73 b.
1282.	C. A. 66 a; 201 a.
1283.	S. K. M. III. 58 a.
1284.	C. A. 147 b; 439 a.
1285.	M. 58 b.
1286.	C. A. 12 a; 42 a.
1287.	C. A. 300 b; 914 a.
1288.	C. A. 75 b; 219 b.

1289.	Tr. 78.
1290.	S. K. M. II.² 44 a.
1291.	S. K. M. II.² 43 b.
1292.	F. o¹

IV. PROPHECIES.

1293.	C. A. 143 a; 426 a.
1294.	C. A. 143 b; 426 b.
1295.	C. A. 362 a; 1134 a.
1296.	C. A. 362 b; 1134 b.
1297.	Br. M. 42 b.
1298.	I.² 15 a.
1299.	I.² 15 b.
1300.	I.² 16 a.
1301.	I.² 16 b.
1302.	I.² 17 a.
1303.	I.² 17 b.
1304.	I.² 18 a.
1305.	I.² 18 b.
1306.	I.² 19 a.
1307.	L. 91 a.
1308.	K.² 1 b.
1309.	C. A. 127 b; 390 a.
1310.	Br. M. 212 b.
1311.	S. K. M. II.² 35 b.
1312.	S. K. M. II.² 3 a.
1313.	S. K. M. II.² 69 a.

V. DRAUGHTS AND SCHEMES FOR THE HUMOROUS WRITINGS.

1314.	Br. M. 42 b.
1315.	C. A. 66 b; 201 b.
1316.	H.² 15 b.
1317.	S. K. M.² 12 a.
1318.	J.¹ 39 b.
1319.	H.¹ 44 a.
1320.	H.² 14 b.
1321.	Tri. 73.
1322.	S. K. M. III. 66 b.
1323.	L. o¹.
1324.	S. K. M. III. 48 a.
1325.	L. 72 b.
1326.	I.² 91 a.
1327.	G. 89 a.
1328.	C. A. 36 b; 116 b.
1329.	W. XXX.
1330.	F. 47 a.
1331.	C. A. 68 b; 203 b.
1332.	Tr. 2.
1333.	B. M. 129 b.
1334.	C. 19 b.
1335.	C. A. 75 b; 219 b.

XXI.
LETTERS.—PERSONAL RECORDS.—DATED NOTES.

1336.	C. A. 143 b; 426 b.
1337.	C. A. 211 b; 621 a.

1338.	F. 37 b.
1339.	Br. M. 155 a.
1340.	C. A. 388 a; 1182 b.
1341.	S. K. M. III. 29 a.
1342.	S. K. M. III. 23 b.
1343.	S. K. M. III. 79 b.
1344.	C. A. 308 b; 339 a.
1345.	C. A. 328 b; 983 b.
1346.	C. A. 316 a; 958 a.
1347.	C. A. 316 b; 958 b.
1348.	M. D.
1349.	C. A. 310 a; 944 a.
1350.	C. A. 364 b; 1138 b.
1351.	C. A. 243 b; 729 a.
1352.	C. A. 278 a; 850 a.
1353.	C. A. 179 b; 541 a.
1354.	C. A. 304 a; 925 a.
1355.	W. XXXI.
1356.	H.³ 89 a.
1357.	C. A. 380 a; 1179 b.
1358.	W. An. III. 241 a.
1359.	C. A. 4 b; 11 b.
1360.	C. A. 38 b; 124 a.
1361.	C. A. 17 b; 67 b.
1362.	W. 174 a.
1363.	C. A. 65 b; 199 b.
1364.	C. A. 248 a; 737 a.
1365.	Br. M. 251 b.
1366.	Br. M. 253 a.
1367.	S. K. M. III. 85 a.
1368.	C. A. 188 b; 564 b.
1369.	F. U.
1370.	W. Ant. I. 1 a.
1371.	C. A. 103 a; 325 a.
1372.	Br. M. 272 a.
1373.	C. A. 70 b; 208 b.
1374.	S. K. M. I. 1 b.
1375.	F. 1 a.
1376.	W. An. III. 217 a.
1377.	G. o¹.
1378.	C. A. 245 a; 731 a.

XXII.
MISCELLANEOUS NOTES.

1379.	Cod. Atl. 243 a; 727 a.
1380.	C. 19 b.
1381.	B. 50 b.
1382.	Ash. II. 13 b.
1383.	F. U.
1384.	S. K. M. III. 1 b.
1385.	S. K. M. III. 30 a.
1386.	S. K. M. III. 55 a.
1387.	S. K. M. III. 94 a.
1388.	C. A. 328 a; 980 a.
1389.	H.³ 47 b.

1390.	H.² 14 *b*.	
1391.	H.² 46 *a*.	
1392.	S. K. M. II. 2. 7 *a*.	
1393.	S. K. M. II.² 7 *b*.	
1394.	S. K. M. II.² 12 *a*.	
1395.	S. K. M. II.² 20 *a*.	
1396.	S. K. M. II.² 22 *a*.	
1397.	S. K. M. II.² 27 *a*.	
1398.	S. K. M. II.² 52 *a*.	
1399.	S. K. M. II.² 53 *a*.	
1400.	S. K. M. II.² 63 *a*.	
1401.	S. K. M. II.² 68 *b*.	
1402.	S. K. M. II.² 69 *a*.	
1403.	S. K. M. II.² 75 *b*.	
1404.	S. M. M. II.² 78 *b*.	
1405.	I.² 11 *a*.	
1406.	I.² 70 *b*, *a*.	
1407.	I.² 72 *b*.	
1408.	I.² 87 *a*.	
1409.	I.¹ 28 *a*.	
1410.	W. P. 7 *a*.	
1411.	W. 5 *b*.	
1412.	W. A. II. 202 *b*.	
1413.	W. X.	
1414.	L. o′	
1415.	L. 1 *a*.	
1416.	L. 1 *b*.	
1417.	L. 2 *a*.	
1418.	L. 30 *b*.	
1419.	L. o″	
1420.	Br. M. 202 *b*.	
1421.	F. o′	
1422.	F. 27 *b*.	
1423.	W. An. III. 217 *a*.	
1424.	W. An. III. 232 *b*. (F)	
1425.	M. o′.	
1426.	M. 8 *a*.	
1427.	M. 53 *b*.	
1428.	Mz. o″.	
1429.	Tr. 22.	
1430.	K.² 27 *b*.	
1431.	K.³ 48 *b*.	
1432.	W. An. III. 152 *a*.	
1433.	W. An. IV. 153 *a*.	
1434.	W. An. IV. 167.	
1435.	W. L. 141 *b*.	
1436.	W. L. 141 *a*.	
1437.	W. L. 212 *a*.	
1438.	W. L. 203 *a*.	
1439.	C. A. 11 *b*; 37 *b*.	
1440.	C. A. 19 *b*; 72 *b*.	
1441.	C. A. 27 *a*; 89 *a*.	
1442.	C. A. 70 *a*; 207 *a*.	
1443.	C. A. 113 *a*; 349 *a*.	
1444.	C. A. 118 *b*; 366 *a*.	
1445.	C. A. 145 *a*; 432 *a*.	
1446.	C. A. 176 *b*; 532 *b*.	
1447.	C. A. 185 *b*; 557 *b*.	
1448.	C. A. 222 *a*; 664 *a*.	
1449.	C. A. 313 *b*; 950 *b*.	
1450.	C. A. 358 *b*; 1124 *b*.	
1451.	Br. M. 48 *a*.	
1452.	Br. M. 132 *b*.	
1453.	Br. M. 150 *b*.	
1454.	Br. M. 191 *a*.	
1455.	Br. M. 192 *a*.	
1456.	Mi. A.	
1457.	Br. M. P.	
1458.	C. 15 *b* [1].	
1459.	S. K. M. III. 1 *a*.	
1460.	H.³ 58 *b*.	
1461.	H.¹ 41 *a*.	
1462.	H.³ 57 *a*.	
1463.	Br. M. 271 *b*.	
1464.	G. o″.	
1465.	E. 1 *a*.	
1466.	C. A. 67 *a*; 202 *a*.	
1467.	C. A. 260 *a*; 793 *a*.	
1468.	C. A. F. 279 *a*; 855 *a*.	
1469.	C. A. 207 *a*; 609 *a*.	
1470.	S. K. M. III. 87 *b*.	
1471.	F. o″.	
1472.	Leic. 13 *a*.	
1473.	C. A. 376 *b*; 1168 *a*.	
1474.	L. 94 *b*.	
1475.	W. 191 *a*.	
1476.	Br. M. 279 *b*.	
1477.	J.² 82 *b*.	
1478.	M. 62 *a*.	
1479.	C. A. 284 *b*; 865 *b*.	
1480.	C. A. 121 *a*; 375 *a*.	
1481.	K.² 3 *b*.	
1482.	W. 151 *b*.	
1483.	F. o″.	
1484.	B. M. 71 *b*.	
1485.	C. A. 139 *b*; 419 *b*.	
1486.	Tr. 4.	
1487.	Tr. 57.	
1488.	S. K. M. III. 93 *a*.	
1489.	K.² 2 *a*.	
1490.	K.² 2 *b*.	
1491.	S. K. M. III. 16 *b*.	
1492.	Ash. II. 11 *b*.	
1493.	Tr. 2.	
1494.	W. XXIII.	
1495.	G. 8 *a*.	
1496.	S. K. M. III. 3 *b*.	
1497.	B. 8 *a*.	
1498.	Ash. II. 12 *b*.	
1499.	Leic. 16 *b*.	
1500.	Ash. II. 11 *b*.	
1501.	K.³ 29 *b*.	
1502.	L. 53 *b*.	
1503.	L. 53 *a*.	
1504.	G. 95 *a*.	
1505.	Ash. II. 10 *b*.	
1506.	B. 58 *a*.	
1507.	Br. M. 79 *b*.	
1508.	K.² 12 *b*.	
1509.	B. 4 *a*.	
1510.	Ash. I. 1 *a*.	
1511.	S. K. M. III. 47 *a*.	
1512.	S. K. M. III. 43 *a*.	
1513.	H.³ 77 *a*.	
1514.	H.³ 76 *b*.	
1515.	H.³ 81 *b*.	
1516.	H.² 94 *b*.	
1517.	H.² 16 *b*.	
1518.	H.² 33 *a*. .	
1519.	S. K. M. II.² 4 *a*.	
1520.	S. K. M. II.¹ o′.	
1521.	S. K. M. II.¹ 94 *b*.	
1522.	S. K. M. II.¹ 95 *a*.	
1523.	L. 94 *a*.	
1524.	I.² 1 *b*.	
1525.	Br. M. 229 *b*.	
1526.	C. A. 70 *b*; 208 *b*.	
1527.	Br. M. 271 *b*.	
1528.	F. o″.	
1529.	C. A. 189 *a*; 565 *a*.	
1530.	C. A. 76 *a*; 223 *a*.	
1531.	C. A. 253 *b*; 748 *a*.	
1532.	W. XXXII.	
1533.	C. A. 17 *b*; 67 *b*.	
1534.	C. A. 312 *b*; 949 *b*.	
1535.	B. M. 272 *b*.	
1536.	C. A. 116 *b*; 395 *a*.	
1537.	C. A. 212 *b*; 627 *b*.	
1538.	C. A. 258 *a*; 784.	
1539.	E. o″.	
1540.	Br. M. 227 *a*.	
1541.	Br. M. 42 *b*.	
1542.	Br. M. 212 *a*.	
1543.	H.³ 89 *b*.	
1544.	C. A. 132 *a*; 401 *a*.	
1545.	C. A. 26 *a*; 87 *a*.	
1546.	Ash. I. 18 *b*.	
1547.	W. XII.	
1548.	Br. M. 148 *a*.	
1549.	Br. M. 148 *b*.	
1550.	Br. M. 149 *b*.	
1551.	Br. M. 271 *a*.	
1552.	Br. M. 274 *a*.	
1553.	C. A. 4 *a*; 11 *a*.	
1554.	C. A. 34 *b*; 109 *a*.	
1555.	C. A. 75 *a*; 220 *a*.	
1556.	C. A. 77 *b*; 225 *b*.	
1557.	C. A. 94 *b*; 271 *b*.	
1558.	C. A. 121 *b*; 376 *b*.	
1559.	C. A. 130 *a*; 397 *a*.	
1560.	C. A. 164 *b*; 490 *b*.	
1561.	C. A. 171 *b*; 515 *b*.	
1562.	C. A. 175 *a*; 526 *a*.	
1563.	C. A. 227 *b*; 685 *a*.	
1564.	C. A. 334 *b*; 1017 *b*.	
1565.	C. A. 329 *b*; 993 *a*.	
1566.	Bibl. Melzi.	

APPENDIX

I.

THE HISTORY OF THE MANUSCRIPTS.

1. Leonardo by his will expressly devised all his MSS. and drawings to his younger friend Francesco Melzi, who carried them back to Milan. Four years after Leonardo's death Alberto Bendedeo wrote from Milan to Alfonso d'Este, Duke of Ferrara: *"Et perchè ho fatto mentione de la casa de Melzi, aviso a V. Ex. che un fratello di questo che ha giostrato fù creato de Lionardo da Vinci, et herede et ha molti dè suoi secreti, et tutte le sue opinioni ... Credo ch'egli habbia quelli libriccini de Lionardo de la Notomia, et de molte altre belle cose."* See G. Campori, *Nuovi Documenti.*

When Vasari visited Milan—probably in 1566—he saw Leonardo's MSS. in Francesco Melzi's possession, and wrote as follows: *Lionardo ... di brutti caratteri scrisse lettere, che sono fatte con la mano mancina a rovescio; e chi non ha pratica a leggere, non l'intende, perchè non si leggono se non con lo specchio. Di queste carte della notomia degli uomini n'è gran parte nelle mani di messer Francesco da Melzo gentiluomo milanese, che nel tempo di Lionardo era bellissimo fanciullo e molto amato da lui, così come oggi è bello e gentile vecchio, che le ha care e tiene come per reliquie tal carte, insieme con il ritratto della felice memoria di Lionardo: e chi legge quegli scritti, par impossibile che quel divino spirito abbi così ben ragionato dell'arte e dè muscoli e nervi e vene, e con tanta diligenza d'ogni cosa. Come anche sono nelle mani di, pittor milanese, alcuni scritti di Lionardo, pur di caratteri scritti con la mancina a rovescio, che trattano della pittura e dè modi del disegno e* *colorire. Costui non è molto che venne a Fiorenza a vedermi, desiderando stampar questa opera, e la condusse a Roma per dargli esito; nè so poi che di ciò sia seguito.* (Ed. Sansoni, IV. 37).

In another place Vasari mentions that he himself possessed some drawings by Leonardo.

Lomazzo, the Milanese painter, writes, in 1590 (*Idea del Tempio della pittura,* 2nd Ed., p. 15):

Ma sopra a tutti questi scrittori è degno di memoria Lionardo Vinci, il qual insegnò l'Anatomia dei corpi umani, e dei cavalli, ch'io ho veduta appresso a Francesco Melzi, designata divinamente di sua mano. Dimostrò anco in figura tutte le proporzioni dei membri del corpo umano; scrisse della prospettiva dei lumi, del modo di tirare le figure maggior del naturale, e molti altri libri ... Ma di tante cose niuna se ne ritrova in stampa; ma solamente di mano di lui, che in buona parte sono pervenute nelle mani di Pompeo Leoni, statovaro del Cattolico Rè di Spagna, che gli ebbe dal figliuolo di Francesco Melzi, e n'è venuto di questi libri ancora nelle mani del Sig. Guido Mazenta, Dottore virtuosissimo, il quale gli tiene molto cari.

2. In the short anonymous biography of Leonardo which, as it seems to me, must have been written somewhat earlier than Vasari's *Vite* (published by Milanesi, *Arch. Stor. Ital.* XVI) the MSS. are mentioned in these terms: (*Leonardo*) *tornossene a Milano et dipoi in Francia al servizio del rè Francesco, dove portò assai dè sua disegni, de quali ancora ne lasciò in Firenze nello Spedale di S. Maria Nuova con altre mas-*

serizie et la maggior parte del cartone della sala del Consiglio, del quale è il disegno del gruppo de' cavalli che oggi in opera si vede rimaso in Palazo . . . et lascio per testamento a messer Francesco da Melzio, gentile homo milanese, tutti i danari contanti, panni, libri, scritture, disegni et instrumenti et ritratti circa la pittura et arte et industria sua che quivi si trovava, et fecelo executore del suo testamento.

These references to them, which are the oldest known, may be supplemented by some information which I owe to the kindness of Signor Enrico Stevenson, Scrittore in the Library of the Vatican. MS. 71 Boncompagni (previously Albani 511), XVIth century, contains the catalogue of MSS. belonging to 'Sangallo'. In this catalogue a MS. volume, Tome XXXIX, is thus described: *Openione di Lionardo da Vinci nel dipignere prospettive, ombre, lontananze, altezze, bassezze d'apresso o da lontano, et altro.*

It seems therefore doubtful whether after the death of Francesco Melzi, about 1570, the Melzi family still possessed Leonardo's literary bequest intact, or at any rate, were the sole possessors of it. We have fuller information at the beginning of the XVIIth century, for Leonardo's MSS. had by that time become famous and were sought after as relics and curiosities. Guido Mazenta, who is mentioned by Lomazzo as possessing MSS. by Leonardo, was the brother of the author of an interesting memoir entitled: *Alcune memorie de' fatti da Leonardo da Vinci a Milano e de' suoi libri del P. D. Gio. Amb° Mazzenta, Milanese, Cherico Reg^re minore di S. Paolo altrim^ti detti Barnabiti.*[1] An exact translation of this into French has been given by M. Eugène Piot in the Cabinet de l'Amateur (1863, p. 61—63). I quote from it the following passage relating to the history of the MSS.

A la mort de Melzi ... les manuscrits restèrent dans sa villa de Vaprio, où ses héritiers, qui avaient des goûts et des occupations bien différents,

négligèrent à ce point ces trésors qu'il fut facile à Lelio Gavardi, qui enseignait les humanités dans cette famille, d'en prendre tout ce qu'il voulut et de porter treize de ces volumes à Florence, dans le dessin de les offrir au grand-duc. Mais ce prince tomba malade et mourut à son arrivée, et il vint à Pise chez Manuce. Je lui fis honte de son bien mal acquis, et il en convint. Mes études étaient finies, je devais partir: il me pria de reporter les volumes à Milan, ce dont je m'acquittai de bonne foi en consignant le tout au chef de la famille, le D^r Oratio Melzi, qui fut très-étonné de l'embarras que j'avais voulu prendre, et qui m'en fit don en me disant qu'il avait du même peintre beaucoup d'autres dessins qui demeuraient abandonnés dans des caisses sous les toits de sa villa. Ces livres restèrent donc entre mes mains, et, plus tard, entre celles de mes frères. Ceux-ci en firent un étalage un peu trop grand, racontèrent à ceux qui les voyaient avec quelle facilité je les avais obtenus, de sorte que beaucoup de personnes retournèrent chez le docteur Oratio et en tirèrent des dessins, des modèles anatomiques, et beaucoup de précieuses reliques de l'atelier de Léonard. Pompeo Leoni fut un de ses chasseurs; son père avait été élève de Michel Ange Buonarotti, et lui-même était au service du roi d'Espagne, pour qui il a fait tous les bronzes de l'Escurial. Pompeo promit au D^r Melzi offices, magistratures, siège dans le sénat de Milan, s'il pouvait reprendre les treize volumes et les lui donner pour les envoyer au roi Philippe, grand amateur de ces sortes de curiosités. Excité par de telles espérances, Melzi vole chez mon frère, le prie à genoux de lui rendre les manuscrits qu'ils m'avait donnés; c'était son collègue au collège de Milan, bien digne de sa compassion et de son amitié; sept volumes lui furent rendus. Des six qui restaient à la maison, un fut offert au cardinal Frédéric Borromée; il est aujourd'hui conservé dans la bibliothèque Ambrosienne; c'est un in-folio, couvert de velours rouge, qui traite très philosophiquement de la lumière et des ombres, au point de vue de la peinture, de la perspective et de l'optique. Un autre fut donné à Ambroise Figini, noble peintre de cette époque, qui le laissa à Hercule Bianchi avec le reste de son cabinet. Pressé par le duc Charles-Emanuel de Savoie qui désirait en posséder, j'en obtins de l'amitié de mon frère un troisième que j'envoyai à cette Altesse. Après la mort de mon frère, les trois autres sont parvenus entre les mains de Pompeo Aretino, qui, avec ceux qu'il avait receuillis, en sépara les feuillets pour en former un gros volume qui passa à son héritier Polidore Calchi, et fut vendu ensuite à Galéaz Arconati pour trois cents ducats. Cet homme généreux le conserve dans sa galerie remplie de mille choses précieuses; il a dû plusieurs fois rési-

[1] The Italian MS. by Mazenta was until 1882 in the possession of the firm of booksellers A. Firmin-Didot, of Paris; but I was constantly forbidden to examine its contents. It has lately passed into the possession of an antiquary in Paris. The following interesting passage is again taken from M. Piot's translation, which adequately takes the place of the original: *Ses observations s'étendent mêmes jusqu'aux choses historiques; il y met sous nos yeux les antiques cataractes dont les Ptolomées se servaient en Egypte pour répandre et distribuer les eaux bienfaisantes du Nil; les belles inventions relatives à la navigation de la mer de Nicomédie, au moyen des lacs et des fleuves, dont il est question dans les lettres de Trajan et de Pline; mais je crois que ce curieux génie prenait plaisir à déguiser sous ces noms ceux de Milan et de Nuovocomo (!?).*

ster aux prières du duc de Savoie et d'autres princes qui le lui demandaient: il en a refusé plus de six cents ducats.

3. The MSS. in the possession of the brothers Mazenta, had, it would seem, been gradually reduced to three. Guido Mazenta whose name is to be seen in the MS. given by him to Cardinal Borromeo (see Bibl. No. 2), died in 1613.

In 1636, Count Galeazzo Arconati — who is named in Mazenta's report — presented twelve MS. volumes by Leonardo to the Ambrosian Library at Milan. The explicit deed of gift may be seen, translated into French in the *Cabinet de l'Amateur*, 1861, pp. 53—59. In the catalogue of these MSS. the binding is more particularly described than the contents. The following twelve MSS. were included in this gift. 1. the Codex Atlanticus (Bibl. 38), 2. a MS. now lost, but described as follows:

Le deuxième est un livre in-folio ordinaire, de la grandeur du papier coupé ordinaire. Il est relié en bois couvert de cuir rouge, orné de frises et de fleurs d'or. Le volume est entièrement composé de feuillets de vélin et commence par ces paroles, écrites en rouge: TAVOLA DELLA PRESENTE. *Suivent huit feuillets sans pagination. Elle commence au suivant, qui a un ornement en tête qui dit:* Eccellentis s. prencipe, *etc., et la pagination suit jusqu'au cent vingtième feuillet, quatre-vingt-sept pour le text, trois blancs et le reste des dessins divers coloriés, le premier desquels est intitulé:* Sfera solida, *et le dernier:* Piramis laterata exagona vacua; *au fond du feuillet est un texte grec qui exprime la même chose.*

3. *Le troisième est un livre in-quarto, relié en vélin, sur le dos duquel on lit les paroles suivantes:* DI LEONARDO DA VINCI; *il est de cent feuillets juste, mais le premier manque; sur le second il y a quelques cerises noires, feuilles et fruits coloriés. Dans l'intérieur du volume, au feuillet 49, on a inséré cinq feuillets de dessins variés, armes de hast pour la plupart, et à la fin un autre petit volume (volumetto) de diverses figures de mathématiques et d'oiseaux, de dix-huit feuillets, qui a été cousu dans la même reliure en vélin.*

Bibl. 3, 4. Ash. II and B. The appendix (*volumetto*) is now lost; the last mention of it occurs in Venturi's Essai (1796). Compare No. 1465, Note 4.

4. MS. of 114 leaves (see Bibl. 5, 6, Ash. I and A).

5. *Le cinquième est un autre livre semblable, in-quarto, couvert, comme le précédent, de cinquante-quatre feuillets. Sur le premier sont dessinées diverses têtes bouffonnes, et sur le dernier quatre colonnes de texte, écrites à rebours. Il est marqué sur le dos* LEONARDO DA VINCI.

This description corresponds with the MS., Bibl. 28 Tr. 6.

6. MS. see Bibl. 25, E.

7. MS. see Bibl. 22, F.

8. MS. see Bibl. 26, G.

9. Three MSS. bound in one vol.; see Bibl. 8—10, H[1], H[2], H[3].

10. Two small MSS. bound in one, see Bibl. 13, 14.

11. MS. see Bibl. 18, L.

12. MS. see Bibl. 27, M.

In 1674 Count Orazio Archinti presented to the same Library a MS. by Leonardo, consisting of three small note-books in one Vol.; Bibl. 32—34.

In 1790, Stefano Bonsignori made a short catalogue of the MSS. in the Ambrosian Library at Milan. It includes 1. MS. C. A, see Bibl. 28; 2. MS. B and Ash. II, see Bibl. 3, 4; 3. MS. Ash. I and A, Bibl. 5, 6; 4. MS. D, Bibl. 31; 5. MS. E, Bibl. 25; 7. MS. G, Bibl. 26; 8. MSS. H[1], H[2], H[3], Bibl. 8—10.

The descriptions of the others are too vague and slight to admit of our indentifying by them any MSS. now existing: 6. *Miscellanea; idrostatica, etc. È in-8 piccolo, in cartone rustico.* 9. *Miscellanea. Moto, macchine, macchinette da forar cristalli, etc. È in-16, legato in pergamena.* 10. *Miscellanea in-16, in cartone rustico,* 11. *Miscellanea. Abbozzi informi, moto ecc. È in-16, pergamena* (see Dozio, degli scritti . . . di Leonardo da Vinci. Milano 1871, pp. 21—24). It will be observed that one MS. fewer is here named than in the deed of gift from Count Arconati; on the other hand a MS. *D*, not previously mentioned, is now included. The fifth MS. of Arconati's list is evidently wanting in this list. The volume given to the Ambrosian Library by Cardinal Borromeo in 1603 (Bibl. 2, C) seem also to have been omitted. It is evident then that we cannot exactly determine how many of these MSS. were to be found in the Ambrosian Library in the year 1796. At the suggestion of Bonaparte the Directory of the French Republic conveyed many works of art from Italy into France. So much as this is, at any rate certain: in August 1796 the Codex Atlanticus was in the Bibliothèque Nationale: and "*Douze petits MSS. de Leonardo de Vinci, sur les sciences*" were in the Institut National (Institut de France). The authors of the catalogue of the pictures and MSS. removed from the Ambrosian Library — Peignon, *commissaire de guerre* and le Citoyen Tinet, *agent des Arts'* (dated Milan, May 24, 1796) either do not mention Leonardo's MSS. at all, or — which is more probable — include them under the following somewhat vague designation "*Le Carton des ouvrages de Leonardo d'avinci*". It is certain, on the other hand, that in 1815 the commissary of the

Austrian governement demanded the restoration to the Ambrosian Library of thirteen (or fourteen?) MSS., being the number stated in Venturi's Essay written in 1796. (Venturi says in his essay: *Les Manuscrits sont au nombre de quatorze, parceque le Volume B contient un appendice de dix-huit feuillets qu'on peut séparer et considérer comme le quatorzième volume*).

However, only the Codex Atlanticus found its way back again; the other twelve MSS. remain in the possession of the Institut de France. These facts cover all that is known of the history and fate of the volumes now on the continent, that is to say in France and Italy.

I am unfortunately not in a position to give so full an account of the vicissitudes of such of Leonardo's MSS. as are now in England. Of the MS. volume at Windsor, W. L. (Bibl. 36) Chamberlain tells us (Original Designs, London, 1812): *It was one of the three volumes, which became the property of Pompeo Leoni that is now in his Majesty's possession. It is rather probable than certain that this great curiosity was acquired for King Charles I. by the Earl of Arundel, when he went an Ambassador to the Emperor Ferdinand II. in 1636, as may indeed be inferred from an instructive inscription over the place, where the volumes are kept, which sets forth that James King of England offered three thousand pistoles for one of the volumes of Leonardo's works. And some documents in the Ambrosian Library give colour to this conjecture. This volume was happily preserved, during the civil wars of the last century, among other specimens of the fine arts, which the munificence of Charles I. had amassed with a diligence equal to his taste. And it was discovered soon after his present Majesty's accession, in the same cabinet, where Queen Caroline found the fine portraits of the court of Henry VIII. by Hans Holbein, which the King's liberality permitted me lately to lay before publick.*

Chamberlain, apparently misled by the well-known inscription[1] in the Ambrosian Library seems to assume that Lord Arundel must

[1] The following inscription is on the staircase of the Ambrosian Library
‖ LEONARDI VINCII ‖ MANU . ET . INGENIO . CELEBERRIMI ‖ LUCUBRATIONUM . VOLUMINA . XII ‖ HABES . O . CIVIS ‖ GALEAZ—ARCONATUS ‖ INTER . OPTIMATES . TUOS ‖ BONARUM . ARTIUM . CULTOR . OPTIMUS ‖ REPUDIATIS . REGIO . ANIMO . ‖ QUOS . ANGLIAE . REX . PRO . UNO . OFFEREBAT ‖ AUREIS . TER . MILLE . HISPANICIS ‖ NE . TIBI . TANTI . VIRI . DEESSET . ORNAMENTUM ‖ BIBLIOTHECAE . AMBROSIANAE . CONSECRAVIT ‖ NE . TANTI . LARGITORIS . DEESSET . MEMORIA ‖ QUEM . SANGUIS . QUEM . MORES ‖ MAGNO . FEDERIGO[1] . FUNDATORI ‖ ADSTRINGUNT ‖ BIBLIOTHECAE . CONSERVATORES ‖ POSUERE . ANNO . MDCXXXVII. ‖

have derived the Leonardo MSS. in his possession from Arconati, and not from Spain; but Mr. Alfred Marks of Long Ditton, has lately disproved this clearly in two contributions to the Athenaeum, Nos. 2626 and 2645. John Evelyn in his Memoirs (Vol. I, p. 213 ed. 1818) tells us that when travelling in Italy in 1646 he received from Lord Arundel, then sick at Padua, where he died in the course of this year, advice as to what he should try to see. Afterwards, visiting the Ambrosian Library, Evelyn writes:—

"In this room stands the glorious (boasting) *inscription of Cavaliero Galeazzo Arconati, valueing his gift to the librarie of severall drawings by Da Vinci, but these we could not see, the keeper of them being out of towne and he always carrying the keys with him, but my Lord Martial, who had seene them, told me all but one booke are small, that an huge folio c⌣ntain'd 400 leaves full of scratches of Indians* [sketches of engines?] *&c., but whereas the inscription pretends that our King Charles had offer'd 1,000 l. for them, my Lord himselfe told me that it was he who treated with Galeazzo for himselfe in the name and by permission of the King, and that the Duke of Feria, who was then Governor, should make the bargain: but my Lord having seen them since did not think them of so much worth."*

The leaves of the Codex Atlanticus are numbered up to 393; hence it is probable that in giving this description Lord Arundel had this single MS. in his mind. The MS. W. L. at Windsor which, with the MS. C. A. formerly belonged to Pompeo Leoni now consists of only 234 folio leaves. Arconati (see above) mentions, it is true, one collection only of MSS. *i. e.* MS. C. A. as being in the hands of Pompeo Leoni; but it can hardly be doubted that the MSS. and drawings W. L. were also in his possession, since Leoni's name is given in the inscription on the old binding of the two volumes in the same way.

"Pompeo Leoni of Arezzo, Court sculptor to King Philip II. of Spain, died in Madrid A. D. 1610, as we learn from Carducho *'Dialogos de la Pintura'* (1633). Part of his property was publicly sold at Madrid; some works which had belonged to it being afterwards purchased by Charles the First when, as Prince of Wales, he visited Spain in 1623.

From the Spanish portion of Pompeo's collection thus sold came, in all probability, the two volumes of Leonardo's of which Carducho speaks as being then in the possession of Don Juan de Espina: *"Alli vi dos libros dibujados y manoscritos de mano del gran Leonardo de Vinchi, de particular curiosidad y doctrina"* ("two

books," may we say? "one of sketches, one manuscript"), which the Prince of Wales had in vain sought to purchase. The contents of these volumes Carducho unfortunately describes only in very general terms. In Mr. Sainsbury's 'Original Unpublished Papers illustrative of the Life of Rubens,' we find evidence that Lord Arundel was subsequently in treaty for these very books, or, perhaps, for one of them only. On p. 294 will be found a note of Endymion Porter's "of such things as my Lord Embassador S⟨r⟩ Francis Cottington is to send owt of Spaine for my Lord of Arondell; and not to forget the booke of drawings of Leonardo de Vinze w⟨ch⟩ is in Don Juan de Espinas hands." This is of the date 1629, when Sir Francis was for the third time setting out for Spain as ambassador. His negotiations for the book were unsuccessful, for on January 19⟨th⟩, 1636—37, we find (p. 299) Lord Arundel writing from Hampton Court to Lord Aston, then Ambassador to Spain,—"I beseech y⟨u⟩ be mindfull of D. Jhon. de Spinas booke, if his foolish humor change." There can, I think, be little doubt that, on the change of Don Juan's "foolish humor," a priceless treasure, the object of so many fruitless attempts, at last rewarded the persistence of the great English collector" (A. Marks).

Here, beyond a doubt, only the MS. W. L. is meant, for this, as being a collection of Leonardo's most important drawings, must be regarded as exceptionally precious. But did Lord Arundel ultimately get this Manuscript. We cannot say more than that this seems probable; and for this reason: Hollar engraved drawings of Leonardo's which are now in Windsor and inscribed them "W. Hollar fecit 1646 ex collectione Arundeliana",—drawings which *most probably* were included in this W. L. collection before it was divided.

On the other hand it can be positively shown that Lord Arundel possessed the MS. Br. M., Bibl. 23, which was no doubt purchased by him for a relatively small sum in consideration of the smaller artistic interest of the drawings, and for the same reason it is quite intelligible that no mention should be made of it in the correspondence at the time. But whether the MS. W. L. was purchased by Charles II. when Lord Arundel's collections were sold in Holland, or whether Charles I. had previously acquired it after his journey to Spain as Prince of Wales in 1623—when he, in person, purchased some works of art from among Leoni's collection, is not known. So much as this alone is certain, that it has now for a very long period belonged to the Royal collections.

Though Chamberlain's statement as to the acquisition of Leonardo's MSS. and drawings in the Windsor Library is, as we have seen, probably inaccurate, we may still give credit to his information as to the finding of them by Queen Caroline in Kensington Palace, for he—as Royal Librarian at the time—must certainly have been acquainted with the facts. His statement is moreover confirmed by Walpole (Anecdotes of painting I, 84: *Soon after the accession of the late King, Queen Caroline found in a bureau at Kensington, a noble collection of Holbein's original drawings for the portraits of some of the chief personages of the court of Henry VIII*).

This, however, is by no means the earliest information we possess regarding Leonardo's MSS. and drawings in the possession of Royalty. In the MS. Department of the British Museum I found an old inventory from which I give the following extracts: *List of the draw⟨gs⟩ ‖ in ye Cabinet in ‖ His Maj⟨tys⟩ Lower ‖ Apartment ‖ in this is marked what ‖ has been Deliver'd for ‖ her Maj⟨tys⟩ use ‖ Page 28. A list of the Books of drawings and Prints in the buroe in His Majesty's great Closet at Kensington.*

No. 3. *By Hans Holbein those fram'd & hang at Richmond.*

No. 5. *Prints by Hollar; delivered to her Maj⟨ty⟩ Aug. 1735 and by her lent to Lady Burlington, since put in Volumes and laid in y⟨e⟩ Library at Kensington.*

No. 6. *Drawings by Leonardo de Vinci.*

No. 13. *Drawings by Leonardo di Vinci;— these mark⟨d⟩ with a cross were delivered for her Maj⟨tys⟩ use in y⟨e⟩ year 1728.*

The oldest inventory in Windsor Castle— is only of the beginning of the present century. On p. 23 we find: *"Leonardo da Vinci, Tom. I"* and a list follows of the drawings, comprised on 41 pages. For instance: *page 1 His own portrait, profile, red chalk* (a well known drawing in the present collection). Only a few can be identified, for the descriptions are very brief. On p. 26 we come to *"Leonardo da Vinci, Tom. II"* which is also a list of drawings comprised on 40 pages. It begins: *page 1, the last Supper, the Architecture is varied in the painting at Millan where an open door is represented behind our Saviour, black chalk. NB. This Drawing was not in the Vol. compiled by Pompeo Leoni, but in one of the Volumes in the Buonfiliuolo Collection bought at Venice.* (By the way I mention that the drawing in question, still at Windsor, is not an original drawing, but an old copy). This gives us an incidental clue to a second source whence the treasures of the Windsor collection have been derived. Nothing more, however, is known concerning the Buonfiliuolo collection.

On p. 29 of the Inventory we come to a catalogue of the contents of a third Vol. of 205 sheets, in which 549 drawings are named and shortly described, for instance:

No. 22 } *2 Heads, of Judas and one of the Apostles for the last supper at Milan.*

41 } *1 Mechanical Powers*
 } *1 Anatomy.*

NB. All the Leaves from 41 to 142, except those few marked otherwise, are full of very copious and accurate studys in Anatomy which were done with the assistance of Marc Antonio della Torre &c.

143 } *1* } *Manuscript—Here ends the Ana-*
 } *1* } *tomical study.*

As the reader will have observed, the number of leaves in the MS. W. L. does not correspond to that in either of these three Volumes. There can be no doubt that, at that time most of the drawings had been taken out of it. Recently most of the finest drawings in the Royal collection have been mounted on card-board and arranged in four portfolios, while some of the MS. leaves remain in the folio W. L. (Bibl. 36), and others are mounted on old thin card board, more particularly the texts W. P., Bibl. 15, and W. An. I, Bibl. 1; others again are not mounted nor even—at the present date—arranged. Their large number rendered it necessary that they should be classified according to their contents and the probable date of their being written, with a view to this present publication. I therefore sorted them under the following heads: W. H., Bibl. 16; W. An. II., Bibl. 17; W. M., Bibl. 19; W. An. III., Bibl. 24; W. An. IV., Bibl. 35; W., Bibl. 37. The loose leaves in the Windsor collection are numbered consecutively (from 1 – 249) without any reference to their connection, while the Roman numbers refer to those sheets which are mounted. By this means reference to the originals is facilitated.

It will be noticed that Anatomical writings preponderate greatly, and they are the portion which Vasari most admired, when he had the opportunity of seeing Leonardo's MSS. in Melzi's house.

II.

BIBLIOGRAPHY.

The Manuscripts are arranged here in the same chronological order as shown in Vol. I. pp. 5—7. The numbers of the sheets are generally not by the author, but in a more modern handwriting. The few instances when these numbers are by Leonardo will be found mentioned in the lists. The bindings are in parchment, if not otherwise stated. The following abbreviations have been introduced in the description of the contents (the Italian words are headings used by Leonardo):

A = Acqua (Water).
Ar = Architecture.
F = Forza (Force).
Fo = Fortezza (Fortress).
Ge = Geometry.
M = Moto, colpo (on movement &c.).
Ma = Mathematics.

Mn = Machines.
O = Optics.
P = Peso (Weight).
Ph = Physics.
V = Volatili (Flight of Birds).
+ = blank pages.

1. W. An. I.

1a **1370**, *notes on the skull* | 1b **805** | 2a, *notes on the skull* | 2b + 3a *on the skull and on the teeth* | 3b, 4a *on the skull* | 4b +

2. C.

Inscribed in golden letters on the front cover: · VIDI · MAZENTÆ ‖ PATRITII · MEDIOLANENSIS ‖ LIBERALITATE ‖ AN · M · D · C · III. *Inside the cover:* C and [O].— *On the first sheet (by an unknown hand):* Autographum Leonardi Vincii ‖ cujus in ejusdem rebus gestis meminit ‖ Raphael Trichet Fresneus ‖ agit autem de lumine et umbra.—*First sheet verso:* O.—*Second sheet marked* [₁G,] *and* O. *The following sheets are numbered* 1—30, *by an unknown hand. These numbers disagree with Leonardo's own numbers, here given in brackets (). He seems to have counted the sheets backwards. They are on the back of the sheets, but some are*

wanting: 1ᵃ **254** | 1ᵇ (15) **253** | 2ᵃ **221** | 2ᵇ (14) **220** | 3ᵃ **219** 3ᵇ (13) **218** | 4ᵃ **217** | 4ᵇ (12) **216** and **Pl. VI, 3** | 5ᵃ **252, 215,** and **Pl. VI, 2** | 5ᵇ (11) moto, voce, forza e moto | 6ᵃ del moto dell'aria e dell'acqua | O | 6ᵇ (10) forza e peso, colpo | 7ᵃ colpo, peso e forza; **213,** A | 7ᵇ (9) M, **30,** P 12 *lines,* **160,** F | 8ᵃ **131,** O | 8ᵇ **259, 180, 260** | 9ᵃ O | 9ᵇ O | 10ᵃ **262, 141** and **Pl. II, 2. 3.** | 10ᵃ—11ᵇ O | 12ᵃ **258, 229** | 12ᵇ **289** | 13ᵃ **290** | 13ᵇ **261** | 14ᵃ **256** | 14ᵇ (16) **255, 123** | 15ᵃ M, A | 15ᵇ (1)

720, 1458, 727 | 16ᵃ de ochio, M | 16ᵇ (19) O | 17ᵃ O | 17ᵇ (18) O | 18ᵃ · **303** | 18ᵇ *and* 19ᵃ O | 19ᵇ **1334, 1380** | 20ᵃ *and* 20ᵇ O | 21ᵃ **174** | 21ᵇ (17) **257** | 22ᵃ A, M, O | 22ᵇ (8) P | 23ᵃ **251** | 23ᵇ (7) A | 24ᵃ **250** | 24ᵇ (6) A | 25ᵃ A, O | 25ᵇ (5) M, A | 26ᵃ A | 26ᵇ (4) **931,** acqua e terra | 27ᵃ O | 27ᵇ (3) **53,** O | 28ᵃ M | 28ᵇ (2) P | 29ᵃ *inscribed by an unknown hand:* le carte sono di nʳᵒ 28 cioè Ventiotto. 29ᵇ [G] 30ᵃ O | 30ᵇ +

3. B.

Binding in pig-skin; marked B inside the front-cover. On the first sheet is a short, indistinct note in Spanish, probably by P. Leoni, stating that Leonardo wrote backwards. The following sheets are numbered by very large numbers from 3—90 (see the facsimile Pl. LXXIX, 2): 3ᵃ. *Drawings in water colours, representing some fruits* | 3ᵇ **329, 346, 638, 675, 1188,** F | 4ᵃ **1509, 1131,** Ph | 4ᵇ A, **1212** Ma | 5ᵃ Fo | 5ᵇ *and* 6ᵃ Mn | 6ᵇ Mn | natura de' spechi | 7ᵃ *and* 7ᵇ Mn Fo | 8ᵃ **1497** | 8ᵇ 10ᵃ Arms | 10ᵇ da passare un fiume, Ge | 11ᵃ Mn | 11ᵇ **Pl. XCIV, No. 2 and No. 3,** Mn | 12ᵃ **Pl. LXXXVIII, No. 6 and No. 7, 751** | 12ᵇ Ge, Ar | 13ᵃ Mn, *sketch of flowers* | 13ᵇ *and* 14ᵃ Ge *and sketches of flowers* | 14ᵇ camino, Ma | 15ᵃ **Pl. XCIII, No. 1,** Fo | 15ᵇ **Pl. LXXVII, No. 1 and 2, 742, 743** | 16ᵃ **Pl. LXXVII, No. 3, 741** | 16ᵇ Fo, Me | 17ᵃ Ge | 17ᵇ **Pl. LXXXIX** | 18ᵃ **Vol. II, p. 47, Fig. 1, and Fig. 2** Mn | 18ᵇ **Pl. LXXXVII, No. 2, 755,** Fo | 19ᵃ Fo | 19ᵇ **752,** Ar | 20ᵃ A Mn | 20ᵇ A **511** | 21ᵃ **Pl. LXXXVII, No. 3 and No. 4,** Fo | 21ᵇ **Pl. XXXVIII, Nos. 1—5** | 22ᵃ **Pl. XCIII, No. 2,** Mn | 23ᵃ *construction of bridges* | 23ᵇ **Pl. LXXX, No. 2** | 24ᵃ **Pl. XCVI, No. 2, 757** | 24ᵇ Mn Fo | 25ᵃ A | 25ᵇ **Pl. XC** | 26ᵃ A Mn | 26ᵇ Mn | 27ᵃ **Pl. C, No 5, 788** | 27ᵇ *arms, drawing of a small figure* | 28ᵃ Ge, spechi | 28ᵇ **762, Pl. CII, No. 3** | 29ᵃ Ge, strade che vano attraverso a vno argine d'ū fiume | 29ᵇ Mn | 30ᵃ Ar, Fo | 30ᵇ 32ᵃ *arms* 32ᵇ *on passing a river* **Pl. CIII, No. 2.** | 33ᵇ *and* 44ᵃ Mn | 34ᵇ **Vol. II, page 44, Fig. 3** | 35ᵃ Mn | 35ᵇ **Vol. II, page 45, Fig. 1,** Ar | 36ᵃ **Pl. LXXIV, No. 2, 746,** Mn | 36ᵇ Fo | 37ᵃ **Pl. LXXVIII, Nos 2 and 3** 37ᵇ **Pl. LXXIX, No. 1, 745** | 38ᵃ **745** *Note* | 37ᵇ *canals* | 39ᵃ **Pl. LXXVIII, No. 1, 761** | 39ᵇ **Pl. XCII, No. 1, 753** | 34ᵃ nomi d'arme da offendere, Ge | 40ᵇ a bresscia alla minera del fero sono mādaci d'ū pezo cioè sanza corame ecc.; *arms* | 41ᵃ—46ᵇ *arms* | 47ᵃ Ar | 47ᵇ Mn | 48ᵃ *and* 48ᵇ Fo | 49ᵃ *and* 49ᵇ Mn | 50ᵃ Fo | 50ᵇ **1381,** Mn | 51ᵃ *and* 51ᵇ Mn | 52ᵃ **Pl. XCVII** | 52ᵇ Fo, Mn | 53ᵃ camino | 53ᵇ A Mn | 54ᵃ d'alzare acque, bombarda | 54ᵇ A Mn | 55ᵃ **Vol. II, p. 44 Fig. 2 and p. 56 Fig. 1** | 55ᵇ modo di misurare alteze | 56ᵃ *same subject,* modo chome si debbe riparare a vna furia di soldati | 56ᵃ **Pl. XCII, No. 2 and No. 3, and Vol. II, p. 45 Fig. 2** | 57ᵃ **Pl. XCV, No. 2** | 57ᵇ **Vol. II, p. 51,** Diagram, rivellino | 58ᵃ **1506, 1023,** Ar, lupanario | 58ᵃ Fo | 59ᵃ Mn | 59ᵇ Fo | 60ᵃ **Pl. LXXXII, No. 3, 750** | 60ᵇ *on passing a river* | 61ᵃ **1080,** A | 61ᵇ **1094, 1099** | 62ᵃ **Pl. LXXXV, No. 13,** *on passing a river* | 62ᵇ **1100** | 63ᵃ F. P. | 63ᵇ **1081** | 64ᵃ A Mn | 64ᵇ Stivali da aqua, Mn | 65ᵃ—67ᵃ Mn | 67ᵇ *and* 68ᵃ A | 68ᵇ schale docpie 1ᵃ per lo chastellano l'altra per i provisionati | 69ᵃ—70ᵃ Fo | 70ᵇ Mn, **Pl. CIII, No. 1** | 71ᵃ **Pl. CII, No. 2** | 71ᵇ—73ᵇ | 74ᵃ 75ᵃ *flying machine* | 75ᵃ **Vol. II, p. 56 Fig. 1** | 75ᵇ—77ᵇ Mn | 78ᵃ Fo | 78ᵇ—81ᵃ | 81ᵇ **1117** | 82ᵃ Mn | 82ᵇ **1088** | 83ᵃ Mn | 84—87 *wanting* 88ᵃ Mn | 88ᵇ *flying machine* | 89ᵃ Mn | 89ᵇ V | 90ᵃ Mn | 90ᵇ modo di sfondare vn navilio, voce. — *Inside the back cover is the mark S.*

4. Ash. II.

16 sheets, small numbers; sheets 1 and 16, and 2 and 15 forming originally one sheet, are tinted in blue on the inside and have drawings of arms, drawn with the silverpoint; the outside is left blank. On sheets 3ᵃ and 14ᵃ are three drawings in water colour, apparently not by Leonardo, They represent instruments. 4ᵃ **1127** 4ᵇ **1115,** Fo | 5ᵃ Fo | 5ᵇ **1120,** Mn | 6ᵃ **1116** 6ᵇ **Pl. LXXXV, No. 1—11, Vol. II, p. 45** Fig. 3, p. 74 first lines | 7ᵃ **756, Pl. XCI, No. 1** | 7ᵇ Fo | P, Mn | 8ᵃ **Vol. II, p. 56 Fig. 2, p. 57 Fig. 3 and 4** | 8ᵇ **Pl XCI, No. 2, 754** | 9ᵃ Mn | 9ᵇ *arms* | 10ᵃ *arms and ships* | 10ᵇ **1505,** *arms and a nude youth, resting his left hand on a sword* | 11ᵃ *ships* | 11ᵇ **1492,** *arms* **1500** | 12ᵃ *cars,* **1089** | 12ᵇ **1498** | 13ᵃ **1204** | *four columns of names* | 13ᵇ **1382** | *Sketches of insects, a caricature &c.*

5. Ash. I.

1 ᵃ **1510**, 686, *Drawing of knots*, 1183 | 1 ᵇ *knots*, 1176, Ge | 2 ᵃ 267, 580, 589, 516 | 2 ᵇ 551, 484, 515, 284 | 3 ᵃ 283, 132, 547, 203 | 3 ᵇ 574 and Pl. XXXI, No. 4, the head on the right, 245, 133 | 4 ᵃ 568, 563, 528, 540, 561, 439 | 4 ᵇ 536, 504, 601 | 5 ᵃ 602 | 5 ᵇ 595, 182, 196 | 6 ᵃ 584, 592, 164 | 6 ᵇ 573 and Pl. XXXI, No. 4 the head on the left, 368, 112, 585, 522 | 7 ᵃ 367, 364, 555 | 7 ᵇ 530, 491 | 8 ᵃ 571, 492, 494 | 8 ᵇ 497, 489, 587 | 9 ᵃ 572, 507, 495 | 9 ᵇ 496, 532, 502, 285 | 10 ᵃ 295, 500, 486 | 10 ᵇ 501, 655 | 11 ᵃ 656, 529 | 11 ᵇ 531, 523 | 12 ᵃ Pl. XLI, No. 1, 142, 344, 34, 92 | 12 ᵇ 99, 538, 102, 558 | 13 ᵃ 508, 23, 294, 591 | 13 ᵇ 119, 125, 199 | 14 ᵃ 552, 559, 122, 550 | 14 ᵇ 606, 594 | 15 ᵃ 520, 567, 176, 567 ll. 13—22, 361 | 15 ᵇ 566, 659, 652, 513, 600 | 16 ᵃ 654 | 16 ᵇ 535, 653 | 17 ᵃ 298, 145, 604 | 17 ᵇ 582, 14, 291, 391, 299 | 18 ᵃ 483, 661, 519, 578, 392, 583 | 18 ᵇ 1546, O | 19 ᵃ 887, 894, 565, 576, 588, 557 | 19 ᵇ 542, 709, 509 | 20 ᵃ 139, 140 | 20 ᵇ 138 | 21 ᵃ 48, 236, 205, 533 | 21 ᵇ Pl. III, No. 2, 149 | 22 ᵃ Pl. III, No. 1, 275, 148 | 22 ᵇ Pl. II, No. 1, 61, 40, 546 | 23 ᵃ Pl. VI, No. 4, 224 | 23 ᵇ 173 | 24 ᵃ *a diagram without text* | 24 ᵇ Pl. IV, No. 3, 173 | 25 ᵃ Pl. IV, No. 2, 169 | 25 ᵇ 293, 239, 485, 541, 537, 534 | 25 I ᵃ 171, 352 | 25 I ᵇ *a diagram without text* | 26 ᵃ Pl. XXXVIII, No. 2, 579 | 26 ᵇ P | 27 ᵃ Ma | 27 ᵇ Ge | 27 ᵇ 63 | 27 I ᵃ Ge | 28 ᵃ + | 28 ᵇ 517, 147, 202 | 29 ᵃ Pl. XXXI, No. 2 512 | 29 ᵇ 560, Pl. XXVIII, No. 6, 390, Ph | 30 ᵃ—31 ᵃ P | 31 ᵇ 506 | 32 ᵃ M | 32 ᵇ O, 68.

6. A.

Bound in parchment, marked A *outside and inside the cover. The numbers of the sheets* 1—64 *are in Leonardo's handwriting.*

1 ᵃ 628, 190, 527, 708 | 1 ᵇ [P], [M] 524, 83 | 2 ᵃ O, 235, 518 | 2 ᵇ O, Pl. XVII, No. 1, P, Mn | 3 ᵃ 50 | 3 ᵇ M P O | 4 ᵃ—5 ᵃ P M | 5 ᵇ Ge | 6 ᵃ Ge P | 6 ᵇ Ge | 7 ᵃ Mn, Ge | 7 ᵇ *and* 8 ᵃ M | 8 ᵇ 129, 624, 100, 93, 234 | 9 ᵃ M | 9 ᵇ 88, O, 69 | 10 ᵃ 52 | 10 ᵇ 94, 85 | 11 ᵃ 98 Ge | 11 ᵇ *and* 12 ᵃ Ge | 12 ᵇ Ge, O | 13 ᵃ— 15 ᵃ Ge | 15 ᵇ, 16 ᵃ P Ge | 16 ᵇ—18 ᵇ Ge | 19 ᵃ *acoustics*, M | 19 ᵇ 281, O, *acoustics* | 20 ᵃ 282, O, Ph | 20 ᵇ, 21 ᵃ Ma | 21 ᵇ—22 ᵇ M | 23 ᵃ 549, 514, 586, M, *acoustics* | 23 ᵇ A | 24 ᵃ M, 1134, A | 24 ᵇ—25 ᵇ A | 26 ᵃ A, M | 26 ᵇ O M | 27 ᵃ M 58 | 27 ᵇ M A | 28 ᵃ M | 28 ᵇ Pl. XXII, No. 4, 369, 596 | 29 ᵃ Pl. XXII, No. 3, 359 | 29 ᵇ O, M | 30 ᵃ—35 ᵇ M P 30 ᵇ 383 | 36 ᵃ M P, *acoustics* | 36 ᵇ 55 | 37 ᵃ O, 56 | 37 ᵇ 57, O | 38 ᵃ O, 86 | 38 ᵇ 41, Pl. XXXI, No. 3, 526 | 39 ᵃ—40 ᵃ Ge | 40 ᵇ 543 | 41 ᵃ 544 | 41 ᵇ 545 | 42 ᵃ O, 527 | 42 ᵇ 525, P A | 43 ᵃ *acoustics*, 706, A | 43 ᵇ—48 ᵃ M P | 48 ᵇ 792, P | 49 ᵃ P | 49 ᵇ 786 | 50 ᵃ 790, 779 | 50 ᵇ Ma, 780 | 51 ᵃ 781, Mn | 51 ᵇ—52 ᵇ P M | 53 ᵃ 795, 791, 776 | 53 ᵇ M P | 54 *is wanting* 55 ᵃ M P O | 55 ᵇ 929, 967, 941 | 56 ᵃ A 968, 944 | 56 ᵇ 945 Ph | 57 ᵃ Ph, 1083 | 57 ᵇ M | 58 ᵃ A | 58 ᵇ A, 934, 940, 943 | 59 ᵃ— 61 ᵃ A | 61 ᵇ M O | 62 ᵃ M P | 62 ᵇ 311, *two heads of horses*, P | 63 ᵃ 312, Pl. VIII, No. 1 | 63 ᵇ A | 64 ᵃ 898, 889, A | 64 ᵇ O 214, 249, 873. *The following blank sheet has the marks* S *on the front, and* Sᵇ *and the number* 4, *on the reverse. They are by an unknown hand. — A splendid edition of the whole volume was published in* 1881 *by A. Quantin, Paris. It contains photographs of all the texts. M. Charles Ravaisson-Mollien, the editor, has added to the facsimile the transcript of the Italian, a French translation, notes and an elaborate index.*

7. S. K. M. III.

Marked 32 *on the first sheet by an unknown hand:* 1 ᵃ 1459 | 1 ᵇ 1384 | 2 ᵃ—3 ᵃ Ph | 3 ᵇ 1496, del moto delle corde | 4 ᵃ— 8 ᵃ *pullies* | 8 ᵇ Ge | 9 ᵃ Ar | 9 ᵇ + | 10 ᵃ Vol. II, p. 89 the last two diagrams | 10 ᵇ—11 ᵃ Mn 11 ᵇ + | 12 ᵃ P | 12 ᵇ + | 13 *and* 14 *are wanting* | 15 ᵃ + | 15 ᵇ, 16 ᵃ A | 16 ᵇ 1491 | 17 ᵃ 1179 | 17 ᵇ Ph | 18 ᵃ—19 ᵃ P | 19 ᵇ 651 | 20 ᵃ P | 20 ᵇ—23 ᵃ Ge | 23 ᵇ 1342 | 24 ᵃ Mn | 24 ᵇ + | 25 ᵃ 498 | 25 ᵇ 1118 | 26 ᵃ *knots* | 26 ᵇ Ge | 27 ᵃ Mn | 27 ᵇ + | 28 ᵃ *and* 28 ᵇ Ge | 29 ᵃ 1341 | 29 ᵇ Mn | 30 ᵃ 1385 | 30 ᵇ Ar | 31 ᵇ cientro della gravità | 32 ᵃ aquaforte | 32 ᵇ Mn | 33 ᵃ O | 33 ᵇ—34 ᵃ Mn | 34 ᵇ + | 35 ᵃ Mn | 35 ᵇ Ge | 36 ᵃ Pl. XCIX, No. 2 | 36 ᵇ 1169 | 37 ᵃ Ge | 37 ᵇ 208 | 38 ᵃ M | 38 ᵇ, 33 ᵃ + | 39 ᵇ—41 ᵇ P | 42 *is wanting* | 43 ᵃ 1512 | 43 ᵇ, 44 ᵃ + | 44 ᵇ M | 45 ᵃ 1276, franc° | 45 ᵇ, 46 ᵃ P | 46 ᵇ 1121 | 47 ᵃ 1511 | 47 ᵇ Vol. II, p. 71 Fig. 1 | 48 ᵃ 662, 1324 | 48 ᵇ 764 | 49 ᵃ 1135 | 49 ᵇ Mn | 50 ᵃ 731 | 50 ᵇ— 51 ᵇ Mn | 52 ᵃ M | 52 ᵇ A, 629 | 53 ᵃ 614, 646, 732 | 53 ᵇ M | 54 ᵃ moto della saetta | 54 ᵇ forma di corpo | 55 ᵃ Vol. II, p. 71 Fig. 2, 647, 1386 | 55 ᵇ 734 | 56 ᵃ 735 | 56 ᵇ distantia | 57 ᵃ buse | 57 ᵇ Mn | 58 ᵃ 1283 | 58 ᵇ

384 | 59ᵃ Ph | 59ᵇ A | 60 *is wanting* | 61ᵃ A | 61ᵇ M | 62ᵃ cavaletti da lauorare | 62ᵇ *a diagram* | 63ᵃ + | 63ᵇ A | 64ᵃ Ge | 64ᵇ **1132** | 65ᵃ Mn | 65ᵇ **Pl. CVIII, No.**3, **813**, M | 66ᵃ **812** | 66ᵇ **1322** | 67ᵃ Ma | 67ᵇ + | 68ᵃ *a sketch of clouds* | 68ᵇ *sketch of a horse* | 69 *is wanting* | 70ᵃ + | 70ᵇ *circles* | 71ᵃ A | 71ᵇ, 72ᵃ *sketches of legs of horses* | 72ᵇ *sketches of windows* | 73ᵃ Mn | 73ᵇ **1281** | 74ᵃ M, **846** | 74ᵇ passavolante | 75ᵃ P | 75ᵇ, 76ᵃ + | 76ᵇ Mn | 77ᵃ **1187** | 77ᵇ fossa, strumenti | 78ᵃ + |

78ᵇ Ar | 79ᵃ **Pl. LXXXV, No.** 14 | 79ᵇ **1343** | 80ᵃ P | 80ᵇ **1150** | 81ᵃ Ar | 81ᵇ *circle* | 82 *is wanting* | 83ᵃ, 83ᵇ Mn | 84ᵃ *circles* | 84ᵇ + | 85ᵃ **633, 1367** | 85ᵇ—87ᵃ *sketches of costumes* | 87ᵇ **1470** | 88ᵃ *circle* | 88ᵇ centro del mondo, P | 89ᵃ Ma | 89ᵇ, 90ᵃ P | 90ᵇ *acoustics* | 91ᵃ **794** | 91ᵇ, 92ᵃ P Ar | 92ᵇ A | 93ᵃ **1488** | 93ᵇ **1271** | 94ᵃ **1387** | 94ᵇ bonifatio *. — See No.* 20 *for the history of this MS.*

8. H.³

The three small Note books H³ H² H¹ *are bound in one Volume. From the dirty state of the sheets at the beginning and at the end of each division it becomes apparent that Leonardo had used them separately. The cover is in parchment and is twice marked* H *on the outside and once inside, and* Q *on the back of the first sheet. Inside the back cover is the mark* Qᵃ, *and on the last sheet but one* N N 48, *meaning probably the number of sheets originally belonging to* H.³ *MSS* H² *and* H³ *are numbered throughout. The sheets of* H³ *are also numbered* 1—47, *below the text and in a reversed position. The numbers here given are above the text* | 47ᵃ A | 47ᵇ **1389** | 48ᵃ Ma | 48ᵇ dimmi semai, *sketch of a man's head in profile* | 49ᵃ, 49ᵇ Mn | 50ᵃ **670** | 50ᵇ, 51ᵃ notes | 51ᵇ **689** | 52ᵃ **999** | 52ᵇ **736** | 53ᵃ **1264, 690** | 53ᵇ—55ᵃ Mn | 55ᵇ

Sketch reproduced with No.1112 | 56ᵃ, 56ᵇ P | 57ᵃP, **1462** | 57ᵇ M. *sketch of a horse* | 58ᵃ *sketch of horses and oxen drawing a car* | 58ᵇ **1460** | 59ᵃ—60ᵇ Mn | 61ᵃ **831** Mn | 61ᵇ—69ᵇ Mn | 70ᵃ **691** | 70ᵇ **1191** | 71ᵃ **1192** | 71ᵇ—73ᵃ Mn | 73ᵇ **Pl. LXXXV, No.** 16, **768** | 74ᵃ il ciĕtro dell' ochio fia for dell'abaco ¹/₈ di a.b. | 74ᵇ—76ᵃ Mn | 76ᵇ **1514** | 77ᵃ **1513** | 77ᵇ, 78ᵃ + | 78ᵇ *terminations of Latin verbs* | 79ᵃ—80ᵃ *slight sketches* | 80ᵇ, 81ᵃ Mn | 81ᵇ **1515** | 82ᵃ *Sketch of a car drawn by horses* | 82ᵇ—84ᵃ Mn | 84ᵇ, 85ᵃ—86ᵃ *drawings of gear* | 85ᵃ **27** | 85ᵇ, 86ᵇ, 87ᵇ, 88ᵃ, *conjugation of the Latin verb* | 88ᵇ **644** | 89ᵃ sum, eram &c. **1356** | 89ᵇ **1543** | 90ᵃ—92ᵇ amo, amas, amat &c. | 93ᵃ amor, amaris &c, **1139** | 93ᵇ, 94ᵃ amo, legione cōtiene 6063 persone | 94ᵇ **1516**.

9. H.²

See introductory note to No. 8. — *The first sixteen sheets are numbered twice,* 1—16 *being also written below the texts, but in reversed order.* 1ᵃ **232** | 1ᵇ **692** | 2ᵃ, 2ᵇ A Mn | 3ᵃ *a sketch* | 3ᵇ **1265** | 4ᵃ—11ᵃ A | 11ᵇ *knots,* A | 12ᵃ *knots,* Mn | 12ᵇ **1197**, *a sketch of ornaments* | 13ᵃ **693** | 13ᵇ, 14ᵃ A | 14ᵇ **1390, 1320**, M | 15ᵃ M | 15ᵇ **694, 1316** | 16ᵃ A | 16ᵇ **1517** | 17ᵃ A, **1010 Note** | 17ᵇ **Pl. CX, No.**2, **1024** | 18ᵃ **152** | 18ᵇ Mn | 19ᵃ, 19ᵇ A | 20ᵃ A, **464** | 20ᵇ A | 21ᵃ A M | 21ᵇ, 22ᵃ A | 22ᵇ Mn | 23ᵃ **228**, A | 23ᵇ Mn | 24ᵃ Mn | 24ᵇ—25ᵇ A Mn | 26ᵃ, 26ᵇ A P | 27ᵃ **Pl. XXIII, No.** 3, **377** | 27ᵇ M Mn | 28ᵃ A | 28ᵇ **206**,

105, 163 | 29ᵃ A | 29ᵇ A, **304** | 30ᵃ A | 30ᵇ A, padiglō di legni a vigievine | 31ᵃ M | 31ᵇ molino | 32ᵃ A | 32ᵇ A P | 33ᵃ **91, 1518** | 33ᵇ M | 34ᵃ—35ᵇ A | 36ᵃ Mn | 36ᵇ—37ᵇ canale | 38ᵃ **828, 31** | 38ᵇ Mn | 39ᵃ, 39ᵇ A | 40ᵃ *sketch of a barrel on a car,* A **32** | 40ᵇ **671** | 41ᵃ M A | 41ᵇ **845** | 42ᵃ ricordati quādo cōmĕti lacque ‖ dallegar prima la speriĕza ‖ e poi la ragione | 42ᵇ **134** | 43ᵃ **1014** | 43ᵇ **33** | 44ᵃ P | 44ᵇ P A | 45ᵃ A | 45ᵇ Ge | 46ᵃ **1391** | 46ᵇ **620**, yhs maria **1493**, *and by an unknown hand the mark* Y 46.

10. H.¹

See introductory note of No. 8. — *The text is upside-down on the first* 28 *sheets.* 1ᵃ amo, amas amat &c., **1026** | 1ᵇ + | 2ᵃ amabam &c., A | 2ᵇ, 3ᵃ + | 3ᵇ 4ᵃ *forms of* amo | 4ᵇ SK | 5ᵃ **1220** | 5ᵇ **1221** | 6ᵃ **1222** | 6ᵇ **1223** | 7ᵃ **1224** | 7ᵇ **1225** | 8ᵃ **1226** | 8ᵇ **1227** | 9ᵃ **1228** | 9ᵇ **1229** | 10ᵃ **1230** | 10ᵇ

1231 | 11ᵃ **1232** | 11ᵇ **1233** | 12ᵃ **1234** | 12ᵇ **1235** | 13ᵃ **1236** | 13ᵇ **1237** | 14ᵃ **1238** | 14ᵇ **1239** | 15ᵃ **1240** | 15ᵇ, 16ᵃ + | 16ᵇ **1194** | 17ᵃ **1241** | 17ᵇ **1242** | 18ᵃ **1243** | 18ᵇ **1244, 643** | 19ᵃ **1245** | 19ᵇ **1246** | 20ᵃ **1247** | 20ᵇ **1248** | 21ᵃ **1249** | 21ᵇ **1250** | 22ᵃ **1251** | 22ᵇ **1252** | 23ᵃ

1253 | 23^b 1254 | 24^a 1255 | 24^b 1256 | 25^a 1257 | 25^b 1258 | 26^a 1259 | 26^b 1260 | 27^a 1261 | 27^b 1262 | 28^a Mn | 28^b tessta della viola | 29^a 29^b Mn | 30^a— 31^a A | 31^b 308 | 32^a 842, Ge | 32^b, 33^a knots | 33^b Mn, 1164 | 34^a A | 34^b Mn | 35^a knots | 35^b 782 | 36^a 783 | 36^b Mn | 37^a P | 37^b A | 38^a 1025 | 38^b A Mn | 39^a, 39^b Mn | 40^a 695 | 40^b 696 | 41^a 1461 | 41^b— 43^a Mn | 43^b knots and sketch | 44^a P, 1319 | 44^b, 45^a sketches of tents | 45^b, 46^a instruments | 46^b A | 47^a Mn | 48^a A M | 48^b 1263 |

11. S. K. M. II.²

The two MSS. S. K. M. II² and S. K. M. II¹ *are bound in one volume; the sheets are separately* *numbered on the top of each front sheet, but the* *two volumes are placed in the binding in reversed* *position, so that the two parts begin at the opposite ends of the volume.* 1^a **Vol. II, p. 62** sketch | 1^b 666, 697 | 2^a 665 | 3^a 1312, Ma | 3^b Ma | 4^a 1519 | 4^b + | 5^a M | 5^b, 6^a + | 6^b M | 7^a 1392, M | 7^b M, 1393 | 8^a Mn | 8^b + | 9^a Ge | 9^b Mn | 10^a *sketch of* *a flower* | 10^b O | 11^a P | 11^b **Pl. LXXXV,** **No. 15, Vol. II, p. 74 below** | 12^a 1394, 1317, *sketch of a head* | 12^b Ar | 13^a knots | 13^b Mn | 14^a 372 | 14^b, 15^a Mn | 15^b Fo | 16^a M | 16^b 103, P | 17^a Ph | 17^b, 18^a Mn | 19^b 998 | 20^a 1395, 376, **Pl. XXIII, No. 2** | 20^b, 21^a P | 21^b *sketches* | 22^a 1396 | 22^b—23^b *sketches* | 24^a 1196 | 24^b—25^b *sketches* | 26^a + | 26^b Ma | 27^a 1397 | 27^b + | 28 *is wanting* | 29^a + | 29^b *slight sketch of a woman* seated, holding a child in her lap | 30^a + | 30^b sketch | 31^a P | 31^b + | 32, 33, 34 *are wanting* | 35^a V | 35^b 1311 | 36^a M | 36^b Ma | 37^a *acoustics* | 37^b M | 38—42 *are wanting* | 43^a + | 43^b 1291 | 44^a 1290 | 44^b *knots* | 45, 46, 47 *are wanting* | 48^a—49^a *knots* | 49^b + | 50^a *sketch of a head* | 50^b, 51^a + | 51^b, 52^a Ge | 52^b 1398 | 53^a 1399 | 53^b, 54^a Ge | 54^b Mn | 55 *is wanting* | 56^a + | 56^b sketch | 57^a—59^a Ma | 59^b *sketch of a head* | 60^a + | 60^b, 61^a Ma | 62^a Ge | 62^a + | 62^b Ge | 63^a 97, 1400 | 63^b—64^b Ma | 65^a— 66^b Mn | 67^a Ar | 68^a Mn | 68^b 1401 | 69^a 1313, 1402 | 69^b + | 70, 71, 72 *are wanting* | 73^a + | 73^b M | 74^a P | 74, 75^a + | 75^b 1403 Mn | 76^a Ge | 76^b 154 | 77^a—78^a Ge | 78^b 667, 1404 | 79^a Ma | 80^a Mn | 80^b *knots.* — *On the same sheet are the marks* K K *62 and 25 by an unknown hand.*

12. S. K. M. II.¹

See preliminary Note of No. 11. — *The* *numbers of the sheets are in Leonardo's hand-* *writing and begin from the end, going backwards.* *The first sheet or cover sheet has no number* | **1520, M, 612** | 1^a **36** | 1^b Ge | 2^a—26^a P | 26^b—28^a *de chonfregatione* | 28^b—42^b P | 43^a **1137** | 43^b 66^a P | 66^b **787** | 67^a P, **1206** | 67^b **784** | 68^a—69^a *perpetuum mo-* bile | 71^b Ar | 72^a **793** | 72^b—75^b P | 76^a— 86^a Mn | 86^b **Sketch Vol. I, p. 201** *and* **Vol. II, p. 99 below** | 87^a—88^b Mn | 89^a **793 Note** | 89^b Mn 90^a—93^b *peso*—94^a *centro del mondo,* A | 94^b **1521** | 95^a **733, 627, 1522** | 95^b *mechanica potissimum in fine incipiendū, this note is not in Leonardo's hand-* *writing, but by a later hand.*

13. I.²

This and M S I¹ are bound in one volume. *The mark I is outside and Q and Q 3 inside the* *cover.* 1^a *magistr* M^{to} *jachomo (this note is* *not in Leonardo's handwriting).* 1^b **1524, 704** | 2^a—7^b *Latin and Italian vocabulary* | 4^a *has* *also the note* simon de calima tintore | 8^a **Vol.** **II, p. 68 Fig. 1 and 2** | 8^b—10^b Mn | 11^a **1405** | 11^b M | 12^a—14^a A | 14^b Ma | 15^a **1298** | 15^b **1299** | 16^a **1300** | 16^b **1301** | 17^a **1302** | 17^b **1303** | 18^a **1304** | 18^b **1305** | 19^a **1306** | 19^b—24^a A | 24^b **932** | 25^a Ge | 25^b—31^b A | 31^b M | 32^a *second Latin declination* | 32^b—36^a A | 36^b— 38^a M | 38^b—43^a M | 44^a—47^a M | 47^b *sketches of knots and shells* | 48^a *sketch of a dog's* head | 48^b *contrapeso* | 49^a *ornamental design* *of two cornucopiae* | 49^b *sketch* | 50^a—56^b M | 57^a, 58^a A, 58^b + | 59^a **679** | 59^b + | 60^a A | 60^b—61^b M | 62^a **Pl. LXXXV, No. 13,** | 62^b P | 63^a *acoustics* | 63^b + | 64^a— 66^a M | 66^b—70^a A | 70^b—71^a **1406** | 71^b, 72^a M | 72^b **1407** | 73^a—74^a A | 74^b M | 75^a A | 75^b—78^a *Latin vocabulary* | 78^b + | 79^a, 79^b A | 80^a—81^b *voce d'echo*—82^a **1160** | 82^b M **1477** | 83^a—86^a M P | 86^b uterque, utraque &c. | 87^a **1408** | 87^b alius, alia &c. | 88^a qui que quod | 88^b M | 89^a— 90^a amo, amas &c. | 90^b **672** | 91^a **673, 1326** | 91^b *numbers.* — *The two following* *sheets bear only the marks* Q 3 *and* Q.

14. I.[1]

See No. 13 *preliminary note.* — 1—12ᵃ
Ge | 12ᵇ **394** | 13ᵃ, 13ᵇ Ge | 14ᵃ, 14ᵇ M |
15ᵃ **1140 Note** | 15ᵇ—17ᵃ Ge | 17ᵇ **241** |
18ᵃ **1151 242** | 18ᵇ Ar | 19ᵃ *sketch* | 19ᵇ
37* | 20ᵃ **38** | 20ᵇ—23ᵃ Mn | 23ᵇ *da forare
cristalli* | 24ᵃ—25ᵃ *sketches of shields* | 25ᵇ
—27ᵇ Mn | 28ᵃ **1409** | 28ᵇ—32ᵃ Mn | 32ᵇ
1017 | 33ᵃ O | 33ᵇ Ge | 34ᵃ **1018** | 34ᵇ—
37ᵃ Mn | 37ᵇ **Pl. XXVIII, No. 5, 188, 452** |
38ᵃ O | 38ᵇ, 39ᵃ *sum, es, est* &c. | 39ᵇ
1318 | 40ᵃ *quis vel qui que quod vel quid*
&c. | 40ᵇ—42ᵇ Mn | 43ᵃ O | 43ᵇ—46ᵃ
Mn | 46ᵇ *sketch* | 47ᵃ **1092 Note** | 47ᵇ
sketch 48ᵃ **463** | 48ᵇ Mn. — *The Marks* I I ·
48 *and* · 20 · *are by an unknown hand.*

15. W. P.

*Most of these researches are written on
loose sheets of unequal size. The dimensions
of each sheet are here given in brackets:* 1ᵃ
(20¹/₂ × 30 Cm) **324** | 1ᵇ **322** 2ᵃ (21³/₄ ×
26¹/₂) **310, 337, Pl. VII, Nos. 1 and 2*** | 2ᵇ
sketch of a horse's legs, measurements and notes.
3 Iᵃ (13¹/₂ × 14¹/₂ Cm) **Pl. XI, 318** | 3 IIᵃ
(17 × 15 Cm) **Pl. VII, No. 4, 327, 321** |
3 Iᵇ, 3 IIᵇ + | 4ᵃ (21 × 12¹/₂ Cm) **Pl. XIX,
No. 1, 347** | 4ᵇ **325** | 5ᵃ (44 × 32 Cm) **341
ll. 1—4, 317 ll. 1—13, 625, 341 ll. 5—8, 317
ll. 14—17, Pl. XXXV, No. 1, 348 ll. 16—55,
ll. 11—15, Pl. XVII, No. 2, 336, 348 ll. 1—
10 | 707, 348, 56—68** | 5ᵇ **Vol. II, p. 44
Fig. 1 and p. 47 Fig. 3** | 6 Iᵃ (21¹/₂ × 16
Cm) **Pl. VIII, No. 2, 332** | 6 Iᵇ **333** | 6 IIᵃ
(22 × 14³/₄ Cm) **Pl. XIV, No. 2, 334** | 6 IIᵇ
Pl. XVI, No. 1, 335 | 7ᵃ (40 × 28 Cm) **1410,
314, 338, 328, Pl. XIII, 326, 330, Pl. XIV,
No. 1** | 7ᵇ **349, Pl. XX, 339, Pl. XVI, No. 2,
342** | 8ᵃ (28 × 20¹/₂ Cm) **Pl. XV, 331, 345,
323** | 8ᵇ + | 9ᵃ (27 × 20¹/₂) V | 9ᵇ+ | 10ᵃ,
10ᵇ (22 × 16 Cm) Mn | 11ᵃ (29¹/₂ × 20 Cm)
Pl. LXIII, 684 | 11ᵇ **685** | 12ᵃ **Pl. X, 316**. —
Sheets 9—12 *which treat on different subjects
are only added here, because in the Windsor
Collection they form a set with Sheets* 1—8.
*The thin cards, on which these sheets are
mounted have a broad ornamental border in
water colours.*

16. W. H.

With regard to these studies see Vol. II, p. 4.
The sheets are numbered 46—68, *differing in size,
and many not mounted are coloured in various
tints: Compare also Lomazzo,* Trattato dell'arte
della pittura I chap. 20, IV, 23 *and* Idea del
tempio della pittura chap. 16. — *Vasari also
mentions these studies.* 64. **716** | IV. **717**.

17. W. An. II.

*The sheets forming this treatise are all of the
same size and originally formed a small book.
At present the sheets are separated. The old
numbers and marks which are to be found on
most of the sheets are here given in brackets after
the new numbers:* 36 (21) **797** | 36ᵇ *muscles
of the leg* | 37ᵃ **814, Pl. CVIII, No. 4** | 37ᵇ
the veins on the head &c. | 38ᵃ (0) 38ᵇ *veins
of the leg* | 39ᵇ *veins on the leg and on the
spine* | 39ᵇ **801** | 40ᵃ *nervi, matrice* | 40ᵇ + |
41ᵃ (7) *Delli musscholi che movā li labri della
bocha* | 41ᵇ *nervi, matrice* | 42ᵃ (10) *nervi* |
42ᵇ *veins of the leg* | 43ᵃ (8) *Delli musscholi
che movā la lingha* | 43ᵇ *muscles of the foot,*
843 | 44ᵃ (3) *veins of the arm* | 44ᵇ *veins* | 74ᵃ
(12) *veins of the womb* | 74ᵇ *muscles on the
arm of the ape* (scimmia) *and of man* (omo) |
75ᵃ (2), 75ᵇ *muscles of the leg* | 76ᵃ *dello
vfitio de mesoplevri* | 76ᵇ **Pl. CVIII, No. 1,**
809 | 77ᵃ (21) *muscles of the leg* | 77ᵇ, 78ᵃ
(11) *veins of the leg* | 78ᵇ *veins of the hand* |
84ᵃ (10) 84ᵇ *the chest* | 85ᵃ *the lungs* | 85ᵇ
albero di tutti i nervi | 86ᵃ (13) *arteries* | 86ᵇ
veins of the arm | 87ᵃ)14) *the lungs,* 87ᵇ *the
heart* | 125ᵃ—127ᵃ (4) *blood-vessels* | 127ᵇ *the
spine* | 128ᵃ (5) *the mouth and the lips* | 128ᵇ
matrice di uaccha | 156ᵃ, 156ᵇ *genitals* | 173ᵃ
(16. 17—*two sheets, not separated*) *intestines*
827 | 173ᵇ **816** | 178ᵃ, 178ᵇ *intestines* | 183ᵃ
veins on the neck | 183ᵇ *veins* | 201ᵃ (M)
bones | 201ᵇ **1215** | 202ᵃ (·B·) **1412, 838** | 202ᵇ
839 *genitals,* | 203 (24) **1178, 375, Pl. XXIII,
No. 1** | 203ᵇ **357, Pl. XXII, No. 1** | 204ᵃ (3)
stomacho | 204ᵇ *vene, fegato* | 205ᵃ *della
forza de' mvsscholli* | 205ᵇ *misenterio* | 206ᵃ
(I)*polmone* | 206ᵇ *vesscicha,* **817** | 242 (N)
1214 | 242ᵇ **1213**.

18. L.

This volume is in the original cover; it is a thin card of light blue colour. It is marked L on the outside and Q c *inside:* O¹ **1414, 1323, 1102** | 1ᵃ **1002, 1415** | 1ᵇ **1416** | 2ᵃ **1417, 648,** *knights kneeling* | 2ᵇ Ma | 3ᵃ *sketch of a head* 3ᵇ 4ᵃ *knights kneeling* 4ᵇ A | 5ᵃ *a note* | 5ᵇ *knots* | 6ᵃ **1034** | 6ᵇ **1035** | 7ᵃ, 7ᵇ Fo | 8ᵃ colōbaia | 8ᵇ Ma | 9ᵃ—10ᵃ *plans* | 10ᵇ **1036** | 11ᵃ + | 11ᵇ—12ᵃ Mn | 12ᵇ, 13ᵃ + | 13ᵇ AO | 14ᵃO | 14ᵇ *notes* | 15ᵃ **1019** | 15ᵇ **1037, Pl. XCIV, No. 1** | 16ᵃ P Ar | 16ᵇ Fo | 17ᵃ A | 17ᵇ P | 18ᵃ, 18ᵇ Mn | 19ᵃ Fo | 19ᵇ **Pl. CX, No. 3,** *left side* **1038** | 20ᵃ **Pl. CX No. 3,** *right side* **765** | 20ᵇ Ma | 21ᵃ **1054** | 21ᵇ—23ᵃ Ma | 23ᵇ Mn | 24ᵃ Fo | 24ᵇ—26ᵃ Mn | 26ᵇ P | 27ᵃ Mn | 27ᵇ P, **378** | 28ᵃ Mn | 28ᵇ *knots* | 29ᵃ Fo | 29ᵇ Mn | 30ᵃ A | 30ᵇ Mn **1418** | 31ᵃ—33ᵃ A | 33ᵇ Mn **1039** | 34ᵃ—36ᵃ Mn | 36ᵇ **1040, Pl. CX, No. 4** | 37ᵃ Ar | 37ᵇ Ma | 38ᵃ—39ᵃ Ar | 39ᵇ Mn | 40ᵃ **1041** 40ᵇ, 41ᵃ Mn | 41ᵇ **35** | 42ᵃ—44ᵇ M | 45ᵃ

Ma | 45ᵇ Ar | 46ᵃ Fo | 46ᵇ **1042** | 47ᵃ **1043** 47ᵇ A | 48ᵃ, 48ᵇ Ar | 49ᵃ—52ᵇ Mn | 53ᵃ M **1503** | 53ᵇ **1502** | 54ᵃ—60ᵇ V | 61ᵃ Ar | 61ᵇ—62ᵇ V | 63ᵃ—65ᵇ Fo | 66ᵃ **1109, Pl. CX, No. 1** | 66ᵇ **1044** | 67ᵃ **1045** | 68ᵃ, 68ᵇ Ar | 69ᵃ P A | 69ᵇ—71ᵃ Mn | 71ᵇ *a sketch* 72ᵃ **1046** | 72ᵇ **1325** | 73ᵃ Ge | 73ᵇ, 74ᵃ Ar 74ᵇ, 75ᵃ Fo | 75ᵇ **307** M | 76ᵃ **981** | 77ᵃ **1047** 77ᵇ **226** | 78ᵃ **1048** A | 78ᵇ **1049** | 79ᵃ **488,** citadella | 79ᵇ Ge | 80ᵃ voce | 80ᵇ *drawing of a draped figure, very like the one on Pl. XXVIII, no 7* | 81ᵃ Ge | 81ᵇ *sketch of trees* | 82ᵃ **1047 Note** | 82ᵃ and 83ᵃ Vol. II, p. 244, sketch 83ᵇ, 84ᵃ *outline sketch of mountains* | 84ᵇ P 85ᵃ Mn | 85ᵇ P | 86ᵃ Ge | 86ᵇ Mn | 87ᵃ **449** | 87ᵇ **393** | 88ᵃ *sketch* | 88ᵇ **1050** | 89ᵃ *sketches* | 89ᵇ Mn | 90ᵇ **1199** | 91ᵃ **1307** | 92ᵃ **623,** M | 92ᵇ Mn | 93ᵃ Ma | 93ᵇ voca bolo lombardo &c | 94ᵃ **1523** | 94ᵇ **1474, 1052** O" **1053, 1198, 1419,** *and, by an unknown hand:* Le carte sono 94 cioè nouàta quart.

19. W. M.

See Vol. II, p. 224 and No. **1051** *Note.* *As to the Maps in MS.* W. L. *see No.* 36. *The following maps are on separate sheets* 1. **Pl. CXIII,** *The original is somewhat larger* (19 × 13¹/₄ in) *the whole is executed in water colours. The rivers are in blue* 2. **Pl. CXIV,** (15³/₄ XII, in) | 3. *Part of the Arno, in water-colours* (39 × 22) **Pl. CXII.** 4 *Map of a part of Tuscany, in water colours* (40 × 27 Cm), *including* Livorno, Pisa, Luccha, Volterra. 5. *Central Italy* (45 × 23 Cm) *within the limits of* Corneto, Rimini, Pesaro, *washed in Indian ink.* 6. *Study for the Map* Pl. CXIII, *washed in Indian ink; the names are written in Leonardo's ordinary writing* (28 × 21 Cm).

20. S. K. M. I.¹

This small MS. is bound in one Volume with MS. S. K. M. I². On the first sheet is the note, written in German: 𝕷𝖊𝖔𝖓𝖆𝖗𝖉𝖔 𝖉𝖆 𝖁𝖎𝖓𝖈𝖎 𝖉𝖊𝖗 𝖌𝖗ö𝖋𝖙𝖊 𝕸𝖆𝖑𝖊𝖗 ‖ 𝖆𝖚𝖌 𝖉𝖊𝖗 𝖎𝖙𝖆𝖑𝖎𝖊𝖓𝖎𝖋𝖈𝖍𝖊𝖓 𝕾𝖈𝖍𝖚𝖑𝖊 1452 𝖟𝖚 𝖁𝖎𝖓𝖈𝖎 𝖌𝖊𝖇𝖔𝖗𝖊𝖓, 𝖙𝖗𝖆𝖙 1502 𝖆𝖑𝖌 𝕶𝖗𝖎𝖊𝖌𝖌𝖇𝖆𝖚𝖒𝖊𝖎𝖋𝖙𝖊𝖗 𝖎𝖓 𝖉𝖎𝖊 𝕯𝖎𝖊𝖓𝖋𝖙𝖊 ‖ 𝕳𝖊𝖗𝖟𝖔𝖌𝖌 𝖁𝖆𝖑𝖊𝖓𝖙𝖎𝖓 𝕭𝖔𝖗𝖌𝖎𝖆, 𝖚𝖓𝖉 𝖋𝖙𝖆𝖗𝖇 1519. — *This volume and the two others now in the Forster Library of the South Kensington Museum, London, were given to Mr Forster by Lord Lytton, who is said to have bought them at Vienna for a low sum. The title of the treatise on sheet* 1ᵃ *is given in* **1374, Note;** *no other subject is discussed on the 38 sheets which form this MS.* 1ᵇ **1374** jo voglio abbassare la grosseza d'una tavola a data grosseza sanza mvtatione di sua largheza | domādo quāto cressce in sua lūgezza &c. | 4ᵃ, 6ᵃ, 8ᵇ, 11ᵃ, 12ᵃ, 16ᵇ *are blank.* — *On the last sheet* 39ᵃ *is the mark* 46.

21. S. K. M. I.²

See introductory note to No. 20. — *At the end of this Note book is the mark* B B 14. *This MS. has the pages numbered* 1—28. — 1—4 Mn | 5 **635, 649** | 6 Mn | 7 **385** | 8 **650,** **636** | 9 Mn | 10 Mn A | 11—15 Mn A | 16 de pōderibus, modo di misurare vn alteza | 17—28 Mn A.

22. F.

The cover of thin grey card is original. It has the mark F inside and outside. o' **1421, 1292** | 1ᵃ **1375, 848** | 1ᵇ Ge | 2ᵃ A | 2ᵇ **2** | 3ᵃ A | 3ᵇ, 4ᵃ P | 4ᵇ libro 10 delle varie profondita e globlosita ... dell'acque, **880** | 5ᵃ libro 9, dell'acqua che passa per un bottino, **879** | 5ᵇ **911, 1208** | 6ᵃ **881** | 6ᵇ flusso e reflusso | 7ᵃ—8ᵃ A | 8ᵇ **882** | 9ᵃ, 9ᵇ A | 10ᵃ **883** | 10ᵇ, 11ᵃ Ge | 11ᵇ **862**, A | 12a—17ᵇ A | 18ᵃ **302** | 18ᵇ—21ᵇ A | 22ᵃ **244**, Pl. XLI, 3, 4 | 22ᵇ **861** | 23ᵃ **5, 277** | 23ᵇ—24ᵇ A | 25ᵃ ochiale di cristallo &c. | 25ᵇ **867** | 26ᵃ P | 26ᵇ A | 27ᵃ **939** | 27ᵇ **1422** | 28ᵃ—30ᵃ O | 30ᵇ A | 31ᵃ—34ᵃ O | 34ᵇ Libro 32 del moto che fa il fuoco | 35ᵃ Libro 42 delle pioggie | **474** | 35ᵇ—37ᵃ O | 37ᵇ **1338** | 38ᵃ A | 38ᵇ—40ᵃ O | 40ᵇ, 41ᵃ A | 41ᵇ **858**, V | 42ᵃ A, *anatomy* | 42ᵇ—46ᵇ A | 47ᵃ **1330** | 47ᵇ—48ᵇ A | 49ᵃ P | 49ᵇ P, O | 50ᵃ **1106** | 50ᵇ, 51ᵃ Ge | 51ᵇ, 52ᵃ M | 52ᵇ, 53ᵃ A | 53ᵇ A V | 54ᵃ—55ᵃ A | 55ᵇ Ge, *cells* | 56ᵃ **866**, **617** | 56ᵇ *acoustics* | 57ᵃ **912** | 57ᵇ—59ᵇ Ge | 60ᵃ **913, 870** | 61ᵃ M, **1087** | 61ᵇ—64ᵇ O | 65ᵃ—67ᵃ A | 67ᵇ dell' arco celeste | 68ᵃ A, **1107** | 68ᵇ A | 69ᵃ P | 69ᵇ—72ᵇ A | 73ᵃ **942** | 73ᵇ Ph | 74ᵃ, 74ᵇ M | 75ᵃ **278** | 75ᵃ M A | 76ᵃ O | 76ᵇ **1010** | 77ᵃ A | 77ᵇ **877** | 78ᵃ, 78ᵇ | 79ᵃ delli animali che àn l'ossa di fori &c. | 79ᵇ delle ossa de pesci che si trovà ne' pesci petrificati | 80ᵃ nichi e loro necessaria figura | 80ᵇ de nichi ne' mōti | 81ᵃ—82ᵃ A | 82ᵇ prova che la spera dell'acqua è perfettamente tonda | 83ᵃ **371**, G | 83ᵇ P | 84ᵃ **903** | 84ᵇ **904** | 85ᵃ **905** | 85ᵇ—86ᵇ O | 87ᵃ aria | 87ᵇ **922** | 88ᵃ **923** | 88ᵇ—90ᵃ A | 90ᵇ **924** | 91ᵃ—92ᵃ A | 93ᵃ **893** | 93ᵇ, 94ᵃ A | 94ᵇ **874**, O | 95ᵃ A, O | 95ᵇ **806** | 96ᵃ *chemical materials* **613** | 96ᵇ **1184, 626**, *chemical materials* | Oᵘ carte 96 à questo Libro sāza la coperta, **1483, 1471** ll. 1—3, **1528, 884, 698, 1471** ll. 4, 5.

23. Br. M.

Bound Volume in the MSS. Department of the British Museum, numbered · Plut. ÇLXV. D *and* 263 *Arundel Collection. This collection takes its name from Thomas Howard, twenty-third Earl of Arundel, whose MSS. were originally divided between the Royal Society and the College of Arms, but in* 1831 *those which had been in the possession of the Royal Society were acquired for the British Museum. — On the second sheet is the note:* "Soc. Reg. Lond (ex dono Henr. Howard) Norfolcensis". — *This volume has been partly made up from loose sheets of unequal size and quality of paper. Only the first sheets can be assigned to the date indicated at the head of Vol:* 1ᵃ **4**, M | 1ᵇ—18ᵇ Ph | 19ᵃ **906** | 19ᵇ—23ᵇ Ge | 24ᵃ, 24ᵇ mantice | 25ᵃ A, **875** | 25ᵇ A, *geology* | 26ᵃ modo brevissimo di misurare una distanza | 26ᵇ—27ᵇ Ma | 28ᵃ **895, 876** | 29ᵃ, 29ᵇ A | 30ᵇ **982** | 31ᵃ, 31ᵇ P | 32ᵇ **6** | 33ᵃ—34ᵇ A | 35ᵃ **925** | 35ᵇ **926** | 36ᵃ A | 37ᵃ—42ᵃ P M | 42ᵇ **1314, 1297, 1541** | 43ᵃ V M | 43ᵇ M 44ᵃ **350** | 44ᵇ P | 45ᵃ **928** | 45ᵇ—47ᵇ Ma Ph 48ᵃ **1451** | 48ᵇ—56ᵇ Ge, Mn | 57ᵃ O | 57ᵇ— 61ᵃ A, O, Ge | 62ᵃ **109** | 62ᵇ Ge | 63ᵃ + | 63ᵇ Mn | 64ᵃ le proportioni delli archi &c. | 64ᵇ **830** | 65ᵃ—77ᵇ Ph Ma | 71ᵇ **1484** | 72ᵇ centro della gravita | 78ᵃ + | 78ᵇ **888** | 79ᵃ P | 79ᵇ **1507** | 80ᵃ—93ᵃ Ph Ma | 93ᵇ **207** | 94ᵃ **892** | 94ᵇ **896** | 95ᵃ A | 95ᵇ O | 96ᵃ V | 96ᵇ—102ᵇ Ph Ma | 103ᵃ **897** | 103ᵇ—112ᵃ Ph O | 112ᵃ, 113ᵃ + | 113ᵇ **458** | 114ᵃ **453** | 114ᵇ **459, 435** | 115ᵃ + | 115ᵇ **227** | 116ᵃ—119ᵃ P | 119ᵇ + | 120ᵃ l'universo non à cosa minor ne piv bassa che'l suo ciētro | P | 120ᵇ A | 121ᵃ bastioni | 121ᵇ Ma | 122ᵃ **927** | 122ᵇ + | 123ᵃ—124ᵇ P | 125ᵃ + | 125ᵇ *sails* | 126ᵃ P, **architectural drawing Vol. II, p. 68 Fig. 3** | 126ᵇ V, A | 127ᵃ—128ᵇ P M | 129ᵃ + | 129ᵇ **1333**, V | 130ᵃ A, aria | 131ᵃ **1216** | 131ᵇ **45** | 132ᵃ **46** | 132ᵇ **1452** | 133ᵃ, 133ᵇ Ma | 134ᵃ, 134ᵇ V | 135ᵃ, 135ᵇ A M | 136ᵃ **1130** | 136ᵇ— 137ᵇ Mn | 138ᵃ **789, 772 and Pl. CVI** | 138 + | 139ᵃ **645** | 139ᵇ fiamme | 140ᵃ Mn | 140ᵇ M | 141ᵃ + | 141ᵇ **778 and Pl. CV, 4—7** | 142ᵃ Ge | 142ᵇ + | 143ᵃ—145ᵇ Mn | 146ᵃ V, P | 146ᵇ + | 147ᵃ A | 147ᵇ **851** | 148ᵃ **1548** | 148ᵇ **1549** | 149ᵃ **1015** | 149ᵇ **1550** | 150ᵃ + | 150ᵇ **1453** | 151ᵃ **859** | 151ᵇ—154ᵇ M Ma | 155ᵃ **1339** | 155ᵇ **1218** | 156ᵃ **1217** | 156ᵇ **994, 1219, 1162** | 157ᵃ **Pl. CIV 770** | 157ᵇ **Pl. CV 775, 771** | 158ᵃ **777, 773** | 158ᵇ **785** | 159ᵃ Ma | 159ᵇ **774** | 160ᵃ—166ᵃ Ma Ph | 166ᵇ V | 167ᵃ— 168ᵃ A | 169ᵃ **605, 305** | 169ᵇ + | 170ᵃ *chemicals* | 170ᵇ **181**, 165 ll. 1—5, **172, 127**, 165 ll. 6—9, **167** | 171ᵃ **110, 136, 143, 126** | 171ᵇ **510, 76**, O | 172ᵃ + | 172ᵇ **471, 454, 476** | 173ᵃ **687** | 173ᵇ **916** | 174ᵃ **615**, P, M | 174ᵇ **871** | 175ᵃ **860, 1129 and Pl. CXXI***| 175ᵇ A | 176ᵃ **917, 857** | 176ᵇ—187ᵇ Ph Ma | 188ᵃ **231** | 188ᵇ—190ᵃ Ph Ma | 190ᵇ **916** | 191ᵃ **918, 1156, 1454** | 191ᵇ Mn | 192ᵃ + | 192ᵇ **1455, 763** | 193ᵃ + | 193ᵇ—202ᵃ Ph Ma | 202ᵇ **1420** | 203ᵃ—211ᵃ Ph Ma | 211ᵇ **266** | 212ᵃ

1542 | 212b 1310 | 213a + | 213b—219a Ph Ma | 220a 75, 84 | 220b, 221a Ma | 221b 74 | 222a + | 222b—223b Ge | 224a P *sketches of mountains and view of a cavern* | 224b + | 225a *decorative designs* | 225b + | 226a, 226b M | 227a 1540 | 227b P | 228a, 228b M | 229a + | 229b 1525 | 230a Mn | 230b Ph | 231a + | 231b 678, *sketch with figures* | 232a, 232b Ge | 233a A | 233b 964 | 234a— 235a Ph | 235b, 236a + | 236b 965 | 237a, 237b + | 238a—242b Ph Ma | 243a 185 | 243b + | 244a—247 Ge | 248a + | 248b 186, 124 | 249a, 249b + | 250a 674 | 250b 251a + | 251b 1365 | 252a + | 252b sa- goma | 253a 1366 | 253a *sketch of a child's head, drawn with the silverpoint* | 254a—255a + | 255b—262b Mn 263a + | 263b 1079 264a—268 Ph Mn | 269a 1074 and Pl. CXV | 269b 1076 | 270a *sketches* 270b 744, 747, 1075, 1077 | 271a 1551 | 271b 1463, 1527 A | 272a 1372 | 272b 1535 | 273a *sketches* | 273b 1004 | 274a 1552, 1005 | 274b, 275a + | 275b *canals* | 276a—277a del vēto | 277b 473 | 278a *sketch of a river* | 278b 1144 | 279a Ge | 279b 1476, 914 | 280a— 282a Ge Ph | 282b, 283a + | 283b centro della gravita, *and sketches.*

24. W. An. III.

Among the numerous anatomical drawings in the Windsor Collection there is one set which appears to have formed originally a Volume by itself. Here the paper is of a thin greyish blue colour and of a rather rough surface. Leonardo seems to have made use of it exclusively for this particular treatise. All the sheets are of the same size. Each of them is marked by a Roman capital letter, as shown here in brackets. Sheet 217 bears the date 1513. — 115a (B) *on veins* | 115b *the heart* | 116a (K) *blood-vessels* | 116b + | 117a (E) *spine and shoulders* | 117b + | 118a (H) *blood-vessels* | 118b + | 161a (O) *blood-vessels* | 161b + | 192a (T) *the arms*, A | 192b + | 193a (V) *vento* | 193b + | 196a (P) *muscles* | 196b + | 217a (G) polmone 1376, 1423 | 217b + | 225a (N) battimēnto del cuore | 225b + | 226a (M) 850 | 226b + | 227a (H) cuore, polmone | 227b + | 228a (R) cuore, O | 228b *the heart and veins* | 229a (A), 229b *the heart* | 230a (S) discorso delli nerui muscoli, corde &c., 815 | 230b + | 232a (F) *the heart* | 232b 121, 265, 292 ll. 1—3, 1424, 292 ll. 4—11, 59, 287, 209, 195, 204, 158, 1424: *The sheet W. L. 136 (X) originally belonged to this series of sheets.*

25. E.

The cover of thin grey card is the original binding. The outside bears the mark E. B is twice written inside the cover. The compiler of the treatise on painting in the Vatican library (Urbinas 1270) *which was published by* Manzi *in* 1817, *and by* Ludwig *in* 1882 *gives a few passages from this MS, of which he correctly notes the corresponding number of pages, to which the mark B is added.* o' 915, 479* | 1a 1465, 1064, 1020 P | 1b Ge, P | 2a del cognoscere la parte settentrionale della calamita, M | 2b 211 | 3a de cōdensatione, 360, 238 | 3b 117, 467 | 4a 562, Ge | 4b *acoustics*, 935 | 5a A | 5b, 6a P | 6b 366, 470, 403 | 7a P | 7b, 8a Ge | 8b 1155, Ma | 9a—11a Ge | 11b Mn | 12a 930 | 12b—14a strumenti aquatici | 14b per fare l'arco | 15a 230, 156, 380 | 15b 869 | 16a 108, 825 | 16b 107 | 17a 237, 153, 268, 153, 355 | 17b 24 | 18a 286 | 18b 440, Pl. XXVIII, No. 3 *right side* | 19a 461, 441, Pl. XXVIII, 3 *left side* | 19b 363* | 20a 362, P | 20b, 21a P | 22a—23b V | 24a + | 24b —27a Ge | 27b Machina murale | 28a Mn, Ph | 28b—29b Ph Ma | 30a Ge | 30b O, 212 | 31a 161 | 31b 135, 1190, 197, Pl. XLI, No. 5 | 32a Pl. IV, No. 1, 162, 198 | 32b 264, 159, 240, 157 | 33a Ge, del centro della gravità | 33b Da generare vento mirabile | 34a Mn | 34b, 35a Ph | 35b—51a V | 51b Ma | 52a—54a V | 54b P | 55a, 55b P | 56a Ge | 56b—75a PM | 75b, 76a Mn | 76b—79b P M | 79b 225, 17 | 80a 222, 1065 | 80b 15, 223 | 0″ le carte sono ... giusto 96 cioè Nouantasei: *this note is not in Leonardo's handwriting* | 480, 1539.

26. G.

The cover of thin grey card is the original binding. Inside and outside the cover is the mark G. *The numbers of the sheets are in Leonardo's handwriting.* O' 1377, le carte sono di numero giusto 96 cioè Nouantasei eccetto che māca il 7 et il 18 col suo conpagno 31. *This note is by an unknown hand* | 1a 1033 | li pedali delli alberi ànno superficie ... 1b 1057 | 2a Mn | 2b 426 | 3a 425 | 3b 118, 872, 427 | 4a 428 | 4b 429 ll. 1—11, 406, 429 ll 12—14 | 5a 405, Mn | 5b

503,505 | 6^a 455 | 6^b 607 | 7 *is wanting* | 8^a 1495, 1161, 19, 421, 430 | 8^b 431 | 9^a 432 9^b 442 | 10^a del moto dell' aria 423 | 10^b Pl. XXVIII, No. 2, 424, 433 | 11^a *sketch of a horse's head and note* | 11^b 556, 460 | 12^a 436 | 12^b 247 | 13^a 399 | 13^b 90, P | 14^a 400, P | 14^b A | 15^a 437, 603 | 15^b + | 16^a M | 16^b 415 | 17^a—18^b Ge | 19^a 554 | 19^b 465, 443 | 20^a A | 20^b 444 | 21^a 445 | 21^b 446 | 22^a 447 | 22^b 448, 468 | 23^a 469 23^b 564 | 24^a 422 | 24^b *short notes about plants* | 25^a 482, 499 | 25^b 450 | 26^a 590* | 26^b Pl. XXVIII, No. 4, 451 | 27^a 413 | 27^b 457, 418, Pl. XXVII, No. 3 | 28^a 414, Pl. XXVII, No. 4 | 28^b 434, 438 | 29^a 417, Pl. XXVII, No. 5 | 29^b 106 | 30^a P M | 30^b 416 | 31 *is wanting* | 32^a 155 | 32^b 404 | 33^a 412, 402, Pl. XXVII, No. 2 | 33^b 419, 553 | 34^a 885* | 34^b 397 | 35^a A, 398 | 35^b 407 | 36^a 408 | 36^b 409 | 37^a 401, 263, 49, sagoma | 37^b 481, A | 38^a 949, A | 38^b—40^a P, Ge | 40^b, 41^a Mn | 41^b, 42^a V | 42^b G | 43^a 726, Pl. LXXVI, No. 2 | 43^b Ge | 44^a 829 | 44^b de cigognola | 45^a, 45^b Mn | 46^a de potentia della voce | 46^b 637 | 47^a Mn 1205 | 47^b sagoma | 48^a 974 | 48^b 946 | 49^a 1201, 947 | 49^b 976, A | 50^a Ge | 50^b del moto de navili | 51^a 410 | 51^b Mn | 52^a 769, Mn | 52^b Ge | 53^a 641 | 53^b 16, 89, 306, 569 | 54^a 1113 | 54^b, 55^a M | 55^b—62^a Ge | 62^b M | 63^a P | 63^b, 64^a V | 64^b 820 | 65^a V | 65^b + | 66^a—69^b Ge | 70^a 966 | 70^b—72^b Mn | 73^a—75^a P M | 75^b 729 | 76^a—88^a Mn, Ph | 88^b 411 | 89^a 1327, 1166 | 89^a de potentia | 90^a 835 | 90^b A | 91^a vēto | 91^b on clouds | 92^a on the wings of the fly | 92^b vento, della velocità de' nuvoli | 93^a A | 93^b, 94^a Mn | 94^b P | 95^a 1504, Mn | 95^b 1158, Mn | 0″ 1464.

27. M.

The cover of thin grey card is the original binding, marked M outside the cover. 0' 1425 | 1^a—3^b Ge | 4^a 699, Pl. LX, No. 2 | 4^b 700, Pl. LX, No. 3 | 5^a 701, Pl. LX, No. 4 | 5^b Ge | 6^a *on the earth* | 6^b—7^b Ge | 8^a 1426 | 8^b—36^a Ma | 36^b—53^a P M | 53^b 1427 | 54^a, 54^b bombarda, passavolanti | 55^a 373 | 55^b, 56^a ponte 56^b Mn | 57^a—58^a M | 58^b 1285, 1152 | 59^a—61^b Ph M | 62^a 1478 | 62^b—66^b Ph Mn | 67^a 821 | 67^b—76^b Ph M | 77^a + | 77^b 420, Pl. XXVIII, No. 1 | 78^a P | 78^b 395, Pl. XXVII, No. 1, left side | 79^a 396, Pl. XXVII, No. 1, right side | 79^b 116* | 80^a 115 | 80^b Ge | 81^a—84^a Mn | 84^b, 85^a + | 85^b Ge | 86^a camino | 86^b—88^a Ge | 88^b + | 89^a—94^b Ph, Mn. O″ mark Q.

28. Tr.

Marked S inside the cover and on the first sheet. At the beginning of the Volume is the following note: 1783·5· Gennaro· Questo Codicetto di Leonardo da Vinci era del Signor Don Gaetano Caccia Cavaliere Nouarese, ma domiciliato in Milano, morto l'anno 1752 alli 9 di Gennaro sotto la Parocchia di S. Damianino La Scala. Jo Carlo Triuulzio l'acquistai dal detto Caualiere intorno l'anno 1750 unitamente a un quinario d'oro di Giulio Maporiano e a qualche altra cosa che non più mi ricordo dandoli in cambio un orologio d'argento di ripetizione che io due anni avanti aveva comperato usato per sedici gigliati mache in verità era ottimissimo, che però questo codicetto mi viene a costare sei in sette gigliati. *In the MS. the pages are numbered, not the sheets.* 2 1493, *caricatures*, 1332, 1189 | 3 1469 Note, *ships* 4 1486 | 5 Mn | 6 P Mn | 7 853 Ar Mn | 8, 9 *list of words* | 10 + | 11 1202 | 12 891 | 13 Fo | 14 840 | 15 Pl. XCIX, No. 1, 758 | 16 Pl. C, No. 3 | 17 Vol. II, p. 61 Fig. 1 and 2 | 18, 19 + | 20 *lists of words*, 144 | 21 Pl. C, No. 2 | 22 1429, 177 | 23—26 *lists of Italian and Latin words* | 27 Mn | 28 863, 168* | 29 201, 146 | 30 *sketch of a male figure* | 31 *list of words* | 32 1173 | 33, 34 Mn | 35—38 *lists of Italian words* | 39 1193, *Italian words* | 40 *Italian words*: 41 Pl. C, No. 4, Vol. II, p. 61 | 42 Pl. LXXXI, No. 1 | 43 *sketch of a building resembling the one given* on Pl. LXXVIII, No. 1 | 44 *geometrical sketch* | 45 1147 | 46 Ph | 48 1128 | 49 854, 640, *acoustics* | 50 *list of Italian words* | 51 *list of Italian words*, 1148 | 52 737 | 53 bombarda, 738 | 54 739 | 55 740 | 56 bombarda | 57 1487, 1181, *list of Italian words* | 58 nulla può essere · scripto per nvouo ricerchare ¶ ecquale cosa dite a me stesso prometta, — *list of Italian words* | 59 *sketch of a head*, fornello, *list of Italian words* | 60 *list of Italian words* | 61 A, *list of Italian words* | 62 *list of Italian words* | 63 Mn | 64 A, *list of Italian words* | 65 1145 | 66 *list of Italian words*, bombarda | 67 *list of Italian words* | 68 1209, 43, 1174, *list of Italian words* | 69 *acoustics* | 70 1146, 1138, *list of Italian words* | 71 M, 539 | 72 *list of Italian words* | 73 1321,

Mn | 74 **28** | 75 **1136**, **296** | 76, 77 + | 78
Mn, **1141**, **1289**, **622** | 79 P | 80 + | 81 M, *list
of Italian words* | 82—95 *list of Italian words* |
96 *on warfare, list of Italian words* | 97 *lists
of Italian words* | 98 triboli | 99 *sketch of a*

bow | 100—104 *lists of Italian words*. — *A
short account of this MS was published in* 1881
by count Giulio Porro *in the* Archivio Storico
Lombardo VIII, IV. *There is also a facsimile
of p.* 59.

29. Leic.

*Bound volume in leather cover. On the first
five sheets before the beginning of the original
MS are the following Notes. On* 1ª *marked in
pencil* 596: This treatise on the nature, weight
and motion of water... has never been printed.
On the reverse of the modern title may be found
an extract from the life of Lionardo da Vinci, by
Dufresne, in which this volume is particularly
mentioned. It appears from the title page (al-
though the name of the possessor has been obli-
terated) that it has belonged to Giuseppe Ghezzi,
an eminent painter at Rome. — W. Roscoe.
1ᵇ + | 2ª + | 3ª Libro Originale ‖ Della
Natura, peso, e moto delle Acque, ‖ Com-
posto, scritto, e figurato di proprio ‖ Carattere
alla mancina ‖ Dall' Insigne Pittore e Geo-
metra ‖ Leonardo da Vinci ‖ In tempo di
Ludouico il Moro, nel condur ‖ che fece le
Acque del Nauilio della ‖ Martesana dall' Adda
a Milano. ‖ Si autentica con la precisa Men-
tione che ne fà Raffaelle du fresne nella Vita
di detto Leonardo, descritta nel suo Libro
stampato in Parigi da Giacomo Longlois l' Anno
1651 intitolato ‖ Trattato ‖ Della Pittura ‖ Ac-
quistato 'con la gran forza dell'Oro' (*these words
cover an erasure*), per sublimare ‖ le fatigose
raccolte del suo studio ‖ da ‖ Giuseppe Ghezzi
Pittore in Roma ‖ 3ᵇ (*in another handwriting*)
Soleua il Vinci scrivere Alla mancina, secondo
l'uso degli Ebrei, nella qual maniera erano
scritti quei sedici Volumi de quali di già
abiamo fatto menzione, et esendo il carattere
buono, si legeua assai facilmente mediante un
spechio grande, è probabile ch'egli facessi
questo, accio tutti non legessero così facilmente
i suoi scritti. L'impresa del nauiglio di Marte-
sana gli diede ocasione di scriuere un libro
della natura, peso e moto delle Aque pieno di
gran numero di disegni di varie rote, Machine
per molini, a regolár il corso dell'aque, e le-
uarle in Alto | 4 + | 4ª (*in an earlier hand-
writing*) Libro scritto da Leonardo Vincio che
tratta del sole, della luna del corso dell' acqua
dei ponti e dei moti | 4ᵇ + | *The arrangements
of this MS. are somewhat unusual. On the
head of many pages there are title lines here
placed between* ' ' *giving the numbers of* '*cases*' (casi)

or *subjects treated on the page. Most of these
cases are introduced by* 'Come' (*How, or that*).
1ª **864** | 1ᵇ **1082**, **901** | 2ª **902**, Pl. **CVIII**,
No. 5 | 2ᵇ Come si debbe votare vno stagno
che sbochi nel mare, Ph on the moon | 3ª A,
985 | 3ᵇ A | 4ª **300**, **1060** | 4ᵇ A | 5ª **957**,
971, **919**, **907**, luna | 5ᵇ A | 6ª libro 2° delle
diuersità dell'onde dell' acqua | 6ᵇ **958**, A,
977 | 7ª dell'acqua della luna, Ar | 7ᵇ A, O |
8ª A, **386**, Pl. **XXIV**, **No. 3**, Ph | 8ᵇ '8'
987 | 9ª 'Carte 10 e cōclusioni 853' **988**,
921 | 9ᵇ '16' **989**, **721**, **1055**, **1061**, A | 10ª
'15' 3ʳᵈ *case*: **1063**, **980**, **990**, Mn | 10ᵇ '15'
991, **1056**, **1101**, **936**, **1085**, Mn | 11ª 'casi
13' A | 11ᵇ 'casi 27', 4ᵗʰ *case* **1058**, 7ᵗʰ **969**,
9ᵗʰ **1029** | 12ª 'casi, — in queste 7 carte e
casi 657 d'acque e di sua fōdi' | 12ᵇ 'casi 24'
A | 13ª 'casi 16' **1472**, 4ᵗʰ *and* 5ᵗʰ **959**, 15ᵗʰ
and 16ᵗʰ **1008** | 13ᵇ 'casi 16' A | 14ª 'casi 21'
A | 14ᵇ 'casi 24' A | 15ª 'propositioni 26'
1ˢᵗ *and* 2ⁿᵈ **972** | 15ᵇ 'propositioni 38' **920** *on
the margin* | 16ª 'pro positioni 23' A | 16ᵇ
'casi 18' **1499** *on the margin*, **973** | 17ª 'casi
29' A | 17ᵇ 'hordine del libro delle acque, casi
28' **956** | 18ª 'casi 32', 22ⁿᵈ **1011** | 18ᵇ 'casi
16', **1007** *on the margin* | 19ª 'casi 17' | 19ᵇ
'casi 37' | 20ª 'casi 32', 7ᵗʰ **992**, 14ᵗʰ *and* 15ᵗʰ
953, 16ᵗʰ **995** | 20ᵇ 'casi 24' A | 21ª 'propo-
sitioni 12', 2ⁿᵈ **1027** | 21ᵇ 'proⁿⁱ 25', 4ᵗʰ **948**, 5ᵗʰ,
6ᵗʰ **849**, **963**, 7ᵗʰ **1096**, 8ᵗʰ **963** ll. 7, 8 | 22ª 'casi
29' 9ᵗʰ **1097** | 22ᵇ 'casi 39', 12ᵗʰ *and ff.* **1114**, **I**,
the last **996** | 23ª 'casi 20' 6ᵗʰ **997** | 23ᵇ 'casi 15'
A | 24ª 'casi 20' 24ᵇ A | 25ª 'casi 12 questi
son casi che ànno a stare nel principio' *on air
and water* | 25ᵇ 'casi 15' A | 26ª 'casi 18'
A | 26ᵇ 'casi 15' A | 27ª 'casi 23' A | 27ᵇ
'19' 13ᵗʰ **1071**, 7ᵗʰ **1086**, 8ᵗʰ **954** | 28ª '8' **1110** *on
the margin*, **1021** | 28ᵇ '15' A | 29ª '13' A | 29ᵇ
aria | 30ª **899** | 30ᵇ A | 31ª '900. 5 cōclu-
sioni 9' **962** *on the margin*, 5ᵗʰ **1091**, 6ᵗʰ *and ff.*
1090, **984** *on the margin* | 31ᵇ, 4ᵗʰ **1068**, 5ᵗʰ
1108, 8ᵗʰ *and* 9ᵗʰ **978** | 32ª A, **1028** | 32ᵇ
1098 | 33ª A | 33ᵇ **970** | 34ª **1000**, A | 34ᵇ
933, **1095**, **1072**, A | 35ª **960** | 35ᵇ **937** |
36ª **938**, centro del mondo, **301**, **993**, 36ᵇ
900, A.

30. Mz.

The grey card cover is original. The sheets are twice numbered, in Leonardo's handwriting and by a more recent hand. The original numbers are here given in brackets, because they are not consecutive, subsequently they have been altered: 0' **728** | 1ᵃ (3) **1154,** P | 1ᵇ Ge P | 2ᵃ (4) P | 2ᵇ V | 3ᵃ (6) **1122,** V | 3ᵇ V | 4ᵃ (6?), 4ᵇ V | 5ᵃ (8 *altered in* 7) | 5ᵇ V | 6ᵃ (9 *altered in* 8) | 6ᵇ, 7ᵃ (10 *altered in* 9) | 7ᵇ V | 8ᵃ (12 *altered in* 11) **1168,** V, Ge | 8ᵇ, 9ᵃ (13 *altered in* 12) V | 9ᵇ **1124** | 10ᵃ (14 *altered in* 13) **705** | 10ᵇ, 11ᵃ (15 *altered in* 14) | 11ᵇ V | 12ᵃ (16 *altered in* 15) **1123** | 12ᵇ V | 13ᵃ (17 *altered in* 16) V, **1125, 381** | 13ᵇ baga, V | 0" **1428,** and **the architectural drawing reproduced Vol. II, p. 67.**

31. D.

Marked D *inside and outside the cover of grey card,* S *inside the back cover. Four blank sheets are at the beginning. This MS. treats of the eye. The following texts are a selection of the headings.* 1ᵃ Perchè la natura non fece equal virtu e potentia nella virtu visiva | 1ᵇ perchè li razzi de' corpi luminosi si fan tāto maggiori quanto son più remoti dal lor nascimēto | 2ᵃ se l'idolo over simulacro à terminato sito sopra dell'ochio o no . . . come la rettitudine del concorso delle spetie si piega nello entrare nell'ochio | 2ᵇ come le spetie di qualūche corpo che per alcuno spiraculo passano all'ochio s'inpremon sotto sopra nella sua popilla e'l senso le vede diritte | 3ᵃ come le cose destre nō pajono destre alla virtù visiva, se le sue spetie non passan per due intersegationi | 3ᵇ come le spetie si danno alla virtù visiva con due intersegationi per neciessità | 4ᵃ perchè lo spechio scambia alli simulacri delli obieti li lati destri ne' sinistri e li sinistri ne' destri | 4ᵇ che sia vero che ogni parte della popilla abbia uirtù visiua | 5ᵃ dell'ochio delli animali nocturni | 5ᵇ La popilla dell'ochio si muta in tante varie grandezze quante son le varietà delle chiarezze o scurità delli obbietti che dināti se li rapresentano | 6ᵃ Il simulacro del sole è vnico in tutta la spera dell'acqua che vede ed è veduta da esso sole ma pare diuiso in tante parti quanti son li ochi delli animali che in diversi siti vedono la superfitie dell'acqua | 6ᵇ La popilla dell'ochio à virtù visiua tutta per tutto e tutta in ogni sua parte | 7ᵃ come la popilla piglia li simulacri delle cose antiposte all'ochio solamente dalla luce e non dallo obbietto | 7ᵇ perchè la cosa destra non pare sinistra nell'ochio | 8ᵃ **71** | 8ᵇ dimostratione perchè l'ochio vede adietro a se cose poste nelli spati laterati | 9ᵃ dell'ochio vmano | 9ᵇ perchè li corpi luminosi mostrano li lor termini pieni di diritti razzi luminosi | 10ᵃ delle spetie delli obbietti che passano per stretti spiracoli in loco oscuro | 10ᵇ delle spetie delli obbietti infuse per l'aria. — *At the end four blank sheets, two bearing the mark* S.

32. K.¹

The three MSS K¹ K² K³ *are bound in one Volume with a leather cover inscribed* LEONARDI ‖ VINCI ‖ *in golden letters. The sheets of each MS. are separately numbered. Inside the cover are the marks* K *and* 13. *On the first sheet is the inscription:* Commentarii autographi ‖ Leonardi Vincii ‖ Pictoris Architecti ‖ cerissimi ‖ quos dono dedit ‖ Bibliothecae Ambros. ‖ Comes Horatius Archintus ‖ Ingenuarum Artium ‖ studiosissimus ‖ Anno MDCLXXIV ‖ *Then follow four blank sheets.* 1ᵃ A, *and the mark* 44 | 1ᵇ Ma | 2ᵃ **1067** | 2ᵇ Ge | 3ᵃ Dividi il trattato delli vccelli in 4 libri &c. | 3ᵇ—14ᵃ V | 14ᵇ *sketch of a male figure* | 15ᵃ + | 15ᵇ, 31ᵃ Ge ma *in black chalk* | 31ᵇ—48ᵃ *in ink* | 47ᵇ *has the mark* O O **47** | 48ᵇ + |

33. K.²

The introductory note No. 32. 1ᵃ P | 1ᵇ **1308** | 2ᵃ **1489** | 2ᵇ **1490** | 3ᵃ Ma | 3ᵇ **1481** | 4ᵃ—8ᵃ Ge | 8ᵇ + | 9ᵃ—11ᵃ V | 11ᵇ de fiumi | 12ᵃ Ma | 12ᵇ **1508** | 13ᵃ Ge | 13ᵇ 14ᵃ + | 15 *is wanting* | 16ᵃ—17ᵃ Ma | 17ᵇ, 18ᵃ A | 18ᵇ + | 19ᵃ—27ᵃ Ma | 27ᵇ **1430** | 28ᵃ—32ᵃ Ma.

34. K.³

See introductory Note No. 32. 1ᵃ la setola del bue | 1ᵇ—9ᵃ Ge | 9ᵇ Mn | 10ᵃ—11ᵇ Ge | 12ᵃ + | 13ᵃ—16ᵃ A | 16ᵇ Ma | 17ᵃ—19ᵇ A | 20ᵃ **1073** | 20ᵇ—21ᵇ A | 22ᵃ de muscoli | 22ᵇ—25ᵃ A | 25ᵇ **113** | 26ᵃ **114** | 26ᵇ—27ᵇ A | 28ᵃ **808** | 28ᵇ, 29ᵃ aqua del navilio | 29ᵇ **1501, 824** Pl. CVIII, No. 2 | 30ᵃ M | 30ᵇ **657*** | 31ᵃ M | 31ᵇ **175,** O | 32ᵃ + | 32ᵇ **630** | 33ᵃ, 33ᵇ Mn | 34ᵃ, 35ᵃ calcidonio | 35ᵇ manica | 36ᵃ colla di riso | 36ᵇ **749,** Pl. LXXXII, No. 2 | 37ᵃ A | 37ᵇ *chemicals* | 38ᵃ Ph | 38ᵇ—40ᵃ O | 41ᵃ, 41ᵇ V | 42ᵃ, 42ᵇ O | 43ᵃ—44ᵃ M | 44ᵇ—47ᵇ popilla | 48ᵃ vaso | 48ᵇ **1431,** *and the mark* L L 48.

35. W. An. IV.

The treatise is written on loose sheets of equal size (compare No. 24*); here the paper is white in colour. The old marks on some of the sheets are here given in brackets.* 157ᵃ (·B·) **798, 822** | 157ᵇ *muscles of the spine* | 7ᵃ (AA) **810** | 7ᵇ + | 80ᵃ (Cn) *the spine* | 80ᵇ *busts of two men* | 89ᵃ (3) *bones of the leg* | 89ᵇ *muscles of the arm and of the neck* | 90ᵃ (3) (Ma), 90ᵇ, 91ᵃ (99) *arm and shoulder* | 91ᵇ *the spine* | 129ᵃ (P) *blood-vessels* | 129ᵇ pol- mone | 130ᵃ, 130ᵇ figuratione della mano | 131ᵃ albero di uene | 131ᵇ + | 132ᵃ, 132ᵇ *the leg* | 134ᵃ *muscles* | 134ᵇ + | 141ᵃ (17) ufitio del polmone, Ge | 145ᵃ (O) *bones of the foot* | 145ᵇ *muscles of the arm* | 146ᵃ (P) *the torso* | 146ᵇ *head and hand* | 147ᵃ, 147ᵇ *mus- cles* | 148ᵃ (110) *the leg* | 148ᵇ *the torso* | 149ᵃ *on veins* | 149ᵇ *the spine* | 151ᵃ nervi, **802** | 151ᵇ *coitus,* **841, 1482,** per queste figure si dimōstrerà la cagione di molti pericoli diferite e malattie | 152ᵃ *embryos,* **1432,** *coitus,* **658** | 152ᵇ *embryos* | 153ᵃ **1433,** *intestines* | 153ᵇ *embryos,* **29, 818** | 154ᵃ de utilità strumentale de' membri | 154ᵇ + | 155ᵃ *coitus,* 155ᵇ + | 159ᵃ *muscles* | 159ᵇ + | 160ᵃ (18) *torso, the heart* | 160ᵇ *the face* | 162ᵃ (·8·) Ge | 162ᵇ + | 163ᵃ *the heart* | 163ᵇ **3,** *the heart*; 164ᵃ (·D·)—165ᵃ del core | 165ᵇ *a woman's head, drawn by a pupil* | 166ᵃ (B) del cuore | 166ᵇ *the stomach* | 167ᵃ (O) *on veins,* **1434** ll. 1—7, **819,** 7, **1434** ll. 8—17, **796** | 167ᵇ *the heart* | **370** | 169ᵃ (F) *the heart* | 169ᵇ *intestines* | 170ᵃ (o/o) albero delle corde | 170ᵇ *muscles* | 171ᵃ (o/o) albero delle vene | 171ᵇ *intestines* | 172ᵃ Ge, *intestines,* **1133** | 172ᵇ Ge | 174ᵃ *intestines* | 174ᵇ *the neck* | 177ᵃ *the strait-gut* | 177ᵇ + | 181ᵃ—182ᵃ *the heart* | 182ᵇ + | 184ᵃ (7) **832, 837** | 184ᵇ seguita l'articulatione della voce umana | 189ᵃ P | 189ᵇ *muscles of the eye* | 199ᵃ *the ribs* 199ᵇ A | 200ᵃ (·G·) | 200ᵇ *intestines* | 211ᵃ *muscles of the leg* | 211ᵇ + | 212ᵃ *muscles* | 212ᵇ + | 213ᵃ Ge, *Anatomy* | 213ᵇ + | 214ᵃ, 214ᵇ Ge, *intestines* | 216ᵃ *muscles of the torso* | 216ᵇ + | 218ᵃ (·H·) polmone, **570** | 218ᵇ + | 220ᵃ (1A·) *vene* | 220ᵇ + | 221ᵃ 221ᵇ *muscles of the foot* | 222ᵃ *bones of the arm* | 222ᵇ *the torso* | 223ᵃ Polmone | 223ᵇ *urine-bladder* | 234ᵃ l'inpeto del sangue | 234ᵇ la revolutione del sangue nel anteporta del cuore, O | 250ᵃ che vfitio faccino li muscoli delle coste | 218ᵇ +.

36. W. L.

The history of this Volume is given on pp. 482, 483. *Here as in the MS.* C. A. *the original sheets were fixed on the sheets of the volume, but most of them have been taken out again. The following references are exclusively to such sheets as are still to be found undetached in this celebrated volume. The size varies greatly. On the folio No.* 124 *(containing no drawing at present) is the Spanish note:* ogni falsaua esta y nosecuēta. *The back of some sheets is covered by the mounting.* 132ᵃ **886,** Ma | 136ᵃ Mn | 141ᵃ **1436** | 141ᵇ **1435** | 145ᵃ A **597,** Pl. V, **183,** B **66, 270, 78,** C **276,** D **81,** ll. 24—53, **120, 81** ll. 15—23, ll. 54—97* | 145ᵇ A **288,** B **77,** C **80, 47, 87,** D **79** ll. 1—5, **274, 81** ll. 1—14, **73, 79** ll. 6—12 | 146ᵃ **62, 130** | 146ᵇ Ma | 198ᵃ **682** | 198ᵇ **683** | 199ᵃ 199ᵇ A | 200ᵃ *sketch of a head.* 200ᵇ *sketchmaps of the Valle Brembana with the names and distances of the villages from* Bergamo *and* Ponte a San Piero *up to the* Val Tellina, *and of the* Val Trompia *between* Brescia *and the* lago d'Idro. 203ᵃ **1438,** Ge Mn | 203ᵇ *sketch for the map on fol.* 212ᵃ | 212ᵃ *part of the* Arno river **1437** | 212ᵇ *sketch-plan of* Florence, **1004** Note, **1016** Note | 217ᵃ *five plans, showing the divisions of some fields* | 217ᵇ *water colour drawing of a villa with gardens (not by Leonardo)* | 224ᵃ *sketch-map of the* Val di Serio *between* Bergamo *and* Ardese, *with numbers showing the distances between the*

villages | 224ᵇ *small map of the same valley, map of the* Oglio *between* Palazzolo *and* Ponte secco: Pontaseg—confini d'Italia, *sketch-map of rivers between* Bergamo *and* Brescia | 226ᵃ *sketch of the valley of the Arno* **1006** | 229ᵃ *plan of* Imola **1051 and Pl. CXVI, No. 1** | 231ᵃ *map of the river Arno near* Florence | 231ᵇ *whirlpools* | 234ᵃ *sketch of river* | 234ᵇ *map of the valley of the Arno including* Florence, Prato, Pistoja, Lucca *and* Empoli.

37. W.

The detached sheets of MSS. in the Windsor Collection chiefly treat on Anatomy. They vary greatly in size, nor is there any consecutive order. The following account of the very rich materials must therefore be confined here to general statements 1ᵃ. **387, Pl. XXIV, No. 1** | 1ᵇ + | 2ᵃ Fo | 2ᵇ + | 3ᵃ **379, 297, Pl. XXIII, No. 4** | 3ᵇ *drawing of a head* | 4ᵃ Mn, *Anatomy* | 4ᵇ *writing by an unknown hand with the date* 1443 | 5ᵃ A P **1411** | 6ᵃ 6ᵇ *measurements of a horse* | 8ᵃ *drawing of legs* | 8ᵇ Joannes de pasqualibus debet dare etc. *by an unknown hand;* 9ᵃ *sketch of a head, not by* Leonardo; 9ᵇ P M., *drawing of a horse* **Vol. II p. 24 above to the left** | 10ᵃ—35ᵇ *chiefly small drawings* | 36ᵃ **797** | 36ᵇ *legs and muscles* | 45ᵃ *intestines* | 45ᵇ + | 69ᵃ Mn, 69ᵇ + | 70ᵃ **Pl. LII, No. 1** | 70ᵇ + | 71ᵃ — 73ᵇ *mostly sketches* | 79ᵃ 79ᵇ *anatomy of the head* | 81ᵃ 83ᵃ *anatomy* | 83ᵇ + | 88ᵃ *the muscles* | 88ᵇ + | 92ᵃ—99ᵃ *sketches* | 100 *standing male figure* | 100ᵇ + | 101ᵃ **Pl. XXXVIII, No. 3** | 101ᵇ + | 102ᵃ (19. 21) **Pl. XXVIII, No. 7** | 102ᵇ + | 103ᵃ *standing male figure* | 103ᵇ + | 104ᵃ **Pl. VII, No. 5** | 104ᵇ + | 105, 111—114 *various sketches* | 119ᵃ **313 Pl. VII, No. 3** | 120ᵃ 121ᵃ *sketches of heads* | 122ᵃ **Pl. CI, No. 3** | 123ᵃ *a similar drawing* | 129ᵃ *blood-vessels* | 129ᵇ polmone | 136ᵃ—144 *anatomy, various notes and sketches* | 158ᵃ **608, Pl. XXXV No. 2 and 3** | 158ᵇ **609** | 165ᵃ cuore polmone | 165ᵇ *drawing of a female head, not by* Leonardo | 174ᵃ **1362** | 175—180 *anatomy* | 185ᵃ—187ᵇ *anatomy* | 188ᵃ Ar | 188ᵇ *anatomy* | 190 Ar, Ph | 190ᵇ *anatomy* | 191ᵃ Ge, **1475** | 191ᵇ *intestines* | 194ᵃ

195ᵇ *muscles, the heart* | 197ᵃ **351, Pl. XIX, No. 2** | 197ᵇ *sketches* | 198ᵃ *legs* | 207—209 Mn Ph | 210ᵃ **799** | 210ᵇ popilla de'animali notturni | 215ᵃ **358, Pl. XXII, No. 2** | 215ᵇ + | 219ᵃ 219ᵇ *muscles of the arm* | 224ᵃ *veins* | 224ᵇ + | 231ᵃ **477, Pl. XXXVI, Pl. XXXVII** | 233ᵃ A, 233ᵇ + | 235—238ᵃ vento, A, P, *anatomy* | 238ᵇ **807** | 239ᵃ **811** | 239ᵇ + | 240ᵃ Io ò per strumento di questo 4° libro a maneggiare 6 cose, cioè polo, subbio, leva, corda, peso e motore | 240ᵇ **365, 269** | 241ᵃ **1157, 1358, 844, 1210** | 241ᵇ + | 243ᵃ **681, Pl. LXII, No. 2** | 243ᵇ + | 244ᵃ *sketches of trees* | 244ᵇ + | 245ᵃ *sketch of fire* | 245ᵇ + | 246ᵃ **Pl. XL, No. 2** | 246ᵇ + | 247ᵃ—249ᵃ *sketches of horses* | 250 *anatomy.—The following Roman numbers refer to selected drawings with MSS., most of which are mounted on cartoons:* I **Pl. XXXII, 137, 575, 577** | II **170** | III **356, Pl. XXI** | IV **389 Pl. XXV** | V **Pl. XXVI*** | VI **456** | VII **475** | VIII **642**, IX **688, Pl. XLIV** | X **710, 1413, 878** | XI **711, Pl. LXXV** | XII **713, 1175**, XIIᵇ **1547** | XIII **639, 714, 852, 1186** | XIV **715** | XV **717** | XVI **Pl. LXXX, No. 4** (*reversed in the reproduction*) | XVII **Pl. LXXXIII, 1103,** XVIIᵇ **1104** | XVIII **CII, No. 1** | XIX **Pl. CI, No. 1, 760** | XX **Pl. CI, No. 3** | XXI **800, 833** | XXII **803** | XXIII **804, 1494** | XXIV **823** | XXV **856** | XXVI **868** | XXVII **909** | XXVIII **1022** | XXIX **1140** | XXX **1329** | XXXI **1355, Pl. CXXII** | XXXII **1532, Vol. II p. 24 the sketch on the right.**

The Arabic numbers of sheets not given among the foregoing references will be found inserted in the notices of the various treatises at Windsor Castle, given previously under separate headings.

38. C. A.

This best known and most voluminous Volume is composed of loose sheets of various size, each folio containing one or more sheets of original MS. The mounting is the same as in the Volume W. L. Such sheets as have notes on both sides are not fixed by their back to the folio sheets, but set into a paper frame. The numbering of sheets refers only to the folios. In the interest of identification and in order to facilitate a comparison of the writing on the opposite sides of one *and the same sheet, I have introduced here, in addition to the numbers of Leoni's folio sheets, second numbers which refer to the separate original sheets.—In the following description it seemed to me desirable to refrain from giving detailed accounts of the contents of such sheets, as do not bear upon the various subjects of the present publication, the more so, as the order of the sheets, being quite accidental, throws no light whatever on the connection of the various stu-*

dies extending over about thirty years. Outside the cover is the inscription in golden letters: DISEGNI . DI MACCHINE. ‖ DELLE . ARTI . SECRETE ‖ ET . ALTRE . COSE ‖ DI . LEONARDO DA VINCI ‖ RACCOLTI DA ‖ POMPEO LEO ‖ NI ‖ On the back of the cover is the No. 248 . 1^a, 1^a and 1^b, 1^b **95** | $2^a\,2^a$—$4^a\,10^a$ Mn | $4^a\,11^a$ **1553** | $4^b\,11^b$ **631, 1359**. *The following drawings and texts nearly all refer to machines* | $7^a\,19^a$ **1119** | $11^a\,37^a$ P | $11^b\,37^b$ **1439** | $12^a\,42\,^a$ **1286**, Sketch Vol. II p. 62 | 16^b Pl. XCVI, No. 1 | $17^a\,67^a$ Mn | $17^b\,67^b$ **1361, 1533** | $19^a\,72^a$ Ph | $19^b\,72^b$ **1440**, Mn | $26^a\,87^a$ **1545** | $26^b\,87^b$ Mn | $27^a\,89^a$ **1441** | $27^b\,89^b$ *canons* | $30^b\,96^b$ **200**, Pl. XLI, No. 2 | $34^b\,109^b$ **1554** | $36^a\,115^a$ **178** | $36^b\,116^b$ **1328**, A, M | $87^b\,124^b$ **1360** | $41^a\,132^a$ **101** | $41^b\,132^b$ A, Antonius Salualichus. $44^a\,137^a$ *farai la natomia dell'alie d'uno vcello insieme colli muscoli del petto motori d'esse alie* | $44^b\,137^b$ **272, 353** | $45^a\,140^a$ **1001** | 140^b *canals* | $46^b\,144^b$ **150** | $58^a\,180^a$ **1142** | $64^a\,197^a$ Ma $64^b\,197^b$ **1203** | $65^a\,198^a$ V. | $65^b\,199^b$ **1363** | $66^a\,200^a$ **1268** ll. 1—15, **1277, 1268** ll. 16—25, **1278** | $66^a\,201^a$ **1282, 1279, 1273** | $66^b\,206^b$ **1269, 1315, 1270** ll. 1—25, **1274, 1270** ll. 26—36 | $67^a\,202^a$ **1466** | $67^b\,202^b$ *superfitie* | $67^b\,203^b$ **702** | $68^a\,203^a$ Ar | $68^b\,203^b$ **1331** | $70^a\,207^a$ **1163, 1440, 619** | $70^a\,207^a$ **1163, 1442, 619** lionardo mio *etc. by an unknown hand* | $70^b\,207^b$ **632, 621** | $70^b\,208^b$ **1526, 1373, 1525** | $71^b\,209^b$ **616** | $72^b\,211^b$ **1016** Pl. CIX | $73^a\,214^a$ **669** | $75^a\,219^a$ **1275, 1170, 20, 1143, 1159** | $75^a\,200^a$ **1555** | $75^b\,219^b$ **1288, 1165, 847, 1207, 1200, 1335** | $75^b\,221^b$ **748**, Pl. LXXXI, No. 2 | $76^a\,223^a$ **1530** | $76^b\,223^b$ V, *voce d'eco* | $77^a\,225^a$ Ge | $77^b\,225^b$ **1556, 855** | $78^a\,228^a$ **610**, Pl. XXXVIII, No. 1, 472 | $83^b\,240^b$ **951** | $84^b\,245^a$ **51** | $85^a\,247^a$ **1149** | $86^a\,250^a$ Ge | $86^b\,250^b$ **1059** | $89^a\,258^a$ **836, 834** | $94^a\,271^a$ Ge | $94^b\,271^b$ **1557** | $94^b\,276^b$ **1093, 1111** | $98^b\,308^a$ **354** | $100^b\,313^b$ **64** | $103^a\,325^a$ **1371** | $108^a\,338^a$ *aqua, vino* | $108^b\,338^b$ **1185** | $108^b\,339^b$ **634** | $111^a\,345^a$ **1171**, O | $111^b\,345^b$ **865** | $113^a\,349^a$ **1443** | $114^{1/2\,b}\,355^b$ **128** | $115^a\,357^a$ **11, 1266** | $115^b\,357^b$ **1195** | $116^a\,359^a$ **1536** | $117^a\,361^a$ **1267, 1280** | $117^b\,361^b$ **12, 9, 21, 10** | $118^a\,366^a$ **1444** | $121^a\,375^a$ **1480** | $121^a\,376^a$ Ge | $121^b\,376^b$ **1558** | $123^b\,380^b$ **82** | $124^a\,383^a$ **248, 192, 246** | $124^b\,383^b$ **243, 983** | $127^b\,390^b$ **1309** | $130^a\,397^a$ **1559** | $130^a\,398^a$ **42** | $130^b\,398^b$ **151, 104** | $132^a\,401^a$ **1544** | $133^b\,404^b$ **70** | $136^a\,412^a$ **65** | $136^b\,412^b$ **25, 60** | $137^a\,414^a$ **1066** | $137^a\,415^a$ **593** | $139^a\,420^a$ **660** | $139^b\,419^b$ **1485** | 420^b **210** | 421^b **1012** | $142^a\,425^b$ **96** | $143^a\,426^a$ **1293**, Pl. CXVIII, Pl. CXIX, 1136 note | $143^b\,426^b$ **1336, 1294**, Pl. CXVI, CXVII | $145^a\,432^a$ **1446, 487** | 146^b

434^a **194** | 146 IIa 436^a **8** | $147^b\,439^b$ **1284** | $151^a\,449^a$ **1153** | $152^a\,451^a$ **611** | $152^a\,452^a$ **986** | $153^b\,455^b$ **1180** | $157^a\,463^a$ **309, 581, 526 note, 466** | $157^b\,466^a$ **961, 950, 979** | $162^b\,482^b$ **955** | $164^a\,490^a$ Ge | $164^b\,490^b$ **1560** | $171^a\,515^a$ Ge | $171^b\,515^b$ **1561** | $172^b\,516^b$ **1272** | $173^b\,520^b$ **233** | $174^a\,523^a$ **184** | $175^a\,526^a$ **1562** | $175^b\,526^b$ M, bombarda | $176^b\,533^b$ **725** | $176^b\,532^b$ **1446** | $176^b\,531^b$ **67** | $178^a\,536^a$ **374, 271** | $179^b\,541^b$ **1353** | $181^a\,546^a$ Ge | $181^b\,546^b$ **493**, Pl. CI, No. 2 | **280, 462**, V | $184^b\,555^b$ **189** | $185^a\,557^a$ *corda* | $185^b\,557^b$ **1447** | $187^a\,561^a$ Ge, **910** | $187^a\,562^a$ **273, 187**, Pl. IV, No 5 | $187^b\,562^b$ **1211** | $188^b\,564^b$ **1368** | $189^a\,565^a$ **1529** | $192^b\,571^b$ **279** | $196^b\,586^b$ **548, 490**, Pl. XXXI, No. 1 | $200^a\,594^a$ **13, 39** | $201^a\,597^a$ **54, 179**, Pl. IV, No. 4 | $201^b\,598^b$ **72** | $202^b\,599^b$ Pl. LXXXVI | $205^a\,605^a$ and 606^a *astronomy* | $207^a\,609^a$ **1469** | $211^a\,619^a$ **1030** | $211^b\,619^b$ **1031** | $211^b\,621^a$ **1337** | $212^b\,626^b$ **1084** | $212^b\,627^b$ **1537** | $213^a\,628^a$ *superfitie* | $213^b\,628^b$ **712**, Pl. LXXVI, No. 1 | $217^a\,641^a$ V, Mn | $217^b\,641^b$ Magnifico mio messer simone *(five lines, left to right)* | $218^b\,648^a$ **18** | $221^b\,661^b$ *sketch-map pavia, milan, lodi, brescia* | $222^a\,664^a$ **1448** | $223^b\,671^b$ **1172** | $227^b\,685^b$ **1563** | $228^b\,687^b$ **703** | $231^b\,696$ **1062** | $233^a\,700$ **1013** | $234^a\,702^a$ **890** | 237 IIb 715^b **191**, Pl. VI, No. 1 | $243^a\,727^a$ **1379** | $243^b\,727^b$ *vaso pieno*, Ma | $243^b\,729^a$ **1351** | $245^a\,731^a$ **1378**, Ge | $246^a\,733^a$ **111** | $248^a\,737^a$ M, **1364** | $252^b\,748^b$ **1531** | $256^a\,773^a$ **1105** | $258^a\,784^a$ **618, 1538** | 258^b **785**, *fedelissimo amico aviso ti come qui ne dì passati fu uno (not continued)* O Ma | $260^a\,793^a$ **1467** | $262^a\,799^a$ Pl. XCIX, No. 3 | 266 IIb 813^b Pl. LXXXVII, No. 1 | $270^a\,821^a$ **1032** | $272^b\,833^b$ **724**, O | *sketches of hats* | $278^a\,850^a$ **1352** | $278^b\,850^b$ Mn | $279^a\,855^a$ **1468** | $280^a\,857^a$ **759** | $284^a\,865^a$ **1003** | $284^b\,865^b$ **1479, 1177** | $286^b\,870^b$ **718** | $292^a\,888^a$ **826** | $292^b\,889^b$ *five lines about Rome, not by Leonardo* | $292^a\,891^a$ Mn | $293^b\,891^b$ Vol. II. p. 63. | $298^a\,902^a$ *notes about washing, and:* bucato di Salai | $300^b\,914^a$ **1287** | $303^a\,924^a$ Pl. C, No. 1 | $304^a\,925^a$ **1354** | $308^a\,938^a$ Pl. LXXXII, No. 1, A | $308^b\,939^b$ **1344** | $310^a\,944^a$ **1349** | $312^b\,949^b$ **1534** | $313^a\,951^a$ **730** | $313^b\,950^b$ **1449** | $316^a\,958^a$ **1346, 722** | $316^b\,958^b$ **1347** | $317^a\,959^a$ **680** | $318^a\,961^a$ **766** Pl. CIII, No. 3 | $321^b\,971^b$ **1092**, Pl. CXI, No. 2 | $328^a\,980^a$ **1388**, *sketch of a river* | $328^b\,983^b$ **1345, 723** | $929^a\,991^a$ *sketch map: castiglione aretino, montecchio etc.* | $329^b\,992^a$ *sketch map: Corneto, Valley of the Tiber* | $329^b\,993^a$ **1078, 1565** | $334^b\,1017^b$ **1564** | $337^b\,1062^b$ **598, 22** | 339^a, 1033^a **26** | $341^a\,1052^a$ **599, 382** | $341^b\,1055^a$ **908** | $344^b\,1066^a$ **388**, Pl. XXIV,

No. 2 | 346ᵃ, 1072ᵃ **478** | 349ᵃ 1085ᵃ **Vol. II p. 104 architectural drawing** | 350ᵃ 1089ᵃ **340** | 353ᵃ 1105ᵃ **1069** | 354ᵃ 1108ᵃ **Pl. LXXXIV** | 358ᵇ 1124ᵇ **1070, 1450** | 362ᵃ 1134ᵃ **1295** | 362ᵇ 1134ᵇ **975, 1296*** | 363ᵃ, 1136ᵃ **193** | 364ᵃ, 1138ᵃ Mn | 364ᵇ 1138ᵇ **1350** | 365ᵇ 1141ᵇ **1167** | 372ᵃ 1156ᵃ **1126** | 376ᵇ 1168 **1473** | 380ᵇ 1179ᵇ **1357** | 382ᵃ 1182ᵃ **1340, 719** | 384ᵇ 1189ᵇ **1112** | 387ᵃ. 1197ᵃ **1009, 1198ᵃ, Pl. LXXXII, No. 4** | 389ᵃ 1208ᵃ Ar | 393ᵇ 1222ᵇ Mn (*Last sheet*).

39—55.

39. *The drawings and MSS. by Leonardo in the Royal Library*, Turin, *are mounted on card. Card* 7 **319**, Pl. **XII** | 7ᵇ Mn | 25 Mn | 17 **1182** | 11 **320** | 1 **1369** Note, Pl. **I** | 5 Pl. **XLII** | 6 Pl. **CXX**.

40. Florence, *Uffizi Collection of drawings Frame* 115 No. 446 **663, 1383**. *A drawing of a machine is on the back.*—*Drawing of Landscape* (28 × 19¹/₂ Cm) *in a portfolio, not exhibited, not mounted nor numbered*. **1369**.

41. Venice, *Academy of Fine Arts, Room VIII, Frame IV*, 16, **315**, Pl. **IX**, *Frame V* | 1ᵃ *Notes on P* | 1ᵇ Pl. **XCIV**, No. 4, *Frame V* | 4ᵃ Pl. **LV** | 4ᵇ *Notes on P, Frame V* | 9ᵃ Pl. **LIV** | 9ᵇ *Motori de' corpi, notes* | *Frame VI* 3 Pl. **XVIII, 343** *Frame X*, 8, Pl. **XLVI, 668**.— *The drawing* Pl. **LIII** *is in a portfolio in the library of the Academy* (*exhibited in* 1883).

42. *Among the drawings by Leonardo in the Gallery of the Ambrosian Library there is only one with a MS. note:* **1456**.

43. *Collection of drawings, made by P. Resta, a large bound volume in the Ambrosian Library contains an anatomical drawing with notes by Leonardo.*

44. Munich, *Pinacoteca, a drawing with notes on warfare.*

45. *The collection of drawings made by* Vallardi, *a large volume in the Library of the* Louvre *contains a sheet with notes on arms and several drawings by* Leonardo, *but only two out of these bear on the subjects of this publication:* Pl. **LXXX** and Pl. **LXXX**, No. 1.

46. Louvre, *Collection of drawings, mounted on card* (*not exhibited*) *see* **Vol.** 1 *p*. 297 *and No.* **594** Note.

47. Paris, *Collection of drawings in the possession of* M. Armand; *a drawing with MS. note similar to that at* Munich *and to that in the Collection of* A. Morrison, Esq. London.

48. *British Museum, Printroom. Several drawings by* Leonardo: **1457** *and* Pl. **LII**, No. 2 *and a drawing with MS. notes on warfare.*

49. *A mounted sheet* Pl. **LXII**, No. 1 **664**, *in possession of* A. W. Thibaudeau, Esq. London.

50. *Collection of* A. Morrison, Esq. (*see* No. 47).

51. *Collection of the late Prince Henry of the Netherlands; one sheet containing notes and a diagram, referring to Perspective.*

52. *The five Manuscript sheets formerly in the possession of* Libri (*described in his catalogue of the reserved portion*), *were bought in* 1862 *by the Marquis of* Breadalbane. *After his death they came into the possession of the* Hon. Mr. Baillie Hamilton, Langton, Berkshire. *Here they seem to have mysteriously disappeared, and I have not been able to trace them any further.*

53. *In the Library of Christ Church Oxford; two mounted drawings preserved in portfolios. The first is marked* 4 *and has notes on machines, on weight and a sketch of a horseman fighting. The second is reproduced in parts in Vol. 1* Pl. **LIX**, Pl. **LX**, No. 1, Pl. **LXI 676, 677**.

54. Modena, Archivio Palatino: No. **1348**.

55. *Treatise of* Francesco di Giorgio, MS. *in possession of* Lord Ashburton, *with notes in* Leonardo's *handwriting written on the margin, on Fol.* 13ᵇ **767**, *on Fol.* 25ᵃ **952**, *on Fol.* 27ᵇ **44**. *Others on mechanics &c. on Fol.* 15ᵇ, 32ᵃ, 41ᵃ *and* 44ᵇ.

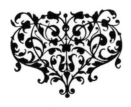